ISBN 0-8108-0311-9

Sculpture Index

by

Jane Clapp

**Volume 2 — Sculpture of the Americas,
the Orient, Africa, the Pacific Area,
and the Classical World
Part 1 : A-G**

The Scarecrow Press, Inc. Metuchen, N.J. 1970

Contents

Symbols for Books Indexed

ACA Art in California. A survey of American art with special reference to California painting, sculpture and architecture--past and present, particularly as those arts were represented at the Panama-Pacific International Exposition. San Francisco, R. L. Bernier Publisher, 1916

ADA Adams, Adeline Valentine. Spirit of American sculpture; written for the National Sculpture Society. New York, 1929

ADAM Adams, J. T., and others. Album of American history. 6 v. New York, Scribner, 1944-61. Volumes 1, 3, 5 indexed.

ADD Addison Gallery of American Art. Phillips Academy, Andover, Massachusetts. Handbook. 1939

ADL Adam, Leonard. Primitive art. 3rd ed. London, Cassells Co. Ltd., 1954

AGARC Agard, Walter Raymond. Classical myths in sculpture. Madison, University of Wisconsin Press, 1951.

AGARN Agard, Walter Raymond. The New architectural sculpture. New York, Oxford University Press, 1935

ALB Albright-Knox Art Gallery. Catalogue of painting and sculpture in the permanent collection. Edited by Andrew C. Ritchie. Buffalo, N. Y., Buffalo Fine Arts Academy, 1949

ALBA Albright-Knox Art Gallery. The Gallery. Samuel C. Miller, editor. Buffalo, New York

ALBB Albright-Knox Art Gallery. Contemporary British painting and sculpture, from the collection of the Albright-Knox Art Gallery and special loans. Buffalo, N. Y., Albright-Knox Art Gallery, 1964

ALBC Albright-Knox Art Gallery. Catalogue of contemporary paintings and sculpture. The Room of Contemporary Art Collection. Edited by Andrew C. Ritchie, Buffalo, N. Y., Buffalo Fine Arts Academy, 1949.

i

ALBC--1-4 Albright-Knox Art Gallery. Contemporary Art: Acquisitions Buffalo, N. Y.

--1 1954-1957 --3 1959-1961
--2 1957-1958 --4 1962-1965

ALBG Albright-Knox Art Gallery. Gifts to the Albright-Knox Art Gallery from A. Conger Goodyear, December 14-January 6, 1963

ALBK Buffalo Fine Arts Academy. Albright-Knox Art Gallery. Kinetic and optic art today, catalog of an exhibit February 27-March 28, 1965. Buffalo, N. Y., Buffalo Fine Arts Academy, 1965

AM Brussels. Exposition Universelle et Internationale, 1958. American art: four exhibitions. 17 April to October 18, 1958. New York, American Federation of Arts, 1958

AMA Amaya, Mario. Pop as art, a survey of the New Super Realism. London, Studio Vista, 1965 Published in U. S. under title: Pop Art...and after. New York, Viking Press, 1966

AMAB American Abstract Artists. World of abstract art. New York, George Wittenborn, 1957

AMF American Federation of Arts. Art in our country, handbook. Washington, D. C., American Federation of Arts, 1923

AMHI American Heritage. Book of Indians. American Heritage; distributed by Simon and Schuster, 1961

AMHP American Heritage. American Heritage book of the pioneer spirit. American Heritage; distributed by Simon and Schuster, 1959

AMON Amon Carter Museum of Western Art, Fort Worth, Texas. The artist's environment: West Coast, an exhibition presented by the Amon Carter Museum of Western Art, Fort Worth, Texas, in collaboration with the University of California at Los Angeles Art Galleries and the Oakland Art Museum, 1962-1963. 1962

AP American Philosophical society. A catalogue of portraits and other works of art in the possession of the American Philosophical Society. Philadelphia, The Society, 1961 "Every president until very recent years is represented, with the addition also of many other officers and distinguished members." (p. v)

ARN Arnheim, Rudolf. Art and visual perception:
Psychology of the creative eye. Berkeley,
University of California, 1957

ART Artist in America, Editors. The artist in
America. New York, W. W. Norton, 1967

ARTA Art of Australia, 1788-1941; an exhibition of
Australian art... under the auspices of the
Carnegie Corporation. Published for the
Carnegie Corporation by the Museum of
Modern Art, New York, 1941.

ARTJ Art treasures from Japan. Catalog of an ex-
hibition held jointly by the National Commis-
sion for Protection of Cultural Properties and
the participating museums in the United States
of America and the Dominion of Canada.
Tokyo, Kodansha International, 1965

ARTS Arts Council of Great Britain. Welsh Committee.
Sculpture 1961. London, Arts Council, 1961

ARTSA Arts Council of Great Britain. Background, the
artist and his environment: Alan Davie,
Merlyn Evans, Ivon Hitchens, Victor Pasmore.
London, Arts Council, 1965

ARTSB Arts Council of Great Britain. Contemporary
British sculpture

 --58 1958 --64 1964
 --61 1961 --65 1965
 --62 1962 --66 1966

ARTSBR Arts Council of Great Britain. Welsh Committee.
British art and the modern movement, 1930-
1940. London, Arts Council, 1962

ARTSC Arts Council of Great Britain. Construction
England. London, Arts Council, 1963

ARTSCH Arts Council of Great Britain. Chromatic
sculpture (folder). London, Arts Council, 1966

ARTSI Arts Council of Great Britain. Twenty Italian
sculptors. London, Arts Council, 1966

ARTSM Arts Council of Great Britain. In motion, an
Arts council evolution of kinetic art. London,
Arts Council, 1966

ARTSN Arts Council of Great Britain. Art Nouveau in
Britain. London, Arts Council, 1965

ARTSP Arts Council of Great Britain. Painters of the
Brucke. London, Arts Council, 1964

ARTSR Arts Council of Great Britain. Edinburgh
Festival Society. Rumanian art treasures:
Fifteenth to eighteenth century. London, Arts
Council, 1965

ARTSS	Arts Council of Great Britain. Sculpture from the Arts Council collection. London, Arts Council, 1965
ARTST	Arts Council of Great Britain. Towards Art II, sculptors from the Royal College of Art. London, Arts Council, 1965
ARTSW	Arts Council of Great Britain. Welsh Committee. Art in Wales. London, Arts Council, 1962
ARTSY	Arts Council of Graet Britain. Contemporary Yugoslav painting and sculpture. London, Arts Council, 1961
ARTV	Art treasures from the Vienna collections, lent by the Austrian government, 1949-1950
AS	Asia Society. Masterpieces of Asian art in American collections, as shown in Asia House, New York City, January-February, 1960. New York, Asia Society, 1960
ASH	Ashton, Leigh, and Basil Gray. Chinese Art. 6th impression. London, Faber and Faber, 1953
ASHS	Ashton, Leigh, ed. Style in sculpture. London, Oxford University Press, 1947 Account of changes in style during last 1,000 years. Basedon an exhibition held at Victoria and Albert Museum, London, in 1946
AUB	Auboyer, Jeannine, and Robert Goepper. The Oriental world, New York, McGraw-Hill Book Co. , 1967
AUBA	Aubert, Marcel. Art of the High Gothic Era (original French title: Le Triomphe de l'Art Gothique). New York, Crown Publishers, 1965
AUES	Auerbach, Arnold. Sculpture, a history in brief. London, Elek Books, 1952
AUM	Aumonier, William, ed. Modern architectural sculpture. New York, Scribner, 1930
BAA	Baal-Teshuva, Jacob. Art treasures of the United Nations. New York, Thomas Yoseloff, 1964
BALD	Baldinger, Wallace S. , and Harry B. Green. The visual arts. New York, Holt, Rinehart, and Winston, 1960
BALTW	Baltimore Museum of Art. Alan Wurtzburger Collection of African sculpture. Baltimore, Baltimore Museum of Art, 1958
BAN	Bandi, Hans-Georg. Art of the Stone Age. London, Methuen; New York, Crown Publishers, 1961
BAR	Barbanson, Adrienne. Fables in ivory; Japanese netsuke and their legends. Rutland, Vt. , Charles E. Tuttle, 1961

BARD Bardi, P. M. Colorslide tour of the museum of Sao Paulo, Brazil. New York, Harry N. Abrams (Panorama Colorslide Art Program, v. 7)

BARD--2 Bardi, P. M. The arts in Brazil; a new museum at Sao Paulo. Milan, Edizione del Milione, 1956

BARG Palace of the Bargello, and the National Museum. Handbook and itinerary. Florence. Arnaud Publisher, 1963 (Mirabilia Series)

BARSTOW Barstow, Charles L. Famous Sculpture. New York, The Century Company, 1921

BAS Baschet, Jacques. Sculpteurs de ce temps. Paris, Nouvelles editions francaises, 1946

BATT Batten, Mark. Stone sculpture by direct carving. London, Studio Publications, 1957

BAUR Baur, John I. H. Revolution and tradition in modern American art. Cambridge, Harvard University Press, 1951

BAZINB Bazin, Germain. Baroque and Rococo art. London, Thames and Hudson; New York, Frederick A. Praeger, Publishers, 1964

BAZINH Bazin, Germain. A history of art from prehistoric times to the present. New York, Houghton Mifflin, 1959

BAZINL Bazin, Germain. The loom of art. New York, Simon and Schuster, 1962

BAZINW Bazin, Germain. World history of sculpture. Greenwich, Ct., New York Graphic Society, 1968

BEAZ Beazley, John Davidson, and Bernard Ashmole.
4074. 01-103 Greek sculpture and painting to the end of the Hellenistic Period. Cambridge, Cambridge University Press; New York, Macmillan, 1932 Reprint of chapters on Greek art in Cambridge Ancient History--text revised and new pictures added

BECK Beckwith, John. Art of Constantinople. New York, Phaidon Publishers; distributed by New York Graphic Society, 1961

BECKC Beckwith, John. Coptic sculptures, 300-1300. London, Alec Tiranti, 1963

BECKM Beckwith, John. Early Medieval art. London, Thames & Hudson; New York, Frederick A. Praeger, Publishers, 1964

BED Beddington, Jack. Young artists of promise. London, New York, Studio Publications, 1951

BEN	Benesch, Otto. Art of the Renaissance in Northern Europe. New York, Phaidon Publishers; distributed by New York Graphic Society, 1965
BER	Berlin. Akadamie der Kunste. Tscheckoslowakische Kunst der Gegenwart. Berlin, Akademie der Kunste, 1966
BERCK	Berckelaers, Ferdinand Louis. The sculpture of this century, by Michel Seuphor (pseud). New York, George Braziller, 1960
BEREP	Berenson, Bernard. The passionate sightseer; from the diaries, 1947 to 1956. New York, Simon and Schuster, 1960
BERL	Berlin. Staatliche Museen. Art treasures from the Berlin State Museums. Introduction by John Russell. Leipsig, Edition Leipsig, 1962; New York, Harry N. Abrams, 1964
BERLE	Berlin. Staatliche Museen zu Berlin. Deutche Bildwerke aus seiben Jahrhunderten. Berlin, Museen, Skulpturen-Sammlung, 1958
BERLEI	Berlin. Staatliche Museen zu Berlin. Italien-ische Plastik des 15-17 Jahrhunderts. Museen, Skulpturen-Sammlung, 1963
BERLEK	Berlin. Staatliche Museen zu Berlin. Kunstwerke der Skulpturen-Sammlung in Bode-Museen. Berlin, 1962
BERLER	Berlin. Staatliche Museen zu Berlin. Romische Skulpteren, Antiken-Sammlung. Berlin, Museen zu Berlin, 1965
BERLES	Berlin. Staatliche Museen zu Berlin. Staatliche Museen zu Berlin. Leipzig, Veb Edition, 1963 "...a selection from the most beautiful and precious objects...of every department." Text in German, English, French
BIB	The Bible in art; miniatures, paintings, draw-ings and sculptures inspired by the Old Testament. London, Phaidon Press, 1956
BIH	Bihalji-Merin, Oto. Yugoslav sculpture in the twentieth century. Beograd, Mihajlova, 1955
BISH	Bishop, Minor L. Fountains in contemporary architecture. New York, October House, 1965
BL	Lothrop, S. K. Pre-Columbian art: Robert Woods Bliss Collection. Text and critical analyses by S. K. Lothrop. London, Phaidon Press, 1957
BLUA	Blunt, Anthony. Art and architecture in France, 1500-1700. London, Penguin Books, 1953
BLUC	Blunt, Cyril George Edward. A history of Russian art, from Scyths to Soviets. London, New York, Studio Publications, 1946

BMA	Baltimore Museum of Art. 200 objects in the Baltimore Museum of Art, compiled by Gertrude Rosenthal. Baltimore, The Museum, 1955
BMAF	Baltimore Museum of Art. 1914--Fiftieth Anniversary exhibition. Baltimore, The Museum, 1964
BO	Boardman, John. Greek art. London, Thames & Hudson; New York, Frederick A. Praeger, Publishers, 1964
BOA	Boas, Franz. Primitive art. Paper reprint. New York, Dover, 1955 Unabridged reprint of first edition of 1927
BOAS	Boase, T. S. R. English art, 1100-1216. Oxford, Clarendon Press, 1953
BOASE	Boase, T. S. R. English art, 1800-1870. Oxford, Clarendon Press, 1959
BODE	Bode, Wilhelm von. Florentine sculptors of the Renaissance. 2nd ed., rev. London, Methuen; New York, Scribner, 1928
BOE	Boeck, Urs. Sculpture on buildings. London, A. Zemmer; New York Universe Books, 1961 Plastik am Bau; beispiele europaischer bauplastic vom altertum bus zur neuzeit
BOES	Boesen, Gudmund. Danish museums. Copenhagen, Committee for Danish Cultural Activities Abroad, 1966
BON	Bonython, Kim. Modern Australian painting and sculpture, a survey of Australian art from 1950-1960. Adelaide, Griffin Press, 1960
BOSMA	Boston Museum of Fine Arts. Arts of the Near East. Boston, Museum of Fine Arts; distributed by October House, 1962
BOSME	Boston Museum of Fine Arts. European masters of our time, catalog of an exhibition at the museum October 10 through November 17, 1957. Boston, The Museum, 1957
BOSMEG	Boston Museum of Fine Arts. Ancient Egypt as represented in the Museum of Fine Arts, Boston. Text by William S. Smith. 4th ed. New York, Beacon Press, 1960
BOSMG	Boston Museum of Fine Arts. Greek Gods and Heroes. 5th ed. Boston, The Museum, 1962
BOSMGR	Boston Museum of Fine Arts. Greek and Roman portraits, 470 B. C. - A. D. 500, by Cornelius Vermeule. Boston, The Museum, 1959

vii

BOSMI	Boston Museum of Fine Arts. Illustrated handbook. Boston, The Museum, 1964
BOSMP	Boston Museum of Fine arts. Masterpieces of primitive art, catalog of an exhibition held at the Museum, October 16 through November 23, 1958. Boston, The Museum; distributed by October House, 1958
BOSMT	Boston Museum of Fine Arts. The Trojan War in Greek art, a picture book. Boston, The Museum, 1965
BOSTA	Boston. Institute of Contemporary Art. American art since 1950. Loan exhibition sponsored by the Poser Institute of Fine Arts, Brandeis University, and Institute of Contemporary Art, Boston, November 21-December 23, 1962. Boston, The Institute, 1962
BOW	Bowness, Alan. Modern sculpture. London, Studio Vista Limited; New York, E. P. Dutton, 1965
BOWR	Bowra, C. M. Classical Greece. New York, Time, Inc. 1965
BOY	Boyd, E. Popular arts of Colonial New Mexico. Santa Fe, Museum of International Folk Art, 1959
BOZ	Bozhkov, Atanas. Bulgarian art. Sofia, Foreign Language Press; distributed by Vanous, 1964
BR	Encylopaedia Britannica. Chicago, Encyclopaedia Britannica, Inc. , 1966
Index of illustrations in Sculpture article, v. 20	
BRIE	Brieger, Peter. English art, 1216-1307. Oxford, Clarendon Press, 1957
BRIO	Brion, Marcel. Art of the Romantic Era. London, Thames & Hudson; New York, Frederick A. Praeger, Publishers, 1966
BRION	Brion, Marcel, ed. Art since 1945. New York, Harry N. Abrams, 1958
BRIONA	Brion, Marcel. Animals in art. New York, Franklin Watts, 1959
BRIONR	Brion, Marcel. Romantic art. New York, McGraw-Hill, 1960
BRIT	Great Britain. British Council. British Pavilion: Five young British artists, XXXIII Venice Biennale, 1966
BRITM	British Museum. General Introductory Guide to the Egyptian collection in the British Museum, by I. E. S. Edwards. London, British Museum, 1964
BRO	Broadbent, Arthur Tee. Sculpture today in Great Britain, 1940-1943. London, John Tiranti, Ltd. , 1944

BROO Brookgreen Gardens, Brookgreen, South
Carolina. Brookgreen Gardens, sculpture, by
Beatrice Gilman Proske. Brookgreen, S. C.,
printed by order of the Trustees, 1943

BROWF Brown, Frank P. English Art Series--3 vols in
1. London, Isaac Pitman & Sons, 1933
V. 1 London Buildings; v. 2 London Paintings;
V. 3 London Sculpture

BROWMS Brown, Milton Wolf. The story of the Armory
Show. New York, Joseph H. Hirshhorn
Foundation, 1963

BRUM Brumme, Carl Ludwig. Contemporary American
sculpture. New York, Crown Publishers, 1948

BRY Bryson, Lyman, ed. An outline of man's knowl-
edge of the modern world. New York, McGraw-
Hill Book Co., 1960

BSC Berlin. Staatliche Museen (Berlin-Dahlem). Bild-
werke des christlichen Epochen von der
Spatantike bis zum Klassizismus, aus den
Bestanden der Skulpturenabteilung. Berlin-
Dahlem, Preussischer Kulturbesitz; Munchen,
Prestel-Verlag, 1966

BUH Buhler, Alfred, et al. The art of the South Sea
Islands. New York, Crown Publishers, 1962

BUL Bullard, Frederic Lauristen. Lincoln in marble
and bronze. New Brunswick, Rutgers Uni-
versity Press, 1952
Published for the Abraham Lincoln Associa-
tion, Springfield, Illinois

BULL Bulliet, Clarence Joseph. Art masterpieces in a
Century of Progress fine arts exhibition at
the Art Institute of Chicago. Chicago, North-
Mariano Press, 1933
V. 1 indexed

BURC Burckhardt, Jacob Christoph. Civilization of the
Renaissance in Italy. 3rd rev ed. London, New
York, Oxford University Press, 1960 reprint

BURL Burling, Judith, and Arthur Hart Burling.
Chinese art. London, Studio Publications,
1953

BURN Burnham, Jack. Beyond modern sculpture: The
effects of science and technology upon the
sculpture of this century. New York, George
Braziller, 1968

BUSB Busch, Harald, and Berud Lohse, eds. Baroque
sculpture. Frankfurt, U. M. Schau Verlag;
London, B. T. Batsford; New York, Macmillan
Co., 1964

BUSG	Busch, Harald, ed. Gothic Europe. London, B. T. Batsford; New York, Macmillan Co., 1959
BUSGS	Busch, Harald, and Bernd Lohse, eds. Gothic sculpture. New York, Macmillan Co., 1963
BUSH	Bushnell, G. H. S. Ancient arts of the Americas. New York, Frederick A. Praeger, Publishers, 1965
BUSR	Busch, Harald, and Bernd Lohse, eds. Renaissance sculpture. London, B. T. Batsford, 1962; New York, Macmillan Co., 1964
BUSRO	Busch, Harald, and Bernd Lohse, eds. Romanesque sculpture. London, B. T. Batsford, 1962; New York, Macmillan Co., 1963
BUT	Butterfield, Roger. The American past. New York, Simon and Schuster, 1947
CAB	Cabanne, Pierre. Great collectors. New York, Farrar Straus, 1963
CAF	Caffin, Charles H. American masters of sculpture. New York, Doubleday, Page & Co., 1903
CAH	Cahill, Holger, and Alfred H. Barr, eds. Art in America; a complete survey. New York, Reynal & Hitchcock, 1935
CAHA	Cahill, Holger, and Alfred H. Barr, eds. Art in America in modern times. New York, Reynal & Hitchcock, 1934
CAL	Calvesi, Maurizio. Treasures of the Vatican. Geneva, Editions d'Art Skira; distributed by World Publishing Co., 1962
CALA	Calas, Nicolas, and Elena Calas. The Peggy Guggenheim Collection of Modern art. New York, Henry N. Abrams, 1966
CALF	California State Fair & Exposition, Sacramento. Catalog of Art Exhibit. Sacramento 17 catalogs indexed: --48 1948 to --65 1965. 1964. catalog not available locally
CAM	Montreal. Museum of Fine Arts. Handbook of the Collections--painting, sculpture, decorative arts. Montreal, The Museum, 1960
CAMI	Montreal. Museum of Fine Arts. Images of the Saints (L'Art et Les Saints), exhibition catalog, March 5-April 4, 1965. Montreal, The Museum, 1965
CAN	Ottawa. National Gallery of Canada. Catalogue of paintings and sculpture, edited by R. H. Hubbard. v. 1. Older Schools. Toronto, University of Toronto Press, 1957

CAN--2	_____. v. 2 Modern European schools. 1959
CAN--3	_____. v. 3. Canadian schools
CAN--4	Ottawa. National Gallery of Canada. 300 years of Canadian art. Ottawa, National Gallery, 1967
CANK	Canaday, John. Keys to art. New York, Tudor Publishing Co., 1962
CANM	Canaday, John. Mainstreams of modern art. New York, Simon and Schuster, 1959
CARL	Carli, Enzo. Musei Senesi. Novara, Instituto Geografico de Agostini, 1961 Musei e Monumenti series
CARNI	Carnegie Institute. Department of Fine Arts. Pittsburgh International Exhibition of Contemporary Painting and Sculpture. The Institute 4 catalogs indexed since 1952, when exhibition became triennial:

--58	1958
--61	1961
--64	1964
--67	1967

CARP	Carpenter, Edward. A House of Kings; the history of Westminster Abbey. London, John Baker, 1966
CARPE	Carpenter, Rhys. The esthetic basis of Greek Art. New York, Longmans, Green, 1921; reprint Bloomington, Indiana University Press, 1959
CARPG	Carpenter, Rhys. Greek sculpture: A critical review. Chicago, University of Chicago Press, 1960
CARR	Carrieri, Raffaele. Pittura, scultura d'avanguardia (1890-1950) in Italia. Milan, Edizione della Conchiglia, 1950
CART	Carter, Dagny Olsen. Four thousand years of China's art. rev ptg. New York, Ronald Press, 1951
CARTW	Cartwright, W. Aubrey. Guide to art museums in the United States. East Coast--Washington to Miami. New York, Duell, Sloane & Pearce, 1958
CAS	Cassou, Jean, et al. Gateway to the twentieth century, New York, McGraw-Hill Book Co., 1962 French title: Les Sources du XXe siecle, les arts en Europe de 1884 a 1914. Exhibit Nov 4, 1960 - Jan 23, 1961, Paris, Musee d'art moderne. London, Thames & Hudson, 1962

CHICA	Chicago. Art Institute. Annual American exhibition of paintings and sculpture. Chicago, The Institute

Chicago. Art Institute. Annual American exhibition of paintings and sculpture. Chicago, The Institute
31 catalogs listed: 24th (1911) through 60th (1951)--broken listings:

--24	1911	--35	1922	--45	1932
--25	1912	--36	1923	--46	1935
--26	1913	--37	1924	--47	1936
--27	1914	--38	1925	--48	1937
--28	1915	--39	1926	--49	1938
--29	1916	--40	1927	--51	1940
--30	1917	--41	1928	--52	1941
--31	1918	--42	1929	--53	1942
--32	1919	--43	1930	--54	1943
--33	1920	--44	1931	--60	1951
--34	1921				

CHICB Chicago. Art Institute. Brief illustrated guide to the collections. Chicago. The Institute, 1941

CHICC Chicago. Art Institute. Chicago collects, September 20-October 27, 1963. Chicago, The Institute, 1963

CHICH Chciago. Art Institute. Half a century of American art, November 16, 1939-January 7, 1940. Chicago, The Institute, 1939

CHICP--1 Chicago. Art Institute. Catalogue of a Century of Progress exhibition of paintings and sculpture, lent from American collections, edited by D. C. Rich. 2nd ed. Chicago, The Institute, 1933

CHICP--2 Chicago. Art Institute. Catalogue of a century of Progress exhibition of paintings and sculpture. Chicago, The Institute, 1934

CHICS Chicago. Art Institute. Modern sculpture in the collections of the Art institute of Chicago. Chicago, The Institute, 1940

CHICSG Chicago. Art Institute. Sculpture: A generation of innovation, catalog for exhibit, June 23-August 27, 1967. Chicago, The Institute, 1967

CHICT Chicago. Art Institute. Treasures of Versailles, a loan exhibition from the French Government..., 1962-1963. Chicago, The Institute, 1962

CHR Christensen, Erwin O. The index of American design. New York, Macmillan Co., 1950

CHRH Christensen, Erwin O. History of western art. New York, New American Library (Mentor), 3rd ptg 1961

CHRP Christensen, Erwin O. Pictorial history of western art. New York, New American Library, 1964

CIN Cincinnati. Art Museum. Contemporary American sculpture, works by artists resident in Ohio, Indiana, Illinois, Michigan, Wisconsin, Minnesota, Kentucky, and Missouri. Cincinnati, Art Museum, 1961

CIR Cirici-Pellicer, Alexander. Treasures of Spain, from Charles V to Goya. Geneva, Editions d'Art Skira, 1965

CLAK Clark, Kenneth. The nude: a study in ideal form. New York, Pantheon Books, 1956

CLE Cleveland Museum of Art. Handbook. Cleveland, The Museum, 1966

CLEA Cleveland Museum of Art. Paths of abstract art, by Edward B. Henning. Cleveland, The Museum; distributed by Harry N. Abrams, 1960

COL Collier's Encyclopedia. New York, Crowell-Collier, and Macmillan, 1966
Index of illustrations in Sculpture article

COLG Colgate, William G. Canadian art, its origin and development. Toronto, Ryerson Press, 1943

COLW Colonial Williamsburg, Inc. The Abby Aldrich Rockefeller folk art collection, a descriptive catalog by Nina Fletcher Little. Boston, Little, Brown, 1957

CON The Connoisseur Period Guides, ed by Ralph Edwards and L. G. G. Ramsey. 6 vol. New York, Reynal and Co. 1957
--1 The Tudor Period, 1500-1603
--2 The Stuart Period, 1603-1714
--3 The Early Georgian Period, 1714-1760
--4 The Late Georgian Period, 1760-1810
--5 The Regency Period, 1810-1830
--6 The Early Victorian Period, 1830-1860

COOMA Coomaraswamy, Ananda K. Arts and crafts of India and Ceylon. New York, Farrar, Straus, 1964

COOMH Coomaraswamy, Ananda K. History of Indian and Indonesian art. New York, E. Weyhe, 1927; reprint, New York, Dover Publications, 1965

COOP Cooper, Douglas. Great private collections. New York, Macmillan Co., 1963

COOPC Cooper, Douglas. Courtauld Collection. University of London, Athlone Press, 1954

COOPF Cooper, Douglas. Great family collections. London, Weidenfeld and Nicolson; New York, Macmillan Co. , 1965

COPGE Copenhagen. Ny Carlsberg Glyptothek. Egyptian sculpture in the Ny Carlsberg Glyptothek, by Otto Koefoed Petersen. Copenhagen, 1962

COPGG Copenhagen. Ny Carlsberg Glyptothek. Guide to the collections, by Vagn Poulsen. 11th ed. Copenhagen, 1966

COPGM Copenhagen. Ny Carlsberg Glyptothek. Moderne skulptur dans og udenlandsk, by Haarvard Rostrup. Copenhagen, 1964

COR Corcoran Gallery of Art, Washington, D. C. Illustrated handbook of paintings, sculpture, and other art objects (exclusive of the W. A. Clark Collection). Washington, D. C. , The Gallery, 1939

CPL California Palace of the Legion of Honor, San Francisco, California. Handbook of the collections. 4th ed. San Francisco, The Palace, 1960

CRAVR Craven, Thomas A. The rainbow book of art. Cleveland, World Publishing Co. , 1956

CRAVS Craven, Wayne. Sculpture in America. New York, Thomas Y Crowell, 1968

CRU Crump, Charles George, ed. Legacy of the middle ages. Oxford, Oxford University Press, 1926; 1962 reprint

CUM Cummings, Paul. A dictionary of contemporary American artists. New York, St. Martin's Press, 1966

DA--1 --2 Davidson, Marshall B. Life in America. Boston, Houghton Mifflin, 1951 2 v

DAIN Daingerfield, Marjorie Jay. The fun and fundamentals of sculpture. New York, Scribner, 1963

DAM Damaz, Paul. Art in European architecture. New York, Reinhold Publishing Corp. , 1956

DAN Daniel, Howard. Adventures in art, a guide to gallery-going. London, New York, Abelard-Schumann, 1960

DECR Decker, H. Romanesque art in Italy. London, Thames & Hudson; New York, Harry N. Abrams, 1960

DENV Denver. Art Museum. Guide to the collection. Denver, The Museum, 1965

DENVK Denver. Art Museum. Samuel H. Kress Col-
 lection of paintings and sculpture. Denver,
 The Museum, 1954
DESA Desroches-Noblecourt, Christiane. Ancient
 Egypt; the New Kingdom and the Amarna
 Period. London, Oldbourne Press; Greenwich
 Ct., New York Graphic Society, 1960
DETC Detroit Institute of Arts. Collection in progress:
 selections from the Lawrence and Barbara
 Fleischman collection of American art.
 Detroit, The Institute, 1955
DETD Detroit Institute of Arts. Decorative arts of the
 Italian Renaissance, 1400-1600, exhibition in
 memoriam--William R. Valentiner, Nov 18,
 1958-Jan 4, 1959. Detroit, The Institute, 1958
DETF Detroit Institute of Arts. Flanders in the fif-
 teenth century, exhibit Oct-Dec 1960.
 Detroit, The Institute, 1960
DETI Detroit Institute of Arts. Art in Italy, 1600-1700,
 organized by Frederick Cummings. Detroit,
 The Institute; distributed by Harry N. Abrams,
 New York, 1965
DETS Detroit Institute of Arts. Sculpture in our time:
 Italy, France, Germany, Russia, Spain,
 Great Britain, the United States; collected by
 Joseph H. Hirshhorn, exhibit May 5-August
 23, 1959. Detroit, The Institute, 1959
DETT Detroit Institute of Arts. Treasures from the
 Detroit Institute of Arts. Detroit, The
 Institute, 1960
DEVA Devambez, Pierre. Greek sculpture. New York,
 Tudor Publishing Co., 1960
DEVI--2 Devigne, Marguerite. Art treasures of Belgium,
 1951-1954. 2 v. New York, Belgian Govern-
 ment Information Center, 1954
 v 2, with subtitle: Sculpture, indexed
DEW Dewey, John. Art as experience. New York,
 Minton, Balch & Co., 1934
DEY De Young Memorial Museum, San Francisco.
 Illustrations of selected works. San
 Francisco, The Museum, 1950
DEYE De Young Memorial Museum. European works
 of art in the De Young Museum. Berkeley,
 Diablo Press, for the de Young Museum
 Society, 1967
DEYF De Young Memorial Museum. Frontiers of
 American art. San Francisco, 1939

DIS Disselhoff, Hans Dietrich, and Sigvald Linne. Art of ancient America. London, Methuen; New York, Crown Publishers, 1960

DIV De Valentin, Maria M., and Louis de Valentin. Everyday pleasures of sculpture. New York, James H. Heineman, 1966

DOCA Dockstader, Frederick J. Indian art in America: The arts and crafts of the North American Indian. Greenwich, Ct., New York Graphic Society, 1961

DOCM Dockstader, Frederick J. Indian art in Middle America: Precolumbian and contemporary arts and crafts of Mexico, Central America, and the Caribbean. Greenwich, Ct., New York Graphic Society, 1964

DOCS Dockstader, Frederick J. Indian art in South America: Pre-Columbian and contemporary arts and crafts. Greenwich, Ct., New York Graphic Society, 1967

→ DODD Dodd, Loring Holmes. The golden age of American sculpture, an anthology. Boston, Chapman & Grimes, 1936

DOU Douglas, Frederick H., and Rene d'Harnoncourt. Indian art of the United States. New York, Museum of Modern Art; distributed by Simon and Schuster, New York, 1941

DOV Dover, Cedric. American Negro art. 2nd ed. Greenwich, Ct., New York Graphic Society, 1960

DOWN Downer, Marion. The story of design. New York, Lothrop, Lee and Shepard Co., 1963

DR Drioten, Etienne. Egyptian art. New York, Golden Griffin Books, 1950

DREP Drepperd, Carl W. Pioneer America, its first three centuries. Springfield, Mass, Pond-Ekberg Co.
Reprint of 1949 ed published by Doubleday

DUNC Duncan, David Douglas. The Kremlin. Greenwich, Ct., New York Graphic Society, 1960

DUR Durant, Will J. Story of Civilization. v 4. Age of Faith. New York, Simon and Schuster, 1950

DURS Durst, Alan, Wood carving. rev ed. London, New York, Studio Publications, 1959

EA Encyclopedia Americana, International Edition. New York, Americana Corp., 1967
Index of illustrations in Sculpture article, v. 24

ELIS Eliscu, Frank. Sculpture: Techniques in clay, wax, slate. Philadelphia, Chilton Co., 1959

ENC Encyclopaedia of the arts, consulting editor Herbert Read. London, Thames & Hudson; New York, Meredith Press, 1966

ESC Monastery San Lorenzo de El Escorial. Tourist guide, text and notes by Matilde Lopez Serrano. 2nd ed. Madrid, Editorial "Patrimonio Nacional", 1966

ESD Esdaile, K. E. English church monuments, 1510-1840. London, B. T. Batsford, 1946; New York, Oxford University Press, 1947

EVJE Evans, Joan. English art, 1307-1461. Oxford, Clarendon Press, 1949

EVJF Evans, Joan. Art in Medieval France, 987-1498. London, New York, Oxford University Press, 1948

EVJL Evans, Joan. Life in Medieval France. London, Phaidon Press, 1957

EX Expo 67. Official guide. Toronto, Maclean-Hunter Publishing Co., 1967

EXM Expo 67. Man and his world: International Fine Arts Exhibition, 28 April-27 October, 1967. Montreal, Expo 67, 1967

EXS Expo 67. International exhibition of contemporary sculpture, introduction by Guy Robert. Montreal, Expo 67, 1967

FAA Fagg, William Butler, and Margaret Plass. African sculpture, an anthology. London, Studio Vista, Ltd.; New York, E. P. Dutton & Co., 1964

FAAN Fagg, William Butler. Nigerian images; the splendor of African sculpture. London, Lund Humphries; New York, Frederick A. Praeger, Publishers, 1963

FAIN Faison, Samson Lane. A guide to the art museums of New England. New York, Harcourt Brace & Co., 1958

FAIR Fairman, Charles E. Art and artists of the Capitol of the United States of America. Washington, D. C., U. S. Government Printing Office, 1927
 69th Congress, 1st Session. Senate Document No. 95

FAIY Faison, Samson Lane. Art Tours and detours in New York State. New York, Random House, 1964

FAL	Faldi, Italo. Galleria Borghese, le sculture dal secolo XVI al XIX. Rome, Istituto Poligrafico dello Stato, 1954
FAUL	Faulkner, Ray Nelson, et al. Art today, an introduction to the fine and industrial arts. 4th ed. New York, Holt, 1963
FEIN	Feininger, Andreas. Maids, madonnas and witches. New York edition, Harry N. Abrams, 1961
FIN	Finlay, Ian. Art in Scotland. London, Oxford University Press, 1948
FISH	Fisher, Ernest Arthur. An introduction to Anglo-Saxon architecture and sculpture. London, Faber & Faber, 1959
FLEM	Fleming, William. Arts and ideas. rev ed. New York, Holt, 1963
FOC--1 --2	Focillon, Henri. Art of the west in the Middle Ages. 2 v. London, Phaidon Press; Greenwich, Ct., New York Graphic Society, 1963 v 1. Romanesque art v 2. Gothic art
FOU	Fourcade, Francois. Art treasures of the Peking Museum. New York, Harry N. Abrams, 1965
FPDEC	Musee des Arts Decoratifs, Palais de Louvre, Pavillon de Marsan. Catalogue jeune peinture, jeune sculpture, biennale 57. Paris, 1957
FPMO	Musee d'art Moderne de la Ville de Paris. Onze sculpteurs americains de l'Universite de California, Berkeley. Exhibit 28 Sept-3-Nov, 1963
FRA	Frankfurt, Henri. Art and architecture of the ancient orient. 3rd revd impression. Hammondsworth, Baltimore, Penguin Books, 1963
FREED	Freeden, Max Hermann von. Gothic sculpture, the intimate carvings. Greenwich, Ct., New York Graphic Society, 1962
FREEMR	Freeman, Lucy Jane. Italian sculpture of the Renaissance. New York, Macmillan Co., 1901, reprinted 1927
FREM	Fremantle, Anne. Age of faith. New York, Time, Inc., 1965
FRIED	Friedman, B. H., ed. School of New York: Some younger artists. London, Evergreen Books; New York, Grove Press, 1959
FRY	Fry, Roger, Vision and design. New York, Brentano's, 1920; reprint 1947, Meridian
FRYC	Fry, Roger. Chinese art. 5th impression. London, B. T. Batsford, 1952

FUR Furtwangler, Adolf. Masterpieces of Greek Sculp-
 ture. new and enl ed. Chicago, Argonaut, 1964
 Reissue of 1895 ed. with revisions
GABO Gabo, Naum. Of divers arts. New York, Bollingen
 Foundation; distributed by Pantheon Books,
 New York, 1962
GAD Gador, E., and G. O. Pogany. Ungarische
 Bildhauerkunst. Budapest, Corvina Verglag.
 1955
GAF Guide to the art treasures of Paris (Guide
 Artistique de France). Paris, Editions Pierre
 Tisne, 1964; New York, E. P. Dutton, 1966
GAM Gamzu, Haim. Paintings and sculpture in Israel;
 half a century of the plastic arts in Eretz,
 Israel. new, enl and rev ed. Tel-Aviv, Dvir
 Publishers, 1955
GARB Garbini, Giovanni. The ancient world. New
 York, McGraw-Hill Book Co., 1966
GARDAY Gardner, Albert Ten Eyck. Yankee stone-cutters:
 The first American school of sculpture, 1800-
 1850. New York, published for the Metro-
 politan Museum of Art by Columbia University
 Press, 1945
GARDE Gardner, Ernest Arthur. Six Greek sculptors.
 London, Duckworth and Co., 1910; reprinted
 New York, Scribner, 1915
GARDH Gardner, Helen. Art through the ages. 4th ed,
 New York, Harcourt, Brace & World, 1959
GARDHU Gardner, Helen. Understanding the arts. New
 York, Harcourt, Brace 1932
GARL Garlick, Kenneth. British and North American
 art to 1900. New York, Franklin Watts, 1965
GAU Gauthier, Maximilien, ed. Louvre: Sculpture,
 ceramics, and objects d'art. London, Old-
 bourne Press, 1961; New York, Appleton
 (Meredith), 1964
GAUN Gaunt, William. Observer's book of sculpture.
 New York, Frederick Warne, 1966
GEL Gelder, Van Hendrik Enno. Guide to Dutch art.
 The Hague, Government Printing and Publish-
 ing Office, 1952
GER Gerson, Horst, and Engelbert Hendrik ter Kuile.
 Art and architecture in Belgium--1600 to 1800.
 Harmondsworth, Baltimore, Penguin Books,
 1960
GERN Gernsheim, Helmut. Focus on architecture and
 sculpture, an original approach to the photo-
 graphs of architecture and sculpture. London,
 Fountain Press, 1949

GERT Gertz, Ulrich. Plastik der Gegenwart. 2. erweiterte Aufl. Berlin, Rembrandt-Verlag, 1953

GIE Giedion-Welcker, Carola. Contemporary sculpture: an evolution in volume and space. 3rd rev ed. London, Faber & Faber; New York, Wittenborn, 1960

GIT Giteau, Madeleine. Khmer sculpture and the Angkor civilization. New York, Harry N. Abrams, 1966

GLA Glass, Frederick James. Modelling and sculpture. London, B. T. Batsford, 1929

GLE Gleichen, Lord Edward. London's open-air statuary. London, New York, Longmans, Green, 1928

GOE Goetz, Hermann. India: Five thousand years of Indian art. London, Methuen; New York, McGraw-Hill Book Co. , 1959

GOLDE Goldscheider, Ludwig. Etruscan sculpture. Phaidon ed. London, Allen; New York, Oxford University Press, 1941

GOLDF Goldscheider, Ludwig. Five hundred self portraits from antique times to the present day in sculpture, painting, drawing, and engraving. London, Oxford University Press, 1937

GOLDR Goldscheider, Ludwig. Roman portraits. London, Allen; New York, Oxford University Press, 1940

GOLDWA Goldwater, Robert, and Marco Treves. Artists on art. 3rd ed. New York, Pantheon Books, 1958

GOMB Gombrich, Ernst Hans Josef. The story of art. 11th ed. London, Phaidon Press, 1966

GOME Gomez Moreno, Manuel. The golden age of Spanish sculpture. Greenwich, Ct. , New York Graphic Society, 1964

GOODA Goodrich, Lloyd, and John Ireland Howe Baur. American art of our century. New York, published for the Whitney Museum of American Art by Frederick A. Praeger, Publishers, 1961

GOODF Goodrich, Lloyd, and E. Bryant. Forty artists under forty, from the collection of the Whitney Museum of American Art. New York, Frederick A. Praeger, Publishers, 1962.

GOODT Goodrich, Lloyd. Three centuries of American art. New York, Frederick A. Praeger, Publishers, 1966 Pictorial survey of American art from Colonial times to present based on historical exhibition, "Art of the United States: 1670-1966", marking

opening of new building of the Whitney
Museum of American Art, New York City

GOOS Goossen, E. C., et al. Ferber--Hare--Lassaw,
trois sculpteurs americains. Paris, Le Musee
de Poche, 1959
English language edition: Three American
sculptors. New York, Grove Press, 1959

GOR Goris, Jan-Albert. Modern sculpture in Belgium.
3rd rev ed. New York, Belgian Government
Information Center, 1957

GRAB Grabar, Andre. Art of the Byzantine Empire.
Baden-Baden, Holle Verlag; London, Methuen;
New York, Crown Publishers, 1966

GRANT Grant, Michael. Myths of the Greeks and Romans.
Cleveland, World Publishing Co., 1962

GRAT Grate, Pontus, ed. Treasures of Swedish art.
Malmo, Allhem Publishers, 1963
Originally published on the occasion of the
exhibition, "Tresors d'art suedois", opened
May 30, 1963, at the Louvre, Paris

GRAYR Gray, Camilla. Russian art: The great experi-
ment. 1863-1922. London, Thames & Hudson,
New York, Harry N. Abrams, 1962

GRID Gridley, Marion E., comp. America's Indian
Statues. Chicago, The Amerind, 1966

GRIG Grigson, Geoffrey. Art treasures of the British
Museum. London, Thames & Hudson; New
York, Harry N. Abrams, 1957

GRIS Griswold, Alexander B., et al. Art of Burma,
Korea, and Tibet. New York, Crown
Publishers, 1964

GROS Groslier, Bernard Philippe. Art of Indochina,
including Thailand, Vietnam, Laos and
Cambodia. London, Methuen; New York,
Crown Publishers, 1962

GROSS Gross, Chaim. The technique of wood sculpture.
New York, Vista House Publishers, 1957

GRU Grube, Ernest J. World of Islam. New York,
McGraw-Hill Book Co., 1966

GUG The Solomon R. Guggenheim Museum, New
York. A handbook of the collection. New
York, The Museum, 1959

GUGE The Solomon R. Guggenheim Museum, New
York. Guggenheim International Exhibition,
1967--Sculpture from twenty nations. New
York, The Museum, 1967

GUGH	Solomon R. Guggenheim Museum, New York. Modern sculpture from the Joseph H. Hirshhorn collection. New York, The Solomon R. Guggenheim Foundation, 1962
GUGP	Arts Council of Great Britain. Peggy Guggenheim collection--exhibition at Tate Gallery, 31 Dec 1964-7 March 1965. 2nd ed. London, Arts Council, 1965
GUID	Guidol, Jose. Arts of Spain, Garden City, N. Y., Doubleday, 1964
GUIT	Guitton, Jean. The Madonna. Paris, Editions Sun; New York, Tudor Publishing Co., 1963
GUN	Gunnis, R. Dictionary of British sculptors, 1660-1851. London, Odhams Press, 1953; Cambridge, Harvard University Press, 1954
HAD	Hadas, Moses. Imperial Rome. New York, Time, Inc., 1965
HALE	Hale, John. Renaissance. New York, Time, Inc., 1965
HAM	Hammacher, A. M. Colorslide tour of the Kroller-Muller Museum, Otterlo, Holland. New York, Harry N. Abrams, 1961 (Panorama Colorslide Art Program, v. 12)
HAMF	Hammacher, A. M., and R. Hammacher Vandenbrande. Flemish and Dutch art. New York, Franklin Watts, 1965
HAMM	Hammacher, A. M. Modern English sculpture. New York, Harry N. Abrams, 1967
HAMP	Hamilton, George Heard. Painting and sculpture in Europe, 1880 to 1940. Harmondsworth, Baltimore, Penguin Books, 1967
HAMR	Hamilton, George Heard. Art and architecture of Russia. London, Baltimore, Penguin Books, 1954
HAN	Hanfmann, George M. A. Classical sculpture. Greenwich, Ct., New York Graphic Society, 1967
HAR	Hare, Richard Gilbert. The art and artists of Russia. London, Methuen; Greenwich, Ct., New York Graphic Society, 1965
HARO--1 --2 --3	Harold, Margaret, comp. Prize-winning sculpture. Fort Lauderdale, Florida, Allied Publications, 1964-1966 Bk 1. 1964 Bk 2. 1965 Bk 3. 1966
HART--1 --2	Hartmann, Sadakichi. A history of American art. 2 v. Boston, L. C. Page, 1932

HARTS	Hartmann, Sadakichi, ed. Modern American sculpture; a representative collection of the principal statues, relics, busts, statuettes and specimens of decorative and municipal work, executed by the foremost sculptors in America in the last twenty years. New York, Paul Wenzel and M. Krakow, 1918
HARVGW	Harvey, John. The Gothic world, 1100-1600, a survey of architecture and art. London, B. T. Batsford, 1950
HAUS	Hauser, Arnold. Mannerism. London, Routledge & Kegan Paul, 1965 v 2: 322 plates
HAUSA	Hauser, Arnold. The social history of art. London, Routledge & Paul; New York, Knopf, 1951; Vintage 4 v paperback ed, 1957
HAY	Hayes, Bartlett H. Naked truth and personal vision. Andover, Mass., Addison Gallery of American Art, 1955
HEMP	Hempel, Eberhard. Baroque art and architecture in central Europe. Harmondsworth, Baltimore, Penguin Books, 1965
HENNI	Henning, Edward B. Fifty years of modern art, 1916-1966. Cleveland, Cleveland Museum of Art; distributed by Western Reserve University Press, Cleveland, 1966
HENT	Hentzen, Alfred. Deutsche Bildhauer der Gegenwart. Berlin, Rembrandt Verlag, 1934
HERB	Herbert, Eugenia W. The artist and social reform; France and Belgium, 1885-1898. New Haven, Yale University Press, 1961
HERM	Leningrad. Ermitazh. The Hermitage Museum; a short guide. Moscow, Foreign Languages Publishing House, 1955
HERMA	Leningrad. Ermitazh. Art treasures in the USSR, v. 2. The Hermitage State Museum; painting and sculpture; 20 reproductions. Moscow and Leningrad, State Art Publishers, 1939
HF	Hall of Fame for Great Americans, at New York University. Official handbook, edited by Theodore Morello. New York, New York University Press, 1967
HOB	Hobson, R. L. Chinese art; 100 plates in color. 2nd rev ed. London, Ernest Benn, 1954
HOF	Hoffman, Malvina. Sculpture inside and out. New York, W. W. Norton, 1936

HOO	Hooper, J. T. and C. A. Burland. The art of primitive peoples. London, The Fountain Press, 1953
HOR	Horizon Magazine. Horizon book of ancient Greece. New York, American Heritage Publishing Co., 1965
HORS	Horizon Magazine. Shakespeare's England. New York, American Heritage Publishing Co., 1964
HOW	Howe, Thomas C. Colorslide tour of the California Palace of the Legion of Honor. New York, Harry N. Abrams, 1961 (Panorama Colorslide Art Program, v. 11)
HUB	Hubbard, Robert H., ed. Anthology of Canadian art. Toronto, Oxford University Press, 1960
HUBE	Hubert, Gerard. Les Sculpteurs Italiens en France sous la Revolution, L'Empire, et la Restauration, 1790-1830. Paris, Editions E. De Boccard, 1964
HUN	Hunter, Samuel. Modern painting and sculpture. New York, Dell Publishing Co., 1959 4th ptg 1963
HUNT	Henry E. Huntington Library and Art Gallery, San Marino, California. Sculpture in the Huntington Collection, by R. R. Wark. San Marino, 1959, 2nd ptg 1960
HUNTA	Henry E. Huntington Library and Art Gallery, San Marino, California. The Huntington Art Collection, a handbook. 8th ed. San Marino, 1964
HUNTV	Henry E. Huntington Library and Art Gallery, San Marino, California. Visitor's guide to the exhibitions and gardens. San Marino, 1964
HUX	Huxley-Jones, T. B. Modelled portrait heads. London, Studio Publications, 1955
HUYA	Huyghe, Rene. Art treasures of the Louvre. New York, Harry N. Abrams, 1960
HUYAR	Huyghe, Rene. Art treasures of the Louvre. New York, Harry N. Abrams, 1951
IBM	International Business Machines Corporation. Sculpture of the Western Hemisphere, permanent collection IBM Corporation. New York, 1942
IND	India (Republic). Ministry of Information and Broadcasting. Museums and art galleries. Delhi, Indian Ministry of Information and Broadcasting, 1956
INTA--1 --2	International art sales, edited by George Savage. London, Studio Books; New York, Crown

 Publishers
 --1 1961
 --2 1962

IRW Irwin, David. English neoclassical art. London, Faber & Faber, 1966

JAG Jagger, Sergeant. Modelling and sculpture in the making. London, New York, Studio Publications, 1933; 1947 reprint

JAL--1-5 Jalabert, Denise. La sculpture francaise. 5 v. Paris, Musee National des Monuments Francaise, 1958

 1--v. 1. Sculpture pre-romane et romane III^e-XII^e siecle)

 2--v. 2 Sculpture gothique aux XII^e et $XIII^e$ siecles

 3--v. 3. Sculpture gothique aux XIV^e et XV^e siecles

 4--v. 4. Sculpture de la Renaissance. XVI^e siecle

 5--v. 5. Sculpture des Temps Modernes, XII^e, $XIII^e$, et XIX^e siecles

JAM James, Juliet Helena (Lumbard). Palaces and courts of the Exposition; a handbook of the architecture, sculpture and mural paintings, with special reference to the symbolism. San Francisco, California Book Co., 1915

JAMS James, Juliet Helena. Sculpture of the Exposition palaces and courts, descriptive notes on the art of statuary at the Panama-Pacific International Exposition. San Francisco, H. S. Crocker Co., 1915

JAN Janis, Sidney. Abstract and surrealist art in America. New York, Reynal & Hitchcock, 1944

JANSH Janson, Horst W., and Dora Jane Janson. History of art, a survey of the major visual arts from the dawn of history to the present day. New York, Harry N. Abrams, 1962

JANSK Janson, Horst W., ed. Key monuments of the history of art: A visual survey. Englewood Cliffs, N. J., Prentice-Hall, 1959; Harry N. Abrams, New York, 1964 ptg

JAR Jarnuszkiewicz, Jadwiga. Modern sculpture in Poland. Warsaw, Polonia Publishing House, 1958

JLAT Junior League of Albuquerque. Twentieth century sculpture, exhibit at the University Art Museum, University of New Mexico, March 25-May 1, 1966. Albuquerque, University of New Mexico, 1966

JOH Johnson, Lillian (Bass). Sculpture, the basic methods and materials. New York, David McKay Co., 1960

JOHT Johnstone, William. Creative arts in Britain from the earliest times to the present. London, Macmillan, 1950

JOO Joosten, Ellen. The Kroller-Muller Museum, Otterlo, Holland. New York, Shorewood Publishers, 1965

JOR--1 Joray, Marcel. La sculpture modern en Suisse.
--2 Neuchatel, Editions du Griffon, 1955-1959 L'Art Suisse Contemporain, v 12, v14

KAH Kahler, Heinz. The art of Rome and her empire. London, Methuen, 1963; New York, Crown publishers, 1962

KAM Kampf, Avram. Contemporary synagogue art, developments in the United States, 1945-1965. New York, Union of American Hebrew Congregations, 1966

KAP Kaprow, Allan. Assemblages, environments and happenings. New York, Harry N. Abrams, 1966

KEPS Kepes, Gyorgy, ed. Structure in art and in science. New York, George Braziller, 1965

KEPV Kepes, Gyorgy, ed. Visual arts today. Middleton, Ct., Wesleyan University Press, 1960

KIA Kidder, Alfred, and Carlos Samoya Chinchilla. Art of the ancient Maya. New York, Thomas Y. Crowell Co., 1959

KIDM Kidder, J. Edward, ed. Masterpieces of Japanese sculpture. Tokyo, Bijutsu Shuppansha; Rutland, Vt., Charles E. Tuttle, 1961

KIDS Kidson, Peter. The medieval world. New York, McGraw-Hill Book Co., 1967

KITS Kitson, Michael. The age of the Baroque. New York, McGraw-Hill Book Co., 1966

KN Nelson Gallery-Atkins Museum, Kansas City, Mo. Sound...Light...Silence: Art that performs, catalog, text by Ralph T. Coe. Kansas City, The Museum, 1966

KO Koepf, Hans. Masterpieces of sculpture from the Greeks to modern time. New York, G. P. Putnam's Sons, 1966

KRA Samuel H. Kress Foundation. Art treasures for America; an anthology of paintings and sculpture in the Samuel H. Kress collection, commentary by Charles Seymour. New York, Phaidon Press, 1961

KRAM Kramrisch, Stella. The art of India: Traditions of Indian sculpture, painting and architecture. 3rd ed. London, Phaidon; distributed by New York Graphic Society, 1965

KUBA	Kubler, George. Art and architecture of ancient America. Harmondsworth, Baltimore, Penguin Books, 1962
KUBS	Kubler, George, and Martin Soria. Art and architecture in Spain and Portugal and their American Dominions, 1500-1800. Harmondsworth, Baltimore, Penguin Books, 1959
KUH	Kuh, Katherine W. Art has many faces. New York, Harper, 1951
KUHA	Kuh, Katherine W. Artist's voice. New York Harper, 1962
KUHB	Kuh, Katherine W. Break-up. London, Adams & Mackay; Greenwich, Ct., New York Graphic Society, 1965
KUHN	Kuhn, Charles Louis. German and Netherlandish sculpture, 1280-1800: The Harvard collections. Cambridge, Harvard University Press, 1965
KUHNG	Kuhn, Charles Louis. German Expressionism and abstract art: The Harvard collections. Cambridge, Harvard University Press, 1957
KUL	Kultermann, Udo. Junge Deutsche Bildhauer. Mainz, Berlin, Florian Kupferberg, 1963
KULN	Kultermann, Udo. The new sculpture: Environments and assemblages. New York, Frederick A. Praeger, 1968
KUN	Kung, David. Contemporary artist in Japan. Honolulu, East-West Center Press, 1966
LAC	Laclotte, Michel. French art from 1350 to 1850. New York, Franklin Watts, 1965
LAF	LaFollette, Suzanne. Art in America. New York, Harper, 1929
LAH	Los Angeles County Museum of Art. Illustrated handbook. Los Angeles, The Museum, 1965
LAHF	Los Angeles County Museum of Art. Five younger Los Angeles artists. Los Angeles, The Museum, 1965
LAJ	La Jolla, California. Museum. New Modes in California painting and sculpture, May 20-June 26, 1966. La Jolla, Museum of Art, 1966
LANG	Lange, Kurt, and Max Hirmer. Egypt: Architecture, sculpture, painting in 3000 years. 3rd ed rev. London, Phaidon Press; Greenwich, Ct., New York Graphic Society, 1961
LARA	Larousse encyclopedia of prehistoric and ancient art. London, Paul Hamlyn; New York, Prometheus Press, 1962

4070-02-
113

LARB	Larousse encyclopedia of Byzantine and medieval art. London, Paul Hamlyn; New York, Prometheus Press, 1963
LARK	Larkin, Oliver W. Art and life in America. rev ed. New York, Holt, 1960
LARM	Larousse encyclopedia of modern art, from 1800 to the present day. London, Paul Hamlyn; New York, Prometheus Press, 1965
LARR *N6450* *.H813*	Larousse encyclopedia of Renaissance and Baroque art. London, Paul Hamlyn; New York, Prometheus Press, 1964
LAS	Lassus, Jean. Early Christian and Byzantine World. New York, McGraw-Hill Book Co., 1967
LAWC	Lawrence, Arnold Walter. Classical sculpture. London, Cape, 1929 *NB 85.L3*
LAWL *808 1. U6- 101*	Lawrence, Arnold Walter. Later Greek sculpture and its influence on East and West. London, Cape; New York, Harcourt & Brace, 1927 "The illustrations have been drawn largely from American museums and have in general been selected to include as many unpublished and unfamiliar objects as possible." (p. xv)
LEE	Lee, Sherman E. Colorslide tour of the Cleveland Museum of Art, Cleveland, Ohio. New York, Harry N. Abrams, 1960 (Panorama Colorslide Art Program, v. 8)
LEEF	Lee, Sherman E. History of Far Eastern art. New York, Harry N. Abrams, 1964
LEU	Leuzinger, Elsy. Africa: The art of the Negro peoples. London, Methuen; New York, McGraw-Hill Book Co., 1960; reprint 1962
LIC	Licht, Fred S. Sculpture--The 19th and 20th centuries. Greenwich, Ct., New York Graphic Society, 1967
LIL	Lill, Georg. Deutsche Plastik. Berlin, Volksverband der Bluchefreunde, 1925
LIP	Lippard, Lucy R. Pop art. London, Thames & Hudson; New York, Frederick A. Praeger, 1966
LIPA	Lipman, Jean Herzberg. American folk art in wood, metal and stone. New York, Pantheon Books, 1948
LIPW	Lipman, Jean Herzberg, ed. What is American in American art? New York, McGraw-Hill Book Co., 1963

LLO Lloyd, Seton. The art of the ancient Near East.
 London, Thames & Hudson; New York,
 Frederick A. Praeger, Publishers, 1961
LOH Lohse, Bernd, and Harald Busch. Art treasures
 of Germany. London, B. T. Batsford, 1958
LOM Lommel, Andreas. Prehistoric and primitive man.
 New York, McGraw-Hill Book Co., 1967
LOND London County Council. Sculpture in the open air,
 catalog. London, The Council
 --5 1960
 --6 1963
 --7 1966
 Triennial exhibit. 1966 exhibit author: Greater
 London Council
LONDC London. County Council. Sculpture 1850-1950,
 exhibition at Holland Park, London, May to
 September, 1957. London, The Council, 1957
LONG Long, Edward John. America's national monu-
 ments and historic sites; a guide... Garden
 City, N. Y., Doubleday, 1960
LOT Lothrop, Samuel K. Treasures of ancient
 America. Geneva, Editions d'Art Skira;
 distributed in U. S. A. by World Publishing
 Co., Cleveland, 1964
LOUM Musee National du Louvre. Les sculptures
 Moyen Age, Renaissance, temps modernes au
 Musee du Louvre, by Michele Beaulieu,
 Marguerite Charageat, and Gerard Hubert.
 Paris, Editions des Musees Nationaux, 1957
LOWR Lowry, Bates. The visual experience. Englewood
 Cliffs, N. J., Prentice-Hall; New York,
 Harry N. Abrams, 1961
LULL Lullies, Reinhard, and Max Hirmer. Greek
 sculpture. rev ed. New York, Harry N.
 Abrams, 1960
LUN Luna Arroyo, Antonio. Panorama de la escultura
 mexicana contemporanea. Mexico, Ediciones
 del Instituto Nacional de Bellas Artes
LYN Lynton, Norbert. The modern world. New York,
 McGraw-Hill Book Co., 1965
LYNC Lynch, John. How to make mobiles. London,
 Studio Publications; New York, Thomas Y.
 Crowell Co., 1953
LYNCM Lynch, John. Metal sculpture--new forms, new
 techniques. New York, Studio-Crowell, 1957
LYNCMO Lynch, John. Mobile design. New York, Studio-
 Crowell, 1955

LYT	Lytton Center of the Visual Arts. Contemporary California Art from the Lytton Collection. Los Angeles, The Center, 1966
MACL	Maclagen, Eric Robert Dalrymple. Italian sculpture of the Renaissance. Cambridge, Harvard University Press, 1935
MAE	Marlborough-Gerson Gallery, New York. The English eye, November-December, 1965. New York, The Gallery, 1965
MAG	Magazine of Art. Painters and sculptors of modern America; introduction by Monroe Wheeler. New York, Thomas Y. Crowell Co., 1942
MAI	Maillard, Robert, ed. A dictionary of modern sculpture. London, Methuen, 1962; New York, Tudor Publishing Co., 1960
MAIU	Maiuri, Bianca. National Museum, Naples (Le Musee National) Novara, Instituto Geografico de Agostini, 1959 French and English text
MAL	Male, Emile. Religious art: From the 12th to the 18th century. Pantheon Books, 1949
MALL	Mallowan, M. E. L. Early Mesopotomia and Iran. London, Thames & Hudson; New York, McGraw-Hill Book Co., 1965
MALV	Malraux, Andre. Voices of silence. New York, Doubleday, 1953
MAN	Mansuelli, G. A. The art of Etruria and early Rome. New York, Crown Publishers, 1965
MARC	Marchiori, Giuseppe. Modern French sculpture. New York, Harry N. Abrams, 1963
MARI	Maritain, Jacques. Creative intuition in art and poetry. New York, Pantheon Books, 1953
MARQ	Marquand, Allan. A text-book of the history of sculpture. rev ed. New York, Longmans, Green, 1911; 1925 reprint
MARTE	Martel, Jan and Joel Martel. Sculpture. Paris, Moreau, 1928
MARY	Maryon, Herbert. Modern sculpture, its methods and ideals. London, I. Pitman, 1933
MAS	Masterworks of Mexican Art from Pre-Columbian times to the present. Catalog Los Angeles County Museum of Art Exhibition, October 1963-January 1964, text by Fernando Gamboa. Los Angeles, The Museum, 1963
MATT	Matt, Leonard von. Art in the Vatican. New York, Universe Books, 1962

MATTB	Matt, Leonard von. Baroque art in Rome. 1st American ed. New York, Universe Books, 1961
MATZ	Matz, Friedrich. Art of Crete and early Greece, the prelude to Greek art. London, Methuen; New York, Crown Publishers, 1962
MCCA	McCarthy, Mary. The stones of Florence. New York, Harcourt, Brace & Co. , 1959
MCCL	McClinton, Katherine Morrison. Christian church art through the ages. New York, Macmillan 1962
MCCUR	McCurdy, Charles, ed. Modern art; a pictorial anthology. New York, Macmillan, 1958
MCSPAD	McSpadden, Joseph Walker. Famous sculptors of America. New York, Dodd Mead, 1927
MEILC	Meilach, Dona, and Elvie Ten Hoor. Collage and found art. New York, Reinhold, 1964
MEILD	Meilach, Dona, and Don Seiden. Direct metal sculpture. New York, Crown Publishers, 1966
MEN	Mendelowitz, Daniel Marcus. History of American art. New York, Holt, 1960
MERC	Mercer, Eric. English art: 1553-1625. Oxford, Clarendon Press, 1962
MERT	Mertz, Barbara. Temples, tombs and hiero-glyphs: The story of Egyptology. New York, Coward-McCann, 1964
MID	Antwerp. Open Air Museum of Sculpture, Middelheim Park. Middelheim das plastik, museum im freien. Berlin, Rembrandt Verlag, 1959
MILLE	Miller, Alec. Stone and marble carving. Berkeley, University of California Press, 1948
MILLER	Miller, Alec. Tradition in sculpture. New York, London, Studio Publications, 1949
MILLS	Mills, John W. Technique of sculpture. New York, Reinhold, 1965
MINB	Ministero della Publica Istruzone. Direzione Generale delle Antichita e Belle Arti. Villa Borghese, by Paolo della Pergola. Rome, Istituto Poligrafico della Stato, 1954
MINC	Minneapolis. Institute of Arts. Four centuries of American art. Minneapolis, The Institute, 1964
MINE	Minneapolis. Institute of Arts. European art today; 35 painters and sculptors. Loan exhibition--Sept 23-Oct 25, 1959. Minneapolis, The Institute, 1959
MINF	Minneapolis. Institute of Arts. Fiftieth anniversary exhibition catalog, November 4, 1965-January 2, 1966. Minneapolis. The Institute, 1965

MINP	Minneapolis. Institute of Arts. Paintings and sculpture from the Minneapolis Institute of Arts, a loan exhibition. Minneapolis, The Institute, 1957
MIUH	Michigan. University Museum of Art. Handbook of the collection. Ann Arbor, The University, 1962
MOD	Musee National d'Art Moderne, Paris. Catalogue-guide, by Jean Cassou, Bernard Dorival, and Genevieve Homolle. Paris, Musee National d'Art Moderne, 1954
MOHN	Mohaly-Nagy, Laszlo. The new vision. 4th rev ed. New York, George Wittenborn, 1947
MOHV	Moholy-Nagy, Laszlo. Vision in motion. Chicago, Paul Theobald, 1956
MOLE	Molesworth, H. D. European sculpture from Romanesque to Neoclassic. London, Thames & Hudson; New York, Frederick A. Praeger, Publishers, 1965
MOLS--1 --2	Molesworth, H. D. Sculpture in England. 2 v. London, New York, published for the British Council by Longmans, Green, 1951 v. 1. Medieval v. 2. Renaissance and early nineteenth century
MONT	Monteverdi, Mario, ed. Italian art to 1850. New York, Franklin Watts, 1965
MOO--1 --2	Moore, William. The story of Australian art from the earliest known art of the continent to the art today. Sidney, Angus & Robertson, 1934
MOREYC	Morey, Charles Rufus. Christian art. New York, Longmans, Green, 1935; reprint Norton, 1958
MOREYM	Morey, Charles Rufus. Medieval art. New York, Norton, 1942
MOT	Motherwell, Robert, ed. Modern artists in America. 1st series. New York, Wittenborn, Schultz, 1952
MU	Munro, Eleanor C. Golden encyclopedia of art. New York, Golden Press, 1961
MUE	Muensterberger, Warner. Sculpture of primitive man. London, Thames & Hudson; New York, Harry N. Abrams, 1955
MUL	Muller, Theodor. Deutsche Plastik der Renaissance bis zum dreissig jahrigen Krieg. Konigstein am Taunus, K. R. Langewiesche, 1963
MULS	Muller, Theodor. Sculpture in the Netherlands, Germany, France, and Spain: 1400-1500. Harmondsworth, Baltimore, Penguin Books, 1966

MUNC	Munsterberg, Hugo. Art of the Chinese sculptor. Rutland, Vt., Charles E. Tuttle, 1960
MUNJ	Munsterberg, Hugo. Arts of Japan: An illustrated history. Tokyo, Rutland, Vt., Charles E. Tuttle, 1957
MUNSN	Munson-Williams-Proctor Institute. 1913 Armory Show, 50th Anniversary exhibition, 1963. Utica, N. Y., The Institute, 1963
MUR	Murdock, Myrtle Cheney. National Statuary Hall in the nation's capitol. Washington, D. C., Monumental Press, 1955 Illustrates 78 statues presented by states, and 8 statues received by gift, purchase or commission
MURA	Muraro, Michelangelo, and Andre Grabar. Treasures of Venice. Geneva, Albert Skira; distributed in U. S. A. by World Publishing Co., 1963
MURRA	Murray, Peter, and Linda Murray. Art of the Renaissance. New York, Frederick A. Praeger, Publishers, 1963
MYBA	Myers, Bernard S. Art and civilization, New York, McGraw-Hill Book Co., 1957
MYBG	Myers, Bernard S. German expressionists, a generation in revolt. concise ed. New York, McGraw-Hill Book Co., 1963
MYBM	Myers, Bernard S. Modern art in the making. 2nd ed. New York, McGraw-Hill Book Co., 1959
MYBS	Myers, Bernard S. Sculpture: Form and Method. London, Studio Vista; New York, Reinhold, 1965
MYBU	Myers, Bernard S. Understanding the arts. New York, Holt, 1958
NAD	Nadeau, Maurice. History of surrealism. New York, Macmillan, 1965
NATP	National Portrait Gallery, London. Catalogue of seventeenth century portraits in the National Portrait Gallery, 1625-1714, compiled by David Piper. Cambridge, Cambridge University Press, 1963
NATS	National Sculpture Society, New York. Contemporary American sculpture, The California Palace of the Legion of Honor, Lincoln Park, San Francisco, April to October 1929. New York, Press of the Kalkhoff Co., 1929
NATSA	National Sculpture Society, New York. Exhibition of American sculpture, catalogue--156th Street

4070.01-132

4109-01-111

8083.04
-100

West of Broadway, New York, April 14 to August 1, 1923. New York, 1923 "...best works from all parts of the country, as well as that of Americans now abroad."

NATSS National Sculpture Society, New York. New York, The Society, 1967 -67: 34th 1967

NCM North Carolina. Museum of Art, Raleigh. Masterpieces of art; in memory of William R. Valentiner, 1880-1958. Exhibition North Carolina Museum of Art, April 6-May 17, 1959. Raleigh, The Museum, 1959

NEL Nelken, Margarita. Escultura mexicana contemporanea. Mexico, Ediciones Mexicanas, 1951

NEUW Neuhaus, Eugen. World of art. New York, Harcourt, Brace, 1936

NEW New Art around the world: Painting and sculpture. New York, Harry N. Abrams, 1966

NEWA Newark Museum. Fifty years, a survey. Newark, The Museum, 1959

NEWAS Newark Museum. A survey of American sculpture, late 18th century to 1962. Newark, The Museum, 1962

NEWAW Newark Museum Association, Newark, N. J. Women artists of America, 1707-1964, exhibition catalog. Newark, 1965

NEWM Newmeyer, Sarah. Enjoying modern art. New York, Reinhold, 1955

NEWTEA Newton, Eric. The arts of man; an anthology and interpretation of great works of art. London, Thames & Hudson; Greenwich, Ct., New York Graphic Society, 1960

NEWTEB Newton, Eric. British sculpture, 1944-1946. London, J. Tiranti; New York, Transatlantic Arts, 1947

NEWTEE Newton, Eric. European painting and sculpture. 4th ed. Harmondsworth, Baltimore, Penguin Books, 1956; reprinted 1958

NEWTEM Newton, Eric. Masterpieces of European sculpture. New York, Harry N. Abrams, 1959

NEWTER Newton, Eric. Romantic rebellion. London, Longmans, Green, 1962; New York, St. Martins, 1963

NEWTET Newton, Eric, and William Neil. 2000 years of Christian art. London, Thames & Hudson; New York, Harper, 1966

NM--1 -8 Metropolitan Museum of Art. Guide to the collections. New York, The Museum

--1	American Wing. 1961
--2	Ancient Near East art, by Vaughn Emerson Crawford, et al. 1966
--3	European arms and armor. 1962
--4	Egyptian art. 1961
--5	Greek and Roman art, by Dietrich von Bothmer. 1964
--6	Islamic art, by Marie G. Lukens. 1965
--7	Medieval art. 1962
--8	Western European arts, by Edith A. Standen. 1963
NM--10	Metropolitan Museum of Art. Guide to the collections, Part I: Ancient and Oriental art-- Egyptian, Mesopotamian, and Classical, Far Eastern, Near Eastern, Oriental armor. New York, The Museum, 1934
NM--11	Metropolitan Museum of Art. Guide to the collections, Part II: European and American art--Medieval art, Renaissance and Modern art, American Wing, arms and armor, painting, prints. New York, The Museum, 1934
NM--12	Metropolitan Museum of Art. The Cloisters: The building and the collection of medieval art in Fort Tryon Park, by James J. Rorimer. rev ed. New York, The Museum; distributed by New York Graphic Society, Greenwich, Ct., 1962
NM--13	Metropolitan Museum of Art. American sculpture, 1951; a national competitive exhibition, December 7, 1951 to February 24, 1952. New York, The Museum, 1951
NM--14	Metropolitan Museum of Art. Chinese sculpture in the Metropolitan Museum of Art, by Alan Priest. New York, 1944
NM--15	Metropolitan Museum of Art. The Lewisohn Collection, foreword by Henry Francis Taylor, and introduction by Theodore Rousseau. New York, The Museum, 1951
NMA	Metropolitan Museum of Art. Art treasures of the Metropolitan. New York, Harry N. Abrams, 1952
NMAB	Museum of Modern Art. Abstract painting and sculpture in America, by Andrew Carnduff Ritchie. New York, The Museum, 1951
NMAC	Museum of Modern Art. Cubism and abstract art, by Alfred H. Barr. New York, The Museum, 1936

NMAD	Museum of Modern Art. The new decade; 22 European painters and sculptors, edited by Andrew Carnduff Ritchie. New York, The Museum, 1955
NMAF	Museum of Modern Art. American folk art; the art of the common man in America, 1750-1900. New York, The Museum, 1932
NMAJ	Museum of Modern Art. New Japanese painting and sculpture, by Dorothy Miller and William Lieberman. Catalog of the work of 46 artists. New York, The Museum; distributed by Doubleday, 1964
NMAM	Museum of Modern Art. Americans 1942; 18 artists from 9 states, edited by Dorothy Miller. New York, The Museum, 1942
NMAN	Museum of Modern Art. African Negro art, edited by James Johnson Sweeney. New York, The Museum, 1935
NMANA	Museum of Modern Art. Ancient arts of the Andes, by Wendell C. Bennett, and Rene d'Harnocourt. New York, The Museum, 1954
NMANA--1	Museum of Modern Art. 32 masterworks of Andean art, from an exhibition: Ancient arts of the Andes. Supplement to Ancient arts of the Andes, catalog. New York, The Museum, 1955
NMAP	Museum of Modern Art. American painting and sculpture, 1862-1932. Eighteenth loan exhibit catalog, October 31, 1932-January 31, 1933. New York, The Museum, 1932
NMAR	Museum of Modern Art. Recent American sculpture, catalog with text by James Thrall Soby. New York, The Museum, 1959
NMAS	Museum of Modern Art. American sources of modern art. New York, Norton, 1933
NMASO	Museum of Modern Art. James Thrall Soby collection of works of art pledged or given to the museum. New York, The Museum, 1961
NMAT	Museum of Modern Art. Twenty centuries of Mexican art. New York, The Museum, 1940
NMFA	Museum of Modern Art. Fantastic art, Dada, Surrealism, edited by Alfred H. Barr. 3rd ed. New York, The Museum, 1948
NMG	Museum of Modern Art. German art of the twentieth century, by Andrew Carnduff Ritchie. New York, The Museum; distributed by Doubleday, 1958

NMI	Museum of Modern Art. Italian masters, lent by the Royal Italian government, exhibition January to March 1940. New York, The Museum, 1940
NML	Museum of Modern Art. Latin-American collection of the Museum of Modern Art, by Lincoln Kirstein. New York, The Museum, 1943
NMN	Museum of Modern Art. New horizons in American Art, with an introduction by Holger Cahill. New York, The Museum, 1936
NMPS	Museum of Modern Art. Painting and sculpture from sixteen American cities. New York, The Museum, 1933
NMS	Museum of Modern Art. New Spanish painting and sculpture, text by Frank O'Hara. New York, The Museum; distributed by Doubleday, 1966
NMSS	Museum of Modern Art. Arts of the South Seas, by Ralph Linton. New York, Simon and Schuster, 1946
NNMMA	Museum of Modern Art. Americans 1963, edited by Dorothy Miller. New York, The Museum, 1963
NNMMAG	Museum of Modern Art. German painting and sculpture, introduction and notes by Alfred H. Barr. New York, The Museum, 1931
NNMMAP	Museum of Modern Art. Art in progress, survey prepared for the fifteenth anniversary of the Museum. New York, The Museum, 1944
NNMMARO	Museum of Modern Art. Art in our time; an exhibition to celebrate the tenth anniversary. New York, The Museum, 1939
NNMME	Museum of Modern Art. Modern masters from European and American collections. New York, The Museum, 1940
NNMMF	Museum of Modern Art. Fifteen Americans, edited by Dorothy Miller. New York, The Museum, 1952
NNMMFO	Museum of Modern Art. Fourteen Americans, edited by Dorothy Miller. New York, The Museum, 1946
NNMML	Museum of Modern Art. Living Americans; paintings and sculpture by living Americans. Ninth loan exhibition. New York, The Museum, 1931
NNMMM	Museum of Modern Art. Masters of modern art, edited by Alfred H. Barr. 3rd rev ed. New York, The Museum; distributed by Doubleday, 1959

NNMMS	Museum of Modern Art. Sixteen Americans, edited by Dorothy Miller. New York, The Museum, 1959
NNMMT	Museum of Modern Art. Twelve Americans, edited by Dorothy Miller. New York, The Museum, 1956
NNWB	Whitney Museum of American Art. Between the Fairs: Twenty-five years of American art, 1939-1964, by John I. H. Baur. New York, published for Whitney Museum of American Art by Frederick A. Praeger, Publishers, 1964
NOG	Nogara, Bartolomeo. Art treasures of the Vatican. Bergamo, Istituto Italiano d'Arti Grafiche; New York, Tudor Publishing Co., 1950
NORM	Norman, Percival Edward. Sculpture in wood. London, Studio Publishers; New York, Transatlantic Arts, 1954
NOV	Novotny, Fritz. Painting and sculpture in Europe, 1780-1880. Harmondsworth, Baltimore, Penguin Books, 1960
NPPM	Museum of Primitive Art, New York. Masterpieces in the Museum of Primitive Art. New York, The Museum; distributed by New York Graphic Society, Greenwich, Ct., 1965
NYW	New York World's Fair, 1939-1940. American art today. New York, National Art Society, 1939
NYWC	New York World's Fair, 1939-1940. Complete catalogue of the paintings and sculpture. Masterpieces of art. rev and enl ed. New York, Art News, 1940 (?)
NYWL	World's Fair, New York, 1965. American Express Pavilion. Art '65: Lesser known and unknown painters; young American sculpture--East to West. Catalog, text by Wayne V. Anderson. New York, American Express Co., 1965
OAK	Oakland Art Museum, Oakland, Calif. Pop art USA, catalog text by John Coplans. Oakland, The Museum, 1963
OST	Osten, Gert von der. Plastik des 20. Jahrhunderts in Deutschland, Osterreich und der Schweiz. Konigstein im Taunus, K. R. Langewiesche, 1962
OZ	Ozenfant, Amedee. Foundations of modern art. rev ed. New York, Dover, 1952

PAA	Pennsylvania Academy of Fine Arts, Philadelphia. Annual exhibition of painting and sculpture. Philadelphia, The Academy

--25	1925	--46	1946
--28	1928	--47	1947
--40	1940	--48	1948
--41	1941	--49	1949
--42	1942	--52	1952
--44	1944	--53	1953
--45	1945		

PACH	Pach, Walter. Classical tradition in modern art. New York, Thomas Yoseloff, Publishers, 1959
PACHA	Pach, Walter. Art museum in America. New York, Pantheon Books, 1948
PAG--1-15	Pageant of America; a pictorial history of the United States, edited by Ralph Henry Gabriel and others. Washington Edition. New Haven, Yale University Press, 1925-1929 15 v
PAI	Paine, Robert Treat, and Alexander Soper. Art and architecture of Japan. reprint with corrections. Harmondsworth, Baltimore, Penguin Books, 1960
PAL	Pallottino, Massimo. Art of the Etruscans. London, Thames & Hudson; New York, Vanguard, 1955
PANA--1 --2	Pan American Union. Guia de las colecciones publicas de Arte in Los Estados Unides. 2 v. Washington, D. C. Union Panamericana, 1951, 1954 v. 1. Costa Oriental: Florida a New York v. 2. Nueva Inglaterra
PANB	Panofsky, Dora, and Erwin Panofsky. Pandora's box. rev ed. New York, Pantheon Books, 1962
PANM	Panofsky, Erwin. Meaning in the visual arts. Garden City, N. Y., Doubleday, 1955
PANR	Panofsky, Erwin. Renaissance and renaissances in western art. Stockholm, Almquist and Wiksell, 1960
PANS	Panofsky, Erwin. Studies in iconology. New York, Oxford University Press, 1939; paper ed. New York, Harper, 1962
PAR--1 --2	Parkes, Kineton. Art of carved sculpture. 2 v. London, Chapman, 1931 v. 1. Western Europe, America and Japan v. 2. Central and Northern Europe
PARS--1 --2	Parkes, Kineton, Sculpture of today. 2 v. London, Chapman; New York, Scribner, 1921 v. 1. America, Great Britain, Japan v. 2. Continent of Europe

PAS	Pasadena Art Museum. New American sculpture, exhibit catalog, February 11 through March 7, 1964. Pasadena, The Museum, 1964
PAU	Paulme, Denise. African sculpture. London, Elek Books; New York, Viking, 1962
PEAR	Pearson, Ralph M. Modern renaissance in American art, presenting the work and philosophy of 54 distinguished artists. New York, Harper, 1954
PEL	Pelligrini, Aldo. New tendencies in art. New York, Crown Publishers, 1966
PEN	Pendergast, W. W. , and W. Porter Ware. Cigar store figures in American folk art. Chicago, Lightner Publishing Co. , 1953
PEP	Pepper, Stephen Coburn. Principles of art appreciation. New York, Harcourt, Brace, 1949
PER	Perry, Hubert Montagu. New materials in sculpture--glass fibre, polyester resins, cold casting in metal, vinamould hot melt compounds, vinagel. 2nd rev and enl ed. London, A. Tiranti, 1965
PERL	Perlman, Bennard B. The immortal Eight. New York, Exposition Press, 1962
PERR 8073.33†	Perry, Stella George (Stern). The sculpture and mural decoration of the Exposition; a pictorial survey of the art of the Panama-Pacific International Exposition. San Francisco, P. Elder, 1915
PEVE	Pevsner, Nikolaus. Englishness of English art. London, Architectural Press, 1956
PEVP	Pevsner, Nikolaus. Pioneers of modern design. New York, Museum of Modern Art, 1949 Revision of: Pioneers of the modern movement, 1936
PH	Phillips Collection, Washington, D. C. The Phillips Collection, a museum of modern art and its sources. Catalogue. Washington, D. C. , The Collection, 1952
PIE	Pierson, William Harvey, and Martha Davidson, eds. Arts of the United States: A pictorial survey. New York, McGraw-Hill Book Co. , 1960
PM	Paris. Musee National d'Art Moderne. Catalogue-guide, by Jean Cassou, et al. Paris, The Museum, 1950
POM	Pope, Arthur Upton. Masterpieces of Persian Art. New York, Dryden, 1945

POPG	Pope-Hennessy, John. Introduction to Italian sculpture. v 1. Italian Gothic sculpture. London, Phaidon Publishers; Greenwich, Ct., New York Graphic Society, 1955
POPR	Pope-Hennessy, John. Introduction to Italian sculpture. v. 2. Italian Renaissance sculpture. London, Phaidon Publishers; Greenwich, Ct., New York Graphic Society, 1958
POPRB	Pope-Hennessy, John. Introduction to Italian sculpture. v. 3. Italian High Renaissance and Baroque sculpture. London, Phaidon Publishers; Greenwich, Ct., New York Graphic Society, 1963
POR	Porada, Edith, and R. H. Dyson. Art of ancient Iran: Pre-Islamic cultures. London, Methuen; New York, Crown Publishers, 1965
POST--1 --2	Post, Chandler Rathfon. History of European and American sculpture from the early Christian period to present day. 2 v. Cambridge, Harvard University Press, 1921
PPA	Philadelphia Museum of Art. The Louise and Walter Arensberg Collection. v. 1. 20th century painting and sculpture. Philadelphia, The Museum, 1954
PRAD--1 --2	Museo del Prado. Catalogo de la Escultura. v 1. Escultura Clasicas; v. 2. Esculturas, copias e imitaciones de las antiguas (Siglos XVI-XVII), by A. Blanco. Madrid, Museo, 1957
PRAEG	Praeger picture encyclopedia of art. New York, Frederick A. Praeger, Publishers, 1958
PRIV	A private view, by Bryan Robertson, and others. London, Thomas Nelson, 1965
PUL--1 --2	Pulitzer, Louise, and Joseph Pulitzer. Modern painting, drawing and sculpture collected by Louise and Joseph Pulitzer. 2 v. Cambridge, Fogg Art Museum, 1958
PUT	Putnam, Brenda. The sculptor's way. 1st rev ed. New York, Watson-Guptill Publications, 1948
RAD	Radcliffe, A. G. Schools and masters of sculpture. New York, D. Appleton, 1894; reprint 1908
RAMS	Ramsden, E. H. Sculpture: Theme and variations, towards a contemporary aesthetic. London, Lund Humphries, 1953 "Review of sculptural achievements of the first half of the twentieth century."

RAMT	Ramsden, E. H. Twentieth-century sculpture. London, Pleiades Books, 1949
RAY	Rayner, Edwin. Famous Statues and their stories. New York, Grosset & Dunlap, 1936
RDAB	Rice, David Talbot. Art of the Byzantine era. New York, Frederick A. Praeger, Publishers, 1963
RDB	Rice, David Talbot. Art of Byzantium. London, Thames & Hudson: New York, Harry N. Abrams, 1959
RDE	Rice, David Talbot. English art: 871-1100. Oxford, Clarendon Press, 1952
RDI	Rice, David Talbot. Islamic art. London, Thames & Hudson; New York, Frederick A. Praeger, Publishers, 1965
READA	Read, Herbert, Art and society. 3rd ed. London, Faber & Faber, 1956
READAN	Read, Herbert. Art now, an introduction to the theory of modern painting and sculpture. 2nd ed. London, Pitman, 1960
READAS	Read, Herbert. Art of sculpture. 2nd ed. London, Faber & Faber; New York, Pantheon Books, 1961
READCO	Read, Herbert. Contemporary British art. rev ed. Harmondsworth, Baltimore, Penguin Books 1964
READCON	Read, Herbert. Concise history of modern sculpture. New York, Frederick A. Praeger, Publishers, 1964
READG	Read, Herbert. Grass roots of art. New York, Wittenborn, 1955; 1961 reprint, Meridian
READI	Read, Herbert. Icon and idea. Cambridge, Harvard University Press, 1955
READM	Read, Herbert. Meaning of art. London, Penguin Books, 1949
READO	Read, Herbert. Origins of form in art. New York, Horizon Press, 1965
READP	Read, Herbert. Philosophy of modern art. New York, Horizon Press, 1953; 1955 reprint, Meridian
READS	Read, Herbert. Surrealism. New York, Harcourt, Brace, 1936
REAU	Reau, Louis, L'art religieux du moyen-age (la sculpture). Paris, Fernand Nathan, 1946
REED	Reed, Merrilla. Historic statues and monuments in California. San Francisco, Author, 1956
RHC	Rhode Island School of Design, Providence. Contemporary boxes and wall sculpture. Catalog,

text by Daniel Robbins. Providence, The School, 1965

RHS Rhode Island School of Design, Providence. Sculpture in the collection of the artist. Exhibit catalog, January 30-February 24, 1963. Providence, The School, 1963

RICH Richardson, Edgar Preston. Way of western art, 1776-1914. Cambridge, Harvard University Press, 1939

RICHT Richter, Hans. Dada: Art and anti-art. New York, McGraw-Hill Book Co., 1965

RICHTH Richter, Gisela M. Handbook of Greek art. 4th ed. London, Phaidon Press; Greenwich, Ct., New York Graphic Society, 1965

RICJ Rich, Jack C. Materials and methods of sculpture. New York, Oxford University Press, 1947

RIJ Amsterdam. Rijksmuseum. Het Rijksmuseum, kreuze van de afbeeldingen entekst, van E. R. Meijer. Amsterdam, Van Ditmar, 1965

RIJA Amsterdam. Rijksmuseum. Art treasures of the Rijksmuseum, texts by Arthur F. E. Schendel, and B. Haak. New York, Harry N. Abrams, 1966

RIT Ritchie, Andrew Carnduff. Sculpture of the twentieth century. New York, Museum of Modern Art, 1952

ROBB Robb, David M. Art in the western world. 4th ed. New York, Harper, 1963

ROODT Rood, John. Sculpture with a torch. Minneapolis, University of Minnesota Press, 1963

ROODW Rood, John. Sculpture in wood. Minneapolis, University of Minnesota Press, 1950

ROOS Roos, Frank J. Illustrated handbook of art history. rev ed. New York, Macmillan, 1954

ROOSE Rooses, Max. Art in Flanders. New York, Scribner, 1931

ROS Rosenberg, Jakob, et al. Dutch art and architecture: 1600-1800. Harmondsworth, Baltimore, Penguin Books, 1966

ROSE Rosenbaum, Robert. Cubism and twentieth century art. New York, Harry N. Abrams, 1961

ROSS Ross, Malcolm Mackenzie, ed. Arts in Canada; a stock-taking at mid-century. Toronto, Macmillan, 1958

ROSSI Rossi, Filippo. Colorslide tour of the Pitti Palace, Florence. New York, Harry N. Abrams, 1960 (Panorama Colorslide Art Program, v. 10)

ROTH Roth, Cecil, ed. Jewish art; an illustrated
 history. New York, McGraw-Hill Book Co.,
 1961
ROTHS Rothschild, Lincoln. Sculpture through the ages.
 London, Whittlesley House; New York,
 McGraw-Hill Book Co., 1942
ROTHST Rothschild, Lincoln. Style in art. New York,
 Thomas Yoseloff, 1960
ROTJB Rothenstein, John. British art since 1900.
 London, Phaidon Publishers; distributed by
 New York Graphic Society, Greenwich, Ct.,
 1962
ROTJG Rothenstein, John. The Tate Gallery. London,
 Thames & Hudson; New York, Harry N.
 Abrams, 1958
ROTJT Rothenstein, John. A brief history of the Tate
 Gallery. London, Pitkin Pictorials, 1963
ROUT Rousseau, Theodore. Colorslide tour of the
 Metropolitan Museum of Art, New York City.
 New York, Harry N. Abrams, 1961
 (Panorama Colorslide Art Program, v. 5)
ROW Rowland, Benjamin. Art and architecture of
 India: Buddhist, Hindu, Jain. 3rd rev ed.
 Harmondsworth, Baltimore, Penguin Books,
 1967
ROWE Rowland, Benjamin. Art in East and West: An
 introduction through comparisons. Cambridge,
 Harvard University Press, 1954
ROY Roy, Claude. Art of the savages. New York,
 Arts, 1958
RITC Rice, Tamara Talbot. Ancient arts of Central
 Asia. London, Thames & Hudson; New York,
 Frederick A. Praeger, Publishers, 1965
RTCR Rice, Tamara Talbot. Concise history of
 Russian art. London, Thames & Hudson;
 New York, Frederick A. Praeger, Publishers,
 1963
RUBL Rublowsky, John, and K. Heyman. Pop art. New
 York, Basic Books, 1965
RUS Ruskin, Ariane. Pantheon story of art for young
 people. London, Heinemann; New York,
 Pantheon Books, 1964
SAID Said, Hamed, ed. Contemporary art in Egypt.
 Belgrade, Jugoslavia Ministry of Culture and
 National Guidance, in cooperation with Pub-
 lishing House "Jugoslavia," 1964
 Missing plates: 47; 68-73

xlv

SAL	Salvini, Roberto. Modern Italian sculpture. London, Oldbourne; New York, Harry N. Abrams, 1962
SALT	Saltus, John Sanford, and Walter E. Tisne. Statues of New York. New York, G. P. Putnam's Sons, 1922
SAN	Santangelo, Maria. Etruscan museums and monuments. Novara, Istituto Geografico de Agostini, 1963 French and English text
SANT	Santos, Reynaldo dos. L'art portugais: Architecture, sculpture et peinture. Paris, Librairie Plon, 1953
SAO	Sao Paulo, Brazil. Meseu de Arte Moderna. Bienal. Catalogo

--1	1951	--5	1959
--2	1953	--6	1961
--3	1955	--7	1963
--4	1957	--9	1965

SBT	Santa Barbara. Museum of Art. Three young collections; selections from the collections of Donald and Lynn Factor, Dennis and Brooke Hopper, Andre and Dory Previn. Santa Barbara, The Museum, 1967
SCHAEF	Schaefer-Simmern, Henry. Sculpture in Europe today. Berkeley, University of California Press, 1955
SCHEF	Schefold, Karl. Myth and legend in early Greek art. Munich, Hirmer Verlag. 1964; London, Thames & Hudson, New York, Harry N. Abrams, 1966
SCHERM	Scherer, Margaret R. Marvels of ancient Rome. New York, Phaidon, 1956
SCHMI	Schmitz, Carl A. Oceanic sculpture, the sculpture of Melanesia, Greenwich, Ct., New York Graphic Society, 1962
SCHMU	Schmutzler, Robert. Art Nouveau. Stuttgart, Verlag Gerd Hatje; New York, Harry N. Abrams, 1964
SCHN	Schneir, Jacques F. Sculpture in modern America. Berkeley, University of California Press, 1948
SCHO	Schoder, Raymond B. Masterpieces of Greek art. 2nd rev ed. Greenwich, Ct., New York Graphic Society, 1965
SCHW	Schwarz, Karl. Jewish sculptors. Tel-Aviv, Jerusalem Art Publishers; distributed by M. Neuman, 1954

SCOM	Scottish National Gallery of Modern Art, Edinburgh. Catalog, The Gallery. Edinburgh, HMSO, 1963
SCON	National Gallery of Scotland. Illustrations. Edinburgh, HMSO, 1965
SCUL	Scultura Italiana del XXO secolo, prefazione de Palma Bucarelli. Rome, Editalia, 1957
SDF	San Diego. Fine Arts Gallery. Catalog, a selective listing of all the collections of the Fine Arts Society, San Diego. San Diego, Fine Arts Society, 1960
SDP	San Diego. Palace of Fine Arts. Balboa Park. California Pacific International Exposition, 1935. Illustrated catalog of the official art Exhibition. San Diego, Frye & Smith, 1935
SEAA	Seattle World's Fair. Art since 1950, American and International. Seattle, 1962
SEAM	Seattle World's Fair. Catalogue: Masterpieces of Art, Fine Arts Pavilion, April 21 to September 4, 1962.
SEATL	Seattle Art Museum. Ten from Los Angeles. Catalog, text by John Coplans. Seattle, The Museum, 1966
SECK	Seckel, Dietrich. Art of Buddhism. London, Methuen; New York, Crown Publishers, 1964
SEG	Segy, Ladislas. African sculpture speaks. 3rd ptg. New York, Hill & Wang, 1961
SEIT	Seitz, William C. Art Israel: 26 painters and sculptors. New York, Museum of Modern Art; distributed by Doubleday, 1964
SEITA	Seitz, William C. Art of Assemblage. New York, Museum of Modern Art, 1961
SEITC	Seitz, William C. Contemporary sculpture. New York, Art Digest, 1965
SEITR	Seitz, William C. The responsive eye, catalogue. New York, Museum of Modern Art, 1965
SELZJ	Selz, Jean. Modern Sculpture: Origins and evolution. New York, Braziller, 1963
SELZN	Selz, Peter H. New images of man. New York, Museum of Modern Art, 1959
SELZP	Selz, Peter H. Directions in kinetic sculpture, with an introduction by George Rickey and statements by the artists. Berkeley, University of California, University Art Museum and Committee for Arts and Lectures, 1966
SELZPN	Selz, Peter H., and Mildred Constantine, eds. Art Nouveau. New York, Museum of Modern Art; distributed by Doubleday, 1959

SELZS Selz, Peter H. Seven decades: 1895-1965, cross currents in Modern Art. Greenwich, Ct., New York Graphic Society, 1966

SET Seton, Julia M. American Indian arts. New York, Ronald Press, 1962

SEW Sewall, John Ives. History of western art. rev ed. New York, Holt, 1961

SEY Seymour, Charles. Sculpture in Italy: 1400-1500. Harmondsworth, Baltimore, Penguin Books, 1966

SEYM Seymour, Charles. Masterpieces of sculpture from the National Gallery of Art, Washington, D. C. New York, Coward McCann, 1949

SEYT Seymour, Charles. Tradition and experiment in modern sculpture. Washington, D. C. American University Press, 1949

SEZ Seznec, Jean. Survival of the pagan gods. New York, Pantheon Books, 1935

SFAA San Francisco. Museum of Art. Art in the 20th century. Exhibition commemorating the tenth anniversary of the signing of the United Nations charter, June 17-July 10, 1955. San Francisco. The Museum, 1955

SFAF San Francisco. Museum of Art. Fifty California artists. Catalog. 1962

SFAP San Francisco Art Association. Painting and Sculpture. Berkeley, University of California Press, 1952

SFGC San Francisco. Golden Gate International Exposition, 1939-1940. Department of Fine Arts. Contemporary art; official catalog, Division of Contemporary Painting and Sculpture. San Francisco, 1939

SFGM San Francisco. Golden Gate International Exposition, 1939-1940. Masterwords of five centuries. San Francisco, San Francisco Bay Exposition Co., 1939

SFGP San Francisco. Golden Gate International Exposition 1939-1940. Pacific cultures. San Francisco, Exposition, 1939

SFMB San Francisco. Museum of Art. British art today. Catalog, Nov 13-Dec 16, 1962. San Francisco, The Museum, 1962

SFPP San Francisco. Panama-Pacific International Exposition, 1915. Sculpture and mural paintings in the beautiful courts, colonnades and avenues of the Panama-Pacific Exposition, text by Jessie Niles Barnes. San Francisco, R. A. Reid, 1915

SG--2-7	Sculptors Guild, New York. Sculpture, catalog of annual exhibition at Lever House, New York --2 1960 --5 1963 --3 1961 --6 1964 --4 1962 --7 1965
SGO	Sculptors Guild, New York. Outdoor sculpture exhibition. New York, The Guild, 1938- --1 1938 --10 1948 --2 1939 --17 1955 --4 1942
SGT	Sculptors Guild, New York. Sculptors Guild Traveling Exhibition, 1940-1941. New York, The Guild, 1940
SHAP	Shapley, Fern Rusk, and John Shapley. Comparisons in art; a companion to the National Gallery of Art, Washington, D. C. Greenwich, Ct., New York Graphic Society, 1957
SICK	Sickman, Laurence, and Alexander Soper. Art and architecture of China. 2nd ed. Harmondsworth, Baltimore, Penguin Books, 1960
SIN	Singleton, Esther, ed. Famous sculpture as seen and described by great writers. New York, Dodd, Mead, 1910
SLOB	Slobodkin, Louis. Sculpture, principles and practice. Cleveland, World Publishing Co., 1949
SMI	Smithsonian Institution. Authentic reproductions of the originals in the Smithsonian Institution. v 1. Sculpture reproductions by Alva Museum Replicas, Inc., New York, and Ram Studios, Arlington, Va.
SMIBJ	Smith, Bradley. Japan: A history in art. New York, Simon and Schuster, 1964
SMIBS	Smith, Bradley. Spain: A history in art. New York, Simon and Schuster, 1966
SMITP	Smithsonian Institution. National Portrait Gallery. Nucleus for a national collection, entries compiled by Robert G. Stewart. Washington, D. C., Smithsonian Institution, 1966
SMITR	Smithsonian Institution. National Portrait Gallery. Recent acquisitions. Washington, D. C., Smithsonian Institution, 1966
SMIW	Smith, William Stevenson. Art and architecture of ancient Egypt. Harmondsworth, Baltimore, Penguin Books, 1958
SOBYA	Soby, James Thrall. After Picasso. New York, Dodd, Mead, 1935

SOBYT	Soby, James Thrall, and Alfred H. Barr. Twentieth century Italian art. New York, Museum of Modern Art, 1949
SOT	Sotriffer, Kristian. Modern Austrian art. New York, Frederick A. Praeger, Publishers, 1963
SOTH	Sotheby, firm, Auctioneers, London. Ivory Hammer, Sotheby sales. New York, Holt --1 Year at Sotheby's, 1962-1963. 1964 --2 _____ 1963-1964. 1964 --3 _____ 1964-1965. 1965 --4 Art at auction, 1965-1966. 1966
SP	Sprengel, Bernhard. Sammlung Sprengel. Exhibit of the Sprengel Collection: Kunstverein Hannover, Kestner-Gesellschaft, Hanover Niedersachsisches Landesmuseum, Oct 10-Nov 28, 1965. Hanover, 1965
SPA	Spaeth, Eloise. American art museums and galleries. New York, Harper, 1960
SPE	Speiser, Werner. Art of China. New York, Crown Publishers, 1960
SPI	Spinden, Herbert Joseph. Maya art and civilization, rev and enl with added illustrations. Indian Hills, Colo, Falcon's Wing Press, 1957 Plates indexed
ST	Styles of European art, introduction by Herbert Read. London, Thames & Hudson, 1965; New York, Harry N. Abrams, 1967
STA	Stadler, Wolfgang. European art; a travellers' guide. New York, Herder & Herder, 1960
STE	Stewart, Virginia. 45 contemporary Mexican artists. Stanford, Stanford University Press, 1951
STECH	Stech, Vaclav Vilem. Baroque sculpture. London, Spring Books, 1959
STI	Stiles, Raymond S. The arts and man. New York, McGraw-Hill Book Co., 1940
STM	Stad Antwerpen Kunst Historishe Musea. Openlucht Museum voor Beeldhouwkunst, Middelheim. Antwerp, The Museum
STON	Stone, Lawrence. Sculpture in Britain: The Middle Ages. Harmondsworth, Baltimore, Penguin Books, 1955
STRONGC	Strong, Donald E. The classical world, New York, McGraw-Hill Book Co., 1965
STRONGD	Strong, D. E. Roman imperial sculpture; an introduction to the commemorative and

 decorative sculpture of the Roman empire
 down to the death of Constantine. London,
 A. Tiranti, 1961

SULI Sullivan, Michael. Introduction to Chinese art.
 London, Faber & Faber; Berkeley, University
 of California, 1960

SULT Sullivan, Michael. Chinese art in the twentieth
 century. London, Faber & Faber; Berkeley,
 University of California Press, 1959

SUNA Sunset Publishing Company. Art treasures in
 the West. Menlo Park, Calif, Lane Magazine
 and Book Co., 1966

SWA Swarzensi, Hans. Monuments of Romanesque
 art. London, Faber & Faber; Chicago, Uni-
 versity of Chicago Press, 1954

SWANJ Swann, Peter C. Introduction to the arts of
 Japan. Oxford, Bruno Cassirer; New York,
 Frederick A. Praeger, Publishers, 1958

SWANJA Swann, Peter C. Art of Japan. Baden-Baden,
 Holle Verlag; New York, Crown Publishers,
 1966

SWANNC Swann, Peter C. Art of China, Korea and Japan.
 New York, Frederick A. Praeger, Publishers,
 1963

TAFT Taft, Lorado. History of American sculpture.
 new ed. New York, Macmillan, 1930

TAFTM Taft, Lorado. Modern tendencies in sculpture.
 Chicago, published for the Art Institute of
 Chicago by University of Chicago Press, 1921

TAT Tatlock, Robert Rattray, ed. Spanish art; an
 introductory review of... sculpture. New York,
 Weyhe, 1927

TATEB Tate Gallery. Modern British paintings, draw-
 ings, and sculpture, by Mary Chamot, and
 others. London, Oldbourne Press, 1964
 v. 1. Artists A-L
 v. 2. Artists M-z
 This catalog, one "of a new series of detailed
 catalogs to be printed by the Tate Gallery,"
 lists and pictures the work of British artists
 born in or after 1850

TATEF Tate Gallery. Foreign paintings, drawings and
 sculpture, by Ronald Alley. London, Tate
 Gallery, 1959

TATES Tate Gallery. British sculpture since 1945, by
 Dennis Farr. London, Tate Gallery, 1965

TAYFF Taylor, Francis Henry. Fifty centuries of art. rev
 ed. New York, Harper, 1960

TAYFT	Taylor, Francis Henry. Taste of angels; a history of art collecting from Rameses to Napoleon. New York, Little, Brown, 1948
TAYJ	Taylor, Joshua C. Learning to look: A handbook for the visual arts. Chicago, University of Chicago Press, 1957
THOR	Thorp, Margaret (Farrand). The Literary sculptors. Durham, N. C., Duke University Press, 1965
THU	Thurston, Carl. Structure of art. Chicago, University of Chicago Press, 1940
TOK	Tokyo National Museum. Pageant of Japanese art. v. 3. Sculpture. popular ed. Tokyo, Toto Shuppan Co.; distributed by Charles E. Tuttle, Rutland, Vt., 1952
TOKC	Tokyo. National Museum of Western Art. Catalog. Tokyo, The Museum, 1960 Text in Japanese and French, also English titles of works
TOLC	Toledo Museum of Art. Chilean contemporary art, and exhibition sponsored by the Ministry of Education of the Republic of Chile, and the Faculty of Fine Art of the University of Chile. Toledo, The Museum, 1946
TOR	Toronto. Royal Ontario Museum. Art treasures in the Royal Ontario Museum, by Theodore Allen Heinrich. Toronto, McClelland & Stewart, 1963; Greenwich, Ct., New York Graphic Society, 1964
TORA	Toronto, Art Gallery of Toronto. Painting and sculpture, illustrations of selected paintings and sculpture from the collection. Toronto, The Gallery, 1959
TOW	Townsend, James Benjamin. 100; The Buffalo Fine Arts Academy, 1862-1962. Buffalo, N. Y., Albright-Knox Art Gallery, 1962
TREW	Trewell, Margaret. Classical African sculpture. rev ed. London, Faber & Faber; New York, Frederick A. Praeger, Publishers, 1964
TRI	Trier, Eduard. Form and space; sculpture of the Twentieth century. London, Thames & Hudson; New York, Frederick A. Praeger, Publisher, 1962
TUC	Tuchman, Maurice, ed. American sculpture of the sixties. Los Angeles, Los Angeles County Museum of Art, 1967

UCIF University of California. Irvine. Five Los
Angeles sculptors. Catalog for an exhibit, Jan
7 to Feb 6, 1966. Irvine, University of
California, 1966

UCIT University of California. Irvine. Twentieth century
sculpture, 1900-1950, selected from California
collections. Catalog for an exhibit, October 2-
24, 1965. Irvine, University of California,
1965.

UCLD University of California, Los Angeles. Virginia
Dwan Collection. Catalog, October 3-24, 1965.
The University, 1965

UIA--6-13 Illinois University. College of Applied Arts. Bi-
ennial exhibition of contemporary American
painting and sculpture. Urbana, The University

--6	1953	--10	1961
--7	1955	--11	1963
--8	1957	--12	1965
--9	1959	--13	1967

UMCF Harvard University. William Hayes Fogg Art
Museum. Survey of the Fogg Collection. 1964

UNA United American Sculptors. First annual exhibi-
tion, catalog. New York, 1939

UND Underwood, Eric Gordon. Short history of English
sculpture. London, Faber & Faber, 1933

UNNMMAM Museum of Modern Art. Modern works of art;
fifth anniversary exhibition, November 20,
1934-January 20, 1935. 2nd ed New York, The
Museum, 1936

UNNMMAS Metropolitan Museum of Art. American sculpture,
a catalogue of the collection of the Metropolitan
Museum of Art, by Albert Ten Eyck Gardner.
Metropolitan Museum of Art; distributed by
New York Graphic Society, 1965
160 photographs representing "all major
sculptures and schools from the early 19th
century to the present."

UPJ Upjohn, Everard Miller, et al. History of world
art. 2nd rev ed. New York, Oxford University
Press, 1958

UPJH Upjohn, Everard, Miller, and J. P. Sedgwick.
Highlights: An illustrated handbook of art
history. New York, Holt, 1963

USC United States Congress. 88th Congress, 2nd Ses-
sion. Compilation of works of art and other
objects in the United States Capitol, prepared
by the Architect of the Capitol, under the
direction of the Joint Committee on the Library.

	Washington, D. C., U. S. Government Printing Office, 1965 House Document No. 362
USNC	United States National Gallery of Art. Preliminary catalogue of paintings and sculpture. Washington, D. C., The Gallery, 1941
USNI	United States National Gallery of Art. Book of illustrations. 2nd ed. Washington, D. C., The Gallery, 1942
USNK	United States National Gallery of Art. Paintings and sculpture from the Kress Collection. Washington, D. C., The Gallery, 1945
USNKP	United States National Gallery of Art. Paintings and sculpture from the Kress Collection, acquired by the Samuel H. Kress Foundation, 1945-1951. 2nd ed. Washington, D. C., The Gallery, 1959
USNKS	United States National Gallery of Art. Supplement to the Kress Collection in the National Gallery, by Felix Frankfurter. New York, The Art Foundation, 1946
USNM	United States National Gallery of Art. Makers of history in Washington, 1800-1950. Catalog of an exhibition celebrating the sesquicentennial of the establishment of the Federal Government in Washington, June 29-November 19, 1950. Washington, D. C., The Gallery, 1950
USNP	United States National Gallery of Art. Paintings and sculpture from the Mellon Collection. Washington, D. C., The Gallery, 1949
VA	Vaillant, George Clapp. Artists and craftsmen in ancient Central America. New York, American Museum of Natural History, 1949
VAL	Valcanover, Francesco. Colorslide tour of the Accademia Gallery, Venice. New York, Harry N. Abrams, 1961 (Panorama Colorslide Art Program, v. 9)
VALE	Valentiner, Wilhelm Reinhold. Origins of modern sculpture. New York, Wittenborn, 1946
VEN	Venice. Biennale di Venezia, Esposizione internazionale d'Arte. Catalog. Venice, The Biennale

--97	1897, v. 2	--34	1934
--99	1899	--36	1936
--1	1901	--38	1938
--3	1903	--40	1940
--5	1905	--42	1942
--7	1907		

```
--10   1910              --48   1948
--12   1912              --50   1950
--14   1914              --52   1952
--20   1920              --54   1954
--22   1922              --56   1956
--24   1924              --58   1958
--26   1926              --60   1960
--28   1928              --62   1962
--30   1930              --64   1964
--32   1932              --66   1966, v. 33
```
31 catalogs indexed. 1895, v. 1, and 1909,
v. 8, contain no illustrations of sculpture

VER Vermeule, Cornelius. European art and the classical past. Cambridge, Harvard University Press, 1964

VEY Vey, Horst, and Xavier de Salas. German and Spanish art to 1900. New York, Franklin Watts, 1965

VICF Victoria and Albert Museum. Fifty masterpieces of sculpture. London, HMSO, 1951

VICG Victoria and Albert Museum. The Great Exhibition of 1851: A commemorative album. Compiled by C. H. Gibbs-Smith. A description of the Hyde Park Crystal Palace, with over 200 illustrations. London, HMSO, 1950

VICK Victoria and Albert Museum. Kings and queens of England, 1500-1900. London, HMSO, 1937

VICO Victoria and Albert Museum. One hundred masterpieces, Renaissance and modern. London, HMSO, 1931

VICOR Victoria and Albert Museum. The Orange and the Rose--Holland and Britain in the age of observation, 1600-1750. An exhibition...October 22 to December 13, 1964. London, The Museum, 1964

VOL Volbach, W. F., and M. Hirmer. Early Christian art. London, Thames & Hudson; New York, Harry N. Abrams, 1961

WADE Wadsworth Atheneum, Hartford, Ct. Eleven New England sculptors: Loan exhibition, July 18 through September 15, 1963. Hartford, Ct., Atheneum, 1963

WAG Wagner, Frits A. Art of Indonesia. Baden-Baden, Holle Verlag; New York, McGraw-Hill Book Co., 1959

WALD Waldberg, Patrick. Surrealism. Geneva, Skira, 1962

WALK Walker, John. Colorslide tour of the National
 Gallery of Art, Washington, D. C. New York,
 Harry N. Abrams, 1960
 (Panorama Colorslide Art Program, v. 2)
WALKA Walker Art Center, Minneapolis. New art of
 Argentina. Minneapolis, The Center, 1964
WALKB Walker Art Center, Minneapolis. New art of
 Brazil. Minneapolis, The Center, 1962
WALKC Walker Art Center, Minneapolis. Classic tradition
 in contemporary art. Exhibit catalog, April 24
 through June 28, 1953. Minneapolis, University
 of Minnesota, 1953
WALKE Walker Art Center, Minneapolis. Expressionism
 1900-1955: Walker Art Center... Minneapolis,
 The Center, 1956
WALKR Walker Art Center, Minneapolis. Reality and
 fantasy, 1900-1954. Exhibit catalog, May 23,
 through July 2, 1954. Minneapolis, The Center,
 1954
WALKS Walker Art Center, Minneapolis. Eight sculptors.
 Minneapolis, The Center, 1966
WALKT Walker Art Center, Minneapolis. Ten American
 Sculptors; an exhibition organized by Walker
 Art Center and shown in the American section
 of the VII Bienal de Sao Paulo in Brazil,
 September 28 through December 31, 1963.
 Minneapolis, The Center, 1963
 Text in Portuguese and French
WALTA Walters Art Gallery, Baltimore. Catalogue of the
 American works of art including French medals
 made for America, by E. S. King and M. C.
 Ross. Baltimore, Trustees of the Gallery,
 1956
WARN Warner, Langdon. Enduring art of Japan. 2nd
 ptg. Cambridge, Harvard University Press,
 1958
WATT Watt, Alexander. Art centers of the world--
 Paris. Cleveland, World Publishing Co., 1967
WB World Book Encyclopedia. Chicago, Field
 Enterprises, 1967
 Index of illustrations in Sculpture article
WCO--1-3 World Confederation of Organizations of the
 Teaching Professions. Man through his art.
 Greenwich, Ct., New York Graphic Society
 --1 v. 1. War and peace. 1964
 --2 v. 2. Music. 1964
 --3 v. 3. Man and animals. 1965

WDCM	Washington, D. C. Gallery of Modern Art. Permanent collection, catalog. Washington, D. C., The Gallery, 1966
WEB	Webster, T. B. L. Art of Greece: The age of Hellenism. New York, Crown Publishers, 1966
WEG	Wegner, Max. Greek masterworks of art. New York, George Braziller, 1961
WES	West, Robert. Spanish sculpture from the 15th to the 18th century. Munich, Hyperion, 1923
WHEE	Wheeler, (Robert E.) Mortimer. Roman art and architecture. New York, Frederick A. Praeger, Publishers, 1964
WHIN	Whinney, Margaret, and Oliver Millar. English art, 1625-1714. Oxford, Clarendon Press, 1957
WHINN	Whinney, Margaret. Sculpture in Britain, 1530-1830. Harmondsworth, Baltimore, Penguin Books, 1964
WHITEH	White House Historical Association. The White House, an historic guide. Washington, D. C., The Association, 1962
WHITJ	White, John. Art and architecture in Italy, 1250-1400. Harmondsworth, Baltimore, Penguin Books, 1966
WHITN	Whitney Museum of American Art, New York. Between the Fairs: 25 years of American art, 1939-1964, by John I. H. Baur. New York, Frederick A. Praeger, Publishers, 1964
WHITNA	Whitney Museum of American Art. Nature in abstraction; the relation of abstract painting and sculpture to nature in twentieth-century American art. Text by John I. H. Baur. New York, Macmillan, 1958
WHITNA-- 1-19	Whitney Museum of American Art. Annual exhibition of contemporary American sculpture, water colors and drawings. New York, The Museum

9o7H.01-109

--1	1946	--10	1955	--19	1968
--2	1947	--11	1956		
--3	1948	--12	1956/57		
--4	1949	--13	1957		
--5	1950	--14	1958		
--6	1951	--15	1960		
--7	1952	--16	1962		
--8	1953	--17	1964		
--9	1954	--18	1966		

19 catalogs indexed, 1946 through 1968.
Sculpture exhibit biennial beginning in 1958

WHITNB Whitney Museum of American Art. Business buys American art... exhibition by the Friends of the Whitney Museum, March 17-April 24, 1960 New York, The Museum, 1960

WHITNC Whitney Museum of American Art. Catalogue of the collection. New York, published for The Museum by Rudge, 1931

WHITNF Whitney Museum of American Art. The Museum and its Friends--Twentieth-century American art from the collections of the Friends of the Whitney Museum, a loan exhibition, April 30-June 15, 1958. New York, The Museum, 1958

WHITNF-- Whitney Museum of American Art. The Museum
2 and its Friends--Eighteen living American artists selected by the Friends of the Whitney Museum, a loan exhibition, March 5-April 12, 1959. New York, The Museum, 1959

WHITNF-- Whitney Museum of American Art. The theatre
4 collects--fourth loan exhibition by the Friends of the Whitney Museum, April 10-May 16, 1961. New York, The Museum, 1961

WHITNF-- Whitney Museum of American Art. The Friends
7 collect--Recent acquisitions by members of the Friends of the Whitney Museum, a loan exhibition, May 8-June 16, 1964. New York, The Museum, 1964

WHITNFA Whitney Museum of American Art. Juliana Force and American art, a memorial exhibition, September 24-October 30, 1949. New York, The Museum, 1949

WHITNFY Whitney Museum of American Art. The first five years--Acquisitions by the Friends of the Whitney Museum, 1957-1962, exhibition May 16-June 17, 1962. New York, The Museum, 1962

WHITNM Whitney Museum of American Art. Modern American painting and sculpture, Roy and Marie Neuberger Collection, exhibition, November 17-December 19, 1954. New York, The Museum, 1955

WHITNN Whitney Museum of American Art. New Decade: 35 American painters and sculptors, exhibition, May 11-August 7, 1955. New York, The Museum, 1955

WHITNP Whitney Museum of American Art. Pioneers of modern art in America, exhibition, April 9-May 19, 1946. New York, The Museum, 1946

WHITNR Whitney Museum of American Art. The collection
of the Sara Roby Foundation, exhibition,
April 29-June 14, 1959. New York, The
Museum, 1959

WHITNS Whitney Museum of American Art. Howard and
Jean Lipman Foundation, New York. Con-
temporary American sculpture, selection 1.
New York, The Museum, 1966

WHITNT Whitney Museum of American Art. 20th century
artists; a selection of paintings, sculpture and
graphic arts from the Museum's permanent
collection. New York, The Museum, 1939

WHITNY Whitney Museum of American Art. Young Ameri-
--1 can art--Young America. New York, The
--3 Museum
 --1 Thirty American painters and sculptors
 under thirty-five. 1957
 --3 ----------. 1965
 The second Young American art exhibition
 in 1960 included 30 painters, no sculptors

WHITT Whittet, G. S. Art centers of the world--London.
Cleveland, World Publishing Co. , 1967

WHY Whyte, Bertha K. Seven treasure cities of Latin
America. New York, October House, 1964

WILL Willetts, William. Chinese art. New York,
George Braziller, 1958

WILM Wilenski, Reginald Howard. Meaning of modern
sculpture. London, Faber & Faber, 1932;
New York, Frederick A. Stokes, 1933

WILMO Wilenski, Reginald Howard. Modern movement in
art. 1st American ed. New York, Thomas
Yoseloff, 1957

WIN Wingert, Paul Stover. Sculpture of Negro Africa.
New York, Columbia University Press, 1950
"Examples illustrated by plates are all in
American collections. " (p. vi)

WINGP Wingert, Paul S. Primitive art, its traditions
and styles. New York, Oxford University
Press, 1962

WIT Wittkower, Rudolf. Art and architecture in Italy,
1600-1750. 2nd rev ed. Harmondsworth,
Baltimore, Penguin Books, 1965

WOLD Woldering, Irmgard. Art of Egypt. New York,
Crown Publishers, 1963

WOLFFA Wolfflin, Heinrich. Art of the Italian Renaissance.
New York, Putnam, 1913; 1963 reprint, New
York, Schocken Books

WOLFFC	Wolfflin, Heinrich. Classic art: An introduction to the Italian Renaissance. 2nd ed. New York, Phaidon, 1953; 1959 reprint
WOLFFP	Wolfflin, Heinrich. Principles of art history. 6th ed. London, G. Bell, 1932; 1950 reprint, New York, Dover
WOOLM	Woolley, Leonard. Art of the Middle East, including Persia, Mesopotamia, and Palestine. New York, Crown Publishers, 1961
WOR	Chicago. World's Columbian Exposition. Official illustrations, edited by Charles M. Kurtz. Chicago, 1893
WORC	Worcester Art Museum, Massachusetts. Art through fifty centuries, from the collections of the Worcester Art Museum. Worcester, Mass., The Museum, 1948
WORR	Worringer, Wilhelm. Form in Gothic. London, A. Tiranti, 1957; New York, Schocken Books, 1964
WPN	Warsaw. Museum Narodowe. National Museum in Warsaw, handbook of the collection. Warsaw, 1963
WW	Who's who among Japanese artists. Prepared by Japanese National Committee for the International Association of Plastic Arts, under the auspices of Japanese National Commission for UNESCO. Tokyo, Printing House, Japanese Government, 1961
YAH	Yale University. School of Fine Arts. Handbook of the gallery. New Haven, Associates in Fine Arts, 1931
YAP	Yale University. Gallery of Fine Arts. Paintings, drawings and sculpture collected by Yale alumni, an exhibition, May 19-June 26, 1960. New Haven, 1960
YAPO	Yale University. Portrait index, 1701-1951. New Haven, Yale University Press, 1951
YAS	Yashiro, Yukio. 2000 years of Japanese art. New York, Harry N. Abrams, 1958
ZOR	Zorach, William. Zorach explains sculpture--what it means and how it is made. New York, Tudor, 1960

Sculpture Location Symbols

(Locations given are from publications indexed
and may not be current.)

Collections not Identified by
Geographic Location

-A	Coll. Ackerman-Pope
-Ac	Art of This Century
-Ad	Coll. Larry Adler
-Bak	Coll. Dr. Ruth Morris Bakwin
-Be	Coll. Alan Bennett
-Br	Coll. Joseph Brummer
-Bu	Coll. Mrs. Cora Timkin Burnett
-Bur	Coll. G. Burt
-But	Coll. John Butler
-Cal	Coll. Mrs. Meric Callery
-Cha	Coll. Mme Annick du Charme
-Chal	Galerie Chalette (UNNCh)
-Co	Coll. O. Le Corneur
-Coi	Coll. J. Coifford
-Col	Coll. Colonel Norman Colville
-Cos	Coll. Maurice Coskin
-Cr	Coll. Templeton Crocker
-Cu	Coll. Curtis
-D	Coll. P. J. Dearden
-Da	Coll. Mr. David M. Daniels
-Dan	Coll. Baron Ino Dan
-Dav	Coll. B. A. Davies
-De	Coll. Demotte
-Dot	Former Coll. Dottari
-Dug	Coll. Dugald-Malcolm
-E	Coll. G. W. Elliott
-El	Coll. Samuel Ellenburg
-Ep	Coll. Epstein
-Eu	Former George Eumorfopoulos Coll.
-Ev	Coll. Walker C. Everett
-F	Coll. A. Flowers
-Fab	Coll. Fabius
-Fe	Coll. Mme. Feron-Stoclet

-Fej	Coll. Paul Fejos
-Fig	Coll. Figdor
-Fo	Coll. Mrs. David McHattie Forbes
-For	Forum Gallery
-Foy	Folye Art Gallery
-Fr	Coll. Harry G. Friedman
-Fu	Fujita & Company
-Gaf	Coll. Rene Gaffe
-Gal	Coll. Signora P. Varzi Galliate
-Gar	Coll. Margaret Gardiner
-Ge	Coll. Gernsheim
-Gir	Coll. Dr. Maurice Girardin
-Go	Coll. Maurice Goldmann
-God	Coll. Y. and A. Godard
-Gol	Coll. Bertrand Goldberg
-Goldschmidt	Coll. Robert Goldschmidt
-Gr	Coll. Chaim Gross
-Gri	Coll. Marcel Griaule
-Gu	Coll. Late Franklin Mott Gunther
-Gue	Coll. Leonce-Pierre Guerre
-Guen	Coll. Guennol
-H	Coll. Late Mrs. Christian R. Holmes
-Ha	Coll. Tatsujiro Hashimoto
-Ham	Coll. Hamlin
-Han	Coll. Dr. James Hanson
-He	Coll. Baron Eduard von der Heydt
-Hea	Coll. G. E. Hearn
-Heb	Coll. Mrs. Jean Hebbeln
-Hee	Coll. N. Heeramaneck
-Her	Coll. Mr. and Mrs. Arnold L. Herstand
-Ho	Coll. Mr. and Mrs. Edward Jackson Holmes
-Hof	Coll. Hoffmann
-Hol	Coll. Mrs. Margot Holmes
-Hou	Coll. Mrs. Frank Lewis Hough
-Hs	Coll. Blair Hughes-Stanton
-I	Coll. R. Sturgis Ingersoll
-Ii	Coll. Shoichi Iijima
-J	Coll. Ralph Jonas
-Ja	Coll. Jameson
-K	Coll. Kramer
-Ka	Coll. Mrs. Otto K. Kahn
-Kam	Former Coll. Kamor
-Kau	Coll. Edgar Kaufmann, Jr.
-Kay	Coll. Harold Kaye
-Ke	Coll. D. G. Kelekian
-Kei	Coll. Mrs. Alex Keiller (EKink)
-Kev	Coll. H. Kevorkian
-Kj	Coll. Carl Kjersmeier

-Ko	Coll.	Fahim Kouchakji
-La	Coll.	A. Lancaster
-Le	Coll.	Leconsfield
-LeG	Coll.	Le Guillou
-Leff	Coll.	Leff
-Lem	Coll.	Samuel and Lucille Lemberg
-Leo	Il Leone Gallery	
-Lint	Coll.	Ralph Linton
-Lo	Coll.	Mr. and Mrs. Milton Lowenthal (UNNLow)
-Loc	Coll.	Dr. Alain Locke
-Lov	Coll.	C. Buxton Love, Jr.
-Mac	Coll.	MacGregor
-Mag	Coll.	Alex Maguy
-Mar	Coll.	Mr. and Mrs. Arnoid Maremont
-Marc	Coll.	Stanley Marcus
-Mart	Coll.	Bradley Martin
-Mas	Coll.	Baron Taro Masuda
-Masl	Coll.	Mr. and Mrs. Samuel H. Maslon
-May	Coll.	Albert Mayeux
-Maye	Coll.	William Mayer
-Me	Coll.	Gustav Metzger
-Met	Coll.	Mr. and Mrs. John Metzenberg
-Mo	Coll.	Mrs. William H. Moore
-Mon	Coll.	R. de Montagne
-Moo	Coll.	Mrs. Irina Moore (EMoo)
-Mu	Coll.	Andrew Muir
-Mug	Coll.	M. Mugica Gallo
-Mul	Coll.	Dr. O. Muller-Widmann
-Mur	Coll.	K. C. Murray
-Nez	Coll.	Kaichiro Nezu
-No	Coll.	Kichibei Noda
-Nol	Coll.	Mr. and Mrs. Kenneth Noland
-O	Coll.	W. O. Oldman
-Od	Coll.	R. H. M. Ody
-Og	Coll.	Yasuyuki Ogura
-Ol	Coll.	Jules Olitski
-Op	Coll.	H. J. Oppenheim
-P	Coll.	P. Peissi
-Pas	Coll.	Jack Passer
-Pe	Coll.	M. Peltzer
-Pem	Coll.	Mr. and Mrs. Murdock Pemberton
-Pi	Coll.	Pitcairn
-Pl	Coll.	Margaret Plass
-Pla	Coll.	Webster Plass
-Ple	Coll.	Rene Pleven
-Pr	Coll.	Vincent Price
-Pry	Coll.	Dr. M. G. M. Pryor
-Q	Coll.	John Quinn

-Ra	Coll. Oscar Raphael
-Raf	Coll. Alexander Rafaeli
-Ras	Coll. Rene Rasmussen
-Rath	Coll. Mr. and Mrs. Gustave Rath
-Re	Coll. Bernard Reis
-Ril	Coll. Mr. and Mrs. Chapin Riley
-Ro	Coll. Mr. and Mrs. Paul Robeson
-Rob	Coll. Mrs. J. Rosenbaum
-Rog	Coll. Mrs. M. A. Rogers
-Roth	Coll. Elie de Rothschild
-Ru	Coll. Rutherston
-Rub	Coll. William Rubin
-Rus	Coll. John Russell
-Rome	Coll. Harold Rome
-Sai	Saidenberg Gallery
-Sal	Coll. Canon Quirk Salisbury
-Sch	Coll. Schnell
-Scha	Coll. Dr. Rosa Schapire
-Sh	Coll. Mr. and Mrs. Joseph R. Shapiro
-Si	Coll. Professor Roy Sieber
-Sip	Coll. Walter Siple
-Sm	Coll. Rebecca and Candida Smith
-So	Coll. Mr. and Mrs. Edward Sonnenschein
-St	Coll. R. Stora
-Sti	Coll. E. Clark Stillman
-Sto	Coll. Storno
-Stu	Peter Stuyvesant Foundation
-Sug	Coll. Suco Sugiyama
-Sw	Swiss Confederation
-T	Coll. Mr. and Mrs. Yves Tanguy
-Ta	Coll. M. A. Tachmindji
-Til	Coll. Paul Tilles
-Tm	Turan Museum
-Tr	Coll. Margaret Trowell
-V	Vasarely Collection
-Va	Coll. Dr. Vanbremeersch
-Van	Formerly Coll. Mrs. van den Berg
-Ve	Coll. Verite
-Vet	Coll. P. S. Verity
-Vog	Coll. Dr. Felicitas Vogler
-Wa	Coll. Edward M. M. Warburg
-Wal	Coll. Furst Ottingen Wallerstein
-War	Coll. John W. Warinner
-We	Coll. Captain Welch
-Wh	Coll. M. D. Whyte
-Wi	Coll. Wielgus
-Wil	Coll. William Wilder (UWi)
-Win	Coll. Mr. and Mrs. David J. Winton

-Wo	Coll. Dr. Nathaniel S. Wolf
-Y	Coll. Howard Young (UNNYo)
-Z	Coll. Ed. Zern

Austria

-AE	Emperor of Austria
AA	Altenburg
AAdB	Admont. Benedictine Abbey
AF	Friesach, Carinthia
AFrP	Frauenstein. Parish Church
AGJ	Graz. Landesmuseum Johanneum
AGLG	----- Landesmuseum Joanneum. Alte Galerie
AGM	----- (near). St. Martin Church
AGuC	Gurk. Cathedral
AI	Innsbruck
AIA	----- Schloss Ambras
AIFr	----- Franciscan Church
AIH	----- Hofkirche
AIHe	Innsbruck. Helbinghaus
AIT	----- Tiroler Landesmuseum Ferdinandeum
AK	Klosterneuberg Convent Church
AKe	Kefermarkt
AKrS	Kremsmunster. Stifliskirche
AL	Lochen
AM	Mils bei Hall, Tyrol
AMa	Mauer bei Melk
AMeA	Melk. Abbey Church (Benediktinerabtei Melk)
AMon	Mondsee Abbey Church
APA	Pressburg. Palace of Administration (Now: Bratislavia, Czechoslovakia)
APC	Pressburg. Cathedral
ASF	Salzburg. Festival Theatre
ASFr	----- Francescan Convent
ASM	----- Mirabell Palace
ASS	----- Salzburger Museum Carolino Augusteum
ASSt	----- Achiepiscopal Stables
ASc	Schleedorf
ASch	Schongrabern
AStGF	St. Georgen a. d. Mattig. Filialkirche
AStPS	St. Polten. Schweighof
AStW	St. Wolfgang Parish Church
ASta	Stams
AVA	Vienna. Albrechts-Platz
AVAB	----- Akademie der Bildenden Kunste
AVAg	----- Church of the Augustinians (Augustinerkirche)
AVAr	----- Archaeological Museum
AVAs	----- Aspern

AVB	----- Coll. Gustav Benda
AVBa	Vienna. Austrian Baroque Museum (Osterreichische Galerie. Barokmuseum) (AVO)
AVBe	----- Belvedere Palace
AVC	----- Capuchin Church (See also AVKa)
AVD	----- Daun-Kinsky Palace
AVE	----- Coll. Este
AVEu	----- Prinz Eugen Stadtpalais
AVEv	----- Evangelical Church
AVG	----- Graben
AVH	----- Hofmuseum
AVHa	----- Coll. Counts Harrach
AVHof	----- Hofburg
AVI	----- Austrian Ministry of the Interior
AVJ	----- Josefplatz
AVK	----- Kunsthistorishes Museum
AVKa	----- Kapuzinerkirche (See also AVC)
AVL	----- Furstlich Lichtensteinsche Gemaldegalerie
AVM	----- Museum of Fine Arts
AVMH	----- Municipal Hall
AVMa	----- Karl Marx Hof
AVMe	----- Mehlmarkt
AVN	----- New Market
AVNM	----- Naturhistorisches Museum
AVNeP	----- Neustadt Parish Church
AVO	----- Osterreichische Galerie (AVBa)
AVOA	----- Osterreichisches Museum fur angewandte Kunst
AVOG	----- Osterreichisches Gesellschafts- und Wirtschafts-Museum
AVOI	----- Austrian Museum for Art and Industry
AVS	----- St. Stephen's Cathedral (See also AVSt)
AVSc	Vienna. Schwarzenberg Garden
AVSch	----- Schatzkammer
AVSt	----- Stephansdom (See also AVS)
AVT	----- Museum of the Twentieth Century (Museum des 20. Jahrhunderts)
AVU	----- Upper Belvedere
AVV	----- Museum fur Volkerkunde
AVVC	----- Vienna County-Council Tenements
AVW	----- Woodworkers' School
AVWi	----- Residence, corner of Wildbretmarkt and Brandstatte
AWG	Wiener Neustadt. St. George

Afghanistan

AfB	Bamian. Bamian Museum
AfKM	Kabul. Kabul Museum
AfT	Tashkurghan

Algeria

AlAL	Algiers. Coll. R. Lopez
AlAMB	----- Musee National des Beaux-Arts
AlCA	Cherchel. Musee Archeologique
AlDM	Djemila. Musee Archeologique
AlG	El Greiribat (site)
AlOM	Oran. Oran Museum (Musee Municipal DeMaeght)
AlTW	Tassili. Wadi Djerat
AlTi	Timgad. Musee Archeologique

Argentina

ArBNB	Buenos Aires. Museo Nacional de Bellas Artes
ArBT	----- Museo Instituto Torcuata di Tella
ArJ	Jujuy

Australia

AuAH	Adelaide. Coll. Mr. and Mrs. E. W. Hayward
AuANG	----- National Gallery of South Australia
AuBA	Brisbane. Queensland Art Gallery (Brisbane Gallery)
AuBJ	----- Coll. Mr. and Mrs. Brian Johnstone
AuBT	----- Town Hall
AuMA	Melbourne. Coll. D. L. Adam
AuMB	----- B'nai Israel Temple
AuMC	----- Coll. Dr. P. H. Cook
AuMCu	----- Coll. Peter Cullin
AuMGV	----- National Gallery of Victoria
AuMMV	----- National Museum of Victoria
AuMU	----- University of Melbourne
AuMV	----- Victoria Gallery of Art
AuMMo	----- Museum of Modern Art of Australia
AuPW	Perth. Art Gallery of Western Australia
AuSAu	Sidney. Australian Museum
AuSC	----- Commonwealth Bank of Australia
AuSF	----- New South Wales Forest Commission
AuSH	----- Morning Herald Office
AuSM	----- St. Mary's Basilica
AuSN	----- Art Gallery of New South Wales
AuSS	----- Coll. Ronald Steuart
AuST	----- Coll. Tony and Margaret Tuckson

Belgium

-BQE	Coll. Queen Elizabeth of Belgium
BA	Antwerp. Koninklijk Museum voor Schone Kunsten--Musee Royal des Beaux-Arts (See also BAR
BAA	----- St. Andrew's Church
BAB	----- Museum Mayer van den Bergh
BAC	----- Cathedral
BAG	----- Grand Palace
BAH	----- Hessenhuis
BAHe	----- Coll. Jan van Herck
BAJ	----- Coll. J. Janssen
BAKE	----- Kunsthistorische Musea der Stad Antwerpen--Musee d'Histoire del'Art de la Ville d'Anvers. Etnografisch Museum-- Musee d'Ethnographie
BAKO	----- Openluchtmuseum voor Beeldhouwkunst Middelheim--Musee de Sculpture en plain air Middelheim (BAM)
BAM	----- Middelheim (BAKO)
BAMu	----- Museum
BAO	----- Oplinter
BAP	----- St. Pauluskerk
BAR	----- Musee Royal des Beaux-Arts (See also BA)
BARo	----- Coll. Max Rooses
BAT	----- Hotel de Ville
BAndCh	Anderlecht. Church
BBA	Brussels. Musees des Arts Decoratifs
BBAr	----- Coll. Maurice d'Arquian
BBB	----- Banque Nationale
BBBo	----- Botanical Garden
BBC	----- Cathedral St. Gudule (See also BBGu)
BBCi	----- Musee et Parc de Cinquantenaire (See also BBRA)
BBCo	----- Galerie Cogeime
BBD	----- Coll. Philippe Dotremont
BBG	----- Coll. B. Goldschmidt
BBGr	----- Coll. E. Graeffe
BBGu	----- Ste Gudule (See also BBC)
BBH	----- Musee de la Porte de Hal
BBHV	----- Town Hall
BBHo	----- Coll. Baron Horta
BBJ	----- Palais de Justice
BBL	----- Coll. Baroness Lambert
BBLa	----- Banque Lambert
BBLo	----- Lombeek Notre Dame

BBLou	----- Avenue Louise
BBM	----- Musee Constantin Meunier
BBMG	----- Convent Church of St. Michael and St. Gudula
BBMa	----- Maison du Peuple
BBMu	----- Museum
BBN	----- Notre Dame de la Chapelle
BBNi	----- Coll. Peers and Nieuberg
BBP	----- House of Parliament
BBR	----- Musees Royaux des Beaux-Arts de Belguique
BBRA	----- Musees Royaux d'Art et d'Histoire (See also BBCi)
BBRP	----- Royal Palace
BBS	----- Coll. Jacques Stoclet; Coll. Adolphe Stoclet
BBTa	----- Tassel House, 12, rue de Turin
BBU	----- Coll. M. T. Ullens de Schooten
BBV	----- Musee Communal de Bruxelles
BBVe	----- Coll. Vernanneman
BBW	----- Coll. Withof
BBWit	----- L. Wittamer-De Camps Residence
BBa	Bastogne
BBo	Boom
BBrB	Bruges. Belfry
BBrC	----- Musee d'Eglise Notre Dame--Museum van de O. L. Vrouwkerk (See also BBrN)
BBrG	----- Gruuthusemuseum--Musee Communal Archeologique et d'Art Applique
BBrJ	----- Musee du Palais de Justice--Museum van het Gerechtshof
BBrJe	----- Musee de l'Hospital St. Jean
BBrJer	----- Church of Jerusalem
BBrN	----- Church of Our Lady (See also BBrC)
BBrO	----- Musea van de Commissie van Openbare Ondestand--Musees de l'Assistance Publique
BBrS	----- St. Salvator Church
BBrSa	----- Saint-Sauveur Cathedral
BBrSt	----- Stadhuis--Hotel de Ville
BBra	Brabant (Gaasbeek)
BCouH	Courtrai. Coll. T. Herbert
BCouN	----- Notre Dame
BDA	Dilbeek. St. Ambrose Church
BDiN	Diksmuiden. St. Nicolas
BDieS	Diest. St. Sulpitius Church
BES	Essen, near Dismuiden. Soldiers' Graveyard
BEtG	Etterbeek. St. Gertrude Church

BF	Friedhof in Essen
BFuSt	Furnes/Veurne. Museum of the City Hall
BGA	Ghent. Museum of Antiquities
BGB	----- Belfry
BGBa	----- St. Bavon Cathedral (See also BGC)
BGC	----- Abbaye de St.-Bavon (See also BGBa)
BGM	----- Coll. Baron Minne
BGMO	----- Museum voor Oudheden der Bijloke
BGMS	----- Museum voor Schone Kunsten
BGeD	Geel. St. Dimphna Church
BGo	Goesen
BHN	Huy (Liege). Notre Dame
BHaM	Hal. St. Martin
BHaN	----- Notre Dame
BHakS	Hakendover. St. Sauveur Church
BHasC	Hasselt. Church of the Recollects
BHasN	----- Notre Dame
BI	Ixelles
BKH	Kontich. Coll. Rev. Josse van Herck
BL B	Liege. St. Barthelemy Church
BLC	----- St. Paul Cathedral
BLCr	----- St. Croix
BLCu	----- Musee Curtius
BLG	----- Coll. Fernand C. Graindorge
BLJ	----- St. Jacques
BLL	----- Musee d'Archeologie et des Arts Decoratifs de la Ville de Liege
BLMB	----- Musee des Beaux-Arts
BLMD	----- Musee Diocesan
BLN	----- Notre Dame de St. Servais
BLeL	Leau. St. Leonard
BLiG	Lierre. St. Gommarius
BLo	Lombeek
BLouC	Louvain. Musee d'Art Chretien de l'Universite Catholique
BLouJ	----- St. Jacques Church
BLouN	----- Notre Dame Hors la Ville
BLouP	----- Collegiate Church of St. Pierre
BMC	Mechelen (Malines). Cathedral
BMJ	----- St. Jean
BMO	----- Onze Lieve Vrouwe van Hanswijk
BMP	----- Church of St. Peter and St. Paul
BMR	----- St. Rombout
BMoB	Mons. Boussu-lez-Mons
BMoW	----- Ste. Waudru
BMoWa	----- St. Waltrudis
BNG	Nivelles. Shrine of St. Gertrude
BNN	----- St. Nivelles

BNaM	Namur. Museum
BNaP	----- Pont des Ardennes
BOW	Overijse. Coll. Mme. de Carniere-Wouters
BOsN	Ostende. Coll. Pierre Nolvic
BRoC	Le Roeulx. Coll. S. A. S. le Prince de Croy-Roeuls
BSV	Soignes. St. Vincent
BTC	Tervueren. Koninklijk Museum voor Midden-Afrika--Musee Royal de l'Afrique centrale (formerly: Musee Royal du Congo Belge)
BTiG	Tirlemont. St. Germain
BToN	Tongren. Collegiate Church of Notre Dame
BTouC	Tournai. Tournai Cathedral of Notre Dame; Treasury
BTouM	----- Museum
BTouMad	----- St. Marie Madeleine
BVCh	Vise. Church
BWi	Wildern
BZ	Zuerbempde

Bolivia

BoLA	La Paz. Museo al Aire Libre
BoLB	----- Coll. Fritz Buck
BoP	Pakotia, Lake Titicaca Basin
BoPoL	Potosi. San Lorenzo Church
BoT	Tiahuanaco

Brazil

BrBA	Brasilia. Alvariadi Palace
BrBP	----- President's Palace
BrBaD	Bahia. Desterro Convent
BrCJ	Congonhas de Campo. Church of the Good Jesus (Shrine of Bom Jesus de Matozinhos) (See also BrMJ)
BrMI	Minas Gerais (Ouru Preto). Museu de Inconfidencia
BrMJ	----- Bom Jesus (See also BrCJ)
BrNL	Niteroi. Sao Lorenzo de los Indios
BrOF	Ouro Preto. Sao Francisco
BrObM	Obidos. Santa Maria
BrREd	Rio de Janeiro. Ministry of Education Building
BrRF	----- Convent of St. Francis
BrRI	----- Itamarati Palace, Foreign Ministry
BrRMo	----- Museu do Arte Moderna do Rio de Janeiro
BrRN	----- Museu Nacional des Bellas Artes
BrRS	----- Coll. Don C. da Silva-Negra

BrSan	Santos
BrSpA	Sao Paulo. Museu de Arte
BrSpC	----- Museu de Curia Metropolitiana
BrSpE	----- Emboi Church
BrSpL	----- Biblioteca Municipal
BrSpM	----- Museu de Arte Moderna de Sao Paulo
BrSpMo	----- Coll. Renoldo Motta
BrSpP	----- Prado House

Burma

BuMn	Myinpagan. Nanpaya Temple
BuPA	Pagan. Ananda Temple
BuPM	----- Archaeological Museum
BuW	Wet-Kyi-in Ku-Byauk-Kyi

Bulgaria

BulPW	Plowdim (Plovdiv). Archaeological Museum
BulSA	Sofia. Archaeological Museum
BulSJ	----- Court of Justice
BulSN	----- National Gallery of Art

Canada

-CL	Laing Galleries
-CN	Coll. C. S. Noxon
-CZ	Coll. Mr. and Mrs. Sam Zacks
CBG	British Columbia Government
CBlS	Blackburn Corners. Public School
CCT	Caughnawaga, Quebec. Tekakwitha Indian School
CHBN	Halifax. Bank of Nova Scotia
CLA	Lorette (Jeune-Lorette). Fabrique de Saint-Ambrose
CLH	----- Chapelle Huronne
CMB	Montreal. Coll. Mr. and Mrs. Peter Bonfman
CMBi	----- Coll. Henry Birks
CMC	----- Museum of Contemporary Art
CMD	----- Dominion Gallery
CMFA	----- Museum of Fine Arts
CMH	----- Hotel-Dieu
CML	----- Coll. Suzie and Nandor Loewenheim
CMN	----- National Bank of Canada
COB	Ottawa. Coll. Dr. Marius Barbeau
COD	----- Dominion Archives
COK	----- Coll. Yousuf Karsh
CON	----- National Gallery of Canada
CONM	----- National Museum of Canada
COP	----- Parliament Building
COR	Royal Ontario Museum of Art (See also CTRO)

COr F	Ile d'Orleans. La Fabrique de la Paroisse de Sainte-Famille
CQA	Quebec. Archeveche de Quebec
CQAr	----- Archives of Quebec
CQH	----- Hotel Dieu
CQL	----- Legislative Building (See also CQPa)
CQMA	----- Musee de l'Institut des Arts Appliques du Quebec
CQN	----- Fabrique de la Paroisse Notre Dame
CQP	----- Musee de la Province de Quebec
CQPa	----- Parliament House (See also CQL)
CQU	----- Ursuline Convent
CTA	Toronto. Art Gallery of Toronto
CTC	----- Coll. Mr. and Mrs. Walter Carsen
CTD	----- Coll. Mrs. Florence Dorsey
CTH	----- Hirschhorn Coll.
CTI	----- Isaacs Gallery
CTO	----- Art Gallery of Ontario
CTQ	----- Queen's Park
CTQE	----- Queen Elizabeth Way
CTR	----- Roberts Gallery
CTRO	----- Royal Ontario Museum
CTROA	----- Royal Ontario Museum of Archaeology
CTS	----- Coll. Mr. and Mrs. Peter A. Silverman
CTW	----- Coll. Mr. and Mrs. Percy Waxer
CVP	Victoria. Provincial Museum of Natural History and Anthropology
CVT	----- Thunderbird Park
CVaA	Vancouver. Vancouver Art Gallery
CVaR	----- Coll. Mr. and Mrs. Francis Reif
CVauM	Vaudreuil. St. Michel
CWH	Winnipeg. Hudson's Bay Company
CWM	----- Coll. J. A. MacAulay
CWP	----- House of Parliament

Cambodia

CaA	Temple of Angkor Wat
CaAB	Angkor. Bakong
CaABS	Angkor Wat. Banteay Srei
CaABaT	Angkor. Baphouon. Angkor Thom
CaABayT	----- Bayon. Angkor Thom
CaAC	Angkor Wat. Dept Archeologique de la Conservation d'Angkor (See also CaSA)
CaAP	----- Prasat Kravanh
CaAT	Angkor. Angkor Thom
CaBan	Banteay Srei
CaBatV	Battambang. Museum of Vat Po Veal

CaK	Koulen
CaPN	Phnom Penh. Musee National Vithei Ang Eng
CaPR	----- Royal Palace
CaPS	----- Musee Albert Sarraut
CaSA	Seimreap. Conservation des Monuments d'Angkor (See also CaAc)

Cameroon

CamAd	Coll. Albert G. Adams, Presbyterian Mission

Ceylon

CeA	Anuradhapura
CeAI	----- Isurumuniya Vihara
CeCNM	Colombo. Colombo National Museum
CeDM	Dedigama. Museum
CeKC	Kandy. Coll. A. R. Casse
CeKD	----- Coll. Dambevinne Family
CeKNM	----- Coll. National Museum
CeN	Nikawewa
CeP	Polonnaruva
CePG	----- Gal Vihara

China

-ChA	Formerly Academia Sinica, Nanking. Now -ChG
-ChG	Coll. The Chinese Government
ChAW	Anyang. Great Tomb at Wu-Kuan-ts'un
ChCC	Chufou, Shantung. Temple of Confucius
ChCha	Chang-ping-chou (ChPekT)
ChH	Hopei
ChHa	Hangchou
ChKM	Kansu. Mai-Chi-Shan Cave Shrine
ChKP	----- P'ing-ling Ssu Caves
ChKa	Kara-Shahr
ChL	Lung-men (Dragon Gate), Pin-yang Cave Temple
ChLL	Liu Li Ko
ChM	Mai-chi-shan Cave Temple
ChN	Nanking
ChPC	Peiping (Peking). Temple of Confucius
ChPekI	Peking. Imperial Palace
ChPek P	----- Peking Museum
ChPekT	----- Ming Tombs
ChSheH	Shensi Province. Tomb of General Ho Chu'u-p'ing
ChShK	----- Tomb of Emperor Kao-tsung
ChShaT	Shansi. T'ien-lung Shan Caves
ChShaY	----- Yun Kang (Cloud Hill) Cave Temples

ChShanT	Shantung. Tomb of Wu Liang Tzu
ChSzC	Szechwan. Ch'u-hsien
ChSzY	----- Ya-chou
ChT	Tun-huang (Caves of the Thousand Buddhas), Chinese Turkestan
ChTaA	Taihoku (formerly: Taipeh). Academia Sinica. Now: Ch-RTAS
ChTaP	Taipei, Taiwan. National Palace Museum and National Central Museum
ChTi	T'ien-Lung-Shan (Heavenly Dragon Mountain)
ChYK	Yun-Kang Caves
ChYM	Yn Men Shan, Shantung
Ch-RTAS	Taipei, Taiwan. Academia Sinica

Chile

ChiE	Easter Island
ChiGC	Graneros. Capilla de la Compania
ChiSC	Santiago
ChiSM	----- Coll. Norbert Mayrock
ChiSMH	----- Museo Nacional de Historia Natural
ChiSMN	----- Museo Nacional de Bellas Artes

Costa Rica

CoSB	San Jose. Banco Central de Costa Rica
CoSBal	----- Coll. Charles Balser
CoSN	----- Museo Nacional de Costa Rica

Colombia

ColBF	Bogota. San Francisco
ColBM	----- Museo Nacional
ColBO	----- Museo del Oro, Banco de la Republica
ColBR	----- Coll. Ruiz-Randall
ColCC	Cartagena. Cathedral
ColCD	----- Santo Domingo Church
ColCI	----- House of the Inquisition
ColCP	----- San Pedro Claver
ColCT	----- Santo Toribio de Mogrovejo
ColPF	Popayan. San Francisco
ColS	San Agustin, Upper River Magdalena
ColSM	----- Museo del Parque Arqueologico
ColTC	Tunja. Cathedral Nuestra Senora de Guadalupe
ColTD	----- Santo Domingo
ColTV	----- Casa Vargas

Congo

ConLM	Leopoldville. Musee de la Vie Indigene

Cyprus

CyNA	Nicosia. Museum of Antiquities
CyNC	----- Cypress Museum

Czechoslovakia

CzBM	Brno. Brno Museum
CzBMM	----- Moravske Museum
CzBV	----- Vegetable Market
CzBeC	Benesov. Collegiate Church
CzBeK	Benesov. Konopiste Castle
CzBes	Bestvinna
CzBiO	Bila Hora, near Prague. Church of Our Lady
CzBrCE	Bratislava (Formerly--1939-1945--GPr). Cathedral Chapel of St. Elemosynarius
CzBrN	----- Slovenske Narodne Muzeum
CzBro	Broumov
CzBu	Bucovice
CzC	Cerveny Hradek
CzCeZ	Ceske Budejovice. Zizka Square
CzCh	Chrudin
CzChl	Chloumek
CzCit	Citoliby
CzD	Decin
CzDo	Dolni Brezany
CzDoU	Dolni Ujezd
CzDu	Duchov
CzGC	Grussau. Cloister Church
CzH	Hradec Kralove (Koniggratz)
CzHl	Hlavenec
CzHo	Horin
CzJ	Jaromer
CzKB	Kuks (Kukus). Bethlehem Wood
CzKH	----- Hospital Church
CzKa	Karlovy Vary
CzKoL	Kosmonosy. Loretto Church
CzKon	Konopiste
CzKosE	Kosice. St. Elizabeth
CzKu	Kutna Hora
CzLi	Libechov
CzLn	Lnare. Castle
CzLoN	Louny. St. Nicholas Church
CzLyE	Lysa nad Labem. Eremitage
CzM	Manetin
CzMo	Moravska Trebova
CzN	Novy Bydsor (Novy Bydzov)
CzNa	Na Cihadle, near Lysa nad Labem
CzNoK	Nove Mesto nad Metuji. Kuks Castle

CzO	Omomouc
CzOp	Opocno
CzOsC	Osek. Cloister Church
CzPA	Prague. Arts and Crafts Museum
CzPAA	----- Archaeological Institute, Czechoslovak Academy of Sciences
CzPB	----- Brevnov
CzPC	----- Clam-Gallas Palace
CzPCS	----- Commercial School
CzPCa	----- St. Catherine Church
CzPCh	----- Charles Bridge
CzPChC	----- St. Charles Church
CzPCl	----- St. Clement's Church
CzPG	----- "The Golden Well"
CzPGa	----- St. Gallus Church
CzPH	----- Hradjin Palace
CzPHC	----- Hradcany Castle
CzPHS	----- Hradcany Square
CzPHo	----- Hopfenstoku
CzPJ	----- St. James Church
CzPJo	----- St. Joseph Church
CzPK	----- Kolovrat Palace
CzPKn	----- Knights of the Cross Church
CzPKr	----- Kreuzherrenkirche
CzPL	----- Little Quarter Square
CzPLo	----- Loretto Church
CzPM	----- Modern Gallery
CzPMo	----- Morzin Palace
CzPMol	----- Moldau Bridge
CzPN	----- National Gallery (Narodni Galerie)
CzPNM	----- National Museum (Narodni Muzeum)
CzPNML	----- National Museum Lapidarium (Lapidarium Narodniho Muzea)
CzPNe	----- New Town
CzPNi	----- St. Nicholas Church
CzPO	----- Olsany
CzPOu	----- Church of Our Lady
CzPOuN	----- Our Lady's Church Na Karlove
CzPP	----- Prague National Museum (Muzeum Hlavniho Mesta Prahy)
CzPS	----- St. Salvator's Church
CzPT	----- Palais Thun-Hohenstein
CzPTh	----- St. Thomas Church in the Little Quarter
CzPTo	----- Town Hall
CzPTr	----- Troja Chateau
CzPTy	----- Tyn Church
CzPV	----- St. Vitus Cathedral

CzPVr	Prague. Vrtba Palace
CzPVy	----- Vysehade Cemetery
CzPW	----- Wallenstein (Waldstein) Palace
CzPa	Pardubice
CzPi	Pisek
CzPlA	Plzen. Arts and Crafts Museum
CzPlB	----- Church of St. Bartholomew
CzPla	Plasy Church
CzPo	Pocatky
CzPolC	Policka. Collegiate Church
CzPrH	Pribram (near). Holy Mountain
CzR	Radic (near Sedlcany)
CzSC	Sloup. Sloup Castle
CzSm	Smirice
CzStC	Stara Boleslav. Chapter House
CzT	Teplice-Sanov
CzUh	Uherski Hradiste
CzV	(Vales
CzVa	(Valec
CzZ	Zirec
CzZd	Zdar
CzZe	Zelena hora
CzZi	Zirovec
CzZir	Zirec
CzZnB	Znojmo. Black Friar's Church

Denmark

DAA	Aarhus. Aarhus Kunstmuseum
DAF	----- Prehistoric Museum (Forhistorisk Museum)
DAK	----- Old Town Museum (Kobstadtmuseet)
DAR	----- Railway Station
DAlH	Aalborg. Aalborg Historiske Museum
DCA	Copenhagen. Amalienborg Square
DCB	----- Galerie Birch
DCBl	----- Coll. Alice Bloch
DCCF	----- Carlsberg Foundation
DCF	----- Frederiksberg Court House
DCH	----- Hirschsprung Coll.
DCJ	----- Coll. Jacobsen
DCJo	----- Coll. Elise Johanson
DCJu	----- Coll. Finn Juhl
DCK	----- Danske Kunstindustrimuseum
DCKA	----- Royal Academy of Fine Arts (Kunstakademiet)
DCN	----- Ny-Carlsberg Glyptotek
DCNM	----- National Museum

DCO	-----	Naval Museum (Orlogsmuseet)
DCOL	-----	Church of Our Lady
DCR	-----	Royal Copenhagen Porcelain Factory
DCRo	-----	Rosenborg Palace Royal Collection
DCSt	-----	Statens Museum for Kunst (Musee Royal des Beaux-Arts)
DCT	-----	Thorvaldsens Museum
DCTo	-----	Tojhusmuseet (Royal Arsenal Museum)
DFW		Frederikssund. J. F. Willumsens Museum
DFaM		Faaborg. Faaborg Museum
DFr		Fredericksberg
DHeK		Helsingor (Elsinore). Kronborg Slot
DHer		Herfursholm Abbey
DHiNF		Hillerod. National historike Museum pa Frederiksborg
DHjoV		Hjorring. Vendsyssels historiske Museum
DHuL		Humleback. Louisiana Museum
DJJ		Jutland. Jelling Church
DML		Maribo. Lolland-Falsters Stiftsmuseum
DOK		Odense. St. Knud Church
DOr		Ordrup
DRM		Ring Kobing. Ringkobing Museum
DRosC		Roskilde. Roskilde Cathedral
DRosM	-----	Roskilde Museum
DRuH		Rudkobing. Rudkobing historiske Museum
DS		Sondermark
DVJ		Vejen. Kunstmuseum (Hansen Jakobsen-Museet)
DVoL		Vordingborg. South Zealand Museum

England

-EB	Coll. Sir Alfred Bossom
-EBa	Coll. T. J. Barnes
-EBar	Coll. Sir Alan and Lady Barlow
-EBl	Coll. Mrs. Blundell-Ince
-EBo	Coll. Muirhead Bone (ELBo)
-EC	Coll. Mrs. M. Copner
-ECo	Coll. Colonel Norman Colville
-ECoo	Coll. M. E. Cooke
-ECr	Coll. Earl of Craven
-ED	Coll. Douglas Duncan
-EDa	Coll. Alex Davidson
-EEd	Coll. E. S. Ede
-EEp	Coll. Sir Jacob Epstein
-EEv	Coll. W. A. Evill
-EF	Coll. Elizabeth Onslow Ford (See also -EO)
-EGr	Coll. E. C. Gregory (ELGre)
-EH	Coll. Ashley Havinden

-EHe	Coll.	John Heaton
-EHea	Coll.	Adrian Heath
-EHo	Coll.	L. Hore Belisha
-EHu	Coll.	Blair Hughes-Stanton
-EI	Coll.	Sir Giles Isham (ENorI)
-EJ	Coll.	Patrick Johnston
-EK	Coll.	Mrs. S. Kaye
-EKe	Coll.	C. S. Kearley
-EKel	Coll.	Kelvingrove
-ELa	Coll.	Sir J. Lavery
-ELi	Coll.	Viscount de L'Isle
-EM	Coll.	Henry Moore
-EMa	Coll.	Gavin Maxwell
-EMac	Coll.	Lord Mackintosh of Halifax
-EMacd	Coll.	Duncan Macdonald
-EMo	Coll.	Mrs. Henry Moore
-EMoo	Coll.	Mrs. Irina Moore
-EMor	Coll.	Canon Mortlock
-EMu	Coll.	Earl of Munster
-EN	Coll.	Duke of Norfolk
-EO	Coll.	Miss Elizabeth Onslow-Ford (See also -EF)
-EPe	Coll.	Petworth
-EPol	Coll.	Sir Montagu Pollock
-EPri	Coll.	R. C. Pritchard
-ER	Coll.	Earl of Roseberry
-ERed	Coll.	C. S. Reddihough, and Margaret Gardiner (EIlkR)
-ERh	Coll.	Richard Rhys
-ERi	Coll.	Howard Ricketts
-ERu	Coll.	Charles L. Rutherston
-ESa	Coll.	Mrs. Philip Samuel
-ESan	Coll.	Earl of Sandwich
-ESy	Coll.	Mrs. H. Synge-Hutchinson
-ET	Coll.	D. Talbot-Rice
-EW	Coll.	Hon. Lady Ward
-EWa	Coll.	Hugh Walpole
-EWe	Coll.	Rebecca West
-EWed	Coll.	Tom Wedgwood
-EWi	Coll.	Mr. F. M. S. Winand
-EWy	Coll.	John Wyndham (EPetL)
-EY	Coll.	F. R. S. Yorke
EA	Coll.	Arts Council of Great Britain (See also ELBrC)
EAb		Abergavenny
EAbb		Abbots Langley, Herts
EAbbot		Abbotsford House. Melrose. Coll. Mrs. Maxwell-Scott (EPL)

EAbe	Aberlady
EAbiH	Abingdon, Berks. St. Helen's
EAc	Acton Church, Suffolk
EAl	Aldworth Church (near Oxford)
EAlp	Alpington, Devon
EAs	Ashbourne Church, Derbys
EAsh	Ashburnham, Sussex
EAshd	Ashdown Forest, Sussex. Children's Settlement
EAth	Atherington, Devon
EAy	Ayston Hall, Rutland. Coll. G. S. Finch
EB	Birmingham. City Museum and Art Gallery
EBB	----- Barber Institute of Fine Arts, University of Birmingham
EBS	Coll. Mrs. Gisela Berthold-Sames
EBad	Badminton House, Glos
EBal	Balderton. St. Giles
EBan	Banwell, Som
EBar	Barfreston, Kent
EBarl	Barlaston. Wedgwood Museum
EBarn	Barnsely Park, Glos
EBarna	Barnack Church
EBarns	Barnstaple, Devon
EBas	Baskingstoke, Hants. The Hyne
EBathA	Bath Abbey
EBe	Bewcastle
EBed	Coll. Duke of Bedford
EBelM	Belgravia. Midland Bank
EBelt	Belton, Lincs
EBer	Berry Pomeroy
EBerkB	Berkshire, Burghfield
EBev	Beverley Minster
EBex	Bexhill
EBi	Bisham, Berks
EBib	Bibury
EBisG	Bishopsgate. Great St. Helen's
EBish	Bishopsteignton
EBishop	Bishopstone
EBl	Bletchingly, Surrey (See also ESurB)
EBle	Blenheim Palace
EBlox	Bloxham, Oxon
EBly	Blyth, Notts
EBo	Bottesford (ELeiB)
EBod	Bodmin, Cornwall
EBosB	Boston. St. Botolphs Church
EBou	Boughton-under-Blean, Kent (EKenB)
EBow	Bowden
EBox	Boxgrove, Sussex

EBrCh	Brent Knoll. Parish Church
EBraL	Bradford on Avon. St. Lawrence
EBradC	Bradford, Yorks. City Art Gallery and Museums
EBraug	Braughing, Herts
EBreE	Brent Eleigh, Suffolk
EBrea	Breamore
EBree	Breedon-on-the-Hill, Leics. St. Mary's
EBriA	Bristol. St. Augustine's
EBriBA	----- City Art Gallery
EBriC	----- Cathedral
EBriL	----- Lord Mayor's Chapel
EBriM	----- St. Mark's Church
EBriMu	----- City Museum
EBriQ	----- Queen Square
EBriS	----- St. Stephen's
EBrid	Bridlington Priory
EBrigA	Brighton. Art Gallery and Museum
EBright	Brightlinsea, Essex
EBrin	Brinsop
EBro	Brocklesby Park, Lincs
EBrom	Brompton-in-Allerton
EBrook	Brookland, Kent
EBru	Bruera, Cheshire
EBu	Bushey Park, Middlesex
EBuC	Buckland Newton, Dorset
EBuckA	Buckinghamshire. Amersham Church
EBuckAy	----- Aylesbury
EBuckC	----- Claydon House
EBuckG	----- Great Hampden
EBuckH	----- Hambledon
EBuckW	----- West
EBul	Bulkington, Warwicks
ECC	Chichester. Cathedral
ECaC	Canterbury. Canterbury Cathedral
ECaK	----- King's School
ECamC	Cambridge. Christ's College
ECamCo	----- Conington
ECamF	----- Fitzwilliam Museum
ECamJ	----- Jesus College
ECamK	----- King's College
ECamKC	----- King's College Chapel
ECamT	----- Trinity College
ECamUA	----- Cambridge University. Museum of Archaeology and Ethnology
ECar	Cardington, Beds
ECas	Castor
EChA	Cheltenham. Cheltenham Art Gallery

EChW	Cheltenham. Coll. Hugo van Wadenoyen
ECha	Chatsworth, Derby. Coll. Dukes of Devonshire
EChar	Chartham, Kent
ECharn	Charney Bassett
EChe	Chenies, Bucks
EChec	Checkendon, Oxon
EChesC	Chester. Cathedral
EChesCh	----- Chapter House
EChev	Chevening, Kent
EChi	Chillington Hall, Staff. Coll. Mrs. T. Gifford
EChic	Chichester Cathedral
EChr	Christchurch Prior, Hants (See also EHaC)
EChri	Christhall, Essex
ECil	Cirencester. Coll. Ingram
ECiM	----- Museum
ECl	Clandon Park, Surrey
ECla	Clacton-on-Sea
ECleN	Clerkenwell. New River Office
EClif	Cliffe Pypard, Wilts
ECo	Corhampton. Corhampton Church
ECod	Codford. St. Peter
ECol	Colerne
EColl	Collingham
ECom	Compton Place, Eastbourne, Sussex
ECon	Conington (ECamCo)
ECorL	Cornwall. Landrake
ECovC	Coventry. Cathedral
ECovG	----- Guildhall
ECr	Croft Castle, Herts
ECra	Cranford, Middlesex
ECro	Crofts, York
ECroom	Croome D'Abitot, Worcs
ECu	Cuckfield, Sussex
EDF	Dorset. Forde Abbey
EDH	----- Coll. John Hubbard
EDM	----- Coll. Melbury Samford
EDMap	----- Mapperton
EDS	----- Sherborne Abbey (ESh)
EDW	----- Whitchurch Canonicorum
EDWe	----- West Chelborough
EDag	Daglingworth Church
EDar	Darley Dale
EDeD	South Devonshire. Dartington Hall
EDee	Deerhurst
EDeer	----- Deerhurst Church
EDen	Denton, Lincs

EDerH	Derbyshire. Hardwick New Hall
EDerN	----- Norbury Church
EDi	Dinton
EDoA	Dorchester. Dorchester Abbey
EDoM	----- Dorset County Museum
EDown	Downside Abbey
EDr	Drayton Beauchamp, Bucks
EDuUO	Durham. University of Durham. Oriental Museum
EDurO	----- Cathedral
EDurCL	----- Cathedral Library
EDurCaC	----- Castle Chapel
EEC	Ely. Cathedral
EEQ	Coll. Her Majesty the Queen
EEa	Easton Neston, Norths (ENorthE)
EEar	Eardisley, Herts (See also EHereE)
EEas	East Barsham, Norfolk
EEd	Edenham, Lincs
EEl	Eltham
EElm	Elmley Castle, Worcs (ENorfE)
EEls	Elsing, Norfolk
EElstA	Elstree. A. T. V. House
EEsA	Essex. Audley End
EEsC	----- Clavering
EEsG	----- Great Maplestead
EEsL	----- Little Easton
EEsLM	----- Layer Marney
EEsN	----- North Ockendon
EEsRE	----- Romford. St. Edward the Confessor
EEsS	----- Stanstead Mountfitchet
EEw	Ewelme, Oxon (EOxfE)
EExC	Exeter. Cathedral
EExP	----- St. Petrock's Church
EExt	Exton, Rutland (ERutE)
EEy	Eyam
E F	Fyfield, Berks
E FaP	Farnham. Pitt-River Museum
E Fai	Fairford
E Faw	Fawsley, Northants
E Fl	Fletton Church
E Fo	Fownhope
E Fr	Framlingham, Suffolk
E Fro	Castle Frome (See also EHereF)
E FuA	Fulham. All Saints
E GC	Gloucester. Gloucester Cathedral
E GGM	----- City Museum
E GM	----- St. Mary-le-Crypt
E GlI	Gloucestershire. Iron Acton

E GlNS	Gloucestershire. Northwick Park. Coll. E. G. (George) Spencer-Churchill
E GlNe	----- Newland
E GlSa	----- Sandhurst
E GlSc	----- South Cerney
E GlSo	----- Southrop
E GlT	----- Twyning
E GoP	Godalming. Phillips Memorial Cloister
E Good	Goodwood, Sussex
E Gos	Gosforth, Cumberland
E Gosf	Gosfield, Essex
E Gr	Great Warley, Essex
E Gro	Groombridge, Kent
E GrtB	Great Bookham, Surrey
E GuU	Gullane. United Free Church
E GuiT	Guildford. Holy Trinity
EHC	Hereford. Hereford Cathedral
EHG	Hertfordshire. Gorhambury
EHR	----- Ross-on-Wye
EHS	Herefordshire. Shobden Church
EHaC	Hants. Christchurch Priory (See also E Chr)
EHaf	Hafod Church, South Wales (Destroyed by fire, 1932)
EHalA	Halifax. All Souls
EHall	Halland, Sussex
EHam	Hampton Court Palace, Middlesex
EHampSW	Hampshire. Stratfield Saye House. Coll. Duke of Wellington
EHan	Handsworth
EHareM	Harewood, Yorks. St. Mary's
EHas	Haselmere, Surrey
EHatCh	Hatfield, Hertfordshire. Parish Church (EHeH; EMiddH)
EHatT	Hatfield Technical College
EHeH	Hertfordshire. Hatfield House (EHatch)
EHeO	----- Great Offley Church (EOf)
EHeT	----- Tring
EHea	Headbourne Worthy
EHem	Hempstead (ELAn)
EHerC	Hereford. (See also EHC)
EHer F	----- Castle Frome (See also EFro; EHereF)
EHereC	Hertfordshire. City Council (EHatT)
EHereCl	Herefordshire. Clifford
EHereE	----- Eardisley (See also ELeo)
EHere F	----- Castle Frome (See also EFro; EHerF)
EHereH	----- Hadam
EHereK	----- Kilpeck
EHereL	----- Leominster (See also ELeo)

EHereLu	----- Ledbury Church
EHereM	----- Much Marcle
EHereS	----- Stretton Sugwas
EHerr	Herringston, Dorset
EHex	Hexham
EHey	Heysham
EHi	High Wycombe, Bucks
EHo	Holkham Hall, Norfolk. Coll. Earl of Leicester
EHoll	Hollingbourne, Kent
EHow	Castle Howard. Coll. George Howard
EHuM	Hull. Market Place
EHyC	Hythe, Kent. Saltwood Castle. Coll. Kenneth Clark
EHydA	Hyde Abbey
EI	Isleworth, Middlesex
EIl	Ilam, Staffs
EIlkR	Ilkley. Coll. C. S. Reddibough, and Mrs. M. Gardiner Bernal
EIn	Ingelsham
EIpM	Ipswich. The Museum
EJ	Jedburgh, Roxburghshire
EJell	Jellinge
EJev	Jevington
EK	Kilpeck Church
EKeM	Kelham, Notts. Society of the Sacred Mission
EKenB	Kent. Boughton-under-Blean
EKenBe	----- Bexley Heath, Red House
EKenBo	----- Borden
EKenC	----- Cobham
EKenCh	----- Chilham
EKenG	----- Goudhurst
EKenK	----- Knole
EKenL	----- Lynsted
EKiF	Kingston-upon-Hull. Ferens Art Gallery
EKilA	Kilburn. St. Augustine Church
EKinK	Kingston Hall. Coll. Mrs. Keller
EKing	Kingswinford
ELA	London, Coll. Miss Marion G. Anderson
ELAl	----- Albert Memorial
ELAll	----- All Saints Church (ELF)
ELAn	----- Church of St. Andrew Undershaft (EHem)
ELAnd	----- Coll. Colin Anderson
ELAs	----- Asylum Road, Old Kent Road
ELAst	----- Coll. David Astor
ELAth	----- The Athenaeum

ELB	London. Coll. Sidney Bernstein
ELBH	----- Broadcasting House
ELBM	----- British Medical Council Building
ELBP	----- Buckingham Palace
ELBR	----- British Rayon Centre
ELBa	----- Old Bailey
ELBag	----- Coll. Mr. and Mrs. Leon Bagrit
ELBan	----- Bank of England
ELBar	----- Coll. Mrs. C. Barclay
ELBarc	----- Coll. David Barclay Ltd
ELBat	----- Battersea Park
ELBe	----- Coll. Alexander Bernstein
ELBed	----- Coll. Richard Bedford
ELBetA	----- Bethnal Green Borough Council
ELBl	----- Bloomsbury Gallery
ELBo	----- Coll. Muriel Bone
ELBou	----- Bourdon House
ELBr	----- British Museum
ELBrC	----- Collection British Council (Arts Council of Great Britain) (See also EA)
ELBrH	----- Brittanic House
ELBrN	----- British Museum--Natural History Museum
ELBra	----- Coll. Erica Brausen
ELBri	----- Brixton Day College
ELBro	----- Brook Street Art Gallery
ELBru	----- Coll. R. Bruce
ELBu	----- Coll. Sidney Burney
ELBur	----- Burlington House
ELC	----- Coll. London County Council
ELCS	----- Cavendish Square (ELCon)
ELCa	----- Paul Cassirer Ltd
ELCh	----- Charterhouse
ELChar	----- Charing Cross
ELCheH	----- Chelsea Hospital
ELCiM	----- Mansion House, London City
ELCiS	----- School, London City (ELLoS)
ELCl	----- Coll. Kenneth Clark
ELCo	----- Coll. Samuel Courtauld
ELCoh	----- Coll. Dennis Cohen
ELCom	----- Commonwealth Relations Office
ELCon	----- Convent of the Holy Child, Cavendish Square (ELCS)
ELCont	----- Contemporary Art Society
ELCop	----- W. T. Copeland & Sons
ELCou	----- County Hall
ELCr	----- Coll. Honorable Lady Cripps
ELD	----- Drian Galleries

ELDH	London. Dorchester House
ELDL	----- Drury Lane Theatre
ELDT	----- Duchess Theatre
ELDa	----- Coll. Sir Percival and Lady David
ELE	----- Embankment Gardens
ELEp	----- Lady Epstein Collection
ELF	----- Fulham Parish Church (ELAll)
ELFH	----- Fishmongers' Hall
ELFa	----- Coll. William Fagg
ELFe	----- Festival of Britain
ELFr	----- Robert Fraser Gallery
ELFu	----- Coll. Capt. A. W. F. Fuller
ELG	----- Gimpel Fils; Coll. Peter Gimpel
ELGH	----- Guild Hall Art Gallery (ELIH)
ELGM	----- Guildhall Museum
ELGa	----- Gas, Light & Coke Co. Building, Kensington
ELGo	----- Coll. E. Goldfinger
ELGol	----- Coll. M. Goldman
ELGom	----- Coll. D. Gomme
ELGr	----- Grocers' Hall
ELGre	----- Coll. E. C. Gregory
ELGro	----- Grosvenor Gallery
ELGroS	----- Grosvenor Square
ELGu	----- Guy's Hospital
ELH	----- Hanover Gallery
ELHC	----- Hampton Court
ELHG	----- Highbury Fields
ELHM	----- Horniman Museum and Library
ELHS	----- Hanover Square
ELHW	----- Hays Wharf
ELHa	----- Harlow Art Trust
ELHe	----- St. Helen's Bishopsgate
ELHi	----- Highgate Cemetery
ELHo	----- Horniman Museum
ELHow	----- Formerly Howitt Collection
ELHu	----- Coll. Dr. Alastair Hunter
ELHul	----- Coll. Lady Hulton
ELHy	----- Hyde Park
ELHyB	----- ----- Bird Sanctuary
ELI	----- Coll. Ionides
ELIA	----- Imperial War Museum
ELIC	----- Institute of Contemporary Arts
ELIH	----- Ironmongers' Hall
ELIHT	----- Institute of Hygiene and Tropical Medicine
ELIM	----- Indian Museum, South Kensington
ELJ	----- Convent of the Holy Child Jesus, Cavendish Square (See also ELCon)

ELJa	London. St. James Churchyard, Piccadilly
ELJe	----- Jewish Museum
ELK	----- Coll. Kasmin Ltd
ELKe	----- Kensington Gardens
ELKeL	----- New Kensington Library
ELKeP	----- Kensington Place
ELL	----- Lord's Gallery
ELLa	----- Lambeth Chapel
ELLan	----- Coll. Allen Lane
ELLe	----- Leicester Galleries
ELLea	----- Leathersellers' Company
ELLew	----- Lewisham
ELLewi	----- John Lewis Partnership Ltd
ELLi	----- Lincoln's Inn Fields
ELLo	----- London Museum
ELLoS	----- City of London School
ELM	----- Coll. J. Pierpont Morgan
ELMa	----- Marlborough Fine Arts Ltd
ELMac	----- Coll. Anne Maclaren
ELMan	----- Coll. D. M. and P. Manheim
ELMar	----- St. Martin-in-the-Fields
ELMarg	----- St. Margaret's Church, Westminster
ELMc	----- Coll. Miss McCaw
ELMcR	----- Coll. McRoberts & Tunnard, Inc.
ELMe	----- Methodist Missionary Offices
ELMi	----- Midland Bank, Prince's Street
ELMil	----- Library of Eric Millar, Lectionary of St. Trond
ELMo	----- Coll. Mount
ELMu	----- Mullard House
ELN	----- National Gallery
ELNH	----- Neville House
ELNL	----- New London-Marlborough Gallery
ELNP	----- National Portrait Gallery
ELNo	----- Coll. Messrs. Novello
ELO	----- Owen School, Islington
ELOl	----- Old Bailey
ELOld	----- Former Coll. W. O. Oldman
ELOldPY	----- Old Palace Yard
ELP	----- Coll. Roland Penrose
ELPC	----- The Painters' Company
ELPO	----- Peninsular and Oriental Steam Navigation Company
ELPS	----- Parliament Square
ELPa	----- St. Paul's Cathedral (See also ELStPG)
ELPad	----- Paddington Street
ELPar	----- Cinema de Paris
ELPaul	----- St. Paul's Church, Clapham

ELPe	-----	Pearl Assurance Company, 252 High Holborn
ELPi	-----	Piccadilly Circus
ELPim	-----	Pimlico Gardens
ELPl	-----	Plaza Theatre, Regent Street
ELPo	-----	Coll. E. J. Power
ELPow	-----	Coll. Alan Power
ELPr	-----	Printers-Stationers' Company
ELQ	-----	Queen Square, Bloomsbury
ELR	-----	Redfern Gallery
ELRA	-----	Royal Academy of Arts
ELRC	-----	Royal College of Physicians
ELRCA	-----	Royal College of Arts
ELRCS	-----	Royal College of Surgeons
ELRE	-----	Royal Exchange
ELRG	-----	Royal Geographical Society
ELRH	-----	Rhodesia House
ELRIA	-----	Royal Institute of British Architects
ELRN	-----	Royal Naval College, Greenwich
ELRS	-----	Royal Society
ELRSA	-----	Royal Society of Arts
ELRe	-----	Regent's Park
ELRed	-----	Red Lion Square
ELRo	-----	Rowan Gallery
ELRog	-----	Coll. Alan Roger
ELRow	-----	Rowley Gallery
ELRr	-----	Metropolitan Railway Building
ELRu	-----	Russell Square
ELRub	-----	Coll. Lawrence Rubin
ELS	-----	Coll. Robert J. Saintsbury
ELSa	-----	Coll. George Salting
ELSad	-----	Coll. Late Michael Sadleir
ELSav	-----	Saville Theatre
ELSc	-----	Coll. Mrs. Violet Schiff
ELSch	-----	School of Hygiene and Tropical Medicine
ELSci	-----	Science Museum
ELSe	-----	Selfridge Building
ELSed	-----	Coll. Mrs. Walter Sedgwick
ELSo	-----	Sir John Soane's Museum
ELSom	-----	Somerset House
ELSoth	-----	Sotheby & Company
ELSp	-----	Spink & Son
ELStA	-----	St. Andrew Undershaft (ELAn)
ELStG	-----	St. Giles, Cripplegate
ELStH	-----	State House
ELStJ	-----	St. James, Piccadilly
ELStJP	-----	St. James, Park Station (ELUR)

ELStL	London. St. Leonard's
ELStM	----- St. Margaret's, Westminster (ELMarg)
ELStP	----- St. Paul's School, West Kensington
ELStPC	----- St. Paul's Cathedral (See also ELPa)
ELStS	----- St. Stephen's, Ipswich
ELStT	----- St. Thomas Hospital
ELSto	----- Stone House
ELSton	----- Coll. Francis Stoner
ELStr	----- Coll. Mrs. G. R. Strauss
ELStu	----- Coll. Peter Stuyvesant Foundation
ELT	----- Tate Gallery
ELTC	----- Temple Church
ELTH	----- Trinity House (ELTr)
ELTL	----- Time-Life Building
ELTLC	----- Time-Life Building. Ville de Cologne
ELTS	----- Trafalgar Square
ELTh	----- Coll. James Thyne
ELTha	----- Tower Hamlets Secondary School for Girls, Biglands Estate
ELTo	----- Arthur Tooth & Sons
ELTow	----- Tower of London Armouries
ELTr	----- Trinity Almshouses, Mile End Road (ELTH)
ELTrS	----- Trinity Square
ELU	----- University College
ELUH	----- Unilever House
ELULC	----- University of London. Colonial Department. Institute of Education
ELULD	----- ----- Percival David Foundation
ELULJ	----- ----- Jewish Historical Society of England, Tuck Collection
ELUR	----- London Underground Railway Office
ELUn	----- Coll. Leon Underwood
ELUs	----- University College. Slade School of Fine Arts
ELV	----- Victoria and Albert Museum
ELVT	----- Victoria Tower Gardens
ELVa	----- Vauxhall Park, S. W.
ELVe	----- Coll. Michael Ventris
ELVg	----- Victoria Gardens Embankment
ELW	----- Waddington Galleries
ELWa	----- Walden House
ELWal	----- Wallace Collection
ELWar	----- Imperial War Museum
ELWat	----- Waterloo Palace
ELWe	----- Westminster Abbey
ELWeB	----- Westminster Bank
ELWeBr	----- Westminster Bridge

ELWeC	London. Westminster Cathedral
ELWeH	----- Westminster Hall
ELWeP	----- Westminster Palace
ELWel	----- Wellington Museum
ELWesP	----- Palace of Westminster, Prince's Chamber
ELWh	----- Whitehall
ELWhi	----- Coll. Hon. and Mrs. Jock Hay Whitney
ELWi	----- Windmill Press, Kingswood
ELWid	----- Coll. Dr. H. P. Widdup
ELWil	----- Coll. Peter Wilson
ELZ	----- Coll. A. Zwemmer
ELanI	Lancashire. Ince Blundell Hall
ELang	Langford, Norfolk
ELap	Lapford, Devon
ELeC	Leeds. City Art Gallery and Temple Newsam House
ELeCh	----- Parish Church
ELeT	----- Temple Newsam House (See also ELeC)
ELeU	----- Leeds University
ELeW	----- Whitkirk
ELec	Leckhamstead, Bucks
ELeiA	Leicestershire. Asby-de-la-Zouch
ELeiB	----- Bottesford
ELeiQ	----- Quorn
ELeiT	----- Theddingworth
ELeicM	Leicester. Leicester Museums and Art Gallery
ELenT	Lenton. Church of the Holy Trinity
ELeo	Leominster (See also EHereL)
ELetS	Letchworth. Coll. Jean Stewart
ELev	Levisham, Yorks
ELewCh	Lewisham. Church
ELiC	Lichfield. Cathedral
ELinC	Lincoln. Lincoln Cathedral of St. Mary
ELinM	----- Lincoln Minster
ELinU	----- Usher Art Gallery
ELincI	Lincolnshire. Irnham
ELincS	----- Spilsby
ELincT	Lincolnshire. Tattershall Castle
ELint	Linton, Kent
ELitB	Little Billing
ELitG	Little Gaddesden, Herts
ELitH	Little Horkesley, Essex
ELitS	Little Saxham, Suffolk
ELivC	Liverpool. Liverpool Cathedral
ELivG	----- St. George's Hall

ELivJ	Liverpool. St. James Chapel
ELivL	----- Liverpool City Museum
ELivLib	----- Liverpool Libraries, Museums, and Arts Committee
ELivW	----- Walker Art Gallery
ELo	Longleat, Wilts. Coll. Marquess of Bath
ELongB	Long Buckby, Hants
ELouC	Loughborough. Loughborough College
ELow	Lowick
ELu	Ludlow. Parish Show
ELutW	Luton Hoo. Wernher College
ELy	Lynsted, Kent (EKenL)
EM	Coll. Mrs. Irina Moore
EMM	Much Hadham. Coll. Miss Mary Moore
EMMo	Much Hadham. Coll. Mrs. Irina Moore (-EM)
EMaA	Manchester. City of Manchester Art Gallery
EMaC	----- Cooperative Insurance Building
EMaCa	----- Manchester Cathedral
EMaM	----- Manchester Museum
EMaR	----- Rylands Library
EMalA	Malmesbury Abbey (See also EWiM)
EMalt	Government of Malta
EMalv	Malvern Priory
EMan	Mansion House
EMap	Mapperton, Dorset
EMar	Layer Marney, Essex
EMe	Melbourne Hall, Derbys
EMel	Melsonby
EMelb	Melbury Bubb, Dorset
EMelbS	Melbury Stampford, Dorset
EMeth	Methley, Yorks
EMi	Mitton, Yorks
EMid	Middleton
EMiddH	Middlesex. Harefield (EMiddH)
EMiddHe	----- Hendon
EMiddS	----- Stanwell
EMoM	Morcambe. Midland Hotel
EMor	Moreton Valence, Glos
EMu	Coll. Earl of Munster
ENI	National Trust. Ickworth, Suffolk
ENP	----- Petworth House, Sussex (EPetL)
ENW	----- Waddesdon Manor, Bucks
ENeB	Newcastle upon Tyne. Blackgate Museum
ENee	Needham Market, Suffolk
ENew	Newent
ENewpG	Newport. Grammar School
ENewpM	----- Museum and Art Gallery
ENoC	Nottinghamshire. City Art Gallery and Museum (The Castle Museum)

ENoH	Nottingham (shire). Hawton Church
ENoK	----- Kingston-on-Soar
ENoL	----- Langar
ENoM	----- Nottingham Museum
ENorG	Northamptonshire. Great Brington
ENorGe	----- Geddington
ENorH	----- Hardingstone
ENorI	----- Coll. Gyles Isham
ENorM	----- St. Matthew Church
ENorP	----- St. Peter's
ENorb	Norbury
ENorfB	Norfolk. Blicking Hall
ENorfD	----- Dersingham
ENorfE	----- Elsing
ENorfH	----- Houghton Hall. Coll. Marquess of Cholmondeley
ENorfI	----- Ingham
ENorfN	----- Norwich Cathedral
ENorfR	----- Reepham Church
ENorthC	Northamptonshire. Castor Church
ENorthCh	----- Charwelton
ENorthE	----- Easton Neston (EEa)
ENorthG	----- Great Brighton
ENorthH	----- Hardingstone
ENorthL	North Leigh
ENorthN	Northamptonshire. Norton
ENorthR	----- Rushton
ENorthS	----- Staverton
ENorthT	----- Tichmarsh
ENorthW	----- Woodford
ENorthWa	----- Warkton
ENorthWh	----- Whiston
ENorthuC	Northumberland. Chipchase Castle
ENorthwH	Northwood. Holy Trinity
ENortoA	Norton. St. Andrew's Church
ENorwC	Norwich. Cathedral
ENu	Nunnykirk, Northumberland
EO	Coll. Gordon Onslow-Ford
EOA	Oxford. Oxford University--Ashmolean Museum
EOAll	----- All Soul's Church
EOAllC	----- All Soul's College
EOB	----- Oxford University--Bodleian Library
EOC	----- Cathedral
EOCa	----- St. Catherine's College
EOCh	----- Christ Church
EOD	----- Divinity School
EOE	----- St. Ebbe's

EOJ	Oxford. St. John's College
EOM	----- Magdalen College
EOMC	----- Merton College Chapel
EON	----- New College
EOO	----- Old Palace
EOP	----- Pitt Rivers Museum
EOPC	----- Pembroke College
EOR	----- Roth Collection
EOS	----- Coll. Prof. C. G. Seligman
EOSc	----- Schools Quadrangle
EOT	----- Trinity College
EOU	----- University College
EOW	----- Wadford College
EOd	Oddington, Oxon
EOf	Offley, Herts
EOldW	Old Warden, Beds
EOsP	Oswestry. Park Hall
EOt	Otley
EOxD	Oxfordshire. Ditchley
EOxH	----- Hanwell
EOxI	----- Iffley
EOxS	----- Stanton Harcourt
EOxT	----- Great Tew
EOxfD	----- Dorchester Abbey
EOxfE	----- Ewelme Church
EOxfS	----- Somerton
EOxfSt	----- Stanton Harcourt
EPL	Port Sunlight. Lady Lever Art Gallery
EPaiK	Paignton. Kirkham Chantry
EParhP	Parkham Park, Sussex
EPeC	Peterborough. Cathedral
EPetL	Petworth. Coll. Lord Leconfield; Coll. John Wyndham
EPo	Powick, Worcester (EWorPo)
EPorL	Port Sunlight. Lady Lever Art Gallery (EAbbot)
EPot	Potterne
EPrH	Preston. Harris Museum and Art Gallery
ER	Coll. Herbert Read
ERad	Radlett. Coll. Pierre Jeannerat
ERam	Ramsbury
EReaM	Reading. Reading Museum
ERec	Reculver
ERed	Redgrave, Suffolk
ERei	Reigate, Surrey
ERet	Rettendon, Essex
ERiE	Ringwood, Hants. Coll. Brian Egerton
ERicP	Richmond. Coll. Alan Power

ERipC	Ripon. Coll. Mayor Edward Compton
ERoC	Rochester. Cathedral
ERock	Rockingham
ERomA	Romsey Abbey
ERos	Rostherne, Cheshire
ERou	Rous Lench
ERu	Ruthwell, Dumfries
ERutB	Rutland. Burley-on-the-Hill (EExt)
ERutE	----- Exton
ESA	Southampton. Southampton University. Faculty of Arts
ESaC	Salisbury. Cathedral
ESaCh	----- Chapter House
ESaCl	----- Clarendon Palace
ESaS	----- Salisbury Plain
ESalM	Salop. Much Wenlock
ESan	Sandon Hall, Staffs
ESeA	Selby Abbey
ESh	Sherborne Abbey, Dorset (EDS)
EShaK	Shawhead. Coll. W. J. Keswick
EShef	Sheffield
ESher	Shelford, Notts
ESho	Shobdon
EShroQ	Shropshire. Quat
EShroW	----- Wroxeter
ESn	Snarford, Lincs
ESoM	Southwell. Southwell Minster
ESoc	Sockburn, Durnham
ESomB	Somerset (shire). Brent Knoll
ESomG	----- Glastonbury
ESomH	----- High Ham Church
ESomM	----- Montacute
ESomHi	----- Hinton St. George
ESomR	----- Rodney Stoke
ESomp	Sompting
ESon	Sonning, Berks
ESou	Southhill, Beds
ESoutU	Southampton. University. Faculty of Arts (ESA)
ESouthC	Southwark. Southwark Cathedral
ESouthS	----- St. Savior's
ESow	Sowerby, Yorks
ESp	Speen, Berks
EStA	St. Andrew-Auckland, Durham
EStal	St. Alkmund
EStB	St. Bartholomew Hyde, Winchester
EStC	St. Cuthbert
EStDS	St. Dunstan, Steepney

EStH	Strawberry Hill
EStM	St. Mary, Warwick
EStMa	St. Maurice Abbey
EStaC	Stafford. St. Chad's
EStafE	Staffordshire. Etruria Museum
EStam	Stamford. Lincs. St. Martin
EStanH	Stanton Harcourt, Oxon
EStap	Stapleford
EStapl	Staplehurst
ESteep	Steeple Aston, Oxon
EStevG	Stevenage, Herts. Barclay School
EStil	Stillingfleet
EStin	Stinsford
ESton	Stonleigh
EStou	National Trust. Stourhead, Wilts
EStowG	Stowlangtoft, Suffolk. St. George's Church
EStowe	Stowe-Nine-Churches. Northants
EStrad	Stradsett, Norfolk
EStratS	Stratford-upon-Avon. Shakespeare Memorial Theatre
EStren	Strensham
ESuAH	Sussex. Arundel. Coll. James Hooper
ESuB	----- Broadwater
ESuC	----- Culford Church
ESuH	----- Holmhurst. St. Leonards
ESuM	----- Midlavant
ESufB	----- Boxted
ESufBe	----- Benhall Lodge, Saxmundham
ESufBu	----- Butley Priory
ESufC	----- Culford
ESufE	----- Elmsett
ESufF	----- Framlingham
ESufG	----- Great Saxham
ESufH	----- Hengrave
ESufW	----- Woodbridge
ESurB	Surrey. Bletchingley. Coll. Earl of Munster (See also EB1)
ESurC	----- Cheam
ESurD	----- Deepdene
ESurE	----- Old Esher
ESurG	----- Godstone
ESurL	----- Loseley
ESurS	Surrey. Stoke d'Abernon. Coll. Lady d'Abernon
ESw	Swine, Yorks
ESwin	Swinbrook, Oxon
ETP	Twyford, Berks. Coll. Mr. and Mrs. R. Palmer

ETar	Tardebigge
ETaw	Tawstock, Devon
ETe	Tewkesbury Abbey, Glos (See also EWT)
EThor	Thorpe. Achurch
ETi	Titchfield
ETiv	Tiverton
ETo	Tottenham, Middlesex
ETof	Toftrees, Norfolk
ETop	Topsham
ETot	Totnes
ETr	Trentham
ETro	Trotten
ETw	Twickenham. All Hallows
EU	Ulcombe
EUp	Upwell
EWC	Worcester. Cathedral
EWT	Tewkesbury Abbey (See also ETe)
EWa	Coll. Peter Watson
EWak	Wakerley
EWakeA	Wakefield. City Art Gallery and Museum
EWal	Waltham Abbey
EWarMB	Warwick. St. Mary's Beauchamp Chapel
EWarS	Warwickshire. Shuckburgh
EWarSC	----- Sutton Coldfield
EWark	Warkton (ENorthWa)
EWarwA	Warwickshire. Aston Hall
EWarwN	----- Newbold-on-Avon
EWat	Watford
EWater	Waterperry
EWeC	Wells. Cathedral
EWeV	----- Corporation of Vicors Choral
EWedA	Wedern Abbey
EWel	Welbeck
EWemE	Wembley. Wembley Exhibition
EWen	Wentworth. Woodhouse
EWes	Westbury
EWestD	West Dereham
EWestGT	West Grinstead. Coll. W. G. Tillman
EWestMB	West Mercea. Coll. Bedford
EWestl	Westley Waterless
EWestmL	Westmoreland. Little Strickland Hall
EWhal	Whalley
EWhi	Whitchurch
EWiG	Wiltshire. Great Durnford
EWiL	----- Lydiard Tregoze
EWiLa	----- Langford
EWiM	----- Malmesbury Abbey
EWil	Wilton House. Coll. Earl of Pembroke

EWim	Wimpole
EWinC	Winchester. Winchester Cathedral
EWinCol	----- College Chapel
EWinF	----- Feretory
EWinM	----- Winchester City Museum
EWindC	Windsor. Windsor Castle
EWindG	----- St. George's Chapel
EWindR	----- Royal Collections
EWindRL	----- Royal Library
EWint	Winterbourne, Steepleton
EWinw	Winwick
EWir	Wirksworth
EWith	Withyham. Parish Church
EWoC	Worcester. Worcester Cathedral
EWob	Woburn Abbey, Beds. Coll. Duke of Bedford
EWolA	Wolverhampton. Municipal Art Gallery and Museum
EWooC	Woodchurch. Church
EWorB	Worcestershire. Badsey
EWorP	----- Pershore
EWorPo	----- Powick (EPo)
EWorS	----- Salwarpe
EWorW	----- Westwood Park
EWorWi	----- Wickhamford
EWorm	Wormington
EWr	Writtle
EY	Coll. Earl of Yarborough
EYoA	York (shire). Alne
EYoB	----- Burton Agnes
EYoBS	----- Barton-le-Street
EYoBe	----- Bedale
EYoBr	----- Brayton
EYoC	----- St. Mary's Cathedral (Museum)
EYoD	----- Dewsbury
EYoE	----- Easby Abbey
EYoG	----- Goldsborough
EYoH	----- Healaugh
EYoJC	----- St. John's College. Chapel
EYoM	----- St. Mary's Museum
EYoN	----- Newby Hall
EYoP	----- Museum of the Philosophical Society
EYoS	----- Silkstone
EYoY	----- Yorkshire Museum

<div align="center">Ecuador</div>

EcQC	Quito. Santa Clara
EcQF	----- San Francisco Church
EcQCom	----- La Compania

EcQM	Quito. La Merced
EcQMe	----- Coll. Alberto Mena
EcQMen	----- Coll. Victor Mena

Egypt

EgAS	Abu-Simel
EgAb	Abydos
EgAbu	Abusir
EgAlB	Alexandria. Coll. Benaki
EgAlC	----- College des Ecoles Chretiennes
EgAlG	----- Greco-Roman Museum
EgAlM	----- Museum
EgAs	Aswan
EgCA	Cairo. Arabic Museum
EgCAl	----- al-Akmar Mosque
EgCC	----- Coptic Museum
EgCG	----- Mirrit Boutros Ghali Coll.
EgCH	----- Habib Gorgui's School, Wekalet El Ghouri
EgCHa	----- Mosque of al-Hakin
EgCI	----- Museum of Islamic Art
EgCM	----- Egyptian Museum (Museum of Antiquities)
EgCMA	----- Museum of Modern Art
EgCMo	----- Church of al-Mo'allaqa
EgCMu	----- Mukhtar Museum
EgCS	----- Permanent Exhibition of Traditional Arts, Sinnari
EgCT	----- Mosque of Ibn Tulun
EgD	Denderah
EgDa	Dashur
EgDe	Deir el-Bahari
EgEd	Edfu
EgG	Giza
EgK	Karnak--northern section site of ancient Thebes
EgKo	Kom Ombo Temple
EgKu	Kurna
EgL	Luxor--southern section site of ancient Thebes
EgMH	Medinet Habu. Temple
EgMe	Memphis
EgPh	Philae
EgS	Saqqara (Sakkara)
EgSi	Sinai
EgT	Thebes
EgTg	Tuneh el Gebel

El Salvador
ElSN San Salvador. Museo Nacional "David J.
 Guzman"

Ethiopia
EtA Aksum

France
FMa Coll. Mme. Helene de Mandrot
FN Coll. Vicomte de Noailles
FAgM Agen. Musee Municipal
FAiF Aisne. Chateau de la Feste-Milon
FAirN Airaines. Notre Dame
FAire Aire sur L'Adour
FAixA Aix. Musee Archeologique
FAixC ----- Aix St. Sauveur Cathedral
FAixM ----- Museum
FAixV ----- Hotel de Ville
FAjN Ajaccio. Musee Napoleonien, Hotel de Ville
FAlP Allier. Benedictine Priory Perrecy-les-
 Forges
FAlbC Albi. St. Cecile Cathedral
FAlbT ----- Toulouse Lautrec Museum
FAls Alsace
FAm Amiens. Cathedral Notre Dame
FAmM ----- Musee de Picardie
FAmbP Ambierle. Priory Church
FAmbo Chateau of Amboise, Touraine
FAnD Angers. Musee David d'Angers
FAnM ----- Musee des Beaux-Arts
FAnd Andlau Church
FAngC Angouleme. St. Pierre Cathedral
FAngM ----- St. Michael d'Etraignes
FAnzCh Anzy le Duc. Church
FArcG Arcueil. Coll. Mme. Roberta Gonzalez
FArce Arc-et-Senans
FArcen Arcenant
FArlA Arles. Musee Archeologique
FArlL Arles. Musee Lapidaire d'Art Chretien
FArlLP ----- Musee Lapidaire d'Art Paien
FArlT ----- St. Trophime
FArrC Arras. Cathedral
FArrM ----- Musee Municipal, Palais St. Vaast
FArt Arthies. Village Church
FAsN Assy. Eglise Notre Dame de Toute Grace
FAsnCh Asnieres-en Montagne. Church
FAuE Auxerre. St. Etienne Cathedral
FAuG ----- St. Germain Church

FAubB	Aube. Priory of Belleroc
FAubC	----- Chaource Church
FAubM	----- Sainte-Madeleine de Troyes
FAuba	Cistercian Abbey of Aubazine
FAuchA	Auch. St. Marie Cathedral
FAulCh	Aulnay. St. Peter Church
FAutL	Autun. St. Lazare Cathedral; Treasury
FAutLa	----- Musee Lapidaire
FAutR	----- Musee Rolin
FAuxN	Auxonne. Notre Dame
FAvL	Avalon. St. Lazare
FAveV	Aveyron. Charterhouse of Ville franche-de-Rouergue
FAven	Avenas. St. Vincent Church
FAviC	Avignon. Musee Calvet
FAviL	----- Musee Lapidaire
FAzCh	Azay le Rideau. Church
FBCh	Beaulieu. Abbey Church
FBaP	Bar-le-Duc. St. Pierre
FBarM	Bar-sur-Aube. St. Maclou
FBay	Bayel
FBayeC	Bayeux. Cathedral
FBe	St. Benoit sur Loire (See also FStBF)
FBeaE	Beauvais. St. Etienne
FBeaM	----- Musee Departmental del'Oise (Musee de Beaunais)
FBeau	Beaune
FBeauF	Beaufort sur Duron
FBel	Belz
FBelfC	Belfort. Chateau
FBerN	Berven. Notre Dame de Berven
FBesC	Besancon. Cathedral
FBesM	----- Musee des Beaux-Arts
FBess	Bessen Chandesse
FBi	Les Billanges Haute-Vienne
FBioL	Biot. Musee Fernand Leger
FBir	Biron
FBlB	Blois. Basilica of Our Lady of the Trinity
FBlaM	Blasimon. St. Maurice
FBlaz	Blazemont
FBod	Bodilis
FBorA	Bordeaux. Musee des Beaux-Arts
FBorAq	----- Musee d'Aquitaine
FBorAr	----- Archives Deparmentales de la Girone
FBorC	----- Cathedral
FBorCr	----- St. Croix Church
FBorL	----- Musee Lapidaire
FBouC	Bourges. Hotel Jacques Coeur

FBouCa	Bourges. St. Etienne Cathedral
FBouM	----- Museum
FBouc	Bouches-de-Rhone (FPlan)
FBour	Le Bourget-du-Lac
FBourg	Bourg-Dun Church
FBrK	(Brou, near Bourge-en-Bresse. Klosterkirche
FBrN	(----- St.-Nicholas-de-Tolentin
FBra	Brasparts
FBran	Brantome
FBre	Bredons
FBriM	Brive. Musee Ernest-Rupin
FBu	Bury. Village Church
FC	Carnac
FCC	Chartreuse de Champmol
FCa	Calais
FCahC	Cahors. St. Etienne Cathedral
FCahE	----- Jardin de l'Eveche
FCamM	Cambrai. Musee de Cambrai
FCamb	Cambronne-les-Clermont. Church
FCap	Cap Blanc
FCar	Carennac
FCarcN	Carcassonne. St. Nazaire
FCarp	Carpentras
FCe	Cellefrouin
FCh	Chartres. Notre Dame Cathedral
FChE	----- Jardins de l'Eveche
FChM	----- Musee des Beaux-Arts
FChaM	Champeaux. St. Martin Collegiate Church
FChaa	Chateau de Chaalis, Oise
FChad	Chadenac Church
FChai	Palais de Chaillot
FChalD	Chalon-sur-Saone. Musee Denon
FCham	Benedictine Abbey of Chamalieres
FChambM	Chambery. Museum
FChambS	----- Musee Savoisien
FChambo	Chambon du Lac
FChamp	Champigny-sur-Veude
FChanC	Chantilly. Musee Conde; Coll. Princess de Conde and Duc d'Aumale (FValle)
FChaoJ	Chaource. St. Jean Baptiste
FChar	Charlieu. Abbey
FCharF	----- Church of St. Fortunat
FChareD	Charente-Maritime. Abbaye-aux-Dames
FChareP	----- Parish Church St. Pierre d'Aulnay
FChari	Benedictine (Cluniac) Priory la Charite-sur-Loire
FCharr	Charroux
FChat	Chateau-Thierry

FChatA	Chatillon-sur-Seine. Musee Archeologique
FChatF	Chateau de la Ferte-Milon
FChatL	Chateau Larcher
FChatM	Chateau de Mainneville en Vexin
FChatMo	Chateau de Montal
FChate	Chateaudun. Castle
FChateC	----- St. Chapelle
FChatea	Chateaulin
FChateauP	Chateauneuf. St. Pierre Church
FChatel	Chatel-Montagne
FChatiM	Chatillon-sur-Seine. Musee Archeologique
FChau	Chauvigny. Eglise St. Pierre
FChauN	----- Notre Dame Church
FChaur	Chauriat
FChauvH	Chauvirey, Le Chatel. St. Hubert Chapel
FCheM	Cher. Marognes Church (FMonoCh)
FCiN	Civray. St. Nicolas
FCiv	Civaux. St. Gervais. St. Protais Church
FCl	Cluny. Abbey
FClF	----- Musee Lapidaire du Farinier
FClO	----- Musee Ochier
FCleC	Clermont-Ferrand. Maison du Centaure
FCleN	----- Notre Dame du Port
FCler	Clery. St. Andre
FClo	Clohars-Foursnant
FCoA	(Conques. St. Foi Abbey
FCoF	(----- St. Foy Treasure
FCoi	Coizard
FColU	Colmar. Musee d'Unterlinden
FComB	Comminges. St. Bertrand
FCorF	Correze. St. Fortunade
FCorbS	Corbeil. St. Spire
FCotA	Cote-d'Or. Benedictine Abbey St. Andoche de Saulieu
FCotB	----- Bussey-le-Grand Village Church
FCotT	----- Benedictine Priory Thil-Chatel
FCr	Cruas
FCreB	Crery-en-Valois. Bouillant
FCun	Cunault
FDA	Dijon. Commission des Antiquites du department de la Cote-d'Or
FDAr	----- Musee Archeologique de Dijon
FDB	----- St. Benigne
FDC	----- Carthusian Monastery (former Charterhouse of Champmol)
FDJ	----- Palais de Justice
FDL	----- Musee Lapidaire
FDM	Dijon. Musee des Beaux-Arts

FDMil	Dijon. Maison Milsand
FDN	----- Notre Dame de Dijon
FDa	Damvillers
FDam	Dammartin-en-Goele. Collegiate Church Notre Dame
FDampN	Dampierre. St. Nicholas
FDie	Die
FDin	Dinan
FDo	Dol, near Brittany
FDon	Donzy le Pre
FDouM	Douais. Musee de Douais
FDrH	Drome. Hauterives
FDreM	Dreux. Musee d'Art et d'Histoire
FEC	Ecos. Church
FEc	Ecouis. Notre Dame Church
FEoC	----- Collegiate Church
FEcCh	Ecouen. Chateau
FEch	Echillais
FElC	Elne. Cathedral
FEnM	Enserune. Musee National
FEnnV	Ennezat. St. Victor
FEntM	Entraigues. St. Michael Church
FEpM	Epinal. Musee Departmental des Vosges
FEuC	Eu. Convent Church
FEuL	----- St. Laurent
FEurC	Eure-et-Loire. Chateaudun. Castle Chapel
FEvT	Evreux. St. Taurin Church
FEvr	Evron
FFP	Fontainebleau. Musee National du Chateau de Fontainebleau
FFPF	Fontainebleau. Musee National du Chateau de Fontainebleau Galerie Francois I
FFa	Falaise
FFen	Fenioux
FFla	Flavigny sur Ozerain
FFo	Folleville
FFonCh	Fontaine-les-Dijon. Church
FFou	Foussais
FFrB	Franche-Comte. Brou Abbey (FBrK)
FGA	Grenoble. Place St. Andre
FGM	----- Musee de Grenoble
FGaG	Gard. Benedictine (Clunaic) Abbey St. Gilles
FGapM	Gap. Musee des Hautes-Alpes
FGarB	Garches. Coll. Adrienne Barbanson
FGeM	Gensac-la-Pallue. St. Martin Church
FGiG	Gisors. St. Gervais--St. Protais
FGrM	Gres des Vosges. Eglise de Munster
FGreL	Grenoble. St. Laurent Crypt

FLeHM	----- Musee du Havre
FLeHaM	Le Haye. Musee de la Haye
FLeMC	Le Mans. Cathedral St. Julien
FLeMN	----- Notre Dame de la Couture
FLeMa	Le Mas-D'Azil
FLeMeCh	Le Mesnil-Aubry. Church
FLePM	Le Puy. Musee
FLePN	----- Notre Dame
FLePrM	Le Pradot. Coll. Mme de Mandrot
FLecL	Lectoure. Musee Lapidaire
FLesE	Les Eyzles. Les Eyzles Museum
FLesM	Lespugue. Musee de Lespugue
FLevN	Levis-saint-Nom. Notre Dame de la Roche
FLh	L'Hospital St. Blaise
FLiP	Lille. Musee Palais des Beaux-Arts
FLiV	----- Boulevards Vauban et Liberte
FLiW	----- Musee Wicar
FLich	Licheres. Parish Church
FLimM	Limoges. Musee Municipal
FLisC	Lisieux. Cathedral
FLoB	Loiret. Abbey Church St. Benoit-sur-Loire
FLoc	Locmariaquer
FLocr	Lacronan
FLoiA	Loir-et-Cher. Benedictine Abbey St. Aignan
FLonC	Longpont-sur-Orge. Coll. William Copley
FLong	Longpoint-sous-Monthiery
FLotL	Lot-et-Garonne. Benedictine (Clunaic) Priory
FLouP	Louveciennes. Park
FLouvM	Louviers. Musee Municipal
FLouvN	----- Eglise Notre Dame
FMP	Moissac. Abbey Church St. Pierre (Eglise Abbatiale)
FMaB	Marseilles. Musee Borely
FMaG	----- Coll. Leonce Pierre Guerre
FMaL	----- La Major
FMaLo	----- Musee de Longchamps
FMaM	----- Musee des Beaux-Arts
FMagCh	Magny. Parish Church
FMai	Chateau de Maisons-Laffitte
FMain	Mainneville
FMalCh	Malicorne. Church
FManN	Mantes. Depot Lapidaire de la Collegiale Notre Dame
FMarCh	Martel. Parish Church
FMarcC	Marcorssis. Celestins Church
FMarm	Marmoutier. Abbey Church
FMars	Marsat
FMarv	Marvejois

FMarviM	Marville. Chevalier Michel House
FMas	Masevaux
FMau	Maurs
FMaur	Mauriac. Notre Dames des Miracles
FMeA	Meudon. Coll. Arp-Hagenbach
FMeD	----- Coll. Nelly van Doesburg
FMeR	----- Rodin Museum
FMea	Meaux
FMea B	----- Musee Boussuet
FMeal	Meallet
FMelH	Melle. St. Hilaire
FMelr	Melrand
FMen	Menec
FMetM	Metz. Musee Centrale
FMo	Montierender
FMoe	Moeze
FMolM	Molsheim. Metzig
FMolo	Molompize
FMonP	Montlucon. St. Pierre Church
FMone	Monesties-sur-Ceron. Hospital Chapel
FMont	Mont San Michel
FMonta	Chateau de Montal
FMontauI	Montauban. Musee Ingres
FMontb	Montbenoit (FJuB)
FMontc	Benedictine (Cluniac) Priory Montceau-l'Etoile
FMontco	Montcontour. Chapel Notre-Dame-du-Haut
FMonte	Montespan
FMontf	Montferrand
FMontmO	Montmorillon. Octogone
FMonto	Montoire
FMontp F	Montpellier. Musee Fabre
FMontpeM	Montpezat-de-Quercy. St. Martin Church
FMontrV	Montrouge. Coll. Mrs. S. Vitullo
FMontre	Montreal en Auxois
FMontroM	Schloss Montrottier. Musee Leon Mares
FMontsO	Montsoult. Maison des Peres de l'Oratoire
FMor F	Morlaas. St. Foy
FMorlM	Morlaix. St. Mathieu
FMoroCh	Morogues. Church (FChem)
FMouD	Moulins. Musee Departmental et Municipal
FMouL	----- Chapel Lycee Banville
FMouzN	Mouzon. Abbey Church Notre Dame
FMoz	Mozac
FMu	Mussy-sur-Seine
FMur	Murbach. Abbey Church
FND	Neuilly-en-Donjon
FNaB	Nantes. Musees des Beaux-Arts de Nantes

FNaC	Nantes. Cathedral
FNaCha	----- Chateau
FNaD	----- Musee Departementaux de Loire-Atlantique (Musee Archeologique Thomas Dobree)
FNaS	----- Musee des Salorges (Musee de la Marine et des Industries Nantaises)
FNanB	Nancy. Church Notre Dame de Bonsecours
FNanC	----- Cathedral
FNanCo	----- Cordeliers Church
FNanE	----- Musee de l'Ecole de Nancy
FNanF	----- Franciscan Church
FNanG	----- Grayfriars Monastery Chapel
FNanH	----- Musee Historique Lorrain
FNanM	----- Musee de l'Ecole de Nancy
FNeC	Nevers. Nevers Cathedral
FNeuN	Neuville-sous-Corbie. Notre Dame de l'Assumption
FNeui	Neuilly en Donjon
FNeuwP	Neuwiller. Church St. Pierre-St. Paul
FNiMM	Nice. Musee Massena
FNia	Niaux
FNieM	Nievre. Benedictine (Cluniac) Priory St. Marie de Donzy-le-Pre
FNimC	Nimes. Cathedral
FNimL	----- Musee Lapidaire
FNoA	Normandy. American Cemetery
FNog	Nogent. Le Rotrou
FNorCh	Nordpeene. Church
FNot	Notre Dame de Tronoen
FOA	Orleans. Benedictine Abbey St. Aignan
FOM	----- Musee des Beaux-Arts
FOlM	Oloron. St. Marie
FOr	Orange
FOu	Ourscamp. Abbey
FPA	Paris. Arc de Triomphe
FPAf	----- Musee des Arts Africains et Oceaniens (Formerly: Colonial Museum)
FPAl	----- Place de l'Alma
FPAm	----- Hotel Amelot de Bisseuil
FPAn	----- Coll. Anguera
FPAp	----- Galerie Apollinaire
FPAr	----- Archives Nationales
FPArm	----- Musee de l'Armee
FPArt	----- Art Market
FPAu	----- Hotel Aubert de Fontenay
FPB	----- Galerie Claude Bernard
FPBA	----- Bibliotheque de l'Arsenal

FPBN	Paris. Bibliotheque Nationale
FPBe	----- Galerie Berggruen
FPBea	----- Hotel de Beauvais
FPBeau	----- Coll. Countess Jean de Beaumont
FPBer	----- Castel Beranger
FPBeu	----- Coll. Michel Beurdeley
FPBi	----- Coll. Henry Bing
FPBig	----- Coll. Etienne Bignon
FPBo	----- Musee Bourdelle
FPBog	----- Coll. Zhenia Bogoslavskaya
FPBr	----- Galerie Breteau
FPBre	----- Coll. Andre Breton
FPBu	----- Galerie Jean Bucher (Galerie Bucher-Myrbor)
FPC	----- Cathedral
FPCF	----- Comedie Franciase
FPCa	----- Galerie Louis Carre
FPCal	----- Coll. Meric Callery
FPCar	----- Place du Carrousel
FPCarn	----- Musee Carnavalet
FPCas	----- Coll. Jeanne Castel
FPCe	----- Musee Cernuschi
FPCh	----- Champs Elysees
FPChT	----- Theatre Champs-Elysees
FPCha	----- Galerie Chardin
FPChad	----- Coll. Dr. Paul Chadourne
FPChal	----- Hotel de Chalons-Luxembourg
FPChap	----- Sainte Chapelle
FPChapE	----- Chapelle Expiatoire
FPChi	----- Coll. Compagnie de la Chine et des Indes
FPCl	----- Musee de Cluny
FPCle	----- Galerie Iris Clert
FPCo	----- Galerie Daniel Cordier
FPCol	----- Palais des Colonies
FPCom	----- Hotel Comans d'Astry
FPCon	----- Conservatory of Arts and Crafts
FPConc	----- Place de la Concorde
FPCr	----- Galerie Creuzevault
FPD	----- Coll. Gustave Dreyfus
FPDB	----- Coll. D. B. C.
FPDa	----- Coll. Alfred Dabor
FPDav	----- Coll. David-Weill
FPDavr	----- Coll. Jean Davray
FPDe	----- St. Denis
FPDec	----- Musee des Arts Decoratifs
FPDel	----- Coll. Mr. and Mrs. Deltcheff
FPDen	----- Place Denfert-Rochereau

FPDer	Paris. Coll. Andre Derain
FPDou	----- Coll. M. Douchet
FPDr	----- Galerie du Dragon
FPDro	----- Galerie Rene Drouin
FPDrou	----- Galerie Drouant-David
FPDru	----- Galerie E. Druet
FPDu	----- Coll. Jacques Dubourg
FPE	----- Ecole des Beaux Arts
FPEn	----- Musee d'Ennery
FPEth	----- Musee Ethnographique
FPEu	----- St. Eustache
FPF	----- Coll. M. Edmond Foule
FPFa	----- Galerie Paul Facchetti
FPFe	----- Coll. Felix Feneon
FPFl	----- Galerie Karl Flinker
FPFo	----- Castel Beranger, No. 16, rue La Fontaine
FPFr	----- Galerie de France
FPFra	----- Theatre Francaise
FPFre	----- Coll. Madame Freundlich
FPFri	----- Coll. Jean Fribourg
FPFu	----- Coll. Jean Furstenberg
FPG	----- Musee Guimet
FPGH	----- Coll. Mme Roberta Gonzalez-Hartung
FPGM	----- Galerie Mai
FPGP	----- Eglise St. Gervais-et-St. Protais
FPGe	----- Benedictine Abbey St. Germain des Pres (FPStGe)
FPGeo	----- Coll. Geoffrey-Dechaume
FPGi	----- Coll. Giacometti
FPGie	----- Coll. Gieseler
FPGiv	----- Galerie Claude Givaudan
FPGo	----- Coll. Mme Roberta Gonzalez-Hartung
FPGod	----- Coll. A. Godard
FPGr	----- Coll. Pierre Granville
FPGre	----- Rue de Grenelle, Faubourt, Saint-Germain
FPGu	----- Coll. Paul Guillaume
FPH	----- Musee de l'Homme
FPHI	----- Hotel des Invalides (Les Invalides)
FPHa	----- Coll. Hans Hartung
FPHai	----- Coll. Claude Bernard Haim
FPHaj	----- Coll. Mme. Etienne Hajdn
FPHe	----- Coll. Mme Bela Hein
FPHu	----- Editions La Hune
FPHug	----- Coll. Georges Hugnet
FPI	----- Cemetery (later Square or Place)of the Innocents

FPIF	-----	Institut de France
FPInst	-----	Institute Francaise d'Afrique Noir
FPInt	-----	Galerie Internationale d'Art Contemporain
FPIo	-----	Galerie Alexandre Iolas
FPJ	-----	Coll. Edward Jonas
FPJC	-----	Jardin des Carmes
FPJu	-----	Palais de Justice
FPJur	-----	Coll. Jurtzky
FPK	-----	Coll. Daniel-Henry Kahnweiler
FPKe	-----	Coll. Georges Keller
FPKn	-----	Galerie Knoedler
FPKo	-----	Coll. Mme. Jeanne Dosnickloss-Freundlich
FPL	-----	Louvre
FPLa	-----	Cimitiere du Pere Lachaise
FPLan	-----	Coll. Landau
FPLar	-----	Galerie Jean Larcade
FPLau	-----	Coll. Mme. H. Laurens
FPLe	-----	Galerie Louis Leiris
FPLeb	-----	Coll. Robert Lebel
FPLec	-----	Coll. Olivier Le Corneur
FPLef	-----	Coll. Andre Lefebvre
FPLev	-----	Parc de Levallois
FPLeve	-----	Coll. Andre Level
FPLo	-----	Coll. Eduard Loeb
FPLoe	-----	Coll. Pierre Loeb
FPLop	-----	Coll. Arturo Lopez-Willshaw
FPLou	-----	St. Paul-St. Louis Church
FPLu	-----	Luxembourg Gallery and Gardens (Musee de Luxembourg now: Musee National d'Art Moderne)
FPM	-----	Musee National d'Art Moderne (Formerly: FPLu)
FPMM	-----	Musee National des Monuments Francais
FPMP	-----	Musee d'Art Moderne de la Ville de Paris
FPMV	-----	Coll. Mouradian and Vallotton
FPMa	-----	Galerie Maeght; Coll. Aime Maeght
FPMai	-----	Coll. Maillard
FPMal	-----	Coll. Andre Malraux
FPMar	-----	Coll. Louis Marcoussis
FPMarm	-----	Musee Marmottan
FPMaz	-----	Bibliotheque Mazarine
FPMe	-----	Cabinet des Medailles, Bibliotheque Nationale
FPMet	-----	Metro Station
FPMeti	-----	Conservatoire National des Arts et Metiers

FPMeu	Paris. Coll. Leon Meyer
FPMi	----- Late Coll. Mire
FPMic	----- Place Saint-Michel
FPMo	----- Montmartre Cemetery (FPMont)
FPMon	----- Hotel des Monnaies
FPMone	----- Musee Monetaire
FPMont	----- Cimitiere de Montparnasse; Boulevard Montparnasse
FPMontb	----- Musee de Montbrison
FPMor	----- Musee National Gustave Moreau
FPMori	----- Coll. Antony Moris
FPN	----- Notre Dame de Paris
FPNa	----- Place de la Nation
FPNo	----- Coll. Vicomtesse de Noailles
FPO	----- Place de l'Observatoire
FPOp	----- Place Le Opera; Musee de l'Opera
FPOr	----- Musee Missionnaire des Orphelins d'Anteuil
FPOrt	----- Coll. George Ortiz
FPOu	----- Musee de la France d'Outremer
FPP	----- Place de Pyramides
FPPL	----- Pere Lachaise, end of avenue
FPPM	----- Parc Monceau
FPPP	----- Musee du Petit Palais
FPPT	----- Ministry of Posts and Telecommunications
FPPa	----- Musee du Jeu de Paume
FPPal	----- Musee de Paleontologie
FPPav	----- Pavillon de Flore
FPPe	----- Coll. M. P. Peissi
FPPol	----- Coll. J. P. Polaillon
FPPr	----- Coll. Miriam Prevot
FPR	----- Musee Rodin
FPRa	----- Coll. M. and Mme. Maurice Raynal
FPRan	----- Galerie Jacqueline Ranson
FPRas	----- Coll. Rene Rasmussen
FPRasp	----- Boulevards Raspail and Montparnasse
FPRat	----- Coll. Charles Ratton
FPRay	----- Coll. Man Ray
FPRe	----- Galerie Denise Rene
FPRen	----- Renoir et Colle
FPReno	----- Coll. Renou
FPRev	----- Coll. Emery Reves
FPRi	----- Galerie Rive Droite
FPRid	----- Ridgeway Collection
FPRo	----- Coll. Henri Pierre Roche
FPRoc	----- St. Roch (FPStR)
FPRoh	----- Hotel de Rohan

FPRos	Paris. Coll. Paul Rosenberg
FPRot	----- Coll. R. de Rothschild
FPRoth	----- Coll. A. de Rothschild
FPRoths	----- Coll. Elie de Rothschild
FPRou	----- Coll. Madeleine Rousseau
FPRoyG	----- Palais Royal Gardens
FPRu	----- Coll. Lawrence Rubin
FPRud	----- Coll. E. Rudier
FPS	----- Coll. Michel Seuphor
FPSC	----- Societe Centrale Immobiliere de la Caisse des Depots
FPSa	----- Coll. George Salles
FPSc	----- Schoffer
FPSe	----- Senat
FPSi	----- Galerie Simon
FPSo	----- Church of the Sorbonne
FPSon	----- Coll. Mrs. Ileana Sonnabend
FPSor	----- The Sorbonne
FPSp	----- Coll. Darthea Speyer
FPSt	----- Galerie Stadler
FPStE	----- Sainte-Chapelle
FpStE	----- St.-Etienne-du-Mont
FPStG	----- Bibliotheque St. Genevieve
FPStGe	----- St. Germain des Pres Church (FPGe)
FPStL	----- St. Paul-St. Louis (FPLou)
FPStR	----- St. Roch (FPRou)
FPStS	----- St. Sulpice
FPStSe	----- St. Severin
FPSu	----- Hotel du Sully
FPT	----- Coll. Tristan Tzara
FPTa	----- Coll. Taillemas
FPTo	----- Palais de Tokio
FPTou	----- Pont de la Tournelle
FPTr	----- Trocadero
FPTu	----- Jardins des Tuileries
FPU	----- UNESCO Building
FPV	----- Coll. Dina Vierny
FPVG	----- Galerie Villand et Galanis
FPVa	----- Coll. de Vasselot
FPVe	----- Coll. Pierre Verite
FPVi	----- Galerie Lara Viniy
FPVic	----- Place des Victoires
FPVr	----- Hotel de la Vrilliere (Banque de France)
FPY	----- Galerie "Y"
FPZ	----- Coll. Christian Zervos
FPaM	Paray le Monial. Musee du Hieron
FPai	Paimpont. Abbey Chapel

FPar	Parthenay le Vieux
FPauM	Pauillac. Chateau Mouton-Rothschild
FPeC	Perpignan. St. Jean-le-Vieux Church
FPeCA	----- Cathedral Annex
FPeJ	----- St. Jean Cathedral
FPenM	Penne (Tarn). La Magdeleine Cave
FPenc	Pencran. Church
FPenmN	Penmarch. St. Nonna Church
FPer	Perrecy Les Forges
FPl	Pleyben
FPla	Plaimpied. Church
FPlan	Plan d'Orgon. Bouche-du-Rhone (FBouc)
FPle	Pleumeur-Bodou
FPlo	Plougastel-Daoulas
FPloeA	Ploermel. St. Armel Church
FPloub	Ploubezre
FPloug	Plougonven
FPoA	Poitiers. Musee des Antiquaires de l'Ouest
FPoB	----- Musee des Beaux-Arts
FPoC	----- St. Pierre Cathedral
FPoM	----- Mellebaude Crypt
FPoMo	----- Benedictine (Clunaic) Priory Montierneuf
FPoN	----- Collegiate Church Notre-Dame-la-Grande
FPoP	----- Palace of Jean, Duc de Berry
FPoR	----- St. Radegonde
FPolH	Poligny. St. Hippolyte Collegiate Church
FPon	Pontoise
FPontL	Pont. L'Abbe D'Arnoult
FPontT	Pont-Aven. Tremalo Chapel
FPor	Port-Royal
FPrM	Pradet. Coll. Mme. Helene de Mandrot
FPra	Prayssas
FPro	Provence
FProvH	Provins. Hopital General
FPutM	Puteaux. Mairie de Puteaux
FPutV	----- Coll. Jacques Villon
FPuyM	Puy de Dome. Benedictine (Cluniac) Abbey Mozac
FPuyN	----- Notre Dame de Puy
FPuyV	----- Benedictine (Cluniac) Priory Volvic
FRB	Rouen. Hotel du Bourgtheroulde
FRC	----- Cathedral Notre Dame
FRS	----- Musee le Secq des Tournelles
FRaC	Rampillon. Templars' Church of St. Eliphe
FRamL	Rambouillet. Laiterie de la Reine
FReB	Rennes. Musee de Bretagne

FReM	Rennes. Musee de Rennes
FRet	Retaud
FRey	Reygades
FRhA	Rheims. Musee Archeologique
FRhC	----- Notre Dame Cathedral; Musee de Cathedral
FRhL	----- Musee Lapidaire
FRhM	----- Maison des Musiciens
FRhMu	----- Musee des Beaux-Arts
FRhPl	----- Place Royale
FRhR	----- Musee Saint Remy
FRiG	Rionm. Hotel Guimoneau
FRiM	----- Museum
FRiN	----- Eglise Notre Dame du Marthuret
FRie	Rieux-Minervois
FRiq	Riquewihr
FRoC	Rodez. Notre Dame Cathedral
FRoF	----- Musee Fenaille
FRoM	----- Museum
FRon	Ronchamp
FRosN	Roscoff. Notre Dame de Croaz Baz
FRouM	Roubaix. Coll. Jean Masurel
FRousG	Rousillon. St. Genis-des-Fontaines
FRouvC	Rouvres-en-Plaine. Church
FRuB	Rueil-Malmaison. Parc de Bois-Preau
FRuM	----- Musee National de Chateau de Malmaison
FSaM	Sanguesa. St. Maria La Real
FSai	Saintes
FSal	Salers
FSali	Salignac
FSan	Chateau de Sansac
FSau	Saulieu
FSeC	Senlis. Notre Dame Cathedral
FSeM	----- Musee de Haubergier
FSeN	----- Cathedral
FSel	Selles-sur-Cher
FSemM	Semur-en-Auxois. Museum
FSemN	----- Notre Dame
FSemu	Semur en Brionnais
FSenC	Sens. Tresor de la Cathedrale
FSenM	----- Musee Principal
FSep	Sept-Saints
FSer	Chateau Serrant
FSerr	Serrabone
FSevM	Sevres. Musee National de Ceramique
FSevR	----- Coll. H. P. Roche
FSi	Sizun

FSim	Simorre
FSoM	Souillac. St. Marie
FSoN	----- Notre Dame Abbey Church
FSoi	Soissons
FSol	Solesmes. Benedictine Abbey St. Pierre
FSom	Sommery
FSor	Sorde L'Abbaye
FSouP	Souvigny. St. Pierre
FStA	St.-Germain-en-Laye. Musee des Antiquities Nationales
FStAi	St. Aignan sur Cher
FStAm	St. Amand-le-Pas
FStAn	St. Andre de Sorede
FStAv	Staint Ave. Notre Dame de Loc Chapel
FStAve	St. Aventin Church
FStBF	Saint-Benoit-sur-Loire. Benedictine Abbey Fleury
FStBe	Saint-Bertrand-de-Comminges
FStBen	St.-Benoit-sur-Loire
FStC	St. Catherine de Fierbois
FStCl	St. Claude
FStD	St. Die
FStEM	St. Etienne. Musee Municipal d'Art et d'Industrie
FStFCH	St. Fortunade Church (FCorF)
FStFl	St. Flour
FStFo	St. Fort sur Gironde
FStG	St. Germain. Musee des Antiquites Nationales au Chateau de Saint Germain en Laye
FStGB	----- Le Vesinct. Garden Eugene Rudier
FStGe	St. Genis des Fontaines
FStGen	St. Genou
FStGi	St. Gilles du Gard. Abbey Church
FStGu	St. Guilhem-le-Desert. Benedictine Abbey
FStH	St. Hermine (FHu)
FStHe	St. Herbot Church
FStJ	St. Jean de Joigny (F Joi J)
FStJA	St. Jean d'Angely
FStJLCas	St. Jean-de-Luz. Casino
FStJo	St. Jouin de Marnes
FStJu	St. Julien de Jonzy
FStJun	St. Junien
FStLC	St. Laurent. Collegiate Church
FStLo	St. Loup-de-Naud
FStME	St. Mihiel. St. Etienne
FStMM	----- St. Mihiel Church
FStMS	----- St. Sepulcre Church

FStMa	St. -Martin-de-Boscherville. Abbey Church St. Georges
FStMal	St. Malo
FStMar	St. Marie de Menez Hom
FStMi	St. Michel de Cuxa
FStMic	St. Michel d'Entroygues
FStNC	St. Nectaire. St. Nectaire Church
FStOB	St. Omer. Musee des Beaux-Arts
FStPM	St. Paul. Foundation Maeght
FStPa	St. Paul de Varax
FStPau	St. Paul de Vence
FStPaul	St. Paul Les Dax
FStPol	St. Pol de Leon
FStQL	St. Quentin. Musee Antoine Lecuyer
FStRJ	St. Remy. Julii Monument
FStRe	St. Reverien
FStRiC	St. Riquier. Abbey Church
FStS	St. Saturnin
FStSe	St. Sever
FStTh	St. Thegonnec
FStRu	St. Tugen
FStYCh	St. Yrieix. Church
FStrC	Strasbourg St. Thomas Cathedral (FStr F)
FStrCN	----- Notre Dame Cathedral
FStr F	----- Frauenhaus Museum (FStrC)
FStrM	----- Musee des Beaux-Arts
FStrMu	----- Munster
FTB	Toulouse. Hotel de Bagis
FTL	----- Musee Lapidaire
FTM	----- Museum
FTMA	----- Musee des Augustins
FTMD	----- Benedictine (Clunaic) Abbey St. Marie-la-Daurade
FTR	----- Musee Saint-Raymond
FTS	----- Saint-Sernin Church
FThM	Thouars. St. Medard Church
FThu	Thuret
FToH	Tonnerre. Hotel Dieu
FTouP	Tournus. St. Philibert Abbey
FToulV	Toulon. Hotel de Ville
FTourC	Tours. Cathedral
FTourMA	----- Musee des Antiquites
FTrA	Troyes. Musee des Beaux-Arts
FTrC	----- St. Jean Cathedral
FTrH	----- Hotel de Dieu
FTrM	Troyes. Le Madeleine
FTrN	----- St. Nizier
FTrP	----- St. Pantaleon

FTrU	Troyes. St. Urban Church
FTre	Tregunc
FTreg	Treguier
FTro	Tronoen
FTuc	Le Tuc d'Audoubert (Ariege)
FV	Versailles. Musee de Versailles
FVa	Vaux-le-Vicomte
FVal	Vallauris
FValc	Valcabrere
FValeM	Valenciennes. Musee des Beaux-Arts
FVall	Valloiros. Cistercian Abbey
FValle	Vallery (F Chan C)
FVarM	Varzy. Musee Municipal
FVareB	Varennes. Brignoles Church
FVeM	Vezelay. Abbey Church St. Madeleine
FVeMu	----- Museum
FVenT	Vendome. La Trinite
FVencR	Vence. Chapel of the Rosary
FVes	Vesin
FVia	Vienne. St. Andre-le-Bas Church
FViC	----- St. Maurice Cathedral
FViL	----- Musee Lapidaire Chretien
FViP	----- Benedictine Abbey St. Pierre deChauvigny
FVil	Villemagne
FVillC	Villeneuve-les-Avignon. Eglise Collegiale
FVillaCh	Villandry. Church
FVille	Villefranche de Rouergue
FVo	Vouvant. Notre Dame
FYG	Ydes. St. Georges Church

<p align="center">Finland</p>

FiHA	Helsinki. Atheneum Art Museum (Ateneumin Taidemuseo)
FiHK	----- National Museum of Finland (Kansallismuseo)
FiHR	----- Railroad Station
FiHV	----- Coll. Veikko Vionoja
FiKA	Kajaani. Coll. Rosa Arola
FiOP	Orivesi. Parish Church

<p align="center">Germany</p>

-GB	Coll. Rudolf Buhler
-GH	Coll. Dr. Werner Haftmann
-GS	Estate of Dr. Rosa Schapire
-GW	Coll. Dr. Clemens Weiler
GAaC	Aachen. Aachen Cathedral Treasury
GAaM	----- Minster

GAcCh	Accum, near Wilhelmshaven. Parish Church
GAl	Alpirsbach. Abbey Church
GAltT	Altoetting. Treasury of Altoetting
GAlte	Altenerding
GAm	Amorbach. Abbey Church
GAnL	Andernach. Liebfrauenkirche
GArN	Arnsberg. Musee Napoleon
GAsP	Aschaffenburg. St. Peter's
GAsS	----- Schloss Kapelle
GAuA	Augsburg. Annakirche
GAuAF	----- ----- Fugger Chapel
GAuAr	----- Former Arsenal (Armory) (GAuZ)
GAuC	----- Cathedral
GAuM	Augsburg. St. Moritz
GAuMAx	----- Maximilianstrasse; Maximiliens Museum (Staatsgalerie)
GAuR	----- Rathaus
GAuSt	----- Stadtisches Museum
GAuU	----- Church St. Ulrich and St. Afra
GAuZ	----- Zeughauses von Elias Holl (GAuAR)
GBA	Berlin. Altes Museum
GBAF	----- Academy of Fine Art
GBAnt	----- Antiquarium
GBAr	----- Arsenal (GBZ)
GBB	----- Karl Buchholz Gallery
GBBe	----- Coll. City of Berlin
GBBu	----- Buntes Theatre
GBC	----- Paul Cassirer
GBCa	----- Cathedral
GBCh	----- Charlottenburg Palace
GBCha	----- Chancellery
GBCo	----- Berlin Conservatory
GBD	----- Deutsches Museum
GBDo	----- Dortheenstadtische Kirche
GBE	----- Ethnographical Museum
GBF	----- Coll. Max Frohlich
GBFB	----- Fruhchristlich-Byzantinische Samm-lung, part of GBSBe
GBFl	----- Flechtheim Gallery
GBFle	----- Coll. Alfred Flechtheim
GBFr	----- Friedrichstrasse
GBG	----- Coll. Prof. Gonda
GBH	----- Coll. Frau Hannah Hoch
GBI	----- Islamisches Museum
GBK	Berlin. Kaiser Friedrich Museum. Now: Bodemuseum, part of GBSBe
GBKam	----- Kamecke House
GBKath	----- Katholischekirche, Wansee

GBKl	Berlin. Coll. Dr. von Klemperer
GBKo	----- Georg Kolbe Museum
GBKol	----- Coll. Dr. Hans Kollwitz
GBKr	----- Coll. Hanns Krenz
GBKu	----- Kunstgewerbemuseum. Now: Bode-museum, part of GBSBe
GBL	----- Lustgarten
GBLa	----- Laurentiuskirche, Moabit
GBM	----- Berlin Museum; State Museum
GBMK	----- East Berlin Museum fur Deutsche Geschichte
GBMu	----- Berlin Munzkabinett. Now: Bode-museum, part of GBSBe
GBN	----- National Gallery
GBNa	----- Former National Museum
GBNe	----- New Museum
GBNea	----- East Berlin Nationalgaleries
GBNew	----- New People's Theatre
GBNi	----- St. Nicholas
GBO	----- Old Museum
GBOs	----- Ostasiatische-Sammlung
GBP	----- Pergamon Museum Now: Part of GBSBe
GBPO	----- Post Office
GBR	----- Royal Palace
GBRat	----- Rathaus
GBRau	----- Rauch Museum. Now: Part of GBSBe
GBRe	----- Rheingold Restaurant
GBReu	----- Coll. Kurt Reutti
GBS	----- Staatliche Museum (Ehemals Staatliche Museen, Dahlem Museum, West Berlin
GBSB	----- Staatsbibliothek
GBSBe	----- East Berlin Staatliche Museen zu Berlin
GBSBeA	----- ----- Agiptisches Museum
GBSBeM	----- ----- Munzkabinett
GBSBeV	----- ----- Vorderasiatisches Museum
GBSBeVo	----- ----- Museum fur Vokskunde
GBSM	----- Staatliche Munzsammlung
GBSS	----- Schlossmuseum (Staatliche Schlosser und Garten)
GBSc	----- Skulpturen-Sammlung. Now: Part of GBSBe
GBSch	----- Galerie Schuler
GBSe	----- Coll. Ernst Seeger
GBSp	----- Galerie Springer
GBV	----- Vorderasiatisches Museum

GBVo	Berlin. Museum fur Volkerkunde
GBW	----- Emporium Wertheim
GBWan	----- Wannsee Bathing Beach
GBWe	----- Coll. Louis Werner
GBWis	----- Coll. Dr. Wissinger
GBZ	----- Zeughaus (GBAr)
GBaB	Bamberg. Staatliche Bibliothek
GBaC	----- Cathedral
GBaE	----- Alter Ebracher Hof
GBaH	----- Historisches Museum, in Alten Hofhaltung
GBadL	Bad Salzuflen. LVA Clinic
GBadeCe	Baden-Baden. Old Cemetery
GBadeS	----- Spitalskirche
GBauS	Bautzen. Staatmuseum
GBavR	Bavaria. Pilgrimmage Church of Rohr
GBavW	----- Die Wies (GDich; GWP)
GBerS	Berchtesgaden. Schlossmuseum
GBes	Besigheim
GBiH	Biberachender Riss. Coll. Dr. Hugo Haring
GBir	Birnau. Pilgrimmage Church
GBl	Blaubeuren. Benedictine Monastery
GBoM	Bonn. Munsterkirche
GBoRL	----- Reinisches Landesmuseum
GBorCh	Borghorst. Church
GBrA	Braunschweig. Alstadt Town Hall
GBrB	----- Burgplatz
GBrC	----- Cathedral
GBrD	----- Burg Dankwarderode
GBrR	----- Rathaus
GBrSM	----- Stadtisches Museum
GBrU	----- Staatliches Herzog Anton Ulrich Museum
GBranC	Brandenburg. St. Catherine Church
GBreC	Breisach. Cathedral
GBremC	Bremen. Cathedral
GBremF	----- Focke-Museum
GBremK	----- Kunsthalle
GBremR	----- Roseliushaus
GBremU	----- Ubersee-Museum
GBruR	Brunn. Rathaus
GBuCa	Buckeburg. Castle Chapel
GBucCh	Buchau/Federsee. Former Ladies' Convent Church
GBucH	----- Hospital Chapel
GBuck	Bucken on the Weser
GCM	Cassel. Museum
GCS	----- Staatliche Kunstsammlungen

GCeS	Celle. Schloss Celle
GChS	Chemnitz. Schlosskirche
GChaS	Charlottenberg Schloss
GCiCo	Cismar. Former Convent Church
GCoA	Cologne. Antoniterkirche
GCoAA	----- Galerie Aenne Abels
GCoC	----- Cathedral
GCoCh	----- Deutz Parish Church
GCoE	----- Erzbischofliches Diozesan-Museum
GCoG	----- St. Gereon Church
GCoH	----- Hildegardis Gymnasium
GCoHa	----- Coll. Lucy Haubrick-Millowitsch
GCoJ	----- Coll. Carl Jatho
GCoK	----- St. Kunibert's
GCoKK	----- Kunstgewerbmuseum der Stadt Koln
GCoKo	----- Coll. H. Konig
GCoKu	----- Kolnischer Kunstverein
GCoM	----- St. Maria im Kapitol Church
GCoO	----- Museum fur Ostasiatische Kunst der Stadt Koln
GCoP	----- Coll. Prof. Helmut Petri
GCoPa	----- Pantaleon
GCoR	----- Rautenstrauch-Joest Museum fur Volkerkunde der Stadt Koln
GCoRat	----- Rathaus
GCoRh	----- Rheinpark
GCoRom	----- Romisch-Germanisches Museum
GCoS	----- Schnutgen-Museum, Cacilienkloster
GCoSt	----- Coll. Stein
GCoU	----- University
GCoW	----- Wallraf-Richartz Museum
GCobD	Coburg. Ducal Foundation
GCobV	----- Veste Coburg Coll. (GVeC)
GConC	Constance. Constance Cathedral
GConM	Constance. Munster
GConR	----- Rosegartenmuseum Konstanz
GCrL	Creglingen. Herrgottkirche
GDA	Dresden. Albertinum (Staatliche Kunstsamm-lungen)
GDG	----- Grunes Gewolbe
GDH	----- Hofkirche
GDM	----- Museum
GDP	----- Porzellansammlung. Part of GDA
GDS	----- Stadtische Sammlungen
GDSc	----- Schilling Museum
GDZ	----- Zwinger Palace
GDaD	Darmstadt. Deutschen Vereinsbank
GDaH	----- Hessisches Landesmuseum Darmstadt

GDaI	Darmstadt. Coll. Dr. H. J. Imela
GDaM	----- Museum Darmstadt
GDaMat	----- Mathildenhohe
GDaP	----- Porzellanschlosschen
GDaR	----- Russian Chapel
GDalP	Dalhem. Pfarrkirche
GDeH	Dentz. Heribert Church
GDetP	Detmold, Prison
GDiCh	Die Wies. Church (GBavW; GWP)
GDiesS	Diessen. Stifliskirche
GDo	Doberan
GDonF	Donaueshingen & Heilisenberg. Coll. Princes Furstenberg
GDorR	Dortmund. Reinoldkirche
GDuK	Duisberg. Wilhelm-Lehmbruck-Museum der Stadt Duisberg
GDur	Durnstein
GDusB	Dusseldorf. Coll. Bagel
GDusC	----- Coll. Clausmeyer
GDusH	Dusseldorf. Hetjensmus
GDusHa	----- Coll. Ursala Haese
GDusK	----- Kunstmuseum
GDusM	----- Museum Dusseldorf
GDusMa	----- Mannesmann-Gebaude
GDusMe	----- Herrensitz Merrerbusch
GDusMey	----- Coll. Klaus Meyer
GDusR	----- Rolandschule
GDusRG	----- Rheinische Girozentrale
GDusS	----- Bankhaus Simons
GDuSc	----- Galerie Schmel
GDusV	----- Coll. Alex Vomel
GDusmS	Dusseldorf-Mettmann. Coll. F. Schniewind
GE	Eckernforde Church
GEA	Essen--Werden. Abbey Church
GEAr	Essen. Arenberische, A. G.
GEC	----- Cathedral Treasury
GEF	----- Museum Folkwang
GEK	----- Krupp von Bohlen Residence
GEV	----- Verwaltungsgabaude, Gute-Hoffung-shutte
GEiC	Eichstatt. Cathedral
GEn	Enger
GErB	Erfurt. Bartusserkirche
GErC	----- Cathedral
GErM	----- Marienkirche
GErS	----- St. Severus Church
GErU	----- Ursuline Convent
GEssF	Esslingen. Frauenkirche

GF	Frankfurt. Stadlische Galerie
GFB	----- Bethmann's Museum
GFC	----- Galerie Daniel Cordier
GFF	----- Frankfurt Gallery
GFFarb	----- Farbenindustrie
GFFo	----- Forshungsinstitut
GFFr	----- Friedhofskapelle
GFG	----- Coll. Helmutt Goldeckemeyer
GFH	----- Museum fur Kunsthandwerk
GFK	----- Liebfrauenkirche
GFKu	----- Museum fur Kunsthandwerk
GFL	----- Liebieghaus (Stadtische Skulpturen-Sammlung)
GFM	----- Museum fur Vor-und Fruhgeschichte
GFS	----- Sindlingen
GFSt	----- Stadelsches Kunstinstitut
GFStb	----- Stadtbibliothek
GFSts	----- All Saints Church
GFV	----- Museum fur Volkerkunde
GFiCh	Fischbach. Parish Church
GFlK	Flensburg. Kunstgewerbe-Museum
GFrec	Freckenhorst
GFreiA	Freiburg im Breisgau. Augustiner Museum
GFreiC	----- Cathedral
GFreiM	----- Marienkirche
GFreiUK	----- University. Kunstgeschichtliches Institut
GFreiUL	----- ----- University Library
GFreiUP	----- ----- Physics Institute
GFreuC	Freuenstadt. Stadtkirche
GFriC	Fritzlar. Collegiate Church
GFu	Furstenfeldbruck
GFulF	Fulda. Fasanerie Palace
GFusM	Fussen. Former St. Mang Convent Church
GGL	Gotha. Library
GGLM	----- Landesmuseum
GGM	----- Gotha Museum
GGeK	Gelnhausen. Kaiserpfalz
GGeL	----- Marienkirche
GGelH	Gelsenkirchen. Haus Tollmann
GGelS	----- Schalker Gymnasium
GGelT	----- Stadttheater
GGerC	Gernrode. Collegiate Church
GGmS	Gmund. Sommer, Schwabusch
GGnC	Gnesen. Cathedral
GGoJ	Goslar. Jakobikirche
GGoK	----- Kaiserhaus
GGoM	----- Marketplace

GGoMu	Goslar. Goslarer Museum
GGoN	----- Neuwerkskirche
GGosCh	Gossweinstein. Pilgrimage Church
GGotV	Gottingen. Sammlung des Instituts fur Volkerkunde
GGrC	Gross-Camburg. Collegiate Church
GGuC	Gustrow. Cathedral
GGunM	Gunzberg. Heimatmuseum Gunzberg.
GGutP	Gutersloh. Prison
GH	Hamburg. Kunsthalle
GHB	----- Estate Hermann Blumenthal
GHBar	----- Ernst Barlach Haus
GHG	----- Coll. Dr. Guhr
GHH	----- Galerie Rudolf Hoffmann
GHK	----- Kunsthalle
GHKG	----- Museum fur Kunst und Gewerbe
GHM	----- Museum
GHP	----- Primary School Hamburg-Niendorf
GHPe	----- Church of St. Peter
GHPl	----- Planten und Blomen
GHR	----- Coll. Hermann F. Reemstma
GHS	----- Coll. Samson
GHV	----- Hamburgisches Museum fur Volkerkunde und Vorgeschichte
GHVa	----- Coll. Jan Bontjes van Beek
GHVo	----- Volkspark
GHaA	Hannover. Aegidientor Platz; Ruins of St. Aegidienkirche
GHaB	----- Galerie Dieter Brusberg
GHaBo	----- Boeckler-Allee
GHaG	----- Grupenstrasse
GHaK	----- Kestner-Museum
GHaKL	----- Museum fur Kunst und Landesgeschichte
GHaL	----- Nidersachsiche Landesgalerie
GHaM	----- Merz Building
GHaMu	----- Museum
GHaMK	----- Marketkirche
GHaN	----- Neues Haus
GHaS	----- Coll. Dr. Bernhard Sprengel
GHaSt	----- Stadtpark
GHaU	----- Union Boden
GHaW	----- Welfen-Museum
GHaWa	----- Residence, Waldhausenstrasse 5, Teil auf Nahme
GHagF	Hagen. Folkwang Museum (Now: Karl-Ernst-Osthaus Museum)
GHagO	----- Stadtiches Karl-Ernst-Osthaus Museum
GHageM	Hagenau. Museum

GHalC	Halberstadt. Cathedral (Museum)
GHalL	----- Liebfrauenkirche
GHallL	Halle. Landesmuseum fur Vorgeschichte
GHallM	----- Moritzkirche
GHallSt	----- Stadt. Museum
GHallStG	Halle. Staatliche Galerie Moritzburg
GHallgP	Hallgarten. Parish Church
GHamT	Hamborn. Coll. August Thyssen-Hutte
GHeN	Hennef. Coll. Dr. Walter Neuerburg
GHef	Heffenthal bei Axchaffenberg
GHeiA	Heidelberg. Deutsches Apotheken-Museum
GHeiC	----- Heidelberg Castle
GHeilK	Heilbronn. St. Kilian's
GHiC	Hildesheim. Cathedral
GHiG	----- St. Godehard
GHiM	----- St. Michael Church
GHiMa	----- Magdalen's Church
GHiMu	----- Museum
GHiRP	----- Roemer-Pelizaeus-Museum
GHilV	Hilden. Volksschule
GHirZ	Hirsau. St. Aurelius Kirche
GHo	Hoven. Former Convent Church
GHofCa	Hofhegnenberg. Castle Chapel
GHomS	Homburg. Schloss Homburg
GJS	Jever. Stadtkirche
GKU	Kiel. University
GKaS	Kappenberg. Schlosskirche
GKalN	Kalkar. Nikolaikirche
GKapCh	Kappenberg. Church
GKarB	Karlsruhe. Badische Landesmuseum
GKarBu	----- Bundesgartenschau
GKarH	----- Coll. Dr. Hans Himmelheber
GKoS	Konigsberg. Now: Kalingrad, USSR, since 1945. Stadtische Kunstsammlungen
GKoSc	----- Schloss
GKonC	Konigslutter. Collegiate Church
GKot	Kotzschenbroda. Church
GKrA	Krensmunster. Abbey
GKrefW	Krefeld. Kaiser Wilhelm Museum
GLB	Leipsig. Museum der Bildenden Kunste
GLBi	----- State Library
GLK	----- Kunstgewerbe Museum
GLV	----- Museum fur Volkerkunde
GLS	----- Stadtgeschichtliches Museum
GLVo	----- Volkerschlactdenkmal
GLaM	Landshut. St. Martin
GLaR	----- Residenz

GLangW	Langen. Schloss Wolfsgarten. Coll. Prince Ludwig von Hessen und bei Rhein
GLeA	Leverkusen. Alkenrath
GLeM	----- Stadtisches Museum Leverkusen, Schloss Morsbroich
GLeMa	----- Mathildenhor
GLeiM	Leisnig. Matthauskirche
GLiC	Limburg. Cathedral Treasurey
GLiD	----- Diozesan-Museum
GLichCh	Lich. Convent Church
GLoM	Lorch. Marienkirche
GLuA	Lubeck. Annenmuseum
GLuB	----- Behnhaus
GLuC	----- Katherinenkirche
GLuCa	----- Cathedral
GLuH	----- Museen der Hanestadt Lubeck
GLuM	----- Marienkirche
GLuT	----- Town Hall
GLunT	Luneberg. Town Hall
GMA	Munich. Museum Antiker Kleinkunst
GMAl	----- Albertinum
GMAlt	----- Alte Pinakothek
GMAr	----- Archaeological Seminar
GMAs	----- Asam Church (Church St. Johann Nepomuk) (GMJ)
GMB	----- Bayerische Staatsgemalesammlungen
GMBN	----- Bayerisches Nationalmuseum
GMBo	----- Coll. Bohler
GMBu	-----Bugersaal, Carmelite Church (GMH; GMM)
GMD	----- Deutsches Museum von Meisterwerken der Naturwissenschaft und Technik
GME	----- Elvira Photographic Studio
GMEt	----- Museum of Ethnography
GMF	----- Fruenkirche
GMG	----- Gliptothek (GMSA)
GMH	----- Stadt-under Kulturgeschichte Munchens, Munchener Stadtmuseum (GMStM)
GMHo	----- Hofgarten
GMJ	----- St. John Nepomuk Church (GMAs)
GMK	----- Reiche Kapelle
GML	----- Galerie van de Loo
GMLa	----- Landesversorgungsamt
GMM	----- Munich Museum (Stadtmuseum) (GMH)
GMMS	----- Staatliche Munzsammlung (GMSA)
GMMa	----- Maximilian Platz
GMMi	----- St. Michael's Church
GMN	----- Nymphenburg

GMOp	Munich. Opera House
GMP	----- St. Peter
GMR	----- Residenzmuseum
GMRC	----- Reiche Kapelle
GMRat	----- Alter Rathaussaal (GMH)
GMS	----- Staatsbibliothek
GMSA	----- Staatliche Antikensammlungen (GMG)
GMSG	----- Staatsgalerie; Neue Staatsgalerie
GMSGal	----- Stadtische Galerie im Lenbachhaus
GMSH	----- Student's Hostel
GMSM	----- Staatliche Munzsammlung
GMSch	----- Hermann Schwartz Coll.
GMSt	----- Students' House
GMStm	----- Stadtmuseum (GMH)
GMT	----- Galerie Thomas
GMU	----- University
GMV	----- Staatliches Museum fur Volkerkunde
GMVan	----- Galerie van de Loo
GMT	----- German Transport Exhibition, 1953
GMaM	Mannheim. Kunsthalle
GMaSS	----- Sammlungen des Ehemaligen Schloss-museums und Stadtgeschichtliche Sammlungen
GMaV	----- Volkerkundliche Sammlungen der Stadt Mannheim
GMaW	----- Wohnhaus
GMagC	Magdeburg. Cathedral
GMagK	----- Kulturhistorisches Museum
GMagM	----- Market Place
GMaiA	Mainz. Altertumsmuseum
GMaiC	----- Cathedral
GMaiH	----- Historic Museum
GMaiMu	----- Museum
GMaidP	Maidbronn. Pfarrkirche
GMarE	Marburg. Elizabethkirche
GMarU	----- Marburger Universitatsmuseum fur Kunst and Kulturgeschichte
GMari	Mariental, near Helmstedt. Convent Church
GMariaCo	Maria Laach. Convent Church
GMarl	Marl
GMau	Maulbronn. Cistercian Monastery
GMeC	Merseberg. Cathedral
GMeiC	Meissen. Cathedral
GMetB	Metten. Benedictine Convent Church
GMiC	Minden. Cathedral
GMuC	Munster. Cathedral
GMuL	----- Landesmuseum fur Kunst und Kulturgeschichte

GMur	Murrhardt
GNA	Nuremberg. All Saints Chapel, House of the Twelve Brothers
GNG	----- Germanisches Nationalmuseum
GNH	----- Holzschuler Kapelle
GNL	----- St. Lorenz
GNM	----- Moritzkapelle
GNP	----- Pellerhaus
GNR	----- Rathaus
GNS	----- Sebalduskirche
GNaC	Naumberg. Cathedral
GNeC	Nenningen. Friedhofs Kapelle
GNeuU	Neu-Ulm (GH)
GNeubM	Neubirnau. St. Mary Parish Church
GNeumH	Neumunter. Coll. Aris. Hain
GNeusM	Neuss. Marienkirche
GNevS	Neviges. Coll. Willy Schniewind
GNi	Niederrottweil
GNoG	Norlingen. Parish Church St. George
GNonC	Nonnberg. Collegiate Church
GOL	Oberwesel. Liebfrauenkirche
GObP	Obermenzing. Church of the Passion
GOlL	Oldenburg. Landesmuseum fur Kunst und Kulturgeschichte
GOlR	----- Rodenkirchen
GOlV	----- Varel Church
GOsC	Osnabruck. Cathedral
GOsR	----- Rat Haus
GOtA	Ottobeuren. Abbey Church
GPA	Paderborn. Albinghof Monastery
GPC	----- Cathedral
GPD	----- Erzbischofliches Diozosanmuseum
GPF	----- St. Francis
GPaS	Passau. St. Severin
GPoN	Potsdam. Neues Palais
GPoS	Schloss Sanssouci
GPolM	Polling. Heimatmuseum
GPrC	Pressburg (German protected state 1939-1945; Now: CzBr). Cathedral
GPreCh	Preetz. Former Convent Church
GQS	Quedlinburg. Servatius Church
GRR	Rohr. Stifelskirche
GRaJ	Ratisbon. St. Jakob
GRavC	Ravensberg. Church
GReM	Reutlingen. Marienkirche
GRecI	Recklinghausen. Ikonenmuseum
GRecS	----- Stadtische Kunsthalle
GRegC	Regensburg. St. Jacob's Cathedral

GRegE	Regensburg. St. Emmeram's
GRegN	----- Niedermunsterkirche
GRegP	----- Prufening bei Regensburg
GRegS	----- Schloss Sunching Chapel
GRei	Reichenberg
GRemR	Remscheid. Deutches Rontgen-museum
GRoJ	Rothenberg. St. James
GRoJa	----- St. Jakob
GRonR	Ronsdorf. Rathaus
GRosC	Rosheim. Parish Church
GRotL	Rottweil. Kunstsammlung Lorenzkapelle
GRott	Rott-am-Inn
GRotte	Rottenbuch
GSaW	St. Wolfgang
GSaaS	Saarbrucken. Saarlandmuseum
GSaaU	----- Universitat
GSalA	Salem. Abbey
GScC	Schleswig. Cathedral
GSch	Schoneiche. Ev. Kirche
GSchl	Schleissheim
GSieg	Siegburg. Abbey
GSigK	Sigmaringen. Kaserne
GSoP	Soest. St. Patroklus
GSonMo	Sonnenberg. Monastery
GSpC	Speyer. Cathedral
GSpP	----- Historisches Museum der Pfalz
GStA	Stuttgart. Antikensammlung
GStCh	----- Convent Church
GStF	-----Familienbesitz
GStL	----- Lindesmuseum
GStLa	----- Landtagsgebaude
GStLan	----- Landesgewerbemuseum
GStLe	----- Coll. Lehmbruck
GStLu	----- Galerie Lutz & Meyer
GStM	----- Museum
GStMu	----- Galerie Muller
GStP	----- Coll. K. G. Pfahler
GStR	----- Raichberg-Mittelschule
GStS	----- Coll. Frau Schlemmer
GStSt	----- Staatsgalerie Stuttgart
GStT	----- Coll. Dr. Thiem
GStWL	----- Wurttembergisches Landesmuseum
GStaH	Starnberg. Stadliche Heimatmuseum
GStaW	Starnberg. Wurmgau Museum
GStad	Stadthagen
GSteH	Stettin. Stadtisches Museum
GStei	Steinhausen. Church
GSteinCh	Steingaden. Pilgrimage Church

GSterR	Sterzing. Rathaus
GSti	Stift Neuberg
GStrM	Stralsund. Kulturhistorisches Museum
GStrN	----- Nicolaikirche
GStraJ	Straubing. St. Jakob
GStraU	----- Ursulinenkirche
GStre	Strehla
GTB	Trier. Bischofliches Museum
GTC	----- Domschatz Cathedral (Cathedral Treasury)
GTD	----- Dreifaltigkeitskirche
GTL	----- Liebfrauenkirche
GTP	----- Landesmuseum
GTR	----- Rheinisches Landesmuseum
GTaH	Tallim. Church of the Holy Ghost
GTe	Teutoburg Forest
GTrP	Treves. Provincial Museum (See also GTP)
GTuIU	Tubingen. Vorgeschichtliche Sammlungen des Institutes fur Vor- und Fruhgeschichte
GTuL	----- Coll. Frau Anita Lehmbruck
GTuS	----- Stiftskirche
GTutG	Tuttlingen. Gewerbeschule
GUC	Ulm. Cathedral
GUH	----- Hochbrauamt
GUM	----- Munster
GUU	Ulm. Ulmer Museum
GUbM	Uberlingen. Museum
GUbN	----- St. Nicholas
GV	Vierzehnheiligen. Pilgrim's Church
GVeC	Veste Coburg (GCobV)
GViF	Villengen. Finunzamt (Revenue Office)
GWLM	Wiesbaden. Landesmuseum
GWP	Wies. Pilgrim Church (GBavW)
GWa	Waldessen, Bavarian Forest
GWeA	Werden-Essen. Abbey Church
GWecS	Wechselburg. Schlosskirche
GWeiG	Weimar. Goethehaus
GWeikS	Weikersheim. Schloss Weikersheim
GWeinCh	Weingarten. Convent Church
GWeisCh	Weissenregen. Pilgrimage Church
GWelC	Weltenburg. Convent Church
GWelM	----- Monastery Church
GWes	Westerwald
GWeyC	Weyarn. Ehemalige Klosterkirche (Church of the Augustinian Canons)
GWiM	Wismar. St. Mary's
GWic	Wickrath
GWieL	Wiesbaden. Landesmuseum

GWieSA	Wiesbaden. Stadtisches Museum Wiesbaden
GWienCo	Wienhausen. Convent Church
GWiesCh	Wies. Pilgrimage Church (GBavW)
GWoC	Worms. Cathedral
GWuB	Wurzburg. Bergerspital
GWuC	----- Cathedral
GWuE	----- Erbach Monastery
GWuH	Wurttemberg. Hohenzollern Burgkappele
GWUL	----- Luitpold Museum
GWuM	----- Marienkirche
GWuMai	----- Mainfranisches Museum (GWuR)
GWuN	----- Neumunster
GWuP	----- Residenz
GWuPG	----- Palace Gardens
GWuR	----- Otto-Richter-Halle der Freunde Main-frankisher Kunst and Geschichte
GWuV	----- Veitschochheim
GWuW	----- Martin von Wagner-Museum der Universitat Wurzburg
GWupJ	Wuppertal. Coll. R. Jahrling
GWupM	----- Von der Heydt-Museum der Stadt Wuppertal
GWupZ	----- Coll. Dr. Ferdinand Ziersch
GWurP	Wurzach. Residenz
GXC	Xanten. Collegiate Church
GZR	Zwenkau. Dr. Raabe House
GZer	Zerstort
GZuCh	Sweifalten. Convent Church

Ghana

GhA	Accra

Greece

GrAA	Athens. Acropolis; Acropolis Museum
GrAAG	----- Agora Museum
GrAAm	----- American School of Classical Studies
GrABy	----- Byzantine Museum
GrAC	----- Ceramics Museum (GrAK)
GrADip	----- Dipylon
GrAE	----- Erechtheum
GrAF	----- Ecole Francaise d'Athenes
GrAG	----- German Archaeological Institute
GrAK	----- Museum of Old Athens, and Museum of Keramaikos GrAK)
GrAM	----- Museum
GrAN	Athens. National Museum
GrANA	----- National Archaeological Museum
GrAP	----- Parthenon
GrAPa	----- Coll. E. Papastratos
GrAS	----- Stoa of Attalos Museum

GrAT	Athens. Theatre
GrCM	Corfu. Museum
GrCP	----- Royal Palace Museum
GrCAM	Candia. Candia Museum
GrChM	Chalcis. Chalcis Museum
GrCo	Cos. Museum
GrCorA	Corinth. Archaeological Museum
GrCyA	Cyrene. Museum of Antiquities
GrDM	Delphi. Delphi Museum
GrDeC	Delos. House of Cleopatra and Dioscourides
GrDeF	----- Temple of Good Fortune
GrDeM	----- Museum
GrDi	Didyma
GrElM	Eleusis. Eleusis Museum
GrEpM	Epidaurus. Epidaurus Museum
GrFH	Foce del Sele. Temple of Here
GrHA	Heraclion. Archaeological Museum
GrHM	----- Museum
GrKA	Korkyra. Temple of Artemis
GrKM	Korkyra. Museum
GrKavM	Kavalla. Kavalla Museum
GrKeA	Keos. Temple at Ayia Irini
GrKnM	Knossos. Palace of Minos
GrLyM	Lycosura. Lycosura Museum
GrMy	Mycenae
GrMycA	Mykonos. Archaeological Museum
GrNM	Nauplion. Archaeological Museum
GrOM	Olympia. Olympia Museum
GrOZ	----- Temple of Zeus
GrPM	Piraeus. Archaeological Museum
GrRA	Rhodes. Archaeological Museum
GrRM	----- Museum
GrSaA	Salonica. Archaeological Museum (See also GrTheA)
GrSaD	----- Hagios Dimitrios
GrSaG	----- Arch of Galerius
GrSamM	Samos. Samos Museum
GrSamT	----- Tigani Museum
GrSamV	----- Vathy Museum
GrSpM	Sparta. Archaeological Museum
GrTeM	Tegea. Tegea Museum
GrTenM	Tenos. Museum
GrThM	Thasos. Museum
GrTheA	Thessaloniki. Archaeological Museum (See also GrSaA)
GrTiM	Tigani. Museum
GrVM	Vathy. Museum

Guatemala

Gu GN	Guatemala City. Museo Nacional de Arqueologia y Entologia
Gu La	La Amelia
Gu P	Piedras Negras
Gu Q	Quirigua
Gu T P	Tikal. University of Pennsylvania Museum
Gu Y	Yaxchilan

Hungary

HBA	Budapest. Museum of Fine Arts
HBB	----- Burg
HBBP	----- Budapest City Park
HBBu	----- Budaorsi Street
HBD	----- Gyorgy Dozsa Street
HBG	----- Gellertberg
HBJ	----- Attila Jozsef Platz
HBK	----- Lajos Kossuth Platz
HBKf	----- Kerepsi Friedhof
HBM	----- Matthias Church
HBMA	----- Museum of Authors
HBMa	----- Margaret Island
HBNG	----- Magyar Nemzeti Galeria
HBNM	----- Magyar Nemzeti Museum
HBP	----- Petofi Platz
HBS	----- Stalin Platz
HBV	----- Varmuzeum
HBa	Baja
HC	Cluj
HDCa	Debrecen. Calvinist Church
HEC	Eztergom. Cathedral (Treasury)
HEg	Eger
HJC	Jak. Church
HJa	Jaszbereny
HNK	Nagatetny. Kastelymuzeum
HPD	Pecs. Dommuzeum
HSz	Szekesfahervar
HVi	Visegrad

Haiti

Ha P	Port-au-Prince

Honduras

HoC	Copan

Hong Kong

HonC	Hong Kong. Coll. J. D. Chen

-IF	Coll. Franchi
-IR	Coll. Marchese Rainieri Pao Lucci de Calboli
-IRe	Regina Madre
IAC	Agrigento, Agrigento Cathedral
IAM	----- Museo Civico Archeologico
IacL	Acqui. Coll. Otto Lenghi
IAeG	Aegadian Islands. Grotta di Levanzo
IAlM	Altomonte Calabro. Chiesa Madre
IAnM	Anagni. Cathedral Santa Maria
IAncL	Ancona. Loggia della Mercanzia
IAncM	----- Santa Maria della Piazza
IAoO	Aosta. Collegiate Church Sant'Orso
IApA	Apulia. Acerenza Cathedral
IApL	----- Lucera Cathedral (Treasure)
IAqB	Aquila. St. Bernardino
IAqM	----- Museo
IArC	Arezzo. Cathedral
IArM	----- Parish Church St. Maria Assunta e San Donato
IArP	----- Pinacoteca e Museo Medioevale e Moderno
IArPi	----- Pieve
IAsF	Assisi. St. Francesco
IAsM	----- St. Maria degli Angeli
IAscS	Ascanio Senese. Museo d'Arte Sacra
IAtB	Atrani. San Salvatore di Bireto Church
IAvT	Avezzano. Villa Torlonia
IB	Barzio. Museo di Barzio
IBR	Barzia. Museo Rosso
IBSC	Borgo San Dalmazzo. Cemetery
IBaM	Bari. Museo Communale
IBaN	----- Basilica Sannicola
IBaP	----- Cathedral San Nicola Pellegrino
IBaS	----- Cathedral San Sabino
IBagP	Bagheria. Villa Palagonia
IBai	Baiae
IBarA	Barletta. San Andrea Church
IBarCo	----- Museo e Pinacoteca Communale
IBarM	----- St. Maria Maggiore
IBarMN	----- National Museum
IBardM	Bardo. Musee National
IBargC	Barga. Cathedral San Cristofano
IBarzR	Barzio. Medardo Rosso Museo
IBe	Benevento
IBeB	Bergamo. Baptistry
IBeC	Benevento. Cathedral

IBerBi	Bergamo. Biblioteco Civica
IBerC	----- Colleoni Chapel
IBerM	----- S. Maria Maggiori
IBiV	Bitonto. Cathedral San Valentino
IBoA	Bologna. Archiginnasio
IBoC	----- Museo Civico
IBoCas	----- Coll. Countess Avia Castelli
IBoD	----- San Domenico Maggiore
IBoF	----- San Francesco
IBoM	----- S. Maria della Vita
IBoMS	----- S. Maria dei Servi
IBoN	----- Piazza del Nettuno
IBoP	----- Basilica di San Petronio
IBoPa	----- San Paolo
IBobC	Bobbio. San Colombano
IBolM	Bolzano. San Martino
IBolS	----- Staalliche Museen
IBolbG	Bolbec. Gardens
IBolsC	Bolsena. Antiquarium della Chiesa di Santa Cristina
IBomM	Bominaco. Parrochiale Santa Maria
IBomaO	Bomarzo, near Viterbo. Orisisin Palace
IBorC	Borgo. San Donnino Cathedral (IFidC)
IBrM	Brescia. Brescia Museum
IBrMC	----- Civico Museo dell'Eta Cristiana
IBrMV	----- Santa Maria de Vincoli
IBrMa	----- Coll. Luigi Marzoli
IBrS	----- Benedictine Abbey San Salvatore
IBriB	Brindisi. Benedictine Church San Benedetto
IBriL	----- Basilian Church Santa Lucia
IBuF	Buscate. Coll. Egone Fischi
ICC	Casentino. Chiesa Maggiore
ICaM	Capua. Museo Provinciale Compano
ICadC	Cadenabbio. Villa Carlotta
ICadu	Caduti
ICae	Caere
ICagC	Cagliari. Cathedral
ICagM	----- Museo Archeologico Nazionale
ICanP	Canosa di Puglia. Cathedral San Sabino
ICao	Caorle
ICasC	Castelvetrano. Museo Selinuntino
ICaseC	(Caserta. Great Cascade
ICaseP	(----- Palazzo Reale
ICasoC	Casole d'Elsa. Cathedral
ICeM	Cesena. Biblioteca Malatestiana e Raccolte Communali
IChT	Chieti. Cathedral Santi Tomaso e Giustino
IChiE	Chiusi. Museo Etrusco

ICi	Cividale del Friuli. Tempietto longobardo di Santa Maria in Valle
ICiB	----- Baptistry
ICiD	----- Cathedral San Donato
ICiM	----- S. Maria della Valle
ICiMa	----- S. Martino
ICivCM	Civitale, Castellana. Cathedral S. Maria
ICoC	Cosenza. Cosenza Cathedral
IComC	Como. Cathedral
IComP	----- Coll. Parizzi
IComVC	----- Villa Carlotta
ICorC	Cortona. Museo Civico
ICorE	----- Museo dell'Accademia Etrusca
ICorF	----- St. Francis Church
ICrC	Cremona. Cathedral
IEC	Empoli. Collegiate
IFA	Florence. Galleria dell'Accademia
IFAnn	----- SS. and Piazza Annunziata
IFAr	----- Museo Archeologico di Firenze
IFArg	----- Museo degli Argenti
IFB	----- Galleria Buonarroti
IFBL	----- Biblioteca Laurenziana
IFBN	----- Biblioteca Nazionale Centrale
IMBad	----- Badia
IFBap	----- San Giovanni Baptistry
IFBar	----- Bargello (See also IFMN)
IFBard	----- Museo Bardini
IFBe	----- Coll. Bernard Berenson
IFBo	----- Boboli Gardens
IFBon	----- Coll. Count Contini Bonacossi
IFBu	----- Coll. Marchese Bufalini
IFC	----- S. Maria del Fiore Campanile
IFCO	----- Museo dell'Opera del Duomo (See also IFOp)
IFCas	----- Villa Castello
IFCh	----- Chiesa del Carmine
IFCl	----- Clercq Coll.
IFCol	----- Societa Columbaria
IFCr	----- Santa Croce
IFD	----- Officina Pietre Dure
IFDa	----- Palazzo Davanzati
IFE	----- English Cemetery
IFEg	----- S. Egidio
IFF	----- Cathedral S. Maria del Fiore
IFFP	----- San Francesco da Paolo
IFFr	----- Palazzo della Fraternita
IFG	----- Giotto's Tower
IFGa	----- S. Gaetano

IFGh	Florence. Palazzo Gherardesca
IFGo	----- Palazzo Gondi
IFGu	----- Palazzo Guicciardini
IFH	----- Coll. Mrs. Elisabeth Brewster-Hildebrand
IFI	----- Ospedale degli Innocenti
IFJ	----- Borgo San Jacopo
IFL	----- Loggia dei Lanzi
IFLo	----- San Lorenzo (IFMe)
IFLor	----- Piazza San Lorenzo
IFLu	----- Lungarno Serristori
IFMA	----- S. Maria degli Angioli
IFMF	----- Museo di S. Maria del Fiore
IFMN	----- Museo Nazionale (See also IFBar)
IFMNA	----- Museo Nazionale di Antropologia
IFMO	----- Museo dell'Opera
IFMa	----- San Marco
IFMar	----- S. Maria Novella
IFMe	----- Medici Chapel, San Lorenzo (IFLo)
IFMi	----- Basilica de San Miniato al Monte
IFMich	----- Or San Michele (IFO)
IFMis	----- Misericordia
IFMo	----- Church of the Madonna dell'Impruneta, Chapel of the Holy Cross
IFMod	----- Galleria d'Arte Moderna
IFMon	----- R. Di Montalvo Coll.
IFO	----- Orsanmichele (IFMich)
IFOp	----- Museo dell'Opera del Duomo (See also IFCO)
IFP	----- Palazzo Pitti
IFPC	----- Pazzi Chapel
IFPG	----- Porta S. Giorgio
IFPa	----- Palazzo Panciatichi
IFPal	----- Galleria Palatina
IFPao	----- Hospital of S. Paolo
IFPe	----- Villa della Petraia
IFPoT	----- Ponte Santa Trinita
IFR	----- Railway Station
IFS	----- Palazzo Strozzi
IFSi	----- Piazza della Signoria
IFSp	----- S. Spirito
IFT	----- Santa Trinita
IFTr	----- Coll. Leone Traverso
IFU	----- Galleria degli Uffizi
IFV	----- Palazzo Vecchio
IFVia	----- Via dell'Angelo
IFViaC	----- Via Cavour

IFaC	Faenza. Cathedral
IFeG	Ferrara. Cathedral San Giorgio
IFeMA	----- Museo Archeologico Nazionale
IFeMC	----- Museo della Cattedrale (IFeG)
IFeS	----- Palazzo Schifanoia
IFerP	Ferentillo. Abbey S. Pietro
IFiB	Fiesole. Museo Bandini
IFiC	----- Cathedral
IFiD	----- Villa Dupre
IFiM	----- S. Maria Primerana
IFidC	Fidenza. Cathedral (IBorC)
IFoF	Folgino. Cathedral S. Feliciano e Messalina
IFogL	Foggia (Near). Abbey Church San Leonardo di Siponto
IFogM	----- Cathedral S. Maria Icona Vetere
IFoglCh	Fogliano. Parish Church
IForB	Forli. S. Biagio
IForP	----- S. Pellegrino
IForPC	----- Pinacoteca Communale
IFosC	Fossombrone. Cathedral
IFr	Frasiarolo Lomellina
IGP	Gropina. Parish Church San Pietro
IGaM	Gaeta. Cathedral S. Maria Assunta
IGeA	Gela. Gela Antiquario
IGenC	Genoa. San Lorenzo Cathedral
IGenI	----- Via degli Indoratori
IGenM	----- S. Maria di Carignano
IGenU	----- University
IGrA	Grottaferrata. Abbey
IGuR	Guastalla. Piazza Roma
IGubD	Gubbio. Ducal Palace
IIO	Ivrea. Coll. Centro Olivetti
ILaC	Lake Como. Villa Carlotta
ILaOG	Lake Orta. San Giulio
ILaVM	La Verna. Chiesa Maggiori
ILaVaM	La Valletta. Museum
ILeC	Lecce. Santa Croce
ILeN	----- Santi Niccolo e Cataldo
ILegP	Legnano. Coll. Franco Pensotti
ILeghD	Leghorn. Piazza della Darsena
ILoB	Lodi. Cathedral San Bassiano
ILorC	Loreto. Basilica della Santa Casa
ILuC	Lucca. Duomo San Martino
ILuCiv	----- Museo Civico
ILuF	----- San Frediano Church
ILuP	----- Pinacoteca
ILuR	----- San Romano
ILuSG	----- SS. Simone e Giuda

ILucL	Lucina. San Lorenzo
ILugM	Lugnano in Teverina. Parish Church Santa Maria Assunta
ILugT	----- Coll. Baron H. H. Thyssen-Bornemisza
IMA	Milan. Basilica Sant'Ambrogio
IMAM	----- Civica Galleria d'Arte Moderna
IMAP	----- Arco della Pace
IMAr	----- Galleria dell'Ariete
IMB	----- Pinacoteca di Brera
IMBa	----- Banca Commerciale
IMBo	----- Boschi Coll.
IMBro	----- Galleria Borromini
IMC	----- Tesoro del Duomo (Opera del Duomo)
IMCa	----- Coll. Cardazzo
IMCe	----- Milan Cemetery
IMCi	----- Museo Civico
IMCiA	----- Museo Civico Archeologico
IMCin	----- Piazzale delle Cinque Giornate
IME	----- S. Eustorgio
IMF	----- French Institute
IMFi	----- E. Fischi Coll.
IMGa	----- Coll. J. Gabriolo
IMGal	----- Galleria dell'Ariete
IMGi	----- Coll. Giampiero Giani
IMGr	----- Galleria del Grattacielo
IMI	----- Industrial Fair
IMJ	----- Palace of Justice
IMJe	----- Coll. Emilio Jesi
IMJu	----- Coll. Jucker
IML	----- Coll. Mrs. Alice Lampugnani
IMLo	----- Galleria Lorenzelli
IMLor	----- Lorenzin Coll.
IMLu	----- Coll. Antonio Lucchetti
IMM	----- Coll. Gianni Mattioli
IMMG	----- Sta. Maria delle Grazie
IMMa	----- Coll. Paolo Marinotti
IMMar	----- S. Maria Presso S. Celso
IMMi	----- Galleria del Milione
IMN	----- San Nazaro Maggiore
IMNav	----- Galleria del Naviglio
IMO	----- Casa degli Omenon
IMP	----- Museo Poldi Pezzoli
IMPa	----- Coll. Adriano Pallini
IMPan	----- Coll. Conte Giuseppe Panza di Biumo
IMPe	----- Coll. Carlo Peroni
IMR	----- Coll. R. M.
IMRC	----- Coll. R. C.
IMRa	Milan. Coll. Aldo Ravelli

IMRo	Milan. Coll. Rocca
IMS	----- Museo del Castello Sforzesco
IMSa	----- Sacristy S. Satiro
IMSc	----- Galleria Schwarz
IMT	----- 9th Triennale of Milan
IMTon	----- Toninelli Arte Moderna
IMW	----- Coll. Francesco Wildt
IMagM	Magliano de'Marsi (near). Abbey Church S. Maria in Valle Porclaneta
IManA	Mantua. Sant'Andrea
IManB	----- Broletta
IManD	----- Galleria e Museo di Palazzo Ducale (Palazzo de Te)
IMarA	Marzobotto. Antiquarium
IMasC	Massa Marittima. Cathedral
IMatB	Matera. S. Giovanni Battista Church
IMazC	Mazzaro del Vallo. Cathedral
IMeC	Messina. Messina Cathedral
IMeD	----- Piazza del Duomo
IMeDo	----- Coll. Donato
IMeMN	----- Museo Nazionale
IMedM	Medina de Rioseco. S. Maria
IMo	Modena. Cathedral San Geminiano; Museo del Duomo
IMoE	----- Galleria, Museo e Medagliere Estense
IMoG	----- Gallery
IMoGi	----- San Giovanni Battista
IMoM	----- Museum
IMonC	Monza. Monza Cathedral Treasury
IMonoP	Monopoli. Cathedral San Pietro
IMonrB	Monreale. Benedictine Cloister
IMonrC	----- Cathedral S. Maria la Nuova
IMons	Monselice
IMontC	Montepulciano. Cathedral
IMtAL	Mt. Athos. Monastery of Lavra
IMu	Murano
IMugM	Mugnano. S. Michele
INA	Naples. S. Angelo a Nilo Church
INAn	----- S. Anna dei Lombardi
INAr	----- Arche of Alphonso of Aragon
INC	----- S. Chiara
INCa	----- Castelnuovo
IND	----- S. Domenico Maggiore
ING	----- S. Giacomo degli Spagnuoli
INGal	----- Galleria Nazionale
INGio	----- S. Giovanni a Carbonara
INL	----- S. Lorenzo Maggiore
INM	----- S. Maria Donna Regina

INMA	Naples. Museo Archeologico Nazionale
INMC	----- Museo e Gallerie Nazionali di Capodi- monte
INMCap	----- S. Maria a Capella Vecchia
INMG	----- S. Maria delle Grazia Coponapoli
INMM	----- S. Maria Materdomini
INMO	----- Monte Oliveto
INMP	----- S. Maria del Parto
INMar	----- S. Martino
INN	----- Museo Nazionale
INNM	----- Naples Museum
INO	----- Monte Oliveto
INP	----- Monte di Pieta
INS	----- Capella Sansevero de'Sangri
INSe	----- S. Severo
INaM	Nardo. Cathedral S. Maria
INeA	Nuttuno. American Cemetery
INoG	Novara. Basilica S. Giulio
IOM	Olympia. Museum of Olympia
IOrC	Orvieto. Cathedral
IOrD	----- S. Domenico
IOrF	----- S. Francesco
IOrM	----- Museo dell'Opera del Duomo
IOsM	Ostia. Museum
IOsO	----- Museo Ostiense
IOsS	----- Museo degli Scavi
IPA	Padua. Arena Chapel
IPAn	----- St. Anthony Church
IPC	----- Museo Civico di Padova
IPE	----- Eremitani (See also IPadE)
IPS	----- Piazza del Santo (IPSA)
IPSa	----- Santo
IPSA	----- Basilica Sant'Antonio (IPS)
IPaB	Parma. Baptistry
IPaM	----- Cathedral S. Maria Assunta
IPaMA	----- Museo Nazionale di Antichita
IPadC	----- Duomo
IPadE	----- Eremitani (See also IPE)
IPadS	----- Santo
IPadU	----- Universita degli Studi
IPaeM	Paestum. Museo Archeologico Nazionale
IPalA	Palermo. Cave of Addaura, Monte Pelligrino
IPalAg	----- S. Agostino
IPalC	----- Museo Civico
IPalD	----- D. Domenico
IPalF	----- S. Francesco
IPalG	----- Convento della Gancia

IPrD	Prato. Duomo
IPrDe	----- Villa Demidoff
IPrM	----- Museo Communale
IPrMC	----- S. Maria in Carceri
IPraM	Pratolini. Villa Medici
IRA	Rome. S. Agostino
IRAM	----- Augustus Mausoleum
IRAP	----- Ara Pacis Augustae
IRAf	----- Museo Africano
IRAg	----- S. Agnese in Piazza Navona
IRAgr	----- Agricultural Fair, 1953
IRAj	----- Coll. Marquis d'Ajeta
IRAl	----- Villa Albani
IRAle	----- S. Alessio on Aventine
IRAn	----- Antiquarium Communale
IRAnd	----- S. Andrea al Quirinale Church
IRAndr	----- S. Andrea delle Fratte
IRAndrV	----- S. Andrea delle Valle
IRAp	----- SS. Apolstoli
IRAr	----- Argentarii Arch, Forum Boarium
IRArd	----- Cave Ardeatine
IRArt	----- Galleria Nazionale d'Arte Moderna
IRArtC	----- Galleria Nazionale d'Arte Contemporanea
IRAt	----- Galleria l'Attico
IRAte	----- Aterii Mausoleum, Via Labicana
IRB	----- Galleria (Villa) Borghese
IRBa	----- Coll. Luce Balla
IrBal	----- S. Balbina
IRBar	----- Galeria Nazionale Palazzo Barberini
IRBara	----- Coll. Barracco
IRBarb	----- Piazza Barberini
IRBarbe	----- Coll. Prince Urbano Barberini
IRBarn	----- S. Bernardino alle Terme
IRBarr	----- Museo Barracco
IRBer	----- S. Bernardino alle Terme (IRBarn)
IRBi	----- S. Bibiana Church
IRBie	----- Coll. Baron Marschall von Beiberstein
IRBoc	----- Piazza Bocca della Verita
IRC	----- Museo Capitolino
IRCa	----- Piazza del Campidoglio
IRCae	----- Palazzo Caetani
IRCap	----- Capitoline Hill
IRCapit	----- Capitol
IRCar	----- S. Carlo alle Quattro Fontane
IRCat	----- Museum of Praetexta Catacomb
IRCath	----- S. Caterina da Siena
IRCe	----- Cardinal's Church S. Cesareo
IRCec	----- S. Cecelia Church

IRChi	Rome. Museo Chiaramonti
IRChia	----- Coll. Michelangelo Chiaserotti
IRCiR	----- Museo della Civilta Romana
IRCl	----- S. Clemente
IRCo	----- Palazzo dei Conservatori (IRC)
IRCoB	----- Conservatore Braccio Nuovo
IRCol	----- Coll. Princes Colonna
IRColo	----- Piazza Colonna
IRCon	----- Constantine Arch
IRCor	----- Galleria Corsini
IRCos	----- S. Costanza
IRD	----- Palazzo Doria
IRDi	----- Diocletian Bath
IRF	----- Museo del Foro
IRFAO	----- FAO (Food and Agriculture Organization) Headquarters
IRFa	----- Fascist Revolution Exhibition Hall
IRFo	----- Antiquario Forense
IRFr	----- S. Francesco a Ripa Church
IRFra	----- Coll. Franchetti
IRG	----- Coll. Riccardo Gualino
IRGe	----- Il Gesu Church
IRGeM	----- Gesu e Maria Church
IRGes	----- Museo dei Gessi
IRGi	----- Museo Nazionale di Villa Giulia
IRGio	----- S. Giovanni in Laterano
IRGiof	----- Coll. Avvi Candeloro Gioffre
IRGiu	----- Coll. Riccardo del Giudice
IRGr	----- S. Gregorio al Celio
IRH	----- Hadrian's Villa
IRI	----- S. Ignazio Church
IRJ	----- S. John Lateran (IRGio)
IRK	----- K. L. M. Ticket Office
IRL	----- Lateran Museum
IRLC	----- Museo Lateranense Cristiano
IRLP	----- Museo Profano Lateranense
IRLa	----- Lanceolotti Palace
IRLat	----- Galleria L'Attico
IRLo	----- S. Lorenzo Fuori le Mura
IRLor	----- S. Lorenzo in Lucina
IRLu	----- Coll. Luigi de Luca
IRLud	----- Villa Ludovisi
IRM	----- S. Maria in Aracoeli
IRMA	----- S. Maria Antiqua
IRMAn	----- S. Maria degli Angeli
IRMAni	----- S. Maria dell'Anima
IRME	----- Museo della Antichita Etrusco-Italiche
IRML	----- S. Maria di Loreto

IRMM	Rome. S. Maria Spora Minerva
IRMMag	----- S. Maria Maggiore
IRMN	----- Museo Nazionale
IRMP	----- S. Maria del Popolo (IRPo)
IRMPa	----- S. Maria della Pace
IRMV	----- S. Maria della Vittoria (IRVi)
IRMa	----- Palazzo Massimi
IRMar	----- Coll. Signora Germane Marucelli
IRMarc	----- S. Marcello Church
IRMari	----- Coll. Benedetta Marinetti
IRMarl	----- Marlborough Gallery
IRMart	----- Coll. Mrs. Brigida Martini
IRMat	----- Piazza Mattei
IRMaz	----- Coll. Nattale Mazzola
IRMe	----- La Medusa
IRMo	----- Galleria Nazionale d'Arte Moderna
IRMoP	----- Cappella Monte di Pieta
IRMos	----- Mostra Augustea
IRMu	----- Museo Mussolini
IRN	----- Galleria Nazionale d'Arte Moderna
IRNC	----- Museo Nuovo Capitolino
IRNa	----- Piazza Navona
IRO	----- Galleria Odyssia
IROS	----- Ospedale di S. Spirito
IROb	----- Obelisco Galleria d'Arte
IRP	----- St. Peter's
IRPA	----- Ponte S. Angelo
IRPM	----- Formerly Ponte Molle
IRPa	----- S. Paolo fuori la Mura
IRPam	----- Coll. Pamphili
IRPe	----- Museo Petriano
IRPi	----- S. Pietro in Vincoli
IRPiM	----- S. Pietro in Montorio
IRPig	----- Pigorini Museum
IRPo	----- S. Maria del Popolo (IRMP)
IRPog	----- Coll. Sergio Pogliani
IRPol	----- Palazzo Poli
IRPr	----- Museo Nazionale Preistorico ed Etnografico Luigi Pigorini
IRR	----- Palazzo Riccardi
IRRi	----- Via di Ripetta
IRRh	----- Knights of Rhodes Loggia
IRRo	----- Museo di Roma
IRRr	----- New Railroad Station
IRS	----- Galleri Schneider
IRSa	----- Santa Sabina
IRSac	----- Palazzo Sacchetti
IRSal	----- Galleria La Salita

IRSe	Rome. Palazzo San Severino
IRSeb	----- S. Sebastiano Church
IRSen	----- Senato della Repubblica
IRSil	----- S. Silvestro al Quirinale
IRSk	----- Coll. Odyssia A. Skouros
IRSp	----- Palazzo Spada
IRSt	----- Stazione Termini
IRSu	----- S. Susanna
IRT	----- Museo Nazionale delle Terme
IRTa	----- Tabularium
IRTh	----- Museum of the Thermae
IRTi	----- Arch of Titus
IRTo	----- Torlonia Museum
IRTr	----- Trajan Forum
IRUA	----- University. Istituto Archeologia
IRV	----- Vatican and Sistine Chapel
IRVB	----- ----- Biblioteca Apostolica Vaticana
IRVE	----- ----- Museo Gregoriano Etrusco
IRVG	----- ----- Musei Gregoriano Profano e Pio Cristiano
IRVM	----- Villa Medici
IRVMad	----- Villa Madama
IRVP	----- Vatican--Grottoes of St. Peter
IRVen	----- Museo del Palazzo Venezia
IRVi	----- S. Maria della Vittoria
IRZ	----- Zuccari Palace
IRZe	----- Museo della Zecca
IRZu	----- Coll. Dr. Carolo Zuccarini
IRaA	Ravenna. Archbishop's Palace
IRaB	----- Baptistry of the Orthodox
IRaC	----- Cathedral
IRaF	----- S. Francesco
IRaM	----- S. Maria in Porto Fuori
IRaMA	----- Museo Arcivescovile
IRaMN	----- Museo Nazionale
IRaP	----- Pinacoteca dell'Accademia di Belle Arti
IRaS	----- S. Apollinare in Classe
IRaSN	----- S. Apollinare Nuovo
IRaV	----- Museo di San Vitale
IRavP	Ravello. Cathedral S. Pantaleone
IReM	Reggio. Calabria Museo Nazionale
IRegG	Reggio Emilia. Oratorio S. Giovanni
IRiB	Rimini. Biblioteca Civica Gambalunga, al Tempio Malatestiano
IRiF	----- S. Francesco Chapel
IRiP	----- Pinacoteca Communale e Museo Civico, al Tempio Malatestiano

IRuM	Ruvo di Puglia. S. Maria Cathedral
ISA	Siena. Museo Archeologico
ISB	----- Baptistry of St. John (ISG)
ISC	----- Opera del Duomo (Cathedral Museum)
ISCL	----- Cathedral Library
ISCa	----- Oratory S. Caterina
ISD	----- S. Domenico
ISF	----- Fonte Gaja
ISG	----- S. Giovanni (ISB)
ISL	----- Public Library
ISM	----- S. Maria della Scalla (ISoS)
ISMa	----- San Martino
ISO	----- Osservanza
ISOs	----- Chiesa dell'Ospedale (ISM)
ISP	----- Palazzo Publico
ISPC	----- Piazza del Campo
ISPN	----- Pinacoteca Nazionale di Siena
ISPa	----- Loggia di S. Paolo
ISPi	----- S. Pietro Ovile
ISaC	Salerno. Cathedral S. Maria degli Angeli
ISal	Salo. Commune
ISanFC	San Frediano. Parish Church S. Cassiano
ISanR	San Remo
ISang	San Giulio
ISarF	Sarzana. S. Francesco
IScP	Scarperia, near Florence. Prepositura
ISeP	Sessa Aurunga. Cathedral S. Pietro
ISeg	Segesta
ISo	Solferino
ISpC	Spoleto. Cathedral
ISpE	----- S. Eufemia Church
ISpM	----- Cathedral S. Maria Assunta
ISpMC	----- Museo Civico
ISpP	----- Monastery Church S. Pietro
ISpeM	Sperlonga. Museo Archeologico della Grotto di Tiberio
IStG	S. Gabrial
IStGi	S. Gimignano (Siena). Museo d'Arte Sacra, Basilica Collegiata di S. Maria
ISuC	Susa. Cathedral Treasury
ISyA	Syracuse. Palazzolo Acreide
ISyM	----- Museo Archeologico Nazionale
ISyAr	----- Museo Medioevale, Palazzo Bellomo
ISyMN	----- Museo Nazionale
ITA	Turin. Museo di Antichita
ITAA	----- Museo d'Arte Antico, Palazzo Madama
ITAR	----- Armeria Reale

ITC	Turin. Piazza San Carlo
ITE	----- Museo Egizeo
ITG	----- Formerly Gualino Coll.
ITM	----- Turin Museum
ITMC	----- Museo Civico di Torino
ITMo	----- Galleria d'Arte Moderna
ITP	----- Pinacoteca
ITS	----- Piazza dello Statuto
ITaN	Tarquinia. Museo Nazionale Tarquiniese
ITarN	Taranto. Museo Archeologico Nazionale
ITiC	Tivoli. Cathedral
ITiE	----- Villa d'Este
ITiH	----- Hadrian's Villa
IToC	Torre de' Passeri. Abbey Church S. Clemente a Casauria
ITolN	Tolentino. S. Nicola
ITorC	Torcello. Cathedral
ITosC	Toscanella. Palazzo Campaneri
ITrM	Trieste. Trieste Museum
ITrMC	----- Museo Civico
ITrMCR	Trieste. Museo Civico Revoltella
ITraA	Trapani. Santuario dell'Annunziana
ITranC	Trani. Cathedral
ITranO	----- Ognissanti Church
ITreC	Treviso. Cathedral
ITroC	Troia. Cathedral
ITuM	Tuscania. Basilica S. Maria Maggiore
IUM	Urbino. Museum
IUNM	----- Gallerie Nazionale della Marche, Palazzo Ducale
IVA	Venice. Museo Archeologico
IVAc	----- Gallerie del'Accademia
IVAr	----- Arsenal
IVAt	----- Ateneo Veneto
IVC	----- S. Maria del Carmine
IVCO	----- Ca' d'Oro
IVCa	----- Campanile
IVCam	----- Campiello Angaran, House No. 3717
IVCar	----- Coll. Cardazzo
IVCas	----- Castiglione d'Olona
IVCi	----- Coll. Count Vittoro Cini
IVCl	----- S. Clemente all'Isola
IVCo	----- Museo Correr e Quadreria Correr
IVE	----- S. Elena
IVF	----- S. Maria Gloriosa dei Frari (IVMF)
IVFr	----- S. Francesco dela Vigna
IVG	----- Peggy Guggenheim Foundation
IVGC	----- S. Giovanni Cirstostomo

IVGM	Venice. S. Giorgio Maggiore
IVGP	----- Piazza SS. Giovanni e Paolo
IVGi	----- S. Giuliano
IVGio	----- S. Giobbe
IVL	----- S. Lazzaro dei Mendicanti
IVLib	----- Libreria Vecchia
IVLo	----- The Loggatta (IVMa)
IVM	----- St. Mark Cathedral; Treasury of St. Mark's
IVMM	----- S. Maria dei Miracoli
IVMS	----- S. Maria della Salute
IVMa	----- Piazza San Marco (IVLo)
IVMar	----- S. Maria del Carmine
IVMarc	----- Marcian Library
IVMe	----- Coll. Vittorio Meneghelli
IVMi	----- Scuola della Misericordia
IVMo	----- Galleria Internazionale d'Arte Moderna
IVMoi	----- S. Moise
IVMu	----- Museum
IVMF	----- Maria dei Frari (IVF)
IVMG	----- S. Maria Gloriosa del Frari
IVN	----- S. Nicolo dei Tolentini
IVNav	----- Museo Storico Navale
IVP	----- Palazzo Ducale e Divione Tecno Artistica
IVPes	----- Galleria Pesaro
IVPi	----- Piazzetta
IVR	----- S. Rocco
IVS	----- Coll. Norman Sherman
IVSM	----- Scuola di S. Marco
IVSa	----- S. Salvatore
IVSe	----- Seminario Patriarcale
IVSi	----- S. Simeone Grande
IVT	----- S. Trovaso
IVZ	----- S. Zaccaria
IVaM	Varese. Villa Mirabello
IVadM	Vado Ligure. Coll. Eredi Martini
IVeA	Verona. S. Anastasia
IVeC	----- Musei Civici di Verona
IVeD	----- Coll. Dr. Dabini
IVeF	----- Via delle Fogge
IVeFe	----- S. Fermo Maggiore
IVeG	----- S. Giovanni in Fonte
IVeM	----- S. Maria Antica
IVeMC	----- Musei Civici di Verona
IVePC	----- Palazzo del Consiglio
IVeV	----- Castel Vecchio
IVeZ	----- S. Zeno

IVelA	Velletri. Antiquarium
IVenA	Venosa. Monastery Abbazia della Trinita
IVerC	Vercelli. Museo Camillo Leone
IVerE	----- Cathedral S. Eusebio
IVerMC	Verona. Museo Castelvecchio
IVerZ	----- Basilica di S. Zeno Maggiore
IViL	Vicenza. S. Lorenzo
IVipF	Vipiteno. Frauenkirche
IVitF	Viterbo. S. Francesco
IVoC	Volterra. Cathedral
IVoD	----- Duomo
IVoG	----- Museo Etrusco Guranacci
IVu	Vulci

Iceland

IcR	Rekjavik
IcRN	----- National Museum

India

InA	Amaravati. Archaeological Museum (site)
InAc	Achalgarth
InAhS	Ahmadabad. Sidi Sayyid Mosque
InAiH	Aihole. Haccappyagudi Temple
InAj	Ajanta
InAlM	Allahabad. Municipal Museum
InAlaM	Alampur. Museum
InAr	Archaeological Survey of India
InAu	Aurangabad
InBa	Badami
InBam	Bamiyan
InBan	Banaras. Bharat Kala Bhavan Museum of Indian Arts and Archaeology
InBangMy	Bangalore. Mysore Government Museum
InBarM	Baroda. Baroda Museum
InBaraL	Barabar. Lomas Rishi
InBel	Belur
InBenB	Benares. Bharata Kala Parisad
InBenH	----- Hindu University. Bharat Kala Bhavan
InBerC	Berhampore. Coll. Maharaja of Cossimbazar
InBhL	Bhuvaneshvara Temples. Lingaraja Temple
InBhM	----- Muktesvara Temple
InBhR	----- Raja Rani
InBhS	----- State Museum of Art and Archaeology
InBhV	----- Vaital Deul
InBha	Bhaja
InBhe	Bheraghat
InBij	Bijapur

InBo	See IndJB
InBod	Bodh Gaya
InBomA	Bombay. United Asia
InBomW	----- Prince of Wales Museum of Western India
InCB	Calcutta. Bangiya Sahitya Parisad
InCI	----- Indian Museum
InCP	----- Coll. Ponten-Moller
InCS	----- School of Art
InCV	----- Victoria Memorial Hall
InCh	Chandigar
InDA	Delhi. Museum of Antiquities
InDCA	----- Central Asian Antiquities Museum
InDN	----- National Museum of India
InDQ	----- Qutb Mosque
InDab	Dabhoi
InDe	Deogarh
InDi	Dilwara
InE	Elephanta
InElK	Elura. Kailasanaha Temple
INF	Fatehpur Sikri
InGA	Gwalior. Central Archaeological Museum
InGM	----- Man Singh's Palace
InGS	----- Shastri
InGanB	Gangaikondasolapurum. Brihadisuma Temple
InHH	Halebid. Hoyshaleshvara Temple
InHoG	Hoti-Mardan. Former Guides' Mess
InHyM	Hyderabad. Hyderabad Museum
InJC	Jaipur. Central Museum
InK	Karle
InKaKa	Kanchipuram. Kailasanatha Temple
InKal	Kalugumalai
InKan	Kanheri
InKarM	Karachi. Karachi Museum
InKhA	Khajuraho. Archaeological Museum
InKhD	----- Kali Devi Temple
InKhK	----- Kandarya Mahedeva Temple
InKhP	----- Parshvanatha Temple
InKhT	----- Laksmana Temple
InKhV	----- Visvanatha Temple
InKoS	Konarak. Surya Temple
InKu	Kumbhakonam
InKum	Kumbharia
InLM	Lucknow. Lucknow Museum
InLaM	Lahore. Lahore Museum
InM	Mamallapuram
InMP	----- Pallava Monument
InMaM	Mathura. Curzon Archaeological Museum

InMadM	Madras. Government Museum and National Art Gallery
InMadhB	Madhya Pradesh. Bhilsa Museum
InMeA	Melapaluvar. Agastyesvara Temple
InMod	Modhera
InMtAN	Mount Abu. Tejahpala's Temple to Neminatha
InN	Nayagarth
InNa	Nachna-Kuthara
InNad	Nadia (Sirohi)
InNag	Nagarjuna Konda. Archaeological Museum
InNagpM	Nagpur. Central Museum
InNalM	Nalanda Museum
InNo	Nokhas.
InOKat	Orissa. Katak District
InOR	----- Rani Gumpha
InOs	Osia
InP	Parasurameswar Temple
InPaM	Patna. Patna Museum
InPat	Pattadakal
InPer	Perur
InPitA	Pitalkhora. Archaeological Survey of India Coll.
InRa	Rajim
InRaiM	Raipur. Museum
InRajS	Rajasthan. Sikar Museum
InRajsM	Rajshaki. Museum
InRanN	Ranakpur. Neminatha Temple
InRat	Ratnagiri
InReV	Rewa. Venkata Vidya Sadan Museum of Art and Archaeology
InSM	Sanchi. Museum
InSaAM	Sarnath. Archaeological Museum
InSaM	----- Sarnath Museum
InShV	Shirangam. Temple of Vishnu
InSi	Sirpur
InSo	Sopara
InSrS	Srirangar. Sri Partap Singh Museum
InTP	Tirumala Tirupati. Srinivasa Perumal Temple
InTaB	Tanjore. Brihadeshavara (Great Temple)
InTaM	----- Tanjore Museum
InTaR	----- Rajrajesvara
InTadR	Tadpatri. Ramasvami Temple
InTe	Tewar
InTirSv	Tirumala. Srinivasa-Perumal
InTr	Trichinopoly
InU	Udayagiri, Madhya Bharat; Madhya Pradesh
InV	Vijayanagar

Indonesia

IndA	Angkor Wat
IndAB	----- Bakong Pyramid
IndBB	Bali. Bedulu
IndBBa	----- Bangli
IndBK	----- Kubu Tambahan
IndBaM	Java. Batavia Museum
IndJB	----- Borobudur (Stupa of Barabadur)
IndJC	----- Chandi Panataran
IndJCa	----- Candi Mendut
IndJCh	----- Chandi Djago
IndJD	----- Dieng
IndJL	----- Loro Jongrang. Siva Temple
IndJM	----- Madjakarta Museum
IndJMa	----- Mantingan
IndJP	----- Prambanam
IndJPa	----- Panatram
IndJS	----- Surawana
IndJT	----- Trawulan Site Museum

Iraq

IRQ	Babylon
IrBagI	Baghdad. Iraq Museum
IrN	Nimrud

Iran

IranB	Bishapur
IranBe	Behistan
IranF	Firuzabad
IranHG	Hamadan. Gumbat-i-Alaviyan
IranI	Isfahan
IranK	Kuh-i-Khwaja
IranKo	Khorsabad
IranL	Linjan
IranM	Masjid-i-jami (Mosque)
IranN	Naksh-i-Rustam
IranNaM	Nayin. Masjid-i-Jami
IranP	Persepolis
IranPa	Pasargadae
IranTA	Teheran. Archaological Museum
IranTB	Taq-i-Bustan
IranTF	Teheran. Coll. Foroughi
IranTM	----- Museum
IranTN	----- National Museum
IranTS	Tang-i-Sarwak

Ireland

IreA	Ahenny
IreB	Belfast
IreCP	Clare Picture Guild
IreDC	Durham. Cathedral
IreDNB	Dublin. National Museum of Ireland
IreLA	Londonderry. Altnagelvin Hospital
IreLN	----- N. W. Hospital
IreM	Momasterboice
IreN	New Orange

Israel

-IsAp	Coll. Aplit
-IsL	Coll. Mrs. J. List
IsCh	Chorazin. Synagogue
IsEA	Ein-Harod. Art Center
IsHM	Haifa. Museum of Modern Art
IsJA	Jerusalem. Museum of Antiquities
IsJB	----- Bezalel National Art Museum, Israel Museum
IsJJ	----- Jerusalem Museum
IsJK	----- Knesset Garden
IsJP	----- Museum of the Patriarchs
IsJR	----- Billy Rose Art Garden
IsJRe	----- Coll. A. Reifenberg
IsN	Nazareth. Franciscan Convent
IsNG	----- Greek Patriarch Museum
IsTI	Tel Aviv. Galerie Israel Ltd
IsTS	----- Coll. Schwimmer
IsTT	----- Tel Aviv Museum
IsTel	Tel Hai

Japan

-JN	Coll. T. Nakazawa
-JS	Coll. Sumitomo
-JSe	Coll. Seigenji
-JY	Coll. Y. Yamasaki
-JYas	Coll. Y. Yasuda
JAk	Akishino. Monastery
JAoE	Aomori-ken. Coll. E. Chigoya
JAshS	Ashikaga. Seido
JAtH	Atami. Hannya-in
JChu	Chuson-ji
JE	Ennoji Temple (JKaE)
JFK	Fukuoka. Kanzeon-ji (Buddhist Temple)
JGY	Gumma. Coll. Yamazaki
JHK	Hyogo. Kakurin-ji
JHiP	Hiroshima. Peace Park; Peace Center

JHirC	Hraizumi. Chuson-ji
JHisC	Hisachi-yuno. Civic Collection
JHo	Hokkedo
JIC	Iwata. Chuson-ji
JIseA	Isenzaki. Coll. Aikawa
JIshT	Ishikawa. Coll. Saburo Toma
JIwH	Iwashiro. High School
JJi	Jingoji
JKB	Kyoto. Byodo-in
JKD	----- Daihoon-ji
JKDa	----- Daigo-ji
JKDai	----- Daigaku-ji
JKG	----- Gansen-ji
JKH	----- Hokai-ji
JKHa	----- Coll. Setsuya Hashimoto
JKHo	----- Hokongo-in
JKJ	----- Jingo-ji
JKJo	----- Joruri-ji
JKK	----- Kozan-ji
JKKa	----- Coll. S. Kawai
JKKo	----- Koryu-ji
JKKu	----- Kurama-dera
JKKy	----- Kyo-o-gokoku-ji
JKM	----- Matsuno-o
JKMu	----- Kyoto Museum; Kyoto Municipal Museum of Art
JKMy	----- Mycho-in
JKN	----- Nanzen-ji
JKNa	----- Natsuno-o Jinsha
JKNi	----- Nishi Hongan-ji
JKR	Kyoto. Rokuharamitsuji
JKS	----- Sanjusangendo Temple
JKSe	----- Seiryo Temple
JKSi	----- Galerie 16
JKSo	----- Sokujoin
JKY	----- Yamada Art Gallery
JKZ	----- Zushin-in
JKaE	Kanagawa. Enno-ji
JKaK	----- Kotuku-in
JKaM	----- Meigetsu-in
JKaMat	----- Coll. N. Matsudaira
JKamM	Kamakura. Meigetsuin
JKamT	----- Tokeiji
JKoS	Kochi. Sekkei-ji
JKoKU	Kokugakuin University
JKoyH	Mt. Koya. Hojoin Temple
JKur	Kuramadera
JNA	Nara. Akishino-dera

JNC	Nara. Chugu-ji (Nunnery)
JNCh	----- Chogaku-ji
JND	----- Daian-ji
JNE	----- Enjo-ji
JNG	----- Gango-ji
JNH	----- Horyu-ji
JNHa	----- Hase-dera
JNHo	----- Hokke-ji
JNHor	----- Horinji
JNJ	----- Joruru-ji
JNK	----- Kofuku-ji
JNKan	----- Kanaya Miroku-dani
JNKas	----- Kasufa Jinja
JNKo	Nara. Nara Kokuritsu Hakabutsukan (Nara National Museum)
JNM	----- Muro-ji
JNO	----- Ok-dera
JNOn	----- On Zuto (mound)
JNOni	----- Onio-ji
JNS	-----Shorin-ji
JNSa	----- Saidai-ji
JNSh	----- Shin Yakushi-ji
JNSho	----- Shoso-in
JNT	----- Todai-ji
JNTa	----- Taimi-ji
JNTac	----- Tachibani-dera
JNTe	----- Tierakusha
JNTo	----- Toshodai-ji
JNY	----- Yakushi-ji
JNa	Nagasaki
JNiR	Nikko-shi. Ronnoji Jokodo Homotsuden (Treasure House of the Jokodo, Ronnoji Temple)
JOY	Oita. Yusuhara Hachiman-gu
JOsKa	Osaka. Kanshin-ji
JOsS	----- Shitenno-ji
JOsY	----- Yachu-ji
JSD	Shiga. Daiho Jinja
JSK	----- Kogen-ji
JSO	----- Onjo-ji
JSanN	Saitama-ken. Coll. Yoshio Negishi
JSen	Senko-ji
JSh	Shojoji
JTA	Tokyo. Coll. Mitsutake Arisaka
JTB	----- Coll. Raymond Bushnell
JTH	----- Coll. Moritatsu Hosokawa
JTI	----- Coll. Imperial Household Office
JTK	----- Coll. Motomasa Kanze

JTKi	Tokyo. Kinokuniya
JTKo	----- Coll. I Kongo; Coll. Kongo Family
JTM	----- Coll. Gakunan Matsubara
JTMa	----- Coll. Seigyo Matsubara
JTMat	----- Matsubara Coll.
JTMi	----- Minami Gallery
JTMu	----- Coll. Munsterberg
JTN	----- Coll. Sumio Nakazawa
JTNM	----- National Museum
JTNMM	----- National Museum of Modern Art
JTNMW	----- National Museum of Western Art
JTNa	----- Nakamura Coll.
JTO	----- Okura Museum
JTOk	----- Coll. Okue
JTS	----- Coll. Kusuo Shimizu
JTSh	----- Shudo Museum
JTT	----- Tokyo Gallery
JTTan	----- Tokyo University--Coll. Anthropological Faculty
JTY	----- Coll. Yoichiro Nakamura
JTeU	Tenri. University Research Museum
JTo	Toji
JTohU	Tohoku. University
JTsH	Tsugaoka. Hachiman Shrine
JUB	Uji. Byodo-in
JUb	Ube
JWK	Wakayama. Kongobu-ji
JWKo	----- Kokoku-ji
JWS	----- Shochi-in
JYH	Yokahama. Coll. Hara

Jordan

JoAM	Aman. Museum
JoJA	Jerusalem. El Agsa Mosque
JoJF	----- Archaeological Museum of the Studium Biblicum Franciscanum
JoJJ	----- Jerusalem Museum
JoJP	----- Palestine Archaeological Museum

Korea

-KL	Former Li Royal Museum
-KCh	Coll. Chun Hyung-pil
KKN	Kyongju. National Museum, Branch
KKS	----- Sokkuram Rock Temple
KSD	Seoul. Ducksoo (Toksu) Palace Museum of Fine Arts
KSN	----- National Museum
KSo	Sosan
KSok	Sokkul-am

	Kenya
KeN	Nairobi

	Lebanon
LA	Anjar
LBB	Beirut. Coll. Emile Bustani
LBN	----- Musee National
LBaB	Baalbeck. Temple of "Bacchus"

	Laos
LaVV	Vientiane. Vat Phra Keo Museum

	Libya
LiL	Leptis Magna Museum (ruins)
LiTA	Tripoli. Archaeological Museum
LiTC	----- Castello Natural History Museum

	Malta
Ma	Malta

	Malaysia
MalSU	Singapore. University of Malaya Art Museum
MalTP	Taiping. Perak Museum

	Mexico
-Mec	Coll. A. Carrillo Gil
-MeF	Coll. F. V. Field
-MeFe	Coll. F. Feuchtwanger
-MeH	Coll. S. Hale
-MeO	Coll. Dolores Olmeda de Olvera
-MeP	Coll. Guy Puerto
MeAA	Acolman. San Agustin Monastery
MeAn	Angagua
MeCM	Campeche. Museo Regional de Campeche
MeCh	Chichen Itza
MeChi	Chiapas
MeCu	Cuernavaca
MeDC	Desierto de Leones. Convent
MeGA	Guadalajara. Museo de Antropolgia de Guadalajara
MeGuH	Gunajunto. Dolores Hidalgo
MeH	Hochob
MeJUA	Jalapa. University of Veracruz. Museo de Antropologia
MeK	Kabah
MeL	Labna
MeMA	Mexico City. Coll. Sra. Machido Armila
MeMAR	Mexico City. Museo de Arte Religioso

MeMB	Mexico City. Coll. Mr. and Mrs. Manuel Barbachano
MeMC	----- Coll. Miguel Covarrubias
MeMCa	----- Cathedral of Mexico City Treasure
MeMCap	----- Capitol
MeMCo	----- Coll. Gustavo Corona
MeME	----- Experimental Museum
MeMF	----- Nacional Financiera Building
MeMG	----- Coll. Mr. and Mrs. Jacques Gelman
MeMI	----- Instituto Nacional de Bellas Artes
MeMM	----- Galeria de Arte Mexicano
MeMMu	----- Conservetorio Nacional de Musica
MeMN	----- Museo Nacional de Antropologia e Historia
MeMO	----- Coll. Lola Olmeda de Olvera
MeMP	----- Coll. Barbachano Ponce
MeMR	----- Coll. van Rhijn
MeMRi	----- Museo Diega Rivera
MeMS	----- K Stavenhagen Coll.
MeMSa	----- Sagrario Metropolitano
MeMU	----- Universidad Nacional de Mexico
MeMadC	Villa Madero. Parish Church
MeMeY	Merida. Museo Arqueologico de Yucatan
MeMi	Mitla
MeMo	Monte Alban
MeMon	Monterey
MeMorM	Morelia. Museo Regional de Michoacan
MeOM	Oaxaca. Museo Regional
MeOY	----- Yanhuitlan
MeP	Palenque
MePi	Piedras Negras
MePuM	Puebla. S. Maria Tonantzintla
MeQC	Queretaro. S. Clara
MeSLM	San Luis Potosi. Museo Regional Potosini
MeSalA	Salamanco. San Agustin
MeTa	El Tajin
MeTam	Tamazalapan
MeTax	Taxco. Santa Prisca y San Sebastian Church
MeTeM	Teotihuacan. Museo Arqueologico de Teotihuacan
MeTep	Tepotzotlan
MeTlO	Tlaxcala. Nuestra Senora de Ocotlan
MeTla	Tlalmanalco
MeToM	Toluca. Museo
MeTr	Tres Zapotes
MeTu	Tula
MeU	Uxmal
MeVP	Villahermosa. Parque Olmec (La Venta Parque)

MeVa	Valsequilo
MeVeJ	Vera Cruz. Museo Regional de Jalapa
MeViM	Villahermosa. Museo Regional
MeX	Xochicalco
MeYBr	Yachilan. British Museum
MeZC	Zacatecas. Cathedral

Melanesia

MelNb	New Britain

Morocco

MorM	Marrakesh
MorRA	Rabat. Musee des Antiquites Pre-Islamique

Netherlands

NAA	Amsterdam. Museum van Aziatische Kunst
NAD	----- Dam Palace (Old Town Hall)
NAE	----- The Exchange
NAG	----- Gemeentamusea
NAH	----- Handelmaat-Schaprij
NAJ	----- Jewish Historical Museum
NAN	----- Nieuwe Kerk
NAR	----- Rijksmuseum
NAS	----- Stedelijk Museum
NASt	----- Stocker Coll.
NASu	----- Suikerrui
NAT	----- Koninklijk Institut voor de Tropen
NATJ	----- Koninklijk Paleis (Royal Palace; formerly: Hall of Justice)
NATe	----- Technical School
NAW	----- Coll. Dr. van der Wal
NAlL	Alkmaar. St. Lawrence Church
NArP	Arnhem. Provinciehuis
NAsT	Ascona. Coll. Baron von der Heydt
NBG	Breda. Groote Kerk
NBP	----- Protestant Museum
NBaS	Baarlo. Coll. Kasteel Scheres
NBeG	Bergen, Op Zoom. Grote Kerk
NBeT	----- Town Hall
NBoA	Bockhoven. St. Anthony Church
NDN	Delft. Nieuwe Kerk
NDoG	Dordrecht. Coll. Mrs. S. van Gijn
NDoO	----- Our Lady Church
NEA	Eindhoven. Stedelijk van Abbe-Museum
NEK	----- Kunst-Licht-Kunst Exhibition
NEnG	Enkhuizen. St. Gommarus Church
NGM	Groningen. Groninger Museum

NHB	The Hague. Bouwegelust Settlement
NHG	----- Gemeentemuseum
NHH	----- Haags Gemeentemuseum
NHM	----- Mauritshuis (Koninklijk Kabinet van Schilderijen)
NHP	----- Koninklijk Penning Kabinet
NHS	----- Scheurleer Museum
NHaGK	Haarlem. Grote Kerk
NHaW	----- Coll. Frits A. Wagner
NHeB	's-Hertogenbosch. Brotherhood of Our Lady
NHeJ	----- St. John's Church (NShJ)
NHoen	Hoenderloo
NKR	Katwijk. Reformed Church
NKaT	Kampen. Town Hall
NLP	Leiden. Pieter Kerk
NLR)	----- Rijksmuseum van Oudheden
NLRO)	
NLRV	----- Rijksmuseum voor Vokenkunde
NLS	----- Stedelijk Museum--"De Lakenthal"
NLW	----- City Weigh House
NLeF	Leeuwarden. Fries Museum
NMaC	Maastricht. Cathedral
NMaO	----- Our Lady Church
NMaS	----- St. Servatius
NOK	Otterlo. Rijksmuseum Kroller-Muller
NOuH	Oudenaarde. Hotel de Ville
NRB	Rotterdam. De Byenkorf Store
NRBo	----- Bouwcentrum
NRBoy	----- Museum Boymans-van Beuningen
NRC	----- Rotterdam City
NRH	----- Coll. van Hogen dorpplein
NRL	----- Museum voor Land- en Volkenkunde
NRP	----- Post Office
NRU	----- Unilever Building
NRhC	Rhenen. St. Cunera Church
NRiI	Rijswijk. In de Bogaard Shopping Center
NSM	Steyl. Museum van het Missiehuis
NScA	Scheveningen. St. Anthony
NSchL	Schiedam. Coll. C. S. Lechner
NShJ	's-Hertogenbosch. St. Jan (NHeJ)
NT	Tilburg. City Collection
NUA	Utrecht. Archepiscopal Museum
NUC	----- Centraal Museum
NWA	Wassenaar. Coll. Elisabeth Anderson
NWa	Waalwijk
NZH	Zandvoort. Coll. Baron Edward von der Heydt

NZoL	Zoutleeuw. St. Leonard
NZuW	Zutphen. St. Walburg

Nigeria

-NiO	Coll. Oni of Ife
NiB	Bussa
NiBeM	Benin City. Benin Museum
NiEHI	Esie. House of Images
NiEM	----- Esie Museum
NiEkA	Ekiti. Arinjale Palace
NiEwO	Ewohimi. Onogie Palace
NiG	Nigerian Government Coll.
NiIA	Ife. Museum of Ife Antiquities
NiIO	----- Coll. Oni of Ife
NiIk	Ikom
NiJA	Jos. Federal Department of Antiquities
NiJF	----- Coll. William Fagg
NiJ M	----- Jos Museum
NiJe	Jebba
NiLN	Lagos. Nigerian Museum
NiOM	Oron. Oron Museum
NiOwO	Owo. Coll. Chief Oludasa
NiT	Tada

Nicaragua

NicMN	Managua. Museo Nacional

Norway

NoA	Al
NoBV	Bygdoy. Viking Ship House
NoDM	Drammen. Drammens Museum
NoK	Kristiansung
NoOB	Oslo. Oslo Byes Vel
NoOF	----- Frogner Park
NoOM	----- Oslomuseum
NoON	----- Norsk Hydro Administration Building
NoONas	----- Nasjonalgalleriet
NoOUO	----- Universitetets Oldsaksamling
NoR	Ramsunberg
NoTC	Trondheim. Cathedral Museum
NoTNK	----- Nordenfjelske Kunstindustrimuseum
NoTi	Tind
NoTin	Tingelstadt
NoU	Urnes

New Zealand

NzAM	Auckland. Auckland War Museum
NzChC	Christchurch. Canterbury Museum

NzDO	Dunedin. Otago Museum
NzWD	Wellington. Dominion Museum

Oceania

OM	Melanesia

Poland

PBE	Breslau (Wloclawek). St. Elizabeth
PBS	----- Silesian Museum
PByMa	Masadell' Alta Silesia
PCB	Cracow (Krakow). St. Barbara
PCC	----- Cathedral
PCL	----- Church of Our Lady
PCN	----- Muzeum Naradowe w Krakowie
PCO	----- "Old" Synagogue
PCW	----- Cathedral on the Wawel
PDM	Danzig. Marienkirche
PGC	Gniezno (Gniezo). Cathedral
PGd	Gydnia
PM	Malbork (Marienburg)
PO	Olstyn
PPN	Poznan. Muzeum Narodowe w Poznaniu
PSP	Szczecinek. Museo Pomerania Occidentale
PTJ	Torun (Thorn). St. John
PTrA	Tremessen. Abbey Church
PWC	Warsaw. Coll. Warsaw City
PWN	----- Muzeum Narodowe
PWP	----- Palace of Culture and Science
PWS	Warsaw. Coll. H. and S. Syrcus
PZ	Zakopane
PZaS	Zamosc. Synagogue

Pakistan

PaKM	Karachi. National Museum
PaLC	Lahore. Central Museum
PaMA	Mohenjo-Daro. Archaeological Museum
PaPA	Peshawar. Archaeological Museum
PaPM	----- Provincial Museum
PaTA	Taxila. Archaeological Museum

Panama

PanPN	Panama City. Museo Nacional

Paraguay

ParT	Trinidad. Mission

Peru

PeA	Arequipa

PeC	Chanchan
PeCh	Chavin de Huantar
PeChiH	Chiclin. Coll. Rafael Larco Hoyle
PeCuA	Cuzco. Museo Arqueologico Universitario
PeCuAl	----- Almudena Church
PeCuB	----- Belen Church
PeCuBl	----- San Blas
PeCuC	----- Cathedral
PeCuCo	----- Compania
PeCuM	----- Museum
PeCuMA	----- Museo de la Universidad
PeH	Huaca Dragon
PeLA	Lima. Coll. Alzamora
PeLB	----- Buena Muerte
PeLC	----- Cathedral
PeLF	----- San Francisco
PeLL	----- Coll. Rafael Larco Hoyle
PeLLar	----- Museo Rafael Larco Herrera
PeLM	----- Coll. Miguel Mujica Gallo
PeLMA	----- Museo Nacional de Antropologia y Arqueologia
PeLN	----- Museo Nacional
PeLNA	----- See PeLMA
PeLO	----- Coll. Pedro de Osma
PeLP	----- San Pedro Church
PeLQ	----- Quinta Presna
PeP	Punkuri

Portugal

PoAC	Alcobaca. Cistercian Church
PoAlC	Almoster. Convent
PoAlhCh	Alhodas. Church
PoAr	Arouca. Monastery
PoAvJ	Aveiro. Convento de Jesus
PoAvM	----- Museum
PoBD)	Batalha. Dominican Monastery
PoBM)	
PoBo	Bobadela
PoBrI	Braga. Igreja dos Jesuitas
PoCC	Coimbra. Cathedral
PoCM	----- Museu "Machado de Castro"
PoEA	Elvas. Coll. Marquesa Alegrete
PoLA	Lisbon. Museu Nacional de Art Contemporanea
PoLB	----- Tower of Belem
PoLC	----- Conceicao Velha
PoLCa	----- Cathedral
POLCo	----- Meseu Nacional des Coches

PoLD	Lisbon. Sao Domingos de Benfica
PoLE	----- Eglise de Encarnacao
PoLG	----- Fundacao Calouste Gulbenkian
	(Gulbenkian Collection)
PoLM	----- Museum
PoLN	----- Nossa Senhora da Pena
PoLT	----- Terreiro do Paco
PoLPC	----- Praca do Comercio
PoLV	----- Coll. Ernesto de Vilhena
PoOB	Opporto. Sao Bento da Vitoria
PoOC	----- Santa Clara Church
PoPC	Portalegre. Cathedral
PoQ	Queluz
PoSP	Sintra. Palace Chapel
PoTaJ	Tartov. Jesus Chapel
PoTo	Tomar
PoTiB	Tibaes. Benedictine Monastery

Puerto Rico

-PrC	Coll. C. Conde III
PrSC	San Juan. Cathedral
PrSI	----- Instituto de Cultura Puertorequena
PrSS	----- San Jose Church
PrSU	----- University of Puerto Rico Museum

Rumania

RA	Alba Iulia
RBC	Bucharest. Ministry of Culture
RBM	----- Museum of Art
RBMN	Bucharest. Muzeul de Arta al Republicii
	Populare Romine
RBP	----- Pynacothec
RCP	Clujo. Pynacothec
RD	Dragomirna Manastery Museum
RTP	Targu Jiu. Public Gardens

Russia

RuA	Alexander III Museum
RuB	Bush
RuCL	Chernyakhovsk. Lutheran Parish Church
RuDC	Djvari. Church
RuKH	Kiev. Historical Museum
RuKaC	Kazan. Kazan Cathedral
RuKuB	Kutais. Bagrat III Church
RuLA	Leningrad. Anichkov Bridge
RuLAc	----- Academy of Fine Arts
RuLAd	----- Admiralty Square
RuLH	----- The Hermitage

RuLL	Leningrad. Lazarus Cemetery
RuLMAS	----- Museum of Academy of Sciences
RuLPP	----- SS. Peter and Paul Cathedral
RuLR	----- Russian Museum
RuLW	----- Winter Palace
RuLo	Lvov (Lwow)
RuMA	Moscow. Abramtsevo Museum
RuMCA	----- Church of the Annunciation
RuME	----- Director Art Exhibitions
RuMFA	----- Museum of Fine Art
RuMH	----- State Historical Museum
RuMK	----- Kremlin
RuMKA	----- Kremlin. State Armory Palace
RuMKP	----- ----- Grand Palace
RuMM	----- Ministry of Culture
RuMT	----- Tretyakov Gallery
RuMV	----- Monastery of the Virgin of the Don
RuNI	Nerl. Intercession Church
RuNoS	Novgorod. St. Sophia Cathedral
RuOp	Opiza. Church
RuP	Pavlovsk
RuPet	Peterhof
RuSM	Smolensk. Museum of Smolensk
RuTC	Tsebalda. Church
RuTiG	Tiflis. Georgian National Museum
RuTs	Tsarkoe Selo. Catherine Palace
RuVD	Vladimir. St. Dmitri Church
RuVoM	Vologda. Vologda Museum
RuYG	Yuriev-Polski. St. George Cathedral
RuYaE	Yaroslal. St. Elijah Church
RuYeM	Yerevan. Erivan Museum
RuZM	Zagorsk. Zagorsk Museum

San Salvador

San S	El Salvador

Scotland

ScAA	Aberdeen. Aberdeen Art Gallery
ScAM	----- Marischal College
ScD	Durisdeer
ScDuP	Dundee. Panmure Salon
ScEA	Edinburgh. National Museum of Antiquities of Scotland
ScECS	----- Edinburgh Castle--Scottish Naval and Military Museum
ScEG	----- St. Giles Cathedral
ScEK	----- Coll. Prof. J. R. King
ScEM	----- Scottish National Gallery of Modern Art

ScEN	Edinburgh. National Gallery of Scotland
ScENP	----- Scottish National Portrait Gallery
ScEP	----- Parliament House
ScER	----- Royal Scottish Museum
ScEW	----- Willow Tea Room
ScGA	Glasgow. Art School
ScGC	----- Corporation Coll.
ScGG	----- Glasgow Art Gallery and Museum
ScGU	----- Hunterian Museum, and University of Glasgow Art Collections
ScGlK	Glenkiln. Coll. W. J. Keswick
ScI	Iona
ScLLM	Liverpool. Liverpool City Museum
ScPa	Paisley
ScSK	Shawhead. Coll. W. J. Keswick

Senegal

SeDI	Dakar. Musee de l'Institut d'Afrique

Sweden

-SnB	Coll. Bo Boustedt
SnB	Blackeberg
SnGG	Gothenberg (Gotesborg). Gotaplastern
SnGK	----- Goteborgs Konstmuseum
SnGoB	Gotland. Burs
SnGoBu	----- Bunge Museum
SnGoG	----- Gammelgarn
SnGoM	----- Martebo
SnHH	Helsinki. Coll. Mrs. Sara Hilden
SnHN	Helsingborg. Navigation Monument
SnHa	Hahnstad
SnHaek	Haelsingland. Enanger's Kyrokomuseum
SnKS	Kalmar. Kalmar Slott och Museum (Castle and Provincial Museum)
SnLM	Lidingo. Millesgarden
SnLi	Linkoping
SnMA	Medelpad. Alno Church
SnMoH	Molndal. Coll. A. Hellstrom
SnNM	Narke. Mosjo-Kyrka
SnR	Coll. H. M. King of Sweden
SnRo	Rolagsbro
SnSA	Stockholm. Art Gallery
SnSAc	----- Academy
SnSAr	----- Medelhavsmuseet
SnSB	----- Bank of Sweden
SnSC	----- Concert Hall
SnSCa	----- Cathedral
SnSE	----- Statens Etnografiska Museum

SnSEn	Stockholm. Enskilda Bank
SnSH	----- Statens Sjohistoriska Museum
SnSHM	----- Statens Historiska Museum
SnSJ	----- Coll. G. Jungmarker
SnSK	----- Royal Collection
SnSL	----- Coll. S. Linne
SnSLa	----- Coll. M. Lagrelius
SnSLi	----- Lidingo
SnSM	----- Hotel Malmen
SnSMi	----- Tillhor Millesgarden
SnSN	----- Nationalmuseum
SnSNH	----- National History Museum
SnSNM	----- Nationalmuseum Moderna Museet
SnSNi	----- St. Nicholas Church
SnSNo	----- Noriska Museet
SnSO	----- Ostasiatiska Museet
SnSS	----- International Sports' Fair, 1950
SnSSM	----- Swedish Match Company
SnSSt	----- Stadtmuseum
SnSSta	----- Stadium
SnSSto	----- Storkkyra
SnSSv	----- Coll. Carl P. Svensson
SnST	----- Thielski Galleriet
SnSW	----- Wasavarvet (Wasa Dockyard)
SnSkW	Skokloster. Coll. Counts Wrangel and Brahe
SnUU	Uppsala. University Museum
SnVB	Vadstena. Former St. Birgitta Convent Church
SnVa	Vange
SnVal	Vallingby
SnVas	Vasteras
SnVax	Vaxjo
SnViG	Visby. Gotlands Fornsal
SnW	Westeras

South Africa

-SoL	Coll. S. Love
SoCG	Capetown. Gallery of South African Art
SoCSoM	----- South African Museum
SoDA	Durban. Durban Museum and Art Gallery
SoJB	Johannesburg. Coll. Bidel
SoJR	----- Rozetenville School of Arts and Crafts
SoL	Leefontein
SoM	Maretjiesfontein
SoPH	Pretoria. Coll. Erik Holm
SoPT	----- Transvaal Museum

SpMaC	Madrid. Casino de Madrid
SpMaCo	----- Cofradia de los Navarros
SpMaD	----- Monastery de Las Descalzas Reales
SpMaF	----- S. Fernando Academy
SpMaH	----- Coleccion de la Real Academia de la Historia
SpMaHF	----- Hospicio de S. Fernando
SpMaHu	----- Coll. J. Huarte
SpMaL	----- Museo de la Fundacion "Lazaro Galdiano"
SpMaM	----- Museo Nacional de Arte Moderno
SpMaMo	----- Galeria Juana Mordo
SpMaN	----- National Museum
SpMaOr	----- Plaza de Oriente
SpMaP	----- Museo Nacional del Prado
SpMaPal	----- Royal Palace
SpMaPlM	----- Plaza Mayor
SpMaR	----- Real Academia de S. Fernando
SpMaRA	----- Museo de la Real Armeria
SpMaU	----- University Chapel
SpMalC	Malaga. Cathedral
SpMalD	----- S. Domingo
SpMeA	Merida. Museo Arqueologico de Merida
SpMed	Medina de Rioseco
SpMuJ	Murcia. Ermita de Jesus
SpMuS	----- Museo Salzillo
SpOC	Orvieto. Cathedral
SpPa	Palos
SpPalV	Palencia. Villalcazar de Sirga
SpPalmC	Palma de Mallorca. Cathedral
SpPalmL	----- "La Lonja"
SpPamC	Pamplona. Cathedral
SpParC	El Pardo. Capuchin Monastery
SpPob	Poblet. Monastery
SpRS	Rio Seco. San Francisco
SpRipM	Ripoll. Monastery S. Maria
SpRoG	Roussillon. S. Genis-des-Fontaines
SpRod	Ciudad Roderigo
SpSC	Seville. Cathedral
SpSCar	----- Caridad
SpSG	----- S. Gregorio
SpSHC	----- Hospital de la Caridad (SpSCar)
SpSI	----- S. Isidoro del Campo
SpSJ	----- S. Juan de la Palma
SpSL	----- S. Lorenzo Church
SpSLu	----- S. Luis
SpSM	----- Museum
SpSMA	----- Museo Provincial de Bellas Artes

SpSP	Seville. S. Paula
SpSQ	----- Quinta Augustia
SpSS	----- S. Salvador
SpSUC	----- University Chapel
SpSaI	Santiponce. S. Isidoro del Campo
SpSalC	Salamanca. New Cathedral
SpSalE	----- S. Esteban
SpSalF	----- Cologio Fonseca. Irish College
SpSalO	----- Old Cathedral
SpSalU	----- Old University
SpSalaC	Sala. Collegiata
SpSanC	Santiago de Compostela. Cathedral
SpSanH	----- Hospital
SpSanM	----- S. Martin Pinario
SpSangM	Sanguesa. S. Maria la Real
SpSanta	Santa Domingo de Silos (SpD)
SpSarC	Sargossa. Cathedral
SpSarP	----- Pilar
SpSeC	Segovia. Cathedral
SpSeM	----- S. Maria de Nieva
SpSeP	----- El Parral Monastery Church
SpSiC	Siguenza. Cathedral
SpSilD	Silos. S. Domingo (SpD)
SpSoD	Soria. S. Domingo
SpSolC	Solsona. Cathedral
SpTC	Toledo. Cathedral
SpTCl	----- S. Clara
SpTHA	----- Hospital de Afuera
SpTHT	----- Hospital de Tavera
SpTJ	----- Juan de los Reyes Church
SpTL	----- Coll. Duchess of Lerma
SpTT	----- Synagogue El Transito
SpTTo	----- S. Tomas
SpTaC	Tarragona. Cathedral
SpTeC	Teruel. Cathedral
SpToM	Toro. Colegiata de S. Maria la Mayor
SpU	Ubeda
SpVA	Valladolid. Iglesia de las Augustias
SpVG	----- Colegio di S. Gregorio
SpVM)	----- Museo Nacional de Escultura
SpVME)	
SpVMP	----- Museo Provincial de Bellas Artes
SpVMad	----- Magdalen Church
SpVMar	----- S. Martin Church
SpVN	----- Nuestro Senora de las Angustias
SpVP	----- S. Pablo
SpVaA	Valencia. Palace of the Marques de Dos Aguas
SpVi	Vich

SpZM	Zamora. Magdalena Church
SpZP	----- S. Pedro de la Nave
SpZT	----- Museo de la Catedral
SpZarC	Zaragoza. Cathedral
SpZarS	----- La Seo

Sudan

SuJbA	Jebel (Gebel) Barkal. Amon Temple
SuKM	Khartoum. Museum
SuN	Naga

Switzerland

-SwA	Coll. Theodore Ahrenberg
SwAM	Agaune. Treasury of S. Maurice
SwAr	Arenenberg aum Untersee. Napoleonmuseum Arenberg
SwAvR	Avenches. Musee Romain
SwBA	Basel. Antikenmuseum
SwBB	----- Coll. Bernouilli
SwBBe	----- Galerie Beyeler
SwBC	----- Cathedral
SwBF	----- Feuerwache
SwBFe	----- Galerie Feigel
SwBH	----- Coll. Marguerite Hagenbach
SwBHa	----- Handels-schule
SwBHi	----- Coll. R. von Hirsch
SwBK	----- Offentliche Kunstsammlung
SwBKH	----- Kunsthistorisches Museum
SwBKM	----- Kunstmuseum
SwBKl	----- Klingenthal Museum
SwBKo	----- Am Kohlenberg
SwBM	----- Coll. O. Muller; Muller-Widman Coll.
SwBMi	----- Minster
SwBMo	----- Galerie d'Art Moderne
SwBN	----- Neubadschule
SwBR	----- Stadt Seite der Mittleren-Rheinbrucke
SwBS	----- Coll. Maja Sacher
SwBSt	----- Staatlicher Kunstkredit
SwBV	----- Museum fur Volkerkunde und Schwizerisches Museum fur Volkshunde Basel
SwBeB	Bern. Coll. Serge Brignoni
SwBeC	----- Cathedral
SwBeF	----- Federal Government Coll.
SwBeG	----- Stadtisches Gymnasium
SwBeH	----- Bernisches Historisches Museum
SwBeK	----- Kunsthalle
SwBeKM	----- Kunstmuseum

SwBeKo	Bern. Konservatorium
SwBeKor	----- Kornfeld & Klipstein
SwBeMe	----- Coll. F. Meyer-Chagall
SwBeMu	----- Munster
SwBeR	----- Rupf Foundation
SwBeRu	----- Coll. Hermann Rupf
SwBeT	----- Tiefeenauspital
SwBi	Bienne
SwBie	Biel
SwCha	Chaux-de-Fonds. Musee des Beaux-Arts
SwChuM	Chur. Minster
SwD	Dornach
SwFC	Fribourg. Cathedral
SwFM	----- Museum
SwGA	Geneva. Musee d'Art et d'Histoire
SwGAd	----- Coll. Adler
SwGAs	----- Salle des Assemblees de la S. D. N.
SwGDR	----- Coll. Della Ragione
SwGG	----- Coll. M. P. Geneux
SwGGi	----- Edizione Claude Givaudan
SwGK	----- Galerie Krugier
SwGL	----- Coll. Arch. Mario Labo
SwGU	----- University
SwGW	----- Foundation C. Waechter
SwGo	Goteburg
SwGrP	Grenchen. Park-Theatre
SwI	Interlaken
SwLG	Lucerne. Gletscherpark
SwLaC	Lausanne. Cathedral
SwLaJ	----- Coll. Mr. and Mrs. Samuel Josefowitz
SwLaL	----- Landesausstellung
SwLaM	----- Musees du Vieux-Lausanne
SwLigV	Ligornetto. Museo Vela
SwMG	Maloja. Alberto Giacometti. Residence
SwMon	Montreux
SwMus	Mustair Monastery, Cantons de Grisson
SwNJ	Neuchatel. Coll. Marcel Joray
SwNe	Neu Birnau. Church
SwPC	Payerne. Payerne Church
SwSGB	St. Gallen. Stiftsbibliothek
SwSGCh	----- Former Convent Church
SwSGH	----- Handelshochschule
SwSGHM	----- Heimatmuseum
SwSMT	St. Maurice. Tresor de l'Abbaye
SwSMo	San Moritz
SwSiV	Sion. Musee de Valere
SwSoM	Soleure. St. Mary's Church
SwStM	Staws. Historiches Museum

```
SwTC          Thayngen. Church
SwWh          Winterthur. Coll. Mme. Hahnloser
SwWK          ----- Kunstmuseum Winterthur
SwWR          ----- Coll. Dr. Oskar Reinhard (t)
SwZA          ----- Agricultural and Trade Fair, 1947
SwZB          ----- Coll. Dr. Rudolph Blum
SwZBe         ----- Coll. Dr. Walter Bechtler
SwZBr         ----- Coll. Erica Brausen
SwZBu         ----- Coll. Buhrle
SwZBur        ----- Coll. Curt Burgauer
SwZC          ----- Coll. August Carl
SwZCon        ----- Convention Building
SwZE          ----- Ethnological Collection
SwZG          ----- Grossmunster
SwZGi         ----- Coll. S. and C. Giedion-Welcker
SwZGia        ----- Giacometti Foundation
SwZGim        ----- Gimpel and Hanover Galerie
SwZH          ----- Coll. von der Heydt
SwZHo         ----- Hospital Garden (SwZUH)
SwZHu         ----- Galerie Huber
SwZK          ----- Kunsthaus (SwZMN)
SwZKa         ----- Kanton of Zurick
SwZKr         ----- Coll. Krayenbuhl
SwZKu         ----- Kunstgewerbemuseum der Stadt Zurich
SwZL          ----- Galerie Charles Leinhard
SwZLe         ----- Coll. Elsy Leuzinger
SwZMAp        ----- Museum for Applied Arts (SwZKu)
SwZMN         ----- Musee National Suisse (SwZK)
SwZMe         ----- Coll. Michel E. Meyer
SwZP          ----- Public Park
SwZR          ----- Museum Reitberg
SwZS          ----- Schwizerisches Landesmuseum
SwZUH         ----- University Hospital (SwZHo)
SwZUV         ----- Universitat-Zurich-Sammlung fur
                    Volkerkunde
SwZZ          ----- Galerie Renee Ziegler

                          Syria
SyAN          Aleppo. Musees National d'Alep
SyB           Boghaz-Keul
SyDN          Damascus. Musee National de Damas
SyN           Nemrud Dagh
SyS           Saktche-Gozu

                         Turkey
TAA           Ankara. Archaeological Museum
TAH           ----- Hittite Museum
TAkK          Aksaray. Kebir Cami
```

TAnM	Antayla (formerly: Adalia). Archaeological Museum
TB	Bogazkoy
TC	Cachemish
TDU	Divrigi. Ulu Cami
THH	Hatay. Hatay Museum
TIAM	Istanbul. Archeological Museum
TIAt	----- At-Meidan
TIH	----- Hagia Sofia
TIHip	----- Hippodrome
TIJ	----- St. John Studion
TIM	----- National Museum (Constantinople Museum)
TIO	----- Ottoman Museum
TIS	----- Hagios Sergios and Hagios Bacchus
TITh	----- Obelisk of Theodosius
TITo	----- Topkapi Saray Museum
TIv	Ivriz
TIzA	Izmir (Formerly: Smyrna). Archeological Museum
TKE	Konya. Ethnographical Museum
TKM	----- Ince Minare Madrassa
TKa	Karatepe
TMA	Manisa. Archaological Museum
TSM	Sivas. Gok Madrassa
TVA	Lake Van. Aght'amar (Church)
TY	Yasidikaya

Thailand

ThBF	Bangkok. Monastery of the Fifth King
ThBNM	----- National Museum
ThBNe	----- Coll. Mr. and Mrs. E. L. Neville
ThBP	----- Wat Paa Keo
ThBY	----- Coll. H. R. H. Prince Chalermbol Yugala
ThSM	Savankhalok. Wat Mahathat
ThW	Wat Cetiya Luang

Tunisia

TuCM	Carthage. Carthage Museum
TuQM	Quirawan. Great Mosque
TuTA	Tunis. Musee Alaoui
TuTB	----- Musee National du Bardo

United States

-UA	Coll. John P. Anderson
-UAd	Coll. Elbridge Adams
-UAi	Coll. Dorothy Ainsworth

-UB	Coll. Col. Sam Berger
-IBa	Coll. Mr. and Mrs. Walter Bareiss (UCtGB)
-UBak	Coll. Mr. and Mrs. Louis C. Baker
-UBar	Coll. Monroe G. Barnard
-UBe	Coll. H. Benevy
-UBl	Coll. Lawrence H. Bloedel
-UBr	Coll. Mr. and Mrs. Austin Briggs
-UBru	Avery Brundage Foundation
-UBu	Coll. Mr. and Mrs. William A. Burden
-UBur	Coll. Lt. John Burke
-UC	Coll. Mr. and Mrs. Oscar Cox
-UCop	Coll. W. Copley
-UCr	Coll. Mr. and Mrs. Sumner McK. Crosby
-UCro	Coll. Mrs. W. W. Crocker
-UD	Coll. Mr. and Mrs. Bruce C. Dayton
-UDel	Coll. Mr. and Mrs. Kurt Delbanco
-UDr	Coll. Katherine S. Dreier
-UE	Coll. Armand G. Erpf
-UF	Coll. Roy S. Frieuman
-UFi	Coll. Mr. and Mrs. Sol Fishko
-UFis	Coll. Mrs. Henry Fischbach
-UFit	Coll. H. William Fitelson
-UFl	Coll. Mr. and Mrs. Malcolm K. Fleschner
-UFlo	Coll. Milton Flower
-UFo	Coll. Mr. and Mrs. James W. Fosburgh
-UFor	Coll. Mr. and Mrs. Walter B. Ford, II (UMiDFor)
-UForc	Coll. Juliana Force
-UG	Coll. Richard P. Gale
-UGa	Coll. Naum Gabo
-UGar	Coll. Mr. and Mrs. Lewis Garlick
-UGard	Coll. Mr. and Mrs. Robert Gardner
-UGe	Coll. Titus C. Geesey
-UH	Coll. Mr. and Mrs. J. W. Hambuechen
-UHa	Coll. Mrs. Ira Haupt
-UHam	Coll. Mr. and Mrs. George Heard Hamilton
-UHar	Coll. Mr. and Mrs. Averill Harriman
-UHe	Coll. Mr. and Mrs. Henry J. Heinz, II
-UHem	Coll. Mrs. Barklie McKee Henry
-UHo	Coll. Mrs. Frederick W. Hilles
-UHil	Coll. Susan Morse Hilles
-UHir	Coll. Al Hirschfeld
-UJ	Coll. Philip Johnson
-UK	Coll. Mr. and Mrs. Illi Kagan
-UKa	Coll. Edgar J. Kaufmann
-UKam	Coll. Dr. George Kamperman
-UKi	Coll. Mr. and Mrs. Sidney Kingsley
-UKn	Coll. Mr. and Mrs. Seymour H. Knox

-UKl	Coll. Dr. Nathan Kleine
-UL	Coll. Lloyd Family
-ULa	Coll. Robert M. LaFollette, Jr.
-ULan	Coll. J. Patrick Lannon
-ULaw	Coll. Jack Lawrence
-ULe	Coll. Reginald LeMay
-ULes	Coll. Mac Le Sueur
-ULev	Coll. Robert H. Levi
-ULi	Coll. Jean Lipman
-ULo	Coll. Alain Locke
-UM	Coll. Mrs. Eugene Mayer
-UMa	Coll. Mr. and Mrs. Robert Meyer
-UMan	Coll. Dr. and Mrs. Mandelbaum
-UMi	Coll. Mr. and Mrs. G. MacCulloch Miller
-UMo	Coll. Anne Morgan
-UN	Coll. Mrs. Elie Nadelman
-UNe	Coll. Babette Newburger
-UNel	Coll. Marion John Nelson
-UO	Coll. Mr. Robert Ossorio
-UPa	Coll. Mr. and Mrs. Charles S. Payson
-UPh	Coll. Margaret Phillips
-UPhi	Coll. Mr. and Mrs. William Phillips
-UPr	Coll. Stuart Preston
-URa	Coll. Oscar Raphael
-URe	Coll. Mr. and Mrs. Stanley R. Resor
-URic	Coll. Horace Richter
-URica	Coll. James H. Ricau
-URo	Coll. Mr. and Mrs. Saul Rosen
-URon	Coll. Dr. and Mrs. Bernard Ronis
-URos	Coll. George Rosborough
-URu	Coll. Prof. William Rubin
-US	Coll. Arthur M. Sachler
-USc	Coll. Mr. and Mrs. Robert C. Scull
-USch	Coll. Stephen Karl Scher
-USchw	Coll. Mr. and Mrs. Seymour Schweber
-USe	Coll. Mr. and Mrs. Charles Seymour, Jr.
-USim	Coll. Mrs. Robert E. Simon
-USm	Coll. Mr. and Mrs. Solomon Byron Smith (UICSm)
-USo	Coll. Dr. and Mrs. Eugene Solow
-USt	Coll. J. Starrels; Coll. Eugene von Stanley
-USta	Coll. Blair Stapp
-USte	Coll. Mrs. D. O. Stewart
-USto	Coll. M. and R. Stora
-UStor	Coll. Dr. Gilbert Stork
-UT	Coll. Mr. and Mrs. Burton Tremaine
-UTe	Coll. David A. Teichman
-UTh	Coll. Mr. and Mrs. John S. Thacher

-UTho	Coll. G. David Thompson
-UTo	Coll. Mr. and Mrs. Benjamin Townsend
-UTom	Coll. Jay B. Tomlinson
-UTow	Towle Silversmiths Coll.
-UW	Coll. Weiner
-UWa	Coll. Mrs. Eleanor Ward
-UWar	Coll. Edward M. M. Warburg
-UWe	Coll. Mr. and Mrs. Frederick R. Weisman
-UWeb	Coll. Mrs. J. Watson Webb
-UWei	Coll. Fred Weisman
-UWi	Coll. William Wilder
-UWic	Coll. Forsyth Wickes
-UWin	Coll. Lewis Winter
-UY	Coll. Hanford Yang

--Alaska

UAB	Baranof Island
UAK	Ketchikan
UAWW	Wrangel. Coll. Walter Waters

--Alabama

UAlBC	Birmingham. City Museum and Art Gallery
UAlMC	Mobile. Conti Street
UAlTC	Tuskegee Institute. George Washington Carver Museum

--Arkansas

UArC	Caddo Gap

--Arizona

UAzGT	Grand Canyon. El Tovar Hotel
UAzKP	Kitt Peak
UAzP	Prescott
UAzPhA	Phoenix. Phoenix Art Museum
UAzTUA	Tuscon. University of Arizona. Arizona State Museum
UAzTeUAm	Tempe. Arizona State University. Collection of American Art

--California

UCA	Anaheim
UCAn	Angels Camp
UCArP	Arcadia. Pony Express Museum
UCBC	Berkeley. University of California. University Art Museum
UCBCA	----- ----- Robert H. Lowie Museum of Anthropology
UCBa	Bakersfield

UCBeC	Beverly Hills. Coll. Mr. and Mrs. Donn Chappellet
UCBeE	----- Temple Emmanuel
UCBeF	----- Harry A. Franklin Gallery
UCBeFa	----- Coll. Mr. and Mrs. Donald Factor
UCBeG	----- Coll. Mr. and Mrs. Gersh
UCBeH	----- Coll. Mr. and Mrs. Melvin Hirsh
UCBeK	----- Kleiner Foundation; Coll. Mr. and Mrs. Burt Kleiner
UCBeP	----- Coll. Mr. and Mrs. Vincent Price
UCBeR	----- J. W. Robinson (Department Store)
UCBeS	----- Coll. Mr. and Mrs. Richard E. Sherwood
UCBeSc	----- Coll. Taft Schreiber
UCBeSh	----- Coll. Mr. and Mrs. Arthur Shapiro
UCBeW	----- Coll. Mr. and Mrs. Frederick H. Weisman
UCBuC	Burlingame. Coll. Mrs. William W. Crocker
UCCA	Carmel. Coll. Bruno Adriani
UCCo	Corona del Mar
UCD	Donner Lake
UCElC	Elsinore. El Colorado Geriatric Hospital
UCFCM	Fresno. Courthouse Mall
UCFCi	----- Civic Mall
UCFM	----- Mooney Park
UCFaS	Fairfield. Solano County Free Library
UCGF	Glendale. Forest Lawn Cemetery
UCHA	Hollywood. Coll. Louise and Walter Arensberg
UCHW	----- Coll. Billy Wilder
UCHi	Hillsborough
UCHu	Humboldt County
UCLA	Los Angeles. Coll. Dr. and Mrs. Nathan Alpers
UCLAd	----- Coll. Mr. and Mrs. Abe Adler
UCLAn	----- Ankrum Gallery
UCLAs	----- Coll. L. M. Asher Family
UCLB	----- Coll. Mr. and Mrs. Sidney F. Brody
UCLBl	----- Coll. Irving Blum
UCLBla	----- Coll. Mr. and Mrs. Michael Blankfort
UCLBr	----- Coll. David E. Bright
UCLC	----- Comara Gallery
UCLCM	----- Los Angeles County Museum of Art
UCLCa	----- Carthay Center
UCLCal	----- Federal Plaza Building, 5670 Wilshire Boulevard
UCLCo	----- Comara Gallery
UCLD	----- Dwan Gallery; Coll. Virginia Dwan Kondratief

UCLE	Los Angeles. Everett Ellin Gallery
UCLEl	----- Coll. Jim Eller
UCLF	----- Ferus-Pace Gallery
UCLFa	----- Coll. Donald and Lynn Factor
UCLFe	----- Feigen/Palmer Gallery
UCLFei	----- Feingarten Galleries
UCLFr	----- Coll. Mr. and Mrs. Harry A. Franklin
UCLG	----- Griffith Park
UCLGa	----- Coll. Mrs. Digby Gallas
UCLGe	----- Coll. J. Paul Getty, Malibu residence
UCLH	----- Coll. Dennis and Brooke Hopper
UCLJ	----- Coll. Edwin Janss
UCLJa	----- Coll. Joan Jacobs
UCLK	----- Kleiner Foundation
UCLL	----- Felix Landau Gallery
UCLLa	----- Lafayette Park
UCLLe	----- Coll. Mr. and Mrs. Robert Levyn
UCLLi	----- Lincoln Park
UCLLy	----- Lytton Savings and Loan Association Coll; Coll. Bart Lytton
UCLM	----- Coll. Mr. and Mrs. Louis McLane
UCLMP	----- MacArthur Park
UCLMc	----- Coll. Mrs. James McLane
UCLMcc	----- Coll. Mr. and Mrs. John McCracken
UCLMo	----- Coll. William Moore
UCLN	----- Coll. Rolf Nelson Gallery
UCLO	----- Olvera Street
UCLP	----- Coll. Mr. and Mrs. Ingo Preminger
UCLPL	----- Los Angeles City Public Library
UCLPa	----- Herbert Palmer Gallery
UCLPla	----- Plaza, North Main Street
UCLPr	----- Coll. Mr. and Mrs. Otto Preminger
UCLPs	----- Primus-Stuart Gallery
UCLR	----- Esther Robles Gallery
UCLRo	----- Coll. Robson
UCLRow	----- Coll. Robert A. Rowan
UCLS	----- Stendahl Galleries
UCLSo	----- Southwest Museum
UCLSt	----- Coll. Miss Laura Lee Stearns
UCLSte	----- Coll. Josef von Sternberg
UCLStu	----- David Stuart Galleries
UCLUC	----- University of California at Los Angeles Art Gallery
UCLUn	----- Union Park
UCLV	----- Coll. Dr. W. R. Valentiner
UCLW	----- Coll. Dr. and Mrs. George J. Wayne
UCLWi	----- Nicholas Wilder Gallery
UCLaH	Laguna Beach. Coll. Sterling Holloway

UCLjD	La Jolla. Dilexi Gallery
UCLjS	La Jolla. Scripps Institute of Oceonography
UCLo	Los Gatos
UCLonC	Long Beach. California State College
UCLonL	----- Lincoln Park
UCM	Monterey
UCOB	Oakland. Temple Beth Abraham
UCOL	----- Latham Square
UCOLo	----- Jack London Square
UCOT	----- Tiden Regional Park
UCOTe	----- Teamster's Union Building
UCPL	Point Loma
UCPaP	Pasadena. Ambassador College
UCPaH	----- Coll. Walter Hopps
UCPaL	----- Coll. Mrs. F. L. Loring
UCPaM	----- Pasadena Art Museum
UCPaR	----- Coll. Mr. and Mrs. Robert Rowan
UCPaT	----- Coll. Mr. and Mrs. Thomas Terbell
UCPalL	Palo Alto. Lanyon Gallery
UCRM	Rancho Santa Fe. Coll. Mrs. Charles Meyer
UCSBC	Santa Barbara. University of California
UCSBM	----- Santa Barbara Museum
UCSDB	San Diego. Balboa Park
UCSDC	----- San Diego State College
UCSDCi	----- Civic Center
UCSDF	----- Fine Arts Gallery of San Diego
UCSDL	----- Point Loma
UCSDP	----- Presidio Park
UCSDSCo	----- San Diego County Administration Building
UCSDUC	----- University of California
UCSFB	San Francisco. Bolles Gallery
UCSFBe	----- Berkeley Gallery
UCSFBo	----- Bohemian Club
UCSFC	----- David Cole Gallery
UCSFCP	----- California Palace of the Legion of Honor
UCSFCh	----- Coll. Thomas Church
UCSFCi	----- City Hall
UCSFD	----- Dilexi Gallery
UCSFDeY	----- M. H. de Young Memorial Museum
UCSFDi	----- Dilexi Gallery
UCSFDo	----- Mission Dolores
UCSFE	----- Temple Emanuel
UCSFF	----- St. Francis Church, Montgomery Avenue and Vallejo Street
UCSFFein	----- Charles Feingarten Gallery
UCSFG	----- Golden Gate Park

UCSFH	San Francisco. Huntington Park
UCSFHa	----- Coll. Mr. and Mrs. Walter A. Haas
UCSFHan	----- Hansen Galleries
UCSFHar	----- Coll. Henry C. Hart
UCSFHe	----- Coll. Mrs. Sally Hellyer
UCSFHu	----- Coll. Henry Hunt
UCSFI	----- International Airport
UCSFJ	----- Japanese Tea Gardens
UCSFK	----- Thomas Starr King Elementary School
UCSFL	----- Lincoln School
UCSFLa	----- Laguna Honda Home
UCSFLi	----- Lincoln Park
UCSFM	----- San Francisco Museum of Art
UCSFMa	----- St. Mary's Square
UCSFMab	----- Market, Bush, and Battery Streets Intersection
UCSFMar	----- Marina Park
UCSFMars	----- Marshall Square
UCSFMat	----- Market, Third and Kearney Streets Intersection
UCSFO	----- Coll. Otis Oldfield
UCSFP	----- Presidio
UCSFPL	----- San Francisco Public Library
UCSFPan	----- Panama-Pacific Exposition, 1916
UCSFPo	----- Portsmouth Square
UCSFR	----- Coll. Mrs. Madeleine H. Russell
UCSFS	----- San Francisco Stock Exchange
UCSFU	----- Union Square
UCSFV	----- Veterans Memorial Building
UCSFW	----- Washington Square
UCSFWa	----- Coll. Brooks Walker
UCSFWal	----- Coll. Col. and Mrs. H. D. Walter
UCSaC	Sausalito. David Cole Gallery
UCSacP	Sacramento. Plaza Park
UCSalH	Salinas. Hartnell College
UCSjJ	San Jose. St. James Park
UCSjM	----- Mission San Jose Museum
UCSl	San Leandro
UCSluM	San Luis Obispo. Mission San Luis Obispo
UCSmH	San Marino. Henry E. Huntington Library and Art Gallery
UCSmaB	San Mateo. Temple Beth El
UCSmaH	----- Hillsdale Mall
UCSmoP	Santa Monica. Coll. Mr. and Mrs. Gifford Phillips
UCSo	Sonoma
UCSs	San Simeon
UCStanU	Stanford. Stanford University Museum

UCStbA	Santa Barbara. Coll. Mr. and Mrs. Richard McC. Ames
UCStbL	----- Coll. Wright Ludington
UCStbM	Santa Barbara. Museum of Art
UCStbMo	----- Coll. Sigmund Morgenroth
UCStbT	----- Coll. Mrs. Warren Tremaine
UCStiM	Santa Inez. Mission Santa Inez
UCU	Upland
UCWB	Whittier. Broadway-Whittier Department Store

--Colorado

UCoCT	Colorado Springs. Taylor Museum, Colorado Springs Fine Arts Center
UCoDA	Denver. Denver Art Museum
UCoDC	----- Civic Center
UCoDCap	----- State Capitol
UCoDK	----- Coll. Vance Kirkland
UCoLM	----- Coll. Phyllis Montrose
UCoDS	----- Coll. Mr. and Mrs. Caswell Silver

--Connecticut

UCtBL	Byram. Coll. Mrs. Albert A. List
UCtBlC	Bloomfield. Connecticut General Life Insurance Company
UCtBrB	Bridgeport. Temple B'nai Israel
UCtBrP	Bridgewater. Coll. George D. Pratt
UCtCL	Cannondale. Coll. Howard and Jean Lipman
UCtES	East Glastonbury. Cemetery
UCtFA	Fairfield. Coll. Mary Allis
UCtGB	Greenwich. Coll. Mr. and Mrs. Walter Bareiss
UCtGeR	Georgetown. Coll. Sally Ryan
UCtHB	Hartford. Bushnell Park
UCtHC	----- Constitution Plaza
UCtHCap	----- State Capitol
UCtHCi	----- City Hall
UCtHM	----- Mutual of Hartford Insurance Building
UCtHP	----- Public Park Department
UCtHW	----- Coll. Samuel J. Wagstaff, Jr.
UCtHWA	----- Wadsworth Atheneum
UCtLW	Litchfield. Coll. William L. Warren
UCtMG	Middlebury. Coll. Mrs. Miriam Gabo
UCtMeT	Meriden. Coll. Mr. and Mrs. Burton Tremaine
UCtMyM	Mystic Seaport. Mariners' Museum
UCtNcA	New Canaan. Coll. Lee A. Ault
UCtNcC	----- Coll. Charles Carpenter

UCtNcJ	New Canaan. Coll. Philip Johnson
UCtNcS	----- Coll. Mr. and Mrs. James Thrall Soby
UCtNhC	New Haven. Coll. Mr. and Mrs. George Heard Hamilton
UCtNhHi	----- Coll. Mr. and Mrs. F. W. Hilles
UCtNhL	----- Coll. Dr. Ralph Linton
UCtNhP	----- Yale University. Peabody Museum of Natural History
UCtNhR	----- ----- Beineche Rare Book and Manuscripts Library
UCtNhY	----- ----- Campus
UCtNlA	New London. Lyman Allyn Museum
UCtOPo	Oakville. Post Office
UCtPO	Pomfret Center. Coll. Mrs. Culver Orswell
UCtPS	----- Pomfret School
UCtSB	Stamford. Coll. Alfons Bach
UCtSS	----- Coll. Herman Shulman
UCtT	Tomkinsville
UCtWB	Wilton. Coll. Mr. and Mrs. Lester T. Beall
UCtWaI	Waterbury. Temple Israel
UCtWaM	----- Mattatuck Historical Society
UCtWeI	Westport. Temple Israel
UCtWesB	West Hartford. Temple Beth El
UCtWiD	Winsted. Coll. Mrs. Walter Davenport
UCtWoT	Woodbury. Coll. Mrs. Yves Tanguy
UCtWooJ	Woodbridge. Congregation B'nai Jacob
UCtY	----- Yale University Art Gallery, New Haven

--Washington, D. C.

UDCA	Arlington Memorial Bridge
UDCArl	Arlington Cemetery
UDCB	----- Coll. Mrs. Edward Bruce
UDCBl	----- Coll. Mr. and Mrs. Robert Woods Bliss
UDCBlu	----- Coll. Allan Bluestein
UDCBu	----- Coll. Mr. and Mrs. William A. M. Burden
UDCC	----- Corcoran Art Gallery
UDCCap	----- United States Capitol
UDCCapS	----- ----- Statuary Hall
UDCD	----- Dumbarton Oaks
UDCDo	----- Coll. Owen Dowdson
UDCFo	----- Folger Library
UDCFr	----- Freer Gallery of Art
UDCG	----- Gallaudet College

UDCGr	Washington, D. C. Gres Gallery
UDCH	----- Howard University
UDCI	----- Interior Department Building
UDCIn	----- Coll. Indian Arts and Crafts Board
UDCJ	----- Jefferson Place Gallery
UDCJu	----- Judiciary Square
UDCK	----- Coll. Mr. and Mrs. Andrew S. Keck
UDCKr	----- Coll. Mr. and Mrs. David Lloyd Kreeger
UDCL	----- Library of Congress
UDCLP	----- Lincoln Park
UDCLa	----- Lafayette Park
UDCLi	----- Lincoln Memorial
UDCLl	----- Coll. Mrs. H. Gates Lloyd
UDCM	----- Coll. Mrs. Eugene Meyer
UDCMa	----- Coll. Mrs. May
UDCMo	----- Gallery of Modern Art
UDCN	----- National Gallery of Art
UDCNA	----- National Academy of Sciences
UDCNC	----- Episcopal National Cathedral
UDCNM	----- National Museum
UDCNMS	----- ----- Smithsonian Institution
UDCNMSC	----- ----- ----- National Collection of Fine Arts
UDCNMSP	----- ----- ----- National Portrait Gallery
UDCP	----- Phillips Gallery
UDCPa	----- Pan American Union (Organization of American States)
UDCPo	----- Washington Post Office
UDCR	----- Rock Creek Park
UDCRC	----- Rock Creek Park Cemetery
UDCS	----- Swiss Embassy
UDCSc	----- Scottish Rite Temple
UDCSin	----- Temple Sinai
UDCSw	----- Coll. Carleton Byron Swift
UDCT	----- Robert A. Taft Memorial
UDCTr	----- United States Treasury Building
UDCTy	----- Coll. W. R. Tyler
UDCW	----- White House
UDCWpa	----- W. P. A. Art Program

--Delaware

UDeWG	Wilmington. Coll. Titus G. Geesey
UDeWi	Winterthur. Winterthur Museum

--Florida

UFMP	Miami Beach. Arthur Godfrey Road and Pine Tree Drive

UFMiH	Miami. Hope Lutheran Church
UFOT	Ormond Beach (near). Tomoka State Park
UFPN	Palm Beach. Norton Gallery
UFSR	Sarasota. Ringling Museum of Art
UFSsS	Silver Springs. Silver River
UFWN	West Palm Beach. Norton Gallery

--Georgia

UGAA	Atlanta. Atlanta Art Association
UGAU	----- Atlanta University
UGCU	Calhoun (Near). U. S. Highway 42 and State Highway 225 Intersection
UGS	Savannah
UGSM	Stone Mountain

--Hawaii

UHE	Ewa
UHHA	Honolulu. Academy of Arts
UHHB	----- Bernice Pauahi Bishop Museum

--Illinois

UIBJ	Benton. Coll. Dr. and Mrs. Richard Johnson
UIBaF	Barrington. Coll. Mr. and Mrs. Owen Fairweather
UICA	Chicago. Art Institute
UICAC	----- Arts Club
UICAb	----- Abbott Laboratories
UICAd	----- Adler Planetarium
UICAl	----- Coll. Mr. and Mrs. James M. Alter
UICAll	----- Coll. Robert Allerton
UICAr	----- Coll. Albert L. Arenberg
UICB	----- Board of Trade Building
UICBa	----- Coll. Mr. and Mrs. Herbert Baker
UICBe	----- Coll. Mr. and Mrs. Edwin A. Bergman
UICBen	----- Coll. Richard M. Bennett
UICBl	----- Coll. Leigh B. Block
UICBla	----- Coll. Blair
UICBr	----- Coll. Avery Brundage
UICC	----- Century of Progress Electrical Building
UICCar	----- Carson, Pirie, Scott Department Store (Formerly: Schlesinger-Meyer Building)
UICCh	----- Chicago Historical Society
UICCo	----- Cook County Courthouse
UICCu	----- Coll. W. Cummings
UICE	----- Elks National Memorial Building

UICEm	Chicago. Temple Emanuel
UICEp	----- Coll. Mrs. Max Epstein
UICF	----- Allan Frumkin Gallery
UICFa	----- Coll. Dr. Edith B. Farnsworth
UICFai	----- Fairweather-Hardin Gallery
UICFe	----- Richard Feigen Gallery
UICFea	----- Fairweather-Hardin Gallery
UICFein	----- Charles Feingarten Galleries
UICFl	----- Coll. L. Florsheim
UICG	----- Grant Park
UICGa	----- Garfield Park
UICGi	----- Coll. Willard Gidwitz
UICGid	----- Coll. Mr. and Mrs. Gerald Gidwitz
UICGil	----- Gilman Galleries
UICGl	----- Glenview
UICGr	----- Coll. Mr. and Mrs. Everett D. Graff
UICH	----- Coll. Mr. and Mrs. Leonard Horwich
UICHa	----- Fairweather-Hardin Gallery
UICHaf	----- Coll. Charles C. Haffner III
UICHar	----- Coll. William Harris
UICHi	----- Coll. Mr. and Mrs. Milton Hirsch
UICHo	----- B. D. Holland Gallery
UICHod	----- Coll. Mr. and Mrs. Barnet Hodes
UICHok	----- Coll. Mr. and Mrs. Edwin E. Hokin
UICI	----- Institute of Design
UICIn	----- Inland Steel Company
UICJ	----- Jackson Park
UICJu	----- Coll. Stephen Junkunc III
UICJud	----- Coll. Mrs. Sylvia Shaw Judson
UICK	----- Coll. Mr. and Mrs. B. Kowalsky
UICL	----- Lincoln Park
UICM	----- Coll. Mr. and Mrs. Arnold H. Maremont
UICMa	----- Coll. Mr. and Mrs. Lewis Manilow
UICMain	----- Main Street Galleries
UICMar	----- Coll. Mr. and Mrs. Henry A. Markus
UICMarq	----- Marquette Building
UICMic	----- Coll. Mr. and Mrs. D. Daniel Michel
UICMid	----- Midway Plaisance
UICMo	----- Montgomery Ward Building
UICN	----- Coll. Arthur J. Neumann
UICNe	----- Coll. Mrs. Albert H. Newman
UICNet	----- Coll. Mr. and Mrs. Walter A. Netsch, Jr.
UICNeu	----- Coll. Mr. and Mrs. Morton G. Neumann
UICNh	----- Chicago Natural History Museum (Formerly: Field Museum)

UICO	Chicago. Ontario East Gallery
UICPa	----- Palmer College
UICS	----- Coll. Howard Shaw
UICSc	----- Museum of Science and Industry
UICSch	----- Coll. Mrs. Ida Schutze
UICSe	----- Coll. Dr. and Mrs. Herman Serota
UICSh	----- Devorah Sherman Gallery
UICSm	----- Coll. S. B. Smith
UICSt	----- Coll. Mr. and Mrs. Joel Starrels
UICSte	----- Steinberg Collection
UICT	----- St. Thomas the Apostle Church
UICU	----- University of Chicago
UICUO	----- ----- Oriental Institute
UICW	----- Coll. Mr. and Mrs. Edward H. Weiss
UICWa	----- Washington Park
UICWi	----- Coll. Mr. and Mrs. Raymond Wielgus
UICWo	----- Coll. Mr. and Mrs. Charles H. Worcester
UICZ	----- Coll. Mrs. Ernest Zeisler
UICZu	----- Coll. Mr. and Mrs. Suzette Morton Zurcher
UICa	Cairo
UIChUK	Champaign. University of Illinois. Krannert Art Museum
UID	Danville
UIDeM	Decatur. Macon County Building
UIDeMi	----- Milliken University
UIEB	Evanston. Coll. Prof. William R. Bascom
UIDi	Dixon
UIF	Freeport
UIGH	Glencoe. Coll. Mr. and Mrs. Howard G. Haas
UIGP	----- Coll. Mr. and Mrs. Jay Pritzker
UIGS	----- Coll. Herman Spertus
UIL	Lawrence County
UIOS	Oak Park. Coll. Mr. and Mrs. Joseph R. Shapiro
UIOa	Oak Brook
UIOrR	Oregon. Rock River--East Bank
UIPP	Peoria. St. Paul's Church
UIQI	Quincy. Coll. George M. Irwin
UIRB	Rock Island. Black Hawk State Park
UIRiH	River Forest. Temple Har Zion
UIRiT	River Front. West Suburban Temple
UIRoG	Rosamund. Rosamund Grove Cemetery
UISCap	Springfield. State Capitol
UISI	----- Illinois State Museum of Natural History and Art

UISO	Springfield. Oak Ridge Cemetery
UIUU	Urbana. University of Illinois
UIUUA	----- ----- College of Fine and Applied Art
UIWA	Winnetka. Coll. Mr. and Mrs. J. W. Alsdorf
UIWM	----- Coll. Mr. and Mrs. Arnould H. Maremont
UIWMa	----- Coll. Mr. and Mrs. Robert B. Mayer

--Iowa

UIaAI	Ames. Iowa State University
UIaDCap	Des Moines. State Capitol
UIaDaM	Davenport. Davenport Public Museum
UIaDeN	Decorah. Norwegian-American Historical Museum
UIaFtL	Fort Dodge. Public Library
UIaIU	Iowa City. University of Iowa
UIaKR	Keokuk. Rand Park
UIaLC	Lakeview. Crescent Park
UIaOC	Oskaloosa. City Park
UIaW	Webster City

--Idaho

UIdBA	Boise. Boise Art Association

--Indiana

UInBH	Bloomington. Coll. Mr. and Mrs. Henry R. Hope
UInBU	Bloomington. University of Indiana
UInF	Fort Wayne
UInGB	Gary. Temple Beth El
UInGL	----- Lake County Children's Home
UInIH	Indianapolis. John Herron Art Institute
UInII	----- Indianapolis Hebrew Congregation
UInIU	----- University Park
UInNU	Notre Dame. University of Notre Dame Art Gallery
UInNhW	New Harmony. Workingmen's Institute
UInO	Odon
UInPP	Plymouth (near). Highway between Pretty Lake and Twin Lakes
UInSB	South Bend. Temple Beth El
UInSBM	----- Coll. Mrs. Olga Mestrovic
UInTB	Terre Haute. Coll. Mr. C. H. Biel (Biel, Inc., Tobacco Company)
UInTL	----- Coll. Mrs. Leroy Lamis
UInTP	----- Coll. A. W. Pendergast
UInW	Wabash

	--Kansas
UKHL	Henderson Point. Logan Grove Farm, junction Smoky Hill and Republican Rivers
UKLP	Leavenworth. Coll. Paul D. Parker
UKLaH	Lawrence. Haskell Institute
UKLaUM	----- University of Kansas. Museum of Art
UKMB	Mission. Coll. James Baldwin
UKMH	Medicine Lodge. High School Block
UKTCap	Topeka. State Capitol
UKWA	Wichita. Wichita Art Museum

	--Kentucky
UKyCovM	Covington. St. Mary's Cathedral
UKyFCap	Frankfort. State Capitol
UKyFH	----- Kentucky Historical Society
UKyH	Hodgensville
UKyLA	Louisville. Temple Adath Jeshurun
UKyLC	----- Cherokee Park
UKyLS	----- J. B. Speed Art Museum
UKyPJ	Paducah. Jefferson and 18th Streets Intersection

	--Louisiana
ULaBCap	Baton Rouge. State Capitol
ULaNA	New Orleans. Isaac Delgado Museum of Art
ULaNL	----- St. Louis Cemetery
ULaNM	----- Louisiana State Museum
ULaNMid	----- Middle American Research Institute
ULaNU	----- Union Passenger Terminal Plaza

	--Massachusetts
UMAP	Andover. Phillips Academy. Addison Gallery of American Art
UMAmA	Amherst. Amherst College. Mead Art Building
UMArR	Arlington. Robbins Memorial Park
UMAuC	Auburn. Cemetery
UMB	Boston. Boston Museum of Fine Arts
UMBA	----- Boston Atheneum
UMBB	----- Back Bay Fens
UMBC	----- Boston Common
UMBCo	----- Commonwealth Avenue
UMBCon	----- New England Conservatory of Music
UMBCons	----- Consolidated Gas Building
UMBCoo	----- Coll. Ananda K. Coomaraswamy
UMBCr	----- Coll. Mr. and Mrs. Henry C. Crapo
UMBF	----- Forest Hills Cemetery
UMGFC	----- Fenway Court

UMBFH	Boston. Faneuil Hall
UMBG	----- Public Gardens
UMBGa	----- Isabella Stewart Gardner Museum
UMBGr	----- Granary Burying Grounds
UMBH)	----- Massachusetts Historical Society
UMGHS)	
UMBK	----- King's Chapel
UMBMc	----- Coll. Mrs. Q. A. Shaw McKean
UMBMi	----- Boris Mirski Gallery
UMBO	----- Coll. 180 Corporation
UMBOS	----- Old State House
UMBP	----- Coll. Stephen D. Paine
UMBPL	----- Boston Public Library
UMBPS	----- Phipps Street Burying Ground
UMBPa	----- Park Square
UMBPac	----- Pace Gallery
UMBR	----- Coll. Mr. and Mrs. Perry T. Rathbone
UMBS	----- Scollay Square
UMBSh	----- Shore Galleries
UMBSo	----- Boston Society
UMBSol	----- Coll. Mr. and Mrs. Richard Solomon
UMBSt	----- Old State House
UMBSw	----- Swetzoff Gallery
UMBSwa	----- Coll. Mrs. Georg Swarzenske
UMCA	Cambridge. Mt. Auburn Cemetery
UMCB	----- Busch-Reisinger Museum
UMCC	----- St. Catherine's Church
UMCCa	----- Coll. Harriet Hosmer Carr
UMCCo	----- First Church of Cambridge Congregational
UMCF	----- Fogg Art Museum
UMCH	----- Harvard University
UMCHG	----- Harvard University. Biological Laboratory
UMCHC	----- ----- College Library
UMCHG	----- ----- Graduate Center
UMCHL	----- ----- Law School
UMCHR	----- ----- Robinson Hall
UMCM	----- Massachusetts Institute of Technology
UMCMC	----- ----- Chapel
UMCMt	----- Mt. Auburn Cemetery
UMCP	----- Peabody Museum of Archaeology and Ethnology
UMCR	----- Coll. Mr. and Mrs. Perry T. Rathbone
UMCRo	----- Coll. B. Rowland
UMCS	----- Coll. Sachs

UMCSe	Cambridge. Semitic Museum
UMChO	Chatham. Col. Elliott Orr
UMCha	Charlemonte, West of Shunpike Bridge
UMCheW	Chestnut Hill. Coll. Mr. and Mrs. Max Wasserman
UMCoL	Concord. Concord Free Public Library
UMCoS	----- Sleepy Hollow Cemetery
UMCohL	Cohasset. Coll. Harry V. Long
UMF	Fitchburg
UMGG	Groton. Groton School
UMGlA	Gloucester. Cape Ann Scientific, Literary and Historical Association
UMHF	Harvard. Fruitlands Museum
UMHa	Haverhill
UMHoJ	Holyoke. St. Joseph Hospital Chapel
UMJ	Jamaica Pond
UML	Lowell
UMLaC	Lawrence. Chemical-Plastic Division, General Tire and Rubber Company
UMLexT	Lexington. Town Hall
UMMR	Medford. Isaac Royall Mansion
UMMaS	Manchester. Stark Park
UMMarH	Marblehead. Marblehead Historical Society
UMMe	Methuen
UMMi	Milton
UMNSA	Northampton. Smith College. Museum of Art
UMNaE	Nantucket. Coll. Mrs. Edward H. Evans
UMNeCSt	Newton Center. Coll. Mr. and Mrs. Stephen A. Stone
UMNeS	Newton. Temple Shalom
UMNeW	----- Coll. Mr. and Mrs. Max Wassermann
UMNewC	----- Centre Street Burying Ground
UMNewO	New Bedford. Old Dartmouth Historical Society and Whaling Station
UMNoP	Norwood. Coll. G. A. Plimpton
UMPC	Plymouth. Cole's Hill
UMPP	----- Pilgrim Hall
UMPiB	Pittsfield. Berkshire Museum
UMPrG	Princeton. Albart Garganigo, Museum of Antique Autos
UMProC	Provincetown. Chrysler Art Museum
UMQG	Quincy. Granite Railway Company
UMSaE	Salem. Essex Institute
UMSaP	----- Peabody Museum
UMSoD	South Hadley. Mt. Holyoke College. Dwight Art Memorial
UMSouD	Southbridge. Wells Historical Museum
UMSpA	Springfield. Museum of Fine Arts

UMSpB	Springfield. Coll. Dr. and Mrs. Malcolm W. Bick
UMSpBe	----- Temple Beth El
UMSpBi	----- Coll. Mr. Raymond A. Bidwell
UMSpBu	----- Coll. H. Wesson Bull, Jr.
UMSpTB	----- Temple Beth El
UMStO	Sturbridge. Old Sturbridge Village
UMStoC	Stockbridge. Chesterwood--Studio of Daniel Chester French
UMSwT	Swampscott. Temple Israel
UMWA	Worcester. Worcester Art Museum
UMWAS	----- American Antiquarian Society
UMWE	----- Elm Park
UMWH	----- John Woodman Higgins Armory
UMWHS	----- Worcester Historical Society
UMWaB	Waltham. Brandeis University
UMWe	Wellfleet
UMWelC	Wellesley. Wellesley College. Farnsworth Museum of Art; Jewett Art Center
UMWelCL	----- ----- Wellesley College Library
UMWesD	Westwood. Coll. Richard L. Davisson
UMWh	Whittinsville
UMWiB	Williamstown. Coll. Mr. and Mrs. Laurence Bloedel
UMWiC	----- Sterling and Francine Clark Art Institute
UMWiL	----- Williams College. Lawrence Art Museum
	--Maryland
UMdAN	Annapolis. United States Naval Academy
UMdBC	Baltimore. Colonial Dames of America, Chapter 1
UMdBF	----- Friends of Art
UMdBG	----- Greenmount Cemetery
UMdBH	----- Hebrew Congregation
UMdBJ	----- Johns Hopkins University
UMdBM	----- Baltimore Museum of Art
UMdBMH	----- Baltimore Historical Society
UMdBMay	----- Coll. Saidie A. May
UMdBMo	----- Morgan State College
UMdBO	----- Temple Oheb Shalom
UMdBP	----- Peabody Institute
UMdBPM	----- Peale Museum
UMdBV	----- Mt. Vernon Square
UMdBW	----- Walters Art Gallery
UMdBWu	----- Coll. Mr. and Mrs. Alan Wurtzburger
UMdF	Fort Lincoln. Cemetery

UMdFr	Frederick
UMdHW	Hagerstown. Museum of Fine Arts of Washington County
UMdPW	Pikesville. Coll. Mr. and Mrs. Alan Wurtzburger

--Maine

UMeBS	Bath. Loyall Sewall
UMeBrB	Brunswick. Bowdoin College. Museum of Fine Arts
UMeES	East Sullivan. Coll. Mrs. John Spring
UMeKB	Kennebunkport. Boat House Museum
UMeNB	Nobleboro. Coll. Mr. and Mrs. Henry Beston
UMeOA	Ogunquit. Museum of Art
UMeOL)	----- Coll. Robert Laurent
UMeOR)	
UMeP	Portland
UMeRR	Rockland. Coll. David Rubenstein

--Michigan

UMiAUA	Ann Arbor. University of Michigan. Art Gallery
UMiBC	Bloomfield Hills. Cranbrook Academy Museum
UMiBiC	Birmingham. Coll. Dr. and Mrs. Meyer O. Cantor
UMiBiW	----- Coll. Mr. and Mrs. Harry Lewis Winston
UMiBloC	Bloomfield Hills. Cranbrook Academy of Art
UMiCC	Cranbrook. Christ Church
UMiCI	----- Cranbrook Institute of Science
UMiCad	Cadillac
UMiD	Detroit. Institute of Arts
UMiDAth	----- Detroit Athletic Club
UMiDE	----- Eastland Center
UMiDF	----- Coll. Dr. G. Frohlicher
UMiDFe	----- Feinberg Collection
UMiDFl	----- Coll. Mr. and Mrs. Lawrence A. Fleischman
UMiDFo	----- Coll. Mr. and Mrs. Edsel B. Ford
UMiDFor	----- Coll. Mr. and Mrs. Walter B. Ford II
UMiDFr	----- Coll. Mrs. Michael Freeman
UMiDG	----- General Motors Plant (UMiWaG)
UMiDH	----- J. L. Hudson Gallery
UMiDK	----- Coll. Dr. George Kamperman
UMiDW	----- Coll. Mr. and Mrs. Harry Lewis Winston

UMiDbE	Dearborn. Edison Institute
UMiDbFM	----- Henry Ford Museum and Greenfield Village
UMiFB	Flint. Coll. Mrs. Everett L. Bray
UMiGN	Grosse Point. Coll. John S. Newberry
UMiGT	Grosse Pointe Farms. Coll. Robert H. Tannahill
UMiH	Mississippi. Hall of Fame
UMiI	Ironwood
UMiK	Kalamazoo
UMiL	L'Anse (Near). Site of Old Baraga Mission
UMiMH	Muskegon. Hackley Park
UMiPD	Pleasant Ridge. Coll. Dr. and Mrs. Brewster Broder
UMiPP	----- Coll. Mr. and Mrs. Max J. Pincus
UMiPoC	Pontiac. City Hall
UMiWaG	Warren. General Motors Technical Center (UMiDG)
UMiWpa	W. P. A. Art Program
UMiY	Ypsilanti

--Minnesota

UMnCJ	Collegeville. St. John's Abbey Church
UMnD	Duluth
UMnMC	Minneapolis. Coll. Mr. and Mrs. Morris Chalfen
UMnMD	----- Coll. Mr. and Mrs. Bruce B. Dayton
UMnMF	----- Church of St. Francis Xavier Cabrini
UMnMI	----- Minneapolis Institute of Arts
UMnMM	----- Minnehaha Creek, approximately 100' above Minnehaha Falls
UMnMP	----- Coll. Alfred F. Pillsbury
UMnMPL	----- Minneapolis Public Library
UMnMR	----- Coll. Mr. and Mrs. John Rood
UMnMU	----- University of Minnesota
UMnMW	----- Walker Art Center
UMnRA	Red Wing. Coll. John P. Anderson
UMnR	Red Lake River, 8 miles west of Red Lake Falls, or 13-1/2 miles northeast of Crookston
UMnStPB	St. Paul. Temple B'nai Aaron
UMnStPC	----- City Hall
UMnStPCo	----- Cochran Park
UMnStPM	----- Temple Mount Zion
UMnStPR	----- Coll. E. R. Rieff
UMnWD	Wayzata. Coll. Mr. and Mrs. Richard S. Davis
UMnWi	Winona

	--Missouri
UMoA	St. Louis. Art Palace
UMoC	George Washington Carver National Monument
UMoKB	Kansas City. Coll. James Baldwin
UMoKF	----- Findlay Galleries
UMoKNG	----- William Rockhill Nelson Gallery,
	Atkins Museum
UMoKP	----- Penn Valley Park
UMoKUP	----- University of Kansas City Park
UMoKY	----- Yellow Transit Freightlines
UMoSD	St. Louis. Coll. Lionberger Davis
UMoSF	----- Forest Park
UMoSFe	----- Federal Building
UMoSL	----- City Art Museum
UMoSLA	----- Aloe Plaza
UMoSLG	----- Coll. Vladimir Goischmann
UMoSLH	----- Missouri Historical Society
UMoSLM	----- Mercantile Library
UMoSLMa	----- Coll. Mr. and Mrs. Morton D. May
UMoSLMe	----- Memorial Building
UMoSLP	----- Coll. Joseph Pulitzer, Jr.
UMoSLPf	----- Coll. Mrs. Henry Pflager
UMoSLS	----- Coll. Mrs. Mark C. Steinberg
UMoSLSo	----- Coll. Dr. Conrad Sommer
UMoSLWa	----- Washington University
UMoSLWe	----- Coll. Mr. and Mrs. Richard K. Weil
UMoSLa	----- Lafayette Park
UMoSW	----- Washington University. Art Collection
UMoSpA	Springfield. Springfield Museum of Art
UMoT	Tupelo
	--Mississippi
UMsCPo	Carthage. Post Office
	--Montana
UMtB	Big Hole. Battlefield National Monument
UMtBuC	Butte. W. A. Clarke House
	--New York
UNAS	Auriesville. Shrine of North American
	Martyrs
UNA1B	Albany. Temple Beth Emeth
UNA1E	----- New York State Museum, State Educa-
	tion Building
UNA1I	----- Albany Institute of History and Art
UNArG	Ardsley. Geigy Pharmaceuticals
UNAu	Auburn
UNBB	Brooklyn. Brooklyn Museum

UNBBa	Brooklyn. Coll. Dr. Avrom Barnett
UNBC	----- Courthouse
UNBE	----- Eastern Parkway at Bedford Avenue
UNBG	----- Grant Square
UNBGar	----- Garfield Restaurant
UNBHP	----- Borough Hall Park
UNBL	----- Coll. Mr. and Mrs. Menahem Lewin
UNBMA	----- Brooklyn Memorial Arch
UNBP	----- Prospect Park
UNBiR	Binghamton. Roberson Memorial Center
UNBoS	Bolton Landing. Coll. David Smith
UNBrB	Brewster. Chester Beach Memorial Studio
UNBroL	Brookhaven. Coll. Mr. and Mrs. Knute D. Lee
UNBuA	Buffalo. Albright-Knox Art Gallery
UNBuF	----- Forest Lawn Cemetery
UNBuG	----- Guaranty Building
UNBuGo	----- James Goodman Gallery
UNBuHS	----- Buffalo and Erie County Historical Society
UNBuMS	----- Museum of Science
UNBuT	----- Coll. Mr. and Mrs. David A. Thompson
UNCV	Centerport. Vanderbilt Museum
UNCooF	Cooperstown. Fenimore House and Farmers' Museum
UNCooHS	----- New York State Historical Society
UNCooJ	----- Coll. Louis C. Jones
UNCooL	----- Lakewood Cemetery
UNCooO	----- Otsego Hall Site
UNCorC	Corning. Corning Museum of Glass
UNEE	Elmira. Elmira College
UNFC	Forest Hills. Forest Hills Cemetery
UNFI	----- Temple Isaiah
UNGA	Great Neck. Coll. Lester Avnet
UNGB	----- Temple Beth El
UNGE	----- Congregation of Temple Emanuel
UNGK	----- Coll. Mr. and Mrs. Harold Kaye
UNGS	----- Coll. Mr. and Mrs. Robert C. Scull
UNGaA	Garden City. Adelphi University
UNGeH	Geneva. Hobart College
UNGlH	Glen Falls. Hyde Coll.
UNGloS	Gloversville. Coll. Mr. and Mrs. Jacob Schulman
UNHG	Harrison. Coll. Mr. and Mrs. Kurt H. Grunebaum
UNHaC	Hamilton. Colgate University
UNHasS	Hastings-on-Hudson. Coll. Irene and Jan Peter Stern

UNHi	Hicksville
UNHoM	Hoosick Falls. Coll. George S. McKearin
UNHuF	Hudson. American Museum of Fire Fighting
UNHyR	Hyde Park. Franklin D. Roosevelt National Historical Site
UNIC	Ithaca. Cornell University
UNICM	----- ----- Medical School
UNICW	----- ----- Andrew Dickson White Museum of Art
UNKJ	Kingston. Coll. Fred J. Johnston
UNKS	----- Senate House and Senate House Museum
UNKijR	Kifkuit. John D. Rockefeller Hudson River Estate
UNKinS	Kings Point. Coll. Mr. and Mrs. Rudolph B. Schulhof
UNLF	Lake George. Fort George Park
UNLL	----- Lake George Battleground
UNLaK	Lawrence. Coll. Leon Kraushar
UNMW	Manhasset. Payne Whitney Bird Garden
UNMi	Mineola
UNMilB	Millburn. B'nai Israel Synagogue
UNMoS	Mountainville. Storm King Art Center
UNNA	New York City. Coll. Lisa Arnhold
UNNAC	----- A. C. A. Gallery
UNNAb	----- Coll. Abrams Family
UNNAd	----- Coll. James S. Adams
UNNAdr	----- Adria Art Gallery
UNNAl	----- Alan Gallery; Landau-Alan Gallery
UNNAld	----- Coll. Larry Aldrich
UNNAmA	----- American Academy of Arts and Letters
UNNAmM	----- American Museum of Natural History
UNNAmN	----- American Numismatic Society
UNNAmT	----- American Tobacco Company
UNNAme	----- Amel Gallery
UNNAn	----- David Anderson Gallery
UNNAp	----- Appellate Court Building
UNNArn	----- Coll. Mrs. Lisa Arnhold
UNNAs	----- Astor Place
UNNAu	----- Coll. Mr. and Mrs. Lee A. Ault
UNNB	----- Grace Borgenicht Gallery
UNNBa	----- Coll. Bay
UNNBak	----- Coll. Walter C. Baker
UNNBake	----- Coll. Richard Brown Baker
UNNBaker	----- Baker Coll.
UNNBakerl	----- Coll. R. Lynn Baker
UNNBan	----- Banfer Gallery
UNNBar	----- St. Bartholomew's Church
UNNBarb	----- Coll. Joel Barber

UNNBaro	New York City. Barone Gallery
UNNBat	----- Battery Park
UNNBe	----- Coll. Martin Becker
UNNBec	----- Coll. Mr. and Mrs. Ian Beck
UNBBel	----- Coll. Richard Bellamy
UNNBen	----- Coll. Mr. and Mrs. Robert M. Benjamin
UNNBene	----- Coll. Mr. and Mrs. Charles B. Benenson
UNNBi	----- Coll. Alexander M. Bing
UNNBia	----- Bianchini Gallery
UNNBir	----- Coll. Dr. Junius B. Bird
UNNBiri	----- Coll. Ben Birillo
UNNBl	----- Coll. Dr. Henry L. Blank
UNNBla	----- Coll. Jacob Blaustein
UNNBli	----- Coll. Donald M. Blinken
UNNBlu	----- Blumenthal Coll.
UNNBlum	----- Coll. Ruth and Leopold Blumka
UNNBo	----- Coll. Alice Boney
UNNBon	----- Bonwit Teller Building
UNNBoni	----- Galeria Bonino
UNNBow	----- Bowling Green
UNNBoy	----- Boyer Galleries
UNNBr G	----- Bronx Grand Concourse
UNNBr H	----- Bronx Municipal Hospital Group
UNNBr R	----- Bronx River
UNNBro	----- Coll. Mr. and Mrs. Jerome Brody
UNNBroa	----- Broadway and 73rd Street Intersection
UNNBroad	----- Broadway and 63rd Street Intersection
UNNBru	----- Brummer Galleries
UNNBry	----- Bryant Park
UNNBu	----- Buchholz Gallery
UNNBur	----- Coll. Mr. and Mrs. William A. M. Burden
UNNBy	----- Byron Gallery
UNNByk	----- Bykert Gallery
UNNC	----- Leo Castelli Gallery; Coll. Mr. and Mrs. Leo Castelli
UNNCC	----- New York State Chamber of Commerce
UNNCR	----- Columbia Records
UNNCT	----- Collins Tuttle and Company
UNNCa	----- Carstairs Gallery
UNNCag	----- Coll. John Cage
UNNCah	----- Coll. Holger Cahill
UNNCal	----- Coll. Mrs. Mary Callery
UNNCar	----- Carlebach Gallery
UNNCarr	----- Coll. W. Frederick Carreras
UNNCart	----- Coll. Dagny Carter

UNNCas	New York City. Castellano Gallery
UNNCat	----- Coll. T. Catesby Jones
UNNCc	----- Columbia Circle
UNNCent	----- Central Park
UNNCent M	----- Central Park Mall
UNNCh	----- Galerie Chalette
UNNCha	----- Channin Building, 42nd Street and Lexington Avenue
UNNChan	----- Margit Chanin, Ltd.
UNNChas	----- Chase Manhattan Bank, 410 Park Avenue
UNNChasP	----- Chase Plaza
UNNChr	----- Coll. Walter P. Chrysler, Jr.
UNNChri	----- Coll. Lansdell K. Christie
UNNCi	----- Museum of the City of New York
UNNCit	----- City Hall Park
UNNCity	----- City College
UNNCl	----- Coll. Stephen C. Clark
UNNCla	----- Claremont Avenue and 122nd Street Intersection
UNNCo	----- Columbia University
UNNCoE	----- ----- Earl Hall
UNNCob	----- Cober Gallery
UNNCoh	----- Coll. Mr. and Mrs. Erich Cohn
UNNCohe	----- Coll. Mr. and Mrs. Wilfred P. Cohen
UNNCol	----- College of the City of New York
UNNColi	----- Coll. Mr. and Mrs. Ralph F. Colin
UNNCon	----- The Contemporaries
UNNCoo	----- Cooper Union Museum; Cooper Square
UNNCor	----- Cordier & Ekstrom
UNNCot	----- Cottier & Company
UNNCr	----- Coll. Louise Crane
UNNCro	----- Coll. Frank Crowninshield
UNNCu	----- New York Custom House
UNNCun	----- Coll. John J. Cunningham
UNND	----- Downtown Gallery
UNNDa	----- Daily News Building
UNNDar	----- D'Arcy Gallery
UNNDe	----- Coll. Mr. and Mrs. Pierre Delfausse
UNNDeN	----- Tibor de Nagy Gallery
UNNDel	----- Delexi Gallery
UNNDi	----- Terry Dintenfass Gallery
UNNDik	----- Coll. Mr. and Mrs. Charles M. Diker
UNNDo	----- Downtown Gallery
UNNDoc	----- Coll. Dr. and Mrs. Frederick J. Dockstader
UNNDor	----- Dorsky Gallery
UNNDr	----- Coll. Katherine Dreier
UNNDu	----- Coll. John A. Dunbar

UNNDuv	New York City. Coll. Albert Duveen
UNNDw	----- Dwan Gallery
UNNE	----- Egan Gallery
UNNEl	----- Robert Elkon Gallery
UNNEli	----- Coll. Eliot Elisofon
UNNElk	----- Coll. Mr. and Mrs. Herman Elkon
UNNEm	----- Andre Emmerich Gallery
UNNEmi	----- Coll. Mr. and Mrs. Allan D. Emil
UNNEn	----- American Enka Corporation
UNNEr	----- Coll. Hobe Erwin
UNNEri	----- Coll. Ernest Erickson
UNNErl	----- Coll. Mr. and Mrs. Arthur L. Erlanger
UNNF	----- Frick Collection
UNNFa	----- Coll. Mr. and Mrs. Myron S. Falk-Jun
UNNFar	----- Coll. Farragut Junior High School
UNNFe	----- Federal Hall Memorial
UNNFei	----- Richard Feigen Gallery
UNNFein	----- Charles Feingarten Galleries
UNNFer	----- Ferargil Galleries
UNNFerb	----- Coll. Mr. and Mrs. Herbert Ferber
UNNFi	----- Fine Arts Associates
UNNFie	----- Coll. Mr. and Mrs. Leonard S. Field
UNNFis	----- Fischback Gallery
UNNFl	----- Flushing Meadow Park
UNNFo	----- Fort Greene Park
UNNFor	----- Coll. Dr. James A. Ford
UNNForm	----- Forum Gallery
UNNFou	----- Four Seasons Restaurant
UNNFr	----- Coll. Dr. Maurice Fried
UNNFra	----- Allan Franklin Gallery
UNNFre	----- French and Company
UNNFri	----- Rose Fried Gallery
UNNFru	----- Allan Frumkin Gallery
UNNFur	----- Coll. Dr. and Mrs. Irving Furman
UNNFut	----- Coll. Futterman Corporation
UNNG	----- Solomon R. Guggenheim Museum
UNNGal	----- Coll. A. E. Gallatin
UNNGan	----- Coll. Mr. and Mrs. Victor W. Ganz
UNNGe	----- Otto Gerson Gallery
UNNGel	----- Coll. Henry Geldzahler
UNNGer	----- Coll. George Gershwin
UNNGl	----- Coll. Mr. and Mrs. Arnold B. Glimcher
UNNGo	----- Coll. A. Conger Goodyear
UNNGol	----- Coll. Noah Goldowsky and Richard Bellamy
UNNGoo	----- Coll. Philip L. Goodwin
UNNGood	----- Coll. Jerome Goodman

UNNGr	New York City. Grand Central Art Galleries
UNNGra	----- Gramercy Park
UNNGrah	----- Graham Gallery
UNNGran	----- Grant Boulevard and 161st Street Intersection
UNNGrand	----- Grand Central Moderns
UNNGre	----- Greely Square
UNNGree	----- Green Gallery
UNNGreen	----- Coll. Sarah Dora Greenberg
UNNGri	----- Grippi and Waddell Gallery
UNNGro	----- Coll. Chaim Gross
UNNGru	----- Coll. Mr. and Mrs. B. Sumner Gruzen
UNNGu	----- Coll. B. C. Guennol
UNNGua	----- Guaranty Trust Company
UNNGutm	----- Coll. Melvin Gutman
UNNH	----- Coll. Joseph H. Hirshhorn
UNNHF	----- Hall of Fame for Great Americans, New York University
UNNHS	----- New York Historical Society
UNNHa	----- Coll. Laura Harden
UNNHah	----- Stephen Hahn Gallery
UNNHal	----- Coll. Hiram J. Halle
UNNHan	----- Hansa Gallery
UNNHanc	----- Hancock Square
UNNHar	----- Coll. Mr. and Mrs. S. Hartman
UNNHard	----- Coll. Laura Harden
UNNHarl	----- Harlem River Houses
UNNHarm	----- Harmon Foundation
UNNHarn	----- Coll. Mr. and Mrs. Rene d'Harnoncourt
UNNHas	----- Coll. Haskell
UNNHau	----- Coll. Mrs. Ira Haupt
UNNHe	----- Coll. Mr. and Mrs. Maxime L. Hermanos
UNNHea	----- Coll. William Randolph Hearst
UNNHee	----- Coll. Mr. and Mrs. Nasli M. Heeramaneck; Heeramaneck Galleries
UNNHel	----- Coll. Dr. and Mrs. Julius S. Held
UNNHell	----- William Heller, Inc.
UNNHer	----- Herald Square
UNNHew	----- Coll. Robert Hewitt
UNNHis	----- Hispanic Society of America
UNNHo	----- Coll. Mrs. C. R. Holmes
UNNHous	----- New York City Housing Project
UNNHu	----- Coll. Rev. Robert C. Hunsicker
UNNHy	----- Coll. Mrs. Louis F. Hyde
UNNI	----- Alexander Iolas Gallery
UNNIb	----- Coll. International Business Machines
UNNIn	----- International Nickel Company

UNNInAI	New York City. New York International Airport. International Arrivals Building
UNNInB	----- Coll. International Business Machines
UNNIs	----- Coll. Mr. and Mrs. Joseph S. Iseman
UNNJ	----- Martha Jackson Gallery; Coll. Martha Jackson
UNNJa	----- Sidney Janis Gallery
UNNJac	----- Coll. Mr. and Mrs. Martin D. Jacobs
UNNJan	----- Coll. Sidney Janis
UNNJe	----- Jewish Museum
UNNJo	----- Galerie Alexander Jolas
UNNJoh	----- Coll. Philip C Johnson
UNNJohn	----- Cathedral of St. John the Divine
UNNJon	----- Coll. T. Catesby Jones
UNNJos	----- Coll. Mr. and Mrs. Samuel Josefowitz
UNNJu	----- Coll. Charles S. Jules
UNNK	----- M. Knoedler and Company
UNNKa	----- Coll. William Kaufman
UNNKag	----- Coll. Mr. and Mrs. Illi Kagan
UNNKau	----- Coll. Edgar Kaufmann
UNNKe	----- Coll. Kevorkian
UNNKen	----- Coll. Messrs. Kennedy-Garber
UNNKl	----- Kleemann Galleries
UNNKle	----- J. J. Klejman
UNNKley	----- Kleykamp Collection
UNNKlo	----- Coll. Mr. and Mrs. A. J. T. Kolman
UNNKo	----- Samuel M. Kootz Gallery; Coll. Mr. and Mrs. Samuel Kootz
UNNKor	----- Kornblee Gallery
UNNKou	----- Coll. Fahim Kouchakji
UNNKr	----- Kraushaar Galleries; Coll. Leon Kraushaar
UNNL	----- Coll. Fritz Low-Beer
UNNLI	----- Liberty Island
UNNLa	----- Isabel Lachaise Estate (Felix Landau Gallery, Los Angeles, and Robert Schoelkopf Gallery, New York City)
UNNLad	----- Coll. Mr. and Mrs. Harold Ladas
UNNLaf	----- Lafayette Park and Washington
UNNLam	----- Coll. Mr. B. Lambert
UNNLas	----- Coll. Mrs. Imbram Lassaw
UNNLe	----- Lejva Coll.
UNNLef	----- Lefebre Gallery
UNNLefe	----- Coll. Mr. and Mrs. John Lefebre
UNNLeh	----- Coll. Robert Lehman
UNNLei	----- Fred Leighton, Inc.
UNNLev	----- Mortimer Levitt Gallery
UNNLevi	----- Coll. Mr. and Mrs. Irving Levick

UNNLevy	New York City. Coll. Julien Levy; Julien Levy Gallery
UNNLew	----- Coll. Adolph Lewisohn
UNNLi	----- Coll. Mr. and Mrs. Albert List
UNNLie	----- Coll. Mrs. Charles J. Liebman
UNNLin	----- Coll. Mr. and Mrs. Jack Linsky
UNNLinc	----- Lincoln Center, New York State Theatre
UNNLip	----- Coll. Mr. and Mrs. Howard W. Lipman
UNNLipc	----- Coll. Jacques Lipchitz
UNNLiv	----- Museum of Living Art
UNNLo	----- Coll. R. Loewy
UNNLoe	----- Albert Loeb Gallery
UNNLoo	----- Formerly Coll. C. T. Loo
UNNLow	----- Coll. Mr. and Mrs. Milton Lowenthal
UNNLu	----- Edward R. Lubin, Inc.
UNNM	----- Pierpont Morgan Library
UNNMAI	----- Museum of the American Indian
UNNMB	----- Manhattan East River Bridge
UNNMC	----- Museum of the City of New York
UNNMEA	----- Museum of Early American Folk Arts
UNNMG	----- Midtown Galleries
UNNMM	----- Metropolitan Museum of Art
UNNMMA	----- Museum of Modern Art
UNNMMC	----- ----- The Cloisters
UNNMPA	----- Museum of Primitive Art
UNNMa	----- Marlborough-Gerson Gallery
UNNMac	----- Coll. Mrs. Clarence H. Mackay
UNNMad	----- Madison Square; Madison Square Garden
UNNMan	----- Manufacturers' (Hanover) Trust Company
UNNMar	----- Marine Museum
UNNMark	----- Royal S. Marks Gallery
UNNMart	----- Coll. Bradley Martin
UNNMas	----- Masonic Temple
UNNMat	----- Pierre Matisse Gallery
UNNMatC	----- Coll. Mr. and Mrs. Pierre Matisse
UNNMay	----- Mayer Gallery
UNNMi	----- James A. Michener (Foundation)
UNNMid	----- Midtown Gallery
UNNMil	----- Coll. Mrs. David M. Milton
UNNMo	----- Coll. Earl Morse
UNNMo	----- Former Coll. J. Pierpont Morgan
UNNMoh	----- Coll. Sybil Moholy-Nagy
UNNMor	----- Coll. Charles Lucien Morley
UNNMorn	----- Morningside Avenue and 116th Street Intersection

UNNMu	New York City. Coll. Warner Munsterberger
UNNMul	----- Coll. Mr. and Mrs. Aladar Mulhoffer
UNNN	----- National Academy of Design
UNNNS	----- National Sculpture Society
UNNNa	----- Coll. Dene Ulin Nathan
UNNNag	----- Tibor de Nagy Gallery
UNNNas	----- Lillian Nassau Antiques
UNNNe	----- Coll. Mr. and Mrs. Roy R. Neuberger
UNNNeg	----- Coll. T. S. and J. D. Negus
UNNNeu	----- Coll. J. B. Neuman
UNNNew	----- Coll. Arnold Newman
UNNNi	----- Nierendorf Gallery
UNNNo	----- Leo Nordness Galleries
UNNO	----- Olivetti Showroom
UNNOd	----- Galleria Odyssia
UNNP	----- Coll. I. M. Pei
UNNPL	----- New York City Public Library
UNNPa	----- Betty Parsons Gallery; Coll. Mrs. Betty Parsons
UNNPac	----- Pace Gallery
UNNPach	----- Coll. Mrs. Nikifora L. Pach
UNNPan	----- Pan-American Building
UNNPar	----- Parma Gallery
UNNPark	----- Coll. Mrs. Bliss Parkinson
UNNParkp	----- Park Place Gallery
UNNPas	----- Georgette Passedoit Gallery
UNNPau	----- Coll. Mr. and Mrs. David Paul
UNNPe	----- Peridot Gallery
UNNPear	----- Coll. Mr. and Mrs. Henry Pearlman
UNNPed	----- Coll. Mrs. William A. Pedlar
UNNPen	----- Coll. Helen Penrose
UNNPenr	----- Penrose & Edgette
UNNPer	----- Perls Gallery
UNNPerl	----- Coll. Katherine M. Perls
UNNPerr	----- Coll. Mr. and Mrs. Hart Perry
UNNPers	----- Perspectives Gallery
UNNPet	----- Coll. Eric N. Peters
UNNPl	----- Players' Club
UNNPly	----- United States Plywood Company
UNNPo	----- Poe Cottage and Park
UNNPoi	----- Poindexter Gallery
UNNPol	----- Coll. Mrs. Frances M. Pollack
UNNPr	----- Printing House Square
UNNPs	----- Public School No. 34
UNNR	----- Paul Rosenberg & Company
UNNRa	----- Stephen Radich Gallery
UNNRad	----- Radio City. Music Hall
UNNRadT	----- ----- Time & Life Building

UNNRan	New York City. Randall House
UNNRay	----- Coll. Mrs. Bernard E. Raymond
UNNRe	----- Coll. Mr. and Mrs. Bernard J. Reis
UNNReh	----- Frank K. M. Rehn Gallery
UNNRei	----- Coll. Mr. and Mrs. P. Reinhardt
UNNRes	----- Coll. Mrs. Resor
UNNReu	----- Reuben Gallery
UNNRey	----- Coll. Jeanne Reynal
UNNRi	----- Riverside Drive
UNNRie	----- Coll. Mr. and Mrs. Victor S. Riesenfeld
UNNRiv	----- Riverside Park
UNNRo	----- Coll. Nelson A. Rockefeller
UNNRoIII	----- Coll. Mrs. John D. Rockefeller, III
UNNRob	----- Sara Roby Foundation
UNNRoc	----- Rockefeller Center; Rockefeller Plaza
UNNRocIII	----- Coll. John D. Rockefeller, III
UNNRocA	----- Rockefeller Center. Associated Press Building
UNNRocIn	----- ----- International Building
UNNRocR	----- ----- RCA Building
UNNRocU	----- ----- United States Rubber Company Building
UNNRocl	----- Coll. Laurence Rockefeller
UNNRoj	----- Coll. John D. Rockefeller, Jr.
UNNRojm	----- Coll. Mrs. John D. Rockefeller, Jr.
UNNRok	----- Roko Gallery
UNNRos	----- Coll. Mrs. Blanche B. Rosett
UNNRose	----- Coll. Billy Rose
UNNRosen	----- Paul Rosenberg & Company
UNNRoss	----- Coll. Mr. and Mrs. Walter Ross
UNNRossa	----- Coll. Mr. and Mrs. Arthur Ross
UNNRu	----- Coll. Helena Rubenstein
UNNRub	----- Coll. William Rubin
UNNRum	----- Coll. Mrs. Charles Cary Rumsey
UNNRy	----- Coll. Sally Ryan
UNNS	----- Jacques Seligmann & Company
UNNSC	----- Sculpture Center (Clay Club)
UNNSa	----- Coll. Mark M. Salton
UNNSai	----- Saidenberg Gallery; Coll. Mr. and Mrs. Daniel Saidenberg
UNNSal	----- Coll. L. J. Salter
UNNSalp	----- Salpeter Gallery
UNNSar	----- Coll. Mr. and Mrs. Robert W. Sarnoff
UNNSc	----- Coll. Mr. and Mrs. John B. Schulte
UNNSch	----- Coll. Baron von Schoeler
UNNScha	----- Bertha Schaefer Gallery
UNNSchi	----- Coll. Norbert Schimmel

UNNSchin	New York City. Coll. Gustave Schindler
UNNScho	----- Robert Schoelkopf Gallery
UNNSchw	----- Coll. Mr. and Mrs. Seymour Schweber
UNNSchwa	----- Charles M. Schwab Residence
UNNSchwar	----- Coll. Mr. and Mrs. Eugene M. Schwartz
UNNScu	----- Coll. Robert C. Scull
UNNSe	----- Segy Gallery
UNNSeg	----- Coll. Ladislaw Segy
UNNSel	----- Coll. Mr. and Mrs. Wladimir Selinsky
UNNSele	----- Selected Artists Galleries
UNNSev	----- 70th Street and Fifth Avenue Intersection
UNNSh	----- Coll. Herman Schulman
UNNSha	----- Coll. Ben Shahn
UNNSi	----- Coll. Mrs. Kenneth Simpson
UNNSim	----- Coll. Mr. and Mrs. Robert E. Simon, Jr.
UNNSl	----- Charles E. Slatkin Galleries
UNNSli	----- Coll. Mr. and Mrs. Alan B. Slifka
UNNSo	----- Coll. Benjamin Sonnenberg
UNNSol	----- Coll. Dr. A. Solomon
UNNSolo	----- Coll. Mr. and Mrs. Sidney Solomon
UNNSon	----- Coll. Mr. and Mrs. Michael Sonnabend
UNNSp	----- Coll. Charles B. Spencer, Jr.
UNNSt	----- Staempfli Gallery. Coll. Mrs. Emily B. Staempfli
UNNStG	----- St. George, Staten Island
UNNStJ	----- St. John the Divine Cathedral
UNNStM	----- St. Mary-the-Virgin Church
UNNStMa	----- St. Mark's Church-In-the-Bowery
UNNStP	----- St. Paul's Chapel
UNNStT	----- St. Thomas Church
UNNSta	----- Stable Gallery
UNNStam	----- Coll. Theodoros Stamos
UNNStatL	----- Staten Island. Mt. Loretto
UNNSte	----- Coll. Mrs. Jack Stewart
UNNStei	----- Gallery Gertrude Stein
UNNSteic	----- Coll. Kate Rodina Steichen
UNNStep	----- Stephen Wise Towers, New York City Housing Authority
UNNSter	----- Marie Sterner Gallery
UNNSti	----- Coll. Chauncey Stillman
UNNSto	----- Allan Stone Gallery
UNNSton	----- Coll. Mrs. Maurice L. Stone
UNNStr	----- Coll. Mr. and Mrs. Percy S. Straus
UNNStra	----- Coll. Mrs. Herbert N. Straus
UNNStre	----- Coll. Jon Nicholas Streep
UNNSu	----- Coll. Mrs. Cornelius J. Sullivan

UNNSw	New York City. Coll. Mr. and Mrs. James Johnson Sweeney
UNNT	----- Trinity Churchyard
UNNTa	----- Tanager Gallery
UNNTel	----- New York Telephone Building
UNNTh	----- St. Thomas Church
UNNTha	----- E. V. Thaw and Company
UNNTho	----- J. Walter Thompson Company
UNNThor	----- Coll. Mrs. Landon K. Thorne
UNNTi	----- Tishman Realty and Construction Company, 666 Fifth Avenue
UNNTo	----- Pierre Tozzi Gallery
UNNTr	----- Sub-Treasury Building
UNNU	----- Union Square
UNNUL	----- Union League Club
UNNUN	----- United Nations
UNNUS	----- United States Steel Corporation
UNNUn	----- Coll. Irwin Untermeyer
UNNV	----- Curt Valentin Gallery; Estate Curt Valentin
UNNVa	----- Van Cortland Park
UNNVaS	----- ----- Shakespeare Garden
UNNVe	----- Coll. Carl van Vechten
UNNVi	----- Catherine Viviano Gallery
UNNVo	----- Coll. Vogelgesang
UNNW	----- Whitney Museum of American Art
UNNWa	----- Coll. Mrs. Benjamin P. Watson
UNNWad	----- Coll. Jane Wade, Ltd
UNNWadd	----- Waddell Gallery
UNNWag	----- Coll. Samuel Wagstaff, II
UNNWal	----- Wall Street
UNNWalk	----- Maynard Walker Gallery
UNNWar	----- Coll. Mrs. George Henry Warren
UNNWarb	----- Coll. Edward M. M. Warburg
UNNWarbu	----- Coll. Mrs. Felix M. Warburg
UNNWard	----- Coll. Mrs. Eleanor Ward
UNNWarh	----- Coll. Andrew Warhol
UNNWash	----- Washington Arch
UNNWashS	----- Washington Square
UNNWat	----- Coll. Peter Watson
UNNWats	----- Coll. Thomas J. Watson
UNNWe	----- Weyhe Gallery
UNNWei	----- Coll. J. Daniel Weitzman
UNNWein	----- Coll. William H. Weintraub; Weintraub Gallery
UNNWeis	----- Coll. L. Arnold Weissberger
UNNWer	----- Coll. Frederic Wertham
UNNWi	----- Willard Gallery

UNNWil	New York City. Wildenstein & Company
UNNWill	----- Coll. Marian Willard
UNNWin	----- Coll. Mr. and Mrs. Paul S. Wingert
UNNWis	----- Coll. Mr. and Mrs. Howard Wise
UNNWise	----- Howard Wise Gallery
UNNWisej	----- Coll. John Wise
UNNWo	----- World House Galleries
UNNY	----- Coll. Hanford Yang
UNNYam	----- Coll. Messrs. Yamanaka
UNNYo	----- Coll. Mrs. Howard Young
UNNZ	----- Coll. Mr. and Mrs. Charles Zadok
UNNZw	----- Zwemmer Gallery
UNNe	New Rochelle
UNNoF	Northampton. First Church
UNOR	Ogdensburg. Remington Art Memorial
UNOlP	Olcott. Coll. Charles R. Penney
UNOyB	Oyster Bay. Coll. Mr. and Mrs. Joseph L. Braun
UNPR	Pocantico Hills. Coll. John D. Rockefeller
UNPV	Poughkeepsie. Vassar College. Art Museum
UNPaM	Painted Post. Monument Square
UNPeGPo	Penn's Grove. Post Office
UNPoH	Pound Ridge. Coll. H. J. Halle
UNPorK	Port Chester. Congregation Kneses Tifereth Israel
UNQC	Queens. Queens College
UNRW	Roslyn. Coll. Mrs. H. P. Whitney
UNRoA	Rochester. Rochester Museum of Arts and Sciences
UNRoB	----- Chapel B'rith Kodesh
UNRoR	----- University of Rochester. Memorial Art Gallery
UNRocF	Rockville Center. Coll. Mr. and Mrs. Walter Fillin
UNS	Saratoga
UNSaS	Sag Harbor. Suffolk County Whaling Museum
UNSatP	Satterwhite. Coll. Dr. Preston Pope
UNScK	Scarsdale. Coll. Lee A. Kolker
UNSt	Stony Brook
UNSyU	Syracuse. Syracuse University. Lowe Art Center
UNSyo	Syosset, Long Island
UNTB	Tarrytown. Temple Beth Abraham
UNUtM	Utica. Munson-Williams-Proctor Institute
UNWM	Westbury. Coll. Edwin D. Morgan
UNWo	Woodstock
UNYG	Yonkers. Greystone, Samuel Untermeyer Residence

| UNYH | Yonkers. Hudson River Museum |
| UNYM | ----- Memorial Park |

--Nebraska

UNbL	Lincoln. Antelope Park
UNbLCap	----- State Capitol
UNbLP	----- Pioneer's Park
UNbLS	----- Coll. Frederick Seacrest
UNbLU	----- University of Nebraska. Art Gallery
UNbOJ	Omaha. Joslyn Art Museum
UNbOL	----- Lincoln School
UNbOLe	----- Coll. Mr. and Mrs. Robert E. Lee

--North Carolina

-UNcS	Coll. Xanti Schawinskj
UNcCC	Charlotte. Coll. Mrs. Martin Cannon, Jr.
UNcG	Guilford. Courthouse
UNcMtR	Mt. Gilead. Coll. Horace Richter
UncRA	Raleigh. North Carolina Museum of Art
UNcRV	----- Estate Dr. W. R. Valentiner

--North Dakota

UNdBCap	Bismark. State Capitol
UNdBM	----- Mandan Village Site, north of Bismark
UNdNF	New Town (near). Four Bears Bridge, east side Missouri River

--New Hampshire

UNhCP	Concord. St. Paul's School
UNhCS	Cornish. Saint-Gaudens Memorial
UNhHD	Hanover. Dartmouth College
HNhMC	Manchester. Central High School

--New Jersey

UNjE	East Orange
UNjJL	Jersey City. Lincoln Park
UNjL	Lincoln
UNjLaS	Lakewood. Congregation Sons of Israel
UNjLeS	Leonia. Coll. Mr. and Mrs. Gilbert Stork
UNjM	Morristown
UNjMiI	Millburn. Congregation B'nai Israel
UNjMoM	Montclair. Montclair Art Museum
UNjMon	Monmouth
UNjNBL	New Brunswick. Coll. Dr. and Mrs. Seymour Lifschutz
UNjNewC	Newark. Courthouse
UNjNewL	----- Lincoln Park
UNjNewM	----- Newark Museum

UNjNewP	Newark. Prudential Life Insurance Company
UNjNewPl	----- Newark Public Library
UNjPA	Princeton. Art Museum of the University
UnJPK	----- Coll. Mr. and Mrs. Patrick J. Kelleher
UNjTJ	Teaneck. Jewish Community Center

--New Mexico

UNmAA	Albuquerque. Coll. Mr. and Mrs. Clinton Adams
UNmAAl	----- Temple Albert
UNmAUA	----- University of New Mexico. University Art Museum
UNmCS	Chimayo. El Santuario
UNmCoL	Coolidge. Austin Ladd Collection
UNmGK	Gallup. Kimballs Wholesale Company
UNmSC	Santa Fe. Cristo Rey Church
UNmSL	----- Laboratory of Anthropology
UNmSM	----- Museum of New Mexico
UNmSMF	----- Museum of International Folk Art
UNmSN	----- University of New Mexico
UNmSR	----- Radio Plaza
UNmTJ	Taos. Coll. Mr. and Mrs. William H. Jones

--Ohio

UOA	Adams County
UOAG	Akron. General Tire and Rubber Company. Chemical-Plastics Division
UOAl	Alliance
UOBP	Barberton. Portage Park (Indian Park)
UOCiA	Cincinnati. Coll. Mrs. Philip R. Adams
UOCiE	----- Thomas J. Emery Memorial
UOCiH	----- Hebrew Union College Museum
UOCiL	----- Lytle Park
UOCiM	----- Art Museum
UOCiT	----- Taft Museum
UOClA	Cleveland. Cleveland Art Museum
UOClAn	----- Congregation Anshei Chesed
UOClF	----- Fairmont Temple
UOClK	----- Coll. Mrs. Ralph King
UOClP	----- Park Synagogue
UOClPr	----- Coll. Mrs. Francis F. Prentiss
UOClW	----- Western Reserve Historical Society
UOClWi	----- Coll. H. Wise
UOCoGA	Columbus. Columbus Gallery of Fine Arts
UOCoSM	----- Ohio State Museum
UODA	Dayton. Art Institute
UOGM	Gates Mills. Coll. Katherine W. Merkel
UOGW	----- Coll Mrs. Walter White

UOGn	Gnadenhutten
UON	Niles
UOOC	Oberlin. Oberlin College
UOSW	Sylvania. Coll. Mr. and Mrs. Harry B. Walchuck
UOTA	Toledo. Toledo Museum of Art
UOTF	----- Fallen Timbers Battle Site, Route 577, Lucas County
UOTW	----- Coll. Mr. and Mrs. Otto Wittmann, Jr.
UOTiMF	Tiffin. Monument Square, Frost Parkway
UOUO	Urbana. Oakview Cemetery
UOUPl	----- Urbana Public Library
UOWW	Wilberforce. Wilberforce University

--Oklahoma

UOkAI	Anadarko. Indian Hall of Fame
UOkBW	Bartlesville. Woolaroc Museum
UOkCR	Claremore. Will Rogers Memorial
UOkF	Fairfax Cemetery
UOkNU	Norman. University of Oklahoma. Stovall Museum
UOkOO	Oklahoma City. O'Neil Park
UOkOR	----- Will Rogers Park
UOkTB	Tulsa. Boston Avenue Methodist Church
UOkTG	----- Thomas Gilcrease Institute of American History and Art
UOkTI	----- Temple Israel
UOkTP	----- Philbrook Art Center

--Oregon

UOrEA	Eugene. University of Oregon. Museum of Art
UOrEU	----- University of Oregon
UOrPA	Portland. Portland Art Museum
UOrPF	----- Fountain Gallery of Art
UOrPG	----- Coll. Mr. Jan De Graaff
UOrPL	----- Lloyd Center
UOrPW	----- Washington Park
UOrSCap	Salem. State Capitol

--Pennsylvania

UPAT	Altoona. Coll. Mr. and Mrs. Frank M. Titelman
UPBK	Bear Run. Coll. Edgar Kaufman
UPDB	Doylestown. Bucks County Historical Society
UPDoM	Downingtown. Coll. Mr. and Mrs. Earle Miller
UPE	Elizabethtown

UPEaC	Easton. Congregation Covenant of Peace
UPG	Germantown
UPGe	Gettysburg
UPGeP	----- National Military Park
UPHCap	Harrisburg. State Capitol
UPHP	----- City Park
UPLF	Lancaster. Pennsylvania Farm Museum of Landis Valley
UPLaF	Lancaster. First Reformed Church
UPMeB	Merion. Barnes Foundation
UPPA	Philadelphia. American Philosophical Society
UPPB	----- Coll. William Bullitt
UPPBal	----- Coll. Frederic L. Ballard
UPPCh	----- Coll. Phillip Chapman
UPPCi	----- City Hall Square
UPPCom	----- Philadelphia Commercial Museum
UPPCrt	----- Federal Courthouse
UPPE	----- Pennsylvania Academy
UPPEaS	----- East Park. Strawberry Hill
UPPF	----- Fairmont Park
UPPFW	----- West Fairmont Park
UPPFed	----- Federal Reserve Bank
UPPFi	----- Fidelity Mutual Life Insurance Company
UPPFr	----- Franklin Inn Club
UPPH	----- Coll. Earl Horter
UPPHS	----- Historical Society of Pennsylvania
UPPHo	----- Pennsylvania Hospital
UPPI	----- Independence Hall
UPPIN	----- Independence National Historical Park
UPPIT	----- Integrity Trust Company Building
UPPIn	----- Coll. R. Sturgis Ingersoll (UPPeI)
UPPIns	----- Insurance Company of North America
UPPJ	----- John G. Johnson Coll.
UPPL	----- Little Gallery of Contemporary Art
UPPM	----- Committee on Masonic Culture of the R. W. Grand Lodge F. and A. M. of Philadelphia
UPPMc	----- Coll. Henry P. McIlhenny
UPPO	----- Coll. Dr. Perry Ottenburg
UPPPA	----- Pennsylvania Academy of Fine Arts
UPPPM	----- Philadelphia Museum of Art
UPPR	----- Rodin Museum
UPPRo	----- Congregation Rodeph Shalom
UPPS	----- Shakespeare Memorial
UPPU	----- University Museum
UPPUL	----- Union League
UPPUn	----- University of Pennsylvania
UPPW	----- Witherspoon Building

UPPeI	Penllyn. Coll. Mr. and Mrs. R. Sturgis Ingersoll (UPPIn)
UPPiA	Pittsburgh. Alcoa Building
UPPiC	----- Carnegie Institute
UPPiS	----- Coll. Mrs. Alexander Crail Speyer
UPPiT	----- Coll. G. David Thompson
UPPiW	----- Coll. Gordon Bailey Washburn
UPRHS	Reading. Historical Society
UPScE	Scranton. Everhart Museum
UPT	Titusville
UPUF	Uniontown. Fayette County Courthouse
UPWI	Wissahickon. Indian Rock
UPWoW	Womelsdorf (near). Conrad Weiser Memorial Park

--Rhode Island

URBK	Bristol. King Philip Museum
URCN	Cranston. Narragansett Brewing Company.
URIND	Narragansett. Coll. Mr. F. LeB. B. Dailey
URLW	Little Compton. Coll. Mrs. Thomas F. Woodhouse
URNewB	Newport. Coll. Wesson Bull
URNewW	----- Coll. Forsyth Wickes
URNoS	North Kingston. South County Museum
URPB	Providence. Temple Beth El
URPD	----- Rhode Island School of Design. Museum of Art
URPHS	----- Rhode Island Historical Society
URPW	----- Roger Williams Park
URTI	Tiverton. Island Park Amusement Company, Island Park
URWP	Westerly. Coll. Harden de V. Pratt
URWaM	Watch Hill. Memorial Building, Ray Street

--South Carolina

UScCh	Charleston
UScCoM	Columbia. Columbia Museum of Art
UScF	Fort Mill
UScGB	Georgetown. Brookgreen Gardens

--South Dakota

USdCT	Custer (near). Thunder Mountain, Black Hills
USdM	Mt. Rushmore
USdSt	Standing Rock Reservation

--Tennessee

UTCH	Chattanooga. Hamilton County Courthouse
UTF	Fort Donelson Military Park

UTGCo	Greeneville. Courthouse
UTKU	Knoxville. University of Tennessee
UTL	Lookout Mountain
UTLe	Lewis County
UTNF	Nashville. Fisk University. Carl van Vechten Gallery of Fine Arts
UTNO	----- Temple Oheb Shalom
UTNV	----- Vine Street Temple
UTSN	Shiloh National Military Park

--Texas

UTxAM	Addison. Coll. Mr. and Mrs. John D. Murchison
UTxBUM	Baird. University of Texas. Texas Memorial Museum
UTxDC	Dallas. Coll. Mr. and Mrs. Clark
UTxDE	----- Temple Emanuel
UTxDG	----- Coll. Mr. and Mrs. S. Allen Guiberson
UTxDH	----- Hall of State
UTxDM	----- Dallas Museum of Fine Art
UTxDMe	----- Coll. Algur H. Meadows
UTxDMa	----- Coll. Mr. and Mrs. Stanley Marcus
UTxDS	----- Coll. Stanley Seeger, Jr.
UTxDSt	----- Statler-Hilton Hotel
UTxES	El Paso. Temple Sinai
UTxFF	Fort Worth. Coll. Andrew B. Fuller
UTxFJ	----- Coll. Karen Carter Johnson
UTxFW	----- Coll. Mr. and Mrs. Ted Weiner
UTxHA	Houston. Museum of Fine Arts
UTxHMe	----- Coll. Mr. and Mrs. Jean de Menil
UTxHO	----- Coll. Mrs. Kenneth Dale Owen
UTxHS	----- Coll. Mr. and Mrs. Robert D. Straus
UTxHSc	----- Coll. Kenneth Schnitzer
UTxLB	Longview. Longview National Bank
UTxSAJ	San Antonio. San Jose
UTxSAR	----- Coll. Mr. and Mrs. Frank Rosengren
UTxSJ	San Jose. Mission

--Utah

UUPB	Provo. Brigham Young University
UUSP	Salt Lake City. "This is the Place", Mormon Pioneer Trail Monument
UUST	----- South Temple and Main Streets Intersection

--Virginia

UVAG	Alexandria. Coll. Walter S. Goodhue
UVAr	Arlington

UVCU	Charlottesville. Universitv of Virginia
UVH	Holden's Creek, Accomack Co.
UVJ	Jamestown National Historic Site. Colonial National Historic Park
UVJC	----- Churchyard
UVM	Monticello
UVMtV	Mt. Vernon
UVNH	Norfolk. Hermitage Foundation Museum
UVNM	----- Norfolk Museum of Arts and Sciences
UVNeM	Newport News. Mariners Museum
UVRCap	Richmond. State Capitol
UVRCapG	----- ----- Capitol Grounds
UVRHi	----- Virginia Historical Society
UVRJ	----- Hotel Jefferson
UVRMu	----- Virginia Museum of Fine Arts
UVRVU	----- Virginia Union University
UVUM	Upperville. Coll. Mr. and Mrs. Paul Mellon
UVW	Williamsburg (Colonial Williamsburg)
UVWC	----- Williamsburg College
UVWL	----- Ludwell-Paradise House
UVWM	----- College of William and Mary
UVWR	----- Abby Aldrich Rockefeller Folk Art Collection

<center>--Vermont</center>

UVtAK	Algiers-in-Guilford. Coll. Robert S. Kuhn
UVtBH	Bennington. Historical Museum
UVtBuF	Burlington. Robert Hull Fleming Museum
UVtMCap	Montpelier. State Capitol
UVtMHS	----- Vermont Historical Society
UVtNB	North Bennington. Bennington College
UVtOB	Old Bennington. Bennington Museum
UVtSM	Shelburne. Shelburne Museum

<center>--Washington</center>

UWaMM	Maryhill. Maryhill Museum of Fine Arts
UWaSA	Seattle. Seattle Art Museum
UWaSB	----- Coll. Mrs. Robert Block
UWaSC	----- Cedar, Denny, and 5th Streets Intersection
UWaSD	----- St. Dunstan's Hall
UWaSF	----- Coll. Mrs. Charles Frick
UWaSN	----- Northgate Shopping Center
UWaSPL	----- Seattle Public Library
UWaSPh	----- Seattle Center Playhouse
UWaSSU	----- Washington State Museum, University of Washington
UWaSSe	----- Seattle Center

UWaSU	Seattle. University of Washington
UWaSW	----- World's Fair, 1962
UWaSWr	----- Coll. Mr. and Mrs. Charles B. Wright

--Wisconsin

UWiAC	Ashland. Ashland County Courthouse
UWiB	Burlington
UWiCM	Cedarburg. Meta-Mold Building
UWiGC	Green Bay. Courthouse Square
UWiH	High Cliff State Park (near Sherwood)
UWiKC	Kenosha. Courthouse
UWiLR	Lacrosse. Riverside Park
UWiMA	Milwaukee. Milwaukee Art Institute; Milwaukee Art Center
UWiMC	----- Milwaukee Cemetery
UWiMCap	Madison. State Capitol
UWiMM	Milwaukee. Coll. Dr. Abraham Melamed
UWiMP	----- Milwaukee Public Museum
UWiMV	----- Coll. Mr. and Mrs. William D. Vogel
UWiMZ	----- Coll. Mr. and Mrs. Charles Zadok
UWiMaH	Madison. State Historical Society
UWiMaT	----- Coll. R. and Mrs. Michael J. Thurrell
UWiOM	Oshkosh. Menominee Park
UWiOP	----- Paine Art Center
UWiR	Racine
UWiRiC	Ripon. Ripon College
UWiWC	Waupun. City Hall
UWiWP	----- Shaler Park

--West Virginia

UWvCI	Charleston. Temple Israel
UWvHH	Huntington. Huntington Galleries
UWvWM	Wheeling. Memorial Boulevard and National Road Intersection

Uganda

UgKU	Kampala. Uganda Museum

Uruguay

UrMN	Montevideo. Museo Nacional de Bellas Artes

Venezuela

VCM	Caracas. Museo Nacional de Bellas Artes
VCMC	----- Maternidad Clinic
VCMN	----- Museo Nacional de Ciencias Naturales. Department of Anthropology
VCS	----- Student Residence Center

VCU	Caracas. Caracas University
VCUA	----- Ciudad Universitaria. Great Auditorium

Vietnam--North

Vn-nHM	Hanoi. Hanoi Museum of E. F. E. O. (Revolutionary and Armed Resistance Museum)
Vn-nTM	Tourane. Tourane Museum
Vn-nTP	----- Musee Henri Parmentier

Vietnam--South

Vn-sSN	Saigon. National Museum

Wales

WAM	Abergavenny. Priory Church of St. Mary the Virgin
WAO	----- Our Lady and St. Michael Church
WBCh	Brecon. Priory Church
WCaN	Cardiff. National Museum of Wales
WCarN	Caernarvon. Royal Borough Council
WGC	Glamorgan. Glamorgan County Hall
WHW	Harlech. Wernfawr
WWe	Welshpool. Borough Council

Yugoslavia

YBMG	Belgrade. Modern Gallery
YBN	----- Narodny Muzej
YBNC	----- New Cemetery
YBYT	----- Yugoslav Trade Union Council
YBa	Batina Skela
YBj	Bjelovar
YBrP	Brac Island. Petrinovic Mausoleum
YBrS	----- Supetar
YBra	Brazza
YBri	Brioni
YCM	Cetinje. Museum
YCaMa	Cavtat. Racic Mausoleum
YDG	Dubrovnik. Umjetnicka Galerija (Galerie d'Art)
YDjC	Djakovo. Cathedral
YKC	Korcula (Curzola) Cathedral
YKa	Katowice
YKam	Kamnik
YL	Ljubljana
YLM	----- Mestni Musiz Ljubljani (Ljubljana City Museum)
YLMo	----- Moderna Galerija

YLN	Ljubljana. Narodna Galerija
YLT	----- Tivoli Park
YMtA	Mount Avala
YOM	Otavice. Mestrovic Mausoleum
YPM	Pristina. Muzej Kosova e Metohije
YR	Radimlja
YRaM	Ragusa. Mortuary Chapel
YRiMG	Rijeka. Moderna Galerija
YSB	Split. Baptistry
YSC	----- Cathedral
YSiC	Sibenik. Cathedral
YSkMG	Skoplje (Skopje). Modern Gallery
YSkS	----- Holy Savior Church
YSpK	Split. Coll. A. Kotunaric
YSt	Studenica Monastery
YTC	Trogir. Cathedral
YU	Urh
YZE	Zagreb. Council for Education and Culture of Croatia
YZMG	----- Moderna Galerija
YZS	----- Stone Gate
YZSt	----- Student Center
YZZ	----- Galerije Grada Zagreba (Zagreb City Gallery)
YZZS	Zagreb. Galerije Grada Zagreba. Galerija Suvremene Umjetnosti (Contemporary Art Gallery)
YZaA	Zadar. Arheoloski Muzej

Preface

Sculpture Index is a guide to pictures of sculpture in a selected number of about 950 publications that may be found in public, college, school, and special libraries. The two volumes of Sculpture Index are:

Volume 1. Sculpture of Europe and the Contemporary Middle East

Volume 2. Sculpture of Americas, Orient, Africa, Pacific Area, and Classical World

In addition to providing a key to pictures of sculpture, Sculpture Index should prove a valuable reference work through presenting an extensive listing of sculptors (identified in most instances by nationality and dates of life or work), in showing locations of sculptured works, in identifying titles of works by sculptor, and in providing an iconographic aid through the extensive subject listings of figures and incidents in Christian and other religions, of historical, literary, and mythological characters and events, of zoological forms, and of sepulchral and other social representations.

Sculpture Listed: Indexed are pictures of three-dimensional works (carved, cut, hewn, engraved, cast, modeled, welded, or otherwise produced) in a variety of materials (including wood, metal, clay, terracotta, ivory, ceramics, wax, mixed media, marble). The size of the sculpture listed ranges from monuments and memorials, freestanding figures, room reliefs, facades and screens to miniature objects, such as jewels, medals, and coins. Types of sculpture listed in this index, including works of "minor" and "applied" arts, are:

Portraits-- Statues, busts, cameos, seals, medals, effigies;

Architecture and Architectural Elements--Arches, columns, capitals, facades, wall decoration, doors and gateways, tombs, monuments and memorials;

ccxxiii

Church Furniture and Accessories--Shrines, pulpits,
candelabra, altars, fonts, screens;

Decorative and Utilitarian Objects--Masks, book
covers, gems, coins, jewelry, netsuke,
figureheads, play sculpture, garden
figures, fountains, sundials, weather-
vanes, reliquaries, musical instruments.

The time range of listed sculptures is from prehistoric fertility
and hunting figures to contemporary Time/Space Art--as-
semblages, boxes, wall sculpture, environments, happenings,
kinetic and optic art.

Information Given in Index: Sculptures are listed:

(1) By name of artist (or by nationality, area or tribe);
(2) By title, when distinctive;
(3) By subject, selectively.

For each work listed, the information (as given in the
publications indexed) may include:

Artist--Name, alternate names by which known,
nationality, dates of life or work;

and under listing by artist:

Original Location--Geographic area, monument,
temple, or other building;

Material of Work--with indication of method of working,
as beaten, cast, engraved, mosaic;

Dimensions of Work--Measurements are given in inches,
unless otherwise indicated. Single
measurement refers to height; two
measurements to height and width; three
measurements to height, width, and
depth. Dimensions may be rounded to
the nearer (or greater) half inch above
twenty-four inches;

Location of Work--Institution, public or private col-
lection, or city in which work may be seen
is indicated by Location Symbol, given in
the section "Sculpture Location Symbols".
As an example, the Location Symbol FPL

indicates a sculpture is located in the Louvre, Paris, France.

Identification, inventory, catalog, acquisition, or accession number of work follows the Location Symbol, if that information is given in indexed publications;

Books in Which Picture of Sculpture Appears--The publication in which the listed work is pictured is indicated by the Books Indexed Symbol, given in the section "Books Indexed Symbols"

Books Indexed: The publications indexed were chosen to include generally significant, up-to-date, and readily obtainable books, handbooks and catalogs--primarily general art histories, ready reference art books, national and regional art histories in English. While emphasis is on the sculpture of the Americas and Europe since 1900, an effort was made to index publications picturing sculpture of other areas and times, including sculpture designated Ancient, Classical, Oriental, African, Pre-Columbian, Pacific Area, Byzantine and Early Christian, Medieval, Renaissance, and Baroque. Among publications indexed are a limited number of specialized art histories; museum catalogs and handbooks; "classic" out-of-print titles; foreign language publications--French, German, Spanish, Italian; and catalogs of single and recurring group exhibitions (as, Venice Biennale, Sao Paulo Bienal, Carnegie International, Pennsylvania Academy Annual, Illinois University Biennial, London County Council Exhibitions, Whitney Museum Annual). Monographs on individual artists are excluded.

Acknowledgments: The assistance of many libraries and publishers is gratefully acknowledged, with particular thanks to those organizations, individuals, and publishers who provided publications otherwise unavailable. Especially appreciated was the publishers' help in making available four books released late in 1968:

Burnham, Jack. Beyond Modern Sculpture. George Braziller (BURN)
Cheney, Sheldon. Sculpture of the World. Viking Press (CHENSW)
Craven, Wayne, Sculpture in America. Thomas Y. Crowell (CRAVS)
Kultermann, Udo. The New Sculpture: Environments and Assemblages. Frederick A. Praeger (KULN)

Abbreviations

*	Indicates "Descriptive Title"--used when exact title not known	excl	excluding
		exec	executed by
		ext	exterior
#	Following Title, indicates more than one work with this title	fac	facade
		fig(s)	figure(s)
		fl	floruit (flourished)
ad	additional	Foll	Follower(s) Following; and Attribution, as: After, Atelier, Circle of; Influence of, Manner of, School of, Shop of, Studio of, Style of, Workshop of
aft	after		
ant	antiquities		
ap	appendix		
archt	architect		
attrib	attributed work(s)		
avg	average		
b	born	fr cov	Front cover
bef	before	front	frontispiece
beg	beginning	H	height
bk cov	book cover	ht	half title page
c	century (following number); circa (preceding number)	il	illustration(s)
		il p	Notes on Illustrations page
		incl	including
cat	catalog	int	interior
circ	circumference	L	length
cl	classical	LS	life size
cm	centimeter(s)	Lt	left
col	pictured in color	m	meter(s)
coll	collection	mem	memorial
cont	contents page	mil	millenium
cov	cover, or jacket	miscell	miscellaneous
d	died		
D	depth	ms(s)	manuscript(s)
dec	decade	N	North
Demol	demolished	NW	Northwest
det	detail	orig	original
Dm	diameter	(p)	extrapolated page number
drg	drawing		
E	East	per	period
ea	each	pl	plate (illustration or figure)
ep	end papers		
equest	equestrian figure	pr	preface page

pseud	pseudonym
ptd	painted, polychromed
Q	quarter
reconstr	
	reconstructed;
	reconstruction
Rt	right
S	South; Saint
Sc	Sculpture
SE	Southeast
Sq	Square
SS	Saints
t	title page
u	university
W	West; Width

Volume 2

Sculpture of Americas, Orient, Africa
Pacific Area, and Classical World

Index to Pictures of Sculpture

1

Abundance (Abundantia)
 Bitter. Plaza Fountain
 Greek--5th c. B. C. Grimani
 "Abundance"
 Harley. Abundance
 Indian--Andhra. Abundance,
 pillar figure
 Roman--3rd c. Sarcophagus
 --"Sarcophagus of Balbinus"
ABYSSINIAN
 Ethiopian Obelisk, Arabian
 stylized doors decoration
 4th c.
 GARB 113 (col) EtA
Acacius, Saint
 Folk Art--Spanish American
 (U. S.). St. Acacius, bulto
Acanthe, Calchidice
 Greek--5th c. B. C. Coin,
 Acanthe: Lion Attacking
 Bull, Acanthe city emblem
Acanthus
 Coptic. Capital: Stylized
 Acanthus and garlanded
 cross
 Coptic. Capitals: Acanthus
 Foliate
 Etruscan. Urn: Gorgon Head
 with Acanthus Foliation
 Greek. Corinthian Column:
 Acanthus design
 Greek--4th c. B. C. Acan-
 thus Leaves, detail
 Hellenistic. Table Support:
 Akanthos, slab
 Roman--1st c. B. C. Ara
 Pacis: Acanthus, foliate
 Roman--1st c. Acanthus
 Scroll, relief
 Roman--2nd c. Temple of
 Venus Genetrix, panel:
 Acanthus Scroll
ACANTHUS LEAF CAPITAL
 ENC 4
Accordions See Musicians and
 Musical Instruments
ACCORSI, William
 Clock Gargoyle found objects:
 Samovar, keys, metal
 clock face, chains, wood
 MEILD 125 UNNNa
 Small Prince found objects:
 Letter opener, chain,
 nails, tin, wood, and
 stained glass
 MEILD 122 UNNNa
ACHAEMENIAN
 Ahuramazda: Holding
 Flower, in winged disc,

relief, Throne Hall,
 Persepolis 5th c. B. C.
 limestone; 29-3/4
 BOSMA pl 51; CHENSW
 172 UMCF (1943.1062)
Ahuramazda: Riding Sun
 Disk, relief
 GARB 107 IranP
Antelope, pendant c 5th c.
 B. C. silver; L: 4
 NM-2:32; NMA 28 UNNMM
 (47.100.89)
Apadana, East staircase 6/5th
 c. B. C.
 BAZINW 125 (col) IranP
Archers of the Royal Guard
 ("The Immortals"), frieze,
 Susa 5th c. B. C. glazed
 tile; 72
 BAZINH 107; BAZINW 126
 (col); GAF 139; HUYA pl
 13; HUYAR 90; JANSK 92;
 LARA 117; LLO 247 (col);
 PRAEG 106 (col) FPL
--head detail
 LARA 296
Archers, frieze, Palace of
 Darius, Susa: Single figure
 detail
 LARA 144 (col) ELBr
Armlet: Confronting Griffins,
 Oxus Treasure 5/4th c.
 gold; 12.3x11.5 cm
 CHENSW 173; POR 173
 (col) ELV
Armlet: Opposing Winged
 Monsters, Oxus Treasure
 c 400 B. C. gold; 5
 FRA pl 190A; GARB 108;
 GARDH 89; LARA 301;
 LLO 253; RTC 138 ELBr
Bactrian Leading Camel,
 stairway relief, Palace of
 Xerxes 486/85 B. C.
 stone; 36
 FRA pl 184B; UPJ 655;
 UPJH pl 12D IranP
Bactrian Leading Camel,
 relief Persepolis end 6th c.
 B. C. limestone; 17
 GRIG pl 42 ELBr
Bearded Head stone
 CHENSW 169 BBS
Bull-Column, Persepolis
 FRA pl 180C
Bull-Head Capital 5th c.
 B. C. stone; 18-1/2
 NM-2:32 UNNMM
 (47.100.83)

Kazbec Dish: Confronting
Swans, Stepantsminda 6th
c. B. C. silver
RTC 24 RuTiG
King or Prince, head, Per-
sepolis 5th c. B. C.
turquoise; 4-3/4
COOP 258 FPDavr
Lion Attacking Bull, relief,
Palace H, Persepolis 5th
c. B. C. limestone; W:
69
BOSMA pl 47; BOSMI
209 UMB (36.37)
Lion Attacking Bull, Apadana
of Xerxes, Persepolis 521/
486 B. C. stone
FRA pl 179B; LARA 293;
MARQ 49; MYBA 59;
UPJ 656; UPJH pl 12E
IranP
Lion Head Finial c 5th c.
B. C. marble
CLE 13 (UOClA (62.26)
Lions, Palace of Darius,
Susa glazed brick
CHENSW 170 FPL
Lions, Lions' Heads, Boars'
Heads, plaquettes c 400
B. C. gold; largest:
1-15/16x2-1/4
TOR 21 CTRO (957.160.2-8)
Lion's Head c 5th c. B. C.
stone; 23.5x13 cm
POR 163 (col) IranTA
Male Figure silver
LLO 252 ELBr
Median Leading Two Parthians,
relief, Apadana of Darius,
Persepolis 5th c. B. C.
limestone; W: 30
BOSMA pl 48 UMB
(39.586)
Median Lion Strangler 5th c.
B. C. lapis lazuli
CLE 12 UOClA (60.175)
Median Servant Bearing
Dishes, relief, Persepolis
5th c. B. C. limestone
BOSMA pl 52 UMCF
(1943.1066)
Median Servant Carrying
Kid, relief, Persepolis
5th c. B. C. limestone;
26
BOSMA pl 54 UMCF
(1943.1065)

Mountain Sheep (Mouflon) 5th
c. B. C. silver overlaid
with gold; L: 2-3/4
BOSMA pl 58 UMB (59.14)
Persian Goat c 500 B. C.
bronze
COOP 172 FPRoths
Ostrich Hunt, seal
CHENSW pr; 173 UMdBW
Persepolis Support: Three
Lions bronze; 9
FRA pl 188A
Persian Guardsman, relief,
Persepolis 5th c. B. C.
limestone
BOSMA pl 50 UMCF
(1943.1063)
--limestone; 21
BOSMA pl 49 UMB
(40.170)
Persian Servant Carrying
Offering, relief, Perse-
polis 5th c. B. C. lime-
stone; 27-3/4
BOSMA pl 53 UMB (31.372)
Plaque: Opposed Winged Lions
8th c. B. C. gold;
4x6-1/8
MU 34 (col) UNNMM
Prince With Crown, head
5/4th c. B. C. Egyptian
Blue; 6.5x6 cm
POR 161 (col) IranTA
Procession of Medes and
Persians, detail, Apadana
of Darius and Xerxes,
Persepolis
LLO t UICUO
Processional Dignitaries stair-
case relief 5th c. B. C.
BAZINW 126 (col) IranP
Processional Figures, staircase
relief, Apadana of Xerxes,
Persepolis 518/460 B. C.
GARB 93 (col) IranP
--Soldiers
LARA 117
--Soldiers with Spears
LARA 294
--Syrian Tribute Bearers
GARB 108
--Tribute Bearers
CHENSN 37, 247; LARA
295; MYBA 59; WB-17:196
Tribute Camel, procession
relief, Palace of Darius
BOWR 158-59

Protome: Ibex 5th c. B. C.
bronze; 12-1/8
BOSMI 209 UMB
Relief, Hall of One Hundred
Columns, Persepolis
FRA pl 180A
Rhyton: Gazelle's Head 8/7th
c. B. C. bronze
BAZINW 124 (col) IranTF
Rhyton: Goat 11/9th c. B. C.
bronze; 24 cm
CHAR-1:152 FPL
Rhyton: Gryphon, Oxus
Treasure silver; 10
FRA pl 191
Rhyton: Lion-Monster c
5th c. B. C. gold; 16x24
cm; Dm at rim; 14 cm
POR 165 (col) UNNMM
Rhyton: Snarling Lion c 5th c.
B. C. gold; 6-3/4
NM-2:33 UNNMM (54.3.3)
Rhyton: Winged Lion 5/3rd c.
B. C. gold
GARB 95 (col); JANSH
65; LLO 250 (col) IranTA
Royal Guards, processional
frieze, Palace of
Darius I H: 20
STRONGC 81 (col) ELBr
Royal Guardsman, Palace of
Ataxerxes, Susa 404/358
B. C. glazed brick; c
18 cm
POR 153 (col) FPL
Royal Hero Battling Lion-
Headed Monster, relief
485/65 B. C. H: 34 cm
POR 157 (col) IranP
Seals: Ostrich Hunt; Lion
Hunts; Opposing Men
and Animals
CHENSW 173 FPBN;
ELBr; UMB
Servant Bearing Wineskin,
relief, Palace of Xerxes,
Persepolis 485/65 B. C.
limestone; 21-1/2x11-1/2
DETT 25 UMiD (31.340)
Servants Bearing Wineskins,
covered bowl fragment,
Persepolis 4th c. B. C.
stone; 34x25-1/2
NM-2:32 UNNMM (34.158)
Spearmen, Palace of Darius
I, Susa glazed brick
CHENSW 171 FPL

Susa Weight: Lion, detail
c 5th c. B. C. L: 53.5 cm
POR 163 (col) FPL
Textile Ornament: Winged,
Horned Lion in Twisted
Wire Hoop 4th c. B. C.
gold; Dm: 11.5 cm
POR 175 (col) UICUO
Tomb of Ataxerxes II hewn
rock
LARA 296 IranN
Tomb of Darius 5th c. B. C.
rock facade; 73
BAZINW 126 (col); CHENSN
254; LARA 297 IranN
Tomb of Xerxes c 465 B. C.
stone
UPJ 651 IranN
Torques, with Lions' Heads
4th c. B. C. gold; Dm:
c 20 cm
POR 173 (col) FPL
Tribute Bearer, relief,
Persepolis limestone;
28-1/2x14-1/8
BMA 86 UMdBM
Tribute Bearers
FRA 182; 183 IranP
--relief, Palace of Darius I,
Persepolis stone
CHENSW 162; 170
--stone; 88 cm
POR 155 (col) IranP
--: Human and Animal
Figures, conventionalized
trees, relief, Apadana
522/465 B. C.
GARDH 88 IranP
Tripylon Staircase, Perse-
polis
FRA pl 178B; pl 179A
Winged Genius, gate jamb
relief limestone; figure
H: 2.9 m
POR 143 (col) IranPa
Winged Goat 6/4th c. B. C.
silver and gold; 27.5 cm
CHAR-1:151 (col) FPL
Winged Ibex, on satyr's head,
jar handle silver inlaid
·ith gold
FRA pl 192
Winged Ibex, vessel handle
4th c. B. C. gilded silver
POR 171 (col) FPL
Winged Lion Roundel 6/5th c.
B. C. gold MU 34 (col)
UICUO

ACHAEMENIAN and SASSANIAN
 8 Coins: Mithradates I;
 Mithradates II; Arsaces;
 Ardashir I; Fire Altar;
 Shapur I; Khusraw II
 5th c. B. C.; 7th c. A.D.
 gold, or silver
 POR 177 (col) UNNAmN
Acheloi
 Etruscan. Antefixes: Silen;
 Maenad; Acheleos
Achelous
 Etruscan. Decorative Shield:
 Achelous, river god, head,
 Tarquinia
Achievement, panel. Chambellan
Achilles
 Cheirisophos. Priam and
 Achilles, goblet
 Connelly. Thetis and Achilles
 Etruscan. Helmet Cheek
 Piece: Palmette; Achilles
 and Troilus
 Greek--7th c. B. C. Achilles
 --Ajax: With Body of Achilles
 --Penthesilia Vanquished by
 Achilles, shield relief
 Greek--6th c. B. C.
 Achilles Slaying Troilus,
 shield relief
 --Shield Strip
 Greek--5th c. B. C.
 Achilles#
 Pergamene. Achilles, torso
 Roman--3rd c. Achilles and
 Penthesilea Sarcophagus
 --Achilles and Polyxena,
 sarcophagus
 --Death of Achilles,
 sarcophagus
 --Sarcophagus: Achilles
 Among the Daughters of
 Lycomedes
Achilles Sarcophagus. Roman--
 3rd c.
Achilleus, Julius
 Roman--3rd c. Sarcophagus
 of Julius Achilleus: Farmer
 in Roman Campagna
Acilia Sarcophagus. Roman--3rd c.
Los Acolchados. Minujin
ACORN, John T. (American)
 Torso fiberglas; 30
 HARO-2: 11
Acrobat Handle# Etruscan
Acrobat Dancer# Gross
Acrobatic Dancers. Gross

Acrobats
 Brown, A. M. Acrobat
 Calder, A. Acrobats
 Callery. Acrobats with Bird
 Callery. The Pyramid
 Colima. Acrobat Vessel
 de Creeft. Acrobats at Rest
 Folk Art--Mexican. Revolving
 Acrobat, toy
 Gross. Acrobats#
 Gross. Trapeze Girl
 Hittite. Sword Eater and
 Acrobats, relief
 Khmer. Acrobats, relief
 Krentzin. Acrobats
 Lachaise. Acrobat
 Lipchitz. Acrobat on Horse-
 back
 Mallary, R. The Acrobat
 Minoan. Acrobat#
 Tlatilco. Dancer and
 Acrobat
 Tlatilco. Jar: Acrobat
 Vera Cruz. Hacha: Diving
 God, or Acrobat
Acropolis Maiden
 Greek--7th c. B. C. Kore
 (Acropolis Maiden)
Acrotere. Kohn, G.
The Act. Goodelman
Act of Love. Mattox, C.
Actaeon
 Etruscan. Urn: Actaeon Set
 Upon by Hounds of Artemis
 Greek. Artemis and Actaeon,
 metope
 Greek--6th c. B. C. Actaeon,
 metope
 Greek--5th c. B. C. Actaeon
 Manship. Actaeon
 Manship. Actaeon and Diana
 Roman--2nd c. Sarcophagus:
 Garlands; Myth of
 Actaeon
ACTON, Arlo (American 1933-)
 Ball 1966 mixed media;
 102x29x90
 TUC 61
 Circle in the Sun 1964 wood
 and ptd metals; 85x73x84
 HARO-1: 14; UIA-13: 136,
 137 UCSFHan
 Departure of the Seventh 1962
 hardwoods; 72
 AMON 33; CALF-61 UCSFB
 Hipster 1962 wood; 192x137x
 70 cm FPMO

Joseph H. Choate Medal;
 obverse and reverse silver,
 bronze
 NATSA 266
Joseph Henry bronze
 HARTS pl 1
--(plaster cast) 1911 bronze;
 78
 CRAVS fig 12. 10 UDCNMSC
Joseph Hodges Choate, relief
 profile
 HOF 142 UNNUL
Joseph Story, bust bronze
 HF 111 UNNHF
Library of Congress Doors
 HARTS pl 32 UDCL
Madonna, tympanum
 CAF 104 UNNBar
Miss De F. , bust polychrome
 NATS 3
Miss Pond, bust marble
 TAFT 389
A Nordic Type, head gilded
 bronze
 NATSA 3
Peggy Gantt, plaque Galvano
 bronze
 NATSA 267
Pizzaro c 1903
 PAG-1:141
Priestess of Culture
 JAMS 55; PERR 125;
 SFPP
Primavera, bust 1893 colored
 marble
 CRAVS fig 12. 7; PAG-12:
 200; TAFT 544 UDCC
Seascape 1935 limestone;
 35-1/2x60x14-1/2
 BROO 29 UScGB
The Singing Boys, relief 1804
 marble; 36
 CRAVS fig 12.8 UNNMM
Three Portrait Busts
 HARTS pl 33
Tympanum, St. Bartholomew's
 Church
 TAFT 392 UNN
War Memorial
 NATS 4 UMF
Welch Monument, relief
 ADA 102; HARTS pl 32
 UNAu
William Cullen Bryant, bust
 bronze
 HF 18 UNNHF
William Cullen Bryant, seated
 figure 1911
 ACA pl 222; CRAVS fig

12. 9; SALT 50; SFPP
 UNNBry
William Ellery Channing, bust
 bronze
 HF 51 UNNHF
Adams, John (2nd President of U.S.
 1735-1826)
 French, D. C. Vice-
 President John Adams, bust
 Paramino, J. F. John Adams,
 bust
Adams, John H. I. (1792-1834)
 Browere. John Adams, age
 90, life mask
Adams, John Quincy (6th President
 of U. S. 1767-1848)
 King, J. C. John Quincy
 Adams, bust
 Quinn, E. T. John Quincy
 Adams, bust
ADAMS, Marta (Mexican)
 Ant Hill (Hormiguero)
 LUN
 Portrait
 LUN
Adams, Maude (American Actress
 1872-1953)
 Evans. Maude Adams, mask
Adams, Samuel (American Revolu-
 tionary Patriot and Statesman
 1722-1803)
 Milmore. Samuel Adams
 Whitney, A. Samuel Adams
Adam's Gift. Salerno, C.
Adams Memorial. Saint-Gaudens
Adena See Indians of North America--
 Ohio
Adena Pipe
 Indians of North America--
 Ohio. Pipe: Male Figure
Les Adieux. de Creeft
Adipala
 Indian--Hindu. Adipala Killing
 Buffalo Demon
Adjustable Torso. Nevelson, M.
The Adjutant. Jackson, H. B.
ADKINS, Donald G. (American)
 Abraham and Isaac welded
 steel; 34
 HARO-2: 25
ADLER, Samuel M. (American 1898-)
 Construction with Five Figures
 1966 wood and oil; 40x78x
 4-3/8
 UIA-13:144
Adolescence. Korbel
Adolescence. Margoulies, B.
Adolescence. Schmitz, C. L.
"The Adolescent". Huastec

Adolescent. Margoulies, B.
Adolescent Head. Buckley
Adolescent Shishkabob. Pierron
Adolescente. Zuniga, F.
Adolescents. Talbot, G. H.
Adonis
 Etruscan. Engraved Mirror
 Adonis (Atunis) and Lasa
 Etruscan. Tomb Monument:
 Dying Adonis
 MacMonnies, F. W. Venus
 and Adonis
Adonis (dog). Harvey
Adoration of the Cross, relief
 detail. Saint-Gaudens
Adoumas See African--Adoumas
Adrastus See Lycurgus
Adrian
 Roman--2nd c. Adrian, head
Adrian II. Maldarelli, O.
Adugbologe of Abeokuta (d c 1943)
 Egungun Cult Mask: Man with
 Hare's Ears, Abeokuta,
 Yoruba wood; 17-1/4
 FAA 90 GStL
Adventurous Bowman
 MacNeil, H. A. Column of
 Progress
Adzes
 Africa--Bawongo. Ceremonial
 Adze
 Eskimo. Adze Handle
 Indians of South America--
 Peru. Adze
 Maori. Chief's Ceremonial
 Adze
 Maori. Chief's War Adze
 Melanesian--New Caledonia.
 Ceremonial Adze
 New Guinea. Adze
 Quileute. Adze and Handle
 Polynesian--Cook Islands.
 Ceremonial Adze#
 Polynesian--Hervy Islands.
 Ceremonial Adze#
Aeakes
 Greek--6th c. B. C. Aeakes
 (?), seated figure
AEGINA, SCHOOL OF
 Archaic Male Head 6th c.
 B. C.
 ROOS 28E IFAr
AEGINETAN
 Bearded Warrior, head,
 Acropolis, Athens
 GARDE 47
Aegis (Goatskin with Gorgon's Head)
 Greco-Roman. Athena:
 Wearing Aegis

Aegisthus
 Greek-Archaic. Murder of
 Aegisthus by Orestes,
 relief
 Greek--6th c. B. C.
 Clytemnestra and Aegisthus
 Slaying Agamemnon
Aelia Flaccilla (1st Wife of Theo-
 dosius The Great d 386)
 Roman--4th c. Aelia Flaccilla
 Roman--4th c. Coin: Aelia
 Flaccilla
Aeneas
 Grafly. Aeneas and Anchises
 Roman--1st c. B. C. Ara
 Pacis, east side frieze:
 Aeneas Sacrificing
Aeneolithic Epoch See Barbarian
Aenfloga. Rauschenberg
Aeolic Capital. Greek--Archaic
Aeolic Capital. Greek--7th c. B. C.
Aerial Act. Lippold
Aerial Bombardment. Metlay
Aerial Object. Cronbach
Aesculapius See Asclepius
Affection. Zorach
Afghan Hounds. Hamlin
AFGHANISTAN
 Ascetic, bust Hadda 4th c.
 BAZINW 241 (col) AfKM
 Bodhisattva, Fondukistan
 7/8th c. terracotta
 BAZINW 254 (col) FPG
 Bodhisattva, head 4/5th c.
 stucco; 9
 AS UWaSA
 Buddha 3rd c. lime plaster
 ROWE 43 AfKM
 Buddha, head, Hadda stucco
 BAZINW 242 (col) AfKM
 Buddha, head, Hadda 5th c.
 stucco
 CHENSW 255 ELV
 Colossal Buddha 4/5th c. sand-
 stone; 53 m
 SECK 187 (col) AfB
 Demon, head, Hadda 2/5th c.
 stucco
 BAZINW 241 (col) AfKM
 Devata, head 4/5th c. stucco
 ROWE 45 UMB
 Female Torso 7/8th c.
 BAZINW 253 (col) FPG
 Girl Playing with Goose, in-
 cised plaque, Begram c
 2nd c. ivory; 3x2-1/2
 AUB 39; MALV 158 AfKM
 Man in Helmet, medallion 1st
 c. B. C. plaster
 BAZINW 168 (col) AfKM

Spirit with Flowers, Hadda
4/5th c.
 BAZINW 241 (col) FPG
Two Women, plaque, Begram
2nd c. ivory; 13-3/8
 AUB 22 (col) FPG
Woman Riding Leograph, chair
fragment c 2nd c. ivory; 9
 AUB 23 (col) FPG
Yakshi, throne plaque 2nd c.
ivory
 BAZINW 240 (col) AfKM
AFO See AFRICAN--AFO
Africa
 French, D. C. Africa, one of
 four figures representing
 continents
 Roman--3rd c. Sarcophagus,
 Via Latina
 Shapsak. Africa
AFRICAN
"African Venus" wood
 CHENSN 594; CHENSW
 417 FPCa
Bird 19th c.
 DIV 65 UNNChas
Female Figure wood
 DURS 62
--wood
 ZOR 33
--19th c. wood
 FEIN pl 33 UNNAmM
Figure hammered brass sheets
over wood core; c 24
 FAIN 142 UMPiB
--wood
 HOF 45
--wood
 ZOR 5, 209
--wood
 GROSS fig 48 UNNGro
Giraffe Spoons wood
 NORM 83
Horned Headdress
 OZ 265
Horse and Rider
 CHENSN 595 FPCa
Idol wood
 VALE 55 FPRat
Male Figure
 WILM 112 ELBed
Mask
 ZOR 4
Mask: With Face Tattooing
 OZ 239
Mask, horned
 ZOR 98
Musical Instruments
 ZOR 293

Neck Rest, East Africa wood;
5
 WIN pl 118 UMCP (72775)
Ram, head
 JOHT pl 14
Sacred Dance Masks
 OZ 244
Sculpture, including Helmet
 Mask
 DIV 36
Seated Woman wood
 KUH 17
Two Seated Figures--male
 and female
 DEW 234 UPMeB
--ABUA
Animal Mask wood: L: 24
 FAA 125 ELBr
Dance Mask, Lower Orashi
 River
 TREW pl 4
Obukele Society Horizontal
 "Water Spirit" Mask wood;
 60 cm
 TREW pl 8 ELBr
Obukele Society Mask wood;
 24
 SEG 177 -Pla
Water Spirit: Many-Finned
 Shark wood; L: 48
 FAA 126 ELBr
--ADOUMAS
Mask H: 6
 SEG 185 FPH
--AFO
Headdress Mask, with
 Chameleon on horn-like
 forms wood; 11-1/2
 FAAN pl 141 ELBr
Mother and Child--2 groups
 19th c. wood; 23; and
 27-1/2
 FAAN 143a, b ELHM
Stool Supported by Two
 Standing Females wood; 23
 FAAN 142 GBVo
--AGNI
Funerary Figure, Fanti Region
 terracotta; 15
 NMAN #395 FPT
Seated Figure pottery; 16
 SEG 173 FPH
--ALANGUA
Seated Figure wood; 18
 SEG 172 -Heb
--ASHANTI
Akua'ba, girl's fertility doll
 to insure beautiful children
 --flattened, geometric figure
 FEIN pl 109 UNND

--wood
 TREW pl 21 ELBr
--wood; 9 and 14-1/2
 FAA 13 UNNNew
--wood; 10
 GABO 75 -UGa
--wood; 11-1/2
 GRIG pl 152 ELBr
--wood; 11-3/4
 ROY 36 ELBr
--19th c. (?) wood; 13-1/2
 TOR 158 CTRO (925.27.38)
--wood; 14-1/2
 WINGP 105 SwBV
--wood; 15-1/2 and 13-1/2
 WIN pl 28 CTROA
 (HA.1965; HA.1968)
Badge of King's Minister
 (Akrafokonmu) bronze;
 Dm: 6-3/4
 FAA 115 -Leff
Black Pottery Bowl, Ghana W:
 30 cm
 PAU pl 12 FPH (No.
 86.145.6)
Ceremonial Stool wood; 8
 SEG 85 UNNSe
Funerary Head clay; 12-3/8
 NPPM pl 18 UNNMPA
 (59.241)
Funerary Head pottery; 28
 SEG 174 NLV
Gold weight: Chameleon bronze;
 L: 3-5/8
 NPPM pl 13 UNNMPA
 (57.235)
Gold Weight: Equestrian
 bronze; 9 cm
 TREW pl 21 ELBr
Gold Weight: Crocodile with
 Fish brass; L: 5
 SMI 2 UDCNMS
Gold Weights H: 1-1/2 to
 1-3/4
 WINGP 107 UNNMPA
Gold Weights brass
 SEG 153 ELBr
Gold Weights: Human and
 Animal Figure bronze;
 3 cm
 ADL 10B EOP; -Ro
Gold Weights: Lizards;
 Turtle
 LARA 84 ELBr
Gold Weights: Mother with
 Nursing Children brass;
 2-1/2
 FAA 29 ELBr

Gold Weights: Proverbs;
 Animals; Scenes from Daily
 Life bronze; 1 to 2-1/2
 WIN pl 29 UPPU; UNBuMS
Gold Weights; Gold Dust
 Storage Box weights:
 bronze; 3/4 to 3
 BALTW 20 UMdBM
King Mask, Ghana gold;
 2/3 LS: 6-7/8
 LEU 111 (col) ELWal
Kuduo--Divination Bowl,
 Ghana brass; 4-1/4
 LOM 170 GMV
Kuduo, casket on elephant
 brass; 7-1/2
 SEG 173 -Pla
Kuduo, urn, Gold Coast
 bronze; 8-3/4
 WIN pl 30 UCLMo
Kuduo, vessel for souls,
 Ghana brass; 12-1/2
 LEU 114 (col) SwZUV
Mother Nursing Child, detail
 wood
 FEIN pl 52 UNND
Ornament: Three Elephants
 filigree gold; L: 2-3/4
 FAA 117
Pendant: Crocodile gold; L:
 4-1/4
 GARDH 637 UOClA
Pendant: Turtle gold; 4
 NPPM pl 14 UNNMPA
 (60.36)
Stool--geometric support,
 Ghana H: 57
 PAU pl 13 FPH (No.
 54.52.2
Umbrella Top: Snake and
 Hornbill wood; 19-1/2
 NORM 84 ELBr
Urn gold; 6-3/4
 FAA 116 ELBr
--ASHANTI, or AGNI/BAULE
Gold Weight: Antelope brass;
 1-1/8
 MUE pl 20 NLRV (505-5)
Gold Weight: Fish brass;
 L: 2-1/8
 MUE pl 21 NLRV
 (360-5311)
Gold Weight: Mounted Exe-
 cutioner brass; 2-7/8
 MUE pl 22 NLRV (360.5303)
--ATOUTOU (AITUTU)
Antelope Mask, with human
 face wood; 16
 MUE pl 11 EWestGT

Figure and Two Fly Whisks
gold leaf on wood; figure:
13; Whisk Handles: 6-1/2
to 8-1/2
NMAN #144, 146, 150
GKarB
Mask: Antelope wood; 15-3/4
ROTHS 275 FPRat
Mask: Horned wood; 13
NMAN #116 FPRat
Mouse Oracle Container, with
seated Male Figure (Mice
Divination Box), Ivory
Coast wood; 11
MUE pl 10; PAU pl 11
FPH (33.132.1)
--AZANDE
Throwing Knife (Shongo)
H: 18
SEG 194 UNNStr
--BABAN
Carved Pillar: Execution by
Hanging, North Cameroon
MUE pl 24, pl 25
SwBV (III, 1082)
--BABEMBE (WABEMBE)
Alunga: Mask Facing Two
Ways, feather hair wood;
16 (excl feathers)
FAA 42 -Bi
Ancestor Figure H: 6
SEG 186 NLV
Ancestor Statue, seated figure
with scarification, Gabun
wood; 7 SEG 32 UNNSe
Female Figure, tattooing wood
FEIN pl 63 UNNCar
Figure H, 14
SEG 227 UNNSe
Male Figure H: 5
SEG 186 -Sti
Male Figure wood; 26-1/4
MUE pl 48 BTC (14797)
--BABINDJI
Hood Mask H: 13
SEG 194 BTC
Magic Figure, Kasai wood; 25
MUE pl 49 BTC (43942)
Mask H: 12
SEG 195 BTC
--BABOA
Mask H: 13
SEG 194 BTC
--BADJOKWE
Comb with Head wood; 7
WIN pl 113 CTROA
(HAC. 339, 578)
Crouching Human Figure wood;
31-7/8
ROY 52

Figure H: 17-1/2
WINGP 177 ECamUA
Snuffbox: Woman seated on
chair wood; 5-1/2
WIN pl 111 UNBB (22.1089)
Staff with Head wood; 18
WIN pl 113 CTROA
(HA.506)
Stool: Supported by Seated
Figures wood; 12
WIN pl 109 UNBuMS
(C12714)
Stool: Two Tiers of Support
Figures wood; 13-1/4
WIN pl 112 CTROA
(HAC.392)
--BAFO
Horn Head, Cameroons ivory;
4-1/2
SEG 50 UNNSe
Mask
CHENSP 287
--BAGA
Banda Mask of Simo Secret
Society, French Guinea
PAU pl 4 (col)
--wood; 56
LEU 98 (col) SwZR
--Nalou
TREW pl 31 SeDI
Dance Headdress wood with
metal; 49
BALTW 18 UMdBM
Drum, Guinea early 20th c.
ptd wood; 66-1/2
TOR 155 (col) CTRO
(958.170)
Drum: Supported by Figures
wood; 55
BOSMP #8 UNNCar
Drum: Supported by Head of
Kneeling Female Figure
H: 44-1/2
FAA 113 ELBr
Figure wood; 31
SEG 164 FPH
Male Figure H: 25-1/4
WINGP 96 UNNMPA
Male Figure, French Guinea
wood; 26-1/2
WIN pl 9 UNBuMS (C13.46)
Nimba, fertility figure wood;
24
LEU 96 (col) SwZR
Nimba head wood; 30
SEG 164 -Pla
Nimba Headdress of Simo
Secret Society wood;
46-1/2 NPPM pl 7 UNNMPA
(56.261)

Nimba Headdress wood; 49
BOSMP #7 UNNKle
Nimba Mask wood
TREW pl 30 SeDI
--19th c. wood; 47
EXM 318 UICA
--wood; 49
TOR 159 CTRO
(957.224) •
--wood; 55
CALA 263 IVG
--wood; L: 22-3/4
FAA 158 ELBr
--wood and straw; 44
BAZINW 224 (col); TREW
pl 30 ELBr
Nimba Shoulder Mask, Guinea
wood; 47
DENV 136 UCoDA (374-QA)
--Girl's Head, French Guinea
wood, copper eyes;
25-1/4
LEU 96 (col) SwZR
Simo Mask wood and fibre;
25
SEG 119
Simo Society Bird Head,
Guinea wood; 11-1/2
SEG 49 UNNSe
Simo Society Masked Dancer,
French Guinea
SEG 83
Snake ptd wood
CLE 302 UOClA (60.37)
Snake Fetish wood; 75
BOSMP #9 UNNKle
--BAGA, or NALU
Banda Mask: Human-
Antelope-Crocodile H: c 60
FAA 121 SwZUV
--BAHOMA
Male Figure H: 5
SEG 196 UNNSe
--BAHUANA
Figure Holding a Bag wood
CHENSW 412 UNNMat
Pendant ivory; 2-1/2
SEG 196 BTC
Pendant: Double Head ivory;
2-1/2
SEG 196 BTC
--BAJOKWE
Female Figure
CHENSP 286
Figure: Forearms Issuing
from Knees wood c 8
FAA 82 ConLM

Girl Mask, Southern Congo,
wood
LEU 191 (col) BTC
--BAKETE
Figure H: 5
SEG 197 UNNSe
Mask H: 13
SEG 197 UNNSe
--BAKONGO
Bininongi, kneeling tomb
figure black wood; 22
MUE pl 55 BBRA (ET 36-2)
Chief stone
LARA 83 BBRA
Cup: Human Head c 19th c.
wood; 7-1/2
READAS pl 167 ELBr
Female Figure wood; 19-1/4
FAA 137 -R
Fetish Figure wood;5
SEG 74 UNNSe
--wood; 6
SEG 74 UNNSe
--wood; 8
SEG 71, 73 -Marc; UNNSe
Fetish Figure wood, mirror;
11
BALTW 27 UMdBM
--Lower Congo wood, mirror;
19
LEU 170 (col) BAKE
Initiation Ceremony Figure
(Thafu Malungu) H: 13
SEG 198 BTC
Konde, nail fetish: Animal
Form wood; 13
SEG 72 BTC
--Human Figure wood; 20
SEG 72 FPH
--Human Figure wood; 24
SEG 20 CTRO
--Two-Headed Dog wood; L:
24
FAA 87 ELBr
Male Figure, kneeling H:
11-1/2
SOTH-4:165
Masks H: 11, and 18
SEG 199 BTC
Maternity Figure H: 11
SEG 198 BTC
--Mother Holding Child wood;
12
SEG 36 UNNSeg
Memorial Figures soapstone;
16-1/2, and 16
FAA 25 ELBr

Mother and Child
 DEVI 2 BTC
--Angola wood; 13
 COOP 267 ESuAH
Mother and Nursing Child
 H: 11-3/4
 WINGP 143 ScER
--soapstone; 9
 SEG 35 UNNSeg
--wood
 FEIN pl 47 UNBB
-- --kneeling figure wood; 31
 MUE pl 56 SwBV (III,3120)
Seated Boy, Angola wood; 8
 COOP 267 ESuAH
Seated Female Figure
 FEIN pl 34 UNNCar
Squatting Figure, Chief's Fly
 whisk handle wood;
 2-3/4
 FAA 78 -R
Tomb Figure, Angola stone;
 27 cm
 PAU pl 25 FPH (No.
 53.73.1)
Vase, engraved interlocking
 bands: Buina (carving-knife)
 Pattern wood; 8
 ADL pl 7A ELBr
--BAKOTA
Dance Mask 20th c. wood
 ENC 12
Double Mask 19th c. wood
 and copper; 22-3/4
 PUL-1: pl 60
Figure H: 19
 WINGP 139 SwBV
Funerary Figure brass over
 wood
 GARDH 638 COR
--wood; 22-1/2
 FAA 36 UPPU
--wood and copper
 SELZJ 22
--wood and copper leaf
 PAU pl 20
Mask, Gaboon face H: 37 cm
 PAU pl 23 (col) FPH
 (No. 35.80.41)
--: Human Form copper;
 16-1/2
 ROY 57 FPH
Masks copper; 16-1/2, and
 10-5/8
 ROY 56 (col) FPLec; FPT
Mbulu Ngulu (Guardian Figure;
 Guardian of the Bones;
 Spirit of the Dead),

funerary figure, affixed to
 casket containing bones,
 French Gaboon (Gabon,
 Gabun)
 KUHB 113
--H: 12, and 20
 SEG 188, 46 FPH
--beaten sheet copper; 22
 LOM 164 GMV
--wood, applied metal
 TREW pl 39 ELBr; FPH
--wood, brass and copper
 overlay; 20-1/2
 HOO 164
--wood, brass and copper
 overlay; 21-1/4
 NEWA 112; WIN pl 70
 UNjNewM (24.249)
--wood, brass and copper
 overlay; 23
 BALTW 25 UMdBM
--wood, brass overlay; c 21,
 and 20
 WIN pl 69 CTROA
--wood, brass overlay;
 27-3/4
 READO 44;
 ROSS pl 10
 UDCNMS
--wood, copper overlay;
 22-1/2
 ROTHS 257 UNNRu
--wood, copper overlay; 24
 SEG 99 UNNSeg
--wood, metal mountings
 FEIN pl 17/18 UNNCar
Figure 19th c. wood, metal-
 covered; c 22
 UPJ 552
--19/20th c. wood, brass
 overlay; 30
 JANSH 26; JANSK 32 SwZUV
--19/20th c. wood, brass and
 copper overlay; 26-1/2
 JANSH 26; MUE pl 29
 FPRat
Naja: Reliquary Figure wood,
 metal; 30-3/8
 NPPM pl 25 UNNMPA
 (61.247)
--BAKOUELE
Animal Mask H: 38
 SEG 188 -Pla
Heart-Shaped Mask wood;
 9-1/2
 ROY 39 (col) FPT
--BAKUBA (BUSHONGO)
Animal (Itombwa) Divination

Figure wood; 2
SEG 11 BTC
--wood; L: 12-1/2
WIN pl 87 UNBuMS
(C 12608)
"Bombo" Mask wood, with
beads and copper 13
NEWA 112 UNjNewM
Bope Kena wood; 55 cm
TREW pl 43 BTC
Bope Pelenge wood
TREW pl 43 ELBr
Box wood; 3-1/4x7-1/2
WIN pl 86 UNBuMS
(C 12697)
Ceremonial Cup H: 6
SEG 200, 201 UNNSeg
--H: 6
SEG 200 UCoDA
--H: 7
SEG 200 UCoDA
--H: 9
SEG 200 -Sti
--H: 9, and 10
SEG 200 BTC
--H: 11
SEG 200 -Til
--wood; 12
SEG 103 BTC
--: Human Head wood; 9-1/2
SEG 29 UNNSeg
Cup H: 6
WINGP 159 SnSE
--: Effigy Cup, Central
Congo stained and polished
hardwood; 6-1/2
WINGP 156 SnSE
--Human Figure wood; 5-1/2
NMAN # 498 EOS
Cups wood
LARA 88 ELBr
--wood; 5 to 7
WIN pl 84 UNBuMS
(C 12769; C 12700; UNBB
22.1487)
--: Double Heads; Cylinder
wood; 5 to 7
WIN pl 85 UNBB (22.1488;
22.173)
Dance Mask ptd wood
CLE 303 UOClA (35.304)
Drinking Horn H: 10
SEG 202 BTC
Faceless Doll c 1909 H: 7
FAA 15 ELBr
Female Figure wood
FEIN pl 65 UNNAmM
Goblet: Face wood; 24 cm
TREW pl 2 BTC

Goblet: Human Figure wood;
11
SEG 105 UNNStr
Goblet: Human Head wood;
8-1/2
MUE pl 40 FPRat
Hand, utensil H: 14
SEG 202 BTC
Initiation Ceremony Mask
wood; 13
SEG 17 -Rog
Kata Mbula, seated figure
1800/10 wood; 20
LEU 179 (col); MUE pl
39; PAU pl 28 BTC
(15256)
King's Palm Wine Cup:
Horns of head forming
handle wood; 11
FAA 148 ELBr
Kneeling Figure H: 16
SEG 203 BTC
Ladle: Human Left Hand
wood; 18-3/4
FAA 80 ELBr
Mask H: 13 to 27
SEG 203, 204 BTC
Mask ptd wood, with beads,
shells, raffia cloth; 13-1/2
BALTW 25 UMdBM
Mask: Cowrie Shells H: 14
SEG 204 BTC
Mask: Cowrie Shells
(Mashamboy) H: 16
SEG 205 UNNSe
Mask, Kete ptd wood and
straw; 13
BAZINW 225 (col) UDCNMS
Memorial Column, funeral
memento powdered red
camwood; 11-1/2
FAA 46 ELBr
Misha Pelenge wood
TREW pl 43 ELBr
Ointment Box wood; 4, and 9
SEG 202 UNNSe; BTC
Ox iron
MALV 610
Ritual Palm Wine Beaker:
Human Head wood, with
cowrie shells; 21 cm
BOE 43 DCNM
Royal Figure
LARA 88 ELBr
Shamba of Bolongongo, 93rd
King of the Bushongo,
kneeling figure wood; 21-1/2
SEG 12; TREW pl 43
ELBr

Shamba of Bolongongo, seated
 figure
 WINGP 153 ELBr
--c 1600 wood; 12-1/2
 EXM 42 (col) ELBr
Yolo Secret Society Emblem:
 Hand wood; L: 17-1/4
 MUE pl 41, 42 BTC (7163)
--BUKUNDU
Figures wood; 17-1/4
 LOM 162 GMV
--BAKWELE
Brazzaville Mask wood; 20-3/4
 NPPM pl 24 UNNMPA
 (56.218)
--BALEGA (LEGA; formerly--
 in Swahili; WAREGA)
Bwami Secret Society Dance
 Figure: Masks on Shoulders
 wood; c 10
 FAA 37 UDCNMS
Bwami Secret Society Figure
 wood; c 6
 FAA 38 BTC
--: Old Man wood; c 4
 FAA 50 BTC
Bwami Secret Society Genga
 Figure ivory; 4-1/2
 FAA 144 -Bi
Bwami Secret Society Mask
 ivory; 8-1/2
 NPPM pl 30 UNNMPA
 (61.285)
--: Heart-Shaped Face in Egg-
 Form H: c 6
 FAA 151 -Bi
Effigy Head ivory; 5-7/8
 ROY 65 SwZR
Figure H: 8-1/2
 WINGP 178 SnSE
--ivory: 4
 WIN pl 107 UNBuMS
 (C 12692)
--ivory; 5-1/4, and 6
 SEG 40 -Sti; UNNSeg
--ivory; 10-1/4
 NMAN # 447 BBS
Figure: Arms Raised Over
 Head ivory; 8-5/8
 ROY 15
--wood; 9-1/4
 NMAN # 446 FPRat
--wood; 9-1/4
 READAS pl 36A UMnRA
Figure: With Two Faces,
 Belgian Congo wood; 8-5/8
 ROY 12 BTC
Figures: Half Figures ivory;
 7-1/4, and 9
 WIN pl 106 UNBuMS

(C 15565; C 15566)
Head ivory, cowrie shell eyes;
 5
 MUE pl 35 FPRat
--ivory, cowrie shell eye;
 6-1/4
 NMAN # 514 FPHe
Head: On Long Neck ivory;
 8-1/4
 BALTW 28 UMdBM
Head Rest ivory; 4-3/4
 NMAN # 472 FPCa
Janus Figure: Double
 Statuette, back-to-back
 human figures, west of Lake
 Kivu ivory
 SOTH-3:158; 159
Janus Figure: Male and
 Female Figures ivory,
 stained reddish black; 6-1/4
 FAA 144 ELBr
Katanda, Bwami Society Figure,
 multiple perforations wood;
 c 10
 FAA 82 BTC
Lega Mask wood; 7
 SEG front UNNSeg
Mask ivory; 7
 SEG 228 -EEp
--ivory; 8-1/4
 NMAN # 465 BBS
--wood; 8-5/8
 NMAN # 462 FPRat
--wood, raffia fringe; 6-1/2
 WIN pl 108 UNBuMS
 (C 12690)
--20th c. wood, kaolin, and
 raffia
 CHICC 24 UICHok
--: Human Face, Belgian
 Congo ivory; 6-3/4
 ROY 64 BTC
--: Secret Society Mask ivory
 CHENSW 403 UNNMPA
--: Stylized Human Face wood;
 8-1/4
 ROY 16 formerly FPRat
Miwami Secret Society Mask,
 with perforation decoration
 ivory; 7-5/8
 NMAN # 455 FPCa
Maomi Secret Society Four-
 Faced Figure, dance staff
 finial(?) ivory; 5-1/2
 MUE pl 33 FPRat
Moami Secret Society Ritual
 Mask ivory; 8
 MUE pl 45 SwZUV(10246)
Ritual Figure wood
 CHENSW 413 UMnRA

--BALI
Elephant Head H: 28
SEG 183 -Pla
--BALUBA
Amulet: Human Figure ivory;
3
SEG 207 BTC
Ancestor Figure wood; 90 cm
TREW pl 45 BTC
--wood; 31
FAA 140 ScER
--: "Long-Faced Style" H:
29-1/2
LEU 200 (col) SwZUV
--: head detail
DEVI 2; MALV 550 BAH
--: Urna wood; 19
LOM 167 GMV
Arrow Quiver H: 20
SEG 209 BTC
Ax: Emblem of Chief; Corn
Pestle wood; 14-3/8; 9-1/2
LEU 193 (col) SwZR
Ax: With Head Decoration
wood and iron; L: c 12;
blade L: 9-1/2
WIN pl 104 CTROA
(HAC. 26)
Ax, head H: 15
SEG 209 UNNSe
Charm ivory 4
BALTW 29 UMdBM
Chief's Stool wood; 20-1/2
BAZINW 225 (col) BTC
Chief's Stool, detail: Female
Supporting Figure Head,
Buli wood; 21-1/2
CHENSN 593; MUE pl 37
FPH (D41.1.1)
Chief's Stool, female figure
support H: 16-1/2
HOO 160
Chief's Stool, kneeling female
support wood; 19-1/2
BOSMP #46 UMCP
Chief's Stool, kneeling female
support wood; 21
SEG 25 BTC
Chief's Stool, kneeling female
supoort late 19th c. wood
NORM 81 ELBr
Chief's Stool, supporting
figure wood; 19
SEG 97 BTC
Covered Bowl: Held by Two
Figures wood; 8
SEG 57 BTC

Covered Bowl, with Lizard
Handle: Held by Two
Figures wood; 11x17-1/2
MUE pl 43 BTC (3861)
Cup: Squatting Human Figure
wood; 10-7/8
DENV 137 UCoDA
(401-QA)
Dance Mask ptd wood
FAIY 30 UNBuMS
Female Ancestor Figure 19th
c. wood
NORM 80 ELBr
--: Urna wood, fibre skirts;
14-1/2
LOM 166 GMV
Female Figure H: 12-1/2
WINGP 171 NLV
--detail ivory
FEIN pl 28 UNBB
Female Figure Amulet, Urua
ivory; 5-1/2
MUE pl 34 NWA
Female Figure wood; 14-1/2;
13-1/2; 15
HOO 160, 161
Female Head 19th c. wood
FEIN pl 12 UMCP
Figure H: 11, and 13
SEG 206 UNNSe; -Ling
--Central Style wood
TREW pl 45 ELBr
Figure Holding Bowl (Kabila
Ka Vilie) H: 7-1/2
SEG 207 UNNSe
Head-Shaped Vessel; Lidded
Jar and Bowl wood; 11-1/2;
9-3/4; W: 11
LEU 180 (col) SwZUV;
SwZR
Hermaphrodite wood; 8-1/2
MUE pl 46 NTC (520)
Kifwebe Secret Society Mask
H: 13
SEG 209 BTC
--ptd wood; 14-5/8
NPPM pl 31 UNNMPA
(56.56)
--wood, fibre beard; 17-1/2
MUE pl 44; SEG 43 BTC
(23470)
--: Helmet Mask H: 25-1/2
LEU 198 (col); SEG 208
BTC
Kneeling Woman Holding Bowl
(Beggarwoman) Buli
19/20th c. wood; 18-1/2

BAZINW 226 (col); DEVI
2; JANSH 28; JANSK 31;
MALV 552; MU 13; MUE
pl 38; SEG 208; TREW
pl 47 BTC (14358)
Male Figure black-tinted wood;
34
BAZINW 226 (col) (Ethno-
graphic Mus) BA
Male Figure 19th c. wood; 27
READAS pl 166; READO
45 ELBr
Mask
LARA 75 FPRat
--
MALV 551 -R
--striated wood; 62 cm
TREW pl 48 BTC
Neck Rest, female figure
support ivory; 7
LEU 195 (col) FPRat
--seated female figure support
wood; 5-1/2
WIN pl 105 UMCP (B1567)
Neck Rest: Two Female Figure
Support H: 6-1/2
SEG 207 -Pla
Neck Rest: Two Seated
Female Figure Support
H: 7
SEG 207 BTC
Pregnant Female Figure wood;
35
LARM 245; MUE pl 31,
pl 32 BTC (23459)
Seated Figure wood; c 5
ADL pl 73 ELBr
Seated Woman; detail wood;
19
LOM 165, front GMV
Seated Woman Holding Bowl
(Kabila) wood; 12-1/2
WIN pl 101 UPPU
(AF 5120)
Shene-Malula Mask, Central
Congo ptd wood, with
cowrie shells; 9
LEU 182 (col) SwZR
Staff Head: Female Figure
wood; 2
SEG 26 UNNSeg
Staff Head: Two Figures
H: 41
SEG 209 BTC
Stool wood, blue and white
head; 23-1/4
NPPA pl 29 UNNMPA
(61.47)

Stool: Ancestral Couple Sup-
port, Long-Faced Buli-
style wood; 53.5 cm
ADL pl 6 GBVo
(III c. 14966)
Stool: Elephant H: c 10
FAA 14 GStL
Stool: Female Figure Support,
Buli-style H: 55 cm
PAU pl 30 FPOr
Stool: Kneeling Female Figure
Support wood
GARDH 638 UPMeB
Stool: Kneeling Female Figures
Support, Buli-style H: 20-
1/2
WINGP 172, 173 GStL
Stool: Male and Female Figure
Support wood
CHENSW 416 GBSBeVo
Stool: long-faced style, Buli
wood
TREW pl 46 GDaH
Stool: long-faced style, Buli
wood; 53 cm
TREW pl 46 ELBr
Stool: seated woman support
wood; 17
WIN pl 102 UPPU (AF 5121)
Stool: Two Squatting Figures
Support wood; 16
MUE pl 52 BTC (33144)
Tattooed Female Figure
FEIN pl 67 UPPU
Water Pipe with Female
Figure wood; 22
WIN pl 103 UNBB (22.1108)
Woman Holding Bowl
WINGP 168 IFAr
--wood
CHENSW 415 ELBr
Woman Supporting Seat wood
CHENSW 415 FPOr
--BALUBA/BADJOKWE
Neck Rest, supported by
female figures wood; 6
WIN pl 110 CTROA
(HA.644)
--BALUBA, and BAPENDE
Heads and Figures: Fetishes
CHENSW 417 UNBuMS;
UNNMPA
--BALUMBO
Ghost Mask: Ogowe River
Area wood; 7-1/2
MUE pl I (col) NAT
(1772/846)
--c 19th c. ptd wood; 11-3/8
EXM 324 UNNMPA

Mask ptd wood; 11-1/2
 NEWA 111 UNjNewM
Mukui Society Dance Mask
 20th c. wood, ptd black,
 red and white; 12-1/4
 GRIG pl 148 ELBr
--BALUNDA
Figure H: 12
 SEG 210 BTC
--BALUNDA/BATSHIOKO
Initiation Mask wood; 14
 SEG 44 UNNSe
--BAMBALA
Drummer, wood; 25 cm
 TREW pl 41 BTC
Figure H: 5
 SEG 210 UNNSe
Head Rest, figure support
 wood; W: 10-3/4
 FAA 102 ELBr
Libwe Society Initiation
 Figure H: 28
 SEG 210 BTC
Mother and Child wood; 54
 cm
 TREW pl 41 BTC
--BAMBARA
Ancestor Figure, Mali wood;
 38-1/4
 EXM 146
--wood; 48-5/8
 NPPM pl 4 UNNMPA
 (59.110)
Antelope wood; L: 25-5/8
 ROY 40, 41
--: ex-French Sudan wood
 HAM NOK
--: With Male Young on
 Back, fertility dance
 figures blackened wood;
 27
 MUE pl 5 UNNMu
Antelope Couple, Mali wood;
 38-5/8
 CALA 254 IVG
Boys' Secret Society Mask
 (N'Tomo), Sudan wood;
 24
 WIN pl 5
Cross Bolt
 SEG 159
Dance Headpiece (Chi Wara;
 Tchi Ouara; Tji-'Wara):
 Antelope H: 76 cm
 PAU pl 1 FPH
 (No. 31.74.1826)
--H: c 22
 FAA 152 -Ge

--wood; 8
 SEG 155 -Ras
--wood; 19
 SEG 159 UNNSe
--wood; 19-1/2
 NEWA 113 UNjNewM
--wood; 21
 GARDH 632
--wood; 24-3/4
 WIN pl 4 UPPU (29-12-125)
--wood; 29
 BALTW 9 UMdBM
--wood; 30
 SEG 80 UNNRu
--: Kore Secret Society
 wood; 30-3/4
 LEU 66 (col) SwZR
--wood; 31-1/2
 LEU 78 (col) SwZLe
--wood; 33-1/2
 BALTW 5 UMdBM
--wood; 57
 TOR 157 CTRO (959.46)
--wood and metal; 20
 DENV 137 UCoDA (370-QA)
--20th c. wood
 ENC 12
--20th c. wood; 29-3/4
 GRIG pl 147 ELBr
Female Figure, geometric
 FEIN pl 129 UNNMPA
Female Head wood
 FEIN pl 10 UNNCar
Female Idol, Western
 Sudan wood
 FEIN pl 102 UNNMPA
Fertility Goddess, West
 Sudan
 FEIN pl 104 UNBB
Headdress wood
 TREW pl 29 ELBr; FPH
--: Mali wood; 41 cm
 TREW pl 28 -Kj
Komo Society Mask, with
 crocodile-like jaws, pairs
 of antelope horns wood; 20
 FAA 84 -Si
Mask: Animal wood; 25
 SEG 158 FPH
--: Antelope, Segoni-Kun
 WINGP 90 SwZUV
--H: c 14
 WINGP 31 SwZLe
Mask: Sudan Animal wood;
 16
 WIN pl 6 UnBuMS (C 13457)
Mask, with cowrie shells,
 N'Tomo wood; 15 SEG 91
 UNNSe

Mask with antelope wood; 15
 SEG 89 -Pla
Mule Head wood and metal
 CLE 302 UOClA (35.307)
Neckrest, animal-form wood;
 7-1/8
 CALA 256 IVG
--: supporting figure wood;
 7
 BALTW 14, 15 UMdBM
N'tiedo Society Dance Head-
 dress
 SOTH-4:162
Protective Figure H: 9
 SEG 158 UNNSe
Seated Female, ancestor
 figure, Mali wood; 60 cm
 TREW pl 1 ELBr
--: Sudan wood; 20-7/8
 WIN pl 1 UPPU (AF 5365)
Three-Headed Human wood;
 39
 SEG 89 UNNRu
Tjiwara, bobbin
 CHENSW 419 UPPU
Twin Figure, Sudan wood;
 c 9
 WIN pl 2 UNBB (22.1456)
Woman wood
 CHENSW 413 UNBB
--BAMENDJO
Mask striated wood; 26-3/8
 NMAN #326; ROTHS 271
 NZH
--BAMESSUNG (BEMESSUNG)
Animal Head H: 18
 SEG 183 -Pla
Pipe clay; 6
 SEG 183 UMiBloC
--BAMILEKE
Ancestor Figure wood; 37-1/2
 FAA 59 ELBr
Circular Building, with
 carved posts and figures,
 Batouffam District,
 Cameroons
 PAU pl 17
Hut Columns and Facade
 LARA 88
Pipe: Human Face, Cameroon
 terracotta; 12
 SEG 183; TREW pl 35
 FPH
Seated Male Figure wood;
 99 cm
 TREW pl 35 FPRat
--BAMUM
Ancestor Figure wood; 34
 NPPM pl 23 UNNMPA
 (61.256)

Animal Head H: 28
 SEG 184 NRL
Beaded Throne of Sultan
 Njoya H: 32-3/4
 LEU 150 (col) GBE
Carved Door Frame archi-
 trave W: 2 m
 ADL pl 4 GBVo
Dance Mask: Animal wood;
 10
 SEG 137 UICNh
Kneeling Man wood; 17-1/4
 NMAN #321 NZH
Mask fiber, beads, red
 cloth; L: 28-1/2
 DENV 138 UCoDA (13-BA)
--wood
 TREW pl 36 ELBr
--BANDA
Ritual Object, Nalobi wood
 TREW pl 31 SeDI
--BANGALA
Harp-like Instrument
 WINGP 181 DCNM
--BANGWA
Ancestor Figure H: 36-1/4
 LOM 144 GMV
--wood 32
 ROTHS 259 UNNRu
--: female wood; 82 cm
 ADL pl 2B GBVo
Female Figure H: 33-1/2
 SOTH-4:167 (col)
--wood; 32
 NMAN #319 UNNRu
House Post: Genealogical
 Tree wood; 117
 LOM 143 GMV
Seated Woman Holding Bowl
 wood; 33-1/8
 NMAN #323 FPRat
--BAOULE (BAULE)
Amulet: Mask in filigree
 frame gold
 LARA 87 FPInst
Ancestor Cult mask wood; 14
 SEG 81 -Ev
--: Horned, with surmounted
 animal wood; 16
 SEG 79 -Gol
Ancestor Figure H: 15
 SEG 169 -Z
--wood, glass beads, white
 paint; 18-1/8
 NPPM pl 13 UNNMPA
 (56.365)
Ancestor Figures; Ointment
 Pot wood; 13-3/4; 15-3/4;
 9-3/4 LEU 104 (col)
 SwZR; SwZLe

Animal Head wood; 10
 SEG 79 -But
Bobbins: Animal; Human
 CHENSW 419 FPCa; FPH
Buffalo (Guli) Mask
 SEG 170 -P
 --wood; 28-3/4
 LEU 107 (col) SwZLe
 --wood; 30
 SEG 80 -Kay
Dance Mask wood, colored
 red, white, ochre, black
 NORM 83
Dog-Headed Monkey Holding
 Bowl for Offerings: Judge
 of Souls of Dead wood;
 20-7/8
 MUE pl 14; WINGP 86
 NLRV (3108-1)
Double Mask: Two Faces
 side-by-side, with tattoo
 marks wood; 10-1/2
 MUE pl 12 FPVe
Female Figure H: 15-1/2
 WINGP 85 UCLFr
 --wood; 14
 BALTW 12 UMdBM
 --wood; 47 cm
 TREW pl 22 -Kj
 --wood; 16
 FAA 136 -R
 --wood; 20-1/4
 WIN pl 18 UNNAmM
 (90.1/6994)
 --wood; 20-1/2
 MUE pl 8 SwZUV (10047)
 --: Carrying Children wood;
 17-3/4
 BALTW 12 UMdBM
Female head wood
 FEIN pl 70 UNNCar
 --: elaborate hair style
 wood
 FEIN pl 64 UNND
 --: rear view
 FEIN pl 62 UNND
 --: with tattooing wood
 FEIN pl 16 UPPU
Fetish Figure
 CRAVR 193 UOClA
Figures wood; 16, and 17
 ROY 13
Gong Mallet wood; 9
 WIN pl 23 UNBuMS
 (C 12515)
Gu Mask H: 27 cm
 PAU pl 11 FPH
 (No. 52.13.2)

Guinea Coast Figure wood;
 18-1/8
 BOSMP #17 UNNMPA
Male Figure wood; 44 cm
 TREW pl 22 -Kj
 --wood; 16-1/4
 WIN pl 21 UPPU (29.12.72)
 --wood; 22-7/8
 NMAN #69 FPRat
 --wood, beads; 21-3/4
 NPPM pl 12 UNNMPA
 (60.84)
Mask
 GAF 159 FPH
 --wood
 CHENSW 418 UPPU
 --wood; 30 cm
 TREW pl 23 ELS
 --wood; 15
 WIN pl 22 UNBuMS (C 12719)
 --wood; 15-1/4
 BALT 30 UMdBM
 --: Surmounted by Bird wood;
 15-3/4
 NMAN #101; ROTHS 273
 FPGu
 --: With Horns wood; 17-3/8
 NMAN #84 FPFe
Mask--miniature cast gold
 CLE 302 UOClA (54.602)
Mother Nursing Child
 FEIN pl 48 UPPU
Pendant: Animal Mask gold;
 3-3/8x3-5/8
 NPPM pl 16 UNNMPA
 (56.398)
 --Mask gold; 3-1/2
 SEG 170 -Gue
Ram Mask gold; 3-1/8
 ROY 42 FPT
Ram's Head Pendant gold;
 3-1/2
 NMAN #142 FPT
Seated Female Figure wood;
 17
 WIN pl 20 UPPU (29.12.69)
 --wood; 22
 WIN pl 19 UCBeP
Seated Figure 19th c. H:
 18-1/2
 UPJH pl 302 ScER
Seated Male Figure wood;
 47 cm
 TREW pl 22 ScER
Woman--tattooing and
 elaborate hair style wood
 FEIN pl 60 UPPU
Yaure Mask wood
 LEU 109 (col) SwZR

22

AFRICAN--BAOULE, or GURO

--BAOULE, or GURO
Ancestor Figure wood, ptd
white, with beads; 25-7/8
NPPM pl 17 UNNMPA
(59.23)
--BAPENDE
Bearded Mask ivory; 2-1/4
WINGP 151 UNNWin
Chief's Wife, weathered bust
wood; 17-1/2
FAA 75 -Rome
Cup: Crouching Human Figure
c 1907 wood
NORM 80 ELBr
Female Figure ivory; 13 cm
ADL pl 7C
Female Mask 19th c. ptd
wood; 12-1/2
LOM 160 (col) GMV
Fetish Figure: Human with
Single Horn wood; c 48
FAA 52 ConLM
Fringed Mask raffia and
feather; 9
SEG 212 BTC
Gable Figure: Woman, South-
western Congo H: 23-1/4
LEU 132 (col) SwZR
Head for Chief's House Post--
jutting beard wood, ptd red;
12
FAA 44 ELBr
Hunter's Mask, Congo H:
23 cm
PAU pl 27 BTC
(No. 29738)
Initiation Mask H: 18, and 22
SEG 213, 211 -Lov; UNNSe
Mask H: 11
SEG 212 BTC
Mask: With Pigtails c 19th c.
wood; c LS
READAS pl 169 ELBr
Mask, Central Congo wood;
9-1/4
WINGP 149 ELBr
Mask, amulet ivory; 2-1/2
SEG 55 UNRoR
Masks ivory; 2 to 3
WIN pl 83 UNBB; UPPU
(30-59.1)
--wood
TREW pl 42 ELBr
Miniature Pendant Masks
ivory
TREW pl 42 BTC
Minyaki Initiation Mask wood;
11
SEG 53 BTC

Pendant: Human Face ivory; 3
MUE pl 36 UNNMu
Pendant Mask ivory; 2-3/8
NMAN #521 EOS
--BAROTSE
Bowl for Meat and Vegetables:
Wild Ducks on Lid wood;
L: 12-1/2
LEU f (col) SwZR
Neckrest L: 18
WINGP 182 IFAr
Neckrest and Box: Buffalo
WIN pl 117 UMCP (B 4746)
--BASONGE (BASHONE;
BASSANGE)
Cup: Human Figure wood; c 7
WIN pl 95 UMCP (B 1598)
Equestrian wood; L: 21-3/4
FAAN pl 134a, b EWestMB;
ELHM
Female Head wood, partly
copper mounted
FEIN pl 11 UNNCar
Fetish Figure H: 7, and 35
SEG 214 -Sti; BTC
--H: 40
FAA 35 ELBr
--wood; 7
WIN pl 94 UCtNhL
--wood; 10
WIN pl 93 UPPU (AF 5194)
Fetish Head: Horned Human
wood; 14-1/2
FAA 47 BTC
Figure wood; 42 cm
TREW pl 48 BTC
--wood; 51
SEG 104 -Sti
--: central Congo H: 39-1/2
WINGP 162 GDusMey
Kalebue Mask, Bena Mpassa,
Belgian Congo striated wood;
3-3/4
LEU 187 (col) SwZR
Kifwebe Mask, Central Congo
H: 15-3/4
WINGP 161 SwZUV
Lion Secret Society Mask
wood; ptd; 15
BOSMP #48 UPPU
Mask ptd wood; 24-3/4
NMAN #452 ELBu
Mask striated wood; 13-1/2
WIN pl 96 UPPU (AF1881)
--striated wood; 13-1/2
WIN pl 97 UPPU (AF 5115)
--striated wood; 16
WIN pl 99 UNBuMS (C 13728)

--19th c. striated wood;
14-1/2
READAS pl 168 ELBr
--wood; 55 cm
TREW pl 48 BTC
--wood, colored; 24-3/4
ROTHS 271 ELBu
Stool wood; 15
BALTW 27 UMdBM
Whistle: Bearded Figure
ivory; 2-1/2
SEG 31 -Heb
--BASONGE/BALUBA
Mask, round wood; 17
WIN pl 98 UNBuMS
(C 12776)
--BASUKU
Helmet Mask wood and raffia;
23-5/8
LEU 175 (col) SwZR
Hembe Hood Mask H: 16
SEG 214 BTC
Hermaphrodite Healing Fetish,
Kwango H: 22-3/4
LEU 177 (col) BTC
Hood Mask H: 17
SEG 214 UNNSe
--BASUNDI
Badunga Society Initiation Mask:
H: 17
SEG 215 BTC
Sepulchral Figure, Lower
Congo 19th c. wood; 20
LEU 168 (col) SwZR
--BATANGA
Mask H: 12
SEG 188 NLV
--BATEKE
Double Figure H: 11
SEG 216 UNNSe
Fetish Statue wood; 18
SEG 71 BTC
Headrest, figure support
wood; c 5
FAA 40 GStL
Male Fetish, Congo wood;
12-1/2
WIN pl 77 UPPU (AF 4706)
Mask, Middle Congo H:
35 cm
PAU pl 24 (col) FPH
(No. 32.89.82)
Mask: Disc-Shaped Abstract
Form, French Congo wood,
ptd red and white; 13-3/4
LEU 167 (col) FPH
Mask: Human Face wood;
13-3/8
ROY 60

--BATSHIOKO
Chief's Chair H: 15
SEG 230 BTC
--: with human figures wood;
24
FAIY 30 UNBuMS
Chief's Stool H: 8
SEG 230 BTC
Figure H: 11
SEG 229 NLV
--wood; c 38 cm
TREW pl 48 ELBr
--: from Chief's Stool wood;
34 cm
TREW pl 48 BTC
Masks H: 10, and 15
BTC
Sceptre Head: Seated Figure
wood; 14
SEG 32 -Loc
--BAVILI
Fetish with Nails: H, 47-1/4
ROY 71 ELBr
Mask H: 16
SEG 192 NLV
Nkisi Nkonde, reliquary
figure, Middle Congo nail
studded wood; 66 cm
PAU pl 26 FPH (No. X.
44.82)
--BAWONGO
Ceremonial Adze: Badge of
Carver wood; 13
FAA 49 -R
Palm Wine Cups: Female
Figure wood; 7, and 7-1/2
FAA 78 ELBr
--BAYAKA
Animal Mask H: 26
SEG 218 BTC
Ceremonial Cup H: 4-1/2
SEG 220 UNNSe
Feather Mask H: 12
SEG 218 BTC
Female Figure wood; 11
WIN pl 80 UMCP (B 1554)
Figure H: 19
SEG 216 BTC
--detail: H: 8
SEG 217 UNNSe
Helmet Mask wood, plaited
raffia; 22
LEU 175 (col) SwZUV
Hood Mask H: 11
SEG 218 BTC
Initiation Mask H: 16
SEG 217 BTC
--ptd wood; 12
SEG 95 BTC

--: Surmounted by Leopard
 ptd wood and fibre; 19-1/2;
 leopard L: 31-1/2
 MUE pl 53 SwZUV (D.361)
Male Figure H: 10
 SEG 216 BTC
-- H: 18-1/4
 WINGP 146 UNNMPA
Mask H: 13
 SEG 219 BTC
--H: 56 cm
 PAU pl 26 BTC (No.
 32.991)
--ptd wood
 TREW pl 41 BTC
--wood, raffia; 21
 BOSMP #42 UNNEli
--wood, basketry, raffia; 27
 DENV 138 UCoDA (306.QA)
--: Surmounted by Animal
 ptd wood; 14-1/2
 WIN pl 79 UPPU (AF 1875)
--: With Handle ptd wood;
 10-1/2
 WIN pl 78 UNBB (22.1583)
Mask of Chief of Circumcision
 Rites H: 90 cm
 TREW pl 41 BTC
Ndemba Handle Mask wood; 17
 SEG 91 FPH
Neckrest wood; 5-1/2
 WIN pl 82 UNBuMS
 (C 12781)
Vertical Drum wood; 10-1/4
 BALTW 26 UMdBM
--: with head wood; c 14
 WIN pl 81 UNNSp
Whistle wood; 6
 WIN pl 83 UNBuMS
 (C 12622)
--BAYAKA, or BATSHIOKO
Pipe H: 5-1/2
 SEG 202 UNNSe
--BAYANZI
Female Figure H: 6
 SEG 221 UNNSeg
--BENA BIOMBO
Mask H: 15
 SEG 223 -Heb
--BENA KANIOKA
Drum Player wood; 15-1/4
 NMAN #437 NZH
Pipes: Laughing Women
 H: 13, and 10
 FAA 71 ELBr
Stool Supported by Kneeling
 Woman wood; c 20
 WIN pl 100 UMCP
 (17-41-50/B 1568)

Throne Base, figure with
 cicatrized abdomen
 FEIN pl 68 UMCP
--BENA KOSH
Hood Mask ptd wood; 15
 SEG 96 BTC
--BENA LULUA
Ancestor Figure H: 47 cm
 PAU pl 30 BTC (No. 43850)
--wood; 10
 SEG 23 BTC
Female Figure 19th c. ptd
 wood; 11
 LOM 158 (col) GMV
Fertility Goddess wood
 FEIN pl 41 UNBB
Figure, Bakwa-Ndolo H: 15
 SEG 220 BTC
--: Central Congo H: 12-1/2
 WINGP 165 GHV
Figures wood; 45, and 69 cm
 TREW pl 44 BTC
--wood; 18-1/2, 19, and
 25-1/4
 MUE pl 51, 50 BTC
 (43850; 43858; 33854)
Headrest: Supported by Human
 Figure with Large Feet
 wood; 8
 FAA 48 BTC
Mask H: 23
 SEG 225 BTC
Mbulenga Figure H: 20
 SOTH-4:169
Mother and Nursing Child
 H: 15
 SEG 220 BTC
Pipe wood; 13-1/2
 BALTW 26 UMdBM
--: Scarified Head Bowl, on
 Human Left Hand wood;
 L: 19
 FAA 81 BAKE
Seated Figure wood; 21-5/8
 NMAN #445 FPRat
Squatting Fetish wood; 9-1/2
 WIN pl 92 UPPU (AF 5184)
--BENIN
Aegis-Shaped Pendant bronze;
 6-1/4
 FAAN pl 28 GHVo
Altar Head 16th c. bronze
 FAUL 479 UNNMPA
Altar of the Hand (Ikegobo)
 bronze; 17-3/4
 FAAN pl 40 ELBr
--: Elephants and Other
 Figures 18th c. bronze;
 Dm: 12
 FAA 108 NiJM

Ancestor Memorials: Antelope
Heads
FAA 156 NiEwO
Archer bronze
MALV 545 GBE
Armed Warrior, plaque
bronze
PRAEG 546
--: With Sword and Bini Bow
bronze; 14
FAAN pl 29 GBVo
Armed Warriors, plaques
bronze; 17
SEG 149 ELBr
--16/17th c. bronze
SOTH-2:130
Armlet bronze; 5
SEG 151 UNNSe
--: Yoruba Style, Owo(?)
ivory; c 6
ADL pl 8A ELBr
Armlets ivory; 5-1/4
FAAN pl 32 ELBr
Bell bronze; 5
SEG 151 UNNSe
--bronze; 8
FAAN pl 63 ELBr
--: Human Face and Form
bronze; 6-3/4
ROY 28 formerly FPCa
Bini Girl, head
CHENSW 420 ELBr
Bird bronze; 5
SEG 150 UNNSe
--bronze; 5-1/2
BALTW 13 UMdBM
Bowl: On Open Work
Pedestal bronze; 11-1/2
FAAN pl 63 ELBr
Box: Animal and Plant
Forms 1890's ivory; L: c
6
FAA 130 NiLN
Bracelet, openwork copper;
5-1/8
LOM 170 GMV
Carved Tusk ivory
HOF 207 FPCa
Chief in Court Dress, Udo
Style bronze; 18-1/4
FAA 142 -Pr
Chieftan, head 19th c. wood;
17-1/2
TOR 160 CTRO (959.160)
Cock bronze
LARA 85 ELBr
--bronze; 8
SEG 138 UNNMM

--bronze; 19
FAAN pl 44 GHV
--1500 bronze
ZOR 52
--16/17th c. bronze
BRIONA 90 FPH
Crested Head late period
bronze; 27 cm
TREW pl 16 ELBr
Cup ivory; 7
BOSMP #24 UNNHee
Double Gong ivory; 14
FAAN pl 38 -Ep
--ivory; 14
FAAN pl 39 ELBr
--ivory; 14
SEG 144 NiG
--18th c. bronze; 12
FAAN pl 38 EFaP
Drum 19th c. ivory; 8-5/8
TOR 160 CTRO (929.28)
Dwarves bronze; 23-1/2, and
23-1/4
FAAN pl 25 AVV
Female Figure bronze; 14
SEG 140 ELBr
--bronze; 18-3/4
FAAN pl 37, 36 GBVo
--ivory; 8
SEG 145 UPPU
Female head bronze
HOF 33
Figure ivory; 15
BOSMP #23 UMCP
--: Fish-Tail Legs; Frogs,
plaque bronze; 11
ROY 29 formerly FPCa
--: in court dress bronze;
c 10
FAA 109 NiLN
--: plaque bronze; 15-3/4
ROY 30
--: with bell and leopard-
tooth necklace bronze;
13-1/4
FAAN pl 62 GBVo
Figures bronze; base: 22x13
ROTHS 265 GBVo
--: Adults and Children,
plaque bronze
LARA 86 ELBr
Flute Player 16/18th c.
bronze; 24-7/8
JANSH 27; JANSK 30
UNNMPA
Gate of Oba's Palace, plaque
bronze; 19
FAAN pl 35 GBVo

Girl, head 16th c. bronze;
8-1/2 HOO 154;
READAS pl 165 ELBr
Goblet and Cover: Human
and Animal Motifs 16th c.
ivory; 9
HOO 153
Grotesque: Human Head,
Frog from Mouth,
Snakes from Nostrils,
Enowe Shrine bronze;
c 10
FAA 123 NiBeM
Head bronze
CHENSW 423; TREW pl
14 ELBr
--bronze; 6-1/2
SEG 147 -Pla
--bronze; 9-1/4
WINGP 111 UNNMPA
--bronze, 11
SEG 146 ELBr
--16th c. bronze; 8-1/4
FAAN pl 12 UNNMPA
--c 18th c. ivory; 9
FAAN pl 53 ERiE
--: Surmounted by 4 Ibis,
with snakes from nostrils,
and eyes devouring frogs
bronze; 10-1/2
FAAN pl 18 GBVo
--: Supporting Carved Tusk
bronze; 15 cm
TREW pl 16 ELBr
Head, Udo bronze; 9-1/2
FAAN pl 56 ELBr
--: conical cap and wide
necklace bronze; 14
SEG 148 UPPU
--: in cap 16th c. bronze
SOTH-1: 120
--: in collar bronze
ROTHS 267 FPEth
--: in collar bronze
WILM 108 ELBu
--: in collar c 1550/1650
bronze; 9-1/2
FAAN pl 14a ELBr
--: in collar c 1700 bronze;
14-3/4
FAAN pl 14b GBromU
--: in collar and headdress
bronze; 20-1/8
FAAN pl 15 ELBr
--: in peaked headcovering
bronze
BOA 81
--: spirit cult(?) bronze;
26 cm
TREW pl 16 ELBr

--: with neck rings bronze;
20-1/8
ROY 23 formerly FPCa
Heads, Palace of Oba of
Benin bronze; 8-1/4
MYBS 13 ELBr; -Sch
--: in caps and collars
bronze; 8-1/2, and 4-3/4
FAAN pl 11 ELBr
Hip Mask: Grotesque
FAA 106
--: Human Face with Ele-
phant Tusks and Trunk
bronze; 6-1/2
FAAN pl 28 GHV
Horn Blower bronze; 24-7/8
NPPM pl 19 UNNMPA
(57. 255)
--: Of Oba bronze; 24-1/2
FAAN pl 27; GRIG pl 145
ELBr
--: Nigeria 16/17th c. bronze;
61 cm
TREW pl 2 -O
--: Court style bronze;
25-1/2
EXM 106 UPPeI
Horseman 17th c. bronze
LEU 128 (col) Torso:
SwZUV; Head: ELBr
Hunter: Carrying Antelope
1600/50 bronze; c 14-1/2
EXM 76; FAAN pl 58;
LOM 157 (col); WCO-
3:50 ELBr
Hunter, relief bronze; 18-1/2,
and 12-5/8
NMAN #255 GBVo
Ibis Hunter, plaque bronze; 18
FAAN pl 22 GBVo
Ivory Tusks H: 48
SEG 142 ELBr
Leopard bronze
BAZINW 224 (col) GMV
--bronze; L: 28
NMAN #280 FPRat
--18/19th c. ivory, inset
copper disks; 33x32
BAZINL pl 89; CHENSW
421; GAUN pl 41 (col);
GRIG pl 146; LEU 37 (col);
SEG 143
Leopard: Mask
SOTH-3: 156
Leopard: Oba's Forearm
Ornament ivory, metal
spots; L: 11
FAAN pl 49 ELBr
Leopard, plaque bronze
BAZINH 59

--16th c. ivory
ENC 84
--c 16th c. ivory; 7-1/2
LOM 156 (col) ELBr
Pendant Masks: Human Head,
and Leopard 16th c. bronze;
7-1/4, and 7-1/2
HOO 155
Plaque, fragment 16/17th c.
bronze; 12-1/2
NEWA 110 UNjNewM
Portuguese Crossbowman
c 1600 bronze; 13-3/4
FAAN pl 42 ELBr
Portuguese with Staff of Office
bronze; 18-1/2
FAAN pl 41 AVV
Princess 16th c. bronze
BAZINW 223 (col) ELBr
Princess, head bronze
PANA-2: 2 URPD
--bronze
PANA 2: 145 UVtBuF
--1360/1500 bronze; 9-5/8
ALB 125; FAIY 10 UNBuA
Python Head bronze; L: 16-1/2
FAAN pl 34 GBVo
--c 17th c. bronze; L: 13-1/2
FAA 129 UPPU
Queen Mother 16th c. bronze;
14
FAAN pl 13 ELivL
Queen Mother (Iyoba), head,
lattice-work headdress
16th c. bronze; 15-3/4
ENC 84; GRIG pl 144;
LEU 125 (col); LOM 156
(col); TREW pl 14; WHITT
61 ELBr
Ram Aquamanile bronze; L:
17-1/4
FAAN pl 45 ELBr
Royal Head: Pectoral Mask
16th c. ivory; 8-1/4
BAZINW 224 (col) UNNMPA
Royal Mask ivory; c 8
FAH 66 -Me
Royal Personnage, plaque
16/17th c. bronze
ELIS 105 UNNMPA
Saltcellars ivory; 11-3/4,
and 8-3/4
FAAN pl 55 ELBr
Sceptre: Equestrian red
ivory; 15
FAAN pl 80 ELivL
Sceptre, or Flywhisk, Handle:
Equestrian ivory; 16-1/2
FAAN pl 52 EFaP

Sea Life, plaque bronze;
14-1/2
ROY 27 GBVo
Side-Blown Trumpet: Oba
Riding Elephant ivory;
21-1/2
FAAN pl 54 AVV
Side-Blown Trumpet, Afro-
Portuguese ivory; 15-3/4
FAAN pl 54 ELBr
Staff Surmounted by Bird,
Nigeria bronze; 12-1/4
WIN pl 43 UNBuMS
(C 12763)
Stool, or Throne supported
by coiled python mid 18th
c. bronze; 15-1/2
FAAN pl 26 GBVo
Three Figures in Armor,
wall plaque bronze; 20 cm
PAU pl 14 ELBr
Tree and Harvesters, relief
bronze; 21-7/8
NMAN #257 GDS
Tube: Lizard and Snake,
relief 17th c. bronze
FAA 131
Vase, with Human and
Animal (Turtle) Figures
Bronze; c 8
FAA 107 NiLM
Waist Mask: Snakes from
Nostrils Devouring Frogs
c 16th c. bronze; 6
FAAN pl 19 ELBr
Waist Mask ivory; 9
FAAN pl 81 ELBr
War Game--Board Game:
Board and One Figure
early 17th c. board L: 30
FAA 110 -R; -Rus
War Game--Board Game:
Figures with Rounded Base
early 17th c. H: 2-3/4
FAA 110 ELBr
Warrior bronze
INTA-2: 119
--: head bronze; 21
NCM 256 UMiD
--: plaque 17th c. bronze;
20-1/2
DENV 133 UCoDA (351-QA)
--: relief bronze
PANA-1: 97 UNBB
Warrior-Attendant, plaque
17th c. bronze
CLE 302 UOC1A (54.425)
Warrior: With Shields, Club,
and Lance 17th c. bronze;
NCM 256 UMiD (26.10; 26.11)

Woman Holding Mirror or
 Tray, plaque bronze; c 6
 ADL pl 7D ELBr
Young Prince, head 16th c.
 bronze; 8
 COOP 264 ESuAH
--BENJABI
Bakosi Mask H: 12
 SEG 188
Head H: 12
 SEG 189 UNNGro
--BINI
Antelope Head wood; 16-3/4
 FAAN pl 104b UPPU
Bini Warrior, plaque 16th c.
 bronze; 30-1/2
 FAAN pl 20 GBVo; GHV
Bird, plaque bronze; 17
 SEG 109 UPPU
Igbile Cult Mask wood;
 21-1/4
 FAAN pl 107 ERiE
Igbodo-Igbile Cult Mask
 wood; 24
 FAAN pl 106 UICWi
Mask: Tribal Marks on
 Forehead brass; 6-1/4
 FAA 146 ELBr
Osanobua, and other Gods
 in River Goddess' Shrine
 1958 mud
 FAA 138 NiU
Pectoral: Human Face Mask
 iron, ivory, copper,
 stone; 9-3/8
 NPPM Africa Sect
 UNNMPA (58.100)
Ram Head , Ubumwelao wood;
 13-3/4
 FAAN pl 103 ELBr
--wood; 14-3/4
 FAAN pl 105 UICNh
--BISSAGOS ISLANDS,
 Portuguese Guinea
Bull Mask wood; W: 50-1/2
 FAA 157 ELBr
Human Right Hand with 4-
 Jointed Fingers, dancer's
 wrist ornament wood;
 12-1/2
 FAA 80 ELBr
Male and Female Figures
 wood; 19-1/2, and 17-1/4
 FAA 95 ELBr
--BOBO
Buffalo Mask ptd wood; 29-1/2
 LEU 90 SwZR
Mask ptd wood; 10
 SEG 163 FPH

--wood; 10
 SEG 86 FPH
--: Beaked Animal wood; 25
 SEG 98 -Heb
--: Horned wood; 18
 SEG 162 FPH
Masks
 PAU pl 3 (col)
--ptd wood; 175, and 62 cm
 TREW pl 32 FPH
--BOBO/ FING
Dance Helmet-Mask of Do
 Guardian Spirit wood, ptd
 blue and white; 15-1/4
 LEU 89 (col) SwZR
--BRON
Bovine Head, Gold Coast
 ceramic; 9-1/2
 BALTW 22 UMdBM
Male Head bronze; 6
 SEG 174 -Pla
--BUSHMAN
Eland Antelope, rock engrav-
 ing L: 28.5 cm
 ADL pl 1A SoCSoM
--BWAKA
Female Figure wood; 13-3/8
 ROY 43 BTC
Figure H: 20
 SEG 225 BTC
Initiation Mask H: 15
 SEG 225 BTC
--CABINDA
Two-Headed Dog, Mouth of
 Chiloongo River 19th c.
 wood, nails, animal
 teeth; 11x22-3/4
 SEITA 83 FPH
--CAMEROON See also
 African--Baban; --Bafo;
 --Bamileke; --Bamum;
 --Bangwa; --Duala;
 --Gabon; --Mende
Bowl: Supported by Animals
 wood; 10-1/2
 WIN pl 55 UNBuMS (C
 13039)
Dance Mask, Bacham 19/20th
 c. wood; 26-3/8
 BAZINW 224 (col);
 LEU 149 (col) SwZR
Douala Prow 19th c. ptd
 wood; 31-1/2
 LOM 151 (col) GMV
Female Figure wood; 22-1/2
 BALTW 23 UMdBM
--: Nursing Child wood;
 19-1/4
 BALTW 22 UMdBM

Figure wood; 15-1/2
 WIN pl 51 UICNh
 (175691)
Head H: 7
 SOTH-4: 166
--wood; 7-1/2
 NMAN # 317 UNNRu
Janus Mask wood; 17-3/4
 NMAN # 325 GDaH
Lintel with Felines wood;
 7x41
 WIN pl 57 UNBuMS
 (C 13040)
Male Figure wood; 18
 WIN pl 54 UMCP (B 4931)
Male Figure wood; c 20
 WIN pl 53 UMCP (B 4959)
--wood; 23
 NMAN # 322 UNNHa
Mask H: 9
 WINGP 131, 132 GHV
--brass; 5-1/8
 BALTW 23 UMdBM
--wood; 50 cm
 TREW pl 36 ELBr
--19th c. wood; 20
 UPJ 551; UPJH pl 303
 GStL
--: Animal wood; 13
 WIN pl 58 UNBuMS
 (C 13037)
--: Animal wood; 18
 WIN pl 59 UCtNhL
--: Bearded brass; 12
 WIN pl 60
 UNNAmM (90.1/7488)
--: Bearded wood, beard of
 human hair; 16
 MUE pl 23 SwZUV (10079)
--: Human Head
 BOA 82
--: Many-Headed 19th c.
 wood; 22
 UPJ 552 GStL
--: With Headdress wood; 21
 NMAN # 328 UNNCro
--: With Red Granules,
 Djumperi wood; 12-1/2
 NMAN # 333 FPLoe
Mother and Child
 BAZINL pl 91 FPL
Pipe Bowl: Seated Figure
 black clay; 8
 WIN pl 62 UICNh (174983)
Pith Figurine
 SEG 50 UWiMP
Seated Figure Holding Bowl
 wood; 16-1/4
 WIN pl 52 UNBuMS (C 12516)

Snake, Yaounde ptd wood;
 55-1/4
 LOM 163 GMV
Staff: Surmounted by Seated
 Figure and Dog brass; 10
 WIN pl 61 UMCP
Stool: Supported by Animals
 H: 16
 WINGP 128 GStL
--: Supported by Animals
 wood with beaded surface;
 16; Dm: 17
 WIN pl 56 UICNh (175559)
--: Supported by Seated
 Figures Holding Children
 wood; 22
 NMAN # 336 FPBig
--CHAD
Sao, ancestor figure pottery;
 20 cm
 PAU pl 15 FPH
Sao, ancestor head pottery;
 10 cm
 PAU pl 15 FPH
Sao Funerary Figure 10/16th
 c. terracotta
 BAZINL pl 28 FPH
--CHAMBA (CHAMBRA)
Ancestor Figure, Northern
 Nigeria wood
 TREW pl 1
Ancestor Figures wood;
 18-3/4, and 18-1/2
 FAAN pl 38a, b ELBr
--: on conical base wood; 20
 FAAN pl 139 GStL
Mask: Cow
 FAA 16 GStL
--CONGO See also African--
 --Babembe;--Bakongo;
 --Bakuba; --Baluba;
 --Bapende; --Basonge;
 --Basundi; --Bayaka;
 --Bena Kanioka; --Bena
 Lulua; --Gabon;
 --Mangbetu
Animal Head, house panel ptd
 wood; 18-7/8
 CALA 261 IVG
Bark Painting, with super-
 imposed Bird Figure,
 Bankanu H: 43-1/4
 LEU 172 (col) BTC
Box, Knife Case: Over-all
 Basket Motif 16/18th c.
 ivory; c 12
 FAA 118 UMiD
Circumcision Mask, Leopold-
 ville ptd wood, straw,
 21-5/8 CALA 259 IVG

Dance Mask, Asalampasu wood,
 metal, vegetable fibers;
 24-3/8
 CALA 258 IVG
Elongated Figure, pierced for
 Wall suspension, Bambole
 wood; 47
 FAA 99 ELBr
Europeans wood
 TREW pl 3 BTC
Figure wood; 25-5/8
 ROY 18
Harp, Vele Valley 19th c.
 WCO-2:59 (col) SwZR
--: Human Figure, Haut
 Oubangi, Ngbaka
 WCO-2:58
--: Human Figure, Kasai
 River H: 34-1/2
 HOO 164
Head
 CHENSW 417 UPPU
Headrest, figure support,
 Batetela wood; 5-1/2
 FAA 40 ELBr
Kneeling Female Figure
 wood; 11-1/2
 WIN pl 73 UNNAmM
 (90.1/5898)
--wood; 12
 WIN pl 74 UMCP (B 1582)
Lega Figure wood; 7
 SMI 3 UDCNMS
Male Ancestor Figure wood;
 19
 FAA 155 -Gr
Male Figure wood; 23
 FAA 76 NiJF
Male Head, Wells River
 volcanic tuffa; 7-3/4
 LEU 39 (col) SwZR
Mask: Abstract Head
 SUNA 98 UCLUC
--: Cicatrix Decoration
 H: 12-3/4
 FAA 146 UNBB
--: Cicatrix Decoration
 19th c. H: 16
 UPJ 620 (col) SwZUV
Medicine-Containing Figure
 wood, cowrie shell closing
 cavity in stomach; 25 cm
 TREW pl 40 BTC
Mother and Child, kneeling
 figures wood; 9-1/2, and
 13
 HOO 163
Owl Head, house panel ptd
 wood; 18-7/8
 CALA 261 IVG

Ritual Figure: Arms Raised
 over Head wood
 CHENSN 17 -UA
Seated Figure 19th c. wood;
 10-3/4
 UPJ 553; UPJH pl 303
 UNBB
--: With Inclined Head
 steatite; 10
 MUE pl 54 NAT
 (N.A.M. 136-33)
Seated Male Fetish wood; 8
 WIN pl 76 UNBuMS (1649)
Seated Mother: Holding
 Furled Umbrella, and Son
 wood; 31
 FAA 73 ELBr
Seated Mother and Child
 wood; 12-1/4
 WIN pl 75 UNBB (22.1136)
Throwing Knife
 RUS 159 UNNMPA
War Horn 19th c. ivory;
 L: 30-1/2
 TOR 160 CTRO (920.49)
Woman Holding Bowl wood
 FAIN 39 UCtY
--CONGO--BELGIAN CONGO
Crucifix Figure 16/17th c.
 brass; 11
 SEG 21; TREW pl 3 BTC
Figure wood; 32-3/4
 ROTHS 259 FPGu
Head wood; 13-3/4
 CANM 4; SEW 900 UPPU
Idol wood
 VALE 55 UNNMat
Kneeling Figure wood
 BAZINH 60 BTC
Mask
 MYBA 10 BTC
--wood
 VALE 55 UMiD
--wood; 11-1/2
 NMAN #458 FPDer
--wood; 15-1/2
 NMAN #466 FPT
Seat: Kneeling Female Figure
 Support (possible tribal
 throne), MaNyema wood;
 18-1/2
 ROTHS 269 GLV
--CONGO--FRENCH CONGO
Amulet wood; 6-5/8
 NMAN #420 FMaG
Fan wood, leather; 18-1/8
 NMAN #422 FPGu
Heart-Shaped Mask wood;
 9-1/2
 NMAN #414 FPT

--DAN (DAN-GUERE;
 DANGERE)
Mask
 CALF-53
--
 GOMB 428 SwZR
--
 PAU pl 8
--H: 8-5/8
 WINGP 102 UNNMPA
--ptd wood; 9
 NMAN #53 FPLoe
--wood; 8-5/8
 NMAN #99 FPGu
--wood; 9
 SEG 84 -Fej
--wood; 9
 SEG 126 UNNSeg
--wood; 10-5/8
 NMAN #98; READAS pl
 37a FPGu
--wood, fibre hair; 10
 SEG 133 -Ep
Mask: Bird Head wood;
 9-7/8
 NMAN #115 UNNRu
Mask: Human Face wood;
 7-7/8
 ROY 54
--wood; 9-1/2
 ROY 59
--: with headcovering H:
 10-1/2
 FAA 53 -EEp
Mask: Initiation Mask wood; 8
 SEG 129 UNNSeg
Mask: Toothed Face wood;
 9-1/2
 NMAN #79 FPChad
Mask: Toothed Woman wood;
 with metal teeth; 8-1/2
 MUE pl 15 EWestGT
Mask: poro Secret Society
 wood; 8-5/8
 NPPM pl 8 UNNMPA
 (57.109)
--wood; 9-1/2
 LOM 156 (col) GMV
--wood; 22 cm
 TREW pl 25 ScER
--wood; 32 cm
 TREW pl 25 -Kj
--wood; 36 cm
 TREW pl 25 FPMi
--20th c. black polished wood;
 8-3/4
 GRIG pl 149; TREW pl
 25 ELBr
--: Rough Carbed Geometric

Features H: c 9
 GARDH 639 UCtY
--: Smooth Face H: 8
 GARDH 639 UCtY
Masks: Bearded wood; 6,
 and 5-3/4
 FAA 134 ELBr
Mother Mask, Ivory Coast
 wood
 LEU 101 (col) SwZUV
--DENGESE
Figure wood; 140 cm
 TREW pl 44 BTC
Funerary Figure H: 20
 SEG 226 BTC
Seated Sovereign H: 21-1/2
 SOTH-4:165
Tattooed Chief, seated com-
 memorative figure,
 Central Congo wood;
 26-3/4
 LEU 185 (col) SwZUV
--DOGON (DONGON)
Ancestor Figure wood
 TREW pl 27 ELBr
--wood; 24-1/2
 FAUL 100 UNNMPA
--: Couple
 MALV 571 UPMeB
--: Couple wood; 75 cm
 TREW pl 26 UPMeB
--: Couple wood; 24-3/4,
 and 26-1/4
 LEU 83 (col); LOM 142
 SwZR
Ancestor Mask wood
 LARA 83 -Gri
Andumboulou, mask H: 15-1/2
 WINGP 95 NLV
Cult Object, Mali wood; W:
 46-1/2
 CALA 253 IVG
Dance Mask wood
 BAZINL pl 90 (col) ELBr
--(Satimbe?) wood
 CLE 302 UOClA (60.169)
--: Cross of Lorraine-shape
 LARA 83 FPH
Door wood; 32
 SEG 161 FPH
Equestrian, "Tellem Style",
 Sanga Area, Mali
 SOTH-4:164
Female Ancestor Figure,
 Tellem wood; 38-1/2
 LEU 82 (col) SwZR
Female Figure wood; 26
 SEG 160 -Ep
--: "Tellem" Head c 1800 H:
 23-1/2 FAA 100 -R

Granary Window, or Shutter,
with three ancestral figures,
relief wood; 15-1/2
MUE pl 1 FPH (06.3.2)
Hermaphrodite wood; 34 cm
TREW pl 27 FPH
--wood; 82-7/8
NPPM pl 1 UNNMPA
(58.97)
--: seated figure, Bandiagara
wood; 27-1/4
NMAN #1 FPCa
Horse and Rider
LARA 82 -Gri
--: Mali 19th c. wood;
26-1/4
TOR 157 CTRO (958.123.2)
Kneeling Five-Faced Figure
darkened wood; 13
MUE pl 2 FPRas
Male Figure wood; 36
BOSMP #3 UNNKle
Mask wood; 15-1/4
BALTW 10 UMdBM
--wood; 40
SEG 160 FPH
--(Satimbe) wood; 43-5/8
NPPM pl 3 UNNMPA (61.5)
--: Abstract Face wood; 15
SEG 93 FPH
--: Hare wood, cloth; 13-3/8
ROY 53 FPH
--: Horned wood
TREW pl 27 ELBr
--Horned wood; 18
SEG 161 FPH
--: Horned, with superimposed
figure wood
TREW pl 27 ELBr
--: Hyena wood; 15
SEG 161 FPH
Mpti Clan Effigy Figure wood;
12-1/2
MUE pl 3 FPH (35.105.155)
Mother and Child wood; 39-1/2
FAA 96 -EEp
Ritual Object wood; 17-1/8
NPPM pl 2 UNNMPA
(62.156)
"Robber's" Mask, French
Sudan H: 42 cm
PAU pl 2 FPH
(No. 35.60.195)
Seated Female Figure wood;
21-1/4
NMAN #5 FPMar
--19th c. wood; 23
UPJH pl 302; WIN pl 7
UPPU (29-12-97)

--: Holding Child wood;
21-3/5
WIN pl 8 UPPU (29-12-98)
Seated Figure wood; 27-1/8
CALA 255 IVG
--DUALA
Canoe Prow wood; 26x220 cm
PAU pl 18; TREW pl 37
FPH (No. 34.171.1013)
War Canoe Decoration
LEU 153 (col) SnSE
--EKOI
Headdress Mask skin on
wood; 7
SEG 183
--19th c. skin on wood;
29x28
TOR 163 CTRO (935.10.1)
--: Human Head animal
skin on palm wood frame;
9
WIN pl 50 UNBuMS
(C 13147)
--: Human Head animal skin
on wood; 10
FAAN pl 130 GCoR
--: Human Head animal skin
on wood, wooden pegs for
hair; 10-1/4
FAAN pl 131b ELivL
--: Monkey animal skin on
wood; L: 8-1/2
FAAN pl 131a ELHM
--:-With Crest animal skin
on wood; c 45 cm
TREW pl 11 ELBr
Janus: Male, Female Heads,
helmet mask, Cross River
Area antelope skin cover;
19-1/4
LEU 145 (col) SwZUV
Male Figure, violent face;
Nkim wood; 13-1/2
FAA 51 ELBr
Memorial Figures, engraved
face and designs stone
FAA 18, 19 NiIk
--ELMINA
Stool: Two Figure Support
1880 wood; 28
FAA 39 ELBr
--ESIE
Figure soapstone; 27-1/2
FAAN pl 75 NiEHI
--: detail
SEG 180 NiE
Figures, Ilorin Province
stone; average H: 22
ADL pl 11A

Head soapstone; 11-1/2
 FAAN pl 76 NiEHI
Seated Figure soapstone;
 18-1/2
 FAAN pl 74 NiEHI
Seated Figures, in Sacred
 Grove stone
 SEG 69 NiE
--FANG (FAN; PAHOUIN (in
 French); PAMUE (in
 Spanish); PANGWE
Ancestor Figure, Jaunde H: 23
 SEG 189 -Pas
--half figure; head detail
 wood; 18
 SEG 114, 115 UNNSe
--seated figure wood; 17
 SEG 76 -Gaf
Bieri, Haut O'Gue wood
 GROSS fig 46 UNNRu
--: Osheba copper strips
 covering wood; 22-1/2
 GABO 74 FPH
Bieri, half length wood;
 11-3/4
 NMAN #350 FPChad
Bieri, head wood; 13-1/2
 NMAN #370 UNNRu
--wood; 17-1/4
 ROY 9
--wood; 17-3/4
 NMAN #366 FPGu
Bieri, reliquary figures wood;
 23, 19-1/4, and 16-1/2
 LEU 156 (col) SwZR
Burial carving wood
 TREW pl 38
Byeri, funeral statue H:
 70 cm
 PAU pl 19 ELBr
Dance Mask 19th c. ptd wood,
 raffia fibre beard-fringe;
 9-1/2
 GRIG pl 153 ELBr
--: Ngi Society 19th c. wood,
 ptd white with dark grey
 bands; 19-3/4
 GRIG pl 151 ELBr
Effigy Holding Wand wood; 22
 MUE pl 27 FPH (08.9.1)
Female and Male Figures, half
 lengths wood; 21-1/2, and
 26-1/2
 WIN pl 65, 66 UMCP
 (B 4973; B 4974)
Female Fetish
 FEIN pl 105 UMCP
Figure H: 9
 FAA 145 -R

--H: 20-1/2
 WINGP 137 SwBV
--: bust wood; 13
 ROY 68 FPLec
-- wood; 60 cm
 TREW pl 38 -HS
--wood; 20-1/2
 ROY 67
--wood; 29
 SEG 33 -Ep
--19th c. wood; 22-1/2
 UPJH pl 303 UNNMPA
Guardian Figure wood; 18
 MUE pl 26 SwBeB
Head wood
 TREW pl 38
--wood
 CHENSP 287; CHENSW
 417 UNNMPA
--wood; 11-3/4
 ROY 69
--wood; 15-1/2
 MUE pl 28 FPH (41.13.10)
--wood; 20-1/2
 ROY 45 ELBr
Head on column wood; 15
 SEG 33 -Ep
Male Ancestor Figure wood;
 12-3/4
 BALTW 8; BMA 93 UMdBM
Male Ancestor Figure
 MYBA 11
Male Figure wood; 30
 WIN pl 67 UPPU (AF 5188)
Male Half Figure, holding
 child wood; 22
 BOSMP #34 UMCP
Mask H: 22
 SEG 192 UCoDA
--ptd wood, fibre hair;
 21-1/2
 DENV 135 UCoDA (7-QA)
--: Ngi Society wood,
 whitened; 25-1/4
 LEU 158 (col) BBW
--wood, whitened; 29-1/2
 ROTHS 273 GBVo
--Pongwe
 MALV 562 FPH
--: Human Face wood;
 28-3/8
 ROY 34 GBVo
--: Human Face (copy) bronze
 FAA 11; MYBS 62 FPOu
--: Human Face wood; 15
 ROY 33 formerly FPRat
Reliquary Figure wood, metal;
 25-1/4
 NPPM pl 27; SEITC 63
 UNNMPA (61.284)

--: Ogowe River ptd wood;
10-1/8
DENV 135 UCoDA (314-QA)
Woman, head
BAZINH 454
--GAMU GOFA
Warrior Commemorative
Figures wood; 18-1/2,
and 16-1/2
LEU 207 (col) SwZUV
--GEH
Mask: Initiation Mask wood; 8
SEG 101 -Lint
Mask: Poro Secret Society
Initiation H: 9
SEG 168 UNNSe
--H: 16
SEG 169 -Lint
--cloth covered hinged jaw,
with suspended seeds wood;
10
WIN pl 14 UMCP
(40-34.50/4588)
--GHANA
Mask: Horned late 18th c.
ptd wood
WCO-3:12
--GIO
Female Figures bronze
FEIN pl 45 UMCP
Mask: Animal Head
FAA 124
--: Dancer's Clown, Liberia
H: 8-1/2
SMI 3 UDCNMS
--: Poro Secret Society wood;
11-1/2
WIN pl 16 UMCP
(37-77.50/2618)
--GOLA
Janus Mask, Liberia wood
FAIN 123 UMCP
--GOLD COAST
Human Animal Figures,
Tallensi Children clay
ADL 11B
Lobi Mask gold; 3-1/2
NMAN # 165 FPKe
Native Compound 20th c. hand-
molded mud
READAS pl 1
--GREBO
Mask ptd wood; 27-1/2
NPPM pl 9 UNNMPA
(56.217)
--GRUNSHI (GURUNSI)
Horned Mask, Gold Coast
wood; 58
SEG 175 ELBr

--GUERE/DAN
Initiation Mask wood; 8
SEG 102 UNNSeg
--GUERE-OUOBE (GUERE-
OWOBE; GUERE-WOBE)
Animal Mask H: 10
SEG 78
Initiation Mask wood; 10
SEG 82, 171 UMCP;
UNNGro
Mask, Ivory Coast
PAU pl 8
--GUERZE
Mask: Bearded wood; 8
SEG 165 SeDI
--GUINEA See also African
Baga
Head Prehistoric stone;
10-1/4
NPPM pl 6 UNNMPA
(60.35)
--GUINEA--FRENCH GUINEA
Baga Bird ptd wood
BRIONA 124 FPH
Bellows wood; 24-3/4
NMAN # 48 FPMori
Idol wood; 40-1/2
NMAN # 40 FPSa
--GURO (GOURO)
Female Figure wood; c14
FAA 79 -E
Male Figure wood; 16-1/2
WIN pl 24 UPPU (29-12-81)
Mask wood
CHENSW 418 UPPU
--: Antelope ptd wood
CHENSW 418 UCBCA
--: Antelope wood
TREW pl 23 ELBr
--: Antelope wood; 12
SEG 81 -Pla
--: Bird Head wood; 10-1/4
NMAN # 114 FPRat
Mask: Horned wood; 10-1/4
BALTW 19 UMdBM
--wood; 16-1/8
ROY 51 (col) FPLec
--: surmounted by Bird, wood;
20-1/2
WIN pl 25 UPPU (29-35-1)
Mask: Horned Animal Form
wood; 20-1/2
ROY 61 FPH
Mask: with Incised Headdress
wood; 12
MUE pl 16 UNNMu
Mask: with Single Horn wood;
9
SEG 134 -Raf

Masks: Antelope; Cow wood
NEWTEA 282, 283 ELBr;
UNNSe
Masks: Zig-Zag Hair Fringe
wood; 12-1/4, and 13-3/4
LEU 109 (col) SwZR
Weaver's Bobbin: Bowl on
Human Head darkened
wood; 6-1/2
MUE pl 19 FPH (30.64.1)
Weaving Pulley, human head
decoration H: 5
SEG 82
Zamie Mask: Antelope wood;
19-1/2
FAA 153 ELBr
--GURO, or SENUFO
Weaving Bobbins: Human
Form wood; 6-3/4 to 8-5/8
ROY 46, 47
--IBIBIO
Ancestor Figure, Oron Clan
Epku wood; 105 cm
TREW pl 7 NiJA
--18/19th c.
LEU 144 (col) UNNMu
--wood; 42
SEG 178 -Mur
Dance Headdress wood, hide
CHENSW 414 UNNMPA
"Deformity" Mask H: 35 cm
TREW pl 10 ELBr
Figure wood; 18-1/4
FAAN pl 123b EIpM
--: Seated on Barrel wood;
35
FAAN pl 125 ELHM
Male Figure H: 12-1/2
WINGP 125 ELBr
--: Ugo District wood; 10
FAAN pl 123a ELBr
Mask: Ekpo Secret Society
H: 13
WINGP 124 NiLN
--: Ekpo Secret Society--
Human Head wood; 14
FAAN pl 124 GStL
--: Ekpo Secret Society--
Ram's Head wood, fibre
fringe; 16
FAAN pl 126, 127 ELivL
--: Ekpo Secret Society,
with hinged jaws wood; 12
LEU 142 (col) GStL
--: Horned H: 14
SEG 178 -Pla
--: Secret Society wood;
12-1/2
BALTW 11 UMdBM

--: Skull wood, leather;
20 cm
TREW pl 10 ECamUA
--: Surmounted by Model Hut,
with monkey and human
skulls ptd calabash,
leather; 28
FAA 83 ELBr
Seated Female Figure, mask
top, Nigeria wood; 24
WIN pl 47 UCtNhL
--IBO (IGBO)
Altarpiece for Yam Spirit,
Ifijioku terracotta; 18-1/2
FAAN pl 112, 113 ELBr
Death Mask, Southeastern
Nigeria wood, ptd white; 17
LEU 140 (col) UNNAmM
Figure, "cubist"-form wood;
6-1/2
FAA 41 ELBr
Funerary Screen: Ekine Play
Figures H: 36
FAA 86 ELBr
Head bronze; 3
FAA 68 NiLN
--: Scarified Face bronze; 3
FAAN pl 73 ELBr
Headdress: Ogbom Figure
wood; 80 cm
TREW pl 7 NiLM
--: Ogbom Seated Figure,
with head carried on head,
Bende H: 33
FAA 30 NiLN
--: Ogbom Play Dance wood;
28-1/2
FAAN pl 122 ELBr
Headdress Mask: With White
Face wood; 15-1/2
FAAN pl 114 GCoR
Ikenga (personal shrine)
wood; 19-3/4
FAAN pl 116a ELBr
--: Right Hand Altar wood; 9
FAA 155 ELBr
Ikenga Figure H: 19
SEG 176 UNNSe
--wood; c 80 cm
TREW pl 7 ELBr
Mask wood; 8
SEG 107 UNNSeg
--wood; 15-1/2
WINGP 122 NiLN
--19th c. wood; 17-3/4
UPJ 551; UPJH pl 303
UNNMPA
--: Ekkpe Play Headdress
Mask--Elephant Spirit

wood; 17x36
FAAN pl 119; TREW pl 5
ELBr
--: Ekkpe Play Headdress
Mask--Maiden Spirit wood;
15-1/2
FAAN pl 118 ELBr
--Funerary Mask (Maw),
Nigeria wood; 16-1/2
WIN pl 46 UNNAmM
(90.1/7587)
--wood; 17-1/2
WIN pl 45 UPPU (AF 5371)
--: Horizontal, Ekkpahia
wood; 68 cm
TREW pl 8 ELivL
--: Maji, or Ogu wood; 19
SEG 156 MUR
Mask: Mba, for Yam Harvest
Iko Okochi Festival wood;
20
FAAN pl 116b EMaM
--wood; 20
FAAN pl 117 NiLN
Mask: Mmo Mask, Agbobo ptd
wood; 12
SEG 176 UNNAmM
-- --crested, Onitsha wood;
40 cm
TREW pl 5 ELBr
--: Mmo Society White-Faced
Maiden Spirit, Onitsha
wood; 19 cm
TREW pl 5 UgKU
--: Mmo Masquerade Cult--
decorated human face H: 16
FAA 55 ELBr
--: Mmwo Society Dance Mask
wood; 14-1/4
FAAN pl 115 ELFa
Mask: Okorosia Play, Orlu,
Owerri Province wood;
27 cm
TREW pl 6 ELivL
Mask: Tortoises and Coiled
Snakes, relief wood; 15-1/4
FAA 128 ELBr
Mask: Ulaga Horizontal, north-
west of Awka
TREW pl 8
Masks: Water Spirits wood; 45
to 83
FAAN pl 120, 121 GStL;
ELiL
Pendant: Ram's Head, with
Two Flies bronze; 3-1/2
FAAN pl 71 ELBr
Pot, with small kneeling figures
in round, circling lip 1880's

ceramic; 14-1/2
FAA 139 ELBr
Shrine Vessel, Kwale H: 14
WINGP 119 ELBr
Stand, with male and female
figures open work bronze;
11
FAAN pl 72 NiLN
--IDAH
Royal Mask: Ata of Idah
c 1515 brass; 12
FAA 67
--IFE (AFA; IFI; IFO)
See also African--Yoruba
Crowned Male Head bronze;
c 15
ADL pl 10A
Female Head 12/15th c.
terracotta; 9-1/4
MU 12 UWaSSU
Head bronze
CHENSW 423 GBSBeVo
--bronze; 13-3/8
ROY 20 -NiO
--striated
GAUN pl 40 (col) ELBr
--striated brass; 12
FAAN pl 5 NiIA
--bronze; 14-1/4
FAAN pl 9; TREW pl 13
ELBr
--striated terracotta
BOA 82
--striated terracotta; 5-3/4
FAAN pl 3 UNNGu
--terracotta; 5
FAAN pl 4 NiIA
--terracotta; 7-1/4
FAA 64 ELBr
--: Ita Yemo terracotta;
9-1/4
FAA 60; WINGP 113 NiIA
--: Olokun(?) striated bronze
PAU pl 14 ELBr
--: With Perforations around
Mouth bronze; 12
FAAN pl 6, 7 NiIA
Heads bronze; 8-1/4
FAA 65 ELBr; -Sch
--terracotta
CHENSW 422
--terracotta
FAA 60
-- (casts) terracotta; 7-1/2
NMAN # 292-295 GFFo
King, head c 14th c. bronze
ENC 415
King and Princess, heads
bronze ZOR 181

Lajuwa, head c 14th c. terra-
cotta; LS
TREW pl 13 NiIO
Male and Female Heads,
Nigeria striated bronze;
12-1/2, and 19-3/4
WIN pl 40 UIEB
Male Head (copy)
HUX 64
--(copy) bronze
GARDH 635 UNNAmM
--striated bronze
MALV 544 NLO
--12th c. bronze; 13-1/2
JANSK 29 NiIO
--13th c. clay
LEU 123 (col) -NiO
Male Heads bronze; c 12
ADL pl 9A, 9B
Masks: Sakapu Society
Masks, Southern Nigeria
blackened wood
PAU pl 16 ELBr
Oni of Ife: In Ceremonial
Robes bronze; 4-7/8
FAAN pl 10 NiBeM
--: half figure bronze; 14
FAAN pl 8 NiIA
--: head with parallel
furrows--tribal masks 13/14th
c. Bronze; 14-1/4
GRIG pl 143; LARA 81;
LEU 119 (col); LOM 156
(col); READAS pl 164; SEG
58 ELBr
Oni of Ife and Consort
bronze; 12
FAA 69 NiIA
Ritual Vessel: Queen bronze;
4-1/2
LEU 121 (col) -NiO
Woman's Head pre-13th c.
BAZINL pl 92 NiIA
--11/15th c. terracotta;
6-1/2
BAZINW 223 (col) GBVo
--IGALA
Amdo Mask wood, fibre
fringe; 14
FAAN pl 144 NiLN
Ikpelikpa Mask wood; 24
FAA 98 NiLN
--IJAW
"Kakenga" Ancestor Figure
H: 66
HOO 158
Man on Stylized Elephant,
Niger Delta wood; 26
INTA-1: 104

Mask H: 15
SEG 179 ELBr
--H: 26
SEG 178 ELHo
--wood; c 14
WIN pl 49 UMCP (E 6764)
--: Hippopotamus H: 18
SEG 178 NLV
Mask Headpiece wood; c 30
WIN pl 48 UMCP (E 14379)
--IJO
Ejiri: Human Figure on
Animal Form
FAA 34
Guardian Spirit wood; 25-1/2
NPPM pl 22 UNNMPA
(60.128)
Male Figure brass, wood;
33-1/2
FAAN pl 111 EMaM
--: In European Hat early
19th c. wood; 38
FAA 97 ELBr
Mask: Water Spirit, Otobo
wood; 18-1/2
FAAN pl 109 UICWi
Otobo, Hippopotamus Mask,
Kalabari wood
LEU 135 (col) ELBr
Sacrificing Man on Elephant-
Leopard wood; 25-3/4
FAAN pl 108 NiLN
Sekiapu Society Funerary
Shrine (duen fobara) wood;
45-1/2
FAAN pl 110 ELBr
--ISOKO
Human Figure: Ivbri Figure
on Head wood; 13
FAA 33 ELBr
--ITUMBA
Mask wood; 14
FLEM 714 UNNMMA
--IVORY COAST See also
African--Atoutou; --Baoule;
--Dan; --Guro; --Senufo
Bobbin: Animal-form wood;
6-1/8
NMAN #140 FPCa
--: Bird-form, Upper
Sassandra wood; 8-5/8
NMAN #139 FPFe
--: Human Head wood; 5-7/8
NMAN #141 FPCa
--: Human Head wood; 7-1/4
NMAN #135 UNNCro
Funerary Figure, scarified
head, Agni, Krinjabo black
terracotta; 8 MUE pl 17

Gold Weight: Fish bronze;
 L: 2-1/4
 NMAN # 224 UNBBa
Gold Weights: Animal-Form
 KUHB 78, 79 UNNMMA
--: Bird, Fish, Ant-eater
 bronze; L: 2 to 3-1/2
 NMAN # 227-229 UNNHa
Gong Hammer wood; 6-7/8
 NMAN # 170 FPGu
Male Figure wood; 42
 NMAN # 54 ELBed
Mask wood
 PANA-1: 88 UPPU
--wood
 SEYT 52 UDCNMS
--: Antelope
 MALV 569 FPH
--: Bearded wood
 READA pl 18 FPRat
--: "Firespitter"
 RUS 157 UNNMPA
--: Horned black and red
 wood; 15
 NMAN # 83 FPFe
--: Human Face wood
 READM pl 21
--:-Slit Eyes, spaced teeth
 MALV 542 FPH
Masks wood
 SEYT 44 UDCNMS
Seated Couple
 RUS 156 UNNMPA
Spoon, with Bird wood; L:
 8-1/4
 NMAN # 177 FPGu
--KAKA
Ancestor Figures wood
 SEG 56 UWiMP
--KANIOKA
Polychrome Mask wood;
 11-3/4
 NMAN # 449 GHV
--KARUMBA
Antelope Headdress ptd wood;
 30
 DENV 137 UCoDA
 (407-QA)
Antelope Mask 20th c.
 MINF -Her
--KASAI
Goblet: Human Head wood
 NMAN # 482 FPTr
Shamba Bolongongo c 1800
 wood
 NORM 81 ELBr
Tattooed Female Figure wood
 FEIN pl 101 UNNAmM

--KIFWEBE
Mask, with white markings
 H: 64 cm
 PAU pl 29 BTC (No. 30593)
--KISSI
Figure stone; 5-7/8
 ROY 10 FPH
Figures soapstone; 8-1/2,
 and 10
 FAA 21 ELBr
--stone
 CHENSW 412 FPH
Head, backward tilted face
 L: 10-1/2
 FAA 23 ELBr
Nomoli Figure 16th c.
 soapstone; 7-1/4
 FAA 22 ELBr
Pombo, funerary figure
 steatite; 6
 SEG 164 SeDI
--stone; 3-1/2
 SEG 108 UNNSe
--KONO
Bearded Mask wood; 8
 SEG 165 SeDI
--KOTA
Reliquary Figure sheet brass
 on wood; 22-1/2
 CALA 260 IVG
--KOULIME
Mask wood; 7
 SEG 172 -Pas
--KRA (KRAN)
Ga-Sua, oracle fetish mask,
 with feather crown termite
 hill earth, set with animal
 teeth and horns; 24-1/2
 FAA 85 UPPU
Woman, head detail wood
 FEIN pl 61 UMCP
--KUKURUKU
Human Head wood; 27-1/2
 FAA 101 ECamUA
--KURUMBA
Dance Headdress: Antelope
 Head, Aribinda 20th c.
 ptd wood; 43
 LOM 154 (col) GMB
Headdress: Female Antelope
 ptd wood; 39-1/8
 NPPM pl 5 UNNMPA
 (63.41)
--KUYU
Ebotita, man-serpents,
 Middle Congo
 PAU pl 22
Figure H: 27
 SEG 190 -Gir

Headdress: Snake Dance
Headdress wood; 14-1/2
LEU 165 (col) FPRat
Helmet Mask wood; c 16
FAA 102 GFV
Mask Ornament H: 24
SEG 190 -Pla
--LANDUMA
Mask, Guinea wood; 29
SEG 49 UNNSeg
--LIBERIA
Mask: Poro Secret Society
wood; 11-1/4
BALTW front UMdBM
Poro Secret Society Masked
Dancer
SEG 83
--LOANGA
Bust wood; 7-7/8
NMAN # 404 FPRat
Female Figure wood; 6-5/8
NMAN # 391 CamAd
Monkey whistle part wood;
4-3/4
NMAN # 421 FMaG
Musical Instruments wood;
5-3/4 to 7-3/4
NMAN # 424-27 UNNRu
Tusk ivory; 14
SEG 190
--MAJUBI
Mask H: 17
SEG 191 FPH
--MAKONDE
Mask stained wood; 8-7/8
DENV 138 UCoDA
(369-QA)
--wood; 13-1/2
FAA 133 -Tz
--: Beaded Spiral Decoration,
East Africa wood; 13-1/2
LEU 211 (col) GStL
--: Monkey 20th c. wood;
8-1/4
LOM 159 (col) GMV
--: With Deformed Lip wood
FEIN pl 69 UNNCar
--: With Lip Plug wood; 9
ADL pl 5B ELBr
--MALINKE
Horned Mask wood; 24
SEG 163 FPRou
--MAMBUNDA, or LOVALE
Mask: Human Face H: 16-3/4
FAA 57 -EEp
--MANGBETU
Ceremonial Jar pottery; 13
SEG 39 -Bag

Cylindrical Box wood; c 20
WIN pl 116 UMCP (B 1591)
Double Effigy Jar pottery;
8-1/2
WIN pl 115 UNNAmM
(90.1/4693)
Effigy Jar pottery; 7-7/8
WIN pl 114 UNNAmM
(90.1/4692)
--pottery; 10-1/2
BALTW 29 UMdBM
Female Figures H: 19
SEG 226 BTC
Kundi, bow harp animal skin
cover; strings of giraffe
hair and bast fibre; 38-1/2
LEU 204 (col) SwZR
Mother and Child wood; 24
FAA 135 UNNAmM
--MANO
Mask: Poro Secret Society
stained wood; 10
DENV 135 UCoDA (254-QA)
--wood; 10-1/2
WIN pl 15 UMCP
(37-77-50/2657)
--wood; 22
WIN pl 13 UMCP
(37-77-50/2744)
Mask: Poro Secret Society
Initiation H: 9
SEG 167 UNNSe
--: scarification wood; 8
SEG 123 UMCP
Staff: Poro Secret Society
wood, metal detail; 4-1/2
WIN pl 17 UMCP (L/279)
--MAYOMBE (MAYUMBE)
Container: Kneeling Pregnant
Woman wood; 9-1/4
MUE pl 47 BTC (43642)
Medicine-Containing Figure
wood, fragments of mirror,
nail studding, and pieces of
metal; 83 cm
TREW pl 40 BTC
Mother and Child wood; 9
BAZINW 225 (col); TREW
pl 40 BTC
Mother God
VEN-22:91
--MENDE (BAMENDE; BEKOM;
BIKOM; MENDI; SHERBRO)
Chief's Stools, with over life-
size figures H: 185 cm,
and 194 cm
ADL pl 3 GBVo
Divination Figure (Yassi):

Sierra Leone wood; 17-1/2
WIN pl 12 UPPU (37-22-279)
Equestrian, fragment steatite;
4-1/4
BALTW 11 UMdBM
Female Ancestral Figure wood
FEIN pl 27 UNNAmM
Head, Sierra Leone steatite;
9
MUE pl 7 SwBV (III, 1122)
Mask, British Cameroons
19/20th c. wood; 26-1/2
JANSH 29; JANSK 33 SwZR
--: Bundu Secret Society
blackened wood
TREW pl 24 ELBr
--H: c 46 cm
TREW pl 24 ELBr
--c 1900 wood; 15-3/4
EXM 330 BTC
--: Guinea 20th c. wood,
metal strips
CHICC 38 UICHi
--: Sierra Leone H: 22-1/2
WINGP 99 SnSE
Mask: Bundu Secret Society
Initiation Mask wood; 17
SEG 52 UCoDA
Mask: Human Face, sur-
mounted by 3 dogs wood;
17
FAA 56 ScEK
--Toothed Mouth and High
Hair wood; 18
SEG 18 UNNSe
Minsereh, figure wood
TREW pl 24 ECamUA
Nomoli, figure soapstone
TREW pl 24 ELS
Nomori, figure steatite; 7
SEG 121 ELBr
--(Numori), figure, Sierra
Leone steatite; 5-1/2
MUE pl 6 SwBV (III, 2567)
Oracle Figure H: 8
SEG 166 UPPU
Woman's Secret Society Mask
wood; 15
BALTW 19 UMdBM
--MPONGWE
Dance Mask 19th c. ptd wood;
12
GRIG 41 (col); PRAEG
548 (col) ELBr
Mask H: 37 cm
PAU pl 21 FPH (No.42.1.1)
--wood, ptd black and white;
c 10
ADL pl 5A

--: Ghost Mask, young woman
wood; 11
ALB 123 UNBuA
--: Initiation H: 15
SEG 191 UNNSe
--: White Faced
TREW pl 39 ELBr
--wood
TREW pl 39 ELivL
--MOSSI
Dance Mask H: 42
SOTH-4: 169
Male and Female Figures
wood, white bead eyes;
19, and 19-3/4
MUE pl 4 UNNMu
Mask: Koba Antelope,
Yatenga Region wood;
42-1/2
LEU 86 (col) SwZR
--: Surmounted Female Figure
19th c. wood
CHICC 33 UICBa
--: Surmounted Human Figure
wood; 43
SEG 163 UNNRu
Masks, Western Sudan ptd
wood; 160 to 218 cm
TREW pl 33 FPRu
--NGBANDI
Figure H: 22
SEG 210 UNNSe
--ivory; 7
SEG 226 UNNSeg
--: in Fibre Skirt H: 35
SEG 226 BTC
--NGERE
Mask H: 15
WINGP 103 UCBeF
--: Human Face, tubular
eyes, open toothed mouth
clay on basketry; 12-1/2
FAA 54 -R
--NIGERIA (including: Bariba;
Ham; Jebba; Montl) See
also African--Ekoi; --Ibo;
--Ife; --Nok; --Nupe;
--Tada
Flask: Three Relief Faces
bronze; 13-1/2
FAAN pl 60 GBVo
Bell: Head bronze; 8
FAAN pl 65 GBVo
Bowman, half figure, Jebba
bronze; 36-1/2
FAAN pl 57
Ceremonial Mask
DEY 155 UCSFDeY
Curved Door wood
SLOB 238 UNBB

Dance Headdress, Ham 1949
FAA 43
Eshu, God of Uncertainty wood;
15-3/4
COOP 266 ESuAH
Female Figure: Sickness Cure,
Baltip, Montol wood; 15-1/2
FAA 58 -Wi
Figure c 1952 wood; 12
FAA 33 -Si
--: British Nigeria
CHENSN 592 -He
Head: Horned, Cross River
skin covered
TREW pl 11 ELBr
--striated bronze
GOMB 26 ELBr
--: With Cap bronze; 6-3/4
CHENSW 421; FAAN pl 59
GBSBeVo
Hemispherical Head bronze;
Dm: 7
FAAN pl 69
EFaP
The Hunter bronze; 37 cm
TREW pl 17 ELBr
Janus-Headed Mask, Cross
River H: c 42 cm
TREW pl 11 ECamUA
Leopard Skull bronze; L,
7-3/4
FAAN pl 68 GBVo
Male Head 12th c. striated
bronze; 13-1/2
JANSH 26 NiIO
Man: Mudfish Head, holding
snake bronze; 13
FAAN pl 70 GBVo
Man and Woman Playing
Board Game, resting
leopard in background
bronze; 5
FAAN pl 61 EFaP
Mask Top: Two Human Faces
wood; 10-5/8
ROY 48 GBVo
Men and Two Elephants
bronze; 10
FAAN pl 67 UPPU
Odudua, Afo Style wood, ptd
black; 60 cm
TREW pl 20 ELHM
--: Kneeling, with flanking
female figures, Ekiti
Style ptd wood; 110 cm
TREW pl 20 ELBr
Pendant Plaque: Oba, flanked
by two attendants bronze; 6
FAAN pl 66 GBVo

Staffs: Abstract Animal-horn
Design, Bariba H: c 48
FAA 28 NiB
Waist, or hip mask: Elephants
bronze; 8-1/2
FAAN pl 64 GHV
Warrior, detail, British
Nigeria, Jebba bronze;
figure H: 44
SEG 61 NiJe
--NOK
Cylinder Head 2nd/1st c.
B. C. terracotta; 8
FAA 8; LOM 168 NiJM
Head terracotta
LARA 85 NiIM
--terracotta; 18 cm
TREW pl 12 ELBr
--terracotta; 17 cm
TREW pl 12 ELBr
--terracotta; 5-1/2
FAA 32 NiJM
--terracotta; 7-1/2
SEG 181 NiG
--500 B. C./200 A.D.
terracotta; 6-1/2
FAAN pl 1 NiJM
--12/13th c. terracotta; c 6
FAA 9
--: long-eared substyle
terracotta; 8
FAAN pl 2 NiJM
Male Head, inverted cone
shape terracotta; 8-1/4
FAA 9
Pole Top wrought iron;
22-1/2
LOM 169 GMV
Spherical Head terracotta;
3-1/2
FAA 8 NiJM
--NUPE
Eloojao Mask wood; 26-3/4
FAAN pl 140 GBVo
Mask: Human Face, animal
horns H: 25-1/2
FAA 12 ELBr
--OGONI
Elu Mask, with hinged jaw
wood; 20 cm
TREW pl 6 ELivL
--OGU, or MAJI
Ike Okochi Festive Mask,
Afikpo District, Ogoja
Province wood
TREW pl 9
--ORON
Ekpu, ancestor figure,
Calabar H: 36
FAA 10 NiOM

--wood; c 30
 FAA 94 NiJM
Ekpu: Bearded Chief in Euro-
 pean Hat
 FAA 143
--: Two Memorial Figures
 wood; 26
 FAAN pl 128, 129 NiJM
--OSYEBA
Bieri Figure, Gabon copper
 on wood; 20-1/2
 MUE pl 30 UNNMu
Figure copper on wood; 22-
 1/2
 NMAN #377 FPT
--OWO
Armlet: Human and animal
 figures ivory; 6-3/4
 FAA 129 ELBr
Osamasinmi: Yam-Ceremony
 Increase Head, with ram's
 horns wood; 17
 FAA 149
--SENUFO
Bird ptd wood; 56-1/8
 CALA 262 IVG
--20th c. wood, ptd red;
 55-1/2
 LOM 155 (col) GMV
Bird Headdress (Por Pianong)
 wood, ptd red and white;
 59-5/8
 NPPM pl 11 UNNMPA
 (60. 57)
Crouching Figure H: 10
 SEG 171
Dance Helmet H: 19-1/2
 SOTH-4:164
Deble: Rhythm Pounder
 wood; 42-1/2
 NPPM pl 10 UNNMPA
 (58. 7)
--: Lo Society Ritual Figure,
 Northern Ivory Coast
 wood; 37-1/2
 LEU 92 (col) SwZR
Door wood; 60x40
 NMAN #168 UPPU
--: Alligator, Birds, Turtles,
 Masks, Equestrians, "Do"
 Secret Society wood;
 52-1/2x34-1/2
 ROTHS 279 UDCM
Equestrian H: 12-1/2
 WINGP 90 ELBr
--wood
 TREW pl 34 ELBr
--wood; 51-1/8
 CALA 255 IVG

Female Ancestor Figure wood;
 19 cm
 TREW pl 34 -Kj
--1840/50 H: 21
 MU 12 UNNPet
Female Figure wood; 6-1/2
 WIN pl 26 UNBuMS (C 13727)
Female Figure: Bowl on Head,
 stick in right hand wood;
 23-1/2
 MUE pl 9 SwZUV (10074)
--: Cylindrical Base H: 36
 SOTH-4:168
Female Head wood
 FEIN pl 9 UNNAmM
Figure wood
 FEIN pl 71 UNNMPA
Figure wood; 10-1/4
 ROTHS 263 FPT
--wood; 22
 SEG 118 UNNRu
Flamespitter Mask ptd wood;
 34
 DENV 137 UCoDA (401-QA)
--(Firespitter Mask): Antelope
 wood; 32-3/4
 LEU 95 (col) SwZR
Granary Door, three-panelled,
 relief wood; 41-3/4
 DENV 134 UCoDA (403-QA)
Lo Society Dance Figure wood;
 53
 FAA 97 -R
Mask metal on wood
 TREW pl 29 FPH
--wood; 36 cm
 TREW pl 34 FPH
--wood; 10-1/2
 WIN pl 27 UNBB (22-507)
--: Animal wood
 TREW pl 34 FPH
--wood; 16
 SEG 162 -Pla
--wood; 31-1/2
 FAA 17 ELBr
--: Buffalo with horns and
 tusks ptd wood; 35
 MUE pl 13 FPRat
--Double Animal wood; 18-
 1/8x26-3/4x13
 CALA 256 IVG
--: Helmet wood; 14
 SEG 110 UNNRu
Mask: Horned wood; 15-3/4
 FAA 150 ELBr
--wood; 29
 SEG 162 FPH
--brass on wood; 16-1/2
 NMAN #76 FMaG

--: scarification wood; 11
SEG 131 -Wo
--: Shell wood; 14
FAA 150 -R
Mask, Korhogo
PAU pl 5
Maternity Figure wood
CLE 302 UOClA (61.198)
Mother Nursing Child
FEIN pl 49 UNND
Rhythm Pounder: Man wood
CHENSW 414 UNNMPA
Seated Couple wood; 10-1/4
ROY 19
--SHANGO
Equestrian wood
HOF 48 FPCa
--SHILLUK
Hyena 20th c. dark brown
burnished clay, impressed
cord; 7
GRIG pl 150 ELBr
--SIERRA LEONE
Bearded Head steatite; 9
HOO 159
Bundu Secret Society Female
Mask H: 17
HOO 159
Female Figure: In Boots,
Tenne H: 22-1/2
FAA 31 UPPU
--: Tenne H: 38-1/2
FAA 31 ELBr
Nomolli, fertility charm
soapstone; 10-1/2
COOP 267 ESuAH
--SUDAN, BRITISH See also
African--Dogon
Headdress: Buffalo, Okuni
wood; 26
NMAN #306 FPRat
--SUDAN, FRENCH
Antelope Lying Down, mask
top, Mande, Suguni wood;
26
BRIONA 124; CHENSW
419; HOF 223; MALV
570; NMAN #9; ROTHS
275 FPCa
Bird, mask top wood, ptd
black
BRIONA 124
Covered Bowl: Surmounted
by Equestrian wood;
29-1/2
NMAN #34 FPHe
Female Figure wood; 19-5/8
NMAN #4 FPLeve

--: Bandiagara wood; 30
NMAN #13 UNNHa
Figure wood; 14-3/4
ROTHS 261 UNNRu
Mask: Surmounted by Figure
wood; 25
ROTHS 273 UPPH
Mule, head wood; 14-1/2
NMAN #10 FPCa
--TADA
Plaque: Human and Animal
Figures--Fishes, Crabs
bronze; 6-3/4
FAA 105 -Pl
Seated Figure bronze; 20
FAAN 17
--bronze; 22
SEG 67 NiT
--bronze; 55 cm
TREW pl 17
--TAGO
Figure pottery; 7
SEG 193 FPH
--TIGONG
Funeral Trumpets, Cameroons
SEG 50 UWiMP
--TIV
Male and Female Figures c
19th c. wood; 48, and 47
FAAN pl 135 GBVo
Snufftaker brass; 6-1/4
FAA 131 UPPU
--TOMA
Landa Initiation Mask H: 18
SEG 166 FPH
Landa Mask of Poro Society,
French Guinea wood;
22-3/4
LEU 67 (col) SwZR
Mask wood; 35-3/8
CALA 259 IVG
Stiltwalker's Mask, French
Guinea
PAU pl 7
--UPPER VOLTA (Including
Aribinda) See also Bobo
Antelope Dance Headdress,
Kurumba
CANK 132
--
CANK 132 FPH
--wood, inlaid with seeds;
27-1/2
LEU 85 (col) FPH
--URUA
Fetish, with calabash and shells
wood; 14-1/8
NMAN #489 FPT

Headrest: Seated Woman
 Support wood; 6-3/4
 NMAN #468 NZH
Mask: Human Face, incised
 decoration wood
 BOA 70
--VATCHIVOKOE
 (VATSHIOKWE)
Bench: Four Crouching Figure
 Supports and Female Figure
 Backrest wood; 21
 MUE pl 57 BTC (15743)
Figure, carrying two jars
 wood; 23-1/4
 ROTHS 263 GBVo
Male and Female Figures
 wood; 19-1/2, and 18
 MUE pl 58 NAT (N.A.M.
 138-44a, b)
Mwana-Pwo ("Weeping Girl")
 Mask, with fibre head-
 dress wood; 8-1/2
 MUE pl 59 BTC (43143)
Sceptre Head: Female Head
 wood; 20-1/8
 NMAN #588 FPCa
--: Human Figure wood;
 5-3/4
 NMAN #585 UNNCro
--WAGOMA/BABUYE
Mask H: 11-1/2
 SEG 56 UNNLipc
--WAJA
Charm Figure, bust terra-
 cotta; 4-3/4
 FAAN pl 132 ELBr
--WAKEWERE
Female Fetishes, Tanganyika
 wood
 FEIN pl 103 UNNAmM
--WAMBA
Bearded Head terracotta;
 5-1/2 FAA63 NiJM
--WAZIMBA (MANYEMA)
Headrest: Female Figure
 Support ivory; 6-1/2
 NMAN #470 FPRat
Stool: Kneeling Female
 Support wood; 18-1/2
 NMAN #476 GLV
--WAZIMBA, or BATSHIOKO
Headrest ivory; 16 cm
 TREW pl 45 FPRat
--WEST AFRICA
Female Votive Figure
 ROTHST pl 43 formerly
 FPGu
Head
 JOHT pl 27

Male Figure, Tago (Lake
 Chad) Pre-Islamic ceramic
 ADL pl 1B
--WOBI
Male Mask, cowrie hair,
 suspended bells and beads
 LARA 65 (col) -Vet
--YAKOUBA
Spoon: Stylized Human Form
 wood; 18-1/2
 ROY 38 formerly FPRat
--YEMO
Staff Mount: Two Gagged
 Heads, Ita Yema bronze;
 3-1/2
 FAA 62 NiIA
--YORUBA See also African
 --Ife
Ancestor Figure wood; 12
 SEG 113 UNNSeg
Armless Figure ivory; 4-1/2
 SEG 108 UNNSe
Armlet ivory; 6-3/4
 FAAN pl 102 ELivL
--: Owo Style ivory
 SOTH-2:131
Armlets 17th c. ivory; Dm:
 c 3-1/2
 FAA 112 GUU
Bell Heads: Human Heads
 bronze; 8, and 5-1/2
 FAA 122 ELBr
Boy in European Dress,
 weaver's heddle pulley top
 wood; 7-1/4
 FAA 70 -Rome
Cult Bowl H: 14-1/2
 WINGP 115 ELBr
Dance Staff: Kneeling Shango
 Worshipper, Oyo Style
 wood; 15-1/2
 FAAN pl 86 ELS
Divination Bowl: Palm Nut,
 Equestrian Support wood; 9
 FAAN pl 94 GBVo
Divination Vessel ptd wood; 25
 WIN pl 36 UCLMo
Drum, Agba, details wood;
 43-3/4
 FAAN pl 90, 91 ELBr
Drum, Ogboni Society wood; 46
 FAAN pl 92 ScAM
Edan Figures, Ogboni H: 7-1/2
 SEG 50 UNNSe
Egun Mask H: 17
 SEG 175 NLV
Epa Mask: Goddess with Child
 on Back wood; 54
 COOP 263 (col) ESuAH

Equestrian ivory; 14.3
 ADL pl 2A
--ptd wood; 15-3/4
 NMAN #239 FPCa
--early 20th c. wood
 LARA 85 ELBr
--: Staff Figure wood;
 11-3/4
 NEWA 111; WINN pl 32
 UNjNewM (24.2458)
--: Dahomey
 NEUW 139 FPCa
Equestrians ivory; 11-3/4,
 and 14-1/4
 FAAN pl 88 ELBr
Eshu or Elegbara Cult
 Staff--horn-like head
 wood, strings of cowrie
 shells; 20
 FAAN pl 97 UICWi
Female Head wood
 FEIN pl 14 UNNCar
Figure ivory; 5
 SEG 75 -Pas
--19th c. H: 14-1/2
 UPJH pl 302 ELBr
--: Mudfish Legs ivory;
 4-3/4
 FAAN pl 98 GStL
Gelede Mask H: 15-1/2
 WINGP 116 ELBr
--wood
 TREW pl 18 ELBr
--wood; 9
 SEG 176 ELBr
--: "The Brazilian" wood; 14
 FAAN pl 80 GStL
Gelede Society Dance Mask:
 Human Head wood; 14-1/2
 FAAN pl 77 ELBr
Gelede Society Double-Faced
 Mask wood; 9
 COOP 264 ESuAH
Gelede Society Mask: Human
 Head surmounted by
 Turtle H: 10-1/2
 HOO 162
Gelede Society Spirit Mask:
 Human Head with separate
 face mask H: 9-1/2
 HOO 162
Head: Elaborate Headdress
 and Cicatrization wood;
 c 9
 FAA 24 NiEM
Headdress: Cone-Shaped
 Mask bronze; 21-3/4
 FAA 147 ELBr

Heads, Eshu ivory; 2-1/4,
 and 4
 FAAN pl 96 GStL
House Posts: God Odudua as
 a Woman; Oba Tala as a
 Horseman H: 53-1/4, and
 52
 LEU 116 (col) FPH
"Ifa" Divination Tray and
 carved tusk Rattle tray
 H: 15-1/2; rattle H: 15
 HOO 156
Kneeling Drummer wood;
 7-1/2
 FAAN pl 95 GBVo
Kneeling Female Figure,
 Shongo Priest's Staff Top,
 Ekiti Style wood; 37 cm
 TREW pl 18 UNNHarn
Kneeling Woman Holding Pot
 ivory; 7-1/4
 FAAN pl 99 ELBr
Male Fetish Figure wood
 SLOB 239 UNBB
Man's Head, with ram's horns
 H: 17 SEG 179 NiOwO
Mask ivory
 MALV 546 ELBr
--ptd wood; 28-3/4
 CALA 257 IVG
--: Double-Faced ptd wood;
 c 9
 WIN pl 38 CTROA
--: Equestrian ptd wood; 52
 HOO 157
--Equestrian and Attendants
 ptd wood; 39
 WIN pl 39 UPPU (AF 2002)
--: Horizontal Human-Animal
 Form, Ijo influence wood
 TREW pl 8 ELBr
--: Mounted Warrior wood;
 40
 SEG 176 ELBr
--: With Turban ptd wood;
 c 11
 WIN pl 37 UNBB (22.757)
Maternity Figure ptd wood;
 28-1/2
 COOP 274 UNNRo
Mother Holding Child on Lap
 wood; 20
 SEG 136 ELHo
Mother with Child wood; c 30
 FAA 141
Mother with Children wood;
 c 20
 FAA 50 CTRO

Mounted Missionary Arriving
in Abeokuta wood; 32-1/2
FAAN pl 82 EBrigA
Odudua 19th c. wood; 27-1/4
TOR 161 CTRO (950.126.1)
Olojufoforo Festival Dance
Mask, Osi wood; 41
FAAN pl 81 NiLN
Omolangidi Doll wood; 11
FAAN pl 78 GBVo
Oni of Ife, bust, memorial
c 13th c. bronze
FREM 58 NiIA
Oracle Board, Ifa, Nigeria
wood; 17
SEG 49 UNNSe
Ore c 1300 H: c 30
FAA 20 NiI
Oshe Shango, sacred wooden
staff, with emblem of
Shango, God of Thunder
H: 19
LEU 132 (col) SwZR
Oya, kneeling female figure
with child on back wood;
15
SEG 136 UNNHarn
Palace Door: Panel scenes with
human and animal figures
wood; 114
FAA 103 ELBr
Palm Nut Bowl, bird support,
Ifa wood; 6-1/2
SEG 49 UNNSeg
Ram Head, Owo ivory; L: 7
FAAN pl 101 GHV
--wood; 19-1/2
FAAN pl 102 ELBar
--wood; 20
SEG 62 -Cos
Rattle ivory; 12-1/4
BALTW 21 UMdBM
--: Four-Faced; and Edan
brass; 14-1/2, and 15
FAAN pl 89 ELBr
Ritual Sword, or Wand ivory;
18
FAAN pl 100 ELBr
Shango, cult Figure wood;
28-1/2
NPPM pl 21 UNNMPA
(56.220)
--: staff: Woman with
Child on Back wood; 16-1/2
FAAN pl 87 UNNHarn
Staff: Supporting Mother and
Child, Nigeria wood; 15
WIN pl 34 UNNHarn
--: With Human Figure wood
PRAEG 561

Staffs: Bird Form H: c 60
FAA 27 NiEkA
--: Human Figures iron,
brass figures; c 54
FAA 28
Stool: Two Tiers of Figures
ptd wood; c 30
WIN pl 35 CTROA
Twin Figures (Ibeji) wood;
8-3/4
WIN pl 33 UNBuMS
(C 12975)
--wood; c 9
WIN pl 33 CTROA (HA 872)
--wood; 9-3/4, and 8-3/4
NEWA 111 UNjNewM
--wood; 10
SEG 73 UNNSeg
--wood; 12-3/4, and 10-1/2
FAAN pl 79 ELBr
Woman and Child, Ekiti Style
wood; 42 cm
TREW pl 18 ELUN
--YORUBA, or FON
Iva Divination Tray wood;
22-1/2
FAA 114
--ZAMBEZI
Kaffer Headrests: Triangle and
Diamond Decoration
BOA 23
--ZOMBO PLATEAU
Nikosi (Lion) Fetish, human
figure decoration, North
Angola H: 23
HOO 157
African Head, Cyrene. Hellenistic
African Beauty. Nelson, M.D.P.
African Eve. Lipshitz
African Landscape. Nickford, J.
African Mahogany. Hague
"African Venus". African
Afternoon of a Faun. Howard, C. de B.
AGAMEDES See POLYMEDES
(AGAMEDES) OF ARGOS
Agamemnon
Cretan. Murder of Agamemnon,
relief
Greek--6th c. B.C. Clytem-
nestra and Aegisthus Slaying
Agamemnon, shield relief
Mycenaen. Mask of Agamemnon
Roman--3rd c. Sarcophagus:
Achilles Among the Daughters
of Lycomedes
Agar in the Desert. Lipchitz
AGASIUS OF EPHESUS
Borghese Gladiator (Borghese
Warrior) early 1st c. B.C.
marble; 1.99 m

BAZINH 67; BAZINW 161
(col); BEAZ fig 180;
CHASEH 146; CLAK 190;
HAN pl 249; LAWC pl 114
FPL
Agassiz, Louis (American Naturalist
1807-73)
Huntington, A. H. Louis
Agassiz, bust
Powers, P. Louis Agassiz,
bust
Agastya
Javanese. Agastya
Agbar
Syrian. Funeral Stele of
Priest Agbar
AGBONBIOFE ADESHINA (Yoruba
d c 1940/44)
House Post: Mounted Warrior
(Jagunjagun), Palace of
Alaye of Efon 1916
FAA 92
Two Epa Masks: Mounted
Jagunjagun; Mother and
Child wood; 43, and
52-3/4
FAAN pl 84 GMV; ELBr
AGESANDAR, POLYDOROS,
ATHENADOROS (Greek fl 1st
c. B. C.)
Laocoon c 50 B. C. marble;
95
BARSTOW 93; BAZINH
505; BAZINW 159 (col);
BEAZ fig 169; BO 214;
BROWF-3:5; CHASEH 143;
CHENSW 130; CHRC 79;
CLAK 229; CRAVR 39;
ENC 543; FLEM 89; GAUN
pl 27; GOMB 75; HAN pl
242; HOR 392; JANSH 120;
JANSK 155; KO pl 23;
LARA 327; LAWC pl 121;
LAWL pl 67; LULL pl 278,
279; MOREYM pl 4; MYBA
126; MYBU 325; NEWTEM
pl 27; NOG 303; POPRB
fig 16; PRAEG 158; RAMS
pl 72b; RAY 24; RICHTH
163; ROBB 324; ROOS
40 B, C; SCHERM pl 146;
SEW 176; SIN 170; ST 67;
STRONGC 80; UPJH pl 36;
VER pl 63 IRV (No. 74)
--engraving
TAYFT fol 336
--central fragment
CAL 126

--head detail
AGARC 40; BAZINH 505;
NOG 304; RUS 32
--16th c. reconstruction
CAL 125
Laocoon (bronze cast) c 1690
COOPF 227 ENorfH
Odysseus and Palladion
175/150 B. C. marble
HAN pl 239 ISpeM
--Odysseus head detail
HAN pl 226
--Odysseus' Helmsman Fall-
ing; head detail
HAN pl 238, pl 240
Aggression. Nash, K.
Aggression. Nickford, J.
Aggressive Act. Ferber
Agias
Lysippus. Agias#
Aglibol
Palmyrene. Three Gods:
Aglibol, Baashamin,
Malakbel, relief
Agnese. MacNeil, H. A.
AGNI See AFRICAN--AGNI
Agog. Putnam, W.
AGORACRITOS OF PAROS (Greek)
Nemesis at Rhamnus, pedestal
fragments
FUR pl G GrAN
AGOSTINI, Peter (American 1913-)
Balloons Rising from a
Basket 1963 H: 88
SEITC 96 UNNRa
Burlesque Queen (Swells/
Woman Series) 1965 plaster;
7x6'
TUC 62 UNNRa
Cage II 1967 plaster, wood,
steel; 76
GUGE 76 UNNRa
Christmas Package 1963
plaster; 23-1/2
NEW pl 41 UNNRa
The Clothesline 1960 bronze;
60x58
WALKT #1 UNNRa
Egg Pile 1964
KULN 73
Hurricane Veronica 1962
plaster; 55-1/4
READCON 257 UNNRa
Lazy Summer Afternoon
plaster; L: 74
SG-4
The Rocker plaster; 39-1/2
x40x42 WHITNA-19

Samurai's Grave 1962 H: 40
 SEITC 24 UNNRa
Saracen 1215 A.D. 1960
 bronze; 29-3/4x25
 LOND-6:#2; WALKT #2
 UNNH: UNNGood
Saracen: 11-1215 A.D. 1960
 bronze; 29-3/4
 SELZS 170 UNNLi
Agricola.# Smith
Agricultural Themes See also
 Harvests and Harvesting;
 Tools and Implements
 American--18th c. Phila-
 delphia Society Agricultural
 Medal
 Assyrian. Eagle-Headed
 Winged Being Pollinating
 Sacred Tree
 --Winged Genie Fertilizing
 Flower, relief
 Bartlett. Apotheosis of
 Democracy
 Bissell. Soldiers' Monument
 (Farmers)
 Egyptian. Agricultural
 Workers, relief
 Egyptian--5th Dyn. Ptah-Hotep:
 Scenes of Daily Life
 --Ti Tomb: Donkeys Thresh-
 ing Wheat; Rams-Tread-
 Planting Seed; Cattle Herd
 Egyptian--6th Dyn. Kitchen
 and Herding Scenes
 Egyptian--Middle Kingdom.
 Herdsman with Cattle
 Egyptian--26th Dyn. Bee-
 Keeping, relief
 Etruscan. Arezzo Plowman,
 with Oxen
 Hellenistic. Farmer Driving
 Bull to Market
 Japanese--Ancient. Farmer
 Carrying Hoe on Shoulder,
 haniwa
 Keep. Sharecropper Woman
 Khmer. Band Accompanying
 Threshers
 Maya. Stela 40: Priest Sow-
 ing Grains of Maize
 Minoan. Harvester Vase
 Roman--1st c. B.C. Farmer
 Taking Produce, Cow and
 Sheep to Market, roadside
 shrine
 Roman--3rd c. Goatherd
 Milking, relief
 --Sarcophagus of Julius
 Achilleus: Farmer in
 Roman Campagna

Roman--4th c. Dish: Pastoral
 Scene
 Schenck. Agriculture
 Skillin, Simeon, Jr.
 "Agriculture"
 Sumerian. Carved Vase:
 Herdsman and Cattle
 --Frieze of Sacred Cattle
 Farm of Goddess Nin-
 Khursag: Priests and
 Cattle
 --Friezes: Cattle; Milking
 Scene
 --Milking and Dairy Scene,
 relief
 Wyle, F. Farm Girl
 Wyle, F. On the Land
Agrippa, Marcus Vipsanius (Roman
 General and Statesman
 63-12 B.C.)
 Hellenistic. Agrippa, bust
 Roman--1st c. B.C. Agrippa#
 --Marcus Agrippa, head
 Roman--1st c. B.C./1st c.
 A.D. Agrippa, head
 Roman--1st c. Agrippa, bust
Agrippina (Wife of Germanicus
 13 B.C.--33 A.D.)
 Roman. Seated Matron
 (Agrippina)
 Roman--1st c. B.C. Agrippina
Agrippina, the Younger (Mother of
 Nero 15 B.C.-59)
 Roman 1st c. Agrippina Minor,
 head
 --Claudius: With Younger
 Agrippina Facing
 Germanicus and Elder
 Agrippina
AGUADA CULTURE
 Plaque: Human Figure Between
 Felines, Argentina 700/
 1000 copper; W: 6-1/4
 BUSH 225 UMCP
AGUILAR GUZMAN, Joaquin (Salva-
 doran)
 Mat Seller wood
 IBM pl 17 UNNI
AGUNNA OF OKE IGBIRA
 House Post: Mounted Warrior,
 Palace of Owa of Ilesha,
 Yoruba 1959
 FAA 93
Ah Kin Koc
 Maya. Whistles: Ah Kin Koc,
 God of Dance
Ahab. Rosenthal, B.
Ahayuta
 Zuni. War God: Ahayuta

Ahiram (King of Byblos c 975 B.C.)
 Phoenician. Sarcophagus of
 Ahiram, King of Byblos
Ahmes
 Egyptian--18th Dyn. Ahmes,
 Mother of Queen Hatshepsut,
 relief
Ahuitzol (Aztec Ruler 1486-1502)
 Aztec. Stone of Tizoc: Slab
 Commemorating Tizoc and
 Ahuitzol
Ahura Mazda (Supreme Creative
 Deity of Zoroasterism)
 Achaemenian. Ahura Mazda#
 Iranian. Zeus-Ahura Mazda,
 statue head
 Sassanian. Investiture of
 Ardashir I by Ahura
 Mazda
 --Investiture of Ardashir II
 by Mithras and Ahura
 Mazda
Ai (King of Egypt)
 Egyptian--18th Dyn. Ai(?),
 head
Ai-Apec
 Mochica. Mountain Jar, with
 Ai-Apec
Aigisthos
 Cretan. Murder of Agamem-
 non, relief
Air
 Aitken. The Elements
 Bitter. Air
 Manship. Air
Air Hammer. Rosenquist, J.
Air Mailman. Maldarelli, O.
Air Raids
 Ubaldi, M. Air Raid
 Weschler, A. Martial Music
 No. 4: Air Raid
Air Show. Kahane
AITKEN, Robert Ingersoll (American
 1878-1949)
 Benjamin Franklin bust bronze
 HF 119; NATS 8 UNNHF
 Comrades in Arms, war
 memorial, Alpha Delta
 Phi bronze
 NATSA 4
 A Creature of God 1910
 marble; L: 34
 MUNSN 149
 Dancing Bacchante
 ACA pl 202
 Daniel Webster, bust bronze
 HF 130 UNNHF
 Dewey Monument
 REED 92 UCSFU

The Elements: Earth, Water,
 Air, Fire, Court of the
 Universe
 ACA pl 312 UCSFPan
 --Air
 JAMS 61
 Elizabeth N. Watrous Award,
 obverse; reverse bronze
 NATSA 269
 Fountain of Earth, Panama
 Pacific Exposition, San
 Francisco
 PAG-12:219; PERR 72;
 SFPP; TOW 37 UCSFPan;
 UNBuA
 --Earth
 JAM 45, 47; JAMS 69;
 PERR 53
 --Earth, Air, Fire, Water
 SFPP
 --Helios
 PERR 79
 --Panel Detail(s)
 ACA pl 302, 303; PERR
 75, 77; SFPP
 George Bellows, bust
 bronze; 18-1/2
 MUNSN 148 UOCoGA
 --1951 bronze; 20-1/2
 UNNMMAS 136 UNNMM
 (51.154)
 George Rogers Clark
 Monument
 PAG-2:44 UVCU
 Hall McAllister
 REED 104 UCSFCi
 Henry Clay, bust bronze
 HF 117 UNNHF
 Michael Angelo
 SFPP
 Michael Friedsam Medal for
 Industrial Art
 NATS 9
 Robert Burns
 NATS 7
 Sun Yat Sen Medal
 RICJ pl 8
 Survival of the Fittest
 JAMS 67
 Thomas Jefferson, bust
 bronze
 HF 123 UNNHF
 --bronze
 WHITNC 216 UNNW
 The Tired Mercury, study
 1910 plaster; 26
 MUNSN 149
 Visit of Marshal Foch to the
 United States, medal;

obverse; reverse 1921
silver, bronze
NATSA 268
William Howard Taft, bust
SFPP
William McKinley
REED 99 UCSFG
Zeus bronze; 40
BROO 146 UScGB
AITUTU See AFRICAN--BAOULE
Aiyanar. Indian--Hindu--17th c.
Aizen
 Japanese--Kamakura. Aizen
Aizen Myo-o. Koen
Ajanta Caves. Indian--Gupta
Ajax
 Etruscan. Lasa Covering
 Body of Ajax
 --Suicide of Ajax#
 Greek--7th c. B.C. Ajax:
 With Body of Achilles,
 relief
 --Peraea Seal: Suicide of
 Ajax
 Greek--6th c. B.C. Ajax
 Threatening Cassandra,
 shield relief
 Greek--5th c. B.C. Suicide
 of Ajax
 Von Ringelheim, P. Ajax
Akaad-1. Barron, H.
AKASHI YODAYU (Japanese)
 Books, sword guard iron
 SOTH-4:175
Akbar the Great (Emperor of
 Hindustan 1542-1605)
 Indian--Moghul. Coin: Akbar
 the Great
Akbar's Column, Indian--Moghul
AKELEY, Carl Ethan (American
 1864-1926)
 Wounded Comrade bronze
 NATSA 7
Akeley, Frances
 Horn. Frances Akeley, half
 figure
AKERS, Paul (Benjamin Paul Akers)
 (American 1825-61)
 Dead Pearl Diver 1857
 marble
 CRAVS fig 8.10 Mus of
 Art UMeP
 Edward Everett, bust 1854/56
 marble
 CRAVS fig 8.9 Historic
 Soc UMeP
Akhenaton See Ikhnaton
Akhtihetep
 Egyptian--6th Dyn. Mastaba
 of Akhtihetep

Akhnaton See Ikhnaton
AKKADIAN See also Babylonian;
 Sumerian
 Bearded Head 2500/2000 B.C.
 alabaster
 BAZINW 101 (col) UICUO
 --: Bismaya gypsum; 3-1/4
 FRA pl 41
 --: Ninevey bronze; 14-3/8
 GARB 38 IrBaI
 Bearded Head of King,
 Ninevey 3rd mil B.C.
 LARA 162 UrBagI
 Cylinder Seal: Animal
 Combat c 2300 B.C. H:
 1-1/4
 NM-2:11 UNNMM (55-65.5)
 --: Animals and Hunters in
 Mountain Landscape c 2200
 B.C. diorite; 1-1/2
 BOSMA pl 6 UMB (39.199)
 Cylinder Seal: Figures and
 Animals in Landscape c
 2200 B.C. diorite; 1-1/2
 BOSMI 203 UMB (34.199)
 --: Gilgamesh and Lion
 2500/2350 B.C.
 BAZINW 102 (col); FRA
 pl 45A ELBr
 --: God Zu, bird-man led
 before god with vase of
 flowing water green and
 yellow serpentine; 1.6x
 1
 GAU 17 FPL
 --: Hero and Beasts c
 2340/2180 B.C. serpentine;
 1-1/16
 BOSMA pl 8 UMB (34.177)
 --: Heroes Fighting Beasts
 c 2340/2180 B.C. lapis
 lazuli; 7/8
 BOSMA pl 7 UMB (27.647)
 --: Hunting Scene;
 Physician's Charm stone
 CHENSW 70 UMB; FPL
 --: Mythological Opposing
 Figures--horned-bull man
 and lion c 2300 B.C.
 Dm: 1.04
 MU 29 UNNM
 --: Mythological Scenes
 2350/2150 B.C.
 GARB 39 ELBr
 Female Divinity, head
 c 2300/2100 B.C.
 BAZINW 104 (col) FPL
 Foundation Figure in Turban
 c 2125 B.C. bronze;
 7-3/4 SOTH-3:145 (col)

Molten Galleon lead alloy; 30
SGO-17
No Just Cause lead alloy
WHITNA-16: 6
Polemos metal alloy
WHITNA-17: 8
Sculpture 1944
MOHV 230
Synagogue Facade Sculptures,
project 1959
KAM 61
ALBERT, Drusilla (American)
Apprehensive Horse white
pottery
NYW 175
ALBERT, Totila (Chilean 1892-)
Rainbow (Arco Iris)
TOLC 57
ALBERTS, Thealtus
Looking East mahogany
IBM pl 72 UNNIb
Albinus, Decimus Clodius Septimus
(Roman General d 197)
Roman--2nd c. Clodio
Albino(?), head
ALBRIGHT, Malvin Marr (American
1897-)
Old Monk of San Luis Rey,
bust
NATS 11
Albright, Mr. and Mrs.
Fraser, J. E. Mr. and Mrs.
Albright, plaque
ALBRIZIO, Humbert (American
1901-)
Blow Fish pink granite;
L: 17
SG-3
Head of Athlete 1955 blue
marble; 18
PIE 383; SGO-17 UNNKr
Head of My Father 1935/36
bronze; 15
UIA-6: pl 49
Kneeling Figure
PAA-53
Lazarus bronze; 20
SG-7
Night Bird granite; W: 19
SG-4
--#2 ebony; 28
SG-6
Seated Figure cherry wood
BRUM pl 2 UNNKr
Seated Woman rosewood; 44
SG-2
Vertical Form ebony; 45
SG-5

ALCAMENES (Alkamenes) (Greek fl
440 B.C.)
Aphrodite of the Gardens,
Pompeii (copy) 5th c.B.C.
MIAU 12 INN
Hermes, head (Roman copy)
c 450/530 B.C.
FUR 87; RICHTH 112 TIM
Hermes Propylaios (late
Roman copy)
FUR pl F UNNMM
ALCAMENES--FOLL
Goddess, head
FUR 86 GB
ALCIATI, Enrique
"El Angel", Independence
Monument
LUN
Alcibiades (Athenian General and
Politician c 450-404 B.C.)
Greek--5th c. B.C.Alcibiades
Roman. Alcibiades, bust
Alden, John (Mayflower Pilgrim
1599?- 1687)
Rogers, J. John Aldenand
Priscilla
O ALEIJADINHO See LISBOA, A.F.
ALEUT
Long-peaked Hunting Hat
c 1850 ptd wood, incised
ivory beads, sea lion
whiskers; 8-3/4
LOM 113 (col) UNNMAI
Alexander II (King of Egypt) See
Ptolemy X
Alexander III (King of Macedon
356-323 B.C.), known as:
Alexander the Great
Greek(?). Alexander on
Horseback
Greek--4th c. B.C. Alexander
the Great#
--Cameo: Profile Heads of
Alexander and Mother,
Olympias
--Stater, Thrace: Alexander
the Great
--Tetradrachma
Hellenistic. Alexander the
Great#
--Gem: Alexander, profile
head
--Lysimachus Tetradrachma:
Alexander the Great
--Sarcophagus of Abdalongmos,
detail: Equestrian Battle
Scene; Alexander with Lion
Helmet

Lysippus. Alexander Sarcophagus
Lysippus. Alexander the Great, head
Lysippus--Attrib. Alexander the Great, bust
Roman--4th c. B. C.
Alexander, bust
Alexander, John W.
MacNeil, H. A. Alexander Memorial
Alexander Aigos. Egyptian--Ptolemaic
Alexander Balas I (Fl 152-145 B. C.)
Hellenistic. Alexander Ballas, Smyrna
Alexander Severus (Roman Emperor 208?-35)
Roman--3rd c. Alexander Severus#
Alexander the Great See Alexander (King of Macedon)
Alexandria
Alexandrian. Medicine Box-Lid: Personification of Alexandria
Coptic. Pulpit of Henry II: Alexandria, personification
ALEXANDRINE
Aphrodite(?) 5th c. bone
BECKC pl 29 UMdBW (No. 71. 52)
Apollo and Daphne, relief 5th c. ivory
BECKC pl 30 IRaMN
Dionysos 5th c. bone
BECKC pl 28 UMdBW (No. 71. 47)
The Dioscuri; Pasiphae and the Bull, relief 5th c. ivory
BECKC pl 37 ITrMC
Farnese Cup: Nile Symbolic Scene, cup cameo; Gorgon's Head, outside, Ptolemaic grey onyx on brown background
MAIU 163 (col), 162 INN
Male Figure 1st c. B. C.
LAWL pl 104C GMG
Medicine Box--Lid: Personification of Alexandria; Side: Dionysus between Maenad and Satyr 4/5th c. ivory
BECKC pl 19 UDCD (No. 47. 8)
Multiple Diptych: Life of Christ, as Christ Enthroned

6th c. ivory; 16x12-5/8
RDAB 19 FPMe
Nereids, plaques 5th c. bone
BECKC pl 27 ELV
Silenus and Bacchantes 5th c. bone
BECKC pl 25 FPL
Silenus, Maenad, Satyr, Boy, Carving fragments 5th c. bone
BECKC pl 26 ELV
Supper Party, with reclining diners, Pyx, Cathedral Treasure 5th c. ivory
BECKC pl 31-34 GWieSA (No. 7856)
ALEXNOR OF NAXOS (Greek)
Orchomenos Stele: Man Playing with Dog (Stele of Alexenor) c 500/490 B. C. marble
CHRP 63; LAWC pl 27B; RICHTH 78 GrAN
ALFEREZ, Enrique (American)
Clayre Barr, head terracotta
NYW 174
Alfredo. Valera, V.
ALI IBN MUHAMMAD AS-SALIHI (Persian)
Animal-form Incense Burner 12th c. pierced bronze, copper inlay; L: 18-1/2
RDI 75 RuLH
ALKAMENES See ALCAMENES
Alkmena. Young, M. M.
All Around the Square. Smith, D.
All Things Involved in All Other Things.
Bauermeister, M.
ALLAN, Harry (American)
Dridler plaster
UNA 1
ALLAN, Julian Phelps
The Raising of Jairus' Daughter, relief stone
PUT 74
Allegory--Margarita Island. Narvaez
Allegory of Salvation, relief. Roman
Allegresse. Vonnoh, B. P.
Allegro. Konti
Allegro Ma Non Troppo, incised. Hesketh
Allen, Ethan (American Revolutionary Hero 1737-89)
Mead. Ethan Allen
ALLEN, Frederick Warren (American 1888-)
Charles J. Connick, head wood; 18 NMPS # 104

Head Study granite
 NYW 174
ALLEN, Louise (American)
 Annunciation
 CHICA-43:#213
 Bronze Mask
 NATS 12
 Circe bronze
 CHICA-30
ALLEN, Margo (American)
 Hopi, head terracotta
 SCHN pl 16
Allen, Thomas
 di Bona. Thomas Allen,
 head
Allen, William (American States-
 man 1803-79)
 Niehaus. William Allen
Alligator Bender. Choate
Alligator God. Indians of South
 America--Venezuela
"Alligator Vessel". Maya
Alligators
 African--Senufo. Door, relief
 Calusa. Alligator Head
 Flannagan. Alligator, tondo
 Indians of Central America--
 Nicaragua. Guardian Spirit:
 Man and Alligator
 Indians of Central America--
 Panama. Ornaments
 Poor, H. V. Nude with
 Alligator
Allston, Washington (American
 Artist and Author 1779-1843)
 Brackett. Washington Allston,
 head
 Clevenger. Washington Allston,
 bust
ALLWARD, Walter Seymour
 (Canadian 1876-1955)
 The Storm bronze; 13-1/4
 CAN-3:363 CON (1816)
 William Lyon MacKenzie
 COLG 201 CTQ
Alma Mater. French, D. C.
ALMAZAR, Hugo (Bolivian)
 Wind in the Heights, relief
 wood
 IBM pl 3 UNNIb
Almsgiving See Largesse
Alogon #2. Smithson, R.
Alone. Hartwig
ALONSO, Matteo (Argentine 1878-
 1955)
 Christ of the Andes,
 Argentine-Chile Border
 BR pl 14 Ar

Alou
 Sumerian. Praying Figures:
 God Alou(?); and female
 figures
Alpacas
 Inca. Alpaca#
 Inca. Miniature Figures:
 Man, Alpaca, Llama
Alph. Rocklin, R.
Alpha and Omega
 Coptic. Tombstone of
 Rodia, Faiyum--with Ankh
 and Letters Alpha and
 Omega
Alphabets
 Gill, E. Incised Alphabets
"Alpheios"
 Greek--5th c. B. C. Temple
 of Zeus, Olympia, east
 pediment, detail:
 "Alpheios"
Alphonso X (King of Leon and
 Castile 1221-84), known as
 "The Wise"
 Cecere. Alphonso X,
 medallion head
ALSTON, Charles (American 1907-)
 Torso
 DOV 156
ALSTON, Florence (American
 1891-)
 Garden Plaque 1950 iron and
 concrete; 24x32
 SFAP pl 88 UCSFCh
ALTAIAN
 Necklet: Stag, Pazyryk 5th
 c. B. C. wood
 RTC 33 RuLH
Altar of Aphrodite
 Greek--5th c. B. C.
 Ludovisi Throne
Altar of Augustan Peace
 Roman--1st c. B. C. Ara
 Pacis Augustae
Altar of Peace
 Roman--1st c. B. C. Ara
 Pacis Augustae
Altar of Silence. Chung
Altar of the Twelve Gods, Athens.
 Greek--5th c. B. C.
Altars See also Retables; Shrines
 Achaemenian and Sassanian.
 8 Coins
 African--Benin. Altar of the
 Hand
 African--Ibo. Altarpiece for
 Yam Spirit
 Anderson, J. R. Altar

Underground Railway, relief
model for marble
SCHN pl 109 UNBuHS
AMATEIS, Louis (Italian-American
1855-1913)
Door: Transom (Apotheosis
of America; and 8 panels:
Jurisprudence, Science,
Fine Arts, Mining,
Agriculture, Engineering,
Naval Architecture and
Commerce 1904 13'10"x
7'3-1/2' (with frame)
USC 377 UDCNMS
Amazons See also Penthesilea
Etruscan. Amazon, head
Etrusco-Italic. Wounded
Amazon, torso fragment
Giorgi. Two Amazons
Greco-Roman. Sarcophagus:
Battle of Greeks and
Amazons
Greek. Amazon#
Greek. Greek Battling
Amazon, frieze
Greek. Wounded Amazon
Greek--6th c. B. C.
Hercules, and an Amazon,
metope
Greek--5th c. B. C. Amazon#
--Amazonomachy, frieze
--Baia Amazon, head
--Greeks Battling Amazons,
relief
--Temple of Apollo: Battle
of Greeks and Amazons
--Two Amazons
--Wounded Amazon
Greek--5/4th c. B. C.
Greeks Battling Amazons,
embossed cuirass
Greek--4th c. B. C. Amazon#
--Mausoleum at Halicarnas-
sus: Battle of Greeks and
Amazons
Hebald. Battle of Amazons
Kresilas. Amazon#
Kresilas. Lansdowne Amazon
Kresilas. Wounded Amazon#
Kresilas--Attrib. Wounded
Amazon
Kresilas--Foll. Amazon
Martinelli, E. Amazon
Parthian. Amazons Hunting
Lions, plate
Pergamene. Dead Amazon
Phidias. Amazon, headless
and handless

Phidias. Fight between Greek
and Amazon, Shield of
Athena Parthenos
Polyclitus. Amazon#
Polyclitus. Gems: Amazon
Polyclitus. Wounded Amazon
Polyclitus--Foll. Amazon
Roman. Amazon
Scopas. Mausoleum at
Halicarnassus
Sotades. Rhyton: Amazon
Strongylion--Foll. Amazon
on Horseback
Timotheus. Mounted Amazon,
fragment
AMBELIAN, Harold (American 1912-)
Buoyant Woman, sketch
plaster
SGO-10:1
Dancer plaster
UNA 2
Dreamer Bronze; 30
SGO-17
Sculpture*
MOT 94 UNNSalp
Ambrose, Saint
Baillairge. St. Ambrose
Amdo Mask. African--Igala
Ameinokleia
Greek--5th c. B. C. Stele
of Ameinokleia
Amelung's Goddess
Greek--5th c. B. C. Europa
Amemptus
Roman--1st c. Funerary
Altar of Freedman
Amemptus
Amen (Amon; Amun)
Egyptian. Amon, relief
Egyptian--12th Dyn, Sesostris
I before Amon holding
Flail
Egyptian--18th Dyn. Amen
(Amon), idealized head
of King Tutankhamon
--Amen (Amun)#
--God Amen-Ra and Queen
Hatshepsut, obelisk relief
--Shrine of Bark of Amun
--Thutmose III: in Atef
Crown and God Amun
--Tutankhamen as God Amon
Egyptian--19th Dyn. Amon-Re
Amenemhat See Amenemhet
Amenemhat-ankh
Egyptian--12th Dyn. Amenem-
hat-ankh, Keeper of the
Secrets of Ptah-Sokar

Amenemhet I (Amenemhat;
 Amenhet)
 Egyptian--12th Dyn. Amenem-
 hat I, seated figure
Amenemhet III (King of Egypt
 1849-1801 B.C.)
 Egyptian--12th Dyn. Amenemhet
 III#
Amenhet See Amenemhet
Amenhotep (High Priest)
 Egyptian--20th Dyn. Amen-
 hotep, High Priest, before
 Ramses IX
Amenhotep, scribe
 Egyptian--18th Dyn. Amenhotep
 (Amenophis), scribe of
 Amon's Offering Table
Amenhotep, Son of Hapu (Chief
 Architect of Amenhotep III)
 Egyptian--18th Dyn. Amenhotep
Amenhotep I (King of Egypt
 reigned c 1557-40 B.C.)
 Egyptian--18th Dyn. Amenho-
 tep II#
 --Hathor: As Goddess of
 Death in shape of Sacred
 Cow, with Amenophis II
 Drinking from her Udder
Amenhotep III (Amenophis III;
 Memnon) (King of Egypt
 reigned c 1411-1375 B.C.)
 Egyptian--18th Dyn. Amen-
 hotep III#
 --Colossi of Memnon,
 Funerary Temple of Amen-
 hotep III
 --Commemorative Scarab of
 Amenhotep III
Amenhotep IV See Ikhnaton
AMENOMIYA JIRO (Japanese 1889-)
 Man 1956 bronze; 182x79 cm
 WW 203
Amenophis See Amenhotep
Amenophis IV See Ikhnaton
Ameny
 Egyptian--Middle Kingdom.
 Ameny, seated figure
America--New York Blue. Nevelson,
 L.
America Welcoming the Pan-
 American Nations. Ruckstuhl,
 F. Quadriga
AMERICAN
 Barbara Fritchie, tondo
 bronze
 PAG-11:168 UMdFr
 Mayor John Mason
 PAG-6:30 UCtMy

--17th c.
 Chest wood; 34
 CRAVS fig 1.8 UDeWi
 Connecticut-type Carved Chest
 LARK 17 UNNMM
 Joseph Tapping Gravestone:
 Winged Skull d 1678
 CRAVS fig 1.3 UMBK
 Lord Baltimore Six Pence--
 obverse; reverse
 PAG-4:288 UNNAmN
 Massachusetts Twelve
 Shilling Piece--obverse;
 reverse
 PAG-4:287 UNNAmN
 Oak and Pine Tree Shillings,
 Massachusetts--obverse;
 reverse 1652
 PAG-4:288; 8:14 UNNAmN
 Robert Morris Gravestone:
 Winged Skull d 1681
 CRAVS fig 1.1 UMCo
 Sailor c 1868 wood; LS
 CRAVS 1.36 UNNHS
 Sunflower, chest detail
 1650/1700 wood
 NM-1:6 UNNMM (10.125.
 689)
--18th c.
 "The Canton", ship model
 PAG-4:26 UPPCom
 Capital: Scrolls with Floral
 and Geometric Motif
 LARK 27 UMMR
 Chalkley Hall Doorway,
 Frankford, Pa. c 1776
 stone
 NM-1:2 UNNMM (57.142)
 Chancel Decoration, St.
 Michael's Choir c 1755
 CRAVS fig 1.9 UScCh
 Chandelier
 LYNCM 73 UNNCoo
 Country Maid c 1785 wood
 CRAVS fig 1.16 UMBHS
 Fire-Back, Principiolo 1767
 iron
 PAG-5:179 UMdBMH
 Gardener c 1785 wood
 CRAVS fig 1.15 UMBHS
 George III, equestrian, New
 York City figure demolished
 and used to make bullets
 (wood cut by Alexander
 Anderson)
 ADAM-1:360 UNN
 George Washington, medallion
 head USC 327 UDCCap

Haverhill, Mass. , detail
1818
NM-1: 39 UNNMM (12. 121)
Fireplace, with reliefs,
 including: Battle of Lake
 Erie
 WHITEH 103 UDCW
Flora c 1820/ 25 white pine;
 57-3/ 8
 CRAVS fig 3. 6 UDeW
General Hancock, equest
 LONG 156 UPGeP
General Nathaniel Greene,
 equest
 LONG 186 UNcG
General Robert E. Lee,
 equest, Seminary Ridge
 LONG 156 UPGeP
Gilt Fruit Basket, with
 kneeling bisque angels
 WHITEH 36 UDCW
Gladiator
 REED 158 UCSFG
Gnadenhutten Monument:
 Commemorating Militia
 Massacre of Indians,
 March 8, 1782
 PAG-10: 236 UOGn
Grave Marker of Captain
 Meriwether Lewis
 PAG-2: 172 UTLe
Hard Times Token--obverse;
 reverse
 PAG-8: 264 UNNAmN
Haystack Monument
 PAG-10: 143 UMWi
Iron Grille, detail
 LARK 164 UAlMC
John Henry Hobart Memorial
 PAG-10: 156
 UNNT
John Witherspoon
 PAG-10: 129 UPPF
Junipero Serra
 REED 15 UCM
"Lion", Chebacco Schooner,
 model
 PAG-3: 300 UDCNM
Lotta's Fountain
 REED 169 UCSFMat
Man, bust plaster; 26-1/ 2
 AP 169 UPPA
Milepost, Cumberland Road
 PAG-4: 54 UKyFH
Old-Style Fishing Schooner,
 model
 PAG-3: 300 UDCNM
Pathfinders Who Won the
 West, plaque presented by

Daughters of the State of
 Missouri
 PAG-2: 281 UMoS
Pennsylvania Mantel, Betz-
 hoover House, Carlisle
 NM-11: 90 UNNMM
The Pinky, ship model
 PAG-3: 302 UDCNM
Poe Memorial
 PAG-11: 189 UNNMM
Poodles Carrying Baskets
 Parian Ware
 MEN 260 UNNMM
Prayer Book Cross
 REED 10 UCSFG
Red Jacket, monument figure
 1891 bronze, granite base;
 figure H: 96, on 14' base
 GRID 56 UNBuF
Rococo-Revival Punch Bowl,
 with bisque caryatids
 WHITEH 69 UDCW
Seal of the Schuylkill Fishing
 Company
 PAG-15: 14
Simeon DeWitt, bust 1830
 plaster; 25
 AP 139 UPPA
State of New York Trophy to
 National Rifle Association
 1873
 PAG-15: 169
Stourbridge Lion, train replica
 PAG-4: 105 UDCNM
The "Tiger", Pinky Schooner
 model
 PAG-3: 302 UDCNM
United Bowmen of Philadelphia
 Trophies
 PAG-15: 164 UPPHS
U. S. Congressional Medal
 awarded Johnston Blakeley--
 obverse; reverse 1879
 PAG-6: 301
U. S. Congressional Medal
 Awarded Lewis Warrington
 --obverse; reverse 1879
 PAG-6: 301
U. S. Congressional Medal
 presented to Edward Preble
 --obverse
 PAG-6: 282
U. S. Congressional Medal
 presented to Thomas
 Truxton--obverse; reverse
 PAG-6: 280
U. S. Polo Association
 Championship Cup
 PAG-15: 276

Viking Ship, model
 PAG-1: 69 UDCNM
Wellfleet Tombstones
 KUY 12, 13 UMWe
--20th c.
Abraham Lincoln 1914?
 BUL 169 UMoM
Bear Flag Monument
 REED 32 UCSo
Beethoven, bust 1915?
 (replica of New York
 figure)
 REED 124 UCSF
Bishop Baraga Monument
 1960 marble; LS
 GRID 18 UMiL
Boy with Leaking Boot
 bronze
 REED 144 UCFCM
Catawba Confederate Indians,
 memorial to confederate
 dead 1900 limestone;
 10'
 GRID 55 UScF
Chester Rowell, seated figure
 REED 103 UCF
Chief Hopocan c 1911
 GRID 89 UOBP
Chief Joseph of the Nez
 Perce, head, memorial
 column
 LONG 37 UMtB
Chief Menominee 1909
 granite; 20' (with base)
 GRID 23 UInPP
Commodore Sloat Monument
 REED 40 UCM
Davis Challenge Cup, tennis
 trophy
 PAG-15: 155
Donner Pioneer Monument
 REED 54 UCD
Father Hidalgo
 REED 78 UCLUn
First American Golf
 Championship Cup
 PAG-15: 284
The First Church in Virginia,
 Robert Hunt Memorial
 Tablet
 PAG-10: 68 UVJ
Four Bears Monument 1932
 bronze, on marble pedestal,
 concrete base; 9'
 GRID 64 UNdNF
Francis Makemie
 PAG-10: 99 UVH
General Naglee, relief
 REED 84 UCSjJ

Hand Sculptures
 MOHV 67 UICI
Hearst Memorial Fountain
 REED 108 UCSFG
Helena Modjeska Monument
 REED 45 UCA
Henrico Medallion, com-
 memorating destruction
 of University at Henrico
 by Indians
 PAG-10: 71 UMdBC
Hiawatha 1964 colored fibre
 glass; 52
 GRID 44 UMil
International Peace Memorial
 National Monument, on
 Lake Erie
 LONG 205 UO
The Iron Workers, Inter-
 national Exposition, 1900,
 Paris
 PAG-5: 314
James Marshall
 REED 56 UCP
Langley Medal: Aviation
 Honor awarded by Smith-
 sonian Institution
 PAG-4: 331
Madonna of the Trail
 REED 18 UCU
Mark Twain
 REED 52 UCAn
"Mayflower", model
 PAG-1: 197 UDCNM
Medicine Lodge Peace Treaty
 Monument 1929 figures: LS
 GRID 48 UKMH
Nekahwah Shetunkah, monu-
 ment figure H: 13' (with
 base)
 GRID 67 UOkF
New York State Peace Monu-
 ment, Point Park: Column
 with Northern and
 Southern Soldier Holding
 U.S. Flag
 LONG 196 UTL
Noble Redman, Pawnee
 Scout 1920 cement
 GRID 32 UKHL
Old Trumbull Gallery, relief
 detail, chapel Street
 Entrance frieze
 YAH 6 UCtY
Original Horse-Drawn Rail-
 way, commemorative
 plaque 1921
 PAG-4: 103 UMQG

Pan-American Exposition dec-
orative figures 1901
CRAVS fig 13.7
Pioneer Preacher, equest
PAG-10:248 UOrSCap
Robert Emmet
REED 39 UCSFG
Sequoyah bronze
BRID 24 UGCU
Shields of Great Patrons of
Art, Wall decoration
Sculpture Hall
YAH 8 UCtY
Squanto, bust
PAG-1:204 UMPP
Stevenson Memorial
REED 110 UCSFPo
Tishomingo, bust bronze
GRID 100 UOkAI
Trinidad Head Cross
REED 11 UCHu
U.S. National Battlefield
Site Memorial
LONG 218 UMoT
William McKinley 1902
REED 100 UCSjJ
Zachary Taylor, bust
marble
FAIR 110; USC 170
UDCCap
Zwingli, Schlatter, and
early pastors of the
congregation, memorial
tablet 1732/1850
PAG-10:115 UPLaF
American Academy of Arts and
Letters Medal. Fraser, J.E.
American Bison. Hardy
American Dawn. Nevelson, L.
American Geographical Society
Medal. Fraser, L.G.
American Indian. Mestrovic
American Institute of Mining
Engineers Medal. De Fran-
cisci
American Miner's Family. Harkavy
American Monarch. Roszak, T.
American Moon. Whitman, R.
American Numismatic Society
Wienman, A.A. J. Stanford
Saltus Award for Medallic
Art
American Pioneer, equest. Borglum,
S. H.
American Red Cross, 1917-19,
Medal. French, D. C.
American Scene on Metal
Structure. Guteman

The American Sphinx
Milmore, M. Sphinx
The American Supermarket. Watts,
R. M.
American Venus. Florio
American Youth. Howard, C. de B.
America's Cup. American--19th c.
AMES, Alexander (American)
Bust of a Woman c 1840
wood; 21-1/4
PIE 376 UVWR (57.701.3)
Child, head 1847 ptd oak;
14-1/2
LIPA pl 181 formerly
UNNCun
Head of a Boy 1847 wood;
18
PIE 376 UNCooHS
(N-402.55)
AMES, Sarah Fisher (American
1817-1901)
Abraham Lincoln, bust
marble
USC 169 UDCCap
Amida (Sanskrit: Amitabha)
Chinese--Ch'i. Amitabha
Buddha
Chinese--Liao. Amitabha
Buddha, seated figure
Chinese--Sui. Amitabha
Buddha#
Chinese--T'ang. Amida
--Amitabha Buddha#
Chinese--Wei. Amitabha
Buddha
Chinese--Wei/Sui. Buddha
Amitabha and Attendants
Indian--Hindu--18th c.
Avalokiteshavara
Bodhisattva, Dhyan
Buddha Amitabha in Head-
dress
Inakaku. Amida Nyorai
Japanese--Ashikaga. Amida
Buddha
Japanese--Fujiwara. Amida
Nyorai
Japanese--Hakuho. Shrine
of Lady Tachibana: Amida
Triad
Japanese--Kamakura. Amida
Buddha
--Amida Nyorai
Javanese. Amitabha Buddha,
niche figure
Jocho. Amida Nyorai
(Amitabha)
Jocho, and Foll. Five
Attendants of Amida Nyorai

Koshun. Amida
AMINO, Leo (American 1911-)
 Creature of the Deep 1953/54
 plastic; L: 66
 FAUL 399; WHITNN 9
 UNNSC
 Family Totem mahogany; 74
 UIA-6:pl 25
 Jungle 1950 mahogany; 56
 CHRC fig 256; MEN 641;
 WHITNA 26 UNNW
 Liquid Enclosure 1953 plastic
 with wood; L: 27
 WHITNN 9 UNNSC
 Mother and Child Paldao wood
 UNA 3
 Rite of Spring Hydrostone
 BRUM pl 3 UNNSC
 Spring translucent plastic
 BRUM pl 4; SCHN pl 126
 Triumphant Warriors
 mahogany; 46
 NM-13:#49
 Walpurgis Night
 HAY 88 UMAP
 Zoophite No. 1. 1952 plastic,
 wire, colored mesh and
 threads; L: 14
 PIE 383 UNNSC
AMIOT, Laurent (Laurent Amyot)
 (Canadian 1764-1838)
 Censer silver; 10-7/8
 CAN-4:51 CON
 Chalice silver gilt; 11
 CAN-4:51 CON
 Monstrance silver; 16
 CAN-4:51 COR
 Pax silver; 4-1/2x2-1/2
 TOR 194 CTRO (960.139)
Amitabha See Amida
Amith. Palmyrene
Amity. Callery
AMLASH
 Beaker: Lions Attacking
 Rams 10th c. gold; 43-1/4
 COOP 259 FPDavr
 Bowl: Lion Demons and
 Gazelles 12/11th c. B.C.
 gold; 11 cm
 POR 93 (col) FPL
 Bowl of Hasanlu: Weather
 God 12/11th c. B.C.
 gold; 20.6x28 cm
 POR 95 (col), 97 (col)
 IranTA
 Bull, vessel 12/11th c. B.C.
 clay; c 27x c 27 cm
 POR 104 (col) UNNHee

Female Figure, Iran
 1200/1100 B.C. pottery; 6
 DENV 149 UCoDA (O-189)
Gazelle Cup c 900 B.C. gold;
 2-1/2; Dm: 3-3/8
 NM-2:29 UNNMM (62.84)
Marlik Beaker: Bulls Flank-
 ing Tree 12/11th c. B.C.
 gold
 POR 92 (col) IranTA
Rhyton: Bison 9/8th c. B.C.
 terracotta
 BAZINW 124 (col) IranTF
Rhyton: Zebu Bull c 900/800
 B.C. pottery; 10
 BOSMI 207 UMB (61.381)
Two Female Idols c 900 B.C.
 terracotta
 COOP 172 FPRoths
Two Stag Pendants bronze;
 10x7 cm; 10.5x7.3 cm
 POR 104 (col) UNNMM
Vessel: Zebu, Iran 1200/1100
 B.C. pottery; 9
 DENV 149 UCoDA
 (O-78)
Vessel: Zebu 7th c. B.C.
 terracotta
 SUNA 257 UWaSA
Woman 2nd mil B. C. clay
 CHENSW 31 UNNScha
Zebu c 900 B.C. terracotta;
 11-5/8
 NM-2:29 UNNMM (61.263)
Ammenemes See Amenemhet
Ammunition Carrier
 Hoff. Anzac Memorial
Amo. Lober
Amon See Amen
Amor Caritas. Saint-Gaudens
L'Amore
 Longman. L'Amour
Amorites
 Egyptian--20th Dyn. Wall
 Tiles
Amorous Lion. Perry, R. H.
Amosis
 Egyptian--17th Dyn. Amosis,
 second prophet of Amon-
 Re, and his Mother,
 Beket-Re
L'Amour. Longman
Ampersand. Chryssa
Amphiaraus
 Etruscan. Death of
 Amphiaraus
 Greek--6th c. B.C. Lycurgus
 and Amphiaraus Fighting in
 Front of Adrastus

Amphibian. Kwiatowski
Amphitrite See also Poseidon
 Roman--1st c. B.C. Altar
 of Domitius Ahenobarbus
Amphora
 Greek--7th c. B.C. Amphora
 Hellenistic. Amphora: Centaur
 Handles; body relief:
 Seven Against Thebes
Ampudius
 Roman--1st c. Grave relief
 of Ampudius, corn
 merchant, with wife and
 daughter
AMRATIAN CULTURE See
 EGYPTIAN--PREDYNASTIC
Amsterdam Wave. Haacke, H.
Amulets See Charms
Amun See Amen
Amusement Park. Smith, D.
AMYOT, Laurent See AMIOT,
 Laurent
Anacreon
 Greek--5th c. B.C. Anacreon
 Lyricos
 Phidias--Attrib. Anacreon
 Phidias--Foll. Anacreon
 Borghese
Anadyomene Fountain
 Manship. Venus Anadyomene
Anahita
 Hunt, W. M. The Horses of
 Anahita
 Sassanian. Plate: Goddess
 Anahita
 Sassanian. Wine Vessel:
 Anahita
Ananda, Disciple of Buddha
 Ceylonese. Ananda Attending
 the Parinirvana of the
 Buddha
 Chinese--T'ang. Ananda,
 head
 Indian--Gupta. Ananda
 Attending Parinirvana of
 the Buddha
 Khmer. Mucalinda Buddha
 seated on Ananda
Ananta
 Indian--Gupta. Ratha: Vishnu
 Lying on World Serpent
 "Endless" (Ananta)
 --Vishnu: On the Serpent
 Ananta
 Indian--Pallava. Vishnu
 (Visnu) Anantashayin (Sleep
 of Vishnu; Vishnu Re-
 clining on the Serpent
 Ananta (Infinity))

Anapteroma. Lekakis
ANASAZI
 Zoomorphic Vessel,
 Tularosa Canon, N.M.
 1100/1300 clay; 8x9
 DOCA pl 16 UNNMAI
 (18/6406)
Anastasius Diptych. Roman--6th c.
Anath (Ugaritic Epic Character)
 Bactrian. Wine(?) Bowl,
 repousse: Eagle; Anath
 Cycle Scenes
ANATOLIAN
 Bull c 2100 B.C. copper,
 with alloy overlays; 3-5/8
 BOSMA pl 10 UMB (58.14)
 Cuneiform Tablet, Kultepe
 c 1900 B.C. clay;
 1-9/16x1-11/16
 NM-2:15 UNNMM (58.108)
 Hacilar Figurine c 5400 B.C.
 earthenware; 5-1/8
 NM-2:1 UNNMM (64.90)
 Karatepe Reliefs
 FRA pl 165
 Lachish Figurine c 7th c.
 B.C. earthenware; 7-1/8
 NM-2:15 UNNMM
 (34.126.53)
 Mother Goddess, Hacilar
 c 5700/5600 B.C. baked
 clay; 4-1/8
 GARB 71 TAA
 Mother Goddess, seated
 figure, Catal Huyuk 6th
 mil B.C. baked clay;
 3-5/8
 GARB 70 TAA
 Sistrum, with Birds and
 Bull's Horns, Horoztepe(?)
 late 3rd mil B.C. bronze;
 13
 NM-2:14 UNNMM (55.137.1)
 Stag Standard, Alaca Huyuk
 c 2400/2200 B.C. bronze,
 with silver inlay; 20-1/2
 GARB 54 (col) TAA
 Stamp-Cylinder Seal 14th c.
 B.C. hematite; 2-1/4
 BOSMA pl 12 UMB
 (98.706)
 Sun Disk Standard, Alaca
 Huyuk c 2400/2200 B.C.
 bronze; 9-1/8
 GARB 54 (col) TAA
The Anatomy Lesson. Seley, J.
Anatomy of Violence. Nash, K.
Anaxagoras (Greek Philosopher 500-
 428 B.C.)

Greek--5th c. B.C. Coin:
 Anaxagorus, seated figure
Ancestor. Lipton
Ancestor Figures See also Epku;
 Tiki
African--Babembe. Ancestor
 Figure
--Ancestor Statue
African--Baluba. Ancestor
 Figure#
--Female Ancestor
 Figure(s)#
African--Bambera. Ancestor
 Figure#
--Seated Female Ancestor
 Figure
African--Bamum. Ancestor
 Figure
African--Bangwa. Ancestor
 Figure#
African--Baoule. Ancestor
 Figure(s)#
African--Baoule, or Guro.
 Ancestor Figure
African--Bena Lulua.
 Ancestor Figure
African--Chad. Sao,
 ancestor figure
African--Chamba. Pair
 Ancestor Figures#
African--Congo. Male
 Ancestor Figure
African--Dengese. Tattoed
 Chief, seated com-
 memorative figure
African--Dogon. Ancestor
 Figure(s)#
--Female Figure--"Tellem"
 head
African--Fang. Ancestor
 Figure#
--Male Ancestor Figure
African--Gabon.
 Ancestor Figure
--Female Ancestor Figure
--Male Ancestor Figure
African--Ibibio. Ancestor
 Figure#
African--Ijaw(?). "Kakenga",
 ancestor figure
African--Kaka. Ancestor
 Figures
African--Oron. Ancestor
 Figure
African--Senufo. Female
 Ancestor Figure#
African--Yoruba. Ancestor
 Figure

Babbar. Ancestor Figure
Borneo--Siang. Ancestor
 Post
Dayak. Ancestor Figure:
 Tempatong or Hampatong
Easter Island. Ancestor
 Figure#
--Figures: Female and
 Ancestor Spirit
--Male Ancestor Figure#
--Memorial Figure
Indians of South America--
 Peru. Ancestor Figure
Indonesian. Ancestor Figure#
Leti. Squatting Ancestor
 Figure
Maori. Ancestor Figure,
 gable ornament (Tekoteko)
--Embracing Ancestral
 Figures, panel
Melanesian. Door Jambs:
 Ancestor Figures
Melanesian--Admiralty
 Islands. Female Ancestor
 Figure--squatting male
 figure on head
Melanesian--New Caledonia.
 Door Post: Stylized
 Female Ancestor Figure
Melanesian--New Hebrides.
 Ancestor Figure#
--Two-Headed Ancestor
 Figure
Melanesian--New Ireland.
 Ancestor Figure#
--Uli(s) soul figures#
New Guinea. Ancestor
 Figure#
--Male Ancestor Figure
Polynesian. Ancestor Figure
Polynesian--Cook Islands.
 Ancestor Figure
Roman--1st c. Roman
 Patrician with Busts of
 his Ancestors
Sumatran--Nias. Three
 Ancestor Figures
Ancestors. Sawada
Ancestral Panel. Maori
Ancestral Ritual III. Brose
Anchieta and Child. Cipicchia
Anchietta, Jose de (Jesuit
 Missionary: "Apostle of
 Brazil" 1533-97)
Carvalha. Monument to
 Padre Anchietta
ANCHORITE ISLANDS
 Lime Spatulae: Naturalism

(Lizard) to Abstraction
READA pl 10 ELBr
Ancient Shield. Kikuhata
Ancient Song. Niizuma, M.
Ancient Symbol. Yoffe, V.
Ancient Tombstone
BARSTOW 10
"...and the bush was not
consumed..."
Ferber
"...and they shall beat their swords
into plowshares." Marans
Andante. Korbel
Andara
Chosei. Twelve Guardians
of Yakushi
Andersen, Hans Christian
Gelert. H. C. Anderson
ANDERSON, Jeremy R. (American
1921-)
Ad Bellum Purifacandum
1962 redwood, ironwood,
plumwood; 95
SFAF UCSFD
Altar 1963 enamel, redwood,
pine, privet; 89x31x33-1/2
TUC 63
Early Morning Hours 1966
enamel, redwood, fruit-
wood; 45x35x23-1/2
TUC 65 (col) UCSFD
Number 2 redwood; 63
UIA-7: pl 49
Temptation of St. Anthony
1965 redwood, masonite,
plastic; 19-1/2x10-1/2x
34-3/4
TUC 64 UCSFD
Tower wood; 54
UIA-8: pl 46
Untitled 1951 plaster; 8x14x10
SFAP pl 6
Untitled 1961
AMON 35 UCSFD
ANDERSON, John (American 1928-)
Baroque wood; 96x96x96
WHITNA-19
Big Sam's Body Guard ash
WHITNA-17
Roll wood; 48
WHITNA-18:16
Yoke 1962 H: 72
SEITC 79 UNNSto
ANDERSON, La Monte (American)
Owl alabaster; 20
HARO-3: 6
ANDERSON, Lewis (American)
Fish wood
NYW 175

Anderson, Mr.
Wolter. Mr. Anderson, head
ANDERSON, Robert W.
Collage Construction 1961
MEILC 58
Andes. Colvin
ANDHRA (EARLY) See INDIAN--
ANDHRA (EARLY)
ANDHRA (LATE) See INDIAN--
KUSHAN
Andirons
Celtic. Fire Dog
Folk Art--American. "Hessian
Soldier", andiron
Linder, H. Three Pairs of
Andirons
Revere, Paul, & Sons.
Andirons
Andrade, Mario de
Giorgi. Mario de Andrade,
head
ANDRADE MOSCOSO, Jaime
(Ecuadorian)
Walnut Tree walnut
IBM pl 15 UNNIb
Andraetta. Cecere, G.
ANDRE, Carl (American)
Lock 1967 painted chipboard;
1/2x16x16
TUC 66 (col) UCLD
ANDREI, Giovanni (Italian 1770-1824)
See FRANZONI, Giuseppe
ANDREWS, Oliver
Iron Tree 1960 steel and iron;
36; MEILD 83; STAF UNNAl
The Keeper of the Night welded
steel, ptd black
LYNCM 131 UNNAl
Spring Song galvanized wire
LYNCM 19 UNNAl
Stalks welded bronze
LYNCM 131 UNNAl
Andromeda
Etruscan. Andromeda#
Moretti, G. Andromeda
Andromeda I. Newman
Andumboulou Mask. African--Dogon
ANGEL, John (American 1881-)
Chapel Tympanum
AUM 77 UNjP
St. John the Divine, clay model
MILLER il 187 UNN
Angel in Pursuit. Marshall, J.
Angel of Death. Weinberg
The Angel of Death Staying the Hand
of the Young Sculptor
French, D. C. Death and the
Young Sculptor
Angel of Joshua. Kaish

Angel of Peace. Lentelli
Angel of the Expulsion. Weinberg, E.
Angel of the Soul
 Mestrovic. Racic Mausoleum
ANGELA, Emilio (Italian-American
 1889-)
 Goose Boy, garden group
 bronze
 NATSA 8
ANGELL, Blanche (American)
 Free Will wood
 UNA 4
ANGELL, Joseph
 Pitcher: Vineyard and
 Harvest 1854/ 55 silver
 gilt
 SCHMU pl 86 UNNCoo
Angels
 Adams, H. Angel, relief
 detail
 Alciati. "El Angel"
 American--19th c. Gilt
 Fruit Basket, with
 kneeling bisque angels
 Baskin. Angry Angel
 Baskin. Benevolent Angel
 Berlinguet--Attrib. Angel
 Holding Legend
 --Angel with Book
 Caspicara. Angel de la
 Guardia
 Chinese--Wei. Buddha:
 Attended by Bodhisattvas,
 Priest and Flying Angels,
 altarpiece
 --Flying Angels
 Coptic. Angels and Saints
 before an Arcade
 Couper. Attending Angel#
 Davidson, R. Praying Angel
 Epping. Pagan Angel
 Folk Art--American.
 Weathervane: Angel
 Folk Art--Brazilian. Angel
 Folk Art--Mexican. Musical
 Angel
 French, D. C. Clark
 Memorial: Angel
 French, D. C. Memorial
 Angel
 French, D. C. Praying
 Angels
 Greenough, H. Angel and
 Child
 Hering, E. W. Baptismal
 Font
 Hidalgo y Costilla. "El
 Angel"

Hoffman-Ysenbourg. Angel
Japanese. Angel, seated
 figure
Japanese--Fujiwara. Angel,
 wall figure
Japanese--Hakuho. Music-
 Playing Angel
Japanese--Suiko. Angel on
 Canopy
Jobin. Flying Angels
Korean. Bell of Kyongju,
 detail: Flying Angel
Latin American--18th c.
 Angel as Candlebearer
Lawrie. Angel of the Old
 Dispensation
Levasseur. Angel
Mead. Recording Angel
Mestrovic. Angel#
Perceval, J. Fighting Angels
Romano-Indian. "Angel"
Saint-Gaudens. Amor Caritas
Saint-Gaudens. Angels for
 Morgan Tomb
Schwarzott. Angel Relief
Simms, C. Angels
Weinberg, E. Captive Angel
Weinberg, E. Foreboding
 Angel
Angels for Lorca. Dine
Angels Teasing Taurus. Rhoden, J.
Angles. Rood
ANGLO-SAXON
 Goddess of Early Britain(?)
 Auston-Severn 1st c.
 JOHT pl 8
Angry Angel. Baskin
The Angry Carpenter. Barrett
Anguish. Roszak
Angulo. Cabrera, Geles
Angustia. Colinas
Anima Mundi. Talbot, W.
Animal and Flower Forms,
 tympanum. Islamic
Animal and Young. Hayes
Animal Form I. Caparn
ANIMAL STYLE (Central Asia)
 Griffon-Dragon Devouring
 Reindeer, Pazyryk
 6/ 5th c. B.C. wood and
 leather
 LEEF 29 RuLH
Animal Weights. Smith, D.
Animals See also names of animals,
 as Birds; Buffaloes and
 Bison; Cats; Dogs; Insects;
 Lions; Monkeys and Apes

African--Ashanti. Gold
 Weights: Proverbs, Ani-
 mals, Scenes from
 Daily Life
African--Ivory Coast. Gold
 Weights: Animal-form
Ceylonese. Animal Figure,
 panel
Chinese--Chou. Quadruped
Chinese--Han. Animal#
 --Two Fighting Animals,
 plaque
Chinese--Ming. Warrior
 and Animal Guardian
 Figures
Chinese--Shang. Animal
 Figure(s)#
Chinese--T'ang. Animal
 Figure
Chinese, or Scythian.
 Animal Decorations
Decker, A. Animal Studies
Egyptian--Pre-Dynastic.
 Animal-Forms
--Animal Palette(s):
 Elephant, Horse, Turtle,
 Rhinoceros, Fish
Egyptian--6th Dyn. Papyrus
 Thicket Trip, with
 animals
Egyptian--12/13th Dyn.
 Animal-form Inlays#
Egyptian--17th Dyn. Inlay
 Animal Figures
Etruscan. Animals--real
 and imaginary, plaques
Etruscan. Perugia Carriage
Folk Art--American.
 Animal Figures and
 Soldier
Folk Art--Surinam. Animal
 Figures
Germanic. Buckle Clasp,
 opposing animals
Germanic. Clasp, animal-
 form
Greek--Archaic. Animal
 --Fighting Animals
Hayes. Young Animal
Hittite. Cylinder Seal:
 Human and Animal
 Figures
Indian--Andhra. Stupa, San-
 chi. Stupa 1, Northern:
 Animal(s)#
Indian--Deccan. Fighting
 Animals
Indian--Indus Valley. Amulets
 or Seals: Animal Symbols

Indian--Pallava. Descent of
 Ganges
Indo-European. Equestrian,
 Animals, including Dog
Islamic. Figures and
 Animals in Polyfoil
 Medallions, jar
Islamic. Incense Burner:
 Animal-form
Khmer. Menagerie Observed
 by Spectators, relief
Lenzi. A. Animals, relief
Luristan. Standard Finial:
 Opposed Animals
Maya. Hacha: Animal head,
 profile
Minoan. Seal: Lion Attack-
 ing Bull
Mitannian. Cylinder Seal:
 Bull-Man and Goddess
 Destroying Lion; other
 animals in sacred tree
Mitannian. Cylinder Seal:
 Seated Figure Drinking
 Through Tube; Animal
 Figures
Mycenaean. Animal
 Figure, striped
Ordos. Animal Figure,
 trapping
Ordos. Animal-form
 Ornaments
Paleolithic. Feline
Roman. Animals: Pig,
 Sheep, Bull, relief
Sarmatian. Beast Attacking
 Bird, ornament
Sarmatian. Plaque: Snake
 Fighting Animal Figure
Scythian. Animals Fighting,
 plaque
Scytho-Sarmatian. Animal-
 style Belt Buckle
Sumerian. Cylinder Seal:
 Frieze of Animals and
 Mythological Figures
Sumerian. Cylinder-Seal:
 Running Animals
Sumerian. Trough: Animal
 Figures beside Byre
Toltec. Animal Head, with
 human head in jaws
Toltec. Pyramid
Veraguas. Bells: Deer,
 Turtle, Bird
Veraguas. Pendants: Birds,
 Frogs, Jaguars, Monkeys,
 Armadillos, Deer,
 Crocodiles

Animals, Imaginary See also names
of animals, as Centaurs;
Cerberus; Chimeras;
Dragons; Gorgons; Griffins;
Horses, Winged; Hydra;
Leogryph; Lions, Winged;
Medusa; Minotaur; Pegasus;
Phoenix; Scorpion-Man;
Sea Horses; Sea Monsters;
Sea Serpents; Sphinxes;
Unicorns; Wasgo
Achaemenian. Armlet:
 Opposing Winged Monsters
Achaemenian. Rhyton: Lion-
 monster
Achaemenian. Winged Goat
African--Ijo. Sacrificing Man
 on Elephant-Leopard
Assyrian. Khorsabad Gate:
 Winged Bull with five
 legs and human head
Batak. Man Seated on
 Mythical Animal, the
 Singa
Chavin. Incense Vessel:
 Mythical Being: Llama
 and Beast of Prey
Chavin. Stirrup Jar: Puma-
 headed Snakes
Chinese--Chou. Bird-Dragon,
 relief
Chinese--Shang. Tiger-
 Elephant
Chinese--Six Dynasties.
 Mythological Animal
Cocle. Pendant: Fantastic
 Animal
Egyptian--1st Dyn. Palette
 of King Narmer
Elamite. Monster:
 Lion-headed Human
Etruscan. Bucchero Jug:
 Fantastic Animal Driven
 by a Man
Folk Art--Mexican. Toy:
 Legendary Monster
Folk Art--Mexican. Toy
 Whistle: Woman-headed
 Bird
Follett. Many-Legged
 Creature
Greco-Persian. Lion, griffin,
 gem
--Winged Ibex
Indian--Hindu--18th c.
 Dragon-headed Birds,
 window

Indians of Central America--
 Costa Rica. Pendant:
 Mythological Animal
Indians of Central America--
 Panama. Pendant:
 Fabulous Animal(s)#
Indians of Mexico. Two-
 headed Animal
Iranian. Winged Ibex, vase
 handle
Khmer. Many-headed Serpent
 with Elephants' Trunks
Kowal. Mythical Monster
Kwakiutl. Mythical Monster,
 mask
Luristan. Bit Plates: Human-
 headed winged bull.
Luristan. Finial: Opposed
 Monsters
Luristan. Winged Bull, bit
Luristan. Winged Goat
Maori. Manaia, bird-man
 creatures
Maori. Marakihau, legendary
 man-fish
Marlyk. Mug: Winged Bull,
 relief
Maya. Incense Burner:
 Mythological Human-
 headed Bird
Maya. Vase, stamped
 design: Bird Men
Mitanian. Cylinder Seal:
 Bull-Man and Goddess
 Destroying Lion
Mycenaean. Seals: Demons,
 Goddesses
Nicoya. Pendant: Fantastic
 Animal
Persian. Bit Plaque: Polaris
 Throttling Winged Lion
 (Summer) Trampling on
 Deer (Winter)
Persian. Bull-Man, head
 capital detail
Persian. Darius Fighting
 Winged Monster
Persian. Winged Bull,
 brick relief
Sassanian. Carafe: Dancers;
 Animal Motifs
Scythian. Lion-Griffin
 Attacking Horse, belt
 buckle
Scythian. Lion-Gryphon,
 aigrette
Sinhalese. Eaves Tile:
 Fantastic Animal

Sumerian. Harp of Queen
Shubad: Human-headed
Bulls
Sumerian. Human-headed
Bull
Sumerian. Imdugud (lion-
headed eagle)
Sumerian. Libation Vase:
Serpents and Legendary
Animals
Sumerian. Monster: Lion-
headed Clawed Human
Urartian. Human-headed
winged Bull
Aninia
Roman--3rd c. Dionysos
Sarcophagus
Anita. Glinsky
Anjou. Seley, J.
Ankh
Coptic. Ankh and Bird,
stele relief
Coptic. Tombstone of
Rodia, with ankh and
letters Alpha and Omega
Egyptian--22nd Dyn. Sekhmet,
seated figure, sun disk
on forehead, holding ankh
Ankhesenamun (Wife of Tutankhamen)
See Tutankhamen
Ankhhaf (Son-in-Law of Cheops)
Egyptian--4th Dyn. Ankhhaf,
bust
Anklets
Indian--Kushan--Gandhara.
Anklets
Ankhnynesut
Egyptian--6th Dyn. Ankh-ny-
nesut, tomb relief
Ankusha, elephant hook
Indian--Hindu--17th c.
Ceremonial Ankusha
ANNAND, Douglas (Australian
1903-)
Search for the Truth, mural
detail colored plaster of
paris blocks; 45x30
BON 73 AuMU
Anne, head. Scaravaglione, C.
Anne, Saint
Canadian--19th c. St. Anne
Annenkof, Georges
Zadkine. Georges Annenkof,
head
Anniversary Waltz. Clark, J.
Another October. Bouras
Anshutz, Thomas
Grafly. Thomas Anshutz,
head

Ansieta. Lagos
Ant Hill. Adams, M.
Anteaters
African--Ivory Coast. Gold
Weights: Bird, Fish,
Ant-Eater
Antelopes
Achaemenian. Antelope
African--Ashanti, or Agni/
Baoule. Gold Weight:
Antelope
African--Atoutou. Antelope
Mask
African--Bambara. Antelope#
--Dance Headpiece:
Antelope#
African--Benin. Ancestor
Memorials: Antelope
Heads
African--Bini. Antelope Head
African--Fon. Antelope
African--Guro. Mask:
Antelope
--Masks: Antelope; Cow
--Zamie Mask: Antelope
African--Ivory Coast. Mask:
Antelope
African--Karumba. Antelope
Headdress
African--Kurumba. Dance
Headdress: Antelope Head
African--Mossi. Koba
Antelope Mask
African--Senufo. "Fire-
Spitter" Mask: Antelope
African--Sudan. Mask
Crest: Antelope
African--Sudan--French.
Antelope#
African--Upper Volta.
Antelope#
Assyrian. Cup: Antelope
Head
Coptic. Amphora between
Two Antelopes
Egyptian--18th Dyn. Oint-
ment Bowl: Bound
Antelope
Hittite. Antelope with Young,
plaque
Jonas, L. P. Giant Sable
Antelope
Manship. Indian and Prong-
horn Antelope
Manship. Pronghorn Antelope
Paleolithic. Running Cow
Antelope
Sumerian. Cylinder Seal:
Antelopes#

Sumerian. Cylinder Seal:
Resing Antelopes
Sumerian. Patera: Hunting
Scene; Antelope
ANTENOR (Greek Fl late 6th c.
B. C.)
Acropolis Maiden, Doric
type (Kore) c 510/500
B. C. Island marble
RICHTH 72; STI 166;
UPJH pl 24 GrAA
Anteros
Roman. Eros and Anteros
Supervising a Cockfight,
relief
Anthem II. Thompson, J.B.
Anthony, Saint
Anderson, J. R. Temptation
of St. Anthony
Colombian--16th c.
Retable of St. Anthony
Folk Art--Mexican. St.
Anthony, santo
Folk Art--Spanish-American
(U.S.). St. Anthony of
Padua
Anthony, Susan Brownell (American
Woman-Suffrage Advocate)
Johnson, A. Pioneers of
Women's Suffrage Memorial
Putnam, B. Susan B.
Anthony, bust
Anthropomorphicals I and II.
Castro-Cid
Antigone
Rinehart, W. H. Antigone
Antikythera Youth. Greek--4th c.
B.C.
Antimachus of Bactria
Hellenistic. Coin: Antimachus
of Bactria
Antimobile. Westermann, H. C.
Antinous (Page and Favorite of
Emperor Hadrian 117-38)
Indian--Gupta. Antinous, head
Roman. Antinous#
Roman--1st c. Antinous
Roman--2nd c. Antinous#
--Farnese Antinous
Antinous (Suitor of Penelope in
Odyssey)
Greek--5/4th c. B. C.
Antinous, bust
Antioch
Eutychides. Tyche of Antioch
ANTIOCHIA
Two Breastplates hammered
gold; W: 22; Dm: 12
NMANA 143 UPPU
(SA 2701; SA 2704)

ANTIOCHUS, SON OF DRYAS
Mousa, wife of Phraates IV,
head 37/32 B. C. marble
HAN pl 274 IranTA
Antiochus I of Commagene (69-34
B. C.)
Parthian. Antiochus I and
Mithras, relief
Antiochus I of Syria (King of
Selucidae of Syria 324-261
B. C.), called Antiochus
Soter
Greco-Roman. Hierothesion
of Mithridates
Hellenistic. Coin: Antiochus I#
Selucid. King Antiochus I,
relief
Antiochus III of Syria (King of
Selucidae of Syria 242-187
B. C.), called Antiochus the
Great
Hellenistic. Antiochus III,
the Great, head
Roman--2nd c. B. C.
Antiochus III, the Great
Antiope (Queen of the Amazons)
Greek--7th c. B. C. Theseus:
Carrying off Antiope
Antipodes. Lassaw
"Antium Girl". Hellenistic
ANTONAKOS, Stephen (Greek-
American 1926-)
Marie's First Neon 1965
neon tubing, enamel
coated aluminum; 44x48x48
WHITNS 8 UNNW
Marie's Second Neon 1965
neon, metal, transformer
67x24x24
KN pl A
Orange Vertical Floor Neon
1966 neon and metal;
108x72x72
TUC 67 UNNFis
Turquoise Hanging Neon
1966/67 54x40x21
CARNI-67:#241 UNNFis
White Hanging Neon 1966
neon and aluminum
ART 240 UNNFis
Antonia (Wife of Drusus)
Roman--1/2nd c. Antonia,
wife of Druses
Antoninus Pius (Roman Emperor
86-161)
Roman--2nd c. Antoninus
Pius#
--Apotheosis of Antoninus
Pius and his wife,
Faustina

Laurent. Birth of Venus
MacMonnies, F. W. Venus
 and Adonis
Manship. Venus Anadyomene,
 fountain
Paleolithic. Venus#
 (fertility figure)
Praxiteles. Aphrodite#
Praxiteles--Attrib.
 Aphrodite from Arles
Praxiteles--Foll. Aphrodite#
Praxiteles--Foll. Capitoline
 Venus
Praxiteles--Foll. Medici
 Venus
Praxiteles--Foll. Townley
 Venus
Praxiteles--Foll. Venus of
 Arles, headless fragment
Roman. Commodus and
 Crispiana as Mars and
 Venus
Roman. Venus#
Roman--1st c. Aphrodite of
 Aphrodisias
--Roman Woman as Venus
Roman--2nd c. Venus Rising
 from the Sea
Scudder, J. Eros and
 Aphrodite
Story, W. W. Venus
Williams, W. Venus Rising
 from the Sea
Zadkine. Venus
Aphrodite Benetrix. Greek--5th c.
 B. C.
Aphrodite Genetrix. Greek--5th c.
 B. C.
Aphrodite Genetrix
 Greek--5th c. B. C. Venus
 "Genetrix"
 Greek--5/4th c. B. C.
 Aphrodite (Venus Genetrix)
 Hellenistic. Aphrodite
 Genetrix
Aphrodite Kallipyge. Hellenistic
Aphrodite Medici. Hellenistic
Aphrodite of Capua. Hellenistic
Aphrodite of Cnidus. Praxiteles
Aphrodite of Cyrene. Praxiteles
Aphrodite of Melos. Hellenistic
Aphrodite of Syracuse. Hellenistic
Aphrodite of Thespiae
 Greek--4th c. B. C. Venus
 of Arles, replica of
 Aphrodite of Thespiae,
 by Praxiteles
Aphrodite Rising from Sea

Greek--5th c. B. C.
 Ludovisi Throne, front
 panel: Birth of Aphrodite
Apis Bull#. Egyptian--26th Dyn.
Aplane X. Horiuchi
Apocalyptic Rider. Ferber
Apocalyptic Rider. Winkel
Apollinaris# Cornell
Apollo See also Apulu; Kouroi
Alexandrine. Apollo and
 Daphne, relief
Boetian. Apollo
Coptic. Apollo and Daphne
 relief
Etruscan. Apollo#
Etruscan. Relief Mirror:
 Apollo (Apulu); Zeus
 (Tinia); Hermes (Turms)
Euphranor. Apollo Patroos,
 headless figure
Greco-Roman. Apollo
Greco-Roman. Hierothesion
 of Mithridates
Greek. Apollo#
Greek--Archaic. Apollo#
Greek--8th c. B. C. Apollo#
Greek--7th c. B. C. Apollo#
--Leto Giving Birth to
 Apollo, amphora
--Meeting of Apollo and Zeus
Greek--6th c. B. C. Apollo#
--Herakles and Apollo,
 metope
--Siphnian Treasury: Apollo
 and Herakles Contest for
 the Tripod
Greek--6/4th c. B. C. Coins
Greek--5th c. B. C. Apollo#
--Coin, Catana: Apollo:
 head
--Lentini Tetradrachma:
 Chariots; Apollo, head
--Omphalos Apollo
--Strangford Apollo
--Temple of Zeus, Olympia:
 Apollo
--Tetradrachm, Leontinoi:
 Apollo, head
Greek--5/4th c. B. C.
--Parthenon: Apollo
--Parthenon: Poseidon and
 Apollo
--Seated Gods: Poseidon,
 Apollo, Artemis
Greek--4th c. B. C. Apollo#
--Coin: Apollo
--Coin, Clazomenae: Apollo,
 head

Punishment of Dirke (Roman
 copy) c 150 marble; L:
 3.08 m
 HAN pl 267 INN
Apostles See also names of
 Apostles
De Marco. Christ and his
 Apostles, cruciform relief
 of heads
Apothecary. Cornell
Apotheosis
 Archelaus of Priene.
 Apotheosis of Homer
 Baskin. Apotheosis
 Hellenistic. Apotheosis of
 Homer
 Lekakis. Apotheosis
 Roman--1st c. Apotheosis of
 Antoninus
 --Apotheosis of Augustus,
 relief
 Rome--2nd c. Apotheosis of
 Antoninus Pius and his
 wife Faustina
 --Apotheosis of Claudius
 --Arco di Portogallo
 (demolished), frieze detail:
 Apotheosis of Sabina
Apotheosis of America
 Amateis, L. Door:
 Transom (Apotheosis of
 America)
Apotheosis of Democracy. Bartlett
Apoxyomenos (The Scraper).
 Lysippus
Appar
 Indian--Chola. Saivite Saint
 Appar, with hoe
Apparition. Caparn
Appassionata. Fasano
Appeal to the Great Spirit. Dallin
Appel, Karel
 Falkenstein. Painter Karel
 Appel
APPLE, Billy (American)
 Solar 15 1966 neon form
 BURN 308 UNNWise
 2 Minutes, 3.3 Seconds
 1962 ptd bronze; c 5-1/2
 LIP 51 UNNBia
Apple Press. Clarke, T. S.
An Apple Shrine. Kaprow
Apples of Hesperides
 Greek--5th c. B. C.
 Temple of Zeus, Olympia
Apprehensive Horse. Albert, D.
The Apprentice. Sanford, B.
L'Apres-Midi d'un Faune. Baker, B.

April. Light, A.
April Strolling. Novak, G.
Aprobates
 Greek--5th c. B. C.
 Parthenon: Aprobates
Apsaras
 Chan. Apsaras, head
 Chinese--Six Dynasties.
 Flying Apsaras Holding
 Bowl in Right Hand,
 relief
 Chinese--T'ang. Apsara
 Chinese--T'ang, or Five
 Dynasties. Dancing
 Apsaras
 Chinese--Wei. Apsaras Play-
 ing Drum, relief
 --Flying Apsara
 Chinese--Wei/Sui. Apsaras
 Plucking Stringed
 Instrument
 Indian--Ganga. Surya Deul
 Temple: Apsaras, facade
 Indian--Gupta. Ajanta Caves,
 Cave 16: Apsaras,
 bracket figure
 --Apsaras
 Indian--Hindu--7th c. Apsara,
 detail
 Indian--Rajputana. Apsaras,
 relief
 Japanese--Suiko. Apsaras,
 with lotus halo, Playing
 Biwa
 --Banner (Ban)#
 Khmer. Apsaras#
Apuleius, Lucius (Roman Philosopher
 and Rhetorician fl 2nd c.)
 Roman--4th c. Apuleius,
 head, medallion
Apulu See Apollo
Aquamaniles
 African--Benin. Leopards:
 Aquamaniles
 --Ram Aquamanile
 Islamic. Griffin: Aquamanile
 Persian. Bull Aquamanile
Aquarium. Rickey, G.
Ara See Altars
Ara Grimani.
 Hellenistic. Grimani Altar
Ara Pacis Augustae. Roman--1st c.
 B. C.
Ara Pietatis. Roman--1st c.
Arabesque. Rosenbauer, W.
Arabia. de Creeft, J.
ARABIAN
 Eros Riding on Lioness c 75/50
 B. C. bronze; .635 m
 HAN pl 279 UDCNS

Arabian. Archipenko
Arabian Mare, Lianna. Cash
ARABO-EGYPTIAN
 Plaque: Fruit and Flower
 Scrolls, with human and
 animal figures 12th c.
 ivory; 8.3x2.4
 GAU 125 FPL
Arachne
 Hunt, R. Arachne
Aramaeans
 Hittite. Armaean King, relief
ARAMECAN
 Chariot Soldiers; Sphinx,
 reliefs, Carchemish
 FRA pl 161
Arapacana-Manjusri See Manusri
ARAPAHO
 Sun Dance Skull, Wind River,
 Wyoming 1900/20 ptd
 buffalo skull; 16x24
 DOCA pl 212 (col)
 UNNMAI (13/5098)
ARAWAK
 Bird Idol 900/1600 porphyry;
 5
 SMI 12 UDCNMS
 Mask, Puerto Rico stone
 CHENSW 429 UNNMPA
 Mountain Stone, Dominican
 Republic
 CHENSW 428 FPH
 Three-Pointed Idol: Human
 Face Pre-Columbian
 stone; 2-3/4
 SMI 12 UDCNMS
Arc. Liberman
Arc de Triomphe. Winkel
Arc-Wing. Smith, D.
Arca, Navis
 Aura, Portus. Milonadis
Arcadia. Eakins
Arcadius (Eastern Roman Emperor
 377?-408)
 Roman--4th c. Arcadius#
 --Column of Arcadius
ARCESILAUS--FOLL
 Venus Genetrix(?), headless
 figure, after Alcamanes,
 or Callimachus c 50 B.C.
 stone
 CHENSW 117; LAWC pl
 72B; ROOS 340; STI 306
 IRT
Arch. Kiesler
Arch Brown. Chamberlain, J.
Arch No. 2. Gabo
Arch of Constantine. Roman--2nd c.

Arch of Titus. Roman--1st c.
Archangels
 Coptic. Saint and Archangel,
 stele
 Coptic. Virgin and Child
 between Archangels#
 Lipton, S. Archangel
Archaeological Find# Ortiz, R.
ARCHELAUS OF PRIENE
 Apotheosis of Homer, with
 Muses and Personifications
 of Iliad and Odyssey, relief,
 Bovillae c 125 B. C.
 marble; 1.14 m
 HAN pl 269; LAWC pl
 115; RICHTH 171 ELBr
Archers
 African--Benin. Archer
 Assyrian. Archers
 Assyrian. Elamite Archers
 Assyrian. Two Bowmen,
 relief fragment
 Casella, F. M. The
 Primitive Marksman
 Egyptian--3/4th Dyn. Archers,
 mastaba
 Epimenes. Archer, gem
 Epimenes--Attrib. Gem:
 Kneeling Archer
 Folk Art--American.
 Weathervane: Indian Archer#
 Greek--6th c. B. C.
 Temple of Aphaia, Aegina:
 Scythian Archer
 Greek--5th c. B. C.
 Cypriote Archer
 --Temple of Aphaia, Aegina:
 Heracles as Archer
 Greek--4th c. B. C.
 Herakles Bowman
 Jennewein. Archer
 Khmer. Archers, relief
 Moi. Straw Figures, with
 bow and arrow
 Persian. Archers#
 Roman. Archers, relief
 Tennant, A. V. Archer--
 Tejas Warrior
Archers of Demorgoi. Mestrovic
Arches
 Gallo-Roman. Triumphal
 Arch#
 McKim, Mead & White,
 Archts. Arch of the Set-
 ting Sun
 MacMonnies. Brooklyn
 Memorial Arch
 Mexican--17th c. Arch of
 the Bridge

Nuraghic. Archer
Roman. Flying Victories from
 Spandrels of Roman Tri-
 umphal Arches
Roman--1st c. Arch of
 Carpentras
Roman--2nd c. Arch of
 Marcus Aurelius
--Arch of Septimius Severus
--Arch of Trajan, Benevento
Roman--3rd c. Arch of
 Argentarii
--Arch of Septimus Severus
Roman--4th c. Arch of
 Constantine
--Arch of Galerius
--Arch of Galerius--Small
 Arch
--Triple Arch
Ruckstuhl, F., and others.
 Dewey Arch
Ward, John. Dewey Tri-
 umphal Arch
ARCHIMBAULT, Louis (Canadian
 1915-)
 Les Dames Lunes, three
 pieces bronze; 25-1/2;
 24-1/2; and 27-1/2
 CAN-4:179 CON
 Femme se Coiffant bronze;
 15-1/8
 CAN-3:339 CON (6421)
 Night and Day terracotta; 24
 ROSS 34; TORA 89 CTA
 (52/7)
 L'Oiseau de Fer steel
 ROSS 36 CQP
 --c 1950 iron; 120
 CAN-4:163; HUB pl 132
 CON
 Seated Woman 1954 bronze
 VEN-56: pl 91 CON
 Wall, Canadian Pavilion,
 Brussels World Fair
 1958
 ROSS 37
 Young Couple 1954 bronze;
 108
 EXS 59
ARCHIPENKO, Alexander (Ukranian-
 American 1887-1964)
 Arabian 1936 bronze; 26
 CUM 44
 Architectural Figure 1957
 wood, ptd (from terra-
 cotta of 1937); 34
 BERCK 230
 The Bather 1915 ptd wood,
 paper, and metal;

20x11-1/2
 HAMP pl 100B; PPA 1
 UPPPM
--sculpto-painting 1915 wood,
 metal and paper; 20-1/8
 x11-1/2
 NMAC pl 95 UCHA
Bathing Woman
 VEN-20: 23
Black Torso 1909 bronze
 MAI 9
Boxers (Boxing; Boxing
 Match) bronze; 24
 BMAF 51 UNNPer
--1913
 ENC 220
--1913
 ST 432 AVT
--1913 terracotta; 30
 NMAC pl 94 UCHA
--1914 bronze; 24
 SELZS 58 UDCBlu
--1914 plaster; 23-1/2x18
 BAZINW 431 (col); GIE
 51; MARC 31 UNNG
--1935, 2nd version of 1914
 work terracotta; 31
 CALA 94; GUGP 25;
 LARM 320; LIC pl 235;
 READCON 125 (col);
 ROSE pl 192 IVG
The Bride 1935 terracotta
 CASS 95; MILLER il 198
Bronze
 MARTE pl 5
Carrousel Pierrot 1913 ptd
 plaster; 23-5/8
 GUG 185; SELZJ 208
 (col) UNNG
"Dual" 1955 terracotta, ptd;
 23
 BERCK 230
Family Life
 CHASEH 522; TAFTM 31
Empire 1956 bronze
 CHENSW 488
Female Figure ptd terra-
 cotta
 HOF 288
Female Torso c 1909
 alabaster; 18-3/4
 DETS 24 UNNH
Femme avec les Bras
 Croises 1922 bronze
 CASSTW pl 15 UNNNeu
Figure plastic
 SCHN pl 122
--1935
 MOHV 223

Flat Torso 1914
 ROOS 279C -Bak
--1914 bronze
 CHENSW 488 UNNPer
--1914 bronze; 15x3-1/2x
 1-1/2
 UCIT 9, 10 UCPaR
--1914 gilt bronze; c 40 cm
 CASSTW pl 16 UNNLo
--1914 polished bronze
 RAMS pl 71a
Friends 1937 Mexican onyx;
 26
 RICJ pl 48
Glorification of Beauty
 ROOS 279G GB
The Gondolier 1914
 BERCK 26
Group pottery
 MARTE pl 5
Head marble
 MARTE pl 5
Head--Construction with
 Crossing Planes 1913
 bronze; 15
 GIE 84; MAI 8 UNNPer
Hollywood Torso 1936 bronze;
 36-1/4
 NEWAS 23
Madonna 1932 marble
 BAUR pl 104
Medrano 1912 wood, glass,
 metal; 32
 UPJ 636
--1915 ptd tin, wood, glass,
 oil cloth; 50
 GIE 55; GUG 187; ROSE
 pl 203; SELZJ 221; TRI
 41 UNNG
Medrano I (Juggler) 1912
 BURN 207
Metal Lady, relief 1923
 copper, brass, lead;
 54x19-1/2
 LIC pl 234; WALKC 21
 UCtY
--
 UNNMMAM 154 UNNDr
Negress 1911 cement; c 17
 MUNSN 178
Nude
 NEUW 159
--1915 bronze; 13-3/4
 NNMMAP 134 UNNMMA
Nude Torso
 RAY 73 UNBB
Onward (Vorwarts) 1947
 plexiglass
 GERT 134

The Past silver-plated bronze;
 14
 RICJ pl 2
Repose (Le Repos)
 CHENSP 251
--1911 bronze; 13-1/2
 MUNSN 42
--1912 plaster
 BROWMS cat 602 UNNArt
Sculpture*
 EXS 16
--1936
 MOHN 43
Seated Figure 1916 terra-
 cotta; 21-3/4
 LYN 104 GDusK
--(Sitzende Figur) 1946
 plexiglass
 GERT 135
Seated Mother 1911
 ENC 37
--1911 bronze; 23-5/8
 (with base)
 READCON 74 GDuK
Seated Woman
 ZOR 294
--colored terracotta
 AUES pl 61
--(Femme Assise) marble
 MARTE pl 33
Silhouette chromium plated
 bronze
 BRUM pl 5
--1910 chromium plated
 bronze
 SELZJ 220 GDaH
--silver-plated terracotta
 SCHN pl 132
Silver Torso 1930 chromium-
 plated bronze
 CHENSS 706
Sitting Mother ptd terracotta;
 22
 CASS 132 UNNBoy
Space and Light lucite
 BRUM pl 6
The Spirit of this Century,
 "Modeling of Light" 1947
 plastic illuminated from
 within; 22-1/2
 PIE 383
Spring 1925 gilt bronze
 CASSTW pl 18 UNNHar
Standing Figure 1920
 Hydrostone; 5-1/2
 GIE 52; LIC pl 233;
 MAI 8 GDaM
--replica from plaster of
 1920; 72 BERCK 27 GDaM

Standing Woman 1920 terra-
cotta; 26
RAMS pl 71b
Statue in Iron 1952
MAI 9 UMoKUP
Struggle (La Lutte) 1914 ptd
plaster; 23-3/4
GUG 185; SELZJ 224
UNNG
Suzanne lead casting; 20
RICJ pl 38
Torso
CHENSP 292
--marble
MARTE pl 42
--silvered bronze
CASS 69
Torso, female bronze
PRAEG 458
Torso in Ceramic and
Mosaic 1928
CASSTW pl 19
Torso in Space 1936
metalized terracotta;
L: 50
GOODA 66; SFGC 80
UNNW
--1946 chrome-plated bronze;
10
CRAVS fig 15.20; HAY 25;
JLAT 7 UMAP
Torso of a Woman 1922
marble
SELZJ 221 GMaM
Torso of Spring
NATS 18
La Vie Familiale 1935
terracotta; 18
MUNS 42
Walking 1912 H: 26-1/2
SEITC 181 UNGAv
--1936 terracotta
FAUL 460
--1957 bronze; 16-1/2
UIA-9:pl 51 UNNPer
Walking Woman terracotta
AUES pl 63
--(Walking) 1912 bronze;
26-1/2
DENV 92; HAMP pl 100A;
JLAT 6; ROSE pl 90
UCoDA (A-466)
White and Black 1938 terra-
cotta inlay; 20
RICJ pl 2
White Torso 1916 silvered
bronze
CASSTW pl 17; PUT 176
GBN; UNNRei

Woman Combing her Hair
bronze
AUES pl 62
--1914 bronze; 72
EXS 60 IsJR
--c 1915 bronze
LARM 320
--1915
STA 207
--1915 bronze
KUHB 50 UNNPer
--(Haarkammende Frau)
1915 bronze; 13-3/4
GERT 133; MCCUR 261;
RIT 138 UCtNhH
--1915 bronze; 13-3/4
BURN 151; CRAVS fig
15.19; MEN 630; ROSE
pl 209 UNNMMA
Woman Doing her Hair 1916
terracotta; 22
BERCK 27 GDusM
Woman with a Fan 1914
bronze polychrome;
25-5/8
READCON 73
Young Girl
CASS 69
Architects and Architecture
Indian--Hindu--12th c.
Goddess Sarasvati, Saluted
by Two Architects
Architectural Construction# Bladen
Architectural Figure. Archipenko
Architectural League of New York
Medal. MacNeil, H. A.
Architectural League of New York
President's Prize. French,
D. C.
Architectural Models See also
Churches; Cities; Houses
African--Gold Coast. Native
Compound
Architectural Plans
Assyrian. Fortified Town-
Plan, Section, and
Elevation
Sumerian. Gudea, seated
figure holding architectural
plan
Archivolt
Coptic. Archivolt#
Arco. Martinelli, E.
Arco Iris.
Albert, T. Rainbow
Ardashir I (Persian King 224-41)
Achaemenian and Sassanian.
Eight Coins

Sassanian. Investiture of
 Ardashir I by Ahura
 Mazda
Sassanian. Rock Carving:
 Combat between Ardashir and
 Artabanus V
Ardashir II (Persian King fl 379-83)
Sassanian. Ardashir II(?)
 Hunting Lions, plaque
Sassanian. Investiture of
 Ardashir II by Mithras
 and Ahura Mazda
Ardeshir. Marcheshaw Davierwalla
Ardhanarisvara. Khmer
Ardjuna
 Javanese. Ardjuna, and
 Prabu Grilling Wesi
Ardjuavivaha Theme. Javanese
Ardoksha
 Indian--Kushan--Gandhara.
 Coin: King Kanishka;
 reverse: Goddess
 Ardoksha
 Indian--Sunga. Coin:
 Huvishka; Ardoksha
Area Two. Jones, H.
ARENAS BETANCOURT, Rodrigo
 (Colombian-Mexican 1919-)
 See also Gonzalez
 Camrena
 Los Amantes ptd terracotta
 NEL
 La Huida black terracotta
 NEL
 Man in the Sun
 LUN
 La Medicina y la Enfermedad,
 group for Instituto de
 Cancerologia
 NEL
 La Minera wood
 IBM pl 9 UNNIb
 Mujer Banandose terracotta
 NEL
 Mujer Maya terracotta
 NEL
 La Nina de la Trenzas bronze
 NEL
 El Pescador black terracotta
 NEL
 Project for University of
 Mexico Building
 NEL
Areobindus
 Roman--6th c. Areobindus
 Diptych
Ares (Mars)
 Etruscan. Mars, or Warrior
 in Armor

Etruscan. Mars from Todi
Greek. Ares
Greek--5th c. B. C. Ares(?)
 helmeted head
--"Borghese"-type Ares, bust
Nakian. Marte e Venus
Phidias--Foll. Ares#
Roman. Commodus and
 Crispiana as Mars and
 Venus
Roman--1st c. B. C. Altar
 of Domitius Ahenobarbus,
 frieze: Sacrifice to Mars
--Hero Sacrifice to God Mars
Roman--4th c. Ares,
 fragment
--Column Base: Sacrifice to
 Mars
Scopas--Foll. Ares Ludovisi
Ares Borghese. Phidias--Foll.
Arethusa
 Euaenetus. Syracusan
 Dechadrachm: Quadriga
 and Prize Armor;
 Arethusa, head
 Greek--5th c. B. C.
 Demareteion, Syracuse:
 Arethusa: head
 Kimon. Decadrachm of
 Syracuse: Arethusa,
 fountain-nymph, head
 surrounded by Dolphins
 Kimon. Syracuse Coin:
 Arethusa, spring nymph
Argo
 Greek--6th c. B. C.
 Sicyonian Treasury
Argonauts
 Greek--6th c. B. C.
 Metope: Argonaut Expedi-
 tion Scene
 --Sicyonian Treasury
 Plautios, N. The Ficorini
 Casket: Argonaut Story
 Scene
Argos. Konzal
Arhat
 Chinese--Six Dynasties.
 Arhat, with Third Eye
 Japanese--Tokugawa. Arhat
 Khmer. Arhat
 Khmer. Sima Decorated with
 an Arhat
Aria. Goodelman
Ariadne
 Etruscan. Ariadne Discovered
 by Dionysos and his
 Companions

Greek--7th c. B. C.
 Theseus: Wooing Ariadne,
 relief
Greek--4th c. B. C.
 Ariadne#
 --Deserted Ariadne, head
 --Dionysus and Ariadne,
 relief
Hellenistic. Ariadne#
Hellenistic. Sleeping
 Ariadne#
Lovet-Lorski. Ariadne
Parker, H. Ariadne
Parthian. Dish: Triumph of
 Dionysius, with Ariadne
 and Hercules
Roman--3rd c. Dionysus and
 Ariadne, sarcophagus
 relief
Ariadne (Empress fl c 515)
 Roman--6th c. Empress
 Ariadne, head
ARIBINDA See AFRICAN--UPPER
 VOLTA
Ariel
 Lonzar. Ariel
Aries. Halden
Aries. Talbot, W.
Arikkharer (Prince of Ethiopia d
 c 15 B. C.)
 Egyptian--Ptolemaic.
 Arikkharer Slaying his
 Enemies
Arise! Rox, H.
Aristanemi
 Indian--Hindu--13th c.
 Marriage Party of
 Aristanemi
Aristion, Warrior of Marathon
 Aristocles. Stele of Aristion
ARISTOCIES (Greek)
 Stele of Aristion c 510 B. C.
 marble; 96
 BO 86; CARPG pl VIII;
 CHASE 27; DEVA pl 68;
 LAWC pl 18A; LULL pl
 71; RICHTH 78; ROOS
 28L, 27A; SCHO pl 22
 (col); SEW 48; ST 36;
 STA 8; STRONGC 55
 (col); UPJH pl 24; WEG
 23 GrAN (29)
Aristogeiton
 Critius and Nesiotes.
 Tyrannicides: Harmodius
 and Aristogeiton
 Greek--5th c. B. C.
 Aristogeiton, head

Aristotle
 Greek. Aristotle, head
 Greek--4th c. B. C.
 Aristotle, head
 Hellenistic. Aristotle
 Roman. Aristotle, bust
Arje. DeLap
Arjuna Rath See Pandava (Five)
 Raths
Arjuna's Penance
 Indian--Pallava. Descent of
 the Ganges
Ark of Covenant
 Albert, C. Ark Doors
 Aronson, B. Ark Doors#
 Eisenshtat. Ark
 Filipowski. Ark
 Harrison, W. Ark Doors
 Horn. Ark and Eternal Light
 Kaish. Ark
 Mendelsohn. Ark
 Miller, E. Ark on Staves
 Rosenthal, B. The Ark
 Schor, I. Doors of the Thirty-
 Six, ark doors
 Simon, S. Ark
Ark of Wisdom. Rosenthal, B.
Arks
 Hellenistic. Altar of Zeus,
 Pergamon: Building
 Auge's Ark
Arkesilas IV of Cyrene
 Greek--5th c. B. C.
 Arkesilas IV of Cyrene,
 head
Armadillos
 Hardy. Armadillo
 Maya. Armadillo
Armchair. Kusama
Armchair. Oldenburg
Armed Liberty
 Crawford. Freedom
Armillary Sphere
 Manship. The Cycle of Life
Armor
 African--Benin. Three
 Figures in Armor
 Aristocles. Stele of Aristion
 Boetian. Quadriga, tomb
 figure
 Chinese--Six Dynasties, or
 Sui. Scale Armored Male
 Mortuary Figure
 Chosei. Twelve Guardians of
 Yakushi
 Etruscan. Chariot Panel:
 Armed Warriors in Combat
 Etruscan. Mars from Todi

Etruscan. Tomb Relief: Three-
headed Dog; Armor
Euaenetus. Syracusan Decka-
drachm: Quadriga and
Prize Armor
Greek. Ares: Fighting
Giants, frieze
Greek--7th c. B. C.
Achilles, with Gorgon
Shield, relief
Greek--6th c. B. C.
Temple of Aphaia Aegina
Greek--5th c. B. C. Warrior of
Aegina
Greek--4th c. B. C. Thebes
Drachm: Protesilaos Ad-
vances from his Ship
Huntington, A. H. Joan of
Arc, equest
Japanese--Ancient. Armed
Man, haniwa
Japanese--Ashikaga.
Officer's Armor
Japanese--Fujiwara. Tobatsu
Bishamon Ten
Japanese--Kamakura. Grand
Armor
Japanese--Kamakura. Sateira,
and Bikara, guardian
generals
Japanese--Kamakura. Suit
of Armor
Pennsylvania German. Patch-
box from Kentucky Rifle
Roman--1st c. B. C. Augustus
Addressing his Army
--Torso in Armor
--Victories and Trophies--
Armor and Shield
Roman--1st c. Emperor in
Armor, torso fragment
Roman--2nd c. Marcus
Aurelius Column:
Marcus Aurelius Receiving
Conquered Barbarians
--Trajan Column
Roman--3rd c. Trajan
Sestertius: Hector Charges
into Battle in Quadriga
Sassanian. King in Armor
on Horseback
Sotades. Rhyton: Amazon
Tonetti, F. M. L.
Armored Horseman
Turkish--15th c. Mail and
Plate Armor
Turkish--15/16th c. Armor
for Man and Horse

--Armguards
Indian--Hindu--17th c. Arm
Guard
--Breastplates
Greek--7th c. B. C. Meeting
of Apollo and Zeus, Ac-
companied by Other Gods
and Goddesses, cuirass
Greek--6th c. B. C.
Olympian Breastplate,
fragment
Japanese--Ancient. Man
Wearing a Cuirass,
haniwa
--Greaves
Greek--6th c. B. C.
Greave: Flying Gorgon
--Helmets
Afghanistan. Man in Helmet,
medallion
African--Bayaka. Helmet
Mask
Bronze Age--Denmark.
Kneeling Figure in Horned
Helmet
Bronze Age--Scandanavian.
Horned Helmet
Chinese--Shang. Warrior's
Helmet
Cocle. Helmet: Crocodile
God
Cypriote. Bearded Aphrodite
in Assyrian Helmet
Egyptian--18th Dyn. Amen-
hotep III: Wearing Blue
Crown (War Helmet)
Elamite. Ceremonial Helmet
Etruscan. Helmet#
Etruscan. Helmeted Warrior,
relief head
Etruscan. Plumed Helmet
Etruscan. Soldier in
Villanovan Helmet
Etruscan. Warrior in Swan
Helmet
Greek--8th c. B. C.
Soldier in Conical Helmet,
head fragment
Greek--7th c. B. C. Helmet
Maker
Greek--7/6th c. B. C.
Helmet
Greek--6th c. B. C. Corin-
thian Helmet
Greek--5th c. B. C.
Athena: In Helmet
--Leonidas, head detail
--Stele: Helmeted Warrior

Hawaiian. Figure in Helmet
Hawaiian. Helmet
Hellenistic. Caryatid:
 Helmeted Head
Hellenistic. Sarcophagus of
 Abdalonymos
Indian--Hindu--17th c.
 Mahratta Helmet
Islamic. Ottoman Ribbed
 Helmet
Japanese--Ancient. Helmet
Japanese--Tokugawa. Armor
 Mask
Miochin Nobuiye. Helmet
Mycenaean. Helmet,
 reconstruction
Nootka. Helmet: Seal's Head
Olmec. Colossal Male Head
 in Helmet
Palmyrene. Parade Helmet
 with "portrait" visor
Quimbaya. Male and Female
 Dieties; Helmet
Roman. Helmet: Scenes
 from Sack of Troy
Roman--1st/2nd c. Cere-
 monial Helmet and Vizor-
 Mask
Roman--2nd/4th c.
 Gladiatorial Helmet
Roman--Britain. Face-Mask
 Helmet
Scythian. Helmet
Sumerian. Helmet of
 Meskalamidug
Syrian. Warrior in Helmet
Tlatilco. Male Figure in
 Helmet
Tlingit. War Helmet#
Tsimshian. Winged-Frog
 Helmet
Turkish. Helmet#
Urartian. Helmet of
 Argyshat I
Veracruz. Male Head in
 Crocodile Helmet
--Shields
Australian Aboriginal
 Shield(s)#
Aztec. Shield Stone
Bronze Age--Sweden. Haga
 Barrow Treasure
Cretan. Shield: Zeus with
 Winged Musicians
Etruscan. Decorative
 Shield, Tarquinia, with
 head of River-God, Achelous

Etruscan. Monteleone
 Chariot: Fighting Soldiers
 with Gorgon Shield
Etruscan. Shield Boss: Lions
 and Central Floral Design
Greek--8th c. B. C. Warrior:
 With Dipylon Shield
Greek--6th c. B. C. Warriors,
 embossed shield
Greek--5th c. B. C.
 Wounded Hero
Indians of North America.
 Shields
Islamic. Shield
Japanese--Ancient. Human-
 headed Shield, haniwa
Maya. Four Whistles
Maya. Man Holding Shield
Maya. Warrior with Shield
Maya. Whistle: Eagle
 Warrior with Shield and
 Club
Melanesian--Solomons.
 Shield
Mixtec. Ceremonial Shield
Mycenaean. Painted
 decorated frieze, Tirynus:
 Figure-of-Eight Shields
New Guinea. Asmat War
 Shield
--Battle and Dance Shields
--Ceremonial Dance Shield
--Dance Shield#
--Head-Hunters Shield:
 Human Face
--Shield#
--Two Battle Shields
Phidias. Athena Parthenos
Phidias. Fight between
 Greek and Amazon, detail,
 Shield of Athena Parthenos
Phidias. Strangford Shield
Sioux. Dance Shield
Tlingit. Shield
Armor, Horse
 Chinese--Chou. Frontal for
 Horse Armor
 Turkish--15/16th c. Armor
 for Horse and Man
Armored Animal. Hayes
Armored Figure No. 1. Farr
Armored Horse No. 8. Farr
Arms See Hands
The Army
 MacMonnies Brooklyn
 Memorial Arch
Army of Ashurbanipal on the
 March, relief. Assyrian

ARNOLD, Anne (American 1925-)
 Cheetah 1963 wood; L: 75
 SEITC 35 UNNFis
 Elephant 1963 wood; 84
 SEITC 35 UNNWise
 Geoffrey 1963 H: 42
 SEITC 85 (col) UNNFis
 Humpty 1964 wood; 42
 SEITC 35 UNNFis
 Jimmy
 SG-7
 Rhinoceros 1964 wood; 104
 SEITC 35 UNNFis
ARNOLD, Hillis (American)
 Medical Care, relief plaster
 NYW 174
ARNOLD, Ralph
 Construction to Time 1961
 wood and antique clock
 mechanisms
 MEILC 66
 Untitled Construction
 weathered wood, playing
 cards, newspaper
 MEILC 60
ARONIS, Tom
 Porpoise, mobile
 LYNCMO 107
 Puzzle, mobile
 LYNCMO 94
ARONSON, Boris (American)
 Ark; Column details wood,
 metal, enamel; 11·3'x8'
 KAM 217, 219, 220-21
 UDCSin
 Ark Doors 1953 black walnut;
 72x48
 KAM 214 UNFI
 Ark Doors, sketch
 KAM 218 UDCSin
 Eternal Light 1961 bronze; 72
 KAM 222 UDCSin
 Menorah 1961 bronze; 102
 KAM 223 UDCSin
ARONSON, David (American 1923-)
 Blind Sampson 1962 bronze;
 22
 UAI-11:45 UMNeCSt
 Delilah 1962 bronze; 22
 UIA-11:45 UMBMi
 High Priest 1964 bronze; 27
 UIA-12:171 UNNNo
ARONSON, Naum (Russian-American
 1872-1943)
 The Prophet, head bronze
 SCHW pl 11 JTT
AROWOGUN (Yoruba)
 Door, four registers relief carv-
 ing wood; 48 FAAN pl 93 NiLN

L'Arringatore
 Etruscan. Aulus Metellus
Arrival. Konzal
Arrivederci Roma. Langlais
L'Arrotino
 Hellenistic. Slave Sharpening
 Knife
Arrow Homage to Times Square.
 Chryssa
Arrow No. 1. Chryssa
Arrowheads
 Indians of North America.
 Flaked Points
 Japanese--Tokugawa.
 Ceremonial Arrowhead
 Paleolithic. Arrowhead
Arrows
 Totonac. Palma: Bundle
 of Arrows
Arsaces See Mithradates
Arsinoe I (Wife of Ptolemy II d
 247 B. C.)
 Hellenistic. Gonzaga Cameo:
 Ptolemy (Philadelphus)
 and his wife, Arsinoe
Arsinoe II (Wife of Lysimachus of
 Thrace and Ptolemy II
 Philadelphus)
 Hellenistic. Arsinoe II, head
 Hellenistic. Ochtadrachm
Arsinoe III (Wife of Ptolemy IV)
 Hellenistic. Arsinoe III, head
 Hellenistic. Coin: Arsinoe
 III, head
Art. Lopez, C. A.
Art Box. Rauschenberg, R.
Art War Relief. Manship
Artabanus V (King of Parthia
 fl 209-27)
 Sassanian. Rock Carving:
 Combat between Ardashir
 and Artabanus V
Artagnes
 Greco-Roman. Hierothesion
 of Mithridates
Artaxerxes I (King of Persia 464-24
 B. C.)
 Persian. Wine Bowl of
 Artaxerxes I
Artaxerxes II (King of Persia d 359
 B. C. called Mnemon)
 Persian. Tomb of Artaxerxes II
Artemis (Diana)
 Corbett. Artemis Agrotera
 Damophon. Artemis from
 Lykosura, head
 Derujinsky. Diana
 Diederich. Diana and Hound

Ellerhusen. Artemis, reclin-
ing figure, over-gateway
relief
Etruscan. Artemis#
Folk Art--American. Weather-
vane: Diana
Greco-Roman. Artemis, head
Greco-Roman. Diana of
Ephesus, many-breasted
figure
Greek. Artemis#
Greek--7th c. B. C. Artemis
from Delos
Greek--6th c. B. C.
Artemis#
--Nike of Delos
--Siphnian Treasury
Greek--5th c. B. C. Death
of Actaeon
Greek--5/4th c. B. C.
Parthenon: Artemis
--Seated Gods: Poseidon,
Apollo, Artemis
--Three Fates (Demeter,
Persephone Artemis)
Greek--4th c. B. C.
Artemis#
Hellenistic. Artemis and
Satyrs at Altar, relief
Hellenistic. Artemis,
Demeter, Anytos, heads
Hellenistic. Diana, torso
Huntington, A. H. Diana of
the Chase
Huntington, A. H. Youthful
Diana
McCartan, E. Diana
Mackennal, B. Wounded Diana
MacMonnies. Diana
Manship. Diana
Olaguibel. "La Flechadora"
Patigian, H. Diana
Praxiteles--Attrib. Diana of
Gabies
Praxiteles--Foll. Artemis#
Rinehart. Latona and Her
Children, Apollo and
Diana
Roman--1st c. B. C.
Archaistic Artemis
Roman--2nd c. Artemis of
Ephesus, many-breasted
figure
--Diana of Ephesus
--Sarcophagus: Slaughter of
Niobids by Apollo and
Artemis
Romano-Indian. Dish: Diana
and Actaeon

Saint-Gaudens. Diana#
Scudder, J. Young Diana
Talbot, G. H. Vision of
Diana
Warner, O. L. Diana
Artemis Brauronia. Greek--5th c.
B. C.
Artemis from Gabii. Greek--4th c.
B. C.
Artemis from Tralles. Hellenistic
Artemis from Versaille.
Greek--4th c. B. C.
Artemesia
Greek--4th c. B. C.
Artemesia
Artemision Zeus
Greek--5th c. B. C.
Poseidon, Cape
Artemisium
Artemision Zeus. Onatas
Arthur. Kane, M. B.
Arthur, Bovet
Young, M. M. Bovet Arthur,
a laborer
Arthur, Chester Alan (21st
President of the U.S.
1830-86)
Bissell. Chester Alan Arthur
Saint-Gaudens. Chester A.
Arthur, bust
Artillery Coming to a Halt
Shrady, H. M. Grant
Memorial
ARTIS, William (American 1919-)
Heads
DOV 154 UNNHarm
Artist and the Muse. Kaz
Artists
Fraser, J. E. Head of a
Young Artist
ARTSCHWAGER, Richard (American
1924-)
Description of Table 1964
formica; 26-1/4x32x32
WHITNS 38 UNNW
Executive Table and Chair
formica on wood; chair:
54; table: 44x44x25
LIP 137 UNNC
100 Locations paint, hair,
wood, plastic
WHITNA-19
Tortoise-Shell Aurora Trip-
tych 1966 wood, parkwood
formica; 47-1/2x59-1/2x6
KN pl B
Untitled 1964 H: 30; 45
SEITC 80 UNNC
Arx. Abbott

Arybaloi

 87

Arybaloi
Greek--7th c. B. C. Perfume
flask
Inca. Seated Man Carrying
Arbyallus on Strap
As Americas. Roca Rey
As the Earth Sings--Pennsylvania
Dutch Family. Swallow
ASAKURA FUMIO (Japanese 1883-)
Game bronze; LS
WW 204
Head 1959 bronze; 46 cm
WW 203
Asanga
Unkei. Asanga and Vasuband-
hu, as attendants of
Maitreya
ASAWA, Ruth (American 1926-)
Number 9-1956 brass wire;
66
PIE 383 UNNPe
Asbury, Francis (American
Pioneer Methodist 1745-1816)
Lukeman. Francis Asbury,
equest
Ascending Apertures. Kallem
Ascending Man. Zajac
Ascension. Konzal
Ascension of Inanna. Lassaw
Ascent. Caesar
Ascent. Hancock, W.
Ascent. Hartwig
Ascetics
Afghanistan. Ascetic, bust
Indian--Kushan--Gandhara.
Bearded Ascetic
ASCHENBACH, Paul
Man on Stilts forged iron
LYNCM 101
Speakers Table forged iron
LYNCM 102 UNNSC
Asclepius (Aesculapius;
Asklepios)
Greek. Asculepius Healing
Suppliant
Greek. Zeus, or Aesculapius
Greek--4th c. B. C.
Asklepios#
--Patient Offering Replica of
Cured Leg to
Ascelapius, relief
--Votive relief, dedicated to
Asklepios: Physician
treating Patient
Myron. Asklepios from
Melos, head
Roman. Hygeia, Goddess
of Health, with Serpent,
symbol of Aesculapius

Scopas--Foll. Asklepios
Ashait (Queen of Egypt)
Egyptian--11th Dyn. Ashait,
sarcophagus
ASHANTI See AFRICAN--ASHANTI
ASHBEE, Charles Robert
(American 1863-1942)
Pendant 1900 gold and silver,
with enamel and pearls
CAS pl 291
Ashford, Bailey K.
Daingerfield. Dr. Bailey K.
Ashford, head
ASHIKAGA See JAPANESE--
ASHIKAGA
Ashinaga and Tenaga
Chikamasa. Ashinaga Yawn-
ing and Tenagu Sleeping
Japanese--Tokugawa.
Netsuke: Ashinaga and
Tenaga
ASHLEY, Solomon (American)
Gravestone: Colonel Oliver
Partridge, Deerfield,
Mass. 1792 marble
LIPA pl 177
Ashtari. Phoenician
Ashura
Japanese-Tempyo. Ashura
Japanese-Tempyo.
Hachibushi
Ashurbanipal (King of Assyria
669-26 B. C.)
Assyrian. Army of
Ashurbanipal on the
March, relief
Assyrian. Ashurbanipal#
Assyrian. Sack of the City
of Hamanu by
Ashurbanipal, relief
Assyrian. Stele of
Ashurbanipal
Ashurnasirpal (King of Assyria
fl 1038-20 B. C.)
Assyrian. Ashurnasirpal#
Ashurnasirpal II (King of Assyria
fl 884-59 B. C.)
Assyrian. Ashurnasirpal II
Asia. Calder, A. M.
Asia, figurehead
Folk Art--American.
Figurehead: Asia
Asia. French, D. C.
ASIA MINOR
Ibex 2nd mil B. C. bronze;
5.8 BRIONA 55 FPL
"Asiatic"
Roman--3/4th c. Sidamara
Sarcophagus, front:
"Asiatic"

Askance. de Mars
ASKIN, Walter (American)
 Jacob's Feast bronze; 43
 HARO-3: 17
Asklepios See Asclepius
Askoi, animal-shaped vessels
 Etruscan, Askos, with
 equestrian figure
Askos, vase in form of wineskin
 Hellenistic. Scylla, askos
ASMAT
 Ritual Barque, West Irian
 ptd wood; 88-1/8
 CALA 253 IVG
Asoka Capitals
 Indian--Maurya. Capital
Asoka Tree
 Indian--Kushan. Asoka Tree
Asokan Column. Indian--Maurya
ASPALOGA
 Effigy Vessel, Gadsden
 County, Florida 1200/1500
 clay; 13
 DOCA pl 35 UNNMAI
 (17/3410)
Aspasia
 Greek--5th c. B. C.
 Aspasia#
ASPASIOS
 Gem: Athena Parthenos,
 profile red jasper
 FUR pl E; SEW 116 IRT
Aspelta (King of Egyptianized Sudan)
 Egyptian--25th Dyn. Aspelta
Aspen. Calder, A.
Aspiration. Lux
Aspiration and Inspiration.
 Borglum, S. H.
Assemblages See names of artists:
 Cornell; Dine; Indiana;
 Rauschenberg
 Lassaw. Assemblage
Assembly of Gods
 Greek--5th c. B. C. Temple
 of Athena Nike
Asses See Donkeys
Assiut (Local Diety of Kynopolis)
 Egyptian--4th Dyn. Menkura
 between Hathor and Assiut
Assurbanipal See Ashurbanipal
Assurnasirpal See Ashurnasirpal
ASSYRIAN See also Babylonian;
 Mesopotamian; Sumerian
 Altar of Takulti-Ninurta I,
 Assur c 1250/10 B. C.
 H: 21
 FRA 73B
 Amulet: Demon Pazuzu,
 personification of south-

west wind 8th c. B. C.
 bronze; 6
 BAZINW 122 (col); CHAR-
 1:114; FRA pl 118B;
 GAU 42 FPL
Arabian Woman Captive with
 Camels, relief, Central
 palace, Nimrud 8th c.
 B. C. limestone; 36
 GRIG pl 46 ELBr
Archers, frieze, Susa 6/4th
 c. B. C. tile; 1.47 m
 CHAR-1:156 (col) FPL
Army of Assurbanipal on the
 March, relief, Palace of
 Assurbanipal, Khorsabad
 BAZINH 39 ELBr
Ashurbanipal: Feasting,
 relief, Nineveh 668/26
 B. C. W: 53
 UPJH pl 11D ELBr
 : Hunting in Chariot,
 frieze, Nimrud c 850
 B. C. 30x100'
 JANSK 90; ROOS 11D
 ELBr
 : Hunting Lions, relief
 650 B. C. stone; 66
 GARDH 83; GAUN pl 12;
 WHITT 64 ELBr
 : Hunting Lions, relief,
 Nineveh 7th c. B. C.
 alabaster; 20-1/8
 BERL pl 98; BERLES
 98; MU 31 GBSBeV
 (VA 960, 963)
 : Hunting the Wild Ass,
 relief, Nineveh 7th c.
 B. C.
 LARB 63 ELBr
 : In Chariot, relief,
 Nineveh 7th c. B. C.
 limestone; 31.5
 GAU 38; LARA 164 FPL
 : In Chariot on Lion Hunt,
 relief stone; 62
 FRA pl 110
 : Killing Lion with Sword,
 relief, Nineveh stone; 21
 FRA pl 109
 : Lion Hunting in
 Chariot, relief, Cyzicus,
 Ionia stone
 BAZINH 62; MYBS 18
 ELBr
 : Mounted Hunter 668/26
 B. C.
 CHASEH 47; CRAVR 26;
 ROOS 11F ELBr

: Shooting Lion, relief,
Nineveh
GARB front ELBr
: With Queen in the Garden,
relief, Kuyunjik H: 21
CHRP 44; FRA pl 114
ELBr
Ashurbanipal's Arab War,
relief, Nineveh stone;
59
FRA pl 102B
Ashurnasirpal
CRAVR 28 ELBr
: 885/60 B. C.
LARA 244
: 885/60 B. C.
LARA 244
: 885/60 B. C. H; 40
UPJH pl 10C ELBr
: Annointed by Eagle-headed
winged Figure, relief
883/59 B. C.
READI pl 22B ELBr
: Hunting, Nimrud 9th c.
B. C. limestone
BAZINW 120 (col) ELBr
: Hunting; Winged Dieties
Fertilizing Plants, relief,
Palace of Ashurnasirpal,
Nimrud
GLA pl 26 ELBr
: Hunting Lions, relief,
Nimrud
CHENSN 31; GARB 47;
MARQ 46; UPJH pl 11C
ELBr
: Receiving Tribute, relief,
Nimrud stone; 39
FRA pl 88
: Victorious in Battle,
Nimrud
LLO 197 ELBr
: With Attendant, relief
MARQ 37 ELBr
: With Attendant, relief
9th c. B. C. alabaster;
2.15 m
CHAR-1:106; CHENSN
30 FPL
: With Djinn Bearing
Offerings before the
Sacred Tree, relief
LARA 149 ELBr
: With Protecting Diety,
relief
CHASEH 43 ELBr
Ashurnasirpal II 883/59
B. C. amber; 9-1/2
CHENSW 71; MU 30 (col)
UMB

: Nimrud 9th c. B. C. H:
36
FRA pl 82
: 9th c. B. C. alabaster;
43
BAZINW 123 (col);
CHASEH 40; CHENSW
71; FRAN pl 82; GARB
45 ELBr
Ashurnasirpal II, profile
head, relief c 870 B. C.
COPG 20 DCN
(A. E. I. N. 1723)
Ashurnasirpal II, relief,
Nimrud
SEW 25 UMWiL
Ashurnasirpal II: At War,
relief, 9th c. B. C.
stone; 39
FRA pl 84
: Hunting Lions 883/59
B. C. limestone; 39x100
CHRP 41; FRA pl 87;
FRAN pl 87; GARB 47;
JANSH 58; LARA 148
ELBr
: Storming a City, relief,
Nimrud 883/59 B. C.
38x85
MU 30-1; MYBA 52 ELBr
: With Attendants, Nimrud
stone; 92
FRA pl 89
: With his Cup-Bearer,
Kalhu Palace c 900
alabaster
NM-10:23; RAY 8;
ROBB 287 UNNMM
Ashurnasirpal II: Lion Hunt,
relief alabaster
STI 136
Assyrian Palace Room (Room
11), partial view
BERLES 93 GBSBe
Assyrians at Source of
Tigris, gate hinge band,
Balawat bronze; 11
FRA pl 91
Assyrians Battling Foreigners,
relief, Palace of Senna-
cherib, Nineveh lime-
stone; W: 33-1/4
BOSMA pl 23 UMB
(60.134)
Assyrians Melting Down
Captured Urartian Bronze
Statues, relief (from
Flandin drwg) 7th c.
B. C. limestone
RTC 57

Attack on Walled City, relief,
Palace of Ashurnasirpal,
Nimrud
LLO 198 ELBr
Attendant with Two Horses,
relief fragment 7th c.
B. C. brownish alabaster;
7-1/2x10-1/2
WORC 11 UMWA
Babylonian Women Captives
of Assyrians, relief,
Palace of Sennacherib,
Nineveh limestone; W:
33-1/2
BOSMA pl 24; BOSMI 205
UMB (60.133)
Balawat Gate, detail 858/24
B. C. bronze; strip:
10-1/2
GARB 47 ELBr
Barakab and his Scribe,
relief, Sam'al c 730 B.C.
basalt; 44-1/8
BERL pl 96; BERLES
96 GBSBe (VA 2817)
Battle Scenes, reliefs,
Palace of Sennacherib: Bat-
tle in Wooded and Mountain-
ous Country; Storming a
Town
WOOLM 190, 192 ELBr
--Battle Scene
CHENSW 74
--Battle in Marshy Country
stone; 60
FRA pl 99, 100; LLO
200-201; WOOLM 191
Bearded Figure, Nimrud
9/7th c. B. C. ivory
5-7/8x1-3/4
TOR 17 (col) CTRO
(959.91.1)
Booty from a City Taken by
Tiglath Pileser III,
relief H: 40
FRA pl 94B
Browsing Bull 9/7th c.
B. C. ivory; 2-3/4x6-1/8
TOR 17 (col) CTRO
(959.91.2)
Bull Capital, Susa 521/485
B. C. grey marble;
5.8 m
CHAR-1:154; ROOS 13D
FPL
Campaign of Shalmaneser
III, relief bronze
LLO 202-3; WOOLM 189
ELBr

Capture of a City, relief
LLO 208 ELBr
Capture of a Town,
Nineveh relief (cast)
8th c. B. C.
LARA 319
Capture of Lackish by
Sennachereb, relief
MARQ 43 ELBr
Capture of Madaktu by
Assurbanipal, relief,
stone; 59
FRA pl 103
Capture of Susa, Nineveh
668/26 B. C.
GARB 66 ELBr
Chaldean Head
BARSTOW 19
Champleve Panel, Fort
Shalmaneser, Nimrud
8th c. B. C. ivory;
4-3/16
NM-2:22 UNNMM
(61.197.1)
Chariot Race, Cyzicus,
Ionia 6th c. B. C.
BAZINH 63 TIM
Chariots and Horsemen,
relief, Khorsabad
MARQ 40 FPL
Citadel Gate A; Winged
Genius stone
FRA pl 77B; 83
City Attacked with Battering
Ram, relief stone; 39
FRA pl 86
Colossal King, Sargon's
Palace, Nineveh stone
BEAZ fig 9
Combat of Lion and Bull,
relief
WCO-3:21
Conquest of Urartu by
Shalmaneser III in 859
B. C., gate, Balawat
9th c. B. C. bronze
RTC 56 ELBr
Courtiers Facing Sargon,
relief, Khorsabad stone;
120
FRA pl 96
Cult Relief: Fertility God,
Assur gypsum; 48
FRA pl 72
Cup: Antelope Head bronze;
5-1/2
FRA pl 118A DCNM
Cylinder Seal: Hero Holding
two gryphons and Sacred

Tree 1200/1000 B. C.
sard; 1-1/2
BOSMA pl 16 UMB (25. 67)
Cylinder Seal: Human Battling
Flanking Animals 13/12th
c. B. C. H: 1-1/8
NM-2:19 UNNMM
(43.102.37)
Cylinder Seal: Ishtar; Winged
Genius between Confronting
Winged Bulls 9/7th c.
B. C.
GARB 68 ELBr
Cylinder Seal: King; Winged,
Eagle-Headed Genie;
Sacred Tree c 1000/700
B. C.
GARB 45 ELBr
Cylinder Seal: Mythological
Figure Flanked by Two
Bulls c 900/700 B. C.
chalcedony; 1-1/2
BOSMA pl 28 UMB (27.649)
Cylinder Seal: Ostrich Hunt
grey marble; 3.1 cm
WOOLM 184 UNNMM
Cylinder Seal: Sacred Barque
with Priest in front of
Altar supported by Bull,
"Brocade Style" Jamdat
Nasr Period, c 3000 B.C.
lapis lazuli; 43 mm
WOOLM 26 GBS
Cylinder Seal: Stag and Trees
LLO194 UNNMM
Cylinder Seal: Stag in Forest
grey chalcedony; 2.8 cm
WOOLM 187 FPBN
Cylinder Seals
FRA pl 119
Defeat and Flight of Elamites,
relief, Nineveh H: 52; 81
FRA pl 104-6; LLO 207
ELBr
Deportation of Populations,
relief 7th c. B. C.
alabaster
BAZINW 122 (col) FPL
Djinn with Two Pairs Wings,
relief 8th c. B. C.
LARA 118 FPL
Dog, Kultepe ptd clay
LLO 148 (col) TAA
"Doorkeeper Lion", five-
legged 9th c. B. C.
HAUSA pl 6 ELBr
Eagle: Sun Symbol, relief
5th c. B. C.
WCO-3:43

Eagle-Headed, Winged Being
Pollinating Sacred Tree,
relief
RAY 8; ROOS 11G UNNMM
Eagle-Headed, Winged Diety,
relief
RAD 42 ELBr
Eagle-Headed, Winged Genie,
relief, Nimrud 9th c.
B. C. gypseous alabaster;
45. 3x20. 9
GAU 36 FPL
Elamite Archers, relief,
Palace of Ashurbanipal,
Nineveh limestone; 14-1/2
BOSMA pl 27 UMCF
(1953. 13)
Fan Handle, Nimrud ivory;
5-3/4
FRA pl 166B ELBr
Fantastic Being--winged, with
human head, Urartu 8/7th
c. B. C. gold covered
bronze, gem inlay
HERM il 26 RuLH
Female Figure: Three-
Faced, Palace of Kalhu
c 8th c. B. C. ivory
FEIN pl 124 UNNMM
Female Heads, Nimrud ivory;
7
FRA pl 168C
Five-Legged, Winged Bull,
with human head, Khors-
abad 8th c. B. C.
alabaster; 4. 2 cm
CHAR-1:103-4 FPL
Fortified Town--plan, section,
elevation, relief
BAZINH 16
Fugitives Swimming to a
Fortress, relief, Palace
of Ashurnasirpal, Nimrud
stone; 39
CHASEH pl 44; FRA pl
85; FRAN pl 85; ELBr
Genius and Trees of Life,
relief, Palace of
Ashurbanipal II, Calah
9th c. B. C. alabaster;
230 cm
BERLES 94-95; BERL
pl 94-95; GBSBe (VA 949)
Gilgamesh and the Lion,
relief, Palace of Sargon
II, Khorsabad 8th c.
B. C. alabaster; 166.5
BAZINW 121 (col); CHAR-
1:104-5; GAU 41 FPL

Griffin and Sacred Tree, relief,
Nimrud H: 43 FRA pl 90
Gryphon, cauldron handle,
Ziwiye 7th c. B. C. gold; L:
3-1/8; W: 2-1/8
RTC 72 IranTA
Head, Nimrud ptd ivory
LLO 211 (col) IrBagI
--8th c. B. C. ivory
LAWC 98 ELBr
Head of Youth, relief, Palace
of Ashurbanipal, Nineveh
668/26 B. C. limestone;
W: 3-1/2
BOSMA pl 26 UMB
(33.685)
Herd of Gazelles, Kuyunjik
stone; 21
FRA pl 113
Horse, head, relief 7th c.
B. C.
MILLS pl 24 ELBr
Horse Led by Groom, relief,
Palace, Nineveh 7th c.
B. C. limestone; 51
GRIG pl 45 ELBr
Horseman, relief, Palace of
Sennacherib, Nineveh
limestone; W: 11-1/2
BOSMA pl 25 UMB (33.683)
Human Figures and Horses,
relief, Palace of Sargon
II, Khorsabad 8th c. B.C.
CHASEH pl 45 FPL
Human-Headed, Winged Bull,
Palace of Ashurnasirpal
II
NM-10:21 UNNMM
Human-Headed, Winged Lion
and Bull Guardians,
Palace of Ahurnasirpal II,
Nimrud 883/59 B. C.
bull: 10'3-1/2"; lion:
10'2-1/2"
NM-2:18 UNNMM
(32.143.1, 2)
Hunters and Archers, relief,
Palace of Ashurbanipal,
Kuyunjik, Nineveh 668-26
B. C.
MILLER il 18 ELBr
Hunters with Lions
BARSTOW 20
Hunting Scene, relief,
Ashurbanipal Palace,
Nineveh 7th c. B. C.
stone; 42
CHENSN 32; CHENSW 74;
LLO 205;READA pl 15 ELBr

Hunting Scene, relief,
Khorsabad
CHENSW 72; FRA pl 98
Hunting Wild boars, relief
Nimrud
AUES pl 4 ELBr
Khorsabad Gate with
Guardian, Winged Five-
Legged Human-Headed
Bulls, Citadel of Sargon
II 742/706 B. C.
JANSK 74 IranKo
--detail
CHRH 56; TAYFF 6 (col)
--throne room guardian
stone; 180
FRA pl 77A; FRAN pl 77
--oblique view
RAY 8-9
--during excavation
JANSH 57
--8th c. B. C. alabaster;
192.9
BAZINH 15; BAZINW
121 (col); GAU 37; LARA
149; MALV 77; WOOLM
181 FPL
--H: c 16'
LLO 196; STI 134 UICUO
King 9/8th c. B. C. Baltic
amber, with gold breast-
plate; 9-5/16
BOSMA pl 20; FRA pl
80-81; LLO 195 (col)
UMB (38.1396)
King: Approaching Sacred
Tree with Genie, relief,
Nimrud 883/59 B. C.
alabaster; 86
GARB 46 ELBr
King: In his Chariot, relief
7th c. B. C. alabaster
BAZINW 122 (col) FPL
Kings and Winged Genii
Pollinating Sacred Tree,
relief 884/59 B. C.
alabaster
STI 135
Kneeling Winged Genius,
relief, Palace of
Ashurnasirpal II, Nimrud
alabaster; 30
FAIY 54 UNRoR
Lady of the Well, Nimrud
8th c. ivory
LARA 149 IrBagI
Lamb Carrier, relief c 750
B. C. basalt; 110 cm
BERLES 97 GBSBe
(VA 3007)

Palace of Ashurnasirpal,
Nimrud
LLO 204 ELBr
Two Divine Attendants,
great cartouche of
Prince, panel, Nimrud
ivory
LLO 217 ELBr
Two Warriors behind Fixed
Shield, relief, Palace
of Sargon II, Khorsabad
8th c. B. C.
HERM il 32 RuLH
Urpalla, King of Tyana,
before God Sandas, relief
rock
FRA pl 164
Votive Object, inscribed in
cuneiform, Assur c
1325 B. C. limestone
GRIG pl 14 ELBr
Warrior, relief, Temple of
Ashurnasirpal 8th c. B. C.
alabaster
SLOB 232 FPL
Warrior Leading Two Horses,
relief 7th c. B. C.
BRIONA 57 FPL
Warriors, relief
BAZINH 15 FPL
Winged Being, relief
RAY 9
Winged Being and King's
Arms Bearer, relief,
Palace of Ashurnasirpal
II, Nimrud 883/59 B.C.
CHRH fig 15; GARDH 83;
MYBA 50 UNNMM
Winged Diety, head detail,
relief, Palace of
Ashurnasirpal, Nimrud
marble; 25x18-1/4
UMCF UMCF (1940.13)
Winged Diety, relief 882/57
B. C.
HOF 31 IRBarr
--: Nimrud 883/59 B.C.
MU 30 UMoKNG
--: Palace of Ashurnasirpal,
Nimrud
MYBU 318 UNNMM
Winged Diety before Holy
Tree, relief, Ashurnasirpal
II, Nimrud
HERM il 33 RuLH
Winged, Eagle-Headed Diety,
relief fragment, Palace
of Ashurnasirpal II,
Nimrud H: 19-1/2

DENV 151 UCoDA (O-36)
Winged Figure, head detail,
relief limestone; 89
BOSMI 205 UMB (33.731)
Winged Figure, relief 11th
c. B. C.
PANA-2:127 UMAmA
--
CHENSN t; CHENSW 72
UMdBW
Winged Figure Holding Deer,
relief
JOHT pl 39
Winged, Five-Legged Human-
Headed Bull
BARSTOW 19; CRAVR 29
--9th c. B. C. alabaster;
124
GARB 46; LARA 121;
ROOS 11C ELBr
--883/59 B. C. alabaster;
123-1/2x122x26
GARDH 81; MU 30; MYBA
50; ROOS 11B; SEW 25;
UPJH pl 9F UNNMM
Winged Genie, Khorsabad
8th c. B. C. alabaster;
53.6x34.4
GAU 43 FPL
--: Palace of Ashurnasirpal
II 9th c. B. C. alabaster
CLE 10; LEE UOClA
(43.246)
--openwork plaque c 710
B. C. ivory; 6-1/8
NM-2:21 UNNMM
(58.122.7)
--relief, Nimrud 9th c. B.C.
alabaster; 1.03 m
CHAR-1:107 FPL
--relief, Palace of
Ashurnasirpal, II, Nimrud
883/59 B. C. alabaster;
92x66
NM-2:20 UNNMM (31.72.2)
Winged Genie and Tree,
Palace of Ashurnasirpal,
relief 883/59 B. C.
alabaster; Sq: 31
YAH 14 UCtY
Winged Genie Fertilizing
Flower, relief 9th c. B.C.
CARTW 129 UVRMu
Winged Genius Fertilizing
Sacred Tree, relief,
Palace of Ashurnasirpal
II, Nimrud limestone; 89
BOSMA pl 18 UMB
(33.731)

Winged Genius Fertilizing
Tree of Life, relief 9th c.
B. C. gypsum; 40-1/2x
34-5/8
EXM 306 (col) FPL
Winged Genius, relief 883/59
B. C. alabaster; 93-1/4
x53-1/2
WORC 10 UMWA
Winged Genius Flanking
Sacred Tree, Nimrud
alabaster; 55x36
TOR 19 CTRO (939.11.2)
Winged Genius Holding Mace,
relief, Palace of
Ashurnasirpal II, Nimrud
limestone; c 96
BOSMA pl 19 UMB (81.56)
Winged Guardian, relief,
Palace of Ashurnasirpal
9th c. B. C. alabaster
VALE 88 UNNMM
Winged Lion, Palace, Nimrud
SIN 34 ELBr
Winged Male Figure in Field
of Papyrus Flowers 9/7th
c. B. C. ivory, with
green paste and lapis
lazuli inlay; 5-7/8x
1-3/4
TOR 17 (col) CTRO
(961.13.5)
Winged Man Offering Branch
with Pomegranates, Palace
of Ashurnasirpal II
ROOS 11E UNNMM
Wild Asses Hunted with
Mastiffs, relief, Nineveh
668/26 B.C. H: 21
FRA pl 112; GARB 67
ELBr
Winged Bull, relief 5th c.
B. C. ptd tile
HOF 31 FPL
Wounded Lioness (Dying
Lioness), relief, Palace
of Ashurbanipal, Nineveh
668/26 B. C. limestone;
25x39-1/2
BAZINH 41; BRIONA 56;
CHASEH 47; CHENSN
33; CHENSW 74; CHRH
54; CRAVR 26; FRA pl
111A-B; FRAN pl 111;
GARDH 84; GRIG pl 40;
HAUSA pl 6; JANSH 61;
JANSK 91; LARA 163;
MALV 625; MYBA 53;
PRAEG 112; ROBB 288;

ROOS 13E; SEW 25; STI
138; UPJ 48; UPJH pl
11E; WCO-3:20-21 ELBr
ASSYRIAN and PHOENICIAN
Cylinder Seals green jasper;
chalcedony; .023-.046 m
CHAR-1:116 FPL
ASSYRIAN and BABYLONIAN
Seals c 1500/550 B. C.
CHENSW 76 ELBr; UICUO
Assyrian Lion. Lobel, P. A.
ASSYRO-BABYLONIAN
Bull, relief
BARSTOW 19
Vulture; Bull, relief
BARSTOW 19
ASSYRO-SCYTHIAN
Plaque: Stags; Ibexes;
Lions' Masks 7th c. B.C.
repousse gold; L:
11-3/4
RTC 73 (col) IranTA
Astarte
Bronze Age--Syria. Pendant:
Astarte
Phoenician. Astarte at the
Window
ASTEIOUNOUS OF LARISA
Dherveni Krater: Dionysos,
Maenads, and Satyrs
320 B. C. bronze; 73
WEB 21 (col) GrSaA
Astralagus Player. Greco-Roman
Astrolabio. Bonevardi
Astyanax
Greek--6th c. B. C. Death
of Astyanax, shield relief
ASUKA See JAPANESE--SUIKO
ASUNSOLE, Ignacio (Mexican 1890-)
Blanca, la Negrita bronze
NEL
Cuenta Estrellas bronze
NEL
Hablara a los Siglos; detail
bronze
NEL
Jules Romains, head bronze
NEL
M. Bonneau, French
Ambassador, head bronze
NEL
Monument to Alvaro Obregon
detail
LUN; NEL MeM
Monument to Maternity
(Monumento a la Madre)
NEL MeMon
Nude (Desnudo)
NEL

Painter F. Goitia, head borax
NEL
Pastorcito Otomi bronze
NEL
Asura Bana, Demon King
Khmer. Asura Bana, relief
At Prayer
Lauck. Monk at Prayer
At the End of the Trail
Fraser, J. E. End of the
Trail
At the Party. King, W. D.
At the Stake. Medellin
At the Zoo. Dombek
ATACAMENO
Four Tablets; Two Snuff
Tubes: Human and Animal
Motifs, North Chilean
BUSH 224-5 UNNAmM
Snuff Tablet wood; 6
NMANA 125 UNNAmM
(4100/8911)
Snuff Tablet wood; 6-1/4
NMANA 125 UNNAmM
(41.0/8754)
Ataeon
Etruscan. Death of Ataeon
Atar Luhas, god
Hittite. Atar Luhas, seated
figure with attendant
lions
Atargatis
Parthian. Hadad and
Atargatis, God and
Goddess of Syria
Atellanae Actor. Hellenistic
Aten
Egyptian--12th Dyn. Sesotris I
and God Aten, pillar
relief
Egyptian--18th Dyn. Ikhnaton
(Akhenaten) and Family,
votive relief showing sun-
disk, symbol of Aten
--Ikhnaton (Akhenaten) and
family showing symbol of
Aten, Sun God: Sun-
disc with Rays Ending in
Hands, and Crux Ansata
Ateti
Egyptian--6th Dyn. False
Doors, tomb of Ateti
ATHAPASCAN
Mask: "Up River" Person,
Anvik, Alaska 1900/16
wood; 22-1/2
DOCA pl 72; DOU 176
UNNMAI (5/8667)

Athena (Minerva)
Aspasios. Gem: Athena
Parthenos, profile
Endoios(?). Athena, headless
figure
Etruscan. Athena#
Etruscan. Cauldron, Marsciano
Etruscan. Heracles and
Minerva
Etruscan. Minerva Promachus
Etruscan. Mirror: Birth of
Athena-Minerva
Euboulides. Athena, head
Euphranor. Athena Giustiniani
Gallo-Roman. Minerva of
Poitiers
Greco-Etruscan. Athena--2
figures
Greco-Roman. Athena#
Greco-Roman. Procession of
Gods: Hermes and Athena,
relief
Greek. Athena#
Greek. Mourning Athena,
relief
Greek. Pallas Giustiniani
Greek--7th c. B. C. Birth
of Athena#
Greek--6th c. B. C. Athena#
--Athenian Tetradrachm:
Athena
--Birth of Athena, shield
relief
--Perseus: Beheading
Medusa
--Shield Strip: Birth of
Athene
--Stater of Priene(?):
Athena in Helmet, head
--Temple of Aphaia Aegina;
Athene
--Temple of Athena,
Acropolis, Athens:
Athena, head
--Tripod: Perseus with
Athena
Greek--6/4th c. B. C. Coins
Greek--5th c. B. C.
Athena#
--Athenian Coin: Athena,
head; Owl
--Hope-Farnese Type Athena
--Parthenon: Birth of Athena
--Parthenon, interior, with
Phidias Athena (restored
model)
--Temple of Athena Nike
Greek--4th c. B. C. Athena#

--Kassandra and statue of
 Athena
Hellenistic. Athena#
Hellenistic. Patera: Athena,
 seated figure with helmet,
 sword, and aegis
Kimon. Tetradrachm of
 Syracuse: Athena, head;
 Quadriga
Kresilas--Foll. Pallas of
 Velletri
Landis, Lillian. Athena
Myron. Athena and
 Marsyas
Onatas. Athena and Warriors,
 pediment figures
Phidias. Athena#
Phidias. Fight Between Greek
 and Amazon, detail, Shield
 of Athena Parthenos
Phidias--Foll. Albani Athena
Phidias--Foll. Aphrodiasias
 Coin: Athena Parthenos
Phidias--Foll. Athena#
Phidias--Foll. Hope Athena
Phidias--Foll. Medal: Athena
 Parthenos
Phidias--Foll. Varvakeion
 Athena
Phidias--Foll. Velletri Athena
Pyrrhoes--Attrib. Farnese
 Athena (Athena Hygeieia)
Reder, B. Pallas Athena
 with Raven
Roman--1st c. B.C. Minerva
Roman--2nd c. Athena, copy
 of lost Greek bronze
--Hope Athena, copy of Greek
 5th c. work, "Varvakeion
 Athena" by Phidias--Foll.
Athena Farnese. Phidias
Athena from Velletri. Greek--5th c.
 B. C.
Athena Lemnia. Phidias
Athena Medici. Greek--5th c. B. C.
Athena-Minerva. Etruscan
Athena Parthenos. Phidias
Athena Promachus. Phidias
Athenian Treasury, Delphi. Greek--
 5th c. B. C.
ATHENION (Greek)
 Zeus Downing Giants, cameo
 3rd/2nd c. B. C.
 sardonyx
 RICHTH 242 INN
ATHENODORUS See AGESANDER
Athlete with Fillet
 Polyclitus. Diadumenos

Athletes See also Games and Sports
 Greco-Roman. Athlete
 Greek--6th c. B. C. Athletes
 Training, relief
 Greek--5th c. B. C. Athlete#
 --Stele: Athlete#
 Greek--5/4th c. B. C.
 Athlete, victor in bowing
 contest
 Greek--4th c. B. C.
 Athlete, head#
 Hellenistic. Stele of
 Metrodorus: Prize Vase,
 Athlete's Strigil, Sponges
 and Flask
 Olmec. Gladiator
 Olmec. Seated Athlete
 Polyclitus. Athlete#
 Polyclitus--Foll. Athlete
 Polyclitus--Foll. Westmacott
 Athlete
 Stephanus. Athlete
Atisha. Tibetan
ATKINS, Herbert Henry (American)
 Spirit of the Sea bronze
 NATSA 11
 Telesis
 NATS 17
Atlanersa
 Egyptian--25th Dyn. Altar of
 Atlanersa
Atlanta
 Manship. Atlanta
Atlanta Fountain. Roman
Atlantean Figures
 Maya. Atlantean Figures#
 Toltec. Atlantean Figure
The Atlantic
 Piccirilli, A. Main
 Memorial: The Atlantic
Atlantica. Waugh, S. B.
Atlas
 Greek--5th c. B. C. Temple
 of Zeus
 Lawrie. Atlas
 Lee. Atlas
Atlas Figures
 Roman--2nd c. Kneeling
 Persian
ATSIDI CHON (Navajo)
 Bridle before 1880 silver;
 L: 17-1/2
 DOCA pl 171 UNNMAI
 (22/8176)
Atlatl
 Aztec. Atlatl, ceremonial
 spear thrower
 Nazca. Atlatl Handle

Paleolithic. Atlatl
Atlantis
 Florio. Queen of Atlantis
Atmosphere and Environment VI.
 Nevelson, L.
Atom. Burnham
The Atom. De Lue, D.
Atom. Snelson
Atom Bomb Panic. Pereza, H.
ATOUTOU See AFRICAN--
 ATOUTOU
Attendant of Ebih II. Sumerian
Attending Angel# Couper
ATTIC See GREEK
Attitudes of Man. Chinni
Atun
 Egyptian--19th Dyn. Seti I
 before Atun, relief
Atunis, Etruscan God See Adonis
Audrey# Snelson
Audry. Snelson
Audubon, John James (American
 Artist and Naturalist
 1785-1851)
 Calder, A. S. John James
 Audubon, bust
 Lathrop. John James
 Audubon, medal
AUER, Lili (American)
 Garden Figure cement
 NYW 176
Auge
 Greek--4th c. B. C. Mirror:
 Hercules Attacking
 Priestess Augustus,
 Hellenistic. Great Altar of
 Zeus, Pergamon: Telephos
Auge's Ark
 Hellenistic. Altar of Zeus,
 Pergamon: Building
 Auge's Ark
Augeian Stable
 Greek--5th c. B. C. Temple
 of Zeus, Olympia: Her-
 cules: Cleaning Augeian
 Stable
AUGUR, Hezekiah (American
 1791-1858)
 Alexander Metcalf Fisher,
 bust, after S. F. B. Morse
 "Portrait of Professor
 Fisher" 1827 marble; 27
 PIE 377; YAPO 41 UCtY
 (1827. 3)
 Jephthah and his Daughter
 1828/32 marble
 CRAVS fig 3. 4; LARK
 104; PIE 377 UCtY
 (1835-11A-B)

Oliver Ellsworth, bust marble
 USC 185 UDCCap
August. Light, A.
August Afternoon. Palsey, Jeanne B.
August Raven. Smith, D.
August, the Squared Fire. Edwards, M.
Augustine, Saint
 Noguera, P. de. St. Luke,
 St. Sebastian, and St.
 Augustine
Augustus (First Roman Emperor
 63 B. C. -14 A. D.), original
 name: Gaius Julius Caesar
 Octavius
 Cleomanes. Octavius as
 Orator
 Indian--Sunga. Coin: Kujula
 Kadphises; Augustus, head
 Roman. Augustus#
 Roman--1st c. B. C. Ara
 Pacis Augustae
 --Augustus#
 --Carved Gem: Emperor
 Augustus as Neptune
 Driving Four Sea Horses
 --Denarius: Octavianus
 --Octavius: As Orator
 --Victor, wreathed head:
 Augustus(?)
 --Young Augustus, head
 detail
 Roman--1st c. B. C./1st c.
 A. D. Augustus#
 Roman--1st c. Apotheosis of
 Augustus, relief
 --Augustus#
 --Dieified Augustus and
 Imperial Heirs
 --Julius Caesar Octavianus,
 silver denarius
 --Seal of Augustus: Sphinx
Aulos See Musicians and Musical
 Instruments
Aulus Metellus. Etruscan
Auntie. Durchanek
Auntie. Timotheus
Aurelia. Lipchitz
Auriga, head. Greek--5th c. B. C.
"Auriga" (Charioteer). Roman--
 Early Empire
AURIGNACIAN See PALEOLITHIC
Aurora
 Baizerman. Aurora
 Roman. Cameo: Aurora
 Driving Biga
AUSLENDER, Stephen
 Sam #1 steel bars, stainless
 steel sheet, brass-plated
 nuts and bolts MEILD 161

The Awakening. Glinsky
The Awakening. Laurent
The Awakening. Nicolosi, J.
The Awakening. Pattison, P.
The Awakening. Sterling, L. M.
Awakening. Wolff, A.
Awakening. Zorach, W.
Awakening Mountain II. Chinni
Awakening of Faith. Hashimoto, C.
Awakening of Spring. Konti
Awil, kneeling worshipper.
 Babylonian
Awls
 Iowa. Awl
 Scythian. Awl, with animals
Axe God. Maya
Axes
 African--Baluba. Ax#
 Bronze Age--Central Europe.
 Decorated Battle Axe
 Bronze Age--Syria. Axe
 Head, with Lion's Head
 Bronze Age--Syria. Perforated
 Axe Head
 Chimu. Ceremonial Axe
 Chinese--Ch'in. Yin-Style
 Ceremonial Axe Head
 Chinese--Chou. Axe Head
 Chinese--Han. Axe Head
 Chinese--Shang. Axe#
 Chinese--Shang. Executioner's
 Axe
 Copper Age. Axe Hammer
 Diaguita. Incised Axe
 Egyptian--18th Dyn. Ah-hotep
 Axehead
 --Axehead#
 Elamite. Axe of Untash Humban
 Hittite. Funerary Figures, with
 winged sun disc and Minoan
 Double Axe
 Indians of Central America--
 Costa Rica. "Axe God"
 Indians of Central America--
 Costa Rica. Axe Heads:
 Diety-form
 Indians of Central America--
 Nicaragua. Monolithic
 Axe
 Indians of Central America--
 West Indies. Taino Axe
 Heads
 Indians of Mexico. Ax: Human
 Form
 Indians of North America--
 Alabama. Monolithic Axe
 Indians of South America--
 Bolivia and Ecuador. Ax
 Blades

 Indians of South America--
 Brazil and Ecuador. Ax
 Heads
 Indians of South America--
 Chile. Monolithic Axe
 Iranian. Axe Head
 Luristan. Axe#
 Maya. Man Carrying an Axe,
 bust
 Maya. Necklaces; Axe Gods
 Melanesian--Solomons. Axe
 Minoan. Double Axe
 Minoan. Votive Double Axe
 Neolithic--France. Polished
 Axe
 Neolithic--Sweden. Boat Ax
 Neolithic--Sweden. Elk-
 shaped Ritual Axe
 Olmec. Celts#
 Olmec. Ceremonial Axe
 Olmec. Kunz Anthropomorphic
 Axe
 Persian. Ax Head
 Steppe Art. Ceremonial Axe
 Syrian. Axe
 Tajin. Hacha, ceremonial axe
 Vera Cruz. "Baby Face" Axe
 Head
 Vera Cruz. Hacha: Male
 Head with Dolphin Crest
 Zapotec. Axe Head
AY-O (American)
 Hydra, environment 1962
 7x7'
 KAP pl 31-32
Ayagapata
 Indian--Kushan--Mathura.
 Ayagapata with Jina
Aycock, Charles Brantley
 (American Lawyer and
 Educator 1859-1912)
 Keck. Charles Branton
 Aycock
Ayer, N. W.
 Renzetti, A. N.W. Ayer, bust
Aylesford Bucket. Iron Age
Aymara. Nunez del Prado
Aysh-Ke-Bah-Ke-Ko-Zhay
 (Chippewa Chief), Flat Mouth
 Vincenti. Aysh-Ke-Bah-Ke-
 Ko-Zhay, bust
Azada
 Persian. Mirror Back:
 Bahram Gur and Azada
AZANDE See AFRICAN--AZANDE
"Azara Bust"
 Lysippus--Foll. Alexander,
 bust

AZERBAIJAN
Bearded Head before 1000 B. C.
copper CHENSW 169
UNNMM
Bearded Head 2nd mil B. C.
bronze, hollow cast;
13-1/2
POM 40, 41 -Br
Bull, head 2nd mil B. C.
bronze, hollow cast; 6
POM 36 UOClA
Bull Head c 1200 B. C.
bronze, hollow cast; L:
3-1/2
CHENSW 168; POM 34
-Ka
Crucifixion 2nd mil B. C.
bronze, hollow cast; L:
6-3/4
POM 37 -Br
Deer Holding Frame for
Ritual Vessel 2nd mil
B. C. bronze, hollow
cast; L: 12
POM 35 -Br
Lion, head c 1000 B. C.
terracotta, hollow cast;
4-1/4
POM 37 -Br
Lion Mask c 1400 B. C.
cast gold; 12
POM 23 -Mo
Offering Tripod: Polaris and
Deer Heads (Lunar
symbol) 2nd/1st mil
B. C. terracotta; Dm: 12
POM 38 -H
Semite, head 2nd mil B. C.
bronze, hollow cast; 5-1/4
POM 39 -Br
AZTEC
Atlatl, ceremonial spear
thrower; Sculpture
decoration gold leaf;
L: 22-3/8
DIS 78 (col) IRPr
Ball Player, San Jose de
Acatenco, Puebla white
pottery; 5
BUSH 73 UMCP
Breast Ornament: Double
Headed Serpent Shield and
Turquoise L: 17-1/2
AMHI 91 (col) ELBr
Cacoa Pod Figure, Amatlan
1000/1500 red ptd stone;
14
DOCM pl 24 (col) UNBB

Calendar Stone, Tenochtitlan
after 1502 Dm: 11-1/2'
AMHI 78; KUBA pl 16A;
LOT 57; SPI-2:pl 42
MeMN
Ceremonial Brazier: Maize
Diety, Copal 1324/1521
ochre terracotta;
21-1/4x23-1/4
MAS cat 837 MeMN
Ceremonial Brazier: Mask of
Tlaloc, Atzcapotzalco
1324/1521 terracotta
45-5/8x16-1/8
MAS cat 840 MeMN
Ceremonial Urn: Figure in
Headdress ceramic
RAY 75 UNNMAI
Chalchihuitlicue (Our Lady of
the Turquoise Skirt),
Goddess of Flowing Water
ZOR 36
--
NMAS # 20 UNNAmM
--c 1450/1500 basalt (rear
view)
SEYT 4-5 UDCN
--basalt; 6-3/4
BL pl XXXV UDCBl
--c 1450 volcanic rock, red
ochre; 20-1/2
ALB 171 UNBuA
--kneeling figure dark green
diorite; 5
BL pl XXXV UDCBl
Chicomoatl, maize goddess
14th c. volcanic stone;
17-3/8
DENV 110 UCoDA
(NW-496)
Coatlicue ("Lady of the
Serpent Skirt"), Goddess
of Earth, Life and Death
ENC 731; SPI-2: pl 45;
ZOR 252
--late 15th c. andesite; 99
BUSH 61 UNNAmM
--: Cozcatlan 1324/1521
basalt; 46x15-3/8
MAS cat 787 MeMN
--: Main Plaza, Mexico City
15th c. andesite; 99
FAUL 101; GARDH 607;
HALE 105; JANSH 551;
JANSK 373; KUBA pl 20;
LOT 59; MU 106; MYBA
202; NMAT 43 MeMN

--: kneeling figure with relief
of skulls, Calixtlahuaca
1324/1521 basalt; 29-7/8x
19-1/4
MAS cat 788 MeMN

Coiled Feathered Serpent
(Xiucoatl); base: glyph
for "Two Reed" year and
crest of Montezuma II 1507
quartz-diorite; Dm: 17-7/8
BL pl XLII (col), 242
UDCBl

Coiled Plumed Serpent stone;
8-1/2x15-3/4
DIS 93 (col) MeMN

--: Quezalcoatl 1324/1521
basalt; 9-7/8x15-3/4
MAS cat 821 MeMN

Coiled Rattlesnake; base
rhylite--porphyry; Dm: 24
BL pl XL (col), XLI;
WCO-3:44 (col) UDCBl

Coiled Snake granite; 16-7/8
x9
MAS cat 819 MeMN

--: with open jaws green
granite; 29-1/2x39-1/2
MAS cat 820 MeMN

Coyalxanhiu, mask jade
NMAS #59 UMCP

Coyolxauhqui, head,
Tenochtitlan 15th c. diorite
KUBA pl 24 MeMN

Cuauhxicalli: "Eagle Vessels",
for heart sacrifices,
Tenochtitlan c 1500 stone
KUBA pl 16B AVV

--: Recumbent Jaguar,
sacrifical bowl, Tenochtitlan
volcanic stone; Dm:
24-1/2; Depth: 10-1/4
DIS front (col) MeMN

--: Tiger Vessel, for blood
sacrifices, Tenochtitlan
c 1500 basalt; 36-5/8x
47-1/4x88-5/8
KUBA pl 22; MAS cat
803; PAG-1:133 MeMN

Cup, with projecting skull
decoration jadeite; 2-5/8
BL pl XLVIII (col)
UDCBl

Dead Warrior, head
Tenochtitlan c 1500 basalt;
12-3/16
KUBA pl 23A; NMAT 46
MeMN

Dog stone
CHENSW 444 MePu

Drum, with eagle decoration
c 1500 wood
KUBA pl 17b MeToM

Eagle Knight, warrior's
head in eagle headdress
andesite; 15x12-1/4
AMHI 90; MAS cat 811;
NMAT 46 MeMN

Ear Spools obsidian; crystal;
Dm: 1 to 1-9/16
BL pl L (col) UDCBl

Ehacatl, God of the Wind,
seated figure c 1200/1500
basalt, obsidian; 15-3/8
EXM 314 MeMN

Grasshopper, Chapultepec
red carnelite; 18-1/2x
6-3/4
LOT 63 (col); MAS cat
833 MeMN

Grasshopper red stone; L: 18
BUSH 63 UNNAmM

Head, Veracruz pottery;
3-5/8
BUSH 73 UMCP

Huehueteotl, Fire God,
vessel 250/650 orangeware;
12-1/2
DOC, pl 25 (col) UNNMAI
(16/6067)

Incense Burner, Tlateloco
pottery; 42
LOT 55 MeMN

Jar: Lizard relief figure,
Isla de Sacrificios onyx; 9
LOT 68 (col) MeMN

Jar: Monkey onyx; 12-1/2
BL pl LI UDCBl

Kneeling Woman c 1500
basalt
KUBA pl 23B UNNAmM

Labrets crystal; L: 2-7/8;
and gold; 1-5/8
BL pl L (col) UDCBl

"El Luchador"
LUN

Maize Goddess (Corn
Goddess), Mexico c 15th c.
basalt
PACHA 219 UNNAmM

--: kneeling figure
NMAS #19 UNNAmM

Male Figure 1325/1521
stone; 13-1/2
UPJH pl 301 UNNMPA

Male Head, dead man,
Veracruz 1324/1521 basalt;
12-1/4x11 MAS cat 808
MeMN

Maquilxochitl 1200/1521 lava;
13
SMI 9 UDCNMS
Mask mosaic
GAUN pl 17 (col) ELBr
Mask: Male Head, pierced
ears grey green stone;
4-1/4
DIS 91 (col) SwBV
Mask; back: glyph for "Two
Reed" year 1507 green
stone; 7-1/4
BL pl XLIII (col), 242
UDCBl
Monkey, God of Dance
basalt; 11-3/4x7-7/8
MAS cat 829
National Stone of Mexico
SPI-2: pl 44
Necklace: 18 Skulls shell,
hematite inlay; bead
H: 15/16; L: 16-3/4
BL pl XLVI (col) UDCBl
Pendant: Rattlesnake, with
Human Head between Jaws
blackstone; 4-1/4
BUSH 63 UMCP
Plumed Coyote basalt; 21-
5/8x9
MAS cat 830 MeMN
Priest of Xipe, in skin of
sacrificed victim H:
15-3/4
LOT 61 (col) SwBV
Puma; Jaguar andesite; 11;
10-1/8
NMAT 51 MeMN
Pyramid of Sacred Warfare,
site of Montezuma's
Palace (stone model)
c 1500 H: 48
KUBA pl 15B MeMN
Quetzalcoatl (Feathered
Serpent; Plumed Serpent)
basalt; 9-7/8
EXM 364 MeMN
Quetzalcoatl stone; 22-1/2
NPPM pl 101 UNNMPA
(57. 242)
--: Poised to Strike
basalt; 13-3/4x3-7/8
MAS cat 817 MeMN
--: With Human Head
porphyry
LARA 100 FPH
--: abstract frieze
LUN MeX
--: bust
PAG-1: 135

--: feathered serpent altar
stone
VALE 127 MeMN
--: frieze detail, Temple of
Xochicalco
BAZINH 52 MT
--: head, Great Pyramid
SPI-2: pl 40 MeM
--: head, Tenochtitlan 14th
c. volcanic stone; 22
DENV 111 UCoDA
(NW-499)
Rattlesnake stone; 13-1/4
CHENSW 445; NPPM
pl 102 UNNMPA (57. 2)
Reclining Jaguar andesite;
9-1/2x17-3/8
MAS 834 MeMN
Sacrificial Knife obsidian
blade, mosaic on wood
handle
PAG-1: 133 UNNAmM
--: with eagle warrior
chalcedony blade, wooden
handle with mosaic of
malachite, turquoise,
shell; L: 13-3/8
AMHI 94 (col); BUSH
66-67 (col) ELBr
Sacrificial Temple Pyramid
(Teocalli) jade; 1-3/4
BUSH 59 UMCP
Seal: Monkey red pottery;
1-7/8
BUSH 70 UMCP
Seated Man stone
CHENSW 443 FPH
Seated Monkey, Tacubaya
15th c. stone
CLE 292 UOClA (54. 125)
Seated Rabbit jadeite;
c 7-1/8
BL pl XXXIX (col),
XXXVIII UDCBl
Serpent Head black
olivine basalt; L:
14-1/16
BL pl XLI UDCBl
"Seven Serpent" Corn
Goddess, kneeling figure
basalt; 14-9/16
NMAT 49 MeMN
Shield Stone
SPI-2: pl 43 MeC
Skull hollow crystal;
2-11/16
BL pl XLVIII (col) UDCBl
Skull jadeite; 2-1/2
BL pl XLVIII (col) UDCBl

Xipe Totec: In Skin of
 Sacrificed Captive, rear
 view stone; c 9-3/8
 BL pl XLV (col), XLIV
 UDCBl
Xipe Totec, head shell;
 2-1/8
 BL pl XLVI (col) UDCBl
Xipe Totec, head stone;
 4-1/8
 DIS 86 (col) NASt
Xipe Totec, head 15th c.
 H: 8-3/4
 MU 106 UPPPM
Xipe Totec: Mask 15th c.
 basalt; 9
 BUSH 60; CHENSN 597;
 CHENSW 443; GRIG pl
 130; KUBA pl 18
 ELBr
--reverse
 GRIG pl 131
Xipe Totec, seated figure of
 "Flayed Lord" in human
 skin ptd stone; 15-3/4
 DIS 96 (col) SwBV
Xochipilli ("Flower Prince";
 "Prince of Flowers"),
 God of Flowers, Dance,
 Games, Music and
 Happiness
 LUN
--: Tlalmanalco 1324/1521
 andesite; 31-1/8x15-3/4
 MAS cat 798 MeMN
--15th c.
 CLE 292 UOClA (49.555)
--: seated figure
 LARA 106 MeMN
--: seated figure
 c 12th c. stone; 10-7/8
 EXM 162 UOClA
--: seated figure 14/15th c.
 basalt; 21-3/4
 GRIG pl 129 ELBr
--: seated figure 15th c.
 volcanic stone; 29-1/2
 LOM 86 (col) GMaV
Xolotl, guide of the dead
 on their netherworld
 journey, and incarnation
 of planet Venus--repre-
 sented as a skeleton neph-
 ritic stone; 11-1/4
 DIS 101 (col) GStL
(loan from GStWL)
Young God stone
 CHENSW 443 MeMN

Young Man, Tamuin
 LUN
AZTEC, or MIXTEC
 Mask: Human Face wood,
 with turquoise and shell
 mosaic; 7-1/4
 LOT 64 (col) IRPr
Aztec. Hord
AZUMA, Kengiro (Japanese 1926-)
 MU 5-56 1962 bronze;
 22-1/8 (with base)x
 12-1/4
 NMAJ 68 IMTon
 MU S-116 1963 bronze;
 30-5/8x18-1/4x9-1/4
 NMAJ 69 IMTon
AZUME (Goemai, or Ankwe Tribe,
 Nigeria d c 1950)
 Woman terracotta; 11-3/4
 FAAN pl 133 ELBr
 Woman, seated figure 20th c.
 pottery; 18
 FAA 74 ELBr

B, Miss
 Slobodkin. Miss B., head
B15. McDowell, B. C.
B. G. Red, Price, K.
BLT. di Suvero
Baal
 Phoenician. Baal#
 Syrian. Baal with Lance,
 relief
Baashamin
 Palmyrene. Three Gods:
 Aglibol, Baashamin,
 Malakbel, relief
BABAN See AFRICAN--BABAN
BABBAR
 Ancestor Figure, with
 geometric design wood;
 17-1/2
 MUE pl 73 SwBeH
 (Baber 3)
Babe (Legendary Blue Ox)
 Pippinger, R. Paul Bunyan
BABEMBE See AFRICAN--BABEMBE
The Babes in the Wood. Crawford
BABINDJI See AFRICAN--BABINDJI
BABOA See AFRICAN--BABOA
Baboons See Monkeys and Apes
Baby. Manship
Baby, head. Roman--Empire
Baby and Frog. Recchia, R. H.
Baby Boy. Marisol
Baby Girl. Marisol
Baby Goat. Fraser, L. G.
Baby Head. Beach

Kudurru, or Boundary Stone,
of Melishipak II, King of
Babylon, Susa c 1200
B. C. black limestone;
.68 m
CHARA-1: 98; LARA 140;
WOOLM 171 (col) FPL
Mace Head, surmounted by
animal, Tepe Hissar III
copper
MALL 123
Mastiff, Sumu-ilum vase, Larsa
stone; 3-1/2
FRA pl 67B FPL
Mother-Goddess, Tepe Hissar
III alabaster, with copper
head rings
MALL 123
Mother Goddess, Ur 2nd mil
B.C.
FEIN pl 40 UPPU
Moufflon, bowl fragment,
Ishchali stone; 4-1/2
FRA pl 67A UICUO
Musicians: Woman; Monkey
terracotta
LAWL pl 105A ELBr
Old Palace of Babylon Throne
Room Facade: Lions;
Palms 1580 B. C.
colored glazed brick; 40'
BERL pl 104 (col); BERLES
104 (col); GBSBeV
--Lion
GARB 89 (col)
Processional Way, detail
(restored) 1580 B. C.
original street: 17x328
yards
BERL pl 99; BERLES 99
GBSBeV (VA Bab 1379-1407)
--Lion(s)
GARDH 85; PRAEG 113;
RAY 9
--Lion
TOR 18 CTRO (937. 14. 1)
--Lion terracotta; L: 53
BRIONA 55 FPL
--Lions colored glazed
bricks; 118-3/4
BERL pl 101 (col);
BERLES 101 (col) GBSBeV
(VA-Bab 1383-84)
--Lion enameled tile; 40x81-
3/4
FAIN 33; YAH 7 UCtY
--Lion of Ishtar colored
glazed brick; W: 92
BOSMA pl 30 (col) UMB
(31. 898)

--glazed brick; 38-1/4x89-1/2
CHENSN 34; NM-2: 30
UNNMM (31. 13. 2)
--glazed brick
CHENSW 75 URPD
Seal, Babylonian Collection
CHENSW 63 UCtNhR
Spearmen, Susa, relief, c 500
B. C. colored glazed
artificial sandstone; 183 cm
BERLES 100 GBSBe
(VA 14647)
Stele of Hammurabi 1728/
1686 B. C. black basalt;
88-5/8
BAZINH 19; CHAR-1: 54;
GARB 42; LARA 163 FPL
--Hammurabi Receiving Law
from Sun God Shamash
black basalt; 28
CHAR-1: 55; FRA pl 65;
UPJH pl 11A
--Code of Hammurabi
BAZINW 105 (col); HUYAR
77; JANSH 56; JANSK 88;
LARA 118; LLO 130;
MYBA 47; WOOLM 99
--Hammurabi Code, with in-
scription of Code
GAU 33-35
Stele of Ur Nammu III: King-
ship Conferred by Gods
(reconstructed) c 2100 B. C.
limestone; 10x5'
MALL 110 UPPU
--fragment
GARDH 75
Susa Vase, with Goat stone; 30
FRA pl 68C FPL
Two Divinities Escorting King,
relief
MARQ 32 GB
Votive Plaque early 2nd mil
B. C. terracotta, from
mold; 5-3/16
NM-2: 16 UNNMM (48. 104. 1)
Warad-Sin, King of Larsa,
foundation figure c 1825
B. C. bronze; 10-1/4
BOSMA pl 11 UMB (37. 1151)
Weight: Lamb 2nd mil B. C.
stone; L: 8-1/2
YAH 13 UCtY
Bacchanale
Greco-Buddhist. Bacchanalian
Relief
Indian--Kushan--Gandhara.
Bacchanalian Frieze
Indian--Kushan--Mathura.
Bacchanalian Scene

Tetradrachma: Euthydemus--
in old age 1320 B. C. silver
RTC 133 ELBr
20-Stater Coin: Eucratides,
King of Bactria 167/159 B.C.]
ROW pl 30 FPBN
Wine(?) Bowl, repousse:
Eagle; and Anath Cycle
Scenes, Seleucid silver;
Dm: 8
POM 33 -Ke
Yakshi: Begram 1/4th c.
ivory
RTC 125 PaKM
Bad Day at Shattuck. Voulkos
Badges
African--Ashanti. Badge of
King's Minister
(Akrafokonmu)
African--Bawongo. Cere-
monial Adze: Badge of
Carver
BADII, Libero (Italian-Argentinean
1916-)
Liberty 1961 bronze; Dm: 20
WALKA 29
Night and Day 1957 bronze
MAI 16
BADJOKWE See AFRICAN--BADJOKWE
BADLAM, Stephen See SKILLIN,
Simeon, Jr.
Badunga Society
African--Basundi. Badunga
Society Initiation Mask
BAERER, Henry
Beethoven, bust 1884 bronze
SALT 74 UNNCentM
Beethoven, bust 1894 bronze
SALT 132 UNBP
General Fowler 1902 bronze
SALT 118 UNNFo
General Warren 1896
SALT 126 UNBP
John Howard Payne, bust
1873 bronze
SALT 130 UNBP
Baetyli
Bronze Age--England.
Baetylus, Folkton
Tumulus
BAFO See AFRICAN--BAFO
BAGA See AFRICAN--BAGA
Baga Bird. African--Guinea,
French
Bags Down. Chamberlain, J.
Bahian Negress. Hamar
BAHOMA See AFRICAN--BAHOMA
Bahram Gur
Persian. Bahram Gur Hunt-
ing with Falcon

Persian. Medal: Bahram Gur
Enthroned, and Hunting
Persian. Mirror Back:
Bahram Gur and Azada
BAHUANA See AFRICAN--BAHUANA
BAILLAIRGE, Francois (Canadian
1759-1830)
St. Ambrose, relief wood;
79-1/2
CAN-4:41 CLA
St. John the Evangelist c 1800
wood, gilt; 10-3/4
CAN-3:343; CAN-4:37 CON
The Virgin c 1800 wood, gilt;
10-3/4
CAN-3:342; CAN-4:37 CON
(6773)
Virgin and Child c 1800
fruitwood; 26
CAN-4:37; HUB pl 13 UMiD
BAILLAIRGE, Francois--ATTRIB
Doves Drinking wood applique
relief, gilt; 6
HUB 9 COB
BAIN, Robert (South African)
Port Elizabeth Reserve Bank
Doors, bronze; 12'
NEWTEB pl 5
BAIZERMAN, Saul (Russian-American
1889-1957)
The Artist's Mother, head
1940/49 hammered
copper; 13
DETS 28 UNNH
Aurora 1950/57 hammered cop-
per FAUL 463 UNNWo
Bust of a Woman hammered
copper; 23
UIA-6:pl 51
Crucifixion, relief 1947/52
copper; 8'
UIA-8:pl 22
Eve 1937/39 hammered
copper; 1.20 m
SCHW pl 35
Exuberance, relief 1932/39
hammered copper; 1.6x2 m
BRUM pl 7; PEAR 105;
RICJ pl 32; SCHW pl 36
Firebird 1950/57 hammered
copper
MEILD 149 UNNWo
Head of a Young Woman 1935
copper; 15
RICJ pl 33
Italian Woman 1920 bronze;
6-1/2
RICJ pl 31
Lovers hammered copper
NYW 183

Machine Man ("City People"
 Series) plaster
 SGO-2:pl 1
March of the Innocents,
 relief hammered copper
 ROTH 893; SGO-1:pl 1
Mediterranee 1951/55 cop-
 per; L: 36
 WHITNF 7:27 UNNColi
The Miner hammered copper
 CHICA-60:#6
Nana 1938 hammered copper;
 96
 NNMMARO pl 285
Nike 1949/52 hammered
 copper; 66
 AM # 56; SPA 154 UMnMW
Road Builder's Horse 1921
 RICJ pl 31 UNNW
Serenity 1937
 PEAR 105
Silence
 PAA-49
Slumber 1948 hammered
 copper; L: 40
 GOODA 137; PIE 383;
 WHITN 30 UNNW (48. 20)
Suckling hammered copper
 SGT pl 1
Ugesie 1936 copper; c 60
 PAA 52; RICJ pl 33
Vestal 1955 hammered
 bronze; 37
 MAI 17; SEITC 170 UNNLi
BAJOKWE See AFRICAN--BAJOKWE
Bajorelieve. Zuniga, F.
Baked Potato. Oldenburg
BAKER, Bryant (English-American
 1881-)
 L'Apres-Midi d'Un Faune
 1934 Tennessee marble;
 81
 BROO 250 UScGB
 Casat Rodney, gift of State
 of Delaware marble
 MUR 22; USC 255
 UDCCapS
 Edward D. White, bust
 FAIR 369; USC 187
 UDCCap
 John M. Clayton, gift of
 State of Delaware marble
 MUR 22; USC 234
 UDCCapS
 Pioneer Woman bronze
 NATSS-67:2
 Thomas Alva Edison, bust
 bronze HF 80, 84 UNNHF

Thomas Jonathan Jackson,
 bust bronze
 HF 101 UNNHF
William Crawford Gorgas,
 bust bronze
 HF 77 UNNHF
William E. Borah, gift of
 State of Idaho bronze
 MUR 28; USC 230
 UDCCapS
William Howard Taft, bust
 marble
 USC 187 UDCCap
Young Lincoln, seated on
 oak log 1935 bronze
 BUL 194 UNBu
Baker, Edward Dickinson (American
 Soldier and Statesman
 1811-61)
 Stone, H. Edward Dickinson
 Baker
BAKER, George P. (American
 1931-)
 Aluno 622 welded aluminum;
 21x28
 HARO-1:11
 Dome-632 1963 bronze;
 14-3/4x13-1/4x11-1/4
 WHITNW 45 UNNW
 Neres
 CALF-59
 Ram's Head stone
 NYW 179
 Second Waiting 1963 bronze;
 L: 22
 LYT UCLLy
 Spiral bronze; 9-1/4
 WHITNA-18:17
 Spiral 1966
 KULN 121
 Watcher 1965
 KULN 121
Baker, Josephine
 Calder, A. Josephine Baker
BAKER, Robert (American)
 Chapel Tympanum
 AUM 76 UNjP
BAKETE See AFRICAN--BAKETE
Baking See Cooking and Food
 Preparation
Bakira
 Japanese--Tempyo. Twelve
 Guardian Kings of
 Yakushi, two figures:
 Bakira, and Indara
BAKONGO See AFRICAN--BAKONGO
BAKOSI
 African--Benjabi. Mask

BAKOTA See AFRICAN--BAKOTA
BAKOUELE See AFRICAN--
 BAKOUELE
Baku, the Dream-Eater (Elephant-
 Ox-Lion)
 Japanese--Tokugawa. Netsuke:
 Baku Mounted by Sage
BAKUBA See AFRICAN--BAKUBA
BAKUNDU See AFRICAN--BAKUNDU
BAKWELE See AFRICAN--
 BAKWELE
Bala, Friar
 Indian--Kushan--Mathura.
 Boddhistattva Sakyamuni,
 dedicated by Friar Bala
Balaha
 Khmer. The Horse Balaha,
 detail
Balancing. Gross
Balancing Toy. Folk Art--American
Balarma
 Khmer. Krishna and Balarma
Balbal (Stone Dame)
 Soghdian. Balbal
Balbinus, Decimus Caelius Calvinus
 (Roman Emperor d 238)
 Roman--3rd c. Balbinus#
 --"Sarcophagus of
 Balbinus"
 --Sarcophagus of Junius
 Balbus and Maecia Faustina,
 parents of Emperor
 Gordian III
Balbus (Roman Consul fl 1st c.
 B. C.)
 Roman--1st c. B. C.
 Balbus, equest
BALEGA See AFRICAN--BALEGA
BALI See AFRICAN--BALI
BALINESE
 Garuda 19th c. ptd wood;
 29-3/4
 DENV 177 UCoDA (O-419)
 Elephant's Cave, Goa Gadjah,
 with Grotesque: Witch's
 Mask
 LEEF 247 IndBB
 Gunungan, Wayang-Kulit
 H: 21
 WAG 134 (col) NAT
 Horse and Rider wood; 18
 WAG 211 (col) NAT
 Kneeling Figure
 CASS 100 ELRow
 Kris Stand with Kris 18th c.
 Kris: 25-3/4 (in scabbard);
 stand H: 23-1/4
 NM-3:30 UNNMM
 (36. 25. 1273a, b 1276)

Man with Dog 20th c.
 wood; 7
 WAG 222 (col) NAT
Ornamented Temple: Hindu
 Gods
 WAG 203 (col) IndBBa
Peace, Southwest Foyer,
 General Assembly
 Building satinwood; 36
 BAA pl 18 UNNUN
Singa--winged lion ptd wood;
 19-1/4
 WAG 207 (col) NAT
Terrace Stairway with
 Entrance Gate
 WAG 189 (col) IndBK
BALL, Thomas (American
 1819-1911)
 Charles Sumner 1877 bronze
 CRAVS fig 7. 6 UMBG
 Daniel Webster 1876 bronze
 SALT 76 UNNCent
 Daniel Webster, bust 1853
 plaster
 CRAVS fig 7. 2 UMBA
 Daniel Webster, bust 1868
 marble; 30
 EA 463; UNNMMAS 21
 UNNMM (13. 214)
 Emancipation Group (Lincoln
 Freeing the Slaves)
 1875/76 bronze
 BUL 149; CRAVS fig 7. 5;
 PAG-9:29; 12: 185;
 PIE 377; TAFT 146
 UDCLP
 George Washington, equest
 1864 (cast 1869) bronze
 CRAVS fig 7. 4; PIE 377;
 POST-2:230; TAFT 143
 UMBG
 Henry Clay 1858 bronze;
 31-1/2
 CRAVS fig 7. 3 UNcRA
 Lincoln Memorial 1876
 BUL 149 UMBPa
 Peace in Bondage 1863
 TAFT 140
 Reverend Ephriam Peabody,
 bust c 1855 marble
 CRAVS fig 7. 1 UMBK
Ball. Acton
Ball-Court Marker. Maya
Ball Games See Games and Sports
BALLAINE, Jerry (American
 1934-)
 H. and Hardart No. 14
 plastic lacquer; 50x60x12
 WHITNA-19:fr cov

Dream Blossoms
 HARTS pl 44
God Pan (Pan)
 CAF 28; HARTS pl 22
 UNNCo
The Hewer 1902 marble
 CAF 29; DODD 66; HARTS
 pl 7; PAG-12:206; TAFT
 362 UICa
Maidenhood 1896 marble; 36
 BROO 42; MCSPAD 194;
 TAFT 370 UScGB
Man and the Serpent
 HARTS pl 42
Pennsylvania State Capitol:
 Left Entrance Relief--
 Brotherly Love (Brother-
 hood), and Burden of
 Labor (Burden of Life;
 Work) 1917
 CHASEH 515; LAF 231;
 ROOS 244A-B; TAFTM
 123 UPHCap
--Burden of Labor
 POST-2:256; TAFTM 123
--Kneeling Figure
 TAFTM 126
Prodigal Son
 TAFTM 126 UPHCap
--1906 marble; 37
 MUNSN 148 UPPiC
The Refugee c 1930
 marble; 48
 NMAP #120; PIE 383 UNNCl
Rising Woman marble
 CHENSP 301; PAG-12:
 205; RICH 190 UNNRoj
Un Souffle de Lointain
 HARTS pl 50
Struggle of the Two Natures
 of Man (I Feel Two Natures
 Struggling Within Me--
 reputedly suggested by
 Victor Hugo's poem, "Je
 Sens Deux Hommes en
 Moi"; The Two Natures
 1894 marble; 126
 CRAVS fig 12.15; DODD
 65; HARTS pl 22; HOF 66;
 LARK 281; MCSPAD 200;
 MEN 487; NM-11:68; RAY
 66; TAFT 357; UNNMMAS
 87; UPJH pl 276 UICA;
 UNNMM (96.11)
Two Friends, memorial
 CAF 34; HART-2:61;
 HARTS pl 42
The Unbroken Law 1902/10
 marble CRAVS fig 12.16
 UPHCap

Woman
 TAFT 545; TAFTM 126
 UNNMM
BARNES, Samuel T. (American)
 Wild Swan Decoy c 1890
 wood ptd white, black
 beak; L: 33-1/2
 LIPA pl 124 UNNBarb
Barney's Beanery. Kienholz
BARNHORN, Clement John
 (American 1857-)
 Boy Pan with Frog
 ACA pl 246; SFPP
 Madonna plaster replica of
 limestone original in St.
 Mary's Church, Chicago
 NATSA 16; PAG-12:199
 UKyCovM
 Maenads' Dance, relief
 HARTS pl 59
 Magdalen
 TAFT 520 UOCiM
Baron's Moon. Smith, D.
Baroque. Anderson, John
BAROTSE See AFRICAN--BAROTSE
Barr, Clayre
 Alferez. Clayre Barr, head
BARR, David (American)
 Construction No. 50
 laminated pine; cube: 12
 HARO-2:7
 Relief Construction No. 20
 copper-faced, ptd wood;
 Sq: 30
 HARO-2:7
Barrakab (Barrekub) (King of
 Zinjirli)
 Assyrian. King Barrakab and
 his Scribe
 Assyrian. Stele of Barrakab
BARRETT, Oliver O'Connor (English-
 American 1908-)
 The Angry Carpenter 1949
 PEAR 134
 Don Quixote 1949
 PEAR 135
 Erl King English elm
 SGO-10:2
 Requiem, relief Nopowood
 BRUM pl 8 UDCDo
BARRON, Harris
 Akaad--1 bronze; 22
 ROODT 81
Barry, John (American Naval
 Officer 1745-1803)
 Boyle, John Barry
 O'Connor, A. Commodore
 John Barry
BARSOTTI, Hercules (Brazilian)
 Construction SAO-5

116 BART, Robert

BART, Robert (American 1923-)
 Untitled aluminum; 84
 WHITNA-18:18
 Untitled 1965 aluminum
 alloy; 67x67x72
 WHITNS 35 UNNW
BARTHE, Richmond (American 1901-)
 Blackberry Woman 1932
 bronze
 DOV 148; LARK 393; SGO-
 2:pl 3 UNNW
 Booker T. Washington, bust
 1945 bronze
 DOV 148; HF 44 UNNHF
 Boxer 1942 bronze; 16
 UNNMMAS 174 UNNMM
 (42.180)
 Boy Seated plaster
 SGO-4:pl 1
 Exodus; Dance, reliefs 1938
 marble
 DOV 100 UNNHarl
 Feral Benga
 DOV 148
 General Dessalines, equest
 DOV 147 HaP
 George Washington Carver,
 bust
 DOV 7 UTNF
 Henry Tanner, bust 1928
 DOV 177 UInGL
 John Gielgud as Hamlet, bust
 bronze
 SGT pl 2
 Laurence Olivier as Hotspur,
 bust
 DOV 150
 Mary
 DOV 148 UNNIb
 The Mother plaster
 NYW 178
 Negro Dancing Girl
 HOF 149
 The Negro Looks Ahead
 DOV t
 Ram Gopal (Dance of Siva)
 DOV 149 -ULo
 Shoe Shine Boy 1938
 DOV 148 UOOC
 Wetta 1933
 DOV 148 UNNHarm
BARTHOLOMEW, Edward Sheffield
 (American 1822-58)
 Frederick Marquand, bust
 marble; 29-1/8
 YAPO 74 UCtY
 Millard Fillmore, bust 1856
 plaster; 32
 CRAVS fig 9.5 UMdBMH

 Sappho c 1856 marble; 68
 CRAVS fig 9.6 UCtHWA
BARTLETT, Paul Wayland
 (American 1865-1925)
 Apotheosis of Democracy
 (Democracy Protecting
 the Arts of Peace): Peace
 Protecting Genius; Agri-
 culture and Industry, East
 Front Pediment, House
 Portico 1911/16
 12xc 60'
 FAIR 483; PIE 383; USC
 379 UDCCap
 --Peace Protecting Genius,
 center group
 FAIR 482 ; MCSPAD 166
 The Bear Tamer 1887
 bronze; 68-1/2
 CRAVS fig 12.5 UDCC
 The Bear Trainer (The
 Bohemian; Bohemian
 Bear Tamer) 1887 bronze;
 68-1/2
 MCSPAD 156; RAY 66;
 UNNMMAS 90 UNNMM
 (91.14)
 Charles Grafly, head
 WHITNC 218 UNNW
 Christopher Columbus
 HARTS pl 23; TAFT 384
 UDCL
 Fledgling 1895 bronze; 3-3/4
 BROO 32 UScGB
 Ghost Dancer (Dancing
 Indian)
 HARTS pl 58; TAFT 375
 UPPPA
 Lafayette, equest 1908
 bronze
 HARTS pl 51; PAG-12:206;
 PERR 131; SFPP; TAFT
 379; TAFTM 127 FPCar
 --: reduced replica of
 Louvre courtyard original
 1899/1907 bronze
 CRAVS fig 12.4 UDCC
 Main Entrance Frieze:
 History, Philosophy,
 Romance, Religion,
 Poetry, Drama c 1905
 marble
 PIE 384 UNNPL
 --Philosophy, History,
 Romance, Religion
 TAFTM 127
 Michelangelo
 CAF 92; CRAVS fig 12.6;
 DODD 77; HARTS pl 23;
 TAFT 372 UDCL

Robert Morris plaster
 NATSA 19
Soldiers' and Sailors'
 Monument
 PAG-13:227 UMnD
Speaker's Lobby Tablet
 FAIR 279 UDCCap
Wounded Lion
 HARTS pl 58
 Portraits
Grafly. Paul W. Bartlett,
 bust
Bartlett Aphrodite
 Greek--4th c. B. C.
 Aphrodite
Bartlett Head
 Greek--4th c. B. C.
 Aphrodite
BASANEZ ROCHA, Carlos (Mexican)
 Fire Dance
 IBM pl 22 UNNIb
Baseball See Games and Sports
BASEN, Dan (American 1939-)
 Luncheon on the Grass
 1965 mixed media con-
 struction; 8-3/4x8-1/2
 RHC #1 UNNSto
 Sardine Cans 1964 sardine
 cans, wood, glass; 17-1/2x
 13-1/2x2-1/4
 WHITNS 47 UNNW
BASHONGE See AFRICAN--BASONGE
Basil, head. Zorach
Basile
 Greek--5th c. B. C. Basile
 Abducted from Underworld,
 relief
Basilica Aemilia
 Roman--1st c. Punishment
 of Tarpeia, frieze
Basilica of Maxentius
 Roman--4th c. Tritons and
 Nerieds, frieze
Basilica Ulpia
 Roman--1st c. Victories,
 architrave and frieze
Basins See also Fonts
 Greek--7th c. B. C. Basin
 Supported by Goddesses
 Phoenician. Basin:
 Warriors; Geese; Snakes
BASKERVILLE, Margaret
 (Australian 1861-1930)
 Sir Thomas Bent
 MOO-2:98
Basket Capitals# Coptic
Basketball. Spampinato
Basketry Mark. New Guinea

BASKIN, Leonard (American 1922-)
Angry Angel
 SPA 80 UNUtM
Apotheosis wood
 WHITNA-17
Barlach, head poplar wood;
 17-3/4
 READCON 27 UNJNBL
Benevolent Angel 1962 birch;
 29-1/4
 MINC UNGloS
Caprice 1963 bronze;
 25x25-1/2x11-3/4
 ALBC-4:77; CUM 49;
 WHITNF-7:52 UNBuA
Dead Man plaster, for
 bronze; 36
 WHITNA-18:19
Great Bronze Dead Man 1961
 bronze; L: 72
 LOND-6:#4 UNNB
The Great Dead Man 1956
 limestone; 70
 SELZN 37
Hanged Man
 LIPW 133
Hephaestus 1963 bronze;
 63-1/4
 CHAN 203; WHITN 80
 UNNW
Isaac, relief 1958 bronze;
 23
 UIA-10:162 UNNB
John Donne in his Winding
 Cloth 1955 bronze; 21-3/4
 DETS 30 UNNH
Laureatte Standing 1957
 cherry; 36
 NMAR
Man with Dead Bird 1954
 walnut; 64
 NEWAS 36; PIE 384;
 SELZN 34 UNNMMA
 (25. 57)
Oppressed Man 1960 ptd
 pain; 31
 GOODA 192 UNNW
Owl 1960 bronze; 20-1/2
 READCON 228 UNNH
Poet Laureate 1956 bronze;
 9
 CHENSW 499; SELZN 36;
 UIA-8:pl 33 UNNNe
St. Thomas Aquinas wood
 CHENSW 500 UMnCJ
Seated Man 1956 bronze;
 13-1/2
 SELZN 38 UNNHel

Seated Man with Owl 1959
ART 207; LIPW 135 UMNSA
Seated Woman 1961 oak; 54
CARNI-64:272; UIA-11:113
UMBMi
Tiresias 1963 bronze; 53x24
SELZS 180 UNNB
Walking Man 1955 oak; 17-1/2
SELZN 38 UMSpB
BASONGE See AFRICAN--BASONGE
BASS, Thomas (Australian 1916-)
Trial of Socrates copper
deposit on plaster; 9x14'
BON 71 AuMU
BASSANGE See AFRICAN--BASONGE
Bassus, Junius
Roman--4th c. Sarcophagus of
Junius Bassus
Bastet, cat-headed goddess
Egyptian--Ptolemaic. Cat-
Figure of Bastet
--Bastet, seated cat with
golden earrings
Bastien-Lepage, Jules (French
Artist 1848-84)
Saint-Gaudens. Jules Bastien-
Lepage, relief
BASUKU See AFRICAN--BASUKU
BASUNDI See AFRICAN--BASUNDI
Basu Sen (Basu Sennin)
Japanese--Kamakura. Basu
Sennin#
Basuto Boy. Palmer, R.
Bat Gods
Indians of Central America--
Panama, or Costa Rica.
Pendant: Bat God
Quimbaya. Stylized Bat
God(?)
BATAK
Magic Wand (Tunggal Panaluan),
with mythological carving
wood, hair, feathers;
67-3/4
MUE pl 64-66 NAT (1653-1)
Man Seated on Mythical
Animal--The Singa, lid of
magic horn, Sumatra
wood; 12
MUE pl 67 NAT (137-599)
BATANGA See AFRICAN--BATANGA
BATEKE See AFRICAN--BATEKE
BATEMAN, John, and A. S. CALDER
Caryatid, Court of Palms
PERR 91
BATES, Gladys Edgerly (American
1896-)
Morning 1935 plaster; 29
CHICH pl 78; CHICA-46:#236

Bath Gorgon. Roman--2nd c.
Bathers
Archipenko. The Bather
Archipenko. Bathing Woman
Cashwan. Bather
Cavallito. Bather
Doidalsas. Aphrodite Bathing
Glinsky. Bather
Greek--6th c. B. C. Woman:
Holding Ewer and Basin
Greek--5th c. B. C.
Woman: Bathing in Tub
Konzal. Bather
Lentelli. Bagnante
Lentelli. The Bather
Lipchitz. Bather#
McGrath, E. The Bathers
Marisol. The Bathers
Rosin, H. Bather
Rudy, C. Bather
Slobodkin, L. Bather
Stewardson. The Bather
Tabata. Bathing
Bathing Figure. Brann
"Bathing-Hut" Shrine, model. Boetian
Bathsheba
Slobodkin. Bathsheba
Bathtub Collage. Wesselmann
Bathtubs
Roman. Granite Bath
Bato Kwannon (Horse Headed)
See Kwannon
Baton de Commandement.
Paleolithic
Batons See Scepters
Bats
Indians of Central America--
Costa Rica. Pendant: Bat
Indians of Mexico. Bat
Indians of South America--
Colombia. Man with Bat
Attributes
Indians of South America--
Ecuador. Bat
Indians of South America--
Peru. Bat
Stevens, L. T. Bat
Toltec. Bat, relief
Totonac. Palma; Bat-Man
Zapotec. Mask: Vampire Bat
BATSHIOKO See AFRICAN--
BATSHIOKO
BATTAINI, Ambrose (American)
Head cement
NYW 178
BATTENBERG, John N. (American
1931-)
Johnny's First Trip 1966 cast
aluminum; 95x77x58
UIA-13:40 UCLR

Battering-Rams
 Assyrian. City Attacked with
 Battering Ram, relief
 Greek--5th c. B. C. Bat-
 tering Ram
 Roman--2nd c. Column of
 Trajan: Dacians Attack
 Roman Camp
BATTERSON, James Goodwin
 William Jenkins Worth
 Monument, equest in
 granite obelisk bronze
 obelisk H: 50'
 SALT 44 UNNMad
Battle-Field Palette. Egyptian--
 Predynastic
Battle Hymn of the Republic.
 Rocklin
Battle of Plattsburgh Centenary
 Medal. Swanson, J. M.
Battle of Potidaia
 Greek--5th c. B. C.
 Epitaph for Athenian
 Fallen in Battle of
 Potidaia, inscription
 fragment
Battle of Princeton
 MacMonnies, F. Washington
 at the Battle of
 Princeton, relief
Battle of San Romano. Prince, R.
Battle of the Amazons. Hebald
Battles See War and Battles
BAUDIN, Edmond
 Bronze Stairway: Eagles
 and Putti 1857/59
 USC 358, 359 UDCCap
BAUER, Dennis
 Untitled welded steel
 MEILD 118 (col)
BAUER, Sol A. (American)
 Slav Dancer wood
 NYW 182
BAUER, Theodor (American)
 Fountain, sketch
 HARTS pl 55
BAUERMEISTER, Mary (American
 1934-)
 All Things Involved in All
 Other Things ptd wood,
 glass; 90x60x45
 WHITNA-19
 No Faces glass
 WHITNA-17
 No More Straws 1965 canvas
 on wood, with plastic
 drinking straws, photo-
 graphs, honeycombs,

wooden spheres, lenses
 on plexiglass
 RHC #2 UNNBoni
BAUM, Don
 A Pony Ride 1962 driftwood,
 work boards, paper,
 child's plastic horse
 fragments
 MEILC 62
 La Somnambule 1962 drift-
 wood, turned wood,
 mannequin head
 MEILC 61
 The Tickler 1962 weathered
 wood; worn brushes,
 rubber tubing
 MEILC 62
BAUM, Max (American)
 Blind Beggars
 DEYF #250
BAVILI See AFRICAN--BAVILI
BAWONGO See AFRICAN--
 BAWONGO
BAXTER, John (American 1912-)
 Instruments at the Silence
 Refinery 1960 driftwood,
 shells, stones, metal;
 16-7/8x24-3/8
 SEITA 141 UCSaC
 Phoenix 1951 bronze; 4-1/2
 SFAP pl 7
 Summer Geese 1961 stone
 and wood; 6
 UIA-11:50 UCSFC
 Yellow Harpy
 SFAF
BAY, Juan (Argentine 1892-)
 Estructura Pictorica Madi
 ABAM 82
BAYAKA See AFRICAN--BAYAKA
BAYANZI See AFRICAN--BAYANZI
Baylor, Courtnay
 Cresson. Courtnay Baylor,
 head
Bayon. Khmer
Bayonet Menacing Flower.
 Calder, A.
Be Kind to Animals. Montelbano
BEACH, Chester (American
 1881-1956)
 Actors Fund Medal: Actors;
 Masks of Comedy and
 Tragedy 1910 bronze;
 Dm: 2-1/2
 MUNSN 146 UNBrB
 Asa Gray, bust bronze
 HF 66 UNNHF
 Baby Head
 TAFTM 136

Beyond
 ACA pl 203; SFPP;
 TAFTM 137
The Big Wave c 1912 bronze;
 16
 MUNSN 153 UNBrB
Children's Year Medal,
 United States Children's
 Bureau bronze
 NATSA 270
Crying Baby
 TAFTM 136
The Early Ages, Altar Tower,
 Court of Ages
 PERR 69 SFPP
Eli Whitney, bust bronze
 HF 89 UNNHF
Fountain: Pan
 CHICA-40
Fountain of the Waters (The
 Rivers Fountain)
 NATS 25 UOC1A
Glint of the Sea colored
 plaster
 NATSA 20
Head in Gray marble
 TAFTM 136
Karl Maria von Weber, bust
 1907
 SALT 146 UNBP
Oscar W. Underwood, bust
 marble
 USC 193 UDCCap
Peter Cooper, bust bronze
 HF 135 UNNHF
Sacred Fire
 TAFTM 137
Samuel Finley Breese Morse,
 bust bronze
 HF 87 UNNHF
School Art League Saint
 Gaudens Medal for
 Draughtsmanship, uniface
 1917 bronze
 NATSA 270
Sea Horses
 PAA 25
Service to the Nation
 NATS 24
Surf marble
 NYW 177
Sylvan marble; 68-1/2
 BROO 212 UScGB
Unveiling of Dawn marble;
 26
 CHICA-28: MUNSN 154
 UNNMM
Versaille Peace Medal--
 obverse; reverse

silver; bronze
 NATSA 271
Walt Whitman, bust bronze
 HF 34 UNNHF
Wave Head
 TAFTM 136
Woman's Head marble
 PAG-12:220
Beach Figure. Grippe
Beach Scene. Smith, D.
Beaches Wood. Pavia, P.
Bead and Reel
 Greek--5th c. B. C.
 Erechtheum: Moulding
 Bands
BEADLE, Paul (English-Australian
 1917-)
 Bushfire red gum; 18'
 BON 69
Beadle, William Henry Harrison
 (American Educator 1838-
 1915)
 Webster, H. D. William
 Henry Harrison Beadle
Beads
 Michoacan. Tubular Beads
 Olmec. Tubular Beads
Beakers
 African--Bakuba. Ritual
 Palm Wine Beaker:
 Human Head
 Amlash. Beaker: Lions
 Attacking Rams
 Amlash. Marlik Beaker:
 Bulls Flanking Tree
 Chimu. Beaker#
 Inca. Effigy Face Beaker
 Inca. Keru
 Islamic. Beaker
 Mannean. Beaker
 Neolithic--Denmark. Rindum
 Vessel, lugged beaker
BEAL, Sondra (American 1936-)
 Alaska Mary Anne ptd wood
 WHITNA 17
 Between II 1965 H: 48
 SEITC 93
 Winter's Wake 1965 ptd wood
 and motors; 84x63x57
 NYWL 87
BEAN, Bennett (American 1941-)
 Untitled plexiglas; 72x36x
 4-1/2
 WHITNA-19
BEAN, Francis E.
 Black Forest sheet iron; 26
 ROODT 82
Bear Flag Monument. American--
 20th c.

Bear Mother
 Edensaw. Bear Mother
 Delivered by Caesarian
 Section
 Haida. Bear Mother Myth
 Kwakiutl. Totem Poles:
 Thunder Bird; Bear
 Mother
 Tsagay. Bear Mother
Bear Tamers
 Bartlett. The Bear Tamer
 Chinese--Han. Funerary
 Figures: Juggler; Man
 with Bear on a Pole
The Bear Trainer
 Bartlett. Bohemian Bear
 Trainer
Bearded Aphrodite. Cypriote
Bears
 Amateis, E. R. Three Bears
 Bartlett, P. W. Bear
 Trainer
 Bartlett, P. W. Bohemian
 Bear Tamer
 Bufano. Bear and Cubs
 Bufano. Bears
 Cavallito. Polar Bear
 Chapin. Bear Cub
 Chinese--Chou. Bear Tamer
 Chinese--Chou. Seated Bear
 Chinese--Chou. Table Leg:
 Bear
 Chinese--Chou/Han. Seated
 Bears
 Chinese--Han. Bear#
 Chinese--Han. Seated Bear#
 Chinese--Han. Support: Bear
 Chinese--Shang. Squatting
 Bear
 Chinese--Shang. Yu: Bear
 Swallowing Man
 Chinese--Sung. Head Rest,
 relief of Bear Tied to
 Stake
 Davis, Richard. Bear
 Deming. The Fight
 Eskimo. Bear; Seal
 Eskimo. Toy Bears
 Folk Art--American. Bear's
 Head
 Folk Art--American. Door
 Stop: Bear
 Ford. Cinnamon Bear
 Haida. Ceremonial Ladle:
 Bear Decoration
 Haida. Figure with Bears
 Haida. Plate: Bear Crest
 Haida. Shaman's Dance
 Rattle: Bear Head

 Hoffman, E. F. Winnie
 the Pooh
 Indians of North America--
 Alaska. Seated Bear,
 Totem
 Indians of North America--
 Northwest Coast. Dish:
 Bear
 Koryak. Carved Figures:
 Human and Animal--Bear;
 Rabbit
 Kwakiutl. Interior House Post:
 Grizzly Bear
 Manship. Bear
 Manship. Walking Bear
 Marlyk. Bear, ritual vessel
 Paleolithic. Amber Birds
 and Bears
 Paleolithic. Headless Bear
 Prokopiof, B. Grizzly Bear
 Puccinelli, R. Bear
 Roth, F. G. R. Polar Bears
 Rudy, C. Indian and Bear
 Cubs
 Russell, C. M. Bluffers
 Russin, R. I. Polar Bear
 Sassanian. Bear, house panel
 Siberian. Bear Fighting Tiger
 Sosui. Kintaro Mounted on
 Bear, netsuke
 Stewart, A. T. Silver King,
 a polar Bear
 Tlingit. Chief Shakes' House
 Screen: Bear
 Tlingit. Comb, with Bear
 Holding Fish
 Tlingit. Mask: Bear
 Tsimshian. Bear#
 Tsimshian. Shaman's Dance
 Rattle: Raven, Bear, and
 Eagle
 Vagis, P. Bear and Cub
 Walter, C. The Cub
 Walter, E. Primitive Man
 Warnecke, H. Bear Cub
 Warner, H. Bear
 Williams, W. Cub Eating
 Fish
BEASLEY, Bruce (American 1939-)
 Icarus 1962 cast aluminum;
 92x95x50 cm
 FPMO
Beast, Hayes
The Beast Dominant. Wolff, A.
Beasts. Clark, L.
The Beat. Macdonald, J.
Beatrice
 MacNeil, H. A. Beatrice, bust
 Maldarelli, O. Beatrice

Beauregard, Pierre G. T.
(American Army Officer
1818-93)
Buberl. General Beauregard,
equest
The Beautiful Servant. Zadkine
Beauty and the Beast
Laurent. Beauty and the
Beast
Walter, E. Fountain: Beauty
and the Beast
Beauty's Wreath for Valor's Brow.
Couper
Beavers
Haida. Beaver, slate totem
pole
Haida. Ceremonial Dance
Rattle: Beaver Head
Haida. Headdress: Beaver,
with Dragonfly on Chest
Indians of North America--
Northwest Coast. Spoons
Kaskaskia. Beaver Bowl
Kitksan. Beaver, Shaman's
rattle
Tlingit. Beavers, spoon
handle
Tlingit. Halibut Hook:
Beaver
Tsimshian. Beaver, head-
dress ornament
BECKER, Robert B. (American)
Cellist iron
WHITNA-9
BECKMAN, John (American)
Two Ghosts Jitterbugging
plasticum
SCHN pl 135
Beckoning Man. West, T. E.
Bedabenokwa
Daoust, S. Tete de Jeune
Huronne
BEDORE, Sidney
Spirit of the Northwest 1931
stone; 84 (on 48" base)
GRID 19 UWiGC
Bedroom# Oldenburg
Beds
Ceylonese. Bedhead: Animal
Motif
Folk Art--American. Eagle:
Bed Headboard
Folk Art--Brazilian. Figure
Reclining on Bed
Rauschenberg, R. The Bed
Streeter, T. Bed
Bedspring. Dine
Beecher, Henry Ward (American
Clergyman 1813-87)

Corbin. Henry Ward Beecher
Folk Art--American. Cigar
Store Figure: Henry Ward
Beecher
Rhind, M. Henry Ward
Beecher, bust
Rogers, J. The Fugitive's
Story
Ward, J. Q. A. Henry Ward
Beecher Monument
BEECHER, Labans (American)
Andrew Jackson, figurehead
of Constitution, Boston
Navy Yard c 1834 ptd
wood; c 120
CHR 188 (col); LIPA pl
12; PIE 376 UNNMar
(M 52. 11AB)
BEER, Friedrich
Washington Irving, bust 1885
SALT 52 UNNBry
BEER, Kenneth J.
Industrials iron, steel
MEILD 111 UMiD
Beer Drinker. Sanderson, R. P.
BEER SHEBA
Female Head, As-Sakadi ivory
ROTH 57
Male Figure ivory; 33 cm
ROTH 55 IsJA
Pin: Pelican, Abu-Matar
Bowe
ROTH 58
Bees
Cretan. Pendant: Two Bees
with Honeycomb
Egyptian--4th Dyn. Hete-
pheres Funerary Bed:
Hieroglyphs
Egyptian--20th Dyn. Bee-
keeping, relief
Minoan. Pendant: Two Bees
with Honeycomb
Pennsylvania German. The
Swarm of Bees, stove
plate
Beeshekee (Chippewa Warrior),
English translation: Buffalo
Lassalle. Beeshekee, bust
Vincenti. Beeshekee, bust
Beethoven, Ludwig von (German
Composer 1770-1827)
American--20th c. Beethoven,
bust
Baerer. Beethoven#
Crawford. Beethoven
Juszko. Beethoven, seated
figure
BEGG, John (American)
Fish Story HAY 74 UMAP

Beggars

123

Beggars
 African--Baluba. Kneeling
 Female Figure Holding
 Bowl
 Hellenistic. Negro Beggar
BEGHE, Bruno
 Joseph Ward marble
 USC 264 UDCCap
The Beginning. Flannagan
BEGRAM
 Guardian Angel Aspara,
 Afghanistan
 WATT 61 FPG
BEHL, Wolfgang (German-
 American 1918-)
 Goose Girl bronze; 29
 UIA-8:pl 44
Beings, Imaginary See also Animals,
 Imaginary; Grotesques;
 Monsters
 African--Nigeria. Man: Mud-
 fish Head, Holding Snake
 Akkadian. Cylinder Seal:
 Mythological Opposing
 Figures--Horned Bull Man
 and Lion
 Assyrian. Eagle-Headed
 Winged Being Pollinating
 Sacred Tree
 Assyrian. Fantastic Being:
 Winged, with Human Head
 Assyrian. Winged Being
 Assyrian. Winged Genie
 Inca. Gate of the Sun:
 Condor-Headed Human
BEJAR, Feliciano (Mexican 1924-)
 Christ
 LUN
 Virgin and Child
 LUN
Beket-Re
 Egyptian--17th Dyn. Amosis,
 second prophet of Amon
 Re, and his mother,
 Beket-Re
BEKOM See AFRICAN--MENDE
Bel
 Palmyrene. God Bel
BELGIAN CONGO See AFRICAN--
 CONGO, BELGIAN
BELING, Helen (Mrs. Lawrence
 R. Kahn) (American 1914-)
 Bus Stop Densite: L: 53
 SGO-17; UIA-8:pl 124
 Crenellated and Arched
 Belplast; 48
 SG-4
 Day's End Belplast; 32
 SG-3

 Eternal Light 1961 cast
 bronze; 24
 KAM 168 UCtWooJ
 Man with a Cloak Belplast;
 60
 SG-5
 Menorah 1959 bronze; 48
 KAM 172 UCtWaI
 Seated Man Belplast; 51
 SG-6
 Stretched Out Like the
 Evening Against the Sky
 Belplast; L: 66
 SG-7
 The Weight of My Crown
 Belplast; 28
 SG-2
Bell, Alexander Graham (American
 Inventor 1847-1922)
 Dykaar. Alexander Graham
 Bell, bust
 Martineau, S. Alexander
 Graham Bell, bust
 Martineau, S. Alexander
 Graham Bell, medal
BELL, Enid (American)
 Mother and child marble
 NYW 183
BELL, John W. POTTERY,
 Waynesboro, Pa.
 Lion c 1850 pottery
 LIPW 39
 Squirrel Bottle 1881/95
 green pottery; 7-1/2
 LIPA pl 145 UDeWG
BELL, Larry (American 1939-)
 Caixa Fantasmagorica,
 relief
 mural 1963/65 121.9x
 121.9 cm
 SAO-8 UCLF
 Eclipse 1966 glass, chrome
 plated brass; 54-1/2x
 14-1/4x14-1/4
 WHITNS 43 UNNW
 Memories of Mike 1967
 vacuum plated glass;
 Sq: 24-1/4
 GUGE 125 (col) UNN
 Untitled glass, rodium
 plated brass; 24
 WHITNA-18:20
 Untitled glass mirror; 8-1/4x
 8-1/4x8-1/4
 SBT UCLH
 Untitled 1964 coated glass
 and metal; Sq:12-1/4
 SEATL 13 UCLF
 Untitled 1965
 KULN 147

Untitled 1965 coated glass and
metal
SEATL 11 (col)
Untitled 1966 coated glass
and rhodium plated brass;
Sq: 20
BAZINW 447 (col); BURN
153 UNNPac
Untitled 1966 coated glass and
rodium plated brass; 20x
20x20
TUC 83 (col) UCLF;
UNNPac
Untitled 1967 coated glass
and rodium plated brass;
12x12x12
TUC 68 UCLF; UNNPac
Untitled 1967 coated glass and
rodium plated brass; 15x
15x15
TUC 69 UCLF; UNNPac
Untitled, construction 1964
glass, mirrors, and
polished steel; 63-1/2 (with
base)x15-1/4x15-1/4
ALBC-4:60 UNBuA
Untitled Sculpture coated
glass, metal frame;
Sq: 12
UCIF UCLF
Untitled Sculpture 1964 coated
glass and metal; Sq: 14
LAJ #1 UCLF
Untitled Sculpture 1965 coated
glass, metal frame; 8x8x8
UCIF 10 (col) UNNPac
Untitled Sculpture 1965 coated
glass, metal frame;
10x10x10
UCIF 11 UCLF
BELLA COOLA
Mask H: c 15
WINGP 360 CVP
Mask early 19th c. 19-1/2
x21
UPJ 556 (col) SnSE
BELLAMY, John H. (American)
Eagle Figurehead, United
States Frigate Lancaster
1810 ptd wood, originally
gilded; W: 18-1/2'
CAH 110; CAHA 52; LIPA
pl 20 UVNeM
La Belle Augustine. Gregory, A.
Bellerophon
Greek--7th c. B. C.
Bellerophon: On Pegasus
Attacking Chimera,
plaque

Greek--5th c. B. C.
Bellerophon: Slaying the
Chimera
Lipchitz. Bellerophon
BELLING, Rudolf (German-
American 1886-)
Head 1923 bronze; 15
UNNMMAM #157
Bellows, George (American
Painter 1882-1925)
Aitken. George Bellows, bust
Bowes, George Bellows, head
Bellows, Henry
Saint Gaudens. Dr. Bellows
Memorial
Bellows
African--Guinea, French.
Bellows
Bells See also Chung; Dotaku
African--Benin. Bell#
African--Nigerian. Bell:
Head
African--Yoruba. Bell-Heads:
Human Heads
Chinese--Chou. Bell#
Chinese--Chou. Bell,
interlocking snake motif
Chinese--Chou. Po: Bell
Chinese--Chou. Ritual Bell
Chinese--Shang. Bell,
engraved upright gong
"Chung"
Folk Art--American. "Bell
in Hand", inn sign
Folk Art--American Negro.
Servants' Bell
Indians of Central America--
Costa Rica. Bell: Stag
Decoration
Indians of Central America--
Panama. Jaguar Belled
Ornament
Indians of Central America--
Panama. Three Ornaments
Japanese--Fujiwara. Bell with
Vajra
Javanese. Bell
Mixtec. Pendant: Sun Disk
with Human-Shaped Bell
Toshihide. Koyohime and
the Bell of Dojo-ji,
netsuke
Veraguas. Bells: Deer,
Turtle, Bird
Veraguas. Bird Bell
BELSKIE, Abram (Abraham Belski)
(Russian/English-American
1907-)

Christ Child 1934 marble;
36-3/4
BROO 392 UScGB
Symelus Siren c 1950
marble
SCHW pl 87
Walter Reed, medal: obverse;
reverse bronze
HF 10 UNNHF
Belt Hooks
Chinese--Chou--Warring
States. Belt Hook
Belt Plates
Bronze Age--England. Belt
Plates
Belts
Greek--6th c. B. C. Temple
of Artemis, Corfu:
Medusa's Snake Belt
Khmer. Lady of Koh Krieng:
Belt
New Guinea. Bark Belt
Phoenician. Belt, 4-tiered
relief: Man Fighting Lions
Steppe Art. Belt: Hunting
Scene
Belvedere Torso. Apollonius
BEMESSUNG See AFRICAN--
BEMESSUNG
BEN, Henry
The Mingo 1928 bronze; 72
GRID 19 UWvWM
Ben. Westerman, H. C.
BEN-SCHMUEL,Asher
Walt Whitman, head
RAY 70 UNBB
BEN-SHMUEL, Ahron (American
1903-)
Berber Girl 1929 bronze;
L: 10
MAG 123 UMNSA
Boxers Coopersburg granite
NYW 177
Dancer 1935 Tennessee
marble; 36
MAG 121
Head of a Young Man 1932
Barre granite
NMAP #122
Pugilist 1929 black granite;
21
MEN 635; NNMMARO pl
299 UNNMMA
Reclining Figure 1932 bronze;
L: 12
MAG 123 UNNWarb
Seated Woman 1932 granite;
13

CAH 120; CAHA 62; SCHW
pl 71; UNNMMAM #156
UNNMMA
Torso serpentine; c 47
RICJ pl 48 UNBuA
Torso of a Boy 1930 black
granite; 28-3/4
PIE 384 UNNMMA
(314. 41)
Torso of a Girl 1944 green
serpentine; 42
ALBC 167 UNBuA
Wrestlers 1931 Quincy
granite; c 3/4 LS
RICJ pl 49; SFGC 80
Young Poet granite
IBM pl 83 UNNIb
BENA BIOMBO See AFRICAN--
BENA BIOMBO
BENA KANIOKA See AFRICAN-
BENA KANIOKA
BENA KOSH See AFRICAN--BENA
KOSH
BENA LULUA See AFRICAN--
BENA LULUA
Benediction. Ferguson
Benediction. French, D. C.
Benediction I. Lipshitz
Benediction. Walker, N. V.
Beneventum Head. Polyclitus--Foll
Benevolent Angel. Baskin
BENGALESE
Buddha 5th c. copper
CHENSW 257 EB
Buddha in Earth-Touching
Pose 9th c. B. C. black
chlorite; 37
LEEF 114 UOClA
Siva-Sakti 10th c. stone
CHENSW 267 ELBr
Surya, sun god 12th c.
stone
CHENSW 267 ELV
Temptation of Buddha 11/12th
c. bronze; 5-1/2
LEEF 114 UOClA
BENIN See AFRICAN--BENIN
BENJABI See AFRICAN--BENJABI
Benjamin, Miss
Nickerson, R. Miss
Benjamin of Jamaica, head
BENNETT, G. K. (American)
Untitled
CALF-63
BENNETT, John (American 1935-)
Liaison 1966 ptd wood,
polyester; 78
KULN 109; WHITNA-18:21

Bennett, Richard M. (American
 Architect)
 Horn. Richard M. Bennett,
 bust
Bennett Stela. Tiahuanaco
Bennington Pottery Deer.
 American--19th c.
BENSON, Stuart (American 1877-)
 Lucette bronze
 NYW 181
 Woman of Provence bronze;
 10-3/4
 CHICH pl 70 UICA
Bent, Thomas
 Baskerville. Sir Thomas Bent
BENTON, Fletcher (American
 1931-)
 Polarized Purple 1965 metal,
 electrified; 10x10x6
 NYWL 89
 Synchronetic C-11 1966
 plexiglas and aluminum;
 16-1/2x20x4
 UIA-13:162 UCBeSh
 Synchronetic C-4400-S Series
 1966 aluminum and
 plexiglas; 70x60x9
 TUC 70 UCLR
 Synchronetic C-8800 Series
 1966 aluminum and
 plexiglas; 83x70x11
 TUC 71 UCLR
 Tri-Hexagon, Third Phase
 1966 aluminum and
 plexiglas; 65x54x10-1/4
 TUC 84 (col) UCLR
 Yin and Yang 1965 aluminum
 sprayed with automotive
 laquer, and wood;
 Dm: 15-1/2; D: 4
 SELZP 19 UCLR
Benton, Thomas Hart (American
 Statesman 1782-1858)
 Doyle, A. Thomas H. Benton
 Hosmer. Thomas Hart Benton
BENVENUTO, Elio (American)
 Mother and Child
 CALF-52:32
Benzaiten, goddess of speech and
 learning, knowledge and
 music
 Japanese--Kamakura.
 Benzaiten#
 Japanese--Tempyo.
 Benzaiten
Berber, head. Hellenistic
Berber Girl. Ben-Shmuel
"Berenice". Hellenistic

Berenike I
 Hellenistic. Octadrachm:
 Ptolemy I and Berenike I
Berenike II (Wife of Ptolemy III
 Euergetes)
 Hellenistic. Dekadrachm:
 Berenike II
BERGE, Dorothy (American 1922-)
 The River is Queen bronze
 on copper; 40
 ROODT 83 UMnMU
BERGE, Edward (American 1876-)
 Boy with Frog, fountain
 ACA pl 247; SFPP
 Jack Lambdin, plaquette
 Galvano gilt
 NATSA 272
 Muse Finding the Head of
 Orpheus, Garden Exhibit
 Colonnade
 ACA pl 233; PERR 153;
 SFPP
 Reflection
 CHICA-25
 The Scalp
 ACA pl 236; SFPP
 Sea Urchin bronze
 NATSA 23
 Sun Dial
 SFPP
 Wildflower
 ACA pl 245; JAMS 71;
 PERR 141; SFPP
 Will-O'-The-Wisp
 CHICA-28
 William B. Graves,
 medallion bronze gilt
 NATSA 273
BERGEY, Grace (American)
 Horse
 DEYF #251
BERGIER, Arnold (American)
 Memorial Alcove 1953
 86x124
 KAM 173 UMdBH
BERGSCHNEIDER, Johnfried Georg
 (American 1920-)
 Contemplation of Violence
 concrete aggregate; 31
 UIC-6:pl 45
Berinbau
 Cravo. Player on the
 Berinbau
BERLANT, Tony (American 1941-)
 The Cracked White House
 steel, plywood; 83x72x71
 WHITNA-19
 King Size I, construction 1963

ptd metal; 9-3/4x8-1/4
OAK 16 UCLStu
Marriage of New York and
Athens 1966 aluminum over
plywood; 124x72x72
TUC 72 UCLStu
Miss Constance House 1965
enameled steel on wood;
53x22-3/4x21-1/2
LAHF
Miss Sandra House 1965
aluminum, linoleum, cloth,
paper on wood; 64x26-5/8
x25-1/2
LAHF
Miss Sandy House 1965
aluminum, stainless steel
on wood; 53x22-1/2x
21-1/2
LAHF UCLCM
BERLIN, Eugenia (Canadian 1905-)
Marius Barbeau, head
bronze; 14-1/2
CAN-3:340 CON (6474)
"Berlin Goddess". Greek--6th c.
B. C.
BERLINGUET, Francis-Xavier--
ATTRIB (Canadian)
Angel Holding Legend wood;
65
CAN-3:340 CON (6378)
Angel with Book wood; 65
CAN-3:340 CON (6739)
BERMUDEZ, Jose (Cuban-American
1922-)
Relief Under Vigo 1960
36x46
CARNI-61:#31 UDCGr
BERMUDEZ, Ramon (American)
Mother and Child stone
NYW 176
Seated Figure
PAA 41
Bernard of Clairveaux, Saint
(French Ecclesiastic 1091-
1153)
Sibell, J. Bernhard of
Clairveaux
Bernardo, relief. Huntington, C.
Bernstein, Leonard
Martinelli, E. Leonard
Bernstein Conducting the
New York Philharmonic
BERONDA, Beonne
Lynx soap carving
PUT 298

Berry Dish. Milonadis
BERTOIA, Harry (Italian-American
1915-)
Flower 1958 steel, bronze,
and chrome; 40
NMAR
Gold Tree brass, copper,
and steel; 108x47x36
AM #177 UVRMu
Hanging Sculpture, Main
Banking Room
MEILD 189 UNNMan
Landscape bronze; 4-3/4;
base: 7-3/8x8
NCM 251 UNcRV
The Pod 1956 steel, bronze,
and nickel silver; 25-1/2
ROODT 8 UMnMU
Screen 1954 steel, brass,
copper, and nickel; 16x70
x2'
LYNCM 159; MEILD 70;
PIE 384; TRI 252;
WHITNB 9
--detail
BERCK 212; LYNCM 158;
MEN 530
Sculpture welded metal;
26-1/4
NCM 251 UNcRV
Sound Sculpture 1961 bronze
wires, supported by 4
bronze posts; 53
DENV 104 UCoDA (A-910)
Sound Study 1960 phosphor
bronze; 31-1/2
UIA-10:48 UICFai
Spring bronze; 33
WHITNA-18:22 UNNChas
Sun 1959 steel, brass,
copper, nickel; 72x72
WHITNB 46 UNArG
Tree bronze; 14x11
NCM 251 UNcRV
Untitled bronze, brass, steel
MEILD 157 UICHa
Untitled music wire, brass,
bronze
MEILD 20 UICHa
Untitled rods and circular
metal forms
MEILD 76 ELG
Untitled stainless steel
WHITNA-16: front
Untitled 1960 bronze, brass,
copper, nickel; 69-1/4

BURN 42; UIA-11:94
UICFen; UNNSt
Untitled 1960 copper, nickel,
brass
MEILD 77 UNNChas
Untitled 1960 steel, copper,
bronze, brass, nickel;
77-1/2
WHITNF-7:35 UNNSar
Urn 1962 bronze; 47x51
LOND-6:#5 READCON
263 UNNSc
Bes
Egyptian--18/19th c. Bes(?)
Egyptian--Saite. Courtier
Bes, seated figure
Egyptian--Ptolemaic. Bes
Levantine. Three Inlays:
Griffin, Bes, Sphinx
Be-Sha-E-Chi-E-Di-Esha (Crow
Indian)
Sawyer, E. Be-Sha-E-Chi-E-
Di-Esha, medallion
BESNER, Frances (American)
Hanks plaster
UNA 5
Betel-Chewing Equipment See
equipment: Lime Containers,
Mortars, Pestles, Spatulas
BETIJOQUE
Effigy Rattle c 500 ptd clay;
2x5-1/2
DOCS pl 35 UNNMAI
(4/8743)
Woman with Two Babies
c 500
ptd clay; 8-1/2
DOCS pl 34 (col) UNNMAI
(4/8740)
Better Babies Medal. Fraser, L. G.
Betty Lamps
Folk Art--American. Betty
Lamp#
Folk Art--American. Ipswich
Betty Lamp
Between. Ossorio, A.
Between II. Beal
Between Heaven and Earth.
Lipchitz, J.
Between Yesterday and Tomorrow.
Howland
BEVAN, Sylvanus (American)
William Penn
PAG-10:105 UPPHo
Beyond. Beach
Bezalel
Horn, M. Ark and Eternal
Light: Moses Receiving the
Law; Bezalel Carving the
Cherubim

Bezmes. Egyptian--3rd Dyn.
Bhagiratha
Indian--Pallava. Bhagiratha
Worshipping Siva
Indian--Pallava. Descent of
the Ganges: Bhagiratha
at Shrine of Siva
BHUBANESWARA (Indian)--ATTRIB
Woman with Child, Orissa
11th c. sandstone
IND 16 InCI
Bhudevi
Indian. Vishnu in the Guise
of a Cosmic Boar
Rescuing Bhudevi
Bianca# Malderalli
Bibakara
Japanese--Tempyo. Bibakara
Bible Box. Folk Art--American
Biblical Themes See also Jesus
Christ; Mary, Virgin; and
names of other Biblical
Characters
Coptic. Diptych Leaf: Old
and New Testament
Scenes
Peruvian--17th c. Bible
Scenes
Roman--4th c. Sarcophagus:
Old and New Testament
Scenes
--Sarcophagus of the Two
Brothers
Bicho. Clark, L.
BICKFORD, Nelson M. (American)
Pelican
CHICA-29
Bicycle Rack. Sorrelle, H.
Bicycles. Arowogun. Door, four
registers relief carving
BIELEFELD, Ted (American)
Greyhound
CALF-58
BIELER, Ted (Canadian 1938-)
Double Shell
EXS 39
Bienville, John Baptiste LeMoyne
Sieur de
Gregory, A. Bienville
Monuments
Bieri (Byeri), Funerary Figure
African--Fang. Bieri#
African--Fang. Reliquary
Head
African--Osyeba. Bieri
Figure
Bifurcated Tower. Calder, A.
The Big Bear. Gerstein
Big Change. Watts, R. M.
The Big Change. Westermann, H. C.

African--Baoule. Mask, sur-
mounted by bird
African--Benin. Bird#
African--Bini, plaque
African--Congo. Bark Painting
with Superimposed Bird-
Figure
African--Ivory Coast. Gold
Weights: Bird, Fish, Ant-
Eater
African--Senufo. Bird#
African--Senufo. Door, relief
African--Sudan, French. Bird,
mask top
African--Yoruba. Staffs:
Bird Form
Archambault. L'Oiseau de Fer
Bartlett. Fledgling
Baskin. Caprice
Bilxula Indians. Mask:
Thunder Bird
Callery. Composition of Birds
Callery. Three Birds in Flight
Caparn. Bird#
Caparn. A Gathering of
Birds
Chamberlain, G. Wounded
Bird
Chimu. Bowl Base, bird
motif
Chimu. Vase: Double-Headed
Bird Design
Chinese. Tripod Vessel: Bird
Cover
Chinese--Archaic. Bird
Chinese--Ch'ien Lung.
Aquatic Birds
Chinese--Ch'ing. Vase:
Floral and Bird Motif
Chinese--Chou. Mongolian
Boy with Two Jade Birds
Chinese--Chou--Warring
States. Girl with Birds
on Two Sticks
Chinese--Han. Horse and
Bird Motif, sgraffiti design
Chinese--Han. Legend of Hou Yi:
Divine Archer Shooting Down
God of Ten Sun in Form of
Birds. tomb relief
Chinese--Shang. Bird#
Chinese--Shang. Fang-i,
over-all decoration includ-
ing bird motif
Chinese--Shang. Ritual Vessel:
Bird Surmounting T'ao-
T'ieh Masks
Chinese--Shang. Ritual Wine
Cup: Bird

Chinese--Six Dynasties:
Writer's Waterpot: Bird
Chiriqui. Pendant: Bird
Coptic. Ankh and Bird, stele
relief
Coptic. Bird, niche figure
Coptic. Cross Surrounded by
Birds
Cutler. Bird
Der Harootian. Bird
Der Harootian. Sea Bird
Duble. Bird
Dubon. Birds
Egyptian--5th Dyn. Bird
Relief
Egyptian--9th Dyn. Bird,
panel
Egyptian--18th Dyn. Hiero-
glyph: Bird
Etruscan. Perugia Carriage
Flannagan. Early Bird
Folk Art--American. Decoy#
Greek--8th c. B. C. Magic
Wheel, with Eleven
Nesting Birds
Greek--7th c. B. C. Bird
--Seal: Bird
Greek--5th c. B. C. Stele:
Woman Holding Bird
Haida. Housepost: Eagle,
Cormorant
Haida. Shaman's Dance
Rattle: Raven, Bear,
Eagle
Hancock, W. Zuni Bird
Charmer
Hare. Frightened Bird
Hartwig. Bird Form
Hartwig. Fledgling
Herman. Bird
Hittite. Human Figures and
Birds of Prey, Relief
Hopewell. Raven or Crow
Ornament
Hopi. Kachina: Hummingbird
Howard, R. B. The
Inspector
Howard, R. B. The
Scavenger
Ica. Birds, ceremonial
agricultural implement
Indians of Central America--
Costa Rica. Bird, staff
head
Indians of Central America--
Costa Rica. Knife: Stylized
Bird
Indians of Central America--
Panama. Bird Pedestal Bowl

Indians of Central America--
 Trinidad. Bird-Shaped
 Vessel
Indians of North America--
 Florida. Bird Jar
Indians of North America--
 Northwest Coast. Canoe
 Ornament: Bird
Indians of South America--
 Colombia. Finial: Double-
 Headed Bird
Indians of South America--
 Colombia. Staff Handle:
 Birds
Indians of South America--
 Ecuador. Bird
Indo-Chinese. Bird Ornament
Islamic. Vessel: Bird
Issai Tomei. Bird, Bee,
 and Camellia Branch,
 sword guard
Japanese. Bird
Japanese--Ancient. Bird in
 Flight
Japanese--Momoyama. Carved
 Panel: Bird
Japanese--Tokugawa. Ojme,
 metal button: Bird in Egg
 Design
Jones, W. L. Birds
Khmer. Bird Hunt, relief
King, B. Bird
Kowal. Bird
Kwakiutl. Bird
Kwakiutl. Cannibal Society
 Bird Mask
Kwakiutl. Mask: Cannibal
 Bird
Lewers, G. Flight of
 Birds
Madagascar. Horn Bird
Mannaen. Handle: Bird
Masayoshi. Sparrow and Head
 of Millet, sword guard
Maya. Bird, staff head
Melanesian--Admiralty
 Islands. Bowl#
Melanesian--New Ireland.
 Malanggan Frieze:
 Open-Work and Figurative
 Designs--Bird and Snake
Melanesian--New Ireland.
 Symbolic Carving: Fish-
 Legged Figure, Soul Bird
 Emerging from Mouth;
 Crowning Bird
Micronesian--Palau Islands.
 Bowl: Bird
Mochica. Effigy Jar: Bird

Morrison, C. Obstinate Bird
Morrison, M. Jungle Birds
Morrison, M. Marsh Birds
Mound Builders. Pipe: Bird
Mounts. Bird
Near Eastern. Bird of Prey
Niehaus, C. H. Three
 Fountain Figures
Noguchi. Square Bird--Bird E
Paleolithic. Amber Birds and
 Bears
Paleolithic. Magdalenian
 Weapons: Dagger. Harpoon,
 Dart Thrower, with
 Bird on Handle
Persian. Bird
Quimbaya. Bird#
Roman--1st c. Floral and
 Vine Ornament, with bird,
 tomb relief
Rood. Three Birds
Roszak. Fire-Bird#
Roszak. Migrant
Roussil. Bird#
Schmitz, C. L. St. Francis,
 head
Seljuk. Bird
Shonnard, E. F. Marabou
Sinu. Finial Bird
Smith, D. The Royal Bird
Stankiewicz. My Bird
Sueberkrop. Strand Birds
Sumerian. Cylinder Seal:
 Bird and Gazelle Motif
Syrian. Bird on Column
Tlatilco. Vessel: Bird
Tlingit. Hawk, food tray
Tlingit. Masks: Hawk,
 Flicker
Tlingit. Rattle: Hawk Head
Trudeau, Y. Famille
 d'Oiseaux
Tsimshian. Bird-Shaped Dish
Tsimshian. Headdress: Hawk
Tsimshian. Spoon Handle:
 Hawk
Ungerer, T. Broom Bird
Volten. Bird
Bird's-Head War Club. Melanesian--
 New Caledonia
Birds in Flight. Callery
Bird's Nest# Gross
Bireme
 Roman--Republican Per.
 Temple of Fortuna Primi-
 genia, Palestrina, relief:
 Bireme Manned by
 Soldiers

BIRO, Ivan
Untitled 1963 cast and
welded copper
MEILD 140 UNNScha
Birth
Aztec. Tlazolteotl (Ixcuina,
Ixcuna), "Mother
Goddess", Goddess of
Childbirth, Giving Birth
Barnard. The Birth
Campoli. Birth
Colima. Recumbent Preg-
nant Female About to
Give Birth
Edensaw. Bear Mother
Delivered by Caesarian
Section
Birth of Aphrodite
Greek--5th c. B. C.
Ludovisi Throne, front
panel: Birth of Aphrodite
Birth of Death. Campoli
Birth of Forms. Zadkine
Birth of the Muses. Lipchitz
Birth of Venus. Nakian
Birthday. Smith, D.
Birthday Painting. Lukin
Bishamon Ten
Japanese--Fujiwara. Tobatsu
Bishamon Ten
Japanese--Suiko. Guardian
Kings
Bishops
Folk Art--American. Figure-
head: Bishop
Folk Art--Puerto Rican.
Mercedarian Bishop
Folk Art--Spanish
American (United States).
Bishop, bulto
Suzor-Cote. The Bishop
Bison See Buffaloes
Bispoles
New Guinea. Bispoles
(ceremonial poles): Up-
right Canoe with Human
Figures
BISSAGOS ISLANDS See AFRICAN--
BISSAGOS ISLANDS
BISSELL, George Edwin (American
1839-1920)
Abraham de Peyster, seated
figure bronze
SALT 6 UNNBow
Abraham Lincoln Monument
1893 BUL 153 ScE
Chancellor James Kent c
1899 bronze CRAVS fig
7.17 UDCL

Chester Alan Arthur 1898
bronze
SALT 36 UNN
Chester Alan Arthur 1899
bronze
CRAVS fig 7.16 UPP
John Watts bronze
HARTS pl 1; TAFT 249
UNNT
Lycurgus
HARTS pl 30; TAFT 246
UNNAp
Mary Justina de Peyster,
bust c 1886 marble;
26-1/2
UNNMMAS 37 UNNMM
(07.113)
Soldiers' Monument, details:
Mechanic, Farmer, Center
group
HARTS pl 14, 40 UCtWa
BISSON, Peter (American)
Abraham Lincoln 1915
granite; 84
BUL 168 UCLonL
Biton See Cleobis
BITTER, Karl Theodore Francis
(Austrian-American 1867-1915)
Air, Administration Building
north entrance, Columbian
Exposition, Chicago 1893
CRAVS fig 13.3 UNNHS
Carl Schurz Memorial 1913
bronze; 108
SALT 110 UNNMorn
--relief detail
TAFTM 119
Caryatid
HARTS pl 38
Columbian Exposition,
Chicago: Administration
Building Sculpture 1893
CRAVS fig 13.1
Decorative Figure
HARTS pl 38
Dr. William Pepper, seated
figure 1895/98 bronze
CRAVS fig 13.2; HARTS
pl 27 UPP
--side panel
HARTS 29
Franz Segel, equest 1907
bronze
SALT 100 UNNRiv
Kasson Memorial
TAFTM 119 UNUt
Painting, facade figure
HARTS pl 38
UNNMM

Peace
 HARTS pl 34 UNNAp
Pediment
 TAFTM 118 UWiMCap
Plaza Fountain
 DIV 72; TAFTM 119;
 PAG-12: 209 UNN
 --detail: Figure bronze; 24
 BROO 89 UScGB
Pruning the Vine, model
 plaster
 PAG-12:208 UNNMM
Signing of Louisiana Purchase
 Treaty
 ACA pl 219; PAG-8: 210
Standard Bearer, equest
 HARTS pl 16; TAFT 458
Thomas Jefferson, seated
 figure
 PERR 133; SFPP
Thomas Lowry Memorial
 TAFTM 118 UMnM
 --Reliefs
 TOW 36 UNBuA
Villard Memorial
 TAFT 461 UNNCC
Bitterns
 Rush. Water Nymph and
 Bittern
BITTERS, Stan (American
 Three Sunflowers
 CALF-61
Biwa See Musicians and Musical
 Instruments
BJURMAN, Andrew (Swedish-
 American 1876-)
 Spirit of the Southwest
 wood
 NATS 28; PAR-1: 148
"Blacas Head"
 Greek--4th c. B. C.
 Asklepios, head
BLACK, David E. (American 1928-)
 Headstone 1959 ceramic
 CIN #1
Black. Price, K.
Black and Blue. Lynch
Black Beast. Calder, A.
Black Box. Smith, A.
Black Boy (Blackamoor)
 Folk Art--American. Cigar
 Store Figure: Black Boy
Black Bull. Davis, E. L.
Black Butte. Voulkos, P.
Black Calvary. Jones, P. J.
Black Cathedral. Edwards, G. E.
Black Crescent, mobile. Calder, A.
Black Eagle. Piccirilli, H.

Black Figure. Gross
Black Floor Piece. Paris, H.
Black Forest. Bean
Black Goat. Maldarelli, O.
Black Hand Saw. Dine
Black Hawk (Sauk Indian Chief 1776-
 1838)
 Folk Art--American. Cigar
 Store Figure: Black Hawk#
 Richards, D. Black Hawk
 Stinson, H. Black Hawk
 Taft, L. Black Hawk
Black Head. de Creeft
Black Knight of Auchterarder
 Haseltine. Aberdeen Angus
 Bull
Black Knight on a Unicorn.
 McCullough
Black Majesty. Nevelson, L.
Black Moon. Nevelson, L.
Black Obelisk
 Assyrian. Obelisk of
 Shalmaneser III
Black Pagoda
 Indian--Ganga. Surya Deul
Black Panther. Mylander
Black Panther. Williams, W.
Black Partridge
 Rohl-Smith, C. Fort
 Dearborn Massacre
Black Progress. Israel, R.
Black Queen. Key-Oberg
Black--Red--Yellow. de Rivera
Black Sun. Noguchi
Black Triangle. Bladen
Black Venus. Nunez del Prado, M.
Black, White and Red. Calder, A.
Black Widow. Calder, A.
Black Widow. Kienholz
Black X. Sugarman, G.
Blackberry Woman. Barthe
Blackboard. Price, A.
Blackburn: Song of an Irish
 Blacksmith. Smith, D.
Blackfoot Man. Hoffman, M.
The Blacks. Marisol
Blacksmiths
 French, D. C. Blacksmith
 Reading
 Roman. Blacksmiths at
 Work, relief
 Sumerian. Blau Monuments
Blackstone, William (English
 Jurist 1723-80)
 Jones, T. H. Blackstone,
 medallion head
BLADEN, Ronald (Canadian-
 American 1918-)

Architectural Construction
No. 1 1964 H: 108
SEITC 61
Architectural Construction
No. 2 1964 H: 126
SEITC 61
Black Triangle 1966 ptd
wood, for metal; 112x141
x120
GUGE 76; KULN 138
UNNFis
Three Elements 1965 ptd
aluminum and wood
ART 249 UNNFis
Untitled 1962 H: 96
SEITC 61
Untitled 1965
KULN 138
Untitled 1965 ptd wood and
aluminum--three units of
each;
TUC 73 UNNFis
BLAI, Isabel (American)
Release cedar; 72
HARO-1: 7
Blair, Francis P. (American
Statesman 1821-75)
Doyle, A. Francis P. Blair
BLAIR, John (American)
Pintail Drake Decoy 1868
ptd wood
ART 87 UVtSM
Pintail Drake Decoy 1868
ptd wood L: 17-3/8
LIPA pl 123
UNNBarb
BLAIR, Robert Ernest (American)
Thusnelda wood
NYW 181
Blair. Brecht
Blakeley, Johnston
American--19th c. United
States Congressional
Medal Awarded Johnston
Blakesley
Blanca, la Negrita. Asunsole
BLANCO, Jose Miguel (Chilean
1839-97)
Drummer at Rest (El Tambor
en Descanso)
TOLC 35
Blatas, Arbit
Lipchitz. Arbit Blatas
Blau Monuments, shale plaque and
tool. Sumerian
BLAZYS, Alexander (Russian-
American 1894-)
The Sculptor terracotta;
L: 38 NMPS #109

Tartar Dancer bronze
NYW 179
BLEIFELD, Stanley (American)
Margaret Sanger Award
bronze
NATSS-67: 3
Bleriot. Cornell
The Blessing. Kaish
The Blind. Miramontes
The Blind. Taft, L.
Blind. Tovish, H.
Blind Animal. Squier, J.
Blind Beggars. Baum, M.
The Blind Girl. Kearns
Blind Harpist. Egyptian--18th Dyn.
Blind Harpist. Leach, E. M.
Blind Ignus. Kienholz
The Blind Man. Tovish, H.
Blind Sampson. Aronson, D.
Blithe Spirit. Kaz
Blizzard. Simons, A. C.
BLOCK, Adolph (American)
Joseph Siegal, bust plaster
NATSS-67: 4
Temptation plaster
SCHN pl 103 UNBGar
Block. Nagare
Block Statue.
Egyptian--26/30th Dyn.
"Block Statue"
BLODGETT, George Winslow
(American 1888-)
Tewa Indian: Albert Lujan,
head 1930/34
bronze; 10-1/4
BROO 440 UScGB
--
UNNMMAS 162 UNNMM
(33.139)
Blodgett, William Tilden (American
Philanthropist 1823-75)
Ward, J. Q. A. William
Tilden Blodgett, head
BLOMFIELD, Reginald
Cross of Sacrifice
NATSE KeN
"Blond Boy", head fragment. Greek
--5th c. B. C.
The Blond Ephebe
Greek--5th c. B. C. "Blond
Boy"
BLOOMER, Kent C. (American
1935-)
Sequence C, Number 1 and
Number 2 1958 brass;
22
NMAR
Blossom. Fields
Blossoming. Lipchitz

Blow Fish. Abrizio
"Blow Wind, Blow". Ingels, K. B.
Blue and Black Construction.
 de Riviera
Blue and Silver. Willenbecher, J.
Blue, Black and White. Sugarman
Blue Construction. Smith, D.
Blue Disk. Kelley, E.
Blue Dots. Fukushima
Blue Fish. Runyon
"Blue Head"
 Egyptian--18th Dyn. Royal
 Head
Blue in the Middle. Vasa
Blue Jay. Kline
Blue Klacker. Randell, R.
Blue Parallel. Hatchett
Blue Peen Hammer. Hudson
Blue Post and Lintel.
 McCracken, J.
Blue Rider of Astana.
 Chinese--T'ang
Blue Seven. Mattox, C.
Blue Tandem. Valentine, D.
"Blue Vase". Roman--1st c.
Blue Wall. Mason, John
Blue War Crown. Egyptian
"Bluebeard"
 Greek--6th c. B. C.
 Temple of Athena,
 Acropolis, Athens
Blues Player. Lipton
Bluffers. Russell, C. M.
BLUM, Helaine D. (American)
 Triangle bronze; 39
 NM-13:#18
BLUM, Lucille Swan (American)
 The Chinaman bronze
 WHITNC 220 UNNW
Blumenstein, Dr.
 Lucker. Dr. Blumenstein,
 head
BLYTHE, David G. (American
 1815-65)
 Lafayette 1845 walnut; 100
 PIE 377 UPUF
Boars See Swine
BOAS, Simone Brangier
 (American 1895-)
 Meditation mahogany
 SGT pl 3
 Mother and Child mahogany;
 18
 NMPS #103 UMdBF
 Weather Vane zinc
 SGO-2:pl 5
 Woman pink Tennessee
 marble
 SGO-1:pl 3

 Woman marble
 NYW 181
Boat Accumulation. Kusama
Boat Ax. Neolithic--Sweden
Boats See Ships
Bobbins
 African--Bambara. Tjiwara
 African--Baoule. Bobbins
 African--Guro. Weaver's
 Bobbin: Bowl on Human
 Head
 African--Guro, or Senufo.
 Weaving Bobbins: Human
 Form
 African--Ivory Coast.
 Bobbin#
BOBO See AFRICAN--BOBO
Bocchoris Vase. Egyptian
Bochim: The Weepers. Kaish
BODE WAGON WORKS, Cincinnati,
 Ohio
 "United States", circus
 wagon c 1875 ptd wood;
 L: c 22'
 LIPA pl 91 UFSR
BODEN, Pamela (English-
 American 1911-)
 Steeplechase 1962 wood
 construction; 41
 UIA-11:195 UCSFC
Bodhgaya Plaque. Indian--Sunga
Bodhi-Tree
 Indian--Andhra (Early).
 Stupa, Sanchi: Bodhi
 Tree Shrine
 Indian--Kushan--Mathura.
 Bodhi-Tree Shrine
 Indian--Sunga. Bodhi-Tree
 Shrine#
Bodhidarma (Founder of Ch'an Sect)
 Chinese--Sung. Bodhidarma
 Crossing the Yangtze
 River on a Leaf, Blanc
 de Chin porcelain
Bodhisattva See also Avalokitesvara,
 Likesvara, Padmapani
 Afghanistan. Bodhisattva,
 head
 Central Asian. Bodhisattva,
 head
 Ceylonese. Bodhisattva#
 Chinese. Bodhisattva#
 Chinese--Ch'i. Bodhisattva#
 Chinese--Ch'i. Monk and
 Two Bodhisattvas
 Chinese--Chou. Bodhisattva
 Chinese--Ming. Bodhisattva#
 Chinese--Ming. Patriarch
 Tamo Bodhidharma

Horse; Horse and Rider
6th c. B. C. ptd clay;
5-1/2; 5-1/4
GRIG pl 57 ELBr
Kouros
LAWC pl 41A
Kouros 5th c. B. C.
LAWC pl 41A GrA
Kouros: Face Detail,
Sanctuary of Apollo, Ptoios
c 550 B. C. limestone;
13.15
DEVA pl 38, 44-5; LULL
pl 28, 29; RICHTH 68
GrAN (15)
Man Ploughing with Two
Horses 7th c. B. C.
terracotta
RICHTH 218 FPL
Perseus Slaying Medusa,
amphora relief H: 51-1/4
SCHEF pl 15 FPL (CA
795)
Pithos: Perseus and Medusa,
relief
RICHTH 296 FPL
Quadriga, tomb figure 6/7th
c. B. C. terracotta
DEVA pl 21; RICHTH 218
GrAN
Seated Goddess c 580 B. C.
yellow ochre clay, with
cream slip, decorated in
black glaze, and red; 7
GRIG pl 56 ELBr
Seated Woman 4th c. B. C.
Terracotta
SOTH-4:159
Stag and Does 6/5th c. B.C.
terracotta; 5-1/2;
4-7/16; 2-1/4
NM-5:11 UNNMM
(06.1145, 51.11-13,
53.192-4)
Water Wagon with Amphorae,
Euboea 7th c. B. C.
RICHTH 218 GrAN
Woman, statuette 8th c.
B. C. terracotta
RICHTH 217 UMB
BOGOTAY, Paul (American)
Horse and Rider 1956 cast
bronze
CIN # 2
BOGHOSIAN, Varujan (American
1926-)
The Clown 1959 plaster and
lead; 12-1/2
UIA-10:173 UMBSw

Coronation wood, iron, clay,
brass; 74x47-1/2x13
WHITNA-19
The Key to the Kingdom
wood, sculpt-metal; 37-1/2
WHITNA-18:20
Music 1964 wood and metal;
30x71
RHC #3
Night and Day (Orpheus and
Pluto) 1963 wood, steel;
12x12x7-1/4
WHITNS 31 UNNW
The Bohemian
Bartlett, P. W. Bohemian
Bear Tamer
Bohemian Bear Tamer. Bartlett,
P. W.
BOHLAND, Gustav (Austrian-
American 1897-)
Fantasy
NATS 31
Boiuna. Martins
Bokonrinef (Pharoah of Egypt d 728)
Egyptian--24th Dyn.
Bocchoris Vase: Scenes
of Pharoah Bokonrinef
Boldini, Giovanni (Italian Painter
1845-1931)
Hoffman, M. Giovanni
Boldini, head
Bolivar, Simon (South American
Liberator 1783-1830)
Centurion. Simon Bolivar,
equest
Farnham. Simon Bolivar,
equest
Fioravanti. Simon Bolivar
BOLIVIAN
Portal, Church of San
Lorenzo, Pre-Colombian
influence 1728/44
BAZINB 224 BoPoL
Bolli Atap, magical figure to keep
off sickness. Sarawak
BOLLING, Leslie (American
1898-)
Salome 1934 wood
DOV 80 UNNHarm
Washerwoman 1933 wood
DOV 71 UNNHarm
BOLLINGER, William (American)
Series 55 1966 extruded,
anodized aluminum
channels; L: 318-3/8'
KN pl C
"Bologna Head"
Phidias. Athena Lemnia,
head ("Bologna Head")

BOLOMEY, Roger (American 1918-)
 Hoboken #7 1963 poly-
 urethane, wood; 62-1/2x
 47x9
 WHITNS 7 UNNW
 Hoboken #10 1964 poly-
 urethane; 48x56
 CUM 62; SG-6
 Hoboken #12 1964/65 poly-
 urethane; 84x132
 UIA-13:65 UNNMark
 Hoboken #13 polyurethane
 and wood
 WHITNA 17
 Malacandra 1965 poly-
 urethane and aluminum;
 56x62x28
 NYWL 91
 Wind-Gate polyurethane,
 aluminum; 103
 WHITNA-18:23
BOLOTOWSKY, Ilya (Russian-
 American 1907-)
 Column October 1964 aquatec
 on wood; 48
 CUM 63
Bolton, Isabel
 Simkhovitch, H. Isabel
 Bolton, head
The Bomb-Thrower. Sterne, M.
"Bombo" Mask. African--Bakuba
Bon Marche. Kaprow
The Bond. Quimby, H. Z.
Bondage. Heber
Bone II. Kiesler
Bone and Muscle. Novak, S.
Bone Creature. Squier, J.
BONEVARDI, Marcelo (Argentine-
 American 1929-)
 Astrolabio 1964 mixed
 media; 41x39
 UIA-12:107 UNNBoni
La Bonne Nouvelle. Zadkine
Bonneau, M.
 Asunsolo. M. Bonneau,
 French Ambassador, head
BONNER, Elizabeth Calvin
 (American)
 Bronze No. 2 bronze; 14
 HARO-3:33
BONTECOU, Lee (American 1931-)
 Sculpture*
 EXS 51
 Untitled 1959 72x72
 CARNI-61:#40 UNNC
 Untitled 1959 canvas and
 metal
 MEILD 166 UMNSA

Untitled 1959 canvas and wire;
 8x5x2
 RHC #4 UNNE1
Untitled 1960 construction of
 steel, canvas, cloth and
 wire; 72x56x20
 SEITA 139 UNGS
Untitled 1960 metal and
 canvas; 43-1/2x51-5/8
 TOW 111 UNBuA
Untitled 1960 welded steel;
 38-1/2x30
 SELZS 177 UNNLi
Untitled 1961 H: 72
 SEITC 59
Untitled 1961 welded steel
 and canvas; 72x84x36
 BOSTA 61; SEAA 61
 UNNC
Untitled 1961 welded steel
 and canvas; 181x165x63
 cm
 LIC pl 263 UNNW
Untitled 1962
 KUL 102
Untitled 1962 H: 65
 SEITC 59 -USchw
Untitled 1962 H: 75
 SEITC 75 UNNC
Untitled 1962 H: 76
 SEITC 59 UNNJe
Untitled 1962 stainless steel
 and canvas; 76
 NEW pl 38 UNNLi
Untitled 1964
 KULN 102
Untitled 1964
 KULN 103
Untitled 1964 H: 40
 SEITC 59
Untitled 1965/66 mixed
 media; 40x126x48
 CHICSG UNNC
Untitled 1967 54x20-7/8
 CARNI-67:#246 UNNC
Untitled, wall relief 1959
 welded steel, leather,
 wire; 40x30x9
 PAS #1 UCLAs
Untitled, wall relief 1960
 welded steel, canvas,
 wire; 55x105x26
 PAS #3 UCLD
Untitled #37, wall relief
 1961 welded steel, canvas,
 wire; 51x48-1/2x15
 PAS #4 UCLD
Bonten (Taishaku Ten) See also
Brahma

Japanese--Fujiwara. Bonten
Japanese--Tempyo. Bonten
Japanese--Tempyo. Deva
(called Bonten)
Japanese--Tempyo. Taishaku
Ten
Bonus Eventus
Euphranor. Bonus Eventus,
headless figure
Euphranor. Gem: Bonus
Eventus
Boogie-Woogie Boys. Rood
Book Cases and Stands See also
Rahla
Chinese--Ch'ien Lung.
Imperial Poetry Cabinet
Book No. 6 (Treasures of the
Metropolitan).
Samaras, L.
Book of Life. Christopher
Books See also Readers
Akashi Yodayu. Books,
sword guard
Coptic. Antiphonary Cover
Polyeuctus. Demosthenes
with Rotolus
Boomerangs
Australian Aboriginal.
Boomerangs
Boone, Daniel (American
Frontiersman and Explorer
1734-1820)
Franklin. Daniel Boone
Polasek. Daniel Boone, bust
Yandell, E. Daniel Boone
Booth, Edwin Thomas (American
Actor 1833-93)
American--19th c. Edwin
Booth, gravestone tondo
Quinn, E. T. Edwin
Booth, bust
Quinn, E. T. Edwin Booth
as Hamlet
The Booth. Linder, J.
Bootjacks
Folk Art--American.
Bootjack#
Bope Kena (Bakuba King)
African--Bakuba. Bope Kena
Bope Pelenge (Bakuba King)
African--Bakuba. Bope
Pelenge
Borah, William Edgar (American
Lawyer and Statesman
1865-1940)
Baker, B. William E. Borah

BORATKO, Andro (American)
Torso cast stone
IBM pl 87 UNNIb
BORCHNERDT, Fred
Tempest plow parts
MEILD 124
Boreads
Greek--6th c. B. C.
Boreads and Harpies
Borghese Gladiator. Agasias
Borghese Mars
Polyclitus. Doryphorus
"Borghese"-Type Ares. Greek--
5th c. B. C.
Borghese Vase. Hellenistic
Borghese Warrior
Agasias. Borghese Gladiator
BORGLUM, Gutzon (John Gutzon
Borglum) (American 1871-1941)
Abraham Lincoln, head
marble /
FAIR 382; USC 170 UDCCap
Abraham Lincoln, head
bronze
IBM pl 57 UNNIb
Abraham Lincoln Memorial
PAG-7:13 UNjNewC
--Abraham Lincoln, seated
figure c 1910 bronze;
c 60
BUL 164; STI 814
Alexander H. Stephens, gift
of State of Georgia marble
MUR 26; USC 262 UDCCapS
Confederate Memorial
RAY 68 UGSM
--First Line of Figures
MCSPAD 236
Cowboy bronze
VALE 118 UMiD
Daniel Butterfield 1918
bronze
SALT 108 UNNCla
The Flyer bronze
PAG-12:209 UVCU
Indian and Puritan, detail:
Indian 1916 stone, on
bronze shaft; figures:
LS; overall H: 22'
GRID 53 UNjNewPl
John Campbell Greenway,
gift of State of Arizona
bronze
MUR 88; USC 240
UDCCapS
John Ruskin, seated figure
1904 bronze; 15
UNNMMAS 102 UNNMM
(06. 406)

Mares of Diomedes 1904
bronze
MEN 480 UNjNewM
--1904 bronze; 62
CRAVS fig 13.15; DODD
93; EA 462; UNNMMAS
101 UNNMM (06.1318)
Mount Rushmore National
Monument: George
Washington, Thomas
Jefferson, Theodore
Roosevelt, Abraham
Lincoln 1927-43 rock; each
head, chin to forehead:
c 60'
BR pl 14; CRAVS fig
13.17; CHRP 433; LONG
48, 49; MILLE 5 USoM
--Washington and Jefferson,
head
RAY 69
Philip Henry Sheridan,
equest, Sheridan Circle
MCSPAD 226 UDC
Pot of Basil (Earth) bronze
NATSA 27
Wars of America 1925/26
bronze
CRAVS fig 13.16 UNjNew
Washington on the Way to
Ohio, 1753
PAG-6:70
Zebulon Baird Vance, gift
of State of North
Carolina bronze
FAIR 433; MUR 60;
USC 263 UDCCapS
BORGLUM, Gutzon, and
BORGLUM, Lincoln
Thomas Brackett Reed,
bust (completed by
Lincoln Borglum) marble
USC 192 UDCCap
BORGLUM, Lincoln See also
Borglum, Gutzon
Sacajawea under construction
1966 structural steel,
concrete, glass; 530'
GRID 62 UNdBM
BORGLUM, Solon Hannibal
(American 1868-1922)
American Pioneer (The
Pioneer)
JAM 119; JAMS 30;
PERR 35; SFPP
Aspiration and Inspiration
1920 larger than LS
GRID 54 UNNStMa

Burial on the Plains
TAFT 487
Captain Bucky O'Neil, equest
bronze
MARY pl 136 UAzP
Cowboy Mounting
CAF 152
Dancing Horse
HARTS pl 41
Fighting Bulls 1900 bronze;
4-1/4
BROO 75; ELIS 106
UScGB
George Washington
ACA pl 238
George Washington 1911
bronze; 23-3/4
CAN-2:201 CON
Horse and Colt in the Wind
HARTS pl 41
Indian Mourners
TAFTM 137
Jacob Leister
PAG-8:20 UNNe
Lame Horse
HARTS pl 41
Lassoing Wild Horses
HARTS pl 26
Lost in a Blizzard marble
CAF 153
A Meeting on the Plains
HARTS pl 58
Mounting a Bronco
HARTS pl 26
A Night Hawk, equest
HARTS pl 26
On the Border of the White
Man's Land
CHASEH 513; POST-2:
253; TAFT 485 UNNMM
Rough Rider, equest bronze
NATSA 28; PAG-12:210
Sioux Indian Buffalo Dance,
Louisiana Purchase
Exposition, St. Louis,
1904 (bronze replica)
CRAVS fig 14.6 Kennedy
Galleries UNN
Stubborn, equest
HARTS pl 58
Tames
CAF 160
BORMACHER, Ralph
Giraffe 1965 steel rods,
melted
MEILD 97
BORNEO
Ancestor Mask ptd wood,

feathers
BAZINW 231 (col) DCNM
Incised Human Figure on
Shield wood, polychrome
ADL 134 ELBr (No. 7291)
BORNEO--SIANG
Ancestor Post wood; 2 m
ADL pl 13C SwBV
BORNSTEIN, Eli (Canadian 1922-)
Structurist Relief in Five
Parts ptd wood; 21-1/2
x51-1/4
CAN-4:195 CON
Borobudur Temple. Javanese
BORONDA, Beonne (American)
Fawn plaster
NYW 177
Bosatsu
Japanese--Fujiwara.
Bosatsu. Gyodo Mask
Japanese--Fujiwara/Kama-
kura. Monju Bosatsu and
Attendants
Japanese--Nara. Bosatsu
Seated in Contemplation
(Hanka-Shiyui)
Japanese--Suiko. Bosatsu
Japanese--Tempyo. Bonten
Japanese--Tempyo. Shuho-O
Bosatsu
Tori Busshi. Shaka Triad
Unkei. Machaku Bosatsu
BOSCOREALE
Cleopatra's Cup 1st c. B.C.
engraved silver; Dm: 9.1
CHAR-1:193; GAU 107
FPL
Oenochoe of Victories
1st c. B. C. silver;
.24 m
CHAR-1:192 FPL
BOSTON AND SANDWICH GLASS
COMPANY
Dolphin Candlestick 19th c.
vaseline yellow pressed
glass
CHR 102 UNNMM
BOSTON AND SANDWICH GLASS
COMPANY--ATTRIB
Whale-Oil Lamp 19th c.
blown flint glass
CHR 175 UNBB
Boston Relief
Greek--5th c. B. C. Boston
Throne
Boston Throne See also Ludovisi
Throne
Greek--5th c . B. C.
Boston Throne

BOTEY, Gimenez (Mexican)
Composition
LUN
Lion
LUN
Maidens (Las Doncellas)
LUN
"Bottle Symbol"
Carthagenian. Stele: "Symbol
of Tanit", engraved with
"Bottle Symbol"
Iberian. Cloaked Woman,
votive figure
Bottles
African--Nigerian. Flask:
Three Faces in relief
Bell, John W. , Pottery.
Squirrel Bottle
Caddoan. Water Bottle
Chinese--Ch'ing. Bottle:
Floral and Insect Design
--Scorpion
Chinese--T'Ang. Molded
Bottle: Bacchanalian
Figures
Chinese--T'ang. Pilgrim
Bottle
Krentzin. Clown Bottle
Las Bocas. Effigy Bottle
Mycenaean. Feeding Bottle:
Cow
Quimbaya. Bottle
BOUDIN, Eleanor (American)
Mangbetou Girl, Congo
CHICA-44: #222
Voodoo Priestess bronze
NYW 180
Bougainvillea. Calder, A.
Boundary Markers
American--18th c. Mason
and Dixon Boundary
Stone
Babylonian. Kudurru#
Kassite. Boundary Stone of
Marduknadinakhe
BOURAS, Harry (American 1931-)
Another October 1962 forged
and welded steel, found
objects, concrete
MEILD 172
Coastal Terrain 1964 welded
metal embedded in cement
MEILD 124
Core welded steel and
concrete; 48x60
HARO-1:33 ; MEILD
176 UICA
The D's Testament 1961
wood, steel, and plumbing

fixtures; 36x48
SEITA 121 UICAl
8th Terrain 1964 welded steel,
 wood
MEILD 175 UICO
Lesser Source 1962 welded
 sheet metal, rods
MEILC 64
New Terrain 1964 metal
 forms
MEILD 23
BOURGEOIS, Louise (Mrs. Robert
 John Goldwater) (French-
 American 1911-)
Anglard de Salers plaster; 18
 SG-3
Garden at Night 1953
 cypress; 48
WALKR 27 UNNE
--1953 wood; 36
GIE 288 UICM
--1953 wood; 36
BERCK 193; WHITNA
 30 UNNSta
Labyrinthine Tower cast
 iron; 18
 SG-6
--1962 H: 21
SEITC 25 UNNSta
Lair #2 cement; W: 36
 SG-7
Listening Figure 1949
 wood
AMAB 155
One and Others 1955 ptd and
 stained wood; 20-1/4
GOODA 234; LARM 407;
 MAI 33; TRI 117 UNNW
Sleep II marble; 23-1/2x
 24x31
WHITNA-19
Sleeping Figure 1950 balsa
 wood; 74-1/2
PIE 384; READCON 203
 UNNMMA (3.51)
Summer 1960 plaster; W: 21
 SG-2
Unidentified
MOT 86 UNNPe
BOUTIN, Al
Taurus 1965 steel, wood
MEILD 117 (col)
BOUVIER, Adrienne
Kateri Tekakwitha 1923
 stone
GRID 58 UNAS
The Bow. Ferber
Bow Case
Scythian. Chertomlyk Bow Case

Bowditch, Nathaniel (American
 Mathematician and Astronomer
 1773-1839)
Hughes R. B. (after).
 Nathaniel Bowditch, bust
BOWES, Julian (American)
George Bellows, head colored
 plaster
WHITNC 237 UNNW
Bowls
Achaemenian. Winged Lion
 Rhyton, Bowl and Finials
African--Ashanti. Black
 Pottery Bowl
African--Baluba. Covered
 Bowl#
African--Baluba. Kneeling
 Female Figure Holding
 Bowl
African--Barotse. Bowl for
 Meat and Vegetables
African--Benin. Bowl
African--Cameroon. Bowl
African--Fon. Woman: Sup-
 porting Palm Nuts Bowl
African--Sudan, French.
 Covered Bowl
African--Yoruba. Cult Bowl
African--Yoruba. Divination
 Bowl
African--Yoruba. Palm Nut
 Bowl
American--19th c. Rococo-
 Revival Punch Bowl
Amlash. Bowl#
Bactrian. Bowl#
Bactrian. Wine(?) Bolw
Bronze Age. Coracle-
 Shaped Bowl
Caddoan. Feline Bowl
Chimu. Bowl Base
Chinese--Ch'ien Lung. Bowl
Chinese--Ming. Bowl
Chinese--Sung.
 Chrysanthemum-Design
 Bowl
Chinese--Sung. Lotus-
 Pattern Bowl
Egyptian. Cosmetic
 Accessories
Egyptian--1st Dyn. Bowl
Egyptian--21st Dyn. Tanis
 Bowl
Elamite. Bowl
Etruscan. Bowl
Euripedes--Foll. Megarian
 Bowl
Fiji. Priest's Bowl
Fini. Turtle Effigy Bowl#

Gallic. Cylindrical Samian
 Bowl
Greek--8th c. B. C. Bowl
Guetar. Bowl
Haida. Bowl
Hawaiian. Ceremonial Food
 Bowl
Hawaiian. Food Bowl
Indian--Kushan. Bowl
Indian--Kushan--Gandhara.
 Buddha and Buddha's
 Begging Bowl
Indians of Central America--
 Haiti. Grotesque-Decorated
 Bowl
Indians of Central America--
 Panama. Bird Pedestal
 Bowl
Indians of Central America--
 Panama. Bowl#
Indians of North America--
 Alabama. Bowl: Bird
Indians of North America--
 Alabama. Crested Wood
 Duck Bowl
Indians of North America--
 California. Spider Bowl
Indians of North America--
 Northwest Coast. Animal-
 Form Bowl
Indians of North America--
 Northwest Coast. Seal
 Bowl
Indians of South America--
 Argentina. Effigy Bowl
Indians of South America--
 Brazil. Bowl on Stand
Indonesian. Bowl
Iranian. Bowl
Kaskaskia. Beaver Bowl
Kwakiutl. Potlach Feast
 Bowl
Luristan. Bowl
Maya. Bowl#
Maya. Covered Tripod Bowl
Maya. Cylindrical Tripod
 Bowl#
Maya. Hemispherical Bowl
Melanesian--Admiralty
 Islands. Bowl#
Melanesian--Admiralty Islands.
 Food Bowl
Melanesian--Admiralty Islands.
 Large Bowl
Melanesian--New Hebrides.
 Bowl
Melanesian--Solomons. Bowl#
Melanesian--Solomons.
 Ceremonial Bowl

Mesopotamian. Bowl
Micronesian--Palau Islands.
 Bowl
Mississippi Culture. Effigy
 Bowl
Mixtec. Whistling Bowl
Nazca. Globular Bowl
New Guinea. Bird-Shaped
 Food Bowl
New Guinea. Food Bowl#
New Guinea. Spiral-Incised
 Bowl
New Guinea. Tami-Huaon
 Double Bowl
Paracas. Incised Globular
 Bowl
Persian. Repousse Bowl
Persian. Wine Bowl#
Phoenician. Bowl
Phoenician. Two Bowls#
Polynesian--Austral Islands.
 Handled Bowl
Polynesian--High Island.
 Bowl
Polynesian--Marquesas. Bowl#
Sauk. Ceremonial Bowl
Sumerian. Bowl
Sumerian. Ritual Bowl
Sumerian. Stone Bowl
Syrian. Ugarit Bowl
Tairona. Incised Bowl
Tiahuanaco. Bowl: Skull
Waugh, S. B. Europa and
 the Bull, etched glass bowl
Winnebago. Effigy Bowl
The Bowman, equest. Mestrovic
Bowmen See Archers
BOWYER, William (American)
 Governor Endecott's Sundial
 1630
 ADAM-1: 72 UMSaE
Box. Rohm, R.
The Box. White, B.
Box No. 3. Samaras, L.
Box No. 9. Samaras, L.
Box No. 27. Samaras, L.
Box No. 33. Samaras, L.
Box No. 40. Samaras, L.
Box with Skull
 Samaras, L. Box No. 40
Boxer. Silanion
Boxer Vase. Cretan
Boxes See also Bontecou; Cornell,
 J.; Fuller, S.; Lichten-
 stein; Nevelson; Samaras
 African--Ashanti. Gold Dust
 Weights; Gold Dust
 Storage Box
 African--Bakuba. Box

African--Bakuba. Ointment
 Box#
African--Benin. Box
African--Congo. Box, knife
 case
African--Mangbetu.
 Cylindrical Box
Chinese--Ch'in. Yin-Style
 Casket
Chinese--Ch'ing. Box
Chinese--Ch'ing. Covered
 Box
Chinese--Ch'ing. Octagonal
 Box, and Cover
Chinese--Ming. Box#
Chinese--Ming. Circular Box
 and Cover
Chinese--Ming. Cylindrical
 Box and Lid
Chinese--Ming. Lacquer Box
Chinese--T'ang. Box
Coptic. Cylindrical Box
Egyptian--18th Dyn. Chapel-
 Shaped Coffer
Egyptian--18th Dyn. Ointment
 Box#
--Toilet Box
--Ungent Box
Eskimo. Drill Bows with
 incised record of hunting
 and fishing; Antler box
Etruscan. Footed
 Cylindrical Casket
Etruscan. Rectangular
 Container
Etruscan. Round Container
Etruscan. Toilet Box
Folk Art--American. Desk
 Box
Hispano-Moresque. Casket
Hispano-Moresque. Relief
 Decorated Casket
Indian--Hindu. Jewel Casket
Indonesian. Bamboo
 Container
Iranian. Casket
Islamic. Box
Islamic. Casket
Islamic. Mango-Shaped Box
Koltsu. Writing Accessories
 Box
Maori. Feather Box#
Mycenaean. Embossed Box
Persian. Casket
Persian. Cylindrical Box
Phoenician. Casket
Plautios, N. The Ficorini
 Casket

Roman--3/4th c.
 Cylindrical Pyxis
Siculo-Arabic. Casket
Sumatran-Batak. Amulet Box
Tiahuanaco. Box
Boxing See Games and Sports
Boy and Duck, fountain group.
 MacMonnies
Boy and Fawn. Cecere
Boy and Fighting Cock. Hoffman, M.
Boy and Frog. Hering, Elsieward
Boy and Panther. Evans
Boy and Panther Cub. Hoffman, M.
Boy and Squirrel. Hancock, W. K.
Boy at a Machine. Hebald
Boy from Acropolis
 Greek--6th c. B. C.
 Kouros (Boy from
 Acropolis)
Boy in Trench, Daniels, J. P.
Boy of Kalivia
 Greek--6th c. B. C.
 Kouros (Boy of Kaliva)
Boy of the Piave. Piccirilli, A.
Boy Pan with Frog. Barnhorn
Boy Riding Goose
 Greek--5th c. B. C. Toys
The Boy Scout. McKenzie, R. T.
Boy Scout Fountain. O'Connor, A.
Boy Seated. Barthe
Boy with Axe. Japanese--Ashikaga
Boy with Bird. Midener
Boy with Birds. Wines, J.
Boy with Dolphin. Horn
Boy with Dolphin. Roman--1st c.
 B. C./1st c. A. D.
Boy with Fish, fountain. Perry,
 R. H.
Boy with Fish. Pratt, B. L.
Boy with Flute. Schnier
Boy with Frog, fountain. Berge, E.
Boy with Goose. Boethus of
 Chalcedon
Boy with Goose. Hellenistic
Boy with Leaking Boot.
 American--20th c.
Boy with Snails. Renier, J. E.
Boy with Squirrel. Jennewein
BOYCE, Richard (American 1920-)
 Proteus Changing I 1965
 unique bronze; 14
 UIA-13:110 UCLL
 Venus Torso Mexican onyx
 WHITNA-16:7
 A Victory 1963 Mexican
 onyx; 46
 UIA-12:55 UNNAl
Boydille. Chamberlain, J.

Boyhood. Rumsey, C. C.
BOYLE, John J. (American 1851-
 1917)
 The Alarm 1884 bronze; LS
 GRID 14 UICL
 Benjamin Franklin, seated
 figure
 HARTS pl 27
 Chippewa Family bronzed
 plaster study
 PAG-1:6 UDCNM
 Francis Bacon
 HARTS pl 23
 John Barry
 SFPP
 Returning from the Hunt
 SFPP
 The Savage Age in the East;
 The Savage Age in the
 West, East Esplanade,
 Pan-American Exposition,
 Buffalo, New York, 1901
 CRAVS fig 13.5
 The Stone Age (The Stone
 Age in America; Stone
 Age Mother) 1888 bronze;
 LS
 CAF 215; CRAVS fig
 13.13; GRID 63; HARTS
 pl 46; PAG-12:197; TAFT
 405 UPPFW
Boynton, Nathaniel
 Calverly. Nathaniel
 Boynton, bust
Boys and Gazelle. Francisci
The Boys from Avignon. Seley, J.
Bracelets
 Achaemenian. Armlet#
 Achaemenian. Torques with
 Lions' Heads
 African--Benin. Armlet(s)#
 African--Benin. Bracelet
 African--Benin. Leopard:
 Oba's Forearm Ornament
 African--Benin. Mask; Arm
 Ornament
 African--Owo. Armlet
 African--Yoruba. Armlet(s)#
 Bronze Age--England. Two
 Spiralled Armlets
 Egyptian--18th Dyn. Ah-Hotep
 Bracelet
 Elamite. Ziwiye Bracelet
 Etruscan Praeneste Bracelet
 Indian. Armlet
 Indian. Bracelet
 Iron Age--England. Bracelet
 Kurdistan. Bracelet

 Persian. Armlet
 Roman--2nd/3rd c. Bracelet
 Scythian. Bracelets
 Sumatran. Bracelet
Los Braceros. Cruz
BRACHO, Carlos (Mexican)
 Maternity
 LUN
 Water Carrior (Aguadora)
 LUN
BRACHO, Gabriel Oscar
 Rustic Woman bronze
 IBM pl 33 UNNIb
BRACKETT, Edward A. (American
 1818-1908)
 Washington Allston, head
 1844 marble; 26 (excl
 base)
 CRAVS fig 6.4; GARDAY
 pl 7; PIE 378; UNNMMAS
 19 UNNMM (95.8.2)
Brahma See also Shiva
 Burmese. Brahma#
 Cuvandoja. Brahma
 Indian--Chola. Brahma: as
 Shiva, seated figure
 Indian--Deccan. Rashtrakuta
 Indian--Gupta. Brahma#
 Indian--Hindu--7th c. Brahma
 Praised by Risis
 Indian--Hindu--10th c. Brah-
 ma, 4-headed
 Indian--Hindu--13th c.
 Brahma
 Indian--Hindu--15th c.
 Brahma#
 Indian--Hindu--18th c.
 Brahma
 Indian--Kushan--Gandhara.
 Stupa Reliquary: Buddha,
 with Indra and Brahma
 Khmer. Brahma on Hanisa,
 lintel
Brahma Cattle
 Indian--Indus Valley. Seals:
 Brahma Bull
Brandeis, Louis D. (American
 Jurist 1856-1941)
 Flavin, E. P. Louis D.
 Brandeis, head
BRANN, David R. (American)
 Bathing Figure soapstone; 29
 HARO-3:20
BRANNING, Marion (American)
 Doe bronze; 30-1/4
 BROO 398 UScGB
Brant, Joseph (Thayendanegia--"He
 Sets Two Bits") (Mohawk

Chief 1742-1807)
Wood, P. Joseph Brant
Brass Form. Institute of Design
 Student
Brass Fountain. Rocklin
Brass Tail Monkey #1. Flannagan
Brauronian Artemis See Artemis
 Braur onia
Braziers
 Aztec. Ceremonial Brazier#
 Etruscan. Brazier Stand#
 Etruscan. Three-Sided
 Foot of Brazier Stand
 Israelite. Brazier: Pillar
 Capitals
 Maya. Drum-Shaped Brazier
 Persian. Zoomorphic
 Perfume Brazier
 Teotihuacan. Brazier
 Zapotec. Xipe Totec, seated
 figure: Brazier
BRAZILIAN
 Christ Carrying the Cross,
 head detail
 BARD-2: pl 302
 Negro Idol, Bahia wrought
 iron; 12-1/2
 BARD-2: pl 195 BrSpA
 --17th c.
 St. Lawrence, detail ptd
 wood
 BAZINW 401 (col) BrNL
 --18th c.
 Friar ptd wood
 BARD pl 72 BrSpC
 Jesuit Mission Altar
 Decoration, detail wood;
 43-1/4
 BARD-2: pl 194
 Ostensory: Sun
 LARR 360 BrBaD
 Weeping Madonna wood
 BARD pl 71
 --20th c.
 Mermaid, Afro-Brazilian
 Fetish Cult wood
 BARD pl 70 BrBa
 Street Lamp Base: Equestri-
 an Nymphs
 BARD-2: pl 100 BrSan
"The Brazilian"
 African--Yoruba. Gelede
 Mask: "The Brazilian"
Brazilian Man. Fiori
BRCIN, John David (Russian-
 American 1899-)
 Fantasy
 NATS 33

Rt. Rev. Dr. Mardary
 PAA-25
Bread and Wine. Kane, M. B.
Breastplates See also Armor;
 Pectorals
 Antiochia. Two Breastplates
 Colima. Breastplate
 Mixtec. Breastplate Repre-
 senting Xipe-Totec
 Mixtec. Pendant:
 Mictlantecutli
 God of Darkness
 and Death
 Olmec. Breastplate
 Olmec. Semi-ovoid Breast-
 plate
Brebeuf, Jean de (Colonial
 Missionary to Hurons 1593-
 1649)
 Canadian--19th c. Jean de
 Brebeuf, bust reliquary
BRECHERET, Victor (Brazilian
 1894-1955)
 Female Figure*
 MARTE pl 25
 O Indio e a Suacuapara
 1950/51 bronze; 80 cm
 SAO-1; SAO-4 BrSpM
 Monument to the Bandeirantes
 BARD-2: pl 122 BrSp
 Native Figure with Incisions--
 from the Group, "Stones"
 1947
 MAI 39
 St. Francisco
 SAO-1
 Sleeping Venus 1926
 BARD-2: pl 121 BrSpP
 Woman*
 MARTE pl 23
BRECHT, George (American 1926-)
 Blair, Rearrangeable
 Assemblage 1959 c
 60x18x24
 KAP pl 36
 Redemption Box 1961 mixed
 media; 12x6x6
 OAK 19
 Repository 1961 movable
 objects in constructed
 cabinet; 40-3/8x10x3
 LIP 71 UNNMMA
Breckenridge, Hugh Henry
 (American Painter 1870-1937)
 Grafly. Hugh Henry
 Breckenridge, head
Breckenridge, John Cabell (Ameri-
 can Lawyer and Statesman
 1821-75)

Voorhees. Vice President
John C. Breckenridge,
bust
BREER, Robert (American 1926-)
Self-Propelled Styrofoam
Floats 1965/66
BURN 355 UNNBoni
Styrofoam Floats, moving
down country road
SELZP 25
Breese, E. Yarde
Flanagan. Capt. E. Yarde
Breese, medal
BRENNER, Henry (American)
Circus Group bronze
SFGC 81
BRENNER, Victor David (Russian-
American 1871-)
Collis Potter Huntington,
relief
CAF 168
John Hay Medal, Rowfant
Club, Cleveland, Ohio--
obverse 1912
NATSA 275
Peace, relief
NATSA 274
Torchbearer*, commemora-
tive plaque, 50th anni-
versary of University of
Wisconsin bronze
PAG-12: 212
Brescia Head. Kresilas--Foll
Breton Peasant, head. Shonnard
Brett Klar/Klar. Haacke
BRETZFELDER, Anne (American)
Seated Figure marble
NYW 177
BREUER, MARCEL, &
ASSOCIATES, Architects
Annunciation Priory Fountain
BISH UNdB
Baptismal Fountain
BISH UMnCJ
Brewing See Cooking and Food
Preparation
BREWSTER, George Thomas
(American 1862-1943)
Robert Edward Lee, bust
bronze
HF 103 UNNHF
Brickmakers, tomb models.
Egyptian--11th Dyn
Brides
Archipenko. The Bride
Greek--5th c. B. C.
Eros: Visiting a Bride,
plaque
Rosenthal, B. Bride

Stankiewicz, R. The Bride
Trajan, T. The Bride
Weinberg, E. The Bride
The Bridge. Woodham, J.
BRIDGES, George (American)
Laughing Man
IBM pl 45 UNNIb
Briga do Galos. Cravo
Brigham, Charles
Folk Art--American. Grave-
stone: Charles Brigham
BRIGHAM, Emma Francis
(American 1855-81)
Maria Mitchell, bust bronze
HF 69 UNNHF
BRIGHT, Barney (American 1927-)
Gaea 1959 plaster
CIN # 4
Brihadisvara Temple. Indian--Chola
BRINDESI, Olympio (American)
Fountain of the Hippocampus
PAA-25
Sun Dial
PAA-28
BRINGHURST, Robert P.
(American 1855-)
The Kiss of Eternity
TAFT 528
Briseis
Manship. Briseis
"Britannicus"
Roman--1st c. Nero as a
Child ('Britannicaus")
Brite, James
Niehaus. Mr. and Mrs.
James Brite, plaque
British-American Cup Medal. De
Francisci
British Soldiers. Katz, A.
Brittany Girl's Head. Ripley, L. P.
Brittany Peasant
Shonnard, E. F. Breton
Peasant
BRITTON, Edgar
Judgment of Paris steel,
brazed with bronze; 12
ROODT 84 UCoDM
BRIZZI, Ary (Argentine 1930-)
Construcao a Partir de Dios
Arcos de Circun Ferencia
1963 anodized aluminum;
70x70x60 cm
SAO-8
"Brocade Style"
Sumerian. Cylinder-Seal:
"Brocade Style" Pattern
Sumerian. Cylinder-Seal:
Running Animals, "Bro-
cade Style"

Brock, Mrs.
 Salvatore, V. D. Mrs.
 Brock, head
Broken Crock. Kreis
Broken Heart. Lippold
Broken World. Judd, J. E.
Bromfield, Louis
 Tarleton, M. Louis Brom-
 field, head
BRON See AFRICAN--BRON
The Broncho Buster. Remington
The Bronco Buster. Proctor, A. P.
Bronx River Soldier. Lazzari, J. B.
BRONZE AGE--Austria
 Hallstatt Chariot with
 Figures, Styria bronze
 LARA 173 AGLG
 --Balearic Islands
 Bull's Head, Costitx (Majorca)
 bronze
 GUID 15; LARA 169
 SpMaA
 --Central Europe
 Decorated Europe Battle Axe
 bronze
 LARA 204 EOA
 Votive Chariot , Duplaja
 LARA 206 YBN
 --Denmark
 Kneeling Figure in Horned
 Helmet c 800 B. C.
 bronze; 10 cm
 BOES 28 DCNM
 Spiral Decorated Plaque
 bronze
 LARA 171 SnSSt
 --England
 Baetylus, Folkton Tumulus
 hard chalk
 LARA 205
 Belt Plates, Bush Barrow
 Tumulus Burial c 1450
 B. C. gold
 BAZINL pl 47 ELBr
 Two Spiraled Armlets c
 1350 B. C.; c 1200
 B. C. Dm: 3-1/4; 4-1/4
 TOR 3 (col) CTRO
 (952.184.2; 952.184.1)
 --Hungary
 Cauldron of Milavec, chariot
 model
 LARA 173
 --Iran
 Female Figure, Turang-Tepe
 c 2000 B. C. bronze;
 9-7/8
 FEIN pl 86 UPPU

 Mother Goddess, Asterabad
 clay
 CHENSW 31 UPPU
 --Ireland
 Dress-Fastener c 1000 B. C.
 gold; disks: Dm: 2
 TOR 3 (col) CTRO
 (918.3.100)
 Gorget, or Lunula c 1500
 B. C. gold; Dm: 7-1/4
 TOR 3 (col) CTRO
 (939.14.1)
 --Italy
 Chief and Warriors, Sardinia
 bronze
 LARA 207 ICagM
 Door-Slab, detail, Castelluc-
 cio Tomb 1900/1800 B. C.
 rock
 BAZINL pl 8 ISyAr
 Mother and Child bronze
 LARA 203
 --Scandanavia
 Horned Helmet, Vikso c
 800 B. C. bronze; 17.7
 cm (excl horns)
 BOES 29 DCNM
 Ornaments: Female Figure,
 two-headed animal,
 buckler, Denmark bronze
 LARA 216 DCNM
 Plaque with Spiral Ornamenta-
 tion, Denmark bronze
 LARA 217 DCNM
 Razor with Boat Design
 bronze
 LARA 216
 Ritual Drum with Solar
 Wheels
 LARA 217 SnSN
 Spear Point, engraved
 decoration 8/9th c. B. C.
 bronze
 BAZINW 89 (col) DCN
 Trundholm Sun Chariot: Sun
 Disc on Two Wheels Drawn
 by Horse on Four Wheels
 c 1200 B. C. bronze, with
 gold-plated sun disc; L:
 50 cm
 BAZINW 96 (col); BOES
 29; CHRH 25; LARA 172;
 PRAEG 170 DCNM
 --Horse, head
 LARA 216
 --Spain
 Cult Chariot: Hunter and
 Hounds Pursuing Boar

1st mil B. C.
LARA 173 FStG
--Sweden
Female Idols 1200 B. C.
FEIN pl 108
Gorget, spiral ornamenta-
tion cast bronze; B:
3-1/2; W: 7-1/4
GRAT 28 SnSHM (11217)
Haga Barrow Treasure:
Sword; Fibula bronze;
sword L: 30-1/2; clasp
L: 5-1/4
GRAT 31 (col) SnSHM
(11915)
--Syria
Axe Head with Lion's Head,
Ugarit 15/14th c. B. C.
LARA 179
Pendant: Astarte, Ugarit
gold
LARA 182 FPL
Perforated Axe Head, Ugarit
19th c. B. C. bronze
LARA 178
Seated Figure, Ugarit bronze
LARA 180
Two Cult Figures, Ugarit
20/18th c. B. C. silver,
with gold torques
LARA 179
Ugarit Weights: Bull; Human
Head 15/14th c. B. C.
LARA 180
--Turkey
Stag, tomb figure 2nd mil
B. C. bronze
LARA 182 TAA
--Wales
Coracle-Shaped Bowl, Wales
c 1200/900 B. C. L:
7-1/4
ARTSW 19 ELBr
Cup, Wales c 1400/1000 B. C.
H: 2-5/8
ARTSW 5, 18 WCaN
Lunula, Llanlyffini c 1600/
1400 B. C. gold; Dm: 9
ARTSW 18; LARA 204
ELBr
--Yugoslavia
Kilcevac Idol terracotta
(drwg of missing original)
LARA 203 YBN
BRONZE AGE/IRON AGE--Italy
Fibula c 1000 B. C. gold;
L: 2-3/4
TOR 95 (col) CTRO
(918.3.93)

Bronze Nimbus. Helfant
Bronze No. 2. Bonner
Bronze Range. Vaillancourt, A.
Bronze Sculpture. Schmidt, J.
Bronze Tablet# Chryssa
Bronze Zoological Garden Gateway.
Manship
Brooches See also Fibulae
Celtic. Brooches
Celtic. Tara Brooch
Etruscan. Earrings, Todi;
Brooch with Ionic Silen
Etruscan. Gold Brooches
Iron Age. Spectale Brooch
Roman--3/4th c. Crossbow,
military cloak brooch
Sassanian. Gryphon Brooch
Scytho-Greek. Brooch
Brook, Alexander (American Painter
1898-)
Nakian. Alexander Brook,
head
BROOK, Federico Bernardo
(Argentine 1933-)
Form S/162 1962 nickled
iron, stone
VEN-62: pl 102
Brookgreen Gardens Medal. Lathrop
Brooklyn
French, D. C. Brooklyn,
seated figure, with
Child Reading
Brooklyn Memorial Arch.
MacMonnies
Brooks, Phillips (American
Clergyman 1835-93)
French, D. C. Phillips
Brooks, bust
Pratt, B. L. Bishop Brooks
Saint-Gaudens. Phillips
Brooks Memorial
BROOKS, Richard Edwin (American
1865-1919)
Charles Carroll, gift of
State of Maryland bronze
FAIR 403; MUR 42; USC
232 UDCCapS
Eve
HARTS pl 50
John Hanson, gift of State of
Maryland bronze
FAIR 404; MUR 42; USC
242 UDCCapS
Thomas Cass
TAFT 503 UMBG
The Brooks. Konti
Broom Bird. Ungerer, T.
Broome Street. Mallary

BROS, Robert (American)
 Serenity plaster
 NYW 179
BROSE, Morris (American 1914-)
 Ancestral Ritual III 1959
 cast bronze
 CIN # 6
 Procession bronze
 WHITNA-17:10
Brotherhood of Man. Melicov
Brotherly Love
 Barnard. Pennsylvania
 State Capitol
Brothers of the Wind. McKenzie,
 R. T.
BROUGHTON, Owen (Australian
 1922-)
 Owl 1949 Osage orangewood; 18
 RAMS pl 60a
 Porpoise 1948 Tasmanian black-
 wood: c3 pl 60b
BROWERE, John Henri Isaac
 (American 1792-1834)
 Henry Clay, age 48, life
 mask 1825
 ROOS 242F UNCooHS
 James Madison, age 74, life
 mask 1825
 bronze; 29
 PIE 378 UNCooHS
 (N-12. 57L)
 John Adams, age 90, life
 mask 1825 bronze; 30
 PIE 378; ROOS 242G
 UNCooHS (N-2. 57L)
 Marquis de Lafayette, age
 67, life mask 1824
 FAIY 173 UNCooF
 Pierre Corlandt Van Wyck,
 bust c 1830 plaster
 CRAVS fig 3.2
 Thomas Jefferson, age 82,
 life mask 1825
 BUT 80; FAIY 173;
 LARK 106; ROOS 242E
 UNCooHS
BROWN, Ann M. (American)
 Acrobat porcelain
 NYW 176
Brown, Charles Brockden (American
 Novelist 1771-1810)
 McKenzie, R. T. Charles
 Brockden Brown, profile
 relief
BROWN, Edmond
 Carrousel Rooster 19th c.
 ROOS 256A UDCN
Brown, Father
 Rhind. Father Brown
 Memorial

BROWN, Henry Kirke (Henry Kirke
 Bush Brown) (American
 1814-86)
 Abraham Lincoln 1868/69
 bronze
 BUL 145; SALT 136 UNBP
 Abraham Lincoln 1868/70
 granite
 BUL 144; PIE 378; ROOS
 245E; SALT 30 UNNU
 Buffalo Hunt, equest
 HARTS pl 13
 George Clinton, gift of State
 of New York bronze
 FAIR 258; MUR 58; USC
 235 UDCCapS
 George Washington, equest
 1853/56 bronze
 CAH 50; CHASEH 495;
 CRAVS fig 5.4; HART-2:
 33; LAF 123; LARK 186;
 PAG-12:183; PIE 378;
 POST-2:225; RAY 61;
 ROOS 243B; SALT 28;
 TAFT 115; THOR pl 13;
 UPJ 570; VALE 93 UNNU
 Nathaniel Green, Senate Hall
 1867 marble
 CRAVS fig 5.3; MUR 70;
 TAFT 119; USC 240
 UDCCapS
 Philip Kearny, gift of State
 of New Jersey bronze
 MUR 56; USC 244
 UDCCapS
 Philip Kearny, bust 1872
 bronze; 30
 UNNMMAS 13 UNNMM
 (00.9)
 Richard Stockton, gift of
 State of New Jersey
 marble
 FAIR 390; MUR 56; USC
 262 UDCCapS
 Ruth 1845 marble; 56
 CRAVS fig 5.12 UNNHS
 Thomas Cole, bust after
 1840 marble; 28-1/4
 UNNMMAS 12 UNNMM
 (95.8.1)
 William Cullen Bryant, bust
 c 1846 marble; 26-1/4
 CRAVS fig 5.1 UNNHS
Brown, John (American Abolition-
 ist 1800-59)
 Bannarn. John Brown, head
BROWN, Judith (American)
 Noah's Arc 1964 H: 10
 SEITC 180 UNNAv

November 2b, 1963 steel;
c 8x36
HARO-2:38
BROWN, Marechal (American)
Five Mobiles Mounted on
Panel
LYNCMO 119
Four Dancers Under the Moon,
mobile balsa wood
LYNC 76
Mantis in Flight green balsa
wood
LYNC 87
Mobile basswood, brass wire
LYNCMO 111
Mobile holly, lead weight
LYNCMO 118
Variations on a Theme balsa
wood
LYNC 86
BROWN, Sonia Gordon (Russian-
American)
Alma Morgenthau, head bronze;
LS
SGO-17
Bas Relief bronze
SGT pl 4
The Family plaster
SGO-1:pl 4
Mila Nannetti, head bronze;
LS
SG-2
Seated Figure bronze
NYW 180
Skater plaster
SGO-2:pl 6
Vespa bronze; L: 16
SG-3
Virgin plaster; 35
SG-4 -UFit
BROWNE, Tom Martin (American)
War Horse bronze; 40x50
HARO-2:17
Brownell, Thomas Charles
Ives, C. B. Reverend
Thomas Charles Brownell,
bust
BROWNING, Elizabeth Barrett
(English Poet 1806-61)
Story, W. W. Elizabeth
Barrett Browning, bust
Browning, Robert (English Poet
1812-89)
Miller, A. Robert
Browning, tondo
Brownson, Orestes Augustus
(American Preacher and
Journalist 1803-76)
Kitson, S. J. Brownson, bust

Brumby. Shillam, L.
BRUMIDI, Constantino (Italian-
American 1805-80)
United States Capital--
Rotunda Frieze: Historical
Events of the United States
1877
USC 301 UDCCap
BRUMME, C. Ludwig (German-
American 1910-)
Madonna Italian alabaster
BRUM pl 10 UNNSC
Negra black and gold Italian
marble
SCHN pl 118
Salome ebony
ROODW 67
Soliloquy purple heart wood
BRUM pl 9 UNNSC
BRUNET, Emile
Kateri Tekakwitha 1954 bronze
on granite base; 10'
(incl 4' base)
GRID 65 CCT
BRUNETTIN, Alfred
Untitled 1964 shaped and
formed sheet steel
MEILD 163
Brush Holders
Chinese--Ch'ing. Brush
Holder
Chinese--Ch'ing. Brush Pot
Chinese--Ch'ing. Landscape
on Brush Pot
Chinese--K'ang Hsi. Brush
Holder
Brush Washers
Chinese--K'ang Hsi. Brush
Washer
Brussels Construction. de Rivera
Brutus
Roman--3rd c. B. C.
Brutus, head
Brutus, Lucius Janius (Roman
Consul fl 509 B. C.)
Greek--4/1st c. B. C.
Brutus, head detail
Brutus, Marcus Junius (Roman
Politician 85?-42 B. C.)
Etruscan. Capitoline Brutus
Hellenistic. Brutus
Roman--1st c. B. C.
Aureus: Brutus in Laurel
Wreath
Bryan, William Jennings (American
Orator 1860-1925)
Evans. William Jennings
Bryan

BRYANT, Olen (American)
 Man wood; 27
 HARO-3:2
Bryant, William Cullen (American
 Poet and Editor 1794-1878)
 Adams, H. William Cullen
 Bryant#
 Brown, H. K. William Cullen
 Bryant, bust
 Rogers, J. William Cullen
 Bryant, bust
 Thompson, L. William Cullen
 Bryant, bust
BRYAXIS (Greek)
 Equestrian, statue base relief
 c 340/300 B. C.
 RICHTH GrAN
 Mausoleum at Halicarnassus,
 North face frieze: Greeks
 and Amazons Fighting
 marble
 LULL pl 216 ELBr (1019)
BRYAXIS--FOLL
 Mausolus c 350 B. C. marble;
 120 BAZINW 147 (col)
BRYGOS (Greek fl 5th c. B. C.)
 Attic Rhyton: Dog's Head
 SAN 133 IRGi
Brymner, William
 Hill. William Brymner, bust
BRYNNER, Irena (American)
 Jewelry cast gold
 ELIS 129
BUBA, Joy
 Dr. Florence Rena Sabin,
 seated figure bronze
 USC 257 UDCCapS
The Bubble Dance. Frishmuth
BUBERL, C. (American)
 Drummer Boy
 HARTS pl 57
 General Beauregard, equest
 HARTS pl 57
 United States Soldier
 HARTS pl 57
BUCHAN, Marion (American)
 Young Girl cast stone
 NYW 181
Buchanan, James (Fifteenth President
 of United States 1791-1868)
 Dexter. James Buchanan, bust
The Buckaroo. Proctor, A. P.
Buckets
 Iron Age. Aylesford Bucket
 Iron Age. Hallstatt Buckett
 Islamic. Bucket
Buckingham, William Alfred
 Warner, O. L. Governor
 Buckingham, seated figure

Bucklers See Armor--Shields
Buckles
 Chinese--Han. Belt Buckle
 Chinese--Han. Belt Clasp
 Chinese--Han. Buckle#
 Germanic. Buckle Clasp
 Indonesian. Belt Buckle, with
 bells
 Islamic. Seljuk Open-Work
 Buckle
 Koban. Belt Buckle#
 Roman--2nd c. Belt Buckle
 Roman--4/5th c. Catterick
 Buckle
 Scythian. Buckles: Horse,
 Tiger
 Scythian. Lion-Griffin Attack-
 ing Horse, belt buckle
 Scytho-Altaian. B-Shaped
 Buckle#
 Scytho-Altaian. Buckle: Fight-
 ing Wolf and Serpent
 Scytho-Sarmatian. Animal-
 Style Belt Buckle
 Shouchou. Buckle
BUCKLEY, Jean (American)
 Adolescent Head
 CALF-59
 Walking Girl
 CALF-60
Buckner, Strap
 Amateis, R. R. Strap Buckner
 and the Devil
Buckskin Man. Franklin
Bucrania
 Roman--1st c. B. C. Vase
 Mould: Dancers, Altars,
 Bucranis
 Roman--Augustan. Caffrelli
 Sarcophagus
 Roman--1st c. B. C. /1st c.
 A. D. Sacrificial Altar
 with Bukranion
 Roman--1st c. Frieze Frag-
 ments: Laurel Tree,
 Bukrania with Garlands
 --Funerary Altar of Memmius
 Ianuarius
 --Temple of Vespasian, frieze:
 Bukrania and Sacrificial
 Implements
Buddha and Buddhism See also Amida;
 Dainichi; Maitreya; Sakyamuni;
 Yakushi. See also names of
 Divinities, Guardians, and
 Attendants, as Asanga, Ashura,
 Bodhisattvas, Devas, Five
 Rajas, Hachiman, Kuan Yin,
 Ten Judges of Hell, Vasubandhu,
 Vimalakirti

Burmese. Buddha#
Cambodian. Buddha, head#
Campa. Buddha#
Ceylonese. Buddha#
Chinese. Buddha#
Chinese--Ch'i. Buddha#
Chinese--Liao. Buddha
Chinese--Ming. Buddha,
 seated figure
Chinese--Six Dynasties. Bud-
 dha, head
Chinese--Sui. Buddha
Chinese--Sung. Buddha
Chinese--Sung; Indian.
 Buddha
Chinese--T'ang. Buddha#
Chinese--Wei. Buddha#
Greco-Buddhist. Buddha#
Indian. Buddha and Two
 Bodhisattvas
Indian--Gupta. Buddha#
Indian--Hindu--7th c. Buddha#
Indian--Hindu--8th c. Buddha#
Indian--Hindu--9th c. Buddha
Indian--Kushan. Buddha#
Indian--Kushan--Andhra
 (Early). Buddha#
Indian--Kushan--Andhra
 (Late). Buddha#
Indian--Kushan--Gandhara.
 Buddha#
Indian--Kushan--Gandhara.
 Stupa Reliquary: Buddha
Indian--Kushan--Mathura.
 Buddha#
Indian--Pala. Buddha#
Indian--Sunga. Coin: Kanishka;
 Buddha
Indian and Chinese. Buddha
 Hairdress Styles--8 heads
Indian, Japanese, Chinese.
 Buddha and Bodhisattva
Indo-Eurasian. Tun-Huang
 Shrine: Buddha
Indonesian. Buddha
Japanese. Buddha#
Japanese. Udyana Buddha
Japanese--Asuka. Buddha,
 seated figure
Japanese--Fujiwara. Buddha#
Japanese--Hakuho. Buddha#
Japanese--Heian. Miroku Butsu
Japanese--Tempyo. Buddha
Japanese--Tokugawa. Buddha
Javanese. Buddha#
Khmer. Buddha#
Korean. Buddha#
Korean. Seated Buddha

Korean. Sokkuram Buddha,
 seated figure
Laotian. Buddha Walking
Nepalese. Buddha, seated
 figure
Nepalese. Jewelled Buddha,
 seated figure
Siamese. Buddha#
Siamese. Mask of Buddha
Siamese--Ayudhya. Buddha#
Siamese--Chiengsen. Buddha
Siamese--Dvaravati. Buddha
Siamese--Dvaravati. Standing
 Buddha
Siamese--Lopburi. Buddha#
Siamese--Sukhotai. Walking
 Buddha
Siamese, or Cambodian.
 Buddha, head
Sumatran. Buddha
Thai. Crowned Buddha, head
Thai. Standing Buddha
Thai--Dvaravati Style.
 Buddha#
Thai--Late Siamese. Buddha
Thai--U-Thong Style. Buddha
--Attendants and Attributes
 see also types of Attendants,
 Divinities and Guardians, as
 Apsaras; Bodhisattvas;
 Devas; Lohans
Burmese. Obelisk: Horizontal
 Shelves--Sri. tondi;
 Buddha Figure
Burmese. Thandawgya, seat-
 ed figure
Chinese. Buddhist Altarpiece
Chinese--Chou. Buddhist
 Saint, head
Chinese--Ming. Buddhist
 Divinity
Chinese--Ming. Three
 Buddhist Female Dieties
Chinese--Six Dynasties.
 Buddhist Figure, relief
Chinese--Sung. Buddhist
 Procession: Three
 Musicians and Dancers
Chinese--Sung. Indian
 Attendant
Chinese--T'ang. Buddhist
 Figure
Chinese--T'ang. Buddhist
 Procession: Musicians
 and a Dancer
Chinese--T'ang. Buddhist
 Votive Tablet
Chinese--T'ang. Cave
 Temple: Niche Figures

Chinese--T'ang. Disciples of
 Buddha, cave figures
Chinese--Wei. Arhat, relief
Chinese--Wei. Buddhist
 Stele#
Chinese--Wei. Buddhist Figure,
 relief
Chinese--Wei. Buddhist Seated
 Figure
Greco-Indian. Buddhist Saint
Gothico-Buddhist. Buddhist
 Head
Indian--Gupta. Ananda Attend-
 ing Parinirvana of the
 Buddha
Indian--Hindu--9th c. Bodhisat-
 tva Padmapani, relief
Indian--Kushan. Adoring
 Attendant
Indian--Kushan--Gandhara.
 Buddhist Apollo
Indian--Kushan--Gandhara.
 Rabula Before his Father
Indian--Sunga. Devadhamma
 Sabha
Indo-Eurasian. Disciples
 Ananda and Kasyapa
Japanese. Buddhist Figure
Japanese--Fujiwara. Buddhist
 Deity
Japanese--Hakuho. Buddhist
 Figure
Japanese--Kamakura. Buddha
 Followers: Mawara-Nyo,
 and Basu-sen
Japanese--Kamakura. Buddhist
 Deity: Destroyer of Evil
Japanese--Tempyo. Attendant
Japanese--Tempyo. Incised
 Lotus Petal, detail
Japanese--Tempyo-Jogan. Hand
 of Buddha
Javanese. Samantabhadra
Kaikei. Kongo Satta
Kaikei--Foll. Daikasho and
 Subotai
Khmer. Bayon Temple: Tower
 with Face of Bodhisattva
 Lokesvara
Khmer. Buddhist Memorial
 Figure, head
Khmer. Buddhist Stele
Nepalese. Buddhist Priest's
 Helmet
Tankei. Zennishi Doji
--Bathing
Javanese. Bath of Bodhisattva
Javanese. Buddha: Bathing
 Before his First Sermon,
 relief

--Bearing Witness
Bengalese. Buddha in Earth-
 Touching Pose
Khmer. Buddha: Bearing Wit-
 ness to His Fearlessness
Siamese--Sukhotai. Buddha call-
 ing the Earth to Witness
Thai. Buddha Calling Earth
 to Bear Witness to His
 Virtue
--Birth
Indian--Andhra (Early).
 Dream of Queen Maya
Indian--Bharhut. Dream of
 Maya
Indian--Shunga. Stupa,
 Bharat: Dream of Queen
 Maya
Japanese--Suiko. Queen Maya
 and the Birth of Buddha
Nepalese. Birth of Buddha
--Conception
Javanese. The Conception of
 Buddha, basrelief
--Jataka
Burmese. Matangajataka,
 plaque
Burmese. Vinilakajataka, roof
 plaque
Indian--Andhra (Early). Ghata
 Jataka
Indian--Andhra (Early. Stupa,
 Amaravati: Muga Pakkha
 Jataka
Indian--Andhra (Early). Stupa,
 Sanchi. Stupa 1. Torana--
 Northern: Visvantara
 Jataka
Indian--Andhra (Early). Stupa,
 Sanchi. Stupa 1. Torana--
 Western: Great Departure,
 Saddanta Jataka
--Stupa, Sanchi. Stupa 1.
 Torana--Western: Monkey
 Jataka
Indian--Gupta. Hariti
Indian--Kushan. Vessantara
 Jataka: Gift of Sacred
 Elephant Jettatura
Indian--Kushan--Gandhara.
 Dipankara Jataka
Indian--Kushan--Mathura.
 Jataka, scene
Indian--Sunga. Lotus Wave
 with Jataka Scene
Indian--Sunga. Mriga Jataka
Indian--Sunga. Stupa, Bharat:
 Ruru Jataka, medallion
Indian--Sunga. Vessantara
 Jataka

Javanese. Hiru Lands in
Hiruka
Javanese. Mriga, or Ruru
Javanese. Prince Sudhana
and his Ladies Drawing
Water from Lotus Pond
Javanese. Sudhana Legend
--Life
Burmese. Bodhisattva's Fast,
relief
Burmese. Buddha: Great
Events of the Final Life,
relief
Burmese. Siddhartha in
Five-Storied Palace
Chinese--Wei. Prince Meets
a Sick Man, relief
Indian--Andhra (Early). Stupa,
Sanchi. Stupa 1. Life
Scenes
Indian--Kushan--Andhra (Late).
Stupa, Amaravati
Indian--Maurya. Buddha, as
a golden stag, relief
roundel
Japanese--Kamakura. Youth-
ful Shaka
Javanese. Buddha Life
Scenes
Khmer. Buddha: On Naga#
Khmer. Buddha: Sheltered
by Mucalinda, the Serpent
King
Khmer. Mucalinda Buddha
Seated on Ananda
Tibetan. Life of Buddha,
plaque
--Locatarra (Lord of the
World)
Indian--Kushan. Buddha: As
Locatarra
Khmer. Buddha: Enthroned:
altarpiece
--Meditation
Chinese--Wei. Siddhartha in
Meditation, relief
Indian--Gupta. Buddha, seat-
ed figure
Indian--Kushan--Gandhara.
Jain Ayagapata, seated
figure
Indian--Kushan--Mathura.
Buddha, seated in dyana
Japanese--Suiko. Siddhartha
in Meditation
Javanese. Dhyani Buddha
Khmer. Buddha: In Con-
templation#

Laotian. Buddha in Con-
templation
Tibetan. Dhyani Buddha
Akshobhya
Tibetan. Dhyani Buddha
Vajrasattva
--Miracles
Indian--Kushan--Gandhara.
Buddha of Great Miracle
--Reassuring
Japanese--Heian. Miroku
Buddha: Abbhaya Mudra
(Fear Not Gesture)
Khmer. Buddha: Making
Gesture which Reassures
--Teaching
Indian--Mayrya. Buddhist
Parable
Javanese. Buddha: Expound-
ing the Law to his Mother
Siamese. Buddha, teaching
mudra
--Temptation
Bengalese. Temptation of
Buddha
Indian. Departure of
Gautama and Temptation
of Buddha, relief
Javanese. Buddha:
Temptation
Tibetan. Buddha, bhumis-
parsa mudra (Touching
the Earth); Tempted by
Mara
--Trinity
Chinese--T'ang. Buddhist
Triad#
Chinese--Wei. Buddhist
Trinity, exterior niche
Japanese--Hakuho. Buddhist
Triad
Japanese--Hakuho. Yakushi
Trinity
Japanese--Tempyo. Amida
Triad, relief
Tibetan. Buddhist Trinity:
Buddha Attended by
Brahma and Indra
Tori Busshi. Shaka Triad
Buddhist Alms Bowl
Chinese--Ch-ien Lung.
Bowl: Buddhist Alms
Bowl Form
BUFANO, Beniamino (Italian-
American 1898-)
Bear and Cubs 1903
SUNA 230 UCSmaH
Bears red porphyry
BRUM pl 12

Honeymoon Couple (The Chi-
nese Couple; Chinese
Friends; Chinese Man and
Woman) 1921 glazed stone-
ware; 31-1/2
UNNMMAS 172 UNNMM
(24.42)
Medals plaster
CHICA-30
Mouse 1956
SUNA 230 UCSmaH
Peace (Dog) polished black
granite, stainless steel
REED 175 UCSFI
The Prayer red porphyry
BRUM pl 11
St. Francis of Assisi Swedish
granite; 18'
REED 42 UCSFF
Sun Yat-sen
REED 142 UCSFMa
Torso silver grey porphyry
DEYF #254
Torso, female Egyptian
porphyry
ZOR 287
Buffalo (Chippewa Warrior) See
Beeshekee
Buffalo Bill
Folk Art--American. Cigar
Store Figure: Buffalo Bill
Buffalo Horse. Remington
Buffaloes and Bison
African--Baoule. Buffalo (Guli)
Mask
African--Barotse. Neck Rest
and Box: Buffalo
African--Bobo. Buffalo Mask
African--Senufo. Mask:
Buffalo with Horns and Tusks
African--Sudan, British.
Headdress: Buffalo
Akkadian. Seal: Heroes Bat-
tling Lions and Water
Buffaloes
Brown, H. K. Buffalo Hunt
Chinese--Ch'in. Recumbent
Water Buffalo
Chinese--Ch'in. Water
Buffalo, covered vessel
Chinese--Chou. Water
Buffalo#
Chinese--Ming. Water Buffalo
Chinese--Sung. Incense
Burner: Lao-tzu on Water
Buffalo
Chinese--Sung. Reclining
Water Buffalo

Chinese--Wei. Water Buffalo,
tomb figure
Clarke, J. L. Buffalo Bull
Davis, Richard. Bison
Folk Art--American. Charging
Buffalo
Fox. Buffalo
Hardy. American Bison
Hardy. Bison
Hare. Buisson d'Elephants
Herz. Young Bison
Indian--Pallava. Descent of
the Ganges: Milking a
Buffalo
Karp. Bison
Khmer. Yama
MacNeil, H. A. Pan American
Exposition, Buffalo, medal:
Buffalo, obverse
Magdalenian. Bisons Mating
Paleolithic. Bison#
Powers, J. P. The Closing
Era
Proctor, A. P. American
Bison
Puccinelli. Buffalo
Russell, C. M. Bluffers
Shrady, H. M. Buffalo
Buffet. Folk Art--Canadian
Bugaku Mask. Japanese--Kamakura
Builders of the Future. Zorach
Building Construction
Egyptian--18th Dyn. Workman
Carrying Beam, relief
Roman--1st c. Building a
Temple with a Crane,
relief
Bulb Pots
Chinese--Ch'ien Lung. Bulb
Pot
Bull Dancing See Games and Sports
Bull Fighting See Games and Sports
Bull Jumping See Games and Sports--
Bull Dancing
Bull Men
Syrian. Bull Men Supporting
Winged Sun Disk, relief
"Bull of Heaven"
Sumerian. Cylinder Seal:
Mythological Subject--Two
Human-Headed Bulls ("Bull
of Heaven")
Bullfrog. Morrison, M.
Bulls See Cattle
BULTMAN, Fritz (American 1919-)
Coat of Male 1961/62 H: 40
SEITC 21 UNNNag

158 Burning Bush

Burning Bush
 Cronbach. Burning Bush
 Ferber, H. "... and the Bush
 was Not Consumed..."
 Vergette, N. Burning Bush
Burns, Robert (Scottish Poet 1759-96)
 Aitken. Robert Burns
 Cummings. Robert Burns
 Partridge, W. O. Burns,
 bust
BURNS, Vincent C. (American)
 Ceremonial Flower metal;
 13
 HARO-2:32
Burr, Aaron (American Politician
 1756-1836)
 Jouvenal. Vice President
 Aaron Burr, bust
Burret, C.
 Fry, S. E. Major C. Burret
 Memorial Fountain
Burro. Fisher
BURROUGHS, Edith Woodman (Ameri-
 can 1871-1916)
 Bacchante bronze; 24-1/2
 BROO 278 UScGB
 Fountain of Youth
 CHENSA 50; JAM 59;
 JAMS 29
 --Youth
 PERR 41; SFPP
 Garden Figure
 SFPP
 John Bigelow, bust c 1910
 bronze; 24
 MUNSN 150 URLW
 On the Threshhold
 PUT 177
 John La Farge, bust 1908
 bronze; 16-1/2
 LAF 255; UNNMMAS
 108 UNNMM (10.199)
Burroughs, John (American Naturalist
 1837-1921)
 Pietro, C. S. John Burroughs,
 bust
Burrows, William
 American--19th c. Burrows
 Medal: Naval Scenes
BURSZTYNOWICZ, Henry
 (American)
 Chrysalis marble; 6x20x6
 HARO-3:24
BURTON, Gloria (American)
 Descent bronze; 23
 HARO-2:29
The Bus. Seiden
Bus Driver. Segal, G.
Bus Riders. Segal, G.

Bus Stop. Beling
Bushfire. Beadle
BUSHMAN See AFRICAN--BUSH-
 MAN
BUSHONGO See AFRICAN--BAKUBA
Business Man. King, W. D.
Bust of a Flower Girl. Reder, B.
Bustabo, Guila
 Montana. Guila Bustabo,
 bust
The Butcher, The Baker, The
 Candlestick Maker. Roth,
 F. G. R.
Butchering, relief. Egyptian--
 5th Dyn.
Butler, Benjamin F.
 Pratt, B. L. Butler
 Memorial
BUTLER, Charles (English-
 American)
 Eve and the Apple wood;
 44
 HARO-2:15
Butler, Prescott, Hall, Children
 Saint-Gaudens. Children of
 Prescott Hall Butler,
 relief
BUTLER, Robert (American 1923-)
 Reclining Figure ceramic
 CIN #7
The Butler Children. Saint-Gaudens
Butter Molds See Molds
Butter Thief
 Indian--Hindu--16th c. Krishna;
 Boy Krishna as Butter
 Thief
Butterfield, Daniel (American Army
 Officer 1831-1901)
 Borglum, G. Daniel
 Butterfield
Butterflies
 Chinese--Ming/Ch'ing. Jade
 Butterfly
 Japanese--Kamakura. Butter-
 flies, cosmetic box
 Kitadai. Butterfly, Mobile
 Lynch. Butterflies, mobile
 Morgan, F. M. Three
 Butterflies
 Roszak, T. American
 Monarch
 Wasey. Butterfly
Buttons
 Japanese--Tokugawa. Manju,
 button: Warrior Subduing
 Dragon
 Japanese--Tokugawa. Ojme#
 Mycenaean. Embossed, en-
 graved garment discs

BWAKA See AFRICAN--BWAKA
Bwame Secret Society Mask.
 African--Balega
BYARS, James (American 1932-)
 Untitled 1960 granite; 9-1/8
 x 6-1/2x6
 WHITNS 15 UNNW
BYERI See BIERI
BYRD, Mary (American)
 Rabbits
 NYW 179
Byre
 Sumerian. Cylinder Seal:
 Sacred Herd Around Seed
 Byre
 Sumerian. Trough: Ewes and
 Rams
C., Miss
 Dallin. Miss C., bust
"El Caballito"
 Tolsa. Monument to
 Charles IV
CABINDA See AFRICAN--CABINDA
Cabot, John (Italian Navigator and
 Explorer 1450-98)
 Cassidy, J. John Cabot and
 his son Sebastian
CABRERA, Geles (Mexican)
 Angulo terracotta
 NEL
 Couple
 LUN
 Figura#--2 figures terracotta
 NEL
 Mujercita terracotta
 NEL
 Woman
 LUN
 Woman, No. 1
 LUN
CABRERA, German (Uraguayan
 1903-)
 Family 1959 cement
 MAI 43 UrMN
 X.X. 25 1962
 VEN-62:pl 203
Cabrillo, Juan Rodriguez
 Cabrillo Monument
CABRILLO MONUMENT
 Reed 8
Cabrini, Mother
 Hauser. Mother Cabrini
Cacao
 Aztec. Cacao-Pod Figure
 Maya. Diety, or Priest, with
 Cacao Pods on Left
 Shoulder

El Cacique. Hurd
CADDOAN
 Feline Bowl 1300/1700 clay;
 3x6
 DOCA pl 40 UNNMAI
 (17/3247)
 Water Bottle, Quachita, Par-
 ish, Louisiana c 1300/1700
 pottery; 5-3/4
 LOM 137 UNNMAI
Cadence. Hovannes
Cadenza. Hesketh
CADORIN, Ettore (Italian-American
 1876-)
 Joie de Vivre
 NATS 38
 Junipero Serra, gift of State
 of California bronze
 MUR 18; USC 258
 UDCCapS
Caduceus See also Mercury
 Greek. Caduceus
CADWALADER-GUILD, Emma
 (German-American)
 William McKinley, bust
 bronze
 USC 170 UDCCap
Caecilius Jucundus, L.
 Roman--1st c. L. Caecilius
 Jacundus
Caeneus
 Greek--7th c. B. C. Caeneus
 and Centaurs
"Caesar". Roman--1st c. B. C.
"Caesar", head. Roman--1st c.
 B. C.
CAESAR, Doris (American 1893-)
 Ascent bronze
 WHITNA-13
 Figure bronze; LS
 FEIN pl 132
 Form bronze; 18
 SG-6
 Hunger bronze
 BRUM pl 14 UNNWe
 Mother and Child cast stone
 NYW 184
 Seated Figure No. 3 bronze;
 23
 SGO-17
 Seated Woman brass
 WHITNA-17:10
 Self Portrait bronze
 SGO-10:3 UIaIU
 Standing Woman bronze
 WHITNA-16:7
 Standing Woman bronze; 74
 SG-5

Standing Woman bronze; 78
 SG-4
Standing Woman 1960 bronze;
 74
 SG-2
Torso 1953 bronze; 58
 GOODA 194 (col); NNWB
 47; PIE 384; WHITN 47
 UNNW (43.30)
Wings bronze; 23
 SG-7
Woman, Child and Hand # 1
 bronze
 BRUM pl 13 UNNBl
Woman in Skirt bronze; 55
 SG-3
Woman Waiting bronze
 SGO-4: pl 2
Caesar, Gaius Julius (Roman General)
 and Statesman 100-44 B. C.)
 Greco-Alexandrian. Gaius
 Caesar, bust
 Roman. Julius Caesar, head
 Roman--1st c. B. C. Julius
 Caesar
 Roman--1st c. Gaius Julius
 Caesar, bust
 --Julius Caesar#
Caffrelli Sarcophagus. Roman--
 Augustan Period
CAGE, Xenia
 Mobiles
 LYNC 85
Cage II. Agostini
Caged Creature. Squier, J.
Caged Instrument. Wrobliewski
Cain. Duble
Caius Vibus Trebomanus Galus
 (Roman Emperor)
 Roman. Caius Vibus
 Trebomanus Galus
Caixa Fantasmagorica. Bell, L.
Cake Boards
 Folk Art--American. Cake
 Board: "Superior" Fire
 Engine
Cakravartin. Indian--Sunga
Calabash
 New Guinea. Calabash
CALANDRIA, Juan Jose (Uruguayan)
 Evolution in Form aluminum;
 30x26x14
 HARO-1: 12
Calaveras, festival skull. Folk
 Art--Mexican
CALCHAQUI
 Plaque bronze; W: c 6-1/2
 NMANA 124 UNNMAI

CALDER, Alexander (American
 1898-)
 Acoustic Ceiling plywood
 panels; L: c 30'
 KUHA 45 VCUA
 Acrobats, from the Circus
 1927
 KUHA 40
 Aspen, mobile
 LYNCMO 23 UNNV
 Bayonet Menacing Flower,
 mobile
 LYNCMO 115 UNNV
 Bifurcated Tower 1950 sheet
 metal, steel wire, wood,
 string; L: 90-1/2
 W: 57
 RIT 215 UNNV
 Big Ear
 LIPW 92
 The Big Gong, mobile
 LYNCMO 20 UNNMMA
 Big Knight, stabile 1963
 ptd steel; 55
 WADE UNNPer
 Big Red, mobile 1959 sheet
 metal, steel wire; L: 114
 WHITNFY UNNW
 Big Red, Yellow and Blue
 Gong 1951 steel, aluminum,
 bronze; 48x72-1/2
 NEWAS 31 UNjNewM
 Black Beast, stabile 1940
 sheet iron; 103
 GIE 209; LIPW 92 UNNV
 --1957 (version of 1940
 original)
 BUEN 39
 Black Crescent, mobile 1960
 KUHB 95 UNNPer
 Black, White and Red,
 mobile 1957 sheet aluminum,
 steel; L: c 14'
 GOODA 256 (col) UNNW
 Black Widow 1960 sheet steel;
 88-1/ 2x173-1/ 4
 LOND-6: # 9 FPMa
 Bougainvillea, mobile 1947
 wire, sheet metal; 76
 READAS pl 211 UCtMeT
 Calderberry Bush 1932 standing
 mobile of steel wire and
 rod, sheet aluminum and
 wood; 84
 READCON 69 (col) UNNSw
 The Cello Player 1966 95x
 76x89-1/ 2
 CARNI-67: # 248 UNNPer

Circus Horse 1926 wire; L:
24
WHITNF-4:8 -UHir
The City 1960
KUHA 48-49 VCM
Clouds Over Mountains,
mobile 1962 ptd and
welded steel; 111x168
CHICSG; MEILD 112
UICA (1963.207)
Cockatoo sheet metal, wire;
c 36
CLEA 73 UPDoM
The Cock's Comb, mobile
1957 metal; L: 50
WHITNA 46 UNNPer
--1960 sheet iron; L: 159
GOODT 117; WHITN 73;
WHITNFY UNNW
The Cone, mobile 1960
metal; 100x110
ALBD-2:#51; TOW 110
UNBuA
Constellation 1943 wood,
metal; Dm: 14
GUG 199 UNNG
--, with Quadrilateral
LYNCMO 71 UNNV
Constellation with Red Object
1943 wood, steel rods
READAN #153 UNNMMA
Conversation, mobile
LYNCMO 96 UNNV
Cow wire construction
JOH 87; LYNCM 33
UNNMMA
--wood
NNMML UCtBrP
Dancers and Sphere,
motorized mobile 1936
KUH 131; KUHA 43
Day and Night 1965 ptd
metal; 60x144
TUC 85 (col) UNNPer
"Diana" c 1934 walnut;
30-1/4
BOSMI 165 UMB (60.956)
Disconnected, stabile
ART 206
The Dog, stabile 1958
steel; 90
BERCK 89; MAI 46
UNNPer
Double Mushroom, stabile
1957 steel; 98
BERCK 89 UNNPer
Estrela da Manha
SAO-2

Face
LYNCMO 75 UNNMMA
Feathers, mobile 1931, wood,
steel rod, lead; 39-1/2
NMAB 108 UNNBu
Fish, mobile
CALA 16 (col) IVG
--
LYNCMO 97 UNNV
--
aluminum wire, glass
LYNCM 110
The Forest is the Best
Place, mobile wire,
ptd metal
RAMS pl 79a
--steel
BRUM pl 16; GERT 183;
LYNCMO 19 UNNBu
Forks and Strainer
aluminum
LYNCM 40
Four Black Bottoms, mobile
1957 metal; Dm: 144
UIA-90:pl 119 UNNPer
Four Planes in Space 1955
ptd steel
AMAB 68; LYNCM 112
UNNPer
Four White Dots, mobile
1959 iron construction; 56
BOW 145; GAUN pl 61
A Gong as Moon, mobile 1953
metal
KO pl 108 FPMa
Gypsophila II, mobile 1950
metal, wire--ptd; 54x65
NMAB 111 UNNBu
Gypsophila on Black Skirt,
mobile
LYNCMO 21 UNNV
Hanging Large-Leaf-
Composition, mobile 1954
wrought iron; 99-1/4x
106-1/4
MYBS 88 NAS
Hanging Mobile
LYNCMO 24-25 UNNV
--1936 aluminum discs,
steel wire
FAUL 380 -Cal
Hello Girls, pool mobile 1964
ptd metal; ea of 3 units;
8'9"; 15'; 22'11"
TUC 74 UCLCM
Horizontal Red, Moon Gong
1957 ptd sheet metal,
metal rods, wire, brass;
UCIT 23, 24

--, with stabile base
 wire, ptd metal
 LYNCM 113 UNNPer
Morning Star 1943 sheet
 iron, wire, wood; 79
 GIE 207
Mervures Minies 1963
 iron; 358 cm
 BOES 141 DHuL
Octopus 1944
 READAN #118
--1964 steel plate; 10'
 TUC 75 UNNPer
On the Great Steeple steel;
 92
 WHITNA-18: 25
The Onion 1965 black ptd
 steel; 72
 SOTH-4: 69
Otto-Mobile, mobile named
 for Otto Spaeth
 LIPW 87 UWiCM
Pagoda 1962 120x79
 CARNI-64: #288
Le Petite Nez, stabile 1959
 black metal; 66-5/8
 ENC 148; READCON
 245 UNNH
Le Plumeau Bleu 1950
 sheet iron, wire; 43-1/4
 GIE 208 FPMa
Polychrome for One to Eight,
 mobile 1962 sheet metal,
 metal rods; 38x162
 JLAT 13 UNNPer
Polygons and Triangles 1963
 welded iron; 110
 SEITC 15
Pomegranate
 BRY 628
--, mobile
 LYNC 10 UNNBu
--, mobile 1949 sheet
 aluminum, steel; c 72x68
 CLEA 72; GOODA 257;
 MEN 640; MYBU 128
 UNNW
Les Ramparts, stabile
 MEILD 193 FStPM
Rat, mobile with stabile
 base wire, ptd metal
 LYNCM 112
Red Construction, mobile
 1956
 MAI 15
Red G. , mobile 1963 metal
 CHENSW 477 UNNPer
Red Gongs, mobile 20th c.
 sheet aluminum, sheet

brass, steel rod and
 wire, red paint; L: c 12'
 PIE 384 UNNMM (55. 181)
Red is the Center 1944 wood,
 wire construction
 LIPW 91 -UJ
Red Palette, mobile 1947
 BAUR pl 89 UNNBu
Red Petals 1942 sheet steel,
 steel wire, sheet
 aluminum; 110
 LIC col pl 5 (col);
 LIPW 91; NNMMAP 145;
 ROOS 282G; SCHN pl
 127; VALE 161 UICAC
Red Pyramid, mobile 1945
 mobile
 MAI 45; SELZJ 15 FPCa
Red Serpent, mobile 1958
 mural
 VEN-62: pl XVIII FPMa
Red Spiral, mobile
 LYNCMO 114
Red Sun, Black Clouds
 1963 metal; 33x130
 HENNI pl 152 UNNPer
Red Turmoil, Blue L 1962
 metal construction;
 36x150
 LYN 132 ELGro
Roman Horseman 1957 iron;
 76
 EXS 68 AVT
Rope Dancer bronze
 MAI 44
Rusty Bottle, mobile 1936
 metal; 96
 SELZS 111 UNNPer
Seven-Footed Beastie 1958
 steel; 84x84
 WHITNF-2: 10
 -UBr
7 Red, 7 Black, 1 White 1952
 MYBA 662 UNNV
Shepard Vogelsant 1930
 wire; 15
 GIE 206 UNNVo
Small Mobile of Seven
 Elements 1958 steel
 TRI 34 (col) GHaS
Snow Flakes, Red Disc,
 mobile 1953
 metal; 54x36
 SELZS 134 UNNPerl
Snow Flurry, May 14,
 mobile 1954 steel,
 aluminum; c 96x168
 HENNI pl 125 UMoKY

Polychrome, mobile
1961 metal; 35x56
CUM 78
Yellow Plane, mobile
LYNCMO 125 UNNV
Yellow Whale, wall mobile
1958 aluminum
CHENSS 707 UNNPer
CALDER, Alexander Milne
(Scottish-American 1846-
1923)
Asia, model 1872/94
plaster
CRAVS fig 13.11
City of Philadelphia
(Model), City Hall
1872/94 plaster
CRAVS fig 13-10
General Meade, equest
HARTS pl 157 UPPF
CALDER, Alexander Stirling
(American 1870-1945)
B. B. Comegys, bust
HARTS pl 56
Depew Memorial Fountain,
memorial to Dr. Richard
J. Depew bronze, marble
AMF 62; PAG-12:211;
TAFTM 139 UInIU
Dr. Marcus Whitman
HARTS pl 14 UPPW
Flower Girl, niche figure,
Court of Flowers
PERR 87
Fountain of Energy, South
Gardens
JAM 141; JAMS front;
SFPP
--details
PERR 15, 17, 18
George Washington, as
President, west pier
before 1918 marble
PIE 384; SALT 18
UNNWash
John James Audubon, bust
bronze
HF 64: PAG-15:306
UNNHF
Little Dear with Tiny Black
Swan colored plastic
NATSA 33
Man Cub c 1901 bronze; 44
UNNMMAS 106 UNNMM
(22.89)
--
PERL 130 UPPPA
Narcissus
HARTS pl 29

Nations of the West:
Enterprise
PERR 59
--: Mother of Tomorrow
JAMS 7; PERR front;
SFPP
Nature's Dance 1938
limestone; 80
BROO 106 UScGB
Our Lady and the Holy
Child
NATS 41
Professor Gross
HARTS pl 48
Reverend Samuel Davies
HARTS pl 14 UPPW
Scratching her Heel
c 1920 bronze; 12
UNNMAMS 107 UNNMM
(22.154)
Slave Girl, niche figure,
Court of Flowers
SFPP
The Star, Court of the
Universe
ACA pl 304; SFPP
UCSFPan
Swann Memorial Fountain
1924 bronze
CRAVS fig 15.7 UPP
Tragedy and Comedy
NATS 40 UPPS
Triumph of Energy
TAFTM 139
Two Brothers
HARTS pl 33
Washington Arch, relief:
George Washington
TAFTM 132 UNNWash
William Penn, bust bronze
HF 127 UNNHF
CALDER, Alexander Stirling;
F. G. Roth; and Leo
Lentelli
Nations of the East
(Nations of the Orient);
Nations of the West
(Nations of the Occident),
surmounting Triumphal
Arches
ACA pl 313 UCSFPan
--Nations of the East
(Nations of the Orient)
CHENSA 28; JAMS 11;
SFPP
--Nations of the West (Na-
tions of the Occident)
CHENSA 28; JAM 51;
JAMS 9; SFPP

Calderberry Bush. Calder, A.
Caldrons
 Bronze Age--Hungary.
 Cauldron of Milavec
 Chinese--Shang. Animal-
 Shape Ritual Kettle
 Etruscan. Cauldron
 Urartian. Cauldron
Calendars
 Aztec. Calendar Stone
 Maya. Stele: Calendar
 Cycle Memorial
 Mixtec. Calendric and Other
 Subjects, bone relief
Calene Ware
 Hellenistic. Calene Guttus
 (Lamp Feeder): Nike
 Sacrificing Bull
 Hellenistic. Calene Phiale:
 Apotheosis of Herakles
Calf Bearer
 Greek--6th c. B. C.
 Moschophorus
CALFEE, William H. (American
 1909-)
 Cylindrical Fountain plaster
 NYW 182
 Druid Oak 1938 H: 40
 MAG 81
 Palmist's Mirrors 1960
 21x13x10-1/2
 CARNI-61:#55 UDCJ
Calhoun, John Caldwell (American
 Lawyer 1782-1850)
 Mills, T. A. Vice President
 John C. Calhoun, bust
 Powers, H. John C. Calhoun
 Ruckstull, F W. John C.
 Calhoun
California. Powers, H.
Caligula (Roman Emperor 37-41)
 Roman--1st c. Caligula#
 --Deified Augustus and
 Imperial Heirs
 Roman--5th c. Caligula, youth-
 ful bust
Caliope
 Roman--2nd c. Caliope,
 seated figure.
The Call. McKenzie, R. T.
Call of the Sea. Frishmuth
CALLAHAN, Michael See USCO
CALLERY, Mary (American 1903-)
 A (Symbol 'A') 1960 brass,
 steel; 15x9
 LARM 410; READCON
 244 UNNK
 Acrobats with Birds 1952
 bronze; 52

 LYNC 81; NEWAS 33;
 UIA-7:pl 7 UNNV
 Amity
 DIV 88 UNNChas
 Amity 1946/47 bronze; 53x65
 BERCK 191; RAMS pl 82b;
 RIT 220 UNNV
 Birds in a Cage, Lobby
 aluminum
 DIV 95 UPPiA
 Birds in Flight 1955 aluminum;
 5x14'
 WHITNB 42 UPPiA
 Bronze Figure
 MAI 46
 Composition of Birds 1954
 aluminum; each of 3 birds:
 12x12'
 PIE 384 UPPiA
 Fables of La Fontaine 1954
 LIC pl 332; MAI 47 UNNPs
 Fish 1962 steel, brass;
 35-1/2
 UIA-12:126 UNNK
 Fish in Reeds 1948 bronze;
 12-3/4x15-1/2
 GIE 252
 Horse plaster model
 VALE 120 UNNMMA
 Lonely Song (Einsames Lied)
 1945 bronze
 GERT 180
 Orpheus bronze
 WHITNA-7
 The Pyramid 1949 bronze; 53
 PUL-1:pl 63
 Sailors, two figures bronze;
 25-1/2
 UIA-8:pl 29
 The Seven 1956 bronze;
 40-1/2x35x20-1/4
 BERCK 247; CARNI-58:
 pl 114
 Study for a Ballet bronze
 TRI 118 UNNK
 Three Birds in Flight 1953
 stainless steel; 9x4x3'
 AM #160
 Unidentified Sculpture
 MOT 87 UNNBu
Calligraph. Ferber
Calligraph in Four Parts. Ferber
Calligraphy See Writing
Calligraphy on a Wall. Ferber
CALLIMACHUS--ATTRIB (Greek)
 Maenad with Goat, relief
 (Roman copy) 5th c. B. C.
 marble; 57-1/2 BAZINW
 145 (col); LARA 280;
 RICHTH 113 UNNMM

Portraits
Hellenistic. Callimachus(?),
head
CALLIMACHUS--FOLL
Spartan Dancers, relief
5th c. B. C.
CLAK 276 GB
Greek--5/4th c. B. C.
Aphrodite (Venus
Genetrix), antique replica
of statue attributed to
Callimachus
Calling, a happening. Kaprow
Callipige Venus
Hellenistic. Aphrodite
Kallipyge
Calumets (Medicine Pipes)
Crow. Calumet
Indians of North America.
Calumet
Sioux. Calumet
CALUSA
Albatross, head, Key Marco,
Florida 1000/1600 wood;
4-1/2x3
DOCA pl 59 UPPU
(41240)
Alligator head, Key Marco,
Florida 15th c. wood;
L: 10-1/4
DOU 79 UPPU (40718)
Deer Mask, Key Marco,
Florida 1000/1600
wood; 5-1/2x7-1/2
AMHI 145; DOCA pl 58
(col); DOU 80; PACHA
227 UPPU (40707)
Seated Cat, or Panther, Key
Marco, Florida 1000/1600
H: 6
DOCA pl 62 UDCNMS
(24901b)
Turtle Head, Key Marco,
Florida 1000/1600 wood;
L: 4
DOCA pl 57 UPPU (40715)
CALVERLY, Charles (American
1833-1914)
Charles Loring Elliott, relief
profile medallion 1868
marble; 14x12
UNNMMAS 34 UNNMM
(94.13.1)
Lafayette S. Foster, bust
FAIR 349; USC 184
UDCCap
Little Ida c 1871 marble;
17x13-1/4
UNNMMAS 35 UNNMM
(94.13.2)

Nathaniel Boynton, bust 1891
marble; 27
CRAVS fig 6.17 New
Hampshire Historical
Society UNhC
CALVIN, Albert (American 1918-)
Outer World 1964 pewter
alloy; 63-1/2x46
UIA-12:103 UNNSta
Calydonian Boar
Greek--4th c. B. C.
Calydonian Boar Hunt,
mirror case
Roman--2nd c. Sarcophagus:
Hunt of Calydonian Boar
CAMARGO, Sergio de (Brazilian
1930-)
Large Relief 1966
KULN 166
Torre Modulata 1966 wood
VEN-66:#150
CAMBODIAN See also Khmer
Buddha 6/7th c. stone
CHENSW 277 UWaSA
Buddha, head 6th c. stone
CHENSW 277 CaPN
Buddha, head 12th c. stone
CHENSW 280 FPG
Buddha, head, Mon type
6/7th c.
clay
CHENSW 275 ThBNM
Buddha, head, Romlok 6th c.
COOMH pl 100
Buddha, head, Tra Vinh
style 6/7th c. bluish
gray sandstone
CLE 241 UOClA (32.43)
Female Figure, Sambor
6/7th c. sandstone; 57
CHENSW 276; EXM 16
FPG
Harihara (Siva-Vishnu),
Prasat Andet
GARDH 535
--7th c. stone; 75
CHENSW 276; COOMH pl
333 CaPN
Heaven and Hell, relief
LEEF 169 CaA
Lokesvara 6/7th c. black
stone; 47
COOMH pl 332 BBS
Three Lintels sandstone;
LEEF 231 FPG
Vishnu, Prasat Andet style
7th c. gray sandstone;
34-1/4
CLE 241; LEEF 228 UOClA
(42.562)

Vishnu, Tuol Dai Buon 7th c.
 stone; c 72
 LEEF 228 CaPS
Cambodian Dancer. Hobson
CAMDEN, Henry P. (American
 1900-)
 Elf, head
 NATS 42
"Camela" Doll. Folk Art--American
Camels and Camel Drivers
 Achaemenian. Tribute Bearers
 Assyrian. Arabian Woman
 Captive with Camels, relief
 Caucasian. Camel
 Chinese. Camel(s)#
 Chinese--Ming. Camel#
 Chinese--Six Dynasties. Camel
 Chinese--T'ang. Bactrian
 Camel Bearing Travelling
 Orchestra
 Chinese--T'ang. Camel#
 Chinese--T'ang. Camel
 Driver#
 Chinese--T'ang. Kneeling
 Camel
 Chinese--Wei. Camel
 Greenbaum. The Snob
 Iranian. Camel
 Kurtz. Desert Bride
 Nabatean. Stele: Camel
 and Driver
 Persian. Bactrian Leading
 Camel
 Persian. Cylinder Seal: Horse
 and Camel
 Persian. Processional
 Figures: Tribute Camel
 Sorcuk. Bactrian Camel,
 head fragment
 Syro-Roman. Syrian Musicians
 on a Camel
Cameos
 Alexandrine. Farnese Cup
 Athenian. Zeus Downing
 Giants, cameo
 Greco-Roman. Cameo:
 Wedding of Cupid and
 Psyche
 Greek--4th c. B. C.
 Cameo#
 Hellenistic. Farnese Plate
 Hellenistic. Gonzaga
 Cameo
 Hellenistic. Medusa, cameo
 Hellenistic. Ptolemaic
 Queen, cameo fragment
 Hellenistic. Zulian Cameo:
 Zeus the Aegis Bearer

 Iranian. Cameo
 Phidias--Foll. Cameo: Eros
 Roman. Cameo: Aurora Driv-
 ing Biga
 Roman--1st c. B. C. Eagle
 Roman--1st c. B. C. / 1st c.
 A. D. Augustus
 Roman--1st c. B. C. / 1st c.
 A. D. Cameo Vase
 Roman--1st c. Cameo, Wales
 Roman--1st c. Claudius and
 Germanicus with their
 Wives
 Roman--1st c. Gemma
 Augustae
 Roman--1st c. Glorification
 of Germanicus
 Roman--4th c. Cameo:
 Honorius and Wife, Mary
CAMEROON See AFRICAN--
 CAMEROON
Camillus
 Roman--1st c. Camillus
Camouflage. Lone Wolf
CAMPA
 Buddha, Binh Dinh 12th c.
 bronze
 COOMH pl 343
 Buddha, Dong-duong 3rd c.
 COOMH pl 342 Vn-nHM
 Siva, Quang-Nma 7th c. stone;
 47-1/4
 COOMH pl 344 Uv-nTM
Campaniae. Pattison, P.
CAMPBELL, Jane Gustin (American)
 King Lear, head cast bronze
 HARO-1: 21
CAMPBELL, Kenneth F. (American
 1913-)
 Ceres marble
 WHITNA-16: 8
 Draco Vermont marble
 WHITNA-17
 Gadfly Carrara white
 marble, on laminated white
 and gray Vermont marble;
 36
 SG-5
 H and I Beam Construction
 No. 1 welded steel; 20x52
 HARO-1: 25
 Nike gray Vermont marble;
 42
 SG-6
 Persephone Returns stone;
 84
 WHITNA-18: 24
 Popeye marble; 84x18x36
 WHITNA-19

Thunder Cloud laminated
 Belgian marble; 64
 SG-7
--1963 laminated black
 Belgian marble; 49x18
 UIA-12: 74 UNNGrand
To Windward Georgia white
 marble; 18x24x72
 HARO-1: 24
Campbell, Reverend
 Folk Art--American.
 Reverend Campbell, Negro
 Minister
Campbell Soup Can Pyramid.
 Warhol
Campesino con Sarape
 Magana, M. Peasant in
 Serape
Camphene Lamp# Folk Art--
 American
COMPOLI, Cosmo (American
 1922-)
 Birth 1958 plaster model,
 for bronze; 39
 SELZN 47 UICF
 Birth of Death 1950 bronze;
 33
 SELZN 46 UICF
 Mother and Child 1958
 marble; 84
 SELZN 48 UICF
 Return of the Prodigal Son
 1957/59 plaster model,
 for bronze; 30
 SELZN 49 UICF
CAMPS-RIBERA (Spanish-
 Mexican 1895-)
 Mitla
 LUN
Campus Martius
 Roman--2nd c. Apotheosis
 of Antoninus Pius and His
 Wife, Faustina
Camunda
 Indian--Hindu--11th c.
 Camunda, head
CANAANITE
 Figure c 100 B. C. bronze
 SEYT 82 UMdBW
Canada Goose. Folk Art--American
Canade. Scaravaglione, C.
CANADIAN
 Censer silver; 10-1/2
 CAN-4: 15 CMBi
 St. Zachary gilt wood; 37
 CAN-4: 16, 18 (col) CQU
 Virgin and Child wood; 19-1/4
 CAN-4: 11 CON

--18th c.
Louis XIV Altar Candlesticks,
 Quebec c 1700 pine and
 basswood; 34 (excl
 pricket)
 TOR 197 CTRO (949. 256)
--19th c.
Flying Angel (II), ptd wood,
 relief; L: 53
 CAN-4: #140 (col) CQP
Jean de Brebeuf, bust
 reliquary silver
 PAG-10: 26 CQH
St. Anne wood; 51-1/2
 CAN-3: 340 CON (6740)
St. Joachim, relief wood,
 gilt; 25-1/2
 CAN-3: 342 CON (6772)
St. John the Evangelist
 wood; 54
 CAN-3: 340 CON (6741)
The Virgin wood; 53
 CAN-3: 340 CON (6742)
--20th c.
Virgin and Child wood, gilt;
 15-1/2
 CAN-3: 340 CON
Canadian Phalanx. Mestrovic
CANCELA, Delia Sara (Argentinian
 1940-)
 The Temptations of Mr. X
 1963 assemblage;
 35-1/2x28
 WALKA 23
Candarosana in Yab Yum
 Nepalese. Candarosana in
 Yab Yun with his Sakti
 and Eight Attendants
Candelabra and Candlesticks See
 also Chandeliers; Menorah
 Aarons. Memorial Candle
 Holder
 Boston and Sandwich Glass
 Co. Dolphin Candlestick
 Canadian--18th c. Louis XIV
 Altar Candlesticks
 Chinese--Sui/T-ang. Candle-
 stick
 Chinese--T'ang. Candlestick
 Etruscan. Candelabra Finials
 Etruscan. Dancer:
 Candelabra Figure
 Etruscan. Candelabra Finials
 Etruscan. Candelabra with
 Winged Human
 Etruscan. Candelabrum#
 Folk Art--American.
 Candlestick(s)#

A Gathering of Birds 1954
cast stone; 20-1/2x20
PIE 384 UNNW (55.18)
Headland bronze
WHITNA-17:10
Landscape Formation #2
bronze; W: 16
SG-5
Pines bronze; 18
SG-4
Stalking Cat bronze
BRUM pl 17 UNNWil
Stallion bronze
SGO-10:4
Torso Hydrastone; 21
SG-6
CAPECCHI, Joseph (Italian-
American 1889-)
Infant Head
NATS 44
Capillary Action II. Rosenquist, J.
Capitals
Acanthus Leaf Capital
American--18th c. Capital:
Scrolls with Floral and
Geometric Motif
Assyrian. Bull Capital
Coptic. Basket Capital
Coptic. Capital#
Coptic. A Tyche, pilaster
capital
Cypriote. Capital
Egyptian. Column, with
Palm Leaf Capital
Egyptian. Palm Capital
Egyptian--3rd Dyn. Palm
Capital
Egyptian--5th Dyn. Palm
Capital
Egyptian--9/10th Dyn.
Egyptian Palm Capital
Egyptian--Middle Kingdom.
Hathor-Headed Capitals
Egyptian--12th Dyn. Bell
Capitals
Egyptian--19th Dyn. Hathor
Capitol
Egyptian--26th Dyn. Hathor
Capital
--Lotus Bell Capital
--Palm Leaf Capital
Egyptian--30th Dyn.
Papyrus Capital
Egyptian--Ptolemaic. Bell-
Shaped Capitals
--Composite Capitals
--"Flower-Branch" and Palm
Frond Capitals
Etruscan. Capital with Four
Female Heads

Gallo-Roman. Figures
Greek. Capital
Greek. Greek Orders of
Architecture: Doric,
Ionic, Corinthian
Greek--Archaic. Aeolic
Capital
Greek--7th c. B. C. Aeolic
Capital
Greek--6th c. B. C.
Siphnian Treasury, Delphi:
Capital--Lotus and
Palmette
Greek--5th C. B. C. Capital
--Corinthian Capital
--Erechtheum: Ionic
Capital
--Ionic Capital
--Temple of Athena Nike:
Capitals
Greek--4th c. B. C.
Choragic Monument of
Lysicrates: Corinthian
Order
--Corinthian Capital
Hatchett. Capital
Hellenistic. Olympieum,
Southeast Corner:
Corinthian Capitals
Indian--Gupta. Ajanta Caves,
Cave 24 Capital
Indian--Hindu--7th c. Capital
Indian--Kushan--Gandhara.
Corinthian Capital
--Ionic Capital
Indian--Maurya. Capital:
Lion#
Islamic. Capital#
Israelite. Brazier: Pillar
Capital
Latrobe. Corn Cob Capital
Latrobe. Tobacco Capital
Loeser. Office Building
Capital
Mnesicles. Ionic Capital
and Architrave
Noguchi. Capital
Persian. Bull-Man Head
Persian. Bulls' Heads
Capital#
Roman. Corinthian Capital
Roman. Ionic Capital
Roman--1st c. B. C.
Composite Capital
Roman--1st c. Arch of
Titus: Roman Composite
Capital
--Capital and Entablature
--Corinthian Capital
Roman--2nd c. Corinthian
Capital

Roman--3rd c. Composite
Capital
Capitoline Aphrodite. Praxiteles--
Foll.
Capitoline Brutus, bust. Etruscan
Capitoline Gladiator
Hellenistic. Dying Gaul
Capitoline Venus
Praxiteles--Foll. Capitoline
Aphrodite
Capitols
Barnard. Philadelphia State
Capitol
CAPLES, Robert Cole (American)
Winnedumah ptd stone
IBM pl 73 UNNIb
CAPPADOCIAN
Four Standards, Alaja Huyuk
H: 9 to 21
FRA pl 123
Two Bulls, Chieftan's Tomb,
Maikop
FRA pl 124B
Two Gods c 2000 B. C.
bronze
COOP 172 FPRoths
Vase, Maikop
FRA pl 124A
Cappadocian Ware
Hittite. Lion Rhyton
Caprice. Baskin
"Captain Jinks of the Horse Marines"
Folk Art--American. Cigar
Store Figure: Captain
Jinks of the Horse
Marines
Captive Angel. Weinberg, E.
Captives See also Slaves and
Slavery
Egyptian--Predynastic. Bat-
tlefield Palette
Egyptian--4th Dyn. Captives
in Bonds, relief
Egyptian--6th Dyn. Bound
Foreign Captive
Palmer, E. D. The White
Captive
Roman--2nd c. Column of
Marcus Aurelius, relief:
Captive Women and
Children
Capture of a City. Coptic
Car Crash. Dine
Car Man
Trova, E. Study/Falling
Man Series
Car of History
Franzoni, C. Clock: Car of
History

Cara Grande". Indians of South
America--Brazil
Caracalla (Roman Emperor
188-217)
Roman--3rd c. Arch at Lep-
cis, panel
--Caracalla#
--Septimius Severus, with
Sons Caracalla and Geta,
Receives Senators, relief
--Young Caracalla, bust
"Caracalla Satanis". Roman--3rd c.
Carafes
Sassanian. Carafe: Dancers;
Animal Motifs
CARAJA INDIANS, Brazil
Female Figures--armless,
dressed in cloth and
bark unfired clay
FEIN pl 110 UNNAmM
CARCHI
Feline-Form Vessel clay;
17-7/8
NMANA 130 UNBB (39.279)
CARDENAS, Augustin (Cuban
1927-)
Plaster 1953
MAI 50
Caress. Maldarelli, O.
The Caress, relief. Schnier, J.
CARIB
Shaman's Mask 1910 feather-
covered wood; 7x9-1/2
DOCS pl 224 UNNMAI
(6/844)
Caricature Heads. Hellenistic
Carita. Kent, A.
CARLBERG, Norman (American
1928-)
Minimal Surface Form 2
1952 marble; 13
NMAR
Project for Column epoxy
and plaster
WHITNA-16: 8
CARLISKY (Argentinian 1914-)
Crucifixion bronze
MAI 51
CARLOS, Padre (Ecuadorian)
S. Pedro de Alcantara,
detail
WHY 163
CARLTON, Jack
Messenger's Flight steel
MEILD 194
Carnac Dolmen
Neolithic--French. Menhir
Carnegie Library Memorial
French, D. C. Blacksmith
Reading

Greek--4th c. B. C.
Cassandra, gold ring
Hellenistic. Gem: Cassandra
Cassel Apollo. Phidias--Foll.
CASSIDY, John (American 1860-)
John Cabot and his Son,
Sebastian
PAG-1: 112
Cassini, Number 2. Perry, C. O.
Cassiopeia No. 3. Cornell
Cast Iron. Schmidt, J.
Castanets See Musicians and
Musical Instruments
Castano, Giovanni
Denghausen. Giovanni
Castano, head
CASTILLO, Fidencio (Mexican
1907-)
Sisters (Hermanas)
LUN
CASTILLO, Rosa (Mexican)
Imploring
LUN
Mestiza Family
LUN
Seated Woman
LUN
Castine. Ortman, G.
Castle of Ants. Mukai
Castle of the Eye. Nizuma
Castor and Pollux
Greenough, H. Castor and
Pollux, relief
Iannelli. Castor and Pollux
Praxiteles. The Horse
Tamers
CASTRO-CID, Enrique (Chilean-
American 1937-)
Anthropomorphicals I and II
plexiglas, aluminum; 65x
20x24
UIA-13: 76 UNNFei
Robots* (Exhibition, Richard
Feigen Gallery, New York,
1965)
BURN 349
"Cat" Stele. Greek--5th c. B. C.
Catacombs. Lipton, S.
Catafalque. Higgins
Catawba Confederate Indians.
American--20th c.
Catch. Hare
Cathedral Image III. Rood
CATLETT, Elizabeth (American
1915-)
Mother and Child
DOV 153
Negro Woman
DOV 154

Cato
Roman--1st c. "Cato"
Cato Uticensis (Cato the Younger)
(Roman Stoic Philosopher
95-46 B. C.)
Roman--1st c. B. C. Cato
Uticensis, bust
Cats
Arnold, A. Humpty
Calusa. Seated Cat
Caparn. Stalking Cat
Chimu. Zoomorphic Stirrup
Vessels
Chinese--Ch'ien Lung. Yellow
Cat
Davis, E. L. Folded Cat
Diederich. Cats
Dombek. The Spirit of the
Cat
Egyptian. Cat, seated figure
Egyptian--12th Dyn. Kitten
Watching Prey
Egyptian--Late Period. Cat
on Papyrus Column
Egyptian--24th Dyn. Cat,
seated
Egyptian--25th Dyn. Cat with
Necklace and Earrings
Egyptian--26th Dyn. Cat#
--Mau, sacred cat of Bast
Egyptian--Saite/Ptolemaic.
Cat, head
Egyptian--27/30th Dyn. Cat#
Egyptian--Ptolemaic. Cat#
Fiene. Hunting Cat
Folk Art--American.
Doorstop: Cat
Folk Art--American. Figure-
head: Cat Head
Folk Art--American. Grave-
stone for Cat
Folk Art--Mexican. Cat of
Tonala
Indian--Pallava. Descent of
the Ganges: Ascetics and
Nagas; Elephants; Ascetic
Cat
--Descent of the Ganges:
Nagas and Naginis; Cat
and Mice
Indians of South America--
Peru. Feline Face, incised
vessel
Japanese. Cat
Japanese--Tokugawa. Netsuke:
Neko, the Cat, as O-toyo
Morrison, M. Sleepy Cat
Nunez del Prado. Cats
Persian--Parthian.

Incense Burner: Feline-
Form Handle
Sawyer, C. Cat and Kittens
Swarz, S. Recollections of a
Mummified Cat
Warneke. Cat
Warneke. Mother Cat and
Kittens
Werner, N. Eastside Tom
Whieldon, T. Seated Cat
Zorach. Child with Cat
Zorach. Male Cat
Zorach. Seated Cat
Catterick Buckle. Roman--4/5th c.
Catskill Aqueduct
French, D. C. Completion
of Catskill Aqueduct
Medal
Cattle See also Agricultural Themes;
Europa; Zebu
Achaemenian. Bull's Head
Achaemenian. Tribute Bearers
African--Bakuba. Ox
African--Bissagos Islands.
Bull Mask
African--Bron. Bovine Head
African--Chamba. Mask: Cow
African--Guro. Masks:
Antelope; Cow
Alexandrine. The Dioscuri;
Pasiphae and the Bull
Amlash. Bull, vessel
Anatolian. Bull
Apollonius and Tauriscus.
Farnese Bull
Assyrian. Browsing Bull
Assyrian. Bull Capital
Assyrian. Combat of Lion
and Bull, bas relief
Assyrian. Cylinder Seal:
Sacred Barque, with Priest
in front of Altar
Babylonian. Ishtar Gate
Borglum, S. H. Fighting Bulls
Bronze Age--Balearic Islands.
Bulls' Head#
Bronze Age--Syria. Ugarit
Weights: Bull
Calder, A. Cow
Cappadocian. Two Bulls
Chinese--Ch'ing. Tureen Cow
Chinese--Chou. Ox Head
Chinese--Han. Bulls Head,
axle cap
Chinese--Shang. Cow, with
Turned Head
Chinese--Shang. Ox Head

Chinese--Shang to 20th c.
Bulls Heads
Chinese--T'ang. Bull
Chinese--T'ang. Traders
with Bullock-Drawn Cart
Cretan. Bull, vase
Cretan. Bull's Head
Davis, E. L. Black Bull
Egyptian--Predynastic.
Palette au Taureau
Egyptian--5th Dyn. Peasants
Driving Cattle and
Fishing
--Ti Tomb: Cattle Herders
Fording a River
--Ti Tomb: Counting Flocks
Egyptian--6th Dyn. Kitchen
and Herding Scenes
Egyptian--11th Dyn. Cattle
and Milking Scene
--Cattle Inspection
Egyptian--12th c. Man
Ploughing with Oxen,
tomb model
--Plow with Oxen
Egyptian--18th Dyn. Two
Cows Feeding
--Voyage to Punt: Frankin-
cense Trees, with Graz-
ing cattle
Egyptian--19th Dyn. Ramses
II and Son Roping a Bull
--Seti I Temple, wall
reliefs: King and Prince
Capturing Bull
Egyptian--20th Dyn. Ramses
III: Hunting Wild Bulls
Egyptian--Ptolemaic. Men
Bringing Sacrificial
Offerings
Epping. Man and Bull
Etruscan. Bull-Headed
Oinochoe
--Ploughman with Two Oxen
Folk Art--American. Butter
Mold: Cow Under Tree
Folk Art--American:
Weather Vane: Bull
Folk Art--Peruvian. El Tor-
ito de Pucara
Frazier, C. Cow
French, D. C. and E. C.
Potter. Indian Corn.
Gallo-Roman. Rearing
Bull
Gallo-Roman. Three-Horned
Bull
Gilbertson. Bull

Greek. Bull's Head Pendant
Greek. Farnese Bull
Greek--7th c. B. C.
 Achilles: And Cattle of
 Aeneus, amphora
--Roundel: Pairs of Flies,
 Human and Bull Heads
Greek--6th c. B. C. Bull
--Moschophorus (Calf
 Bearer)
--Stater of Samos: Fore-
 part of Bull
Greek--5th c. B. C. Coin:
 Acanthe--Lion Attacking
 Bull
--Parthenon: Bulls Lead to
 Sacrifice
--Parthenon: Panathenaic
 Procession--Lowing
 Heifer
--Signature Seals
Greek--5/4th c. B. C.
 Bull's Head Rhyton
Greek--4th c. B. C.
 Byzantium Coin: Herakles
 Strangling Serpents; Cow
 and Dolphin
Halegua. Sad Cow
Hardy. Young Cow
Harris and Company. Cow
 Weathervane
Harrison, C. Bull*
Haseltine. Aberdeen Angus
 Bull: Black Knight of
 Auchterarder
Hellenistic. Farmer
 Driving Bull to Market
Hopfensberger. Cow
Indian. Man and Bovine
 Tomb Figures
Indian--Indus Valley. Seal:
 Bull
Indian--Maurya. Capital:
 Bull
Indian--Pallava. Descent
 of the Ganges: Krishna's
 Cows
Iron Age. Bull
Ito. Bull
Javanese. Bull (Nandi)
Khmer. Cow Suckling Calf
Khmer. Reclining Nandin
Laliberte. Le Repas du Veau
Lathrop. Nancy Lee (Calf)
McNight, R. J. Bull
Manship. Europa
Maya. Dance Mask: Bull
 Head

Mesopotamian. Cylinder Seal:
 Cattle
Miller, R. J. Bull
Minoan. Acrobat on Bull
Minoan. Bull of Crete,
 relief
Minoan. Cow and Calf,
 relief
Minoan. Palace of Knossos,
 relief: Galloping Bull,
 head
Minoan. Rhyton: Bull's
 Head
Minoan. Sacrificial Vessel:
 Bull
Minoan. Seal: Lying Ox, and
 two Lions
Mycenaean. Bull
Mycenaean. Feeding Bottle:
 Cow
Mycenaean. Rhyton: Bull's
 Head
Mycenaean. Vapphoi Cups:
 Capture of Wild Bull;
 Cattle Pasturing
Nadelamn. Standing Bull
Nadelman. Wounded Bull
Nakian. Calf
Nakian. Young Calf
Nuncez del Prado. Native
 Bull
Paleolithic. Bull
Paleolithic. Long-Horned Ox
Paleolithic. Ox
Paleolithic--Denmark. Bahrain
 Bull's Head
Peraza, H. Toro
Persian. Bit Plaque:
 Primeval Ox
Persian. Bull, head#
Persian, Bull's Head
 Capital#
Persian. Bull's Head Ewer
Persian. Lion Attacking
 Bull, relief
Phoenician. Cow Suckling
 Calf
Phoenician. Deer, Cow and
 Calf
Roman--1st c. B. C. Bull
Roman--1st c. B. C. Farmer
 taking Produce, Cow and
 Sheep to Market
--Temple of Apollo, Sosianus,
 frieze: Triumphal Pro-
 cession, with Trumpeter
 and Oxen
--Vase Mould: Dancers,
 Altars, Bucrania

Roman--1st c. B. C. /1st c.
 A. D. Standing Bull
Roman--1st c. Bull
--Cow
--Sacrificial Procession to
 Altars with Animals
Roman--2nd c. Farnese Bull
--Mithras Sacrificing a
 Bull, relief
--Paris and Eros, relief
Rosati, J. Bull
Roth, F. G. R. Highland
 Bull
Rudy, C. Bull Calf
Rudy, C. Young Bull
Sabean. Bull
Scythian. Bull's Head
Shonai Shoami--Foll. Ox,
 sword guard
Speck, W. Bull #1
Steppe Art. Bull, pole
 support
Sterling, L. M. Calf
Sumerian. Bearded Cow
Sumerian. Bull#
Sumerian. Bull's Head, harp
 decoration
Sumerian. Cylinder Seal:
 Cattle#
Sumerian. Cylinder Seal:
 Gilgamesh Training Bull
Sumerian. Cylinder Seal:
 Heraldic Bearded Heroes
Sumerian. Cylin der Seal:
 Presentation to gods
 Shamash and Ishtar, with
 Animal Forms--Opposed
 Goats, Cow and Suckling
 Calf
Sumerian. Cylinder Seal:
 Sacred Herd Around Reed
 Byre
Sumerian. Frieze: Sacred
 Cattle
Sumerian. Harp, bull's
 head decoration
Sumerian. Offering Pitcher:
 Figures of Bulls and
 Lions, in round
Sumerian. Ox
Sumerian. Reclining Cow
Sumerian. Recumbent Bull
Sumerian. Rain-Ring: Bull
Sumerian. Ritual Bowl:
 Bulls and Ears of Corn,
 relief
Syro-Hittite. Rhyton:
 Stand in form of forepart
 of Kneeling Bull

Tomotada. Bull and Calf,
 netsuke
Tralles--Foll. Farnese Bull
Twedt. Steer
Umlauf, C. Steer
Urartian. Bull's Head
Urartian. Deity Standing on
 Bull
Urartian. Two Bulls' Heads,
 large cauldron(?)
 decoration
Vakian, R. Cow
Walters, C. Bull
Waring. Bull
Warneke. Newborn Calf
Cattle, Winged
 Assyrian. Khorsabad Gate
Cattle Raid
 Greek--6th c. B. C.
 Sicyonian Treasury
CAUCA
 Seated Warrior clay; 15
 NMANA 146 UNNAmM
 (T34-1A and B)
CAUCASIAN
 Animal Plaques 1st mil
 B. C. bronze
 CHENSW 86 UICA;
 UNNMM
 Camel bronze
 CHENSW 168 UNNMM
 Ibex, harness ring bronze
 CHENSW 168 UNNMM
 Open Work Plaque c 5th/
 4th c. B. C. bronze;
 5x5-3/8
 NM-2:28 UNNMM (21.166.6)
 Openwork Square Plaque 4th
 c. B. C. bronze
 SOTH-3:155
 Pin bronze
 CHENSW 168 UNBuMS
Caughnawaga Women. Suzor Cote
Cauldrons See Caldrons
Cause One. Melendy
Cavalier Rampin
 Greek--6th c. B. C. Rampin
 Horseman
CAVALLITO, Albino (Italian-
 American 1905-)
 Bather pink Nankato stone
 SGO-2:pl 11
 Figure, unfinished
 hammered lead; 24
 SGO-17
 Pelican limestone
 SGT pl 6
 Polar Bear Cipoline marble
 SGO-1:pl 8

Seal black Belgian marble
 BRUM pl 18 UNNSC
Susanne Belgian marble
 NYW 186
Cavalry Frieze
 Greek--5/4th c. B. C.
 Parthenon: Horseman:
 (Cavalry Frieze)
CAVUNDAJO (Indian)
 Brahma, Kuruvatti 11th c.
 stone; 65-3/4
 COOMH pl 225
 UPPU
Caxton, William (First English
 Printer 1422-91)
 Willis, M. Caxton, head
CAYUGA
 Split-Body Mask: Dehodiat'
 gaiwe, Ontario, Canada
 1890 red and black ptd
 basswood; L: 10-1/2
 DOCA pl 235 UNNMAI
 (19/8335)
CECERE, Gaetano (American
 1894-)
 Adam and Eve plaster
 SCHN pl 115
 Alphonse X, The "Wise",
 medallion head marble
 USC 282 UDCCap
 Andraetta bronze
 NATSS-67:5
 Boy and Fawn 1929 bronze; 33
 BROO 334 UScGB
 Cupid and Stag
 AGARC 166
 Elenore
 PAA-41
 Garden Figure marble
 NYW 185
 George Mason, medallion
 head marble
 USC 285 UDCCap
 Justinian, medallion head
 marble USC 284 UDCCap
 Lincoln 1934
 BUL 192 UWiM
 Overmantel Panel: Equestrian
 Stag Hunt NATS 48
 Roman Peasant, head
 NATS 47; PAA-25
 Simon de Montfort, medallion
 head marble
 USC 282 UDCCap
Ceilings
 Calder, A. Accoustical
 Ceiling
 Colombian--16th c. Decorated
 ceiling, including framed

Delft Plates
 --Mudejar Ceiling
Ecuadoran--18th c. Mudejar
 Ceiling
Indian--Hindu--13th c.
 Dancers, ceiling frieze
Indian--Hindu--13th c.
 Dome Interior
Islamic. Ceiling Decoration
McIntire, Samuel. Room,
 with Decorated Ceiling
Roman--2nd c. Portico Ceiling
Celestial Box. Cornell
Celestial Navigation Box. Cornell
The Cellist, head. Wyle, F.
Cellist
 Zadkine. Seated Harlequin
Cello See Musicians and Musical
 Instruments
CELTO-LIGURIAN
 Severed Head, Entremont
 3rd/2nd c. B. C.
 limestone; 9
 BAZINW 166 (col) FAixM
 Two-Headed "Hermes" 3rd/2nd
 c. B. C. stone; L: 12-1/2
 BAZINW 166 (col) FMaB
 Warrior's Head, Entremont
 3rd/2nd c. B. C. Stone; 12
 BAZINW 166 (col) FAixM
Celts
 Nicoya. Celt, with incised
 human figure
 Olmec. Celt#
 Olmec. Were-Jaguar Infant,
 Celt/
 Roman--1st c. A Celt, head
Cenci, Beatrice (Roman Woman
 1577-99)
 Hosmer. Beatrice Cenci
Censers See also Incense Burners
 Amiot. Censer
 Canadian. Censer
 Chavin. Incense Vessel#
 Chinese--Han. Hill-Censer
 Chinese--Ming. Cloisonne
 Censer
 Etruscan. Censer
 Maya. Censer, in form of Uija-
 Tai, "He Who Sees Every-
 thing"
 Maya. Incense Burner or
 Funerary Urn: Form of
 Ceremonial Figure
Centaurs
 Etruscan. Centaur#
 Etruscan. Tomb Cover
 Greek. Centaur and Lapith,
 relief
 Greek. Gravestone of Metrodorus

Greek--Archaic. Seal:
Centaur Attacked by
Bowman
Greek--8th c. B. C. Man
and Centaur
--Seal: Nessus and Deianeira
Greek--8th/6th c. B. C.
Centaurs--three figures to
show change in form
Greek--7th c. B. C. Caeneus
and Centaurs
Greek--6th c. B. C. Centaur#
--Herakles: Shooting an Arrow
at Fleeing Centaurs
Greek--5th c. Parthenon:
Centaur Triumphant
--Temple of Zeus, Olympia:
Battle Between Lapiths
and Centaur
--Temple of Zeus, Olympia:
Centaur#
Hellenistic. Amphoara:
Centaur Handles
Hellenistic. Centaur
Hellenistic. Old Centaur
Hellenistic. Stele of
Metrodorus
Indian--Sunga. Stupa Sanchi.
Stupa 1: Centaur
(Kimpurusa) and Female
Rider
Manship. Centaur and Dryad
Manship. Lead Vase:
Centaur
Muller, O. P. Centaur
Rimmer, W. Dying
Centaur
Roman--1st c. B. C.
Bowl of Fountain:
Nereids with Centaurs
and Sea Monsters
Roman--1st c. Calices--
two-handled footed cup:
Centaurs and Cupid
--Funerary Altar of Freed-
man Amemptus: Torches
with Garlands, with
Centaur Musicians
Bearing Eros and Psyche
--Vase: Battle with
Centaurs
Urartian. Centauress
Ziegler, F. J. Centaur
Centeocihuatl
Huastic. Centeocihuatl,
Goddess of Maize
Centeotl
Aztec. Tlaxolteotl
Centipedes
Seiyodo. Two Centipedes on

Boar's Tusk, netsuke
CENTRAL ASIAN
Bodhisattva, head 7th c.
BAZINW 253 (col) FPG
Opposing Roosters,
ornament
READM 15 -Ru
Central Park Carrousel. Cornell
CENTURION, Manuel (Mexican
1883-1952)
Fray Bartolome de Las
Casas
LUN MeM
St. Francis of Assisi, relief
LUN
Simon Bolivar, equest
LUN
CEPHISODOTOS See KEPHISODOTOS
Ceracchi, Giuseppe (Italian 1751-
1801)
Folk Art--American.
Alexander Hamilton, bust
(after G. Ceracchi)
Ceramic Sculpture 12. Lichtenstein
Ceramicus (Athenian) See also
Greek--5th c. B. C. Stele
of Hegeso; Greek--4th c.
B. C. Stele of Dexileos
Grave Relief of Protonoe
ROOS 38E GrAA
Cerberus
Crawford. Orpheus and
Cerberus
Greek--Archaic. Cerberus
Lipton. Cerberus
Cercopes
Greek--6th c. B. C. Heracles
and Cercopes
Ceremonial Board New Guinea
Ceremonial Flower. Burns
Ceremonies
Elamite. Susa Ceremony
Model
Ceres See Demeter
CERNIGLIARO, Salvatore (Italian-
American)
Carousel Horse, Dentzel
Carousel Factory c 1903
ptd wood
ART 86
Cernunnos, Celtic God of Wealth
Roman--4th c. Cernunnus
CERNY, George (American 1905-)
Reverie red Sienna marble
BRUM pl 19 UNNSC
Sleeping Beauty
PAA-52

Vixen black Belgian marble;
17
BRUM pl 20; UIA-6: pl 108
UNNSC
Cervantes Saavedra, Miguel de
(Spanish Novelist 1547-1616)
Mora, J. J. Cervantes
Memorial
CEYLONESE
Ananda Attending the
Parinirvana of the Buddha
12th c. granite; 23
JANSK 296 CePG
Animal Figure, panel, Kandy
ivory
COOMA pl 139 ELV
Avalokitesvara, seated
teaching 8th c. bronze;
3-1/2
CHENSN 214; COOMH pl
297 UMB
Bedhead: Animal Motif,
Kandy 18th c. wood; L: 30
COOMA pl 144 CeKNM
Bodhisattva, head, Anad-
hapura 200/300 dolomite
COOMH pl 289 CeCNM
Bodhisattva, seated figure
8th c. bronze
CHENSW 263 UMB
Bodhisattva, or King Duttha
Gamani c 200 dolomite;
over LS
COOMH pl 294 CeA
Buddha 3/4th c. limestone;
over LS
CHENSW 258; COOMA
pl 27 CeA
Buddha c 600 bronze; 16-1/2
RIJA pl 159 NAR
Buddha, Anuradhapura c 200
dolomite; over LS
COOMA pl 2; COOMH pl
293 CeA
Buddha, Dong Duong bronze
ROW pl 137 Vn-nHM
Buddha, Eastern Java c 3rd
c. bronze; 42 cm
SECK 169 (col) NAA
Buddha, Ruvanveli Dagaba
ROW pl 137 CeA
Buddha Nirvana, reclining
figure 13th c. stone; L:
46'
MU 85; UPJ 713 CePG
Buddha Nirvana, with
Ananda 13th c. granite; 23
UPJ 714; UPJH pl 308
CePG

Buddha, seated figure 6/7th
c. dolomite; 79
LEEF 116 CeA
Buddha, seated figure,
Anuradhapura
ROW pl 139 CeCNM
Buddha, seated in Jhana
3/4th c. dolomite; over
LS
COOMH pl 295 CeA
Buddha, seated teaching
Badulla 5/6th c. bronze;
43
COOMH pl 296 CeCNM
(14.118.289)
Buddhist Figures c 200 stone
CHENSW 258 CeA
Couple 5/8th c. stone
CHENSW 259 CeA
Dagaba, model, Anuradhapura
2nd c. B. C.
COOMH pl 292 CeA
"Devil Dance" Mask ptd wood
NEUW 135 ELBr
Duttha Gamani, Ruvanveli
Dagaba
ROW pl 138 CeA
Dvarapala (Door Guardian)
ROW pl 138 CeA
--, relief, Kandy 16/17th c.
ivory; 11-1/16x3-5/8
COOMA pl 134
Elephant, door jamb plaque
17/18th c. ivory
COOMH pl 338
Elephants, relief c 7th c.
rock carving
WCO-3:38, 39 CaAI
Gal Vihara
ROW pl 141 CeP
Hanuman, on pedestal
10/13th c. copper; 21
COOMA pl 49 ELV
Jambhala, mongoose in left
hand 8th c. bronze;
3-1/8
COOMH pl 298 UMB
King on Wicker Throne,
seal, Yatthala Dagaba,
2nd c. B. C. carnelian;
Dm: 3-1/8
COOMA pl 16; ROW pl
212 EMaM
Knife, Kandy 18th c. pierced
and repousse silver
COOMH pl 378 CeKC
Maitreya, head, Anuradhapura
200/300 dolomite
COOMH pl 290 CeCNM

Manikka Vacagar, Shaiva Saint
and Psalmist, Polonnaruva
11/13th c. copper; 21
COOMA pl 47 CeCNM
Moonstone (Iri handa-gala), door-
step, Anuradhapura 5th
c. granulite
COOMH pl 288; LEEF
115; ROW pl 140 CeA
Naga Door Guardian, relief
granulite
COOMA pl 25 CeA
Naga Stone 7/12th c. H:
c 1 m
WCO-3:45
Parakrama Reading Palm-
Leaf Manuscript, Bahu I
12th c. rock figure;
11-1/2'
COOMA pl 34; COOMH
pl 301; ROW pl 142 CeP
Parjanya and Agni, Isurumuni-
ya Vihara
ROW pl 139 CeA
Pattini and Naga King
11/14th c. wood
COOMA pl 45 CeN
Pattini Devi 7/10th c.
copper gilt; 57-1/2
COOMH pl 300; LEEF 117;
ROW pl 145 ELBr
Pendant, Kandy 18th c. gold,
cabochon rubies; W:
2-3/4
COOMH pl 376 CeKD
Rati, plaque ivory; 12-3/8x
4-7/8
ROW pl 212 UCMF
Stele, Anuradhapyra c 300
dolomite
COOMH pl 286 CeA
Stone Relief: Love Scene,
or Donors, Isurumuniya
Vihara
COOMA pl 26 CeA
Sundara-Murti Svami,
Shaiva, boy-saint,
Plonnaruva 12/13th c.
copper; 25
COOMA pl 48; COOMH
pl 243; ROW pl 145
CeCNM
The Sage Kapila 8th c.
granulite; over LS
COOMA pl 31 CeAI
Temple Lamp: Elephant,
Dedigana 12th c. bronze
ROW pl 212 CeDM

Vajrapani 9th c. copper;
4-3/4
COOMH pl 299 UMB
Votive Fan, Kandy 18th c.
gold, cabochon sapphires;
17-1/2
COOMH pl 385 CeK
Youthful Saint bronze
CHENSW 265 CeCNM
CHABOILLEZ, Charles (Canadian
1638(?)-1706)--ATTRIB
Virgin and Child wood; 26
CAN-4:19 CMH
Chacmool, Rain God
Maya-Toltec. Chacmool
Tarascan. Chacmool, Rain
God
Toltec. Chacmool, reclining
figure
CHAD See AFRICAN--CHAD
Chaino. Edwards, M.
Chains
Etruscan. Chain, from
censer
Chairemon
Greco-Egyptian. Tombstone
of Chairemon
CHAIRESTRATOS (Greek)
Themis, Rhamnous c 280
B. C. marble; 2.22 m
BEAZ fig 146; HAN pl
228; RICHTH 155;
WEB 205 GrAN
Chairs See also Stools; Thrones
African--Batshioko. Chief's
Chair
African--Belgian Congo.
MaNyema, seat, possible
tribal throne
Alexandrine. Supper Party,
with reclining diners
Egyptian--18th Dyn. Chair
Egyptian--18/19th Dyn. Chair,
with Lion Paw Legs
Hellenistic. Theater of
Dionysus; Silenus, crouch-
ing figure; Carved Seat
Indians of South America.
Seat
Kusama. Armchair
Oldenburg. Armchair
Samaras. Chairs
Turkestan. Niya Chair
Watts, R. Chair
Chaitya Cave
Indian--Gupta. Ajanta Caves.
Cave 26
Chakrapurusa, Angel of the Disius
Indian--Pala. Chakrapurusa

Big E 1962
 KULN 98
Boydille 1966 fiberglas;
 42x51x42
 TUC 79 UCLD
Coo Wha Zee 1962 welded
 auto metal; 72x60x50
 LOND-6:#11; MILLS pl 68
 UNNC
Essex 1960 ptd automobile
 parts and other ptd metal;
 108x78x43
 SEITZ 138 (col) UNNC
Jackpot 1961 welded auto
 metal and gilt cardboard
 KUHB 131 UNNWarh
Jo-So 1960 automobile parts
 MEILD 123 UNNJ
Kroll 1961 steel; 25-3/4x28
 ALBS-2:#52; TOW 110
 UNBuA
Madame Moon 1964 ptd metal;
 48x74x53 cm
 LIC pl 341; NEW pl 39
 UCLRow
Miss Lucy Pink 1962 ptd
 welded auto metal; 48x45x38
 ART 238; PAS#7 UNNC
Mister Moto 1963 polychrome
 welded steel; 29-1/2x32x23
 PAS#9 UNNC
Nutcracker 1959 welded auto
 parts
 MEILD 123; RICHT pl 109
 UNNC
Sculpture*
 EXS 51
Slauson 1963 ptd welded steel;
 20-1/2x24x15
 KULN 99; PAS#8 UCLD
Sweet William 1962 hammered
 and compressed scrap
 metal; 60x46x62
 MEILD 26; TUC 86 (col)
 UCLCM
Ta Tung 1966 urethane foam;
 21x39x43
 TUC 80 UCLD
Toy 1961 metal and plastic;
 48x38x31
 TUC 78 UCLD
Tung Ting Hu flexible
 polyurethane; 37-1/4x54x
 54-3/4
 GUGE 104 (col)
Untitled ptd steel; 66
 WHITNA-18:26
Untitled 1960 welded metal;
 20x16x12
 READCON 270 UNNH

Untitled 1963 steel (auto-
 mobile parts); 31x37-1/2x
 28
 WHITNS 26 UNNW
Untitled 1965 ptd steel; 59x
 56x39
 CHICSG UNNC
Wildroot metal; 66x65
 CARNI-61:#63; SEAA 65
 UNNJ; UNNSto
 Portraits
Segal. John Chamberlain
 Working
Chameleon
 African--Afo. Headdress
 Mask, with Chameleon Sur-
 mounting Hawk-like Forms
 African--Ashanti. Goldweight:
 Chameleon
Chamerernebti
 Egyptian--4th Dyn. Menkure
 and his Queen
Champion takes the Sun. Hodge
CHAMPLAIN, Duane (American
 1890-)
 Swan Girl
 NATS 51
Champlain, Samuel de (French
 Explorer in America
 1567(?)-1635)
 Chevre. Champlain
 Fornham. Champlain's Con-
 ference with Indian
 Chiefs
Champville Limestone. Hague
Chamunda
 Indian--Chola. Chamunda, one
 of the Earth Mothers
CHANCAY
 Double Vessel 1200/1450 clay;
 8x9-1/2
 DOCS pl 155 UNNMAI
 (16/219)
 Effigy Vessel 1200/1450 ptd
 clay; 10-1/2x16
 DOCS pl 157 UNNMAI
 (19/6621)
 Figure ptd clay; 25
 NPPM pl 122 UNNMPA
 (60.22)
 Globular Jar 1200/1450 ptd
 clay; 11-1/2x16
 DOCS pl 158 (col) UNNMAI
 (16/214)
 Tomb Offering: Loom
 Preparation 1250/1500 llama
 wool woven textile; 14
 DOCS pl 145 UNNAmM
 (41.2/5630)

Egyptian--18th Dyn. Amen-
 hotep III: In His Chariot,
 stele relief
--Amenhotep III (Amenophis
 III): Parading Prisoners
 of War
--Chariot in Harvest Scene
--Charioteers, relief
--Tutankhamon: Victorious
 in Chariot Driving
 Vanquished, pierced
 plaque
Egyptian--19th Dyn. Seti I:
 Fighting Hittites
Egyptian--20th Dyn. Chariot
 drawing from model
--Ramses III: Hunting Wild
 Bulls
Etruscan. Certosa Grave-
 stone, stela
Etruscan. Chariot
Etruscan. Chariot Procession
Etruscan. Monteleone
 Chariot
Etruscan. Perugia Chariot
Etruscan. Stele, Felsina:
 Dragon Fighting Hippocamp;
 Chariots with Winged
 Horses
Etrusco-Italic. Chariot Pulled
 by Winged Horse, frieze
Falkenstein. Chariot
Greco-Roman. Marcus
 Aurelius in Solar Chariot
Greek. Charioteer, relief
Greek. Gem: Chariot Driver
Greek. Gravestone of
 Metrodorus
Greek. Syracuse Coin:
 Quadriga
Greek--8th c. B. C.
 Charioteer
Greek--6th c. B. C. Chariot#
--Charioteer, frieze fragment
--Crater of Vix
--Siphnian Treasury
Greek--5th c. B. C.
 Aphrodite: In Chariot
 Drawn by Eros and Psyche
--Basile Abducted from
 Underworld
--Coin, Syracuse: Chariot
--Demareteion
--Lentini Tetradrachma:
 Chariot
--Libation Bowl: Herakles in
 Chariot

--Lycian Sarcophagus
--Man: Mounting Chariot
--Parthenon: Apobates
--Parthenon: Chariot and
 Soldiers
--Parthenon: Charioteers
Greek--4th c. B. C. Ear-
 rings: Nike Driving Two-
 Horse Chariot
--Mausoleum at Halicarnassus:
 Charioteers
--Stater Philip II, head;
 reverse: Charioteer
 Driving Two Horses
Hittite. Hunting Scene,
 relief
Hittite. Lion Hunt, relief
Hittite. War Chariot, relief
Indian--Andhra (Early).
 Surya in Four-Horse
 Chariot
Iron Age. Hallstatt Cult
 Chariot
Khmer. Lintel
Khmer. Prince on War
 Chariot, relief
Khmer. Wounded Warrior
 Chief Dying on Chariot
Konti. The Despotic Age
Milonadis. Chariot
Mycenaean. Signet Rings:
 Stag Hunt; Combat
Roman--Early Empire.
 "Auriga" (Charioteer)
Roman--1st c. Arch of
 Titus: Triumph of Titus
Roman--2nd c. Marcus
 Aurelius Column: Marcus
 Aurelius Passing a Temple
 on way to Triumphal
 Arch, relief
--Septimus Severus Tri-
 umphal Arch
Roman--3rd c. Arch at
 Lepcis
Roman--5th c. Dionysos in
 a Chariot
Sumerian. Chariot Drawn by
 Four Asses
Sumerian. Chariot Model
Sumerian. Ur Standards
Syrian. Faience Chariot
Syro-Hittite. Chariot and
 Animals
Syro-Hittite. Soldiers in
 Chariot, relief

Charity
 Laurent. Charity
 Manship. Lincoln
 Rush, W. Charity
Charles. King, W. D.
Charles IV (King of Spain 1748-1819)
 Tolsa. Monument to Charles
 IV ('El Caballito'), equest
CHARLES, Clayton R. (American)
 Preacher Williams mahogany
 IBM pl 78 UNNIb
Charms (Amulets, Fetishes, Talis-
 mans) See also Churinga;
 Divination; Fertility Figures;
 Idols; Tiki; Wands; Zemi
 African--Babindji. Magic
 Figures
 African--Baga. Snake Fetish
 African--Bakongo. Fetish
 Figure
 African--Bakongo. Konde,
 nail fetish
 African--Bakota. Mbulu
 Ngulu
 African--Baluba. Amulst:
 Human Figure
 African--Baluba. Charm
 African--Baluba. Female
 Figure Amulet
 African--Bambara. Protective
 Figure
 African--Baoule. Amulet
 African--Bapende. Fetish
 Figure
 African--Basonge. Fetish
 Figure
 African--Basonge. Fetish
 Head
 African--Basuku. Hermaphro-
 dite Healing Fetish
 African--Bateke. Fetish
 Statue
 African--Bavili. Fetish with
 Nails
 African--Bena Lulua. Squat-
 ting Fetish
 African--Congo. Kneeling
 Female Fetish
 African--Congo, French.
 Amulet
 African--Fang. Female
 Fetish
 African--Ijo. Ejiri
 African--Ijo. Sacrificing
 Man on Elephant-
 Leopard
 African--Isoko. Human
 Figure: Ivbri Figure
 on Head

 African--Nigeria. Female
 Figure: Sickness Cure
 African--Urua. Fetish
 African--Wakewere. Female
 Fetishes
 African--Zombo Plateau.
 Nikosi (Lion) Fetish
 Assyrian. Amulet: Demon
 Pazuzu
 Chinese--Han. Amulet: Tiger
 Chippewa. Mide Society
 Medicine Bundle Doll
 Cycladic. Amulet(s)
 Egyptian--1st/2nd Dyn.
 Amulet: Frog
 Egyptian--11th Dyn. Amulet
 Wand
 Egyptian--26th Dyn. Amulet:
 Amuletic Hawk
 Egyptian--28th Dyn. Shawabati
 Egyptian--Late Period.
 Baboon with Eye Amulet
 Egyptian--Ptolemaic. Horus
 on the Crocodiles
 Eskimo. Shaman Doll Charm
 Greek--8th c. B. C. Magic
 Wheel
 Haida. Shaman's Charm
 Hudson. Charm
 Indian--Kushan--Gandhara.
 Amulet Boxes
 Indian--19th c. Disease-
 Warding Charm
 Indians of Central America--
 Costa Rica. Frog Amulet
 Indians of Central America--
 Panama. Girl's Spirit
 Board Image
 --Shurama Figure, curing
 charm
 Indians of North America--
 Arizona. Split-Twig Deer,
 hunting talisman
 Indians of South America--
 Brazil. Topu
 Indians of South America--
 Venezuela. Charms
 Indonesian. Hampatong
 Kitksan. Shaman's Charm
 Kitskan. Soul Catcher
 Luristan. Confronting
 Griffins, talisman
 Luristan. "Gilgamesh"
 Between two Beasts
 Maya. Amulet
 Melanesian--Admiralty
 Islands. War Charm
 Melanesian--New Hebrides.
 Twin-Figure Amulet

New Guinea. Fighting Charm
Otomi. Effigy Cup Figure
Paleolithic. Amulets
Persian. Talisman
Quimbaya. Amulet
Quimbaya. Seated Figure,
 amulet
Sarawak. Bolli Atap, magical
 figure
Sumatran. Amulet Box
Sumerian. Amulets, carved
 gems
Tahitian. Fetish: Adze
Tahitian--Society Islands.
 Fish-head Charm
Tlingit. Seal, charm
Tlingit. Shaman's Charm(s)
Charun, Demon of Death
Etruscan. Sarcophagus;
 detail: Charun
CHASE, Barbara (American 1936-)
 Adam and Eve 1958 bronze
 DOV 144
 The Last Supper 1958 bronze
 DOV 144 UNNSha
 Mother and Child 1956
 orangewood
 DOV 144
 Victorious Bullfighter 1958
 bronze
 DOV 143 UPPO
CHASE, Catherine Maroney (Ameri-
 can 1936-)
 Veronica's Veil 1961 68x60x
 25 cm
 FPMO
CHASE, Elizabeth (American)
 Group bronze
 WHITNC 228 UNNW
Chase, Salmon Portland (American
 Statesman and Jurist 1808-73)
 Jones, T. D. Chief Justice
 Salmon P. Chase, bust
The Chase. Hunt, R.
The Chase. Stankiewicz
Chasidism. Freilicher
"Chatsworth Head". Greek--5th c.
 B. C.
Chauri (Yak Tail Fan)
 Indian--Gupta. Goddess
 bearing Chauri
Chaveyo
 Hopi. Kachina: Chaveyo
CHAVEZ, Edward (American)
 Emperor I walnut; 20
 HARO-3:23
CHAVEZ MORADO, Tomas
 (Mexican 1914-)

Hommage to the Builders of
 Mexico City
 LUN
Prayer (Plegaria)
 LUN
CHAVIN
 Bird and Feline-Head Relief
 BUSH 149
 Carved Jar, Lambayeque
 Valley
 LOT 159 PeLM
 Circular Ear Ornament,
 Lambayeque Valley
 1000 B. C. /1 A. D.
 gold
 AMHI 48 UNNMAI
 Circular Repousse Plaque:
 Stylized Feline Face
 gold; Dm: 4-13/16
 BUSH 152 UDCD
 Crown 720/250 B. C. gold;
 5-1/2x9-1/2
 DOCS pl 94 (col) UNNMAI
 (16/1972B)
 Crown: Feline Diety Flanked
 by Two Birds of Prey
 repousse gold; L: 12
 NMANA 33 PeChiH
 Cup soapstone; 4-1/8
 NMANA-1:fig 5 UDCN
 Cup: Feline Motif Periodone
 stone; 4-1/8
 NMANA 22 UDCN
 Death Mask, movable ears,
 Moon Pyramid, Moche gold
 and copper alloy, with silver
 plate; shell eyes; 10-1/4
 DIS 179 (col) GStL
 Disk gold; Dm: 4-7/8
 NMANA-1:fig 3 UDCN
 Effigy Bowl: Jaguar stone
 NMAS #87 UPPU
 False Head, mummy pack,
 Pachacmac c 1000 ptd
 wood, shell and silver
 eyes, vegetable fibre hair;
 11-1/2
 DIS 204 (col) GBVo
 Feline Mask, Pachacamal
 silver; 8
 NMANA 32 UNNAmM
 (B 9450)
 Fox, embossed head, Moon
 Pyramid, Moche gold,
 copper and silver alloy;
 shell teeth; 6
 DIS 174 (col) GStL

Cheops
 Egyptian--4th Dyn. Cheops#
Chephren
 Egyptian--4th Dyn. Khafre
Cheppewa Family. Boyle
Cheramyes Votary
 Greek--6th c. B. C. Hera of
 Samos
CHERRY, Herman (American)
 Toy
 LYNCMO 79 UNNWe
Cherry Sundae. Oldenburg
Chertihotep. Egyptian--12th Dyn.
Cherubs See also Putti
 Horn. Cherub
CHERULLO, Arnold
 Untitled 1964 sheet metal
 MEILD 115
Chess-Players. Khmer
Chess Set. Gordin
Chests of Drawers. Folk Art--
 American
Chester. Johnson, S.
Chestnuts
 Nagayoshi. Three Chest-
 nuts, netsuke
Chests
 American--17th c. Chest
 --Connecticut Type Carved
 Chest
 American--18/19th c. Chest
 on Chest: Putti, Garlands,
 Urns, Fruit
 Dennis. Chest
 Egyptian--18th Dyn. Chest
 with Hieroglyphs and
 Symbols
 Folk Art--Spanish American
 (United States.) Chest on
 Stand
 Greek--5th c. B. C. Woman:
 Placing Garment in a
 Chest, relief
 Tlingit. Chest
CHEVRE, Paul (Canadian 1898-)
 Champlain
 PAG-1:299 CQ
Cheyenne. Remington
CH'I See CHINESE--CH'I
Ch'i Lin
 Chinese--Han. Unicorn
Chi Wara
 African--Bambara. Dance
 Headpiece
Chia, round tripod ritual vessel
 Chinese--Shang. Chia
CHIBCHA
 Bachue(?), head, burial urn

fragment 1200/1600 ptd
buffware; 10-1/2
 DOCS pl 23 UNNMAI
 (23/920)
Cacique with Oarsman in
Raft, Lake of Siecha
cast gold
 ADL 200 ColBR
Ceremonial Knife cast gold;
7
 NMANA 152 UPPU
 (SA 2753)
--cast gold; 7
 NMANA 153 UPPU
 (SA 2754)
--: Human Face, Columbia
before 1500 gold
 LOWR 185 UPPU
Chieftan, flat figure
1200/1600 gold; L: 5-1/2
 DOCS pl 24 UNNMAI
 (18/9140)
Dignitary on a Litter,
Colombia c 1500 cast
gold
 KUBA pl 119B formerly
 UNNSch
Figure, Colombia c 16th c.
gold; 4
 NEWA 108 UNjNewM
Flat Human Figure, with
staff and shield,
Colombia gold; 2-1/2
 BUSH 240 UMCP
Head: with Headdress
pottery; 3-1/4
 BUSH 243 UMCP
Head, figure fragment,
Colombia pottery; 13/16
 BUSH 243 ELBr
Man, Colombia 15th c. cast
gold, gold wire applique;
6-1/4
 DENV 112 UCoDA
 (NW-471)
Seated Effigy 1200/1600
grayware; 8
 DOCS pl 22 ColBM
Seated Warrior 1200/1600
gold; L: 3-1/2
 DOCS pl 25 UNNMAI
 (13/1577)
Three Figures, flat with
wire overlay cast gold;
3-3/4; 4-1/4; 4-7/8
 NMANA 150 UICNh (6600;
 6620; 6706)
Three Figures, flat with

wire overlay cast gold;
4; 5-1/4; 3-11/16
NMANA 151 UOC1A (47.22;
47.18; 47.23)
Chibcha
 Muisca. Anthropomorphic
 Figure, "Chibcha"
CHICHIMEC
 Jaguar with Cacao Pods
 SPI-2: pl 62
Chickens
 African--Benin. Cock
 Assyrian. Seal: Cockerell
 Motif
 Brown, E. Carrousel
 Rooster
 Central Asian. Opposing
 Roosters, ornament
 Chinese--Ch'ien Lung. Cock
 Colima. Vessel: Chicken
 Davis, E. L. Bantam Rooster
 Davis, E. L. Cock
 Drowne. Cock Weathervane
 Egyptian--5th Dyn. Poultry-
 Fattening Farm, relief
 Flannagan. Triumph of the
 Egg
 Folk Art--American. Car-
 rousel Rooster
 Folk Art--American. Chicken
 Folk Art--American. Cock
 Folk Art--American. Hen
 Folk Art--American.
 "Pennsylvania Pine"
 Rooster
 Folk Art--American. Rooster
 Folk Art--American.
 Weathervane: Cock
 Folk Art--American.
 Weathervane: Cockerell
 Folk Art--American. Weather-
 vane: Crowing Rooster
 on Ball, with Arrow
 Folk Art--American.
 Weathervane: Rooster#
 Folk Art--American Negro.
 Hen
 Folk Art--Canadian. Cock,
 chimney cowl
 Folk Art--Mexican. Toys:
 Rooster, Dog, Adam and
 Eve
 Gallegos. Rooster
 Greek--6th c. B. C.
 Cockerel, relief
 Hnatt. Happy Rooster
 Igbesamwan. Cock
 Japanese--Ancient. Fowl,
 haniwa

 Japanese--Ancient. Hen,
 haniwa
 Japanese--Tokugawa.
 Netsuke: Dutchmen with
 Fowls
 Judean. Ya'azanyahi Seal
 Kaprow. Chicken
 Kearney. The Rooster
 Lamont. Gallic Cock
 Laurent. Rooster
 Lipchitz. Prayer
 Lombard. Hen, weathervane
 Lombard. Rooster
 Masa-Nao. Zodiacal Sign:
 Hare and Cock, netsuke
 Pennsylvania--German.
 Cocks, Rabbits, Goat
 Pennsylvania--German.
 Rooster
 Pennsylvania--German.
 Toys: Eagle, Rooster,
 Two Hens
 Pennsylvania German. Water
 Whistle: Stylized Hen
 Piccirilli, H. Cock
 Rubitschung. Rooster
 Schimmel, W. Toy Animals:
 Rooster, Eagle, Parrot
 Wasey, J. Cocks
 Zorach. Setting Hen
Chicomoatl, Maize Goddess
 Aztec. Chicomoatl
Chief. African--Bakongo
Chief. Murray, R.
A Chief of the Multnomah Tribe.
 MacNeil, H. A.
Ch'ien Lung (Emperor of China
 1735-95)
 Chinese--Ch'ien Lung.
 Imperial Throne
CH'IEN LUNG See CHINESE--
 CH'ING
Chien Moquer. Hayes
CHIHUAHUA, Mexico
 Human Effigy Vessel clay
 CHENSW 31 UNmSL
CHIKAMASA (Japanese)
 Ashinaga Yawning and
 Tenagu Sleeping late
 19th c. ivory; 3-1/4
 SWANJ 212 ELBr
CHILANGA
 Animal Head, relief,
 Salvador stone
 NMAS #36 UNNMAI
CHILD, Thomas (1658-1706)
 Paint Shop Sign, used in
 London 1697; used in
 Boston 1701 wood;

35-1/2x35-1/2
 PIE 378 UMBSo
Child. Judson, S. S.
Child. Zorach
Child and Mother See Mother and
 Child
Child in a Web. Wines, J.
The Child in the Vineyard.
 Putnam, B.
Child on Horse. Zorach
Child Standing. Hare
Child with Cat. Zorach
Child with Shell,* fountain.
 Scudder
Childbirth. Marin, F.
CHILDERS, Paul (American)
 Fugitive wood
 IBM pl 62 UNNIb
 Pugilist plaster
 NYW 182
Children. Granlund
Children on the Beach. Hughes, T.
Children Playing. Gross
Children Playing. Thompson, W. J.
Children's Sculpture
 Dorfman. Mother and Child
 Mosco, M. Miner
Children's Year Medal. Beach
Child's Torso. Wines, J.
CHILEAN
 Altar of San Ignacio 17/18th
 c.
 TOLC 9 ChiGC
Chilean Girl. Roman Rojas, S.
CHILI, Manuel See CASPICARA
Chimalli
 Mixtec. Ceremonial Shield
Chimera
 Chinese. Chimera
 Chinese--Chin. Ram:
 Genie Riding a Chimera
 Chinese--Han. Chimera#
 Chinese--Six Dynasties.
 Chimera#
 Chinese--Wei. Chimera#
 Etruscan. Cauldron
 Etruscan. Chimera of
 Arezzo
 Greek--7th c. B. C.
 Bellerophon: On Pegasus
 Attacking Chimera, plaque
 Greek--6th c. B. C.
 Tripod: Pegasus with
 Athena; Chimaera
 Greek--5th c. B. C.
 Bellerophon: Slaying
 the Chimaera
Chimes See Musicians and
 Musical Instruments

Chimney Cowls
 Folk Art--Canadian. Cock
Chimney Sweep. Kennedy, Simon
Chimpanzees See Monkeys and
 Apes
CHIMU
 Balance Beam Scales; Beam
 L: 4-7/8; 5
 BL pl CXXXVIII (col)
 UDCBl
 Beaker 1250/1500 silver; 7
 DOCS pl 147 UNNMAI
 (19/6607)
 Beaker: Face c 1300/1438
 gold; 6-1/2
 JANSK 376 UICA
 Beaker: Head gold; 6-5/8
 NMANA 88 UICA
 Beaker: Man in Headdress
 and Earspools turquoise-
 inlaid repousse gold;
 7-7/8
 BUSH 201 -Mug
 Beaker, repousse design sil-
 ver; 9-1/2
 NMANA 90 UNNHee
 Bowl Base, bird motif
 beaten silver; Dm: 6-7/8
 LOT 185 (col) PeLL
 Breastplate repousse gold;
 W: 24
 LOT 181 (col) PeLL
 Breastplate; profile gold;
 W: c 15-1/8
 BL pl CXXIX (col), 275
 UDCBl
 Canteen with relief Jaguar
 blackware; 9
 BUSH 198 UMCP
 Ceremonial Axe gold,
 turquoise, shell inlay;
 c 17
 NMANA 91 PeLMA
 Ceremonial Knife gold
 figures, with gold plated
 blade; 12-13/16
 BUSH 204 -Mug
 Ceremonial Chopping Knife:
 Standing Human copper,
 gold handle set with
 turquoise; 16
 LOT 183 (col) PeLM
 Ceremonial Rattle Vases
 silver, repousse,
 engraved
 SFGP pl D, 26-7 PeLN
 Ceremonial Tranchet: Bird-
 Man in Headdress
 LARA 108 PeLNA

Cup: Puma and Cubs
silver; 4
NMANA 86 UNNMor
Dancing Foxes, ceremonial
staff, Chanchan c 1200
bronze
DIS 213 (col) GMV
Double-Spouted and Bridge
Ceremonial Vessel, Lambay-
eque hammered silver;
7-1/4
BUSH 198 -Mug
Drinking Vessel (Pacha):
Man Fishing from Reed
Raft blackware; L:
12-1/4
BUSH 198 UMCP
Ear Ornaments: Man and
Woman c 1000 gold; 1-3/4
DOCS pl 153 UNNMAI
(17/8867)
Ear Whorl: Rowers in
Balsa, with Sail(?)
1250/1500 silver; Dm:
2-1/2
DOCS pl 149 UNNMAI
(16/3455)
Earplug: Bird with Fish
gold
NMANA 118 PeLMA
Earplugs gold; Dm: 2-1/2
NEWA 107 UNjNewM
Earrings; Sequins; Spear
Thrower
BL pl CXXX-CXXXI (col),
275 UDCBl
Earspool gold; 4-1/8
NPPM pl 127 UNNMPA
(58.74)
Earspool gold; W: 3-1/2
NMANA 91 UNNRo
Earspool: Central Head
Encircled by Ten Heads
repousse silver; Dm:
5-1/2
BUSH 203 UNNAmM
Earspool: Two Birds with
Common Body wood,
colored shell inlay; Dm:
1-7/8
BUSH 203 (col) ELBr
Earspool, pair gold; Dm:
3-1/2
NPPM pl 125, 126 UNNMPA
(57.164a, b)
Earspoon copper
BL CXXXIII (col) UDCBl
Embossed Disk 1200/1500
silver; 12-1/2x13-1/2

DOCS pl 150 UNNMAI
(23/6190)
Funerary Mask, Batan Grande,
Lambayeque Valley gold;
W: 28-3/4
NPPM pl 124 UNNMPA
(57.161)
Funerary Mask, Lambayeque
gold; W: 22-3/8
BUSH 202 -Mug
Hands and Forearms beaten
gold, silver-covered
nails; 12-3/4x5
LOT 2 (col) PeLM
Knife 1250/1500 bronze;
6-5/8
DOCS pl 148 UNNMAI
(15/7162)
Knife Blade 1250/1500
bronze; L: 10
DOCS pl 146 UNNMAI
(15/7200)
Large Jar, Chanchan ham-
mered silver; 27-1/4
LOT 184 (col) PeLM
Litter Front, figure
decoration wood; W:
37-7/8
NMANA 120 UOClA
Male Head
PANA-1: 88 UPPU
Mirror Handle: Diety
Holding Two Trophy Heads
wood; 11-5/8
NMANA 116 UNBB
(L.42.87.16)
Monkey Eating Fruit 15th c.
wood; 11-5/8
COOP 280; NPPM pl
129 UNNMPA (56.114)
Mummy Bundle Mask wood;
9-1/2
NMANA 92 UNNAmM
(B/628)
Mummy Mask gold; 12-5/8
BL pl CXXVIII UDCBl
Mummy Mask 1200/1500
gold; 11x18
DOCS pl 151 (col)
UNNMAI (18/4291)
Ornaments: Headband with
Feather; Pins; Feather-
Shaped Pin; Cups gold;
gold and silver
BL pl CXXXII (col)
UDCBl
Panther, club head 1200/
1500 stone
DOCS pl 170 UNNMAI
(15/7289)

Plaques, detail copper-silver
 alloy
 BL pl CXXXIX UDCBl
Portrait Jars clay
 CHENSW 448 GStL
Seated Monkey gold; c 14-1/2
 NMANA 89 UOClA (49.197)
Shrine Figure(?) wood;
 28-1/4
 NPPM pl 128 UNNMPA
 (58.257)
Stirrup Vessel: Embracing
 Couple clay; 7-15/16
 NMANA 87 UICA
Stirrup Vessel: Monkey and
 Man Holding Child
 blackware
 BUSH 199 (col) UMCP
Stirrup Vessel: Puma Nursing
 Cubs clay; 9-7/8
 NMANA 86 UICA
Three Figure Vessels, Peru
 ptd clay; 8-1/2 to 10-1/2
 DEY 150 UCSFDeY
Tweezers 1250/1500
 gold; 2-1/4x2-5/8
 DOCS pl 154 UNNMAI
 (15/7230)
Two Cups: Human Face,
 relief repousse gold
 NMAS #184, #185
 UPPU
Vase: Double-Headed Bird
 Design pottery
 HOO 96
Vessel: One-Eyed Man's
 Head, Peru c 500
 GOMB 31 ELBr
Vessel: Surmounted by Two
 Men Leading Llama Period
 V black pottery; 7-1/2
 NMANA 23 UICA
Vessel: Weaver 100/1250
 ptd clay; 9
 DOCS pl 144 (col) UNNMAI
 (14/3674)
Wall Decoration, molded and
 carved 14/15th c.
 KUBA pl 139A-B PeC
Wall Relief: Birds, Fish,
 Fantastic Animals molded
 clay plaster
 BUSH 197
Zoomorphic Stirrup Vessels:
 Monkey, Cat, Duck
 1250/1500 blackware;
 10x10-1/2
 DOCS pl 143 UNNMAI
 (21/1735; 15/197; 23/6883)

CHIN See CHINESE--CHIN
CH'IN See CHINESE--CH'IN
Chin T'sung Tzu
 Chinese--Sung. Golden Boy
The Chinaman. Blum, L. S.
CHINCHA
 Female Figure 1400/1475
 creamware; 7x18
 DOCS pl 169 UNNMAI
 (19/2768)
CHINESE
 Avalokitesvara: Eleven-
 Headed, Ch'ang-an, Shensi
 WILL-1:387
 Bodhisattva stone
 ZOR 34 UNNMM
 Bodhisattva, head
 WB-17:192 UNNMM
 Bodhisattva Avalokitesvara
 (Kuan Yin) wood
 SWANNC 99 UNNMM
 Buddha, Yun Kang
 TAYFF 16 (col) UNNMM
 Buddha, seated figure, gilt
 bronze
 TAYFF 16 (col) UNNMM
 Buddhist Altarpiece
 TAYFF 18 (col) UNNMM
 Buddhist Saint, head
 LAWL pl 112A UICA
 Buddhist Wheel, with Animal
 Style, plaque
 CART 107 -Maye
 Camel glazed terracotta
 PUT 293
 Camels
 CHENSE 392 UWaSA
 Chimera bronze
 CHENSN 165 UMoKNG
 Dog glazed pottery
 TAYFF 19 (col) UNNMM
 Group of Women
 JOHT pl 70
 Horse's Head baked clay
 PUT 295
 Inscription (rubbing) bronze
 DOWN 56 UMB
 Kneeling Woman Playing
 Stringed Instrument clay
 GARDHU pl 37A UNNMM
 Kuan Yin (Goddess of Mercy)
 LAWL pl 111B UNNMM
 --gilded wood
 TAYFF 16 (col) UNNMM
 --wood
 SDP #9 UCRM
 Kumen Kannon sandalwood;
 37.9 cm
 TOK 33 JNH

Lei, detail bronze
KUH 87 UICA
Lin Chi in Attitude of Shouting
wood; 41x30
STI 517 UWaSA
Lohan, head
KIY 64 UICA
Maitreya Stele, Tusita Heaven
WILL-1: 383
Markura Honzon ('Pillow-Side
Ikons'): Sakyamuni and his
circle, relief inside folding
cylinder wood; 23.4 cm;
Dm: 11.1 cm
TOK 33 JWK
Plaque with Dragons jade
CHENSN 172 UMoKNG
Polo Players, grave figures
PAG-15: 274
UICNh
Ring jade-green, outside;
brown other side; Dm:
5-1/2
FRYC pl 75 ELBr
Ritual vessel
CHENSN 171 -ChG
Rock Sculpture L: 24
READAS pl 224a
SwZR
Stags, flat ornaments jade
CHENSN 169; TAYFF 19
(col) UNNMM
Tree of Life Motif
CART 106 -Ham
Tripod Vessel : Bird Cover
TAYFF 18 (col) UNNMM
Woman, head
ZOR 69 UNNMM
Woman in Ceremonial Dress
ALBA UNBuA
--ARCHAIC (NEOLITHIC),
Before 16th c. B. C.
Bird jade; 4-1/8
LEEF 24 UMoKNG
Chueh, Cheng-Chou, Honan
Pre-An-yang bronze
SWANNC 14 COR
Earth Symbol: Upright
Yellow Jade
CART 55 FPGie
Symbols of Sun and of East
jade
CART 55 -Eu
Three Jade Pieces
CART 56 UNNMM
--SHANG (YIN) DYNASTY,
c 16-11 c. B. C.
Animal Figure bronze
CART 20 UNBuMS

Animal Figure, Anyang
marble
CART 35 -ChA
Animal-Form Ritual Vessel
12/13th c. B. C. bronze
CHENSN 170 UMCF
Animal-Shape Ritual Kettle
12th c. B. C. bronze
BAZINH 435 UDCFr
Applied Ornament: Animal
Head 14/11th c. B. C.
bronze
LARA 222 -Dug
Axe 12/11th c. B. C.
bronze
SWANNC 20 ELBr
Axe 12/11th c. B. C.
bronze; 11-3/8x13-3/4
AUB 97 (col) GBO
Axe 1523/28 B. C. bronze;
W: 5-9/16
CHENSW 190; CLE 244;
LEEF 36 UOClA (37.27)
Axe, Anyang 11th c. B. C.
jade blade, turquoise inlay
shaft; L: 13-1/2
SPE 49 (col) UDCFr
Bell: Engraved Upright Gong
"Chung" bronze
BURL 221 UNNMM
Bird, Anyang ivory
SOTH-3: 169
Bird: Vessel 14/11th c.
B. C. bronze
LARA 223 ELV
Bird: Wine Vessel
ZOR 52
Chariot Ornamentation bronze
CART 16 UMoKNG
Chia, round tripod ritual
vessel bronze; W: 9-7/8
LEEF 40 UDCFr
--12/11th c. B. C. bronze;
9-3/4
AUB 93 ELBr
--, square: Bird(?) Knob
on Lid bronze
SWANNC 20 ELBr
Chueh, Libation Cup, Honan
15th c. B. C. bronze
SUNA 261 UWaSA
Cow, with Turned Head,
Tsing Cover Figure Third
Phase bronze
WILL-1: 172
Dagger-Axe, ko type, Anyang
bronze, jade blade; L:
28 cm
SULI pl 12 SnMoH

Divination Bones--fragments
of scapula inscribed for
divination by oracle, earliest
known form of Chinese
writing
SWANNC 17
Drum bronze; 31-3/8
LEEF 37 -JS
Elephant jade, nephrite; L:
11-3/8
SEAM 17 Ch-RTAS
Elephant-Feline Head c 1200
B. C. jade
CLE 245 UOC1A (52.573)
Executioner's Axe, Ch'i Type
Anyang bronze; L: 23.5 cm
SULI pl 15 UMoKNG
Eyeshield for Horse inlay
CART 17 -ChA
Fang-i, ritual food container,
over-all decoration, includ-
ing bird motif bronze
SWANNC 23 (col) UDCFr
"Fang Ting" Ritual Vessel
bronze; 6-3/4
UMCF UMCF (1943.50.104)
Finial: Female Head, with
Bird-Shaped Headdress
jade; 3-3/4x1-3/4
MIUH pl 73 UMiAUA
Hair Ornaments bone
CART 15 SnSO
Handle 12th c. B. C. bone
SWANNC 15 ELBr
Harness Fitting with Jingle
at each end bronze; L:
13-1/8
COOP 25 SnSK
Harness Ornament turquoise
inlay CART 16 CTRO
Horses, pre-Anyang bronze;
4-1/2
LEEF 28 UOC1A
Knives bronze, with inlay
CART 19 UDCFr
Ku, tall, slender wine vessel
c 1400 B. C. bronze
LOWR 197 UICA
Kuang, covered wine pitcher;
detail bronze; L: 12-1/4
CARTW 24; LEEF 39 (col);
WCO-3:31 UDCFr
--: Animal-Form
CARTW 204 UFWN
--: Animal Head 1550/1050
B. C. bronze; 12
NMA pl 201 (col) UNNMM
(43.26a, b)

Lei, covered container 12th c.
B. C. bronze
CHICB 23 UICA
--13/12th c. B. C. bronze;
20-1/8
AUB 97 (col) GMV
Li, hollow-legged tripod
vessel
HOB pl 73 (col) ELV
Libation Vessel bronze
CHENSW 192 UDCFr
Mask c 1200 B. C. marble
CLE 244 UOC1A (52.585)
Mask: Human Face jade
BURL 261 UMoKNG
Mask: Four Small Human
SOTH-2:142
Monster, ritual vessel bronze;
7-1/5
READAS pl 45 UDCFr
Owl, tomb 1001, Hou-Chia-
Chuang Cemetery, Anyang
1400/1100 B. C. marble;
17-3/4
LEEF 31; SICK pl 1;
UPJ 729; UPJH pl 309
Ch-RTAS
Ox Head, Anyang marble; L:
29.2 cm
SULI pl 6 ChTaA
Ritual Blade white jade;
L: 17-5/8
LEEF 32 UNNEri
Ritual Covered Vessel 12th c.
B. C.
SEYT 9 UDCFr
Ritual Vessel bronze
BURL 222 UNNMM
--bronze
FAIN 120 UMCF
--: Bird Surmounting
T'ao-t'ieh maske, earth
emblem bronze; 11
SPE 47 (col) FPG
--Owl bronze; 8-1/4
MU 87 UOC1A
Ritual Wine Cup: Bird
1766/1622 B. C. bronze;
10
DOWN 59 UNNMM
Ritual Wine Vessel bronze;
9-5/8
NCM 253 UMiD
Sacrificial Vessel: Two Owls,
anyang bronze; 7
SPE 44 (col) JKKa
Seated Man late 2nd mil
B. C. white marble;
5-3/4 SICK pl 2a HonC

Shaft Head 14/11th c. B. C.
bronze
LARA 230 UMnMI
Spear Head 13/12th c. B. C.
jade blade, bronze with
turquoise-inlay socket
BAZINL pl 2 (col) ELBr
Squatting Bear jade; 2-1/8
LEEF 35 UMCF
Stag, pendant jade
SWANNC 32 -US
T'ao-t'ieh Monster Mask
('Glutton Mask') bronze
MU 88 UMoSL
Terminal Ornaments marble
CART 35 UDCFr
Tiger bronze
CART 20 UDCFr
--incised musical stone
SWANNC 15 ChAW
Tiger-Elephant jade; L:
1-5/8
LEEF 35 UOClA
Ting, cauldron-tripod ritual
vessel bronze; 9-1/2
LEEF 39 UWaSA
--, square, Tomb 1004
Hou-Chia-Chuang, Anyang
bronze; 24-1/2
LEEF 38 Ch-RTAS
Toad; Turtle, Royal Tombs,
Anyang
VALE 127
Tsun Wine Vase: Elephant
c 1300/900 B. C. bronze;
L: 38
WILL-1: pl 13 FPG
--: Owl bronze; 8-1/4
HOB pl 74 (col) ELV
--: Rhinoceros 12th c. B. C.
bronze; 8-1/2x14-1/2
AS; SICK pl 4 UICBr
--: Two Rams bronze
SWANNC 19 (col) ELBr
Urn: Animal Form
MALV 276 UNNHo
Warrior's Helmet
CART 17 -ChA
Water Buffalo 2nd mil B. C.
white marble; 4-5/8x
8-3/8
SICK pl 2b ELSed
--, wine vessel c1100 B. C.
bronze; 6-1/2x8-1/2
MUNC 9 (col) UMCF
Wine Vessel bronze
MYBU 223 UICA
--bronze
CHENSW 185 UNNMM

--: Eared Owl bronze
MYBA 172 UICA
Yu, wine bucket, footed
PRAEG 536
--bronze
CART 31 -EU
--: Bear Swallowing Man
bronze; 12-7/8
LEEF 38 -JS
--: Bird Form bronze
CART 31 -Mo
--: Man and Guardian Tiger
14/12th c. B. C. cast
bronze; 14
AUB 93; LOM 40 (col);
SPE 34 (col) FPCe
--: Owls, back-to-back
bronze; 24 cm
SULI pl 11 UDCFr
--SHANG AND CHOU
Knives, animal-head handles
bronze; 26.3 cm; 27.5
cm
SULI pl 13
Man: Stags; Bird jade; stone
CHENSW 39 UMCF;
UNNMM; UDCFr
--SHANG/CHOU
Huo, wine vessels with
spouts c 12/11th c. B. C.
bronze; 7-1/8x8-1/4
SICK pl 3 UDCFr
Mask, Anyang
CART 18 UNBuMS
Pheasant, libation jar bronze
CHENSW 192 UDCD
Tsun: Owl 1027/771 B. C.
bronze
CLE 245 UOClA (51.119)
Wine Vessel: Owl bronze;
12-1/2x8-1/4
MINP UMnMI
--SHANG TO 20th c.
Bull's Heads pottery; bronze;
jade; silver
CART 37 -Cha; UNNCart
--CHOU DYNASTY (including
WARRING STATES
PERIOD) c 11th c. -221
B. C.
Animal Mask bronze
Burl 225 -Hol
Applied Ornament: Tiger
8th/3rd c. B. C. Bronze
LARA 220 FPCe
Ax Head
SOTH-3:166
Ax Head, with Dragon bronze
CHENSW 196 UNNMM

Ax-Shaped Tablet before 220
 B. C. jade; 7-3/4
 READAS pl 40 UMCF
Bayon Toad bronze; 4
 LEEF 47 UNNEri
Bear Tamer (Man with Bear
 on Pole) 5th/4th c. B. C.
 bronze; 6-1/2
 DOWN 63; WCO-3:31 (col),
 30 UDCFr
Bell, Huai Style; top detail
 bronze
 CART 48, 49 UDCFr
--, Hui Hsien, Honan Pottery
 facsimile of bronze
 BURL 177 UHHA
Bird Catcher c 5th c. B. C.
 bronze; 7
 PANA-2:111; WORC 22
 UMWA
Bird-Dragon, pierced relief
 white jade
 BURL 262
Bodhisattva grey limestone; 37
 WILL-1: pl 29 ELV
Carved Ornament jade
 BURL 263 UNNMM
Chariot Burials 4th c. B. C.
 BAZINL pl 51 ChLL
Chariot Fitting 5/3rd c. B. C.
 bronze
 CART 67 UDCFr
Chariot Fittings 5/4th c.
 B. C. gold, silver-inlaid
 bronze
 BAZINL pl 62 (col) ELBr
Chariot Ornament gold inlaid
 bronze
 CART 66 UICA
Chung, clapperless bell
 bronze; 12-1/4
 HOB pl 76 (col) ELBr
--bronze; 26-1/8
 LEEF 45 UDCFr
--600/250 B. C. bronze
 UPJ 732; UPJH pl 309
 BBS
--, Wei Hui Chime
 SOTH-3:167 (col) ELBr
Covered Tripod c 300 B. C.
 silver inlaid bronze; 6
 SPE 70 (col) UMnMI
Crouching Tiger bronze
 BAZINH 433 UMCF
Dagger jade
 SFGP pl B, 18 -Ra
Dancing Girl, tomb figure,
 Chang-Sha, Hunan 4th/3rd
 c. B. C. wood
 CHENSW 32 UWaSA

Deer, Hsin Cheng Tomb jade
 CART 59 UNNMM
Disk jade
 CHENSW 194 ELBr
Dragon 6th/3rd c. B. C.
 bronze; L: 25-1/2
 JANSH 547; JANSK 316;
 SICK pl 7b, 8b BBS
--, flat figure jade
 READM pl 7
--, pendant jade--light
 green with brown markings
 BURL 264 UICA
--, pole end bronze
 SFGP pl D, 14 UMoKNG
--, scabbard tip brownish
 white jade
 BURL 262 UMnMW
Dragon Head, Chin-Ts'un gilt
 bronze, silver foil overlay;
 L: 10-1/16
 CART 67; CHENSW 196;
 LEEF 51 (col) UDCFr
Dragons jade
 CHENSW 186 UDCFr;
 UMoKNG
Drums, Confucian Temple,
 Peking stone; c 31
 ASH 47
Drumstand: Cranes, Ch'ang-
 Sha lacquered wood;
 51-3/4
 LOM 49 (col) UOClA
--: Phoenixes and Tigers,
 Changsha lacquered wood;
 134 cm
 SULI pl 27
Figure clay
 VALE 58 UNNKley
Finial; Chin-Ts'un bronze,
 gold and silver inlay;
 5-5/16
 LEEF 46 UOClA
Finial: Human and Animal
 Form c 900 B. C. jade;
 2-1/2x2-4/5
 MUNC 11 (col) UMCF
Finial: Human Face 1st mil
 B. C. bronze
 BAZINL pl 60 ELBr
Fish glaucous green jade;
 L: 5
 ASH 41 ELBr
--white jade; W: 3-9/16
 LEEF 44 UOClA
Fittings, Coffin(?) bronze;
 2-3/8x3
 COOP 24 SnSK
Frontal for Horse Armor
 bronze SFGP pl B, 17 -Ra

Funerary Pillar of Shen 2nd c.
 H: c 105
 JANSK 317 ChSzC
Grain Jar 11th c. B. C.
 bronze
 CHENSW 191 UDCF
Harness Ornaments bronze
 CART 52 UNjPA
Head, Yun Kang 5th c.
 TAYFF 18 (col) UNNMM
Horned Monster, vessel
 bronze
 CHENSW 191 UNNMM
Horse c 6th/3rd c. B. C.
 bronze; 8-1/4x10-1/4;
 and 7-7/8x9-1/4
 SICK pl 9 UMoKNG
Hu, wine jar 8th/7th c.
 B. C. bronze; 28-3/4
 AUB 97 (col) FPG
--c 6th/3rd c. B. C.
 bronze; 13-7/8x19-1/2
 SICK pl 11 UMnMI
--, with panels showing
 Hunting Scenes 5th/4th c.
 B. C. bronze
 SWANNC 28 UCSFDeY
Huang, segment jade; W:
 5-1/16
 LEEF 48 UOClA
Human Figure c 6th/3rd c.
 B. C. wood; 23
 SICK pl 10 UNNFa
Human Figure, Ch'ang-Sha,
 Yangtze Valley, Hunan
 3rd c. B. C. ptd
 wood
 SWANNC 31 EOA
Huo: Elephant, with elephant
 handle c 1122/249 B. C.
 bronze; 8-1/4
 BAZINL pl 58; BURL 223;
 CHENSW 193; DOWN 62;
 READAS pl 44 UDCFr
Ibex Head, cart pole and
 bronze; L: 2-5/8
 WILL-1: pl 12 UHHA
Ink-Squeeze: Warrior Attack-
 ing Dragon 3rd c. B. C.
 BURL 101 CTRO
Kneeling Figure, torchbearer
 6th c. B. C.
 FRYC pl 18
Kneeling Man Holding Cup
 c 6th/3rd c. B. C.
 bronze; 11-1/8x6
 MINP; SICK pl 8c; SPA
 150 UMnMI

Kuang, covered wine
 pitcher c 1000 B. C.
 bronze; 50 cm (with
 base)
 BOES 43 DCNM
Kuei, ritual serving vessel
 bronze; W: 7-3/4
 SOTH-1: 138
Kuei, food bowl 11th c.
 B. C. bronze; 7-1/2
 AUB 94 ELBr
Kuei: Dragon Handles and
 Decoration bronze
 SWANNC 26 (col) ECiE
Kuei, on stand bronze
 BURL 224 UMnMI
Li-Yu 11th/9th c. B. C.
 cast bronze
 READI pl 9B UDCFr
Libation Cup 1122/255 B. C.
 bronze
 HOF 207 UDCFr
Lu-Kuei Cup, two-handled
 cup on base 9th/7th c.
 B. C. bronze; 19
 SPE 52 (col) FPCe
Mask bronze
 CART 43 UNBuMS
--: Interlaced Dragon
 plaque, Ch'ang-Sha jade;
 W: 2-15/16
 LEEF 49 UOClA
Mirror 771/256 B. C.
 bronze; Dm: 5
 FAIY 28 UNBuMS
--600/250 B. C.
 UPJ 733 UICA
--: Four "T" Designs,
 divided by Leaf Spray,
 against spiral background
 bronze; Dm: 5-1/4
 MIUH pl 70 UMiAUA
--: Interlocked "T" and Dra-
 gon bronze; Dm: c 7
 LEEF 48 UMB
--, inlaid, Chin'Ts'un bronze;
 Dm: 7-11/16
 LEEF 69 (col) JTH
--, Huai Style bronze
 CART 45 UICA
--, square bronze
 SOTH-3: 166
Mirror, Huai Style bronze
 CART 45 UDCFr
Mongolian Boy with Two Jade
 Birds 3rd c. B. C.
 bronze; .285 m
 BOSMI 5 UMB (31.976)

Mules' Head Finials bronze
 SFGP pl D, 19 -Eu
Ordos Horse, ornamental
 plaque 5th/2nd c B. C.
 bronze; 1-1/2
 LOM 52 (col) GMV
Ordos Stag, plaque bronze
 LOM 46
Ornament: Animal Heads and
 Spirals, Siberian
 "Dismembered" Style
 5/2nd c. B. C. bronze; 2
 LOM 50 (col) GMV
Owl-Shaped Jar bronze
 CHENSW 192; FAIN 33 UCtY
Owls matrix of turquoise;
 pale buff jade
 ASH 41 ELSed
Ox Head, chariot decoration
 c 300 B. C. bronze,
 silver inlay; 8-1/2
 SPE 60 (col); SWANNC
 27 (col) ELBr
Pi (Symbol of Heaven),
 ceremonial disk brownish
 grey, white-marked jade;
 Dm: 5
 ASH 33 ELBr
--spinach green jade
 BURL 262
--: Two Dragons on Rim
 5/3rd c. B. C. jade;
 Dm: 8-5/8
 AS (col); BURL 263; CART
 61; CHENSW 195; GARDH
 545; JANSK 316; MU 87
 (col); SULI pl 33 UMOKNG
Po: Bell 5th c. B. C. bronze
 CLE 246 UOClA (30.730)
Pole End 9/6th c. B. C.
 bronze; 13.5
 ASH 39; BURL 224
 UMoKNG
Quadruped 6/3rd c. B. C.
 engraved bronze; 4-1/2
 READAS pl 50; SICK
 pl 7a UDCFr
Rams Heads, sacrificial
 vessel fragments 1200/1000
 B. C. white marble
 FRYC pl 18
Ritual Bell 5/4th c. B. C.
 bronze
 CHENSW 193 UMCF
Ritual Vessel bronze
 CHENSW 192 ELV
--c 1000 B. C. bronze
 FAUL 190 UNNMM

Ritual Wine Vessel
 bronze CHENSW 185 UMCF
Seated Bear gilt bronze
 FRYC pl 64 -Op
Staff Finial, or Handle:
 Monster Head bronze; 6-1/2
 COOP 25 SnSK
Stags, Hsien Cheng Tomb,
 Honan green jade
 BURL 263 UMoKNG
Swords
 CART 52 UNjPA
Table Leg: Bear 3rd c.
 B. C. gold and silver
 inlay on bronze; 5
 SPE 57 (col) UMoKNG
Tapir, Li-Yu bronze; W:
 7-3/16
 LEEF 47 UDCFr
Tiger Head c 300 silver
 inlay bronze; 2-3/4
 LOM 39 (col); SPE
 63 (col) GCoO
Tiger Plaque, Chin-Ts'un
 jade; L: 5-7/8
 LEEF 49 UDCFr
Tigers c 10th c. B. C.
 bronze; 9-7/8x29-5/8
 CHENSW 196; LEEF 43;
 PANA-1:37; SEYT 62;
 SICK pl 6; SULI pl 14
 UDCFr
--Tiger
 BAZINL pl 61; BAZINW
 255 (col);
 HOF 219
Ting, Chin-Ts'un bronze;
 W: 7-1/8
 LEEF 45 UMnMI
--four-legged inscribed name
 of King Ch'eng bronze; 11
 LEEF 40 UMoKNG
Tsun: Owl bronze; 8-1/4
 LEEF 41 UOClA
Two Tomb Figures, Hui
 Hsien, Honan 5th c.
 B. C. high-fired lac-
 quered black clay
 BURL 176 UHHA
Vessel (Type IH) c 1000
 B. C. bronze
 JANSK 315 UDCFr
Vessel: Reclining Stag
 bronze
 BURL 227 UNNMM
Vessel: Reclining Stag
 bronze
 BURL 227
 UNNMM

Yu c 11/9th c. B. C. bronze
11
ASH 37 ELV
CHINESE--HAN DYNASTY, 206
B. C.-220 A. D.
Amulet: Tiger white jade;
L: 7-1/2
AUB 95 FPG
Animal jade
CART 69 UDCFr
Animal, wall decoration
relief (rubbing)
NM-14:pl 2 UNNMM
Animal and Human Tomb
Figure
CART 126 UICA
Animal-Style Applique Plaque,
Sarmatian Type gilt bronze
SOTH-3:168
Attendant, tomb figure 3rd c.
gray ptd pottery
SWANNC 76 EOA
Axe Head greenish-yellow
jade; W: 6
ASH 57; CHENSW 200;
HOB pl 81 (col) ELBr
Battle of the Bridge (rubbing),
Monument 2
NM-14:pl 4 UNNMM
Bear gilt bronze
SOTH-3:168
--gilt bronze
CHENSW 187 BBS
--gilt bronze
SWANNC 48 ELBr
--1st c. gilt bronze;
5-3/8
CHENSN 174; CHENSW
187; SICK pl 16a UMoSL
Belt Buckle, dragon motif,
Lolang, Korea beaten
gold, turquoise inlay
SWANNC 55 (col) UHHA
Belt Clamp 3/2nd c. B. C.
gold-inlaid bronze; L:
6-3/4
LOM 54 (col) GMV
Bucking Ram gilt bronze;
3-1/4
ASH 61 ELBr
Buckle
CART 71 UNNMM
--206 B. C./221 A. D.
jade; L:3-3/8
CHENSW 200; UMCF
UMCF (1943.50.456)
Buckles inlaid gold, silver
and jade
CART 70 UNNCart

Bull's Head, axle-cap bronze;
L: 6-1/2
ASH 57 ELBr
Card Players glazed earthen-
ware; c 8
ASH 71 ELBr
Carriages and Other Figures,
relief (rubbing)
NM-14:pl 3 UNNMM
Cart, grave model terracotta
CART 79 UNNMM
Chimera 3rd c.
ZOR 49
--bronze
CHENSW 199 UMoKNG
--, Tomb of Kao I 209
stone; L: 65
SICK pl 17a ChSzY
Cicadas jade
CART 56 UICNh
Cooking Stove, tomb model
glazed green earthenware
SWANNC 42 EOA
Covered Toilet Box lacquer;
4
AUB 98 (col) ELBr
Dancer, funerary figure
206 B.C./220 A.D.
CANK 68 FPCe
Deer, open-work plaque
bronze; 1-1/2
LOM 99 GMV
Disk bronze, gold and silver
inlay; Dm: 6-1/2
HAN 55 UDCBl
Dog clay
CHENSW 202 COR
Dragon, mounted in bronze
jade, gold and silver inlay
CART 74 UICA
Dragon c 200 gilt bronze;
2-3/5x4-4/5
MUNC 13 (col) UMCF
Dragon, Sinkang, sarcopha-
gus relief 212 stone
WILL-1:275
Dragons jade
CHENSW 202 UNNMM;
UDCFr
Elk brownish-yellow jade; 2
ASH 61 ELBr
Equestrians, tomb relief, Li-
shih 150 stone; 14-1/4;
and 121-1/16
TOR 32 CTRO (925.25.
22 A-B)
Fantastic Animal bronze
CHENSW 199 UOC1A
Fight Between Man and Tiger,
relief MYBA 174 UOC1A

Figures in House, tomb relief
 limestone; 31-1/4x50
 NM-14:pl 5 UNNMM
 (20.99)
Funerary Figures terracotta
 LARA 384
--: Juggler; Man with Bear
 on a Pole 3rd c. terra-
 cotta
 LARA 224 FPCe
Funerary Relief 114
 BAZINW 255 (col) SwZR
Funerary Stone Model Reliefs
 terracotta
 CLE 248 UOClA (25.134;
 25.135)
Guardian Lion c 1st c. gray
 limestone
 FRYC pl 19
Hill Censer, Po-Shan Hsiang-
 Lu bronze; gold, silver,
 turquoise, carnelian inlay;
 6-7/8
 AUB 98 (col); SULI pl 43
 UDCFr
Hill Jar, funerary jar
 LARA 385 UMB
--glazed clay
 CHENSW 201 UMoSL
--glazed earthenware; 8
 ASH 71 ELV
--glazed pottery
 CART 92 UNNMM
--pottery; 8-15/16
 LEEF 67 UDCFr
--206 B.C./220 A.D. lead-
 glazed pottery
 CLE 247 UOClA (48.214)
Horse bronze
 CHENSW 197 UOClA
--jade
 ZOR 49 UNNMM
--3rd c. B.C. terracota
 BRIONA 62 FPCe
--119 B.C. stone; L: 75
 LEEF 64 ChShH
Horse, head clay
 CHENSW 202 COR
--green jade; 7-5/8
 RTC 77 (col) ELV
--jade
 LARA 384 (col) ELV
--jade; 5-1/2
 WHITT 77 ELV
--3rd c. green jade; 18.9 cm
 BURL 264; SULI pl 46 ELV
--, from tomb figure pottery
 SWANNC 47 EGINS

Horse and Bird Motif,
 sgraffito design terracotta
 ELIS 146-47 UNNMM
Horse Attacked by Two Bears,
 plaque 3rd c. B.C./3rd c.
 A.D. bronze
 LARA 231 UNNMM
Horse Trampling a Barbarian,
 Tomb of Ho Ch'u-ping 117
 B.C. stone; 64x75
 UPJ 734; UPJH pl 309;
 SICK pl 13; SULI pl 35;
 SWANNC 46 ChShH
--stone
 LARA 383 FPG
Horse Trapping, Ordos
 bronze; 6
 RTC 44 FPG
House Model 206/222 ptd
 pottery; 52
 DOWN 61; LEEF 58; SULI
 pl 47; UPJ 736; UPJH
 pl 309 UMoKNG
Human Figures light green
 jade; 2-3/4
 ASH 67 ELSed
Jade Ornament H: 5
 FRYC pl 69 ELBr
Legend of Hou Yi, Divine
 Archer: Shooting Down 9
 of 10 Suns in Form of
 Birds, tomb relief
 SWANNC 34
Lion bronze
 CHENSW 199 Coll. Mrs.
 John F. Lewis,
 Philadelphia
Lion stone
 CHENSW 204
Lion 2nd c. stone
 SICK pl 15 ITG
Lion, guardian figure stone
 CHENSN 175
Lion, monumental tomb
 figure stone
 CHENSN 177; RAY 77
 UNNMM
Man, tomb figure unglazed
 earthenware; 28-1/2
 ASH 73 ELBr
Man Fighting Tiger, relief,
 Sian Fu, Shen-Si
 Province terracotta; L:
 c 18
 STI 514 UOClA
Mask bronze; 2-1/4
 LOM 51 (col) GMV
Mirror bronze
 BURL 228 UNNMM

--bronze
CART 68 UNNMM
--bronze
CART 68 UDCFr
--, Graeco-Bactrian motifs
bronze; Dm: 9-1/8
RTC 137 ELV
--, Shang Fang 174 bronze;
Dm: 8-1/4
LEEF 66 UDCFr
--, "TLV" Type bronze; Dm:
20.3 cm
SULI pl 44 UMSpBi
--"TLV"Type bronze; Dm:
5-5/8
LEEF 66 UDCFr
--"TLV" Type, with paired
winged animals bronze;
Dm: 4-3/4
MIUH pl 71 UMiAUA
Mirrors bronze; Dm: 7-1/2;
and 7
COOP 24 SnSK
Musician stone
PANA-2:128 UMSoD
Phoenix, pillar relief
ASH 65 ChSzC
Phoenix-Form Cloak-Hook
bronze, gold and silver
inlay; L: 3-1/4
ASH 61 ELBr
Pi, Symbol of Heaven 202
B.C./220 A.D.
BAZINH 437
Pig in Sty, tomb model, Yueh
Ware
SWANNC 44 EOA
Players at a Board Game,
green glazed earthenware
SWANNC 43 ELBr
Pillar of Shen 2nd c. stone;
105
LEEF 65; SICK pl 14 ChSzC
Pleasure Pavilion, tomb
model pale green glazed
earthenware
SWANNC 41 COR
Pleasure Pavilion, tomb model
glazed pottery; 15-3/4
AUB 95
--25/220 terracotta
LARA 383 FPCe
Pole Finial: Elk, Ordos
1st c. B.C. bronze; 7
GRIG pl 97 ELBr
Pole Top: Wild Ass, Ordos
206 B.C./220 A.D. cast
bronze
CLE 248 UOClA (62.46)

Pots, Yueh Ware 3rd c. B.C.
brown glazed earthenware
SWANNC 45 EOA
"Precious Tree" Stand, ele-
phant procession relief,
Szechwan pottery; 33.9
cm
SULI pl 50
Procession of Officials, tomb
relief, detail (rubbing)
NM-14:pl 1 UNNMM
Recumbent Deer bronze
SFGP pl F, 43 -Ra
Red Bird, symbol of South,
pillar relief 2nd c. stone
UPJ 735 ChSzC
Relief
CART 83 UNBuMS
Relief, I-Nan, Shantung
(rubbing) 3rd c. stone
LEEF 59
Relief, Szechwan 206 B.C./
220 A.D. stone
CLE 247 UOClA (62.280)
Reliefs, Tomb of Wu Liang
Tzu, Shantung (rubbing)
stone
LEEF 60
Scenes of Chinese Life,
reliefs, Shantung stone
CHENSW 203 UNNCoo;
FGP
Seal: Curly-Haired Animal
(reproduction) 57 gold
SMIBJ 34 (col) JTNM
Search for the Tripod of Yu,
slab, Tomb of Wu Liang
Tzu
LARA 382
Seated Bear 2nd c. B.C./2nd.
c. A.D. 6-1/4x8-1/4
UPJH pl 307 UMBGa
Seated Dog, tomb figure
terracotta; c 11
BRIONA 65; LEEF 65
FPCe
Sheep in Pen, tomb model
Yueh Ware
SWANNC 44 EOA
Stags, Tomb of Hsin Cheng,
Honan jade
NM-10:70 UNNMM
Stalking Leopard, cloak-hook
silver, turquoise inlay;
L: 4
ASH 61 ELBr
Stoves, grave furnishings
terracotta
CART 78 SnSO

Support: Bear gilt bronze;
 6-3/4
 GRIG pl 103 ELBr
Three Ponies, open-work
 plaque bronze;
 1-1/2
 LOM 99 GMV
Tiger 2nd c. B. C.(?)
 gold
 READM 17B -Ru
--: Fighting Wild Boar,
 relief, funerary stove
 panel terracotta
 BRIONA 65 FPG
--, plaque silver
 READA pl 21 ELBr
--, plaque, Ordos gilt bronze;
 2
 RTC 44 ELBr
Tomb Casket: Dragon Design
 Pottery
 CARTW 140 UVNM
Tomb Figures 1/2nd c. pottery,
 colored glaze; 25
 SPE 85 (col) GMEt
Tomb of Houo K'iu-ping
 VALE 92
Tomb Relief: Chariot Pro-
 cession c 150 stone
 FAIY 55 UNRoR
Tomb Relief Fragment stone;
 28x42
 ASH 63 FPL
Tomb Tile, detail 2nd/3rd c.
 terracotta
 CLE 248 UOC1A (15.70)
Tombstone: Horses and
 Figures, detail 202 B. C.
 /220 A.D.
 BAZINH 443 UPPU
Tower green glazed pottery;
 38
 DENV 184 UCoDA (O-1055)
Tower House Model c 200
 B. C./200 A.D. pottery; 48
 SPE 83 (col) UMoKNG
Two Fighting Animals, plaque
 bronze; L: 11-1/2 cm.
 SULI pl 32 UDCFr
Unicorn (Ch'i lin), bas relief
 WILL-1: 284
--head 2nd c. B. C. bronze;
 2-3/4
 LOM 54 (col) GMV
Vessel: Duck's Head Handle
 bronze; 7
 GRIG pl 99 ELBr
Visit of Mu Wang to Hai Wang

Mu, relief 2nd c. stone
 UPJ 735 ChShanT
Watch Tower pottery
 CART 80 FPCe
--pottery, iridescent green
 glaze; 47; moat; Dm:
 14-3/4
 TOR 35 (col) CTRO
 (925.25.7A-C)
White Tiger of the West jade
 LARA 395 FPG
Wine Jar, Tiger-Mask
 Handles red pottery,
 iridescent leaf-green
 glaze; 17-1/2
 HOB pl 1 (col) ECamF
Winged Horses, plaques
 bronze
 CHENSW 198 UNNMM
Woman 202/220 terracotta
 BAZINW 254 (col) UMB
World of the Airs, slab,
 Tomb of Wu Liang Tzu
 LARA 382
CHINESE--HAN/WEI
Young Woman terracotta; 19
 NEWA 84 UNjNewM
CHINESE--SIX DYNASTIES,
220-589
Arhat, with Third Eye
 c 500 gilded bronze;
 5-3/5
 MUNC 17 (col) UMCF
Belt Plaque: Dragon; Phoenix
 gilt copper; L ea: 2
 DENV 186 UCoDA
 (O-1058)
Bodhisattva stone
 CHENSW 210 UDCFr
--stone
 SFGP pl J, 64 UPPU
--, head, Yun Kang gray
 sandstone; 14
 NM-14:pl 18, 19 UNNMM
 (42.25.11)
Buddha, head gray limestone;
 16
 NM-14:pl 27 UNNMM
 (42.25.36)
Buddha, seated figure, Yan
 Kang Caves
 CHENSW 189 UNNMM
Buddhist Figure, relief,
 Lung Men Grottoes
 SFGP pl G, 69 -Fu
Buddhist Stele serpentine;
 .5x3-15/16x2-15/16
 NM-14:pl 56 UNNMM (28.17)

CHINESE--CHIN DYNASTY, 265-420
 Cup 3/4th c. jade
 FRYC pl 75 ChPekI
 Kuan Yin: In "Royal Ease"
 Pose ptd wood
 LARB 209 FPChi
 Kuan Yin Bodhisattva: In
 Maharajalila Posture c
 1200 wood
 FRYC pl 25 UICA
 Ram: Genie Riding Chimera,
 Chekiang Province glazed
 stoneware, incised decora-
 tions; 5-3/8; and 11
 FOU 131 (col) ChPekP
CHINESE--CHIN, or YUAN
 Kuan Yin Bodhisattva 12/13th
 c. ptd wood; 75
 EXM 362 (col) UMoKNG
CHINESE--WEI DYNASTY, 386-534
 Adoring Monk c520/25 bronze
 CLE 249 UOC1A (62.213)
 Amitabha Buddha, with
 Bodhisattva redsandstone;
 c 45'
 WILL-1: pl 25 ChShaY
 Apsaras, relief 385/535 stone
 BAZINW 256 (col) UMCF
 Apsaras Playing Drum, relief
 limestone; 21
 ALB 131 UNBuA
 Arhat, Buddhist relief, T'ian
 Lung Shan stone; 35-3/8
 UMCF UMCF (1943.53.I)
 Bodhisattva 6th c.
 MALV 499 ChShaY
 --6th c.
 CANK 63 UNNMM
 --: With Halo gilt bronze;
 9-1/2
 NM-14: pl 37 UNNMM
 (42.25.26)
 --, Lungmen 6th c.
 BAZINH 406 UNNMM
 --, Yun Kang 6th c.
 SICK pl 30b UNNMM
 --, Yun Kang sandstone; 60
 NM-14: pl 17 UNNMM
 (42.25.35)
 --, Yun Kang, stone
 SWANNC 67 ChShaY
 Bodhisattva, colossal head
 6th c. stone
 BURL 239; CHENSW 210
 UPPU
 Bodhissattva, head
 NM-10: 72 UNNMM
 --5/6th c.
 BAZINH 441

--c 500 stone
 SPA 128 UODA
Bodhisattva, relief detail
 6th c. Cave G
 LARA 359 ChYK
Bodhisattva, seated figure
 NM-14: pl 24 UNNMM
 (39.191)
--sandstone; 51
 NM-14: pl 21 UNNMM
 (39.35)
--sandstone; 57-1/2
 NM-14: pl 20 UNNMM
 (22.134)
--6th c. black marble
 UPJ 740 UNNMM
--, Lung Men Caves 6th c.
 stone
 CHENSW 207 UNNLoo
--6th c. black marble;
 20-3/4x14x3
 SDF 129 UCSDF
--, Lung Men 6th c. stone
 CHICC 61
--, Lung Men 6th c. stone
 BAZINH 440; CHENSW
 205; MALV 168; SWANNC
 69 UMB
--Yun Kang Caves
 CART 139 UNNMM
--, Yun Kang Caves stone
 BAZINW 255 (col) FPG
Buddha 437 gilt bronze;
 11-1/2
 SICK pl 29a JIshT
--536 gilt bronze; 61 cm
 CHENSW 209; SULI pl 59
 UPPU
Buddha: Attended by Bod-
 hisattvas, Priest, and
 Flying Angels, altarpiece
 6th c. gilt bronze
 SWANNC 72 UNNMM
Buddha: Colossal Buddha,
 Cave No. 20 c 450/500
 limestone; 45'
 FRYC pl 20; JANSK 321;
 LARA 665; LEEF 137;
 SICK pl 29b; SULI pl 55;
 UPJ 739; UPJH pl 310
 ChShaY
--detail
 FRYC pl 22; SWANNC 65
Buddha: Colossal Head
 stone
 BURL 237 UHHA
Buddha: Flanked by Bod-
 hisattva, interior
 SICK pl 34a ChL

Buddha: Right Hand "Fear
 Not" Gesture; Left Hand
 Benediction Gesture stone
 HUYA pl 14 FPL
Buddha: With Disciples
 Ananda and Kasyapa, Cave
 W 25-1/4x19-1/2'
 SICK pl 33 ChL
Buddha: With Flame Mandorla
 536 gilded bronze; 61 cm
 SECK 191 (col) UPPU
Buddha, detail: Side and
 Lower Hem of Robe, Lung
 Men
 WILL-1:374 ELBr
Buddha, head stone
 BURL 240 UMoKNG
--late 5th c.
 MALV 167 UMB
Buddha, seated figure before
 Flame Mandorla
 6th c. ptd marble
 CARTW 133 UVNH
Buddha and Attendant, Honan
 CHENSW 206 ChL
Buddha and Attendants, niche
 figures, Cave 13 527
 LEEF 141 ChL
Buddhist Altarpiece; detail
 center piece: Sakyamuni;
 Guardian; Boddhisattva
 524 gilt bronze; 30-1/4
 NM-14:pl 29, 30-32;
 PACHA 207 UNNMM
 (30.158.1)
Buddhist Altarpiece 6th c.
 gilt bronze; 23-1/4
 NM-14:pl 34; NMA 194
 UNNMM (38.148.2a-y)
--details: Bodhisattva
 NM-14:pl 34-36
Buddhist Figure, relief,
 Lung Men
 CART 145 UNBuMS
Buddhist Monk bronze
 CHENSW 207 UNNMM
Buddhist Priest 6th c. bronze;
 25-3/4
 NM 14:pl 39 UNNMM
 (28.122.2)
Buddhist Seated Figure, Lung
 Men Caves stone
 CART 144 UNNLoo
Buddhist Shrine 524 gilt bronze;
 30-1/4
 SICK pl 35b UNNMM
--529 gilt bronze; 25-1/2
 SICK pl 37 IFBe

--: Prabhutaratna and
 Sakyamuni 518 bronze;
 10-1/4
 ASH 103; AUB 99 (col);
 CHENSW 209; JANSK 320;
 LEEF 143; SICK pl 36;
 SWANNC 73 FPG
Buddhist Stele (Buddhist
 Votive Stele)
 CHASEH 539 UMBFC
-- c 6th c. 81-1/2x26x7-6/8
 YAH 24 UCtY
--c 500/520
 FRYC pl 15 UNNMM
--523 sandstone; 88-1/2x27
 TOR 39 CTRO (949.100)
--527 stone; 72
 SICK pl 35a UNNLoo
--528
 FRYC pl 22
--c 535/540 stone; 98
 BURL 238; SICK pl 38a
 UMoKNG
--(Trubner Stele) 533/43
 limestone; c 12x44-1/8x
 11-3/16
 BAZINH 407; NM-14:pl 40,
 42-52; SICK pl 44; WILL-
 1:pl 28 UNNMM
 (29.72, 30.76.302)
---, Chang-tzu Hsien, Shansi
 569 stone; 91-1/2
 SICK pl 39a UMoKNG
--: Buddha Between Two
 Attendants c 520 stone
 LARA 390 SwZR
--: Life of Buddha 554 stone;
 84
 ASH 105; CHENSN 185;
 SICK pl 38b; SULI pl 58
 UMB
--: Sakyamuni Trinity 537
 limestone; 30-1/2
 CLE 250; LEEF 142
 UOClA (420.14)
--: Seated Buddha; head
 details limestone; 75x32x
 12
 NM-14:pl 8, 9-16 UNNMM
 (2427)
--: Seated Buddha Flanked by
 Bodhisattvas H: 56-3/4
 WORC 23 UMWA
--: With Inscriptions
 CART 147 UNNMM
Buddhist Stelae 6th c. stone
 CHENSW 208 UMB;
 UMoKNG

Maitreya (Mi-Lo), Pai-Ma
Ssu Temple, Lo-yang
limestone; 1.965x885 m
BOSMI 7 UMB (13.2804)
Maitreya,477 limestone; 57.5
ASH 101; SICK pl 30a
UNNMM
Maitreya, Lung Men 6th c.
limestone
ROWE 53 UMCF
Maitreya: Seated on Lion
Throne 6th c. limestone;
21-1/4
AUB 113 SwZR
Maitreya: With Mandorla 536
gilt bronze; 24
SPE 115 (col) UPPU
Maitreya, seated figure dark
marble; 18
NM-14:pl 23 UNNMM
(39.190)
--5th c. H: 72
FAIN 103; SICK pl 34b;
SLOB 220 UMB
--, Lung Men Caves 512
stone
BURL 238; CHENSW 207
UPPU
Maitreya and Attendants
sandstone
CLE 249 UOClA (59.130)
Maitreya Buddha (Buddha of
the Future) 477 gilt bronze;
55-1/4
NM-14:pl 28; SWANNC 71;
WILL-1:pl 26 UNNMM
(26.123)
Man Feeding Bird, seated
figure 3/5th c. unglazed
earthenware; 8
ASH 95 ELBr
Minor Buddhas and Bod-
hisattvas, niche figures,
Lao Chun Cave 5th c.
FRYC pl 21 ChL
North Wall, Cave Interior
CART 135 ChL
Prince Meets a Sick Man,
relief, Shih Fo SSu 5th c.
stone
UPJ 738 ChShaY
Relief, detail
AUB 114 ChM
--, Lung Men Caves
CART 141 UMoKNG
Sarcophagus, detail c 525
stone; 24x88
JANSK 324; SICK pl 52-53
UMoKNG

Sacrificial Stone House, detail
of "Filial Piety", Tun Yen,
527 limestone; 1.38x2.
x.97 m
BOSMI 7 UMB (37.340)
Sakyamuni (The Historical
Buddha), Cave Temple,
Yun Kang
SWANNC 66 ChShaY
--, principal statue 506/23
stone
TOK 9 ChL
--, torso c 6/7th c. marble;
57
ASH 107 ELV
Sakyamuni Buddha 6th c. Hopei
marble
BURL 240
--338 gilt bronze
WILL-1-342
Sarcophagus Detail: Scenes of
Filial Piety, of Yuanku
c 525 limestone; 56 cm
SULI pl 53; SWANNC
80-81 UMoKNG
Seated Dragon 221/65 ptd
clay
SPA 36 URPD
Seated Lion bronze; 4-1/2
NM-14:pl 38 UNNMM
(42.25.32)
--386/557 bronze
BURL 227 UNNMM
Seated Tiger clay
CHENSW 211 UNNLoo
Siddartha in Meditation,
relief 6th c. stone
BAZINL pl 71 UMB
Statue Bases 385/535 grey
limestone
BAZINW 256 (col) UPPU
Stele, detail 533/43
NM-10:66 UNNMM
Stele of Avalokitesvara
516/17 gilt bronze
SOTH-3:169
Tomb Lintel and Door Jambs;
details gray stone; 7-1/2
NM-14:pl 53, 54-8 UNNMM
(18.56.85-87)
Traveler c 325 terracotta; 13
MU 88 UNNSo
Turkish Groom, Ming Ch'i,
Shenshi 4/6th c. clay; 14
BALD 137 UOrEA
Two Buddhas, minor statues
in niche with frieze of
Buddhas
SWANNC 67 ChShaY

Two Musicians: Seated Woman
 Playing Drum and Lute,
 tomb figures c 500 grey
 earthenware; 8
 ALB 133 UNBuA
Two Women Holding Hands
 grey earthenware, ptd in
 red, white, black; 6-1/8
 COOP 27 SnSK
Walls and, Figures
 CART 136, 137 ChYK
Water Buffalo, tomb figure
 3/5th c. unglazed
 earthenware; 10
 ASH 93 GBVo
Woman, tomb figure pottery;
 15
 COOP 70 IFBe
Women clay
 CHENSW 212-213 COR
Yun Kang Bas Relief, detail
 5th c.
 BAZINH 440; MALV 43 UMB
CHINESE--WEI, or SIX, DYNASTIES
Hares, pair pottery
 BURL 178 UICA
CHINESE--WEI/SUI DYNASTIES
Apsaras, plucking stringed
 instrument 6th c.
 SLOB 223 UMB
Buddha Amitabha and At-
 tendants 593 bronze
 CART 149 UMB
Maitreya 4th c. gilt
 bronze
 NM-10:74 UNNMM
CHINESE--LIANG DYNASTY,
 502-557
Winged Lion, Tomb of
 Hsiao Hsiu after 518
 stone; L: 12'
 FRYC pl 19; GOMB 102;
 JANSK 318; PRAEG 529;
 SICK pl 6; SULI pl 63
 ChN
CHINESE--CH'I DYNASTY, 550-577
Altar 570 stone; 27-1/2
 COOP 68 IFBe
Amitabha Buddha 577 marble;
 105-3/4
 SICK pl 45a; TOR 41 CTRO
 (923.18.13)
Apsara, T'ien Lung Shan
 Caves stone
 CHENSW 211 UMCF
Avalokitesvara, Ch'ang-An
 c 570 stone; 98
 SICK pl 47 UMB

Avalokitesvara Bodhisattva
 grey limestone; 61
 WILL-1:pl 29 AuMV
Bodhisattva black limestone;
 76
 AS; CHENSW 213; LEEF
 144; SULI pl 60; SWANNC
 95 UPPU
Bodhisattva, head 6th c.
 black marble
 ZOR 102 UNNMM
Buddha: Great Buddha,
 Northern Hsiang-t'ang
 Shan 550/77 H: 13'
 SICK pl 39b ChH
Buddha, Hopei 6th c.
 LARB 209 FPCe
Buddha, head stone; 25-7/8
 CHENSW 210; MINP
 UMnMI
Buddha, headless and hand-
 less fragment, Ch'ang-an,
 Shensi c 570 stone; 26
 SICK pl 45b UMoKNG
Buddha's Hand, Hsiang-t'ang
 Shan stone; 25
 DEY 138 UCSFDeY
Buddhist Stele (Votive Stele),
 Shansi 554 gray limestone;
 84
 JANSK 322, 323; LEEF
 142 UMB
--569 stone
 CART 146 UMoKNG
--557 H: 150 cm
 SECK pl 4 SwZR
--: Maitreya as Future
 Buddha 550/77 marble
 CLE 250 UOCIA (17.320)
Demon, relief 550/77 lime-
 stone; 31
 TOR 37 CTRO (960.92)
Dvarapala limestone; 42-7/8
 AUB 115 SwZR
Funerary Couch 550/77 stone;
 45-3/8x25-3/4
 SICK pl 40-41a UMB
--, two side slabs 550/77
 stone; 23-3/4x92-1/8
 SICK pl 40-41b UDCFr
Kuan Yin, with halo and
 stand gilt bronze; 14-1/2
 FRYC pl 68
Maitreya Buddha, seated
 figure with flanking
 Bodhisattva
 WILL-1:pl 28 ChShaT

Amitabha Buddha: Preaching
c 650/700 ptd clay;
larger than LS
SECK 193 (Col) ChT
--, seated figure limestone
CLE 252 UOClA (64.152)
Ananda, head dried lacquer
CART 173 UICA
Animal Figure glazed ceramic
LARA 400 (col) ELBr
Apsara, T'ien Lung Shan
Caves
BURL 241 UNHA
Archer on Horseback, tomb
figure before 700 glazed
ceramic
FRYC pl 17
Armed Warrior, burial figure
clay
HERM il 107 RuLH
Bactrian Camel Bearing
Travelling Orchestra ptd
glazed pottery; c 70 cm
SULI pl 85
Blue Rider of Astana,
Turkesatn 7th c. ptd cera-
mic
SPE 123 (col) InDCA
Bodhisattva dried lacquer
gilded
CHENSW t UNNMM
--dried lacquer gilded;
49-1/2
NM-14:pl 98 UNNMM
(42.25.4)
--gilt bronze; 13-3/4
UMCF UMCF
(1943.53.61)
--limestone; 75-1/2
NM-14:pl 87 UNNMM
(14.78)
--, Hsian T'Ang Shan stone;
68x19x18-1/2
SDF 130 UCSDF
--wood; 15
NM-14:pl 97 UNNMM
(28.136)
--wood; 25
NM-14:pl 96 UNNMM
(L 3353.1)
Bodhisattva; back view; head
detail wood; 45-1/2
NM-14:pl 90-92 UNNMM
(28.123)
Bodhisattva 7th c.
FRYC pl 24 ChL
--7th c. stone
SEYT 10; ZOR 269 UDCFr

Bodhisattva 7/8th c. sand-
stone; 29-1/2
TOR 41 CTRO (953.127)
Bodhisattva 619/907 limestone
NCM 260 UNNMM (14.78)
Bodhisattva 8/9th c. stone
CHENSW 215
Bodhisattva: On Double Lotus
Petal stone
CHENSN 181; CHENSW 215;
MYBA 176 UDCFr
Bodhisattva, T'ien Lung Shan
Caves stone
BURL 242 UNNMM
Bodhisattva, bust fragment
7/8th c.
BAZINW 254 (col) FPG
Bodhisattva, fragment, Lung
Men stone; 18-1/2x13-1/2
NM-14:pl 85 UNNMM
(40.173)
Bodhisattva, head, T'ien Lung
Shan gray sandstone;
15-3/4
NM-14:pl 84 UNNMM
(42.25.12)
--, T'ien Lung Shan 8th c.
BAZINH 437 UNNMM
Bodhisattva, headless and
armless fragment marble;
179 cm
SULI pl 69 UNNMM
--, headless and armless
fragment 7/8th c. marble
GARDH 552
--, headless and armless
fragment 8th c. stone; 38
SICK pl 59b UDCFr
--, headless and armless
fragment, Hopei 8th c.
white marble; 62
SICK pl 59a UOClA
Bodhisattva, headless figure
limestone; 70-1/2
ASH 123 UNNMM
--8th c. H: 38
JANSK 326 UDCFr
Bodhisattva, kneeling Figure
limestone; 22-1/2
ASH 119 UMCF
Bodhisattva, seated figure
CHENSN 182 UNNMM
--9th c. gilt bronze; c 9x
4-3/8
SICK pl 60b UPPPM
--stone
CHENSW 216
--8th c. sandstone; 39-3/8
AUB 100 (col) SwZR

--, seated figure, Cave 143,
Tun Huang 8th c. ptd clay;
48
SICK pl 57b UMCF (1924.70)
Bodhisattva, torso stone
SWANNC 100 UDCFr
--stone; 51-1/2
BAZINW 257 (col) FP
Coll. A. Patino
--, T'ien Lung Shan 8th c.
yellowish sandstone; 98 cm
SECK 225 (col) SwZR
Bodhisattva, a Guardian, and a
Heavenly King, cave temple
672/74 rock figures
SWANNC 68 ChL
Bodhisattva Attendant, left
figure, detail, Lung Man
672/75 H: 40'
SICK pl 56a ChL
Bodhisattva Avalokiteshvara,
three figures ivory; 3-3/4
READAS pl 34 UCDFr
Bodhisattvas, T'ien Lung
Shan c 700 stone
LEEF 154 ChTi
Bodhisattvas, pair wood;
26-3/4; and 26-7/8
NM-14: pl 94, pl 95
UNNMM (39.76.1, 2)
Box: Medallions of Flowers,
Lotus, Birds 8th c. silver
gilt; W: 4-1/2
SPE 130 (col) NAA
Buddha gilt bronze; 8
FRYC pl 67 -EPol
Buddha: Preaching, seated
figure 8th c. gilt bronze; 8
SICK pl 60a UNNMM
Buddha: Vairocana Buddha,
seated figure 672/76 stone;
85'
FRYC pl 24; MALV 166;
SICK pl 55a; UPJ 749;
UPJH pl 310 ChL
Buddha: Udayana Type, head-
less figure 7th c. stone;
145 cm
SULI pl 68 ELV
Buddha: With Attendants,
Shrine figure wood;
8-3/4x4
NM-14: pl 79 UNNMM
(42.25.29)
Buddha, Central Asia wood;
14-1/4
NM-14: pl 80 UNNMM
(29.19)
Buddha, head gray limestone;
17 WORC 24 UMWA

--, head stone
CHENSW 217 ELV
--, head sun-baked mud;
7-1/4
NM-14: pl 81; NMA 196
UNNMM (30.32.5)
--, head, Lung Men
Caves gray limestone
FAIN 195 UMWA
Buddha, seated figure bronze
BURL 228 UNNMM
--dry lacquer; 38
NM-14: pl 83 UNNMM
(19.186)
--gilt bronze
CART 172 UNNMM
--7th c. gilt bronze
UPJ 751 UNNMM
--, T'ien Lung Shan stone;
41-1/2
UMCF UMCF (1943.53.22)
Buddha, seated torso on
pedestal yellowish marble
FRYC pl 25 UMB
Buddha and Bodhisattva,
Cave XXI, T'ien Lung
Shan 7/8th c. H: 43-1/2
SICK pl 55b ChSha
Buddha's Hand black marble;
20-1/2x14-1/8
NM-14: pl 86; ZOR 119
UNNMM (30.81)
Buddhist Figure 618/906
colored stone; 39
READAS pl 177 UDCFr
Buddhist Procession:
Musicians and a Dancer
CARTW 30 UDCFr (24.2)
Buddhist Stele: back view;
side detail; back detail
7/8th c. black marble;
64-1/2x35x12-15/16
NM-14: pl 65-78; SICK pl
58 UNNMM (30.122)
Buddhist Traveler's Shrine,
Turkestan wood; 14-1/4
NMA 195 UNNMM (29.19)
Buddhist Triad stone; 107x
65 cm
TOK 20 JTH
Buddhist Triad Figure stone
CHICB 23 UICA
Buddhist Votive Stele black
marble NM-10: 71 UNNMM
Buddhist Votive Tablet baked
clay; 5-1/4x3-7/8
NM-13: pl 82 UNNMM
(30.137)
Bull 618/907 ptd pottery
CLE 251 UOCIA (29.987)

Camel
 CART 162 UMCF
--clay
 CHENSW 218 UWaSA
--glazed faience
 BRIONA 63 (col) FPCe
Camel (one of pair) ceramic,
 brown and green glaze;
 31-3/4x7-1/2x14; and
 30x7-3/4x12-1/2
 SDF 131 UCSDF
--white pottery, green and
 yellow mottled colorless
 glaze; 33.1
 HOB pl 3 (col) ELBr
--, tomb figure ceramic
 MU 89 UNNMM
Camel and Driver glazed
 pottery
 UPJ 744 UICPa
Camel Driver, tomb figure
 glazed pottery
 SWANNC 118 (col) UWaSA
Camel and Rider pottery,
 yellow-brown, green and
 white glazes
 BURL 179 UOTA
Camel with Rider, model
 white pottery, brown and
 green glaze; 28
 HOB pl 2 (col) ELV
Candlestick, with Acanthus
 Leaves, Coiled Dragons,
 and Lotus Leaves pottery;
 11-7/8
 TOR 58 CTRO (930.65.3)
Cave Temple: Niche Figures
 clay
 SECK 70 (col) ChT
Celestial Being, T'ien Lung
 Shan Cave Temples, Shansi
 SWANNC 96 UMB
Charger and Groom, tomb
 relief, T'ang T'ai-tsung
 stone; L: 206 cm
 CART 168; SULI pl 66
 UPPU
Chicken-Head Spout Ewer
 (Eumorfopolous Ewer) Hsing
 Ware; 15-3/8
 ASH 157; LEEF 280 ELBr
Chorasmian Dancer glazed
 olive green pottery; 8-1/2
 RTC 179 COR
Confucian Divinity(?), seated
 headless figure
 JOHT pl 56
Couch Front stone
 SFGP pl J, 81 -Loo

Dancer
 ENC 868
--
 GAF 163 FPG
--terracotta
 BAZINW 259 (col) ELBr
--, grave figure
 CART 163 UNNMM
--, tomb figure
 GARDH 557 UMoKNG
Dancers, pair of female tomb
 figures ptd clay
 SWANNC 121 ELMo
Dancing Apsaras 9/10th c. dry
 lacquer
 CLE 253 UOClA (53.356)
Dignitary with Sceptre, tomb
 figure 8th c. lead glazed
 pottery; 22
 SPE 139 (col) GCoO
Disciples of Buddha, cave
 figures 6/7th c. ptd clay
 SWANNC 83 ChT
Doorway over Arch stone
 CART 177 UICA
Dvarapala (A Gate Keeper)
 rock carving
 LARA 363 ChL
--7/10th c.
 BAZINH 442 UMCF
Early Jade Pieces
 SFGP pl A, 84-101 -So
Empress and Court, Pin-
 Yang Cave, Lung Men 6th
 c. 76x109
 JANSK 323 UMoKNG
Empress' Imperial Feng Huang
 (Phoenix) Crown; detail
 gold wire, jewelled gold
 flower sprays, birds,
 phoenixes
 BURL 331-32 UNNMM
Equestrian 618/907 glazed
 terracotta
 BAZINW 259 (col) IR
 (Alberto Giuganino Coll)
--, grave figure terracotta
 CART 160 SnSO
Equestrienne Dismounting
 clay
 BURL 179; CHENSW 219
 UMiD
Ewer: Court Lady H: 8-3/8
 MU 91 (col)
Ewer: Horseman Hunting with
 Bows and Arrow glazed
 earthenware; 12-1/2
 RTC 174 (col) EOA
Ewer: Pheasant-head Stopper
 pottery CART 197 -Eu

Ewer: Pheasant, head
 Stopper white-glaze porce-
 lain; 30-1/2 cm
 SULI pl 84 UMnMI
Ewer, molded design pottery
 cream and green glaze;
 24.6 cm
 SULI pl 81 CTRO
Falconer on Horseback glazed
 pottery; 16-7/8
 DENV 189 UCoDA (O-1057)
Female Dancers and Musicians
 pottery
 BURL 180 CTRO
Female Figure 618/907 terra-
 cotta
 BAZINW 259 (col) FPCe
-- 700 three-color pottery;
 13-1/2x4-1/2
 MUNC 25 (col) UIWA
--7/10th c. pottery
 BAZINL pl 64 UMB
Female Musicians, grave
 figures
 CART 163 UHHA
--terracotta; 6-7/8
 WORC 25 UMWA
--618/906 terracotta;
 c 10-3/4
 READAS pl 33 SwZR
Female Polo Player ceramic
 SLOB 222 UMB
Fertility God, head
 STI 516 UICNh
Figure 618/907
 WILM 85
Finial: Dragon with Phoenix
 3rd c. B. C. bronze;
 6-3/4
 DENV 184 UCoDA (O-44)
Flask: Bird-Head Stopper
 LAFA 393 ELBr
Flute Player clay
 CHENSW 220 ELV
Foreign Dancer, funerary
 figure terracotta
 LARA 363 FPCe
Gold Headdress: Peacock
 SWANNC 121 UMnMI
Guardian 7th c. H: 50'
 MU 88 ChL
Guardian Dog glazed
 pottery
 SWANNC 100 ELBr
Guardian King 618/907 stone
 BAZINW 258 (col); BURL
 241 UPPU
Guardian Lion 8th c. marble;
 11-3/4
 AS UMoKNG

Guardian Warrior; rear and
 right profile glazed pot-
 tery; 29
 TOR 45 (col), 46 CTRO
 (923.24.13)
Guardians stone; 50'
 UPJ 750; UPJH pl 310
 ChL
Hairpins 9/10th c. silver
 gilt finials; 11-9/16;
 and 12-7/8
 TOR 49 (col) CTRO
 (959.117.3-2)
Harpist 618/907 lead-
 glazed terracotta; 12-5/8
 CLE 251; LEEF 279
 UOC1A (31.450)
Head dried lacquer
 CHENSW 217 UICA
Horse
 ENC 868
--
 JOHT pl 72
--ceramic
 SUNA 225 (col) UCSFDeY
--clay CHENSW 212 EOA
--glazed pottery; 20-1/2
 LEEF 263 (col) UOC1A
--glazed ceramic; 24-3/8
 AUB 117 GCoKo
--green-glaze; 11
 SOTH-2:137
--pottery, glazed; .76x.796 m
 BOSMI 9 UMB (46.478)
--618/907 lead-glazed
 pottery
 CLE 251 UOC1A (55.295)
--618/906 pottery, blue
 splashed glaze; 11-1/2
 WHITT 61 ELBr
Horse, detail after 683
 stone
 SICK pl 61a ChShK
Horse: In Combat clay
 CHENSW 218 ELBr
Horse: Lying Down green
 marble
 READM pl 17A ELV
Horse: Prancing, tomb figure
 unglazed earthenware;
 16-3/4x19
 ALB 134 UNBuA
Horse: Reared Left Fore-
 Foot pottery
 INTA-1:116
Horse: Saddled ceramic, white,
 green, and brownish yel-
 low glaze; c 24
 FAIY 28 UNBuMS
--glazed ceramic
 NEUW 44 UCSFHar

--ptd terracotta
FAIN 120 UMCF
--700 unglazed clay; 20-3/4
x23-3/4
MUNC 23 (col) UIWA
Horse: Wounded, relief detail,
Emperor T'ai Tsung c 637
gray limestone; 68
BURL 241; JANSK 325;
STI 515; SWANNC 101
UPPU
Horse, mortuary figure
618/906 earthenware;
54 cm
JOO 175 (col) NOK
--, Honan 618-906 pottery;
25.1/2
TOR 51 CTRO (918.21.375)
Horse, Tomb figure ptd
terracotta; 14-1/2
UMCF (1950.86)
--7/9th c. ceramic
GARDH 557 UMCF
Horseman clay, ptd red;
13-3/8
BERL pl 146 GBOs (48)
Horseman; Woman on Horse-
back clay; ea: 34 cm
BERLES 146 GBSBe
(48.c; 47)
Horseman, relief 7th c.
BAZINW 257 (col) UPPU
Horses 7/9th c.
ZOR 26 -Goldschmidt
Kneeling Bodhisattva stone
CHENSW 216 UMCF
Kneeling Camel
618/906 clay; 10x11
JANSK 319 SwZR
Kneeling Worshipper, Kumtura
terracotta
BAZINW 254 (col) FPG
Kuan Yin gilt bronze
SWANNC 100 UMCF
Kuan Yin limestone; 29-3/4
NM-14:pl 88 UNNMM
(29.100.33)
Kuan Yin sun baked mud; 17
NM-14:pl 99 UNNMM
(28.207)
Kuan Yin wood; 15-1/8
NM-14:pl 101 UNNMM
(28.141)
Kuan Yin wood; 18-3/4
NM-14:pl 100 UNNMM
(L 2782.3)
Kuan Yin: Eleven-Headed
8th c. gray sandstone
CLE 253

--, Toyoq, Turkeston wood;
15
AUB 116 GBS
--, fragment c 8th c. sand-
stone; 51
LEEF 154 UOClA
--, niche figure, Ch'i-pao
T'ai, Ch'ang-an 7/8th c.
30-5/8x12-3/8
SICK pl 56b UDCFr
--, relief
LARA 392 UMB
Kuan Yin: Nyoirin Kwannon
9th c. colored wood; 43
LEEF 264 (col) JOsKa
Kuan Yin, headless and arm-
less fragment marble
CLE 253
Kuan Yin, seated figure
RAY 77 UNNMM
--bronze
CHENSW 215 UDCFr
--ptd wood; 17
DENV 191 UCoDA (O-215)
--wood; 43
CHENSW 217; NM-14:pl 93
NMA 205 (col) UNNMM
(42.25.5)
Kuan Yin, seated figure,
Tunhuang Caves
CART 121 UMCF
Ladies clay
CHENSW 221 UWaSA;
UOClA; UPPPM
Lady clay
CHENSW 220 Coll. Royall
Tyler
Lady at her Toilet 7/10th c.
BAZINL pl 63 (col) -Gal
Lady on Horse
CART 162 UHHA
Lion 8th c. white marble;
11-3/4x9-3/4x8
SICK pl 61b UMoKNG
Lion:Devouring Animal veined
marble
BRIONA 71 FPG
Lion: Devouring Prey stone;
10
ASH 124 FPL
Lion: on Rocky Base white
pottery, green splashed
white glaze; 10-1/2
HOB pl 4 (col) ELBr
Lion, Cave of a Thousand
Buddhas 9th c. loess
HERM il 106 RuLH
Lion, head cast iron
CHENSW 219 UMiD

Lohan, head pottery
 CART 173 UOClA
Lohan, seated figure, I-chou
 Chiali
 RAY 76 UNNMM
Lokapala stone
 BAZINW 257 (col) UPPU
Lunette, relief 10th c. stone
 VALE 81 UICA
Lute Player clay
 CHENSW 220 ELBr
Male Figure clay, light
 yellow glaze; 8-1/2
 BERL pl 146; BERLES
 146 GBSBe (43.b)
Male Head dried lacquer
 CHICB 22 UICA
Merchant Holding Wine Skin
 Vessel pottery
 BURL 180; SUNA 236 (col)
 UWaSA
Mirror Dm: 6-1/4
 FRYC pl 65 ELV
--bronze
 BURL 228 UNNMM
--bronze; Dm: 8-3/4
 HOB pl 78 (col) ELV
--: Dragon silvered bronze;
 Dm: 8-1/4
 ASH 147 UMSBi
--: Dragons in Clouds
 8th c. silver; Dm: 7-1/2
 SPE 133 (col) EBriBA
--: Horseman Hunting bronze;
 Dm: 6
 ASH 147 FPL
--: Phoenix and Lion silver
 and lacquer inlay; Dm: 11
 MU 89 UNNMM
--: Sea Horse and Grape bronze;
 Dm: 24.1 cm
 SULI pl 82 UNNFa
Mirrors bronze
 CART 157 UNNMM
Molded Bottle: Bacchanalian
 Figures ceramic, greenish-
 brown glaze
 FRYC pl 31 ELV
Pagoda Base 8th c. stone;
 27-1/4
 LEEF 154 UMoKNG
Palace Ladies Playing Polo
 unglazed pottery, pigment
 traces; 11
 EXM 100 UMoKNG
Peddler, tomb figure
 ceramic
 GARDH 557 UOrPA

Personal Ornaments; gold
 silver
 CART 156 UNNMM
Pilgrim Bottle glazed
 ceramic
 CART 201 UICA
Pilgrim Flask: Flute Player
 and Dancer glazed
 stoneware; 8-5/8x7-1/2
 RTC 178 ELV
Polo Player clay
 CHENSW 219 SnSO
Polo Player pottery
 SOTH-3:171
Priest
 JOHT pl 64
--before 700 white marble
 FRYC pl 16 UPPPM
Resting Dog pottery
 BURL 183
Sakyamuni 7th c. limestone
 SUNA 288 UHHA
--708 white marble; 21
 NM-14:pl 89 UNNMM
 (28.114)
--: As an Ascetic, seated
 figure dry lacquer; 18
 ASH 117 UMiD
Sakyamuni(?) Buddha, Chu-
 Yang, headless fragment
 white micaceous marble;
 57
 WILL-1:pl 31 ELV
--, seated figure, Cave 16
 WILL-1:380 ChShaT
Seated Court Lady Holding
 Mirror glazed terracotta;
 12-1/2
 AUB 101 (col) ELV
Seated Lady glazed earthen-
 ware; 12
 ASH 153 ELV
Seated Lion c 700 stone;
 8x5
 MUNC 21 (col) UIWA
--8th c. marble
 CART 168 UMoKNG
--: Snarling pudding stone;
 9-1/2
 NM-14:pl 76 UNNMM
 (24.74)
Seated Woman Holding Bird
 pottery, green and orange
 glaze; 18
 COOP 150 URNewW
Snarling Lion bronze;
 9-3/4
 NM-14:pl 75 UNNMM
 (42.25.31)

--stone; 11
 ASH 125 FPL
Stem-Cup, miniature engraved
 hunting scene gilt bronze;
 6.4 cm
 SULI pl 80 CTRO
Stemmed Cup gilded silver
 CLE 252 UOC1A (51.396)
Stupa Front 7th c. stone;
 24-1/2
 CART 165; SFGP pl H,
 77; SICK pl 57a
 UMoKNG
T'ai Shih-chih c 800 bronze
 SPA 215 UWaSA
Temple Guardian lacquer
 CHENSW 219 Coll. Charles
 B. Hoyt
Three Women--1 a Dancer,
 grave figures unglazed
 pottery; 7-1/2-8
 GRIG pl 104-106 ELBr
Tomb Door, incised decora-
 tion stone; 25-1/4
 DENV 190 UCoDA (O-872)
Tomb Figure Group glazed
 pottery
 LEEF 279 CTROA
Tomb Figures 2nd Q 8th c.
 three-colored glazed
 pottery
 TOR 43 (col) CTRO
 (918.22.1-13; 918-21.
 287; 923.24-124)
Tomb Guardian unglazed
 pottery; 26
 DENV 188 UCoDA
 (O-1064)
--, bust pottery; 21-3/4
 TOR 47 CTRO (920.1.211)
Tomb Relief, detail gray
 stone; 60x38
 NM-14:pl 77, pl 78
 UNNMM (20.89)
Traders with Bullock-Drawn
 Cart glazed pottery
 SWANNC 119 (col) ELBr
Two Ladies, grave figures
 CART 163 UNNMM
Warrior, terracotta
 SLOB 222 -UB
--: Drawing an Arrow from
 Horse's Side, relief,
 Emperor T'ai Tsung Tomb,
 Tsing Kien, Shenshi
 BAZINH 442 UPPU
--, tomb figure pottery
 BURL 181 UICA

Woman terracotta
 CHENSN 186 CTRO
--618/906 terracotta; 23-1/2
 YAH 24 UCTY
--: In Ceremonial Dress,
 tomb figure pinkish-white
 earthenware; 15-1/16
 ALB 135 UNBuA
--: On Horseback clay, horse
 ptd red; 13-3/8
 BERL pl 146 GBOs (47)
--, tomb figure
 BURL 18 ELBr
Woman Polo Player unglazed
 pottery; 11-3/4
 RTC 179 ELBr
Yakushi Trinity; detail:
 Yakushi 726 bronze; 130
 LEEF 158, 159 JNY
Youth, Graeco-Roman features
 unglazed grey pottery;
 5-1/8
 RTC 179 ELV
CHINESE--T'ANG, or SUNG,
 DYNASTY
Mythical Horse bronze
 CHENSN 173 UOC1A
CHINESE--FIVE DYNASTIES,
 907-960
Potala Kuan Yin, seated
 figure 10th c. sandalwood
 CLE 254 UOC1A (65.556)
Shrine, Central Asia 8/9th c.
 wood
 CART 112 UMoKNG
Soldier Support and Funerary
 Platform, detail platform
 H: 84 cm
 SULI pl 67
CHINESE--LIAO DYNASTY, 937-1125
Amitabha Buddha, seated
 figure 10th c. bronze
 CLE 254 UOC1A (42.1082)
Buddha 10/11th c. stone;
 29'5'
 SICK pl 75a ChShaY
Ewer: Court Lady 937/1125
 porcelain
 CLE 252 UOC1A (53.248)
Lohan, seated figure glazed
 pottery; LS
 SWANNC 143 (col) UPPU
Monk 907/1124 marble; 79
 EXM 21; TOR 54 CTRO
 (922.20.95)
Sakyamuni Buddha, seated
 figure 11/12th c. gilt
 bronze; 10-3/4
 SICK pl 76b UMoKNG

CHINESE--LIAO/CHIN DYNASTIES
Guardian Diety, cave entrance
 SULI pl 87 ChKM
Lohan head 10/13th c. dried
 lacquer; 11-3/4
 SICK pl 81a UICA
--10/13th c. dried lacquer;
 12
 SICK pl 82 UMoKNG
Lohan, seated figure 12/13th c.
 pottery, green, yellow and
 amber glaze; 49-3/4
 TOR 55 CTRO (914.4.1)
Lohan, seated figure on base
 10/13th c. three-color
 pottery; 38-3/4
 SICK pl 83 UNNMM
--10/13th c. three-colore
 pottery; 40x31
 SICK pl 81b; SULI pl 88
 UMoKNG
CHINESE--SUNG DYNASTY, 960-1279
Bodhidarma, Crossing Yangtze
 River on a Leaf Blanc-de-
 Chine Porcelain
 SWANNC 187 (col) ETP
Bodhisattva marble; 86
 NM-14:pl 108-9 UNNMM
 (34.56)
--wood; 12-1/2
 NM-14:pl 102 UNNMM
 (20.30)
--12th c. ptd wood; 75
 SICK pl 78 UMoKNG
--12/13th c. wood; 59-3/4
 SICK pl 76a UPPPM
--13th c. cypress
 CLE 254 UOCIA (63.581)
Bodhisattva: Crowned Head
 iron; 17-3/4
 NM-14:pl 123 UNNMM
 (24.13.58)
Bodhisattva, half figure wood;
 59
 NM-14:pl 113 UNNMM
 (28.56)
Bodhisattva, seated figure ptd
 wood
 INTA-2:117
--12/13th c. wood
 CHENSW 222 Coll. Charles
 B. Hart
--, in Yogi Position c 1000
 ptd wood; 46
 MUNC 27 (col) UNNBo
Bodhisattva Avalokisheshvara
 (Kuan Yin) 960/1279 ptd
 wood
 BAZINW 258 (col); SICK
 231 (col) NAA

--, seated figure wood; 1.41x
 .88x.88m
 BOSMI 15 UMB (20.590)
Bodhisattva Manjusri, Upper
 Temple, Kuang-Sheng-ssu,
 Chao-ch'eng c 1150 ptd
 wood; over LS
 SICK pl 77a ChSha
Buddha, Hsia Hua-Yen-Ssu,
 Ta-t'ung 11th c. lacquered
 clay; 16'
 SICK pl 75b ChSha
Buddhist Monk, cave temple
 11/12th c.
 SWANNC 156 ChM
Buddhist Procession: Three
 Musicians and Dancer,
 frieze 10/11th c.
 MU 88-89 UDCFr
Chrysanthemum-Design Bowl
 Northern Celadon porce-
 lain; 41
 ASH 197 ELBr
Dvarapala 10/11th c. dry
 lacquer; .58x.26 m
 BOSMI 9 UMB (50.1073)
Fawns--a pair gilded bronze
 INTA-2:118
Figure 10/13th c. marble
 BAZINL pl 65 UNNMM
Golden Boy (Chin T'ung
 Tzu) ptd gesso, wood
 core; 27-1/2
 GROSS fig 50; NM-14:
 pl 112 UNNMM (42.25.6)
Guardian King wood; 11-1/2
 NM-14:pl 104,pl 105
 UNNMM (L 2786.25, 26)
Guardian of the World
 9/10th c. cast iron; 21
 SPE 163 (col) SwZR
Hair Ornament gold, with
 pearls, and cabochon
 rubies; L: 4
 TOR 49 (col) CTRO
 (L.960.9.124)
Headrest, relief of Bear
 Tied to Stake, Tzu Chou
 stoneware, dark brown
 glaze relief; W: 11
 GRIG pl 102 ELBr
Incense Burner: Lao-tsu on
 Water Buffalo bronze;
 8-1/4
 CHENSN 184; FAIN 195;
 MYBA 178; WORC 24
 UMWA
Indian Attendant c 1150 ptd
 wood
 SICK pl 77b ChSha

Inkstone: Landscape
 FRYC pl 74 ChPekI
Jade Rock; rear view
 FRYC pl 75, 74 ChPekI
Jug, peonies relief 11th c.
 felspar glaze pottery;
 7-3/4
 SPE 157 (col) UMB
Kuan Yin gilt bronze;
 19-3/4
 NM-14:pl 103 UNNMM
 (42.25.28)
--960/1268 wood
 SWANJ 94 ELV
--960/1279 ptd wood;
 35-1/2
 READAS pl 171 SwZR
--, Yunnan Province gilt
 bronze, with red lacquer,
 17-3/4x2-1/2x2-3/4
 SDF 131 UCSDF
Kuan Yin: Avolikitesvara,
 Bodhisattva of Mercy,
 seated figure gilt bronze
 LARB 209 EOA
Kuan Yin: In Royal Ease
 12th c. ptd wood; 42-1/8
 RIJA pl 158 (col) NAR
Kuan Yin, seated figure
 FAIY 55 UNRoR
--ptd wood
 CHICB 22 UICA
--ptd wood; 74
 SPE 186 (col) UICA
--ptd wood; 38-1/2
 NEWA 84 UNjNewM
--wood; 37
 NM-14:pl 111 UNNMM
 (33.116)
--12th c. wood
 CHENSW 221; FAIN 104
 UMB
--12th c. gilded, ptd wood and
 plaster; 95
 BURL 243; MU 89; NEWTEA
 300 (col) SICK pl 79; SULI
 pl 89 UMoKNG
--12/13th c. ptd wood; 39
 BURL 341 (col); SICK pl
 80a UMoSL
--13th c. bronze; 61-1/2
 BMA 89 UMdBM
--, relief 12th c. stone;
 12-1/2
 YAH 23 UCtY
Kuan Yin, seated in position
 of "Royal Ease", Maharaja-
 lila wood
 SWANNC 144 UMB

Lao Tse on Water buffalo
 bronze
 CHENSW 184 UMWA
Lion, Yueh Ware
 CLE 255 UOClA (66.26)
Lohan, head detail, I-chou
 c 1000
 GOMB 104 formerly GF
Lohan, seated figure
 960/1279
 NCM 260 UNNMM (20.114)
--1099 dried lacquer;
 17-1/2x13
 SICK pl 80b UHHA
--12th c. three-color glazed
 terracotta; c 40
 CHENSW 223; JANSK 327;
 SPE 160 (col) UPPU
Lotus-Pattern Bowl Northern
 Caledon porcelain; Dm: 7
 ASH 195 ELV
Phoenix-Head Vase, Ch-ing-
 pai porcelain
 CLE 255 UOClA (65.468)
Praying Man, fragment
 11th c. marble
 FRYC pl 24 UCLCM
Reclining Water Buffalo dark
 green jade
 BURL 265 UICA
Rhinoceros 11th c. bronze
 SUNA 224 UCSFDeY
Sakyamuni wood; 25-1/4
 NM-14:pl 110 UNNMM
 (32.148)
Seated Snarling Lions wood;
 7-3/4; 7-1/2
 NM-14: pl 106-107 UNNMM
 (28.187.1,2)
Secular Figure, Pao-ting
 LARB 211
Sleeping Avalokitesvara
 MARI pl 6 UICA
Taoist Figure 1127/79 wood,
 ivory
 CLE 254 UOClA (64.368)
Tingware Chicken-Head Ewer
 ENC 860
Tz'u Chou Ware Vase
 porcelain; 14.6
 HOB pl 30 (col)
Vase glazed clay
 CHENSW 222 UDCFr
Woman, head sun-baked mud,
 gesso; 15-1/2
 NM-14:pl 122 UNNMM
 (30.136)
Ying Ch'ing Ware Vase
 porcelain; 9-3/4 HOB pl
 29 (col) ELV

Incense Burner red lacquer, jade
finial; 18
HOB pl 88 (col) ELV
Judge of Hell glazed stoneware;
54
FRYC pl 35 (Col)
ELBr
Kendi (Water Flasks): Ele-
phant and Gourd-Form
porcelain; 17.8 cm; 19 cm
SULI pl 132 MalSU
Kuan Ti dark ivory, ptd black
BURL 268 UPPiC
Kuan Yin porcelain
CHENSW 224 UWaSA
--wood; 35-3/4
NM-14:pl 130 UNNMM (30.54)
--, seated figure clay; 13
BERL pl 149 (col); BERLES
149 (col) GBOs
(72)
--iron, copper; 55x27x22
SDF 131 UCSDF
--wood, lacquered 8-1/4
NM-14:pl 128 UNNMM
(36.40)
--: Head detail 1385 wood;
30-1/4
NM-14:pl 117, pl 119 UNNMM
(L 2786.1)
Kuan Yin of South Sea, T-hua
porcelain c 17th c. H:
17-3/4
CLE 267; LEEF 420 UOClA
(50.579)
Kuan Yin with Child c 1500
ivory; 7
MUNC 29 CVaR
Lacquer Box; All-over Iris
Design Yung-Lo,
1403/24 Dm: 5
FRYC pl 75
Lohan glazed pottery; 41-1/4
NM-14:125 UNNMM (21.76)
--glazed pottery; 50
NM-14:pl 124 UNNMM
(20.114)
--, seated figure 16th c.
glazed terracotta; 37
(excl base) AUB 110
(col) GBO
--, seated figure Chihli
Province pottery, mottled
green and brownish yel-
low glaze
BURL 244
Man 15th c. wood; 39
DURS 50 ELV

Official, seated figure
ivory
SWANNC 187 (col) SnR
Official, seated figure wood,
ptd and lacquered; 31
NM-14:pl 129 UNNMM
(34.31)
Old Men ivory
CHENSW 224 UNNMM; COR
Patriarch Tamo Bodhidharma
"Fukien White" Porcelain;
16-7/8
FOU 166 (col) ChPekP
Plate, with Garden and
Terrace Scene Dm: 13-9/16
LEEF 424 UNNL
Residential Compound,
mortuary model 16th c.
pottery; 70x33
TOR 65 (col) CTRO
(931.13.88-108)
Ridge Tile: Saint Riding a
Phoenix clay, glazed blue-
green, 7-1/2x6-3/4
BERL pl 149 (col);
BERLES 149 (col) GBSBe
(73)
Roof Tile: Fish clay, yellow
glazed; 10-3/4
BERL pl 149 (col);
BERLES 149 (col) GBSBe
(71)
Roof Tile: Guardian Figure
pottery, green and dark
brown glaze; 80 cm
SULI pl 122 UMoKNG
Roof Tile: Yen Lo, seated
figure 16th c. three-color
glaze--green, yellow,
amber; 33
BURL 344 (col); TOR 63
CTRO (923.6.3)
Roof Tiles: Horse; Dragons
BURL 193
Sakyamuni on Peacock 15th c.
wood; 21-3/4
NM-14:pl 132 UNNMM
(20.76.167)
Shan I, the Divine Archer,
Astride the Bird of Dawn
pottery, three-color glaze
BURL 344 (col) CTRO
Shou Shing 15th c. ivory
BURL 267 UPPiC
Siddhartha, relief c 495/550
stone
BAZINW 255 (col) UMB
Spirit Walk, Temple of
Heaven CART 270

Three Buddhist Female Dieties
gilded ivory
BURL 268 -Hou
Vase c 15th c. cloissone
enamel; 17
ASH 297 ELV
Warrior, Sacred Way lime-
stone
AUB 121 ChPekT
Warrior and Animal Guardian
Figures
CART 269 ChPekT
Water Buffalo jade
CLE 267 UOClA (60.282)
CHINESE--MING/CH'ING DYNASTIES
Jade Butterfly
NM-10: 69 UNNMM
CHINESE--CH'ING DYNASTY, 1644-1911
(Includes K'ANG HSI, 1662-
1722; and CH'IEN LUNG,
1735-1795)
Bottle: Floral and Insect
Design--Scorpion cased glass,
pink on turquoise ground; 6
ASH 347 ELV
Box 18th c. jade; 15.2 cm
SULI pl 125 ChTaP
Brush Holder; Taoist Figures
in Landscape 18/19th c.
dark green jade
BURL 266 UMnMW
Brush Pot translucent white
jade; 8
ASH 345 ELBru
Canton Figures gilt wood
BURL 244
Ceremonial Cup 18th c.
rhinoceros horn
BURL 268 UNNMM
Chu K'uei the Immortal
1662/1722
biscuit porcelain and
Chingtechen glazed and
ptd enamel; 6-1/2
FOU 171 (col) ChPekP
Court Headdress 18/19th c.
CART 310 UNNMM
Covered Box red lacquer,
jade and jewel stones;
7x15x14-1/4
HOB pl 92 (col) ELV
Covered Dish: Rat 18th c.
export porcelain; L: 8-5/8
CPL 109 UCSFCP
(1953.20A-B)
Covered Vase jade; 8-1/8
UMCF (1942.185.136)
Cylindrical Vase 18th c. white
jade; Dm: 8
FRYC pl 76 ELV

Danish Captain: M. Tonder;
and Supercargo: P. van
Hurck 1731 Canton ptd
clay; 38 cm; 32 cm
BOES DHeK
Doe 17th c. bronze; LS
BRIONA 97 FPCe
Famille Rose Goose Tureen
and Cover
SOTH-2: 146
Famille Rose Sow Tureen
and Cover
SOTH-2: 136
Fruit and Flower Stand red
imperial lacquer; 36-1/4
HOB pl 96 (Col)
Goddess of Compassion Blanc-
de-Chine
ENC 99
Hairpins: Pierced Flower
Motif with Phoenixes 17th
c. silver gilt, paste
jewels
BURL 332 UNNMM
Hevajra, with a Sakti, Peking
19th c.
GRIS 221 (col)
Ho Hsien Ku 17th c. ivory; 8
ASH 339 BBS
Ibex Head Ewer imperial jade
Chia SOTH-2: 141
Kuan Yin Blanc-de-Chine
SWANNC 223 EOA
--, Fukien Te-hua ware
17th c. white porcelain;
21.6 cm
SULI pl 128 -EBar
--19th c. jadeite
BURL 18 UNNMM
Kuan Yin: On Head of
Dragon, Emerging from
Waves 17th c. porcelain
FRYC pl 47 EPorL
Kuan Yin, seated figure
porcelain
CHENSW 224 UICA
Lan Ts'ai-Ho 19th c. ivory
SGO-4: pl 5
Landscape on Brushpot jade
SWANNC 225 EOA
Landscape/ Panel red, brown
and black lacquer; 63x38
HOB pl 97 (col)
Landscape Panel red lacquer,
with jade, malachite, and
imitation lapis lazuli;
30-3/4x43
HOB 95 (col) ELV
Li Po, Shekwan 18th c. pot-
tery BURL 194

Pectoral gold, pyrite; 6
NPPM pl 75 UNNMPA (63.4)
Pendant: Bird c 15th c. cast
gold
SMI 20 UDCNMS
Pendant: Stylized Figure gold;
7-1/2
NMANA 166 UMiBloC
(1947.9)
Chiron
Dunnwiddie. Dying Chiron
Hellenistic. Chiron, head
The Chiseler. Young, M. M.
Chisels
Lipchitz. Six Chisels
Chisho Daishi (Priest Enchin)
Japanese--Fujiwara. Priest
Chisho Daishi
Chlamydatus
Roman--5th c. Chlamydatus,
torso
Choani. Lekakis
Choate, Joseph Hodges (American
Lawyer and Diplomat 1882-
1917)
Adams, H. Joseph Hodges
Choate, relief profile
Adams, H. Joseph H. Choate
Medal
CHOATE, Nathaniel (American 1899-)
Alligator Bender 1937 Italian
marble; 60-1/4
BROO 388 UScGB
Choate, Rufus (American Lawyer
1799-1859)
French, D. C. Rufus Choate
MacNeil, H. A. Rufus Choate,
bust
Chocalat Menier. Cornell
Chogen
Japanese--Kamakura. Priest
Chogen
Choiseul-Gouffier Apollo. Greek--
5th c. B. C.
Chokaro
Japanese--Tokugawa. Netsuke:
Chokaro and his Horse
CHOLA See INDIAN--CHOLA
Cholita. Pro, R.
Cholmondeley, Lady
Manship. Lady Cholmondeley,
bust
Chomedey, Paul de d 1676
Hebert, L. P. Paul de
Chomedey
Choral Group. Wake, R.
Chorosphere. Lekakis
Choryo (Chang Liang) (Chinese
General d 198 B. C.)

Tomomasa. Choryo and the
Old Man, netsuke
CHOSEI (Japanese)
Twelve Guardians of Yakushi
(Twelve Heavenly
Generals; Juni Shinsho):
Mateira and Andara 1064
wood; 115.3; and 115.1
cm
TOK 41 JKKo
--: Mihira
SMIBJ 73 (col)
CHOSROES See KHOSRAU
CHOSROS See KHOSRAU
CHOU See CHINESE--CHOU
Chow. Renouf, E.
CHRISTENSEN, Lars (Shaker
Artist, Benson, Minn.)
Altarpiece Center Panel:
Crucifixion 1880/90 maple
and black walnut applied
to oak panels
CHR 24 UIaDeN
Altarpiece Panel
DOWN 173
Nativity, altarpiece relief
wood
DOWN 172
Christmas Package. Agostini
CHRISTO (Christo Javacheff)
(Bulgarian-American 1935-)
Dolly 1964 wood, metal,
canvas, polyethylene,
string; 77x54x33
WALKS #1 UNNC
Edifice Public Empaquete 1960
KULN 172
Four Store Fronts, detail
1964/65 wood, galvanized
metal, masonite, plexi-
glass, fabric, wrapping
paper, electric lights;
99x24x432
WALKS #3 UNNC
42390 Cubic Feet Empaquetage
1966
KULN 182, 183
Pushcart 1964 metal, poly-
etheline, string; 40x18x15
WALKS #2 UNNC
Christopher, Saint
Kaz. St. Christopher
Mestrovic. St. Christopher
Pratt, B. L. St. Christopher
CHRISTOPHER, Lucy (American)
Book of Life model, for
stone
SCHN pl 22

Chrome Fruits and Vegetables. Watts,
R. M.
Chrysalis. Bursztynowicz
Chrysalis. Landi, Lily
Chrysalis. Roszak
Chrysanthemum
 Chinese--Sung. Chrysanthe-
 mum-Design Bowl
Chrysaor
 Greek--6th c. B. C. Temple
 of Artemis, Corfu
Chrysippos
 Euboulides. Chrysippos,
 seated figure
CHRYSSA (Chryssa Vardea
 Mavromichali) (Greek-
 American 1933-)
 Ampersand IV 1965
 BURN 305 UNNPac
 Ampersand V 1965
 KULN 196
 Arrow Homage to Times
 Square 1957/60 ptd
 aluminum relief; 96x96
 NNMMA 21 UNNCor
 Arrow No. 1 1959 70x72
 CARNI-61:# 65 UNNPa
 Bronze Tablet I: Homage to
 the Seagram Building
 1956/59 bronze; 57-3/8
 x22-1/2
 NNMMA 22 UNNCor
 Bronze Tablet II 1956/59
 bronze; 29-3/4x14-7/8
 NNMMA 22 UNNCor
 Fragments for the Gates to
 Times Square II 1966
 programmed neon and plexi-
 glas; 43x34-1/16x27-1/16
 ART 247 (col); TUC 81,
 103 (col) UNNW
 The Gates to Times Square
 1966
 KULN 196
 --, No. 4, fragments for
 study 1967 17-1/4x
 13-1/2x19
 CARNI-67:# 251 UNNPac
 Letter E 1960 cast
 aluminum ptd white;
 90x48
 SEAA 66; UNNPa
 Letter T 1959 cast aluminum;
 53x39-5/8
 ALBC-3:# 53 UNBuA
 Projection Letter F 1958/60
 welded and cast aluminum
 relief; 68-3/8x46-1/8
 NNMMA 23 UNNMMA

 Three Arrows 1960 aluminum;
 72x66
 WALKT# 8; WHITNFY
 UNNW
 Times Square Sky 1962 neon
 and aluminum; 60x60
 WALKT #9 UNNCor
Chu K'uei
 Chinese--Ch'ing. Chu K'uei,
 The Immortal
Chueh, libationcup (tripod-shaped
 wine goblet)
 Chinese--Archaic. Chueh
 Chinese--Shang. Chueh
Chulakoka Devata (Culakoka
 Devata)
 Indian--Sunga. Pillar Reliefs
 Indian--Sunga. Stupa,
 Bharat
CHUMASH
 Fishhook
 CHENSW 27 UNNAmM
 Killer Whale, Catalina
 Island 1200/1600 stone;
 6-1/2
 CHENSW 426; DOCA pl 7
 UNNMAI (10/418)
 Whale, Channel Islands,
 Calif stone
 CHENSW 27 UNBuMS
Chunda, Buddhist Goddess
 Indian--Pala. Chunda
CHUNG, Kim (American 1930-)
 Altar of Silence 1960
 welded bronze; 38
 UIA-10:47 UCSFFein
 Sacred Tree copper, brass,
 steel; 53
 ROODT 85
Chung, Clapperless Bell
 Chinese--Chou. Chung
 Chinese--Shang. Bell
Chung-Li Ch'uan, Taoist Immortal
 Chinese--Ming. Chung-Li
 Ch'uan, seated figure
CHUPICUARO
 Figurines 500 B.C./500 A.D.
 pottery
 KUBA pl 61C MeMN
Churchill, Winston Spencer
 Grove. Churchill-Dunkirk
 Medals
Churinga (Tjuringa), sacred stone
 Australian Aboriginal.
 Churinga
 Australian Aboriginal.
 Tjuringa, plaque engraved
 with concentric circles

Churning of Ocean by Gods and
 Demons#
 Khmer
Churning of Sea of Milk
 Khmer. Bridge with Churning
 of the Sea of Milk
 Khmer. Churning of the Sea
 of Milk
 Khmer. Vishnu: Churning the
 Sea of Milk
CHURRIGUERESQUE
 Church Facade Detail c 1745
 NMAT 81 MeTlO
 Doorway
 MYBA 480 MeTlO
 La Ensenanza, retable
 NMAT 83 MeM
Chute Concentrique. Sullivan, F.
CIANFARANI, B. Aristide
 (American)
 Rendezvous plaster
 NYW 184
CIANI, Vittorio A. (Italian-
 American 1858-1908)
 George Clinton, bust marble
 FAIR 323; USC 174
 UDCCap
 Langdon Memorial
 HARTS pl 38
Ciborium
 Lambert, P. Ciborium
 Ranvoyze. Ciborium
Cicadas See Grasshoppers
Cicero
 Roman--1st c. B. C.
 Cicero, head
El Cid Campeador (Rodrigo Diaz
 de Bivar) (Spanish Hero
 1040(?)-1099)
 Huntington, A. H. El Cid
 Campeador, equest#
Cigar Holder. Indians of South
 America--Brazil
Cigar Maker's Family. Pierson
Cigar Store Figures See also
 Folk Art--American. Cigar
 Store Figure#
 Cromwell. Cigar Store Indian
 Dowler. Race Track Tout
 Folk Art--American. Punch
 Kruschke. Sitting Bull
 Melchers, J. Indian Brave
 Ruef. Seneca John
 Rush, William. Indian Brave,
 seated
 Smith, T. Cigarette
 Tecumseh. Indian Squaw, with
 headdress

Cihuateotl, Goddess of Women Dead
 in Childbirth
 Tajin. Cihuateotl
CIMON See KIMON
Cinema. Segal, G.
Cinnamon Bear. Ford
Cinteotl, Corn God
 Toltec. Cinteotl
CIPICCHIA, Ricardo (Brazilian)
 Anchieta and Child wood
 IBM pl 5 UNNIb
Cippi, exterior funeral marker
 Etruscan. Circular Cippus:
 Dancers
 Etruscan. Cippus
 Gallo-Roman. Cippus
Circe
 Allen, L. Circe
 Etruscan. Urn: Ulysses and
 Circe
 Etruscan. Urn: Ulysses in
 the House of Circe
 Mackennal, B. Circe
 Perry, R. H. Circe
 Talbot, G. H. Circe
Circle and Calligraph III. Ferber, H.
Circle in the Sun. Acton
Circle III. Smith, D.
Circles. Liberman
Circles and Angles. Smith, D.
(Circles) 2 CI.IV. Smith, D.
Circular Relief. Gabo
Circus. Cook
Circus. Epping
Circus Animals and Wagons
 See also Carrousel Figures
 Bode Wagon Works. "United
 States", circus wagon
 Calder, A. Circus Horse
 Folk Art--American.
 Christopher Columbus,
 circus wagon figure(?)
 Folk Art--American. Dancing
 Girl, relief figure,
 Sparks Circus Wagon
 Folk Art--American. Dolphin
 Circus Wagon
 Folk Art--American. Seated
 Lion, relief, Sparks
 Bandwagon
 Lawrence. "Golden Age of
 Chivalry"
 Parker Carnival Supply Co.
 Lion Head, relief
 Robb, S. "Medieval Lady,"
 Circus wagon figure
 Sebastian, J. Western
 Hemisphere, circus
 bandwagon

Bicho 1961 aluminum
SAO-6
Invertebrate 1962 aluminum
VEN-62: pl 93
CLARK, Nancy Kissel (American)
Bald Eagle welded steel;
24x36
HARO-2: 3
Clark, William (American Explorer
1770-1838)
Keck. Lewis and Clark
Monument
Clark Memorial. French, D. C.
Clarke, H. A.
Murray, S. H. A. Clarke,
bust
Clarke, James P. (American
Statesman 1854-1916)
Coppini. Senator James P.
Clarke
CLARKE, John L. (American)
Buffalo Bill
AUM 78
Clarke, Susan
Gruppe. Susan Clarke, head
CLARKE, Thomas Shields
Apple Press
REED 65 UCSFG
CLARKE AND RAPUANO, INC.,
landscape Architects
Fountain of the Fairs, New
York World's Fair,
1964/65
BISH UNNFl
Lunar Fountain, New York
World's Fair, 1964/65
BISH UNNFl
Clasps See Fibulae
Classical Study. von Schlegell
Claudia Antonina Sabina
Roman--3rd c. Claudia
Antonia Sabina
Claudius I (Roman Emperor
10 B.C.-54 A.D.)
Roman--1st c. Claudius
Roman--2nd c. Apotheosis of
Claudius
Roman--Britain. Emperor
Claudius, head
Clay, Henry (American Statesman
1777-1852)
Aitken. Henry Clay, bust
Ball. Henry Clay
Browere. Henry Clay, age
48, life mask
Clevenger. Henry Clay, bust
Hart. Henry Clay
Henry, A. P. Henry Clay,
miniature bust

Niehaus. Henry Clay
Clay Pipe Series. Cornell
Clayton, John Middleton
(American Jurist 1796-1856)
Baker, B. John M.
Clayton
Cleanliness is Next to Godliness.
Washburn, K.
Cleft. Kasagi
Clemens, Samuel Langhorne
(American Humorist and
Author 1835-1910)
American--20th c. Mark
Twain
Hibbard, F. H. Mark
Twain
Humphreys, A. Samuel
Langhorne Clemens, bust
Jennewein. Samuel Lang-
horne Clemens, medal
Clement, Carolyn and Patricia
Grimes. Carolyn and
Patricia Clement,
plaquette
Clement, Harold Tripp
Grimes. Harold Tripp
Clement, plaquette
Cleomanes (Athenian) See also
Hellenistic.
Aphrodite Medici
Octavius as Orator 2nd half
1st c. B. C. Parian
marble; 70.9
GAU 110 FPL
Cleopatra VII (Queen of Egypt
69-30 B.C.)
Boscoreale. Cleopatra's Cup
Egyptian--Ptolemaic. Cleo-
patra, relief
Hellenistic. Alexandrian Coin:
Cleopatra VII
Hellenistic. Cleopatra and
Dioscorides
Roman--1st c. B. C. Cup of
Cleopatra with bust of
Cleopatra
Story, W. W. Cleopatra
Cleveland, Grover (22nd President
of U.S.A. 1837-1908)
Evans, Grover Cleveland, bust
CLEVENGER, Shobal Vail
(American 1812-43)
Henry Clay, draped bust
1831/42 marble; 30-1/4
GARDAY pl 7; PIE 378;
UNNMMAS 9 UNNMM
(36.17)
Indian Chief 1843
THOR pl 22

--(Drwg from United States
 Magazine and Democratic
 Review, February 1844 1842 Clubs
 CRAVS fig 6.3
James Kent, bust 1840 plaster;
 26
 CRAVS fig 6.2 UNNHS
Josiah Lawrence bust 1837
 plaster
 CRAVS fig 6.1 UOCiM
Washington Allston, bust
 TAFT 100 UPPPA
CLEWS, Henry Jr. (American
 1876-1937)
 Frederick Delius, mask
 portrait 1916/17
 bronze; 15-3/4
 UNNMMAS 126 UNNMM
 (39.118.1)
 Portrait of Sam bronze
 WHITNC 218 UNNW
Clinton, George (American
 Statesman 1739-1812)
 Brown, H. K. George Clinton
 Ciani. George Clinton, bust
Clio, Muse of History
 Franzoni, C. Clock: Car of
 History
 Roman--2nd c. Clio, seated
 figure
The Cloak. Lipton
Cloak Fasteners See Fibulae
Clock Gargoyle. Accorsi
Clocks and Watches
 Barnard. Clock
 Fellows. The Clock
 Franzoni, C. Clock: Car of
 History
 Willard, A. Wall Clock
 Willard, A., Jr. Tall Clock
Clog Dancer: "Jim Crow". Folk Art--
 American
The Closing Era. Powers, J. P.
The Clothesline. Agostini
The Cloud. de Creeft
Cloud of Peace. Landis, Lily
A Cloud Remembered. Yagi, K.
Clouds and Mountains. Lynch
Clouds of Magellan. Lassaw
Clouds over Mountains, mobile.
 Calder, A.
Clown Bottle. Krentzin
Clowning Mask. Naskapi
Clowns
 Boghosian. The Clown
 Folk Art--American. Cigar
 Store Figure: Clown
 Greenbaum. Clown

Zuni. Kachina Dolls: Mud-
 head Clown
Chippewa. War Club
Easter Island. Fish Club
Fiji. Club
Fiji. Throwing-Club, geo-
 metric decoration
Fiji. Two Carved Clubheads:
 Lotus Club and Paddle
 Club
Haida. Club
Indians of North America--
 Northwest Coast. Club
Indians of South America--
 British Guiana. War Clubs
Indians of South America--
 Peru. Club Head
Iowa. Club
Iroquois. Ball-Headed War
 Club
Iroquois. War Club
Kwakiutl. Club
Mahican. War Club
Maori. Club
Maori. Patu Paraoa, weapon
Maori. Short Club
Maori. War Club (Waha-ika)
Maya. Club Heads
Melanesian--New Caledonia.
 Bird's-Head War Club
Melanesian--Solomons. Dance
 Club
Nootka. Clubs
Oto. War Club
Paumari Indians. Club
Polynesian. Club
Polynesian. War Club
Polynesian--Marquesas. Club
-- Club Head#
--Two Ceremonial Clubs
--War Club
Polynesian-Samoa. War Club
Polynesian--Tonga. Two
 Clubs
Sioux. Ceremonial Club
Tlingit. Fish-Killing Club
Clydesdale Stallion. Lane, K. W.
Clytemnestra
 Cretan. Murder of
 Agamemnon, relief
 Eruipides--Foll. Megarian
 Bowl: Clytemnestra's
 Arrival in Aulis
 Greek--7th c. B. C.
 Clytemnestra Slaying
 Cassandra, relief
 Greek--6th c. B. C. Clytaem-
 nestra and Aegisthus Slaying
 Agamemnon

Mrs. Mary Ann Elizabeth
Cogdell Memorial, St.
Philip's Church 1823
marble
CRAVS fig 3.5 UScCh
Cogswell (H. D.) Historical
Monument
American--19th c. Benjamin
Franklin
COHEN, George (American 1919-)
Anybody's Self-Portrait 1953
framed mirror, mounted on
masonite with other objects;
masonite: Dm: 9-5/8
SEITA 112 UICFe
COHEN, Mrs. Toby (American)
Picketing bronze
UNA 6
COHEN, Nessa (American 1885-)
Sunrise bronze; 11
MUNSN 152
COHN, Ola (Australian)
Penguin
MOO-2:82
Coindreau, Gustavo
Quezada Medrano. Gustavo
Coindreau, bust
Coins
Achaemenian and Sassanian.
Eight Coins
American--17th c. Lord
Baltimore Sixpence
--Massachusetts Twelve
Shilling Piece
--Oak and Pine Tree Shillings
American--18/20th c. Vari-
ous State and Federal Coins
Bactrian. Stater:
Eucratides
Bactrian. Tetradrachm
Bactrian. 20-Stater Coin:
Eucratides
De Francisci. United
States Dollar
Engman. Quarter (Proposed
United States Coin)
Euainetos. Syracusan
Dechadrachm
Evenete. Syracuse Deca-
drachma: Persephone
Crowned with Reeds
Gallic. Coin
Gallic. Parisii Stater
Greek. Athenian Four-Drachma
Coin: Athena; Owl
--Coin(s)
--Elis Coin
--Syracuse Coin: Quadriga
Greek--7th c. B. C. Coins
Showing City Symbols

Greek--6th c. B. C.
Athenian Coin: Gorgon;
Lion Mask
--Athenian Tetradrachm:
Athena
--Coin#
--Paestum (Poseidonia) Coin:
Poseidon with Trident
--Stater#
--Tetradrachm#
Greek--6/4th c. B. C.
Coins
Greek--5th c. B. C.
Agrigentum Tetradrachm:
Two Eagles with Hare;
Scylla and Crab
--Athenian Coin: Athena,
head; Owl
--Coin#
--Decadrachm: Akragas:
Two Eagles on a Hare;
Grasshopper
--Demareteion#
--Lentini Tetradrachma:
Chariot; Apollo, head
--Naxos Coin: Dionysus, head;
Satyr Drinking
--Scione Tetradrachm:
Protegilaos, helmeted head
--Stater, Elis: Eagle's Head
--Syracuse Demareteion:
Nike Crowning Chariot
Race Winner; Arethusa,
head
--Tetradrachm#
Greek--4th c. B. C. Argos
Drachm: Hera, head;
Diomedes Carrying off the
Paladium
--Byzantium Coin: Herakles
Strangling Serpents;
Cow and Dolphin
--Coin#
--Delphi Coin; Demeter, head
Apollo on Omphalos
--Didrachm, Lucanian
Herakleia: Herakles and
the Nemean Lion
--Elis Coin: Zeus, head;
Eagle of Zeus
--Knossos Coin: Hera, head;
Labyrinth
--Stater#
--Tetradrachma, Lysimachus:
Alexander the Great with
Amun Horns
--Thebes Drachm: Protesilaos
Advances from his Ship
Hare. Half-Dollar (Proposed
United States Coin)

Hellenistic. Alexandrian
 Coin: Cleopatra
--Antioch Tetradrachm:
 Seleuces VI
--Antioch Tetradrachm:
 Tigranes I of Armenia
--Coin#
--Dekadrachm: Berenike II
--Lampsacus Stater:
 Orontas
--Lysimachus Tetradrachm:
 Alexander the Great
--Rhodes Coin: Helios, head;
 Rose
--Tetradrachm#
Herakleidas. Tetradrachma
 of Katana: Apollo, head
Hull, J., and R. Sanderson.
 Boston Shilling
Indian--Gupta. Coin#
Indian--Kushan. Coin#
Indian--Kushan--Gandhara.
 Bactrian Coin: Euthydemos
 II
--Coin#
Indian--Moghul. Coin: Akbar
 the Great
Indian--Sunga. Coin #
Indian and Ceylonese. Coins,
 Plaques, Seals
Indiana. United States Plastic
 Penny--red, white, and
 blue (proposed coin)
Jewish--1st c. B. C. Coins
Jewish--2nd c. Coins
Kephisodotus. Athenian
 Coin: Eirene
Kimon. Decadrahm of
 Syracuse
--Syracuse Coin
--Tetradrachm of Syracuse:
 Athena, head; Quadriga
Korean. Knife-Shaped Coins
Latin American--18th c.
 Dubloon
Lippold. Twenty-Five Dollar
 Gold Piece (Proposed
 United States Coin)
Lipton. Nickel (Proposed
 United States Coin)
Macedonian. Coin#
MacNeil, H. A. United
 States Quarter Dollar
Parthian. Coins: Portraits
 and Greek Inscriptions
Persian. Coins: Calligraphy;
 Lion and Peacock
Phidias. Athena, coin

--Athena Parthenos (Copy:
 Carnelian Ringstone and
 Roman coin)
--Athena Promachos, bronze
 statue on Athenian
 Acropolis, copied on
 Roman coins
--Olympian Zeus, Elis coin
Phidias--Foll. Aphrodisias
 Coin: Athena Parthenos
--Athena Parthenos, sketch,
 Athenian coin
--Coin of King Philip of
 Macedon: Zeus Olympios,
 head
Praxiteles--Foll. Athenian
 Coin: Zeus Olympios
Roman. Coin of Caracalla:
 Serapis
Roman--3/1st c. B. C.
 Republican Coins, reverse:
 Voting; Jupiter in
 Elephant-Drawn Chariot
Roman--1st c. B. C. Aureus
 Brutus in Laurel Wreath
--Coins: Herakles; Comedy
 with Mask; Tragedy with
 Mask
--Denarius: Octavianus
--Julius Caesar, head, coin
Roman--1st c. As of Nero:
 Securitas , seated figure
--Aureus#
--Orichalcum: Galba
--Sestertius#
Roman--1/2nd c. Sestertius
 of Trajan: Circus Maximus
Roman--2nd c. Aureus:
 Faustina II
--Coin: Pharos
Roman--3rd c. Coin#
--Trojan Sestertius: Hektor
 Charges into Battle in
 Quadriga
Roman--4th c. Aureus:
 Constantine the Great
--Coin: Aelia Flaccilla
--Double Solidus: Helen
--Solidus#/
Roman--5th c. Coin#
--Siliqua: Galla Placidia
 Solidus#
Roszak. Dime (Proposed
 United States Coin)
Stankiewicz. Dollar,
 rectangular shape (Pro-
 posed United States
 Coin)

Theodotos. Clazomenae
　Tetradrachm: Apollo, head
　　in Laurel Wreath; Swan
Colbert, Jean Baptiste (French
　Statesman 1619-83)
　Fraser, L. G. Colbert,
　　medallion head
Cole, Thomas (American
　Painter 1801-48)
　Brown, H. K. Thomas Cole,
　　bust
Coleman, William F.
　Stackpole, R. William F.
　　Coleman Memorial
　　Fountain
Coles, Abraham (American Poet
　1813-91)
　Ward, J. Q. A. Abraham
　　Coles, bust
COLETTI, Joseph arthur (Italian-
　American 1898-)
　Donata (aged six weeks)
　　plaster; 12
　　NMPS # 105
　John the Baptist, half figure
　　NATS 55
　Klipspringer 1929 bronze; 14
　　BROO 432 UScGB
　Woman plaster
　　NYW 182
Colfax, Schuyler (Vice President of
　the United States 1823-85)
　Goodwin, F. M. Vice
　　president Schulyer Colfax,
　　bust
COLIMA
　Acrobat Vessel clay; 9-1/4
　　NPPM pl 84 UNNMPA
　　(62.167)
　Amphora: Sleeping man,
　　seated, arms crossed on
　　knees, head on arms
　　300/1200 red
　　polished terracotta
　　MAS cat284 -MeO
　Ball Player
　　DIS 28 UCLS
　Breast Plate; profile detail
　　hammered gold; W: 12-1/2
　　BL pl CXVIII, 270 UDCBl
　Circle of Dancers 1st c(?)
　　pottery
　　KUBA pl 59 MeMN
　Costumed Musician Holding
　　Musical Rasp 300/1250 clay;
　　17
　　DOCM pl 12 UNNMAI
　　(22/8838)

Crawling Child Carrying
　Vessel; clay
　DIS 26
Diadem gold
　LYNCM 42 UDCN
Gesturing Figure, seated
　c 500/900
　clay; 11
　JANSK 363 UNNMPA
Dog (Izcuintli) 300/1250
　ochre terracotta; red
　polished paint; 9-3/4x
　16-1/2
　DIS 27 (col); MAS cat 314
　READAS pl 51 MeMN
--6/7th c. earthenware
　CLE 291 UOClA (64.37)
--1000/1500 pottery; 11
　WORC 20 UMWA
Effigy Jar: Man Seated on
　Stool
　LOT 73 (col) MeMN
Effigy Vessel: Dog Wearing
　Human Face Mask pottery;
　8-1/4
　LOT 72 (col) MeMN
Female Figure buff pottery;
　6-1/2
　BUSH; FEIN pl 43 UMCP
--300/1000
　FEIN pl 98 UPPU
--, Tarascan brown
　earthenware; 11-1/8
　NMAT 35 MeMN
Flat Figure, pendant, Higueras
　clay
　DIS 21 (photo) SnSE
Hunchbacked Figure, with
　Incised tattoo, standing on
　fish 300/1250 red
　polished ochre terracotta;
　16-1/2x9-1/2
　MAS cat 293 MeMN
Jar: Seated Hairless Dog
　red slip pottery; 12-1/8
　BUSH 101 ELBr
Magician, seated figure
　200/800 clay; 7
　ELIS 53 UNNEm
"The Maiden of the West" ("La
　Doncella del Occidente"),
　squatting nude figure
　300/1250 ochre terracotta,
　red polished paint
　MAS cat 291 MeMN
Man Blowing Conch Shell
　Trumpet pottery; 16
　BUSH 102 UPPU

Official Seated, male figure
red polished terracotta;
20-1/2x14-5/8 MAS cat
294 MeMN
Old Woman, seated figure red
polished terracotta; 25-1/4
x7-7/8
MAS cat 303 MeMS
Parrot-Footed Gourd Jar red
pottery
BUSH 100 UNNAmM
"El Pensador" Effigy clay;
8-1/2
DOCM pl 13 UNNMAI
(22/5100)
Recumbent Pregnant Female
about to Give Birth red
polished terracotta; traces
of black paint; 19-1/4x
8-1/4
MAS cat 296 -MeO
Seated Female Figure, Los
Ortices red clay, buff
ware face; 9-1/2
DOCM pl 11 UNNMAI
(16/3639)
Seated Prisoner with Hands
Bound behind Back red
polished terracotta;
9-1/2x6-3/4
MAS cat 285 -MeO
Seated Woman glazed
terracotta; 9-1/2x8x6
ALBC-4: 81
Sitting Dog Wearing Human
Mask red polished
terracotta, black mask;
13-3/8x9
MAS cat 316 -MeO
Sitting Howling Dog red
polished terracotta; 12x
16-7/8
MAS cat 322 -MeO
Standing Figure basalt;
47 cm
JOO 173 (col) NOK
Two Flattened Figures--male
and female pottery; 8-1/2;
7-1/8
GRIG pl 127, pl 128
ELBr
Vessel: Chicken ochre polished
terracotta; 7-7/8x5-1/2
MAS cat 328 MeMS
Vessel: Dog
AMHI 58 UWaSA
Warrior 400/800 terracotta
CHICC 15 UICSe

--, seated figure, Tarascan
500/900 burnished terra-
cotta; 11-1/2
TOR 173 CTRO (957.90)
--13th c. ceramic; 15-1/4
DENV 110 UCoDA
(NW-344)
--, vessel clay; 14-3/8
NPPM pl 82 UNNMPA
(57.9)
Water Carrier, nude figure
red polished terracotta;
16-1/2x8-5/8
MAS cat 287 MeGA
Wrestler 300/1250 clay; 10
DOCM pl 15 UNNMAI
(23/208)
COLINAS, Ceferino (Spanish-
Mexican)
Angustia stone
LUN
Collage Construction. Anderson
Collamer, Jacob (American Orator and
Jurist 1792-1865)
Powers, P. Jacob Collamer
Collars
Indians of Central America--
Puerto Rico. Collar
--Collar and Zemes
Quimbaya. Collar
COLLIE, Alberto (Venezuelan-
American 1939-)
Floatile No. 1I 1967
BURN 46 UNNNo
Spatial Absolute No. 2 1964
20x35
CARNI-64:# 398 UNNNo
Spatial Absolute No. 3 1965
aluminum on plexiglas base;
Dm: 18
UIA-13:167 UNNNo
COLLIN, Achille
Osceola ptd plaster
PAG-2:121 UDCNM
COLLINS, Jim L. (American)
Decoy No. 2 H: 48
HARO-1:18 UWvHH
COLOMBIAN
--16th c.
Altar, Rosario Chapel gold
WHY 106 ColTD
Baroque Side Altar
WHY 93 ColCD
Decorated Ceiling, including
framed Delft Plates
WHY 134 ColTD
Main Altar
WHY 89 ColCC

238

Mudejar Ceiling, Chapel of
 Capitan Antonio Ruiz
 Mancipe
 WHY 131 ColT
Pulpit
 WHY 132 ColTD
Retablo of St. Anthony
 WHY 118 ColTV
--17th c
 Chapel
 WHY 127 ColTC
Main Altar
 WHY 89 ColCP
Main Altar
 WHY 97, 123 ColCT
San Rafael, altar figure
 WHY 124 ColTC
--18th c.
Baroque Portal 1770
 WHY 97 ColCI
Colonial Postman. Waugh, S. B.
Color Pod. Drake
El Colorado. Hord
The Colosseum
 Roman--1st c. Sistertius of
 Titus: The Colosseum
Colossi
 Borglum, G. Mount Rushmore
 National Monument
 Ceylonese. Buddha, colossal
 seated figure
 Chinese--Wei. Buddha:
 Colossal Buddha
 Easter Island. Colossal
 Figure(s)
 Easter Island. Monumental
 Human Heads
 Egyptian--18th Dyn. Amenhotep
 III, colossi
 --Colossi of Memnon
 Egyptian--19th Dyn. Ramses
 II, four seated colossi
 --Ramesseum: Ramses II,
 colossi
 Greek. Colossal Cybele,
 seated figure
 Japanese--Kamakura. Amida
 Buddha (Great Buddha of
 Kamakura)
 Olmec. Colossal Mask,
 monument
 Olmec. Colossal Head#
 Olmec. Colossal Male Head
 in Helmet
 Phidias. Athena Parthenos
 Teotihuacan. Water Goddess
Colt. Flannagan
Colt. Warneke, H.

Columbia
 Folk Art--American. Figure-
 head. Columbia#
 French, D. C. Columbia
COLUMBIA RIVER CULTURE
 Mortar, Head, Sauvies I
 stone
 CHENSW 433 UOrPA
Columbian Fountain. MacMonnies
Columbus, Christopher (New World
 Explorer 1451-1506)
 Bartlett. Christopher
 Columbus
 Folk Art--American.
 Christopher Columbus, cir-
 cus wagon figure(?)
 --Cigar Store Figure:
 Christopher Columbus
 Miranda, F. Columbus
 Whitney, G. V. Columbus
 Memorial
Columbus Door
 Rogers, R. Doors, Central
 Portico, East Front:
 Christopher Columbus
Column# Gabo
Column. Scuris, S.
Column Bases
 Greek--4th c. B. C. Column
 Base
 Roman. Column Base: Aeneas
 and Anchises
Column October. Bolotowsky
Column of Progress. See Konti, I;
 MacNeil, H. A.
Columns
 Achaemenian. Columns of
 Apadana
 Carlberg. Project for
 Column
 Chinese--Ming. Column
 Chinese--Ming. Dragon
 Columns
 Coptic. Column, fragment:
 Interlocking Swastikas
 Egyptian. Papyrus Bud
 Column
 --Papyrus Flower Capital
 Half Columns
 Egyptian--3rd Dyn. Papyrus
 Half Columns
 Egyptian--18th Dyn. Papyrus
 Bundle Columns
 --Pillars: Lotus and Papyrus
 Egyptian--19th Dyn. Hypostyle
 Hall: Decorated Columns
 --Palm Column
 --Papyrus Column

Egyptian--25th Dyn. Taharqa
 Column
Egyptian--28th Dyn. Lotus
 Columns
Egyptian--30th Dyn. Hathor
 Column
Greek. Corinthian Column:
 Acanthus Design
--Foliate Pilaster, detail
Greek--6th c. B. C. Column
Indian--Deccan--Rashtrakuta.
 Pillars
Indian--Gupta. Cave 17:
 Column before Central Shrine
Indian--Moghul. Akbar's
 Column
Indian--Vijayanagar. Horse
 Columns
Islamic. Column(s)
Konti. Column of Progress:
 Base Friezes
Lydian. Ionic Column
Maori. Assembly House
 Column
Maya. Columns
Maya. Temple of Warriors,
 Entrance Columns
Mestrovic. Column Figures
Roman--2nd c. Marcus
 Aurelius Column
--Trajan's Column
Roman--3rd c. "Solomonic"
 Twisted Column
Roman--4th c. Column#
Syrian. Column Figure
Thai. Faces and Floral
 Motifs, eastern facade
Toltec. Plumed Serpent
 Column
Toltec. Warrior Columns
Columns of Asoka
 Indian--Maurya. Capital
COLVIN, Marta (Chilean 1915-)
 Andes 1958/59 bronze;
 30 cm
 SAO-5
 Humus 1954 wood
 MAI 61
 Manutara 1957 wood; 43x41
 LOND-5: #14
 Porta do Sol 1964 stone;
 125x120x30
 cm
 SAO-8
 Torres de Silencio 1960 stone;
 300x125x140 cm
 SAO-8
Coma Berenices. Lassaw
Combat-Man. Putnam, A.

Combs
 African--Badjokwe. Comb with
 head
 Coptic. Comb: Vine-Scrolls
 and Winged Horses
 Coptic. Rider Saint: Comb
 details
 Formosan. Combs
 Greek--7th c. B. C. Judg-
 ment of Paris, comb
 Greek--4th c. B. C. Comb:
 Cavalry Battle
 Indian--Hindu--17th c. Comb,
 with deer
 Iroquois. Comb#
 New Guinea. Comb
 Polynesian--Samoa. Combs,
 with pierced and carved
 geometric and floral design
 Romano-Indian. Ivory Comb
 Tlingit. Comb#
Come Hither. Noteriani, P.
Comedy and Tragedy See also Actors;
 Masks;
 Melpomene, Muse of
 Tragedy; Thalia, Muse of
 Comedy
 Beach. Actors Fund Medal:
 Actors; Masks of
 Comedy and Tragedy
 Calder, A. S. Tragedy and
 Comedy
 Egri. Comedy and Tragedy
 Greek. Tragic Mask, Piraeus
 Greek--5th c. B. C. Theater
 Masks: Tragic and Comic
 Hellenistic. Comedy, headless
 and armless figure
 --Comic Masks
 --Masks: Comedy and Tragedy
 --Menander: With Comic
 Masks, relief
 --Necklace: Six Comedy Masks
 --Tragedy
 Roman--1st c. B. C. Coins:
 Herakles; Comedy with
 Mask; Tragedy with Mask
 Roman--2nd/3rd c. Work-
 Basket Fittings: Tragic
 Mask
 Rush, W. Comedy and
 Tragedy
 Torrey. Comedy, relief
Comegys, B. B.
 Calder, A. S. B. B.
 Comegys, bust
The Comet. Duble
Comets and Planets. Onaga, Y.
Comin' Through the Rye. Remington

Coming of the White Man. MacNeil,
 H. A.
Coming Out. Greenbaum
Coming to the Parson. Rogers, J.
Commedia dell'Arte
 Archipenko. Carrousel
 Pierrot
 Folk Art--American. Cigar
 Store Figure: Punch#
 Folk Art--American.
 Harlequin, jumping jack
 Folk Art--American. Punch,
 hand puppet
 Folk Art--Canadian. Punch,
 cigar store figure
 Lipchitz. Harlequin
 Lipchitz. Pierrot Escaping
 Lipchitz. Pierrot Guitarist
 Lipchitz. Pierrot with
 Clarinet
 Lipchitz. Seated Pierrot
 Rood. Harlequin and Child
 Zadkine. Harlequin
 Zadkine. Seated Harlequin
Committee. Stankiewicz, R.
Commodus (Roman Emperor) See
 Verus, Lucius Aurelius
Compact Objects (6). Nakanishi, N.
Compassion See Avalokitesvara,
 Bodhisattva of Compassion
The Competitor. McKenzie, R. T.
The Competitors. Maldarelli, O.
Complaint. Scanga, I.
The Composer. Zadkine
Composicao No. 3 Giorgi
Composite Capital. Roman--3rd c.
Composition Around Two Voids.
 Storrs, J.
Composition in Steel. Lassaw
Composition No. 1. Hofmann, H.
Composition of Birds. Callery
Composition of Forms, relief.
 Sibellino
Composition of Half-Circles.
 Weissmann
Composition of Semi-Cylinder.
 Matsumura
COMPESTELLA (Francisco Vazquez
 Diaz) (Spanish-Puerto
 Rican)
 Sea Gulls of the Tropics
 wood
 IBM pl 84 UNNIb
Comrade in Mourning. Houser
Comrades-in-Arms. War Memorial.
 Aitken
Comrades-in-Arms, Manship
COMTOIS, Ulysse (Canadian 1930-)
 Portail 1964 ptd wood; 10
 CAN-4: 207 CTW

Concentration. Knoop
The Conception of Buddha, bas-
 relief. Javanese
Conch.
 Colima. Man Blowing Conch
 Shell Trumpet
 Khmer. Conch, symbol of
 Vishnu
CONDON, Rudolph (American
 1905(?)-) Laurel 1955
 applewood; 54x 43
 AM # 161
Condor. Nunez del Prado
The Cone. Calder, A.
Cone No. 1. Light
Coney Island, or Roller Coaster.
 Lynch
Confederate Memorial, Stone
 Mountain. Borglum, G.
The Conference. Freilicher
Conflict. Johnson, S.
Confucius
 Chinese--T'ang. Confucian
 Divinity(?), seated
 headless figure
 Japanese--Ashikaga.
 Confucius, seated figure
CONGDEN, William G. (American)
 May plaster
 NYW 184
CONGO See AFRICAN--CONGO
Congo Beauty. Miller, Guy
CONKLING, Mabel (American
 1871-)
 Frederick W. MacMonnies,
 oval
 plaque colored plaster
 NATSA 276
 Urn of the Four Winds
 NATS 57
Conkling, Roscoe (American
 Legislator 1829-88)
 Ward, J.Q.A. Roscoe
 Conkling
CONLON, George
 Cordell Hull, bust bronze
 USC 189 UDCCap
CONNELLY, Pieroe Francis (Ameri-
 can 1841-after 1902)
 Thetis and Achilles 1874
 marble; 56
 CRAVS fig 9.9 UNNMM
CONNER, Bruce (American 1933-)
 Child 1959 wax, wood, nylon;
 35
 CUM 85; SELZS 181
 UCtNcJ
 Couch 1963 mixed media;
 31-1/2x26-1/2x72
 TUC 87 UCLL; UNNA1

Crucifixion 1960 wax, wood,
 nylon cloth; 85
 UIA-10: 55 UNNA1
Last Supper 1961 wax, rags--
 applied to top of wooden
 table; 40x20
 SEITA 89 UNNA1
Looking Glass 1964 mixed
 media; 78x48x12
 TUC 104 (col) UCLL;
 UNNNA1
Medusa 1960 wood, card-
 board, wax; nylon, hair;
 10-3/4x11x22-1/4
 WHITNS 37 UNNW
Tick-Tock-Jelly-Clock
 Cosmotron 1961 mixed
 media; 57-1/2x53-1/2
 TUC 82 UCLL; UNNA1
Connecticut Tercentenary Medal.
 Kreis
Connick, Charles J.
 Allen, F. W. Charles J.
 Connick, head
Conquistador, head. Abbe, E.
Conquistador. Newman, A. G.
Conquistador. Werner, Nat
CONRAD
 General Henry Wager Halleck
 REED 82 UCSFG
CONRAD, Barnaby (American)
 Girl with Snail and Boy
 with Bird
 CALF-60
CONRADS, Carl H. (German-
 American 1839-)
 Alexander Hamilton 1880
 SALT 86 UNNCent
 Daniel Webster, copy from
 Thomas Ball's bronze statue
 of Webster, in Concord,
 N. H. marble
 FAIR 444; MUR 54; USC
 265; UDCCapS
 John Stark marble
 MUR 54; USC 261 UDCCapS
CONSAGRA, Pietro (American
 1920-)
 Imprint of the Sun bronze; 29
 SG-4 UNNSt
Conspirators. Ferber
Constantina, daughter of
 Constantine the Great
 Roman--4th c. Sarcophagus
 of Constantina
Constantinople
 Roman--5th c. Solidus:
 Honorius; Personification
 of Constantinople

Constantine I(Roman Emperor
 272-337), called "The Great"
 Roman--4th c. Arch of
 Constantine
 --Aureus: Constantine the
 Great
 --Constantine#
 --Sarcophagus of
 Constantine
 --Solidus: Constantine#
Constantine II (Roman Emperor
 317(?)- 340), Son of Con-
 stantine the Great
 Roman--4th c. Male
 Head (Son of Constantine
 the Great?)
Constantius I (Roman Emperor
 250(?)-306)
 Roman--3rd c. Coin: Con-
 stantius I
 --Constantius Chlorus, head
 Roman--4th c. Constantius
 Chlorus, relief head
 --The Tetrarchs
Constantius II (Roman Emperor
 317-61)
 Hellenistic. Constantius
 Roman--4th c. Constantius
 II, head
 --Solidus: Constantius II
Constantius III (Roman Emperor
 d 421)
 Roman--5th c. Coin:
 Constantius III
 --Solidus: Constantius III
Constellation. Calder, A.
Constellation. Rasmusen, H.
Constellation with Quadrilateral.
 Calder, A.
Constellation with Red Object.
 Calder, A.
"Constitution", United States
 Frigate
 Beecher. Andrew Jackson,
 figurehead
Constructed Head No. 2. Gabo
Construction Blue and Black.
 de Rivera
Construction. Hotel du Nord.
 Cornell
Construction in Slate. Noguchi
Construction in Space# Gabo
 Gabo. Bijenkorf Monument
 Gabo. Spiral Theme
Construction in Space--
 Continuity.
 Gabo
Construction in Terracotta. Noguchi
Construction in White# Roszak

Roszak. Copernicus
COPP, John A. (American)
St. Francis Assisi
stone; 14
HARO-1:30
COPPER AGE
Axe Hammer, Wales stone;
L: 7-1/8
ARTSW 5 WCaN
Copper Construction. de Rivera
COPPINI, Pompeo (Italian-
American 1870-)
Senator James F. Clarke,
marble
FAIR 439; MUR 16; USC
233 UDCCapS
Texas War Memorial, detail
NATS 59
Coprinus Micaceus, Wingate, A.
COPTIC
Amphora between Two Ante-
lopes, relief 6/7th c.
limestone
BECKC pl 119 FPL
Angela and Saints before an
Arcade, Bawit 5/6th c.
wood
BECKC pl 47 GBSBe
Ankh and Birds, stele,
Erment, Upper Egypt 7/8th
c. limestone
BECKC pl 130 ELV
(No. 220-1894)
Antiphonary Cover: Maenads,
Satyrs, Warrios,
Alexandria 5th c. ivory
BECKC pl 39 SwSGB
(Cod. No. 359)
Aphrodite, limestone niche,
Herakeopolis Magna
5th c.
BECKC pl 62 EgCC
(No. 7052) (M.E. 44068)
Aphrodite, between Two
Figures of Eros,
lamp 5/4th c. bronze
LARB 70
FPL
Apollo and Daphne, relief,
Alexandria 6th c.
ivory; 4-3/4x3-1/4
RDAB 14 IRaMN
Archangel Michael, diptych
leaf, with Greek
inscription,
Constantinople 518/27
ivory
BECKC pl 89 ELBr
Archivolt 6th c. limestone;
L: 1.21 m CHAR-1:210;
GAU 118; LARB 71 FPL

The Ascension, details
2 wood lintels
BECKC pl 42 EgCMo
The Ascension, oliphant
fragment 9/10th c. ivory
BECKC pl 134 UNNMM
(No. 17.190.46)
Ass Eating Fruit in Basket,
door panel 5th c. wood;
L: .15 m
CHAR-1:207 FPL
Basket Capital: Plaitwork,
Ram's Head, Peacocks,
Cross, Saqqara 6th c.
BECKC pl 82 EgCC
(No. 8688) (M.E. 7345)
Basket Capital: Stylized
Leaf Scrolls, Bawit 6th c.
limestone
BECKC pl 80 FPL
Basket Capital: Vine Scrolls,
Saqqara 6th c. limestone
BECKC pl 83 EgCC
(No. 86201) (M.E.39916)
Basket Capital: Vine Leaves
Saqqara 6th c. limestone
BECKC pl 81 EgCC
(No. 8277) (M.E.39844)
Bearded Head 6/7th c.
BECKC pl 54 UDCD (No.
30.10)
--6/7th c. stone
CHENSW 303 FPL
Bearded Saint in Orant
Attitude, relief 6/7th c.
limestone
MCCL pl 1 UDCD
Bird, Niche relief 7/8th c.
limestone
BATT 29; BECKS pl 125
ELV (No. 442-1898)
Capital: Plaitwork and Tree
of Life, Alexandria
6th c. marble
BECKC pl 84 EgCC
(No. 7178) (M.E. 7352)
Capital: Stylized Acanthus and
Garlanded Cross, Bawit
6th c.
BECKC pl 79 FPL
Capitals, Acanthus and Foliate
Motif, Bawit and Saqqara
6/5th c.
LARB 69 FPL
Capture of a City, Ashmunein
5th c. wood
BECKC pl 46 GBSBe
Chapel Facade 6th c. wood;
.35x2.30x.15 m
CHAR-1:210-11 FPL

Christ Enthroned between St.
Peter and St. Paul; Virgin
and Child between angels,
diptych, Constantinople
6th c. ivory BECKC pl 110 GBS
Christ Enthroned in Mandorla,
supported by Two Angels,
Bawit 6th c. limestone
BECKC pl 96 EgCC
(No. 7111 O) (M. E. 37798)
Christ Giving Blessing, with
Allegorical Figures and
Christian Emblems, pedi-
ment relief 4th c.
LARB 70 EgCG
Christ on Mule, relief panel
6/7th c. limestone; 16-1/2x
24 BECKC pl 126; BERL pl
182; BERLES 182 GBSBe
(4131)
Christ Pantocrator, in Man-
dorla, supported by 4 Angels,
Alexandria 6th c. ivory
BECKC pl 109 UMdBW
(No. 71. 303)
Column, fragment: Interlocking
Swastikas, and Floral Motif,
Bawit GAU 119 FPL
Comb: Vine Scrolls and Winged
Horses ivory
BECKC pl 131 GCoS
Cornice Fragment: Dancing
Nereids; Sea Sprite Riding
Dolphin LARB 69 ITrM
Cross Surrounded by Birds,
relief, Saqqara 6/7th c.
limestone
BECKC pl 124 ELBr (No.
1527)
Cylindrical Box: Vine Scroll
Motif ivory
BECKC pl 132 ELV
(No. 136-1866)
Dancing Nereids, Ahnas 5th c.
limestone; . 60 m
HAN pl 333 ITrMC
Dancing Pan, Egypt 4/5th c.
limestone
CLE 30 UOC1A 55. 68)
Daniel between the Lions,
Bawit, relief 5th c. wood
BECKC pl 45 GBSBe
Daniel in the Lion's Den,
pyxis relief c 500 ivory;
. 09 m
HAN pl 332 UDCD
Daphne, Antinoe 5th c.
BECKC pl 61 FPL

--: Two Versions,
Herakeopolis Magna 5th c.
BECKC pl 64 EgCC
(No. 7061) (M. E. 7290);
(No. 5037) (M. E. 45941)
Dionysiac Procession,
Alexandria 5th c. ivory
BECKC pl 38 FPMe
Diptych Leaf: Old and New
Testament Scenes, Alex-
andria 5th c. ivory
BECKC pl 40 IRaMN
Door Panels: Life of Christ,
scenes, Sitt Miriam 13th c.
cedar
BECKC pl 141-45 ELBr
Door Panels: Pentecost;
Stylized Floral and Animal
Decoration, Sitt Miriam
13th c. cedar
BECKC pl 146-47 ELBr
Doors, Church of Sitt Barbara,
Old Cairo, and panel de-
tails: Christ, bust;
Virgin Enthroned between
Apostles 6th c. wood
BECKC pl 97-99 EgCC
(No. 738)
Dryads
BECKW pl 66 GrAlG
The Earth, personification,
arch 5th c. limestone
BECKC pl 71 EgCC
(No. 7072) (M. E. 44070)
Entry into Jerusalem, wood
lintel 4/5th c.
BECKC pl 41 EgCC
Erotes and Vine Scrolls,
relief 6/7th c. limestone
BECKC pl 120 ELBr (No.
1798)
Falcon-Headed God on Horse
Battling Crocodile stone
CHENSW 301 FPL
Female Head, niche figure
fragment 4th c. limestone;
10-1/2
BRITM 236 ELBr (36143)
Figure, low relief c 4th c.
sandstone
BAZINH 117 UDCD
Frieze: Cross and Stylized
Vine Scrolls, Bawit 6th c.
limestone
BECKC pl 93 FPL
Frieze: Garlanded Cross, Bawit
5/6th c. wood
BECKC pl 48 GBSBe

Frieze: Greek Key, Rosettes,
Vegetable Devices 6th c.
limestone
BECKC pl 92 GBSBe
(I 6144)
Frieze: Stylized Foliate Motif,
Chapel B, Bawit 6th c.
LARB 69 FPL
Grave Stele, relief 3/4th c.
BAZINW 204 (col)
GRecI
Grave Stele: Nursing Mother,
relief 5/6th c. limestone;
21-5/8x13-3/8
BERL pl 179 GBFB (4726)
Gravestone, detail: Dove on a
Shell 5/6th c. limestone;
22-3/4x28
VICF 6 ELV (442-1898)
Gravestone of Isis Cult,
relief 4th c. limestone;
38x20. 5 cm
BSC pl 2 GBS (3/59)
Horus on Horseback, Post-
Phoraonic Period
MALV 188 FPL
Leaf Scrolls, with Animals
in roundels: Wild Boar,
Gazelle, Hyena, Dog
5th c. limestone
BECKC pl 76 UNBB
Leda and the Swan
Herakleopolis Magna
5th c.
BECKC pl 70 GrAlG
Leda and the Swan, Herakle-
opolis Magna 5th c. lime-
stone
BECKC pl 69 EgCC
(No. 7026) (M. E. 7279)
Liberation of a Beleagered
City wood; 45x22 cm
BSC pl 4 GBC (4782)
Madonna and Child, Syria or
Egypt 6/7th c. ivory
STI 356 UMdBW
Male Bust, effigy 3rd c.
BAZINW 203 (col) EgCC
Man and his Donkey 5th c.
limestone
BECKC pl 51 DCN
(A. 785) (Ae. I. N. 883)
Martyrdom of St. Thecla
6/8th c. limestone
BECKC pl 121 UNBB
(No. 40. 299)
Mask in Couch Supported
by Erotes and Dolphins,
Giza 4/5th c. limestone

BECKC pl 53 GBSBe
(1. 4452C)
Memorial Stone for Pleinos
7/8th c. limestone; 24
BRITM 235 ELBr (679)
Miracle at Cana, plaque
6th c. ivory
CHENSN 229; CHENSW 295;
READM pl 27 ELV
Nereid Riding Sea Monster
5/6th c. limestone niche
BECKC pl 77 UNBB
(No. 41)
Nereids, Herakeopolis Magna
limestone
BECKC pl 63 EgCC
(No. 7033) (M. E. 7280)
Nereids and Boy on a Dolphin,
Herakleopolis Magna 5th
c. limestone
BECKC pl 60 ITrMC
Niche, Egypt 5th c.
limestone
CLE 30 UOClA (55. 63)
Orans, stele, Faiyum 5/6th c.
limestone
BECKC pl 116 EgCC
(No. 8684)
--
BECKC pl 117 EgCC
(No. 8685)
--6th c. limestone
BECKC pl 118 EgCC
(No. 8686)
Orant Saint, door relief
wood
BECKC pl 137 UNBB
(No. 30. 28)
Orpheus and Eurydice,
Herakleopolis Magna 5th
c.
BECKC pl 68 EgCC
(No. 7004) (M. E. 7286)
Pachomius, Saqqara, relief
6/7th c. limestone
BECKC pl 123 ELBr
(No. 1533)
Pan and a Bacchante, lime-
stone niche, Herakeopolis
Magna 5th c.
BECKC pl 67 EgCC
(No. 7044) (M. E. 72926)
Panel Details: Man Riding
with Hawk; Peacocks, Sitt
Barbara, Old Cairo 11th c.
wood
BECKC pl 135, pl 136
EgCC (No. 778)

Pilaster Details: Panel of
Geometric and Floral Orna-
ment above figures
holding open book; a staff
and an orb 6th c. lime-
stone
BECKC pl 85, pl 86-88
FPL
Pulpit of Henry II: Alexandria,
personification, or Isis of
the Sea; Maenad 6th c.
ivory
BECKC pl 103-105 GAaC
--: Dionysus, two figures
BECKC pl 101, pl 102
--: Emperor; Warrior;
Nereid Riding Sea
Monster
BECKC pl 106, 108
Rider Saint, comb details:
Raising of Lazarus;
Healing the Blind Man,
Alexandria 5th c.
BECKC pl 44 EgCC
River God (Nile?) and The
Earth between Lotus
Flowers, niche fragment
5th c. limestone
BECKC pl 72, pl 73 UNBB
(No. 41. 891)
--, with Eros Holding Duck
5th c.
limestone
BECKC pl 74 EgCC
(No. 7021) (M. E. 46726)
Sacrifice of Isaac, panel
relief, Church of Abu
Sarga, Old Cairo
11/12th c. wood
BECKC pl 140 UNKKe
Saint
BECKC pl 138 UNBB
--, Bawit 6th c. wood
mensola
BECKC pl 100 EgCC
(No. 8786)
--, panel screen, Church
of Abu Saifain, Old Cairo
12th c. wood
BECKC pl 139 EgCC
--, relief fragment Bawit
6th c.
limestone
BECKC pl 91 FPL
Saint and Archangel, stele
5th c. limestone
BECKC pl 90 DCN
(No. A. 789) (Ae. I. N. 884)

St. Menas, flanked by
kneeling Camels, relief,
Monastery of St. Thecla,
Ennaton 5th c. marble
BECKC pl 10 EgAlG
St. Pakene and St. Victor on
Horseback, with Coptic
inscription, relief,
Sohag 7/8th c. limestone
BECKC pl 129 ELBr
(No. 1276)
Seated Isis with Nursing
Horus (Thronende Isis
mit dem Horus Knaben)
limestone; 88. 5 cm
BSC pl 3 GBS (19/61)
Sissinios, equest relief
6/8th c. limestone
BECKC pl 122 UNBB
(No. 40. 300)
Tombstone: Bird, Foliate,
Interlinear Motif 7th c.
limestone; 32
MU 61 ELBr
Tombstone of Apa Dorotheos,
Saqqara 7/8th c. limestone
BECKC pl 127 ELBr
(No. 1523)
Tombstone of Apa Schenoute,
Sohag
BECKC pl 115 GBSBe
(I. 4475)
Tombstone of Jacob 7/8th c.
limestone
BECKC pl 128 ELBr
(No. 1801)
Tombstone of Olympios
BECKC pl 78 UNBB
Tombstone of Rhodia, Faiyum,
with Ankh and Alpha and
Omega 6th c.
limestone
BECKC pl 114 GBSBe
(I. 9666)
Two Erotes Holding Garlanded
Cross, Sohag 5th c.
limestone
BECKC pl 75 EgCC
(No. 7030) (M. E. 7285)
Two Nereids 6th c. lime-
stone; 23-3/8
RDAB 15 ITrMC
Two Victories Holding
Garland Framing a Tyche,
Bawit 6th c. limestone
BECKC pl 94 FPL
--, diptych section, Con-
stantinople 6th c. ivory
BECKC pl 95 IMS

A Tyche, pilaster capital
 4/5th c. limestone
 BECKC pl 52 ELBr
 (No. 1789)
Venus in a Shell, niche
 fragment c 400
 BAZINW 204 (col)
 EgCC
Virgin and Child 9/10th c.
 ivory
 BECKC pl 133 UMdBW
 (No. 71. 297)
--, seated figure, Faiyum
 4/5th c. limestone
 BECKC pl 50 GBSBe
Virgin and Child between
 Archangels 6/7th c. lime-
 stone
 BECKC pl 113 EgCC
 (No. 8006)(M. E. 8704)
Virgin and Child Enthroned
 between Archangels 6/7th c.
 limestone
 BECKC pl 112 EgCC
 (No. 8006)(M. E. 8704)
Virgin and Child Enthroned
 between Archangels Gabriel
 and Michael(?), St. Peter
 and St. Paul(?) 6th c.
 limestone
 BECKC pl 111 EgCC
 (No. 7814)
Virgin of the Annunciation 5/6th
 c. ptd wood; . 285x. 145 m
 BAZINW 204 (col); CHAR-
 1:206 FPL
Wall Decoration, Church of
 el Edra, Deir es Suryani
 Monastery 10th c. stucco
 RDAB 23
Wall Decoration, imitating
 mosaic, pediment
 LARB 68 FPL
Young Boy, niche figure,
 oxyrhynch c 300
 limestone; 19
 BRITM 238 ELBr (1795)
Coq d'Or. Wheelock, W.
Cora
 Greek--5th c. B. C.
 Demeter and Cora--
 Glorification of the Flower
Coral. Jennewein
Corax. Lassaw
CORBETT, Gail Sherman
 Artemis Agrotera
 NATS 60

Kirkpatrick Memorial
 Fountain
 SFPP
Sun Dial Boy
 SFPP
CORBIN, John (American)
 Henry Ward Beecher
 c 1840 body and head:
 chestnut; arms and
 Bible: pine; 21-1/2
 CAH 51; COLW 345
 (col); PIE 376 UVWR
 (701. 11)
 --1850/60 wood; 21
 NMAF # 127
 --1850/60
 ROOS 255C UNNMM
 --1850/60 wood; 21
 LIPA pl 183 UNNMMA
 --wood; 21
 NNMMARO pl 22
 UNNRojm
"Corbulo". Roman--1st c.
Core. Bouras
Corinth. Horwitt
CORMIER, M. (Canadian)
 Door Panels; details:
 Peace, Justice, Truth,
 Fraternity, north entrance,
 General Assembly Building
 nickel-bronze
 BAA pl 29, pl 30
 UNNUN
Cormorants
 Quimbaya. Cormorant
 Tlingit. Bird Idol:
 Cormorant with Papoose on
 Back
Corn
 Cruz. Corn
 Sumerian. Ritual Bowl:
 Bulls and Ear of Corn,
 relief
Corn God
 Maya. Maize God
 Zapotec. Urn: Maize God
Corn Goddess
 Aztec. Maize Goddess
Corn Grinder. Schaefer, M.
Corn Grinders See Pestles
Corn Order. Latrobe
Corn Stele
 Maya. Stele (Corn Stele):
 Corn God and Priest
Cornell, Ezra (American Financier
 and Philanthropist 1807-74)
 MacNeil, H. A. Ezra
 Cornell

CORNELL, Joseph (American
　1903-)
Apollinaris 1952 construction;
　9-3/4x15-3/4
　UIA-13:183 UNNSto
--c 1960 construction;
　14x8-3/4x5
　TUC 91 UNNSto
Apothecary 1950 wooden
　cabinet, glass jars
　containing various objects;
　15-7/8x11-7/8x4-5/8
　SEITA 71 UTxHMe
La Bella, box mixed media
　WHITNA-16:4
Bleriot 1956 box, ptd wooden
　trapeze supported by rusted
　steel spring; 18-1/2x11-1/4
　x4-3/4
　HENNI pl 128; LIC pl 265;
　SEITA 70 UNNWard
Cassiopeia No. 3 1955
　mixed media construction;
　8x12
　RHC #5 UNNSto
Celestial Box mixed media; W:
　14
　WHITNA-18:27
Celestial Navigation Box c 1955
　construction; 8-1/2x15-3/4
　TUC 88 UNNSto
Central Park Carrousel 1950
　wood, glass, iron, wire,
　paper
　MAI 64; MEILC 63
　UNNMMA
Chocolat Menier 1962
　KULN 59
Clay Pipe Series c 1962
　construction; 10x15x5
　TUC 95 UNNSto
Construction: Hotel du Nord
　c 1953 wood, glass,
　paper; 19x13-1/4x5-1/2
　PIE 385 UNNW (57. 6)
De Medici Princess, box,
　c 1952 wood, glass,
　paper; 16x10-1/2x4-1/2
　WALKR 15 UNNFru
Dien Bien Phu, box
　WHITNA-16:4
Dovecote 1952 ptd wood con-
　struction; 17x11-3/4
　SEAA 66 UICM
Du Lion d'Or c 1960
　construction; 9x13x4-1/2
　TUC 93 UNNSto
Eclipse Series c 1960
　construction; 9x14x4-1/2

TUC 92 UNNSto
--c 1962 construction;
　10x16x5
　TUC 94 UNNSto
Fountain Box construction;
　13x8x5
　TUC 89 UNNSto
Habitat Group for a Shooting
　Gallery 1943 cabinet con-
　taining colored cutouts of
　parrots, printed cards,
　and papers behind shat-
　tered glass; 15-1/2x11-1/8
　x4-1/4
　SEITA 70 UCLF
Hotel de l'Ange, construction
　1944
　20x14
　CALA 155 IVG
Medici Slot Machine 1942
　compartmented wooden
　box, with ptd illustrations
　and objects; 15-1/2x12x
　4-3/8
　SEITA 68 UNNRe
Night Skies: Auriga c 1954
　box containing ptd wooden
　construction; 19-1/4x13-1/2
　x7-1/2
　NEW pl 14; SEITA 71 UICBe
Object: Paper Box, Sequins,
　Green Ball 1933
　3-4x3-1/8x2-5/8
　UCIT 19 UCLFe
Object: Pillbox with Mustard
　Seeds 1933 1/2; Dm:
　1-1/8
　UCIT 19 UCLFe
Object: Thimble and Needled
　Steel Ball under Glass
　Dome 1933　2x2
　UCIT 20 UCLFe
Object: Wooden Box, with
　Pins and Sequins 1933 1;
　Dm: 2-3/4
　UCIT 20 UCLFe
A Pantry Ballet for Jacques
　Offenbach 1942 construction;
　10-1/2x18x6
　CUM 89 UICFe
Parrot Music Boy, construction
　1945　　16x9
　CALA 156 IVG
Pavilion 1953 ptd wood,
　pasted paper, glass; 19x12
　HUN pl 48 UNNFerb
Pharmacy, construction
　1943/45 wooden case, glass
　bottles; 14x12 CALA 154;
　LIC pl 264 IVG

Pipe and Glass Box (Eclipse
Series) construction; 6-1/2x
12x5 BAZINW 446 (col)
Planeterium I, box mixed
media
WHITNA-16:5
Postage Stamp Box 1960/65
KULN 92
Shadow Box wooden box with
glass front and brass
rings, and deep frame--
interior: white with yellow
sand and "sea-side"
atmosphere; 5-3/4x9x
3-1/4
LARM 408; READCON
264 ELH
Soap Bubble Box, construction
15x18
CALA 157 (col) IVG
Soap Bubble Set, arrange-
ment of contents, with
additional effects 1936
BAUR 120 UCtHWA
Space Object Box 1959 wood
construction, with ptd
wood, metal rods and
ring, cork ball, cordial
glass containing marble,
starfish, pasted paper;
9-1/2x15x3-3/4
SEITA 68 UCLF
Sun Box Series c 1960
construction; 14x10x4-3/4
TUC 90 UNNSto
Taglioni's Jewel Case
(Casket), object-poem
1940 wooden box, con-
taining ice cubes, jewelry;
11-7/8x8-1/4x4-3/4
NMASO 40; NNMMM 145
UNNMMA
Untitled 1952
KULN 68
Video mixed media
construction
CLE 201 UOClA (64. 143)
Cornell, Katharine (American
Actress 1898-)
Glenny. Katharine Cornell,
head
Corning Fountain. Rhind
Corona. Falkenstein
Corona# Wines, J.
Coronation. Boghosian
CORONEL, Pedro (Mexican 1902-)
Fountain (Fuente)
LUN

Mourning (Duelo)
LUN
Piedad
LUN
CORRELL, Ira A. (American 1873-)
Lincoln 1922
BUL 176 UInO
Corridor. Samaras, L.
Corsini Fibula. Etruscan
Cortes, Hernando (Spanish
Conqueror of Mexico
1485-1547)
Maya. Dance Mask:
Hernan Cortes
Niehaus. Cortez, equest
CORWIN, AUDREY
George Washington Carver,
bust
LONG 125 UMoC
Cosmetic Containers and
Accessories
Egyptian. Cosmetic
Accessories
Egyptian--Pre-Dynastic.
Malachite Eye-paint
Palette: Tortoise
Egyptian--1st/2nd Dyn.
Cosmetic Palette#
Egyptian--18th Dyn. Girl
Swimming after Duck,
ointment spoon
--Ointment Bowl: Bound
Antelope
--Ointment Spoon
--Pomegranate, ointment
spoon
--Toilet Spoon: Palmate
Handle with Figures
Egyptian--19th Dyn. Ointment
Spoons
Etruscan. Praeneste Cos-
metic Boxes: Deer; Dove
Phoenician. Cosmetic Jar:
Duck
--Ungent Pots: Human Form
Cosmic Head. DeLue
Cosmic Presence. Davis, E. L.
COSTIGAN, Ida
Marketing bronze
NATSA 38
Costume See also Articles of
Apparel, as Headdresses;
Sampot
Khmer. Female Costume#
COTE, Jean Baptiste (Canadian
1834-1907)
Last Supper, relief ptd
wood; L: 53
CAN-3:345 CON (3576)

--. relief c 1875 ptd wood;
 27-1/2x47-3/4
 CAN-3:345; HUB pl 42
 CON (6743)
St. Paul c 1880 ptd wood;
 62-3/4x22-1/4
 CAMI pl 93 CMFA
St. Peter c 1880 ptd wood;
 62x30
 CAMI pl 94 CMFA
Cottenham Relief. Greek--5th c.
 B. C.
Cottier, Daniel
 Warner, O. L. Daniel Cottier,
 bust
Cotys (King of Thrace d c 17 B. C.)
 Hellenistic. Cotys, King of
 Thrace, head
Couch. Conner
COULENTIANOS, Costas
 Geometry 1962 stainless steel
 MEILD 86 UNNScha
The Council of War. Rogers, J.
Counterpoint Castle. Lassaw
Country Maid. American--18th c.
COUPER, William (American (1853-
 1942)
 Attending Angel, tomb figure
 granite
 HARTS pl 11 UMMe
--, tomb figure relief
 HARTS pl 11
 Beauty's Wreath for Valor's
 Brow
 TAFT 419
 Man of War
 HARTS pl 17
 Moses
 HARTS pl 11 UNNAp
 Te Deum Laudamus, relief
 TAFT 423
Couple. Cabrera, Geles
The Couple. Lipchitz
Courage
 Lawrie. Courage: Nation
 Battling Snake
Courbet's Column (To Kenneth
 Burke). Scanga
Court of the Lions. Islamic
Courtier Bes. Egyptian
Courtyard Kaprow
COUSINO, Joe Anna (American
 1925-)
 Fish Story 1958/59 ceramic
 CIN # 8
COUSINS, Harold (American 1916-)
 The Forest 1955 brazed iron;
 L: 49
 BERCK 141

Gothic Landscape 1962
 forged iron; 66-1/2x30-3/4
 READCON 240 CTR
Oberon 1958 wrought iron
 CANK 175; MAI 66 -GH
Sculpture 1959 iron; 55-1/8x
 26-3/4x10-5/8
 TRI 164
COUX, Janet de (American 1904-)
 Soubrette 1931 bronze; 14
 BROO 436 UScGB
Coventry. Kohn, G.
Covered Wagons
 Lawrie. Pioneers, relief
COWAN, Theo (Australian)
 Will-o'-the-Wisp
 MOO-2:90
Cowboys See also Remington,
 Frederic; Russell, Charles
 Borglum, G. Cowboy
 Borglum, S. H. Cowboy
 Mounting
--Lassoing Wild Horses
--A Night Hawk
--Stubborn, equest
 Mora, J. J. Fanning a
 Twister
 Proctor, A. P. The Bronco-
 Buster
--The Buckaroo
Cowell, Henry
 Walton, M. Henry Cowell,
 head
COWICHAN
 Dance Mask: Swaixwe, Sky
 Being 1890/1900 wood; 20
 DOCA pl 135 UNNMAI
 (18/1062)
 Mask wood; 19-1/2x11-3/4
 CHENSW 432; DOU 148
 UCoDM (MCow-1-P)
COX, C. Brinton (American)
 Bull Fight
 HARTS pl 26
 Coyote
 HARTS pl 41
COX, Elford Bradley (Canadian
 1914-)
 Face of the Moon marble
 and abalone shell; Dm:
 12-1/2
 ROSS 34; TORA 88 CTA
 (57/7)
 Groundhog marble
 ROSS 39 -CN
Cox, Jamieson
 Folk Art--American.
 Jamieson Cox (?), Fire
 Chief

CRAWFORD, Thomas (American 1814-
57)
The Babes in the Wood 1848
marble; 17-1/2x48-1/2
MEN 340; UNNMMAS 11
11 UNNMM (94. 9. 4)
Beethoven 1854 bronze; 96
PIE 378 UMBCon
Capitol Doors (United States
Capitol Doors) bronze
CHASEH 431; POST-2:111
UDCCap
--East Portico, House of
Representatives Wing,
2nd floor--American
History: 8 panels, 2
medallions 1855/57 (exe-
cuted by William H.
Rinehart 1863/67) bronze;
14'7"x7'4" (incl frame)
FAIR 173; USC 373
--East Portico, Senate Wing,
2nd floor--Revolutionary
War: 6 panels, 2
medallions 1855/57
(executed by William H.
Rinehart 1864) bronze;
14'5-1/2"x7'4"
(incl frame)
CRAVS fig 8. 14; FAIR 172;
PIE 378; USC 375
Charles Sumner, bust 1839
marble; 27
CRAVS fig 4. 11 UMB
Freedom (Armed Freedom;
Liberty; Statue of
Freedom), U. S. Capitol
Dome 1860/63 bronze;
19-1/2
CAH 49; FAIR 170;
PAG-12:182; TAFT 76;
USC 364 UDCCap
--cast bronze
THOR pl 5 UDCL
--plaster model
GARDAY pl 6; USC 391
UDCNMS
The Genius of Mirth 1843
marble; 46
GARDAY pl 5; UNNMMAS
10 UNNMM (97. 13. 1)
Indian Chief, for Senate
Pediment
LARK 183
Justice and History, with
Scales and Scroll 1863
USC 366 UDCCap

Orpheus and Cerberus 1839
marble
AGARC 118; CRAVS fig
4. 12; RAD 555; TAFT
73; THOR pl 3 UMB
Patrick Henry
PAG-11: 52 UVR
Progress of American
Civilization (Past and
Present of America),
pediment, United States
Senate Portico, east
front 1850/56 marble;
c 12'x c 60'
CRAVS fig 4. 13; FAIR
142; PIE 378; TAFT 81;
USC 380 UDCCap
--The Chief Contemplating
the Progress of
Civilization (Indian Chief,
seated) 1850/56 marble;
7'7"
PIE 378; THOR pl 4 UNNHS
Washington Monument,
equest 1850/57
bronze, stone
ADAM-3:107; CRAVS fig
4. 14; PIE 378; TAFT 86
UVRCapG
--John Marshall 1856 bronze
CRAVS fig 4. 15
Crawling Insect. Institute of Design
Student
Crazy Horse (Oglala Sioux Chief
1849(?)-77)
Ziolkowski. Chief Crazy
Horse, equest
Creation. Ferber
The Creation. Goldberg
Creation
Polynesian--Austral Islands.
Tangaroa, Sea God,
Creating Other Gods and
Men
A Creature of God. Aitken
Creature of the Deep. Amino
Creed of Force. Yoffe
CREMEAN, Robert (American
1932-)
Marat, Number 4 metal,
wood, wood-mache
WHITNA-17
Olympia 1960 wood mortise;
57
STAF UCLR
Sibyl II 1959 wood mortise
53
AMON 45 UCLR

CROMWELL, John L. 255

CROMWELL, John L.
 Cigar Store Indian c 1850
 ptd wood; 65
 LIPA pl 60 UOGW
CRONBACH, Robert M. (American
 1908-)
 Abstract Sculpture, Mediation
 Ante Room, General
 Assembly Building bronze
 BAA pl 22 UNNUN
 Aerial Object
 LYNCMO 81
 Burning Bush hammered and
 welded sheet bronze
 MEILD 192
 Crippled Sailor plaster
 NYW 183
 The Family plaster
 SGO-10:6
 Federal Office Building
 Fountain
 BISH UMoS
 Fountain brass
 LYNCM 115 UNNScha
 Fountain Sculpture hammered
 and welded sheet bronze
 MEILD 188 UMoSFe
 Grandmother terracotta; 30
 SGO-17
 Head of an Actress plaster;
 20
 NMPS # 116
 Industry plaster
 UNA 7
 Large Landscape
 MEILD 145 UNNScha
 Magic Tree brass
 WHITNA-11
 Pediment in Plaster
 DEYF # 257
 Pillar of Society polished
 bronze
 SGT pl 8
 Sheila, head terracotta; LS
 SG-4
 Soaring hammered and welded
 bronze and steel; 78
 SG-2
 Sphinx hammered bronze; 30
 SG-7
 Standing Woman hammered
 and welded bronze; 24
 SG-3
 Suspension in Space # 2
 LYNCMO 69

 Trinity Lutheran School
 Fountain
 BISH UNHi
 Young Mother plaster,
 direct
 SGO-4:pl 6
Cronos (Cronus; Kronus; Saturn)
 Elwell. Kronus
 Gero. Saturn
 Greek--6th c. B. C. Temple
 of Artemis, Corfu:
 Cronus
 Nickford, J. Cronos
 Noguchi. Cronos
Crooked Mouth
 Webster, E. Seneca
 Iroquois False Face:
 Crooked Mouth
Cropped Blue Bed. Rivers
CROSS, Louis (American 1896-)
 Diva walnut
 SGT pl 9
 Dragon Slayer plaster
 SGO-10:7
 I Walk stone
 SGO-4:pl 7
 Triumph plaster
 SGO-2:pl 15
Cross
 de Marco. Memorial Cross*
The Cross. Goodman
Cross Bolt. African--Bambara
Cross Form Development.
 Noguchi
Cross of Lorraine
 African--Dogon. Dance
 Mask, in shape of Cross
 of Lorraine
Cross of Sacrifice. Blomfield
Crossbows
 Gallo-Roman. Crossbow
 Fibula
Crosses See also Jesus Christ--
 Crucifixion
 Albert, C. Chapel Altar
 Cross
 American--19th c. Prayer
 Book Cross
 American--20th c. Trinidad
 Head Cross
 Coptic. Basket Capital:
 Plaitwork; Ram's Head;
 Peacocks; Cross
 --Capital: Stylized
 Acanthus and Garlanded
 Cross

--Cross Surrounded by Birds
--Frieze: Cross and Stylized
 Vine Scrolls
--Two Erotes Holding
 Garlanded Cross
Folk Art--American. Cross:
 Fleur de Lis Motif
--Cross, fence detail
Folk Art--Spanish American
 (United States). Olvera
 Street Cross
Indians of South America.
 Gold and Emerald Cross
Roman--6th c. Crux Vaticana
Crossways. Weschler, A.
CROTTY, Harry (American)
 Dancers
 CALF-50:26
CROUCH, Donald E. (American)
 Portrait of a Young Lady
 bronze; 21
 HARO-3:27
Crouching Aphrodite. Hellenistic
Crouching Lion# Persian
Crouching Scribe
 Egyptian--5th Dyn. Seated
 Scribe
Crouching Venus. Greek
CROW
 Calumet (Medicine Pipe),
 Montana 19th c. L: 33
 DOU 135 UCoDA
 (PiCr-1-P)
CROW, J. Claude (American)
 Wild Flower plaster
 UNA 8
Crown of Thorns. Vrana, A.
Crowns
 Achaemenian. Prince with
 Crown, head
 African--Bakuba. Shamba of
 Bolongongo in Flat Crown
 Chavin. Crown
 Chinese--T'ang, or Sung.
 Empress' Imperial Feng
 Huang (Phoenix) Crown
 Chinese--Wei. Kwannon,
 head with Lotus Flower
 Crown
 Cypriot. Colossal Head, in
 Bacchanalian Procession
 Crown
 Egyptian. Blue War Crown
 --Double Crown
 --Hemhemet Crown
 --Red Crown of Lower
 Egypt
 --White Crown of Upper
 Egypt

Egyptian--12th Dyn. Amenem-
 hat III, head in Crown of
 Upper Egypt
--Dashur Crown
--Lahun Crown
--Sesotris I, striding figure,
 with Red Crown of Lower
 Egypt
Egyptian--18th Dyn. Amenho-
 tep III: Wearing Blue
 Crown (War Helmet)
Egyptian--19th Dyn. Ramses
 II: Wearing Crown of
 Upper Egypt
Greek--5th c. B. C. Crown
Hellenistic. Antioch
 Tetradrachm: Tigranes I
 of Armenia, wearing
 Armenian Crown
--Tyche of Antioch--"Good
 Fortune", city-goddess,
 in Castle-Crown
Inca. Chieftain's Jewelry:
 Crown with Four Plumes
Indians of South America--
 Ecuador. Crown
--Plumed Crown
Korean. Crown#
Sassanian. Crowned King,
 head
Scythian. Laurel Coronet
--Olive Leaf Coronet
Thai. Siamese Jeweled Gold
 Crown
Tison, J. Silver Crown,
 worn by Indian Chief
Crows
 Folk Art--American. Decoy:
 Crow
 Hsiung Ping-Ming. Crow
Crucible. Lipton
Crucifixion
 African--Congo, Belgian.
 Crucifix Figure
Crucifixion See Jesus Christ--
 Crucifixion
CRUNELLE, Leonard
 Lincoln, the Debater 1929
 BUL 184 UIF
 Lincoln the Soldier 1930
 BUL 185 UIDi
 Sakajawea 1910 bronze; 12'
 GRID 62 UNdBCap
CRUNELLE, Leonard and Lorado
 TAFT
 Indian Maiden 1926 bronze;
 12' (with 5' pedestal)
 GRID 91 UOTiMF
Crusader. Lipton

Crux Ansata
 Egyptian--18th Dyn. Iknaton
 (Akhenaten) and Family,
 showing symbol of Aten,
 Sun God: Sun Disc with
 Rays ending in Hand, and
 Crux Ansata
Crux Vaticana. Roman--6th c.
CRUX, Juan (Mexican)
 Los Braceros
 LUN
 Corn (El Maize) terracotta
 LUN
 Woman
 LUN
CRUZ-DIEZ, Carlos (Venezuelan
 1923-)
 Fisicromia I 1951 29. 2x29. 2
 CARNI-61:#78 FPRe
The Cry. Noguchi
Crying Baby. Beach
Crying Woman. Salerno, C.
The Crystal
 Gabo. Construction in Space,
 working scale model for
 The Crystal
Cuarto Criciente. Edwards, G. E.
Cuauhtemoc See Guatemotzin
Cuauhxicalli (Eagle Vessel). Aztec
The Cub. Walters, C.
Cub Eating Fish. Williams, W.
Cuba. Indiana
La Cubana. Hord
Cube Form. Mason, J.
Cubi# Smith, D.
Cubic Forms. Studer, M.
Cuenta Estrellas. Asunsolo
CUETO, German (Mexican)
 Abstraccion# bronze
 NEL
 Danzante bronze
 NEL
 Figure
 LUN
 Figure# bronze
 NEL
 Mascara bronze
 NEL
 Orator (Orador)
 LUN
 Priest (Sacerdote)
 LUN
 Rostro hierro
 NEL
 Soldier (Guerrero)
 LUN
Culakoka Devata See Chulakoka
 Devata

CULLEN, Lilliana (American)
 Head Tennessee marble
 SGO-4:pl 8
CUMMINGS (Melvin), Earl
 (American)
 Doughboy
 REED 64 UCSFG
 Enchantment
 ACA pl 213
 John McLaren
 REED 96 UCSFG
 Neptune's Daughter
 NATS 67
 Rideout Memorial Fountain
 REED 98 UCSFG
 Robert Burns
 REED 38 UCSFG
 Sun Dial 1907
 REED 172 UCSFG
 Vigor, half dome figure, west
 facade, Palace of Food
 Industries
 SFPP
Cumulus. Moir
CUNA INDIANS
 Nuchu, European in 19th c.
 dress, fetish figure, San
 Blas, Panama wood;
 12-1/2
 ADL pl 39A ELBr
Cuneiform See Writing--Akkadian;--
 --Anatolian; --Assyrian;
 --Babylonian; --Persian;
 --Sumerian
CUNLIFFE, Mitzi Solomon (American)
 Family Tree rosewood crotch;
 60
 SG-2
 Tree of Life, facade relief
 1947 limestone; 9'x9'
 KAM 107 UInSB
CUNNINGHAM, Earl M. (American)
 Untitled walnut; 42
 HARO-3:21
Cup Bearer, scarab. Greek--6th c.
 B. C.
Cup of Prometheus. Kiesler
Cupboards
 Folk Art--American. Corner
 Cupboard
Cupid See Eros
"Cupid of Phidias"
 Hellenistic. Eros: With Jug on
 Shoulder
Cupids See Putti
CUPISNIQUE
 Annular Stirrup Vessel, with
 human and animal heads
 BUSH 145 ScER

258

Cup, Peru stone; 3-1/2
NPPM pl 104 UNNMPA
(64. 9)
Jar: Aged Wrinkled Face,
Chicama Valley, Peru
LOT 163 PELL
Mouse Effigy Vessel 750/250
B. C. clay; 6x8-1/2
DOCS pl 89 UNNMAI
(16/1971V)
Stirrup Jar clay; 9-5/8
NPPM pl 105 UNNMPA
(59. 4)
Stirrup Jar: Feline Heads
clay; 7-7/8x10-1/4
NMANA-1:fig 6 PeChiH
Stirrup Jar: Human Feline
Head clay; 9-3/4
NMANA-1:fig 11 PeChiH
Stirrup Jar: Seated Man clay
NMANA 31 PeChiH
Stirrup Jar: Seated Woman
clay; 9-1/2
NMANA-1:fig 7 PeChiH
Stirrup Jar: Seated Woman
Suckling Child pottery
BUSH 156
Stirrup Jar: Snake
NMANA 31 PeChiH
Stirrup Jar: Two Intertwined
Snakes clay; 9-1/8
NMANA-1:fig 10 PeChiH
Stirrup Jar, feline motif
clay
NMANA 31 PeLMA

Cups

African--Bakongo. Cup:
Human Head
African--Bakuba. Cere-
monial Cup#
--King's Palm-Wine Cup
African--Baluba. Cup:
Squatting Human Figure
African--Bapendi. Cup:
Crouching Human Figure
African--Basonge. Cup:
Human Figure
African--Bawongo. Palm
Wine Cups
African--Bayaka. Ceremonial
Cup
African--Benin. Cup
Alexandrine. Farnese Cup
Amlash. Gazelle Cup
Assyrian. Cup: Antelope
Head
Aztec. Cup, with projecting
skull decoration

Boscoreale. Cleopatra's Cup
Bronze Age. Cup
Chavin. Cup#
Chimu. Cup
--Ornaments: Headband with
Feather; Pins; Feather-
Shaped Pin; Cups
--Two Cups: Human Face
Chinese--Chin. Cup
Chinese--Ch'ing. Ceremonial
Cup
Chinese--Chou. Libation Cup
--Lu-Kuei Cup
Chinese--Ming. Cup and Stand
Chinese--Shang. Ritual Wine
Cup: Bird
Chinese--Sung/Ming. Two-
Handled Cup
Chinese--T'ang. Stem-Cup
Cupisnique. Cup
Cypriote. Faience Cups
Egyptian--18th Dyn. Cup of
General Thoutii
Egyptian--19/20th Dyn.
Lotiform Cup
Egyptian--22nd Dyn. Lotiform
Cup
Egyptian--Ptolomaic. Footed
Cup
Etruscan. Praeneste Cup,
with Sphinxes
Hellenistic. Cup#
--Footed Cup: Storks
--Kantharos: Scenes from
Iphigenia Tragedy
--Medusa, cameo ("Tazza
Farnese")
--Single-Handed, Footed
Cup
Indians of South America--
Peru. Cups
Marlyk. Cup: Walking
Unicorns
--Mug#
Maya. Cup, with Jaguar
Head Cover
Minoan. Cup, relief: Envoys
Presented to Prince
Mycenaean. Vapphio Cups
Roman--1st c. B. C.
Bacchus Goblet
Roman--1st c. Calices: Two-
Handled, Footed Cup
--Cup#
--Hoby Cup
--Two-Handled, Footed Cup#
Steppe Art. Cup
Sumerian. Tell Agrab Cup#

Syrian. Faience Cup:
Female Head
Curtis, Charles (31st Vice
President of the United
States 1860-1936)
Dykaar. Charles Curtis,
bust
CURTIS, George A. (American
1921-)
Fish on Fork welded metal;
19
UIA-8:pl 25
Curtius, Marcus
Hellenistic. Sacrifice of
Marcus Curtius, bas
relief
CUSHING, L. W., & SONS
Waltham, Mass.
Weathervane: Running Fox
c 1892 copper; L:
21-1/4
COLW 289 (col) UVWR
CUSHING, Robert (Irish-American
1841-96)
Father Drumgoole 1894
bronze
SALT 158 UNNStatL
Millard Fillmore, bust
marble
FAIR 333; USC 175 UDCCap
Cushman, Charlotte Saunders
(American Actress 1816-76)
Grimes. Charlotte Saunders
Cushman, bust
Custodian. Howard, R. B.
CUTLER, Charles (American 1914-)
Bird granite
CIN #10 UOCiA
Head granite
IBM pl 66 UNNIb
Mermaid granite
BRUM pl 22 UVRMu
Cutting, Bronson (United States
Senator)
Shuster, W. Bronson Cutting,
head
CUZCO
Figure gold; 2-3/8
NPPM pl 132 UNNMPA
(62. 159)
Llama silver
BAZINW 230 (col)
UNNAmM
Cuze Kwannon
Japanese--Suiko. Yumedono
Kwannon
Cybele
Greek. Colossal Cybele,
seated figure

Greek--4th c. B. C.
Cybele, seated headless
and armless figure
Hellenistic. Cybele Riding
Lion, with Tambourine
Roman--2nd/1st c. B. C.
Cybele, seated figure
Roman--2nd c. Cybele,
seated headless figure
Wilson, E. Cybele
CYCLADIC
Amulet (Fertility Charm?),
Kimolos 3rd mil B. C.
marble; c 5
READAS pl 31 GrAN
Amulets (Fertility Charms?),
Amorgos, and Paros 3rd mil
B.C. marble; c 5 READAS
pl 31 ELBr
Dog and Young, Argos c 1000
B.C. clay; c 5-1/2 STI 159
UMdBJ
Female Figure marble
LOM 66 GrAN
--c 3000 B. C.
ALBA UNBuA
--1500 B. C. terracotta;
.988 m
HAN pl 14 GrKeA
--, arms crossed on
abdomen
HOR 30 FPL
--marble
CLAK 70 ELBr
--3rd mil B. C. marble;
14-1/4
FEIN pl 29; NM-5 UNNMM
(34. 11. 3)
Female Figures
LARA 184 ELBr
Female Idol 3rd mil B. C.
ST 13 GBS
--3rd mil B. C. stone
CHENSW 23 UNNEm
--c 3000 B. C. marble;
13-1/2x3-7/8
ALB 149; FAIY 2; MU 37;
SEW 36 UNBuA
--3000 B. C. marble
FEIN pl 83 UMWA
--c 2400 B.C. marble; 6-1/2
BOSMI 43; HAN pl 3 UMB
--2000 B. C. marble
FEIN pl 82 UNND
Female Idol: Great Mother,
Paros 3rd mil B. C. marble;
.27 m BAZINW 96 (col);
CHAR-1:43; GAF 139; LARA
185; READI pl 42 FPL

Cygnus. Abbott
Cylindrical Fountain. Calfee
Cyllene. Lassaw
Cymbals See Musicians and
 Musical Instruments
Cynical Eye. Rosenthal, B.
CYPRIOTE
 Archaic Female Figure 2000
 B.C. FEIN pl 23 UMB
 Bearded Aphrodite, in Assyrian
 Helmet 6th c. B.C. lime-
 stone CHENSN 89 UNNMM
 Bearded Figure, Assyrian
 Style MARQ 63 UNNMM
 Bearded Head 6th c. B.C.
 limestone; 12 TOR 94 CTRO
 (948.247b)
 Capitol 6th c. B.C.
 ROOS 17B
 Colossal Head, in Baccanalian
 Procession Crown 6th c.
 B.C. limestone; 19-1/4
 WORC 13 UMWA
 Faience Cups, Cyprus
 FRA pl 153B, pl 153D ELBr
 Fertility Goddess(?)
 FEIN pl 31 UMB
 Fertility Goddess(?) 3rd mil
 B.C. polished terracotta
 CANK 67 FPL
 Figures clay
 CHENSW 88 UNNMM
 God with Horned Cap 12th c.
 B.C. bronze; .55 cm
 HAN pl 13 CyNC
 Head terracotta
 CHENSN 87 UNNMM
 --stone
 CHENSW 103 UNNMM
 Horseman clay
 CHENSW 94 FPL
 --6000/1000 B.C. terracotta
 ZOR 14 UNNMM
 Horses Early Iron Age terra-
 cotta ZOR 14 UNNMM
 Idol c 2000 B.C. terracotta
 LOM 66; READI pl 25B;
 SELZJ 22 FPL
 Male Figure, Egyptian Style
 MARQ 65 UNNMM
 Man Carrying Three-Legged
 Table 6th c. B.C.
 RICHTH 366 ELBr
 Mirror, Handle, Enkomi
 12th c. B.C. H: 5 FRA pl
 149B ELBr
 Mother Goddess: Bird-Beaked
 Figure Late Bronze Age,
 14/13th c. B.C. terracotta

 BAZINW 96 (col); READI pl
 25a FPL
 Priest with Dove yellow
 limestone; 111 RAD 543
 UNNMM
 Priest, head c 500 stone
 CHENSW 103 UNNMM
 Sarcophagus: Chariot Proces-
 sion NM-10:42 UNNMM
 Stand, Curim bronze; 4-1/2
 FRA pl 174B ELBr
 Veiled Woman, head 4th c.
 B.C. terracotta; .065 m
 CHAR-1:170 FPL
Cyprus. Magnussen, E.
Cyrano de Bergerac
 Kaz. Cyrano
Cyrene Venus. Greek
Cyrenian Aphrodite. Hellenistic
Cytherea. Lassaw

D.M., Mrs.
 Myers, E. Impression of Mrs.
 D.M.
D'A-Lal. Cash
"Da Winnah". Young, M. M.
Daboa. Hoffman, M.
Dachshund. McCartan, E.
A. Dacian, head. Roman--1st c.
Dacian Wars
 Roman--2nd c. Trajan's Column
The Daddy Fish. Kienholz
DADSWELL, Lyndon (Australian
 1908-)
 Aboriginal Head 1939 bronze
 ARTA # 134
 Banking, relief aluminum
 panel, beaten and welded;
 12x21' BON 68 AuSC
Daedalid Type Female Bust.
 Cretan
Daedalus
 Grafly. Daedalus, head
Dagaba
 Ceylonese. Dagaba, model
Daggers See also Kris
 Achaemenian. Dagger with
 Lions' Heads on pommel
 Chinese--Chou. Dagger
 Chinese--Shang. Dagger-Axe,
 Ko type
 Egyptian--1st Dyn. Votive
 Dagger
 Egyptian--18th Dyn. Ah-hotep
 Dagger
 Indonesian. Dagger Hilt:
 Figure Handle
 Melanesian--Admiralty Islands.
 Dagger#

Mycenean. Dagger(s)#
Neolithic--Denmark. Daggers
Paleolithic. Magdalenian
Weapons: Dagger
Persian. Dagger, with Lion and
Ibex Heads
Sumerian. Dagger and Filigree
Sheath
Sumatran--Balige. Dagger
Tlingit, or Haida. Dagger
DAGGETT, Maud (American)
Wall Fountain (bronze replica)
ACA pl 210 UCPaL
DAHL, Ron
Guitar Woman cement on arma-
ture MEILD 26
Lion's Mouth welded metal and
concrete, on wood base
MEILD 170
DAHOMEY See AFRICAN--FON
Dashur Crown. Egyptian--12th Dyn
Daibatsu
Japanese--Kamakura. Amida
Buddha
--Great Buddha
DAIDALOS
Apoxyomenos from Ephesos
(Roman copy) 1st half 4th c.
bronze; 76-1/2 KO pl 15 AVK
Daiitoku
Japanese--Fujiwara. Daiitoku,
seated figure
Daikasho See Buddha and Buddhism--
Attendants
Daikoku (Daikaku), God of Wealth
Japanese. Daikaku
Japanese--Kamakura. Daikoku
Ten
Okatomo. Daikoku, netsuke
DAINGERFIELD, Marjorie Jay
(American)
Anne Cannon Reynolds, head
DAIN 35
David Ovens, bust bronze
NATSS-67: 6
Dr. Bailey K. Ashford, head
DAIN 39
Frond Fountain
DAIN 92
Lucy Gins, head
DAIN 34
Navaho Indian, bust
DAIN 72 UNGeH
Dainichi Nyorai (Ich'ji Kinrin; Vairo-
cana Buddha), Supreme Buddha
Chinese--T'ang. Buddha:
Vairocana Buddha
Japanese. Dai Nichi Niorai

Japanese--Fujiwara. Ichiji
Kinrin
Japanese--Tempyo. Vairocana
Buddha
Korean. Vairocana Buddha
Unkei. Dainichi Nyorai
Dale, head. Margoulies, B.
Dalai Lama
Tibetan. Buddhist Wheel of the
Law, Dalai Lama's Emblem
of Authority
Dallas, George Mifflin (Vice President
of the United States 1792-1864)
Ellicott. George M. Dallas,
bust
DALLIN, Cyrus Eaton (American 1861-
1944)
Anne Hutchinson and her
Daughter, Susanna
PAG-10: 45 UMBSt
Appeal to the Great Spirit
(Prayer to the Great Spirit),
equest 1913 bronze; LS
DODD 101; GRID 7; MARY pl
63; NATS 69; PAG-12: 202;
ROOS 245G TAFTM 130
UMBPL
Chief Washakie 1897 bronze 10'
GRID 80 UUST
General Reynolds, equest
HARTS pl 15
General Sherman, equest
HARTS pl 15
Homage to Marshal Foch Medal,
obv and rev 1921 bronze
NATSA 277
Indian Hunter at the Spring 1913
bronze; LS GRID 40 UMArR
The Last Arrow bronze
NATSA 42
Massasoit 1921 bronze
GRID 70; MARY pl 144; PAG-
1: 206 UMPC
The Medicine Man, equest 1899
bronze; LS CRAVS fig 14. 7;
GRID 7; HARTS pl 16; MARY
136; PIE 378; POST-2: 252;
TAFT 497; TAFTM 130 UPPF
Miss C., bust
HARTS pl 56
Mystery Man, Indian Head
bronze MARY pl/19
On the Warpath, equest bronze;
23 BROO 25 UScGB
The Passing of the Redman,
study plaster PAG-1: 64
The Protest, equest
GRID 7

The Scout 1922 bronze; larger
than LS ACA pl 240; GRID
87; PERR 169; SFPP;
TAFTM 130 UMoKP
The Signal of Peace, equest
1894 bronze; LS CHASEH
512; GRID 6; HARTS pl 16;
MARY pl 127; TAFTM 130
UICL
Sitting Bull, head clay
MARY pl 71
DALTON, Peter (American)
Josephine plaster
NYW 189
Logging, relief wood
SCHN pl 112 UMSCPo
Moses plaster, for bronze
SCHN pl 37
"Dama del Cerro"
Iberian. Priestess Making
Offering
"Dame de Brassempouy", female
head. Paleolithic
Les Dames Lunes. Archimbault
Damianus, Flabius (Roman Writer)
Roman--2nd c. Flabius
Damianus
Damned
Khmer. Terrors of the
Damned, relief
DAMOPHON (DAMPHON) OF MAS-
SENE (Greek fl 2nd c. B.C.)
Artemis from Lykosoura, head
end 2nd c. B.C. marble
KO pl 17 GrAN
Anytos, head, temple at
Lykosoura c 180/140 B.C.
RICHTH 169 GrAN
Drapery, carved to show
embroidery, robe fragment,
Lykosoura 180/160 B.C.
LAWL pl 55; WEB 208 GrAN
Head of Goddess mid 2nd c.
B.C. marble
BEAZ fig 196 IRC
Male Female Figures, frag-
ments LAWL pl 54 GrAN;
GrLyM
Dampati. Indian--Sunga
Damsel. Martinelli, E.
DAN See AFRICAN--DAN
Danae Receiving the Shower of Gold
Greek--5th c. B.C. Barbarian
Suppliant
Harootian. Danae and the
Shower of Gold
Dance Like a Comma. George, H.
Dancers See also Masks; Nataraja

Aitken. Dancing Bacchante
Ambellan. Dancer
Aztec. Monkey, God of Dance
Barnhorn. Maenads' Dance,
relief
Barthe. Exodus; Dance, reliefs
Barthe. Negro Dancing Girl
Barthe. Ram Gopal
Bartlett. Ghost Dancer
Bauer, S. A. Slav Dancer
Ben-Shmuel. Dancer
Blazys. Tartar Dancer
Borglum, S. H. Sioux Indian
Buffalo Dance
Calder, A. Dancers and Sphere,
motorized mobile
Callery. Study for a Ballet
Cham. Celestial Dancer
Cham. Dancer(s)#
Cham. Dancing Girl
Chamberlain, G. Dancers
Chinese--Chou. Dancing Girl
Chinese--Chou--Warring States.
Two Dancing Figures
Chinese--Han. Dancer, funerary
figure
Chinese--T'ang. Buddhist Proces-
sion: Musicians and a Dancer
--Chorasmian Dancer
--Dancer(s)#
--Female Dancers and Musicians
--Foreign Dancer, funerary
figure
--Three Women—one a dancer,
grave figures
Clark, A. Kongo Voodo
Colima. Circle of Dancers
Coptic. Cornice Fragment:
Dancing Nereids
Crotty. Dancers
Cueto. Danzante
Duble. Funeral Dancer
Ecuadoran--18th c. Gypsy
Dancer
Egyptian--Predynastic. Dancing
Figure
Egyptian--3rd Dyn. Zosar:
Performing Ritual Dance
with Horus Falcon
Eliscu. Dancing Girl
Elwell. Orchid Dance
Etruscan. Armed Warrior's
Dance, relief
--Bowl, with Two Dancing
Girls on rim
--Cinerary Sarcophagus:
Dancers
--Cinerary Urn: Banquet and
Dancers

--Circular Cippus: Dancers
--Dance Scene
--Lamp Stand: Dancer
--Male Dancer with Headdress
Folk Art--American. Cigar
 Store Figure: Dancing Darky
 (Jim Crow)
--Clog Dancer, "Jim Crow"
-- Dancing Girl, relief, Sparks
 Circus Wagon
--Dancing Negro
Freilicher. Chasidism
Freilicher. Dancers
Frisch. Dance
Frishmuth. The Bubble Dance
Gerber. Dancing Sprites
Greek. Dancing Faun
Greek--8th c. B.C. Circle of
 Dancing Women
Greek--6th c. B.C. Dancer(s)#
Greek--5th c. B.C. Dancing
 Girl, relief
Greek--4th c. B.C. Column
 Dancers
--Dancing Maenad Holding
 Tambourine
--Thyiades, Acanthus Column
 Figure
Grimes. Dancing Figures, two
 medallions
Gross. Acrobatic Dancer#
Gross. Tight-Rope Dancer
Haida. Dancing Medicine Man
Hauser. Martha Graham
Hellenistic. Dancer#
--Dancing Nymph
--Dancing Pygmy
--Satyr: Inviting Nymph to
 Dance
--Veiled Dancer
Hobson. Cambodian Dancer
Hobson. Javanese Dancer
Hoffman, M. Bacchante Russe
Hoffman, M. Daboa, dancing
 girl of Sara Tribe
Hoffman, M. Mongol Dancer
Hoffman, M. Sara Dancing Girl
Horn. Dancer II
Hovannes. Dancer
Howard, C. de B. Dance
Indian. Dancer
--Diety, dancing figure
Indian--Deccan. Siva:
 Bhairava Dancing
Indian--Hindu--7th c. Dancers
 and Musicians, relief
Indian--Hindu--10th c. Dance
 and Music, scenes
--Jain Dancing Girl

Indian--Hindu--11th c.
 Genesha: Dancing
Indian--Hindu--13th c.
 Lakshimi, Deccan
Indian--Indus Valley.
 Dancer
--Dancing Girl
Indian--Sunga. Dancing
 Couple
Indian--Vijayanagar. Krishna
 as the Dancing Butter
 Thief
Indians of Mexico. Dancing
 Woman, plaque
--Female and Male
 Figurines, including
 double-headed figures and
 dancers
Japanese--Ancient. Dancers#
--Dancing Men
--Two Dancers
Japanese--Tokugawa.
 Netsuke: Uzume
Javanese. Dancer, relief
Jennewein. Greek Dance
Kallimachos--Foll. Spartan
 Dancers, relief
Kane, M. B. Harlem
 Dancers
Kaz. Dance Espagnole
Kelsey. Dancing Pickaninny
Khmer. Dancer#
--Flying Figures, relief
--Hevajra, triple-headed
 Mahayana Buddhist
 Divinity
--Siva Dancing, lintel detail
--Vishnu: Dancing
--Woman Dancing relief
Konti. Allegro
Kurtz. Dancing Warrior
Lamden. Joy of Dance
Lekakis. Dance (Choros)
Lembke. Zulu Dancer
Lenz. The Dragonfly:
 Pavlova
Lipchitz. Dancer#
Lipman-Wulf. The Dancing
 Couple
McCullough. War Dance
MacNeil, H. A. Running
 Snake Dancer
MacNeil, H. A. Snake
 Dancer#
Maldarelli, O. East Indian
 Dancer
Manes. The Dancer
Manship. Dance Balustrade

Manship. Dancer and
 Gazelles
Marans. Modern Dancer
Margoulies, B. Dancer
Melanesian--Solomons.
 Dancing Girl
Mestrovic. Dancer
Miles, E. W. Dancing
 Figure
Minoan. Signet Ring: Ritual
 Dance of Four Women
Moselsio. Javanese Dancer
Nunez del Prado, M.
 Dance of Cholas
Olmec. Pendant: Dancer
Paleolithic. Ritual Dance(?)
Potter, B. O. Dancing Girl
Quezada Medrano. La Danze
 Pura
Remojadas. Dancing Girl
Roman. Warriors' Dance
Roman--1st c. B. C.
 Dancing Faun
--Vase Mould: Dancers,
 Altars, Bucrania
Roman--1st c. B. C. /1st c.
 A. D. Lars Dancing
Rubinstein, T. de. Ballet
 Group
Rudy, C. Dancer
Sanford, E. F. Dancer
Sardeau, H. Dancers
Sardeau, H. Dancing Figures
Sassanian. Carafe:
 Dancers
Scopas. Dancing Maenad
Seaver, E. A. Adagio
Spicer-Simson. Katherine
 Gabaudan Medallion
Stankiewicz. Kabuki Dancer
Straight. Dance, mobile
Stewart, D. The Dancer
Swarz. Seated Dancer
Tlatilco. Dancer and
 Acrobat
Unemura. Dancer
Vietnamese. Dancer and
 Musician
Vonnoh, B. P. Allegresse
Weschler, A. The Twist at
 the Met
Wilson, H. Dance
Wyle, F. Dancing Baby
Zapotec. Danzantes, reliefs
Zorach. Dancer Resting
Zorach. Dancing Girl
Zorach. Spirit of the Dance
Dancing Faun
 Hellenistic. Dancing Faun

MacMonnies. Bacchante
Dancing Goat. Laessle
Dancing Horse. Borglum, S. H.
Dancing Nymph. Warner, O. L.
Dandelion. Milonadis
Dandelion. Randell, R.
Danes
 Chinese--Ch'ing. Danish
 Captain
DANHAUSEN, Eldon
 Figures in Copper 1965
 copper; 9'
 MEILD 73
 Modest Maiden 1965 copper
 MEILD 133
 Reaching Figure welded
 metal, concrete
 MEILD 168
 Woman 1963 copper
 MEILD 85 (col)
 Women
 MEILD cov (col)
Daniel (Hebrew Prophet)
 Coptic. Daniel Between the
 Lions, relief
 --Daniel in the Lion's Den
DANIELS, Elmer (American)
 Apage Satana marble
 SCHN pl 41
DANIELS, Jacob Paul (American)
 Boy in Trench plaster
 UNA 9
DANIELS, John (American)
 Adam wood
 NYW 189
Dan'l. Makanna
DANNGERE See AFRICAN--DAN
Danse Fantastique. Wilson, H.
Danse Macabre. Wilson, H.
Danzante. Zapotec
Danzatore Guerriero. Mirko
DAOUST, Sylvia (Canadian 1902-)
 Lucie plaster; 10-1/4
 CAN-3:374 CON (6252)
 Madonna pine
 ROSS 35
 Simone Hudon, bust bronze
 IBM pl 35 UNNIb
 Tete de Jeune Huronne
 (Bedabenokwa) 1936 bronze;
 17
 CAN-3:346 CON (4915)
Daphne
 Coptic. Apollo and Daphne,
 relief
 --Daphne#
 Kaz. Daphne
 Warnecke. Daphne, Allegra
 e Penseriosa

DAPHNIS, Nassos (Greek-
American 1914-)
3-64-5 H: 49-1/2
SEITC 96 UNNC
4-J30-63 1963
KULN 116
10-64-5 1964
KULN 115
Daramete (Wife of Gelon, Tyrant
of Syracuse)
Greek--5th c. B. C.
Darameteion
DARIE, Sandu (Rumanian-Cuban
1908-)
Estructura Transformable
AMAB 80
Darius I (King of Persia 558?-
486 B. C.), called "Darius
the Great"
Achaemenian. Darius I, rock
relief
Persian. Cylinder Seal of
Darius I
--Darius#
--Tomb of Darius I
"The Dark Lady". Khmer
Dark Mother. Duble
Dark Mountains. Kent, A.
Dark Shadows. Nevelson, L.
DARNELL, Jerry A. (American)
Sacrificial Ram
CALF 65
DARRIAU, Jean Paul (American)
Zero G's bronze; 16
HARO-3:31
Dart-Throwers
Paleolithic. Magdalenian
Weapons: Dagger;
Harpoon; Dart-Thrower
with Bird on handle
DARUMA
Byokuyosia. Daruma, netsuke
Japanese--Tokugawa. Inro:
Classical Poets; Netsuke:
Daruma
DA SILVA Joao (Portuguese)
Commemorative Medal,
Centenary of Lisbon
Academy of Fine Arts
CASS 141
DAUDELIN, Charles (Canadian 1920-)
Untitled 1965 bronze; 9-1/4
CAN-4:211 CON
A Daughter of Pan. Perry, R. H.
Daughter of Pyrrha. Taft, L.
Daughter of the Sea. Fry, S. E.
DAVENPORT, Jane (American)
A Study: Fish
NATS 73

David. Greenbaum
David. Kiesler
David (King of Israel)
Lipchitz. David and Goliath
Pattison, A. L. Young
David
Roman--4th c. Plate: David
and Goliath
DAVIDSON, Jo (American 1883-1952)
Albert Einstein, head
LARK 394 UNNW
--original clay
BRUM pl 23 UNNW
--bronze
WHITNT UNNW
Andre Derain, head
CASS 37
Artist's Wife, head marble
NATSA 45
Charles G. Dawes, bust
marble
USC 175 UDCCap
Flora, head
RAY 71 UNNW
Franklin Delano Roosevelt,
bust 1933 bronze
FAIY 212 UNHyR
Franklin Delano Roosevelt,
head
PAA-41
--original clay
BRUM pl 24
Gertrude Stein 1920 bronze;
31
CRAVS fig 15.1; GOODA
33; PIE 385; WHITNFA
17 UNNW (54.10)
Gertrude Vanderbilt Whitney,
bust c 1917
GOODA 14 UNNW
Henry A. Wallace, bust
marble
USC 180 UDCCap
Israel Zangwill, head
marble
SCHW pl 24
James Pryde, head
CASS 37
Japanese Girl Caen stone
WHITNC 224 UNNW
John D. Rockefeller, bust
NATS 71
--1924 marble
NMAP #124 UNPR
Joseph Sprinzak, head 1952
clay, for bronze
SCHW pl 23
Jules Semon Bache, head 1936
terracotta; 10 UNNMMAS
147 UNNMM (49.7.120)

My Niece 1930 bronze; 47
 BROO 282 UScGB
A New Englander, head
 1935
 MEN 627 UMB
Nude 1910 bronze; 25-1/4
 CHICH pl 64 UNNW
Robert Marion La Follette,
 bust 1923 bronze; 22x19
 USNM 97 -ULa
Robert Marion La Follette,
 seated figure marble
 MUR 84; USC 247 UDCCapS
Will Rogers 1939 bronze;
 84
 CRAVS fig 15. 2; MUR 64;
 USC 255 UDCCapS
 --
 GRID 69 UOkCR
DAVIDSON, Robert (American
 1904-)
Bird Girl silver bronze
 NYW 187
Marion, portrait mask
 bronze
 IBM pl 59 UNNIb
Praying Angel
 NATS 74
Davies, Arthur Bowen (American
 painter 1862-1928)
Mowbray-Clarke. Medal:
 Arthur B. Davies
Davies, Samuel (American Educator
 1723-61)
Calder, A. S. Reverend
 Samuel Davies
DAVIS, Emma Lu (American 1905-)
Bantam Rooster 1934 ptd wood,
 copper; 13-3/4
 NMAM 47 UNNW
Black Bull 1935 wood; 34-1/2
 x51
 NMAM 46 UCtWiD
Chinese Red Army Soldier,
 head 1936 walnut; 9-3/4
 NMAM 49 UOrPG
Cock ptd wood, copper legs;
 13-1/2
 LARK 460; RICJ pl 1
 UNNW
Cosmic Presence 1934 wood; L:
 66
 NMAM 45 -Rob
--1934 wood, ptd; L: 66-1/4
 PIE 385 UNNMMA
 (9. 42)
Folded Cat 1941 terracotta;
 L: 18 NMAM 50

Handies--sculptures to be
 felt 1939/41 wood
 NMAM 50
Hsiao Di-Di, head 1936
 walnut; 6-3/4
 NMAM 48
Davis, Jefferson (President of the
 Confederate States of
 America 1808-89)
Lukeman. Jefferson Davis
DAVIS, Richard (American 1904-)
Bear cast stone
 SGT pl 10
--1940 red sandstone; 16
 RICJ pl 49; SCHN pl 80
 -UHen
Bison black granite
 NYW 187
--1938 black granite; L: 36
 MAG 147
--1939 black granite;
 48x28x24
 RICJ pl 49
Fallen Warrior field granite
 SGO-4:pl 9
Girl Reading 1939 Swedish
 granite; 14
 MAG 145
Girl in Granite 1937/38 pink
 Westerly granite; 49-1/8
 NNMMAP 130; RICJ
 pl 48; SGO-2:pl 17
Lion's Share Kisota stone
 SGO-10:8
Maime Tse, head 1935
 alabaster; LS
 MAG 147; SCHN pl 1
DAVIS, Ronald (American 1937-)
Out of Green Box 1964
 acrylic and collage on
 canvas; 69-1/2x79-1/2
 UIA-12:150 UCPalL
Davis Challenge Cup. American--
 20th c.
Davit of Sassoun
Der Harootian. Birth of
 Davit of Sassoun
Dawes, Charles Gates (Vice
 President of the United
 States 1865-1951)
Davidson, J. Charles G.
 Dawes, bust
Dawn
 Beach. Unveiling of Dawn
 Goodelman. Dawn
 Journeay. Dawn
 Lascari. Dawn
 Nevelson, L. Dawn
 Williams, W. Dawn

268 Dawn Light

Dawn Light. Nevelson, L.
Dawn of Christianity
 Palmer, E. D. The Indian
 Girl
Dawn of Day. Shaler, C. A.
The Dawn of Glory. Montana
The Dawn Singer. Hansen, J. L.
Dawning Hour. De Francisci
Dawn's Wedding Feast.
 Nevelson, L.
Day. Vagis, P.
Day and Night. Calder, A.
Day of Wrath. Yoffe, V.
DAYAK
 Ancestor Figure--Tempatong,
 or Hampatong, Borneo
 wood; 41-1/4
 MUE pl 70 NAT (A 4323)
 Borneo Doors, "ornamental
 fanciful" style wood;
 44-1/2
 LOM 98 GMV; ELBr
 Squatting Figure, South
 Borneo highly polished
 wood; 11-1/2
 MUE pl 68-69 NAT
 (1772/1119)
Daylight # 2. Willenbecher, J.
Daywork. Bannarn
Day's End. Beling
Dead Bird. Lippold
Dead Man. Baskin
Dead Pearl Diver. Akers, P.
The Dealers. Marisol
Dearborn Massacre Memorial.
 American--19th c.
Death See also Skeletons; Skulls
 Aztec. Xolotl, guide of the
 dead on their journey
 through the netherworld
 and incarnation of the
 planet Venus, represented
 as a skeleton
 Bringhurst. The Kiss of
 Eternity
 Campoli. Birth of Death
 Etruscan. Canopic Urns:
 Deity of Death
 --Cinerary Urn: Recumbent
 Youth with Demon of Death
 --Cista Handle: Sleep and
 Death Carrying off Fallen
 Memnon
 --Sleep and Death
 Bearing Body of Sarpedon
 Folk Art--American. Grave-
 stone: Skeleton and Grim
 Reaper

 --Grim Reaper
 Greek--4th c. B. C.
 Column Base: Underworld
 (?) Scene
 Indians of Mexico. Lord of
 the Dead, pectoral
 Mixtec. Pectoral: Death
 God
 Saint-Gaudens. Adams
 Memorial
 Winkel. Apocalyptic Rider
Death and the Warrior. French,
 D. C.
Death and the Young Sculptor.
 French, D. C.
Death and Transfiguration. Duble
Death Cart. Herrara, J. I.
"Death Knight", gold pendant.
 Zapotec
Death Masks
 Mycenaean. Mask of
 Agamemnon
Death Staying the Hand of the
 Sculptor
 French, D. C. Death and
 the Sculptor
Deble
 African--Senufo. Deble, Lo
 Society ritual figure
 --Rhythm Pounder
Deborah's Song. de Coux
Debutante. Glickman
DECCAN See INDIAN--DECCAN
Decius, Gaius Trajanus (Roman
 Emperor 201-251)
 Roman--3rd c. Trajanus
 Decius, head#
DECKER, Alice (American 1901-)
 Animal Studies
 PUT 19
 Carrier Pigeon aluminum
 SGO-3:pl 10
 Crap Shooter cast stone
 SGO-1:pl 12
 Flight aluminum
 SGO-2:pl 19
 Sea Breeze cast stone
 SGT pl 11
DECKER, Lindsey (American 1923-)
 Auto-da-Fe II welded steel
 MEILD 106 UMiD
 Gamos II 1960 copper;
 33x20-1/2x15
 WALKT # 14; WHITNA
 16:10
 Genesis welded and forged
 aluminum; W: 72
 ROODT 86

Oracle II 1957 forged and
 welded aluminum
 CIN #11
Screen, five panels 1957
 aluminum; ea panel:
 96x48
 WHITNB 20 UMiDE
Zygote 1961 brass, bronze,
 steel; 37-1/2x35x11-1/2
 WALKT #15
Decorations of Honor See also
 Heraldry; Medals and
 Medallions
Egyptian--18th Dyn. Amenhotep
 III: Wearing Blue Crown
 (War Helmet) and "Gold
 of Courage"
Egyptian--19th Dyn. Ptahmai
 Family, "Gold of Courage"
 Decoration
DE COUX, Janet (American)
 Deborah's Song
 PAA-42
Decoys
 Barnes. Wild Swan Decoy
 Blair, J. Pintail Drake
 Decoy
 Collins, J. L. Decoy No. 2
 Folk Art--American.
 Decoy#
 Godwit. Decoy
 Griffin. Decoy: American
 Merganser Drake
 H. B. Canada Goose Decoy
 Indians of North America--
 Nevada. Duck Decoy
 Orem, A. Sea Lion Decoy
 Pennsylvania German(?).
 Decoy: Loon
DE CREEFT, Jose (Spanish-
 American 1884-)
 Acrobats at Rest granite
 UNA 10
 Les Adieux, relief beaten
 lead; 96
 NM-13:#9
 Annunciation red sandstone;
 41 SG-5
 Arabia beaten lead; 39
 SG-4
 Aux aguets Carrara marble
 CHICA-60:#39
 Black Head
 CHENSP 281
 The Cloud 1939 greenstone;
 13-1/2
 BRY 629; CHENSW 497;
 CRAVS fig 15. 15; FAUL
 491; GOODA 65 (col);

JOH 64; MAI 68;
MCCUR 258; PIE 385;
RIT 191 UNNW (41. 17)
Continuite 1958 pink
 Georgian marble; 26-3/4
 WHITNR 34
Emerveillement
 ZOR 280 UNNMM
Femme Assise 1938 marble;
 16
 DETS 34 UNNH
Figure Studies terracotta
 RICJ pl 13
Guatemala black Belgian
 marble; 21
 SG-7
Head
 CHICA-46:#239
 --
 SGO-1:pl 9
 --black Belgian marble
 SGT pl 12
 --granite; 26
 CHICH pl 71
Himalaya 1942 beaten lead;
 34-1/2
 CHENSN 648; CHENSW
 498; GOODA 136; JOH
 80; RICJ pl 36; WHITNFA
 48 UNNW
The Kiss Mallorcan marble
 SCHN pl 31
Lorraine, head 1949
 PEAR 255
Margaret, head Caen stone;
 larger than LS
 RICJ pl 47
Maternity 1923 granite; 28
 UNNMMAS 149; PEAR
 254 UNNMM (42. 171)
Maturity English stone
 CHICA-54:pl 13
Maya c 1935 Belgian black
 granite
 BAUR pl 102; BRUM pl
 26; PIE 385; SCHN pl 3
 UKWA (M-42)
Muse white Georgian
 marble; 52
 SG-3:WHITNA-16:11
Nebulae 1950
 PEAR 255
New Being Mallorcan
 marble
 SGO-10:9 UNNPas
Nigeria snakewood
 ROODW 130
La Nina green serpentine
 marble; 14
 CUM 96 -UFis

United States Dollar, obv; rev
silver
NATSA 279
Degagee on a Dark Horse. Lange
DE GERENDAY, Laci (American)
Jacques Lipchitz, relief bust
bronze
NATSS-67:76
DE HARIOS, Dora (American)
Ceramic Sculpture
CALF-61
DEHNER, Dorothy (American 1908-)
Landscape with Sun 1962
bronze; L: 14
SG-4
Low Landscape, Sideways
1962 bronze; 15x50
UIA-12:99 UNNWi
Low Landscape, Upright
bronze; 32
SG-6
Oracle and Prophet cast
bronze; L: 33
SG-7
Pair of T-Beams cast bronze;
48
SG-3
Rites at Sal Safaeni Number 2
1957 bronze; 26-1/2
NMAR
Sad Mask for the God of War
cast bronze; 26
SG-5
Three Figures cast bronze;
24
SG-2
Portraits
Simkhovitch, H. Dorothy
Dehner, head
Dehodiat'gaiwe
Cayuga. Split-Body Mask
Deianeira See Nessus
Deidamia
Greek--5th c. B. C. Temple
of Zeus, Olympia: Deidamia
Deification of Homer
Hellenistic. Apotheosis of
Homer
Dekadrachm. Greek
DE LAP, Tony (American 1927-)
Arje 1964 aluminum, board,
plexiglas, lacquer
LARM 411 UCLjD
Four Dots 1963 glass, wood,
and steel construction; 23x
22
UIA-12:142 UCSFD

Houdini's House 1967
aluminum and glass, two
units; ea unit: 6x6x6'
TUC 96 UCLL;
UCSFDi; UNNEl
Isis aluminum, plexiglas
WHITNA-17
Ka 1965 fiberglass, stainless
steel, lacquer; 60x96x13
UCIF 15 UCLL
Lorna Doone 1964 H: 17-1/2
SEITC 79 UCSFDi
Modern Time 1965 aluminum,
baked epoxy /enamel;
14-1/2x24x12-1/2
SEATL 19 (col) UCPaT
Mud Hut 1964 stainless steel,
glass, plexiglas, paint;
15x15x4
WHITNS 20 UNNW
Sorcerer 1965 wood, brass,
lacquer; 54x54x8
LAJ # 13; UCIF 14 (col)
UCLL
Tango Tangles 1966 aluminum,
baked epoxy enamel; 13x13x
13
SEATL 21 UCPaT
Triple Trouble 1966 aluminum,
baked epoxy enamel;
13x22-1/2x13-1/4
SEATL 20 UCPaT
Delilah
Aronson, D. Delilah
Delius, Frank (English Composer
1862-1934)
Clews. Frederick Delius,
mask portrait
Delmatius (Nephew of Constantine
the Great)
Roman--4th c. Coin:
Delmatius
Deloria, Philip (Yankton Sioux
1854-1931)
Lualdi, A. Philip Deloria
Delphi# Rosati, J.
Delphic Pythia
Greek--5th c. B. C.
Barberini Suppliant
DEL PRADO, Marina Nunez See
NUNEZ DEL PRADO,
Marina
Del Rio, Dolores
Zuniga, F. Dolores del Rio,
head
DE LUE, Donald (American 1898-)
The Atom bronze
NATSS-67:8

Cosmic Head plaster, for
granite
SCHN pl 2
Eve plaster, for bronze
BRUM pl 28
Law, relief granite
SCHN pl 105 UPPCrt
Pegasus plaster, for bronze
SCHN pl 70
Spirit of American Youth
DAIN 95 FNoA
Triton, relief plaster, for
marble
SCHN pl 24 UPPFed
The Deluge. Gulielmo
DELUNA, Francis P. (American
1891-)
Crucifixion
NATS 79
DEIZENNE, Ignace Francois
(Canadian 1718-90)
Chalice silver; 10-3/4
CAN-4:21 CMH
DE MARCO, Jean Antoine (French-
American 1898-)
Christ and his Apostles,
cruciform relief of heads
repousse copper; 108
BRUM pl 30; MCCL pl
54 UNNSC
Creole Girl, head red
sandstone; LS
RICJ pl 47
Duck bronze
SGO-4:pl 12
Eve
SCHN pl 26
Facade, War Department
Building, Washington,
D. C., model
RICJ pl 22
Flight, relief white Georgia
marble
SCHN pl 114
Indian Woman, seated figure
Tennessee marble
BRUM pl 29 UNNSC
Memorial Cross* repousse
brass
SGO-10:11
Modern Sphinx Georgia
marble
SGO-2:pl 24
Moses, medallion head
marble
USC 285 UDCCap
Peasant Woman Tennessee
marble
NYW 188

Saint Louis, King of France,
medallion head marble
USC 286 UDCCap
Seated Figure Tennessee
marble
SGO-1:pl 13
DE MARIA, Walter (American)
Museum Piece (drwg for)
1966 aluminum; 3-5/8x
36x36
TUC 97 UNNCor
DE MARS, Dante (American)
Askance bronze; 11-1/2
HARO-3:35
DEME SHODO GENSUKE (Japanese)
Fodu-Myo-O, Noh mask,
netsuke 17th c.
BAR 67 (col) FPEn
De Medici Princess. Cornell
Demeter (Ceres)
Campbell, K. F. Ceres
Franzoni, G., and Andrei,
G. Ceres
Greek. Demeter
Greek--5th c. B. C.
Demeter#
--Exhaltation of the Flower
--Votive Relief: Eleusinian
Dieties: Demeter
Greek--5/4th c. B. C.
Demeter
--Parthenon#
--Parthenon: Demeter,
Persephone, Artemis
Greek--4th c. B. C. Delphi
Coin: Demeter, head
--Demeter#
--Demeter of Cnidos
Hellenistic. Artemis,
Demeter, Anytos, heads
--Demeter(?)
--Shrine of Demeter
Lambert, M. Ceres, head
Leochares. Demeter, seated
figure
Longman. Fountain of Ceres
Phidias--Foll. Ceres
Roman--1st c. Ceres,
candelabrum-stand relief
Roman--3rd c. Julia Domna
as Ceres
Skillin, S., Jr. Ceres, head
Storrs. Ceres
DEMETRIOS, Aristides (American
1932-)
White Memorial Fountain
SUNA 170 UCStan
Demetrius I (King of Bactria fl
206-175 B. C.)

Hellenistic. Tetradrachm:
Demetrios of Bactria
Demetrius II (King of Bactria)
Bactrian. Tetradrachm:
Demetrius
Demetrius I (King of Syria d 150
B. C.)
Hellenistic. "Hellenistic
Ruler"
Demetrius II (King of Syria d c
125 B. C.)
Hellenistic. Demetrius II,
head of statue
DEMING, Edwin Willard (American
1860-)
The Fight 1906 bronze;
7-3/4
BROO 166 UScGB
Democracy Crowning the People
of Athens
Greek--4th c. B. C. Stele:
Law Against Tyranny
Democracy Protecting the Arts
Bartlett. Apotheosis of
Democracy
Demon (Oni) Mask. Japanese
Demons See Devils
Demosthenes
Polyeuctus. Demosthenes#
Roman--1st c. B. C.
Demosthenes, head,
amethyst ringstone
DE MOULPIED, Deborah
(American 1933-)
Form No. 4 1960 vinyl
BURN 156
Den (King of Egypt)
Egyptian--1st Dyn. Den
Striking Asiatic Chieftan,
label
De Neve, Felipe (California
Governor 1740-84)
Lion, H. Felipe de Neve
DENGESE See AFRICAN--
DENGESE
DENGHAUSEN, Franz (American)
Giovanni Castano, head
colored plaster
NYW 189
DENNIS, Thomas (American)
Christ, Ipswich,
Massachusetts 17th c.
NM-1:10 UNNMM
(10. 125. 685)
Density in Red. Lassaw
DENSLOW, Dorothea Henrietta
(American 1900-)
Pelican Rider Tennessee

marble; 30-3/4
BROO 428 UScGB
Departure from Venice. Weiss, H.
Departure of the Seventh. Acton
Depet, Lady
Egyptian--18th Dyn. Lady
Depet, relief fragment
Depew, Richard J.
Calder, A. S. Depew
Memorial Fountain
Derain, Andre (French Painter
1880-1954)
Davidson, J. Andre Derain,
head
DERDERIAN, Ara (American)
A Young Woman concrete; 37
NM-13:# 27
Derelicts. Loring
DER HAROOTIAN, Koren
(Armenian-American 1909-)
Bird sandstone; 24
SG-4
Birth of Davit of Sassoun
Westfield green marble;
L: 48
SGO-17
Danae and Shower of Gold
plaster, bronze patina;
L: 44
SG-3
--1960 bronze; 65x117 cm
LIC pl 325
Descent from the Cross 1952
Georgian marble
PEAR 147
Eagles of Ararat 1955/56
serpentine; 58
GOODA 135; PIE 388
UNNW (56. 22)
Fecundity serpentine marble
WHITNA-17:12
Fighting Cockerels bronze
WHITNA-17
Hercules Fighting the Vulture
1958 serpentine marble; 54
NEWAS 28
Hermaphrodite 1938
PEAR 147
Leda and the Swan white
Alabama marble
BRUM pl 33; WHITNA-2
UNNKr
Prometheus and Vulture
Westfield green marble; 63
BRUM pl 34; SGO-10:12;
UNNMMAS 181 UNNMM
(48. 142)
The Sacrifice 1951 Botticini
marble PEAR 147

Sea Bird, Skyros onyx
CHICA-60:#42
Voice of Orpheus red sand-
stone; 36
SG-2
Derivation. Underhill, W.
DE RIVERA, Jose Ruiz (American
1904-)
Abstract Sculpture, Secretary
General's Office, Secre-
tariat Building bronze
BAA pl 23 UNNUN
Blue and Black Construction
1951 aluminum; 60x65x
75 cm
LIC pl 253 UNNLip
Black--Red--Yellow ptd
aluminum
BRUM pl 32 UNNLev
Brussels Construction 1958
stainless steel; 7x7x5
AM #180; BURN 162;
MEILD 85 UICA
Construction chrome, nickel,
and steel; 13-3/4
UIA-7:pl 61
--copper; 18
NM-13:#45
--1955
MYBU 99 UTxDSt
--1955 polished steel
BERCK 192
Construction Blue and Black
1951 ptd aluminum; L: 47
GOODA 252; PIE 392 UNNW
(52. 16)
Construction No. 1: Homage
to the World of Minkowski
1955 forged chrome-nickel-
steel rod; 14-7/8
AMAB 84; NNMMT 79;
PIE 392 UNNMM (55. 204)
Construction #2 1954 chrome-
nickel-steel sheet, welded;
16
MCCUR 280 UCtBL
Construction #2 1954 chrome-
nickel-steel sheet, welded;
16
NNMMT 81 UNNB
Construction No. II, Red,
Black and Yellow
aluminum; 18
UIA-6:pl 85
Construction #4 1953 stainless
steel; 15x30-1/2
NEWA 48; NEWAS 31
UNjNewM

Construction #5 1955 forged
chrome-nickel-steel rod; 20
NNMMT 83; UIA-8:pl 66
UNNB
Construction #8 1954 forged
chrome-nickel-steel rod;
9-3/8
NNMMT 80; TRI 210
UNNMMA
Construction 14 1953
developed from chrome-
nickel-steel sheet, welded;
10 NNMMT 80 UNNEn
Construction No. 27 1956
chromium-nickel-steel
CHENSP 295; CHENSS
708 UICBl
Construction No. 35 1956
steel; 5-7/8
DETS 88; READCON 238
UNNH
Construction No. 48 1957
chrome-nickel-steel, forged
rod; 9
GIE 221 UNNSt
Construction 56 1958 stain-
less steel; 13x17
NMAR
Construction No. 64 1959
stainless steel
MAI 252
Construction 67 1959 forged
bronze; L: 54
NNWB 65; WHITN 65
UNNB
Construction No. 72 1960
stainless steel, motorized;
32x80
CARNI-61:#331; JLAT 14,
15; TUC 98 UNmAUA
Construction #78 1961 stain-
less steel, motorized;
13x23x15-1/2
UCIT 31, 32
Construction No. 80 chrome-
nickel-steel
WHITNA-16:12
Construction No. 83 1963
bronze; 10-1/2x15x10
SELZS 168 UNNBen
Construction #87 1964
stainless steel; 14x18-1/2
x14
CUM 101; WHITNA 17
-UStor
Construction #93 1966 bronze;
W: 18-1/2
CRAVS fig 16. 14; Coll.

Philip M. Stern
 WHITNA-18:27
Continuum, relief 1955/56
 stainless steel; 84x120
 NNMMT 82; WHITNB 37
 UNNKa
Copper Construction 1949
 copper; 17x40
 LOND-6:# 35 UNNB
Enka Corporation Trade
 Mark (Textile Yarn Manu-
 facturers), Abstraction c
 1954 steel
 FAUL 140
Head
 CASS 47 UNNW
Homage to the World of
 Minkowski 1955
 chrome, nickel, stainless
 steel; 14-7/8
 UNNMMAS 178 UNNMM
 (55. 204)
Life Coopersburg black
 granite
 NYW 186
Sculpture*
 EXS 27
Sculpture Construction
 chrome, nickel steel
 sheet--12 gage--polished
 exterior, cadmium yellow
 interior
 LYNCM 160 UTxDSt
Sculpture Construction No. 2
 12-gage chrome, nickel
 steel sheet, welded
 LYNCM 140
Security 1958 bronze; 24
 WHITNB 28 UNNCT
Untitled chrome nickel steel
 MEILD 104 UNNUS
Yellow Black 1946/47 alumi-
 num; L: 60
 BRUM pl 31; GERT 184;
 MEN 639; NMAB 81; RIT
 205 UNNW
Yellow, Red and Black
 (Gelb, Rot, und Schwarz)
 1946 aluminum, ptd
 GERT 184
Dermys
 Greek--7th c. B. C.
 Kitylos and Dermys
Le Dernier Indian. Hebert, L. P.
DERUJINSKY, Gleb W. (Russian-
 American 1888-)
 Archangel Gabriel
 CHICA-46:# 240

Diana c 1925 bronze; 35-3/4
 BROO 340 UScGB
Eve
 CHICA-40
Station of the Cross:
 Deposition wood
 SCHN pl 110
Torso mahogany
 NATS 81
Descending Angel. Kaish
Descending Night.
 Weinman, A. A. Fountain of
 the Setting Sun
Descent. Burton
Descent from the Cross See Jesus
 Christ--Deposition
Descent of the Ganges. Indian--
 Pallava
Description of Table. Artschwager
Desert Bride. Kurtz
Desert Brier. Lipton
Desert Landscape: Abandoned
 Missile Site. Rood
Desert Queen. Kent, A.
Deserted Ariadne, head. Greek--
 4th c. B. C.
Desha. Lenz
Desks
 Greek-Archaic. Proskynitarion
Deslimitacion Espacial Parabolica.
 Kosice
Desmond, Three Days Old. Putnam,
 B.
DeSoto, Hernando (Spanish
 Explorer 1500-42)
 W. P. A. Project. DeSoto
 Monument
Despair, Seated Youth. Rimmer, W.
Despair. Robus
Despair, bust. Whitney, G. V.
The Despotic Age. Konti
The Despotic Age. MacNeil, H.
Dessalines, Jean Jacques (Haitian
 Negro Leader and President
 1758-1806)
 Barthe. General Dessalines,
 equest
DE STAEBLER, Stephen (American
 1933-)
 A Man 1964 fired clay;
 71x39x20
 NYWL 93
 OM 1962 terracotta; 110x
 155x42 cm
 FPMO
 Stele cast aluminum; 78x42
 HARO-2:36
Destiny. Longman

Gem: Profile of Bearded
Man, scaraboid 5th c.
B. C. red and yellow
jasper intaglio; L: 3/4
BOSMGR pl 3; BOSMI
69; SCHO pl 49 UMB
(23. 580)
Gem: Race Horse 440/400
B. C. chalcedony; L:3/4
BAZINW 164 (col); HAN
pl 150; RICHTH 237; SCHO
pl 49 UMB
Gem: Woman and Maid c 420
chalcedony
RICHTH 237 ECamF
Gem: Heron Standing on One
Leg, scaraboid late 5th c.
B. C. chalcedony
BEAZ fig 227 UMB
Dexileos
Greek--4th c. B. C. Stele
of Dexileos
DEXTER, Henry (American 1806-76)
James Buchanan, bust 1859
marble; 25-1/2
CRAVS fig 6. 6 UDCNMSC
Dharmacakra See Wheel of the Law
Dharmaraja Rath See Pandava (Five)
Raths
Dhyana See Buddha and Buddhism--
Meditation
Diadems
Greek--4th c. B. C. Diadem#
Steppe Art. Diadem:
Rosettes
Diadumenos. Polyclitus
Diagonal Construction. Goodyear
DIAGUITA
Incised Axe 1250/1500 stone;
L: 11
DOCS pl 198 UNNMAI
(13/4232)
"Diana". Calder, A.
Diana. Rudnick
Diana See Artemis
Diana a la Biche
Greek--4th c. B. C.
Artemis of Versailles
Diana of Versaille
Greek--4th c. B. C.
Artemis of Versailles
Dianora. Goulet
Diaz Miron
Urbina, J. M. F. Diaz
Miron, bust
DI BACCARDI, Adio (American)
The Eternal Questioning
plaster
NYW 189

"Jesus Wept" cast stone
IBM pl 74 UNNIb
DI BONA, Anthony (American)
Thomas Allen, head bronze
NYW 188
Dice See Games and Sports
Dick. Walker, C.
Dida Gondola. Smith, D.
Didoufri (Dedefre) (Fl 3000 B. C.)
Egyptian--4th Dyn. Didoufri,
head
Die II. Smith, T.
Die Squatter. Egyptian--25th Dyn.
DIEDERICH, Hunt (W. Hunt
Diederich) (Hungarian-
American 1884-1953)
Cats bronze; c 18
NATSA 50; RICJ pl 28
Diana and Hound
SGO1:pl 16
Fighting Goats 1938 bronze;
39
UNNMMAS 148 UNNMM
(55. 103)
Fire Screen
LAF 251 UNNFer
Firescreens: Dogs iron;
42x41-1/4
RICJ pl 38 UNNW
Goats bronze
RICJ pl 28
The Jockey 1924 bronze;
23-1/4
CAH 116; CAHA 58; NMAP
#126; PIE 385 UNjNewM
(27. 1073)
Playing Dogs
ZOR 47 UNNW
Prancing Horses
CASS 124 UNNGr
Satyr and Nymph
RICJ pl 29
Two Goats bronze; 37
BROO 292 UScGB
Wrestlers stone
NNMML UNNDo
Diego de Alcala, St. See James of
Alcala, St.
Dien Bien Phu. Cornell
DIETSCH, C. Percival (American
1881-)
Mourning Woman
NATS 82
Dig-Devi. Indian--Hindu--8th c.
"Dii Compitales"
Roman. Procession of the
"Dii Compitales"
DILLER, Burgoyne (American
1906-65)

Construction 1940
 BERCK 258
Project for Granite, No. 1
 1963 formica; 84
 GUGE 35 UNNGol
Project for Granite, No. 6
 1963 formica; 68-1/4
 GUGE 36 UNNGol
Project for Granite, No. 10
 1964 formica; 84
 GUGE 37 UNNGol
Diminished Bird. Duble
Diminishing Figure
 Trova, E. Study/Falling
 Man Series
DINE, Jim (American 1935-)
 Angels for Lorca 1966
 KULN 79
 Bedspring, assemblage 1960
 KAP pl 17
 Black Hand Saw 1962
 KULN 67
 Car Crash, happening
 November, 1960
 KAP pl 100, pl 101, pl
 107; SEITA 91 UNNReu
 The Gypsy, assemblage 1959
 48x60x3
 KAP pl 19
 The House, environment
 1960
 KAP pl 15, pl 23, pl 68
 Large Shower Number 1 1962
 oil on canvas, metal and
 rubber; 72x48
 AMA 82
 Long Right Arm with a Candy
 Apple Hand 1965
 KULN 49
 Ribbon Machine mixed media;
 68-1/2
 WHITNA-18:29
 Shining Bed, happening 1960
 KAP pl 70
 Shovel 1962 shovel against
 painted panel; 96x38
 LIP 105 UNNSol
 Smiling Workman, happening
 1960
 KAP pl 67
Diners and Dining
 Alexandrine. Supper Party,
 with reclining diners
 Egyptian--18th Dyn. Ma'y and
 his Wife at Funeral
 Banquet
 Etruscan. Banqueter
 --Cinerary Urn: Banquet
 and Dancers

--Funeral Banquet:
 Sarcophagus Relief
--Iron Age Cinerary Urn:
 Banqueting Scene
--Reclining Banqueter
--Reclining Diner#
--Sarcophagus: Procession;
 Banquet
Greek. Theoxenia
Greek--6th c. B. C.
 Symposiast: Reclining
 Man at Feast
Greek--5th c. B. C.
 Funeral Banquet
--"Satrap" Sarcophagus
Lassaw. The Banquet
Sassanian. Banquet Scenes,
 dish decoration
Segal, G. The Diner
Smith, D. The Banquet
Sumerian. Cult Banquet,
 votive tablet
--Feast, relief
--Ur Standard
Syrian. Funeral Stele of
 Priest Agbar: Ceremonial
 Banquet
Dinner Number 15. Samaras
Dinner Table. Segal, G.
Diocletian (Roman Emperor 245-
 313)
 Roman--3rd c. Diocletian,
 head
--Medallion: Diocletian
Roman--3/4th c. Diocletian(?)
 Enthroned
Roman--4th c. Diocletian,
 head
--The Tetrarchs
DIODA, Adolph (American)
 Crucifix
 PAA-47
DIODALSAS DE BITINIA (Greek)
 Bathing Venus; details (copy)
 marble; 1. 28 m
 PRAD pl 16-18 SpMaP
 Crouching Venus, headless
 and armless fragment
 (copy) c 250 B. C. marble;
 . 64 m
 PRAD pl 76 SpMaP
DIODALSAS DE BITINIA--ATTRIB
 Crouching Aphrodite (Roman
 Copy) 3rd c. B. C. H:
 42-1/4 (with plinth)
 NM-5:28 UNNMM (09. 221. 1)
Diogenes (Greek Cynic Philosopher
 412(?)-323 B. C.)
 Kaz. Diogenes

Diomid# Cresilas
Diomedes
 Greco-Roman. Diomeses and
 Odysseus Preparing to Kill
 Dolon
 Greek. Diomede with the
 Palladium
 Greek--5th c. B. C.
 Diomedes, head
 Greek--4th c. B. C. Argos
 Drachm: Hera, head;
 Diomedes Carrying off
 Paladium
 --Diomedes Stealing Paladion
 Kresilas--Foll. Diomede#
Dione
 Greek--5th/4th c. B. C.
 Parthenon: Three Fates:
 Hestia, Aphrodite, and
 Dione
 --Parthenon: Three Fates--
 Aphrodite in Lap of Dione
Dionysiac Procession. Coptic
Dionysiac Procession: Man with
 Tigers. Roman--3/4th c.
Dionysos I Soter (King of Syria
 fl 162-150 B. C.)
 Hellenistic. Dionysus I Soter
Dionysus (Bacchus)
 Alexandrine. Dionysos
 --Medicine Box--Lid:
 Personification of Alexandria;
 side: Dionysus between
 Maenad and Satyr
 Aseiounous of Larisa. Dherveni
 Krater: Dionysos,
 Maenads and Satyrs
 Coptic. Pulpit of Henry II:
 Dionysus, two figures
 Cypriot. Colossal Head, in
 Bacchanalian Procession
 Crown
 Etruscan. Aradne Discovered
 by Dionysos and his Com-
 panions, pediment fragment
 --Footed Cylindrical Casket,
 Praeneste--handle: Pan
 Supporting Dionysus
 Euphranor. Dionysos from
 Tivoli
 Greco-Roman. Dionysiac
 Procession, relief
 --Dionysus Sarcophagus
 --Mildenhall Dish
 Greek. Dionysus Mystes,
 head
 --Dionysus Vase, detail
 --Oscillium: Dionysian Scene--
 Satyr freeing Snake from
 Basket

--Theoxenia
Greek--5th c. B. C. Naxos
 Coin: Dionysus, head
--Tetradrachm of Mende,
 Macedonia: Dionysus
 Riding an Ass
--Tetradrachm of Naxos,
 Sicily: Dionysos; Silenos
Greek--5/4th c. B. C.
 Parthenon: Dionysos
--Parthenon: Poseidon,
 Apollo, Artemis (Poseidon,
 Dionysos, Hestia)
Greek--4th c. B. C.
 Dionysiac Scene, crater
--Dionysus and Ariadne,
 relief
--Seasons: Following Dionysus
 with Pine Branch
--Silenus: Carrying Infant
 Dionysus
Greek--4/3rd c. B. C.
 Dionysos, fragment
Hellenistic. Bacchus Riding
 Panther
--Bearded Bacchus ("Bacco
 Indiana")
--Dionysos#
--Krater: Dionysiac Scenes
--Shrine: Dionysos and Satyr
--Young Dionysos, wreathed
 head
Lysippus--Foll. Silenus and
 Bacchus
McCartan, E. Dionysus
Parthian. Dish: Triumph of
 Dionysus
Praxiteles. Hermes Carrying
 Infant Dionysus
Praxiteles--Foll. Dionysus
Praxiteles--Foll. Narcissus
 (Dionysus Listening to
 Distant Music)
Roman--Antinous as Bacchus
--Bacchus, headless figure
 wearing tiger skin
--Wreathed Dionysius, head
Roman--1st c. B. C. Bacchus
 Goblet
--Dionysus relief
--Dionysus Visits a Poet, base
 relief
Roman--1st c. Bacchus and
 Satyr
Roman--2nd c. Dionysos, head
--Sarcophagus: Bacchus and
 Ariadne
--Sarcophagus: Indian Triumph
 of Bacchus

Roman--3rd c. Dionysos Sar-
cophagus
--Dionysus and Ariadne,
sarcophagus relief
--Sarcophagus: Bacchus and
the Four Seasons
Roman--5th c. Dionysos in a
Chariot
Salpion of Athens. Vase of
Gaeta: Birth of Dionysus

Diosa
Greek--5th c. B. C. Diosa,
headless figure

Dioscuri
Alexandrine. The Dioscuri
Bactrian. Tetradrachm:
Encatides; Dioscuri
Greek--6th c. B. C. Raid
by Dioscuri, metope frag-
ment
Greek--5th c. B. C. Dioscuri
Dismounting from Horses Held
by a Triton

Dioskuros of Monte Cavallo
Greek--5th C. B. C. Dioskuros
of Monte Cavallo, detail,
Horse Tamers

Diospolis Parva, Local Deity
Egyptian--4th Dyn. Menkure
between Hathor and Local
Diety of Diospolis Parva,
relief

Dipa Laksmi
Indian--Hindu--17th c. Dipa
Laksmi, lamp bearer

Dipankara
Indian--Kushan--Gandhara.
Dipankara Jataka

Diplomats
Egyptian--18th Dyn. Foreign
Ambassadors, relief detail
Minoan. Cup, relief: Envoys
Presented to Prince

Dipylon
Greek--8th c. B. C. Warrior:
With Dipylon Shield
"The Dipylon Head"
Greek--7th c. B. C. Kouros,
head, Dipylon

Directional L Kipp
Dirke.
Apollonius and Tauriscus.
Punishment of Dirke

Disc and Square. Wines
Disco Solar. Mayas
Discobolus (Discus Thrower). Myron
Disconnected. Calder, A.
Discus Thrower
Myron. Discobolus

Discus Throwing See Games and
Sports--Discus

Dishes
Achaemenian. Kazbec Dish
Bactrian. Dish: Elephant
with Howdah and Riders
--Dish: Hercules as Slave;
Slaying Syleus
Chinese--Ch'ing. Covered
Dish: Rat
Chinese--Ming. Black Lac-
quer Dish
Etruscan. Praeneste Dish
Fiji. Priest's Oil Dish
--Shallow Dish: Human Form
Gallo-Roman. Hercules and
the Nemean Lion
Haida. Dish#
Javanese. Fruit Dish
MacNeil, C. B. Chafing Dish
Maya. Covered Dish, parrot-
head handle
Micronesian. Dish
Palestinian. Dish: The
Passion, stylized scenes
Parthian. Dish: Triumph of
Dionysus
Phoenician. Repousse Dish
Roman--4th c. Dish: Pastoral
Scene
Romano-Indian. Dish: Diana
and Actaeon
Sassanian. Banquet Scenes,
dish decoration
--Figured Dish: Mounted Lion
Hunter
--Shapur II Hunting, dish
Scytho-Sarmatian. Dish:
Fighting Warriors
Soghdian. Dish: Equestrian
Hunter
Syrian. Dish
Tlingit. Dish
Tlingit. Feast Dish
Tlingit. Food Dish
Tsimshian. Bird-Shaped Dish
The Disinherited. Freilicher
Diskophoros. Polyclitus
Disks
Chavin. Disk
Chinese--Chou. Huang
Chinese--Han. Disk
Maya. Disk: Seated God
Persian. Gold Discs
Quimbaya. Disk: Stylized
Human Face
Totonac. Mirror(?) Disk

Ward, J. Q. A. William Earl
 Dodge
Doe See Deer
Dog and Cat Fight. Greek--6th c.
 B. C.
Dog Trying to Go to Heaven.
 Frazier, P.
DOGON See AFRICAN--DOGON
Dogs See also Cerberus; Hunters
 and Hunting
 African--Bakongo. Konde, nail
 fetish: Two-headed Dog
 African--Cabinda. Two-
 Headed Dog
 African--Fon. Royal Hunter,
 with dane-gun and dog
 African--Mende. Mask:
 Human Face, Surmounted
 by Three Dogs
 African--Nigeria. Hunter#
 Alexnor of Naxos. Orchomenos
 Stele
 Apollonius and Tauriscus.
 Farnese Bull
 Assyrian. Dog
 --Wild Asses Hunted with
 Mastiffs
 Aztec. Dog
 Babylonian. Mastiff, Sumu-
 ilum Vase
 Balinese. Man with Dog
 Brygos. Attic Rhyton: Dog's
 Head
 Calder, A. The Dog
 Chinese. Dog, glazed pottery.
 Chinese--Han. Dog
 --Seated Dog
 Chinese--T'ang. Guardian Dog,
 glazed pottery
 --Resting Dog
 Colima. Dog#
 --Effigy Vessel: Dog Wearing
 Human-Face Mask
 --Jar: Seated Hairless Dog
 --Sitting Dog, with Human
 Mask
 --Sitting Howling Dog
 --Vessel: Dog
 Coptic. Leaf Scrolls, with
 animal in roundels
 --Martyrdom of St. Thecla
 Cycladic. Dog and Young
 Diederich. Diana and Hound
 --Firescreens: Dogs
 --Playing Dogs
 Duhme. Summer
 Egyptian--Predynastic. Knife
 Egyptian--18th Dyn. Hunting
 Scene of Amenemhet

Egyptian--19th Dyn. Dog
Egyptian--19/20th c. Wolf-
 Dog
Etruscan. Chariot-Cover,
 relief: Boar Hunt with
 Dogs
--Cinerary Urn, reliefs:
 Banquet and Dancers
--Engraved Mirror: Adonis
 (Atunis) and Lasa
--Tomb-Monument: Dying
 Adonis
--Tomb Relief: Three-
 Headed Dog
Folk Art--American. Dog
--Jointed Dachshund
--Spotted Dog
--Toy Dog
Folk Art--Mexican. Toys:
 Rooster; Dog; Adam and
 Eve
Fraser, L. G. Irish Setter
 Club of America Medal
--Snuff
Greatbach, D. Hound-Handle
 Pitcher
Greek. Artemis and Actaeon,
 metope
Greek--7th c. B. C. Soldiers,
 Horse and Dog, tomb
 relief
Greek--5th c. B. C. Death
 of Actaeon
--Funeral Banquet
--Grave Stele: Traveller
 Resting on Stick
--Stele: Seated Youth with
 Dog under Chair
Greek--4th c. B. C. Stele:
 Youth with Dog and Bearded
 Figure
Greenough, H. The Rescue
Hayes. Chien Moquer
Hayes. Chinese Dog
Hebert, L. P. Maisonneuve
 Monument: Iroquois
 Warrior
Hidemasa. Dog, netsuke
Huntington, A. H. Hound on
 the Hill
Indians of Mexico. Two-
 Wheeled Toys
--Human and Dog Figures
Indo-European. Equestrian,
 Animals--including Dog
Jackson, H. B. Draco, wolf
 dog, head
Lathrop. Saluki
Leochares. Eagle and Ganymede

Luristan. Dogs, cheek piece
with bit
Lysippus. Alexander
Sarcophagus
McCartan. Diana
Manship. Diana
Manship. Hound Dog
Manship. Indian Boy Hunter
Manship. Indian Hunter#
Marisol. Woman and Dog
Maya. Whistle: Seated
Mother, with Child and
Dog
Mestrovic. St. Rochus, high
relief
Michnick. Two Puppies
Minoan. Cylinder Seal: Two
Men and Mastiff
--Lenticular Seals: Two
Ibexes and Dog
Mississippi Culture. Vessel:
Dog
Mounts. Poodle
Nakian. The Lap Dog
Nickford, J. Running Dog
Okatomo. Dog, netsuke
Palestinian. Dog Fighting
Lion
Persian. Intaglio Ring:
Sphinx Confronting
Greyhound
Philbrick, E. A. Lady
(a setter)
Proctor, A. P. Pointer
Robus. Dog
Roman. Dying Hunter
--Meleager, with Dog
Roman--1st c. Dog
--Wild Boar Attacked by
Dogs
Roman--2nd c. Farnese Bull
--Sarcophagus: Hunting
Scene
--Satyr and Maenad, relief
Roman--2nd/3rd c. Dog
Confronting Lion, relief
Rumsey, C. C. Hound
Sanford, E. F. Great Dane
Stevens Foundry. "Speaking
Dog", mechanical toy
bank
Sumerian. Mastiff with
Puppies, plaque
Swarz, S. The Guardian
(police dog)
Talbot, G. H. Vision of
Diana (Russian wolf
hounds)

Tlatilco. Vessel: Seated Dog
with Open Mouth
Toltec. Animal-Form Art
Tomotada. Dog, netsuke
Torrey. The Vanishing Indian
United States Potteries.
Poodle
Ward, J. Q. A. Indian
Hunter
--Simon Ward
Zorach. Hound
Dogu Figure. Japanese--Ancient
DOIDALSAS, OF BITHYNIA (Greek
fl 3rd c. B. C.)
Aphrodite Bathing
CHASE 110 UNNMM
--3rd/2nd c. B. C. (Roman
Copy) marble
BEAZ fig 185 FPL
Crouching Aphrodite (Crouch-
ing Venus) (Copy) original:
mid 3rd c. B. C. bronze;
LS
BOE 218; CLAK 350; LAWL
pl 25A FPL
--(Roman marble copy) c 275
B. C.
BAZINW 154 (col) DCN
--(Kneeling Aphrodite),
Hadrian's Villa (Tivoli copy)
c 230 B. C. marble; 43
KO pl 19; RICHTH 156 IRT
Dolce Far Niente. Fasano
Dolio
Roman. Dolio
--Figure and Dolio
Dollard Monument. Laliberte
Dollard's Last Stand
Hebert, L. P. Maisonneuve
Monument, detail
Dolls
African--Bakuba. Faceless
Doll
African--Yoruba. Omolangidi
Doll
Folk Art--American. "Camela
Doll"
--Cornhusk Doll(s)#
--Doll
--Jointed Indian Doll
--Knitted Doll
--Mehitable Hodges (The
Salem Doll)
"Mollie Bentley" Doll
--Quaker Doll
--Rag and Corn-Husk Dolls
--Rag Doll
Folk Art--American Negro.
Doll, post figure

Folk Art--Indian. Craft
 Toys
Greek--5th c. B. C. Female
 Figure: Doll
 --Toys
Inca. Doll, Cerro Plomo
Indians of Mexico. Articulated
 Doll(?)
Indians of South America--
 Peru. Cloth Doll
Mohave. Doll in Cradle Board
Nootka. Movable-Puppet Doll
Seminole. Dolls
Yuma. Dolls
Dolly. Christo
Dolmen See Cromlechs, Dolmen,
 Menhir
Dolon
 Greco-Roman. Diomedes and
 Odysseus Preparing to
 Kill Dolon
Dolphin Candlestick
 Boston and Sandwich Glass Co.
Dolphins
 Barbarossa. Dolphin Fountain
 Coptic. Cornice fragment:
 Dancing Nereids; Sea Sprite
 Riding Dolphin
 --Mask on Couch, supported
 by Erotes and Dolphins
 --Nereids and Boy on a
 Dolphin
 De Francisci. Leaping
 Dolphins
 Etruscan. Sarcophagus Plaque,
 incised detail: Dolphin
 Folk Art--American. Dolphin
 Circus Wagon
 Greek. Eros on the Dolphin
 Greek--7th c. B. C. Island
 Gem: Stag with Dolphins
 Greek--5th c. B. C. Coin,
 Taranto: Hero Riding Dolphin
 --Demareteion
 --Goddess: On Dolphin
 --Signature Seals
 Greek--4th c. B. C.
 Byzantium Coin: Herakles
 Strangling Serpents; Cow
 and Dolphin
 Hawkins. Triton on Dolphin
 Hellenistic. Venus: with
 Dolphin
 Horn. Boy with Dolphin
 Kimon. Syracuse Coin
 Lachaise. Dolphin Fountain
 Lachaise. Jumping Dolphins
 Roman--1st c. B. C./1st c.
 A. D. Boy with Dolphin

Veracruz. Hacha: Male Head
 with Dolphin Crest
DOMBEK, Blanche (American 1914-)
 At the Zoo French oak
 AMAB 146
 Defiance walnut
 ROODW 67
 The Determinant Brazilian
 rosewood
 BRUM pl 36 UNNSC
 Evil-Eyed Bird carved
 wood; 55
 SG-6
 Hierophant mahogany, birch,
 pine; 54
 SG-3
 Madonna bronze; 10
 SG-7
 Sculpture*
 AMAB 74 (col)
 The Spirit of the Cat 1956
 terracotta; 15
 BERCK 193
 Torso of a Dancer English
 Walnut; 18
 SG-5
 Unity snakewood
 BRUM pl 35 UNNSC
Dome--632. Baker, G. P.
Domen, mask. Japanese--Ancient
DOMINGUEZ, Lorenzo (Chilean
 1901-)
 Professor Lifschust, head
 TOLC 83
Dominican See Haitian; Puerto
 Rican
Domitia Lucilla (Roman Empress)
 Roman--2nd c. Domitia Lu-
 cilla (?), head
Domitian (Roman Emperor 81-96)
 Roman--1st c. Domitian,
 head
 --Returning Vespasian,
 Welcomed by Son, Domitian,
 with Lictors
DOMOCHOWSKI, H.
 K. K. Pulaski, bust marble
 USC 196 UDCCap
DOMOTO, Hisao (Japanese 1928-)
 Solution of Continuity, 57--
 12-part screen 1963 alumi-
 num and canvas; ea panel:
 63-1/8x15-3/4
 NMAJ 13 (col)
Donahue, Peter
 Tilden, D. Donahue Monument
Donata. Coletti
DONATO, Guiseppe (Italian-American
 1881-)

Medal
 PAA-28
Pan, Voice of the Forest
 plaster replica
 NATSA 49 UPHP
"La Doncello del Occidente"
 Colima. "Maiden of the
 West"
DONGON See AFRICAN--DOGON
Donkeys
 Assyrian. Wild Asses Hunted
 with Mastiffs
 Chinese--Han. Pole Top:
 Wild Ass
 Coptic. Ass Eating Fruit in
 Basket, door panel
 --Man and his Donkey
 Egyptian. Asses at
 Watering-Place
 --Gathering in the Crops,
 Mastaba wall relief
 Egyptian--5th Dyn.
 Ptahhotep: Asses and
 Herdsman, relief
 --Ti Tomb: Donkeys
 Threshing Wheat
 Egyptian--6th Dyn. Mastaba
 of Akhtihetep
 Flannagan. Ass
 Greek--5th c. B. C.
 Tetradrachm of Mende,
 Macedonia: Dionysus
 Riding an Ass
 Lathrop. Sammy Houston
 Sumerian. Chariot Drawn by
 Four Asses
 --Donkey, mascot on rein-
 guide
Donne, John
 Baskin. John Donne in his
 Winding Cloth
Donner Pioneer Monument. Ameri-
 can--20th c.
DONOGHUE, John Talbott
 (American 1853-1903)
 Venus
 HART-2:57; HARTS pl 50
 The Young Sophocles--Lead-
 ing the Chorus after Battle
 of Salamis
 1885/1927 bronze; 92-1/2
 PAG-12:198; TAFT 433;
 UNNMAS 61 UNNMM
 (27. 65)
Don't Fall. Rivers, L.
Don't Know Why There's No Sun-
 shine in the Sky. Graham
Door F. Melchert

Door-Frames
 American-Bamum. Carved
 Door-Frame
 Maori. Door Frame: Faces
 and Mythological Figures
Door-Jambs
 Melanesian. Door-Jambs:
 Ancestor Figures
 Melanesian--New Caledonia.
 Door-Jamb #
Door Knockers
 Chinese--Ch'i. Monster
 Mask: Door-Ring Holder
 Islamic. Door Knocker
Door Posts
 Melanesian--New Caledonia.
 Door-Post#
 --Pair of Door Posts
Doors See also Gates and Gateways
 Adams, H. Library of
 Congress Doors
 African--Dogon. Door
 African--Nigeria. Carved
 Door
 African--Senufo. Door#
 --Granary Door
 African--Yoruba. Palace Door
 Amateis, L. Door: Transom
 (Apotheosis of America)
 and eight panels
 American--18th c. Chalkley
 Hall Doorway
 --Georgian Doorway
 Arowogun. Door, four
 registers of relief carving.
 Bain. Port Elizabeth Reserve
 Bank Doors
 Bolivian--17th c. Portal,
 Church of San Lorenzo
 Chinese--T'ang. Tomb Door
 Churrigueresque. Doorway
 Colombian--18th c. Baroque
 Portal
 Coptic. Doors, Church of
 Sitt Barbara
 Cormier. Door Panels
 Crawford. Capitol Doors
 Dayak. Borneo Doors
 Faville. Portal of Varied
 Industries Palace
 Folk Art--American. Door
 Stop#
 Goldsmith. Front Doorway
 Greek--5th c. B. C.
 Erechtheum: Decorative
 Patterns, North Door
 Indian--Hindu--18th c. House
 Entrance

Indian--Maurya. Cave
Entrance
Islamic. Mosque Door(s)#
--Portal
--Seljuk Doors: Geometric
and Floral Design
--Seljuk Portal#
Kirchmayer. Church Door
Latin American—18th c.
Portal
Lisboa. Portal and Facade
Lyle. Bank Door
Mameluke. Door Leaf
Maori. Door, Hall of
Judgment
--Door Ornament, fragment
Mexican--16th c. Plateresque
Portal#
Mexican--18th c. Portal of
College of San Ildefonso
Niehaus. Church Doors
Persian. Doors
--Doorways, ruins of
Palace of Darius I
Ricci, U. Commercial
Building Entrance
Rogers, P. Doors, Central
Portico, East Front--
Christopher Columbus
Roman. Burial Chamber Door
Spanish Missions--Texas.
Mission San Jose y San
Miguel de Aguayo: Doorway
Sullivan, L. H. Bronze Door,
Getty Tomb Design
Vrana. Church Doors
Warner, O. L. "Oral
Tradition" Door
Weinman, A. A. Academy
Doors
Whiting, G. V. Portals of
El Dorado
Doors of the Thirty-Six, ark doors.
Schor, I.
DORFMAN, Hyman (American, aged
14 years)
Mother and Child
NNMMS #430
Dorma Figure. Nepalese
Dormeyer Mixer. Oldenburg
Dorothy. Horn
Doryphorus. Polyclitus
Doryphorus
Polyclitus--Foll. Doryphorus,
bust
Roman. Doryphoros, fragment
DO-SHO (Japanese)
Moth, netsuke ivory
SOTH-2:133

Dotaku (Bells)
Japanese--Ancient. Dotaku#
Double-Axe
Minoan. Votive Double-Axe
Double Bean. Strider
Double Creature. Squier, J.
The Double Cross. Mestrovic
Double Crown. Egyptian
Double Face. Stankiewicz
Double Flower. Strider
Double-Headed Figure. Hawaiian
Double Mushroom. Calder, A.
Double Portrait--Torsos. Higgins
Double Ribbon. Moholy-Nagy
Double Shell. Bieler
Double Top. Valentine, D.
Doughboy. Cummings
Douglas, Frederick (American
Negro Writer 1817-95)
Louis, J. E. Frederick
Douglas
Douglas, James (Mining Engineer
1837-1918)
De Francisci. American
Institute of Mining
Engineers Medal: James
Douglas
Dovecote. Cornell
Doves
Baillairge--Attrib. Doves
Drinking
Coptic. Gravestone, detail:
Dove on a Shell
Cypriote. Priest with Dove
Etruscan. Praeneste Cos-
metic Boxes: Deer; Dove
Greek. Dove
Hellenistic. Girl: With Dove
Maldarelli, O. Dove
Melanesian--Solomons. Idol
from War Canoe: Human
Figure with Dove
--Prow Ornament: Man
Holding Dove
Trujillo, C. Pin: Dove
Dow, Louis Henry
Grimes. Louis Henry Dow,
relief profile
Dow Road. Schloss, E.
DOWLER, Charles--ATTRIB
Race Track Tout, cigar
store figure c 1880/90
ptd wood; c 60 (excl base)
LIPA pl 78; PEN 22
UNNPen
Downspouts
Folk Art--American. Down-
spout, Head
Javanese. Fountain, or
Downspout

Les Drapeaux. Ferber
Draped Torso. Albert, C.
Drapery, carved to show
 embroidery. Damophon
Dravpadi Rath See Pandava (Five)
 Raths
Dravspa, Angel
 Sassanian. Rhyton: Angel
 Dravspa
The Dream. Geber
Dream. Nicolosi, J.
Dream. Viterbo
Dream Blossoms. Barnard
Dream of Queen Maya See Maya,
 Queen
Dreamer. Ambellan
The Dreamer. Glinsky
"The Dreamer". Praxiteles
Dreamer. Robus
The Dreamer. Sears, P. S.
The Dreamer of the Forest.
 Zadkine
Dreams. MacNeil, H. A.
Dreams. Morgan, F. M.
DRIESBACH, Walter C. (American
 1929-)
 Reclining Torso 1959 Georgia
 marble
 CIN # 13
Driller. Allan, H.
The Driller, Goodelman
The Driller. Niehaus
The Driller. Young, M. M.
Drill-Bows
 Eskimo. Bow Drill
 --Drill-Bows
Drinkers and Drinking
 Assyrian. Ashurnasirpal II
 Drinking
 Khmer. Drinking from Jar,
 relief
 Mitannian. Cylinder Seal:
 Seated Figure Drinking
 Through Tube
 Sumerian. Cylinder Seal:
 Ritual Banquet--Seated
 Figures Drinking Through
 Tubes
Drinking Horns See Oliphants
 African--Bakuba. Drinking Horn
Driving Image Show. Kusama
DROWNE, Shem (American 1683-
 1776)
 Cock Weathervane, New Brick
 Church, Boston ("Revenge
 Cockerel") 18th c. copper,
 gilded; c 60x12
 CHR 77 UMCCo

Grasshopper Weathervane
 1742 sheet copper, with
 glass eyes; L: c 30
 LIPA pl 25; MEN 146
 UMBFH
 Indian Archer, weathervane,
 Province House Cupola c
 1716 moulded copper; 54x48
 AM# 43, cov (col); ARTS
 86; LARK 44; LIPA pl 30;
 MEN 146; ROOS 256C
 UMBHS
Drowned Girl. Greenbaum
Druid Oak. Calfee
Drumgoole, John C. (Religious
 Worker 1816-88)
 Cushing, R. Father
 Drumgoole
Drumheller Fountain
 Halperin, L. , and
 Associates. Fountain
DRUMM, Don
 Song of Gothic cast and
 welded aluminum
 MEILD 141
Drums See Musicians and Musical
 Instruments
Drunken Old Woman. Myron
Drusus Caesar (Roman Governor
 and Consul 15(?) B. C. -23
 A. D.), called Drusus Junior
 Roman--1st c. Drusus Junior,
 head
The Dry Cleaning Store. Segal, G.
Dryads See also Nymphs; Yakshi
 Coptic. Dryads
 Manship. Centaur and Dryad
DRYFOOS, Nancy (American)
 Torso marble
 NATSS-67:10
The D's Testament. Bouras
Du Lion d'Or. Cornell
"Dual". Archipenko
Dual Form# Moholy-Nagy
Dual Hamburgers. Oldenburg
DUALA See AFRICAN--DUALA
Duality, Eternal Game of Life.
 Hoffman-Ysenbourg
DUBIN, William (American 1937-)
 No. III 1964 exotic hardwoods;
 2-1/2x1x1-1/2
 NYWL 95
 Tertiumquid 1966 exotic hard-
 woods; 37x25x18
 UIA-13:86 UCSFDi
DUBLE, Lu (English-American
 1896-)

Bird terracotta; L: 22
SG-4
Cain 1953 Hydrocal; 38
PIE 385 UNNW (53. 35)
The Comet cast stone
SGO-4:pl 14
Dark Mother plaster; 40
NM-13:# 34
Death and Transfiguration
glazed terracotta; L: 40
SGO-17
Diminished Bird terracotta;
22
SG-3
Funeral Dancer plaster, for
bronze
BRUM pl 38
UNNGr
Juan de Dios, head plaster
SCHN pl 12
Maya Woman, head cast
stone
SGT pl 13
El Penitente plaster, for
bronze
BRUM pl 37 UNNGr
Prayer to the Dead plaster,
for bronze
SCHN pl 34
Stymphalian Bird Hydrocal;
L: 48
SG-2
Ti Kita plaster
SGO-2:pl 25
Voodoo God of the Dead
plaster NYW 188
The Widow patined plaster
SGO-10:13
DUBON, Jorge (Mexican)
Birds (Pajaros)
LUN
Figure
LUN
Peces
LUN
Viper (Vibora)
LUN
DU BOSE, Charles, architect
Constitution Plaza Fountain
BISH UCtHC
Duck Baby
MacMonnies. Boy and Duck
Parsons, E. B. Duck Baby
Ducks
African--Barotse. Bowl for
Meat and Vegetables--
wild ducks on lid
Burmese. Duck

Chimu. Zoomorphic Stirrup-
Vessels
Chinese--Han. Vessel:
Duck's Head Handle
Chinese--Ming. Box: Duck
Clareout. The Duck
de Marco. Duck
Egyptian. 6th Dyn. Mastaba
of Akhtihotep
Egyptian--18th Dyn. Ducks,
swag block detail
--Girl Holding Duck
--Girl Swimming after Duck
--Ointment Box: Swimming
Duck
Egyptian--19th Dyn. Ungent
Holder; Trussed Duck
Egyptian--25th Dyn. Bed-
Leg: Duck
Etruscan. Cinerary Urn,
reliefs: Banquet and
Dancers
--Jug: Duck
--Vase: Duck
Flannagan. Duck
Folk Art--American. Decoy:
Male Eider Duck
Hopewell. Pipe: Spoonbill
Duck
Indians of Mexico. Vessel:
Duck
Kane, M. B. Loving Ducks
Korean. Duck, water-dropper
to dilute ink of ink-stone
Laessle. Duck and Turtle
Fountain
MacMonnies. Boy and Duck
Maya. Duck Vessel
Mochica. Stirrup Jar: Duck
Phoenician. Cosmetic Jar:
Duck
Ryugyoku. Oshidori, mandarin
duck, netsuke
Sumerian. Weight: Duck
Tlatilco. Duck, pot
--Jar: Swimming Duck
--Vessel: Swimming Duck
Walter, C. Inlaid Duck
Dude, in Derby
Folk Art--American. Cigar
Store Figure: Dude
Dudu
Sumerian. Dudu#
Duelin. Greek--6th c. B. C.
Duet. Weinman, A.
DUHME, H. Richard (American
1913-)
St. Francis and the Wolf
1950 bronze CIN # 15

Summer plaster
NATSS-67:11
Duho, backrest. Indians of
Central America--Bahamas
Dukduk Secret Society Mask: Tumbu-
an. New Guinea
DUNBAR, Anna Glenny (Mrs.
Davis T. Dunbar) (American
1888-)
The Jewess, half figure
1934/35 red concrete,
cast; 24
ALBC 169 UNBuA
DUNBAR, Ulric Stonewall Jackson
(Canadian-American 1862-1927)
Martin Van Buren, bust
marble
FAIR 330; USC 180 UDCCap
Thomas A. Hendricks, bust
marble
FAIR 339; USC 176 UDCCap
Dunkirk. Kohn, G.
Dunlop. Voulkos, P.
DUNWIDDIE, Charlotte (French-
American)
Dying Chiron bronze; 16
HARO-3:37
Duo. Phillips, H.
DURANT, Helene (American)
Group walnut
UNA 11
DURCHANEK, Ludvik (Austrian-
American 1902-)
Auntie 1959/60 nickel; 29-1/2
x16x19
WHITNS 9 UNNW
The Family hammered bronze
WHITNA-17:14
Fury 1958 welded sheet
bronze
MEILD 139 UNNMMA
Homo Derelicto 1964/65
KULN 14
Mat Wheeler's Wife 1957/58
bronze; 74
NMAR
Seated Man 1959 hammered
copper; 39
WHITNF--4:4 -UKi
The Wish 1962 hammered
bronze; 74
UIA-11:75 UNNGrah
Durga, "The Inaccessible One",
Wife of Siva See also Devi
Indian--Pallava. Durga
Khmer. Durga, torso
Dustin, Hannah (Colonial Indian
Captive b 1659)
Weeks, C. H. Hannah Dustin

Dutch (Subject)
Japanese--Tokugawa. Net-
suke: Dutchman Holding
Fighting Cock
--Netsuke: Dutchmen with
Fowls
--Netsuke: Kirin and a
Dutchman
Duttha Gamani (King)
Ceylonese. Bodhisattva, or
King Duttha Gamani
--Duttha Gamani
Duveneck, Elizabeth Boott (d 1888)
Duveneck. Elizabeth Boott
Duveneck, effigy
DUVENECK: Frank (American
1848-1919)
Elizabeth Boott Duveneck,
effigy 1891 gilded bronze;
28-1/2x85x38-3/4
NEWAS 16 TAFT 523;
UNNMMAS 57 UNNMM
(27. 74)
Portraits
Grafly. Frank Duveneck,
artist
Dvarapala
Ceylonese. Door Guardian
--Dvarapala
Chinese--T'ang. Dvarapala#
Indian--Deccan--Chalukya.
Dvarapala
Indian--Hindu--10th c.
Dvarapala
Khmer. Dvarapalas, head
Dwara-Pala See Dvarapala
Dwarfs
African--Benin. Dwarves
Egyptian--6th Dyn. Dwarf
Seneb and his Family
Egyptian--18th Dyn. Dwarf
Holding Vase
Greek--6th c. B. C.
Hercules: Carrying Two
Dwarves
Hellenistic. A Dwarf
Maya. Dwarf and Other
Figures, vase detail
Olmec. Seated Dwarf
--Dwarf-like Crying Child
Reder, B. Dwarf with
Cat's Cradle
Sumerian. Cylinder Seal:
Worshipper Presented to a
God
Dwelling. Grow
DYER, Carlus (American 1917-)
Scintillation of Elements 1957
steel and bronze; 59-1/2
NMAR

The Dying Alexander. Greek
Dying Asiatic, head. Hellenistic
Dying Callisto
 Greek--5th c. B. C.
 Barberini Suppliant
Dying Centaur. Rimmer, W.
Dying Gaul. Hellenistic
Dying Gladiator
 Hellenistic. Dying Gaul
The Dying Hercules. Morse,
 S. F. B.
The Dying Indian. Rumsey, C.
Dying Lioness
 Assyrian. Wounded Lioness
 (Dying Lioness)
Dying Persian. Pergamene
DYKAAR, Moses A. Wainer
 (American 1884-1933)
 Alexander Graham Bell,
 bust 1922 marble;
 21-1/2
 USNM 76 UDCNMSC
 Calvin Coolidge, bust
 marble
 USC 174 UDCCap
 Charles Curtis, bust marble
 USC 174 UDCCap
 James B. (Champ) Clark,
 bust marble
 FAIR 454; USC 191 UDCCap
 Nicholas Longworth, bust
 marble
 USC 191 UDCCap
 Thomas B. Marshall, bust
 marble
 FAIR 344; USC 178 UDCCap

E
 Chryssa. Letter E.
E. G. Whitman, R.
Ea
 Mesopotamian. Snake God
 Fighting with Ea and the
 Gods of Fertility. Cylinder
 Seal
Each Others Mine. Rosati
Eads, James Buchanan (American
 Engineer and Inventor 1820-87)
 Grafly. James Buchanan Eads,
 bust
Eagle Knight. Aztec
Eagle Warriors
 Maya. Vase: Eagle Warrior
 --Whistle: Eagle Warrior with
 Shield and Club
 Totonac. Tajin Main Ball
 Court Panel Reliefs:
 Northeast--Sacrifice Scene;
 Southwest--Eagle Warrior
 Ritual

Eagles
 American--18th c. Golden
 Eagle
 Assyrian. Eagle
 Aztec. Drum, with Eagle
 Decoration
 --Standing Drum with carved
 Eagle and Tiger decoration
 Bactrian. Wine(?) Bowl,
 repousse: Eagle; and
 Anath Cycle Scenes
 Baudin. Bronze Stairway:
 Eagles and Putti
 Beach. The Early Ages
 Bellamy. Decorative Eagle
 Bellamy. Eagle Figurehead
 Clark, N. K. Bald Eagle
 Der Harootian. Eagles of
 Ararat
 Egyptian--37/30th Dyn.
 Eagle, faience box
 ornament
 Folk Art--American. Ameri-
 can Eagle
 --American Eagle on Orb
 --Bald Eagle, with Olive
 Branch and Arrows, and
 16 stars, inlaid design
 --Bellamy-Type Eagle
 --Blacksmith's Shop Sign:
 Eagle
 --Eagle#
 --Eagle: Holding Shield and
 Olive Branch, architectural
 ornament
 --Figurehead: Eagle Head#
 --Figure Head: Eagle and
 Snake
 --Fire-Marks: Fire Engine;
 Man; Eagle
 --Spread Eagle, plaque
 Franzoni, C. Justice, with
 Scales and Sword; Eagle
 Greek--6/4th c. B. C. Coins
 Greek--5th c. Agrigentum
 Tetradrachm: Two Eagles
 with Hare; Scylla and
 Crab
 --Decadrachm, Akragas: Two
 Eagles on a Hare; Grass-
 hopper
 --Rhyton: Eagle
 --Stater, Elis: Eagle's head
 --Tetradrachm, Aetna:
 Silenos; Enthroned Zeus
 Facing Eagle in Pine Tree
 Greek--4th c. B. C.
 Earrings: Ganymede with
 the Eagle

--Elis Coin: Zeus, head;
 Eagle of Zeus
Haida. Berry Spoon: Eagle
--Eagle Head, totem pole
 finial(?)
--Totem Pole: Shark; Eagle
Harootian. Eagles of Ararat
Hawkins. Eagle
Hellenistic. Eagle
--Tetradrachm, Ptolemy
 Philadelphus of Egypt:
 Eagle
Hidemasa. Eagle Attacking
 Monkey, netsuke
Hittite. Assembly of Gods
Hurrite. Sphinx Gate: Two-
 Headed Eagle Decoration
Indians of Central America--
 Panama. Pendant: Eagle#
Indians of North America--
 Ohio. Eagle
Indians of South America--
 Peru. Eagle Holding
 Serpent
Japanese--Tokugawa. Kakiemon
 Eagle
Jennewein. Indian and Eagle
Jingo Master, Second.
 Eagle on Rock, swordguard
Kreis. Eagle
Laessle. Defiance
Laessle. Victory (an eagle)
Lawrie. Patriotism: Citizen
 Leaning on Plow; Eagle
Leochares. Eagle and Gany-
 mede
Maya. Eagle, head
Mounts--Attrib. Eagle
Pennsylvania Dutch. Tows:
 Eagle, Rooster and Two
 Hens
Persian. Situla: Hunter
 Pursuing Eagle
Piccirilli, H. Black Eagle
Purrington, H. J. Eagle
 Prow
Reder, B. Woman with Eagle
Roman--1st c. B. C. Eagle,
 cameo
Roman--2nd c. Apotheosis of
 Claudius
Rush, W. Eagle
Saarinen, L. Eagle
Schimmel. Eagle
Schimmel. Eagle and
 Squirrel
Schimmel. Screaming Eagle
Schimmel. Toy Animals:
 Rooster, Eagle, Parrot

Schwarzott. Fighting Eagles
Sprinweiler, E. Eagle
Sumerian. Cylinder Seal:
 Mythological Subject--Two
 Human-Headed Bulls
Tlingit. Ceremonial Hat with
 Eagle
--Eagle Totem
--Pipe Bowl: Eagle
Tsimshian. Headdress:
 Eagle Bearing Frog on
 Chest
Vera Cruz. Eagle Heads
Veraguas. Eagle
--Eagle Pendant
Zapotec. Eagle's Claw
 Vessel
Eakins, Benjamin
 Murray, S. Benjamin Eakins
 bust
EAKINS, Thomas (American 1844-
 1916) See also 'O'Donovan,
 W. R.
 Arcadia, relief H: 17
 SEITC 188 UNNH
 General Grant's Horse, high
 relief 1893/94 bronze; LS
 PIE 379 UNBMA
 Horse, from Group of Four
 Horses 1879 bronze;
 MCCUR 247 UNNK
 Knitting, relief bronze;
 18-1/2x15
 PIE 379 UPPPM (30-32-22)
 Spinning, relief bronze;
 18-1/4x14-1/2
 PIE 379 UPPPM (30-32-21)
 Portraits
 Murray, S. Thomas Eakins,
 seated figure
EAMES, Ray
 Sculpture molded plywood
 NNMMAP 200
Eannatum (Ruler of Lagash c 2550
 B. C.)
 Sumerian. Votive Stele of
 Eannatum
Ear# Miki
Earheart, Amelia
 Putnam, B. Amelia Earheart,
 head
Early Bird. Flannagan
Early Bird. Pierron
Early Morning Hours. Anderson,
 J. R.
Early Spring. Goto
Earrings and Ear Ornaments
 Aztec. Ear Spools
 Chavin. Circular Ear
 Ornament

Chimu. Ear Ornaments
--Ear Spool#
--Ear Whorl: Rowers in
 Balsa, with sail(?)
--Earplug(s)#
--Earrings
Etruscan. Earrings#
--Filigree Earrings
--Gold Earring
Fiji. Chief's Neck Ornament--
 orange cowry on fibre; Ear
 Ornaments
Greek--4th c. B. C.
 Earring(s)#
Hellenistic. Earring: Siren
 Playing Kithara
--Hoop Earrings: Lion-
 Griffin Heads
Indian. Earring#
Indian--Hindu--18th c. Ear
 Pendants
Indian--Kushan--Gandhara. Ear
 Pendant#
Indians of Mexico. Ear Disks
Indians of South America--
 Peru. Ear Ornaments
Indians of South America--
 Peru. Ear Plug
Lambayeque. Ear Plug
Maya. Ear Disks
--Ear Spool
Melanesian--Solomons.
 Personal Ornaments
Mixtec. Belled Ear Disks
Mochica. Ear Disks
--Ear Plug(s)#
Phoenician. Ear Pendant
Polynesian--Marquesas. Ear
 Ornaments#
Pomo. Man's Ornaments: Hair-
 pin; Ear Ornaments
Tiahuanaco. Mosaic Earplugs
Earspoon
 Chimu, and Indians of South
 America--Peru. Earspoon
Earth See also Tellus
 Aitken. Fountain of Earth
 Borglum, G. Pot of Basil
 (Earth)
 Chinese--Archaic. Earth
 Symbol
 Chinese--Shang. Ritual
 Vessel: Bird Surmounting
 T'ao-t'ieh Masks, with
 Earth Emblem
 Coptic. The Earth,
 personification
 Eckhardt. Earth
 Monasterio. La Tierra

Roman--1st c. B. C. Ara
 Pacis Augustae: Tellus
 Panel
--Ara Pacis Augustae,
 enclosure wall relief:
 Terra Mater
Shillam, K. Earth
Spoonburgh, M. Earth
Winkel, N. La Terre
Earth and the Elements. MacKennal,
 B.
Earth Cradle. Chinni
Earth Cradle# Seiden
Earth-Forge II. Lipton
Earth Goddess. Winkel, N.
Earth Loom. Lipton
Earth Mother. Lipton
Earth Mother. Walton, M.
Earthling. Epping
Earthquakes
 Peruvian--17th c. Christ of
 the Earthquakes
East Indian Dancer. Maldarelli, O.
East Side Tom. Werner, N.
Easter
 Kitson, H. H. Easter
Easter Goat. Zajac
EASTER ISLAND
 Ancestor Figure
 SOTH-1:121
 --wood
 LARA 97 ELBr
 --wood
 CHENSW 405 UPPU
 --wood; 14-1/2
 LOM 135 GMV
 --18/19th c. wood; c 16
 UPJ 562
 Ancestor figure, seated
 figure 19th c. ptd and
 bullrush-stuffed bark cloth;
 15-1/2
 LOM 93 (col) UMCP
 Breast Ornament (Rei-miro)
 L: 24
 HOO 94
 --W: 21
 NMSS 43 UNBuMS
 (C 12753)
 --wood; L: 15
 Ceremonial Paddle (Rapa)
 ptd wood; L: 80
 NMSS 46 UDCNM (129749)
 --wood; 32-7/8
 CHENSW t; NPPM pl 54
 UNNMPA (56-309)
 Ceremonial Staff Head: Human
 Head staff L: 59
 HOO 97

Colossal Figure stone
 CHENSW 405; GAUN pl 4
 ELBr
Colossal Figures stone
 PRAEG 560 ChiE
Dance Paddle: Conventionalized
 Human Figure L: 33
 HOO 97
Double Figure toro miro wood;
 15-1/2
 COOP 266 ESuAH
Female Ancestor Figure
 taomiro wood
 FEIN pl 35 UNNAmM
Female Figure toro miro
 wood; 22
 COOP 266 ESuAH
--wood; 23
 NMSS 48 UMCP (47752)
--(Moai Kavakava) wood, bone,
 with obsidian eyes;
 17-1/8
 NPPM pl 53 UNNMPA
 (58.98)
Figure
 ENC 674
--
 CHENSN 4 ELBr
--stone
 BATT 77 ELBr
--18/19th c. stone
 UPJH pl 304 ELBr
Figures ptd tapa cloth cover;
 15; and 12
 NMSS 47 UMCP (53543;
 and 53542)
--: Female and Ancestor
 Spirit; head detail female
 figure toro miro wood; 22;
 and 18
 HOO 95, 96
Fish Club wood; 18
 WINGP 315 ELBr
Hoa-Haka-Nana-Ia, human
 figure sandstone; 8x3'
 ADL pl 28A ELBr
Lizard wood; L:15-1/2
 NMSS 45 UMCP (53601)
--wood; L: 17
 MUE pl 116-117 BBRA
Makemake, Bird-Man God
 wood; L: 17
 NMSS 44 UNNAmM (5/5309)
Male, with Female Figure toro
 miro wood; 15
 HOO 97
Male Ancestor Figure wood; 17
 GARDH 646; NMSS 48
 UPPU (18059)

--wood; 17-1/2
 DEY 147 UCSFDeY
Male Figure tapa covered;
 22-1/2
 BOSMP #69 UMCP
--wood; 18-1/2
 BOSMP #68 UMCP
Memorial Figure, prominent
 ribs and vertebrae
 (Decimated Figure; Emaci-
 ated Figure; Skeletanized
 Male Figure) toromiro
 wood; 17-1/4
 ADL pl 29A; DURS 52;
 MUE pl 118-9 ELBr
 (3287)
--wood; 18
 WINGP 313 ScER
--wood; 18-3/4
 BUH 167 (col) ELBr
Monumental Heads, Rano
 Raraku slope c 17th c.
 stone; to 49'
 BAZINW 226 (col);
 CHENSW 402; HOF 34;
 JANSH 25; JANSK 37; LARA
 93; NMSS 42; VALE 56
 ChiE
--Head stone
 GAF 159 FPH
--Heads, Raraku slope
 SEYT 64-65, 80
 UDCNMS
--(plaster cast)
 ZOR 250, 251 UNNAmM
Rock Engraving, Ko Te Kari,
 Southwest Orongo
 ADL pl 28B
Tangatu Manu (Bird Man),
 Orango rock carving
 LARA 93 ChiE
Yoke wood
 CLE 305 UOClA (63.255)
Easy Greasy, Yuv Gotta Long Way
 to Slide. Potts, D.
Eat. Kaprow
The Eaters. Hare
EAVES, Winslow (American)
 Kneeling Figure marble; 19
 NM-12:#31
 Man, Space and the Unknown
 welded steel
 ZOR 299
Ebb and Flow. Egri
EBERLE, Abastenia St. Leger
 (American 1878-1942)
 Girl and Kitten Awakening
 NATS 86

Roller Skating before 1910
 bronze
 BAUR pl 8; WHITNC 221
 UNNW
 Stray Cat bronze
 NATSA 53
 Windy Doorstep
 NATS 85; NEUW 85
 --bronze
 PAG-12:218 UMWA
 --1910 bronze; 14
 BROO 156 UScGB
Eberstadt, Mary
 Grimes. Mary Eberstadt,
 head
EBERT, D. D. (American)
 Fertility
 CALF-62
Ebih-il
 Sumerian. Ebih-il, super-
 intendent of Ishtar Temple,
 Mari, seated figure
Ebotita, man-serpents. African--
 Kuyu
Ecclesiastics. Winkel, N.
Echelos
 Greek--5th c. B. C. Basile
 Abducted from Underworld
 by Echoles
The Echo. Goeritz
Echo, a Florentine Lady. Stevens,
 L. T.
ECK, Charles Anthony (American)
 Nocturne wood; 55
 HARO-2:39
ECKBO, Garrett
 Forecast Garden Fountain
 BISH UCL
ECKHARDT, Edris (American)
 Earth ceramic
 NYW 188
Eclipse# Wines, J.
Eclipse Series# Cornell
Eclipses
 Indian--Ganga. Surya Deul
 Temple. Rahu, Demon of
 Eclipses
L'Ecrivain. McVey, W. M.
ECUADORAN
 --17th c.
 Facade, with Salomonic
 columns
 WHY 147 EcQCom
 --18th c.
 Altar
 WHY 175 EcQMe
 Flight of the Holy Family into
 Egypt
 WHY 178 EcQMen

Gypsy Dancer wood
 WHY 176 EcQMe
Madonna of the Fifth Seal,
 Our Lady of Quito
 WHY 173 EcQMen
Main Altar silver
 WHY 163 EcQF
Mudejar Ceiling
 WHY 162 EcQF
La Perricholi, bust, garden
 WHY 223 PeLQ
"Piedad", Calvario
 WHY 173 EcQMen
Pulpit
 WHY 158 EcQM
Pulpit
 WHY 162 EcQF
St. Martin Moresque
 WHY 165 EcQMe
San Rafael
 WHY 165 EcQMen
Virgin of Light
 WHY 170
 --19th c.
Marshal Sucre
 WHY 152 EcQ
Edan
 African--Yoruba. Edan
 Figures
 --Rattle: Four-Faced; Edan
Eddy, Mary Baker (Founder of the
 Christian Science Church
 1821-1910)
 Sarrao, L. V. Mary Baker
 Eddy, bust
The Edge Combined No. 1. Levinson
Edge of Red. Padovano, A.
EDELHEIT, Martha (American)
 Frabjous Day, construction
 1960 c 60x42
 KAP pl 10
EDELMAN, Merle James (American)
 Gesture hydrocal; 37
 NM-13:# 25
EDENSAW, Charles (Haida Indian,
 Queen Charlotte Island, B. C.)
 Bear Mother Delivered by
 Caesarian Section 1875/
 1900 argillite; 7x7
 DOCA pl 110 UNNMAI
 (19/3520)
 Miniature Totem Pole: Bear,
 Frog, Raven, Killer Whale
 1850/65 argillite; 23-1/2
 CAN-3:344 CON (3534)
Edifice Public Empaquete. Christo
Edison, Thomas Alva (American
 Inventor 1847-1931)
 Baker, B. Thomas Alva
 Edison, bust

Edison, Thomas Alva 297

Sinnock, J. R. Thomas Alva
 Edison Congressional
 Medal of Honor
EDMOND, Elizabeth (American)
 Woman with Rabbit
 ACA pl 212
EDMONDSON, William (American
 1882-)
 Preacher 1938 limestone
 DOV 80 UNNBakerl
EDSTROM, David
 Florence Nightingale
 REED 121 UCL
 --1939
 REED 120 UCSFLa
Education, relief. Stea, C.
Edward I (King of England 1239-1307)
 Fraser, L. G. Edward I,
 medallion head
EDWARDS, Gudrun Elizabeth
 (Swiss-Mexican 1935-)
 Black Cathedral
 LUN
 Cuarto Creciente
 LUN
 Varsovia Suhuivors (El
 Sobreviviente de Varsovia)
 bronze, wood
 LUN
Edwards, Jonathan (American
 Theologian 1703-58)
 Adams, H. Jonathan Edwards,
 memorial tablet
 Grafly. Jonathan Edwards,
 bust
EDWARDS, Melvin (American
 1937-)
 August, the Squared Fire
 1965 steel; 44x40x30
 LAHF
 Chaino 1964 steel, wood;
 96x102x25
 LAHF
 The Lifted X 1965 steel; 64x
 22x50
 LAHF
 Moving 1965 steel; 41x25x36
 LAHF
 Standing Hang-up #1 1965
 steel; 65-1/2x22x16
 LAHF UCStbA
Effigy. Noguchi
Effigy Figures See also Ancestor
 Figures; Masks; Tombs
 African--Fang. Effigy
 Holding Wand
 --Guardian Effigy
 Luristan. Votive Effigies
 Paleolithic. Effigy

Palmyrene. Woman Funerary
 Bust#
Pueblo. Effigy Figure
Egg-and-Dart
 Greek--5th c. B. C.
 Erechtheum: Moulding
 Bands
Egg Pile. Agostini
Eggs
 Tomokazu. Egg, netsuke
EGRI, Ted (American 1913-)
 Comedy and Tragedy, study
 1958 welded steel,
 bronze; 24
 UIA-10:64
 Ebb and Flow steel, brass; 12
 ROODT 87 UCoDS
 Man Divided welded steel; 51
 HARO-3:27
EGUCHI, Shyu (Japanese)
 Monument No. 1 1963 cherry
 wood; 41-3/8x17x20-3/8
 NMAJ 82 UNNChap
 Monument No. 4 1964 cherry-
 wood; 18-1/4x22x14-1/4
 NMAJ 83 UNNMMA
Egun Mask. African--Yoruba
Egypt
 Roman--2nd c. Egypt,
 personification
Egypt Awakening. Elwell
EGYPTIAN
 Agricultural Workers, relief
 KUH 79
 Anubis as Jackel ptd wood;
 body L: 8-1/4; tail L:
 5-1/2
 TOR 11 CTRO (909. 35)
 Blue War Crown
 CASL 59
 Bow Harp
 ENC 381
 Canopic Jars
 ENC 154
 Cat, seated figure
 CRAVR 21 UNNMM
 Colossal Head granite
 BATT 78
 Cosmetic Accessories: Mirror;
 Ointment Spoon; Ointment
 Bowl: Bound Antelope
 bronze; 12-1/2; wood; L:
 14-1/4; wood; L: 4-1/2
 BERL pl 76 GBSBeA
 (2818; 1877; 8925)
 Double Crown
 CASL 59
 Facade, second propylon,
 Temple of Isis
 GLA pl 24 EgPh

Female Figure
 OZ 205
Gatherine in the Crops,
 mastaba wall
 COPGE cov DCN
Goddess Sekhmet bronze
 HOF 293 UICNh
Hemhemet Crown, Papyrus
 Bundles and Sun Disks
 CASL 58
Hippopotamus blue faience
 BRIONA 50 FPL
--blue faience, with line
 decoration of plants, buds
 LLO 91 UNBB
Horus: Battling Typhon, God
 of Darkness
 SCO-3:49
Horus, the Hawk
 KUH 27
Hyksos Chief, head, Fayoum
 MARQ 7 EgCM
Isis and Osiris bronze; c 8
 STI 78 UPPU
Kneeling Figure (unfinished)
 stone
 GARDH pl 37B; PANM il
 17 EgCM
Ma'et Kere, coffin cover
 GAUN pl 9 (col) EgCM
Male Head
 OZ 157
--diorite
 PUT 233
Male Figure
 LAWC 106
Man in Headdress, head
 marble
 ZOR 258 UNNMM
Mask: Man's Face wood;
 6-1/2
 BOSMI 173 UMB (60.1181)
The Naophorus
 NOG 286 IRV
Obelisk
 ENC 673 EgK
Offering, reliefs
 PUT 50, 51 UNNMM
Osiris, fallen unfinished
 figure red granite
 CASL 26-27 EgAs
Ouah Ab Ra, block statue
 TAYJ 24 FPL
Panels of Hieroglyphics
 CRAVR 20 UNNMM
Papyrus Bud Column
 LARA 157
Papyrus Flower Capital, half
 columns
 ENC 375

Porters wood
 READA pl 65
Prisoners, paired heads black
 basaltic stone
 LAH 19 UCLCM
Profile Head, relief lime-
 stone
 SLOB 133 UNNMM
Queen Tewe
 NOG 285 IRV
Ram, with human figure
 BATT 36 ELBr
Red Crown of Lower Egypt
 CASL 59
Reliefs, limestone
 ELIS 142, 143 UNNMM
Sail Ship with Figures
 OZ 211
Seated Figure granite
 BATT 79
--granite--roughing out to
 finish
 SLOB 132 UMB
Senemut, block statue
 LARA 139 ELBr
Statues, Court of Edfu hollow
 relief
 BARSTOW 14
Temple of Opet, facade
 HOF 191 EgK
Useful Objects: Spoons, Comb,
 Mirror
 STI 105
White Crown of Upper Egypt
 CASL 58
Winged Disk
 BARSTOW 20
Woman, relief fragment
 limestone
 CHENSN 66 UNNMM
Women Carrying Baskets on
 Heads; Soldiers
 OZ 208, 209
Yuny Offering to Osiris lime-
 stone
 DAIN 52
--Predynastic (Prehistoric),
 before c 3200 B.C.
Amratian Hippopotamus
 c 3500 B.C. pottery;
 11-1/2
 BOSMEG 23; BOSMI 171
 UMB (48.252)
Animal-Form Sculptures,
 Abydos and Nikkad
 STI 73
Animal Palette (Palette aux
 Canides) c 3100 B.C.
 schist;. 32x. 17m CHAR-1:
 23 FPL

Animal Palettes: Elephant,
Horse, Turtle, Rhinoceros,
Fish slate
BOSMEG 19 UMB
Badarian Woman, El-Badari
before 3500 B. C. terracotta;
3-1/2
BRITM 24 ELBr (59679)
--before 3500 B. C. ivory;
5-1/2
BRITM 113 ELBr (59648)
Battlefield Palette: Lion,
Vultures, and Ravens Attack-
ing Corpses on Battlefield;
Captives Guarded by
Standards, Hierakonopolis
c 3000 B. C. slate; 17
GARB 129; LARA 115; WOLD
40 ELBr; EOA
Bearded Man, seated figure
calcite; 2-15/16
TOR 8 CTRO (910. 92. 19)
Bird-Headed Diety c 4000 B. C.
ptd terracotta
CANK 53; FEIN pl 80/81
UNBB
Ceremonial Palette: Battle
c 3000 B. C. green slate
BAZINW 100 (col) ELBr
Commemorative Palette frag-
ment: Soldier c 3200 B. C.
slate; 2
NM-4:3 UNNMM (33. 159)
Cosmetic Palette, with Coiled
Snake, Palace and
Animals slate; 3-1/2
NM-4:2 UNNMM (24. 9. 8)
Couteau de Gebel el Arak
ivory, flint; L: . 253 m
CHAR-1:24 FPL
Cylinder Seal, Naga-el-Der
SMIW pl 9 EgCM
Dancing Figure, Amratian,
Naqada
LLO 29 EOA
Female Figure: Great Mother
Mamariyya 4000/3000 B. C.
ptd clay
BAZINW 94 (col) UNBB
Female Figure, Al 'Ubaid
terracotta
LLO 27 UPPU
--, funerary gift 4 mil B. C.
ptd clay; 29 cm
WOLD 22 (col) UNBB
--, funerary gift, Badari
c 4000 B. C. ivory; 14 cm
WOLD 24 ELBr

--, funerary gift, Nagada
c 4000 B. C.
WOLD 26 -Mac
Female Idols terracotta
FEIN pl 89 UPPU
Figure ivory
STI 74
--, Hierakonpolis ivory; 4
SMIW pl 5 UPPU
Figures ivory; 2-3/8
SMIW pl 1b UMdBW
--, Abydos and Hierakonpolis
BOSMEG 21 UMB
--, Gerzean Culture,
Naqada ivory; alabaster
LLO 26 EOA
Furniture Foot: Cattle Foot,
Abydos c 3100 B. C. ivory
CHAR-1:30 FPL
Hippopotamus pottery; L:
10-1/4
SMIW pl 2 UMB
Hooded Man c 3000 B. C.
basalt
CHRP 25 EOA
Human Figures wood and ivory
BOSMEG 21 UMB
Hunter's Palette, Hierakonopolis
LLO 32 FPL
--before 3100 B. C. schist;
L: 26
BRITM 27; LLO 32 ELBr
(20790)
Idol 3rd mil B. C. terracotta
FEIN pl 88 UNNMM
Jackal, El Ahaiwah slate;
L: 15-3/4
SMIW pl 3 UCBCA
Knife, Handle: Hunting Scene--
Lions, Dogs, Ibex; Battle
Scene, Gebel-el-Arak
4th mil B. C. flint blade,
ivory handle; L: 11
BAZINL pl 1 (col);
BAZINW 100 (col);
CHENSW 37; GARB 129;
LARA 63; LLO 31 (col)
FPL
Malachite Eye-paint Palette;
Tortoise, Naga-el-Hai
c 3400 B. C. slate,
shell-inlay eye; 6-1/4
BOSMJ 171 UMB (13. 3492)
Male Figure basalt; 15-1/2
SMIW pl 4 EOA
--c 3300 B. C. basalt;
15-3/4
GARB 131 EOA

--, with emblematic Mace,
Eridu terracotta
LLO 27 IrBaI
Mastaba Reliefs, Chapel of
Kaemarehu H: 67 cm
COPGE pl 8-11 DCN
(A-654)
Min, God of Koptos lime-
stone; 77
READAS pl 29 EOA
Mother and Child 4th mil B. C.
clay
BAZINL pl 25 ELBr
Palette, fragment slate
SMIW pl 6 FPL
Palette au Taureau schist;
. 275 m
CHAR-1:29 FPL
Perfume Spoon: Swimming Girl
Holding Duck c 5000B. C.
(?) wood
GROSS fig 36 EgCM
Ritual Figure: Female with
Raised, In-curving Arms
4000 B. C. terracotta,
ptd
MU 15 (col)
Sickle, Faiyum c 4000 B. C.
wood, flint blades; L: 20
BRITM 23 ELBr (58701)
Vase: Elephant before 3000
B. C. pink limestone; 5-1/4x
6-7/8
GRIG pl 4 ELBr
Woman and Child, figurine
before 3100 B. C. buff
pottery; 6-3/4
GRIG pl 1 ELBr
EGYPTIAN--Dynastic
Canopic Jar and Three Stop-
pers: Sons of Horus c 1000/
500 B. C. H: 12-3/8
(with stoppers)
YAH 11 UCtY
EGYPTIAN--Old Kingdom (1 to 8
Dynasties), c 3200 B. C. --
2445 B. C.
Male Figure, supposed proto-
type of Greek "Apollos"
CHENSN 106
Sphinx of Tanis red granite;
4. 79x2. 06 m
CHAR-1:58 FPL
Tomb Chamber Reliefs
CHASEH 23 UMB
Woman: Grinding Grain
ROOS 4E IFAr
Woman, bust
ROOS 3J EgCM

EGYPTIAN--1st Dynasty
Bowl, Saqqara schist;
Dm: 24
SMIW pl 9 EgCM
Couch Leg: Bull's Leg,
Abydos ivory; 6-1/2
NM-4:4 UNNMM
(26. 7. 282)
Den Striking Asiatic Chieftan,
label, Abydos c 3000
B. C. ivory; L: 2-1/4
BRITM 28 ELBr (55586)
Disk, Saqqara steatite;
Dm: 3-1/2
SMIW pl 9 UCBCA
Jeu du Serpent: Mehen
c 3000 B. C. alabaster;
. 17; Dm: . 40 m
CHAR-1:30 FPL
Jewelry, Naga-el-Der
SMIW pl 11 EgCM
--, Tomb of Zer, Abydos
SMIW pl 11 EgCM
King, Abydos c 3100 B. C.
ivory; 6-1/2
BRITM 128; CHENSW 38
ELBr
(37996)
Male Mask, Hu, Diospolis
Parva ptd plaster; 11
BRITM 230 ELBr (30845)
Narmer, relief slate ; 25
LANG pl 5 EgCM (3055)
Palette of King Narmer:
Narmer with Horus Falcon,
Goddess Hathor in form of
Cow; Narmer Preceded
by Standards--as wild ox,
entwined animals, Hieracon-
polis c 2900/2800 B. C.
slate; 26
CHENSW 38; JANSK 53;
MYBU 359; ROBB 275;
ROOS 3-B, -C; SMIW pl
7; STI 75; UPJH pl 6E;
WOLD 41 EgCM
--both sides
CASL 52, 53; GARB 130;
JANSH 34; LANG pl 4;
LARA 115; LLO 33
Palette with emblem of god
Min, El-Amra c 3100 B. C.
schist; 11-1/2
BRITM 113 ELBr (35501)
Stele of King Zet (Djet)(Stele
du Roi Serpent): Falcon of
Horus and Asp, Abydos
c 3000 B. C. limestone; 57
BAZINW 107 (col); BRIONA

49; CHAR-1:31; GAU 44;
HUYA pl 1; HUYAR 79; LARA
119 FPL
Tombstone of Kehen, relief,
Abydos stone; 33. 9 cm
WOLD 42 GHak
Udimu Striking down Asian
Adversary, ivory plaque--
sandal label, Abydos
LLO 66 ELBr
Votive Dagger c 3000 B. C.
blade--electrum; handle--
ivory; L: 22 cm
CHAR-1:30 FPL
EGYPTIAN--1st/2nd Dynasty
Amulet: Frog
black and white marble;
L: 1-1/2
SOTH-3:146
Baboon c 3000 B. C. alabaster;
20-1/2
BERL pl 69; BERLES 69;
CHENSW 37 GBSBeA
(22607)
Cosmetic Palette: Desert
Animals and Fabulous Beings
slate; 17
LANG pl 2 EOA
Cosmetic Palette: Giraffes and
Palms slate; 12-1/2
LANG pl 3 FPL
Hippopotamus c 3000 B. C.
alabaster; . 65x. 32 m
CANK 131; CHENSW 33;
COPGE pl 1; COPGG 17
DCN (AE L N. 1722)
Lion c 3000 speckeled
granite; L: 12-1/2
LANG pl 1 GBS (22, 440)
Male Figure c 3200 B. C.
stone
CHENSW 37 EOA
Palette: Gazelles Facing
Palm Tree (reconstructed)
11x13
STI 74 EOA
Seated Figure limestone
SMIW pl 12 EgCM
Triumph of King Demenpses,
rock wall relief, Wady Mag-
hare c 3000 B. C.
COPGE fig 5 EgSi
Victory Tablet, fragment
slate; 11
LANG pl 3 EgCM
EGYPTIAN--1st 3rd Dynasty
Nobleman, seated figure,
profile black granite
MILLER il 4 ELBr

EGYPTIAN--2nd Dynasty
Head of King in Crown
of Upper Egypt c 2800
B. C. limestone; 13-1/2
BOSMI 173 UMB (58. 324)
Khasekhem
BOSMEG 14 UMB
--, seated figure,
Hierakonpolis c 2700 B. C.
green slate; 22
GARB 132; SMIW pl 15;
WOLD 45 EgCM
--, seated figure,
Hierakonpolis
LLO 65 EOA
Niche Stone
SMIW pl 14 EgS
--, ptd
SMIW pl 13 EgS
Stela of Peribsen, Abydos
c 2800 B. C. granite;
45-1/2
BRITM 162 ELBr (35597)
EGYPTIAN--3rd Dynasty
Asses at Watering Place,
Sakkarah, relief, Ti's Tomb
BRIONA 54 FPL
Bedjmes, shipbuilder, seated
figure c 2650 B. C. granite;
26
BRITM 184; SMIW pl 21
ELBr (171)
Capital, Zoser Group
SMIW pl 19
Column, with Palm Leaf
Capital, Sakkareh
ROTHST pl 31 UNNMM
Djoser, head detail limestone
CASL 20 (col)
False Door, South Tomb,
Zoser
SMIW pl 19
Foreign Captives, heads,
statue bases
DR 17 EgCM
Kaemsnew, Tomb Figure,
Sakkara
RAY 11
Palm Capital, Temple of
King Unos
LARA 157 EgS
Papyrus Half-Columns, North
Palace, Funerary District
of King Zoser c 2700 B. C.
JANSH 38; SMIW pl 18
EgS
Princess, Sakkareh
STI 161 UMWA

Processional Relief, Sakkareh
ROTHST pl 32 UNNMM
Redyzet, detail H: 32-3/4
SMIW pl 22 ITE
Sanakhte Smiting his Enemies,
relief fragment, Sinai
c 2680 B. C. red sandstone;
L: 17
BRITM 20 ELBr (691)
Sepa and Neset (Sepa and
Nesa) c 2500 B. C. lime-
stone; 60. 6; and 65
GAU 46; SMIW pl 23 FPL
Zeb, relief, Zoser Shrine,
Heliopolis
LLO 74 ITE
Zoser: Performing Ritual
Dance, with Horus
Falcon, relief, Sakkara
limestone
WOLD 68 EgS
Zoser: With Flail, tomb
relief, false door, Sakkara
LLO 75 EgS
Zoser, Sakkara limestone; less
than LS
LLO 69; WOLD 82 (profile)
EgCM
Zoser, head, false door panel,
South Tomb
SMIW pl 20
Zoser, relief
LANG pl 14-15
Zoser, seated figure,
Saqqara c 2650/30 B. C.
limestone; 55
GARB 133; LANG pl 17, 16;
SMIW pl 15 EgCM (6008)
Zoser Shrine, relief fragment,
Heliopolis
SMIW pl 20 ITE
EGYPTIAN--3rd/4th Dynasty
Archers, Mastaba relief, North
Pyramid, Lisht limestone
DIV 14 UNNMM
Funerary Stela, Terenuthis(?)
limestone; 13
BRITM 231 ELBr (59870)
Tombstone of King Wenephes
("Snake") limestone; 98
(original total H)x 25-1/2
LANG pl 6 FPL
EGYPTIAN--4th Dynasty
Ankhaf, Son-in-law of Cheops,
bust, Giza c 2480 limestone,
faced with ptd stucco; 20
BOSMEG 39 (col) FAIN 85;
LANG pl 21 LLO 59;
PACHA 23; READAS pl
145-6; SMIW pl 44; WOLD

89 (col) UMB
Alexander II red granite
DR 151 EgCM
Captives in Bonds, relief
detail, King Sahura Tomb,
Abu Sir c 2400 B. C.
limestone
WOLD 76
Cheops (Khufu), relief
fragment, Lisht
SMIW pl 33 UNNMM
--, seated figure ivory; 3
MARY 135; SMIW pl 31
EgCM
Didoufri, head c 2650 B. C.
ptd red sandstone; . 26 m
CHAR-1:34; MALV 75 FPL
Draught of Fishes, relief c
2800 B. C.
HAUSA pl 5 GBA
Female, bust
ROOS 31 UNNMM
Female Head H: . 14 m
COPGE pl 3 DCN (A 53)
Female Torso limestone; 60
FAIN 185; FEIN pl 116;
WORC 9 UMWA
Furniture of Queen Hetep-heres
SMIW pl 30 EgCM
Goose, relief limestone
CHRP 26 UDCFr
Great Sphinx (Sphinx of
Chephren; Sphinx of
Khafre), Khafre Tomb:
Recumbent Lioness with
Pharoah's Head c 2650
B. C. rock-cut limestone,
masonry; 66x240'; limestone,
Face W: 13'
BARSTOW 17; BAZINW 108
(col); CASL 18-19 (col);
CHENSN 49; CHENSW 36;
CRAVR 24; ENC 843; FAUL
100; GARB 25 (col); JANSH
39; JANSK 45; LANG pl 29;
MILLE 4; MYBA 24; MYBU
118; PRAEG 118; RAY 12-
13; READAS pl 4; ROOS
2D; SIN front; UPJ 28;
UPJH pl 4D; WOLD 61
(col) EgG
--(sketch by Vivant Denon,
1799)
CASL 15
--detail
GARB 26 (col)
Hare Nome of Upper Egypt,
Hathor, Mycerinas, Giza
schist; 33 BOSMET 48;
BOSMI 177 UMB (09. 200)

Hathor, Mycerinus, male
personification of Nome,
fragment, Giza schist;
31-1/2
BOSMI 179 UMB (11. 3147)
Head, Sakkara granite
LLO 60 EgCM
Hemiunu, (Hemium, Herniunu)
Vizier and Architect of
Cheops, seated figure
H: 61-1/2
MERTZ; SMIW pl 31 GHiRP
--head detail
LLO 58
Hetep-heres Carrying Chair:
Back Hieroglyphics c
2686/2565 B. C.
LOWR 175; SMIW pl 30
EgCM
--, Funerary Bed: Canopy,
detail gold casing
SMIW pl 34 EgCM
--: Hieroglyphics--Bee, Asp,
Vulture gold
CASL 156 (col) EgCM
Katep and Hetepheres, seated
figures c 2600 B. C. ptd
limestone; 18-1/2
BRITM 184 ELBr (1181)
Khafre (Chephren, Kephren,
Khefren) 3000 B. C.
MALV 74
--H: . 45 m
COPGE pl 4 DCN (A2a)
--, head fragment alabaster
BOSMEG 45 UMB
--seated figure, head protected
by Falcon of Horus, Giza
c 2850 B. C. diorite; 66;
head: 16
CHENSN 50; CHENSW 40;
COPGE fig 1; CRAVR 20;
DR 21-22; GARDH 54;
GARDHU pl 40; JANSH 40;
JANSK 57; LANG pl 36-39;
LARA 131; LLO 63; MARY
189; MILLER il 5; MYBU
133; NATSE; ROOS 3G, -H;
ROTHS 7, 9; SMIW pl 40;
STI 104; UPJ 37; UPJH pl
4F; WB-17:196; WOLD 77
(col) EgCM (138)
--head detail
CASL cov; CHENSN 43
Khufu-Khaf, Giza
SMIW pl 38
Khufu-Khaf and Wife Receiving
Offerings, relief, Giza
c 2650 B. C.

BAZINW 108; SMIW pl 35
EgCM
Khunera as Scribe c 2800 B. C.
yellow limestone
BOSMEG 50; CRAVR 19
UMB
King, head granite; 21-1/4
SMIW pl 29 UNBB
King's Bodyguard Bowmen,
relief
BOSMEG 37 UMB
Male Figure, detail limestone
DR 28 EgCM
Man and Wife, Memphis tomb
relief c 2600 B. C.
CHRP 22
Memphite Functionary and his
Wife c 2840/2680 B. C.
wood; 27
READAS pl 155 FPL
Men Plowing, Memphis tomb
relief
CHRP 23
Menkure (Mycerinus, Mykerinos)
BAZINH 66 UMB
--detail alabaster; LS
LANG pl 43 EgCM (157)
--, head H: 11-1/2
SMIW pl 42 EgCM
--, head, Giza limestone
LLO 61 UMB
--headless and armless
fragment ivory; 5-1/2
BOSMEG 50; BOSMI 179
UMB
--, seated figure alabaster; 83
BOSMEG 49; BOSMI 175
UMB (09.204)
--and his Queen, Chamerer-
nebti (Khamerernebti), pair-
statue, Giza c 2800 B. C.
gray-green slate; 54-1/2
AUES pl 3; BOSMEG 47;
BOSMI 177; CHASEH 21;
CHENSW 39; CRAVR 16;
FAIN 85; GARB 135; JANSH
40; JANSK 56; LANG pl 44-5;
LLO 54; MU 20; MYBA 25;
NEWTEA 30; ROBB 276;
SEW 22; SMIW pl 44 UMB
(11. 1738)
Menkure between Hathor and
Assiut, local diety of
Kynopolis green slate; 37
DR 24; LANG pl 47 EgCM
(149)
Menkure between Hathor and
local diety of Diospolis
Parva, relief green slate;

38-1/2
LANG pl 46; READAS pl
154 EgCM
Menkure between Goddess
Hathor and Provincial God-
dess green slate
GAUN pl 12; LARA 132
EgCM
Merisankh limestone
DR 29 EgCM
Marytyltes, reserve head
SMIW pl 36 EgCM
Nofer, relief detail, Giza
c 2640 B. C. complete
relief H: 37'
BOSMI 175 UMB (07. 1002)
--reserve head, Nofer Chapel
door jamb
BOSMEG 36 UMB
Nofret, consort of Rahotep,
Medum c 2550 B. C. lime-
stone, ptd; 1. 18 m
LLO 57 (profile); WOLD 83
(col) EgCM
--detail
LARA 132
Offering Niche of Iy-nefer
SMIW pl 28 EgCM
Official Seshem-Nofer, head
red granite; 9-3/4
BOSMEG 53; BOSMI 181
UMB (12. 1487)
Panel of Hesire (Hasy-Ra):
Hesire with Sceptre, Staff,
and Writing Materials, Saqqara
c 2700 B. C. wood; 45
BAZINH 15; BAZINW 107
(col); CHENSN 54; CHENSW
44; GARDH 50; GOMB 37;
JANSH 35; JANSK 54;
LANG pl 18-19; LLO 71; MYBU
318; ROOS 41; UPJH pl 7B;
WOLD 69 EgCM (88)
Personified Estates, Pent
Pyramid
SMIW pl 26 EgDa
Prince, reserve head, Giza
c 2840/2680 B. C. limestone;
10-1/2
GARB 134; GARDH 55;
READAS 142-3 UMB
Prince Ka-wab in his Boat
BOSMEG 44 UMB
Princess, head Gizeh c 2640
B. C. stone
CHENSW 38 UMB
Pyramids of Giza (Pyramids of
Menkure, Khafre, and
Cheops) c 2600/2525 B. C.

avg H: c 275'
CHENSN 49; GARB 24 (col);
JANSK 46; MYBU 118;
READAS pl 4 EgC
Radedef, head H: 11
SMIW pl 41 FPL
Rahotep and his Wife, Nofret,
seated figures, Medum
c 2610 B. C. ptd limestone;
eyes of clear and opaque
quartz; 47-1/4
BAZINW 108 (col); CHRH
fig 4; DR 25-27; GARB
116 (col); HAUSA pl 3;
JANSH 41 (col); JANSK
55; LANG pl 22-24,
pl 25 (col); LLO 57
(profile); MARQ 9; MERT;
PRAEG 115 (col); ROOS
4A; SMIW pl 29; UPJH pl
5B; WOLD 80 (col) EgCM
(223)
--Rahotep, bust detail
ROOS 4B
Relief, Great Pyramid of
Giza(?), detail
BOSMEG 41 UMB
Reserve Head, Mastaba,
Necropolis, Giza c 2590/
2470 B. C. H: 19. 5 cm
WOLD 86 EgCM
Reserve Head(s) of
Princess(es) White lime-
stone; 10-1/2
BOSMEG 34-35; BOSMI
173; LLO 59 UMB (21. 328)
Seated Scribe, Gizeh stone
CHENSW 42 GBS
--, Saqqare, head detail
c 2680/2565 B. C. ptd
limestone
BAZINW 109 (col), 110
(col) FPL
Sepa, statue with staff
c 2750 B. C. limestone;
1. 59 m
CHAR-1:44 FPL
Servant Figures limestone
DR 39 EgCM
Shepseskaf, head alabaster
BOSMEG 51 UMB
Sneferu and Goddess,
relief fragment
SMIW pl 26 EgDa
Sneferu-Seneb, reserve head
SMIW pl 37 EgCM
Sphinx, detail
DR 23, front EgG
Stela of Rahotep, Medum c

2600 B. C. limestone; 32
BRITM 166 ELBr (1242)
Tja-hap-emu quartzite
ZOR 25 UNNMM
Two Descendants of Cheops,
relief fragment, Giza
limestone, green paint
accents; 9-1/16
GABO 78 PoLG
Two Portrait Heads, Royal
Cemetery, Giza limestone;
LS
LANG pl 40-42 EgCM
(6003; and 6005)
Vizier Ankh-Haf, bust ptd
limestone; 21
BOSMI 169 (col) UMB
(27. 442)
Vizier Hemiunu, relief
BOSMEG 45 UMB
Vizier's Herdsmen, relief
(modern restoration) c
2900 B. C. limestone;
15-5/8x27-1/8
DENV 6 UCoDA
(AN-2)
Wepemnofret at Table ("Dining
Table Scene"), tomb relief,
Giza c 2550 B. C. ptd
limestone; W: 66 cm
SMIW pl 39; WOLD 74
UCBCA
Woman H: . 75 m
COPGE pl 2 DCN (A 48)
--stone
CHENSW 41 UMWA
Young King, head fragment
alabaster; 11-1/4
BOSMI 179 UMB (09. 203)
Young Man ("Red Head") sand-
stone; 17 cm
COPGE pl 5 DCN (A 52)
EGYPTIAN--5th Dynasty
Bird Relief, Weserkaf
Temple, Saqqara
SMIW pl 47 EgCM
Brewer c 2500 B. C. limestone
ROTHS 19; ROOS 4F UNNMM
Butchering, relief
BOSMEG 61 UMB
Chancellor Nakhti, tomb figure
c 2450 B. C. wood ptd red;
1. 75 m
CHAR-1:65 (col), 66 FPL
Cranes, tomb relief
GARDH 51 GBS
Doctor Nainkhre, seated figure
limestone
DR 35 EgCM

Famine Scene, relief, Unas
Causeway
SMIW pl 48
EgS
Fayum Portrait Mask 400
hemp papyrus and stucco,
gilded and colored;
22-1/2x17-3/4
DENV 9 UCoDA (An-40)
Fishers and Hunters,
Ptahhotep Mastaba,
Saqqara
DR 41 EgCM
Gift Bearers, tomb relief,
Memphis c 2700 B. C.
COPGG 16 DCN (A 655)
Girl Grinding Corn ptd
limestone; 12-1/2
LANG pl 57 EgCM (818)
--ptd limestone; 14
LANG pl 56 EgCM (114)
Girl Grinding Wheat or
Barley ptd limestone; 11
EXM 64 EgCM
Harvesting Papyrus, relief
BOSMEG 62 UMB
Head, statue fragment,
Saqqara c 2600 B. C. acacia
wood
MILLER il 3 EgCM
Hemu, Castellan of Assiut;
head detail deep red plaster
paste on wood; 2/3 LS
COPGE pl 6, fig 2 DCN
Herding Donkeys, relief,
Mastaba of Akhuhotep,
Saqqara c 2500/2400
B. C. limestone
BAZINW 111 (col) FPL
Interior Wall Relief,
Saqqara stone
CHENSW 44 UMB
Itwesh, relief head, Saqqara
SMIW pl 52 UNBB
The Judge Mehu, relief
BOSMEG 10 (col) UMB
Ka-Aper (Mayor of the Village,
"Shiek el-Beled", Village
Magistrate) c 2550/2500
B. C. sycamore wood; 43
CHASEH 19; CHENSN 52;
CHENSW 41; CHRH fig 5;
DR 32; GARB 136; GARDH
56; GAUN pl 6; HAUSA pl
3; JANSK 57; LANG pl 54;
LARA 131; MARQ 3; MYBA
26; RAY 10; ROBB 277;
ROOS 3-E; ROTHS 11, 13;
ROTHST pl 30; STI 103;

UPJH pl 4E EgCM
(140)
--detail
LANG pl 55
--head detail
OZ 201; ROOS 3-F; SMIW
pl 45
Ka-Pu-Nesu, royal architect
wood
ZOR 192 UNNMM
Male Figure wood
DR 36 EgCM
--, Saqqara wood
DIV 16 UNNMM
Male Head, Gizeh c 2700
B. C. limestone
GOMB 40 AVK
Mastaba of Akhut-Hetep,
relief: Soube's Office;
Fishermen, Saqqara c
2500 B. C. limestone; 13;
and 16-1/2
GAU 49 FPL
Menkauhor, relief limestone;
32. 3
GAU 62, 63 FPL
Meri-re Hasetef, Hierakon-
polis sycamore wood; . 67
m
COPGE pl 7 DCN (A 57)
Metjetjy Relief c 2420 B. C.
ptd limestone; 32-1/2x26
TOR 13 CTRO (953. 116. 1)
Mitry and Wife ptd wood;
52-1/2; 58-1/2
CHENSW 39; NM-4:10 UNNMM
(26. 2. 2, 3)
Neferhotep and Tjentety ptd
limestone; 48-3/4
DR 34; EXM 128 EgCM
Nenkheftka, Dehasha c 2400
B. C. ptd limestone; 51
BRITM 185 ELBr (1239)
Nobleman Hunting on Nile,
relief c 2600
B. C. limestone; 70x68
WORC 8 UMWA
Nude Walking Figure, Saqqara
stone
CHENSW 43 EgCM
Nykauhor and Wife, tomb
relief H: 33
NM-4:7 UNNMM (08. 201. 2)
Offering of Cattle, Ptahhotep's
Mastaba, Saqqara
DR 40 EgCM
Official Nefer Receiving
Funerary Offerings, mastaba
relief
LARA 129 FPL

Official Scribe; detail ptd
limestone; 19-1/2
LANG pl 59, 58 EgCM
(141)
Official of Memphis and Wife
c 2500 B. C. wood; . 70 m
CHAR-1:41 (col)
Orchard with Bird Catchers,
relief, Chapel of Nefer-
her-n-ptah
SMIW pl 50 EgS
Palm Capital granite; 78
(lowest ring to upper
surface of abacus)
LANG pl 48 EgCM
(135)
Panel, False Door of Ny-Kau-
Re, Saqqara c 2500 B. C.
limestone
CLE 2 UOClA (64. 91)
Peasants Driving Cattle; and
Fishing, reliefs, Saqqara
ptd limestone; 32x18; and
27x18-1/2
DETT 16 UMiD (30. 371)
Pen-Meru and his Family;
detail c 2500 B. C. ptd
limestone; 60-3/4
BOSMEG 54; BOSMI 181
UMB (12. 1484)
Potter, funerary figure c
2200 B. C. limestone; 13. 3
cm
WOLD 87 (col) UICUO
Poultry-Fattening Farm,
relief c 2500 B. C. lime-
stone; 15-3/4x41
BERL pl 79; BERLES 79
GBSBeA (14642)
Ptah-Khenuwy and Wife
BOSMEG 58 UMB
Ptahhotep: At Offering Table,
tomb relief limestone
LANG pl 72 EgS
Ptahhotep Mastaba: Asses and
Herdsmen, relief c 2600
B. C.
ROOS 4G EgS
--: False Doors, relief
ROBB 19
--: Scenes of Daily Life--
Agriculture, Crafts,
Musicians
LLO 76-77
Pyramid Texts, tomb,
Pyramid of King Unis
MERT EgS
Ranofer (Ranefer; Ranufer)--
2 figures; details ptd
limestone; 73; 70

Dignitary, "blind-gate" relief,
mastaba of Izi, Edfu sand-
stone; 218x138 cm
WPN pl 1 PWN (139944)
Dwarf Seneb and his Family
c 2350/2200 B. C. ptd
limestone; c 13
DR 38; GARB 135 EgCM
False Door, Tomb of Ateti,
Saqqara c 2320/2160 B. C.
ptd limestone
JANSK 59; LANG pl 73;
WOLD 65 (col) EgCM
False Door of Lector-Priest
limestone; 61x45-3/4x4-1/2
MINP UMnMI
False Door of Neferseshemptah
c 2500 B. C.
STI 85; UPJH pl 7A EgS
Harpooning Hippopotami,
Mereruka Tomb relief
LANG pl 77 EgS
Ha-Shet-Ef wood
CHENSW 43 ELBr
Hawk, head gold; 4
GARDH 57 EgCM
Herdwadjet Khet, relief,
Mereruka Tomb
LANG pl 74 EgS
Horwedja Presenting Statue to
his God c 500 B. C. black
schist
CLE 6 UOClA (3955. 20)
Interior Wall Relief, Saqqara
stone
CHENSW 45 EgCM
Kitchen and Herding Scenes,
relief, Lisht c 2430 B. C.
limestone
ROTHS 25 UNNMM
Male Figure, Gizeh wood
CHENSN 47 UMB
Male Head c 2300 B. C. ptd
limestone; . 23 m
CHAR-1:37 (col) FPL
Mastaba d'Aktihetep, bas
reliefs: Preparation for
Banquet c 2500 B. C.
CHAR-1:38-39 FPL
Mereruka, pillar relief
limestone; c LS
LANG pl 75 EgS
Mereruka and his Sons, relief
SMIW pl 51 EgS
Mereruka Tomb: Sailing
Through the Marshes, relief
ROOS 4H
Nernera copper; 29-1/2
SMIW pl 53 EgCM

Meryrehashtef as a Young
Man, Sedmont c 2200
B. C. wood; 20
BRITM 217 ELBr (55722)
Methethy c 2420 B. C.
SPA 222 UNBB
--c 2400 B. C. ptd wood;
31-1/2
BOSMEG 57; BOSMI 183
UMB (47. 1455)
--, head ptd wood; 31-1/2
SMIW pl 54 UMoKNG
Mummy Mask plaster
BOSMEG 65 UMB
Nekhebu
BOSMEG 64 UMB (13. 3149)
Ny-Kau-Re, seated figure,
Sakkara c 2500 B. C. red
granite
CLE 2 UOClA (64. 90)
Offering Bearers, relief,
Temple of Pepy II
SMIW pl 50 EgS
Papyrus Thicket Trip with
Animals, Mereruka Tomb
relief
LANG pl 76 EgS
Pepi (Pepy) I, head copper
and other materials; 70
LANG pl 78 EgCM (230)
--, head detail copper;
figure H: 69-1/2
SMIW pl 53 EgCM
--, kneeling in making
libation, Saqqara green
slate; 6
LLO 53 (col) UNBB
--, seated figure c 2350/
2200 B. C. alabaster; c 10
GARB 136; SMIW pl 55
UNBB
Pepi (Pepy) II and his Mother
alabaster; 15-1/2
SMIW pl 56 UNBB
Perhernofret, court official
c 2450 B. C. wood; 113 cm
BERL pl 70; BERLES 70
GBSBe (10858)
Prince, reserve head c 2580
limestone; LS
JANSH 43 EgCM
Seated Man and Standing
Woman c 2500 B. C. ptd
limestone; . 85 m
CHAR-:50 FPL
Seated Scribe, with Papyrus
Scroll c 2500 B. C. lime-
stone GAUN pl 7
EgCM

Senedeu-ib-Mehy, Gizeh
 wood
 CHENSW 43 UMB
Servant Figure, kneeling
 baker(?) limestone
 SLOB 218 UMB
Tomb Relief, Saqqara
 CHENSN 56; CHENSW
 513 EgCM
Urchuu, bust fragment
 limestone; c 14
 LANG pl 79 EgCM
EGYPTIAN--7th Dynasty
 Potter, figure c 2600/2400
 B. C. terracotta
 ROTHS 19 UICUO
EGYPTIAN--8th/10th Dynasty
 Figure with Staff wood; 44
 SMIW pl 56 UMB
 Stela ptd limestone
 SMIW pl 57 UPPU
EGYPTIAN--MIDDLE KINGDOM (9
 to 17 Dynasties), c 2445-1580
 B. C.)
 Ameny, seated figure
 LLO 121 ELBr
Baboon, seated limestone
 SLOB 271 FPL
Coffin of Steward Knum-hetep,
 gilded portrait mask, Beir
 Rifa
 LLO 124 ScER
Fish, bold pendant, Illahun
 c 1900 B. C. L: 3. 4 cm
 WOLD 119 (col) ScER
Four Processional Figures,
 tomb models wood
 FAIN 85 UMB
Hathor-Headed Capitals,
 Temple of Hathor
 LARA 158 EgD
Hatshepsut Mortuary Temple,
 reliefs: Queen Hatshepsut's
 Mother; Hatshepsut Drink-
 ing from Udder of Hathor,
 Deir-el-Bahri (from a
 cast)
 LLO 154, 155 EgT; ScER
Head, fragment brown
 quartzite
 SLOB 35 UMB
Herdsman with Cattle,
 relief, Meir
 LLO 127
Man, head, Edfu limestone;
 16 cm
 WPN pl 3 PWN (139935)
Pleasure Boat Model, with
 Figures, tomb furniture

wood; L: 28
 HUYA pl 5; HUYAR 151
 FPL
Senusret-Senebef-Ni, seated
 figure
 LLO 120 UNBB
Sphinx, wearing Nemsit pink
 granite; 81x16'
 HUYA pl 8 FPL
Ukhotep Hunting, relief,
 Meir
 LLO 126
Votive Castanets ivory; . 30 m
 CHAR-1:67 FPL
Woman, in gold decorated
 wig, Lisht
 LLO 123 (col) EgCM
EGYPTIAN--9th Dynasty
 Gatekeeper Maaty's Stela
 Detail, sunk relief
 limestone; 14-1/4
 NM-4:22 UNNMM (14. 2. 7)
Head, fragment, Saqqara(?)
 limestone
 LAH 18 UCLCM
EGYPTIAN--9th/10th Dynasty
 Male Figure c 2100 B. C.
 ivory; . 087 m
 CHAR-1:51 FPL
Soldiers, model: Egyptian
 spearman; Nubian bowmen,
 Assuit Tomb
 CASL 96; MERT EgCM
Tomb Relief c 2400 B. C.
 limestone
 CLE 2 UOClA (801. 30)
Tomb Stela of Four Persons
 c 2200/2050 B. C.
 limestone
 CLE 2 UOClA (200. 14)
Woman Grinding Corn c
 2400 B. C.
 GAUN pl 11 EgCM
EGYPTIAN--10th Dynasty
 Hunting on the Nile, relief,
 Mereruka Tomb c 2250
 B. C.
 JANSK 60 EgS
Wepwawet-Em-Hat c 2100
 B. C. wood; 43-3/4
 BOSMEG 91; BOSMI 185
 UMB (04. 1760)
EGYPTIAN--11th Dynasty
 Amulet Wand c 2000 B. C.
 ivory; L: 14-1/4
 BRITM 121 ELBr (18175)
Ashait, sarcophagus detail
 limestone
 LANG pl 83 EgCM (6033)

Brewer, model, Asyut c 2000
 B. C. wood; L: 14-1/2
 BRITM 9 ELBr (45196)
Brewers' and Bakers' Shops,
 tomb model
 RUS 8 UNNMM
Brick Makers, tomb model
 c 2000 B. C. wood; L: 13
 BRITM 192 ELBr (63837)
Cattle and Milking Scene,
 relief, Princess Kavit's
 Sarcophagus limestone
 DR 52 EgCM
Cattle Inspection, Merket-ra
 model ptd wood; L: 69
 BR 56; SMIW pl 62 EgCM
Cattle Stable, tomb model
 RUS 8 UNNMM
Female Figure with Food
 Container on Head, holding
 duck, relief c 2100 B. C.
 limestone; 21x11
 GRIG pl 25 ELBr
Fishing and Fowling Sciff,
 Mete-Re tomb model, Thebes
 c 2000 B. C. ptd wood;
 L: 45
 LLO 126-7 (col); NM-4:14;
 NM-10;7; NMA pl 24 (col);
 TAYFF 3 (col) UNNMM
 (20. 3. 6)
Fishing with Nets from
 Papyrus Boats ptd wood
 BR 55 EgCM
Hathor, relief 21st c. B. C.
 ptd limestone; 21x13-1/2
 TOR 9 (col) CTRO
 (910. 48. 15)
Kawit, sarcophagus detail
 LANG pl 83; SMIW pl 61
 EgCM (623)
Kawit and Two Servants,
 relief
 HAUSA pl 5 EgCM
Mentuhotep: Slaying Enemy,
 relief limestone; 10-1/2;
 whole relief W: 20-1/2
 LANG pl 82 EgCM
Mentuhotep II, relief head,
 Deir el Bahari
 BOSMEG 70 UMB
Mentuhotep II (Nebhapetra),
 seated figure, Deir el
 Bahari c 2050 B. C. ptd
 sandstone; 72
 GARB 119 (col); LANG
 pl 80, 81; SMIW pl 59;
 WOLD 110 EgCM (287)

Meri, a steward, seated
 figure c 2100 B. C.
 limestone; 22
 BRITM 186 ELBr (37895-6)
Neferu, relief
 SMIW pl 60 UNNMM
--, sunk relief
 SMIW pl 60 UNNMM
Offering Bearer c 2000
 B. C. ptd wood, stucco; 40. 6
 GAU 61 (col); LARA 133
 FPL
--, funerary model, Thebes
 ptd wood
 GROSS fig 35 UNNMM
Palm Capital, Sepulchral
 Temple of King Sahure
 PRAEG 43 EgAbu
Pleasure Boat, tomb model
 RUS 8 UNNMM
--, ptd wood
 BR 54 EgCM
Portico, model house of
 Meket-ra wood; W: 16-3/4
 SMIW pl 62 UNNMM
Rowers ptd wood
 BR 54 EgCM
Servant Carrying Food
 c 2000 B. C. wood
 ROTHS 21 UNNMM
Stela, detail: Seated Figure
 with Hieroglyphics c 2150
 B. C. coelanaglyphic
 (inverse bas relief)
 RICJ pl 3 UNNMM
Stela of Tjetji, Thebes
 c 2100 B. C. limestone; 59
 BRITM 37 ELBr (614)
Stela of Wah-ankh Intef II,
 detail
 SMIW pl 59 EgCM
EGYPTIAN--11/12th Dynasty
Woman Bearing Offerings
 c 2000 B. C. stuccoed and
 ptd wood; 41
 HUYA pl 6; HUYAR 78
 FPL
Zefay-Hapy, chief priest,
 seated figure, Temple of
 Osiris, Assiut 2060/1780
 B. C. H: 20-5/8
 WORC 8 UMWA
EGYPTIAN--12th Dynasty
Amenemhat-ankh, Keeper
 of the Secrets of Ptah-
 Sokar c 1800 B. C. brown
 crystalline sandstone;
 28-3/8 BAZINW 112 (col);
 CHAR-1:51; EXM 4 (col) FPL

Amenemhet (Amenemhat,
 Amenemmes) I, seated
 figure, Tanis black granite;
 2. 68 m
 WOLD 112 EgCM
Amenemhet (Amenemhat,
 Amenemmes) III black
 granite
 DR 45 EgCM
--obsidian; 60
 CHRH fig 6; GARDH 58;
 MU 20 (col) READAS pl
 148; ROBB 279 UDCN
--: Decorative Inscription,
 Temple of Sobek, Crocodile-
 Headed God, Crocodilopolis,
 Faiyum c 1840/1792 B. C.
 limestone; L: 2. 15 m
 WOLD 105 GB
--: Maned Sphinx, Tanis black
 granite; L: 72
 LANG pl 110 EgCM (507A)
--: Maned Sphinx, Tanis
 c 1840/1792 B. C. black
 granite; 39x80
 GARB 138; LANG pl 111;
 WOLD 111 (col) EgCM
 (507B)
--, Thebes c 1800 B. C.
 black granite
 CLE 2 UOClA (60. 56)
--, head basalt
 LLO 116 UNNMM
--, head obsidian
 READM pl 22
--, head obsidian; 4
 GABO 79 PoLG
--, head, three-quarters view
 obsidian
 MILLER il 7
--, head fragment, Kerma
 BOSMEG 94 UMB
--, head in Crown of Upper
 Egypt c 1810 B. C. diorite;
 10-5/8
 BERL pl 74; BERLES 74
 GBSBeA (17950)
--, seated figure yellowish
 limestone; 63
 LANG pl 108 EgCM (284)
-- head detail
 GARB 138; LANG pl 109;
 SMIW pl 68
--, seated figure c 2000 B. C.
 dark grey granite; 30
 GRIG pl 18 ELBr
--, seated figure 19th c. B. C.
 black granite
 HERM il30 RuLH

Ameny-Seneb, seated figure
 SMIW pl 69
Amon, relief . 36x. 28 m
 COPGE pl 18 DCN (A 697)
Atun Greeting Sesostris I,
 pillar relief, Karnak
 c 1900 B. C.
 BAZINW 111 (col) EgCM
Bell Capitals, Luxor Temple
 LARA 158 EgL
Bird, relief, Lisht
 BOSMET 85 UMB
Boat in Water with Plants
 and Fishes, relief limestone;
 W: 38-1/2
 BOSMI 187 UMB (54. 643)
Burial Stele, Gebelein
 BOSMEG 83 UMB
Canopic Jars of Princess
 Sithathoryunet alabaster;
 14-1/2
 NM-4:24 UNNMM
 (16. 1. 45-8)
Chertihotep c 1950 B. C.
 WILM 84 GB
Collar, with Gold Leaf
 Falcon Heads gold,
 turquoise faience, carnelian
 CASL 126 UNNMM
Dashur Crown of Khnumet
 SMIW pl 79 EgCM
Dashur Jewelry of Khnumet,
 Set-Hathor and Meret large
 pectoral; W: 3-1/4
 SMIW pl 80 EgCM
Female Figure c 2000 B. C.
 wood; 48 cm
 BOES 44 DCNM
Fish Pendant gold; L: 1-1/2
 SMIW pl 79 ScER
Foreign Woman and Child
 wood; 6
 SMIW pl 78 ScER
Girdle, Bracelet, and Two
 Armlets of Princess Sithat-
 Horyunet c 1890/1840 B. C.
 gold, carnelian, felspar,
 turquoise and paste
 NMA pl 19 (col) UNNMM
 (16. 1. 5, 8, 12, 15)
"Hawk" Panel, with figure of
 Falcon of Horus, Senwosret
 I's Pyramid limestone;
 14'
 NM-4:19 UNNMM (34. 1. 205)
Headless Female Figure
 grey ivory; . 18 m
 CHAR-1:52 FPL

Hippopotamus ("William") blue
 faience, with lotus draw-
 ings; 4-1/2xc 8
 CHENSN 55; NM-4:17; PUT
 286; RICJ pl 10 UNNMM
 (17. 9. 1)
--c 2000 B. C. faience
 CHENSW 46 UNBB
Hor, Ka Statue wood; 53
 LANG pl 113; SMIW pl 65
 EgCM (280)
--head detail
 LANG pl 112; LLO 118
"Hyksos" Sphinx black granite
 DR 50 EgCM
Ibu, head, Qaw
 SMIW pl 70 ITE
Imret-nebes ptd wood; 86 cm
 DURS 49; WOLD 117 (col)
 NLRO
Kherti-hotep, seated figure
 c 1870 B. C. brown sand-
 stone; 29-7/8
 BERL pl 71; BERLES 71;
 WOLD 114 GBSBeA (15700)
King, Kerma wood
 BOSMEG 94 UMB
King, colossus head black
 granite
 DR 47
King, head limestone
 DR 44 EgCM
--, head c 1820 B. C. stone
 CHENSW 47 PoLG
Kitten Watching Prey blue
 faience with pink spots;
 2-1/2
 BRIONA 50 UNNMM
Lahun Crown
 SMIW pl 78, 79 EgCM
Man stone
 CHENSW 46 FPL
Mirror Handle turquoise and
 gold; 17 cm
 CHAR-1:67 FPL
Nefret, seated figure, Tanis
 H: 44
 SMIW pl 67 EgCM
Nubian Soldiers with Bows
 and Arrows, tomb of Nomarch
 Mesehti, Asyut ptd wood;
 WOLD 115 (col) EgCM
Offering Bearers, relief, Lisht
 SMIW pl 64 UNNMM
--, tomb figures c 1860 B. C.
 wood; L: 21
 BOSMI 185 UMB (21. 326)
Princess Sithathoryunet:
 Solar Falcons Flanking

Royal Cartouche of
 Senwostret II gold, with
 lapis lazuli, carnelian,
 and garnet inlay; 14-1/8
 CHRP 35; NM-4:15; NM-
 10:9 UNNMM (16. 1. 3)
Pillars, details: Hieroglyphic
 Writing, Karnak
 LANG pl 96, 97 EgCM
Platoon of Archers of Prince
 of Assiut ptd wood
 BR 57 EgCM
Plow with Oxen c 2000 B. C.
 ptd wood; 9x17-1/2
 DURS 48; GRIG pl 22
 ELBr
Queen, seated figure black
 granite
 DR 49 EgCM
Royal Head, profile red
 sandstone
 MILLER il 7 FPL
Seated Man yellow limestone;
 22 cm
 COPGE pl 12 DCN (A 61)
Sebek-Em-Hat limestone; 19
 DETT 17 UMiD (51. 276)
Senby Hunting, tomb relief,
 Meir c 1991/1785 B. C.
 limestone
 WOLD 106
Sennuway (Sennuy, Senui),
 seated figure c 1950 B. C.
 black granite; 67-1/2
 BOSMI 189; GARB 137;
 LANG 88, 89; LLO 119
 (profile); SMIW pl 65
 UMB (14. 720)
--head detail
 BOSMEG 92; SMIW pl 66
Sesostris (Senuseret, Se'en-
 Wosret) I ptd wood
 DR 53 EgCM
--, colossus red granite
 DR 43 EgCM
--, seated figure, Lisht lime-
 stone; 78-1/2
 CHASEH 25; HAUSA pl 4;
 LANG pl 85; LLO 125;
 SMIW pl 64 EgCM (301)
--, seated figure c 1900 B. C.
 UPJH pl 5D GB
--, striding figure, with red
 crown of Lower Egypt
 cedarwood; 22
 NM-4:20; NMA 20; ROTHS
 11; SMIW pl 64 UNNMM
 (14-3-17)

--and God Aten, pillar
 relief
 LANG pl 94 EgCM
--and God Ptah, pillar
 relief
 LANG pl 95, 98; LLO 124;
 WOLD 104 EgCM
--before Amen Holding Flail;
 Sesostris I Dedicating
 Sacred Emblem
 GARB 118, 119 (col) EgK
--Chapel: Hieroglyphics
 detail limestone
 LANG pl 90-91, 92-3
 EgK
--Mortuary Temple: Offering
 Scene, Lisht
 ROTHS 23
--Pillar limestone
 DR 51 EgCM
--Pillar: Hieroglyphics
 CASL 149 EgK
--Throne: Horus and Set
 LANG pl 86 EgCM
--Throne: Regional Gods with
 Plant Symbols of Upper
 (Lily) and Lower (Papyrus)
 Egypt
 LANG pl 87 EgCM
Sesostris (Senuseret, Se'en-
 Wosret) III, Deir-el-Bahri
 c 1878/41 B. C. granite;
 59
 DR 46; GARB 139; SMIW
 pl 68 EgCM
--c 1850 B. C. granite; 59
 BRITM 181 ELBr (685)
--, detail H: 35 cm
 COPGE pl 15 DCN (A 3)
--, head
 MERT PoLG
--, head quartzite
 ZOR 99 UNNMM
--, head c 1850 B. C. brown
 stone; 16 cm
 LLO 117; WOLD 113 (col)
 UNNMM
--, head fragment limestone;
 6-1/2
 NM-4:21 UNNMM (26. 7. 1394)
--, head fragment obsidian; 4
 LANG pl 105 UDCN
--, head fragment c 1850 B. C.
 quartzite; 6-1/2
 JANSH 45 UNNMM
--, seated figure dark grey
 granite; 66
 LANG pl 107 EgCM (6049)

--, seated figure c 1880 B. C.
 grey granite; 1. 2 m
 CHAR-1:50 FPL
--, seated figure, Sinai
 BOSMEG 93 UMB
-- as Sphinx diorite; 17x29
 DIV 16; JANSK 61;
 LANG pl 106; NM-4:21;
 NM-10:10; RAY 12 UNNMM
 (17. 9. 2)
--as Sphinx c 1800 B. C.
 granite; c 36
 ROBB 279 UNNMM
--in Crowns of Upper and
 Lower Egypt at Feast of
 Jubilee with Gods Amun of
 Thebes and Monthu, door
 lintel limestone
 LANG pl 102-104 EgCM
Shawabty Figure ptd wood;
 9-1/2
 NM-4:24 UNNMM (11. 150. 13)
Ship of the Dead, tomb model
 CASL 88-89 (col) ELBr
Soul Boat gessoed and ptd
 wood; 14-1/8x23-1/16
 DENV 7 UCoDA (An-72)
"Soul House", model
 BOSMEG 81 UMB
Standing Man H: 50 cm
 COPGE pl 13 DCN
Stela and Block Statue of
 Sihathor c 1850 B. C.
 limestone; 17
 BRITM 187 ELBr (569,
 570)
Stela and Offering Table of
 Sobkherab, Sinai c 1800
 B. C. sandstone; 31-1/2
 BRITM 41 ELBr (694-5)
Three Jerboas brown and white
 faience; 1-1/2
 BRIONA 51 UNNMM
Tombstone of Khui, relief,
 Abydos ptd limestone;
 37x61 cm
 WOLD 108 (col) NLR
Tray Bearer (Portuese d'Auge)
 ptd and stuccoed wood;
 1. 04 m
 CHAR-1:53 (col) FPL
Wah-Ka I, head detail,
 Qaw el Kebir
 SMIW pl 69 ITE
Wah-Ka II, fragment, Qaw
 SMIW pl 70 ITE
Woman wood
 CHENSW 45 UPPU

--, bust c 2000 B. C.
 matrix emerald; 8
 TOW 61 UNBuA
--, head wood; 3-1/2
 LANG pl 84 EgCM
 (4232)
EGYPTIAN--12/13th Dynasty
 Animal-form Inlays, Kerma
 ivory
 SMIW pl 83 SuKM
--, Kerma ivory
 SMIW pl 82, 83 UMB
 Cap Ornaments mica
 SMIW pl 83 SuKM
--
 SMIW pl 83 UMB
EGYPTIAN--13th Dynasty
 "Hyksos" King black granite
 DR 48 EgCM
 Lion, tile, Kerma c 1800
 B. C. blue faience; 46
 BOSMI 187 UMB (20. 1224)
 Meryankhre Mentuhotpe c
 1700 B. C. schist; 8-3/4
 BRITM 43 ELBr (65429)
 Pharoah, bust relief
 CHRH fig 8 UDCN
 Sebekemsaf, Armant black
 granite; 1. 5 m
 WOLD 118 AVN
EGYPTIAN--13/14th Dynasty
 Gebu, keeper of the Seal,
 seated figure c 1700 B. C.
 diorite; LS
 COPG 10; COPGE pl 16
 DCN (A 67)
EGYPTIAN--14/17th Dynasty
 Vizier Lymerou c 1750 B. C.
 sandstone
 CHAR-1:50 FPL
EGYPTIAN--15/16th Dynasty
 Foreign Pharoah, head
 stucco; . 33 m
 CHAR-1:61 FPL
EGYPTIAN--17th Dynasty
 Amosis, Second Prophet of
 Amon-Re, and his Mother,
 Beket-Re diorite; 1. 15 m
 COPGE pl 17 DCN
 (A 68)
 Bellowing Hippopotamus glazed
 clay
 CHENSW 47 ELBr
 Barsheh Carvings: Figures;
 Hand Censer wood
 BOSMEG 97 UMB
 Hathor, head diorite; 20
 MU 17 UNNMM

Hippopotamus, Kerma faience
 BOSMEG 99 UMB
Inlay Animal Figures, Kerma
 ivory
 BOSMEG 101 UMB
Procession, Bersheh
 BOSMEG 96 UMB
Sakhmet, lion-headed with
 ankh, Karnak diorite; 84
 MU 16
EGYPTIAN--17/18th Dynasty
 Equestrian Figure ptd wood
 DIV 16; MARY pl 124;
 ROOS 8B UNNMM
 Kings; detail
 BR 76, 75 EgK
 Tetisheri, seated figure
 c 1565 B. C. limestone; 14
 BRITM 88; MERT; SMIW
 pl 85 ELBr (22558)
EGYPTIAN--NEW KINGDOM (18 to 30
 Dynasties), c 1580-532 B. C.
 Falcons, sculptor's models,
 plaque, Tanis
 BAZINW 144 (col) EgCM
 Female Figure 1580/1090
 B. C. wood; 8
 SLOB 215 FPL
 Priest, Mesheikh c 12th c.
 B. C. wood; 20-1/4
 BOSMI 195 UMB (12. 1240)
 Woman, funerary figure
 1580/1090 B. C. ptd wood;
 9-3/4
 READAS pl 57 UDCN
--1580/1090 B. C. wood, gold
 leaf applied to necklace;
 11-1/2
 READAS pl 58 UDCN
 Young God Ched, stele
 fragment limestone; 28 cm
 CHAR-1:97 FPL
EGYPTIAN--18th Dynasty
 Ah-Hotep Axehead blade;
 L: 5-1/4
 SMIW pl 86 EgCM
 Ah-hotep Bracelet Dm: 4-3/8
 SMIW pl 85 EgCM
 Ah-hotep Dagger L: 11-1/4
 SMIW pl 84 EgCM
 Ahmers, Mother of Queen
 Hatshepsut, Hall of Birth
 Reliefs, Temple of Queen
 Hatshepsut ptd limestone
 LANG pl 123 EgT
 Ai(?), head quartz sandstone
 DR 91 EgCM
 Amarna Life Mask plaster;

10. 6
DESA pl 19 formerly GBS
Amarna Princess, head brown-
ish sandstone; 4. 3x2. 15
DESA pl 17 formerly GBS
Amarna Princess, wigged
head ptd limestone; 6. 1x3. 5
CHAR-1:92; DESA pl 16
FPL
Amen (Amon, Amon-Re, Amun)
TAYFF 5 (col) UNNMM
--: Protecting King
Tutankhamon c 1200 B. C.
grey granite; 87
HUYA pl 4; HUYAR 93 FPL
--, head red quartz sandstone
DR 95 EgCM
--, head c 1350 B. C. diorite;
16
NMA 22; ROTHS 37 UNNMM
(07. 228. 34)
--, idealized head of King
Tutankhamon H: 35 cm
COPGE pl 33 DCN (A 13)
--, statue head black granite;
57 cm
COPGE pl 32 DCN (A 88)
Amenhotep (Amenophis), scribe
of Amon's Offering Table H:
32 cm
COPGE pl 22 DCN (A 70)
Amenhotep (Amenophis), son
of Hapu: As a Scribe
c 1417/1379 B. C. black
granite; 51
EXM 6 EgCM
--: In his Old Age, seated
figure black granite
LANG pl 157; LARA 139
EgCM (46)
--: In his Youth, seated
figure grey granite
LANG pl 156 EgCM
(459)
--, kneeling figure, Karnak
c 1380 B. C. granite; 1. 43 m
WOLD 161 EgCM
--, seated figure grey granite
DR 80, 81 EgCM
--, seated figure H: 56
SMIW pl 114 EgCM
Amenhotep (Amenophis) II:
Offering Sacrifices granite
LANG pl 145 EgCM (448)
--: Under Protection of Hathor,
Deir el Bahari c 1450 B. C.
BAZINW 112 (col) EgCM
--, head
COPGE pl 21 DCN (A 6)

--, head limestone; 5
BOSMI 191 UMB (99. 733)
--, Shabti-Figure, Thebes
c 1450/1425 B. C.
serpentine; 11-1/2
BRITM 155 ELBr (35365)
Amenhotep (Amenophis) III
RUS 11 UNNMM
--wood; 10-3/8
SMIW pl 114 UNBB
--: In his Chariot, stele
relief, Thebes stone
CHENSN 67; CHENSW 50
EgCM
--: Parading Prisoners of
War, triumphal stela lime-
stone
ROTHS 23 EgT
--: Wearing Blue Crown
c 1400 B. C. granite
CLE 3 UOClA (52. 513)
--: Wearing Blue Crown (War
Helmet) and "Gold of
Courage", head fragment
relief c 1380 B. C. lime-
stone; 23-5/8x15-3/4
BERL pl 77; BERLES 77
GBSBeA (14442)
--, colossal Luxor figure
H: 63'
COPGE fig 4; MU 21 EgL
--, death mask c 1370 B. C.
stucco; 7. 1
BAZINW 112 (col); DESA
pl 18 GBS
--, head
DR 94 EgCM
--, head
HOF 138 ELBr
--, head
LEE UOClA
--, head basalt
CASL 55 UNBB
--, head quartzite; 20-1/2
BOSMEG 127; BOSMI 193
UMB (09. 288)
--, head speckled black
granite, traces of ochre
paint; 13
CHAR-1:82; DESA pl 1 FPL
--, head H: 46
SMIW pl 114 ELBr
--, head; left profile plaster;
8
SMIW pl 132-133 GBM
--, head c 1400 B. C. pink
granite; 82. 7
GAU 54 FPL
--, head c 1380 B. C. quartzite
CLE 3 UOClA (61. 417)

--, head of colossal figure,
Thebes c 1420 B. C. golden
brown quartzite; 46
BRITM 183; GRIG pl 20
ELBr (6)
--, headless figure 1400/1362
B. C. brown slate; 9
NM-4:28; WOLD 159 UNNMM
(30. 8. 74)
--, seated figure, Thebes
c 1400 B. C. granite; 93
BRITM 182 ELBr (4)
-- and Tiy: At Feast of Sed,
Kheruef Tomb relief
LANG pl 152 EgT
-- and Tiy, stela c 1380
B. C. sandstone; 12
BRITM 50; SMIW pl 128
ELBr (57399)
Amenhotep (Amenophis) IV,
head c 1350 B. C. wood
BAZINW 114 (col) FPL
--, head, Aten Temple,
Karnak c 1360 B. C. sand-
stone
BAZINW 112 (col) EgCM
--and Nofretete and Daughters
c 1360 B. C.
BAZINW 113 (col) GBS
Anubis: Jackal Head c 1340
B. C. inlaid wood
BAZINW 114 (col); CASL
175 (col) EgCM
Anubis, Luxor Temple,
Thebes H: 1. 6 m
COPGE pl 27 DCN
(A 89)
Aten Shrine Reliefs
SMIW pl 124, 125
EgK
Axehead bronze; L: 4
SMIW pl 98 GBM
--, Semna bronze; L:
4-3/4
SMIW pl 98 SuKM
Baking and Brewing, Ushabti
Group, Tomb of Mecket-Re,
Thebes
ROTHST 30 UNNMM
Blind Harpist, tomb relief
limestone; 11. 8 (detail)
DESA pl 23 NLR
Brother and Sister-in-Law
of Deceased, Tomb of
Ramose c 1375 B. C.
ptd limestone
JANSH 47; JANSK 62 EgT
Ceremonial Sticks, with
Human-Forms, Tutankhamon

Tomb c 1350 B. C. gold
BAZINL pl 49 EgCM
Chair boxwood and ebony
CASL 126 UNNMM
Chair of Sitamon H: 23-1/2
SMIW pl 123 EgCM
Chair of Tutankhamen, detail
inlay; 40-1/8
SMIW pl 148, 149 EgCM
Chapel-Shaped Coffer, Tomb
of Tutankhamen; details:
Tutankhamen and
Ankhesanamun gilded wood;
19
LANG pl 187-189 EgCM
(Tutankhamen Coll. No. 14)
Chariot in Harvest Scene;
Bowing Men, relief, Tomb
of Khaemet (No. 57)
SMIW pl 110 EgT
Chariot of Tutankhamen,
second state. detail
SMIW pl 148
Charioteers, relief, Tell el
Amarna stone; 9-1/2x
21-1/2
UMCF (1960. 170)
Chest of Tutankhamen, lid;
end inlay; 12-1/4
SMIW pl 151, 150 EgCM
Chest with Hieroglyphs and
Symbols cedarwood
CASL 171 (col) EgCM
Colossi of Memnon (northern
figure: "Singing Colossus")
Amenhotep III Funerary
Temple Figures c 1400
B. C. quartzite; 63' (as
preserved); Original H,
with missing crown: 68'
BR 73; ENC 198; GARB
120-21 (col); LANG pl
162, 163; ROOS 7B; SIN
22; SMIW pl 119 EgT
Commemorative Scarab of
Amenhotep III glazed
steatite; L: 3-3/4
NM-4:17 UNNMM (35. 2. 1)
Crowned King, head black
granite
DR 99 EgCM
Cubic Stool of Senmut c 1500
B. C. black granite;
100 cm
BERLES 83 GBSBe (2296)
Cup of General Thoutii gold;
. 022 m; Dm: . 179 m
CHAR-1:77 FPL
Decorated Columns, Temple of
Amon CHENSN 59 EgK

Ducks, swag block detail,
Amarna limestone; L: 21
BOSMI 195 UMB (62. 320)
Dwarf Holding Vase wood
BOSMET 136 UMB
Egyptian Soldiers and
Prisoners, relief limestone;
23. 6x18. 7; and 22. 8x19. 5
DESA pl 30, 31 NLR
Female Head, harp decoration,
Amarna 1375/50 B. C. ptd
wood; 5. 2
CHAR-1:85 (col); DESA pl
20;
GAF 139 FPL
Fish-Shaped Vase c 1370 glass,
with waving stripes; 2-3/4
MU 26 (col) EgCM
Fish-Shaped Vessel, El Amarna
c 1370 B. C. polychrome
glass; L: 5-1/2
BRITM 202 ELBr (55193)
Foreign Ambassadors, relief,
Tomb of King Horemheb
c 1330 B. C. limestone
WOLD 151 NLR
Foreigners Seeking Asylum,
relief limestone; 19. 5x24. 2
DESA pl 29 NLR
Funeral Procession, tomb wall
fragment H: 26 cm
COPGE pl 29 DCN (A 725)
Funeral Scene, tomb wall
fragment . 48x1. 5 m
COPGE pl 28 DCN (A 704)
--: Mourners and Funeral
Meats, relief, Tel El
Amarna c 1360 B. C.
limestone
NCM 259 UMiD (24. 98)
Galley with Fifteen Rowers,
relief, Temple of Deir el
Bahri 1501/1447 B. C.
CHRP 24
Gazelles, Thebes c 1375 B. C.
ptd ivory, on base with
incised desert plants; c
4-1/4
BRIONA 51; LLO 170;
NM-4:32; NMA pl 21 (col)
UNNMM (26. 7. 1292)
Girl Holding Duck, ointment
spoon wood
BOSMEG 136 UMB
Girl Swimming after Duck,
perfume spoon c 1400 B. C.
wood; L: . 305 m
CHAR-1:79; GARDH 68;
LARA 136 FPL

--, ungent spoon, Abu Gurob
c 1400 B. C. wood; L: 30
cm
GAUN pl 10; WOLD 195
(col) EgCM
A God, head detail
CHENSN 60 EgK
Goddess Guarding Canopic
Shrine of Tutankhamen
MERT
Goddesses from Tomb of
Tutankhamen: Neith, Isis,
Selkit
LLO 186 EgCM
Hathor c 1500 B. C. bronze; 10
GRIG pl 19 ELBr
--: As Goddess of Death in
Shape of Sacred Cow, with
Amenophis II Drinking
from her Udder ptd sand-
stone; L: 88
LANG pl 142, 143 EgCM
(445)
--, cow-figure gilded wood
CASL 175 (col) EgCM
Hathor-Headed Pillar, Hathor
Shrine c 1480 B. C.
GARB 123 (col) EgDe
Hatshepsut: As a Sphinx H:
64-1/2
NM-4:26 UNNMM (31. 3. 166)
--: As "King", seated figure
MERT UNNMM
--: Drinking from Udder of
Hathor Cow, Chapel of
Hathor relief, Temple of
Queen Hatshepsut
LANG pl 125 EgT
--: With Offering of Wine Jugs
c 1480 B. C. red granite
ROTHS 15 UNNMM
--, head granite
CASL 55 UMB
--, head c 1475 green schist
CLE 3 UOClA (860. 17)
--, kneeling figure 1490/80
B. C. red granite
PEP pl 12
--, obelisk fragment red
granite
BOSMEG 117 UMB
--, seated figure (Partially
restored) c 1501/1480 B. C.
black granite; 77
CHENSN 57; CHENSW 48;
CRAVR 25; FEIN pl 6;
GARB 141; LLO 166; MERT;
NM-4:27; NM-10:15; PACHA
217; PANA-1:112; RAY 10;

RUS 11; SMIW pl 95;
STI 106; ZOR 257 UNNMM
(29. 3. 2)
--, seated figure limestone;
LS
LANG pl 127; VALE 86
UNNMM
Hatshepsut Obelisks
DR 60 EgK
--: Hatshepsut, relief
LANG pl 128, 130; PRAEG
18
Hatshepsut Sarcophagus, front
relief dark red quartzite
LANG pl 126 EgCM (620)
Head granite
BOSMEG 128 UMB
Headrest: Hare c 1400 B. C.
wood
CHENSW 48 ELBr
Hieroglyph: Bird, Pylon of
Thutmose I
CASL 157 (col) EgK
Hieroglyphic Inscription,
Amenophis III, statue base
ELIS 140 UNNMM
High Priest of Memphis at the
Grinding Stone limestone;
.1 m
COPGE pl 25 DCN (A 15)
Horemhab as Scribe, seated
figure c 1358/53 B. C.
grey granite; 46
LANG pl 198, 199; NM-4:
30; NM-10:13; ROTHS 35;
SMIW pl 140 UNNMM
(23. 10. 1)
Horse Whip Handle ivory;
L: 5-7/8
MU 26 (col) EgCM
--: Running Horse c 1350
B. C. tinted ivory
CHENSN 65; NM-4:32;
NM-10:18; NMA pl 22 (col);
ROUT UNNMM (26. 7. 1293)
Horse and Rider c 1550 B. C.
ptd wood; 12
MU 27 (col); NMA pl 25
(col) UNNMM (15. 2. 3)
Horus with Falcon's Head
8th c. B. C. bronze; 37. 4
GAU 52 FPL
Hunting in the Desert, relief,
Tomb of Rekhmara c
1500/1450 B. C.
WOLD 142 EgT
Hunting Scene of Amenemhet
(Tomb No. 53); detail
SMIW pl 101, 99 EgT

Iamu-Nejeh, block statue
black granite
DR 82, 83 EgCM
Ibis gold, with dark blue
paste in cloisons
BOSMEG 121 UMB
Ibis of God Thoth wood,
stucco, bronze, and glass;
13. 8x5. 5
DESA pl 32 FPL
Ikhnaton (Akhenaten,
Amenhotep IV) c 1360 B. C.
H: 3-1/8
JANSK 64 formerly GBS
--, Amarna c 1365 limestone;
8-3/8
MU 21
--: Enthroned, relief, Tomb of
Ramose (No. 55)
SMIW pl 115 EgT
--: Making an Offering to
the Sun Disk, stele
BAZINH 503 EgCM
--: Praying to Sun, relief
fragment 1380/1352 B. C.
marble; 21-1/4x28-1/4
ALB 137; ALBA UNBuA
--: Seated beneath Sun Disk,
relief
LARA 140 ELBr
--: Worshipping Aten, relief
BOSMEG 133 UMB
--, bust limestone; 21. 7
CHAR-1:84; GAU 55 FPL
--, bust limestone; 31
LANG pl 180 FP
--, bust c 1375 B. C.
ROOS 7H GBS
--, colossus (Colossus of
Amenhotep IV) c 1375
sandstone; 13'
DR 89; GARB 162; SMIW
pl 124-5 EgCM
--, head detail
LARA 141; WOLD 163
--, head
HAUSA pl 4 GBA
--, head ptd limestone; . 22 m
COPGE pl 31 DCN (A 8)
--, head red quartzite; 7
ELIS 166; NM-4:29
UNNMM (30. 8. 54)
--, head wood
MERT FPL
--, head c 1360 B. C. stone
ROTHS 29 EgCM
--, head 1380/1363 B. C.
sandstone; c 8
GARDH 63 GBS

--, head, relief limestone;
5-1/2x4. 3
DESA pl 10 formerly GBS
--, head, relief c 1375 B. C.
ROOS 7F GBS
--, head, relief, Karnak
c 1375 B. C. sandstone
CLE 4 UOClA (59. 188)
--, head fragment limestone;
3-1/4
DIV 16; NM-4:28 UNNMM
(26. 7. 1395)
--, head fragment, Tell el
Amarna c 1370 stucco; 10. 2x
6. 1
CHENSN 63; CHENSW 51;
DESA pl 12; GOMB 43
formerly GBS
--, head fragment, relief
c 1365 B. C. limestone;
3-1/8
JANSH 47 GBS
--, pillar figure, Aton
Temple, Karnak; bust from
pillar figure reddish brown
sandstone; 13'
LANG pl 177, 176; LLO
177 EgCM (6015, 6016)
--, relief detail stone
FAIY 45 UNBuA
--, seated figure c 1360 B. C.
H: 25
UPJH pl 5E FPL
--and family, relief
CHRH 44
--and family, relief limestone;
15-1/4x12-1/4
GARDH 64 GBS
--and family: Beneath Aton,
Sun Disk, sunk relief
limestone; 17
GARB 162; ROTHS 33
EgCM
--and family: Making
Sacrificial Offerings to
Aton, tomb relief Amarna
limestone; c 21
STI 106; WOLD 149 EgCM
--and family: Showing symbol
of Aten, Sun God: Sun Disk
with Rays Ending in Hands,
and Crux Ansata, relief,
Tel el Amarna
LLO 184 GBS
--and his son, seated figure
limestone
VALE 87 EgCM
--and Nefertiti ptd limestone;
. 225 m CHAR-1:88 FPL

--and Nefertiti: Adoring the
Sun, relief c 1379/1361
B. C. alabaster; 39-1/4
EXM 342 EgCM
--and Nefertiti: At Window
of Appearances, relief,
Tomb of Ramose (No. 55)
SMIW pl 116 EgT
--and Nefertiti: With Disc
of Aton, relief; King,
detail, Maket Aton lime-
stone; 13x15. 4
CHASEH 30; DESA pl 8, 9,
11; MYBA 38; ROBB 281
GBS
--and Nefertiti, sculptor's
model, relief, Tell el
Amarna
LLO 180 UNBB
--and Nefertiti, relief, Tel
el Amarna 1370/1352 B. C.
limestone; 16-1/2x29-1/4
NCM 259 UCLCM
(A. 5832. 47. 28)
Ikhnaton Royal Throne, back
panel wood, gold overlay,
silver inlay, stone and
faience
CHRP 29 EOA
Ikhnaton's Daughter, head, El
Amarna sandstone
CHENSN 62 GBS
--, head detail brown
quartzite; 14 cm
COPGE pl 30 DCN (A 12)
--, life mask 1370 B. C.
plaster
MILLS pl 20 ELBr
--, torso, El Amarna
MILLER il 9 ELU
Ikhnaton's Daughters, heads
quartz sandstone
DR 92, 93 EgCM
Imenmes, tomb relief
fragment limestone,
traces of paint; 21. 7
DESA pl 5 FPL
Isis Protecting Foot of
Tutankhamen's Second
Coffin, relief
LARA 119 EgCM
Jar Stand bronze; 2-7/8
SMIW pl 99 UICNh
Kha, Chief of the Great
Place c 1450/1375 B. C.
wood
CANK 57 (col) ITE
Kha-em-het Praying, tomb
relief LANG pl 153 EgT

Nakht-min, head; wife
H: 13-1/2
SMIW pl 113 EgCM
Native Huts in the Punt,
relief, Mortuary Temple
of Queen Hatshepsut, Deir
el Bahari, Thebes
limestone
WOLD 140 EgTD
Nefertiti (Nofretete) H:
15-3/4
GARB 163; SMIW pl 131
GBSBe
--, El Amarna plaster
CHENSW 50 GBS
--c 1370 B. C.
ZOR 100
--: Adoring Aten Sun-Disc
alabaster; 6-1/2
BOSMI 193 UMB (37. 3)
--, Akhet-Aton head brown
quartzite; 13
CASL 25 (col); LANG pl
178, 179 EgCM (6206)
--, head c 1365 pink lime-
stone; 6
DENV 4 UCoDA (An-50)
--, head c 1360 B. C. grey
granite; 8-1/2
BERL pl 73; BERLES 73
GBSBe (21358)
--, head c 1360 B. C. ptd
limestone, rock crystal
eyes; 19-5/8; base W:7. 8
BARD 133; BAZINW 113
(col); CASL 55; CHENSN
col pl 1 (col); CHENSW 51;
CRAVR 25; CHRH fig 7;
DESA pl 13, 14; EA 458;
ENC 24; FEIN pl 3; GARB
154 (col); GARDH 47; JAG
61; JANSH 48; JANSK 63;
LANG pl 181 (col); LLO
182 (col); MU 21 (col);
NEUW 11 (col); PRAEG 122
(col); ROOS 7G; ROTHS 31;
RUS 12 (col); SEW 21;
SMIW pl 130; STI 102; UPJH
pl 6A; WB-17:196; WOLD
167 (col) GBSBe
--, head (reproduction from
original in Berlin) c 1360
B. C. colored stone; c 20
ROTHS 31; UPJH pl 6A
UNNMM
--, head fragments limestone
ZOR 84, 86, 87 UNNMM
--, head relief, Aten c 1375
B. C. sandstone
CLE 4 UOClA (59. 186)

--, relief limestone, gypsum
surface; 8x18-1/2
TOR 12 CTRO (958. 223)
--, torso fragment quartzite;
11. 5
DESA pl 15 FPL
--, unfinished head red
quartz sandstone
DR 90; GAUN pl 8; LARA
142; LLO 185 EgCM
Nefertiti (Nofretete) and
Princesses, relief frag-
ment, Lahun
SMIW pl 125 UPPU
Negro Girl Carrying Jar
boxwood; 4
LLO 162, 163 EDuUO
Nile God Hapi, relief
fragment c 1345 B. C.
limestone; 18
BOSMEG 137; BOSMI 193
UMB (50. 3789)
Nobleman and Wife, seated
figures c 1325 B. C. lime-
stone; 52
BRITM 189 ELBr (36)
Obelisk of Tuthmosis I,
east side
SMIW pl 88 EgK
Offerings, relief
BR 72 EgDe
Officer of State in Full
Court Dress c 1400 B. C.
wood; 11
NORM 64 ELBr
Ointment Bowl: Bound
Antelope 15/14th c. B. C.
wood; L: 11. 4 cm
BERLES 76 GBSBe (8925)
Ointment Box: Grasshopper
ivory; L: 3-1/2
SMIW pl 153 -Guen
Ointment Box: Swimming Duck
ivory; L: 6-1/8
SMIW pl 153 UMdBW
Ointment Spoon 15/14th c.
B. C. wood; L: 36. 5 cm
BERLES 76 GBSBe (1877)
Ointment Spoon: Slave Girl
among Papyrus, handle
c 1400 B. C. wood
COPGG 13 DCN (A-553)
Old Man, relief
SMIW pl 145 UNBB
Ornamental Boat--Girl with
Lotus; Dwarf Poler
CASL 172-173 (col) EgCM
Osiride Statue of Hatshepsut
H: 60-1/4
SMIW pl 94 EgCM

Osiris gilt wood
 LAH 21 UCLCM
Osiris Pillar
 DR 71 EgDe
Panther wood
 BOSMEG 122 UMB
Papyrus-Bundle Columns,
 Temple of Amon c 1400/1360
 B. C.
 GARB 124 (col) EgL
Pectoral gold cloisonne, with
 semi-precious stones and
 glass paste
 CASL 10 (col) EgCM
Pectoral: Vulture and
 Snake gold, semiprecious
 stone inlay
 HUYA pl 7 FPL
Perfume Spoon ivory, turquoise
 inlay; . 025x. 07x. 045 m
 CHAR-1:78 FPL
Pharoah, profile relief lime-
 stone
 READG 112
Pillars: Lotus and Papyrus,
 Temple of Amon
 CASL 13 EgK
Pomegranate Ointment Spoon
 ivory; L: 8-1/4
 SMIW pl 152 UNBB
Priest, relief, Tomb of Pa-
 Aton-em-Heb limestone;
 9-1/2
 DESA pl 22 NLR
Priest Conducting Opening of
 the Mouth Ceremony, relief
 c 1400 B. C. stone
 MYBS 12 ELBr
Priest Offering Sacrifices and
 Musicians, Paatenemheb, tomb
 relief; detail: Blind Harpist
 limestone; 23 LANG pl 196,
 197, NLR
Princess, head blue lapis lazuli
 paste; 8. 7 cm CHAR-1:93 (col)
 FPL
Princess, head, Amarna c 1340
 B. C. ptd limestone; 15 cm
 WOLD 164 (col) FPL
--, head, Amarna c 1350 B. C.
 brown sandstone; 21 cm
 WOLD 165 GB
--, head relief, Amarna
 BOSMEG 133 UMB
Princess, torso red quartzite;
 30 cm
 CHAR-1:101 (col) FPL
Princess Meryetaten (Canopic
 Jar Top of Semenkh-Ka-Re)

alabaster; 7
 NM-4:29; NM-10:12 UNNMM
 (30. 8. 54)
Princesses, relief, Tomb of
 Kheruef (No. 192)
 SMIW pl 112 EgT
Procession of Princesses
 Carrying Sacred Vessels,
 Kheruef tomb relief
 LANG pl 154, 155 EgT
Ptah Temple Sphinx, Memphis
 Temple alabaster; 13x26
 LANG pl 114 EgMe
Ptahmes, pillar relief lime-
 stone; 33-1/2
 DESA pl 25 NLR
Punt Colonnade Details, South
 Wall
 SMIW pl 92, 93 EgDe
Queen, bust limestone
 DR 100 EgCM
Queen, El Amarna c 1380
 B. C. brown sandstone;
 8-5/8
 BERL pl 68 (col); BERLES
 68 (col) GBSBe (21220)
Queen's Head, lid of canopic
 jar, Valley of the Kings
 alabaster; 36 cm
 WOLD 126 (col) EgCM
Ramose Tomb Reliefs:
 Ramose; Feast; Almsgiver
 c 1400/1362 B. C.
 limestone
 LANG pl 166-174 EgT
--: Female Head
 LLO 181
--: Lady in Waiting
 WOLD 150 (col)
Relief, Memphite Tomb of
 Horemheb
 SMIW pl 144 IBoC
Reliefs, unfinished, Tomb of
 Horemheb
 SMIW pl 144 EgT
Royal Head, Amarna style
 c 1360 B. C. hardwood
 BAZINH 27; CHENSW 52;
 GAU 64 (col) FPL
Royal Head, Amarna stone
 CHENSW 52 GBS
Royal Official Mask, Amarna
 c 1350 B. C. stucco; 27 cm
 WOLD 172 (col) GBNa
Royal Statue, torso H: 63 cm
 COPGE pl 14 DCN
The Salt Head ptd limestone; 13
 CHAR-1:62-63; DESA pl 24
 FPL

Satepihu, block statue ptd
limestone
CASL 123 UPPU
Scarab: Seal of Amenhotep
III
VALE 127 UMiD
Scarab, Sacred Lake rose
granite
DR 63
Scribe basalt; 2-1/2
DETT 15 UMiD (31. 70)
Scribe's Palette, with name;
Amosis I c 1570 B. C.
wood; L: 11-1/2
BRITM 83 ELBr (12784)
Seated Couple schist; . 127 m
CHAR-1:51 FPL
Seated Figure c 1500 B. C.
granite
NEWTEA 32 ELBr
Sebekmose Offering to Anubis,
relief
BOSMEG 131 UMB
Sekhmet (Sakhmet)
CASL 74 GBS
--(Lion Head), Thebes
Temple
RAY 10
--, Karnak diorite
PUT 308
--H: 2 m
COPGE pl 26 (A-87)
--, bust, Temple of Mut
SOTH-4:302 ELSoth
--, detail black granite
DR 86 EgCM
--, seated figure
BOSMEG 130 UMB
--, seated figure black
granite; 2. 3 m
CHAR-1:81 FPL
--, seated figure 1413/1377
B. C. granite; 240 cm
WPN pl 6 PWN (143400)
Semenkhare, canopic jar lid,
Semenkhare Tomb alabaster
LANG pl 194 EgCM
--, front and back views
yellow steatite; 25. 3
DESA fr cov, bk cov FPL
--, head quartz sandstone
DR 91 EgCM
--, seated figure 1350 B. C.
yellow steatite; 64 cm
CHAR-1:87 FPL
--and his consort Maritaton
"Promenading in the
Garden", relief c 1350 B. C.
ptd limestone; 9. 4x7. 8

DESA pl 21; WOLD 152
(col) GBNa
Senmut (Senemut, Sennemut):
Holding a Princess 1470
B. C. granite
HOF 141; JAG 59 EgCM
--, block statue with
hieroglyphics quartz; 54 cm
WOLD 160 (col) ELBr
--with Neferure, seated
figure c 1500 B. C. black
granite; 31
BRITM 47 ELBr (174)
--, seated figure c 1500 B. C.
black granite; 39-3/8
BERL pl 83 GBSBeA (2296)
Sennefer, seated court official
with inscribed prayer to
Osiris, block statue,
Thebes c 1500 B. C. black
syenite; 33
GRIG pl 33 ELBr
Sennefer and his Wife black
granite
DR 79 EgCM
Serket, surmounted by
Scorpion
CASL 177 (col) EgCM
Shawabtis, Tomb of Tuthmosis
IV
BOSMEG 120 UMB
Shawabty Figures c 1400 B. C.
TAYFF 4 (col) UNNMM
Shrine for Bark of Amun:
Amenhotep I and Amun;
Amenhotep in Blue Crown
(Kheperesh)
LANG pl 115-117 EgK
Small Throne of Tutankhamen,
back: Tutankhamen wood,
gold leaf cover with glass
glaze and stone inlay
LANG pl 190 EgCM
(Tutankhamen Coll. No. 1)
--back detail: Tutankhamen
LANG pl 191 (col); LARA
143
Soldiers Greeting Amenhotep
III, relief
BOSMEG 132 UMB
Sphinx, with portrait of
Hatshepsut red granite;
65-1/2x11'5"
MU 20 UNNMM
Sphinx of Hatshepsut, Deir el
Bahari c 1490 B. C. red
granite; L: 113
BERL pl 78; BERLES 78
GBSBeA (2299)

Sphinx of Thutmose III
 RAY 12
Stela of Architects Hor and
 Suty c 1400 B. C. granite;
 58
 BRITM 124 ELBr (826)
Temple of Amen (Amun):
 Pylon and Obelisk of
 Thutmose I (Tuthmosis I);
 Obelisk of Hatshepsut
 LANG pl 118 EgK
Teta-Khart, seated figure
 GLA pl 25
Tetiseneb, seated figure
 c 1570 B. C. ptd limestone;
 30. 8 cm
 WOLD 158 (col) GHaK
Thothotep H: 25 cm
 COPGE pl 20 DCN
Three Gods Bearing Offerings,
 Temple relief c 1380 B. C.
 limestone
 CLE 3 UOClA (61. 205)
Thutmose (Tuthmosis) I
 Sarcophagus
 BOSMEG 118 UMB
Thutmose (Tuthmosis) II, head
 stone
 MILLS pl 19 ELBr
Thutmose (Tuthmosis) III black
 granite
 CASL 55 EgCM
--c 1450 B. C. basalt; LS
 BR 74; ROBB 280 EgCM
--, Karnak c 1502/1448 B. C.
 grey-green slate; 79
 GARB 142; LANG pl 132
 EgCM (400)
--head detail
 LANG pl 133; SMIW pl 96
--, Temple of Montu, Medamud
 LLO 167 UNNMM
--: In Atef Crown, and God
 Amu, Hall of Birth relief,
 Temple of Hatshepsut
 LANG pl 120 EgT
--: In Crown of Upper Egypt,
 bearded figure; detail
 grey-green slate; 35
 LANG pl 134, 135 EgCM
 (404)
--: Offering Sacrifices white
 stone; c 14
 LANG pl 131; WOLD 157
 EgCM (428)
--: Smiting Asiatics, 7th
 pylon relief, Temple of
 Amun limestone
 LANG pl 136; LLO 176 EgK

--: Triumphal Figure slate
 BR 74 EgCM
--, detail
 DR 62 EgK
--, head c 1500 B. C. basalt;
 13
 WHITT 67 ELBr
--, head detail
 CHENSN 53; CHENSW 49;
 MERT EgCM
--, profile detail
 LARA 139 EgCM
--, relief, Kumma sandstone
 BOSMEG 119 UMB
--, statue face obsidian
 DR 77 EgCM
Thutmose (Tuthmosis) III, or
 Hatshepsut, statue head
 c 1480 B. C. schist; 18
 BRITM 48 ELBr (986)
Thutmose (Tuthmosis) IV: As
 Sphinx Trampling Enemies,
 throne panel relief 1410
 B. C. L: 11-1/2
 BOSMI 191 UMB (03. 1131)
--and his Mother, Tio, seated
 figures granite; 43
 DR 78; LANG pl 149 EgCM
 (503)
--: Tio's Head
 LANG pl 148
Tiy (Teye, Tiyi), Mother of
 Akhenaten and wife of
 Amenhotep III, head,
 Fayum c 1440 B. C. ptd
 yew, with gold and paste
 inlay; 4-1/4x2. 8
 DESA pl 2; GARB 143;
 MERT; SMIW pl 117;
 WOLD 162 (col) GBSBe
--left profile
 DESA pl 3
--, head fragment yellow
 jasper; 5-1/2
 NM-4:28 UNNMM
 (26. 7. 1396)
Toilet Box, with Leaping
 Animals
 BOSMEG 135 UMB
Toilet Spoon, palmate
 handle with figures
 READG 112
Tomb of Hormin, relief
 JOHT pl 33
Toui (Lady Tui) 1411/1375
 B. C. wood; 13. 4
 BAZINH 27; CHAR-1:89;
 DESA pl 6; GAF 139; GAU
 52 FPL

Isis, Chapel of Osiris, relief,
Seti I Temple
LANG pl 224 (col); LLO
190 (col) EgAb
"Israel" Steal of Merneptah
MERT EgCM
King, inlay head fragment
red jasper; 1
BOSMI 195 UMB (40. 72)
Libyan, temple relief
BOSMEG 142 UMB
Man, head c 1300 B. C. bronze
CLE 4 UOC1A (334. 14)
Merneptah, Pharoah of the
Exodus, seated figure
RAY 11
Mit-Rahina, Ramses II,
detail, Ptah Temple
limestone
LANG pl 242
Mourner, relief c 1330 B. C.
limestone; 19-5/8
BERL pl 80; BERLES 80
GBSBe (12411)
Mourners and Funeral Meats,
relief limestone; 20-3/4
x10-1/2
DETT 18 UMiD (24. 98)
Nefertari, relief
LANG pl 241 EgL
Negro Captives, relief,
Haremhab Tomb c 1325 B. C.
ROBB 282 IBoC
Obelisk
DR 106, 107 EgL
Offerings of Gifts, relief
c 1315 B. C.
CHENSW 53 UNNMM
Official, block statue red
quartzite; 22
SOTH-3:151
Ointment Spoons c 1250 B. C.
wood; 6-1/2; and 9-1/4
NORM 64 ELBr
Onamastic Group of Ramses II:
Representation of Hieroglyphic
Characters Used in Writing
Ramses black granite
DR 118 EgCM
Osiris: With Table of Offer-
ings, relief c 1350 B. C.
MU 16 (col)
Osiris and Goddesses, relief,
Seti I Temple 1318/1298
B. C.
GARDH 65 EgAb
Osiris-Pillars, Ramesseum;
head detail
DR 109, 110 EgKu

Palm Column
BOSMEG 80 UMB
Papyrus Column
BOSMEG 80 UMB
Priests and Priestesses in
Procession Following King
and Queen, relief
Ramses I Temple,
Abydos limestone
DIV 15 UNNMM
Procession of Prisoners,
Haremhab Tomb relief
LANG pl 200-203 NLR
Ptah and Ramses II,
colossal group H: 3. 3 m
COPGE pl 35 DCN
(A 14)
Ptahmai Family, with "Gold of
Courage" Decoration c
1250 B. C. limestone;
39x34-1/2
BERL pl 75; BERLES 75
GBSBe (2297)
Queen, bust limestone
DR 121 EgCM
Ramses I: Enthroned, Abydos
relief
RAY 11
Ramses II 1290/1280 B. C.
quartzite; 40-1/2; circ:
39
SDF 118 UCSDF
--: In Battle, relief
1290/1223 B. C. stone
WCO-1:19 (col) EgAS
--: Kneeling before Amon,
relief
LARA 144
--: Making Votive Offering,
Karnak 1290/1224 B. C.
slate; L: 75 cm
WOLD 192 EgCM
--: Wearing Crown of Upper
Egypt, Karnak c 1250 B. C.
red granite; 106
GRIG pl 28 ELBr
--, bust grey granite
DR 119 EgCM
--, head c 1290 B. C. stone
CHENSW 54
--, four seated colossi,
facade figures 1300 B. C.
sandstone; 65'
CASL 22 (col); CHASEH 26;
CHENSW 54; CHRP 31; GLA
pl 25; LANG pl 243-4; LLO
192; MARQ 15; MERT;
MILLER il 15; MU 14; RAD
22; RAMS pl 1a-b; ROOS 7C;

ROTHS 17; SIN 12; SLOB
187; STI 95; UPJ 35;
UPJH pl 6C; WCO-1:18;
WOLD 177 (col) EgAS
--detail
ENC 4; ROBB 15
--head detail
CHRP 33
--, colossal figure, Karnak
c 1250 B. C. granite;
11'10"
BRITM 56 ELBr (61)
--, colossal figure--upper
part H: 1.25 m
COPGE pl 34 DCN
(A 81 bis)
--, colossal figure--upper
part, Ramesseum, Western
Thebes c 1250 B. C.
granite; 105
BRITM 54 ELBr (1817)
--, colossus head, Luxor
Temple black granite
DR 111 EgCM
--, head
CHENSN 64; CRAVR 20;
TAYFF 4 (col) UNNMM
--, head black granite
CASL 55 ITM
--, head black granite
DR 117 EgCM
--, head ptd quartzite; 17-1/2
NM-4:30 UNNMM (34.2.2)
--, pillar statue(s), Great
Hall central aisle H: c 32'
LANG pl 245; ROOS 7D
EgAS
--, seated among Osiris Triad
black granite
DR 116 EgCM
--, seated figure, Karnak
c 1301/1234 B. C. black
granite; 76-1/2
CHRP 30; GARB 166; LANG
pl 230-1; ROBB 284; SMIW
pl 159 (head detail); WOLD
190 ITE
--, seated figure, sceptre in
right hand alabaster
LARA 144 UPJH pl 6B
(profile) ITM
--, twin statues, colonnade
Figures, Amen Temple
1290/1224 B. C. limestone;
c 20'
CASL 17 (col); CHRH fig 2;
LANG pl 240; LARA 139;
MYBA 35; STI 103; WOLD
181 (col) EgL

Ramses II and Nofretari,
niche figures, Queen's
Temple sandstone
CASL 23 (col) EgAS
Ramses II and Son Roping a
Bull, Seti I Temple
c 1280 B. C.
JANSK 65 EgAb
Ramses II Pectoral, with
royal symbols gold, paste
decorated and jeweled;
13. 5x15. 5 cm
CHAR-1:79 FPL
Ramesseum, Mortuary
Temple of Ramses II
c 1198/1167 B. C.
LARA 142 EgT
--: Hieroglyphic Inscription,
dorsal pillar sandstone
DR 104
--Ramses II, court
colossi(us)
DR 101; WOLD 174 (col)
Ruler, relief fragment rose
granite; 29
BMA 9 UMdBM
Scribe c 1350 B. C. H: 17 cm
COPGE pl 24; COPGG 15
DCN (A 65)
Seated Baboon sandstone
DR 125 EgCM
Seti, Osiris, and Horus,
Seti I Temple, Abydos
c 1350 B. C.
STI 107 UNNMM
Seti (Sethos, Sethosis, Sety)
I red jasper inlay
BOSMEG 143 UMB
--: As Osiris with God Thoth,
Seti I Temple
LLO 191 (col) EgAb
--: Before Atun, Sanctuary
of Re-Harakhte relief,
Seti I Temple
LANG pl 223 EgAb
--: Before Soker, Hall of
Nefertem and Ptah-Soker
relief, Seti I Temple
LANG pl 222 EgAb
--: Fighting Hittites, relief,
Northern external wall,
Hypostyle Hall 1302/1290
B. C. limestone
WOLD 180 EgK
--: In Battle, relief
CHASEH 28 EgK
--: In Presence of Goddess
Hathor, relief, pillar
tomb c 1300 B. C. ptd

Hawara, Steward of Princess
 Amenardis green slate;
 45 cm
 WOLD 211 EgCM
Hershef, Ram-Headed God,
 temple relief c 1200 B. C.
 pale red sandstone; 19
 GRIG pl 23 ELBr
Naval Battle Fought by Ramses
 III Against the People of
 the Sea, relief sandstone
 WOLD 182 EgMH
--: Man of the Sea People
 CASL 50
Perfume Spoon faience
 CHENSW 45 UOTA
Pharoahs stone; 29-1/2
 BARD-2:pl 162 BrSpA
Ramses III: Dispatching
 Libyan, relief, Ramses III
 Temple, Medinet Habu
 sandstone
 CASL 61
--: Hunting Wild Bulls, sunk
 relief, 1st pylon c 1190/
 1160 B. C. sandstone
 GARB 126 (col); GARDH
 64; LANG pl 249: SMIW
 pl 160; WOLD 183 EgMH
--, temple figures
 HOF 29 EgK
--, temple figures, fragments,
 north side, first court
 c 1190/1160 B. C.
 GARB 126 (col) EgT
--, relief, Ramses III Temple
 12th c. B. C.
 BOWR 33 EgMH
--and Court Lady, relief
 BOSMEG 148 UMB
Ramses III Sarcophagus: Isis,
 Hieroglyphic Inscription
 1170/1133 B. C. pink
 granite; 61
 GAU 51 FPL
Ramses IV, triumphal figure
 granite
 LARA 146 EgCM
Ramses VI, triumphal figure
 granite
 DR 131 EgCM
Ramsesnakht, with Naos
 (Shrine) Holding Sacred
 Triad of Thebes: Amun,
 Mut, Khons, Karnak c 1200
 B. C. slate; 40-1/2 cm
 WOLD 194 EgCM
Seated Scribe grey granite
 DR 130 EgCM

Seth c 1200 B. C.
 COPGE fig 6 ELBr
--c 1200 B. C. H: 70 cm
 COPG 12; COPGE pl 37
 DCN (A 99)
Stela of Ramose: Priest and
 his Wife Receiving Offer-
 ings;--Greeting Gods,
 Island relief 1200/1090
 B. C. limestone
 ROTH 27
Temple of Amon: Ram-Headed
 Sphinxes of Entrance
 Approach
 MYBA 32 EgK
Wall Tiles: Foreigners in
 Egypt--Syrian, Philistine,
 Amorite, Kushite, Hittite,
 Ramses III Palace, Medinet
 Habu 1195/1164 B. C.
 faience; 11-3/4
 BOSMA pl 15; DOWN 27
 UMB (03. 1569-1573)
Warship, drwg from relief
 CASL 66
EGYPTIAN--21st Dynasty
Canopic Jars of Neskhons,
 Deir el Bahri c 1000 B. C.
 limestone; 14-1/2
 BRITM 147 ELBr
Hieratic Copy of Decree
 Establishing Ka-Chapel of
 Amenhotpe, son of Hapu
 c 1000 B. C. limestone;
 32
 BRITM 77 ELBr (138)
Tanis Bowl silver; Dm: 7-1/4
 SMIW pl 168 EgCM
Tanis Mask gold
 SMIW pl 167 EgCM
Tanis Vase gold; 15-1/4
 SMIW pl 169 EgCM
Undebunded, Mask gold
 LARA 147
Woman, Tomb figure c
 1000 B. C. wood; 8
 GRIG pl 26 ELBr
EGYPTIAN--21st/22nd Dynasty
Head of a Pharoah
 bronze; .75 m
 CHAR-1:83 FPL
EGYPTIAN--22nd Dynasty
Karomama, consort of
 Takeloth II c 950 B. C.
 bronze, damescened with
 gold, silver, electrum,
 copper; 32. 1
 BAZINW 115 (col); CHAR-
 1:112, 113 (col); GAU 58;
 WOLD 197 (col) FPL

Lotiform Cup faience; 5-5/8
 NM-4:32 UNNMM (26. 7. 971)
Osiris H: 51 cm
 COPGE pl 40 DCN (A 100)
Osirian Triad: Osiris, Isis,
 and Horus gold, lapis lazuli;
 . 09 m
 CHAR-1:108 (col) FPL
Ring with Sacred Symbols,
 Theban Tomb c 800 B. C.
 gold
 SOTH-2:126
Sekhmet, seated figure, Sun
 Disk on forehead, holding
 Ankh c 930 B. C.
 GRIG pl 34 ELBr
Sow with Lily engraved on
 forehead after 850 B. C.
 ebony; L: 4-3/8
 GRIG pl 35 ELBr
Tanis Pectoral W: 3
 SMIW pl 168 EgCM
EGYPTIAN--22nd/23rd Dynasty
 Maat, staff head 952/755 B. C.
 bronze; 13
 DENV 7 UCoDA (An-98)
EGYPTIAN--Late Dynastic (22nd/30th
 Dynasty)
 Falcon 945/332 B. C. faience
 inlay; 6-1/2
 MU 27 (col) UNNMM
EGYPTIAN--24th Dynasty
 Boccoris Vase: Scenes of
 Pharoah Bokonrinef,
 Tarquinia before 728 B. C.
 SAN 159 ITarN
Cat, seated figure bronze
 SLOB 216 FPL
Petamenopet: Seated Scribe
 c 730/715 B. C.
 BAZINW 116 (col) EgCM
EGYPTIAN--24/26th Dynasty
 Sarcophagus: Ibis wood,
 bronze; 13-1/4x19-3/4
 DENV 8 UCoDA (An-69)
EGYPTIAN--25th Dynasty
 Altar of Atlanersa, Gebel
 Barkal 653/643 B. C.
 H: 45-1/2
 SMIW pl 17b UMB
--: Piankhy on Platform,
 Flanked by Horus and Thoth,
 relief 653/643 B. C.
 BOSMEG 168
Altar of Taharqa
 SMIW pl 175 SuJbA
Aspelta, King of Egyptianized
 Sudan 6th c. B. C. black
 granite; 10'9" BOSMEG 167;
 BOSMI 197 UMB (23. 730)

Bed Leg: Duck bronze
 BOSMEG 171 UMB
Block Statues black granite
 BR 136 EgCM
Cat bronze
 VALE 88 UMiD
--, with Necklace and Ear-
 rings bronze; c 6-1/2
 BRIONA 52 FPL
Coffin Lid: Figure c 550 B. C.
 wood; 72-7/8
 BERL pl 81 GBSBeA
 (8237)
Die Squatter, statue of
 Priest 650 B. C. black
 granite
 PRAEG 172
Dish Handle, Daphnae gold; 5
 SMIW pl 179 UMB
Family Group, seated figure
 black granite
 DR 137 EgCM
Green Head, Saqqara green
 schist; 4-1/4
 BOSMEG 176; BOSMI 201;
 SMIW pl 185 UMB (04. 1749)
Harsaphes gold
 BOSMEG 160 (col) UMB
Isis, horned disk headdress,
 ornament gold and crystal
 BOSMEG 169 UMB
Khonsu-ir-aa 670/660 B. C.
 diorite; 17
 BOSMI 195 UMB (07. 494)
Kushite Ornaments: Sphinx on
 Column; Pendant
 BOSMEG 169 UMB
Kushite Pectoral: Winged Isis,
 Nuri, Sudan 538/520 B. C.
 gold; L: 6-1/2
 BOSMEG 172; BOSMI 199
 UMB (20. 276)
Man and Wife, relief, Theban
 Tomb c 660 B. C. limestone
 CLE 5 UOClA (49. 493)
Mentuemhat, bust, Karnak
 c 660 B. C. granite
 BAZINW 115 (col) EgCM
Mirror, papyrus column
 handle silver
 BOSMEG 173 UMB
Mirror Handle silver
 BOSMEG 172 UMB
Mirror Handle of Shabako
 gilded silver; 5-5/8
 SMIW pl 179 UMB
Montuemhet; detail black
 granite
 DR 141, 142 EgCM

Old Man, head c 700 B. C.
crystalline limestone; 8-1/2
BRITM 190 UMB (37883)
Piankhy Relief: Bowing Prince
of Mendes
SMIW pl 174 SuJbA
--: Men Leading Horses
SMIW pl 173 SuJbA
Piankhy Stela, top detail,
Gebel Barkal
SMIW pl 174 EgCM
Recumbent Ram with Figure
of King Taharqa, Kawa,
Nubia c 680 B. C. grey
granite; 16
BRITM 62 ELBr (1779)
Royal Statuette c 700 B. C.
ivory; 20 cm
WOLD 206 (col) ScER
Sacred Group: Ptah and Thoth
in form of Ibis and Apes
wood; .65 m
CHAR-1:135 FPL
Seated Scribe; head detail
slate
DR 135, 136 EgCM
Seated Scribe; profile yellow
quartz sandstone
DR 139, 138
Sheaths electrum
BOSMEG 172 UMB
Taharqa (Taharka) black
granite; 14
cm
COPGE pl 44 DCN (A 19)
--bronze
COPGE fig 7 DCN (A 18)
--, Gebel Barkal; head
detail c 149
SMIW pl 177 SuKM (No.
1841)
Taharqa, head black granite;
13-3/4
GARB 128 (col); SMIW pl
178 EgCM
Taharqa Column
DR 132 EgK
Taharqa Temple, relief,
Sanam
SMIW pl 175 GBM
Takushit silver inlaid bronze;
27-1/2
CHENSW 54; LARA 148;
SMIW pl 169 GrAM
Thoueris, Hippopotamus
Goddess of Pregnancy and
Childbirth green slate
CASL 74; DR 140, 141
EgCM

Vase of Aspelta 593/568 B. C.
gold; 12-1/2
SMIW pl 179 UMB
EGYPTIAN--25/26th Dynasty
Men Boating, Theban tomb
relief
BOSMEG 179 UMB
Pedimenopet, seated figure,
"cubic squatter type"
granite; 12-1/4
LANG pl 252 formerly GBS
Priest, head granite
LANG pl 253 FPL
EGYPTIAN--25/30th Dynasty
Mummy Mask
HOW UCSFCP
EGYPTIAN--Later Period (Before
16th Dynasty)
Cat on Papyrus Column 7/6th
c. B. C. bronze; 19
BOSMI 197 UMB (52. 1026)
EGYPTIAN--26th Dynasty (Saite
Period)
Amulet: Amuletic Hawk elec-
trum; 2-1/2
SOTH-3:146
Ankhesne feribre Sarcophagus:
Goddess Nut, inscribed
figure c 525 B. C. schist;
L: 8'6-1/2''
BRITM 154 ELBr (32)
Apis Bull
BRIONA 53 FPL
--c 600 B. C. bronze; 7
BRITM 116 ELBr (37448)
Baboon with Eye-Amulet
light green faience; 4. 75 cm
WOLD 216 (col) UMdBW
Bee-Keeping, relief, Pubes
Tomb 664/525 B. C.
limestone
WOLD 207 EgT
Cat bronze
ZOR 178
--bronze
SPA 164 UMoSL
--663/525 B. C. cast bronze; 9
WORC 9 UMWA
--: With Pendant c 600 B. C.
bronze; 34 cm
CHAR-1:150 FPL
--, coffin of embalmed cat
c 550 B. C. bronze; 53-
1/2 cm
BERLES 72 GBSBe (2055)
--, head bronze; 4-3/4
SOTH-3:148
--, with ear- and nose-rings
bronze LARA ELBr

--, with earrings, sacred to
Goddess Bastet bronze, with
gold earrings; 19. 7 cm
WOLD 214 (col) UMdBW
Coffin Lid of Priest Hor-Sa-
Iset c 550 B. C. wood;
L: 185 cm
BERLES 81 GBSBe (8237)
Courtier Bes, seated figure
c 663/525 B. C. limestone;
21-21/32
READAS pl 150, 151;
SEYT 16 UDCN
Falcon stone
CHENSW 57
FPL
Falcon of Horus bronze; 15-1/2
DETT 20 UMiD (59. 119)
Female Figure, Daphne
relief
BAZINL pl 156 FPL
Figure, fragment basalt;
12-3/4
DEY 10 UCSFDeY
Figures, relief
SMIW pl 182 UMoKNG
Four Gods Around Palmiform
Column, mirror handle of
King Shabaka c 700 B. C.
gold; 14. 3 cm
WOLD 208 (col) UMB
Goddess, relief, sculptor's
model limestone
RICJ front; ROOS 9H
UNNMM
Hanging Situla bronze
SOTH-1:127
Hathor marble
VALE 88 EgCM
Hathor Capital, Denderah
Temple
ROOS 6A
Hedgehog, vase bronze
CANK 132 FPL
Horus c 600 B. C. bronze;
96 cm
CHAR-1:134 FPL
Horus Falcon bronze; 22-1/2
cm
WOLD 212 (col) UMdBW
Ibis, Sacred Bird of Thoth
wood, bronze; 29 cm
CHAR-1:135 FPL
--wood, bronze; 12
DEY 9 UCSFDeY
--, Tuna el-Gebel gilded wood,
bronze; W: 20-1/2 cm
WOLD front (col) GHaK

Ichneumon, or Pharoah's Rat,
Egyptian (North African)
species of Mongoose
bronze; L: 5
GRIG pl 36 ELBr
Journey of the Sun through
Underworld; Osiris
Enthroned, Taho Sar-
cophagus stone
CHENSW 58 FPL
Khonsirdais, a Priest,
Governor of Upper Egypt
c 600 B. C. bronze; 14
BRITM 210 ELBr (14466)
Kneeling Man clinkstone; 50
cm
COPGE pl 42 DCN (A 82)
Lotus Bell Capital, Edfu
Temple
ROOS 6C
Maat, Goddess of Truth and
Justice glass paste; 6-1/2
SOTH-3:149
--, Tuna el-Gebel bronze
WOLD front (col) GHaK
Male Figure basalt
LARA 151 -Dot
--c 600 B. C. bronze; 67 cm
CHAR-1:139 FPL
--, relief c 535 B. C.
limestone; 13-1/2
BOSMEG 179; BOSMI 197
UMB (49. 5)
Male Head
CHASEH 31 UMB
--H: 23 cm
COPGE pl 48 DCN (A 79)
A Man, profile after 700 B. C.
green basalt
MILLER il 6
Mau, Sacred Cat of Bast,
Goddess of the East
bronze; 10-3/8
DETT 20 UMiD (31. 72)
Mentuemhat, Prefect of
Thebes, detail grey
granite; 53
LANG pl 251; SMIW pl
183 EgCM (935)
--, head detail
LARA 148
--, head and shoulder
fragment H: 19-3/4
SMIW pl 183 EgCM
Mongoose c 600 B. C. bronze
CLE 5 UOC1A (64. 358)
Nefer-Tum silver; 4-1/2
SOTH-3:146

Neith, Sais bronze
 FEIN pl 123 UNNMM
Nekhthorheb, kneeling figure
 plaster; 58. 3
 GAU 59 FPL
Neo-Memphitic Relief H: 38 cm
 COPGE pl 39 DCN (A 714)
Old Man with Statuette of
 Goddess Neith alabaster;
 43 cm
 COPGE pl 41 DCN (A 81)
Osiris, head
 CANK 58 UNBB
--: In Mummy Swathing, with
 Scourge and Sceptre bronze;
 34. 4 cm
 WOLD 210 (col) GHaK
Palm Leaf Capital, Edfu
 Temple
 ROOS 6B
Priest black stone; 8-1/2
 BMA 9 UMdBM
--, head 663/525 B. C. green
 schist; 3-3/4
 READAS pl 147 UDCN
Psamtik I, relief
 SMIW pl 182 ELBr
Royal Head H: 17 cm
 COPGE pl 47 DCN (A 23)
Saitic Dignitary, head c 600
 B. C. basalt
 ROBB 284 UMB
Sarcophagus, detail black
 granite
 DR 144, 145 EgCM
Scribe, squatting "Block"
 statue, with Hieroglyphic
 Inscription diabasic basalt
 LAH 22 UCLCM
Seated Female Figure with
 Child, relief
 SMIW pl 180 UNBB
Seated Figure, relief c
 650 B. C. quartzite
 CLE 5 UOClA (3949. 20)
Standing Man, Greco-Egyptian
 Style H: 75 cm
 COPGE pl 43 DCN (A 86)
Stool, with Two Lions as
 Supports c 600 B. C. wood,
 leather; . 525 m
 CHAR-1:90 FPL
Thoth, seated figure bronze;
 7-1/4
 MU 17 UNNTo
Thoueris, Karnak H: c 42
 STI 76 EgCM
Wa-ab-Ra c 570 B. C. stone
 CHENSW 55 FPL

Walking Figure
 ROOS 10B IRV
Wall Relief, Tomb of Pabasa
 (No. 279)
 SMIW pl 181 EgT
Woman stone
 CHENSW 56 FPL
--, votive figure bronze;
 26-5/8
 READAS pl 59-60 UDCN
EGYPTIAN--26/30th Dynasty
"Block Statue", seated figure
 granite
 SLOB 214 FPL
Cat Goddess bronze
 DIV 7 UNNMM
Isis, bust detail glazed
 earthenware; 12. 5 cm
 FEIN pl 37 UNNMM
Snake; Vulture, back of
 sculptor's model limestone
 DIV 15 UNNMM
EGYPTIAN--27th Dynasty
Ibex, head c 500 B. C. bronze,
 gold inlay; 12-5/8
 BERL pl 68 (col);
 BERLES 68 (col) GBSBeA
 (11404)
Lion blue composition; 1-1/4
 SOTH-3:146
Neit bronze
 CHENSW 56 UPPU
Obelisk in form of Pointed
 Pyramid, Amun Temple,
 Karnak
 PRAEG 15
EGYPTIAN--27/28th Dynasty
Harper, Zaonofer relief
 early 4th c. B. C.
 SMIW pl 186 EgAlM
Priest, head ("Green Head")
 early 4th c. B. C. green
 stone; c 8-1/2
 LANG pl 254; MERT;
 PRAEG 156; ROOS 9F, 9G;
 STI 108; UPJH pl 6D;
 WOLD 231 (col) GBNe
 (12500)
EGYPTIAN--27/30th Dynasty
Agricultural Scenes of Daily
 Life, relief, Tomb Chapel
 of Prince 'Ra'-em-ka/
 NM-4:6; NM-10:5 UNNMM
 (08. 201. 1)
Bearded Man, head 3rd c.
 H: 30 cm
 COPGE pl 49 DCN (A 80)
Black Head of a King, unknown
 Pharoah c 400 B. C. basalt

COPG 14; COPGE pl 45,
fig 8 DCN (A 1)
Cat
 BERL pl 73
 -- c 550 B. C. bronze; 21
 BERL pl 72 GBSBeA (2055)
Eagle c 400 B. C. faience box
 ornament
 CHENSN 70 UNNMM
Meroitic King 3rd/2nd c. B. C.
 red ptd sandstone; 2. 25 m
 COPGE pl 50 DCN (A 24)
Mirror 6/5th c. B. C. bronze;
 31 cm
 BERLES 76 GBSBe (2818)
Sekhmet, seated figure bronze;
 23
 SOTH-4:152
EGYPTIAN--28th Dynasty
 Lotus Columns
 LARA 157 EgL
 Shawabti, Amulet H: 6-1/8
 NEWA 90 UNjNewM
EGYPTIAN--29th Dynasty
 Haker, headless fragment
 black granite; 43-1/4
 BOSMEG 177; BOSMI 199
 UMB (29. 732)
EGYPTIAN--30th Dynasty
 Acolyte, funerary relief c 300
 ptd limestone; 25
 DENV 9 UCoDA (An-35)
Crowned King, head c 400
 B. C. polished black stone;
 45 cm
 BOES 88 DCN
Falcon limestone; 50 cm
 CHAR-1:150 FPL
 --378/341 B. C. bronze
 SOTH-3:148
 --c 350 B. C. basalt; 38 cm
 PRAD pl 81 SpMaP
Female Musicians, relief
 c 350 B. C. limestone
 CLE 6 UOClA (199. 14)
General Tjayhapme, headless
 figure bronze; 29
 NM-4:36 UNNMM (08. 205. 1)
Girls Boating, relief granite
 BOSMEG 181 UMB
Hathor Column
 ELIS 144 UNNMM
Horus Falcon with King Nec-
 tanebo, Heliopolis c 350
 B. C. basalt; 29
 GABO 78; MU 17; STI 109
 UNNMM
King, relief c 300 B. C. stone
 CHENSW 60 URPD

Lion in Repose c 350 B. C.
 limestone; L: 16
 BRIONA 54 UNNMM
Male Head c 360 B. C. black
 basalt
 SOTH-4:152
"Metternich Stela" stone; 33
 NM-4:38 UNNMM (50. 85)
Nechthorheb c 350 B. C.
 stone
 CHENSW 57 FPL
Nectanebo II, kneeling figure
 black stone; 98 cm
 PRAD pl 81 SpMaP
 --, relief granite
 BOSMEG 180 UMB
Nut, relief, sarcophagus,
 Sakkara c 350 B. C. diorite;
 L: 29
 ELIS 141; MU 17 UNNMM
Papyrus Capital, Hibis 4th c.
 B. C. H: 49-1/2
 NM-4:35 UNNMM
 (10. 177. 2)
Priest of God Month, head
 c 350 B. C. greenstone;
 15. 3 cm
 WOLD 220 (col) UNBB
EGYPTIAN--Saite/Ptolemaic
 Cat, head detail 7/1st c.
 B. C. bronze; group L:
 21-25/32
 READAS pl 47 UDCN
EGYPTIAN--Ptolemaic
 Alexander II and Goddess
 Sekhmet, wall relief 1st c.
 B. C. H: 95 cm
 COPGE pl 54 DCN (A 773)
Alexander Aigos, Karnak
 LARA 153 EgCM
Arikkharer Slaying his
 Enemies, relief c 15 B. C.
 8-1/4x9-3/4
 WORC 9 UMWA
Bastet, seated cat with golden
 earrings; head detail 332/
 330 B. C. bronze; 15
 MU 17, 16 UNNMM
Bell-Shaped Capitals, Esneh
 Temple c 280 B. C.
 ROOS 10G
Bes
 CASL 74 UPPU
Bust basalt; 54 cm (with
 base)
 PRAD pl 80 SpMaP
Cat: Mummy Mask
 CASL 73 UPPU
 --, seated on base c 300 B. C

bronze
TAYFF 5 (col) UNNMM
Cat-Figure of Bastet, with
gold nose- and ear-rings
bronze; 13
GRIG pl 38, pl 37 ELBr
Chancellor Petosiris black
slate
DR 156 EgCM
Clenched Hand, ceremonial
yellow glass
DOWN 31 UNNMM
Cleopatra, relief, Denerah
Temple
STI 110
Coiled Snake, offerings box
lid black granite
DR 153 EgCM
Composite Capitals
LARA 158 EgMH
Crocodile Mummy Mask
CASL 73 UNNMM
Crouching Meroitic, royal
statue stuccoed and ptd
sandstone; 80x140 cm
COPGE pl 51 DCN (A 72)
Draped Female Figure
LARA 119 FPL
Falcon of Horus c 200 B. C.
bronze; L: 6
GRIG pl 29 ELBr
--, Court, Temple of Horus
CASL 158; LARA 152 EgEd
Female Torso 300/275 B. C.
green glazed faience; 4-1/2
SOTH-2:127
Figure basalt; 166 cm (with
base)
PRAD pl 81 SpMaP
--basalt; 170 cm (with base)
PRAD pl 81 SpMaP
--, Meroe tomb relief
BOSMEG 185 UMB
"Flower Bunch" and Palm-
Frond Capitals, vestibule
c 145 B. C.
GARB 127 (col) EgKo
Footed Cup, relief decoration,
Meroe silver
BOSMEG 184 UMB
Funeral Mask, bearded man
ptd plaster; 35x27x26 cm
CHAR-1:204 FPL
General Amen-pe-Yom,
fragment, Mendes c 275
B. C. gray granite
CLE 6 UOClA
(48. 141)

General Pamenkhes grey
granite
DR 155 EgCM
Harvesting and Threshing
Grain, relief, Petosiris
Tomb c 325 B. C.
SMIW pl 187 EgTg
Hawk, temple entrance
DR 148 EgEd
Hieroglyphic, male figure
500/330 B. C.
TAYFF 5 (col) UNNMM
Hippopotamus c 300 B. C.
alabaster; L: 29 cm
BOES 88 DCN
Horus on the Crocodiles,
magical stela to ward off
serpents H: 11
NM-4:34 UNNMM (44. 4. 53)
Isis: With Son, Horus 3rd c.
B. C.
FEIN pl 51 UNNMM
--, relief 4th c. B. C. ptd
limestone; 44 cm
WOLD 225 (col) GHaK
--, seated figure, with
Crown of Moon Disc and
Horns of Hator wood with
gold leaf; 15
DENV 7 UCoDA (An-187)
Jed-her(?), Kneeling figure
with shrine of Osiris
323/330 B. C. hard black
stone; 21-1/8
READAS pl 6 UDCN
King, bust c 330 B. C. black
basalt; 18-1/4
YAH 12 UCtY
King before Goddess c 300
B. C. quartzite
DIV 15 UNNMM
Male bust marble
DR 159 EgCM
Man, head stone
CHENSW 56 UCBCA
Men Bringing Sacrificial
Offerings, relief,
Petosiris Tomb, Tuna
el Gebel c 300 B. C.
limestone
WOLD 227
Meroitic Queen, relief,
Pylon of Lion Temple 1st
c. B. C.
SMIW pl 192 SuN
Monolithic Shrine, Philae
c 150 B. C. granite; 99
BRITM 126 ELBr (1134)

Mummy Case: Gold Inlaid
Funerary Scenes H: 66
MU 27 (col)
Mummy Mask 2nd c. ptd
plaster; 8
BOSMI 201 UMB (58. 1196)
Mummy Mask: Old Woman
2nd c. plaster
BOSMEG 189 UMB
Mummy Mask: Young Woman
1st c. plaster
BOSMEG 189 UMB
Negro from Meroe, head,
Nubia c 100 yellow sand-
stone; 30 cm
COPGE pl 53 DCN (A 27)
Noblewomen silver
FEIN pl 122 UNNMM
Obelisk, with inscription,
Philae 1st c. B. C.
CASL 151
Official, headless figure
30 B. C. /400 A. D. black
granite; 35-1/4
YAH 13 UCtY
Ophois, or Upuaut, Wolf-God,
standard wood; L: 2-3/8
GRIG pl 30 ELBr
Pakhom, Governor of
Dendara c 50/30
B. C. granite; 27-1/2
DETT 19 UMiD (51. 83)
Papyrus Capitals, west
colonnade
SMIW pl 189 EgPh
Priest, head basalt
SEW 20 UMB
Ptolemy: Crowned by Upper
and Lower Egypt, relief
MARQ 17 EgEd
Ptolemy, head grey granite
DR 154 EgCM
Ptolemy I, Tarraneh, relief
BOSMEG 181 UMB
Ptolemy I: Rendering Sacrifice
to God Horus, relief,
Chapel of Ptolemy I, Tuna
el-Gebel c 300 B. C. ptd
limestone
WOLD 223 (col) GHiRP
Ptolemy VI, head 2nd c. B. C.
FAIN 222 URPD
Ptolemy VIII(?) H: 14 cm
COPGE pl 46 DCN (A 17)
Pylon, Temple of Horus;
detail 237/212 B. C. c
145x250'
LARA 153; UPJ 32 EgEd

Queen, or Goddess (model
relief)
ROOS 10A UNNMM
Ram's Head, relief,
sculptor's model 7x8-1/2
NM-4:33; NM-10:16;
RICJ front; ROOS 10C
UNNMM (18. 9. 1)
Roman Emperor, Athribis
porphyry
DR 160, 161 EgCM
Rosetta Stone, Fort Julien
196 B. C. basalt; 45
BRITM 70; CASL 150
ELBr (24)
Sacred Bull of Mendes,
sarcophagus; detail
DR 146, 147 EgCM
Sarcophagus: Pfti-Har-si-ese
as Hathor
MARQ 19 GB
Serapis, head marble
DR 152 EgCM
Si-Horui black slate
DR 157 EgCM
Sleeping Negro limestone;
125 cm
COPGE pl 52 DCN (A 61)
Temple of Horus; Offering
Scene, relief 3rd/1st c.
B. C. stone
CHENSW 59, 58 EgEd
--, main pylon, relief facade
237/212 B. C.
ROBB 27
Woman, bust marble
DR 158 EgCM
Woman's Funerary Mask
gilded and ptd plaster
DR 156 EgCM
Winged Pectoral Scarab 5th/
3rd c. B. C. gold, enamel;
L: 5-1/2 SOTH-3:146
EGYPTIAN--6th c.
Pyxis: Allegory of Father
Nile, Reclining Male
Figure ivory; 3-1/4;
Dm: 5
RDAB 16 GWieL
Pyxis: St. Maenas, in niche,
hands raised in prayer,
Alexandria(?) ivory; 3-1/8
x4-1/8
RDAB 16 ELBr
EGYPTIAN--9th c.
Bird, panel, Tulunid Period
LARB 93 FPL
EGYPTIAN--10th c.

Fatimid Ewer: Confronted
Panthers rock crystal; 9
MURA 57 (col) IVM
EGYPTIAN--10/11th c.
Ewer: Animal and Floral
Motif rock crystal; 8-1/2;
Dm: 5-1/2
VICF 10 ELV (7904-1862)
Egyptian Head. Lachaise
Egyptian Writing See Writing--
Egyptian
EGYPTO-ROMAN
Tragic Mask, Medinet el
Fayyum 1st c. faience;
7-1/2
NMA pl 27 (col) UNNMM
(26. 7. 1020)
EGYPTO-SYRIAN
Anthropomorphic Sarcophagi,
Sidon c 360 B. C.
STRONGC 104 TIAM
Ehacatl, God of the Wind
Aztec. Ehacatl
Eidelon. Mossman, W. T.
Eight. Seawright
Eight Planes, Seven Lines. Smith, D.
Eight Rotors, 8 Cubes. Rickey, G.
18 Happenings in 6 Parts. Kaprow
The Eighth. Ferneau
8th Terrain. Bouras
Einsteen, Albert
Davidson, J. Albert Einstein,
head
Eirene (Irene)
Greek. Eirene with Infant
Pluto
Kephisodotus. Eirene
Kephisodotus. Eirene and
Ploutos
EISENSHTAT, Sidney (American)
Ark wood; 18'
KAM 158 UTxES
Ejiri
African--Ijo. Ejiri: Human
Figure on Animal Form
Ekashringa
Indian--Kushan--Mathura.
Young Ekashringa
Ekine Play
African--Ibo. Funerary
Screen: Ekine Play Figures
Ekkpe (Ekpe) Play
African--Ibo. Mask: Ekkpe
Play Headdress Mask
EKOI See AFRICAN--EKOI
Ekpe Play See Ekkpe Play
Ekpo Secret Society
African--Ibibio. Mask: Ekpo
Secret Society

Ekpu
African--Oron. Ekpu#
EKROS (Ekros Rosenberg)
(American)
It's a Long Way to Assisi
HARO-1:8
Sextette bronze; 4-1/2x7
HARO-1:9
El Cabuyal
Indians of South America--
Colombia. Goddess showing
her Son, "El Cabuyal"
"El Sueno"
Praxiteles. "The Dreamer"
ELAMITE
Animal-Form Standard Top
before 1500 B. C. silver;
9 cm
POR 55 (col) IranTA
Axe of Untash Humban, King of
Anzan and Susa 13th c. B. C.
bronze, electrum; L: 125 cm
CHAR-1:94 FPL
Bearded Ruler late 2nd mil B. C.
copper; 13-1/2 NM-2:25
UNNMM (47. 100. 80)
Bowl: Recumbent Ram, Susa
2nd mil B. C. bitumen; 7x21. 3
cm POR 49 (col) IranTA
Ceremonial Helmet c 1300 B. C.
copper; 6-1/2 Dm: 8-13/16
NM-2:24 UNNMM (63. 74)
Curly-Horned Ram, Susa c 3000
B. C. CHENSW 64 FPL
Cylinder Seal: Goats 4th mil
B. C.
GARB 72 ELBr
Dragon Head bronze
CHENSW 69 FPL
Falcon, Susa before 1500 B. C.
gold, blue inlay
POR 53 (col) IranTA
Figure Carrying Sacrificial
Goat 13/12th c. B. C.
electrum; 6. 3 cm
POR 63 (col) FPL
Figure Carrying Sacrificial
Goat 13/12th c. B. C.
silver; 6 cm
POR 63 (col) FPL
Griffin Head 7th c. B. C.
gold; 7x4-1/2 cm
POR 135 (col) IranTA
Kneeling Ibex, Susa 2nd c.
B. C. bitumen; 16. 8x8. 3 cm
POR 49 (col) IranTA
Kneeling Woman c 3000 B. C.
alabaster
CHENSW 64 FPL

Lion's Head, whetstone finial
 13/12th c. B. C. gold;
 33 cm
 POR 63 (col) FPL
Man with Clasped Hands,
 Ziwiye 8th c. B. C. ivory;
 20x6. 6 cm
 POR 129 (col) UOCiM
Monster: Lion-Headed Human
 magnesite; 3-1/2
 CHRH fig 10 UNBB
Queen Napirasu, headless
 figure, Susa 13th c. B. C.
 bronze; 51
 FRA pl 175; GARB 97;
 WOOLM 41 FPL
Quiver Panel bronze; c 22x
 13-1/2x10-1/2 cm
 POR 71 (col) UNNHee
Rein-Ring with Opposing Ibexes
 12/11th c. bronze; 16-1/2
 cm
 POR 65 (col) ELBr
Situla bronze; 16-1/2 cm;
 Dm: 6-1/2x5. 3 cm
 POR 71 (col) UNNHee
Susa Ceremony Model 12th c.
 bronze; L: 60 cm; D: 40 cm
 POR t (col) FPL
Ziwiye Bracelet, with Lion
 Heads 8/7th c. B. C. gold
 POR 136 (col) UNNMM
Ziwiye Pectoral 8/7th c.
 B. C. gold; W: 36 cm
 POR 133 (col) IranTA
Ziwiye Pectoral, fragment
 9th c. B. C. gold repousse;
 7x5. 7 cm
 POR 135 (col) UPPU
Elands
 African--Bushman. Eland
 Antelope, rock engraving
 Paleolithic. Eland Buck
Elche
 Iberian. Lady of Elche
Eleanor. Stewart, D.
Election Torch. Folk Art--American
Electra
 Greek. Electra and Orestes
 Hellenistic. Orestes and
 Electra
 Menelaos. Orestes and Electra
 Pasiteles--Foll. Orestes and
 Electra
Electric Lamps and Fixtures
 Lambert, M. The Nimbus,
 lighting fitting
 Lenz. Electric Light Font.

Element # 3. Falkenstein
Elemental Man. Hoffman, M.
Elementar. Ribeiro, F. J.
Elements. Aitken
Elements in a Life. Hebald
Elements II. Rood
Elenore. Cecere
Elephant Child. Cooper, E.
Elephant Hook See Ankusha
Elephant Spirit
 African--Ibo. Mask: Ekkpe
 Play Headdress Mask:
 Elephant Spirit
Elephanta Sanctuary See Indian--
 Deccan--Rashtrakuta
Elephants See also Ganesha
 African--Ashanti. Casket
 (Kuduo), surmounted by
 Elephant
 --Ornament: Three Elephants
 African--Bali. Elephant Head
 African--Baluba. Stool:
 Elephant
 African--Benin. Altar of the
 Hand (Ikegobo): Elephants
 and other figures
 African--Ijaw. Man on
 Stylized Elephant
 African--Nigerian. Men and Two
 Elephants
 --Waist or Hip Mask: Elephant
 Akeley. Wounded Comrade
 Arnold, A. Elephant
 Bactrian. Dish: Elephant with
 Howdah and Riders
 Ceylonese. Elephant(s)#
 --Temple Lamp: Elephant
 Chinese--Ch'in. Vessel:
 Elephant
 Chinese--Chou. Elephant,
 libation jar
 --"Huo": Elephant
 --Ritual Covered Vessel:
 Elephant
 Chinese--Ming. Guardian
 Elephant
 Chinese--Shang. Elephant
 --Elephant-Feline Head
 --Tsun: Elephant
 Egyptian--Predynastic/Early
 Dynastic. Vase: Elephant
 Flannagan. Elephant#
 Folk Art--Korean. Elephant
 Hare. Buisson d'Elephants
 Huntington, A. H. Running
 Elephant
 Indian. Elephant
 Indian--Andhra (Early). The

Buddha: Subduing Mad
Elephants
--Elephant-Rider plaques
--Stupa, Sanchi. Stupa 1.
Torana, southern, Elephant
frieze
Indian--Deccan--Chalukya.
Kailasanth Temple:
Elephant
Indian--Ganga. Surya Deul
Temple. Elephants
--Surya Deul Temple. Rahu
Indian--Gupta. Elephants
among Lotuses
--Seal of Court of
Vadrantapa, figure with
two elephants
Indian--Hindu--8th c. Chained
Temple Lamp: Elephant
Indian--Indus Valley. Seals
Indian--Kushan--Andhra
(Late). Buddha: Taming
Maddened Elephant
Indian--Kushan--Gandhara.
Plate: War Elephant
Indian--Kushan--Mathura.
Elephant
Indian--Maurya. Elephant
Indian--Pallava. Descent
of the Ganges: Human
Figures; Elephants
Indian--Sunga. Stupa Bharat.
Indra: Riding Elephant
--Stupa Bharat. King on an
Elephant, railing pillar
Iranian. Bowl, with
Elephant
Japanese--Fujiwara. Fugen
Bosatsu
Johnson, G. M. Elephant
Johnson, G. M. Pilot
Khmer. Buddhist Stele
--Elephants, relief
--Khmer Army Moving for
War against Champa
--Troops of Suryavarman II
--War Elephants
--Warrior Overthrown by
Elephant
Lane, K. W. Elephants
Mexican--17th c. Street
Signs: Corner of the
Dummy (Monifato); Corner
of the Elephant
Paleolithic. Elephant,
incised
Proctor, A. P. Trumpeting
Elephant

Roman--3rd/1st c. B. C.
Republican Coins, reverse:
Voting; Jupiter in
Elephant-Drawn Chariot
Roman--2nd c. Sarcophagus:
Indian Triumph of Bacchus
Roth, F. G. R. Performing
Elephants
Roth, F. G. R. Trained
Elephant
Sassanian. Elephants, relief
Tibetan. Bodhisattva Padmapani,
Tribhanga Mudra, with
Elephant, Lion, Winged
Tiger
Waugh, S. B. Elephant
Elephant's Cave. Balinese
Eleusinian Dieties, relief fragments.
Hellenistic
Elevation of the Bowl
Indian--Kushan--Andhra
(Late). Stupa, Amaravati.
Buddha
Elgin Marbles
Greek--4/5th c. B. C.
Parthenon (listing in ELBr)
Elgin's Caryatid
Phidias. Erechtheum Maiden
Elinor. Hammer
Elipse. Bell, L.
ELISCU, Frank (American)
Dancing Girl cast bronze; 6
ELIS 109
Escape bronze; 9
ELIS 10
Penelope bronze
NATSS-67:12
Point of Decision, World War
II War Memorial
ELIS 60 UNICM
Shark Diver plaster, for
bronze
ELIS 61
Elizabeth, bust. Longman
Elizabeth, head. Manship, P.
Elizabeth of Hungary, Saint
Ladd. St. Elisabeth of
Hungary with Roses
ELIZONDO, Fidias (Mexican 1891-)
Kiss
LUN
Woman
LUN
Elk
Chinese--Han. Elk
--Pole-Finial: Elk
Neolithic. Elk Head
Paleolithic. Elk Head

Proctor, A. P. Elk
Ella. Walters, C.
Ella Cry. Kienholz
ELLER, Jim (American)
 Scrabble Board 1962
 mixed media; 14x14
 LIP 154
ELLERHUSEN, Ulric Henry
 (German-American 1879-)
 Artemis, reclining figure,
 over-gateway relief
 plaster model
 NATSA 54
 Guardian of the Arts, Attic of
 Fine Arts Rotunda
 PERR 123; SFPP
 History of Religions, Chapel
 facade
 NATS 89 UICU
 Medal with Enamelled Wings
 NATSA 281
 The Oregon Pioneer plaster
 NYW 190
 Pennsylvania Railroad War
 Service Award, plaquette
 bronze
 NATSA 280
 Priest and Prophet, relief
 NATS 90 UMiCC
 St. Louis Art League Medal,
 obverse; reverse bronze
 NATSA 280
ELLICOTT, Henry Jackson
 (American 1847-1901)
 George M. Dallas, bust
 marble
 FAIR 330; USC 175 UDCCap
 Lincoln c 1867
 BUL 206
ELLICOTT, J. M. (American)
 General McClellan, equest
 HARTS pl 57
Elliott, Charles Loring (American
 Painter 1812-68)
 Calverly. Charles Loring
 Elliott, relief profile
 medallion
Elliptical Arrangement. Roszak
Ellis, Mary Jane, and Nancy
 Walker, N. V. Mary Jane, and
 Nancy Ellis, profile
 medallion
Ellsworth, Oliver
 Auger. Oliver Ellsworth, bust
Ellura Cave See Indian--Deccan--
 Rashtrakuta
ELMINA See AFRICAN--ELMINA
Elmo. Hadzi
Elohim Adonai. di Suvero

Eloojao Mask. African--Nupe
Elu Mask. African--Ogoni
Elves
 Camden, H. P. Elf, Head
ELWELL, Frank Edwin (American
 1858-1922)
 Abraham Lincoln 1911
 BUL 163 UNjE
 Egypt Awakening
 HARTS pl 36; TAFT 412
 FP
 Garret A. Hobart, bust
 marble
 FAIR 339; USC 177
 UDCCap
 Goddess of Fire
 HARTS pl 3
 Intelligence
 HARTS pl 36
 Kronos
 HARTS pl 36
 Levi P. Morton, bust marble
 FAIR 339; USC 178
 UDCCap
 Little Nell
 HARTS pl 40
 Magdalen, bust
 HARTS pl 33
 New Life, mortuary relief
 HARTS pl 38; TAFT 416
 UML
 Orchid Dance
 HARTS pl 3
Emaciated Man. Hellenistic
Emanation in Spring. Chinni
Emancipation Group. Ball
EMANUEL, Herzl (American)
 Refugees plaster
 UNA 12
Emblem for an Aquarium. Negret, E.
Emblems See Heraldry; Symbols
Embrace. Jimenez
Embrace. Lipchitz
Embrace. Lippold
The Embrace. Wheelock, W.
The Embrace. Zorach, W.
Emerging Figure I. Squier, J.
Emerson, Ralph Waldo (American
 Poet and Essayist 1803-82)
 French, D. C. Ralph
 Waldo Emerson, bust
Emerveillement. de Creeft
EMERY, Lin
 "Nodding" Fountain
 BISH UScCoM
Emma-O, King of Hell
 Shuzan. Emma-O, netsuke
Emmet, Robert (Irish Nationalist
 1778-1803)
 American--20th c. Robert Emmet

Environments See Ay-O; Dine, J.;
 Kaprow, A.; Oldenburg, C.;
 Segal, G.
ENWONWU, B. C. (Nigerian)
 Kneeling Female Figure
 contemporary wood; 18-1/2
 ADL pl 40A ELULC
Eos (Aurora)
 Etruscan. Mirror: Eos and
 Kephalos
Epa Mask. African--Yoruba
Ephebe. Greek--4th c. B. C.
Ephebus
 Greek--4/5th c. B. C.
 Parthenon: Horseman, or
 Ephebus
 Phidias--Foll. Ephebus
Epicurus (Greek Philosopher d 270)
 Hellenistic. Epicurus#
Epigraphy See Writing
EPIMENES (Greek)
 Archer, engraved gem
 (scaraboid), Namkratis
 c 500 B. C. chalcedony
 BEAZ fig 218; RICHTH
 235 UNNMM
 Equestrian, scaraboid Egypt
 end 6th c. chalcedony
 BEAZ fig 217 UMB
EPIMENES--ATTRIB
 Gem: Kneeling Archer c
 500 B. C. chalcedony
 intaglio; L: 3/4
 BOSMI 59 UMB (21. 1194)
EPPING, Franc (American 1910-)
 Circus composition metal; 28
 SG-6
 Earthling lignum vitae
 SGO-10:14
 Man and Bull composition
 metal; 30
 SG-4
 Maternity metalized plaster;
 LS
 SG-2
 Mother and Child Tennessee
 marble
 NYW 193
 Pagan Angel sheet brass
 SGO-4:pl 15
 Profiles soapstone; 26
 SGO-17
 Rider composition metal; W:
 21 SG-7
 Riverwoman
 CHICA-53:pl 16
 Scrubwoman pink Tennessee
 marble
 SGO-2:pl 27

Seated girl bronze
 SGT pl 14
Two Figures
 composition metal; 37
 SG-3
Two Women composition metal;
 36
 SG-5
Equation. Kallem
Equatorial Trap. Kohn, G.
Equestrian Fantasy. Vodicka, R. K.
Equestrians See also Amazons;
 Battles; Cowboys; Games and
 Sports--Horse Racing;
 Hunters and Hunting; Indians
 of North America (Subject);
 Soldiers
 African. Horse and Rider
 African--Ashanti. Gold
 Weight: Equestrian
 --, or Agni/Baoule. Gold
 Weight: Mounted Execution-
 er
 African--Basonge. Equestrian
 African--Benin. Horseman
 --Sceptre: Equestrian#
 African--Dogon. Equestrian
 Figure
 --Horse and Rider#
 African--Mende. Equestrian,
 fragment
 African--Senuofo. Door,
 relief
 --Equestrian
 African--Sudan, French.
 Covered Bowl: Surmounted
 by Equestrian
 African--Yoruba. Divination
 Bowl, supported by
 Equestrian
 --Equestrian#
 --Mask: Equestrian
 Aitken. George Rogers Clark
 Monument
 Albarran y Pliego. Toreador
 on Horseback
 American--19th c. General
 Hancock, equest
 --General Nathaniel Greene,
 equest
 --General Robert E. Lee,
 equest
 American--20th c. Pioneer
 Preacher
 Assyrian. Ashurbanipal
 Hunting Lions
 --Hunters and Archers, bas
 relief

Australian Aboriginal.
 Figures: Horse and Rider;
 Emu; Horse
Balinese. Horse and Rider
Ball. George Washington
Barbarossa. Paul Revere,
 equest relief
Barthe. General Dessalines
Bartlett. Lafayette
Bitter. Franz Sigel, equest
Bitter. Standard Bearer
Boetian. Horse; Horse and
 Rider
Bogatay. Horse and Rider.
Borglum, G. Confederate
 Memorial
Borglum, G. Philip Henry
 Sheridan
Borglum, S. H. American
 Pioneer
Borglum, S. H. Captain
 Bucky O'Neil, equest
Borglum, S. H. Rough Rider
Brazilian--20th c. Street
 Lamp Base: Equestrian
 Nymphs
Brown, H. K. George
 Washington
Bryaxis. Equestrian, statue
 base relief
Buberl. General Beauregard,
 equest
Calder, A. M. General
 Meade
Centurion. Simon Bolivar
Chinese--Han. Procession of
 Officials
Chinese--K'ang Hsi. Equestri-
 an Figure
Chinese--T'ang. Archer on
 Horseback
--Blue Rider of Astana
--Equestrian, grave figure
--Equestrienne Dismounting
--Falconer on Horseback
--Horseman#
--Lady on Horse
--Woman on Horseback
Chinese--Wei. Effigy
 Figures--Equestrian and Foot
Cook. Circus
Coptic. Falcon-Headed God on
 Horse Battling Crocodile
--Horus on Horseback
--St. Pakene and St. Victor
 on Horseback
--Sissinios, equest relief
Crawford. Washington
 Monument

Cypriote. Horseman
Dallin. General Reynolds
Dallin. General Sherman
Dallin. Signal of Peace
Dallin. Medicine Man
Eakins. General Grant's
 Horse, high relief
Egyptian. Horus: Battling
 Typhon, God of Darkness
Egyptian--17/18th Dyn.
 Equestrian Figure
--Horseman
Egyptian--18th Dyn. Horse
 and Rider
Ellicott, J. M. General
 McClellan,
Epimenes. Equestrian,
 scaraboid
Epping. Rider
Etruscan. Animal-Form Vase,
 with equestrian figure
--Askos, with equestrian
 figure
--Cinerary Urn: Scythian
 Equestrians
--Pediment Plaque
--Rider, fragment without
 horse
Farnham. Simon Bolivar,
 equest
Farr. Horse and Rider
Ferber. Apocalyptic Rider
Folk Art--American.
 Bootmaker's Sign: Woman
 on Horse
--Cookie Molds: Windmill;
 Horseman
--Fire Back: Horseman and
 Convicts
--George Washington#
Folk Art--Puerto Rican. The
 Three Kings
Folk Art--Spanish American
 (United States). St. James
 the Apostle (Santiago),
 equest, Santo
Fraser, J. E. Flora and
 Sonny-Boy Whitney, relief
French, D. C. Monument to
 General LaFayette, tablet
 relief equest
French, D. C. Washington
French, D. C. and E. C.
 Potter. Washington
Friedlander. Lewis and Clark
 Led by Sacajawea
Friedlander. Symbolic Memori-
 al to the World War
Friedlander. Valor

Fritz. Man on Horseback
Gallo-Roman. Horseman
 Fighting Panther, chariot
 ornament
Germanic. Hornhausen
 Equestrian Group, flat
 relief
Greek. Alexander on
 Horseback
Greek--Archaic. Horse and
 Rider, fragment
--Horseman#
Greek--7th c. B. C.
 Horsemen, frieze
Greek--6th c. B. C. Rampin
 Horseman
Greek--5th c. B. C. Equestrian,
 relief
--Horseman#
--Mounted Warrior, grave
 relief fragment
Greek--4/5th c. B. C.
--Parthenon: Equestrians
--Parthenon: Orating Equestrians
--Parthenon: Panathenaic
 Procession--Equestrians
Greek--4th c. B. C. Amazon#
--Coin, Macedonia: Philip II,
 equest
--Equestrian, mausoleum
 fragment
--Horseman, relief
--Stele of Dexileos
Gross. Bare-Back Riders
Hellenistic. Sacrifice of
 Marcus Curtius, bas
 relief
Huntington, A. H. Don
 Quixote, relief
Huntington, A. H. El Cid,
 Campeador, equest
Huntington, A. H. Joan of
 Arc
Indian--Andhra (Early). Stupa,
 Amaravati. Great
 Departure
Indian--Ganga. Surya Deul
 Temple. Surya, the Sun
 God
Indian--Maurya. Capital:
 Rider
Indo-European. Equestrian,
 Animals, including Dog
Indonesian. Riders on Mount
Islamic. Horseman
Jackson, H. B. Don Quixote
 and Sancho Panza
Jones, P. J. Black Calvary
Kelly. Sheridan's Ride, equest

Kern. Ilia Mourometz
Khmer. Horseman, frieze
--Judgment of the Dead: Dead
 Coming before Yama
Korean. Mounted Warrior
 Figure, vessel
Lachaise. Equestrian Woman
Lipchitz. Acrobat on
 Horseback
Lone Wolf. Camouflage
Lukeman. Francis Asbury
MacMonnies. General Logan
MacMonnies. General Slocum
MacMonnies. The Pioneer
Manship. Joan of Arc Medal
Marisol. The Generals
Matteson, I. Horse and Rider
Melicov. Circus Rider
Melicov. Girl on a Horse
Mestrovic. Kraljevic Marko
Miller, Juanita. Joaquin Miller
Mills, C. Andrew Jackson
New Guinea. Shango, Thunder
 God
Niehaus. Cortez
O'Donovan and Eakins.
 Abraham Lincoln
Palestinian. Horseman
Parthian. Horse and Rider,
 relief
Partridge, W. O. General
 Grant
Persian. Cylinder Seal:
 Horse and Camel
--Fret-Work Revetment Panel:
 Lot and Potiphar's Wife
--Plaque: Jousting Figures,
 wall revetment relief
--Tomb of Darius, rock
 relief
Polasek, A. Slavonic Pagan
 God Svantovit
Pollia, J. P. George
 Washington
Rea, J. L. Home from the
 Fields
Recchia. General John Clark
Remington. Dragoons--1850
--The Mountain Man
--Traper of the Plains--1868
Robus, H. The General
Rogers, J. Fetching the
 Doctor
Roman--1st c. B. C. Balbus
Roman--1st c. Balbus, equest
Roman--2nd c. Apotheosis of
 Antoninus Pius and his
 Wife Faustina

--Marcus Aurelius Column:
Marcus Aurelius Receiving
Conquered Barbarians,
relief
Roman--4th c. Sarcophagus of
St. Helen
Rood. Horseman I
Roth, F. G. R. George
Washington, equest
Ruckstuhl. General Hartranft
Rumsey, C. C. Pizzaro
Russell, C. M. Smoking Up
Saint Gaudens. Robert Gould
Shaw Memorial
--William Tecumseh Sherman
Memorial
Sarniguet. Martin Fierro
Sassanian. Chosros I Hunting
Ibexes, plate
--Chosros II(?), equest
relief
--Rock Carving: Investiture of
Ardashir I by Ahura Mazda
Schuler, H. Four Horsemen
of the Apocalypse
--Generals Lee and Jackson
Shrady, H. M. Grant
Memorial: Artillery Coming
to a Halt
Simmons, F. John A. Logan
Sotades. Rhyton: Amazon
Swarz, S. Conversion of Saul
Thracian. Horseman, votive
relief
Tolsa. Monument to Charles IV
Tonetti, F. M. L. Armored
Horseman
Waggoner. Will Rogers
Ward, J. Q. A. General
Thomas
Wheelock, W. Paul Revere's
Ride
Williams, W. Dawn
Zikaras, T. Horseman
Zorach. Girl on a Pony
--Young Pegasus
Erato
Greek--5th c. B. C. Erato,
seated figure
Erda. Kreis
Erebus. Phillips, B.
Erechtheum. Greek--5th c. B. C.
Erechtheus
Greek--5th c. B. C. Athena
and Erechtheus, record
relief
Les Ergastines
Greek--4/5th c. B. C.
Parthenon: Les Ergastines

--Parthenon: Panathenaic
Procession--Young Athenian
Women (Ergastines)
Ericson, Leif (Norse Mariner)
Holm. Leif Ericson
Saemundssen, N. Leif
Ericson, head
Whitney, A. Leif Ericson
Ericsson, John (Swedish-American
Inventor 1803-89)
Fraser, J. E. John
Ericsson, head
Hartley, J. S. John
Ericsson
Las Erinnias. Roman--2nd c.
Erinyes. Thomas, R. C.
Erl King. Barrett
Erlanga (East Javanese King)
Javanese. Erlanga as Visnu
Riding on Garuda
ERLEBACHER, Walter (American)
Firetree brass, lead
WHITNA-17:15
Eros See also Aphrodite; Psyche
Arabian--South. Eros Riding
on Lioness
Cercere. Cupid and Stag
Coptic. Aphrodite between Two
Figures of Eros
--River God (The Nile?)
with Eros Holding Duck
Etruscan. Fighting Eros
Greek. Cupid
--Eros on the Dolphin
Greek--5th c. B. C. Aphrodite:
In Chariot Drawn by Eros
and Psyche
--Boston Throne, front:
Winged Figure, Eros between
Women
--Eros#
Greek--4th c. B. C. Eros,
relief
--Flying Eros
--Hydria: Eros Holding Mirror
--Mirror: Aphrodite Teaching
Eros Use of Bow
Hellenistic. Eros#
--Helen and Paris Advised by
Aphrodite and Eros, relief
--Running Eros
--Seated Cupid
--Sleeping Eros
Jennewein. Cupid and Gazelle
Phidias--Foll. Cameo: Eros
Polykles of Athens. Sleeping
Eros
Praxiteles--Foll. Eros of
Centocelle

Roman. Eros and Anteros
Supervising a Cock Fight,
relief
Roman--1st c. Funerary
Altar of Freedman Amemp-
tus: Torches with Garlands,
with Centaur Musicians
Bearing Eros and Psyche
Roman--2nd c. Paris and
Eros, relief
Roman--5/6th c. Eros with
Fish
Warner, O. L. Cupid and
Psyche, relief
Erotes See Putti
ERSKINE, Peter (American 1941-)
Ishi ptd wood; 74
WHITNA-18:34
The Undiscovered Self
styrofoam, dynel, epoxy;
18x79x65
WHITNA-19
Erythmanean Boar See Hercules
Escape. Eliscu
ESCOBAR, Marisol See Marisol
ESCOBEDO, Augusto (Mexican 1914-)
Metamorphosis 1; Metamor-
phosis 2
LUN
ESHERICK, Wharton (American
1887-)
Reverence 1943 wood; 12'
PIE 385 UPPF
Spring Beauty olive wood
NYW 191
Eshu, God of Uncertainty
African--Nigeria. Eshu
ESIE See AFRICAN--ESIE
ESKIMO
Adze Handle, Bering Sea
Culture 500/1000 ivory;
L: 12-1/2
DOCA pl 3 UNNMAI
(2/4318)
Animal Mask ptd wood; L:
11-1/4
DOU 176 UNNMAI (10/6031)
Animals: Walrus, Seal, Bear;
Box bone, ivory
COOP 268 ESuAH
Bear; Seal: Harpoon Finger-
rest walrus ivory; L:
2-1/2; and 2
HOO 146
Bow Drill morse ivory; L: 16
SOTH-1:121
Comic Mask wood; 18
DOU 172 UNNMAI
(12/925)

Dance Mask wood
LARA 80 UNNAmM
Dance Mask: Walaunuk,
Kuskokwim River 1875/
1900 driftwood; L: 20
DOCA pl 74 UNNMAI
(9/3432)
Drill-Bows, with incised
record of hunting and
fishing; Antler Box ivory;
L: 13; 15-1/2; 3-1/4
HOO 145
Drum Handle, Point Barrow
1875/1900 ivory; L: 5-1/2
DOCA pl 69 UNNMAI
(21/804)
Fishing Sinker, with incised
fishing exploit record
walrus ivory; L: 5
HOO 146
Greenland Utensils: Pail,
Throwing Stick, Eye-Shade
19th c. wood, carved ivory
decoration; pail H: 29 cm
BOES 40 DCNM
Harpoon Heads, Bering Sea
walrus ivory
SFGP pl c, 162 UDCNM
Hunter's Hat wood, ivory
ornaments; 8x13-3/8
DOU 180 UNNMAI
(10/6921)
Inua Mask: Salmon c 19th c.
ptd wood, feathers; 19
LOM 29 (col) FPBre
Kayak Model 6x20-1/2
DOU 170 UNNAmM
(5/3610)
Kuskokwim Mask: Whale
late 19th c. ptd wood,
feathers; 28-1/2
LOM 29 (col) FPBre
Mask wood
MEN 8 UCBCA
--c 1800 ptd wood; 17
DENV 131 UCoDA
(NESK-1)
--, Ipiutak Culture, Point
Barrow c 1st c. B. C.
ivory
AMHI 31 (col)
--, Kuskokwim River,
Alaska ptd wood, feathers,
string; 45-1/2
NPPM pl 62 UNNMPA
(61. 39)
--, St. Lawrence Island,
Alaska ptd wood; 8
SMI 19 UDCNMS

--, Southwest Alaska wood;
15x9
DOU 31 (col) UCBCA
(2-5854)
Mask: Anthropomorphic early
20th c. wood, walrus
ivory; 9
TOR 180 CTRO (958. 173)
Mask: Man-Eating Demon,
Alaska
GOMB 22 GBVo
Mask: Man-Fish, Yukon wood,
ptd white and reddish
brown; 21-1/4
MUE pl 135 FPRat
Mask: Man-in-the-Moon,
Southwest Alaska 19th c.
ptd wood; 15
AM #13 UCBCA
Mask: Mythical Character
LARA 75 FPH
Mask: Negafok (Cold Weather
Spirit), Kuskwogmiut
1875/1900 wood; 30
DOCA pl 76 UNNMAI
(9/3430)
Mask: Seal wood; 13-3/4x5
DOU 173 UNNHarn
Mask: Seal and its Spirit,
Good News Bay 1875/1900
wood; L: 12-1/2
DOCA pl 79; DOU 171
UNNAmM (12/910)
Mask: Seal Inua, Kuskokwim
River 1875/1900 wood; 9
DOCA pl 77 UNNMAI
(2/446)
Mask: Spirit-Helper 19th c.
ptd wood; c 15
LOM 32 (col) UCBCA
Mask: Spirit of Autumn wood;
Dm: 11-3/4
DOU 177 UNNMAI
(9/3425)
Mask: Swan that Drives White
Whales to Hunters, South-
west Alaska early 20th c.
wood; 22
AMHI 286; DOU 175;
JANSH 30 UNNMAI
(9/3409)
Oil Lamp, Kenai 500/1100
stone; 5x14
DOCA pl 2 UPPU (NA
9251)
Ornaments: Human and
Geometric Design ivory,
bone
BOA 86 UNNAmM

Owl, Cape District soapstone
AMHI 271 CWH
Pipe: Hunting Scenes and
Animals walrus ivory;
L: 33. 6 cm
ADL pl 33A
Pipe, Little Diomede
1850/1900 ivory; L: 14
DOCA pl 70 UNNMAI
(6/8469)
Pipes walrus ivory; L:
5-1/2; 7-1/2
HOO 146
Pregnant Woman, Alaska 19th
c. (?) walrus ivory;
3-1/2
AM #15 UNNMPA
Seal, harpoon fragment,
Alaska
BRIONA 48 FPH
Shaman Doll Charm, Banks
Island 1800/1850 ivory; 5
DOCA pl 68 UNNMAI
(5/9838)
--, Point Barrow 1850/75
ivory; 9-1/2
DOCA pl 71 UNNMAI
(7/7096)
Shaman's Mask ptd wood,
eagle feathers; 32
MUE pl 134 FPLeb
Spirit Mask ptd wood, fur,
feathers; 9x5-1/2
DOU 174 UNNAmM
(6/259)
Spirit Mask, Kuskokwim River
1875/1900 wood; 11
DOCA pl 73 UMiCI
(3225)
Spoon 20th c. walrus
shoulder join; W: 2-1/2
LOM 135 GMV
Totem Pole
MYBA 19 CVT
Totem Poles, Sitka National
Monument
LONG 227 UAB
Toy Bears ivory
DOU 183 UDCIn
Toy Wrestlers, St.
Lawrence Island ivory;
2-1/2x1-1/2
DOU 178 UNNMAI
(13/32520)
Trident-Shaped Object, Punuk
Style, Bering Sea walrus
ivory
SFGP pl c UDCNM

Winged Object, Punuk Style,
Bering Sea walrus ivory
SFGP pl c UDCNM
Wolf Mask 1875/1900 wood;
L: 11
DOCA pl 75 UNNMAI
(12/907)
Eskimo. Hahn, E.
Eskimo Woman. Loring
Espaco e Forma. Iommi
Esquiline Venus
Greek--5th c. B. C. Esquiline
Venus
Essarhaddon (King of Assyria 680-
669 B. C.)
Assyrian. Stele of
Essarhaddon
Essex. Chamberlain, J.
Esther. Johnson, S.
ESTOPINAN, Roberto (Cuban 1920-)
Project for a Fountain 1955
wrought iron
MAI 89
Stratega. Roman--2nd c.
Estrela da Manha. Calder, A.
Estructura Pictorica Madi. Bay
Estructura Transformable. Darie
Etana
Sumerian. Cylinder Seal:
Myth of Etana
Eteocles
Etruscan. Sarteano Urns:
Death of Hippolytus; Duel
between Eteocles and
Polyneices
--Urn: Duel between Eteocles
and Polyneices
The Eternal Call. MacNeil, H. A.
Eternal Force. Lachaise
The Eternal Insomnia of Earth.
Martins
Eternal Light See also Ark of
Covenant
Albert, C. Eternal Light#
Aronson, B. Eternal Light
Beling. Eternal Light
Ferber. Eternal Light
Hare. Eternal Light
Harrison, W. Ark Doors;
Eternal Light
Kepes, G. Eternal Light
Kepes, R., and R. Preusser.
Eternal Light
Lassaw. Eternal Light#
Lipton. Eternal Light#
Mendelsohn. Eternal Light
Rawinsky, H. Eternal Light
Eternal Mother. Gross
The Eternal Questioning. de Biccardi

Ethan Allen (Horse)
Folk Art--American. Weather
Vane: Trotting Ethan
Allen and Sulky
ETHOPIANS
Funerary Stele
BAZINW 232 (col) IRAf
Ethopians
Koss. Ethiopian
Lee. Ethiopian
Phoenician. Lioness Attacking
Ethiopian Boy in Papyrus
Grove
Roman. Ethiopian, head
Etoile, No. 2. Rickey
Etoile Variation II. Rickey
Etrange Alouette des Champs.
Johnson, J.
ETROG, Sorel (Russian-Canadian
1933-)
Flight, No. 2. 1966 40x
69-1/2
CARNI-67:# 24 UMiDH
Ricordo di Guerra 1961/62
bronze
VEN-66:# 154 CMFA
Sculpture*
EXS 39
Standing Figure: Dancer (Duet)
1960/62 bronze; 45-1/4
CAN-4:193 CON
War Memorial II 1961/62
30x42x21
CARNI-64:# 127 UNNFri
ETRUSCAN
Acrobat Handle: Youth,
Ferentinum 4th c. B. C.
bronze; 3. 625
GOLDE pl 103 GMA
Acrobat Handle: youth, Vulci
copper
SAN 100 IRGi
Amazon Head, Arezzo 2nd c.
B. C. clay; 7-1/8
PAL pl 108 IFAr (87674)
Amphora Stand 6th c. B. C.
gold
SOTH-2:126
Andromeda, mirror support(?)
4th c. B. C.
GOLDE pl 116 IFAr
Andromeda-Hesione, figure
fragment, Falerii Veteres
early 3rd c. B. C.
SAN 129 IRGi
Animal-Form Vase, with
equestrian, Villanovantom,
Benacci Cemetery, 8/7th c.
B. C. ceramic SAN 32 UBoC

Animals: Real and Imaginery,
 relief plaques
 SAN 160, 161 ITarN
Antefix: Female Head,
 Capitoline Hill 6/5th c.
 SAN 92 IRCo
Antefix: Gorgon Mask in
 Shell; Veii (Portonaccio),
 Rome c 500 B. C. clay; 7;
 cover-tile: 31-1/2
 PAL pl 88; SAN 113 IRGi
 (2499)
Antefix: Satyr and Maenad,
 Conca (Satricum), Rome
 c 480/470 B. C. clay;
 11-1/4
 PAL pl 87 IVGi (10255)
Antefix: Scilos Head, floral
 scroll, relief 6th c. B. C.
 DIV 22 UNNMM
Antefixes: Silen; Maenad;
 Acheleos, Temple of
 Apollo, Veii
 SAN 114
Apollo
 GOLDE pl 114 IFAr
Apollo, fragment 2nd c. B. C
 terracotta; 56 cm
 MAN 141 (col) IRGi
Apollo(?), head terracotta
 c 500 B. C.
 GOLDE pl 29 IRCo
Apollo, pediment figure,
 Scasatotemple, Falerii
 4th/3rd c. B. C.
 SAN 120 IRGi
Apollo from Veii c 500 B. C.
 terracotta; 69
 BAZINW 169 (col); CHENSW
 137; CHASEH 152; CHRH
 fig 40; GARDH 158; GOLDE
 pl 36-37; JANSH 127;
 JANSK 170; KO pl 26;
 MAN 118 (col); SAN 111-
 112; ST 68; STA 13;
 STRONGC 117 (col); UPJH
 pl 43 IRGi
Arezzo Ploughman, with
 Oxen c 400 B. C. bronze;
 ploughman: 4-1/2
 GOLDE 26; KO pl 27;
 PAL pl 101; SAN 61
 IRGi (24562)
Ariadne Discovered by Dionysos
 and his Companions (Ari-
 adne in Naxos), pediment
 fragment, Civita Alta
 (Sentinum) 2nd c. B. C.
 terracotta; 94 cm; L:

26-3/4
GOLDE pl 42; MAN 163 (col);
 PAL pl 109; SAN 39 IBoC
Armed Fighting Warrior
 bronze; 33 cm
 MAN 93 (col) IFAr
Armed Warrior bronze
 GOLDE pl 70 GBAnt
--bronze; 10-13/16
 COOP 31 UNNBak
--5th c. B. C. bronze; 9
 SOTH-4:156
--, Capestrano 6th c. B. C.
 limestone
 BAZINW 168 (col) ICh
Armed Warrior's Dance,
 relief stone
 CHENSN 157 IRV
Artemis, Civita
 Castellana 5th c.
 B. C. ptd terracotta; 48
 KO pl 26 UMoSL
Artemis, Lake Falterona
 MARQ 117 ELBr
Artemis, Polledrara Tomb
 6th c. B. C. alabaster; 35
 GOLDE pl 79 ELBr
Askos, with equestrian figure,
 Benacci tomb pottery;
 17. 7 cm
 MAN 34 (col) IBoC
Athena 7th c. B. C. bronze
 GOLDE pl 76 IRGi
Athena, head c 500 B. C.
 terracotta
 GOLDE pl 30-31 IChiE
Athena, Tinia, and Giants,
 ridge-beam head revetment
 480/470 B. C. ptd
 terracotta; 1. 15 m
 HAN pl 198 IRGi
Athena-Minerva bronze
 SAN 143 IFAr
Athlete, head c 200 B. C.
 bronze
 CHENSW 143 ELBr
Athlete, mirror handle
 c 300 B. C. bronze
 CLE 21 UOClA (28. 659)
Aulus Metellus, an Official
 (L'Arringatore; Aulus
 Metilius; The Orator)
 c 150 B. C. bronze; 71
 CHASE 159; CHENSW 143;
 GOLDE pl 123-25; GOLDR
 9; HAN pl 281; JANSH 139;
 JANSK 171; LARA 351;
 LAWL pl 97B; MAN 171
 (col); MCCA 31; MILLER

il 54; STRONGC 137 (col);
UPJH pl 44 IFar
--head detail
HAN pl 214; SAN 60
Banqueter c 500 B. C.
bronze; L: 13-1/4
STRONGC 116 (col) ELBr
Barberini Goblet, plastic
Bearers and Griffin
relief c 650 B. C. ivory;
14 cm
MAN 64 (col) IRGi
Barberini Plaque Breastplate,
figures in Zones, Barberini
Tomb c 650 B. C. sheet
gold, granulation and
reliefs; L: 24. 3 cm
MAN 43 (col) IRGi
Battle Scene, acroterium
fragment c 490 B. C. ptd
terracotta; 68 cm
MAN 117 (col) IRGi
Bearded Head 5th c. B. C.
ceramic; 9
DENV 15 UCoDA
(An-115)
Bearded Heads, fragments,
Temple in Via S. Leonardo
ptd terracotta
SAN 67 (col) IOrM
Bearded Man, head 6th c.
B. C. bronze
GOLDE pl 15 IFAr
--330/300 B. C. terracotta;
16 cm
HAN pl 203 IOrM
Belvedere Temple Pediment
Fragments 3rd c. B. C.
SAN 65 IOrM
Bowl, with Two Dancing
Girls on rim 6th c. B. C.
basin H: 2-7/8; figure
H: 6
PAL pl 41 IRGi
Boy, head early 3rd c. B. C.
bronze; 3
JANSH 128 IFAr
--150/100 B. C. bronze; 23 cm
HAN pl 212 IFAr
--1st c. B. C. bronze; 9
PAL pl 122 IFAr
Brazier Stand: Naked Boy
Standing on Carriage
c 510 B. C. bronze;
11-3/4
PAL pl 69 FPL (3143)
Brazier Stand, Vulci: Youth
Holding Pomegranate 6th c.
B. C. bronze; 7-7/8

PAL pl 81 GMSA (55-56)
Browsing Goat, Bibbona
5th c. B. C. bronze; 6.3x10
GOLDE pl 102 IFAr
Bucchero Jug: Fantastic
Animal Driven by a Man,
Sorbo Cemetery, Caere
7/6th c. B. C.
SAN 47 IRVE
Bucket, relief decoration
(line drwg) bronze
CHRP 96 ELBr
Bull, aquamanile; Wheeled
Censer 8/7th c. B. C.
bronze
CHENSW 139 ITaN
Bull-Headed Oinochoe, Chiusi
6th c. B. C.
SAN 47 IFAr
Burial Urn: Head 7th c. B. C.
clay; 29-1/8
LARA 309; PAL pl 20 IFAr
(72729)
Burial Urn: Human Figure
c 600 B. C. terracotta; 32
MU 52 IChE
Caere Tombs: Tomb of the
Seats and Shields; Tomb of
the Stucchi 7th c. B. C.
GOLDE 34 ICae
Caio Norbano Sorice, bust
bronze
CHENSN 151 INN
Candelabra Finials: Discobolus,
Warrior, Athlete, Sleeping
Child 5th c. B. C. bronze
SAN 141 IRGi
Candelabra Finials: Hermes
Escorting Female Figure,
Spina c 400 B. C.
SAN 71 IFeMA
Candelabrum 6th c. B. C.
bronze
GOLDE pl 65 GMA
--c 500 B. C. bronze
GOLDE pl 64 FPL
Candlestick with Winged
Human, Perugia c 300 B. C.
bronze
GOLDE 30 IFAr
Canopic Cinerary Urn: Head
of Terracotta in bronze
model of a Chair 6th
c. B. C.
GARDH 156 IChiE
Canopic Urn c 600 B. C.
GOLDE pl 54 UNNMM
Canopic Urn
GOLDE pl 55 IChiE

Canopic Urn; head-lid detail
c 600 B. C.
GOLDE pl 52 IChiE
Canopic Urn: Human Head lid,
Dolciano 7/6th c. B. C.
bronze
SAN 41 IChiE
Canopic Urns; details: Deity
of Death c 600 B. C.
GOLDE pl 46-51 IChiE
Canopus, human form 550/500
B. C. pottery; 61 cm
MAN 49 (col) IFAr
Capital with Four Female
Heads, Vulci
SAN 99 IRGi
Capitoline Brutus, bust 3rd c.
B. C. bronze; 12-5/8
BAZINW 171 (col); GARDH
159; GOLDE pl 127-128;
GOLDR 7; HUX 60; MAN
173 (col); MU 53; ST 70;
STRONGC 138 (col) IRCo
--head detail
LARA 314
Capitoline Wolf (She-Wolf;
Wolf of Rome) early 5th c.
B. C.
(Infants Romulus and Remus
are Renaissance additions)
bronze; 33-1/2x52
BARSTOW 44; CHENSN 143;
CHENSW 132; GAUN pl 30;
GOLDE pl 98; HAD 10;
JANSH 128; JANSK 172;
LARA 310; MAN 121; READI
pl 11A; SAN 52; ST 69;
UPJH pl 43 IRC
--head detail
GOLDE pl 99
Caryatids, Praeneste c 600
B. C. bronze; 39 cm
HAN pl 195 IRGi
Casket Handle: Two Warriors
Carrying Companion
SAN 139 IRGi
Cauldron, Marsciano, details:
Warriors, Lions and
Sphinxes; Support Reliefs:
Chimaera; Perseus and
Athena 6th c. B. C. bronze;
11-3/4
PAL pl 48-49, pl 52-53
GMSA
Censer 7th c. B. C. bronze;
41
GOLDE pl 66 IRV
Centaur c 520 B. C. bronze
BOSMT pl 8A UMB (09. 291)

--, Tomb Guardian, Vulci
c 600 B. C. nenfro;
30-1/4x31-1/2
MAN 56 (col); PAL pl 38
IRGi
Certosa Gravestone: Fighting
Serpent and Sea Horse;
Voyage to Hades; Fight with
a Gaul early 4th c. B. C.
H: 86
GOLDE pl 3-5 IBoC
Chain, from censer 7th c.
B. C. bronze
GOLDE pl 67 IRV
Chariot (restored) c 600 B. C.
wood, bronze sheathing and
iron tires
GOLDE 31 UNNMM
Chariot-Cover: Boar Hunt
with Dogs; Sea Horses;
Merman; Gorgon Battling
Lions 6th c. B. C.
bronze; L: 11-7/16
PAL pl 50-51 GMSA
Chariot Panel: Armed Warrior
in Combat 6th c.
NM-5:34 UNNMM (03. 23. 1)
Chariot Procession, winged
horses, slab fragment, Pale-
strina 6th c. B. C. terracotta
MAN 88 (col) IRGi
Charioteer Driving Winged
Horse, panel relief bronze
NM-10:38 UNNMM
Chimera of Arezzo (probably
restored by Benvenuto
Cellini) 5th c. B. C.
bronze; 31-1/2
BAZINH 93; BAZINW 169
(col); CHENSN 149; CHENSW
138; GOLDE pl 96; HAN pl
201; READM pl 28; SAN 52;
THU 110; UPJH pl 43 IFAr
--head detail
GOLDE pl 95
--Goat and Serpent Head detail
GOLDE pl 97
Chiusi Cinerary Statue 540/ 520
B. C. MAN appendix pl 13
IPalM
Cinerary Urn: Banquet and
Dancers; Flutist; Dog and
Duck, Chiusi 6th c. B. C.
pietra fetida; 15x24-3/ 4x13
PAL pl 62-63; SAN 58 IFAr
(5501)
Cinerary Urn: Figures; Grif-
fins 7th c. clay; 6-1/2
PAL 22 GCe (Formerly
Berlin Antiquarium)(TC 7711)

Cinerary Urn: Head c 675/
650 B. C. terracotta;
25-1/2
JANSH 123 IChiE

Cinerary Urn: Head; Winged
Goddesses, Cetona 6th c.
B. C. clay; 23
PAL 21 IFAr (79199)

Cinerary Urn: Human Figures
Decoration, Montescudaio c
700 B. C. terracotta;
64 cm
MAN 52 (col) IFAr

Cinerary Urn: Reclining
Couple 1st c. B. C. clay;
16-1/8x28-13-3/8
MAN 174 (col); PAL pl
113; ST 71 IVoG (613)

Cinerary Urn: Reclining Male
Figure; Side Relief: Grif-
fins and Medusa Head c 200
B. C. clay; 15x19-1/4x
12-1/4
PAL pl 112 IPeA (190)

Cinerary Urn: Reclining
Male Figure at Festal Ban-
quet 2nd c. B. C.
alabaster; 22
PAL pl 111; SAN 86 IVoG
(119)

Cinerary Urn: Reclining Male
Figure at Festal Banquet;
Four Lasas; Couch Relief:
Sea Horses c 400 B. C.
pietra fetida; L: 61; figure
H: 33-7/8
PAL pl 93 FPL

Cinerary Urn: Reclining
Woman
MARQ 120 IVo

Cinerary Urn: Reclining
Woman; Armed Soldiers,
relief stone; c 40
GOLDE pl 2 IChiE

Cinerary Urn: Recumbent
Woman
CHASE 159 UMB

Cinerary Urn: Recumbent
Youth with Demon of
Death Reading from Scroll,
Chianciano 4th c. B. C.
pietra fetida; L: 45-1/4
JANSH 125; PAL pl 94;
SAN 59 IFAr

Cinerary Urn: Scythian
Equestrians; Discus
Thrower 5th c. B. C.
bronze; 18-1/2
PAL pl 73-74 UNNMM

Cinerary Urn: Sphinx-
Enthroned Woman Holding
Child, Chianciano 5th c.
B. C. pietra fetida;
35-3/8
KO pl 24; MAN 133 (col);
MU 53; PAL pl 92; SAN
53; VER pl 31 IFAr
(73694)

Cinerary Urn, Tarquinia c
500 B. C. ptd terracotta
MAN 144-145 (col) ITaN

Cinerary Sarcophagus:
Dancers, Chiusi
LARA 308 IFAr

Cinerary Urn 3rd c. B. C.
terracotta; 27-7/8
NM-5:39 UNNMM (96. 9. 223)

Cinerary Urn, Chiusi 160/
140 B. C. terracotta; 42-
3/4x36-5/8x22-1/2
WORC 16 UMWA

Cinerary Urn, with reclining
figure 3rd c. B. C. terra-
cotta; 17-1/4
NEWA 95 UNjNewM

Cippus, Settimello 6th c.
B. C. limestone; 1. 05 m
MAN 58 (col) IFAr

Circular Cippus: Dancers
6/5th c. B. C. travertine
SAN 44 IChiE

Cista: Male and Female
Figures, handle bronze
COPGG 73 DCN (H-243)

Cista: Recumbent Soldier
Carried by Two Winged
Figures, lid handle
3rd c. B. C. bronze; 23
NM-5:38 UNNMM (22. 84. 1)

Cista: Sacrifice of Trojan
Captives at Funeral of
Patroclus c 300 B. C.
bronze; 14-1/2
STRONGC 128 ELBr

Cista, Praeneste c 350 B. C.
bronze
GOLDE pl 58 GBAnt

Cista, with Amazons and
Ducks bronze
CHENSW 140 IRV

Cista Handle: Sleep and
Death Carrying Off Fallen
Memnon 4th c. B. C.
bronze; 5-1/2
CLE 22; EXM 304 UOClA
(45. 13)

Cista Handle: Two Armed
Soldiers Carrying Dead

Comrade c 350 B. C.
bronze
GOLDE pl 61 IRT
Cista Handle: Two Men
Carrying Dead Comrade
c 350 B. C. bronze
GOLDE pl 63 UNNMM
Corsini Fibula gold
LARA 209 IFAr
Dance Scene, Chiusi cippus
relief H: 50 cm
MAN 103 (col) IFAr
Dancer: Candelabra Figure
5th c. B. C. bronze
KO pl 25 FPMe
Dancers, fragment sheet
bronze repousse
MAN appendix pl 9
GMSA
Death-Mask Affixed to Burial
Urn, Chiusi 7th c. B. C.
bronze
LARA 309
Death of Amphiaraus, Talamon
Temple decoration c 200
B. C. terracotta
CAM 167 (col) IFAr
Death of Ataeon alabaster
BAZINW 170 (col) IVoG
Decorative Shield, Tarquinia:
Head of River-God Achelous
6th c. B. C. bronze; Dm:
15-7/8
PAL pl 59 IRV
Demons and Ambush Scene,
sarcophagus 4th c. B. C.
stone
HAN pl 205 IVu
Diver, Perugia 5th c. B. C.
bronze; 5-1/2
KO pl 25; PAL pl 76
GMSA
Earring, Cerveteri 7th c. B. C.
gold; Dm: 3-7/8 PAL pl 26
IRV
Earrings 6th c. B. C. gold;
cylinder L: 5/8 TOR 95 (col)
CTRO (918.3.94a-b)
Earrings, a baule 7/5th c.
B. C. gold
SOTH-4:159
Earrings, Todi; Brooch
with Ionic Selen, Vignanelb
gold
SAN 177 (col) IRGi
Effigy, head
BAZINW 170 (col) DCN
Elongated Figures
KO pl 27 FPL; IRGi; IVoG

--3rd c. B. C. bronze
SAN 142 IRGi
Engraved Mirror 5th/2nd c.
B. C.
GAF 151 FPL
Engraved Mirror: Adonis
(Atunis) and Lasa, with
Dog and Goose, Perugia
4th c. B. C. bronze,
with bone handle; L:
12-1/4; Dm: 6-1/2
PAL pl 91 IFAr (80933)
Engraved Mirror: Youth and
Young Woman c 500 B. C.
bronze; L:9-7/8; Dm:5-3/4
PAL pl 89 GMSA (2971)
Engraved Mirror: Chalchas
c 400 B. C. bronze;
Dm: 6
JANSH 129 IRV
Equestrians, volute Krater
handle 5th c. B. C. bronze;
9
NM-5:36 UNNMM (61.11.4)
Etruscan Cities, relief,
Theatre in Caere c 50
GOLDE 6 IRL
Face-Jug 6th c. B. C.
Bucchero pesante; 9
PAL pl 43 GCeS
Female Dancer 6th c. B. C.
KO pl 25 UMB
Female Dancer with Castenets
5th c. B. C. bronze; 17
KO pl 25 FPL
Female Figure c 600 B. C.
alabaster; 33-1/2
STRONGC 123 ELBr
--3rd c. B. C. bronze
FEIN pl 127 UMB
--, acroterion detail terra-
cotta
MAN appendix pl 10 IRGi
Female Funerary Figure,
head and bust fragments,
Vetulonia 7th c. B. C.
limestone
SAN 49 IFAr
Female Head 5th c. B. C.
GOLDE pl 19 IChiE
--3rd c. B. C. terracotta
GOLDE pl 17
--, Orvieto; detail 3rd c.
B. C. trachyst
GOLDE pl 20-21 IRBarr
--, with diadem 3rd/2nd c.
B. C. bronze; 9. 8
GAU 98 FPL
Female Nude, Orvieto marble
SAN 68 IOrM

Female Votive Figure 4th c.
B. C. bronze
BAZINL pl 10; PAL pl 80
FPL
Fibula 7/6th c. B. C. gold;
L: 3-1/2
TOR 95 (col) CTRO
(918. 3. 96)
Fibula: Lions and Foliate
Decoration, Regolini
Galassi Tomb, Caere 7th c.
B. C. gold
SAN 103 (col) IRVE
Fibula, with Discs, Cerveteri
Necropolis 7th c. B. C. gold
LARA 310 IRVE
Fighting Eros 2nd c. B. C.
bronze; 8-1/4
GOLDE pl 115 IFAr
Fighting Warriors, foot and
cavalry, sarcophagus
CHENSN 157 UMB
Figure on Sea Horse, fragment,
Falerii
SAN 126 IRGi
Figured Situla, Certosa
Etruscan Cemetery: Four
Decorative Bands--Military
Parade; Funeral Proces-
sion; Everyday Life; Real
and Imagined Animals 6/5th c.
B. C. sheet bronze
SAN 34-35 (col) IBoC
Figured Plaque 6th c. B. C.
bronze
SAN 50 (col) IFAr
Figures bronze, terracotta
NEWA 96 UNjNewM
Filigree Earrings gold
ENC 303
Fleeing Girl 350 B. C. bronze;
185 cm
HAN pl 204 IFAr
Footed Cylindrical Casket,
Praeneste--handle: Pan
supporting Dionysus
SAN 140 IRGi
Frieze, detail 3rd c. B. C.
DOWN 112 UNNMM
Funeral Banquet, sarcophagus
4th c. B. C.
GOLDE pl 7 IChiE
Funeral Urn, with portrait
head; head detail c 600
B. C.
GOLDE pl 44-45 IChiE
Gallic Warrior, Civita Alba
c 225 B. C. terracotta;
L: 84 GOLDE pl 43 IChiE

Gigantomachy, fronton detail
5th c. B. C. pyrgi
MAN appendix pl 12
IRGi
Girdle, Benacci Tomb cast
bronze; L: 47. 7 cm
MAN 36 (col) IBoC
Girl, Volterra 6th c. B. C.
bronze; 8-5/8
PAL pl 77 GMSA (3678)
A God bronze
SELZJ 194 FPL
Goddess, Chiusi 6th c.
B. C.
PAL pl 37 IFAr (5506)
Goddess, Volterra c 500 B. C.
bronze
GOLDE pl 74 GMA
Goddess, bust 6th c. B. C.
pietra fetida; 20-1/8
PAL pl 35 IChiE
Goddess, cinerary urn figure
650 B. C. terracotta; 40 cm
HAN pl 194 IChiE
Goddess and Child, Vulca(?)
c 500 B. C. ptd terracotta;
1. 43 m
HAN col pl IV IRGi
Gold Brooches with Animal
figures, Praeneste
SAN 96 (col) IRPig; IRGi
Gold Earring, Perugia
SAN 177 (col) IPeA
Gold Necklace and Earrings,
Regulini Galassi Tomb,
Caere 7th c. B. C.
GOLDE 31 IRV
Gold Pins, Brooches, and
Diadem
GOLDE 31 UNNMM; IRGi;
IPeCiv
Gorgon, Temple of Minerva,
Veii c 500 B. C. H: 18-3/4
KO pl 26 IRGi
Gorgon: Strangling Lions,
Perugia Chariot relief
c 500 B. C. bronze
GARDH 159 GMSA
Gorgon, head 6th c. B. C.
stone
GOLDE pl 1 GMA
Gorgon, head, Temple of
Apollo, Veii c 500 B. C.
ptd terracotta
GOLDE pl 41 IRGi
Grave Stele: Animal Suckling
Human Child, Felsina
4th c. B. C. sandstone;
relief zone; 9-1/4
PAL pl 95 IBo

Grave Stele: Sea Horse;
Carriage 4th c. B. C. sand-
stone; 57-1/8
PAL pl 96 IBo (51)
Greek Myth Relief, Herakles and
Possidon with Trident:
Zeus with Thunderbolt,
Castel S. Mariano 6th c.
B. C. bronze
SAN 78, 79 IPeA
Griffin, protome 7th c. B. C.
COPGG 77 DCN (H 92a)
Griffin, head, Perugia 7th c.
B. C. bronze; 7-1/2
PAL pl 30 GMSA (36)
Gualandi Cinerary Urn, with
plastic and human figure
ornament 7th c. B. C.
SAN 42 IChiE
Handle ivory
SAN 48 IFAr
Handle: Snail; Panther Head,
rim figure 7th c. B. C.
bronze; embossed sheet
bronze
GOLDE pl 100 GBAnt
Handles: Ivory Forearm and
Hands; Man and Lion, Prae-
neste 7th c. B. C.
SAN 146 IRGi
Harpy from Campetti, frag-
ment terracotta
SAN 110 (col) IRGi
Head (Menrua) c 530 B. C.
terracotta
MAN 99 (col) IRGi
Head, Bolsena 3rd c. B. C.
limestone
GOLDE 29 IRBarr
Head, burial urn, Chiusi
c 650/625 B. C. terra-
cotta; 17 cm
HAN pl 193 ISA
Head, fragment 6th c. B. C.
pietra fetida; 11-5/16
MAN 90 (col); PAL pl 36
ICorE (1061)
Head-Jug 4th c. B. C.
bronze; 12-5/8
PAL pl 99 FPL (2955)
Heads, pediment fragments,
Temple, Arezzo
SAN 62 IFAr
Helmet 6th c. B. C. bronze;
8-3/4
DENV 14 UCoDA (An-61)
Helmet, with Forehead-Piece
and Cheek-Piece c 500
B. C. bronze; 9-1/2
PAL pl 58 FPMe (2013)

Helmet Cheek-Piece:
Palmette; Achilles and
Troilus, Vulci bronze
SAN 100
Helmeted Warrior, bust
fragment, S. Omobono
6th c. B. C. 2/3 LS
SAN 93 IRCo
Helmeted Warrior, relief head,
Orvieto nenfro; 16-7/8
PAL pl 60 IFAr
Hera-Juno, bust, Falerii
4th/3rd c. B. C.
SAN 117 IRGi
Heracles and Minerva,
Caere 5th c. B. C. ptd
terracotta
GOLDE 160 FPL
Hercules (Warrior) 5th c.
B. C. bronze
CHENSW 139 UMoKNG
Hermes, head
SAN 112 IRGi
Hermes from Veii (Mercuri-
um) c 500 B. C. terra-
cotta; 14-5/8
BAZINL pl 137 (col);
GOLDE pl 34; MAN 119
(col); PAL 15 (col); SAN
110 (col) IRGi
--head detail
GOLDE pl 35
Hind; Stag; Brolio 6th c.
B. C. bronze; 5-1/4;
5-7/8
PAL pl 31, pl 32 IFAr
(559; 558)
Horse, head bronze
CHENSW 142 IFAr
Horse's Head c 400 B. C.
nenfro
GOLDE pl 101 IRV
House, model, Chiusi
c 300 B. C. wood
GOLDE 18 GBM
Hypogeum of the Volumnii;
detail: Lasae, Urn of
Aruns 3rd c. B. C.
SAN 75-77 IPe
Implement for Suspending
Ladles 5th c. B. C. bronze
GOLDE 17 GBAnt
Incense Burner 2nd c. B. C.
bronze
CLE 23 UOClA (52. 96)
Iron Age Cinerary Urn:
Banqueting Scene, Montes-
acaio 7th c. B. C.
SAN 31 IFAr

Javelin Thrower 5th c. B. C.
bronze; 45. 8 cm
CHAR-1:144 (col) FPL
Jewelry: Necklace; Fibulae;
Diadems 7/5th c. B.C. gold
CHAR-1:148 FPL
Jug: Duck 4/3rd c. B.C. clay;
L: 7-3/4 GAU 97 (col); PAL
pl 100 FPL (H 100)
Jupiter
GOLDE pl 119 GMG
Jupiter, from Satricum,
head c 500 B.C. terracotta
GOLDE pl 32-33 IRGi
Kneeling Satyr 4th c. B.C.
bronze; 17-3/8 PAL pl 102
GMSA
Kouros 7/6th c. B.C. bronze
CHENSW 133 UNNMM
Kouros, head fragment,
Attica marble
SAN 68 IMarA
Kriophoros Figure c 550 B. C.
ivory; 8. 7 cm
MAN 62 (col) IPeA
Lady with Pomegranate
450/400 B. C. bronze; 8
UMCF UMCF (1956. 43)
Lamp c 450 B. C. bronze; Dm:
45 cm MAN 129 (col)
ICorE
Lamp: 16-light: Masks of
Acheloi; Gorgon Lamp
5th c. B.C. bronze
SAN 70 ICorC
Lamp Stand: Dancer 5th c.
B. C. bronze
SAN 141 IFeA
Lasa Covering Body of Ajax,
sard intaglio (cast)
BOSMT pl 35C UMB
(21.1199)
Lebe, or Wine Container:
Mounted Warriors in
Helmets with Swan's
Head Crests; detail c 500
B. C. bronze; 18
GRIG pl 67, pl 66 ELBr
Leopard c 560 B.C. volcanic
stone (nenfro); 24-1/2
BOSMI 53 UMB (61. 130)
Lidded Vase, Caere c 700
B. C. clay
GOLDE 30 IRV
Lion, sepulchral monument
detail, Bolsena 4th c.
B. C. nenfro
GOLDE pl 94 IFAr

Liver, votive offering bronze;
3-1/8x8
GIE 98 IPia
Lycian Sarcophagus, Sidon
5th c. B. C. H: 9'8-3/4"
STRONGC 104 TIAM
Maenad, head 6th c. B. C.
terracotta
GOLDE pl 23 IRGi
Maenad, head 6th c. B. C.
terracotta
GOLDE pl 22 IRCo
"Malavolta" Head, Sanctuary
of Apollo terracotta;
2/3 LS
SAN 109 IRGi
Male and Female Figure
2nd c. B. C. bronze;
13-3/8; 11-1/4
EXM 12 IRGi
Male and Female Figures,
furniture support, Brolio
c 550 B. C. bronze; 36. 4;
36 cm
MAN 91 (col) IFAr
Male Dancer with Headdress,
Chiusi, Thymiaterion detail
bronze
GOLDE pl 71 GBAnt
Male Head 5th c. B. C.
cast bronze; 6
GRIG pl 69; STRONGC 125
ELBr
Male Head 3rd c. B. C.
terracotta
GOLDE pl 16 IChiE
Male Head, Caere 80/50 B. C.
Terracotta
HAN pl 215; SAN 149 IRGi
Male Head, Palestrina
LAWL pl 103 GBM
Male Head, fragment,
Antemmae terracotta
SAN 134 IRGi
Male Head, sarcophagus 1st
c. B. C.
COPGG 75 DCN (H 277)
Male Votive Figure 4th c.
B. C. bronze; 1. 36 m
MAN 139 (col) IBoC
Male Votive Figure, Elba
6th c. B. C. bronze;
10-3/8
PAL pl 65 INMA (5534)
Man, head detail 120/100 B. C.
volcanic tufa; 35 cm
HAN pl 211 DCN

Man, votive head 2nd c. B. C.
terracotta; 8-5/8
PAL pl 120 FPL (4300)
Man and Woman c 675/650
B. C. bronze; 11 cm
HAN pl 189 IFAr
Man from Fiesole, head
bronze; 11-5/8
STRONGC 138 (col) FPL
Man with Wart, head 2nd c.
B. C. marble
GOLDE 29 ELBr
Mars, or Warrior, in Armor,
and Worshipper, Isola di
Fano 5th c. B. C.
San 56 (col) IFAr
Mars from Todi 4th c. B. C.
bronze; 66-1/2
AGARC 45; GOLDE 33,
pl 121; HUX 62; NEWTEM
pl 31; NOG 292; PAL pl
97-98; SAN 102 IRV
--helmeted head
NOG 294
Mars from Todi c 450 B. C.
bronze; 12-1/2
GOLDE pl 106 ELBr
Mask: Bearded Man, from
cinerary urn 7th c. B. C.
bronze; 6
GOLDE pl 14 IChiE
Mask, Chiusi 7th c. B. C.
bronze; 10-1/4
PAL pl 1 GMSA (3395)
Mermaid, Castel S. Mariano
c 520 B. C. bronze;
7-11/16
PAL pl 67 GMSA
Minerva, head, Arezzo Temple
Fronton Fragment terra-
cotta; 12 cm
MAN 169 (col) IFAr
Minerva Promachus (Helmeted
Minerva with Spear, as
Goddess of War) 6th c.
B. C. bronze; 8-1/4
GRIG pl 55 ELBr
--c 500 B. C. bronze; 8-1/4
MAN 95 (col); PAL pl 85
IMoE
Mirror: Birth of Athena-
Minerva 4th/3rd c. B. C.
incised bronze
SAN 37 IBoC
Mirror: Boy with Horse,
incised design bronze;
Dm: 6
BOSMI 77 UMB (99. 495)

Mirror: Eos and Kephalos,
Vulci 5th c. B. C.
SAN 37 IRVE
Mirror: Orpheus Playing Lyre
4th c. B. C. bronze
BOSMG 35 UMB (13. 207)
Monteguragazza Statuettes
SAN 38 (col) IBoC
Monteleone Chariot: Fighting
Soldiers with Gorgon
Shield; Winged-Horse
Chariot c 550 B. C. bronze
GOLDE pl 81-82 UNNMM
Il Obeso, tomb figure
CLAK 10 ITaN
Old Man, head, Cerveteri
(Caere) 1st c. B. C.
terracotta; 12-5/8
KAH 39 (col); PAL pl 123;
PRAEG 143 IRGi
Orion Crossing the Sea, mirror
back c 500 B. C. bronze
READM pl 3 ELBr
Ornaments: Mermaid; Sea
Horse, Perugia and Vulci
6th c. B. C. bronze
GOLDE 17 GMA
Paccianese Tomb of the
Family Pulfna Peris ("Tomb
of the Grand Duke") 3rd/2nd
c. B. C. travertine
SAN 45 IChi
Panther: Devouring Human
Head, handle c 500 B. C.
bronze
GOLDE pl 91 GMA
Panther, head c 600 B. C.
bronze
GOLDE pl 92 IBoC
Pediment Figure, fragment:
Male God, Civita Castellana
(Falerii Veteres) 3rd c.
B. C. clay; 22
PAL pl 110 IRGi
Pediment Fragments, Temple
in Contrada Celle, Falerii
4th/3rd c. B. C.
SAN 128
Pediment Plaque, Veii 6th c.
B. C. clay; 11-3/8x24
PAL pl 64 SwGA (194. 74)
Pegassus, acroterion, Caere
5th c. B. C.
SAN 105
Peleus and Thetis, tripod
stand 540 B. C. bronze;
92 cm
HAN pl 196 GMSA

Perugia Carriage: Hippo-
campus c 500 B. C. bronze
GOLDE pl 88; PAL pl 70
GMA
--: Lion
GOLDE pl 89
--: Marsh Bird
GOLDE pl 90
--: Heracles between Two
Lions; Merman
GOLDE pl 86-87
--: Lions Attacking Deer
6-1/2x22
GOLDE pl 85; PAL pl 70
--: Reliefs
GOLDE 32
--: Reliefs: Battling Animals;
Gorgon
GOLDE pl 83-84
Pin, Cerveteri 7th c. B. C.
gold; L: 12-5/8
PAL pl 25 IRV
Pin, Palestrina: Sirens; Lions;
Horses 7th c. B. C. gold;
L: 6-3/4
PALpl 28 IRPig
Plumed Helmet 8th c. B. C.
bronze; 11-3/4x9-1/4
PAL pl 57 ITaN
Ploughman with Two Oxen
terracotta
HOR 286-287 (col) FPL
Porta dell'Arco 4th c. B. C.
BOE pl 15; SAN 91 IVo
Porta Marzia c 100 B. C.
BOE pl 21; MAN appendix
pl 1 IPe
Praeneste Bracelet 7th c. B. C.
sheet gold; L: 7-1/4
STRONGC 112 (col) ELBr
Praeneste Cosmetic Boxes:
Deer; Dove 4th/3d c. B. C.
wood
SAN 144 IRGi
Praeneste Cup, with Sphinxes
7th c. B. C. gold; 3-1/8
STRONGC 113 (col) IRGi
Praeneste Dish: Animal and
Human Figures 7th c. B. C.
silver gilt
SAN 97 (col) IRPig
Praeneste Ornament gold;
9-5/8
STRONGC 112-113 (col) IRGi
Priest (Vertumnus from Isola
di Fano), votive figure, de-
tail c 500 B. C. bronze; total
H: 10-3/4
GOLDE pl 108 IFAr

Pronged Implement with sur-
mounting feline 5th c. B. C.
bronze
GOLDE pl 56 IFAr
Proserpina, seated figure,
funeral urn; head detail
6th c. B. C. travertine
GOLDE pl 26-28 IChiE
Pyxis: Fighting Animals and
Men ivory
SAN 48 IFAr
Ram, Bibbona 480/470 B. C.
bronze; 9-7/8
PAL pl 72 IFAr (70792)
Reclining Banqueter c 500 B. C.
bronze; L: 4-1/2
CPL 87 UCSFCP (1952. 26)
Reclining Banqueter, vessel
rim-figure c 500 B. C.
bronze; L: 13
GOLDE pl 60 ELBr
Reclining Diner, cinerary urn
3rd c. B. C.
GOLDE pl 9 IChiE
Reclining Diner (Funeral
Banquet; Obesis Etruscus),
sarcophagus relief, Chiusi
2nd c. B. C. stone
BAZINW 169 (col);
CHENSW 140; GOLDE pl 8
IFAr
Reclining Drunken, Bearded
Satyr 6th c. B. C. bronze;
L: 3
SOTH-4:159
Reclining Female Figure,
sarcophagus lid c 200 B. C.
alabaster; LS
GOLDE 23 IChiE
Reclining Man bronze
GOLDE pl 104 IFAr
Reclining Youth, vessel rim-
figure(?) c 500 B. C. bronze;
L: 4-3/8
GOLDE pl 62 UNNMM
Rectangular Container: Incised
Figures, Palestrina 3rd c.
B. C. bronze; 10-1/2
PAL pl 106-107 IRGi
(13133)
Regolini Fibula, Regolin-
Galassi Tomb c 650 B. C.
sheet gold, reliefs and
granulation; L: 32 cm
MAN 44 (col) IRVE
Relief Fragment: Hercules
Fighting, Castel S.
Mariano 530/520 B. C.
bronze SAN 80 IPeA

Relief Mirror: Apollo (Apula),
Zeus (Tinia), and Hermes
(Turms); Bomarzo c 300
B. C. silver; L: 9-3/4; Dm:
4-1/8
PAL pl 90 IFAr (74831)
Rider, fragment without horse
5th c. B. C. bronze; 10-1/2
DETT 31 UMiD (46. 260)
"Rod" Tripods of "Vulci" Type
SAN 101 IRVE; IFeMA
Round Container: Judgment of
Paris, with Lasa and Horses;
Lion's Feet on Toads; Lid
Figures--Amazons, Pales-
trina 4th c. B. C. bronze;
24-3/4
PAL pl 103-105 IRGi
(13199)
Sarcophagus; detail: Charun,
left end c 150 B. C.
HAN pl 206, 207 UMWA
Sarcophagus: Lion, Boar,
Chimera stone
CHENSW 142; SAN 163 ITaN
Sarcophagus: Man; Woman,
Toscanella
LAWL pl 93, 94A, 95 ITosC
Sarcophagus: Mythological
Scenes c 300 B. C. ptd
stone; L: 2. 1 m
MAN 147 (col) IFAr
Sarcophagus: Procession;
Banquet, Villa Sperandiohypo-
geum, Perugia sandstone
SAN 73 IPeA
Sarcophagus: Reclining Couple
MARQ 114 ELBr
Sarcophagus: Reclining Couple
c 300/280 B. C. peperino;
L: 82
BOSMGR pl 29 UMB (L 1070)
Sarcophagus: Reclining Couple,
Cerveteri (Caere) c 600
B. C. ptd terracotta; 46. 1x
78. 7
BAZINW 169 (col); CANK
67; CHAR-1:142-143; CHRP
97; GAF 139; GAU 99, 100
(col); GOLDE 27; HUYA pl
22; HUYAR 20; KO pl 24
FPL
Sarcophagus: Reclining Couple,
Cerveteri 6/5th c. B. C.
ptd terracotta; 56x80
CHENSN 150; CHENSW 134;
GARDH 157; GOLDE pl
10-13; JANSH 124; JANSK
169; KO pl 24 (col); MAN

3 (col); MU 52; SAN 148;
ST 69; UPJH pl 43 IRGi
--head detail
STA 13
Sarcophagus: Reclining Couple,
Citta della Pieve 5th c.
B. C. H: 1. 1 m
MAN 131 (col) IFAr
Sarcophagus: Reclining
Couple, Vulci c 300/250 B. C.
volcanic stone; L: 83
BOSMI 81: HAN pl 209; KO
pl 24 UMB (Atheneum Loan
1281)
Sarcophagus: Reclining Male
Figure 2nd c. B. C. lime-
stone; 27-1/8x95-5/8
x25-1/4
PAL pl 114 ITaN
Sarcophagus: Trojan Cycle--
Sacrifice of Polyxena by
Neoptolemos; Achilles
Sacrificing Trojan Prisoners
on Tomb of Patroclus,
Torre S. Severo 4th c. B. C.
SAN 64 IOrM
Sarcophagus, Caere 6th c. B. C.
terracotta
WATT 94 FPL
Sarcophagus, double, Citta
della Pieve 4th c. B. C.
alabaster
SAN 59 IFAr
Sarcophagus, with Sea Horses;
effigy head detail 4th c.
B. C.
BAZINL pl 142-143 DCN
Sarcophagus of Laris Pulenas
("The Magistrate") 3rd/2nd
B. C. SAN 162 ITarM
Sarcophagus of Seianti Hanunia,
wife of Tlesna, Chiusi c
200 B. C. terracotta
GOLDE 27 ELBr
Sarcophagus of Sejanti Larthia,
Chiusi 2nd c. B. C. ptd
terracotta; L: 1. 72 m
MAN 176 (col); SAN 63 (col)
IFAr
Sarcophagus of Velthur
Partunus ("Sarcophagus of
the Magistrate") 3rd c. B. C.
white stone; 81-1/2
HAN pl 210; SAN 163;
STRONGC 127 ITaN
Sarcophagus Plaque, incised
detail: Dolphin c 2nd c.
B. C. clay; 15-3/4
PAL pl 115 IFAr

Sarcophagus Relief 3rd c.
 B. C. stone CHENSW 142
 UMB
Sarteano Urns: Death of
 Hippolytus; Duel between
 Eteocles and Polyneices
 2nd c. B. C.
 SAN 83 ISA
Satyr, funerary urn, Orvieto
 BAZINL pl 138
Satyr and Maenad c 450 B. C.
 clay; 24
 KO pl 26 IRGi
Satyr and Maenad, Satricum
 c 500 B. C. terracotta
 GOLDE 39 IRGi
Scythian Bowman, Campania
 6th c. B. C. bronze
 GOLDE 16 GBAnt
Scythian Bowman, Sardinia c
 7th c. B. C. bronze
 GOLDE 16 ELBr
Seated Goddess, pediment
 fragment 1st c. B. C.
 SAN 95 IRCo
Seated Man c 600 B. C.
 terracotta; 27 cm
 MAN 54 (col) IRCo
Seated Man, Cerveteri 7th c.
 B. C. ptd terracotta;
 18-1/2
 PAL 23 IRCo
Seated Woman c 600 B. C.
 clay
 CHENSW 135 ELBr
Seated Aoman (Goddess); left
 profile c 600 B. C.
 terracotta
 GOLDE pl 24, 25 IRCo
Seated Youth, funerary figure,
 Caere 7th c. B. C.
 terracotta
 SAN 94 IRCo
Sepulchral Mask c 500 B. C.
 polished terracotta; 7. 75x
 6. 375
 GOLDE pl 93 ELBr
Shadow of Evening, idol
 c 200 B. C. bronze;
 22-1/2
 GIE 104 IVoG
She-Wolf Suckling a Boy,
 funeral Stela 4th c. B. C.
 GOLDE pl 6 IBoC
Shield Boss: Lions and
 Central Floral Design,
 Regulini Galassi Tomb,
 Caere 7th c. B. C. bronze
 GOLDE 20 ELV

Silen-Head, antefix, Lesser
 Temple of Vignale, Falerii
 5th c. B. C. terracotta
 SAN 126 (col) IRGi
Silens, tripod detail 6th c.
 B. C. bronze
 COPGG 71 DCN (H223a)
Silens and Maenads, head
 fragments, Temple of
 Mercury, and Larger Temple
 of Vignale, Falerii
 SAN 123, 124 (col),
 125 (col) IRGi
Silenus, Loeb Collection
 bronze; 17-1/4
 GOLDE pl 117 GMAnt
Silenus and Maenad c 300
 B. C.
 STI 286 IRME
Situla, Vace, Yugoslavia
 5th c. B. C. bronze
 GOLDE 17 YLM
Sleep and Death Bearing Body
 of Sarpedon (cast) intaglio
 scarab
 BOSMT pl 21B UMB
 (21.1200)
Soldier in Vallanovan Helmet,
 Reggio Emilia c 700 B. C.
 bronze
 GOLDE pl 73 IBoC
Spear-Thrower, votive figure
 c 500 B. C. bronze; 18
 PAL pl 68 FPL
Sphinx 6th c. B. C. bronze; 2
 SOTH-4:159
Sphinx, Praeneste, utensil
 fitting c 650 B. C. bronze
 HAN pl 190 IRPe
Sphinx, headless funeral frag-
 ment, Vulci
 SAN 99 IRGi
Standing Lion, jug handle,
 Perugia 6th c. B. C.
 bronze; 8
 PAL pl 71 GMSA
Stele: Fight between Serpent
 and Hippocampus; Journey
 to Underworld, Celtomachy,
 Bologna sandstone; 1. 8 m
 MAN 137 (col) IBoC
Stele, Felsina: Dragon Fight-
 ing Hippocamp; Chariots
 with Winged Horses 6/4th c.
 B. C.
 SAN 36 IBoC
Stele of Avile Tite: Bearded
 Long-Haired Warrior, armed
 with Spear and Bow, Portone

cemetery 6th c. B. C.
SAN 84 IVoG
Stele of Larth Ninie, Long-
Haired Warrior with Spear
and Axe 530 B. C.
SAN 84 IFAr
Stilus, surmounted by school
boy with writing tablet and
bronze pencil, Orvieto
5th c. B. C. bronze
GOLDE 157 GBA
Suicide of Ajax, mirror c 380
B. C. bronze BOSMG 94;
BOSMT 35B UMB (99. 494)
Suicide of Ajax, sard scarab-
form intaglio (cast) 500/475
B. C. BOSMT pl 35A UMB (27. 717)
Swimmer bronze
GOLDE pl 118 GMG
Temple, model c 500 B. C. wood
GOLDE 18 ELBr
Theban Myth Cycle, Temple
at Talamone (Telemonaccio),
reconstructed pediment
detail 2nd c. B. C. terra-
cotta; c1. 45 m
STRONGD pl 5 IFAr
Three-Sided Foot of Brazier
Stand, relief details: Juno;
Hercules c 520 B. C. bronze;
foot: H: 11 PAL pl 54-56
(Pl 55) GMSA IPeA (1413)
Tinia(?), Etruscan Zeus,
Apiro 450 B. C. bronze;
. 405 m
HAN pl 200 UMoKNG
Tinia, head 5th c. B. C. ptd
terracotta; 16 cm
MAN 135 (col) IRGi
Tinia(?), head, Belvedere
Temple, Orvieto 5th c. B. C.
MAN 125 (col)
Tinia(?), head, Conco (Satri-
cum) 5th c. B. C. clay;
9-7/8
PAL pl 86 IRGi (9982)
Toilet Box 4th c. B. C.
bronze
GOLDE pl 59 IRGi
Tomb Cover, Tarquinia, relief
details: Centaurs;
Sphinxes; Griffins 6th c.
B. C. nenfro; 43-1/4x88-
5/8
PAL pl 34 ITaN (4)
Tomb Monument: Dying
Adonis, Tuscany 2nd c.

B. C. clay; 24-3/4x34-5/8
x13-3/4
PAL pl 116 IRV
Tomb Relief 4th c. B. C.
limestone
STRONGC 125 ITarN
Tomb Relief: Three-Headed
Dog; Armor 3rd c. B. C.
stucco PAL pl 9
Tomb, reliefs, Cerveteri
3rd c. B. C. stucco
BAZINW 170 (col)
Tomba Bella (Tomb of the
Reliefs), Caere 4th/3rd c.
B. C.
SAN 157-158
Tombstone 5th c. B. C.
COPGG 69 DCN (H201)
Tripod 5th c. B. C. bronze;
26
NM-5:35 UNNMM (60. 11. 11)
Tripod, detail: Hind Attacked
by Lion 6th c. B. C. bronze;
W: 7 cm
BOES 91 DCN
Tripod and Stand, Praeneste
7th c. B. C. bronze
SAN 145 IRGi
Turan (Aphrodite) c 520/510
B. C. bronze; 20. 2 cm
CHAR-1:137 (col) FPL
Turan (Aphrodite) c 520 B. C.
bronze; 8-1/2
PAL pl 66 GMSA
Turan, Perugia c 480 B. C.
bronze
GOLDE 72 GBAnt
Two Fighting Warriors,
acroterion detail, Temple
of Mercury, Falerii
SAN 122 (col) IRGi
Two Figures, candelabrum
crowning decoration 4th c.
B. C. bronze
MAN appendix pl 14 IBoCas
Two Seated Women c 600 B. C.
terracotta
GOLDE 28 ELBr
Two Worshippers, Montegura-
gazza Stipe 5th c. B. C.
bronze; 24-1/2 cm; 36 cm
MAN 123 IBoC
Two Wrestlers, vessel cover
handle 4th/3rd c. B. C.
bronze MU 53 (col) UMdBW
Tydeus, urn relief: Seven
Against Thebes alabaster
BAZINW 170 (col) IVoG

Typhon c 500 B.C. terra-
cotta
GOLDE 38 IRGi
Ulysses and Sirens, funerary
urn, Volterra 2nd c. B.C.
alabaster; 15-3/8
STRONGC 126 ELBr
Urn, Tomb of Volumnii
LAWL pl 98 IPeV
Urn: Actaeon Set Upon by
Hounds of Artemis alabaster
SAN 89 IVoG
Urn: Duel between Eteocles and
Polyneices terracotta
SAN 46 (col) IChiE
Urn: Gorgon Head with
Acanthus Foliation,
Castiglione del Lago
travertine
SAN 81 IPeA
Urn: Man, Chiusi limestone
GOLDE 33 ELBr
Urn: Reclining Female Figure
alabaster
LAWL pl 99 IVoG
Urn: Reclining Figure
terracotta
LAWL pl 100A IRGi
Urn: Religious Procession
1st c. B.C.
LAWL pl 101 ELBr
Urn: Ulysses and Circe terra-
cotta
SAN 74 IPeA
Urn: Ulysses in the House of
Circe travertine
SAN 74 IPeA
Urn Lid: "husband and Wife",
reclining figures 1st c. B.C.
terracotta
SAN 85 IVoG
Urn of Arnth Velimnes Aules
c 100 B.C. limestone,
stucco; c 1.59 m
HAN pl 208 IPeG
Urn of Larth Purni Curce:
Greeks Battling Trojans,
Citta della Pieve
alabaster
SAN 88 IFAr
Urn of Thania Caesinia
Volumni travertine
SAN 82 IPeA
Urns: Seven Against Thebes;
Ulysses and the Sirens
SAN 87 IVoG
Vase: Duck, Chiusi 4th c.
B.C. ptd terracotta
SAN 90 IFAr

Vases bronze; 7-7/8
BARD 189 BrSpA
Villanovan Hut-Urn, Albano
c 100 B.C.
GOLDE 18 GBM
Villanovan Vessel, Askos,
Benacci Tombs 8th c. B.C
GOLDE pl 57 IBoC
Volterra Tomb of the Gens
Atia ("Tomb of the In-
ghirami") 4th/3rd c. B.C.
SAN 45 IFAr
Votive Figure 7/6th c. B.C.
bronze
CHENSW 136 UPPU
Votive Male Head, Falerii
4th/3rd c. B.C. ptd
terracotta
SAN 134 IRGi
Votive Pediment, Nemi
terracotta
SAN 6 IRGi
Warrior Proto-Etruscan
MALV 620 IRGi
Warrior 6th c. B.C. bronze
CHENSW 137 IRGi
Warrior 6th c. B.C. bronze
CHENSW 137 FPL
Warrior 7/6th c. B.C.
bronze
CHICC 56 UICBr
A Warrior 7/5th c. B.C.
bronze; 6-3/4
MU 52 UNNMM
Warrior 6th c. B.C. bronze
INTA-2:119
Warrior 6th c. B.C. bronze
VALE 40 UNNMM
Warrior 6th c. B.C. bronze;
9-1/2
LAH 32; NCM 35 UCLCM
Warrior c 550 B.C. terracotta;
23
GOLDE 29 UNNMM
Warrior c 500 B.C. ptd and
glazed terracotta; 81-1/4
(Proved 20th c. Forgery)
BALD front (col); DIV 22;
GOLDE 29; HOF 283; MYBA
132; NMA 44 (col); PANA-
1:115; ROTHS 75; TAYFF
9 (col) UNNMM
Warrior 5th c. B.C. bronze
ELIS 107 UNNMM
Warrior 5th c. B.C. bronze;
c 5
FAIY 54 UNRoR
Warrior: Attacking 5th c. B.C.
bronze; 11-3/4 PAL pl 82
FPMe (185)

Warrior: Defending Himself
5th c. B. C. bronze; 4-3/4
PAL pl 83-84 IMoE
Warrior: Setting out for
Battle 5th c. B. C. bronze
DIV 22 UNNMM
Warrior: Sheathed Dagger in
Left Hand bronze
CHENSW 148 UMoKNG
Warrior, Brolio c 600 B. C.
bronze; 14-1/4
PAL 33 IFAr (562)
Warrior, Civita Castellana
c 500 B. C. terracotta
GOLDE pl 40 IRGi
Warrior, colossal head,
Orvieto Necropolis
530/520 B. C. stone; 43 cm
CHENSW 136; LARA 309;
MAN 60 (col) IFAr
Warrior, head c 550 B. C.
terracotta; 55
GOLDE 29 UNNMM
Warrior, head, Veii 5th c.
B. C. ptd terracotta
LARA 320 (col); SAN 107
(col) IRGi
Warrior in Armor 5th c.
B. C. bronze; 13
PAL pl 79 IFAr
--detail
GOLDE pl 107
Warrior in Helmet bronze
CHENSW 146 UNNMM
Warrior in Helmet (Mars?)
7th c. B. C. bronze
GOLDE pl 75 IFAr
Warrior in Helmet 6th c.
B. C. bronze; 10-1/2
GOLDE pl 77 UNNMM
Warrior in Swan Helmet
5th c. B. C. bronze
STA 13 FPMe
Warrior with Plated Cuirass,
Lake Falterona 4th c. B. C.
bronze; 12. 6
GOLDE pl 105 ELBr
Warriors 7th c. B. C. bronze
CHENSW 135 UPPU; UNNMM
Winged Horses 350/300 B. C.
ptd terracotta; 1. 14 m
BRIONA 61; HAN pl 199;
KO pl 27; SAN 178 ITaN
Winged Lion 6th c. B.C.
COPGG 65 DCN(H 194a)
Winged Lion 6th c. B. C.
stone; 37-1/2
NM-5:34 UNNMM (60. 11. 1)

Woman, Perugia 6th c. B. C.
bronze; 6-1/2
PAL pl 78 GCeS
Woman: Plaiting her Hair,
Solaia 2nd c. B. C. clay;
24-3/8
PAL pl 118 IFAr (72727)
Woman, head 550 B. C. bronze;
12 cm
MAN 96 (col) IPeA
Woman, head 3rd c. B. C.
clay
CHENSW 140 IChiE
Woman, head 3rd c. B. C.
nenfro; 13-7/8
PAL pl 117 SwGA
(F. 1313)
Woman, head fragment, Veii
5th c. B. C.
SAN 106 (col) IRGi
Woman and Child, candelabrum
support bronze; 15 cm
MAN 127 (col) IBoC
Woman Revellers, relief,
funeral stone (cippus) c
500 B. C. limestone; 18-1/2
STRONGC 124 ELBr
Worshipper 6th c. B. C.
bronze
GOLDE pl 78 IRGi
Worshipper 6th c. B. C. bronze
VALE 40 UNNNi
Winged Victory, Civita
Castellana 3rd c. B. C.
terracotta
KO pl 27; SAN 129 IRGi
Wounded Soldier helped by
Comrade, candelabrum finial
5th c. B. C. bronze; 5-1/4
NM-5:37 UNNMM (47.11.3)
Writing Tablet--26 letter
alphabet border 8/7th c.
B. C. ivory border
SAN 48 IFAr
"XOANA" Figure, female
bust 6th c. B. C. stone
SAN 40 IChiE
Xoanon, Dea Mater c 600
B. C. bronze
GOLDE pl 80 IFAr
Young Man, head, Fiesole
2nd c. B. C. bronze;
11-3/8
PAL pl 119 FPL
Young Priest, or Athlete,
head with Tutulus c 200
B. C. bronze; 8
GOLDE pl 129; HAN pl 213
ELBr

Youth bronze
GOLDE pl 68-69 UNNMM
Youth (Apollo?) 5th c. B. C.
bronze
GOLDE pl 112 GMA
Youth, Falterona c 500 B. C.
bronze; 8-5/8
PAL pl 76 FPL (66)
Youth, head 430/400 B. C.
terracotta; . 171 m
HAN pl 202 IRGi
Youth, head c 200 B. C.
bronze
GOLDE pl 126 IFAr
Youth, head 2nd c. B. C.
bronze
MAN 175 (col)
Youth, head, Latium(?) 3rd c.
B. C. clay; 13
PAL pl 121 GMSA (1052)
Youth, head, funeral urn lid
c 300 B. C.
GOLDE pl 18 IChiE
Youth, pediment fragment,
Scasato, Falerii
SAN 121 IRGi
Youth, votive figure c 480
B. C. bronze
GOLDE pl 111 IBoC
Youth and Woman, head frag-
ments; Antefix Fragment,
Scasato Temple 4th/3rd c.
B. C. terracotta
SAN 118 (col) 119 (col)
IRGi
Youth on Hippocamp, Vulci
6th c. B. C.
SAN 98 IRGi
Zeus, head, Falerii Veteres
5th c. B. C. terracotta
SAN 116 IRGi
ETRUSCAN, or UMBRIAN
Hut-Urn, Chiusi c 500 B. C.
GOLDE 18 IChiE
ETRUSCO-ITALIC
Chariot Pulled by Winged
Horse, frieze, Esquiline
Hill 6th c. B. C.
terracotta; 24 cm
STRONGD pl 2 IRAn
Wounded Amazon, torso
fragment, Esquiline Hill
5th c. B. C. ptd terracotta;
21 cm
STRONGD pl 3 IRAn
ETRUSCO-ROMAN
Actor C. Norbanus Sorix, head
1st c. B. C. bronze
CHENSW 143 INN

Pantheress bronze
CHENSW 138 UDCD
The Etude. Hovannes
EUAENTUS (Euainetos) (Greek)
Syracusan Decadrachm:
Arethusa, head; Quadriga
c 413/300 B. C. silver;
Dm: 1-3/8
GARDH 138; RICHTH 247
ELBr
Syracusan Dekadrachm:
Quadriga and Prize Armor;
Arethusa, head silver;
Dm: 36 mm
BOSMI 73 UMB (04. 536)
Syracusan Dekadrachm:
Arethusa, Sicily 412/393
B. C. silver; Dm: 1-3/8
TOR 97 CTRO (92. 7. 8)
Syracuse Coin: Arethusa,
profile head c 412 B. C.
silver
SCHO pl 61 (col) ISyAr
Eubouleus, head. Praxiteles
EUBOULIDES OF ATHENS (Greek)
Athena, head c 150/100 B. C.
RICHTH 169 GrAN
Chrysippos, seated figure
c 200 B. C. (reconstructed
copy) marble; 80 cm
RICHTH 167; WEB 205 FPL
Female Head 2nd c. B. C.
BEAZ fig 198 GrA
Euclid. Goode
Eucratides (King of Bactria)
Bactrian. Stater: Eucratides
--Tetradrachm: Eucratides;
Dioscuri
--20-Stater Coin: Eucratides
Eugenie. Rosin, H.
Eumorfopolous Ewer
Chinese--T'ang. Chicken-
Head Spout Ewer
EUPHRANOR (Greek)
Aphrodite, torso
FUR 358 IN
Apollo bronze
FUR 351 ELBr
Apollo (Adonis)
FUR 355 IRV
Apollo Patroos, headless
figure c 350/330 B. C.
FUR 360; RICHTH 144
GrAAg
Athena Giustiniani, Braccio
Nuovo
FUR 362 IRV
Bonus Eventus, headless figure
FUR 360 ELBr

Carnelian: Bonus Eventus
 FUR 350 ELBr
Dionysos from Tivoli
 FUR 351 IRT
Figure
 FUR 351 GD
Hermes of Andros; detail
 FUR fig LXXXII, 364
 GrAN
Lansdowne Paris
 FUR 358
Pan of Winckelmann (Faun),
 head
 FUR 359 GMG (102)
Poseidon from Melos c 200
 B.C. marble CHASE 205;
 FUR 365; KO pl 22;
 RICHTH 159 GrAN
Youth
 FUR 352 FPL
Youth
 FUR 352 DCN
EUPHRANOR--ATTRIB
Male Bust, Herculaneum
 4th c. B.C. bronze
 LAWC pl 94B IN
Euripedes
Bactrian. Bowl: Scenes from
 Tragedies of Euripedes
Greek--5th c. B.C. Euripedes
Greek--4th c. B.C. Euripedes,
 bust
Hellenistic. Euripedes#
EURIPEDES--FOLL
Megarian Bowl: Clytemnestra's
 Arrival in Aulis 3rd/2nd c.
 B.C.
 RICHTH 356 UNNMM
Europa
Greek. Goddesses; Europa
 and the Bull
--Rape of Europa, metope
--Zeus: Abducting Europa,
 relief
Greek--7th c. B.C. Europa
 on the Bull, amphora
 fragment
Greek--6th c. B.C. Europa
 on the Bull, metope
--Sicyonian Treasury
--Zeus and Europa, relief
Greek--5th c. B.C. Europa
Laurent. Europa
Lipchitz. Rape of Europa#
Manship. Europa
Manship. The Flight of Europa
Nakian. Europa
Nakian. Rape of Europa
Nickford, J. Europa with Bull

Waugh, S. B. Europa and the
 Bull, etched glass bowl
Wein, A. W. Europa and the
 Bull
European Jew. Marans
Europeans
African--Congo. Europeans
African--Yoruba. Mounted
 Missionary Arriving in
 Abeokuta
Japanese--Tokugawa. Dutch
 Trumpeter
Eurydice
Greek--5th c. B.C. Altar of
 the Twelve Gods
--Hermes, Eurydice, and
 Orpheus#
Hellenistic. Hermes, Eurydice,
 Orpheus, relief
Manship. Euridice
Piccirilli, F. Euridyce,
 relief
Euterpe
Roman--2nd c. Euterpe,
 seated figure
Euthydemus (Governor of Kapisu,
 Son of Demetrius I)
Bactrian. Tetradrachma:
 Euthydemus#
Hellenistic. Euthydemus
Euthydemus II (King of Bactria)
Indian--Kushan--Gandhara.
 Bactrian Coin. Euthydemos
 II
Euthydicos Kore
Greek--6/5th c. B.C. Kore:
 Dedicated by Euthydikos
Eutropios (Roman Historian fl 4th c.)
Roman--5th c. Eutropios,
 head
EUTYCHIDES (Greek fl 4th/3rd c.
 B.C.)
Tyche of Antioch (Fortune of
 Antioch; "Good Fortune"),
 city goddess in castle-
 crown c 300 B.C. (Bronze
 and marble copies of bronze
 original)
 BEAZ fig 153-155 IFCl;
 HBNM
--(copy) marble; 89 cm
 BO 205; CHASE 110;
 CHASEH 131; ENC 288; HAN
 pl 227; LAWC pl 103A;
 MYBA 120; RICHTH 155;
 ROOS 40H; WEB 205 IRV
--(Roman copy) bronze
 CHASE 118 UNNMM
Evacuee. Lux

Evangeline
 Hebert, H. Evangeline
EVANS, Rudolph (American 1878-1925)
 Boy and Panther (Mowgli)
 bronze; 57
 BROO 140; NATSA 56
 UScGB
 George Bancroft, bust bronze
 HF 17 UNNHF
 Golden Hour marble
 ADA 86; PAG-12:218;
 TAFTM 142 UNNMM
 Grover Cleveland, bust
 bronze
 HF 118 UNNHF
 Henry Wadsworth Longfellow,
 bust bronze
 HF 26 UNNHF
 John Greenleaf Whittier, bust
 bronze
 HF 35 UNNHF
 Julius Sterling Morton bronze
 MUR 52; USC 252 UDCCapS
 Maude Adams, mask
 NATS 92
 Venus Aphrodite
 NATS 93
 William Jennings Bryan
 bronze
 MUR 52; USC 230 UDCCapS
Eve. Goethe
Eve. Kakei
Eve. Lux
Eve See Adam and Eve
Eveil. Lassaw
Even the Centipede. Noguchi
EVENETE (Greek)
 Syracuse Decadrachma:
 Persephone Crowned with
 Reeds c 400 B. C.
 BAZINL pl 136 FPMe
Evening. Flannagan
Evening. Golubic
Evening. King, W. D.
Evening. Manship
Evening. Ruckstuhl
Evening. Schwarzott
The Evening Visitors. Zadkine
Everett, Edward
 Akers, P. Edward Everett,
 head
Everything for Victory. Konzal
Evil-Eyed Bird. Dombek
Evil New War God. Westermann,
 H. C.
Evocation. Rocklin
Evolution in Form. Calandria
Evolving Form. Scanga, I.

Ewers
 Boscoreale. Oenochoe of
 Victories
 Chinese--Ch'ing. Ibex Head
 Ewer
 Chinese--Liao. Ewer: Court
 Lady
 Chinese--T'ang. Chicken-Head
 Spout Ewer
 --Eumorfopolous Ewer
 --Ewer#
 Egyptian--10th Dyn. Fatimid
 Ewer
 Egyptian--22nd Dyn. Ewer:
 Animal and Floral Motif
 Indo-Portuguese. Dragon,
 ewer
 Islamic. Ewer#
 Islamic. Khurasan Ewer
 Persian. Bull's Head Ewer
 --Ewer: Bird Figures
 Roman--1st c. Ewer, infant
 Hercules handle
 Sassanian. Ewer: Gladiator
 Combatting Bear
 Soghdian. Ewer: Undraped
 Females and Rosettes
 Sumerian. Ewer
Executioner. Rosene
Executioners. Rosene
 African--Ashanti, or Agni/
 Baoule. Gold Weight:
 Mounted Executioner
Executive Table and Chair.
 Artschwager
Exedra of "Canopus". Roman--2nd c.
Exhaltation of the Flower, gift
 exchange between Demeter
 and Hades. Greek--5th c. B. C.
Exhibition. Warhol
Exhibition Los Angeles. Morris, R.
The Exhorter. Caparn
Exodus See also Merneptah
 Aarons. Synagogue Facade
 Barthe. Exodus
 Goldberg. Exodus; Revelation
 on Sinai
 Vodicka, R. K. Exodus
Exotic Garden. Westermann, H. C.
Expanding Structure. Falkenstein
Exploding Star. Rood
Explorer. Roszak
Explosion. Porter, C. W.
Expulsion from Eden. Kaish
Extending Horizontal Form. Hunt, R.
Exuberance. Baizerman
The Eye. Seno
Eye Glasses

Folk Art--American. Trade
 Sign: Spectacles
Eye of Time. Taylor, M.
Eye-Shade
 Eskimo. Greenland Utensils
Eyrie. Howard, R. B.
EZEKIEL, Moses (American
 1844-1917)
 Religious Liberty
 PAG-10:124 UPPF
 Thomas Jefferson, bust marble
 FAIR 323; USC 177 UDCCap
Ezekiel and the Angel. Kaish

Fables of La Fontaine. Callery
Facades
 African--Bamileke. Hut Columns
 and Facade
 Albert, C. Synagogue Facade
 Sculptures
 Babylonian. Old Palace of
 Babylon Throne Room
 Facade
 Coptic. Chapel Facade
 de Marco. Facade, War
 Department Building
 Ecuadorian--17th c. Facade
 Egyptian. Facade, Second Pro-
 pylon, Temple of Isis
 Hemerian. Puebla Cathedral
 Facade
 Hispano-Indians of Mexico.
 Montejo Palace: Granadine
 Facade
 Iberian. Compania Facade
 Indian--Gupta. (Ajanta
 Cave(s)
 --Mahabodhi Temple Facade
 Indian--Hindu--18th c. Tower
 Facade
 Indian--Rajput. Shrine Facade
 Islamic. Facade
 --Mosque Facade
 --Mshatta Facade
 Kassite. Male and Female
 Dieties, facade elements
 --Temple Facade
 --Uruk Temple Facade
 Khmer. Southern Facade,
 Main Tower
 Latin American--18th c. Facade
 Maya. House of Governors,
 Facade
 --Iglesia Flying Facade
 --Nunnery#
 --"Palace" Facade: Masks
 Serpents, Geometric Motifs
 --Palace of Masks
 --Temple Facade

--Temple of Warriors
 Mexican--17th c. National
 Library Facade
 Mixtec. Facade
 Rocklin, R. Facade
 Sullivan, L. Main Entrance
 Facade, Carson Pirie
 Scott
 Teotihuacan. Temple of
 Quetzalcoatl
 Tuyru Tupac. Facade
Face. Calder, A.
Face-Board, Ceremonial House
 Roof Decoration. New Guinea
Face of the Moon. Cox, E. B.
Faces. Lipman-Wulf
FADEM, Ken
 Goldfadem found objects
 ptd gold
 MEILD 126
 The Last Yogi steel-welded
 prefabricated objects
 MEILD 23
 Untitled found objects welded
 through plaster mold
 MEILD 129
FAGGI, Alfeo (Italian-American
 1885-)
 Female Nude
 CASS 76
 From the Cross bronze
 CHICA-53:pl 10 UICJud
 Low Relief, Number one
 bronze
 WHITNC 231 UNNW
 Noguchi, head bronze; 11
 ADD 111; HAY 23 UMAP
 The Passion: Two Scenes,
 relief
 RICJ pl 30 UICT
 --: Station of the Cross
 AGARN il 31
 --: XIII Station of the Cross
 BRUM pl 41
 Pieta bronze; 28
 CHICH pl 76; CHICS UICA
 St. Francis
 CAH 116; CAHA 58 UNmSN
 --bronze
 CHENSW 497
 --1915 bronze; 53
 PIE 386 UNBuA (720. 40)
Faience
 Egyptian. Hippopotamus, blue
 faience
 Sumerian. Boar's Head, Nuzi,
 blue faience
"The Fair-Haired Boy"
 Greek--5th c. B. C. "Blond Boy"

Fair Harbour. Weschler, A.
FAIRBANKS, Avard Tennyson
 (American 1897-)
 Esther H. Morris bronze
 USC 252 UDCCap
 Holy Sacrament, relief
 NATS 97
 John Burke bronze
 USC 231 UDCCapS
 Lincoln, the Railsplitter
 1944 bronze
 BUL 201 UHE
 Marcus Whitman bronze
 MUR 92; USC 267
 UDCCapS
 Nebula plaster
 NYW 190
 Rain 1933 bronze; 42
 BROO 268 UScGB
Fairbanks, Charles Warren (Vice
 President 1852-1918)
 Simmons. Vice President
 Charles W. Fairbanks, bust
The Fairy. Gruppe
The Faith of this Nation is Eternal.
 Zorach
Falcons See also Games and Sports--
 Falconry
 Egyptian--1st Dyn. Falcon of
 Horus
 --Stele of King Zet
 Egyptian--12th Dyn. Pectoral
 of Princess Sithathoryunet:
 Solar Falcons
 Egyptian--Late Dynastic.
 Falcon
 Egyptian--26th Dyn. Falcon
 of Horus
 --Horus Falcon
 Egyptian--30th Dyn. Falcon#
 Egyptian--Ptolemaic. Falcon
 of Horus
 Elamite. Falcon
 Persian. Cylinder Seal:
 Falcon and Griffin
 Rood. Falcon
FALKENSTEIN, Claire (Mrs. Claire
 Lindley McCartney) (American
 1908-)
 Chariot bronze, iron
 WHITNA-17
 Corona 1961 metal, glass
 MEILD 166 UNNJ
 Element #3 1960 glass, copper
 MEILD 165 UNNJ
 Expanding Structure 1959 steel
 wire
 MAI 92 UNNMay

Gate, Palazzo Venier dei
 Leoni 1961 welded iron,
 colored glass
 CALA 213 (col); KUHB
 122-123 IVG
Mahogany Sculpture 1951
 mahogany; 96
 RAMS pl 81a
Organic Form limestone
 SCHN pl 123
Painter Karel Apel 1956/59
 iron wire; 27-5/8
Point as a Set, No. 10 1962
 copper tubing; 29-1/2x
 29-1/2x29-1/2
 MEILD 140; READCON
 260 FPSt
Point as a Set, No. 14 1964
 36x42
 CARNI-64:#301 UCLR
Screen Number 2, Internal
 as a Set bronze and welded
 copper in wood
 WHITNA-17:15
Sculpture 1950 copper, brass,
 bronze; 9'
 SFAP pl 18
--1951 mahogany; 8'
 SFAP pl 19
Sculptured Water copper tubes,
 translucent glass
 SUNA 59 UCLCal
Sun XIX 1956/59
 LARM 247
The Fall. Kearl
Fallen Acrobat. Lippold
Fallen Timbers Monument.
 Saville, B.
Fallen Warrior. Davis, Richard
Falling Gaul. Pergamene
Falling Gladiator. Rimmer, W.
Falling Man
 Trova, E. Study/Falling Man
 Series
Falling Shoestring Potatoes.
 Oldenburg
False Doors
 Egyptian--3rd Dyn. False Door
 Egyptian--5th Dyn. Ptahotep:
 "False Doors"
 Egyptian--6th Dyn. False
 Door, Tomb of Ateti
 --False Door of Lector-
 Priest
 --False Door of Neferses-
 hemptah
False Face Society Mask. Seneca
False Head, placed on top of
 mummy pack. Chavin

False Peace Spectre. Smith, D.
The Family. Brown, S. G.
Family. Cabrera, German
The Family. Cronbach
Family. di Valentin
The Family. Durchaner
Family# Geissbuhler
The Family. Goeritz
The Family. Marisol
Family. Mestrovic
The Family. Noguchi
Family. Opgenorth
Family, Ruis, G.
The Family. Walton, M.
The Family. Zorach
Family Cathedral. Robbins, D.
Family Decision. Smith, D.
Family Group. Glickman
Family Life. Archipenko
Family of Five. Gross
Family of Four. Gross
Family Totem. Amino
Family Tree. Cunliffe
Family Tree. Goto
Family Tree. Hamlin
Famine. Cheney
Famine Scene. Egyptian--5th Dyn
FAN See AFRICAN--FANG
The Fanatic. Miramontes
Fancy. Gregor, J. W.
FANG See AFRICAN--FANG
Fang-i, Ritual Food Container
 Chinese--Shang. Fang-i,
 over-all decoration
"Fang Ting" Ritual Vessel.
 Chinese--Shang
FANGOR, Voyciech (Polish-American
 1922-)
 Untitled 1959
 KULN 202
 Untitled 1961
 KULN 202
 Untitled 1964
 KULN 202
Fanning a Twister. Mora, J. J.
Fans
 African--Congo, French. Fan
 Ceylonese. Votive Fan
 Indian--Gupta. Goddess Bearing
 Chauri (Yak Tail Fan)
 Khmer. Palace Woman, relief
 Nichigaki Kanshiro. Fans on
 Wave Ground, sword guard
 Polynesian--Marquesas. Fan
 Handle#
 Polynesian--Raratonga. Sacred
 Fan Handle
 Remojadas. Woman Holding Fan

Fantasia. Kresnoff
Fantastic Garments for the Stage.
 Tanaka
Fantasy. Bohland, G.
Fantasy. Brcin
Fantasy. Gordin
Fantasy. Moore, B.
Fantasy. Polasek, A.
FANTI See AFRICAN--FANTI
FARALIA (American 1916-)
 Oval, Metric Series 1961 wood,
 ptd white; 72x48
 SFAF UCSFM
 Stele: Mars 62 1962 wood
 construction, ptd black;
 108
 AMON 51 UCSFC
FARLEY, Lilias M. (Canadian)
 Decorative Figure cypress
 IBM pl 36 UNNIb
FARLOWE, Horace L. (American)
 Limestone; 46
 HARO-3:36
Farm Girl. Wyle, F.
Farm Horse. Potter, E. C.
Farmer. Koga
Farmers See Agricultural Themes
Farnese Antinous. Roman--2nd c.
Farnese Athena
 Pyrrhaes--Attrib. The
 Farnese Athena (Athena
 Hygieia)
Farnese Bull. Apollonius and
 Tauriscus
Farnese Cup. Alexandrine
Farnese Hera. Greek
Farnese Hercules
 Glycon. Farnese Hercules
 Hellenistic. Farnese Hercules
 Lysippus. Farnese Hercules
 Lysippus--Foll. Farnese
 Hercules
Farnese June, head. Greek--5th c.
 B. C.
Farnese Plate. Hellenistic
FARNHAM, Sally James (American)
 Champlain's Conference
 with Indian Chiefs, panel
 bronze
 PAG-1:297 UDCPa
 Simon Bolivar, equest 1921
 bronze
 SALT 92 UNNCent
FARNSWORTH, Jerry
 Chief Pontiac 1955 H: 8'
 GRID 95 UMiPoC
FARR, Fred (American 1914-)
 Armored Figure No. 1 1957

bronze; 33
UIA-98:pl 25 UNNR
Armored Horse No. 8 1960
bronze; 26
UIA-11:193 UNNRosen
Horse and Rider 1958 bronze; 12
UIA-10: 77 UNNRosen
Jewelry sheet and wire silver
LYNCM 91 UNNMMA
Farragut, David Glasgow (American
Admiral 1801-70)
Grafly. David Glasgow
Farragut, bust
Michnik. Admiral Farragut,
bust
Saint-Gaudens. David Glasgow
Farragut, head
Saint-Gaudens. David Glasgow
Farragut, monument
FASANO, Clara (Italian-American)
Apassionata terracotta; LS
SGO-17
Chinese Girl, head terracotta
SCHN pl 13
Dolce Far Niente terracotta;
L: 19 SG-4
Heroic Head terrazzo
RICJ pl 57; SGT pl 15
Ophelia, head terracotta; 12
SG-2
Penelope terracotta; 33
SG-3
Reclining Figure plaster
NYW 190
Reclining Girl patined plaster;
c LS RICJ pl 16
Roman Holiday terracotta; 14
SG-7
Seamstress terracotta
(antique); 13
SG-6
Strollers plaster, patined
SGO-4:pl 17
Sun Worship patined plaster,
for bronze
SCHN pl 25; SGO-10:15
Wash Day in the Village Piaz-
za terracotta; L: 30
SG-5
Woman and Child cement
BRUM pl 42
The Fascist. Greenbaum
Fate. Hahn, E.
Fate. Kallem
Fates.
Greek--4/5th c. B.C. Parthenon:
Three Fates
Father and Son. Glickman
Father and Son. Hays
Father and Son. Holland, A. E.

Father and Son. Lambert, M.
Father and Son. Urich
Father Nile
Hellenistic. River Nile
Father Time. Folk Art--American
FATOMITE
Horse; Lion bronze
FRY 80
FAUL, Joseph (American)
The Prophet cherry; 25
HARO-1:1
Fauns See also Satyrs
Bachmann. Faun, head
Baker, B. L'Apres-Midi d'un
Faune
Greco-Roman. Smiling Faun,
head
Hellenistic. Dancing Faun
--Smiling Faun
Howard, C. de B. Afternoon
of a Faun
Keck. Fauns at Play
Konti. Young Faun
Lentelli. Faun
Lober. Faun
MacMonnies. Bacchante
MacMonnies. Young Faun and
Heron, fountain group
Manship. Faun and Dryad
Moretti, G. The Faun
Piccirilli, A. Faun's Toliet
Potter, E. C. Sleeping Faun
Putnam, B. Faun with Grapes
Putnam, B. Mischievous Faun
Roman. Drunken Faun
Roman--1st c. B. C. Dancing
Faun
Roman--2nd c. Faun and Goat
Scudder, J. Seated Faun
Faustina, Annia Galeria (Roman
Empress, Wife of Antoninus Pius
c 104-41)
Roman--2nd c. Annia Faustina,
the Elder, head
--Apotheosis of Antoninus Pius
and his Wife Faustina
Faustina, Annia, the Younger (Faustina
II) (Roman Empress, Wife of
Marcus Aurelius c 125-75)
Roman--2nd c. Annia Faustina,
the Younger, head
--Aureus: Faustina II
--Faustina, head
Faustina, Maecia (Roman Empress,
Wife of Balbinus)
Roman--3rd c. Sarcophagus
of Junius Balbus and Maecia
Faustina, Parents of
Emperor Gordian III

FAVILLE, W. B., Architect
 Portal of Varied Industries
 Palace
 CHENSA 54; JAM 17; SFPP
The Favored Scholar. Rogers, J.
Fear. Stewart, A. T.
The Fearful. Yoffe, V.
Feast of Sed
 Egyptian--18th Dyn.
 Amenhotep III and Tiy:
 At Feast of Sed
Feast of the Dead
 Indians of Central America--
 Nicaragua. Sikro, Yapti
 (Feast of the Dead) Dance
 Masks
Feast of the Sacrifice. Jaegers
Feasts See Diners and Dining
Feather Box. Chippewa
Feather Box# Maori
Feathered Serpent See Quetzalcoatl
Feathers, mobile. Calder, A.
Fecundity. der Harootian
Fecundity. Friedman, M.
Feeding Funnel
 Maori. Chief's Feeding Funnel
Feet
 Indian--Hindu--9th c. Feet of
 Nataraja
 Indian--Hindu--17th c. Foot
 of Nataraja
 Roman. Feet, details
FEITU, Pierre
 Louis J. Heintze 1909
 bronze
 SALT 154 UNNBrG
FELDEN, Marie Louise (American)
 Rhododendrons, relief cast
 stone
 IBM pl 82 UNNIb
FELDMAN, Bella Tabak
 Matriarch's Torso steel; 48
 ROODT 88
FELGUEREZ, Manuel (Mexican
 1928-)
 Diana Mural
 LUN MeMCap
 Mural, Mexican Pavillion,
 Seattle Exposition
 LUN
Feline-Faced Figure
 Japanese--Ancient. Dogu
 Figure
Felix, Evangelist
 Grafly. Evangelist Felix,
 head
FELLER, Al (American)
 Mother and Child plaster
 UNA 13

FELLOWS, George (American)
 The Clock
 CALF-53
Fellows, Lawrence
 Bilotti. Lawrence Fellows,
 head
Female Figures. Zadkine
Femme Assise. de Creeft
La Femme au Polos. Sumerian
Femme avec les Bras Croises.
 Archipenko
Femme se Coiffant. Archimbault
Feminine Form. Zadkine
FENCI, Renzo (American)
 Head
 CALF 55
 Rising Figure
 CALF-50:27
Fencing Boy. Gross, C.
FENTON, Beatrice (American
 1887-)
 Nereid Fountain
 NATS 98
 Seaweed Fountain 1920 bronze;
 74
 BROO 256 UScGB
 --, plaster replica
 NATSA 61 UPPF
 Torso bronze
 NYW 191
Feral Benga. Barthe
FERBER, Herbert (American 1906-)
 Agressive Act lead
 BRUM 43 UNNPa
 "... and the Bush was not
 Consumed..." (The Burning
 Bush), north facade figure
 1951 soldered copper, brass,
 lead, tin; 12'8"x7'10"
 KAM 77; MCCUR 279;
 NNMMF 11; PIE 386; RIT
 223; SCHW pl 82; UPJH pl
 279 UNjMiI
 Apocalyptic Rider plaster
 SGO-10:16
 --(Cavalier Apocalyptique)
 1947 bronze; 10 cm
 GOOS pl 1
 The Bow 1950 bronze; 48x45
 SELZS 135 UNNRub
 --1950 lead; 48
 NMAB 124; TRI 24 UNNPa
 Calligraph 1957 bronze; 29x
 39x19
 BOSTA 67; SEAA 67;
 WHITNA-17:17
 Calligraph Cee III 1964
 copper; 105x69
 CUM 115

Calligraph in Four Parts
1957 welded bronze; 10-1/4
x23-1/2
NEWAS 33 UNjNewM
Calligraph in Three Parts
(Calligraphie en Trois
Parties) 1957 copper; 55x
66x30 cm
GOOS pl 10
Calligraphy on a Wall
(Calligraphie avec Mur)
1957 copper; 152x101x45
cm
GOOS pl 9; MAI 95
Circle and Calligraph III
copper; 71x54x24
WHITNA-19
Conspirators walnut
SGO-2:pl 29 UNNMid
Creation 1957 brass, brazed
with brass; 69x42
CLEA 69; HUN pl 32
UOClF
Les Drapeaux 1957 brass,
copper; 136x66 cm
GOOS 15 (col)
Eternal Light, Berlin Chapel
1955 brazed wire; 24
KAM 224 UMWaB
The Flags brass, copper
WHITNA-13 -UPhi
The Flame 1949 brass, lead,
soft solder; 65-1/2
CRAVS fig 16. 10; PIE
386; ROODT 6; WHITNA-5
UNNW (51. 30)
Flat Wall Sculpture 1953
copper, lead; L: 44
WHITNN 26 UNNKo
Fool bloodwood
SGO-4:pl 18
The Game lead
CHICA-60:#53
Green Sculpture 1954 soldered
copper and brass rods; 48
FAIY 9 UNBuA
Green Sculpture II 1954
copper, lead; 42
WHITNN 25 UNNKo
--(Sculpture Verte II) 1954
copper, lead; 40-1/2x43
ALBC-1:#38; CLEA 68;
GOOS pl 5; TOW 83 UNBuA
"He is not a Man" lead, nickel;
72
UIA-7:pl 33
Heraldique 1957 copper;
91x50 cm
GOOS pl 8 UMWiB

Homage to Piranesi copper
WHITNA-17
--1962/63 copper; 92x49
LOND-6:#16; READCON 239
Homage to Piranesi III 1963
copper; 104
GOODT 134
Homage to Piranesi VI copper;
48-1/2
WHITNA-18:31
Large Roofed Sculpture, II
1954 copper; L: 60
WHITNN 26 UNNKo
Menorah, Berlin Chapel
1955 bronze; 60
KAM 225 UMWaB
Mercure 1955 copper; 121x111x
38 cm
GOOS pl 6 UNNRie
Metamorphosis bronze
BRUM pl 44 UNNPa
Ominous Shadow bronze
SCHN pl 129
Personage No. 1 1957 brass;
25
DETS 11 UNNH
Personage No. 4 1957 brass;
72
UIA-9:pl 39
Relief 1952 lead on copper;
12x8
TRI 249 UNMilB
Sculpture, Millburn Synagogue
Facade, New Jersey
copper, lead, brass;
366x243 m GOOS pl 3
--1953 brass, lead, copper;
68
BERCK 189 UNNKo
--1957 brass; 1. 83 mx61 cm
GOOS 13 (col)
Sculpture (Toituree avec
Deuxmurs) 1957 114x132x
56 cm
GOOS 9 (col)
Sculpture Cornue 1949 lead,
copper, brass; 15 cm
GOOS pl 2
Sculpture Toituree 1954
copper; 137x152x55 cm
GOOS pl 4
Spheroid 2 1952 copper, lead,
42
GIE 261 UNNKo
Spheroid 3 1954 steel; 32x25
AM #163 UMiD
The Sun, The Moon, The
Stars 1956 brass; 72
WHITNF 53 UNNLip

The Sun, The Moon, The
Stars II 1956 brass;
71x46x10-1/4
WHITNS 40 UNNW
Sun Wheel (Roue Solaire)
1956 brass, copper,
stainless steel, silver
solder; 56-1/4
AMAB 68; BRY 629; GOODA
231 (col); GOOS pl 7; PIE
386; SPA 75; WHITNA-40
WHITNA-11 UNNW (56. 18)
Three 1958 brass; 89x47x24
CARNI-58:pl 111
UNNKo
To Fight Again 1940 granite; 22
UNNMMAS 179 UNNMM
(42. 178)
Unidentified
MOT 93 UNNPa
The Unknown Political Prisoner
1953
KULN 155
Wrestlers butternut
SGO-1:pl 17; SGT pl 16
FERGUSON, Duncan (American)
Benediction aluminum
NYW 196
Squirrel wood
WHITNC 238 UNNW
FERNEAU, Marie H. (American)
The Eighth cast bronze;
15x24x18
HARO-2:37
Rising Figure--the 7th cast
bronze; 24
HARO-3:13
FERREN, John (American 1905-)
Composition 1936 etching
printed on plaster, carved
and tinted; 19-1/2x11-3/4
NNMMARO pl 324 UNNCr
FERRIS, Jean Leon Gerome
(American 1863-1930)
"Onrust" (Model)
PAG-1:228 UPPI
"The Welcome" (Model)
PAG-1:251 UPPI
Fertility. Ebert
Fertility Figures See also Birth;
Charms; Mother Goddess
African--Ashanti. Akua'ba
African--Baga. Nimba
Fertility Figure
--Nimba Mask#
African--Bambara. Fertility
Goddess
African--Bapende. Gable
Figure: Woman

African--Bena Lulua.
Fertility Goddess
African--Sierra Leone. Nomolli,
fertility charm
Anatolian. Mother Goddess#
Assyrian. Cult Relief:
Fertility God
Babylonian. Fertility Figure
--Fertility Goddess
Chinese--T'ang. Fertility God,
head
Cycladic. Amulet(s)
--Female Figure
--Female Idol: Great Mother
--Fertility Figure
Cypriote. Fertility Goddess#
--Idol
Greek--Archaic. Mediterranean
Mother
Indian--Maurya. Mother
Goddess#
Indian--Vedic. Fertility
Goddess
Indians of South America--
Venezuela. Fertility Idol
Iranian. Goddess of Fertility
Iraq. Fertility Idol
Japanese--Ancient. Dogu
Figure: Feline, Heart-
Shaped Face
Mesopotamian. Woman and
Child: Fertility Goddess
Mycenaean. Pyxis Cover:
Goddess of Fertility
Neolithic. Fertility Figures
--Seated Fertility Figure
Neolithic--Yugoslavia. Female
Head
Olmec, or Laventa. Female
Fertility(?) Figure
Paleolithic. Aurignacian
Statuettes
--Fertility Idol
--Idol
--Venus of Laussel, relief
--Venus of Lespugne
--Venus of Willendorf
Phoenician. Fertility Goddess
pyxis cover
Roman--1st c. Artemis,
multi-breasted figure
Roman--2nd c. Diana of
Ephesus, multi-breasted
figure
Sumerian. Fertility Figure#
Tairona. Venus: Pregnant
Woman
Tlatilco. Female Figures,
fertility symbols

Vietnamese. Female Mask
Festival. Lux
Festivity. Manship, P.
Fetching the Doctor. Rogers, J.
Fetishes See Charms
Fibulae
 Barbarian. Fibulae
 Boetian. Fibula
 Bronze Age--Ireland. Dress-
 Fastener
 Bronze Age--Sweden. Haga
 Barrow Treasure
 Bronze Age/Iron Age. Fibula
 Etruscan. Corsini Fibula
 --Fibula#
 --Regolini Fibula
 Gallo-Roman. Crossbow Fibula
 Germanic. Clasp, animal-
 form
 Greek--8th c. B. C. Fibula#
 Greek--4th c. B. C. Campanian
 filigree Fibula
 Iron Age. Cloak-Fastener
 Palmyrene. Jeweled Fibula
 Plautios, N. The Ficoroni
 Casket
Fiddlehead
 Folk Art--American. Billet
 Head (Fiddlehead)
Field, Eugene (American Poet
 1850-95)
 McCartan, E. Eugene Field
 Memorial
Field Marshal. Herard
FIELDS, Mitchell (American)
 Blossom plaster
 NYW 192; PAA-41
FIENE, Paul (American)
 Fish marble
 WHITNC 234 UNNW
 Hunting Cat bronze
 NYW 191
 Rising Deer composition
 SGO-1:pl 19
FIERO, Emilie L. (American)
 The Owl bronze
 NATSS-67:16
The Fight. Deming
The Fight. Hamar
The Fighter. Miramontes
Fighting Angels. Perceval, J.
Fighting Boys' Fountain. Scudder, J.
Fighting Bulls. Borglum, S. H.
Fighting Cockerels. der Harootian
Fighting Eagles. Koras
Fighting Eagles. Schwarzott
Fighting Gaul. Hellenistic
Fighting Goats. Diederich
Fighting Lions. Rimmer, W.

Fighting Moose. Rockwell, R. H.
Figment. Kent, A.
Figura con Chapeu Bonito.
 Torres, C.
Figura Yacente. Monasterio
Figurative Tree and Fruit. Greene
Figure at a Window. Hare
Figure Attendant dans Le Froid.
 Hare
Figure in Elm. Hague
Figure in Mahogany. Hague
Figure in Shape of a Heart.
 Squier, J.
Figure in the Wind II. Albert, C.
Figure in Walnut. Green, G.
Figure of a Child. Zorach
Figure of Dignity. Flannagan
Figure Sorting the Fruit. Grow
Figure with Bird. Hare
Figure with Face. Neri
Figureheads and Prows See also
 Folk Art--American.
 Figurehead
 African--Cameroon. Douala
 Prow
 African--Duala. Canoe Prow
 --War Canoe Decoration
 Beecher. Andrew Jackson,
 figurehead
 Bellamy. Eagle Figurehead
 Folk Art--American. Eunice
 Adams, sternboard carving
 --Lady with a Rose
 --Paddle-Wheel Panel:
 Monogram and Relief
 Design, SS Mary Powell
 --Stern Carving: Recumbent
 Indian and Lion
 --Stern Decoration from
 Columbia
 --Sternpiece: Female Bust
 Centered in Foliate Scrolls
 --Sternpiece: Seated Man
 Folk Art--Canadian. Figure-
 head of Lady Edmonton
 Fowle, I. Figurehead:
 "Woman in the Wind", used
 as shop sign
 --Lady with Scarf
 Gleason. Figurehead:
 Minehaha
 Hastings and Gleason. Indian
 Chief
 Indians of North America--
 Northwest Coast. Canoe
 Ornament: Bird
 --Wolf. Bella Bella Canoe
 Prow
 Jones, E. George R. Skolfield

FILTZER, Hyman (American)
 Chimpanzee cast stone
 SCHN pl 88
 Leah, garden figure plaster,
 bronze patina
 NYW 194
Final Experiment. Tolerton
Finials.
 Khmer. Chariot Finial#
 --Finial: Hamsa
 Luristan. Standard Finial#
FINK, Bruce
 Untitled wood blocks, metal
 bands
 MEILD 175 UICO
FINKELSTEIN, Max (American)
 One Plus Two Square
 HARO-3:18
 Round X Hex 1965 aluminum
 construction; 31x31
 LAJ #20 UCLFe
 Square Plus 200 1966
 aluminum construction;
 34-1/4x36x2
 UIA-13:122 UCLPa
FINKLE, Melik
 Old Man, head
 NATS 95
Finn, Caesar
 Wood, E. W. Caesar Finn,
 head
Finnish Boy, head. Hancock, W.
FINTA, Alexander (American)
 Reader wood
 UNA 14
FIORAVANTI, Jose (Argentine)
 Simon Bolivar bronze
 IBM pl 1 UNNIb
FIORI, Ernesto de (Italian-
 Brazilian 1858-1935)
 Brazilian Man gesso; 39-1/4
 BARD-2:pl 398 BrSpA
FIORILLO, Anthony (American)
 The Philosopher, relief
 plaster
 UNA 15
Fire Association of Philadelphia
 Folk Art--American. Fire
 Mark
Fire-Backs
 American--18th c. Fire-Back
 Folk Art--American. Fire-
 Back
 "The Highlander"
The Firebird# Roszak
Fire-Bows
 Neolithic--France. Male
 Menhir Statue Carrying
 Fire-Bow

Fire-Dance. Basanez Rocha
Fire-Dogs See Andirons
Fire Engines
 Folk Art--American. Cake
 Board: "Superior" Fire
 Engine
 --Fire Marks: Fire Engine
 --Weathervane: Fire Engine
Fire God. Teotihuacan
Fire Marks
 Folk Art--American. Fire
 Mark: The Green Tree
 --Firemark, Fire Association
 of Philadelphia
 --Fire Marks: Fire Engine;
 Man; Eagle
 Stow, J. Fire Mark of
 Philadelphia Contributor-
 ship: Clasped Hands
Fire Screens
 Diederich. Fire Screens: Dogs
 Hunt. Fire Screen
Firebird. Baizerman
Firemen
 Folk Art--American. Chief
 of the Mechanics' Volunteer
 Fire Brigade of Louisville
 --Fireman
 --Harry Howard, Chief of New
 York Volunteer Fire
 Department
 --Jamieson Cox(?), Fire Chief
 --Weathervane: Fireman
 Patigian, H. Volunteer Fire
 Department Memorial
Fireplaces, Chimney Pieces, and
 Mantels
 Albers. Partition Wall, rear
 wall of free-standing
 fireplace
 American--18th c. Stucco-
 ornamented Fireplace
 American--19th c. Fireplace#
 Tiffany. Fireplace
"Fire-Spitter" Mask
 African--Ivory Coast. Mask:
 "Firespitter"
 African--Senufo. "Fire-
 Spitter" Mask
Firestone. Voulkos, P.
Firetree. Erlebacher
The Firmament, relief. Filipowski
First Born. Maldarelli, O.
First Born. Robus
First Breath of Spring. Parker, H.
The First Church in Virginia.
 American--20th c.
First Personnage. Nevelson, L.

The First Sermon
 Indian--Gupta. Buddha: Preach-
 ing First Sermon in Deer
 Park
First Steps. Zorach
Fish in Reeds. Callery
Fish Lurking. Stankiewicz, R.
"Fish-Mouth" Drum, or Warup.
 New Guinea
Fish on Fork. Curtis, G. A.
Fish Story. Begg
Fish Story. Cousino
Fisher, Alexander Metcalf (1794-1822)
 Auger. Alexander Metcalf
 Fisher, bust
FISHER, Gladys Caldwell (American)
 Burro Colorado red marble
 NYW 195
Fisher Boy. Triebel, F. E.
The Fisherboy. Powers, H.
Fishermen and Fishing
 Arenas Betancourt. El
 Pescador
 Chimu. Drinking Vessel
 (Paccha): Man Fishing
 from Reed Raft
 Egyptian--4th Dyn. Draught
 of Fishes, relief
 Egyptian--5th Dyn. Mastaba
 of Akhut-Hetep, relief:
 Scribe's Office; Fishermen
 Egyptian--Middle Kingdom.
 Fishing Boat model
 Egyptian--11th Dyn. Fishing
 with Nets from Papyrus
 Boats
 Hardin. Nova Scotia Fisher-
 man
 Hebert, L. P. Indian
 Fisherman
 Hebert, L. P. Le Pecheur a La
 Nigogue
 Hellenistic. Old Fisherman#
 Rosenthal, B. Fisherman
 Talcott, D. V. Loafing
 Fisherman
Fishes
 African--Ashanti, or Agni/Baoule.
 Gold Weight: Fish
 African--Ivory Coast. Gold
 Weight: Fish
 --Gold Weights: Bird; Fish;
 Ant Eater
 African--Tada. Plaque: Human
 and Animal Figures--Fishes;
 Crabs
 Albrizio. Blow Fish
 American--19th c. Seal of
 the Schuylkill Fishing
 Company

Anderson, Lewis. Fish
Australian Aboriginal. Rock
 Engravings: Fish Shoal
Calder, A. Fish
Calder, A. Steel Fish,
 mobile
Callery. Fish
Chavin. Magic Fish, double-
 spouted vessel
Chinese--Chou. Fish#
Chinese--Ming. Roof Tile:
 Fish
Colima. Hunchbacked Figure,
 with incised tattoo,
 Standing on Fish
Cravo. Fish
Davenport. A Study: Fish
Egyptian--5th Dyn. Peasants
 Driving Cattle; and
 Fishing
Egyptian--6th Dyn. Mastaba
 of Akhtihotep
Egyptian--Middle Kingdom.
 Fish, pendant
Egyptian--12th Dyn. Fish
 Pendant
Egyptian--18th Dyn. Fish-
 Shaped Vase
--Fish-Shaped Vessel
Fiene. Fish
Folk Art--American.
 Weathervane: Fish
Folk Art--Mexican. Fish of
 Tonala
--Fishes
Gabrielino. Swordfish;
 Sailfish
Greek--6/4th c. B. C. Coins:
 Garlanded Tripod; Fish
Haida. Dish: Sculpin
--Fish, box detail
--totem poles: Sea Monster;
 Sculpin
Hellenistic. Old Fisherman#
Herwitz. Fish
Hopewell. Fish, ornament
Indian--Kushan. Pendant:
 Fishes and Rosette
Indo-Persian. Fish
Khmer. Fish in Sea, relief
Kitadai. Fish, mobile
Lambert, M. Flat Fish
Lambert, M. Shoal of Fish
Lynch. Fish#
Lynch. Sunfish
Masanao. Fish, netsuke
Melanesian. Fish
Melanesian--Santa Cruz
 Islands. Fish

Melanesian--Solomons. Incised
 Canoe Paddles: Frigate
 Birds and Bonito Fish
Miller, D. R. Fish
Moore, B. Pelican and Fish
Morgan, F. M. Fish
Morgan, F. M. Sun Fish
Paleolithic. Fish, relief
Pattison, P. Fish
Phelan, E. Fish
Pratt, B. L. Boy with Fish
Roman--5/6th c. Eros with
 Fish
Runyon. Blue Fish
Schwarzott. Fish Panel
Tlatilco. Effigy Jar: Fish
--Vessel: Fish
Tlingit. Halibut Hook:
 Sculpin
Tokonu Teru Tomo. Fish,
 swordguard
Tomoyishi. Kinko and the
 Carp, netsuke
Tsimshian. Hat, with
 carving of Sculpin
--Sculpin, totem pole detail
Voorhees, C. Fishes
Waring, P. Fish
Wasey, J. Fish
Fishhooks
 Chumash. Fishhook
Fishing Sinker
 Eskimo. Fishing Sinker,
 with incised fishing exploit
 record
Fisicromia I. Cruz-Diez
FISKE, J. W., ORNAMENTAL IRON
 WORKS, New York City
 Deer 1870 hollow cast zinc;
 3-1/2
 CHR 77
 Horse Head Hitching Post
 mid 19th c. ptd cast iron
 CHR 74 (col)
FITZGERALD, James (American
 1910-)
 Fountain of Northwest
 SUNA 243 UWaSPh
Fitz-Greene, Halleck (American
 Poet 1790-1867)
 MacDonald, J. W. A. Fitz-
 Greene Halleck, seated figure
Five by Nine# Hamrol, L.
Five Dollar Billy. Kienholz
FIVE DYNASTIES See CHINESE--
 FIVE DYNASTIES
Five Flowers See Macuilxochitl
Five Knights. Pierron

Five-Legged Bulls
 Assyrian. Khorsabad Gate
Five Lines in Parallel Planes.
 Rickey, G.
Five Rajas
 Japanese--Fujiwara. Fudo
 Myo-o, Chief of the Five
 Rajas
 Mei-en. Kongo Yasha Myo-o,
 from Five Great Rajas
Five Striped Klacker. Randell, R.
Five That Escaped. Johnston
Five Variations within a Sphere
 (For John Cage). Lippold
FJELDE, Paul (American 1892-)
 Nymph 1932 bronze; 61
 BROO 354 UScGB
 Orville Wright, bust bronze
 HF 90 UNNHF
 Peoria Society of Allied Arts
 Award, medal, obverse;
 reverse 1920 bronze
 NATSA 282
 War Service Award to Men of
 Glencoe, Illinois, plaquette,
 obverse; reverse 1919
 bronze Galvano gilt
 NATSA 283
Flaccilla (Wife of Theodosiu,
 Roman Emperor)
 Roman--4th c. Flaccilla(?),
 bust
Flag Gate. Folk Art--American
Flagpole Tops
 Folk Art--American. Eagle:
 Flag Pole Top#
The Flags. Ferber
Flails
 Egyptian--3rd Dyn. Zoser
 with Flail, tomb relief
 Egyptian--12th Dyn. Sesotris
 I before Amen Holding
 Flail
The Flame. Ferber
The Flame. Laurent
Flamen
 Roman--1st c. Ara Pietatis,
 processional frieze:
 Flamen and Lictors
Flamespitter Mask
 African--Senufo. Flamespitter
 Mask
Flamines
 Roman--1st c. B. C. Ara
 Pacis, south frieze
FLANAGAN, John (American 1863-
 1952)
 Agents of Civilization:

Explorer, Soldier, Priest,
Philosopher, finial figures,
Tower of Jewels
 PERR 39; SFPP
Aphrodite, profile medallion
 NATS 102
Augustus Saint-Gaudens,
head 1905/24 bronze; 16-1/4
 NATS 101; UNNMMAS 92
 UNNMM (33. 62)
Captain E. Yarde Breese,
medal bronze
 NATSA 285
Joseph Henry, bust bronze
 HF 67 UNNHF
Medal to the City of Verdun
from the People of the
United States, obverse;
reverse bronze
 NATSA 284
Portrait, profile medallion
 NATS 102
The Priest
 ACA pl 316 UCSFPan
War Service Medal of Marian,
Massachusetts, obverse;
reverse bronze
 NATSA 285
FLANNAGAN, John Bernard
(American 1892-1942)
Alligator, tondo 1932 granite;
Dm:26
 UNNMMAM # 167 UNNWe
Ass granite stone; 8-1/2x
14-1/2
 NEWAS 24 UNjNewM
The Beginning bronze
 MEN 634 UAzTeUAm
--1941 bronze
 VALE 162 UMiDF
Brass Tail Monkey # 1
fieldstone, brass tail
 BRUM pl 45 UNNSel
Chimpanzee rock
 LARK 396 UNNW
Colt stone
 WHITNC 238 UNNW
Dragon 1941 field stone
 VALE 127 UNNBu
Duck granite
 BRUM pl 46 UNNWer
Early Bird stone
 VALE 33 UNNB
--1941 bluestone; 43 cm
 LIC pl 274 UNNV
Elephant
 CASS 116 UNNWe
--1929/30 bluestone; L: 15
 CASS 120; CRAVS fig 15. 13;

GOODA 62; JOH 63; WHITNT
UNNW
Evening basalt; 17
 DETT 277 UMiD (37. 70)
Female Head granite
 ZOR 281 -Gr
Figure of Dignity--Irish
Mountain Goat c 1932
Blessington granite, cast
aluminum horns; 54
 MAG 100; PIE 386;
 UNNMMAS 168 UNNMM
 (41. 47)
Frog field stone
 VALE UMiD
Goat 1930/31 granite; 10-1/2x
18-1/2
 BMA 80; CHENSW 8;
 SEYT 69 UMdBM
Head granite
 NYW 192
--stone
 CHENSW 499 UNNWe
Head of a Child granite
 VALE 33 UNNWe
Jonah and the Whale
 VALE 154 UNNBu
--bronze
 SGO-4:pl 19
--1937 bronze; 29-1/2
 HUN pl 24; JLAT 21
 UMnMI
--1937 stone; 30
 CRAVS fig 15. 14; NCM
 252 UVRMu
--: Rebirth Motif 1937
bluestone; 30-1/2
 ART 189 (col); FAUL 472;
 PIE 386 UNNLow
Kneeling Woman sandstone
 SEYT 71 UDCK
Little Creature 1939 stone; 15
 MAG 100 UNNKau
--1941 stone
 BAUR pl 103 -UKa
Monkey 1939 stone; 11-1/2
 RIT 121 UMiGT
Monkey and Young H: 15
 ADD 112; PACHA 265
 UMAP
Monkey Family 1932/33 stone
 ROWE 124 UMAP
Morning sandstone
 SGO-1:pl 21 UNNSti
Mother and Child, design for
Skyscraper Court 1934/35
red sandstone; 41 MAG
100; PIE 386; NNMMARO
pl 291 UMCF (1940. 51)

New One 1935 bluestone;
 L: 12-5/8
 RICJ pl 48 -ULes
Pelican
 FAIN UMeOA
--1941 bronze; 17-1/2
 DETC 46
Ram 1931 granite; 13-1/2
 NNMMAP 132 UNNMMA
Sleeping Faun stone
 CASS 126 UNNWe
Triumph of the Egg 1937
 cast stone; 12
 SELZS 122 UNNH
--1941 stone
 MAI 96
--1941 stone
 VALE 161 UMiGN
Triumph of the Egg I 1937
 granite; L: 16
 BR 16; MCCUR 258; PIE
 386; RIT 120; UPJH pl
 277 UNNMMA (296. 38)
FLANNERY, Lot (Irish-American)
 Lincoln 1868
 BUL 144 UDCJu
Flappers
 Lenz. Spirit of the Flapper
Flash. Pettibone
Flashlight. Johns
Flasks
 Chinese--T'ang. Flask with
 Bird-Head Stopper
--Pilgrim Flask: Flute
 Player and Dancer
 Palestinian. Pilgrim Flask
 Syrian. Pilgrim Flask: The
 Nativity
"Flat Board Indian"
 Folk Art--American. Cigar
 Store Figure: Indian Brave
 ("Flat Board Indian")
Flat Mouth
 Vincenti, Francis. Ayah-Ke-
 Bath-Ke-Ko-Zhay
Flat Torso. Archipenko
Flat Wall Sculpture. Ferber
Flatiron Stands See Trivets
Flavian Reliefs. Roman--1st c.
FLAVIN, Dan (American 1933-)
 Alternative Diagonals 1964
 KULN 198
 Environmental Compositions*,
 Exhibition, Green Gallery,
 New York 1964 fluorescent
 light bulbs
 BURN 304
 Greens Crossing Greens (to

Piet Mondrian, who
Lacked Green) 1966 green
fluorescent tubing and
frosted translucent plastic
ART 248 (col)
Pink out of a Corner
 KULN 199
Three Fluorescent Tubes
 (Red and Gold) 1963 H:
 48
 SEITC 80 UNNGree
Untitled 1963/66 fluorescent
 light; 8x8'
--1966
 KULN 199
FLAVIN, Eleonar Platt (American
 1910-)
 Louis D. Brandeis, head
 c 1942
 bronze; 30
 USNM 96 UMCHL
Flayed Arm. Tovish, H.
"The Flayed Lord" See Xipe
"La Flechadore". Olaguibel
Fledgling. Bartlett
Fledgling. Hartwig
Fledgling. Littlefield, O.
Fledgling. Roszak
FLEMINGER, Irwin (American 1932-)
 Grand Slam 1964 plexiglass,
 wood, aluminum; 60x48
 RHC # 8
FLERI, Joseph J. (American)
 Sower bronze
 NYW 191
Flies
 African--Ibo. Pendant: Ram's
 Head, with Two Flies
Flight. Abueva
Flight. Decker, A.
Flight. relief. de Marco
Flight. Kane, M. B.
Flight. Lippold
Flight. Smith, D.
Flight into Egypt
 Ecuadoran--18th c. Flight
 of the Holy Family into
 Egypt
Flight No. 2. Etrog
Flight of Birds. Lewers
Flight of Fancy. Kane, M. B.
The Flight of Night
 Hunt, W. M. The Horses of
 Anahita
Flight of Night. Manship
Flint Glass
 Boston and Sandwich Glass
 Co. Whale-Oil Lamp

Flints
 Maya. Eccentric Flints
 Paleolithic. Solutrean Flints
Flip. Seley, J.
Flip and Two Twisters, "Trilogy".
 Lye
Floatile No. 11. Collie
Floating Figure. Lachaise
Floating Figure. Zorach, W.
Floating Sculpture. Grosvenor
Floats
 Haida. Killer Whale Rattle;
 Wooden Float
 Melanesian--Solomons. Float,
 frigate bird shape
Floor Frame. Noguchi
Flora. American--19th c.
Flora, head. Davidson, J.
Flora
 Palmer, E. D. Infant Flora
FLORES DE PEROTTI, Amanda
 Deer bronze
 IBM pl 7 UNNIb
FLORIO, Salvator Erseny (Italian-
 American 1890-)
 American Venus
 PAA 25
 Queen of Atlantis bronze
 NATSA 64
FLORSHEIM, Lillian (American)
 Squares on Diagonals and Rods
 1966 plexiglas; 16x24x16
 UIA-13:107 UICMain
Flotilla. Lynch
Flower Coat. Kusama
Flower Girl. Calder, A. S.
The Flower House. Seiden
"Flower Prince" See Aztec.
 Xochipilli
Flower Vender, semi-automatic
 sculpture. Lipchitz
Flowered Creature. Seiden
Flowering Spearheads. Rood
Flowers
 Abels. Orange Blossom
 Achaemenian. Ahuramazda:
 Holding Flower in Disc
 Afghanistan. Spirit with
 Flowers
 Bertoia. Flower
 Chinese--Ming. Cup and
 Stand: Phoenixes on Peony
 Scroll Background
 Egyptian--5th Dyn. Young
 Woman Smelling Lotus
 Blossom
 Egyptian--18th Dyn. Lotus
 Flower
 --Pillars: Lotus and Papyrus

Folk Art--American. Sunflower
 Design, oak chest panel
Glinsky. The Flower
Greek--6th c. B. C. Stele:
 Youth Holding a Flower
Greek--5th c. B. C. Demeter
 and Cora--Glorification of
 the Flower
--Exhaltation of the Flower
Hellenistic. Genius with
 Flowers
Japanese--Tokugawa. Ojme,
 metal Button: Flower
 Design
Kyokusai. Plum Blossom,
 netsuke
McWhorter, J. Still Life,
 Cockscomb
Pattison, P. Flower
Quimbaya. Idol Holding
 Flowers
Roman--1st c. Floral and Vine
 Ornament, with Bird, tomb
 relief fragment
Shoemi School. Flowers,
 swordguard
Flute See Musicians and Musical
 Instruments
Fluteplayer's Guild Monument.
 Roman--1st c. B. C.
Fly Whisks
 African--Atoutou. Figure and
 Two Fly Whisks
 African--Bakongo. Squatting
 Figure: Chief's Fly
 Whisk Handle
 Indian--Hindu--8th c.
 Attendant Divinity Holding
 Fly Whisk
 Tahitian. Fly Whisk#
 Tahitian--Society Islands. Two
 Sacred Whisk Handles:
 Human Forms
The Flyer. Borglum, G.
Flying Cupid. Scudder, J.
Flying Figure. Lux
Flying Figures. Lachaise
Flying Geese. Rich, F. O.
Flying Victory
 Greek--6th c. B. C. Nike
 of Delos
Flying Wall. Rohm, R.
Foch, Ferdinand (French Soldier
 1859-1921)
 Aitken. Visit of Marshal Foch
 to the United States, medal
 Dallin. Homage to Marshal
 Foch Medal

FOERSTER, Arnold
 Lafayette 1937
 REED 29 UCLLa
Folded Cat. Davis, E. L.
FOLEY, Elizabeth
 Frustra steel; 24
 ROODT 89
FOLK ART--AMERICAN See also
 Corbin; Gleason, William B.;
 Schimmel, W.
 Alexander Hamilton, bust
 (after Giuseppe Ceracchi)
 after 1804 marble; 19
 PIE 375 UNNCi (35. 214A-B)
 American Eagle 1800/30 gilded
 wood; 62
 UNNMMAS 1 UNNMM (59. 89)
 American Eagle Orb, Federal
 Period Ornament, New
 England 1790/1815
 stained oak; 15-1/2x16-1/2
 SMI 1, 25 UDCNMS
 Animal Figures and Soldier
 ptd wood
 DREP 133
 Balancing Man, toy 1875/1900
 ptd pine on hickory base;
 15-1/2
 COLW 317 (col) UVWR
 Balancing Toy wood, metal; 15
 NNMMARO pl 21 UNNRojh
 --c 1840 ptd wood, wire; 15
 LIPA pl 102 UNNMMA
 Bald Eagle, with olive branch,
 arrows, and 16 stars
 18/19th c. inlaid wood
 DOWN 152 UNNMM
 Barber Pole late 19th c.
 ptd cedar
 CHR 67 (col)
 Barley Fork, hand carved
 early 1800's
 FAIY 183 UNCooF
 Bear's Head c 1884 walnut
 CHR 158
 "Bell in Hand", inn sign,
 Temperance Tavern,
 Boston (restoration) 1795
 CHR 67 (col) UMBSt
 Bellamy-Type Eagle late 19th
 c. gilded wood
 CHR 191
 Betty Lamp late 18th c. cast
 brass CHR 173 UICCh
 --early 19th c. wrought iron
 CHR 170
 --, and Stand mid 18th c.
 tin
 CHR 172 UICSc

 Bible Box 17th c. oak; 4-1/2
 CRAVS fig 1. 10 UDeWi
 --, New York wood
 MEN 96 UDCNM
 Billet Head (Fiddle Head):
 Foliate and Floral Scroll
 ptd and gilded wood
 CHR 56 UMeKB
 Binnacle Figure: Man,
 Clipper Ship N. B. Palmer
 1851 ptd wood; 56
 LIPA pl 14 UNNNeg
 Blacksmith's Shop Sign:
 Eagle Holding Arrow 19th
 c. wood; W: 36
 LIPA pl 82 formerly
 UNND
 Bootjack: Fantastic Animal
 19th c. cast iron
 CHR 163 UWiKC
 Bootjack, New England 19th c.
 cast iron
 LIPW 42
 Bootmaker's Sign: Boot,
 Underhill, Vermont wood;
 c 36
 FAIN 243 UVtSM
 Bootmaker's Sign: Woman on
 Horse 19th c. ptd wood; 40
 LIPA pl 71 UPScE
 "Bunch of Grapes", tavern
 sign, Boston 18/19th c.
 wood, ptd
 CHR 66 (col)
 Bust of Man 19th c. ptd
 plaster; 14
 NMAF # 163
 Butcher's Sign 19th c. ptd
 wood; L: 32
 CHR 69 UMNewO
 Butter Mold 1752 unfinished
 wood; L: 7
 LIPA pl 160 UNKS
 --: Cow Under Tree 18th c.
 ADAM-1:119 UPLF
 Cake Board: "Superior" Fire
 Engine c 1800 unfinished
 mahogany; L: 14-3/8; D:
 7/8
 LIPA pl 159 UNNHS
 "Camela Doll", South Haven,
 Michigan c 1855 papier-
 mache head, cloth body
 CHR 144 (col)
 Camphene Lamp 1830/59
 pressed glass
 CHR 175 UNjNewM
 --1853 pressed glass, brass
 CHR 174 UNNHS

Canada Goose 19th c. wood;
 29x15-3/4
 PIE 374 UNCooHS
 (N-156 50 L)
Candlestick, Ohio 19th c.
 pewter
 CHR 71
Candlesticks 1720/50 iron
 MEN 144; UPJH pl 277
 UICA
Carriage Lamp, Civil War
 Period 19th c. brass
 and tin with etched glass
 CHR 174 UICCh
Carrousel Giraffe, Riverside,
 Rhode Island c 1888 ptd
 wood
 CHR 159
Carrousel Goat 1870's oil on
 pine
 PIE 374 UVtSM
Carrousel Horse 19th c. wood
 CHR 158
Carrousel Horse 1880's wood
 CHR 152 (col)
Carrousel Rooster, St. Johns-
 bury, Vermont 19th c. ptd
 wood; 54
 CHR 157 (col)
--19th c. wood, ptd red and
 white; c 48
 LIPA pl 99 (col) UNPoH
Chalkware Deer, Pennsylvania
 19th c.
 CHR 82
Charging Buffalo, Northern
 Iowa 19th c. soft wood
 CHR 141 UIaDeN
Chest of Drawers 17th c.
 DOWN 145 UNNMM
Chicken 19th c. cypress root
 CHR 136
Chief of the Mechanics'
 Volunteer Fire Brigade of
 Louisville 19th c. ptd
 wood; 84
 SPA 111 UKyLS
Christopher Columbus, circus
 wagon figure c 1850 wood,
 originally ptd; 58-1/2
 PIE 374 UVtSM (FC 10)
Cigar Store Figure, Stockbridge
 H: 50-1/2
 NMAF #125
--: Baseball Player 19th c.
 ptd wood; c 60
 LIPA pl 67 URBK
--Black Boy (Blackamoor),
 striped pantaloons 19th c.

H: 48; base: 15
 PEN 50
--: Buffalo Bill ptd wood
 PEN 12 UPDB
--: Captain Jinks of the
 Horse Marines c 1850 ptd
 wood; 73
 LIPA pl 72; MEN 331;
 PEN 37 UNjNewM
--: Chief, Arrow in Right
 Hand, Bow in Left ("Long-
 fellow's Indian, from Allen
 and Fischer's, Boston,
 1874-1918) bronze
 PEN 52 UNNAmT
--: Chief, Shading Eyes From
 Sun with Left Hand
 PEN 50
--: Chief, with Headdress
 ptd mahogany
 PEN 32
--: Chief, with Headdress,
 Cigars in Right Hand,
 Tomahawk in Left Hand
 ptd wood; 68x23-1/2
 AM #60 UVRMu
--: Chief, with Headdress,
 Raised Right Hand
 PEN 38 UOClW
--: Chief, with Headdress,
 Raised Tomahawk in Right
 Hand wood; 75
 (with base)
 PEN xvi
--: Chief, with Headdress,
 Tobacco Roll in Right Hand
 wood; 35; on base: 18
 PEN 4
--: Chief Black Hawk wood
 PIE 373 UNNHS (1956. 86)
--: Chief Black Hawk, bear-
 skin robe, right hand sup-
 porting tomahawk, cigars
 in left hand
 PEN 72
--: Chief Semloh, Smoking
 Cigar, Cigars in Right
 Hand
 PEN 54
--: Christopher Columbus
 ptd wood
 PEN 24
--: Clown ptd wood
 PEN 16 UPDB
--: Dancing Darkey ptd wood;
 54
 LIPA pl 70; PEN 44 UNNHS
--: Darky ptd wood; 48
 LIPA pl 69 UMnStPR

Decoy: Shore Bird 19th c.
 ptd wood
 LIPA pl 126 UNNBarb
Deer 1883 ptd plaster; 10-3/4
 LIPA pl 137 Formerly UNND
Desk Box, chip-carved 18th c.
 wood, ptd and stained;
 L: 18
 CHR 123 UNBB
Devil Bootjack 19th c. cast
 brass; c 10-1/4
 LIPA pl 134 formerly UNND
Dog plaster; 7-1/2
 NMAF # 171
Doll, New Hampshire c 1790
 unfinished pine; c 12
 CHR 147; LIPA pl 111
 URNoS
Dolphin Circus Wagon 19th c.
 ptd wood; L: c 15'
 LIPA pl 92 UFSR
Doorstop: Bear 19th c. cast
 iron; 54
 LIPA pl 158 UVW
Doorstop: Cat 19th c. wood,
 ptd black and white; L:
 12-1/2
 LIPA pl 150 UNjNewM
Doorstop: Striding Man 19th c.
 cast brass
 LIPA pl 135 UVW
Downspout Head, Joseph
 Smith's Mansion, Nauvoo,
 Illinois 1842 ptd tin
 CHR 27
Eagle 19th c. gilded copper;
 L: 15
 CHR 74 (col)
--19th c. wood; 32-3/8
 PIE 375 UNNMM (45. 52)
--: Bed-Headboard, Wilmington
 Delaware 1810 walnut
 CHR 191
--: Tavern Sign(?), Pawtucket,
 Rhode Island 19th c. ptd
 pine; 68
 (with base)
 CAH 51; COLW 309 (col);
 NMAF # 132; NNMMARO pl
 11 UVWR
--: Flag Pole Ornament(?)
 1875/1900 copper; 18-7/8
 COLW 315 (col) UVWR
--: Flag Pole Top 19th c.
 wood, ptd black and white;
 28
 LIPA pl 143 UVW
--: Holding Shield and Olive
 Branch, architectural

 ornament
 HAY 109 UMAP
--: On a Cannon 19th c.
 gessoed and gilded wood
 CHR 194 (col)
--: With Extended Wings
 19th c. wood; 28-1/2
 PIE 374 UVtSM (FE 20)
--1870/75 pine; 29-1/4
 COLW 321 (col) UVWR
Eagle, Grand Central Depot,
 New York City hollow-
 cast iron
 FAIY 248 UNCV
Eagle, Portsmouth, New
 Hampshire 19th c.
 laminated wood; 54 (with
 rope base)
 PIE 374 UVtSM (FE 1)
Eagle, stern board, Charles
 W. Morgan 1841 wood
 FAIN 27 UCtMy
Election Torch, Nauvoo,
 Illinois c 1860 tin
 CHR 173
Eunice Adams, sternboard,
 Eunice H. Adams 1885
 ptd wood; L: 91
 LIPA pl 22 UMNewO
Fashionable Gentleman, shop
 figure 19th c. ptd wood
 CHR 70
Father Time, New York State
 c 1875 wood
 LIPW 43
Female Figure 19th c.
 LIPW 38
Figurehead 18th c. pine trunk
 DIV 65 UNNChas
--: Alice Knowles, New
 Bedford, whaler Alice
 Knowles ptd wood; c LS
 LIPA 27
--: Asia, Bath, Maine 1855
 white oak, oil-ptd
 PANA-2:17; PIE 373
 UCtMy
--: Bishop wood
 FAIN 26 UCtMy
--: Bust of Girl ptd wood; 28
 NMAF # 124
--: Bust of Girl c 1825 pine;
 27-1/2
 COLW 301 (col) UVWR
--: Cat Head 19th c. ptd
 cast iron
 CHR 55 (col) UMMarH
--: Classical Figure c 1830
 wood, originally ptd; 60
 PIE 373 UVtSM (F 517)

--: Columbia 19th c.
wood, ptd white; 46
LIPA pl 11 UNNDo

--Columbia c 1858
ptd wood; 55
LIPA pl 9 UNNPen

--Commodore Perry 1822
wood, originally ptd; 35
CHR 60; PIE 373
UVNeM
(OF 72)

--: Donald McKay 1855
wood; 96
FAIN 26 UCtMy

--: Eagle and Snake
19th c. wood; gold
eagle, black snake;
W: 27
LIPA pl 21 UMSaP

--: Eagle Head c 1850
pine; L: 20
COLW 333 (col) UVWR

--: Eagle Head c 1850 ptd
pine
CHR 54 (col) UMSaP

--Female Bust 19th c.
ptd wood
CHR 57

--: Female Bust, Haverhill,
Massachusetts 1815
CHR 59 (col)

--: General Peter B. Porter,
General Peter Porter
1834
ptd wood; c 18'
LIPA pl 18 UNBuHS

--: Hercules in Lion Skin,
half figure, U.S.S. Ohio
ptd wood; over 84
FAIY 269 UNSt

--: Jenny Lind, Nightingale
of Portsmouth, New
Hampshire 1851
CHR 58 (col) UVNeM

--: Lady with a Rose 19th c.
ptd wood; 38
AM #53; CHR 56; LIPA
pl 4 UVNeM

--: Lady with Umbrella
c 1880
ptd wood; 62
LIPA pl 10 UVNeM

--: Male Bust 19th c.
CHR 58 (col)

--: Male Bust--'Quaker''
19th c.
CHR 59 (col)

--: Minnehaha ptd wood; 75
NMAF #123

--: Sailor 19th c. ptd wood;
69
LIPA pl 16 UMeBS

--: Sea Serpent Head,
Diadem of Gloucester,
Essex 1855 gilded wood
CHR 57 UMGIA

--: Solomon Piper, bust
Boston before 1854
CHR 61 UMSaP

--: Tecumseh 19th c.
bronze reproduction
of wood; 16'
GRID 38 UMdAN

--Twin Girls c 1860 white
oak PIE 373
UCtMyM

--: Victorian Lady ptd
wood; 66
LIPA pl 6 -ULi

--: Victorian Woman ptd
wood; c 60
CHR 59 (col)
UMNewO

--: Woman, Holding Flower,
slave ship Creole
ptd wood--blue dress; 69
LARK 178; LIPA pl 13
UMB

--: Woman in Yellow
c 1835

--ptd wood; 38-1/2
PIE 373
UNCooHS
(N-246.50L)

Fire-Back: Horseman and
Convicts 1750/76
cast iron; 23-3/4
LIPA pl 165 UMSaE

Fire Mark: The Green
Tree, Mutual Assurance
Company, Philadelphia
1784 plaster-covered
cast lead on wood
CHR 49

Fire Mark, Fire Association
of Philadelphia
1817 ptd and gilded
cast iron
CHR 49

Fire Mark: Fire Engine;
Man; Eagle 1830/60
cast iron
LIPA pl 83-84, 85-88
UPPIns

Firehouse Sign, Portsmouth,
New Hampshire
19th c.
FAIN 68 UMAP
Fireman 19th c. ptd plaster;
14-3/4
LIPA pl 138
UDeWG
Fireplace 1885
MEN 401 UMtBuC
Flag Gate c 1870 ptd
wood; 56x40
LIP 20 UNNMEA
Flatiron Stand 19th c.
cast iron
CHR 90
--Scrolls, Flowers, Grapes
19th c. cast iron
CHR 91
Garden Fountain: Mermaid
19th c. ptd wood; 16
LIPA pl 133 -ULi
Garden Urn 19th c.
ptd cast iron
CHR 80
General McClellan
c 1862 ptd wood; c 18
LIPA pl 179
formerly UMeRR
George Washington, bust
1880's terracotta; 26
PIE 375 UVtSM
(1954-514)
George Washington equest
19th c. ptd wood; 18
LIPA pl 156 UCtFA
--19th c. wood, ptd black,
white, gold; 18
MEN 326
UNCooHS
George Washington, lawn
figure metal;
46-1/2
NMAF # 148
Goat 19th c. ptd plaster;
8-1/2
LIPA pl 136
UDeWG
Goose Whistle 19th c.
brown pottery;
L: 3-1/4
LIPA pl 108 UNBB
Gravestone: Charles
Brigham
1781 slate
LIPA pl 172
--: David Thurston 1777
stone; 29-1/2x27-1/2
PIE 374 UMAuC

--: Holmes Children,
East Glastonbury,
Connecticut
sandstone
LIPA pl 176; PIE 373
UCtEC
--: John Foster, Boston
1681
MEN 180
--: Mrs. Bethem Moseley,
Hampden, Connecticut
1750
LIPA pl 175
--: Polly Very, Salem,
Massachusetts 1804
LIPA pl 173
--: Rebekah Row 1680
stone
PIE 374 UMBPS
--: Reverend Samuel Ruggles,
Billerica, Massachusetts
1837
LIPA pl 174
--: Reverend William
Whitwell, Marblehead,
Massachusetts 1781
slate
LIPA pl 169
--: Skeleton and Grim Reaper
1698
LARK 5 UMSaE
--: Thaddeus MacCartny
1705 stone
PIE 374 UMBGr
Gravestone for Cat, New
Hampshire 1800's
LIPW 39
Gravestones, New
England--8 markers
18th c. stone
LIPW 49-56
The Grim Reaper, relief
19th c. (?) cast iron;
52-1/2
PIE 373 UVtSM
(FM 41)
Grotesque Head Jug,
Connecticut greenish
stoneware
CHR 89
Hanged Man, head 19th c.
wood
CHR 138 UCArP
Harlequin Jumping Jack,
Pennsylvania c 1800 wood,
with papier-mache head
and collar
CHR 149 (col) UNNHS

Harry Howard, Chief of
New York Volunteer
Fire Department c 1850
ptd wood; 96
LIPA pl 74 UNNHS
Hen c 1835 wood, ptd dull
gold; c 13
LIPA pl 151
UMeES
"Hessian Soldier",
andiron ptd
cast iron
CHR 53
"The Highlander", fireback
18th c. cast iron
MEN 145
UNNMM
Hitching-Post: Horse's
Head 19th c.
cast iron; 12
LIPA pl 146 UCtWB
Hobby Goat
CHR 147
Horn Brook, gingerbread
mold
PAG-10:264 UMNoP
Huntsman c 1840 ptd
wood; 21-1/2
LIPA pl 155
UNNEr
Importer's Sign: Chinaman
19th c. ptd teakwood
CHR 68
Ipswich Betty Lamp
18/19th c.
tin
CHR 172 UIaFtL
Jagging Wheel, New England
19th c. scrimshaw
LIPW 43
Jail Sign: Felon, Kent
County, East Greenwich,
Rhode Island 19th c.
ptd wood; 34
CHR 65; LIPA pl 76;
MEN 182; PEN 46; PIE
375; UPJH pl 276
URPHS
Jamieson Cox (?), Fire
Chief, Gravesend Exempt
Fireman's Association,
Coney Island c 1850
ptd wood
FAIY 152 UNHuF
Jockey Hitching Post
c 1881 ptd
cast iron
CHR 71 (col)

Jointed Dachshund 19th c.
ptd wood, leather fabric
ears;
L: 21
LIPA pl 106 UNND
Jointed Indian Doll
19th c. sheet tin;
13-1/2
LIPA pl 109 UCtFA
Jug, with Writhing Snakes
Illinois c 1880
stoneware
LIPW 43
Justice, with Scales and
Sword, Courthouse,
Barnstable, Massachusetts
pine; 10'
FAIN 243 UVtSM
Knitted Doll, California
19th c.
wool
CHR 149 (col)
Kris Kringle 19th c. ptd
plaster; 14-1/2
LIPA pl 139 UDeWG
Lamb Trade Sign
1800/1825 pine;
L: 24-1/4
COLW 339 (col) UVWR
Lard-Oil Lamp 19th c.
sheet tin
CHR 175
Locomotive Ornament:
Indian Archer 1875/1900
sheet iron;
17-7/8
COLW 303 (col) UVWR
"Log Hauling", Eau Claire,
Wisconsin 19th c.
wood;
L: 36
CHR 140 UIaDeN
Lumberjacks Sawing a Log,
Eau Claire, Wisconsin
19th c. wood; L: 19
CHR 41 (col) UIaDeN
Mammy Doll 19th c. sawdust
stuffed body, composition
head, wooden limbs
CHR 151 UWiMP
Man in Uniform, bust 19th c. ptd
plaster; 14 LIPA pl 182
formerly UNND
Man with Grapes, barroom
figure 19th c. wood, wire;
15
CHR 69; LIPA pl 66
UMeOL

Sconce, Maine 18th c. sheet
 tin
 CHR 171
Scrimshaw Objects
 FAIY 261 UNSaS
Seated Lion, relief, Sparks
 circus wagon c 1900
 wood
 CHR 159
Seated Woman 19th c. ptd
 wood; 12
 LIPA pl 178 UNNMMA
--, Pennsylvania c 1875
 ptd pine; 12
 COLW 139 (col) UVWR
Sign for J. Williams, Jr.
 Hotel 18th c. marble oval,
 curved iron supports; W: 38
 FAIY 182 UNCooF
Simon Legree, marionette,
 California 19th c. ptd wood,
 cotton shirt, wool trousers
 CHR 150
Slut Lamp wrought iron
 CHR 170
Spotted Dog wood, ptd gray
 and black
 ART 87
Spread Eagle, plaque 18th c.
 marble
 DOWN 150 UNNCoo
Stagecoach, model 19th c.
 wood
 CHR 145 (col) UMSouW
Stern Carving: Recumbent
 Indian and Lion, from
 American Indian c 1785 ptd
 wood; L: 9'9-1/2"
 LIPA pl 24 UNNHea
Stern Decoration, Columbia
 19th c. ptd wood
 LIPA pl 19 ULaNM
Sternpiece: Female Bust
 centered in Foliate Scrolls
 wood; L: 72
 CHR 61
Sternpiece: Seated Man ptd
 wood; L: 75
 LIPA pl 23 UMNaE
Stove Plate: Deer Hunter
 18th c. cast iron; W:
 29-1/2
 LIPA pl 162 UPDB
Stove Plate: Wedding Fable
 1786 cast iron; W: 27-1/4
 LIPA pl 161 UVW
Sunflower Design, oak chest
 panel 17th c.
 DOWN 144 UNNMM

Tavern Sign: Male Figure,
 Bucks County, Pennsylvania
 19th c. ptd wood; 36
 LIPA pl 79 UNNDuv
Tombstones 18th c.
 ELIS 132, 133
Top 19th c. ptd wood
 CHR 145 (col) UNNCi
Toy Dog 19th c. wood, ptd
 grey and black; L: 16
 LIPA pl 105 UDeWG
Toy Horse 19th c. ptd wood;
 L: 13-1/4
 LIPA pl 103 formerly UNND
Toy Locomotive 19th c. tin,
 cast iron--ptd
 CHR 148 (col)
Toy Policeman 19th c. un-
 finished wood; 19
 LIPA pl 101 UMeOR
Toy Riding Horse, Kingston,
 New York wood
 CHR 139
Toy Train, Rye, New York
 1880
 CHR 145 (col)
Toy Whale pine; L: 9-3/8
 COLW 131 (col) UVWR
--19th c. unfinished wood;
 L: 9-1/2
 LIPA pl 118 UNNMMA
Trade Mark of Insurance
 Company of North America:
 Lead Star on Wooden Shield
 1792
 LIPA 61
Trade Sign: Spectacles 19th c.
 ptd and gilded metal; 31x23
 LIP 23 UWiMA
Trade Insignia: Sheet Iron
 Indian, Bronze Eagle
 c 1900 H: c 9
 LIPA pl 53
Victory Crowning Washington
 1850/60 wood
 MEN 327 UDeWi
Weathervane: Angel 19th c.
 ptd wood; L: 27
 LIPA pl 39 -ULi
--: Angel Gabriel Blowing
 Horn, Baptist Church,
 Whiting, Vermont 1814
 CHR 75 (col)
--: Banner, First Church,
 Concord, Massachusetts
 1673 wrought iron, part
 gilded
 CHR 71 (col); MEN 101
 UDCNM

--: Bull 19th c. wood; 44x31
PIE 375 UNCooHS (N--12. 54)
--: Carrier Pigeon c 1860
copper; 17-1/4
COLW 337 (col) UVWR
--: Cock 19th c. copper
CHR 76
--: Cockerel c 1830 wood;
25x46
PIE 375 UVWR (57. 700. 4)
--: Cow cast and stamped
copper; 16-3/4x28
NMAF #157
--: Crowing Rooster on Ball,
with Arrow 1875/1900 body--
copper; tail and arrow--
brass; ball--sheet iron;
20-3/8x26
COLW 343 (col); LIPA pl 34
UVWR
--: Diana early 19th c. sheet
iron; 27
LIPA pl 38 UNNDo
--: Fire Engine, after Amos
Klag Engine of 1860/80
brass, copper, zinc, iron
CHR 47 UPDB
--: Fireman c 1850 ptd sheet
iron; 55
LIPA pl 49 URWP
--: Fish, Rhode Island metal
CHR 75 (col)
--: Formal Horse 19th c. cast
iron body, sheet iron tail;
18x20
FAIY 183; LIPA pl 41; NMAF
#149 UNCooF
--: Grasshopper wood, ptd
gray and yellow; L: c 24
CHR 79 UMSouW
--: Horse
FAIN 242 UVtSM
--: Horse 19th c. cast zinc,
sheet copper; 18
CHR 81
--: Horse, Boston cast iron; 18
NNMMARO pl 12 UNNRojm
--: Horse, model 19th c. cast
iron, sheet iron tail; L: c 40
LIPA pl 40 UCtFA
--: Horse, New England 19th c.
CAH 109; CAHA 51
--: Horse, Pennsylvania 19th c.
wrought and sheet iron
CHR 80
--: Indian Archer 18/19th c.
ptd sheet metal
CHR 74 (col)

--: Indian Archer 18th c. (?)
sheet iron
LIPA pl 28 UCtFA
--: Indian Archer 18th c. (?)
sheet iron; 17
LIPA pl 29 UVW
--: Indian Archer 19th c.
ptd sheet iron; 51
LIPA pl 31 formerly UNNDo
--: Indian Archer 19th c.
H: 30-1/4
PIE 375 UVtSM (FW 80)
--: Indian Archer 19th c. ptd
wood, wire; 36
LIPA pl 27 -ULi
--: Indian Hunter, silhouette
c 1810 ptd sheet iron; 51
PIE 375 UVtSM (FW 4)
--: Indian on Horseback
1850/75 horse--wood;
Indian--sheet iron; L:
39
COLW 283 (col) UVWR
--: Indian Shooting Deer 19th c.
copper, zinc; L: 33
LIPA pl 44 UNNDo
--: Iron Deer, New York
NNMMS #349
--: Liberty c 1865 zinc and
copper gilded; 21
LIPA pl 46 UNNCah
--: Liberty after 1886 copper;
43
COLW 311 (col); LIPA pl
48 UVWR
--: Locomotive cast iron; 9'
MEN 411 UDCN
--: Locomotive sheet zinc
FAIN 242 UVtSM
--: Locomotive and Tender
c 1870 copper, brass, iron;
L: 9'
CHR 81 UMiDbE
--: Man Driving Pig c 1835
ptd wood and wire; L:
31-3/4
LIPA pl 45 UMNewO
--: Mare and Foal c 1850 wood;
ptd red and black; L:
30-3/4
LIPA pl 42 -ULi
--: Pheasant 19th c. sheet
iron; L: 30-3/4
LIPA pl 43; NMAF #155
formerly UNNDo
--: Pike c 1850 copper; L:
35-5/8
COLW 297 (col); NNMMARO
pl 24 UVWR

--: Rooster cast metal, cut-
out tail; 12-3/4
NMAF # 153
--: Rooster c 1825 cast
copper body; sheet copper
tail and crest; 33
COLW 327 (col) UVWR
--: Rooster 19th c. sheet
copper; L: 18
LIPA pl 35 UVW
--: Rooster 19th c. cast iron,
sheet iron tail--ptd red and
white; L: 32-3/4
LIPA pl 36; PIE 376 URPD
(39. 120)
--: Rooster 19th c. cast and
sheet iron; 33x36
AM # 106 UVtSM
--: Running Deer 1875/1900
sheet iron; L: 32-1/2
COLW 335 (col) UVWR
--: Sea Serpent 19th c. (?)
wood; 24x54
PIE 376 UNCooHS (N 152L)
--: Sheep stamped, hammered
and cast metal; 20-1/2x31
NMAF # 158
--: Snake c 1830 iron; L:
29-3/4
COLW 293 (col); PIE 376
UVWR (800. 8)
--: Stylized Rooster ptd wood;
14-1/2
NMAF # 136
--: Swordfish 19th c. sheet
iron, ptd red; L: 32
LIPA pl 37 -ULi
--: Trotter Ethan Allen and
Sulky 1883 gilded copper
and cast iron; L: 24
CHR 80; COLW 323 (col)
UVWR
--: Trotting Horse
HAY 26 UMAP
--: Trotting Horse and Sulky
1875/1900 bodies and
reins--copper; heads--
cast iron; wheels--iron
wire; 17-1/2x37-1/4
COLW 331 (col); NMAF # 151
UVWR
--: Whale, Little Compton,
Rhode Island 19th c. ptd
pine
CHR 77
--, Pennsylvania 19th c. wood,
wire
LIPW 42

Whale-Oil Lamp 19th c. tin,
with brass double burner
CHR 173 UIDaM
Whale-Oil Lamp, used at
sea 19th c. japanned tin
CHR 174 UWiMP
Whirligig 19th c. ptd wood,
metal; 29-1/2
LIPA pl 47 UNNDo
Woman, candleholder ptd
plaster; 16-1/4
NMAF # 162
Wool Yarn Winder 19th c.
ptd wood
LIPW 42
FOLK ART--AMERICAN NEGRO
Doll, post figure walnut
DOV 68
Grotesque Jug 19th c.
DOV 61 UDCN
--, slave pottery type glazed
DOV 67
Hen, fitted cypress pieces
DOV 68
Negro Preacher wood
DOV 68 UICA
Servant's Bell, Natchez 1815
brass
DOV 67
FOLK ART--BRAZILIAN
Angel 18th c. wood; 27-1/2
BARD-2:pl 300 BrMI
Female Bust, Church Ex
Voto
BARD-2:pl 53
Figure Reclining on Bed,
Pernambuco earthenware
BARD-2:pl 60
Funeral, Pernambuco glazed
earthenware
BARD-2:pl 131 BrSpA
Head, with Smallpox Marks,
Church Ex Voto for small-
pox recovery
BARD-2:pl 52
Pernambuco Figure ptd
terracotta; 5-7/8
BARD-2:pl 192
FOLK ART--CANADIAN
Buffet c 1790 scraped pine;
L: 54-1/2
DOWN 166 CQP
Cock, chimney cowl,
Montreal 1720 plate iron
DOWN 167 CQP
Figurehead of Lady Edmonton
1882 ptd wood
PANA-1:21; ZOR 207
UVNeM

Punch, cigar store figure ptd
 wood
 PEN 58
FOLK ART--INDIC
 Craft Toys 20th c. balsa wood
 DOWN 212
 Throne Platform, relief 1513
 GOE 182 (col) InV
FOLK ART--KOREAN
 Elephant 20th c.
 ELIS 167
FOLK ART--MEXICAN
 Calaveras, festival skull for
 Day of the Dead (All
 Souls' Day) 20th c.
 ptd cardboard, tinfoil
 MAS cat 1991-1995
 Candelabra, Puebla ptd
 terracotta; 19-3/4
 NMAT 116 (col)
 Candlestick tin
 LYNCM 74 UNNLei
 Cat of Tonala, Jalisco
 20th c. polished terracotta
 MAS cat 1217
 "Centurion" Mask 18th c.
 wood; 18-1/2
 NMAT 118
 Covered Vessel, in hand,
 Jalisco 19th c. white
 earthenware; 9
 NMAT 119
 The Dead Christ
 LUN
 Fish of Tonala, Jalisco 20th c.
 red terracotta
 MAS cat 1222
 Fishes, Guerrero lacquered
 "Calabaza" fruit; 19-3/4
 NMAT 124 (col)
 Guerrero Figures 20th c.
 DIV 59
 Hunter's Horn, Jalisco H:
 10-1/4
 NMAT 121
 "Judas" Easter Festival
 Figures: Skeleton and a
 Devil reed, covered
 with cardboard and ptd
 paper
 MAS cat 1941-1944
 Lion of Metepec 20th c. ochre
 terracotta
 MAS cat 1526-1545
 Lion on Tonala, Jalisco 20th c.
 polished terracotta
 MAS cat 1216
 Lute-Like Instrument
 armadillo shell; 35-1/8x

9-3/4
 NMAT 127
Masks ptd wood; 12 to 7
 NMAT 128 (col)
--tin
 LYNCM 75 UNNLei
Mermaid of Coyotepec,
 Oaxaca 20th c. black
 polished terracotta
 MAS cat 1149-1178
Musical Angel 17th c. ptd
 stucco
 NMAT 102 MePuM
Rearing Horse of Metepec
 20th c. ochre terracotta
 MAS cat 1526-1545
Retable, Convent of
 Tepotzotlan 18th c. gilded
 and ptd wood; 210x142x31
 MAS cat 871
Revolving Acrobat, toy,
 Jalisco ptd clay; 2-3/4
 NMAT 113
St. Anthony, santo 18th c.
 WHY 70 -MeP
San Isidro Dressed as an
 Indian, Chichen Itza Church
 WHY 70 MeMB
Skeletons, Festival Figures
 for Day of the Dead (All
 Souls' Day), Barrio de
 Jamaica 20th c. ptd
 cardboard
 MAS cat 1945-1990
Toy Whistle: Woman-Headed
 Bird
 KUH 143
Toys: Cowboy; Man Fighting
 Lion ptd wood; 6-1/4; and
 9-13/16
 NMAT 129
Toys: Rooster; Dog; Adam
 and Eve ptd terracotta
 NMAT 120 (col)
Tree of Life, with angels,
 animals, and flowers,
 candlestick, Puebla 20th c.
 ptd terracotta
 MAS cat 1576
FOLK ART--PERUVIAN
Retable, with folding doors
 WHY 274
El Torito de Pucara
 WHY 274
FOLK ART--PUERTO RICAN
Bearded Figure, santo
 WHY 34 PrSI
Madonna, santo
 WHY 34

--, seated figure
WHY 32 PrSI
Mercedarian Bishop, San
German Santo 18th c.
WHY 33
San Rafael, santo wood
WHY 32 PrSI
The Three Kings, equest
WHY 33 PrSI
FOLK ART--SPANISH AMERICAN
(UNITED STATES)
Altarpiece 1763 ptd limestone;
28x18'
PIE 377 UNmSC
Baptismal Font and Stand,
Mission San Luis Obispo
c 1812 copper, pine
CHR 39 UCSluM
Bishop, bulto 19th c. tempera
paint over gesso coated
cottonwood root; 24
BOY 15 (col); PIE 376
UNmSMF (L 5. 56-90)
Candlesconce 1800's tin,
punched with nail and chisel
DOWN 177 UNmSM
--, New Mexico 1800's tin,
stamped with tooling dies
DOWN 176 UNmSM
Christ on Stand 18th c. pine
BOY 9 UNmSMF
Crucifixion, bulto, Moro, New
Mexico 19th c. gessoed and
ptd wood; 60
DENV 90 UCoDA (A-127)
Ecclesiastical Candlestick,
Mission Santa Ines c 1817
pine
CHR 38 UCStiM
Father Jesus ptd wood
MEN 334 UCoCT
Great Power of God (El Gran
Poder de Dios), nicho tin
and glass with miniature
figures
BOY 49 (col) UNmSMF
Holy Trinity c 1800 gesso, cloth,
tempera, cottonwood root;
11-1/2
PIE 376 UNmSM (L. 1. 56-15)
Missal Stand, Mission San Jose
after 1797 pine
CHR 39 UCSjM
The Most Holy Trinity c 1790/
1800 cottonwood, gesso,
cloth, tempera
SPA 172
Olvera Street Cross
REED 12 UCLO

Our Lady of Guadalupe
(Nuestra Senora de
Guadalupe) 19th c.
cottonwood root, gesso,
tempera; 24-1/2
MEN 334; PIE 376 UNmSM
(CW-B-11)
Nuestra Senora de la Luz
c 1760/80 plaster relief
on pine; 32x18-1/2
PIE 377 UCoCT (396)
St. Acacius, bulto, New
Mexico 18th c. ptd wood
CHR 33 (col) UCoCT
St. Antonio of Padua 19th c.
cottonwood root, gesso,
tempera; 17
PIE 377 UNmSM (CW. B. 6)
St. Francis, bulto, New
Mexico 18/19th c. ptd wood
CHR 28 (col) UCLS
St. Francis of Assisi, bulto
c 1875 gessoed and ptd
wood; 33-1/2
DENV 87; PIE 377 UCoDA
(A-126)
St. Isidore with Plowing Angel,
bulto, New Mexico ptd wood
CHR 34 UCoCT
St. James the Apostle
(Santiago), equest, santo
19th c. gesso, tempera,
cottonwood root; 14
BOY 27 (col); PIE 377
UNmSM
San Rafael Archangel, bulto
c 1825/35 wood, tempera
PIE 377 UNmCS
Santo Nino Perdido, in wooden
shrine 19th c. pine box--
painted tempera over gesso;
17x7; figure--cottonwood
root, gesso, tempera; 12
(excl base)
PIE 377 UNmSM (A. 9. 54-
17a and 17b)
Sidesaddle, Nipomo Ranch,
San Luis Obispo, California
19th c. leather and white
felt
CHR 28 (col)
Spur with Leather Tow Strap,
Southern California 19th c.
CHR 40 (col) UCArP
Stirrup, California 19th c.
wood, silver
CHR 31
Virgin, as a young girl 19th c.
gessoed and ptd cottonwood;

30-1/8
DENV 87 UCoDA (A-130)
Virgin and Child, bulto
CHR 36 (col) UCoCT
FOLK ART--SURINAM
Animal Figures 1850/1925
clay; largest: 7x9
DOCS pl 204 UNNMAI
(18/4960; 13/9501;
14/258; 14/265)
Folk Song. Freilicher
FOLLETT, Jean (American 1917-)
Gulliver, assemblage 1956
c 48x96
KAP pl 80
Lady with Open-Door
Stomach, assemblage 1955
47x48
KAP pl 2
Many Legged Creature 1955
mixed media; 40x48
KAP pl 62
Title Unknown, assemblage
1955(?)
c 60x84
KAP pl 35
Folsom Point
Indians of North America--
New Mexico. Spear-Head,
Folsom
FON See AFRICAN--FON
Font Fantastique. Rocklin, R.
Fonts
Folk Art--Spanish American
(United States). Baptismal
Font and Stand
Hering, E. W. Baptismal
Font
Food Platter. Oldenburg, C.
Fool. Ferber
Foot Rests
Maori. Footrest for Digging
Stick (Ko)
Football See Games and Sports
Footprint, scaraboid. Greek--5th c.
B. C.
Footstools
Greek--8th c. B. C. Footstool,
incised horse design
For Democracy. Freilicher
For Giacometti. di Suvero, M.
FORAKIS, Peter (American 1927-)
Magic Box I 1966 stainless
steel polished; 18x12x12
UIA-13:82 UNNParkp
1, 2, 3 Infinity 1966
acrylic lacquer and
metal; ea unit;30x34x34
TUC 102 UNNParkp

Outline 1966
KULN 150
Forbes-Robertson, Johnston
Tompkins, L. Sir Johnston
Forbes-Robertson, head
FORD, Betty Davenport (American)
Cinnamon Bear
CALF-51:27
Goat
CALF-57
Sloth
CALF-56
Ford, Henry B. (American
Industrialist 1863-1947)
Wollner, H. Henry Ford, bust
Foreboding Angel. Weinberg, E.
Foreign Ambassadors, relief.
Egyptian--18th Dyn
Foreign Trade, relief. Schmitz, C. L.
Foreman, M. J.
Polasek, A. General M. J.
Foreman, bust
The Forest. Cousins
Forest Idyl. Polasek, A.
The Forest is the Best Place.
Calder, A.
FORESTER, Russel
Sun Burst*, entrance
sculpture bronze
DIV 66, 67 UCWB
Forever Free. Johnson, S.
Forgings VII, X, VIII. Smith, David
Forks
Calder, A. Forks and
Strainer
Fiji. Priest's Bowl; Cannibal
Forks
Form. Heras Velasco
Form in Blue. Hesketh
Form of Growth. Konno
Formal Reception. Greissbuhler
Formation# Nevelson, L.
Forme en mouvement. Hare
FORMOSAN
Combs wood
SFGP pl AA, 461 -Sug
Door Panel, Taiwan 20th c.
wood, mother-of-pearl
inlay; 67
LOM 77 SwZUV
Spoons wood
SFGP pl AA, 460 -Sug
Forms. Goto
Forms (Transition III). Roszak
Forms in Compression. Townley, H.
Fort Dearborn Massacre. Rohl-
Smith, C.
Fortifications
Assyrian. Fortified Town

Islamic. Court of the Lions
Javanese. Fountain, or
 Downspout
Jellinek. Fountain of the Earth
Jennewein. Tours Fountain
Johnson, Philip, Archt.
 Dumbarton Oaks Wing
 Fountain
--Lincoln Center Fountain
--Pavilion Fountain
Konti. The Brooks
Konti. Fountain
Konti. Two Fountain Figures
Lachaise. Dolphin Fountain
Laessle. Duck and Turtle
 Fountain
Lane, M. Swirlbul Library
 Fountain
Lathrop. Great White Heron
 Fountains
Laurent. Goose Fountain
Lober. Sea-Weed Fountain
Longman. Fountain of Ceres
Lye. Fountain
MacMonnies. Boy and Duck
 (Duck Baby),
 fountain group
MacMonnies. Columbian
 Fountain
MacMonnies. Young Faun and
 Heron, fountain group
Manship. Prometheus
Manship. Venus Ana Dyomene
Marsh, F. D. Tomokie
 Fountain
Martiny. Fountain of
 Abundance
Mercer. Teddy-Bear Fountain
Mitchell and Ritchey, Archts.
 Mellon Square Fountain
Neuhaus and Taylor, Archts.
 Duncan Coffee Company
 Building Fountain
--Holland Mortgage & Invest-
 ment Corporation Fountain
Niehaus, C. H. Three
 Fountain Figures
Nivola, C. Fountain
Nivola, C. Morse and Stiles
 Colleges Fountain
O'Connor, A. Boy Scout
 Fountain
Overhoff, J. Gould Residence
 Fountain
Paddock, W. D. Edward C.
 Mershon Memorial Fountain
Parsons, E. B. Duck Baby
Paulsen, Glen & Associates,
 Archts. First Baptist

Church Youth Center
 Addition Fountain
Pei, I. M. & Associates,
 Archts. Hyde Park
 Apartments Fountain
--Mile High Center Foundation
--Roosevelt Field Shopping
 Center Fountain
Pen, Everett, du. Coliseum
 Fountain
Perry, R. H. Boy with Fish,
 fountain
Perry, R. H. Fountain of
 Neptune: Mermaids;
 Neptune
Petersen, C. Fountain of the
 Seasons
Piccirilli, F. Fountain of
 Spring
Piccirilli, F. Fountain of
 Winter
Pompeiian. Mosaic Fountain
Putnam, A. Mermaid Fountain
Rhind, J. M. Corning
 Fountain
Richards, L. Fountain
Rinehart, W. H. Indian
 Fountain
Risque. Bird Fountain
Rocklin. Brass Fountain
Roman. Atlanta Fountain
Roman. Sarcophagus Fountain
Roman--1st c. B. C. Bowl of
 Fountain: Nereids with
 Centaurs and Sea Monsters
Rood. Fountain#
Rosenthal, B. Fountain(s)#
Salerno, C. Fountain No. 1
Scudder. Child with Shell#
Scudder. Fighting Boys'
 Fountain
Scudder. Frog Baby Fountain
Skidmore, Owings & Merrill,
 Archts. Upjohn Company
 General Offices Fountain
Stackpole, R. William F.
 Coleman Memorial Fountain
Stanford, William. Fountain
Stone, E. D., Archt.
 National Geographic
 Society Headquarters
 Fountain
--Perpetual Branch Bank
 Fountain
--Perpetual Office Building
 Fountain
--Stanford University Clinical
 Science Building Fountain
--United States Pavillion

Fountain, World's Fair,
 1958
Taft, L. Fountain of Time
Tilden, D. Mechanics Fountain
Tsutakawa, G. Bronze
 Fountain
Tsutakawa, G. Fountain
 Group
Tsutakawa, G. Fountain of
 Reflection
Tsutakawa, G. Fountain of
 Wisdom
Tsutakawa, G. J. W.
 Robinson Store Fountain
Vergette, N. Residence
 Fountain
Walter, E. Beauty and the
 Beast
Weinman, A. A. Fountain
 of the Setting Sun
Whitney, G. V. Fountain of
 El Dorado
Yamasaki, M. & Associates,
 Archts. United States
 Science Pavilion Fountain
Zorach. Fountain of Horses
Four Bears
 American--20thc. Four
 Bears Monument
Four Black Bottoms. Calder, A.
Four Dancers under the Moon.
 Brown, M.
Four Days Wise (Arab Colt). Hamlin
Four Deva Kings. Japanese--
 Tempyo
Four Dots. DeLap, T.
Four Forms in Walnut.
 Sugarman, G.
Four Horsemen of the Apocalypse.
 Schuler, H.
Four Horsemen of the Apocalypse.
 Werner, N.
Four Lines Up. Rickey
Four Models, Dormeyer Blender.
 Oldenburg, C.
Four Planes, Hanging. Rickey, G.
Four Planes in Space. Calder, A.
The Four Powers. Patigian, H.
The Four Seasons--putti
 personifying, sarcophagus
 relief. Roman--2nd c.
Four Seedlings. Lippold
4/28/61. Smith, D.
Four White Dots. Calder, A.
Fourth Division Memorial.
 Whitney, G. V.
FOWLE, Isaac (American 1818-53)
 Figurehead: "Woman in the
 Wind" c 1820/30 ivory-

ptd wood
 ART 87; CHR 57; CRAVS
 1. 22; MEN 331 UMBOS
Hardware-Store Sign, shop
 of John Bradford, Boston
 19th c.
 CHR 68 UMBSt
Lady with Scarf, figurehead
 used as a shop sign
 c 1820 wood, ptd white; 76
 LIPA pl 8 UMBOS
Fowle, John
 Lamson. Gravestone of
 John Fowle
Fowler, Edward (American Army
 Officer)
 Baerer. General Fowler
FOWLER, Philip E. (American)
 Jane bronze
 NATSS-67:17
FOX
 Buffalo, Tama, Iowa
 1875/1900 wood; L: 18
 DOCA pl 232 (col)
 UNNMAI (4/7388)
FOX, Austin (American)
 Twenty-One polyester
 NATSS-67:18
FOX, Seymour (American 1900-)
 Head Belgian black marble
 NATS 104; PAR-1:149
Foxes
 Chavin. Fox, embossed head
 Chimu. Dancing Foxes,
 ceremonial staff
 Cushing, L. W. Weathervane:
 Running Fox
 Japanese--Tokugawa. Netsuke:
 Kitsune (Khsune), Fox in
 Woman's Guise
 Judson, S. S. Fox
Frabjous Day. Edelheit
Fragilina. Piccirilli, A.
Fragment for the Gates to Times
 Square II. Chryssa
France
 Holm. Spirit of France
Frances, Head. Gross
Francesca. Cresson
Francis of Assissi, Saint
 Brecheret. St. Francisco
 Bufano. St. Francis of
 Assissi
 Centurion. St. Francis of
 Assissi, relief
 Copp. St. Francis Assissi
 Duhme. St. Francis and
 the Wolf

Faggi. St. Francis
Folk Art--Spanish American
 (U. S.) St. Francis, bulto
--St. Francis of Assissi,
 bulto
Hofmann, M. St. Francis
 and his Animal Friends
Horn, St. Francis
Huntington, C. St. Francis
Janis, C. R. St. Francis
Kersey. St. Francis
Koepnick. St. Francis
Malicoat, C. St. Francis
Mellon. St. Francis
Mestrovic. St. Francis
Portuguese /Brazilian. Birth
 of St. Francis of Assissi
Schmitz, C. L. St. Francis,
 head
Sherwood, R. St. Francis
 and the Wolves
Stevick, R. St. Francis
FRANCISCI, Anthony de (Italian-
 American 1887-)
Boys and Gazelle 1937
 Tennessee marble; 34
 BROO 344 UScGB
FRANK, Mary (English-American
 1933-)
Figure 1958 H: 21
 SEITC 36 UNNRa
Kneeling Woman 1961 H:
 9-1/2
 SEITC 36 UNNRa
Soul Catcher 1961/62 H:
 30-1/2
 SEITC 36 UNNRa
Woman 1960/61 H: 17
 SEITC 36 UNNRa
FRANKEL, Dextra and Charles
Pacific View Memorial Park
 Patio Fountain
 BISH UCCo
Frankenstein. Racioppi
Frankie. Lansing
Frankincense Trees
Egyptian--18th Dyn. Voyage
 to Punt: Frankincense
 Trees, with Grazing Cattle
Franklin, Benjamin (American
 Statesman 1705-90)
Aitken. Benjamin Franklin,
 bust
American--19th c. Benjamin
 Franklin
Boyle. Benjamin Franklin,
 seated figure
Flaxman. Benjamin Franklin,
 bust

Greenough, R. Benjamin
 Franklin
McKenzie, R. T. Edward
 Longstreth Medal of
 Merit
McKenzie, R. T. The
 Youthful Franklin
Plassmann, E. Benjamin
 Franklin
Powers, H. Benjamin
 Franklin
Zorach, W. Benjamin
 Franklin
FRANKLIN, Dwight (American
 1888-)
Buckskin Man
 PAG-2:19
Daniel Boone
 PAG-2:38
Frontier Homestead
 PAG-2:21
Frontiersman
 PAG-2:18
Frontiersmen Viewing
 Kentucky
 PAG-2:20
Iroquois Warriors wax
 PAG-1:26
Franklin Institute
McKenzie, R. T. Edward
 Longstreth Medal of
 Merit
FRANZONI, Carlo (Italian-American
 1786-1819)
Clock: Car of History:
 Clio, muse of History,
 in Winged Car of Time
 1819 marble
 FAIR 43; MUR 13; USC
 355 UDCCapS
Justice, with Scales and
 Sword; Eagle, relief c 1817
 USC 289 UDCCap
FRANZONI, Giuseppe (Italian-
 American d 1815) See also
 Latrobe, B. H. and
 GIOVANNI ANDREI
Ceres; Neptune 1808
 marble; 60
 CRAVS 79 UMdBPM
FRASER, James Earle (American
 1876-1953)
Alexander Hamilton, South
 Steps
 AMF 143; NATSA 67;
 NATSE UDCTr
American Academy of Arts
 and Letters Medal
 MCSPAD 292

American Committee for
Devastated Regions of
France, medal obverse:
Griffon bronze
NATSA 287
Augustus Saint-Gaudens, bust
bronze
HF 143 UNNHF
--, head 1906/07 plaster;
over LS
USNM 134
Elihu Root, bust 1926 bronze;
17-3/4
EA 463; UNNMMAS 127
UNNMM (29. 95)
End of the Trail, equest plaster;
LS GRID 85 UCVM
-- (At the end of the Trail),
equest, original model at Pan
Pacific Exposition, San Fran-
cisco. 1915 plaster, wire;
17'x17' ACA pl 308; CHENSA
42; DODD 102; JAM front;
JAMS 35; MARY pl 65; PAG-
12:217; PERR 37; RAY 67;
REED 176; SFPP; TAFTM
138; Cowboy Hall of Fame
UOkO (bronze copy cast 1970
in Italy from plaster mold of
Caesar Contini to be placed
in Mooney Park, Visalia,
Calif.)
-- (replica) 1915 bronze; 40 BROO
114; CRAVS fig 13. 18 UScGB
-- 1915 plaster, wire
PIE 386
-- 1929 bronze; 12'
GRID 84 UWiWS
Flora and Sonny-Boy Whitney,
equest, relief ACA pl 224
Head of a Young Artist 1929-22/
1933 marble; 16-1/2 RICJ pl
47; UNNMMAS 128 UNNMM
Head of an Old Man
TAFTM 138
John Ericsson, head
MCSPAD 298
John N. Garner, bust marble
USC 176 UDCCap
A Journey Through Life
(Keep Memorial), detail
TAFT 557 UDCR
Lincoln
TAFT 569
Lincoln Memorial, seated figure
1930 BUL 187 UNjJL
Mask of a Young Girl
TAFTM 138

Medal: Augustus Saint-Johns
NATS 108
Meriwether Lewis
NATS 106
Mr. and Mrs. Albright,
plaque bronze
NATSA 287
Primitive Power
NATS 107
Theodore Roosevelt, bust
marble
FAIR 344; MCSPAD 278;
PAG-10:217; PUT 234;
USC 178 UDCCap
United States Navy
Distinguished Service
Cross, study
NATSA 286
Victory
ADA 50
Victory Medal
ADA 107
Williams College War
Service Medal, obverse;
reverse bronze
MCSPAD 292; NATSA 286
FRASER, James Earle, and Thomas
Hudson JONES
Ulysses Simpson Grant, bust
bronze
HF 100 UNNHF
FRASER, Laura Gardin (American
1889-)
American Geographical
Society Medal
NATS 111
Baby Goat 1919 bronze; 7-1/4
BROO 263; CHICA 33;
NATSA 68 UScGB
Better Babies Medal, obverse
bronze gilt
NATSA 288
Colbert, medallion head
marble
USC 282 UDCCap
Edward I, medallion head
marble
USC 283 UDCCap
Gilbert Charles Stuart, bust
bronze
HF 144 UNNHF
Horse Association Medal
NATS 111
Irish Setter Club of America
Medal, obverse bronze
gilt
NATSA 289
Mary Lyon, bust bronze
HF 40 UNNHF

Pipinian, medallion head marble
USC 286 UDCCap
Rosemary Hall Medal, obverse;
reverse 1915 bronze gilt
NATSA 288
Simplicity
NATS 110
Snuff
ADA 98
Fraternity
Cormier. Door Panels
FRAZEE, John (American 1790-1852)
Chief Justice John Jay, bust
marble
USC 186 UDCCap
John Marshall, bust 1834
marble
CRAVS fig 3. 3
John Wells, bust 1824
marble
PIE 379 UNNStP
Judge Joseph Story, bust
1834 marble; 32
CRAVS fig 3. 1; NEWAS 7
UMBA
Self Portrait, head 1829
bronze; LS
CAH 48; PIE 379 UPPPA
--, bust plaster cast
TAFT 31 UPPPA
Thomas H. Perkins, bust
1834 marble; 31
LARK 104; MEN 337;
PIE 379 UMBA
FRAZIER, Bernard (American)
Mare Colt bronze
IBM pl 61; SCHN pl 76 UNNIb
Pillar of Fire, and Pillar
of Smoke, facade relief
1955 concrete; 40'
KAM 119 UOkTI
Rebekah terracotta
SCHN pl 39 UMoSpA
FRAZIER, Charles (American
1930-)
Cow 1965
KULN 58
Drag Racer 1966
KULN 88
Globe 1963 bronze; Dm: 16
UIA-12:153 UCLD
Square World bronze
WHITNA-17
Sweetheart 1962/63 lacquered
wood; 18-3/4x12-1/4x8-1/2
WHITNS 33 UNNW
Untitled (Lips*) 1965
KULN 50

Untitled (Lips on Shingles*)
1965
KULN 51
Untitled (Lips on Sphere*)
1965
KULN 50
FRAZIER, Paul (American 1922-)
Dog Trying to go to Heaven
1954 plaster; 36
WHITNY-1:# 21
Sleeping Child 1954 terra-
cotta; 26
WHITNY-1:# 22
Space Manifold # 5 ptd
canvas, masonite; 118
WHITNA-18:36
FREDERICKS, Marshall (American)
Ape
HOF 228
Torso of a Dancer black
bronze
NYW 190
Free Form. Institute of Design
Student
Free Will. Angell, B.
Freedom See Liberty
FREEMAN, John (American 1922-)
3 Star 1966 laminated and
inlaid wood; 27x15x15
UIA-13:123 UNNMark
FREILICHER, Hy (American 1907-)
Chasidism plaster, for
bronze; 45
SG-6
The Conference ptd wood; 28
SG-7
Dancers plaster; 33
SG-5
The Disinherited wood
SGO-4:pl 20; SGO-10:17
Folk Song Jamaican mahogany;
27
SG-2
For Democracy wood
SGO-2:pl 32
Monk with Accordion
mahogany
SGO-1:pl 24; SGT pl 17
Mother and Child cocobolo
wood; 28
SG-4
The Prophet ebony; 44
SG-3
Refugee wood
NYW 192
FRELINGHUYSEN, Suzy (American)
Sculpture 1954 ptd marble
AMAB 150

FRENCH, Daniel Chester (American
 1850-1931)
 Abraham Lincoln
 STI 814; TAFTM 135 UDCLP
 Abraham Lincoln, seated
 figure, Lincoln Memorial
 1922 marble
 BUL 205; CRAVS fig 11. 11;
 DODD 38; HOF 143; LONG
 164, 128 (col); NATS 114;
 NATSE front; PAG-13:231;
 ROOS 244D UDCLi
 --, model finished H: 19'
 LARK 391 UDC
 --, study for Lincoln Memorial
 figure plaster; 72
 FAIN 158 UMStoC
 Abraham Lincoln, monument
 1912
 BUL 204; DODD 37;
 PAG-13:224; TAFTM 134
 UNbLCap
 Africa, one of four figures
 representing continents
 DODD 26; TAFTM 121
 UNNCu
 Alice Freeman Palmer
 Memorial, chapel
 PAG-10:322; TAFTM 120
 UMWelC
 Alma Mater 1902/03 bronze;
 c 84
 CAF 68; MEN 484; PIE
 379; TAFT 327 UNNCo
 American Red Cross, 1917-
 1919 Medal, obverse;
 reverse bronze
 NATSA 291
 Architectural League of New
 York President's Prize,
 medallion, obverse bronze
 NATSA 291
 Asia, one of four figures
 representing continents
 DODD 25 UNNCu
 Benediction bronze; 37-1/2
 BROO 16 UScGB
 Blacksmith Reading, Carnegie
 Library Memorial
 DODD 32
 Brooklyn, seated figure, with
 Child Reading
 DODD 30; TAFTM 121
 UNNMB
 Chapman Memorial
 HARTS pl 10 UWiMC
 Clark Memorial: Angel
 CAF 61; TAFTM 120
 UNFC

Columbia
 HARTS pl 37
Completion of Catskill
 Aqueduct Medal, obverse
 1917 bronze
 NATSA 290
Death and the Warrior,
 World War I Memorial
 DODD 41; NATS 113 UNhCP
Death and the Young Sculptor
 (The Angel of Death Stay-
 ing the Hand of the Young
 Sculptor; Death Staying
 the Hand of the Sculptor),
 Martin Milmore Memorial
 1892 bronze; 90x18'
 CAF 60; DODD 21; HART-
 2:67; MCSPAD 128; PIE
 379; TAFT 310 UMCMt
--: Angel of Death and the
 Sculptor 1926 copy marble;
 92x99-3/4
 CRAVS fig 11. 13; NM-11:
 69; RAY 64; ROOS 244E;
 UNNMMAS 59; UPJH pl
 276 UNNMM (26. 120)
--: Death Staying the Hand of
 the Young Sculptor (Death
 and the Sculptor) bronze
 HARTS pl 5; PAG-12:196;
 POST-2:245 UMBF
--(cast)
 MARQ 282; RAD 493 UICA
Dewey Medal
 BARSTOW 208; PAG-7:188
Edgar Allen Poe, bust bronze
 HF 31 UNNHF
Frances Parkman Memorial
 1906 granite, bronze
 GRID 40 UMJ
Genius of Creation
 ACA pl 218; CHENSA
 64; JAM 46; JAMS 17;
 PERR 103; SFPP
Henry Wilson, bust marble
 FAIR 337; USC 181
 UDCCap
His Majesty
 DODD 42
In Flanders Fields, War
 Memorial
 NATS 115; TAFT 585 UMMi
John Adams, bust marble
 FAIR 323; USC 172
 UDCCap
John Harvard
 PAG-10:302 UMCH
Lewis Cass marble
 FAIR 393; MUR 46; USC
 232 UDCCapS

FRITZ, Jacob (American)
 Man on Horseback 1809
 reddish-brown pottery;
 9-1/2
 LIPA pl 157 UDeWG
Frog Baby. Parsons, E. B.
Frog Baby Fountain. Scudder, J.
Frog Fountain
 Scudder, J. Frog Baby
 Fountain
Frogs
 African--Benin. Figure:
 Fish-Tail Legs; Frogs
 Chapin. Giant Frog
 Chinese--Six Dynasties. Frog
 Egyptian--1st/2nd Dyn. Amu-
 let: Frog
 Flannagan. Frog
 Frishmuth. Play Days
 Hering, E. W. Boy and Frog
 Hodge. Champion Takes the
 Sun
 Hohokam. Pendant: Frog
 Hopewell. Pipes: Marmot;
 Frog; Snake
 Indians of Central America--
 Costa Rica. Frog Amulet
 Indians of North America--
 Arkansas. Effigy Jar:
 Frog
 Indians of South America--
 Colombia. Frog-Headed
 Crocodile Pendant
 Mochica. Jar: Frog
 Morrison, M. Bullfrog
 Mound Builders. Pipe-Bowl:
 Frog
 --Platform Pipe: Frog
 Nazca. Jar: Frog
 Nicoya. Pendant: Frog
 Pre-Columbian. Gold
 Ornaments: Frogs; Human
 Figures
 Pueblo. Frog
 Recchia, R. H. Baby and
 Frog
 Tsimshian. Headdress:
 Eagle Bearing Frog on
 Chest
 --Winged-Frog Helmet
FROLICH, Haaken
 Jack London, head (repaired
 and recast by Lee Mc
 Carty)
 REED 86 UCOLo
From a Morning in Greece. Lippold
From an Old Photo. King, W. D.
From Chaos Cam Light, relief.
 MacNeil, H. A.

From France. Marisol
From Generation to Generation
 Grafly
From Generation to Generation.
 Stackpole, Ralph
From the Other Side of the Bridge.
 Tanguy
From the Song of Songs# Russin,
 R. I.
Frond Fountain. Daingerfield
Frontenac, Louis (French Soldier
 and Colonial Governor
 1620-98)
 Hebert, L. P. Frontenac
Frontier Homestead. Franklin
Frontier Wall. Wines
Frontiersman. Franklin
Frontiersmen Viewing Kentucky.
 Franklin
FRUDAKIS, Evangelos W. (American)
 Jaccoca plaster
 NATSS-67:21
Fruit
 Hellenistic. Satyr with
 Fruit
Fruit Baskets
 American--19th c. Gilt
 Fruit Basket, with
 kneeling bisque Angels
Fruit Thief. Khmer
Fruit Tree. Hare
The Fruitful Vine, Bimah detail.
 Lipton
Frustra. Foley
FRY, Erwin
 Revolutionary Soldier,
 detail, Ellen Philips
 Samuel Memorial
 SCHN pl 5 UPPF
 Standing Figure Georgia
 marble
 SCHN pl 38
FRY, Sherry Edmundson (American
 1879-)
 Captain Abbey
 TAFTM 141 UCtT
 Daughter of the Sea
 PERR 83
 Fortuna, fountain figure
 CHICA-35; NATSA 79
 Mahaska 1909 bronze; LS
 GRID 22; TAFTM 142
 UIaOL
 Maidenhood 1914 bronze;
 67-1/4
 BROO 316 UScGB
 Major C. Burret, memorial
 fountain
 TAFTM 142 UNNStG

Modesty ("Unfinished
 Figure")
 TAFT 562
Muse and Pan, pylon group,
 Festival Hall: detail:
 Pan
 JAMS 59; PERR 25, 27;
 SFPP
Peace
 SFPP
Reclining Woman, Bacchus
 and other Decorative
 Figures, Festival Hall
 SFPP
Seated Woman bronze
 WHITNC 222 UNNW
Torchbearer, finial figure,
 Festival Hall
 PERR 23
Undine
 CHICA-36
FUCHS, Emil (Austrian-American
 1866-)
 Maiden Meditation marble
 NATSA 80
 Robert Woolston Hunt
 Plaquette, obverse; reverse:
 Labor bronze, silver
 NATSA 292, 293
Fudo See Five Rajas
Fudu-Myo-O (God of Fire and Water-
 falls)
 Deme Shodo Gensuke. Fudu-
 Myo-O, Noh mask, netsuke
 Japanese--Kamakura. Fudu-
 Myo-O
Fugen Bosatsu. Japanese--Fujiwara
The Fugitive's Story. Rogers, J.
Fugue. Glinsky
Fugue. Mundt
Fugue. Rood, J.
Fugitive. Childers
Fugitive. Piccirilli, A.
FUJIWARA See JAPANESE--
 FUJIWARA
Fukukensaku Kwannon
 Japanese--Tempyo. Fukukensaku
 Kwannon
Fukurokuju (God of Longevity)
 Japanese--Tokusawa. Netsuke:
 Fukurokuju
 Masatomo. Fukurokuju,
 netsuke
FUKUSHIMA, Noriyasu (Japanese
 1940-)
 Blue Dots 1966 wood and
 plastic, polychromed;
 52-1/4x126-1/4x43-1/4
 GUGE 124 JKSi

Fulfillment. Vodicka, R. K.
Full Moon
 Lippold. Variation No. 7:
 Full Moon
Full Moon. Martinelli, E.
Fuller, Loie
 Lipchitz. Remembrance of
 Loie Fuller
FULLER, Mary (American)
 Sculpture terracotta; 18
 SFAP pl 20
Fuller, Melville Weston (American
 Jurist 1833-1910)
 Partridge, W. O. Chief
 Justice Melville W.
 Fuller, bust
FULLER, Meta Warrick (Meta Vaux
 Warrick) (American 1877-)
 Water Boy
 DOV 85 UDCH
FULLER, Sue (American 1914-)
 String Composition No. 127
 1965 polypropylene
 threads in plexiglass;
 36x36
 RHC #9 UNNScha
 String Construction, Number
 51 1953 plastic thread,
 aluminum; 33-1/2x45-1/2
 JOH 89; PIE 386 UNNW
 (54-23)
 String Sculpture red, blue,
 and white strings, over
 gray ground; 36x24
 FAIY 223 UNMoS
FULOP, Karoly (American)
 Shooting Star wood
 NYW 193
Fulton, Robert (American Engineer
 and Inventor 1765-1815)
 Roberts, H. Robert Fulton
Les Fumeurs. Laliberte
FUNAKOSHI YASUTAKE (Japanese
 1912-)
 Hagiwara Sakutar, head
 1956 bronze; LS
 WW 205
FU-NAN
 Head in False Attic Window,
 Phuoc-co-tu, Nui-Sam,
 South Vietnam 6th c. (?)
 terracotta; 27 cm
 GROS 54 (col) Vn-sSN
 Krishna Lifting Mount Govard-
 hana, Vatko, Takeo,
 Cambodia, high relief
 514/39 sandstone; 1.61 m
 GROS 58 (col) CaPN
Fundilius. Roman--1st c.

FUNDUKISTAN See also INDIAN
 Sarcophagus Cover, with
 Princely Couple 6/7th c.
 ptd terracotta
 RTC 170 (col) AfKM
Funeral Dancer. Duble
Funeral Processions See Processions
Funeral Pyres
 Roman--2nd c. Arco di
 Portogallo
Funeral Wagon, with mourners.
 Boeotian
Funerals See also Mourners
 Egyptian--18th Dyn. Funeral
 Scene#
 Egyptian--19th Dyn. Mourners
 and Funeral Meats, relief
 Etruscan. Cista: Sacrifice
 of Trojan Captives at
 Funeral of Patroclus
 Folk Art--Brazilian.
 Funeral
 Greek--6th c. B. C. Dead
 Man and Mourners, plaque
 MacNeil, H. A. Marquette's
 Funeral, plaque
 Roman--1st c. Haterii Tomb:
 Funeral Scene with Torches
 and Flute Player
 --Patrician with Bust of his
 Ancestors
Funerary Couch#
 Chinese--Ch'i
Funerary Figures
 African--Bakota. Funerary
 Figure#
 African--Dogon. Male and
 Female Funerary Figures
 Kafiristan. Funerary Figure
 Luristan. Funerary Statuette
 Melanesian--Solomons. Female
 Funerary Figure
Furies
 Durchanek. Fury
 Greek. A Fury, or Medusa,
 head
 Hartley, J. A Fury
 Hellenistic. Sleeping Fury
Furnace Girl. Loring
FURNESS, Frank
 Entrance Detail 1872/76
 SCHMU pl 231 UPPPA
Furniture
 Egyptian--4th Dyn. Furniture
 of Queen Hetep-heres
Furniture Legs and Supports
 Chinese--Chou. Table Leg:
 Bear

 Egyptian--Predynastic.
 Furniture Foot: Cattle
 Foot
 Egyptian--1st Dyn. Couch
 Leg: Bull's Leg
 Egyptian--25th Dyn. Bed-
 Leg: Duck
 Etruscan. Male and Female
 Figures, furniture supports
Furuna
 Japanese--Tempyo. Hachibushi
Fury. Durchanek
Fuse Box. Kuriloff
Fuseo Bust. Greek--6th c. B. C.
The Future. Longman
The Future Generation. Zorach

G. , Dr. L.
 Simkhovitch, H. Dr. L. G. ,
 head
G. Orange. Price, K.
Ga-Sua
 African--Kra. Ga-Sua,
 oracle fetish mask
Gabaudan, Katherine
 Spicer-Simson. Katherine
 Gabaudan Medallion
Gables
 Melanesian--Solomons. Gable
 Figure: Flying Tern
 Micronesian--Palau Islands.
 Gable on Men's House:
 Incised Design and
 Female Figure
 New Guinea. Gable Mask#
 --Gable Ornament
GABO, Naum (Russian-American
 1890-1966), original name:
 Naum Pevsner
 Arch No. 2 1960 phosphor
 bronze; 18
 READCON 109 (col) UNNMa
 Bijenkorf Monument (Con-
 struction in Space;
 Rotterdam Construction)
 1955/57 steel covered
 with bronze; middle sculp-
 ture--stainless steel, base
 covered with Swedish
 granite; 85'
 BERCK 211; BURN 39;
 GIE 185-185; KUHA 99;
 LIC pl 248: MAI 103;
 ROBB 407; ST 448; TRI
 273-274 NRB
 Bust 1916 construction:
 metal and plastic
 SELZJ 246

Carved Stone 1949 Dm: 9-5/8
 GABO pl 40 -Re
Circular Relief 1925 plastic
 on wood; Dm: 19-1/2
 READCON 101
Column 1923 plastic, wood,
 metal; 41
 BR pl 15; CHAN 187;
 CHENSW 506; DAM 59;
 GUG 202; LARM 328;
 MCCUR 264; MEILD 17;
 READCON 100; RIT 151;
 ROOS 282C; SELZJ 239
 (col); TRI 28 UNNG
Column (Space Construction)
 1923 glass, metal; 38-1/2
 NMAC pl 135
--1923 glass, plastic, metal,
 wood; 41
 NNMMAP 140; NNMMARO
 pl 314
Constructed Head No. 2 1916
 sheet iron; 17-3/4
 BERCK 71; BOW 139;
 GABO pl 39; READCON 96
Construction 1922
 RTCR 265; UCIT 5
Construction 1923
 MEN 638 UNNMMA
--1924/25 plastic, glass,
 metal, wood
 FAIN 40; MAI 102 UCtY
--1926
 MOHN 45
--1933
 READAN #58
--1951/52 plastic, wire; L: 15
 PIE 386 UMdBMay
--1956 aluminum, plastic,
 phospher bronze; Dm: 10'
 PIE 386; WHITNB 33
 UNNRocU
Construction for Chicago Swim-
 ming Pool, model, Maryland
 Club Gardens 1932
 metal, glass
 GIES 178
Construction in Space 1928
 BURN 127 UPPPM
--1937 Light blue plastic; 9x9
 JLAT 22; RIT 152 UNPV
--1953
 AMAB 86 (col)
--1953 plastic; 28
 PIE 386
--1953 plastic, stainless steel
 springs, aluminum base; 58
 READCON 108 UCtMG
--1960 H: 15-1/4
 SEITC 23 UNNMa

Construction in Space, Study
 For (Konstruktion in
 Raum--Studie fur) 1951
 brass-netting, steel-wire; 6
 GERT 164; RIT 203
Construction in space,
 working scale model for:
 The Crystal plastic
 (Rhodoide); 9
 CLEA 70 UNPV
Construction in Space--
 Continuity 1941/42 plastic;
 17-1/4
 READI pl 85
Construction in Space with
 Balance on Two Points
 1925 ptd bronze, glass,
 clear plastic; 50x40
 BURN 35; HAMP pl 136
 UCtY
Construction in Space with
 Crystalline Center 1938
 clear plastic; W: 18-1/2
 GABO 5; GIE 188; RAMS
 pl 102a; READCON 105
Construction in Space with
 Red 1953
 KULN 113
Construction on a Line, No. 1
 1935/37 plastic; 17
 WADE UCtHWA
Construction on a Line in
 Space 1937 plastic; 19
 RAMS pl 102C, 103
 ELVe
Construction on a Plane 1937
 plastic; Sq: 19
 RAMS pl 102b
Construction Suspended in
 Space 1950/52 aluminum
 baked black, transparent
 plastic; rolled gold wire;
 phosphor bronze mesh;
 stainless steel wire
 BALD 159; READAS pl
 220-223 UMdBM
Construction with Alabaster
 Carving 1938/39 alabaster.
 plastic; 15-1/2
 BMA 85 UMdBM
Construction with Red 1953
 BERCK 74; GABO pl 37
 (col)
Granite Carving 1964/65
 Pennsylvania granite; 25
 x24x10
 HENNI pl 162 UCtMG
Head 1916 iron; 17-3/8
 GIES 176; KUHA 101; ROSE
 pl 197 NAG

Head of a Woman 1916/17
 celluloid, metal; 24-1/2x
 19-1/2
 GRAYR pl 171; LIC pl 243;
 MCCUR 264; MAI 101;
 READAS pl 214; ROOS
 281A; SELZJ 246
 UNNMMA
Kinetic Construction 1920
 BURN 231
--1953
 MCCUR 265
Kinetic Sculpture 1920 steel
 spring; 30
 GIES 177
Large Head 1916/66 steel; 72
 EXS 78
Linear Construction
 ENC 204
--1942
 BURN 141 UNNG
--1942/43
 plastic READG 113
--1943/43 plastic, plastic
 threads; 13-3/4x13-3/4
 MYBS 70; TATEF pl 17
 ELT (T. 191)
--1950 white plastic
 GARDH 760; MU 261
 UCtNhH
Linear Construction,
 Variation 1942/43 plastic and
 nylon thread construction;
 24-1/4
 CANM 498; KEPS 19; MYBA
 659; PH pl 243; SEW 921;
 SEYT 58; UPJH pl 243
 UDCP
--1946 plastic; Sq: 12
 RAMS pl 101 -EH
Linear Construction with Red
 plastic, stainless steel
 springs, aluminum base
 WHITNA-17:16
Linear Construction No. 1 1942/43
 plastic; 12
 DETS 39 UNNH
--1943 plastic, plastic threads;
 13-1/4x13-1/4
 BOW 141 ELT
Linear Construction No. 2
 1942/43 plastic; 60 cm
 LIC pl 247
--1949 plastic, nylon thread;
 15
 HAMP pl 137
--1949 perspex, nylon thread,
 36
 LYN 131 NAS

Linear Construction No. 2,
 Variation No. 1 1950
 perspex; 24-1/2
 CHRP 431; HAY 102;
 WALKC 31 UMAP
Linear Construction No. 4,
 Black 1955 aluminum,
 stainless steel; 38-1/2
 GABO front (col) UICA
Linear Construction No. 4,
 in Black and Grey 1953
 aluminum, stainless steel
 MEILD 13 UICA
Linear Construction No. 4,
 Variation 2 1962/64
 phosphor bronze, brass,
 stainless steel; 19
 BOW 137
Linear Construction No. 4,
 White 1959 plastic,
 aluminum, stainless steel;
 38-1/2
 GABO pl 41 (col) UNNW
Linear Construction in Space
 1949 plastic, nylon; 36
 GIE 182-183
--1950 plastic, nylon thread
 KUHB 110 UMiBiW
Linear Construction in Space
 No. 2 1949
 BERCK 72
--1949 plastic, nylon
 MAI 102
--1949 plastic, nylon
 LARM 256 NAS
--1950 plastic, nylon thread;
 17
 COOP 301 UMiBiW
Linear Construction in
 Space No. 3
 KEPV 115
Linear Construction in Space
 No. 4 1958 plastic,
 stainless steel; 40x20-1/2
 FAUL 480; GOODA 253;
 GOODT 123; KUHA 98;
 NNWB 63; WHITN 63;
 WHITNFY UNNW
Monument for a Physics
 Observatory 1922 plastic
 metal, wood; 14'
 HAMP pl 135B; READCON
 100 (destroyed)
Monument for an Airport
 1924/25 glass, metal
 NMAB 64
Monument for an Airport
 (Space Construction) 1925/26
 glass and metal on oval

composition base;
19-1/2x28-7/8
NMAC 139
Monument for an Institute of
Physics and Mathematics
1920 glass, bronze; 60 cm
LIC pl 244 -Ru
Repose 1953
KUHA 101
Sculpture 1961/66
KULN 160 NRB
Sculpture, Entrance Hall,
ESSO Building Rockefeller
Center, New York, project
model 1949 iron wire,
plastic; c 17
BERCK 266; GIES 179
UNNMMA
Spheric Theme 1937 opaque
plastic; Dm: 22-1/2
READCON 106
Spiral Theme 1941 plastic;
5-3/8
TATEF pl 29f ELT (T. 190)
Spiral Theme (Construction
in Space: Spiral Theme)
1941 plastic; 7-1/2; base:
24x24
BRY 628; KUH 129; LOWR
202; LYNC 9; NNMMM 127;
RAMS pl 23C; READAN
60; READAS pl 219; READP
240; RIT 153; TRI 208
UNNMMA
Transluscent Variation on
Spheric Theme 1951 version
of 1937 original plaster;
22-3/8
BURN 141; GIE 180-181;
GUG 203; LARM 328; LIC
pl 246; READCON 107
UNNG
The Unknown Political Prisoner
(2nd Prize) (Der Unbekannte
Politische Gefangene),
monumental project 1953
BERCK 7; GERT 165
Variation Linear No. 2 1952/65
stainless steel wire on
plastic; 31x25x25
ALBC-4:69 UNBuA
GABON See AFRICAN--GABON
Gabriel, Angel
Coptic. Virgin and Child
Enthroned between
Archangels Gabriel and
Michael(?)
Derujinsky. Archangel Gabriel

Folk Art--American. Weather-
vane: Angel Gabriel Blowing
Horn
Mestrovic. Archangel Gabriel,
bust
GABRIELINO
Swordfish; Sailfish, Los
Angeles County, California
soapstone; 7; and
11-5/8
DOU 37 UNNMAI
(20/990; 20/1854)
Gabrilowitsch, Ossip (Russian
Pianist and Conductor 1878-
1936)
Putnam, B. Ossip
Gabrilowitsch, bust
Gadfly. Campbell, K. F.
Gaea. Bright
Gaeta
Salpion of Athens. Vase of
Gaeta
GAGE, Merrell (American)
Lincoln, seated figure 1918
BUL 171 UKTCap
Man of Taos Belgian marble
CALF-56
Woman of Taos rosewood
NYW 196
Gaios Ophellios
Dionysos and Timarchides.
Gaios Ophellios, torso
Gait Post. Locks
Gaius (Roman Jurist c 110-180)
Kiselewski. Gaius, medallion
head
Gaja-Laksmi
Indian--Pallava. Descent of
the Ganges: Gaja-Laksmi
Gakko Bosatsu (Gakko Bodhisattva)
Japanese--Tempyo. Bonten
--Gakko Bodhisattva
Gal Vihara
Ceylonese. Gal Vihara
Galactic Cluster # 1. Lassaw
Galaxy. Kiesler
Galaxy of Andromeda.
Lassaw
Galba, Servius Sulpicius (Roman
Emperor 5 B.C. 60 A.D.)
Roman--1st c. Galba
--Orichalcum: Galba
--Sestertius: Galba
Galerius Valerius Maximianus, Gaius
(Roman Emperor d 311)
Roman--4th c. Arch of
Galerius
--Galerius Addresses his
Troops

--The Tetrarchs
Galla Placidia (Roman Emperor of the
 West 388-450)
 Roman--5th c. Solidus: Galla
 Placidia
 --Siliqua: Galla Placidia
Gallas Rock. Voulkos, P.
Gallaudet, Thomas Hopkins
 (Educator of the Deaf 1787-
 1851)
 French, D. C. Thomas
 Hopkins Gallaudet
GALLEGOS, Celso (Spanish-
 American 1857-1943)
 Rooster pine; 11
 PIE 377 UNmSM
 (L. 5. 52-17)
Galli-Curci, Amelita (Operatic
 Soprano 1889-)
 Clark, A. Amelita Galli-
 Curci, bust
GALLIC
 Bearded God, head
 GAF 453
 FLecL
 Coin
 GAF 164 FPMone
 Cylindrical Samian Bowl,
 Wales clay; Dm: 6-1/2
 ARTSW 40 WCaN
 Female Head c 1st c. B. C.
 wood
 BAZINW 185 (col)
 Head
 GAF 486 FNimL
 Hermes Bicephalus, detail,
 Roquepertuse 3rd/2nd c.
 B. C.
 GIE 83 FMaB
 La Tene Style Disk 4th c.
 B. C. gold
 BAZINL pl 244 FPMe
 Money-Bag Decoration,
 Wingles, France 7th c.
 bronze
 LAS 88 BBRA
 Parisii Stater 1st c. B. C.
 gold
 BAZINL pl 131 FPMe
 Sarcophagus 7th c. Pyrenean
 marble
 LAS 87 FTM
 Two-Headed Hermes, portal
 fragments, Roquepertuse
 3rd/2nd c. B. C.
 LARA 212 FMaB
Gallic Cock. Lamont
Gallienus, Publius Licinius

Valerianus (Emperor of Rome
 d 268)
 Roman--3rd c. Gallienus#
 --Medallion: Gallienus and
 Salonina
GALLINASO(?)
 Bridge and Spout Effigy
 Vessel clay; 8-3/8
 NPPM pl 106 UNNMPA
 (59. 187)
GALLO, Frank (American 1933-)
 Critic 1964 polyester resin;
 13x11x13
 WHITNY-3:#23 UNNGrah
 Girl in Sling Chair
 polyester resin
 WHITNA-17 UNjLeS
 Head of a Fighter 1965
 KULN 45
 Love Object 1966 epoxy resin
 reinforced with fiberglas
 and wood; 57x28
 KULN 29; UIA-13:129
 UICGil
 Portrait of the Artist epoxy;
 80
 WHITNA-18:32
 Quiet Nude 1966
 KULN 28
 Squatting Woman*
 EXS 29
 The Swimmer 1964 polyester
 resin; 65x16x41-1/4
 UIA-12:79; WHITNY-3:#24
 UNNW
 Walking Nude 1967
 BURN 329 UICGil
GALLO-GRECIAN
 Mausoleum Base Relief
 1st c. B. C.
 GAF 529 FStRJ
GALLO-ROMAN
 Cippus, with Female Dancer,
 Archeological Institute of
 Luxemburg, Arlon stone
 BAZINW 186 (col)
 Crossbow Fibula 4/5th c.
 bronze
 CLE 44 UOClA (30. 227)
 Detrier Venus bronze
 GAF 422 FChambS
 Entablature
 PANR fig 27 FBorL
 Female Bust stone; 5
 BAZINW 187 (col) FStG
 Figure Panel, St. Astier
 Church, Dordogne stone
 CHENSW 321

Figures, capital of Verecourt,
Vosges
MALV 226 FEpM
Four Trophy Death Masks
GAF 506 FAixA
The Good Shepherd, relief
MALV 145 FArlL
Grave Stele with Effigy 3rd c.
LARA 343 FSenM
Hercules and the Nemean
Lion, dish relief silver
LARB 19 FPMe
Hermes of Roquepertuse
GAF 521 FMaB
Horseman Fighting Panther,
chariot ornament
LARB 315 FStG
Horsemen and Soldiers,
frieze, Arch of Augustus
9 B. C.
BAZINW 185 (col) ISu
Medallion: Probus 3rd c.
LARA 98 FPBN
Medea 2nd c.
BAZINW 187 (col) FArlLP
Minerva of Poitiers 1st c.
GAF 366 FPoB
Ornaments 2nd/3rd c. bronze
and enamel
CLE 44 UOCIA (30. 230-. 234).
Rearing Bull, Autun
BRIONA 70 FPL
St. Sernin, menhir
GAF 463 FRoF
Sarcophagus, detail
GAF 509 FArlLP
Sarcophagus of Sainte-Quitterie
5th c. marble
GAF 441 FAire
Stele
GAF 182 FMetM
Stele of Bellicus the Black-
smith
BAZINW 186 (col) FSenM
Stele with Four Dieties 3rd c.
BAZINW 186 (col) Musee
Archeologique FStr
Three-Horned Bull, Avrigney
BRIONA 69 FBesM
Triumphal Arch 49 B. C.
GAF 525 FOr
Triumphal Arch, remains
GAF 515 FCarp
Vacheres Warrior
GAF 514 FAviL
Venus Anadyomene
MALV 147 FOM
Victory, headless figure
GAF 182 FMetM

Woman in a Shop, stele
GAF 176 FEpM
Gallos, Gaius Vibius Trebonianus
(Roman Emperor 205(?)-253(?))
Roman--3rd c. Trebonianus
Gallus#
GALT, Alexander (American 1827-63)
Bacchante, bust c 1852
marble; 21
CRAVS fig 6. 13 UDCC
Chief Justice John Rutledge,
bust marble
USC 186 UDCCap
GAMBUM (Japanese)
Mushroom and Two Chestnuts,
netsuke wood
SOTH-4:172
Game. Asakura Fumio
The Game. Ferber
Games and Sports
Greek--5th c. B. C. Stele:
Athlete#
Minoan. Sport Scenes, vessel
Polyclitus. Diadumenus
(Athlete with Fillet)
Roman--4th c. Obelisk of
Theodosius, relief:
Theodosius I and his
Family in Imperial Box at
Hippodrome of Constanti-
nople
Thompson, W. J. Children
Playing
--Astragalus (Knucklebones)
Greco-Roman. Astragalus Player
Hellenistic. Two Girls Playing
Knucklebones
--Ball Games
Greek--6th c. B. C. Dog and
Cat Fight; Six Youths
Playing Ball
Greek--4th c. B. C. Ballplayer
--Girl Running with Ball
Tilden, D. Ball Thrower
--Baseball
Folk Art--American. Cigar
Store Figure: Baseball
Player
--Basketball
Spampinato. Basketball
--Billiards
Smith, D. Billiard Player
--Board Games
African--Benin. War Game#
African--Nigerian. Man and
Woman Playing Board Game
Chinese--Han. Players at a
Board Game

Egyptian--1st Dyn. Jeu du
 Serpent: Mehen
Polynesian. Konane Game
 Board
--Boxing
Apollonius. Boxer
Archipenko. The Boxers
Archipenko. Boxing
Archipenko. Boxing Match
Barthe. Boxer
Ben-Shmuel. Boxers
Childers. Pugilist
Coblano of Afrodisia. Boxer
 of Sorrento
Gallo, F. Head of a Fighter
Greco-Roman. The Pugilist
Greek. Dresden Boxer
Greek--4th c. B. C. Boxer#
Hellenistic. Boxer#
--Boy Boxer(?)
Lysistratus. Boxer
Murray, S. The Boxer
Niehaus. Man Tying on the
 Cestus
Policlitus. Boxer
Roman--1st c. B. C. Boxer,
 seated figure
Young, M. M. Boxer(s)#
Young, M. M. "Da Winnah"
Young, M. M. Groggy
Young, M. M. The Knock
 Down
Young, M. M. Right to the
 Jaw
--Bull Dancing
Minoan. Bull Jumper
--Bull with Dancer
--Girl Toreador
--Bull Fighting
Albarran y Pliego. Toreador
 on Horseback
Chase, B. Victorious
 Bullfight
Cox, C. B. Bullfight
Gershoy. Ill-Fated
 Toreador
Kaz. Suit of Lights (Matador)
Lipchitz. Matador
--Card Games
Chinese--Han. Card Players
--Chariot Racing
Assyrian. Chariot Race
Greek--5th c. B. C. Syracuse
 Demarateion: Nike Crown-
 ing Chariot Race Winner
Hellenistic. Altar of Zeus,
 Pergamon: Chariot Race
 between Pelops and
 Oenomaus

Roman. Circus Races with
 Cupids, sarcophagus
Roman--1st c. Cup: Cupids
 Racing Chariots
Roth, F. G. R. Chariot Race
--Checkers
Rogers, J. Checkers up at
 the Farm
--Chess
Khmer. Chess Players, relief
Seiden. Chess Set
--Cock Fighting
Chinese--Six Dynasties. Fight-
 ing Cock
der Harootian. Fighting
 Cockerels
Gonzalez Goyri. Cock Fight
Hoffman, W. Bantam Fighting
 Cock
Japanese--Tokugawa. Netsuke:
 Dutchman Holding Fighting
 Cock
Khmer. Cockfight
Roman. Eros and Anteros
 Supervising a Cockfight,
 sarcophagus relief
Smith, D. Cockfight#
--Cycling
Hovannes. Racing Cyclists
McWhorter, J. Unicycle
--Dice
Decker, A. Crap Shooter
Jungwirth, L. D. Crap
 Shooters
Roman. Dice Player
--Discus
Greek--6th c. B. C. Stele:
 Discus Bearer
Greek--5th c. B. C.
 Discobolos (Discus-
 Thrower)
McKenzie, R. T. Discus
 Thrower
Myron. Discobolus (Discus
 Thrower)
--Dog and Cat Fights
Greek--6th c. B. C. Dog and
 Cat Fight
--Falconry See also Falcons
Chinese--T'ang. Falconer on
 Horseback
Coptic. Panel Details: Man
 Riding with Hawk
Hancock, W. Falconer,
 plaque
Islamic. Filigree Equestrian
 Falconer
Japanese--Ancient. Falconer,
 haniwa#

Jalisco. Warrior, or Ball-Player
Maya. Ball-Court Marker: Op-
posing Equipped Ball Players
--Ball Player in Playing Suit
--Pelote Player, relief on
commemorative disc
--Plaque: Ball-Player in
Headdress
--Sacrifice of Ball-Player,
ball court relief
--Two Teams of Ball Players,
relief
--Whistle: Ball Player in
Belt and Animal Headdress
Nayarit. Ball Court Model,
with Players and Spectators
--Pelote Game
Toltec. Macaw, head, goal in
sacred ball game
Totonac. Stele: Dressing of a
Ball-Player
--Track Events
Greek--6th c. B. C. Ephebean
Athletes: High Jump;
Wrestling; Javelin Throw
--Wrestling
Austin. Head-Scissors
Ben-Shmuel. Wrestlers
Chinese--Chou. Wrestlers#
Colima. Wrestler
Diederich. Wrestlers
Eskimo. Toy Wrestlers
Etruscan. Two Wrestlers,
vessel cover handle
Ferber. Wrestlers
Greek--6th c. B. C. Ephebean
Athletes
Hellenistic. Wrestlers
Indians of North America--
Alaska. Wrestlers
Japanese--Tokugawa. Netsuke:
Wrestlers
Khmer. Wrestlers#
Lysippus--Foll. Wrestler(s)#
Manship. Wrestlers
Nebel, B. Wrestlers
Notaro. Wrestlers
Olmec. Wrestler
Sumerian. Wrestlers Balancing
Jars on Heads
Talcott. Wrestler
Gamos II. Decker
GAMU GOFA See AFRICAN--GAMU
GOFA
Ganas, Attendant Divinities of Siva
Indian--Hindu--7th c.
Ganas Sporting in Air
GANDHARA See INDIAN--KUSHAN

Gandharva
Chinese--Wei. Celestial
Musician
Indian--Gupta. Gandharva and
Apsaras
Indian--Kushan--Gandhara.
Flying Gandharvas
Ganesha (Elephant-Headed God of
Wisdom, Arts, and Sciences)
Indian--Hindu--11th c.
Ganesha: Dancing
Javanese. Stele of Ganesha
Thai. Ganesha
GANGA See INDIAN--ORISSA
Ganga (Goddess of the Ganges)
Indian--Gupta. Ganga Devi
Indian--Kushan--Mathura.
Ganga
Ganges
Indian--Pallava. Descent of
the Ganges
GANIERE, George Etienne (American
d 1935)
Lincoln 1913
BUL 165 UWiB
Lincoln, scroll in left hand
1913
BUL 165 UIaW
Ganjin (Japanese Missionary Priest
fl 763-765)
Japanese--Tempyo. Priest
Ganjin, seated figure
Gantt, Peggy
Adams, H. Peggy Gantt,
plaque
Ganymede
Greco-Roman. Ganymede and
the Eagle
Greek--5th c. B. C. Zeus
Abducting Ganymede
Greek--4th c. B. C. Earrings:
Ganymede with the Eagle
--Ganymede
Leochares. Eagle and
Ganymede
GARAFULIC, Lily (Chilean 1914-)
Portrait: Female Head
TOLC 91
Garage Environment. Kaprow
Garces, Francisco
Kangas, J. P. Padre
Francisco Garces
The Garden. Smith, D.
Garden at Night. Bourgeois
Garden of Eden See also Adam and
Eve
Schimmel, W. Garden of Eden
Garden Sculpture and Ornaments

Indian--Hindu--9th c.
 Monastery Gateway
Indian--Hindu--12th c. City
 Gateway
Indian--Sunga. Gateway and
 Stupa Bharhat
Islamic. Rabat Gate
Japanese--Momoyama. Kara
 Gate
Javanese. Gunungan, with
 Gate of Heaven
Manship. Bronx Zoological
 Garden Gateway
Mycenaean. Lion Gate
Ries, V. Sanctuary Gates
Roman--2nd c. Market Gate
 at Miletus
Sullivan, L. The Golden Gate
Sumerian. Lions, Temple gate
Welton. Gate: Tools, including
 Plow
The Gates to Times Square. Chryssa
Gateway. Lipton
A Gathering of Birds. Caparn
GAULOIS, Helene (American)
 Young girl terracotta
 UNA 18
Gauls
 Etruscan. Certosa Gravestone
 --Gallic Warrior
 Hellenistic. Dead Gaul
 --Dying Gaul
 --Fighting Gaul
 --Gallus
 --Gaul, reclining figure
 --Gaul Slaying Himself,
 Supporting Body of his Wife
 --Ludovisi Gaul
 --Repulse of Gauls
 Roman--1st c. B.C. Cavalry
 Battle between Romans and
 Gauls
 Roman--1st c. Battle between
 Romans and Gauls, relief
 --Triumphal Arch, Orange:
 Battle between Roman
 Cavalry and Gauls
 Roman--2nd c. Sarcophagus:
 Cavalry Battle between
 Romans and Gauls
GAZELLE PENINSULA See NEW
 GUINEA
Gazelles
 Amlash. Gazelle Cup
 Assyrian. Herd of Gazelles
 Coptic. Leaf Scrolls, with
 animals in roundels
 Egyptian--1st/2nd Dyn.
 Palette: Gazelles Facing
 Palm Tree

Egyptian--18th Dyn. Gazelle
Francisci. Boys and Gazelle
Hittite. Men Carrying
 Gazelles
Jennewein. Cupid and Gazelle
Manca, A. Gazelle
Manship. Dancer and Gazelles
Metcalf, Jack. Gazelles
 Running
Nadelman, E. Gazelle
Natufi. Crouching Gazelle
Rotan, W. Gazelle
Scaravaglione, C. Girl and
 Gazelle
Sumerian. Cylinder Seal:
 Bird and Gazelle Motif
GAZZERI, Ernesto
 Mystery of Life
 REED 155 UCGF
GEBER, Hana (American)
 The Dream sterling silver; 10
 HAN-3:11
Gebu, Keeper of the Seal. Egyptian--
 13/14th Dyn.
Geese
 Afghanistan. Girl Playing with
 Goose
 Boethus. Boy with Goose
 Chinese--Ch'ing. Famille-
 Rose Goose Tureen and
 Cover
 Egyptian--4th Dyn. Goose,
 relief
 Etruscan. Engraved Mirror:
 Adonis (Atunis) and Lasa
 Folk Art--American. Canada
 Goose
 --Goose Whistle
 Greek--5th c. B.C. Goose,
 with Goslings
 --Toys
 Greek--4th c. B.C. Aphrodite:
 Riding a Goose
 Guinzburg. Satyr and Goose
 Hasan of Kashan. Alp Arslan
 Salvar
 Hellenistic. Boy with Goose
 Indian. Kailasa Temple: Apsara
 with Goose
 Khmer. Geese, relief
 Laurent. Goose
 Laurent. Goose Fountain
 Phoenician. Basin: Warriors;
 Geese; Snakes
 Scopas--Attrib. Pothos
 (Longing)
 Warneke. Hissing Geese
GEH See AFRICAN--GEH
GEIS, William R. III (American 1940-)
 Untitled (#3) 1964 plaster,

paint, fiberglass; 5-1/2x
47x5-1/2
NYWL 97
"Want Not..." 1965 plaster,
fiberglas; 84x84x42
TUC 106 (col)
GEISSBUHLER, Arnold (Swiss-
American 1897-)
Family bronze; 15
SG-3
--bronze; 20
SG-5
--bronze; 21
SG-3
--bronze; 30
SG-6
Figure cast stone
SGO-10:19
--plaster
NYW 197
Formal Reception bronze; 15
SG-4
Group: "Two Figures" plaster
SGO-4:pl 22
Miss Viaga, head bronze
SGT pl 18
Torso plaster
SGO-2:pl 35
Two Figures bronze; 21 SG-7
GEIST, Sidney (American 1914-)
Out There 1962 H: 35-1/2
SEITC 87 (col)
Standard 3 1951 wood; 94
BERCK 269
Gelede Society
African--Fon. Gelede Society
Mask
African--Yoruba. Gelede Mask#
Geminae. Keyser, E.
Gemini No. 1. Malderelli, O.
Gemma Augusta. Roman--1st c.
Gems
Aspasios. Gem: Athena
Parthenos, profile
Cretan. Gem: Stag
Dexamenos. Gem(s)#
Epimenes. Archer, engraved
gem
Epimenes--Attrib. Gem:
Kneeling Archer
Euphranor. Carnelian: Bonus
Eventus
Greek. Gem#
Greek--7th c. B. C. Pegasus,
carved gem
Greek--6th c. B. C. Satyr,
reclining figure, scarab
Greek--5th c. B. C. Gem:
Stag

--Hades and Persephone,
chalcedony
--Stag, intaglio gem
--Winged Figure Carrying
Girl, carnelian
Hellenistic. Gem#
Phidias. Athena Parthenos
(copy: carnelian ringstone
and Roman coin)
Phidias. Athena Parthenos
(copy: red jasper gem
signed by Aspasios)
Polyclitus. Gem: Apoxyomenos
Polyclitus. Gem: Narkissos
Polyclitus. Gems: Amazons
Roman--3rd/1st c. B. C.
Sculptor Seated on Stool
Sculpting Bust, italic gem
Roman--1st c. B. C. Carved
Gem: Emperor Augustus
as Neptune Driving Four
Sea Horses
--Demosthenes, head,
amethyst ringstone
Sumerian. Amulets, carved
gems: Duck, Frog, Ram
Gendarme Seated. Storrs, J.
GENDUSA, Sam
Design for a Church, repousse
relief copper
MEILD 146
The General. Kallem
The General. Robus, H.
The Generals. Marisol
Genesis. Decker, L.
Genesis. Levitan
Genesis. Pattison, P.
Genetrix. Phillips, Helen
Geniis
Assyrian. Winged Genie#
Genius of Creation. French, D. C.
Genius of Mechanics. Patigian, H.
Genius of Mirth. Crawford
Genius of the Senate (Genius Senatus)
Roman--3rd c. Acilia
Sarcophagus: Genius
Senatus
--Arch at Lepcis, panel:
Sacrifice in Honor of
Imperial House: Julia
Domna with Roma and
Genius of the Senate
Gens Furia Sepulchral Relief: Male
Bust. Roman--1st c.
Gen-so
Japanese--Tokugawa. Netsuke:
Gen-so and Yo-Kihi
Genthe, Arnold
Korbel. Arnold Genthe, head

Hermit 1961 iron
 VEN-62:pl 101
The Sentinel 1957/59 iron
 MAI 110
GERVAN, James R. (American)
 Night Form welded steel;
 18x49
 HARO-2:30
GERZEAN CULTURE See
 EGYPTIAN--PREHISTORIC
GESNER, Herbert M., III (American)
 Multiple Projection Wheel
 1966 plexiglass, aluminum,
 steel, wood, motors, lenses,
 projections
 KN pl D2
Gesture. Edelman
The Gesture. Treiman, J.
Gesture No. 1. Turner, R.
Geta (Roman Emperor 189-212)
 Roman—3rd c. Arch of Septimus
 Severus: Triumphal
 Procession of Septimius
 Severus, with Sons Caracalla
 and Geta
 --Geta, bust
 --Septimius Severus, with
 Sons Caracalla and Geta,
 Receives Senators, relief
Getty Tomb, Graceland Cemetery,
 Chicago
 Sullivan, L. H. Bronze Door
GHANA See AFRICAN--GHANA
Ghea. Saint-Phalle
Ghost Dancer. Bartlett
Ghost Jar. Melchert
Ghost Telephone. Oldenburg, C.
Ghost Toaster. Oldenburg, C.
Ghost Toilet. Oldenburg, C.
Ghost Typewriter. Oldenburg, C.
Ghosts
 Japanese--Tokugawa. Netsuke:
 Ghost Towering over Small
 Man
 Kayan Dayak. Soul-Catcher
 Ghost
Giacometti, Alberto (Swiss
 Sculptor 1901-66)
 di Suvero, M. Memorial for
 Giacometti
GIAMBERTONE, Paul (American)
 Grotesque cement
 UNA 20
GIANAKOS, Cristos (American 1934-)
 Sculpture No. 10 polyester
 resin; 24x30x30
 WHITNA-19
GIANFORTE, Joseph C. (American)
 Herons, relief marble
 NATSS-67:82

Giant Blue Pants. Oldenburg, C.
Giant Blue Shirt with Brown Tie.
 Oldenburg, C.
Giant Branch. Lynch
Giant Frog. Chapin
Giant Good Humor. Oldenburg, C.
Giant Hamburger and Giant Hotdog.
 Oldenburg, C.
Giant Ice Cream Cone. Oldenburg, C.
Giant Mushroom. Seiden
Giant Soft Drum Set. Oldenburg, C.
Giants
 Athenion. Zeus Downing
 Giants, cameo
 Greek--6th c. B. C. Battle
 of Gods and Giants
 --Siphnian Treasury
 --Temple of Artemis, Corfu
 --Temple of Athena,
 Acropolis, Athens; Athena
 and Giant
 Greek--5th c. B. C. Giants,
 heads from Temple of Zeus
 Khmer. Giants
 Roman--2nd c. Sarcophagus:
 Gigantomachy
Gibbon, Edward (English Historian
 1737-94)
 Niehaus. Edward Gibbon
Gibbons, James (1861-1911)
 Miller, J. M. Cardinal
 Gibbons Medallion
GIBBS, Harrison (American)
 Harvest
 PAA-41
Gibbs, Josiah Willard (American
 Physicist 1839-1903)
 Martineau, S. Josiah Willard
 Gibbs, bust
 Martineau, S. Josiah Willard
 Gibbs, medal
GIBRAN, Kahlil (Lebanese-American
 1922-)
 Relic welded steel rod
 WHITNA-17:18
 St. John the Baptist 1956
 welded steel; 84
 UIA-9:pl 18 UNNS
 Seated Nude 1960/61 hammered
 steel; 42
 UIA-11:65 UNNNo
 The Victim 1962 hammered
 steel; 48
 CAMI pl 112 UMBSh
 The Voice in the Wilderness
 1957
 welded iron; 68
 CAMI pl 111 UPPPA
GIBSON, Carter
 Tricycle brass

MEILD 19 UICSh
GIBSON, Robert R. (American)
 Look Homeward plaster
 coated aluminum screen
 foundation; 60-1/2
 HARO-2:16
Gielgud, John (English Actor)
 Barthe. John Gielgud as
 Hamlet, bust
Gifford, Stanford R. (American
 Painter 1823-80)
 Thompson, L. Stanford R.
 Gifford
Gift Bearers, tomb relief.
 Egyptian--5th Dyn
Gifts See also Charity
 Roman--2nd c. Arch of
 Trajan, Benevento
Gigaku
 Japanese. Gigaku Dance
 Mask#
 Japanese--Tempyo. Gigaku
 Dance Mask
Gigantomachy
 Greek--6th c. B. C. Siphnian
 Treasury, Delphi
 Roman--2nd c. Sarcophagus:
 Gigantomachy
GILBERT, Charles Webb
 (Australian 1866-1925)
 Sun and the Earth
 MOO-2:86 AuMGV
Gilbert, John (American Comedian
 1810-89)
 Hartley, J. S. John Gilbert
 as Sir Peter Teazle
GILBERTSON, Boris (American
 1907-)
 Bull limestone
 CHICA-54:pl 15
Gilgamesh (Legendary King of Uruk)
 Assyrian. Gilgamesh and the
 Lion
 Babylonian. Cylinder Seal:
 Gilgamesh and Enkidu Fight-
 ing Sacred Bull and Lion
 Luristan. "Gilgamesh" between
 Felines, cheek plaque for
 bit
 --Gilgamesh between Two
 Beasts, talisman
 --Standard Finial: Gilgamesh
 Holding Opposed Animals
 Sumerian. Cylinder Seal:
 Gilgamesh Taming Bull
 --Harp of Queen Shubad,
 Bull's Head Decoration,
 Ur; Shell Plaque with
 Mythological Scenes,

 including Gilgamesh
 Subduing Human-Headed
 Bulls
 --Vase: Gilgamesh-Type
 Figure Subduing Bull
 Calves
GILL, James (American 1934-)
 Woman in Brown Car Number
 1 1963 bronze, plexiglas,
 enamel; 5x8-3/4x7
 WHITNS 18 UNNW
Gilman, Daniel Coit (American
 Educator 1831-1908)
 Miller, J. M. Daniel Coit
 Gilman, relief
Gingerbread Molds See Molds
GINNEVER, Chuck (American 1931-)
 Wipe Out 1964 lacquered
 steel; 7-1/2x10x11
 NYWL 99
Gins, Lucy
 Daingerfield. Lucy Gins,
 head
GIO See AFRICAN--GIO
GIORGI, Bruno (Brazilian 1903-)
 Composicao No. 3 SAO-1
 Figura
 SAO-1
 Figures bronze
 MAI 118
 A Luta
 SAO-2
 Mario de Andrade, head,
 Bronze Garden 1946
 BARD-2:pl 123 BrSpL
 Two Amazons 1963 bronze;
 31-1/2x16-7/8
 READCON 240
 Two Figures*
 LARM 423 BrBP
Giotto (Florentine Painter 1276(?)-
 1337(?))
 Larrigue. Giotto
Giraffes
 African. Giraffe Spoons
 Bormacher, R. Giraffe
 Egyptian--1st/2nd Dyn.
 Cosmetic Palette: Giraffes
 and Palm
 Folk Art--American.
 Carrousel Giraffe
 Louff. Carrousel Giraffe
 Paleolithic. Giraffe(s)#,
 incised rock figures
 Terris, A. Giraffe Tall
 Standing Structure I
Girard, Stephen (American Business-
 man and Philanthropist 1750-
 1831)
 Rhind. J. M. Stephen Girard

Girdles
 Etruscan Girdle
Girl and Kitten Awakening. Eberle
Girl by a Pool. Grimes
Girl Combing her Hair. Parks, C. C.
Girl from Antium. Hellenistic
Girl from Chios
 Greek--6th c. B. C. Kore.
 Chios
Girl in a Straw Hat. Greenbaum
Girl in Dorian Peplos
 Greek--6th c. B. C. Kore
 (Girl in Dorian Peplos)
Girl in Granite. Davis, Richard
Girl in Sleeved Chiton
 Greek--6th c. B. C. Kore
 (Girl in Dorian Peplos)
Girl in Sling Chair. Gallo
Girl Leaning on an Umbrella.
 Ziegler, L.
The Girl Musician. Zadkine
Girl of Brassempouy
 Paleolithic. "Dame de
 Brassempouy", head
Girl on a Horse. Melicov
Girl on a Wheel. Gross
Girl on a Pony. Zorach
Girl Playing. Mestrovic
Girl Reading. Davis, Richard
Girl Reading. Henn
Girl Reading. Robus
Girl Washing her Hair. Laurent
Girl Washing her Hair. Robus
Girl with a Braid. Lipchitz
Girl with a Flute# Hare
Girl with a Mirror. Gross
Girl with Bird. Umlauf
Girl with Birds. Hebald
Girl with Bobbed Hair. Lachaise
Girl with Crane. Scaravaglione, C.
Girl with Fawn. Scaravaglione, C.
Girl with Fish. Loring
Girl with Fish. Mayor, H. H.
Girl with Gazelle. Scaravaglione, C.
Girl with Guitar. Mestrovic
Girl with Hat. Wilks
Girl with Pigeons, funeral stele.
 Greek
Girl with Snail and Boy with Bird.
 Conrad, B.
Girl with Squirrel. Shaw, S. van D.
Girl with the Curls. Cresson
Girl with the Dolphin. Frishmuth
Girl with Towel. Greenbaum
Girl with Water Lilies. Adams, H.
Girls with a Rail. Loring
Giro d'Italia. Pattison, A. L.

GIROLAMI, George (American)
 Joan of Arc plaster
 NYW 196
GIROUARD, Gerard (American
 Jeune Femme plaster
 UNA 21
Giustiniani Vesta
 Greek--5th c. B. C. Hestia
 Giusttiniani
Gladiator. Konzal
Gladiator Farnese. Kresilas
Gladiators See Games and Sports
GLADSTONE, Gerald (Canadian
 1929-)
 Hanging Sculpture 1964 metal;
 36
 CAN-4:207 CON
 Sculpture*
 EXS 37
GLASCO, Joseph (American 1925-)
 Head 1957 alabaster; 10
 DETS 43 UNNH
 Man Walking 1955 bronze;
 17-1/2
 PIE 386 UNNMMA (190. 56)
 Man with a Mirror bronze;
 17-1/2
 UIA-8:pl 5
Glass, Carter
 Adams, H. Carter Glass,
 relief
Glass Case with Pies. Oldenburg, C.
GLEASON, William B. (American
 fl 1847-58)
 Figurehead: Minehaha 1856
 ptd pine; 70-1/2
 COLW 329 (col) UVWR
GLENNY, Anna (Mrs. Davis Dunbar)
 (American 1888-)
 The Jewess 1934/35 red
 concrete; 24
 NYW 197; PIE 387 UNBuA
 (S-146)
 Katherine Cornell, head 1930
 bronze
 NNMML
 Mrs. Wolcott 1930 bronze
 NMAP # 130
 Negress bronze; 25
 NMPS # 106
GLICENSTEIN, Enrico (Henryk
 Glicenstein) (Israeli-
 American 1870-1942)
 Group mahogany
 SGO-2:pl 37
 Mother and Child mahogany
 SGT pl 20

National Defense redwood
SGO-4:pl 23
Player mahogany
NYW 199; UNA 22
Woman Pioneer terracotta
ROTH 867 IsEA
Glick, George Washington (American
Pioneer 1827-1911)
Niehaus George W. Glick
GLICKMAN, Maurice (Rumanian-
American 1906-)
Debutante bronze; 10
SG-5
Family Group plaster
SGO-2:pl 39
Father and Son bronze; 7-1/2
SG-3
Garden Figure plaster
SGO-10:20
Grief clay
SCHW pl 84
Jacob Wrestling with the
Angel plaster, for bronze;
W: 22
SG-3
Lament bronze; LS
SG-4
Memorial (Lest We Forget
the Victims of Pearl
Harbor, Coventry,
Rotterdam, Warsaw, Bar-
celona, Sevastopol) plaster
SGO-4:pl 24
Negro Mother and Child
bronze
NYW 198
Pearl Divers aluminum
SCHW pl 83
Refugee Mother and Child
Indiana red limestone
SGT pl 21
Susanna aluminum; 48
SGO-17
War Memorial plaster
UNA 23
Young Nude cast stone
SGO-1:pl 26
GLINSKY, Vincent (Russian-
American 1897-)
Anita cast stone
SGO-4:pl 25
The Awakening Carrara marble
BRUM pl 47, 48; PAA-48;
SGO-2:pl 42
Bather limestone; 18
SG-3
The Dreamer marble
SGO-1:pl 28

The Flower bronze
SCHN pl 58; SGT pl 22
Fugue marble
NATSS-67:23
Morning Awakening Carrara
marble; L: 24
SGO-17
Mother and Child ebony
SGO-10:21
--French limestone; 23
SG-2
November 1963 rosewood; 47
SG-6
Panther black Belgian
marble; L: 17 SG-4
Peace plaster
NYW 196
Space, Fountain design
chestnut, for bronze; 60
SG-7
The Thunder California
redwood; 9'
SG-5
Wilbur Wright, bust bronze
HF 91 UNNHF
Glint of the Sea. Beach
Globe. Frazier, C.
Gloria, head. Weschler, A.
Glorification of Beauty. Archipenko
Glorification of the Flower
Greek--5th c. B.C. Demeter
and Cora
GLOVER, LeMaxie (American 1916-)
Moses 1958 cast bronze
CIN #17 UOSW
Gloves
Indians of South America--
Peru. Funerary Gloves,
seven-part gold
"Glutton Mask"
Chinese--Shang. T'ao-t'ieh
GLYCON (Athenian fl 1st c. B.C.)
See also Lysippus
Farnese Hercules (after
Lysippus bronze of 4th c.
B.C.), Baths of
Caracalla, Rome 1st c.
B.C. marble; 127
BAZINW 151 (col); CHASE
139; CHENSW 131; ROOS
36M; SCHERM pl 152 INN
Glyptics See Cameos; Gems; Seals
Go. Hatchett
Go-Ko (King of a Foreign Country)
Japanese--Suiko. Gigaku
Dance Mask
Goalie. Josset

Hellenistic. Greco-Iranian
Divinity
--Olympian Gods in
Procession
Hittite. Assembly of Gods
--God(s)#
--Goddess with Goats, box
lid
--King and God, rock relief
Huastec. Goddess in Conical
Hat (Copilli)
Indian. Diety, dancing figure
--Diety as High Priest,
seated triple-headed
figure
--River Goddess
Indian--Gupta. Mother Goddess
Indian--Indus Valley. Seals:
Brahma Bull; Rhinoceros;
Seated Diety
Indian--Kushan--Andhra (Late).
Female Divinity
Indian--Maurya. Mother
Goddess#
--Winged Goddess
Indians of Central America--
Costa Rica. Pendant:
Crocodile God
--Serpent Diety
Indians of South America--
Colombia. Goddess Showing
her Son, "El Cabuyal"
Indians of South America--
Ecuador. Bat God#
Indians of South America--
Peru. Lime Container,
with Jaguar God
Indians of South America--
Venezuela. Alligator God
Indonesian. Battle of Gods
and Demons, relief
Israelite. Canaanite Diety
Kassite. Male and Female
Dieties, facade elements
Khmer. Churning of the Ocean
by Gods and Demons#
--Diety, head
--Divinity, head
--Female Divinity#
--A God, head#
--Hindu Gods
--Male Divinity
Luristan. God
Maldarelli, O. Goddess of
the Air
Maya. Axe God
--Death-God, head, altar
--Diety, head, with hiero-
glyphic text chaplet

--Effigy Head with Cover:
Jaguar Lord
--God of Virility, nude male
figure
--Goddess#
--Head of God
--Incense Burner: Jaguar
Lord of the Interior of the
Earth
--Maize God
--Maize Goddess
--Mask of Long-Nosed Diety
--Roman-Nosed God
--Vase, molded panels:
Long-Nosed Diety
--Whistling Vessel: Fire God
Melanesian--New Ireland.
Symbolic Carving: Fish-
Legged Figure, Soul-Bird
Emerging from Mouth
Mesopotamian. Snake God
Fighting with Ea and Gods
of Fertility, cylinder seal
Micronesian--Carolines. Diety
Figure
Minoan. Goddess
--Horned-Goddess with Doves
on Head
--Snake Goddess#
Mixtec. God of Death,
breastplate
Mochica. Head Ornament:
Plumed Feline Diety
Mycenaean. Pyxis Cover:
Goddess of Fertility
--Seals; Demons; Goddesses;
Sacred Tree
--Three Dieties
Near Eastern. Goddess, or
Votive Figure
Neo-Sumerian. Goddess,
relief
Neolithic--France. Goddess in
Sepulchral Cave
Palestinian. Canaanite Goddess
Persian. Susa God
Phoenician. God, in Hurri
Diety Headdress
--Goddess
Phrygian. Goddess between
Two Male Musicians
Polynesian--Austral Islands.
Goddess, with geometric
face and body designs
Polynesian--Cook Islands.
Canoe Prow: Fishermen's
God
--District God
Polynesian--Raratonga. District
God#

--Fisherman's God
Polynesian--Tonga. Goddess
Praxiteles--Foll. Goddess
from Chios, head
Quimbaya. Male and Female
Dieties
Roman. Goddess
Roman--1st c. Arch of
Trajan, Benevento: God
and Goddesses
Roman--2nd c. Column of
Marcus Aurelius: Miracle
of the Rain, with Sky God
--Gate of Roman Forum
--Gods in Assembly
Roman--4th c. River Gods
--Rustic Diety
Romano-Buddhist. Goddess
Sumerian. God, head
--Goddess, with Horns of
Divinity
--Goddess Holding Flowing
Vase
--Goddess of Growing
Vegetation
--Horned God, head
--Kneeling God
--Winged Goddess, plaque
Syrian. God Holding Spear
--Jabhul Diety, head
--Six-Winged Genius, relief
--Stele: Weather God
--Weather God, relief
Taino. God, seated figure
Tairona. Seated Diety
Tarascan. Howling Coyote,
God of Mountains, Shooting
Stars at Mysteries of
Night
Teotihuacan. Water Goddess
Tiahuanaco. Gate of the Sun:
Diety
--God with Spear-Thrower, and
Quiver, doorway relief
Zapotec. Funerary Urn: Diety
in Ceremonial Costume and
Headdress
--God, urn affixed to screen
--Jaguar, Diety of Earth and
Death
--Prince of Flowers: God of
Joy, Music and Dancing
--Urn: Seated Diety
"Gods and Humans"
Nivola, C. "Gods and Humans"
Series: Plaque Number 21
"Godsticks"
Maori. God Image, archaic
style "Godstick"

--"Godstick": Hukere
GODWIN, Frances Bryant (American)
Mare and Foal bronze;
12-3/4
BROO 481; NYW 194
UScGB
GODWIT, Hudsonian (American)
Decoy 19th c. ptd wood
CHR 139
GOERITZ, Mathias (German-
Mexican 1915-)
Automex Towers 1963/64
KULN 170
"Ciudad Satelite": Five
Towers (The Square of
the Five Towers), satellite
city of Mexico 1957/58
reinforced concrete--3
white towers, 1 yellow, 1
orange; 120 to 187x164'
BERCK 209; KULN 170;
LUN; MAI 119; TRI 237
MeM
The Echo (El Eco) 1952 H:
177
BERCK 200; KULN 171; LUN
MeME
The Family 1955 wood; 30x27
x6
BERCK 199 UNNCa
Golden Echo 1961
KULN 165
Message No. 1 (Mensaje
No. 1) iron, ptd wood
LUN
Message IX, Job 9:29--
"If I Be Wicked, Why Then
Labour in Vain?" 1958
sculpture-ptg; 71x63
CARNI-61:#128 UNNCa
Mexican Construction
LUN
Moses (Moises) wood, iron
LUN
GOETHE, Joseph (American)
Eve
CALF-57
GOFF, Emery (American)
Madre Verde steatite
NATSS-67:24
Gogh, Vincent van
Zadkine. Van Gogh Drawing
Going Places yellow metal
NEUW 136
Goitia, F. (Mexican Painter)
Asunsolo. Painter F. Goitia,
head
GOLA See AFRICAN--GOLA
GOLD COAST See AFRICAN--GOLD
COAST

Gold Miner's Monument. Lion, H.
"Gold of Courage"
 Egyptian--18th Dyn. Amen-
 hotep III: Wearing Blue
 Crown (War Helmet) and
 "Gold of Courage"
 Egyptian--19th Dyn. Ptahmai
 Family, "Gold of
 Courage", decoration
Gold Torso. Squier
Gold Tree. Bertoia
Gold Weights
 African--Ashanti. Gold
 Weight(s)#
GOLDBERG, Herb (American)
 The Creation, exterior wall
 decoration 1952 terazzo,
 concrete, cast bronze,
 stucco, marble; L: 45'
 KAM 91 UNmAAl
 Exodus, Revelation on Sinai,
 exterior wall decoration
 1952 concrete, agraffito,
 bronze, stainless steel;
 L: 75'
 KAM 92 UNmAAl
Golden Age. Lorenzani
"Golden Age of Chivalry",
 circus wagon. Lawrence
The Golden Bird is Often Sad.
 Stankiewicz, R.
Golden Boy. Chinese--Sung
Golden Cowry
 Fiji. Chief's Neck
 Ornament: Orange Cowry
 on Fibre
Golden Echo. Goeritz
Golden Hawk. Roszak, T.
The Golden Head. O'Connor, A.
The Golden Hour. Evans
Golden House of Nero
 Roman. Archers, relief
Golden Princess#1. Lippold
Goldfadem. Fadem
GOLDSHOLL, Millie
 Mobile--lever-activated
 rolling weights
 MOHV 84
GOLDSMITH, Jonathan (American
 1783-1847)
 Front Doorway, Isaac
 Gillet House, Painesville,
 Ohio ptd wood, glass,
 metal
 CLE 163 UOClA (59. 342)
Golem. Townley
Goliath See David
GOLUBIC, Theodore (American)

Evening, relief marble
 NATSS-67: 84
GOMITAKA (Indian)
 Yaksa Manibhadra c 200
 B. C. sandstone; 103-1/2
 KRAM pl 8 InMaM
Gondolier. Archipenko
A Gong as Moon. Calder, A.
Gongs See Musicians and Musical
 Instruments
Gonoch. Kennedy, R. F.
Gonzaga Cameo. Hellenistic
GONZALES, Julia (American 1908-)
 Woman Combing her Hair
 1936 H: 52
 UPJH pl 279 UNNMMA
GONZALEZ CAMARENA, Jorge
 (Mexican 1908-), and
 ARENAS BETANCOURT,
 Rodrigo
 Independence Monument,
 detail marble; 150
 LUN MeM
GONZALEZ GOYRI, Roberto
 (Guatemalan-American
 1924-)
 Cock Fight 1950 tin
 MAI 123 UCLA
 Ronzinante, head 1953 tin
 VEN-54: pl 61
The Good Life, or Living by the
 Rules. Ortman, G.
Good Night. Vonnoh, B. P.
Good Samaritan. Hardin
Good Shepherd
 Gallo-Roman. The Good
 Shepherd, relief
 Jobin. The Good Shepherd
 Roman. The Good Shepherd,
 sarcophagus relief
GOODE, Joe (American 1937-)
 Canoga Park 1962 oil on
 canvas and milk bottle;
 66x66
 OAK 29 UCLN
 Euclid (Staircase) 1966
 wood, paint, carpeting;
 53x33x54
 SEATL 29 UCLWi
GOODELMAN, Aaron J. (Russian-
 American 1890-)
 The Act copper, lead; 38
 SG-4
 Aria bronze, sheet copper;
 26
 SG-3
 Charging Bull, model terra-
 cotta, for welded sheet

metal; L: 30
SG-2
Dawn sheet copper; 90
RICJ pl 33; SGO-4:pl 26
The Driller bronze; 38 cm
SCHW pl 38
Empty Plate
ROODW 109
Happy Landing Tennessee
pink marble
BRUM pl 49 UNNAC
Hod Carrier wrought iron;
15-1/2
RICJ pl 31
Homeless
PUT 34
Maidenek Concentration Camp
direct plaster
SGO-10:22
Moses, head steel; 38
SG-5
Mother and Child Georgian
marble
SGO-1:pl 30
My Kin wild cherry wood
BRUM pl 50; ROODW 130;
UNNAC
Partisan 1946 plaster, for
bronze; 97 cm
SCHW pl 37; WHITNA-2;
front
Portrait of My Son (Amos J.
Goodelman) Tennessee
marble
SGO-2:pl 43
Rhythms brass; 16
RICJ pl 38; SG-6
The Rope mahogany
ROODW 60
Sarah Carrara marble
NYW 195
Steel Worker plaster
UNA 24
Undaunted mahogany
SGT pl 23
The Unknown steel; 46
SG-7
GOODMAN, Sam
The Cross c 1960 assemblage;
c 108
LIP 104 UNNStei
GOODMAN, Frances M.
Vice President Schuyler
Colfax, bust marble
FAIR 337; USC 174
UDCCap
GOODYEAR, John (American 1930-)
Diagonal Construction 1964
wood, enamel; 34x34
WHITNS 16 UNNW

Hot and Cold Bars aluminum,
plastic, electric circuitry;
5-3/4x5-3/4x72
WHITNA-19
Goose Boy. Angela
Goose Girl. Behl
Goose Girl. Gruppe
Goose Girl. Laurent
Gope Board
New Guinea. Ceremonial
Board
Gopuram. Indian--Pallava
Gordianus III
Roman--3rd c. Gordianus III
GORDIN, Sidney (Russian-American
1918-)
Abstractions
LYNCM 24 UNNB
Chess Set steel-bronze, nickel
plate
LYNCM 98
Construction, January 1955
brass; 28-1/2
WHITN 33 UNNB
Construction # 5 1951 steel,
ptd white and black;
24-1/8x31
MEN 638; NEWA 48
UNjNewM
Construction # 10 ptd steel;
36x41-1/4
AMAB 93; GOODA 255 (col);
PIE 387 UNNW (56.10)
Construction # 13 1956 ptd
steel; 72
WHITNA-12
Deflections 1953 ptd steel;
L: 60
WHITNN 33 UNBL
Fantasy 1957 welded steel;
12-1/2x16x4
BERCK 275
13 1954 steel, ptd black;
silver soldered; 72
SGO-17
17 1955 steel; 56-1/4
NMAR
19-59 welded steel
WHITNA-17:f
26-61 1961 welded steel
MEILD 109 UCSFDi
53-62 bronze
WHITNA-16:13
Promenade 1951 ptd steel; 90
WHITNN 32 UNNB
Rectangular, Number 3, con-
struction steel, ptd black
and white
LYNCM 108
UNNB

Rectangular, Number 5 1952
ptd steel
FAUL 488 UNNB
Sculpture*
AMAB 106 (col)
Gordon, Adam Lindsay
Montford, P. R. Adam
Lindsay Gordon, seated figure
GORDON, Simon
Walt Whitman steel; 64
ROODT 90
Gorgas, William Crawford (American
Physician and Sanitary Engineer
1854-1920)
Baker, B. William Crawford
Gorgas, bust
Gorgets See also Armor
Bronze Age--Ireland. Gorget,
or Lunula
Bronze Age--Sweden. Gorget
Huastec. Gorget#
Indians of North America--
Georgia. Gorget
Indians of North America--
Tennessee. Gorget#
Indians of South America--Peru.
Gorget
Gorgon Shield
Etruscan. Monteleone
Chariot. Fighting Soldiers
with Gorgon Shield
Phidias. Athena Parthenos
Gorgoneion
Roman--1st c. Augustus in
Aegis and Gorgoneion,
cameo
Gorgons See Medusa
Gorillas See Monkeys and Apes
Gorrie, John (American Inventor
1802-55)
Pillares, C. A. John Gorrie,
M. D.
GOSS, William (American)
Repetition of Forms platicum
SCHN pl 136
Gossip. Hellenistic
Gothic Landscape. Cousins
GOTHICO-BUDDHIST
Buddhist Head 4th c. (?)
MALV 159
GOTO, Joseph (American 1920-)
Early Spring welded steel
WHITNA-17:23
Family Tree steel
MEILD 109 UICA
Forms steel; 85
UIA-7:pl 44
Growth with Oval
MEILD 82

Landscape 1957 welded steel
and iron; L: 110
MEILD 88; UIA-8:pl 122
Morning welded steel and
iron
MEILD 88
Number 1 1960/62 steel;
60x72
LOND-6:#19 UNNFru
Number 14 1961/62 steel; 9
UIA-11:76 UICF
Organic Form #1 1951 welded
steel; 11'4-1/4"
PIE 387 UNNMMA (175. 52)
Struggling Form steel
MEILD 12 UICF
GOTTLIEB, Adolph
Voyager's Return
LYNCM 17 UNNMMA
Goucher, J. F.
Schuler, H. Dr. J. F.
Goucher, bust
GOULD, David (American 1929-)
Welded Iron c 1962 H: 42
READCON 238
GOULD, Thomas (American 1818-81)
West Wind 1869
TAFT 191 UMoSLM
GOULET, Lorrie (Lorraine Helen
Goulet; Mrs. Jose de Creeft)
(American 1925-)
Dianora 1960 pine; 90
SG-2
Lovers Russian alabaster; 44
SG-3
La Marseillaise pearwood; 49
SG-5
The Progeny oak; 49
SG-7
Serena white marble; 33
SG-6
Soma Cocobolo wood; 28
SG-4
GOUNDIE, George H. (American
1913-)
Head of a Young Girl 1959
bronze
CIN #18
GOURO See AFRICAN--GURO
Government of the People. Lipchitz
Graces See Three Graces
Gracious Countenance. Turnbull, G.
Graechwyl Hydria. Iron Age
GRAFLY, Charles (American
1862-1929)
Aeneas and Anchises 1893
bronze
CRAVS fig 12. 11 UPPPA

Daedalus, head
 WOR 85
David Glasgow Farragut, bust
 bronze
 HF 99 UNNHF
Dr. Joseph Price, head
 TAFTM 136
Edward W. Redfield, head
 1909 bronze
 CRAVS fig 12. 12 UDCC
Evangelist Felix, head
 CHICA-33
Fountain of Man, East
 Esplanade, Pan-American
 Exposition, Buffalo, New
 York 1901
 CRAVS fig 13. 5
--: Figure
 TAFT 512
Frank Duveneck, bust
 TAFTM 136
--
 CHICA-34
--bronze
 PAG-12:204 UMB
--1915 bronze; 26
 PIE 387 UPPiC (7)
From Generation to Generation
 HARTS pl 21
General Meade Memorial
 1915/25 marble; c20'
 NATS 129; PAA-25; PIE
 387 UDC
George C. Thomas, head
 TAFTM 137
Hermann Kotzschmar, head
 TAFT 577; TAFTM 136
 UMeP
Hugh Henry Breckenridge,
 head c 1899 bronze
 CRAVS fig 12. 13; PERL fol
 130 UPPPA
James Buchanan Eads, bust
 bronze
 HF 73 UNNHF
John Paul Jones, bust bronze
 HF 102 UNNHF
Jonathan Edwards, bust
 bronze
 HF 52 UNNHF
Mystery of the Man Fountain
 HARTS pl 36
Paul W. Bartlett, bust
 TAFTM 137
Pioneer Mother, monument
 1940 bronze
 ACA pl 217; PERR 129;
 REED 58; SFPPfront
 UCSFG

A Study: Female Relief Bust
 with Palm Leaf
 HARTS pl 29
Symbol of Life bronze
 HARTS pl 21; TAFT 506
Thomas Anshutz, head
 TAFTM 136
Truth
 TAFT 509 UMoA
Vulture of War 1895/96
 bronze; 32-1/4
 BROO 54 UScGB
War, study head, Meade
 Memorial plaster
 CHICA-37; NATSA 85
William Paxton, head
 TAFTM 137
 Portraits
Bartlett. Charles Grafly, head
Graham, Martha (American Dancer)
 Hauser. Martha Graham
GRAHAM, Robert (American 1938-)
 Don't Know Why There's No
 Sunshine in the Sky 1965
 wood, glass, clay; 20-1/2
 x11-1/2x6-1/2
 NYWL 101
 Untitled mixed media; 12x22x
 22
 WHITNA-19
 Untitled (Blue Sky and White
 Clouds in Box*) 1967
 KULN 91
 Untitled (8 Figures*) 1966
 KULN 32
 Untitled (Three Showering
 Women*) 1966
 KULN 33
 Untitled (Two Figures*) 1966
 KULN 30 pl 1 (col)
 Untitled (Two Figures*) 1967
 KULN col pl 1 (col)
 Untitled (Two Floating
 Figures*) 1966
 KULN 31
 Untitled (Woman on Ladder*)
 KULN 31
Grain Jar. Chinese--Chou
El Gran Poder de Dios
 Folk Art--Spanish American
 (United States). Great
 Power of God
Grand Camee de la Sainte Chapelle
 Roman--1st c. Deified
 Augustus and Imperial
 Heirs
Grand Slam. Fleminger
Grande Faisca
 Penalba, A. Great Sparkle

Grandma's Boy. Kaprow
Grandmother. Cronbach
Granite Carving. Gabo
GRANLUND, Paul (American 1925-)
 Baccio 1963 bronze; 7
 SEITC 32 UNNFra
 Children 1963 bronze; 20
 SEITC 32
 Crucifixion 1964 bronze; 60
 SEITC 32
 Lotus Eater 1961 bronze;
 11-1/4
 SEITC 32
 Resurrection 1958 cast bronze;
 17
 CIN # 19; UIA-10:84 UICF
Grant, Ulysses Simpson (Eighteenth
 President of the United States
 1822-85)
 Eakins. General Grant's
 Horse, high relief
 Fraser, J. E. and T. H.
 Jones. Ulysses Simpson
 Grant, bust
 Jones, T. H. Ulysses Simpson
 Grant, medal
 Partridge, W. O. General
 Grant, equest
 Schmid. General Grant, bust
 Shrady, H. M. Grant
 Memorial: Artillery Coming
 to a Halt
 Simmons, F. General Ulysses
 S. Grant
Grapes
 Folk Art--American. "Bunch of
 Grapes", tavern sign
Grass. Lye
Grass Cube. Haacke
Grass Cutter. Lira
Grass People I. Stankiewicz, R.
Grasshoppers
 Aztec. Grasshopper
 Bunshojo. Cicada on Oak
 Branch, netsuke
 Chinese--Han. Cicadas
 Drowne. Grasshopper
 Weathervane
 Egyptian--18th Dyn. Ointment
 Box: Grasshopper
 Flannagan. Little Creature
 Folk Art--American. Weather-
 vane: Grasshopper
 Greek--5th c. B. C.
 Decadrachm, Akragas: Two
 Eagles on a Hare; Grass-
 hopper
 Higgins. Grasshopper

Indians of Mexico. Grasshopper
 Weiner. Grasshopper
GRAUSMAN, Philip (American 1935-)
 Pea copper, silver; W: 27
 WHITNA-18:35
 Primal Form copper
 WHITNA-17
Grave Markers See also Monuments
 and Memorials; Stelae; Tombs
 American--17th c. Joseph
 Tapping Gravestone
 --Robert Morris Gravestone
 American--18th c. Mrs.
 Richard Owen Gravestone
 --Mrs. Sarah Davis
 Gravestone
 --Reverend William Hutson
 Gravestone
 --Solomon Milner Gravestone
 American--19th c. Edwin
 Booth, gravestone tondo
 --Grave Marker of Captain
 Meriwether Lewis
 --Wellfleet Tombstones
 Ancient Tombstone
 Ashley, S. Gravestone:
 Colonel Oliver Partridge
 Ceramicus. Grave Relief of
 Dexileos
 Ceramicus. Grave Relief of
 Protonoe
 Chinese--Han. Tombstone:
 Horses and Figures, detail
 Codner. Gravestone:
 Grindall Rawson
 Coptic. Grave Stele: Nursing
 Mother
 --Gravestone#
 --Memorial Stone for Pleinos
 --Tombstone#
 --Young Boy, niche figure
 Egyptian--1st Dyn. Tombstone
 of Kehen, relief
 Egyptian--3rd/4th Dyn. Tomb-
 stone of King Wnephes
 ("Snake")
 Egyptian--12th Dyn. Tombstone
 of Khui, relief
 Egyptian--19th Dyn. Funeral
 Stela#
 Etruscan. Bologna Funeral
 Stele
 --Certosa Gravestone
 --Grave Stele#
 --Stele#
 --Tombstones
 Folk Art--American.
 Gravestone#

--Tombstones
Gallo-Roman. Grave Stele
 with Effigy
Greco-Egyptian. Tombstone
 of Chairemon
Greco-Roman. Soldier's Grave-
 stone: Dead Hero Born
 From Field of Battle
Greek. Gravestone of
 Metrodorus
--Stele#
--Stele of Theano
Greek--6th c. B. C. Ionic
 Temple, monument
Greek--5th c. B. C. Female
 Profile Figure, gravestone
 relief
--Grave Stele#
--Stele#
--Tombstone of Chairedemos
 and Lyceas
--Woman and Child, tombstone
 relief
Greek--5th/3rd c. B. C.
 Warrior, gravestone
Greek--4th c. B. C. Tomb Stele
--Woman: With Mirror,
 Attic grave relief
Hastings, D. Gravestone:
 John Holyoke
Hellenistic. Stele of
 Metrodorus
Indians of Central America--
 Panama. Burial Shaft
Indians of North America--
 Northwest Coast. Grave
 Marker: Totem Figures
Islamic. Iran Tombstone
--Tombstone
Lamson. Gravestone of John
 Fowle
Madagascar. Grave Posts:
 Surmounted by Male and
 Female Figures
Mochica. Grave Post
Mycenaean. Grave Stele#
Palmyrene. Woman Holding
 Child, gravestone relief
Persian. Carved Tombstone:
 Calligraphic Borders and
 Double Prayer Arch
Phoenician. Gravestone of
 Baalyaton
Roman. Grave Marker: Roman
 Couple
Roman--1st c. B. C. Tomb-
 stone: Gaius Septumius
--Tombstone: Man and Woman,
 heads

Roman--1st c. Gravestone,
 with Portrait Busts
--Tombstone Portrait: Male
 Head
Roman--2nd c. Tombstone of
 Petronia Hedone and Her
 Son, Lucius Petronius
 Philemon
Roman--3rd c. Grave Relief
 of Attai
Spartan. Sepulchral Stele:
 Man and Woman
Stevens, J. III. Mercy Buliod
 and her Son
Grave Paddle. Ica
GRAVES, Gloria (American)
 Little Clara's Room,
 assemblage 1960 5x7x8
 KAP pl 4
Graves, William B.
 Berge, E. William B.
 Graves, medallion
Gray, Asa (American Botanist
 1810-88)
 Beach. Asa Gray, bust
GRAY, David (American 1927-)
 Irvine 4 1967 ptd
 aluminum and chrome
 plated steel; 8-5/8x48x72
 TUC 108 UCLF
 L. A. /1 1965 welded steel,
 baked enamel, chrome;
 20x90-1/2x20
 UCIF 18 (col) UCLF
 L. A. /1 1966 chrome and
 enameled steel; 14x9x9-1/2
 LAJ # 27 UCLF
 L. A. /4 1965 welded steel,
 baked enamel, chrome;
 20-1/4x36-1/2x12
 SEATL 23 UCLF
 L. A. /5 1965 welded steel,
 lacquer, chrome plate,
 flock; 13-1/2x9x9
 UCIF 19 UCLF
 L. A. /7 1966 welded steel,
 baked enamel, chrome;
 24x73x18
 SEATL 25 UCLF
 Unit Q 1967 ptd aluminum,
 chrome plated steel; 72x14x96
 TUC 109 UCLF
 Yellow Box with Pipes steel
 WHITNA-17 UWiMaT
Gray Fox. Jones, D.
Great American Nude, No. 54.
 Wesselmann
The Great Bather. Reder, B.

The Great Bieri
 African--Fang. Reliquary Head
Great Blessings of Abraham. Kaish
Great Bronze Dead Man. Baskin
Great Buddha of Kamakura
 Japanese--Kamakura. Amida
 Buddha
Great Captain Rocks. Zogbaum
The Great Dead Man. Baskin
Great Dragon of Quirigua. Maya
Great Events of the Final Life See
 Buddha and Buddhism--
 Final Life
Great Fortune. Lee
Great Goddess
 Persian. Repousse Bowl:
 Great Goddess Riding Lion
Great Image. Chavin
The Great Mask. Mirko
Great Mother. Indian See Uma
Great Mother. Paleolithic
Great Night Column Nevelson, L.
Great Power of God. Folk Art--
 Spanish American (U. S.)
Great Sphinx. Egyptian--4th Dyn.
The Great Stupa See Indian--Sunga;
 Indian--Andhra (Early). Stupa
Sanchi. Stupa 1
Great Turtle
 Maya. Seated Human in Open
 Jaws of the Great Turtle
GREATBACH, Daniel
 Hound-Handle Pitcher c 1838/45
 buff stoneware; 9-3/4
 NEWA 65 UNjNewM
Greaves See Armor
GREBO See AFRICAN--GREBO
GRECO-ALEXANDRINE
 Gaius Caesar, bust 1st c.
 B. C. Egyptian green
 basalt; 10
 COOP 42 EGlNS
 Woman, headless figure
 black basalt; 27
 GAU 53 FPL
GRECO-ASIATIC
 Sarcophagus: Jesus, Apostles
 Peter and Paul, Other
 Saints, Ravenna
 MOREYC 79
GRECO-BUDDHIST See also Indian--
 Kushan--Gandhara
 Bacchanalian Relief, Swat
 Valley 100 gray schist;
 W: c 20
 STI 501 UOClA
 Buddha 3rd/4th c. schist
 LARA 373 FPG

Buddha, head
 BAZINH 413 FPG
--3rd/4th c. schist
 LARA 353 FPG
Devata, Fondukistan
 (Afghanistan) 7th c.
 terracotta
 LARA 356 FPG
Female Figure 1st/2nd c. gold
 SOTH-1:117
Two Young Buddhist Monks,
 Hadda (Afghanistan)
 4/5th c. stucco
 LARA 354 FPG
Woman Worshipper, head,
 Hadda 4/5th c. stucco
 LARA 353 FPG
GRECO-EGYPTIAN
 The Nile
 SIN 156 IRV
 Priest, head 1st c. granite
 GOLDR 7 GMG
 Tombstone of Chairemon:
 Figure Praying between
 Sacred Jackals of Anubis,
 God of Dead limestone
 BECKC pl 49 UNBB
 (No. 16. 90)
GRECO-ETRUSCAN
 Aphrodite c 500 B. C. bronze
 GOLDE pl 110 GMA
 Athena (2 figures); head
 detail 2nd c. B. C. bronze;
 8-1/4
 GOLDE pl 113, 120, 122 IFAr
 Poseidon(?), Bearded Figure
 in Mantle with Thyrsus
 6th c. B. C. bronze
 GOLDE pl 109 GMA
GRECO-INDIAN
 Buddhist Saint, Peshawar
 1st c. B. C.
 LAWL pl 109B GBVo
 Woman and Tree, panel,
 Peshawar 1st c. B. C.
 LAWL pl 110 GBVo
GRECO-ITALIAN
 Lion, body from Delos;
 head--18th c. marble
 BO 10 IVAr
GRECO-PARTHIAN
 Hadad(?), God of Syria, head
 1st/2nd c. B. C. marble;
 6-1/4
 YAH 21 UCtY
GRECO-PERSIAN
 Lion-Griffin, gem 5th c.
 B. C.
 SEW 251 EOA

Tomb of Phylista, Arundel
marble; 70x32
GARL 214 EOA
Torso marble
GRAF 482 FEnM
Tragic Mask, Piraeus bronze
HOR 206 (col) GrAN
Treasury of the Cnidians,
Delphi
TAYFT fol 16 GrD
Two Wrestlers between
Runner and Javelin Thrower,
relief
HOR 160-161 GrAN
Venus of Capua (Roman copy)
RAD 523 INNM
Willa Madama Zeus, upper
half figure
VER pl 5 FPL
Weddell Venus, in sculpture
gallery
IRW pl 9 EYoN
Woman: In Peplos
HOR 265 GFM
Woman: Grinding Flour
terracotta
HOR 269 ELBr
Woman, bust, Farnese
Collection
MAIU 45 INN
Woman and Girl Cooking
terracotta
HOR 269 UMB
Youth Holding Ram's Head
bronze; 6-1/2
COOP 183 UCLGe
Zeus: Abducting Europa,
relief, Sicily
HOR 113 IPalM
Zeus, or Aesculapius marble
MILLER il 28 UMB
Zeus-Hero, Pergamon
CARPG pl 38 TIM
--ARCHAIC
Aeolic Capital: Spreading,
Double-Spiralled, Proto-
Ionic
RICHTH 14
Animal terracotta, gold
leaf cover
ZOR 58 UNNMM
Apollo
RAY 14
Cerberus bronze
BARSTOW 7
Cow Suckling Young, relief
faience
NM-10:26 UNNMM

Deer and Fawn 9/7th c. B. C.
bronze
CHENSW 95 UMB
Female Figure, fragment
VER pl 11 UMB
Female Figures, Jug,
Kerameikos c 650 B. C.
terracotta
RICHTH 220 GrAK
Fighting Animals 10/11th c.
B. C. marble; 61x28 cm
CHAR-1:231 FPL
Figure Fragment, Acropolis,
Athens marble
READI pl 49
Geometric Horse, Phigaleia
9/8th c. B. C. bronze
BEAZ fig 4 ELBr
Herakles Shooting an Arrow
bronze
BOSMG 80 UMB (98. 657)
Horse and Rider, fragment
CHENSN 91 GrAA
Horseman terracotta
ZOR 65 UNNMM
Horseman, Attica clay
CHENSN 71; CHENSW 94
UMB
Horses 9/7th c. B. C.
bronze
CHENSW 95 UNjPA
Idol 3rd/2nd mil B. C.
CHRH 20 UNBB
Kore
CHENSN 109 GrAA
Man, Olympia 9/8th c. B. C.
bronze
BEAZ fig 5 FPL
Murder of Aegisthus by
Orestes, relief panel
(copy) marble; 19
BO 258; CHENSW 104
DCN
Mediterranean Mother,
Senorbi c 1500 B. C.
marble; 17-1/4
GIE 283 ICagM
Nymphs, relief detail
HOR 53 GrAA
Pan
BARSTOW 21
Phallic Man c 2500 B. C.
terracotta; 49 cm
HAN pl 2 GrAN
Proskynitarion, Chios, ptd
and gilded wood; 2. 25 m
BERLES 188 GBSBe
(6594)

Seal: Centaur Attacked by
Bowman stone
BO 34 FPBN (M 5837)
Stag, Protogeometric 11th c.
B. C. terracotta; 26 cm
HAN pl 16 GrAK
Triangular Candelabrum Base,
Neo-Attic marble
CHASE 150 UMB
Votive Tablets: Woman Seated
in Chair with Desk; Man
and Woman, Locri c 500
B. C. terracotta
BEREP 144, 145 IReM
Woman, Athens 9/8th c.
B. C. ivory
BEAZ fig 6 GrA
--8th c. B. C.
Apollo and Heracles Struggling
for Tripod, tripod leg
fragment, Olympia c 700
B. C. bronze; 18-3/8x3-3/4
SCHEF pl 4; WEG 60
GrOM (B 1730)
Bowl: Four Horses on Lid buff
pottery; Dm: 13
GRIG pl 51 ELBr
Charioteer, Olympia bronze;
1. 45 cm
HAN pl 21; RICHTH 174
GrOM; GrAN
Circle of Dancing Women
bronze; c . 075 m
HAN pl 19 GrAN
Coins 8th/1st c. B. C.
DENV 13 UCoDA (AN-154-
157)
Deer and Fawn 750/700 B. C.
bronze; 2-3/4
BO 34; BOSMI 45; GIE
293; HAN pl 18 UMB
(98. 650)
Fibula: Heracles and Moliones,
Crete bronze; 2-3/8
SCHEF pl 6 GrAN
(11765)
Fibula: Heracles Fighting
Hydra; Wooden Horse
rosette Dm: c 1-1/2
SCHEF pl 6 ELBr (3205)
Figure, cauldron fitting
bronze
BEAZ fig 8 GB
Figure, cauldron ring-handle
support, Olympia c 700
B. C. bronze; 14-1/2
BO 36 GrOM (B 2800)
Footstool, incised horse design,
Samos wood RICHTH 363

Geometric Horse bronze;
6-5/16
DEVA pl 1; GARDH 5;
HAN pl 17; HOR 126
(col); NM-5:7; SEW 41;
TAYFF 8 (col); ZOR 63
UNNMM (21. 88. 24)
Geometric Horses bronze;
. 064 and . 081 m
CHAR-1:126 FPL
Goddess, or Votary
c 750/725 B. C. ivory;
24 cm
HAN pl 24; ST 22 GrAN
Gorgon Mask, Tiryns c 700
B. C. ptd terracotta;
20 cm
HAN pl 45 GrNM
Head, Cameirus ivory
LAWC 99 ELBr
Hunter Attacking Lion,
Samos bronze
BO 34 GrSamM
Kouros (Youth, or
Warrior) c 700/675
B. C. bronze; 20 cm
HAN pl 29; RICHTH 175
UMB
Lion, protome c 700 B. C.
bronze; . 255 m
HAN pl 39 GrOM
Magic Wheel, with Eleven
Nesting Birds terracotta;
Dm: 11-1/2
BOSMI 45 UMB (28. 49)
Male Figure c 700 B. C.
bronze; 37 cm
HAN pl 30 GrOM
Man and Centaur bronze;
4-1/2
HOR 126 (col); STRONGC
43 (col); WEG 70 UNNMM
Mare Suckling Foal, geo-
metric style 750/700
B. C. bronze
BAZINW 127 (col) GrAN
Seal: Nessus and Deianeira
W: 1-1/4
SCHEF pl 6 GMMS (A 1293)
Seated Figure bronze
LARA 249 UMdBW
Soldier in Conical Helmet,
head fragment, Amyclae,
near Sparta c 700 B. C.
clay; 4-1/2
BO 37 GrAN
Stallion, votive figure,
Peloponnesus c 750/700
B. C. bronze; 6-1/4

JANSK 117; LULL pl 1
GBSBe (31317)
Theban Storage Jar: Potnia
Theron, Mistress of Arcmales
c 700 B. C. pottery; 49-1/4
STRONGC 49 (col) GrAN
Warrior bronze; . 186 m
HAN pl 20 UNNMM
Warrior: Brandishing Spear
bronze
ST 22 GrAN
Warrior: With Dipylon Shield,
Karditsa c 700 B. C.
bronze; 11
BO 34 GrAN (12831)
Warrior, Athenian Acropolis
cast bronze; 8. 2
LULL pl 2 GrAN (6613)
Warrior and Horse, geometric
style bronze; 15. 2, and
11. 2 cm
WEG 62 GrOM
Warriors, geometric style
bronze; 21; and 23. 7 cm
WEG 63 GrOM; GrAN
Woman, Bell-Shaped Figure
ptd terracotta
HOR 210 (col) UMB
Woman: Priest, Ephesus
LAWC 100 ELBr
Zeus and Typhon, Olympia
bronze; 4-7/16
SCHEF pl 4 UNNMM
(17. 190. 2072)
--8/6th c. B. C.
Centaurs--three figures to
show change in form
LAWC 90
--8/4th c. B. C.
Mask, Carthage glass
BAZINW 165 (col) TuTB
--8th/1st c. B. C.
Gems
CHENSW 109 UMB; UNNMM
--7th c. B. C.
Achilles: and Cattle of Aeneus,
amphora relief, Thebes
c 650 B. C. H: 61-3/4; Dm:
31-7/8
SCHEF pl 25 UMB (528)
Achilles: With Gorgon Shield,
relief
ELIS 49 UNNMM
Aeolic Capital, Larisa lime-
stone
BAZINW 127 (col) TIAM
Ajax: With Body of Achilles,
relief clay; 6-11/16
SCHEF pl 32 INMA

Amphora: Conquest of Troy;
Menelaus Threatening
Helen, Mykonos c 670
B. C. H: 52-3/4
SCHEF pl 34, 35 GrMycA
--: Trojan Horse, with
Soldiers Looking out
Windows, amphora neck
relief
HAN pl 82; HOR 100;
RICHTH 304; SCHEF pl
34, 35
Apollo (Mantiklos Apollo),
votive offering, Thebes
cast bronze; 8
AGARC 7; BAZINW 129
(col); LARA 248; LULL
pl 3; STRONGC 48 (col)
UMB (03. 997)
Apollo: and Infant Dionysus,
Melos
AUES pl 7 GrAN
Apollo, Boetian 700/675
B. C. bronze; 8
BOSMI 47 UMB (03. 997)
Apollo, Crete c 650 B. C.
sheet bronze over wood;
80 cm
HAN pl 26 GrHA
Apollo, head limestone; c 8
STI 163 GrAN
Artemis from Delos c 650
B. C.
ROOS 25E GrAN
Basin Supported by Goddesses,
Isthmia 620 B. C. marble;
1. 26 m
HAN pl 61 GrCorA
Bellerophon: On Pegasus
Attacking Chimaera,
engraved plaque bronze
HOR 106-107 (col) UNNMM
Bird, Perachora c 620/600
B. C. bronze
RICHTH 176 GrAN
Birth of Athena, amphora
relief, Tenos
SCHEF pl 13 GrTenM
--, shield relief c 600 B. C.
strip W: 2-15/16
SCHEF 67 GrO
Caeneus and Centaurs (Kaeneus
and Centaurs), relief,
Olympia c 630 B. C. bronze;
W: 13
SCHEF pl 27; WEG 71
GrOM
Caryatid, Olympia c 640/620
B. C. marble
RICHTH 176 GrOM

Cerveteri Woman, seated figure
terracotta; 21-1/2
STRONGC 111 (col) ELBr
Children of Athens: Fighting
Minotaur, amphora relief
c 670/ 660 B. C. H: 61
SCHEF pl 25 SwBA
Clytemnestra Slaying Cas-
sandra, relief plate bronze;
18-1/4
SCHEF pl 32 GrAN
Coins: City Symbols--Corinth:
Pegasus; Athens: Owl;
Aegina: Tortoise silver;
Dm: 1. 95; 2. 4; 2. 15 cm
NM-5:12 UNNMM
(05. 44. 520, 500, 513)
Crescent Pendant: Two Heads,
Four Birds, Khaniale Tekke,
Knossos gold; W: 2
BO 46 GrHM
Daughters of Proitos(?) ivory;
5-3/8
BO 45 UNNMM (17-190. 73)
Dead Men Torn by Vultures,
relief fragment 680 B. C.
ceramic; . 165 m
HAN pl 83 GrAN
Egyptian Woman, seated figure
LAWC 101
Europa on the Bull, amphora
fragment c 650 B. C.
H: 9-7/8
SCHEF pl 11 FPBN
Female Figure, seated,
Didyma c 600 B. C.
RICHTH 55 ELBr
Female Figures ivory
LARA 249 UNNMM
Female Head, Branchidae
Class
LAWC pl 4B TI
Goddess 675/650 B. C.
ivory; . 095 m
HAN pl 191, 192 IFAr
--c 650 B. C. bronze; 45 cm
HAN pl 36 GrHA
--, seated figure, Prinias
LAWC 101, 102 GrCaM
Goddesses 650/625 B. C. ivory;
13. 7 cm
HAN pl 27; SCHEF pl 14
UNNMM (17. 190. 73)
Griffin: With her Young,
plaque, Crete bronze,
cut-out; 31-1/8x31-1/2
BO 61 FPL (MNC 689)
Griffin, head bronze
COPGG 23 DCN (BR 23)

--, Olympia c 650 B. C.
bronze; 10-1/8
CHRH fig 38; COOP 31;
HAN pl 46 UNNBak
--, Samos bronze; 9-1/4
STRONGC 45 (col) ELBr
Griffin Head, bowl figure,
Samos bronze; 8-5/8
BERL pl 107; BERLES
107 GBSBe (31998)
Griffin Head, cauldron
decoration c 650 B. C.
bronze; 11-1/2
BO 43; DEVA pl 9; MU
40; RICHTH 196, 197;
WEG 75 (col) GrOM (B 945)
"Hawk Priestess", Ephesus
ivory
BEAZ fig 11
Hecabe and Maid-Servants
Taking Robe-Offering to
Athena, amphora relief
c 660 B. C. H: 43-1/4
Dm: 26-3/4
SCHEF pl 30-31 UMB (529)
Helmet Maker 680/650 B. C.
bronze; 5-1/2 cm
HAN pl 22; RICHTH 174
UNNMM
Hera, head fragment c 600
B. C. limestone; c twice
LS
BEAZ fig 27; HOR 64;
LAWC pl 3A; RICHTH 54
GrOM
Heracles: Slaying Centaur
Nessus, relief, Sparta
c 670/660 B. C. ivory; 3
SCHEF pl 24 GrSpM
Heracles: Wrestling with
Lion, shield-relief c 600
B. C. strip W: 2-13/16
SCHEF 68 GrO
Horsemen, frieze, Temple
A, Prinias, Crete 640
B. C. limestone; 84 cm
HAN pl 85 GrHM
Huntsmen, plaque bronze,
cut-out; 7
BO 60 GrOM
Huntsmen, tablet bronze,
cut-out
BAZINH 92 FPL
Island Gem: Stag with
Dolphins c 600 B. C.
steatite; L: 1
BO 62 EOA (1921. 2325)
Judgment of Paris, comb,
Sparta ivory
RICHTH 177 GrAN

446 GREEK--7th c. B. C.

Kitylos and Dermys
 ROOS 25G GrAN
Kneeling Youth c 625 B. C.
 ivory; . 145 m
 HAN pl 28 GrAN
--, Samos ivory; 5-3/4
 BO 45 GrSamM
Kore (Acropolis Maiden)
 MYBA 82 GrAA
Kore (Auxerre Goddess;
 Lady of Auxerre; Maid of
 Auxerre; Nikandre of
 Auxerre; Venus of
 Auxerre; Woman from
 Auxerre), Crete c 640/650
 B. C. limestone; c 24-1/2
 (reputedly earliest Greek
 statue)
 BAZINW 131 (col); BEAZ
 fig 23; BO 65; CHAR-1:
 136; DEVA pl 11-12; JANSH
 82; JANSK 118; LARA 248;
 LAWC pl 2B; LULL pl 6;
 READAS pl 56; RICHTH
 53; SEW 45; ST 28; STA
 9; STRONGC 37: WEG
 129 FPL (3098)
Kore (Girl c 680/650 B. C.
 bronze
 RICHTH 176 UMdBW
--c 650/600 B. C. bronze
 RICHTH 176 TIM
Kore: Two Maidens
 HOR 184 GrAA
Kouros (Youth), Apollo Type,
 Attica (Standing Youth)
 615/600 B. C. marble; c
 28; on plinth: 48
 BEAZ fig 34; BOWR 13;
 CARPG pl II-III; CHAN
 104; CLAK 31; DEVA pl
 18; JANSH 82; JANSK 118;
 LULL pl 11-13; MILLE 9;
 MILLER il 21; MU 41;
 MYBA 79; NEWTEE pl 5a;
 NM-5:9; NM-10:34; PACHA
 31; PANA-1:116; RICHTH
 51; ROBB 293; ROTHS 43;
 ROTHST pl 22; ROWE 11;
 SEW 46; ST 28; STA 8;
 STI 162; UPJ 66; UPJH
 pl 22C-D UNNMM (32. 11. 1)
Kouros (Youth), Delphi
 BEAZ fig 24 GrD
--Dreros c 650 B. C.
 RITHTH 175 GrHM
--, fragment
 HOR 185 GrAA

Kouros, head, Dipylon (The
 Dipylon Head) c 620 B. C.
 marble; 44 cm
 HAN pl 35; RICHTH 50;
 ST 29; WEG 65 GrAN
Kriophoros, rear view
 c 600 B. C. marble; 3. 6 m
 HAN pl 33 GrThM
Leto Giving Birth to Apollo,
 amphora relief, Thebes
 H: 47-1/4
 SCHEF pl 12 GrAN (5898)
Lion: Guarding Grave c 600
 B. C. ptd limestone; L:
 1. 22 m
 HAN pl 41 GrKM
Lion, Menekrates Tomb
 limestone
 BAZINW 127 (col) GrCM
Lion, Smyrna ivory; L: 2-1/4
 BO 44
Lion, couchant detail
 limestone
 DEVA pl 15 GrCP
Lion, waterspout c 650 B. C.
 limestone; L: . 785 m
 HAN pl 40 GrOM
Lion-Head Jug, Proto-
 Corinthian
 RICHTH 290 ELBr
Lioness Attacking Bull
 c 600 B. C. ptd limestone;
 c 67
 STRONGC 50 (col) GrAA
Man, head 7th c. B. C. stone
 CHENSW 94 UWaSA
Man Fighting Lion, tomb
 panel, Xanthus, Lycia
 LAWC 121 ELBr
Marriage of Zeus and Hera,
 relief c 620 B. C wood;
 7-1/2
 SCHEF pl 39
Medusa: With Pegasus,
 metope c 620/610 B. C.
 clay; 22
 BO 59; SCHEF 55 (col)
 ISyAr
--: Medusa, head-antefix,
 Syracuse ptd terracotta;
 56 cm
 HAN pl 81; LARA 307
 ISyAr
Meeting of Apollo and Zeus,
 Accompanied by Other
 Gods and Goddesses, cuirass
 (now lost) c 650 B. C.
 bronze; c 17-1/2 SCHEF 30

Nicandra (Nikandra; Nikandre),
Delos, female figure
dedicated by Nikandre
c 640 B.C. marble; 69
CHASE 5; CHASEH 60;
CHRH 66; HAN pl 38;
RICHTH 53; UPJH pl 23D;
WEG 127 GrAN
Owl c 650 B.C. ptd terracotta;
52 cm
HAN pl 77 FPL
Paris Abducting Helen, shield
relief c 600 B.C. strip
W: 2-13/16
SCHEF 85 GrO
Pegasus, gem steatite
RICHTH 233 UNNMM
Penthesilia Being Vanquished by
Achilles, shield relief
c 600 B.C strip
W: 2-13/16
SCHEF 92 GrO
Peraea Seal: Suicide of Ajax
Dm: 3/4
SCHEF pl 32 UNNMM
(42. 11. 13)
Perfume Flask: Lion-Head
Mouth ("Macmillan
Aryballos"), Thebes
Protocorinthian clay; 2-1/2
BO 49 ELBr (89. 4--18. 1)
Perfume Flask: Owl Proto-
corinthian, c 650 B.C. H: 2
JANSH 79; JANSK 163;
RICHTH 290 FPL
Perseus Slaying Medusa, relief,
Samos c 630/620 B.C.
ivory; c 4
SCHEF pl 17 GrVM
Priest, Ephesus ivory
BEAZ fig 10
Priestess(?), with Distaff,
Ephesus c 600 B.C. ivory;
. 105 m
HAN pl 37 TIAM
Prothesis, mourners at bier,
Attic tomb relief
c 630/620 B.C. terracotta
RICHTH 221 UNNMM
Ram Carrier 640/610 B.C.
bronze; 7-1/8
BO 63 (col); RICHTH 175
GBS
Roundel: Pairs of Flies;
Human and Bull Heads gold
BO 62 FPBN
Running Man bronze; . 105 m
HAN pl 23 FPOrt

Seal: Bird, Melos
DOWN 42 UNNMM
Seals: Lion Attacking Ram;
Man Battling Animals
Dm: 1
NM-5:12 UNNMM
(42. 11. 15; 74. 51. 4223)
Seated Man, Branchidae
LAWC pl 4A ELBr
Slaying of Agamemnon, relief,
Gortyna clay; 3-3/8
SCHEF pl 33 GrHM
Soldiers, Horse and Dog,
tomb relief, Isinda, Lycia
LAWC 122 TIM
Sphinx, incense plate
625 B.C. terracotta;
. 335 m
HAN pl 47 GAK
--, sepulchral stele c 600
B.C.
RICHTH 55 UNNMM
Theseus: Carrying off Antiope,
Queen of the Amazons,
Eretria
HOR 185; LAWC pl 19A
GrChM
Theseus: Fighting Minotaur,
shield relief c 600 B.C.
strip W: 2-13/16
SCHEF 74 GrO
Theseus: Slaying Minotaur,
plaque c 650 B.C. gold;
W: 1-1/2
SCHEF 39 GBS
Theseus: Wooing Ariadne,
relief, Tarentum clay;
3-3/4
SCHEF pl 27
Torso c 650 B.C. marble;
85 cm
HAN pl 31 GrDeM
Warship, Sparta, relief
ivory
RICHTH 177 GrAN
Wedding of Lapiths(?), relief,
Attica c 700 B.C. gold;
L: 8-5/8
SCHEF 41 GBS
Winged Goddess of the Beasts,
plaque, Rhodes
RICHTH 252 ELBr
Winged Youth, relief 650 B.C.
terracotta; 14 cm
HAN pl 76 GrAN
Youth, head c 600 B.C.
marble; 12
NMA 23 UNNMM (32. 11. 1)

Zeus and Hera, furniture
 fragment, Heraion of Samos
 c 625/600 B. C. wood
 RICHTH 178; ST 28
--7/6th c. B. C.
Helmet bronze; 8-7/8
 NM-5:11 UNNMM
 (55. 11. 10)
Kouros bronze
 CHENSW 96 SnSN
Kouros: Dedicated to Poseidon,
 Sounion Cape, Attica
 (Sounion Kouros) c 615/590
 B. C. marble; 10'
 BO 65; DEVA pl 19;
 FLEM 28; GARDH 118; HAN
 pl 50; RICHTH 49; ST 30;
 STRONGC 38 GrAN (2720)
--: Torso
 DEVA pl 16
Lions of Delos marble; 1, 28 m
 CHENSW 99; DEVA pl 22
 (col); HAN pl 44; HOR 148-
 149 (col); NEWTEM pl 1;
 WEG 124 GrDe
--6th c. B. C.
Achilles Slaying Troilus, shield
 relief c 590/580 B. C.
 strip W: 2-1/16
 SCHEF 86 GrO
--, shield strip c 580 B. C.
 W: 2-13/16
 SCHEF 86 GrO
Actaeon, metope, Heraeum,
 Selinus limestone; c 66
 LAWC pl 34B IPar
Aeakes(?), seated figure
 c 540 B. C. marble;
 1. 51 m
 HAN pl 71 GrTiM
Ajax Threatening Cassandra,
 shield relief c 590/580
 B. C. strip W: 2-13/16
 SCHEF 93 GrO
Alabastron: Two Women
 Back-to-Back, Sicily
 BEAZ fig 31 UNNMM
Aphrodite, mirror handle
 CLAK 72 GM
Aphrodite and Erotes, mirror
 handle c 500 B. C. bronze
 BOSMG 55 UMB (04. 7)
Apollo
 BAZINH 66 GrAN
--
 ROOS 26D GrAN
--
 ROOS 26E GrAN

--bronze
 VALE 40 UMB
--c 530 B. C. bronze
 BOWR 19 (col) GrANA
--c 500 B. C. terracotta;
 1. 35 m
 BOE pl 17 IRGi
--, Attica bronze
 CHENSW 105 GrAA
--, torso marble
 GIE 25 FPL
Apollo of Thasos, head
 BAZINH 68; LARA 248
 DCN
Archaic Apollo marble
 SLOB 213 FPL
--, Island of Paros
 SLOB 213 FPL
Aristodicus, grave figure
 c 500 B. C.
 ST 37 GrAN
Artemis bronze; 7-1/2
 BOSMI 51 UMB (98. 658)
--, Pompeii (Roman copy)
 CHASE 141 INN
--, cult image, Ephesus
 (copy) marble
 ENC 283
--, head terracotta
 CLE 20 UOClA (29. 976)
Athena--Doric and Ionic
 Types ptd limestone
 ROTHS 45 GrAA
--, Minorca c 500 B. C.
 bronze; 4-1/4
 BOSMI 57 UMB (No.
 2/54. 145)
Athenian Coin: Gorgon; Lion
 Mask
 BO 117 ELBr
Athenian Tetradrachm: Athena
 silver; Dm: 7/8
 TOR 97 CTRO (958. 68)
Athenian Treasury, Delphi:
 Heracles Capturing the
 Brazen-Footed Hind,
 North metope 490 B. C.
 marble
 DEVA pl 86 GrD
--: Hercules Killing Cycnus,
 metope
 LAWC pl 19B
Athletes Training, relief,
 statue base, Kerameikos
 c 500 B. C. marble; 13x32
 BO 87; LAWC pl 16B;
 LULL pl 62, 63 GrAN
 (3476)

Death of Priam, shield relief
c 570/560 B. C. strip
W: 3-3/8
SCHEF 93 GrO
Dioscuri, Linus, Orpheus
and the Argo, relief
fragment
HAN col pl II (col)
GrDM
Dog and Cat Fight; Six
Youths Playing Ball,
frieze, statue base
c 510 B. C. marble; 13x32
LAWC pl 16A GrAN (3476)
--: Dog and Cat Fight
BOWR 133 (col); DEVA pl
59; LULL pl 64-65
--: Six Youths Playing Ball
(Ball Game)
BOWR 132-133 (col); RICHTH
81; ROOS 27E; STRONGC 60
Draped Female Figure,
headless fragment
CHASE 19 UNNMM
Draped Female Torso,
fragment 520/510 B. C.
marble
FAIN 222 URPD
Draped Figure, Heraeum,
Samos terracotta
LAWC 116
Dueling Fragment, Civilta
Castellana c 500 B. C.
terracotta; c 65 cm
BOE pl 19 IRGi
Ephebean Athletes: High
Jump; Wrestling; Javelin
Throw, Palaestra
CLAK 175; DEVA pl 60;
ROOS 27F; STI 164 GrAN
Europa and the Bull, metope,
Selinus Temple c 590/580
B. C.
LARA 264; RICHTH 65
IPalC
Exploits of Hercules and
Theseus, fragment,
Treasury of Athenians
500/495 B. C.
LARA 273 GrDM
Family Group c 560 B. C.
marble; 1. 6 m
HAN pl 62 GrVM
Female Face, relief fragment,
Ephesus marble (cast)
BEAZ fig 32 ELBr
Female Figure, pillar relief
fragment, Temple of
Apollo, Didyma marble; 22

LULL pl 42 GBS (1721)
--, relief fragment, Mycenae
c 630 B. C. limestone; 16
LULL pl 7 GrAN (2869)
Female Figure of Philippe,
Samos c 560 B. C.
RICHTH 59 GrSamV
Female Figure, Heropolis
LARA 253; ROOS 26F-K
GrAA
Female Head
ROOS 27D IRT
--, Olympia terracotta
14 cm
WEG 133 GrOM
--, Sicyon c550 B. C. ptd
limestone; 1/2 LS
CHASE 20; CHRP; LAWC
pl 41B UMB
(Artemis?) (Roman copy)
c 500 marble
CHASE 51 UMB
Fragments of Ephesus Figures;
Xanthus, reliefs
LAWC pl 7A ELBr
Fuseo Bust, antifix
BAZINL pl 113 ISyAr
Goat, head c 500 B. C.
limestone
CLE 20 UOClA (26. 538)
Goddess: In Embroidered
Robe, Carthage
LARA 303 TuTB
Gorgon, detail, west
pediment, Temple of
Apollo, Corcyra yellowish
limestone; figure H:
2. 79 m
BOE pl 3
Gorgon, west pediment
600/580 B. C. limestone
BAZINW 127 (col) GrCM
Gorgon, head, facing detail
Temple of Apollo, Veii
c 500 B. C terracotta;
43x42 cm
BOE pl 16 IRGi
Grave Stele of Youth and Girl,
surmounted by Sphinx c 540
B. C. marble; 13' 10-11/16"
NM-5:10 UNNMM (11. 185)
Greave: Flying Gorgon c 540
B. C. bronze
RICHTH 198 ELBr
Griffin, head, Olympia
bronze; 1-1/2
LULL pl 4 GrOM (B 145)
Griffin, protome, Olympia
bronze; 14 LULL pl 5 GrOM
(B 945)

Head, Miletus c 535 B. C.
 marble; 8
 BERL pl 111; BERLES 111
 GBSBe (1631)
Head, fragment, Ephesus
 marble; 7-1/2
 DEVA pl 28; LULL pl
 40, 41 ELBr (B 89)
Helmeted Runner c 510/500 B. C.
 RICHTH 76 GrAN
Hera, head, Haraion,
 Olympia limestone; 21. 15
 DEVA pl 14; LULL pl 10;
 WEG 79 GrOM
Hera of Samos (Cheramyes
 Votary), headless figure,
 Samos c 550/590 B. C.
 marble; 75. 6
 BAZINW 131 (col); BEAZ
 fig 30; CHAR-1:140; CHASE
 8; CHASEH 61; CHENSN
 108; CHENSW 96; CHRP
 58; DEVA pl 43; FAUL
 460; FLEM 31;
 GAF 139; GARDH 116;
 GAU 70 HOF 32; HUYA
 pl 15; HUYAR 21; JANSH
 85; LARA 244; LAWC pl
 1C; LULL pl 32-33;
 PRAEG 132; RAY 14;
 RICHTH 59; ROBB 292
 ROOS 25F; SEW 45;
 STI 161; UPJ 67; UPJH
 pl 23F; WILM 20 FPL
 (686)
Heracles c 500 B. C. bronze
 ZOR 184 UNNMM
--c 500 B. C. bronze; . 27 m
 HAN pl 108 GrAN
Hercules: And an Amazon,
 metope, Selinus
 ROOS 28H
--: Brandishing Club,
 Arcadia c 530/520 B. C.
 bronze
 RICHTH 179 UNNMM
--: Carrying Two Dwarves,
 metope, Temple of
 Selinus
 HOR 211 IPaeM
--: Fighting with Geryon,
 shield relief c 570/560
 B. C. strip W: 3-3/8
 SCHEF 69 GrO
--: Shooting at Fleeing
 Centaurs, frieze, Iassos
 540 B. C.
 BOSMG 74; HAN pl 86
 UMB (84. 67)

--: Slaying Cyrinian Stag
 metope, Treasury of
 Athenians, Delphi Parian
 marble; L: 25
 BEAZ fig 53; GARDE 33;
 LULL pl 79 GrDM (2027)
--: With Theseus and
 Perithous in Hades, shield
 relief c 580/570 B. C.
 strip W: 2-7/16
 SCHEF 69 GrO
Heracles, Perachora c 500
 B. C. bronze
 RICHTH 179 GrAN
Heracles and Apollo, metope
 RICHTH 66 GrFH
Heracles and Cercopes 560
 B. C. sandstone; 78 cm
 HAN pl 92 GrPaA
--, shield relief c 560 B. C.
 strip W: 3-3/16
 SCHEF pl 61 GrOM
 (B 2198)
--, metope, Temple C,
 Selinus c 540 B. C.
 RICHTH 65; UPJH pl 24
 IPalC
Heracles and Hydra,
 Acropolis gable c 590 B. C.
 31-1/8x228
 SCHEF pl 54 GrAA
Hermes bronze
 RICHTH 178 UMB
Hermes: Carrying Ram (Hermes
 Kriophorus) c 510 B. C.
 bronze
 AGARC 28; BOSMG 51;
 BOSMI 55; CHASE 21;
 HOR 75 UMB (99. 489)
Hermes from Veii, head
 c 500 B. C. baked clay;
 14-5/8
 NEWTEM 9 (col) IRGi
Homer, head
 HOR 87 UMB
Homeric Battle, frieze
 CHASE 13 GrDM
Horse c 500 B. C. marble
 HOF 222
Horseman, detail c 530
 B. C.
 ptd marble
 DEVA pl 78 GrAA
--, fragment c 560 B. C.
 terracotta; 35 cm
 HAN pl 60 TMA
--, fragment c 530 B. C.
 bronze; . 95 m
 HAN pl 58 GrVM

Hydria bronze
 RICHTH 199 IPaeM
--: Backward Leaning Youth,
 Sala Consilina bronze
 RICHTH 199 FPPP
Ionic Temple, monument,
 Sardis c 550 B. C.
 marble; 62 cm
 HAN pl 84 TMA
Kneeling Youth: Binding Fillet
 on Head, Agora, Athens
 c 530 B. C. clay
 BO 113 GrAAg (P1231)
--: Binding Victory Fillet on
 Head, vase
 HOR 154 GrAAm
Korai
 LAWC pl 14-15 GrAA
 (No. 673, 674, 679, 680)
--: Two Kore from Acropolis
 marble; 92, and 54. 3 cm
 WEG 131 GrAA
Kore
 BATT 92
-- (Verona copy)
 BARSTOW 21
--stone
 CHENSW 100 GrAA
--stone
 CHENSW 100 GrAA
--, fragment
 GAF 431 FLM
--, head detail
 ZOR 260-261
--c 580/560 B. C.
 READI pl 45 GBS
--c 570 B. C. bronze; 27 cm
 HAN pl 63 GrVM
--c 540 B. C. bronze
 RICHTH 178 GBM
--c 510 B. C. marble
 ENC 36
--c 500 B. C. marble
 DEVA pl 61 GrAA
--, Acropolis 530 B. C.
 ptd marble; c 36
 BEAZ fig 49; GARDH 120;
 LARA 253; LULL pl 80-81;
 MU 36 (col); NEWTEM pl
 6; RICHTH 73 GrAA (674)
--: Bearing Votive Offering
 c 510 B. C.
 MYBS 19 GrAN
--: In Chiton, Acropolis,
 Athens c 510 B. C.
 BO 81 GrAA (670)
Kore (Acropolis Maiden)
 PUT 227 GrAA

--(cast)
 RUS 21 UNNMM
--, Ionic type
 c 510/500 B. C.
 STI 166 GrAA
--, half figure fragment
 HAUSA pl 7 GrAA
--, head detail
 CASSM 26 GrAA
Kore (Athenian Girl)
 c 510 B. C. ptd marble;
 . 555 m
 HAN col pl III (col) GrAA
Kore (Girl from Chios;
 Maiden from Chios) 510/525
 B. C. ptd marble; 21-7/8
 BAZINW 131 (col); BO 79
 (col); DEVA pl 58 (col);
 FUR 86; HOR 119 (col);
 JANSH 94 (col); JANSK 120;
 KO pl 5; LULL 12 (col),
 pl 70; RICHTH front (col),
 73; SCHO pl 20 (col) GrAA
 (No. 675)
Kore (Girl in Dorian Peplos;
 Girl in Sleeved Chiton;
 Peplos Kore; Young Girl
 in Chiton and Peplos),
 Acropolis, Kore 679
 c. 530/520 B. C. ptd
 marble; 48 (with 1" plinth)
 BAZINL pl 115 (col); BEAZ
 fig 36; BO 78 (col);
 CHASEH 75; ENC col pl
 2 (col); GARDH 120;
 GAUN pl 22; HAN pl 67;
 JANSH 86; JANSK 122; KO
 pl 2; LULL pl 43-45;
 NEWTEM front (col); RICHTH
 70-71; ROTHST pl 22; ST
 42; STRONGC 51 (col);
 UPJ 72; WEG 120 GrAA
 (No. 675)
--, head detail
 HAN pl 68
Kore (Lady from Cyrene),
 headless fragment
 c 500 B. C.
 SCHO pl 23 (col) GrCyA
Kore (Lyons Kore)
 CARPG pl 4, pl 5 GrAA
Kore (Maiden from Attica)
 c 575/550 B. C.
 RICHTH 58 GBM
Kore ("Sphinx" Kore),
 Acropolis c 500 B. C.
 marble; 92 cm
 HAN pl 69 GrAA

Kore, half figure marble; 21. 4
 LULL pl 27 GrAA (677)
Kore, head marble
 DEVA pl 63 GrAA
Kore, head detail c 530 B. C.
 marble
 DEVA pl 39 GrAA
Kore, head detail c 520 B. C.
 DEVA pl 41 GrAA
Kore, head fragment
 marble
 BEAZ fig 50 GrAA (643)
Kore, headless fragment
 c 550/540 B. C. marble
 CHRP 58 GrAA
Kore, Samos c 575/550 B. C.
 bronze
 RICHTH 178 GrVM
Kore of Antenor
 LAWC pl 18B GrAA
Kore of Nicandra
 LAWC pl 1A GrA
Kore, profile relief
 BO 88 GrAA (1342)
Kouros, marble; 1. 03 m
 CHAR-1:139 FPL
Kouros Naxos marble; 84-1/4
 NEWTEM pl 4 GrAN
Kouros c 540 B. C. marble;
 2. 11 m
 HAN pl 53 GMG
Kouros c 520 B. C. H: 76
 STRONGC 58 GrAN
Kouros c 500 B. C. marble;
 1. 03 m
 HAN pl 55 ISyAr
Kouros, Acropolis bronze
 RICHTH 179 GrAN
Kouros, Delphi bronze; 19. 7
 cm
 WEG 64 GrDM
Kouros, Paros marble;
 40. 6
 GAU 68 FPL
Kouros, Parthenon stone
 MILLER il 25 GrAA
Kouros, Samos bronze
 RICHTH 178 GrVM
Kouros, Volomandra c 575/550
 B. C.
 RICHTH 57 GrAN
Kouros, fragment 560/540
 B. C. marble
 CLE 20 UOClA (53. 125)
Kouros (Apollo of Attica)
 c 540/515 B. C.
 RICHTH 67 GMSA
Kouros (Apollo of Melos)
 c 540 B. C. marble; 84

CHASEH 62; CHENSW 97;
DEVA pl 32-33; LARA 252;
LOWR 235; LULL pl
34-35; PRAEG 11;
RICHTH 57; ROOS 26C;
WEG 26 GrAA (1558)
Kouros (Apollo of Piraeus)
 c 530 B. C. bronze; 75
 BAZINW 130 (col);
 RICHTH 70; STRONGC 51
 (col) GrAN
Kouros (Apollo of Tenea)
 c 575/550 B. C. Parian
 marble; 61
 BAZINH 66; BAZINW
 129 (col); BEAZ fig 29;
 CHENSN 107; CHENSW
 97; CHRH 66; CLAK 32;
 DEVA pl 27; GARDH 119;
 KO pl 3; LAWC pl 41A;
 LULL pl 36-38; MARQ 71;
 RICHTH 56; UPJH pl 23B;
 WEG 23 GMG
Kouros (Boy from Acropolis)
 c 500 B. C. bronze; 27 cm
 WEG 29 GrAA
Kouros (Boy of Kalivia)
 MALV 80 GrAN
Kouros, Boeotia stone
 CHENSW 98 GrAN
Kouros, fragment
 CHASE 15 UMB
--, head
 CHASE 15 UNNMM
--, head
 MALV 78 GrAA
--, head
 ROOS 28G GrAA
--, head marble
 ZOR 103 UNNMM
--, head, stele fragment
 540/530 B. C.
 DIV 23 UNNMM
--, head c 530 B. C.
 Parian marble; 12. 6
 LULL pl 46-47 DCN
 (No. 11--Inv. 418)
--, head c 500 B. C.
 marble
 CHASE 16 UNNMM
--, head 500/490 B. C.
 LARA 239 GrAA
--, head, Temple of Apollo
 Ptoos
 LARA 252 GrAN
--, type figure
 MILLER il 20 GrAN
Jug: Woman, Sicily terracotta
 RICHTH 222 UNNMM

Lamp and Candelabrum:
 Woman, Kameiros, Rhodes
 pale pink terracotta; 19-3/4
 GRIG pl 54 ELBr
Lion; rear view, Miletos
 c 525/500 B.C. marble;
 L: c 54 cm
 HAN pl 42-43 GBS
Lioness, Corfu c 575/550
 B.C. bronze; 3-3/4x6-3/4
 GRIG pl 47 ELBr
Lycurgus and Amphiaraus
 Fighting in Front of Adrastus,
 shield strip attachment
 plate c 570/560 B.C. strip
 W: 2-13/16
 SCHEF 82 GrO
Lyre Player, Thebes terracotta
 HOR 171
Male Figure
 HAUSA pl 7 GrAN
--, relief detail, Tomb of
 Warrior c 510 B.C.
 Parian marble; 40-1/8
 NEWTEM pl 14 GrAN
--: Right Hand Hold Small
 Stag (line drwg) bronze
 CHRP 63 ELBr
Male Head
 LAWC pl 10B GBS
--c 530 B.C. marble; 31 cm
 BOES 89 DCN
Male Torso c 500 B.C. bronze
 READM pl 24 IFAr
Man from Samos c 550 B.C.
 marble; 6-1/4
 STRONGC 59
Medusa Head, handle bronze
 BOSMG 63 UMB (99.462)
Memorial Statue of Kroisos
 ("Croesus"; Kouros from
 Anavysos; Young Kroisos)
 c 525 B.C. ptd marble;
 76
 BO 74; DEVA pl 34-35;
 JANSH 83; JANSK 122; KO
 pl 3; LULL pl 57-61; MYBS
 20; NEWTEM pl 5; PRAEG
 132; RICHTH 67 GrAN
 (3851)
Menelaus Wooing Helen,
 Shield relief c 590/580
 B.C. strip W: 2-7/8
 SCHEF 85 GrO
Metope Detail: Argonaut
 Expedition c 560 B.C.
 BO 82 GrDM
Minotaur cast bronze
 READI pl 44A FPL

Mirror: Girl and Griffins
 c 530 B.C. bronze;
 13-5/8
 BO 116; RICHTH 202 UNNMM
Mirror: Girl and Sphinxes
 c 500 B.C. bronze
 RICHTH 203 GrAN
Mirror, with figure support
 bronze; 13-5/8
 NM-5:11 UNNMM (38.11.3)
Moschophorus (Calf Bearer;
 Calf Carrier; Hermes
 Moschophorus), Athenian
 Acropolis c 570 B.C.
 marble; 65
 BEAZ fig 35; BOWR 65
 (col); CHASEH 65; CHENSN
 112; CHENSW 99; DEVA
 pl 20; HAN pl 52; HOR 212;
 JANSH 84; JANSK 119;
 LARA 252; LAWC pl 8;
 LULL pl 24-25; MARI pl 7;
 NEWTEM pl 2; RICHTH
 61; ROOS 28F; RUS 21;
 UPJ pl 23A; WEG 126
 GrAA (624)
--, head
 BAZINH 500
Mother and Child, relief
 fragment c 530 B.C.
 marble; .385 m
 HAN pl 94 GrAN
Naxian Sphinx, Capital,
 Delphi c 560 B.C. marble;
 .232 cm
 BO 70; DEVA pl 29;
 HAN pl 48; HOR 123; LARA
 239; LAWC pl 5B;
 READI pl 24: ROOS 27G;
 WEG 125 GrDM
Nike of Delos (Artemis;
 Flying Victory; Victory of
 Delos; Winged Nike) 550/520
 B.C. marble; 36
 CHASE 8; CHASEH 64; DEVA
 pl 31; HAN pl 80; LARA
 253; LAWC pl 1B; MYBA
 81; RICHTH 62; ROBB
 294; ROOS 251; UPJ 69;
 UPJH pl 24F; WEG 14
 GrAN
Olympian Breastplate,
 fragment
 LARA 249
Orestes Slaying Aegisthus,
 shield relief c 580 B.C.
 strip W: 2-13/16
 SCHEF 94 GrO

Owl limestone; 3-1/2x4-3/4
 BERL pl 110; BERLES 110
 GBSBe (1722--A 10)
Paestum Poseidonia Coin:
 Poseidon with Trident
 BOSMG 39 UMB (04. 352)
Patera Handle 550/470 B. C.
 bronze; handle L: 8
 TOR 103 CTRA (957. 161)
Peleus and Thetis, relief,
 Tegea c 650 B. C. clay;
 7-1/2
 SCHEF pl 28 GrAN
Perseus: Beheading Medusa
 (Athena, Perseus and
 Gorgon), metope, Temple
 C, Selinus 550/530 B. C.
 brown tufa; 58
 AGARC 27; CHASE 9;
 CHASEH 66; LOWR 30;
 READAS pl 42; ROBB 295;
 ROOS 26B; STA 8; STI 165;
 STRONGC 60; UPJH pl 24
 IPalM
Perseus and Medusa, relief,
 Samos ivory
 RICHTH 180 GrAN
Pharsalos Relief W: 26
 UPJH pl 24 FPL
Plaque: Orestes Slaying
 Clytaemenstra; Theseus
 Winning Amazon Antiope,
 Olympia c 570 B. C. bronze
 SCHEF pl 80 GrOM
Preparation for Chariot Race
 between Pelops and Oenomaus,
 figure fragments, Temple
 of Zeus, eastern
 pediment
 LARA 263 GrOM
Priam Begging Achilles for
 Body of Hector, mirror
 plaque c 560 B. C. bronze; 2
 SCHEF pl 76 GBS
Priestess 570/550 B. C.
 ivory; . 107 m
 HAN pl 25 TIAM
Priestess; profile, Temple of
 Apollo, Didyma c 530 B. C.
 marble; 55cm
 HAN pl 65, 66 GBS
Punishment of Prometheus,
 shield relief c 590 B. C.
 H: c 7-7/8
 SCHEF pl 41 GrOM
Pythagorus, head (Roman
 copy)
 HOR 201 IRC

Quadriga of Apollo, metope
 fragment, Temple C,
 Selinus c 560 B. C.
 LARA 265 IPalM
Raid by Dioscuri, metope
 fragment, Sicyonian
 c 560 B. C.
 LARA 272 IPalM
Rampin Horseman (Cavalier
 Rampin; Payne-Rampin
 Horseman; Rampin Knight;
 Rider's Head) c 560
 B. C. marble; torso:
 c 2. 8'; head: 11-1/2
 BO 75; HAN pl 59;
 LULL pl 30-31; NEWTEM
 pl 3; READAS pl 62;
 READI pl 46; RICHTH
 62; SCHO pl 19 (col);
 STRONGC 52 (col)
 torso: GrAA (590)
 head: FPL (3104)
--: Head
 BEAZ fig 37; CHAR-1:
 141 (col); CHASE 16;
 DEVA pl 40; GAF 139;
 GAU 70-71; JANSH 84;
 JANSK 121; LARA 252;
 LAWC pl 10A; MU 40
"The Rayet Head", youth
 Attic c 530 B. C. Parian
 marble, traces of red
 paint; 31 cm COPGG 27
 DCN (L N. 418)
Runner, Samos c 520/500 B. C.
 bronze
 RICHTH 179 GrVM
Running Nereids(?), metope
 c 510/500 B. C.
 RICHTH 82 GrFH
Running Winged Female
 Figure, Temple metope,
 Sicily c 570 B. C.
 limestone
 COPGG 25 DCN (6a)
Sanctuary of Apollo, Delphi
 CHASE 14
Satyr, reclining figure,
 scarab c 530 B. C. agate;
 L: 7/8
 BO 117 ELBr (Walters
 465)
Seated Female Figure,
 dedicated by Aiakes c 525/
 500 B. C.
 RICHTH 74 GrSamT
Seated Figure, Didymia
 c 560/550 B. C.
 RICHTH 60 ELBr

Seated Figure, Sacred Way,
Temple of Apollo, near
Miletus 550/530 B. C.
GARDH 117 ELBr
Seated Figures, Sanctuary of
Apollo, Branchidae (line
drwg) c 550 B. C. marble
CHRP 60
Seated Man, fragment
530/520 B. C. marble;
1. 08 m
HAN pl 72 GrAK
Seated Priestly Ruler c 570
B. C. marble; 1. 55 m
HAN pl 70 ELBr
Seated Woman c 525/500 B. C.
terracotta
RICHTH 222 UNNMM
Shield Strip: Birth of Athene;
Achilles and Penthesilea;
Ajax and Cassandra;
Hercules and Gorgon,
Delphi c 560 B. C. strip
W: 2-7/16
SCHEF pl 77 GrDM
(4479)
Sicyonian Treasury, metope
fragments c 570/550 B. C.
H: 22-7/8
--: Argo
LAWC pl 6 GrDM
--: Argo and Orpheus;
Dioscuri and Argonauts
SCHEF pl 63
--: Cattle Raid (Dioscuri
and Apharetids Carrying
off Cattle; Three Soldiers
with Cattle of Enemy)
CASSM 77: LAWC pl 6;
SCHEF pl 63
--: Europa on Bull
SCHEF pl 55
Siphnian Treasury, Delphi
530/525 B. C. W: 20'
1-1/2"
UPJH pl 17C GrD
--: Facade (reconstruction in
plaster), Sanctuary of
Apollo c 530/520 B. C.
CHASEH 69; JANSH 88;
JANSK 125; ST 35; STA
6
--: Frieze c 530 B. C.
LAWC pl 13
--: Frieze--Caryatid total
H: 131
DEVA pl 42; KO pl 5;
RICHTH 74

--: Frieze--Caryatid, Sphinx
MYBA 89
--: Frieze--Horses
GARDH
--: Frieze--Horses (cast)
LARA 267 FPL
--: Frieze--Human Figures
CHRH fig 22
--: Frieze--Lotus and
Palmette Capital
BO 72
--East Frieze: Battle
between Greeks and Trojans
HAN pl 87; LULL pl 48;
ROOS 27C; WEG 56
--East Frieze: Battle of Gods
and Giants (Gigantomachy)
BOWR 23 (col); DEVA
pl 49-50; 53; RICHTH 81;
STRONGC 54 (col)
--: East Frieze--Council of
Gods marble; 26
JANSK 125; UPJ 70;
UPJH pl 24E
--(cast)
LARA 266 FPL
-- -- Aphrodite, Artemis,
and Apollo; detail
LULL pl 48-49; ROOS
27B; WEG 156
--: North Frieze--Lion of
Cybele Devouring a Giant
c 525 B. C. marble
DEVA pl 51; HOR 318
--: North Frieze--Battle of
Gods and Giants marble;
c 26
BOE pl 2; CHASEH 71;
DEVA pl 46; HAN pl 89;
JANSH 88; JANSK 124;
LARA 267; LULL pl 48,
50-55; ROTHS 51; WEG
158-159
--: detail: Apollo and
Artemis Battle Giants
BO 85; DEVA pl 48
--: detail: Athena
DEVA pl 47
--: Chariot of Zeus Attacked
by Two Giants
DEVA pl 52
--: Heracles and Cybele
HAN pl 88
--: South Frieze--Carrying
off the Daughters of
Leucippus; Chariot Horses
DEVA pl 54, 55
--: detail: Procession of
Horsemen ROTHS 51

--: East Pediment--Apollo
and Hercules Contest the
Tripod
DEVA pl 56; RICHTH 79
--: East Pediment--A
Soldier
DEVA pl 57
Spartan Warrior bronze
BOWR 138 UCtHWA
--bronze; 5-1/2
WORC 14 UMWA
Sphinx stone
CHENSW 100 GrAA
--: Surmounting Stele c 540
B. C. marble; over 13'
HAN 18; RICHTH 63;
WB-17:197 UNNMM
--: Surmounting Stele, Attica
c 570 B. C. marble; 18
BO 86 GrAN (28)
--, headless grave monument
fragment, Attica c 530
B. C. marble; 55-3/4
BOSMI 53; HAN pl 49;
RICHTH 64 UMB (40. 576)
--, seated figure, fragment,
Acropolis, Athens c 550
B. C. Parian marble;
21-5/8
LULL pl 56; STRONGC 57
GrAA (632)
Stater of Kaulonia: Striding
Figure c 500 B. C. silver
RICHTH 245 ELBr
Stater of Metapontion: Ear of
Bearded Wheat silver
BEAZ fig 228 ELBr
Stater of Poseidonia: Striding
Figure c 525/515 B. C.
silver
RICHTH 245 ELBr
Stater of Priene: Athena in
Helmet, head c 500 B. C.
electrum
BEAZ fig 231 -Ja
Stater of Samos: Forepart of
Bull c 500 B. C. electrum
BEAZ fig 233 ELBr
Stele: Athlete and Girl
LAWC pl 12B UNNMM
Girl's Head: GBS
Stele: Discus Bearer, Athens
Parian marble; 13. 6x17. 8x17. 2
DEVA pl 37; LULL pl 39
GrAN (38)
Stele: Head detail, Attica H:
over 13'
CHASE 26, 27 UNNMM

Stele: Youth Holding a
Flower c 520 B. C.
RICHTH 77 FPL
Stele from Chrysapha:
Spartan Couple Receiving
Offerings
HOR 170; LAWC pl 11 GBS
Stele of Ephebe Parian
marble; 2. 07 m
CHAR-1:138 FPL
Stelae: Menelaus Wooing
Helen; Menelaus Threaten-
ing Helen, Sparta
c 580/570 B. C. H: 26-3/8
SCHEF pl 68, 69 GrSpM
Symposiast: Reclining Man at
Feast, vessel rim,
Dodona c 520 B. C. bronze;
L: 4
BO 114; RICHTH 180;
STRONGC 52 (col) ELBr
(1954. 10-18. 1)
Temple of Apollo, pediment
group: Headless Figures;
Lion
LAWC pl 17B GrD
Temple of Apollo,
Daphnephoros, Eretria:
Theseus Carrying Off
Antiope, west pediment
c 510 B. C. Parian marble
BEAZ fig 52; DEVA pl
65-66; LULL pl 66-68;
ST 37 GrChM (4)
Temple of Artemis, Corfu:
Pediment Reconstruction
STI 226 GrCM
--: Cronus, or Rhea, west
gable figure c 580 B. C.
limestone; 102
SCHEF pl 42
--: Medusa: With Pegasus and
Chrysaor, between Crouch-
ing Lion-Panthers, pediment
fragment limestone; 22. 16
m; plinth; 48-3/4x16. 4'
DEVA pl 24; GARDH 123;
HAN pl 79; LAWC 111
--: Chrysaor
LULL pl 19; head detail
DEVA pl 26
--: Crouching Lion-Panther
yellowish grey limestone;
plinth: 48-3/4x16. 4
LULL 8, 16; head detail
DEVA pl 23 LULL pl 9
--: Medusa (Gorgon), central
figure limestone; c 110

KO pl 7; LARA 268;
LULL pl 92-93; NEWTEM
pl 7; READAS pl 61; SCHO
pl 30 (col); UPJH pl 23E;
WEG front FPL (61)
--, head detail
LULL pl 94-95; WEG 26
--, rear view
BAZINL pl 111
Archer, plasma scarboid,
Cyprus
BEAZ fig 220 ELBr
Ares(?), helmeted head
CHASE 71 UMCF
Aristogeiton, head: profile
477 B. C. marble; 53 cm
PRAD pl 35-36 SpMaP
Arkesilias IV of Cyrene,
head c 450 B. C. bronze;
. 102 cm
HAN pl 151 GrCyA
Artemis: Receiving Sacrifice
of Bull, relief, Brauron
FUR fig 84 GrAN
Artemis, head bronze
FUR fig 86 IPar
--, head, Brauron
FUR fig 87 GrAN
Artemis, relief fragment
436 B. C. marble; c 61 cm
HAN pl 144 GrAA
Artemis Brauronia (Brauronian
Artemis)
FUR fig 85, pl U UNNMM
Aspasia (Roman copy)
c 470/450 B. C.
RICHTH 92 IBai
--(Roman copy)
HOR 271 FPL
Athena
ROOS 34B IRC
--460/450 B. C. marble;
51-3/4
NM-5:17 UNNMM
(42. 11. 43)
Athena: and Erechtheus, record
relief 410/409 B. C.
RICHTH 120 FPL
Athena: Flying her Owl
460 B. C. bronze; 5-7/8
NM-5:19; TAYFF 8 (col)
UNNMM (50. 11. 1)
Athena: Holding Lamp
c 475/450 B. C. bronze
RICHTH 185 UNNMM
Athena: in Helmet bronze
HOR t GrAN
Athena: Reading Decree,
votive relief c 450 B. C.
BO 127 GrAA (1707)

Athena, Ostia (Roman copy)
marble; 86
SUNA 104-105 UCLCM
Athena, head (copy) marble;
54 cm
PRAD pl 72 SpMaP
Athena, helmeted head 400
B. C. marble; 77 cm
PRAD pl 31 SpMaP
Athena, votive relief,
Acropolis, Athens marble;
21. 6
LULL pl 139 GrAA (695)
Athena from Velletri
LAWC pl 57A FPL
"Athena Medici" ("Medici
Torso"; "Minerva Ingres")
(Roman copy) c 450/420
B. C. marble
BAZINW 140 (col); CHAR-
1:167 FPL
Athenian Athlete, head with
fillet marble; 8-1/8
DENV 11 UCoDA (An-21)
Athenian Coin: Athena, head;
Owl
BOSMG 27 UMB (00. 264)
Athlete
CHASE 60 UMWelC
--450/440 B. C.
BEAZ fig 92 UNNMM
--, Croton bronze
CHASE 41 UMB
--, head
CHASE 61 UNNMM
--, head bronze; 33 cm
CHAR-1:165 FPL
--, head, Benevento marble,
copper lips
SCHO pl 44 (col) FPL
--, relief
MATT pl 28 IRV
Attic Funeral Monument:
Battle Scene; details Pentelic
marble; 70x90
LULL pl 179-181 IRAl
(985)
Auriga, head, Delphi c 475
B. C.
MALV 84 GrDM
Baia Amazon, head
MAIU 19 INN
Ball Player bronze
CARPE 85 GrAN
Barberini Suppliant (Abandoned
Dido; Danae Receiving the
Shower of Gold; Delphic
Pythia; Dying Callisto)
Pentelic marble; 40. 2
CHAR-1:169; GAU 81; LARA

288 FPL
Barberini Venus (Roman copy)
CHASE 204 IRV
Basile Abducted from Under-
world by Echelos, relief,
Phaleron c 400 B. C.
marble; 29x34
BO 142; DEVA pl 110, pl
111 (col); LULL pl 188;
MU 46 GrAN (1783)
Battering Ram
bronze
BOWR 70
Battle of the Lapiths and
Centaurs, Opisthodomos
frieze, Theseion 450/445
B. C. H: 85 cm
BOE pl 7 GrA
Bearded Head
FUR 56 IRBar
--540/530 B. C. marble; 23 cm
HAN pl 75 GBS
--; profile marble; 57 cm
PRAD pl 5 SpMaP
Bearded Head, Attica marble;
10-3/4
DETT 26 UMiD (24. 104)
Bellerophon: Slaying the
Chimaera, relief, Melian
c 475 450 B. C.
RICHTH 225
"Blond Boy" (Blond Ephebe; "The
Fair-Haired Boy"), head
fragment c 480 B. C.
marble; 25 cm
BEAZ fig 68; CARPG pl 12;
MILLER il 49; WEG 34
GrAA
Boar, vessel rim figure c 480
B. C. bronze; L: 6-3/8
BOSMI 61 UMB (10. 162)
"Borghese"-Type Ares, bust
LAWC pl 69B GD
Boston Throne (Ludovisi Throne):
Winged Figure with balance
between Cheerful and Pensive
Seated Women; Lyre Player
Old Woman c 470/460 B. C.
marble; 38
BOSMI 63 UMB (08. 205)
--: Contest of Aphrodite and
Persephone, three side
reliefs
BOSMG 57; CHASEH 94
-- -- three side reliefs; head
detail
CHASE 44, 50
--, front: Winged Figure, Eros
between Women; Head of
Old Woman LAWC pl 32-33

--,front--detail:Old Woman
BOSMGR pl 2
Boy 420 B. C. marble
BEAZ fig 96 GrA
Boy: Playing Harp, sard
barrel
BEAZ fig 225 ELBr
Boy: Playing Lyre, relief
fragment marble
DOWN 52; ENC 579 UMB
Boy, Attic grave relief
FUR pl U UICA
Boy, frieze detail, Temple
of Apollo, Thigaleia
c 420 B. C. marble
BEAZ fig 97 ELBr
Boy, torso fragment marble
CHASE 70 UNNMM
Capital, Megara Iblaea, Sicily
c 500 B. C.
BAZINL pl 114 ISyAr
"Cat" Stele c 410 B. C.
marble; 1. 09 m
HAN pl 105 GrAN
Charging Bull, Lucania bronze
CLE 22 UOClA (30. 336)
Chariot, relief c 438 B. C.
marble; 96 cm
HAN pl 134 ELBr
Charioteer of Delphi (Delphic
Charioteer), Sanctuary of
Apollo c 470 B. C. ptd
bronze; 71
BARD 138-139; BEAZ fig
66; BOWR 29 (col); CANK
70; CARPG pl 10; CHASE
33; CHENSW 103; CHRH
fig 24; DEVA pl 97 (col);
ENC 176; FLEM 29; GARDE
49; GARDH 31; GARDHU
48; GAUN pl 23; HAN pl
99, pl 102; JANSH 103;
JANSK 128; KO pl 7; LARA
244; LAWC pl 26; LULL
pl 102-114; MU 42; MYBS
24; NEWTEM pl 11; PRAEG
132; PUT 261; RICHTH 85;
ROBB 298; ROOS 30E-30F;
RUS 22-23; SCHO pl 27 (col),
pl 28 (col); SEW 55 ST 40;
STI 223; UPJ 83; UPJH
pl 26; WEG 36-37 GrDM
(3848, and 3450)
--, detail
BAZINL pl 107 (col); ROBB
291
--, head detail
BAZINW 132 (col); GARDE
50; GOMB 59; HOR 187 (col);
JANSK 129; LULL 16 (col);
STI 224

"Chatsworth Head": Apollo,
Salamis, Cyprus c 360
B. C. bronze; 12-1/2
BO 126 ELBr
Choiseul-Gouffier Apollo
(Roman copy of bronze
original) 470/460 B. C.
BEAZ fig 65: LAWC pl 41A
ELBr
Coin: Anaxagoras, seated
figure
HOR 296 ELBr
Coin, Acanthe: Lion Attack-
ing Bull, Acanthe City
Emblem c 424 B. C.
silver
NEWTEA 42 UNNAmN
Coin, Catana: Apollo,
head c 415/400 B. C. Dm:
1-1/8
JANSH 122; JANSK 160
ELBr
Coin, Naxos: Silenus c 460
B. C. silver; Dm: 1-1/4
JANSH 121; JANSK 159
ELBr
Coin, Pararethus: Winged
God c 500 B. C. silver;
Dm: 1-1/2
JANSH 121 ELBr
Coin, Syracuse: Arethusa,
profile head c 430 B. C.
silver
NEWTEA 41 UNNAmN
Coin, Syracuse: Chariot;
Profile Head c 400 B. C.
silver; Dm: 1-1/2
MU 46
Coin, Syracuse: Female
Profile with Dolphins
MYBU 225 UNNCity
Coin, Taranto: Hero Riding
Dolphin silver; Dm: 1
WCO-3:26 (col) FPBN
Combat between Warrior and
Amazon, relief fragments,
Siris bronze; 7; and 6-1/2
RICJ pl 30 ELBr
Corinthian Capital, Epidaurus
HOR 233 GrEpM
Cottenham Relief, fragment:
Youth and Horse c 485
B. C. 11x12
COOP 183 UCLGe
Crown, detail: Enamelled
Flowers and Rosettes
gold
SCHO pl 50 ITarA

Cypriot Male Figure c 500
B. C. limestone; 46 cm
JOO 173 (col) NOK
Dancing Girl, relief, Melos
terracotta
BOWR 91 (col) FPL
Death of Actaeon, metope,
east side, Temple of
Hera, Selinus c 460 B. C.
yellowish-grey tufa;
section: 1. 62x1. 40 m
BOE pl 5; DEVA pl 88;
LULL pl 126; RICHTH
IPalC
Decadrachm, Akragas: Two
Eagles on a Hare; Grass-
hopper c 408 B. C. silver;
Dm: 1-1/2
JANSK 159
--Two Eagles on Hare
BEAZ fig 242 GM
Decadrachm, Syracuse
BAZINH 92 FPBN
--: Chariot c 479 B. C.
silver; Dm: 1-1/2
JANSK 158
Demareteion, Syracuse:
Arethusa, profile with
Dolphins; Chariot c 479
B. C. silver; Dm: 1-1/2
BEAZ fig 232; GARDH
138; RICHTH 244; THU
111 ELBr
--: Arethusa, profile with
Dolphins; Nike Crowning
Chariot-Race Winner
BOSMG 28; BOSMI 61
UMB (35. 21)
--: obverse: Arethusa
FAIN 86; SCHO pl 61 (col)
--: reverse: Racing Chariot
HOR 282
Demeter
VALE 157 GMB
--terracotta
FEIN pl 26 UMB
--c 480 B. C.
MILLER il 27 GBA
Demeter: Dispatching
Triptolemus, votive
relief c 440 B. C. Pentelic
marble; 95x60
CHENSN 111; LULL pl
172-173; RICHTH 118;
STRONGC 68 GrAN (126)
Demeter and Cora: Glorifica-
tion of the Flower,
Pharsalus c 470 B. C. marble
DEVA pl 87 FPL

Demeter, Kore, and Messenger
437/432 B. C. marble;
1. 73 m
HAN pl 124 ELBr
Departure of the Cavalry,
Opisthodomos frieze,
section H: 1. 06 m
BOE pl 8 GrA
Diomedes, head (copy)
marble; 53 cm
PRAD pl 72 SpMaP
Diosa, headless figure
marble; 62 cm
PRAD pl 32 SpMaP
Dioscuri Dismounting from
Horses held by a Triton,
Locri Parian marble
MAIU 22 INN
Dioskuros of Monte Cavallo,
Quirinae
FUR 98 IR
--, detail: Horse-Tamers
CARPG pl 47B
Discobolos (Discus-Thrower)
c 480 B. C. bronze; 9-1/4
CHASE 41; RICHTH 183
UNNMM
--450/430 B. C. bronze;
. 153 m
HAN pl 116 GrAN
Draped Female Figure marble;
c 24
CHASE 18 UNNMM
--: In Pointed Hat, Tanagra
AUES pl 9 ELBr
Draped Kore, half-figure
fragment
CHASE 12
GrAA
Drinking Man, Tanagra
SUNA 242 UWaMM
Dying Niobid, c 350/360 B. C.
Parian marble; 59
KO pl 9; LULL pl 174-177
IRT (72274)
--(Wounded Niobid), recumbent
pediment figure Parian marble;
62x65 cm
COPGG 33 DCN (399--L N.
472)
Enthroned Goddess: In Chiton
and Mantle, Taranto c 480
B. C. Parian marble;
59-1/2
BERL pl 113; BERLES 113;
DEVA pl 74-75; KO pl 2;
LAWC pl 24; LULL pl
97-101; MU 42; RICHTH
74 GBSBe (1761--A-17)

Epitaph for Athenians Fallen
in Battle of Potidaia, in-
scription fragment 432
B. C.
HOR 306; RICHTH 379
ELBr
Equestrian, relief, public
grave c 430 B. C.
ST 49 IRAl
Erato, seated figure marble;
1. 62 m
PRAD pl 28 SpMaP
Erechtheum: Cella
Decoration c 420 B. C.
marble
BAZINW 144 (col) GrAA
--: Decorative Patterns,
north door
CHASE 206
--: Ionic Capital, north porch
BAZINW 144 (col); CHASE
206
--: Ionic Column Base, north
porch: Intertwining Band
BOE pl 13
--: Moulding Bands
CARPE 105
--: Moulding Bands--Bead-
and-Reel; Egg-and-Dart;
Honeysuckle; Leaf-and-
Dart (Leaf-and-Tongue)
FLEM 16; GARDH 115;
ROOS 20D
--: Moulding Bands--Cornice
Band, southwest corner
cella, above Porch of
Maidens
BOE pl 10
--: Moulding Bands--Egg-and-
Dart
DOWN 50
--: Moulding Bands--Egg-and-
Dart; Palmettes
WEG 152
--: Moulding Bands--Honey-
suckle
SEW 159
--: Pediment (west), and
metope fragments 1. 34x
1. 27 m
BOE pl 9
--: Porch of Maidens (Carya-
tid Porch) 421/406 B. C.
marble; ea figure H: 81
BAZINW 142 (col), 143 (col);
BOE pl 11; BOWR 110;
CHASE 204; CHRP 91;
DAM 24; ENC 284; FLEM
15; GARDHU pl 38;

GERN pl 12; HOR 6
(col), 226-227 (col); LARA
245, 259; MU 44 (col);
MYBA 102; PRAEG 154;
RICHTH 28; ROOS 34C;
SCHOR pl 47 (col);
ST 52; STA 6; STI 215;
STRONGC 84 (col); UPJH
pl 19B; WEB 151 GrAE
--, figure detail (line drwg)
CHRP 92
--, plaited hair
BOE pl 12
--: Caryatid (Roman copy,
Hadrian's Villa, Tivoli)
RICHTH 123
--: Caryatid, south porch
c 410 B.C.
BO 135; CHASE 204;
CHASEH 107; ENC 162; HAN
pl 146; KO pl 5; READAS
pl 20; RICHTH 123; UPJH
pl 31 ELBr
--Caryatid (2nd c. Roman
copy)
BAZINW 143(col) ITiH
--(Roman copy, restored by
Thorwaldsen)
BAZINW 143 (col)
--: Caryatids
DEVA pl 119 (col) GrAE
Eros
FUR pl V IRV
Eros: Carrying off Woman,
sard scaraboid, Cyprus
BEAZ fig 219 UNNMM
Eros: Visiting a Bride,
plaque, Terentum terra-
cotta
RICHTH 726 EOA
EsquilineVenus (replica)
CLAK 76; LARA 287 IRCo
--(Roman copy) c 460 B.C.
HOR 192; HUYA pl 20;
LARA 287 FPL
Europa (Amelung's Goddess)
(cast of Roman copies, after
bronze of 470/460 B.C.)
BEAZ fig 71 GB
Euripides, bust
ENC 287
Exhaltation of the Flower:
Gift Exchange between
Demeter and Hades, relief
marble; 57 cm
CHAR-1:159 FPL
Fallow Deer, sard scaraboid
BEAZ fig 226 UMB

Farnese Hera, head (copy)
marble
MAIU 23; MARQ front
INN
Female Figure, Acropolis,
Athens
GARDE 21
--, Verroia bronze; 10
BO 173 (col) GMSA
(3669)
Female Figure: Doll, Attic
terracotta
CLAK 74 FPL
Female Figure: In Peplos,
fragment marble; 30
COOP 182 UCLGe
Female Figure: Supporting
Incense Burner, Delphi
c 475/450 B.C. bronze
RICHTH 185 GrDM
Female Figure, armless:
In Turban c 400 B.C.
bronze
CLAK 80 GM
Female Figure, headless
BAZINH 501 IRMN
Female Head marble; 10
COOPF 287 -SpA
--(copy) marble; 27 cm
PRAD pl 78 SpMaP
Female Head, Olympeion
BAZINW 132 (col) IAM
--, votive figure fragment
c 500 B.C.
LAWL pl 81A UNNMM
--, votive tondo fragment
c 460 B.C. Parian
marble; 13x13-1/2
LULL pl 138 GrAN
(3990)
--, west pediment, Heraion,
Argos c 420 B.C. marble;
face: 6-1/2
BAZINW 146 (col) GrAN
Female Profile Figure,
gravestone relief, Paros(?)
c 450 B.C. H: 56
BO 127 GBS
Female Torso (replica)
CLAK 76 FPL
Fleeing Niobid marble; 57
KO pl 9 DCN
Footprint, scaraboid, Cyprus
chalcedony
BEAZ fig 222 EOA
Footed Mirror, Corinthian
of Sicyonian bronze
LARA 285 FPL

Fortune (copy) marble; 81 cm
PRAD pl 32 SpMaP
Funeral Banquet L: c 48
LAWC pl 29B TI
Gem: Stag rock crystal;
W: 15/16
GARDH 139 UMB
Giants, heads, Temple of
Zeus
BEREP 102 IAM
Girl: With Cap c 400 B. C.
PACH pl 18 GMA
Girl: With Pigeons, stele,
Paros c 450 B. C. marble;
31-1/2
NM-4:20; NM-10:30
UNNMM (27. 45)
Girl Runner (Marble copy of
bronze original)
LAWC pl 40A IRV
God, torso marble; c 1/2 LS
CHASE 69 UNNMM
Goddess: On Dolphin terracotta
WCO-3:27
Goddess, Cherchel (Roman
copy) c 440 B. C. marble
BEAZ fig 94
--, head (Roman copy)
CHASE 39 UMB
--, head, cult-image marble;
83 cm
WEG 81 IRT
Goose, with Goslings
terracotta
DOWN 44 UNNMM
Grave Stele: Traveller Rest-
ing on Stick, Aegaeum
MAIU INN
--, Megara 420/410 B. C.
marble; 73x36
WORC 14 UMWA
Grave Stele of a Young Girl
c 460 B. C. Parian
marble; 1. 43 m
BERLES 112 GBSBe
(1482--K 19)
Greek and Amazon, relief
(Roman copy of c 150)
438 B. C. marble; 90 cm
HAN pl 113 GrPM
Greeks Battling Amazons,
relief, Temple of Apollo,
Phigaleia c 425/420
B. C.
RICHTH 122 ELBr
Grimani "Abundance" marble;
41-3/4
MURA 2 (col) IVA

Guerrero, bust (copy) marble;
78 cm
PRAD pl 34 SpMaP
Hades and Persephone
c 460/450 B. C.
chalcedony
RICHTH 237 UNNMM
Hand; Foot--details
ZOR 42 GrOZ
Harmodius, head (Roman
copy) 477 B. C. marble;
10
NM-5:16 UNNMM (26. 60. 1)
Harpy Tomb, Lycia: Funerary
Cult Scenes c 500 B. C.
LARA 267; LAWC pl 29A;
SCHO pl 24 (col) ELBr
Hazel-Nut, scaraboid
chalcedony
BEAZ fig 224 UMB
Head
FUR 98 FPL
--bronze
CARPG pl 43A GMG
--c 500 B. C. stone
CHENSW 101 UMoKNG
--, Agora, Athens
terracotta
RICHTH 84 GrAAg
--, Jacobsen Collection
FUR 98 DCN
Helmeted Warrior, pediment
figure, Aegina
HOR 188 IRC
Hephaestus (Haphaestus;
Hephaistos), standing
figure c 460 B. C. bronze;
. 215 m
HAN pl 117; HOR 74;
RICHTH 183 UDCD
Hera (copy) 430 B. C.
marble; 2. 08 m
PRAD pl 1 SpMaP
Hercules (copy) marble;
1. 49 m
PRAD pl 48 SpMaP
Hercules: And the Cretan
Bull, relief c 460 B. C.
marble; 1. 60 m
HAN pl 111 FPL, GrOM
Hercules: Presenting Athena
with the Stymphalian Birds,
fragment, west metope,
Temple of Zeus, Olympia
c 460 B. C. Parian
marble; 1. 57 m
CHAR-1:160-161 FPL
Hercules: Pursuing the

Centaurs, relief Assos
 CHASE 24 UMB
Hercules: With Club and Lion
 Skin H: c 22
 CHASE 40 UMB
Herm, head
 CHASE 71 UNNMM
Hermes c 450/400 B. C.
 terracotta
 RICHTH 227 GrAN
Hermes: and the Graces
 (Hermes et Les
 Charites) c 480 B. C.
 marble; 93 cm
 CHAR-1:157 FPL
Hermes: And the Graces
 Dancing, relief c 500
 B. C. marble
 DEVA pl 91 GrAA
Hermes, bearded head (copy)
 marble; 53 cm
 PRAD pl 33 SpMaP
Hermes, head (copy)
 marble; 47 cm
 PRAD pl 49 SpMaP
Hermes, head fragment
 CHASE 61 UMB
Hermes, Eurydice, and
 Orpheus, relief
 RUS 29 FPL
--c425/420 B. C. (Roman
 copy)
 RICHTH 120 IRAl
Heroic Male Head
 GLA pl 29
Hestia 460 B. C.
 LARA 244 IRCo
Hestia Giustiniani (Giustiani
 Vesta) (Cast of Roman
 copy after bronze of 470/460
 B. C.)
 BEAZ fig 70; CHASE 40
 IRTo
Home-Coming of Odysseus,
 plaque terracotta;
 10-15/16
 HOR 104-105; NM-5:21
 UNNMM (30. 11. 9)
Hope-Farnese Type Athena
 LAWC pl 50B IN
Horse bronze
 FAUL 347 UNNMM
--c 480/470 B. C. bronze;
 15-1/4
 GARDH 121; NMA 28;
 RICHTH 184; TAYFF 8
 (col); WB-17:197; ZOR
 28, 30 UNNMM

--, head detail
 NM-10:29
--c 500 B. C. stone
 CHENSW 101 GrAA
--, from Quadriga, Olympia
 c 470 B. C. cast bronze;
 c 8-3/4
 LULL pl 106; RICHTH 184
 GrAN
--, forepart fragment
 490/480 B. C. marble;
 44-1/2
 STRONGC 62 GrAA
--, head detail
 CHENSP 23 UNNMM
--, head, statue fragment
 marble; 1. 02 m
 PRAD pl 86 SpMaP
--, head, Attic patinated
 bronze; 7. 12
 COOP 261 FPDavr
Horseman, relief marble;
 16-1/2
 COOP 32 UNNBak
Horseman and Enemy,
 sepulchral frieze
 c 430/420 B. C.
 RICHTH 118 IRAl
Horsemen, stele fragment
 Boetian marble
 LAWC pl 60 IRV
--, Parthenon c 440 B. C.
 stone
 CHENSW 113 GrA
"Humphrey Ward" Head:
 Female
 LAWC pl 34A FPL
Hygeia marble
 BARD-2:pl 162-163 BrSpA
Initiation of Triptolemos,
 Eleusis relief marble; 96
 KO pl 8 GrAN
Ionic Capital 421/405 B. C.
 SCHO pl 46 (col) GrAA
Ionic Volute marble
 DOWN 51 UMB
Javelin Thrower, Etruria
 bronze; 17. 9
 BAU 98 FPL
Jumper
 CHASE 43 UNNMM
Jury Ballots
 HOR 166 GrAAm
Kore (Female Figure),
 Acropolis
 ROOS 26K GrAA
--, draped figure
 CHASE 10 GrAA

--, head c 500/490 B.C.
marble; 73
KO pl 2 GrAA
--, votive figure
CHRH fig 21 GrAA
Kore from Klazomenai,
headless figure c 540/525
B.C.
RICHTH 74 FPL
Kore from Xanthos, Lycia
c 470/450 B.C.
RICHTH 93 ELBr
Kouros (Youth) (Roman copy)
marble
DIV 20 UNNMM
--c 480 B.C. marble; 39-3/4
EXM 10 ELBr
--: head: Fillet of Victory
(Roman copy) marble
CHRP 73 UNNMM
--, torso bronze; 92 cm
WEG 34 IFAr
--, torso c 475 B.C.
VER pl 28 UMB
Kouros from Attica, head
fragment c 540/515
B.C.
RICHTH 69 DCN
Kreusa(?), vase handle
c 400 B.C. bronze; 27 cm
HAN pl 181 GStWL
Lapith, head, Olympia
MALV 582
Leda and the Swan, fragment
marble
CHASE 68 UMB
Lentini Tetradrachma:
Chariot; Apollo, head
c 479 B.C. silver; Dm:
26.5 m
BOSMI 61 UMB (55.963)
Leonidas, head detail
HOR 163 GrSpM
"Leucothea" Stela
LAWC pl 28 IRAl
Libation Bowl: Herakles in
Chariot silver
RICHTH 205 ELBr
Lion, head terracotta
CLE 21 UOClA (27.27)
--, seated figure
CHASE 23 UMB
Ludovisi Throne (Altar of
Aphrodite): Front Panel:
Birth of Aphrodite
(Aphrodite Rising from
the Sea; Aphrodite Rising
from the Waves),
relief c 460 B.C. Parian

marble; 42x56
BAZINW 136 (col); BO
155; CARRE 53; CHASE
44; CHASEH 94; CHENSN
105; CHENSW 106; CHRH
fig 23; CLAK 78; CRAVR
37; DEVA pl 83; ENC
col pl 3; GARDE pl 24;
GAUN pl 24; HOF 151;
HOR 66-67; KO pl 8;
LARA 286; LAWC pl 30;
LULL pl 134; MALV 636;
MYBA 93; NEWTEM pl
12; RICHTH 93; ROOS
30B, 30D; ROTHS 47;
ROTHST pl 4; SEW 52
IRT (8670)
--(drwg)
PUT 260
--, detail
RICHTH 94
--, Aphrodite, head detail
LULL pl 135
--: Side Panels--Left:
Hetera Playing the Aulos
(Flute Player; Nude Girl
Playing the Pipes);--
Right
ROTHS 49
--: Side Panels--Left
BAZINW 135 (col); CHASEH
94; CLAK 77; DEVA pl
84; HOR 189; KO pl 8;
LARA 286; LAWC pl 31;
LULL pl 136; MU 37;
NEWTEA 37; ROOS 30C;
SEW 53; STA 9; WEG 172
--: Side Panels--Right:
Crouching Female Figure
ROOS 30A
--: Side Panels--Right:
Kneeling Veiled Woman
Dropping Incense on
Candelabrum
CHASEH 94; DEVA pl 85;
LARA 286; LAWC pl 31
--: Side Panels--Right:
Woman Taking Incense
from Box
LULL pl 137
Lycian Sarcophagus, Royal
Cemetery, Sidon c 420/
460 B.C. Parian marble;
100
LAWC pl 73-74; RICHTH
119 TIAM (No. 63-369)
--, detail: Horses, relief
SCHO pl 54 (col)
--, Side Panels: Lion and

Boar Hunt
LULL 194-197
--, Side Panels, detail:
Horseman on Boar Hunt
GARDE 116
Maenad, relief (Roman copy)
marble
DIV 7; DOWN 45 UNNMM
Maenad and Satyr, Mater
Matuta antefix, Conco
c 475 B. C. H: c 60 cm
BOE pl 18 IRGi
Male Head
CHASE 12 GrAA
--bronze; LS
LAWC pl 22A GrA
--5th c. B. C. marble
BEREP 142 IReM
Male Head: With Fillet
bronze
BOWR 135 (col) GMG
Male Head, Benevento bronze;
13
GAU 79 FPL
Man: Mounting a Chariot
CHASEH 77 GrAA
Man: Saluting Divinity bronze
CHASE 43 UNNMM
Marching Soldiers, Nereid
Monument, Xanthos c 420
B. C. marble
BAZINW 146 (col) ELBr
Mirror c 470 B. C. bronze;
11
TOR 103 CTRO (956. 156)
Mirror: Female Figure
Support c 460/450 B. C.
RICHTH 208 GrAN
--, Corinth bronze
HOR cont
Mirror: Woman Holding Dove
Support c 470/450 B. C.
bronze; 16-1/4
COOP 38; RICHTH 208
UNNBak
Mirror: Woman Wearing Chiton
and Pointed Slippers
Support bronze; 9-1/2
BO 170 IreDNB
Mirror, detail c 470/480
B. C. bronze
CLE 21 UOClA (50. 7)
Mirror Cover: Female Head
RICHTH 209 UNNMM
Mirror Cover: Phaedre
Declaring to Servant her
Love for Hippolytus,
Corinth bronze; Dm: 7-1/4
GRIG pl 79 ELBr

Mirror Handle, draped female
figure c 480 B. C. bronze;
10-1/2
BOSMI 59 UMB (01. 7499)
Mother and Child c 460
B. C. sandstone; 35-3/8
NEWTEM pl 32 IFAr
Mounted Warrior, grave
relief fragment 480/470
B. C. marble; 32
BOSMI 65; CHASE 28
UMB (99. 339)
Mourning Woman, gravestone
c 400 B. C. marble; 48-1/8
NMA 25 UNNMM (48. 11. 4)
--, relief detail c 470 B. C.
RICHTH 95 UMB
Narcissus marble; 1. 16 m
PRAD pl 74 SpMaP
"Narcissus" Type Torso
CHASE 65 UNNMM
Naxos Coin: Dionysus, head;
Satyr Drinking
BOSMG 50 UMB (04. 472)
Nereid, Nereid Monument,
Xanthos, Lycia c 400 B. C.
RICHTH 124 ELBr
Nike c 490 B. C.
RICHTH 76 GrAA
Nike: Taking off her Sandals
(Goddess Adjusting her
Sandal; Goddess of Victory;
Nike of the Balustrade;
Nike Untying her Sandal;
"Sandal-Binder"; Victory
Fastening Sandal; Victory
Loosening Sandal;
Victory Tying Sandal;
Victory Undoing Sandal),
balustrade relief, Temple
of Athena, Nike c 410/407
B. C. marble; 56
BAZINW 145 (col); CHASE
57; CHASEH 109; CHENSN
127; CHENSW 116; CHRP
72; DAIN 53; DEVA pl 131;
FLEM 132; FUR pl 0; GARDH
130; GOMB 68; HAN pl 174;
JANSH 108; JANSK 143;
KO pl 12; LARA 279;
LAWC pl 72A; LULL pl
191; MILLER il 40;
MOREYM pl 2; MYBA
108; NEWTEE pl 5b;
NEWTEM pl 21; RAMS pl
8A; RAY 27; ROBB 312;
ROOS 34E; RUSS 56;
ST 52; STRONGC 69
GrAA (12)

Nike of Paionios c 421
 B. C. Parian marble; 85
 (original H, with base);
 H, to tips of wings--now
 lost: c 114
 LULL pl 178; ROBB 311
 GrOM
 --detail
 CARPG pl 24; MALV 61
Nike Temple, frieze
 LAWC pl 65A ELBr
Niobe with Youngest Daughter
 marble
 KO pl 9 IFU
Niobid, headless figure marble;
 1. 14 m
 CHAR-1:168 FPL
Nude: Right Arm Extended
 bronze
 FAIN 148 UMSoD
Odyssey Scenes, frieze,
 Gjolbaschi c 400 B. C.
 sandstone
 BOWR 39-47 AVK
--: Soldiers
 LAWC pl 65B
--: Battle Relief of Massed
 Armed Soldiers, Heroon
 RICHTH 124
Oenoche, handle with female
 bust c 450 B. C. bronze;
 11
 SCHO pl 38 (col) UMB
Omphalos, Temple of
 Apollo, Delphi
 HOR 316 GrDM
"Omphalos Apollo" (marble
 Roman copy; 70) c 460 B. C.
 bronze
 BAZINW 131 (col); RICHTH
 87 GrAN
Ostrakon 483 B. C.
 HOR 166 GrAAm
Palmette, Ionic Treasury,
 Delphi
 ENC 691
Pan, Lousoi, Arcadia
 bronze; 3-5/8
 BO 172 GBS
Paris Abducting Helen;
 Heracles Slaying Geras,
 shield relief, Olympia
 c 500 B. C. strip W:
 2-11/16
 SCHEF pl 57 GrOM
Parthenos (copy) 438 B. C.
 marble; 98 cm
 PRAD pl 19 SpMaP

"Penelope", fragment c 400
 B. C. marble; 85 cm
 BO 141; HAN pl 217 IranTM
Persephone, bust votive mask
 terracotta
 BOSMG 47 UMB (97. 353)
--, seated figure 470 B. C.
 marble; 1. 51 m
 HAN pl 74 GBS
Phanagorian Sphinx, vessel
 clay
 HERM il 36 RuLH
Posiedon (Artemision Zeus;
 Zeus of Artemision) c 460
 B. C. bronze; 82; arm
 span: 83
 BAZINH 81; BAZINW 135
 (col); BEAZ fig 67; BO 125
 (col); CARPG pl 30;
 CHENSW 108; CHRP 68;
 COL-20: 538: DEVA pl 89
 (col), 90; FLEM 29; GARDH
 122; HAN pl 109; HOR
 186 (col); JANSH 105;
 LULL pl 130-132; MYBU
 20; NEWTEM pl 10;
 RICHTH 89; ROTHS 53;
 ROTHST pl 22; SELZJ
 17; ST 10; STRONGC 85
 (col) GrANA (15161)
--, detail
 BAZINL pl 106 (col); BOWR
 67 (col)
--, head detail
 FUR 216; HOR 62-63 (col);
 LULL pl 25 (col); RICHTH
 90; SCHO pl 29 (col)
--, Cape Artemision (copy),
 Main Lobby, General
 Assembly Building H: 84
 BAA 35, pl 20 UNNUN
Poseidon, armless figure,
 Boetia bronze
 FUR fig 15; LARA 268
 GrAN
Preparation for Wedding of
 Persephone (?), votive
 relief c 470/450 B. C.
 terracotta
 RICHTH 226 IReM
Protesilaos (Roman copy)
 460/450 B. C. H: 87
 (with plinth)
 NM-5:18 UNNMM (25. 116)
Prytaneum of Thassos, relief:
 Hermes and One of Graces
 c 480 B. C. H: 36. 2
 GAU 77 FPL

Ransom of Hector, relief,
 Melos c 440 B. C. terra-
 cotta; 7-3/4x10
 TOR 97 CTRO (926. 32)
Reclining Goat, c 500/450
 B. C. bronze
 RICHTH 185 ELBr
Rhyton: Eagle terracotta;
 . 224 m
 CHAR-1:146 FPL
River God, reclining figure
 c 440 B. C. marble; 63-1/2
 STRONGC 85 ELBr
Rondanini Medusa, head
 CHASE 195 GM
Runner, Olympia bronze
 RICHTH 182 GrOM
Running Girl with Winged
 Ankles bronze; 5-1/8
 BOSMI 67 UMB (98. 662)
Running Maiden c 480 B. C.
 limestone
 BAZINW 132 (col); DEVA
 pl 95; HOR 213; RICHTH
 76 GrElM
"Satrap" Sarcophagus, Sidon
 c 450 B. C. marble
 LAWC pl 42-43; ROTHS
 51 TI
Satyr, head, antefix, Gela,
 Sicily clay; 7-3/4
 BO 113 IGeA
Satyr and Maenad c 480 B. C.
 baked clay; 23-1/4
 NEWTEM pl 30 IRGi
Scione Tetradrachm: Protesilaos,
 helmeted head 500/490
 B. C. silver
 BOSMT pl 13A UMB
Seal Ring: Nereid on Sea
 Horse gold
 BOSMG 39 UMB(95. 92)
Seated Man Cooking Dinner
 over Open Fire terracotta;
 4-1/8
 BOSMI 67; HOR 260 UMB
 (97. 349)
Siege of Troy, wall, Lydia
 c 400 B. C. limestone;
 1. 2 m
 HAN pl 133 AVK
Signature Seals: Charging Bull;
 Resting Heron; Race
 Horse with Broken Reins;
 Kneeling Stag; Kneeling
 Ewe; Dolphin
 BOWR 14-15 UMB
Son of Niobe, recumbent figure
 CLAK 226; LAWC pl 58 DCN

Sophocles, seated reading
 figure
 HOR 293 FPBN
Stag, intaglio gem
 ENC 420
Starting Runner (Hoplitodromos)
 c 480 B. C. bronze; 6-1/2
 BO 171 GTuIU
Stater, Elis: Eagles Head
 silver
 BEAZ fig 238 GB
Stele: Athlete, Crowned with
 Olive Wreath, and Holding
 in Right Hand Aryballos;
 in left hand--Two
 Pomegranates
 LAWC pl 12A UMB
Stele: Athlete, with slave boy,
 Rome c 460 B. C.
 RICHTH 97 IRV
Stele: Athlete, with Strigil
 c 465 B. C. marble
 DEVA pl 94 GrD
Stele: Girl; head detail
 Parian marble; 54
 LULL pl 140-141 GBS
 (K 9. Inv 1482)
Stele: Girl: Carrying
 Pomegranate and Bag,
 Attic
 CHASE 72 UNNMM
Stele: Girl: In Peplos and
 Sandals 460 B. C. Parian
 marble; 56-1/4
 BERL pl 112 GBP (1482--
 K 19)
Stele: Girl: Looking in Mirror,
 Attic
 CHASE 72 UMB
Stele: Girl from Larisa
 LAWC pl 22B GrA
Stele: Girl from Venice
 LAWC pl 40B GB
Stele: Helmeted Warrior
 FUR pl K GrAN
Stele: Seated Headless Woman
 and Standing Attendant,
 Athens
 BEAZ fig 106 GrA
Stele: Seated Woman c 400
 B. C.
 RICHTH 120 UNNMM
Stele: Seated Youth, with Dog
 under Chair c 420 B. C
 RICHTH 117 IGrA
Stele: Timarista and Krito
 c 440/420 B. C. marble;
 79 (with acroterion); W:
 38 to 24 LULL pl 185;
 RICHTH 118 GrRA (13638)

Stele: Victorious Youth,
Sanctuary of Athena, Sunium
Parian marble; 24. 4x19. 6
LAWC pl 37A; LULL pl 96
GrAN (3344)
Stele: Warrior 420 B. C.
marble; 1. 838 m
HAN pl 106 UMWA
Stele: Woman Holding Bird,
Esquiline c 470 B. C.
LAWC pl 27A; RICHTH 97
IRCo
Stele: Woman Holding Oil
Flask, Attic
CHASE 74 UNNMM
Stele: Young Man, Nisyros
marble; 72x24
LULL pl 133 TIAM
(clan t 1142)
Stele: Youth, Aegina c 420
B. C. Pentelic marble; 43
LULL pl 182 GrAN (715)
Stele, detail c 440/430 B. C.
CHAR-1:158 FPL
Stele, fragment, Attic c 400
B. C.
FUR 421 UMoSL
Stele, Aegina c 425 B. C.
ST 51 GrAN
Stele, Salamis 430 B. C.
marble; 110 cm
WEG 21 GrAN
Stele Giustiniani marble;
222 cm
WEG 22 GBS
Stele of Ameinokleia marble;
135 cm
WEG 18 GrAN
Stele of Ampharete 420 B. C.
marble; 1. 2 m
HAN pl 149 GrAK
Stele of Hegeso c 400 B. C.
marble; 59x38
BAZINW 144 (col);
CHASE 100; CHENSW 117;
CHRP 78; DEVA pl 135;
FLEM 53; GOMB 63;
JANSH 109; JANSK 142;
LAWC pl 75; LULL pl 187;
MYBA 109; RICHTH 117;
ROBB 310; ROOS 380;
STA 8; STI 241; STRONGC
69; UPJH pl 31; WEG 19
GrAN (3624)
Strangford Apollo, Severe
Style, Anaphe c 500 B. C.
Parian marble; 47
BEAZ fig 47; DEVA pl
76; FUR pl J; GRIG pl 70;

LARA 268; LAWC pl 41A;
LULL pl 88 ELBr (B. 475)
Strangford Shield: Athena
Parthenos, detail
UPJH pl 28 ELBr
Strategos, head in helmet
FUR 121 GB
Suicide of Ajax, Populonia
bronze; c 11 cm
SAN 50 IFAr
Tauric Artemis, Brauron
FUR fig 85
Telamon, Temple of Zeus
LARA 307 IA
Temple, Segesta 430/420
B. C. L: 200'
READAS pl 9 ISeg
Temple of Aphaia, Aegina
See also Greek--5/4th c.
B. C. Temple of Aphaia
--Heracles as Archer, east
pediment c 490 B. C.
marble; 31
CHENSW 105; DEVA pl 69;
GARDH 124; HOR 94-95;
JANSH 89; LULL pl 86-87;
MU 41; NEWTEM pl 9;
RICHTH 83; SCHO pl 25
(col); STRONGC 59 GMG
(No. 84--A 86)
--Warrior of Aegina
PACH pl 47
--Wounded Warrior, west
pediment
BAZINW 134 (col)
Temple of Apollo, Bassae:
Battle of Greeks and
Amazons, cella frieze
c 425 B. C. H: 25-1/4
BAZINW 147 (col);
BO 140; CHENSW 115;
FUR pl M ELBr
--Battling Figures, frieze
BO 14 (col) EOA
--Female Figure, acroterium
DEVA pl 96 FPL
Temple of Athena, Nike
See also Greek--5th c.
B. C. Nike: Taking off
her Sandals
--Assembly of Gods, frieze
c 420 B. C. marble; . 448
m
HAN 135 GrAA
--Athena and a Victory (Nike)
c 410 B. C. H: 35
BO 136 GrA
--Athena and Nikes, north
face of balustrade

--: Deidamia, head, west
pediment
DEVA pl 100
--: Deidamia: Attacked by
Centaur
JANSH 105
--: Female Figure; head
detail, west pediment
ZOR 262
--: Hercules, detail
SLOB 211
--: Hercules: Cleaning
Stables of Augeas, relief
marble; W: 60
CHASE 38; LAWC pl 39;
ROOS 29C; WEG 161, 164
--: Hercules: Presenting
Athena with Stymphalian
Bird
DEVA pl 92; HAN pl 98,
101; LARA 274; LAWC
pl 36B; LULL pl 108-109;
WEG 167 Athena, Head of
Hercules FPL Torso of
Hercules GrOM
--: Hercules: Supporting
Firmament with Athena;
Atlas Bringing Golden
Apples of Hesperides to
Hercules marble; 63
BEAZ fig 79; RICHTH 98;
ROBB 301
--: Atlas Bringing Golden
Apples of Hesperides to
Hercules
BO 120; DEVA pl 93;
LULL pl 107
--: Hercules: Taming Cretan
Bull marble; 63x60
KO pl 6; SEW 66; UPJ
81; UPJH pl 27 GrOM; FPL
--: Hippodamia, the Bride of
Pirithous, Attacked by
Centaur
FUR 61; JANSK 132; STA 8
--: Kneeling Boy marble;
165 cm
WEG 168
--: Kneeling Girl; Crouching
Slave
DEVA pl 101-102
--: Kneeling Lapith, west
pediment
CARPG pl 15
--: Lapith, head, west
pediment
BAZINW 134 (col)
--: Lapith Woman, west
pediment FUR 79, 86;

LULL pl 117; WEG 168
--: Metope
PRAEG 18
--: Myrtilos, Oinomaos's
Charioteer
LULL pl 113
--: Oinomaos and Sterope(?),
east pediment marble;
3. 025 m
FUR 67; HAN pl 100;
ROOS 29H
--: Sterope; Kneeling Girl
and Horses from Quadriga
of Pelops
LULL pl 111
--: Old Man, head detail,
east pediment
FUR pl L; HAUSA pl 8
--: Old Slave, west pediment
CHASE 51
--: Pediments c 470 B. C.
marble; 130x87
STI 227
--: Pediments (restorations)
CHASEH 90
--: Pediments (restorations);
fragments from east
pediment
CHASE 31
--: Pediments--present and
restoration marble;
130x87
RAY 15
--: Pediments--eastern
(restoration)
UPJ 79
--: Pediments--eastern:
Central Figures
WEG 165
--: Pediments--western
CHRP 65
--: Pediments--western
(restoration)
MYBA 90; RICHTH 98;
UPJH pl 27
--: Pediments--western:
Figures
LAWC pl 36
--: Seer Iamos, east
pediment
BEAZ fig 76; LULL pl
114-115
--: Youth, head, west
pediment
WEG 171
--: Zeus between Oinomaos
and Pelops, east pediment
LULL pl 110

Terminal Bust
 FUR 56 IRC
Tetradrachm, Aetna: Silenos;
 Enthroned Zeus Facing
 Eagle in Pine Tree
 c 470 B.C. electrum
 BEAZ fig 234; RICHTH
 246 BB, from electrotype
 of ELBr
Tetradrachm, Himera: Himera
 silver
 BEAZ fig 236 ELBr
Tetradrachm, Karaman:
 Tissaphernes, Satrap of
 Western Asia Minor c 412
 B. C. silver; Dm: .016 m
 HAN pl 162 ELBr
Tetradrachm, Leontinoi:
 Apollo, head; Lion Head
 Surrounded by Grains of
 Wheat silver
 BEAZ fig 237 ELBr
Tetradrachm of Mende,
 Macedonia: Dionysus
 Riding an Ass c 450/425
 B. C.
 RICHTH 248 ELBr
Tetradrachm of Naxos:
 Dionysos; Silenos (Satyr)
 c 460 B.C.
 RICHTH 246 ELBr
-- --Satyr silver
 BEAZ fig 235 ELBr
Thalia, Muse of Comedy, Ostia
 RAD 502 ELBr
Thassos Relief, fragment
 marble; 14-1/2x25-1/2
 COOP 182 UCLGe
Themistocles, bust (Roman
 copy) c 470/450 B. C.
 marble; 50 cm
 FAIR pl L; HAN pl 152;
 HOR 180; RICHTH 91 IOsM
Three Sileni c 480 B. C. ptd
 marble; tallest: .113 m
 HAN col pl 5 (col) UNNSchi
Tombstone of Chairedemos and
 Lyceas, Salamis marble;
 72x43
 LULL pl 184 GrPM
Torso, Acropolis
 ZOR 40
Torso, metope fragment,
 Temple of Hera
 CHASE 64 GrAA
Toys: Boy Riding Goose;
 Doll, Tanagra terracotta
 BOWR 80 (col)
 ELBr

Two Amazons, one on
 horseback, Greet Each
 Other, intaglio (cast)
 rock crystal
 BOSMT pl 29B UMB (27. 697)
Vase: Negro Boy Attacked by
 Crocodile, Capua c 460
 B. C. clay; 9-1/2
 BO 165 UMB (98. 881)
Venus "Genetrix", headless
 figure (copy) 410 B. C.
 marble; 37 cm
 PRAD pl 83 SpMaP
Victories, parapet relief
 fragment 421/415 B. C.
 marble; 41
 STRONGC 88 (col) GrAA
Victorious Athlete, head
 bronze
 LARA 288 (col) FPL
Votive Relief c 420 B. C.
 Pentelic marble; 72x81 cm
 BOES 90; COPGG 29
 DCN (L. N. 1430)
Votive Relief: Eleusinian
 Dieties, detail: Demeter
 c 450 B. C. marble
 DEVA pl 123 GrAN
Votive Stalk of Reaped Barley,
 Attic gold; 5-1/2
 SOTH-2:126
Warrior, torso
 VER pl 112 UMiD
Wig in Bronze
 BEREP 142 IReM
Winged Figure Carrying Girl,
 carnelian
 RICHTH 235 UNNMM
Woman c 460 B. C. bronze;
 5-1/4
 SOTH-1:116
Woman: Bathing in Tub
 terracotta
 HOR 269 ELBr
Woman: Making Cakes
 ZOR 15 UNNMM
Woman: Placing Garment in
 a Chest, relief, Locria
 c 460 B. C. terracotta
 RICHTH 367 ITarN
Woman: Wearing Peplos
 LAWC pl 38A IRT
Woman: With a Fan, Tanagra
 terracotta
 HOR 270 (col) FPL
Woman, Propylaea c 470
 B. C.
 BEAZ fig 69
 GrA

Woman, head 420/410 B.C.
 marble; 27 cm
 HAN pl 145 GrAN
Woman and Child, tombstone
 relief
 BOWR 79 (col) GrAK
Wounded Amazon
 LAWC pl 64B GB
Wounded Hero
 LAWC pl 47 IRAl
Young Cavalryman 440/438
 B.C. marble; 1.09 m
 HAN pl 104 ELBr
Young Girl, head fragment
 c 470 B.C. terracotta; 15
 NEWTEM pl 8 GrOM
Young Victor, relief
 fragment c 470 B.C.
 ST 41 GrAN
Youth c 450/440 B.C. bronze
 RICHTH 186 FPL
Youth (Athletic Victor) c 480
 B.C. marble; 1.1 m
 HAN pl 95 IAM
Youth, head
 LAWC pl 23B GrAA
--(Roman copy, 2nd c.)
 c 450 B.C. marble; 24.8 cm
 BERLES 115 GBSBe
 (1833--K 146)
--, head, Acropolis
 LAWC pl 44A GrAA
Zeus, head
 CHASE 58 UMB
Zeus: Abducting Ganymede,
 Olympia c 470 B.C. ptd
 terracotta; 42-7/8
 BO 124 (col); DEVA pl
 79, 80 (col); FUR pl K.
 HOR 65 (col); LARA 261;
 LULL 21 (col); pl 105;
 NEWTEM 6 (col); RICHTH
 84; ST 40 GrOM
Zeus of Histaiai c 470/450
 B.C.
 AGARC 32; CLAK 176;
 LARA 275 GrAN
GREEK--5/4th c. B.C.
Antinous, bust (copy)
 marble; 97 cm
 PRAD pl 34 SpMaP
Aphrodite (Venus Genetrix)
 (Roman copy of statue attrib
 to Callimachus) c 430/400
 B.C. marble; 62
 CHENSN 141; GAU 88; KO
 pl 9; LARA 280; RAY 23;
 RICHTH 115 FPL

--(late Hellenistic copy)
 5th c. B.C.
 FUR pl T FPL
Athlete, Victor in Bowing
 Contest marble; 67.7
 GAU 88 FPL
Bull's Head Rhyton silver
 LARA 285 ITrMC
Coins silver
 CHENSW 118 FPBN;
 URPD; UMB
Dancing Girls, Acanthus
 Column marble; figure; 83
 BAZINW 154 (col) GrDM
Demeter
 ROOS 34A IRV
Greeks Battling Amazons,
 embossed cuirass c
 400/370 B.C. bronze
 RICHTH 206 ELBr
Jar: Scythian Warriors
 c 410/380 B.C. electrum
 RICHTH 207 RuLH
Parthenon See also Phidias
--Parthanon Naos (restored)
 RAY 20; ROOS 33B
--Interior (restored model),
 with Phidias. Athena
 MYBA 100; ROBB 50
 UNNMM
--Interior (restored model):
 Athena
 MYBU 96 UNNMM
--
 BOWR 115 (col) GrAP
--Aphrodite marble; 100 cm
 WEG 181 ELBr
--Aprobates, frieze
 BARSTOW 72
--Apollo, east frieze marble
 DEVA pl 127 GrAA
--Artemis, frieze
 HOR 190 (col) GrAA
--Birth of Athena, east
 pediment (reconstruction)
 FLEM 24 UNNMM
--Bulls Led to Sacrifice,
 north frieze
 ROOS 32C GrAA
--Canephore, frieze
 BARSTOW 69
--Cella, western face frieze
 LULL pl 148 GrAA
--Centaur, metope
 RAY 20; WEG 179 ELBr
--Centaur: Fighting Lapith,
 who has fallen to knee
 CHENSW 112; LULL pl 144,
 pl 146 ELBr

--Centaur: Triumphant
 442 B. C.
 HAN pl 112; LULL pl
 142 ELBr
--Centaur, head 447/443 B. C.
 RICHTH 105 ELBr
--Centaur, head 445/442
 B. C. marble; 28 cm
 BOES 45 DCNM
--Chariot and Soldiers
 ROOS 33A GrAA
--Chariot Horses, south frieze
 GARDE 103
--Charioteers
 GOMB 61; UPJH pl 29 ELBr
--Contest between Athena and
 Poseidon for Land of
 Attica, west pediment
 (reconstruction)
 CHASEH 103; FLEM 24
 UNNMM
--Demeter and Persephone
 (Demeter and Kore), head-
 less figures 438/432
 marble; 58-1/2
 BAZINW 139 (col); FLEM
 24; KO pl 11; LARA 277
 ELBr
--Demeter of Cnidus marble
 BARSTOW 227 ELBr
--Dionysos (Mt. Olympus;
 Olympos; Theseus),
 reclining figure, east
 pediment c 435 B. C.
 marble; 55x68
 BARSTOW 65; BEAZ fig
 105; CHASE 56;
 CHENSN 126; CHENSW
 110; CLAK 64; DEVA pl
 120; ENC 708;
 FLEM 24; GARDH 17;
 GLA pl 27; GRIG pl 75;
 HAN pl 122-123; IRW pl 6;
 JANSH 107; JANSK 136;
 LAWC pl 52, 56A; LULL
 pl 164-165; MARQ 85;
 MILLER il 37; MOREYM
 pl 1; MU 42; MYBA 104;
 MYBU 322; RAY 21; ROBB
 304; RICHTH 104;
 ROTHS 61;STI 237;
 STRONGC 64; UPJ 92; UPJH
 pl 30; WEG 180 ELBr
--Draped Headless Female
 Figure, west pediment
 GARDE 100
--Eleusinian Dieties
 Demeter, Kore and
 Artemis (Iris or Hebe?),

east pediment
 CHENSW 111; LULL pl 166
 ELBr
--Equestrians, inner frieze
 SEW 104 GrAP
--Les Ergastines 447/432
 B. C. Pentelic marble;
 1. 05x2. 07 m
 CHAR-1:162-163; DEVA
 pl 118; READAS pl 182;
 RICHTH 106; WEG 186
 FPL
--Female Figure 446/432
 B. C.
 BAZINL pl 108 FPL
--Festival Organizer and
 Sacrificial Bull, South
 frieze
 LULL pl 155 ELBr
--Figures, pediment
 BARSTOW 66
--Figures, east pediment
 SIN 66, 72 ELBr
--Frieze, detail 442/443
 B. C. marble; 41
 READAS pl 185 ELBr
--Frieze, detail seen across
 Ambulatory
 MYBA 99 GrAP
--Frieze, western entrance
 JANSH 96 GrAP
--Girl, head, metope
 fragment c 440 B. C.
 marble
 BEAZ fig 96 GrAP
--Goddess, east pediment
 RAD front ELBr
--Gods Awaiting Festival
 Procession; Offerings for
 Athena marble; 106 cm
 WEG 184, 185 ELBr
--Group of Men, north
 frieze
 ROOS 32D GrAA
--Headless Figures, east
 frieze c 440 B. C. marble;
 43
 FUR pl L; JANSH 142 FPL
--Heifer Led to Sacrifice,
 Panathenaic Procession
 marble; 36
 GARDE 105; GRIG pl
 76; HOR 190-191; LARA
 276; SCHO pl 42 (col)
 ELBr
--Herdsmen Pentelic marble;
 41-3/4
 NEWTEM pl 19 ELBr

--Horse (Horse of Selene; "Moon Horse"), head, right-hand triangular corner, east pediment 442/438 B. C. marble; 20-1/4x32-1/2
BAZINW 139 (col); CANK 48; CHENSW 111; DEVA pl 109; FLEM 25; GRIG pl 74; HAN pl 127; LARA 276; LULL pl 169; READAS pl 46; RICHTH 103; SCHO pl 43 (col); STI 236; WCO-3:25 (col) ELBr

--Horseman, or Eph 447/438 B. C.
ROBB 308

--Horsemen, frieze
BRIONA 59; PRAEG 165 GrA

--Horseman, frieze
MILLER il 35 GrAA

--Horseman, or Ephebus, head, north frieze marble; 79
GAU 76 FPL

--Horsemen, frieze c 330 B. C. marble; 58
WHITT 72-73 ELBr

--Horsemen, frieze (Lord Elgin Cast)
BEAZ fig 98 GrA

--Horsemen (Cavalry Frieze; Panathenaic Festival Relief; Panathenaic Procession; Procession of Horsemen), north frieze c 440/432 B. C. marble; 39 to 43
BAZINH 83; BAZINW 141 (col); BOWR 26-27 (col); BROWF 4; CARPG pl 21; CHASE fig 59; CHASEH 106; CRAVR 37; DEVA pl 11b; GARDH 128; GAUN pl 25; GOMB 62; KO pl 11; JANSH 108; LULL pl 150-154; MILLER il 32; MU 46; MYBA 105; READAS pl 181; UPJ 89 UPJH pl 29 ELBr

--Horsemen (Cavalry Frieze): Equestrian
BOWR 112 (col) ELBr

--Horsemen, south frieze
LULL pl 150 ELBr

--Horsemen, west frieze c 442/438 B. C. marble; 40
BEAZ fig 99, 102; FUR pl N; GARDE 104; GARDHU

pl 51; GRIG pl 73; HOR 182-183; JANSK 139; LARA 276-177; LAWC pl 55; MARY pl 65; MYBU 136; PUT 53; RICHTH 106; ROTHS 63; STI 239; UPJH pl 29 GrAA

--detail
GRIG pl 72

--Horsemen, west frieze c 440/432 B. C. Pentelic marble; 39
BO 133; LULL 149; STRONGC 65 ELBr

--Ilissus (Ilysus; River God), west pediment c 438 B. C.
CHENSN 115; CHENSW 87; CLAK 348; DEVA pl 122; GLA pl 27; HAN pl 130; LARA 277; LULL pl 170; PACH pl 1 ELBr

--Iris, west pediment marble; 68
CARPG pl 19B; CHASE 200; CLAK 185; FLEM 24; ST 50 ELBr

--torso detail
DEVA pl 117

--Iris and Amphitrite, west pediment
LULL pl 171 ELBr

--Iris, Demeter and Persephone marble; Persephone H: 40
GARDE 98; UPJ 91; UPJH pl 30 ELBr

Kekrops and Daughter, west pediment 437/432 B. C. marble; 1. 37 m
HAN pl 129, pl 131 GrAA

--Lapith: And Centaur (Centaur and Lapith), south metope 447/432 B. C. marble; 56
AGARC 31; BEAZ fig 100, 103; BO 132; CHASE fig 58; CHASEH 104; CLAK 179; DEVA pl 112-114; GARDE 75; GARDH 126; HOR 214; LAWC pl 51; LOWR 29; LULL pl 143, 145, 147; MYBS 22; MYBU 152; NEWTEM pl 17; RICHTH 105; ROBB 307; ROOS 32A; STI 238; STRONGC 66 ELBr

--(drw)
CHRH 71 ELBr

--Lapith: And Centaur Fighting
STA 9 GrAA

--Lapith: Conquering a
 Centaur, south metope
 (XXVII) c 447/443 B.C.
 marble; 47 and 50
 ENC 695; FLEM 20;
 GARDHU pl 50B; GRIG
 pl 71; MARQ 83; READAS
 pl 43; ROOS 31; ST 46; UPJ
 88; UPJH pl 29 ELBr
--Maidens
 BAZINW 141 (col) FPL
--Male Head and Figure,
 south frieze
 LULL pl 162 ELBr
--Men and Bull, frieze
 MILLER il 36 GrAA
--Men Sacrificing Bull,
 south frieze
 DEVA pl 128 ELBr
--Nike and a Fate, east
 pediment
 ROOS 31E
--Northeast Corner
 HAN pl 128 GrAA
--Orating Equestrian, frieze
 BOWR 109
--Procession of Maidens, east
 frieze
 CHASE 73 ELBr
--Panathenaic Procession
 447/432 B.C. Pentelic
 marble; 41. 3x81. 5
 GAR 74-75; LULL pl
 158-159 FPL
--Panathenaic Procession:
 Marshal and Maidens
 HAN pl 103 FPL
--Panathenaic Procession:
 Hydria Bearers (Metoikoi
 Carrying Water Jars; Water
 Carriers), northern
 frieze marble; 41-3/4
 BOWR 111; CHASE 209;
 LULL pl 160-161 GrAA
--
 NEWTEM pl 18 ELBr
--Panathenaic Procession:
 Hydria Bearers; Man
 Sacrificing Ram; Man
 Sacrificing Heifer
 DEVA pl 124-126 GrAA
--Pediment, west
 DEVA pl 108
 GrAP
--(J. Carrey facsimile drwg,
 1674)
 RICHTH 102; ROOS 31B
 ELBr

--Poseidon, Apollo and
 Demeter (Poseidon, Apollo
 and Artemis), east cella
 wall
 LULL pl 156; MARQ 90;
 ST 47 GrAA
--detail: Artemis
 LULL pl 157
--detail: Poseidon and
 Apollo marble; 43
 FLEM 22
--Poseidon, Dionysus, and
 Demeter(?), east frieze
 ROOS 32F GrAA
--Poseidon, Helios and a
 Female, east frieze
 BARSTOW 71
--Sacrificial Procession
 marble; .106 m
 WEG 182 GrAA
--detail: Boy from Proces-
 sion of Sacrificial Bulls
 LULL pl 163 GrAA
--Seated Goddess, east
 pediment
 CARPG pl 19A ELBr
--Seated Gods, three figures
 READI pl 48 ELBr
--Seated Gods: Poseidon,
 Apollo, Artemis (Poseidon,
 Dionysos, Hestia) c 440
 B.C. marble; 43
 CHASE 56; CHRH 70;
 FUR pl M; JANSK 138;
 READI pl 48; RICHTH
 107 GrAA
--, detail
 LAWC pl 54
--Sun God's Horses, east
 pediment
 FLEM 24 ELBr
--Three Fates (Demeter,
 Persephone, Artemis;
 Hestia, Aphrodite and
 Dione; Ocean and Her
 Daughters), east pediment
 437/432 B.C. marble;
 48-1/2
 AUES pl 13; BAZINH 82;
 BAZINW 139 (col); BEAZ
 fig 101; BO 130; CHASE
 56; CHASEH 103; CHENSN
 125; CHRH fig 26; CRAVR
 36; DEVA pl 121; FLEM
 25; GARDH 127; GARDU
 pl 45; GLA pl 27; HAN
 pl 125-126; JANSH 107;
 JANSK 137; LARA 276;

LAWC pl 53; MILLER
il 33; MU 42-43; MYBA
104; NEWTEM pl 20; RAY
21; ROBB 305; ROTHS 59;
RUS 25; UPJH 30; WB-17:
197 ELBr
--detail: Aphrodite in the
Lap of Dione ("Dew
Maidens")
KO pl 11;NEWTEA 38;
READAS pl 184
--detail: Aphrodite and Leto
in the Lap of Peitho, or
Dione(?)
LULL pl 167-168
--Victory, east pediment
LARA 279 ELBr
--Victory, west pediment
MARQ 86 ELBr
--Victory, head, ("Laborde
Head"), west pediment
FUR pl G; GAU 85; RAY 5
FPL
--Young Man, head, north
frieze
DEVA pl 115 FPL
--Youth: Tying his Sandal,
west frieze
BARSTOW 68
--Youth, head fragment
HUYA pl 16; LAWC pl 56B
FPL
--Youths: Bearing Wine Jugs
(Jar-Carriers)
GARDH 129; LARA 277;
ROOS 32B GrAA
Temple of Aphaia, Aegina
See also Greek--5th c.
B.C. Temple of Aphaia
--Archer 510 B.C. Parian
marble; 41
KO pl 4 GMG
--Athena, head, east
pediment
DEVA pl 71; LULL pl 82
GMG (No. 89--A 65)
--Athena, head, west
pediment c 510 B.C. Parian
marble; 66
KO pl 4; LULL pl 72;
RICHTH 82 GMG
(No. 74--A 19)
--Athena and Warriors, west
pediment (restored by
Thorwaldsen and Wagner)
c 480 B.C. Parian marble;
Athena H: 66
SIN 82; UPJ 74; UPJH pl
25 GMG

--Fallen Warrior
RAY 5 GMG
--Fallen Warrior (Dying
Warrior; Wounded Warrior),
east pediment c 490 B.C.
marble; 24x72
CHASEH 74; DEVA pl 72;
JANSH 89; JANSK 126;
LULL pl 84; ROBB 296;
UPJ 75 GMG (No. 85--A 41)
--head detail
LULL pl 85; UPJH pl 25
--Fallen Warrior (Dying
Warrior; Wounded
Warrior), west pediment
c 510 B.C. Parian marble;
18x50
LULL pl 74-75 GMG
(No. 79--A 33)
--Fallen Warrior, west
pediment c 510 B.C.
Parian marble; 26x74
JANSK 126; ROOS 28B;
UPJH pl 25 GMG
--Head, pediment
BAZINH 68 GM
--Herakles Bowman, pediment
CARPE 31 GM
--Hurrying Rescuer, east
pediment c 490 B.C.
Parian marble; 37
LULL pl 83 GMG
(No. 88--A 82)
--Lunging Warrior, west
pediment c 510 B.C.
Parian marble; 57
KO pl 4; LULL pl 76
GMG (No. 80--A 14)
--Pediment
STI 226
--Pediment, west (restored
by Thorwaldsen and
Wagner) 500/480 B.C.
W: 45'
CHASEH 73; LULL pl 73;
UPJ 76; UPJH pl 25 GMG
--Pediment, south side
(line drwg)
CHRP 64 GMG
--Scythian Archer, west
pediment
DEVA pl 73; LULL pl 77
GMG (No. 81--A 8)
Trojan Bowman, east pedi-
ment
DEVA pl 70; LARA 263
GMG
--Warrior: Helmet and
Shield, pediment

BO 84; MYBA 86; SEW
49 GMG
--Wounded Warrior, pediment
CHENSN 110 GMG
--Warriors, east pediment
ROOS 28C, 28D
--Warriors, west pediment
LAWC pl 21
Theatre Masks: Tragic and
Comic--Priam; Youth;
Satyr; Buffoon terracotta
BOWR 151 (col); GBSBe;
GrANA; UMB
GREEK--5th/3rd c. B. C.
Warrior, gravestone Pentelic
marble; LS
FAIN 186 UMWA
GREEK--5th/1st c. B. C.
Coins
BERLES 154 GBSBe
GREEK--4th c. B. C.
Acanthus Leaves, detail
marble
DOWN 53 UNNMM
Aeolian Capital, Neandria
JANSH 98
Alexander the Great, head
BARSTOW 63
--
RUS 32 ELBr
--
CARPG pl 43B; LAWL pl
10B GrAA
--, Sparta 356/323 B. C.
H: 9-1/2
BOSMGR pl 10 UMB
(52. 1741)
Alexander Sarcophagus: Hunt-
ing Scene, Sidon marble
BAZINW 153 (col);
CHENSW 122 TIAM
Amazon, equest, Epidaurus
LAWC pl 76B GrAN
Amazon on Horseback,
fragment
BOSMG 85; CHASE 94
UMB (03. 751)
Antikythera Youth ("Paris")
c 340 B. C. bronze; 77
DEVA pl 146 (col), 147;
LULL pl 218-220; NEWTEM
pl 24-25; RICHTH 147;
SCHO pl 58 (col); STRONGC
91 (col) GrAN (13396)
Aphrodite bronze (ancient
replica of Greek original
of c 300 B. C.)
RICHTH 186; ROUT; ZOR
33 UNNMM

Aphrodite: Riding a Goose
CHASE 96 UMB
/ Aphrodite, head (Bartlett
Aphrodite; Bartlett Head)
c 350 B. C. marble; 14-1/2
BEAZ fig 121; BOSMG
58; BOSMI 75; CHASE
83; FAIN 86; HAN pl 177;
ROOS 38G, 38H; SEW
134; STI 266; THU 108
UMB (03. 743)
Aphrodite, head fragment,
Satala, Armenia (later
copy) bronze; 15. 2
LULL pl 282 ELBr (266)
Aphrodite, relief bronze
DOWN 55 UNNMM
Aphrodite, torso (Hellenistic
copy, 1st c. B. C.)
FEIN pl 113, 126 UNNMM
Aphrodite and Eros, Cyrene
terracotta
LARA 284 FPL
Apollo, head
FUR 411 ELBr
--, Attica Pentelic marble;
28 cm
CHAR-1:164 (col) FPL
Apollo Belvedere, Pio-
Clemention Museum c
350 B. C. (Roman marble
copy) marble; 88
BARSTOW 89; CAL 190
(col); CHASE 110; CHASEH
133; CHRC 76; CLAK 50;
ENC 33; FUR fig 72;
GARL 221; GOMB 71; HOR
350; JANSH 116; JANSK
150; LAWC pl 130B; NOG
299; PRAEG 14; RAY 24;
RICHTH 146; ROOS 41A;
SEW 178, 180; SIN 142;
VER pl 114 IRV
--Laocoon and Apollo
Belvedere in Cortile of the
Belvedere (8th c.
engraving)
TAYFT fol 336
Apulian Relief: Floral Motif
LAWL pl 90B UMB
Argos Drachm: Hera, head;
Diomides Carrying off the
Palladium silver
BOSMG 24; BOSMT pl 36C
UMB (10. 247)
Ariadne(?), fragment
LAWL pl 78 SpMaP
Ariadne, head fragment c 300
B. C. marble; 41 cm

BEAZ fig 143; HAN pl
179 GrAN
Aristotle, head (Roman copy)
BOWR 26 (col) IRT
Artemis and Iphigenia,
headless figures
LAWC pl 98A DC
Artemis from Gabii (copy)
FUR pl W; ROOS 361 FPL
Artemis of Versailles (Diana a
la Biche; Diana of
Versailles; Huntress of
Artemis) c 345 B. C.
Parian marble; 78. 7
CHAR-1:172; FUR pl W;
GAY 86; RAD 514; ROOS
40K; SIN 152 FPL
Artemisia
LAWC pl 86 ELBr
Asklepios(?), head, cult
statue, ("Blacas Head"),
Melos c 330 B. C. marble;
23
BO 145 ELBr (550)
Asklepios, seated figure,
Epidauros c 380 B. C.
marble; 64 cm
HAN pl 137; RICHTH 126
GrAN
Athena (Roman marble copy of
bronze original)
BEAZ fig 115 IF
Athena: In Helmet c 350 B. C.
bronze
BOWR 10 (col) GrPM
Athena: In Helmet, detail
bronze
FUR 421 IPAr
Athena, Piraeus c 350 B. C.
bronze; 2. 44 m
HAN pl 171 GrPM
Athlete, head
CHASE 97 UMCF
--
RUS 27 UNNMM
Attic Funeral Vase: Couple
Bidding One Another
Farewell Pentelic marble;
figure H: 14. 2
LULL pl 204 GMG (498)
Ballplayer, Antikythera bronze
CARPG pl 28, 29 GrAN
Battle Scene, Mausoleum,
Halicarnassus stone
CHENSW 122 ELBr
Bearded Bust c 330 B. C.
marble; 69 cm
PRAD pl 4 SpMaP

Bearded Figure, Attic
Funerary Relief fragment
c 320 B. C. Pentelic
marble; 63
LULL pl 240-241 GrAN
(2574)
Bearded Figure, grave stele
fragment, Attica H: 72
WORC 15 UMWA
Bearded God, head,
Alexandria
LAWL pl 17A EgAlG
Boxer, fragment marble
CHASE 90; LAWL pl 5
UNNMM
Boy, fragment Pentelic
marble
CHASE 96 UMB
--, head (Roman copy)
LAWL pl 10A UNNMM
--, sepulchral figure
Pentelic marble; 33. 6
LULL pl 198 GrPM
Byzantium Coin: Herakles
Strangling Serpents; Cow
and Dolphin
BOSMG 72 UMB (09. 270)
Calydonian Boar-Hunt, mirror
case bronze
BOSMG 71 UMB (05. 59)
Cameo: Figures and Horses
BAZINH 92 FPBN
Cameo: Profile Heads of
Alexander and his Mother,
Olympias
HOR 343 AVK
Campanian Filigree Fibula
gold; L: 3-1/2
BOSMI 71 UMB (99. 371)
Caryatid, Tralles, Asia
Minor
LAWL pl 70 TIM
Cassandra (Kassandra), gold
ring c 400/380 B. C.
RICHTH 238 UNNMM
Ceremonial Wreath
SPA 185 UTxHA
Chios Goddess, head
fragment c 350 B. C.
Parian marble; 14. 4
BOSMI 75; DEVA pl 142;
KO pl 17; LAWL pl 6;
LULL pl 242-243; RICHTH
137; ROBB 314 UMB
(10. 70)
Choragic Monument of
Lysicrates: Corinthian
Order ROOS 22C

Coin: Apollo c 380 B. C.
BAZINL pl 132 FPMe
Coin, Clazomenae: Apollo,
head c 380 B. C. silver
BO 177 FPBN
Coin, Macedonian: Philip II,
equest
HOR 342 ELBr
Coin, Pantikapaion, Crimea:
Satyr, head c 350 B. C.
RICHTH 248 ELBr
Column Base (Drum), Temple
of Artemis, Ephesus c 340
B. C. marble; 61
ENC 283; FUR pl U;
GLA pl 29; LULL pl 223;
ROOS 37H; STRONGC 90
(col) ELBr (1206)
--: Figures
LAWC pl 93
--: Hermes
SCHO pl 55 (col)
--: Underworld(?) Scene
DEVA pl 139
Column Dancers marble
LARA 245
Comb: Cavalry Battle,
Solokha gold
LAWL pl 16A RuLH
Comic Actors clay
BO 164 GWuW
--: Two Masked Actors as
Drunken Men
HOR 302 GBS
--, tomb figures, Athens
LAWL pl 2 UNNMM
Contest of Apollo and Marsyas,
relief
CHASE 127 GrAN
Corinthian Capital, Thelos,
Epidaurus c 300 B. C.
H: 25-1/2
BO 153; GOMB 73;
JANSH 98; ROOS 21F; ST
65; UPJ 98; UPJH pl 20D
GrEpM
Crouching Youth, Cythera
Wreck
LAWL pl 15 GrAA
Cybele, seated headless
and armless figure c 300
B. C. marble
BOSMG 36 UMB (99. 340)
Dancing Maenad Holding
Tambourine, Locri c 400
B. C. clay; 7-1/2
BO 162; (col) IReM (4823)
Delphi Coin: Demeter, head;

Apollo on Omphalos
BOSMG 31 UMB (00. 226)
Demeter Parian marble; 32. 2
LULL pl 206 IVA
(No. 6--Inv No 21)
Demeter, fragment c 350
B. C. bronze; 81cm
HAN pl 172 TIzA
Demeter of Cnidos, seated
figure 340/330 B. C.
head--Parian marble;
body--stone; 60
BROWF-3:5; CARPG
pl 40; GARDH 142; GRANT
pl 36; HAN pl 173;
JANSH 114; JANSK 146;
KO pl 14; LULL pl 223;
MILLER il 26; RICHTH 145;
SIN 134; UPJH pl 33 ELBr
(1300)
--: head detail
DEVA pl 143; HOR 69;
LAWC pl 91; LULL 224
Deserted Ariadne, head
LAWL pl 10C GrAN
Diadem: Floral Scroll
Relief, fragment, Canosa
di Puglia gold
BO 176 (col); ENC col
pl 9 (col) ITarN (54114)
Didrachm, Lucanian Herakleai:
Herakles and the Nemean
Lion silver
BEAZ fig 240 ELBr
Diomedes Stealing Palladion,
intaglio (cast) 400/350
B. C. chalcedony
BOSMT pl 36B UMB
(27. 703)
Dionysiac Scene, crater;
detail: Pan c 330 B. C.
gilded bronze; c 80 cm
HAN pl 183-184 GrTheA
Dionysus and Ariadne, relief
bronze
DOWN 54 UNNMM
Draped Woman, Tanagra
terracotta
CHICC 27 UICGr
Earring: Ganymede Carried
Off by Zeus c 350/325
B. C. gold; 2-1/4
NM-5:30; RICHTH 256
UNNMM (37. 11. 9)
Earring: Nike Driving Two-
Horse Chariot c 390/350
B. C. gold; 2
BOSMG tp; 28; BOSMI 73;

HAN pl 188; HOR 264;
RICHTH 256; SCHO pl
51 (col) UMB (98. 788)
Earring, Madytos gold;
2-15/16
NM-5:30 UNNMM
(06. 1217. 11)
Earrings: Wire-Granular
Disks, with pendant
Female Head gold;
2-3/8; Dm: 7/8
BO 175 ITarN (54115)
Elis Coin: Zeus, head;
Eagle of Zeus
BOSMG 22 UMB (04. 892)
Ephebe, fount in sea near
Marathon
DEVA pl 2 (col)
Equestrian, mausoleum frag-
ment marble
MARY pl 125 ELBr
Eros, relief bronze; 5-3/4
NM-5:25 UNNMM
(44.11.9)
Euripedes, bust c 340/330
B. C. (Roman copy)
RICHTH 149 INN
Farewell Scene, funeral
stele fragment
CHICB 11 UICA
Female Figure
LAWL pl 9A UNNMM
--larger than LS
CHASE 102 UMB
--, fragment, Balustrade of
Altar of Athena Polias,
Priene marble; 51
BEAZ fig 159; GRIP pl 77
GB
Female Head
LAWL pl 8 UMCF
--, Cyzicus
LAWL pl 4B GDA
Flying Eros, Tanagra c 300
B. C. terracotta
RICHTH 229 UNNMM
Fortuna marble; 1. 47 m
PRAD pl 7 SpMaP
Funeral Urn: Ulysses' Ship
Sailing Past Siren,
Volterra alabaster; 66x22
cm
WPN pl 22 PWN (143216)
Ganymede marble; 1. 5 m
PRAD pl 20 SpMaP
Girl: In Long Chiton and
Mantle, with Painted Hat
and Fan, Tanagra
clay; 13-3/8

BERL pl 117 (col);
BERLES 117 (col) GBSBe
(T. C. 7674)
Girl Running with Ball,
Tanagra c 320 B. C.
ptd pottery; 12
GRIG pl 81 ELBr
Goddess, head
CHASE 98; ZOR 104
UNNMM
--c 320/400 B. C. marble
HAN pl 180 ITarN
--, head, Alexandria
LAWL pl 17B EgAlG
--, head fragment
PACHA 35 UMB
Grave Monument, fragment
c 400/350 B. C. marble
CLE 22 UOCIA (24. 1018)
Grave Stele, fragment
c 350 B. C. marble;
9-1/4x20-1/8
YAH 16 UCtY
Hades, frieze c 350 B. C.
LAWC pl 90 GM
Helmeted Head, Tegea
marble; 6-7/8
STRONGC 90 (col) GrAN
Hera
FUR 421 IRV
Hera Eleithyia, kneeling
figure 370 B. C.
terracotta; 17 cm
HAN pl 176 GrPaA
Heracles (Roman copy)
H: 1. 4 m
COPGG 35 DCN (250--
I. N. 1720)
--c 325 B. C. (Roman copy)
bronze
RICHTH 186 FPL
Hercules: and Hermes with
Votive Wine Cup on Altar,
relief
CHASE UMB
Hercules: and Stag, relief
CLAK 191 IRaMN
Hercules: In Lion-Skin Cap,
head
CHASE 92 UMB
Hercules, head (copy) marble;
78 cm
PRAD pl 33 SpMaP
Hercules, head (copy)
("Maximino") marble;
84 cm (with base)
PRAD pl 82 SpMaP
Herm Bust (Roman copy)
c 325/300 B. C. H: 20-1/2
BOSMGR pl 7 UMBGa

Muse, torso (copy) marble;
68 cm
PRAD pl 48 SpMaP
Muse, or Artemis c 350 B. C.
bronze; 1. 94 m
FUR pl W; HAN pl 178
GrPM
Negro Boy Sleeping beside
a Pot terracotta
LAWL pl 3A EOA
Neptune; details marble;
2. 36 m
PRAD pl 1-2 SpMaP
Nereid Monument: Nymph,
Xanthos, Lycia c 400
B. C.
BO 146; LAWC pl 76A ELBr
Niobid Chiaramonti H: 69
UPJH pl 33 IRV
Oinochoe (Wine Jug): Erotes
Learning to Fly, relief
clay
RICHTH 345 UNNMM
Old Woman and Child, Tanagra
terracotta
LAWL pl 3b GDA
Patient Offering Replica of
Cured Leg to Ascelpius,
votive relief marble
BOWR 103 GrANA
Persephone, head (copy)
LAWL pl 56A UNNMM
Phiale: Floral, Animal, Human
Forms, Kul Oba gold
BO 174 RuLH
Philosopher(?), bearded head
c 375/400 Pentelic
marble; 17
BOSMI 99 UMB (62. 465)
Philosopher, or Poet, bust,
Herculaneum (Roman copy)
c 350/300 B. C. marble;
15-1/2
BOSMGR pl 6 UMB
(99. 342)
Plate (1st c copy) marble
ENC 719
Ponsonby Head
CHASE 98
Poseidippos, seated figure
RAD 209 IRV
Protesilaos, spearman in
ship's prow
CARPG pl 31A UNNMM
Rhyton: Sheep's Head clay
BO 166 EOA (1947. 374)
Sarcophagus of Mourning
Women, Sidon c 350 B. C.
marble; 71-1/2

BAZINW 152 (col) TIAM
Satyr, Funerary urn,
Derveni
BO 169 GrSaA
Seasons: Following Dionysus
with Pine-Branch, relief
c 300 B. C.
LAWL pl 69 FPL
Seated Female Figure,
Tanagra pottery; 7
CPL 88 UCSFCP
(1925. 28. 2)
Silenus: Carrying Infant
Dionysus (Roman marble
copy, after Greek
original)
BEAZ fig 32; LAWL pl 19
GMG
Socrates (copy) marble
ENC 836
Socrates, Egypt (Roman copy)
BEAZ fig 131; CHENSW
123 ELBr
Soldier, relief, Taranto
LAWL pl 92A NHS
Sophocles c 340 B. C.
(Roman copy, after bronze
original) marble; 76
LAWC pl 92; RICHTH
149; ROOS 38A; STRONGC
97 IRL
Stag, Sybaris bronze, silver
inlaid eyes
BRIONA 60 FPL
Standing Girl, nude figure,
Verria bronze
DEVA pl 137-138 GMG
Standing Lady c 300 B. C.
marble
CLE 23 UOClA (65. 24)
Stater: Philip II, head;
reverse: Charioteer Driving
Two Horses c 350 B. C.
MALV 133, 142 FPMon
Stater, Pantikapaion: Satyr,
head gold
BEAZ fig 244 ELBr
Stater, Tarentum: Taras as
a Boy with his Father,
Poseidon gold
BEAZ fig 245 ELBr
Stater, Thrace: Alexander
the Great gold
BAZINL pl 129 FPMe
Stele: Female Figures,
Sardinia
LAWL pl 89 ICagM
Stele: Head, fragment, Attica
CHASE 102 UMB

Stele: Law Against Tyranny--
Democracy Crowning People
of Athens (seated figure)
336 B. C. marble
BOWR 25 (col); HOR 354-
355 GrAAg

Stele: Seated, and other,
Figures, Athens
BEAZ fig 136 GrA

Stele: Seated Woman, frag-
ment, Attica
CHASE 100 UNNMM

Stele: Slave Boy Weeping for
his Master
HOR 197 GrAN

Stele: Woman with Maid-
servant; head detail Pentelic
marble; 48
LULL pl 202-203 GrAN
(726)

Stele: Youth with Dog and
Bearded Figure, Illissus,
Athens c 350/330 B. C.
Pentelic marble; 66
BEAZ fig 138; GARDE
208; HAN pl 160; LAWC
pl 95; LULL pl 226;
PRAEG 86; RICHTH 151;
STRONGC 73; WEG 18 GrAN
(869)

Stele, Attica
CHASE 102 UMCF

--, Salamis
BEAZ fig 137 GrA

--, fragment: Couple, Athens
Pentelic marble; 56
LULL pl 186 GrAN
(716)

Stele of Dexileos: Equestrian
Warrior Smiting Enemy
394 B. C. marble; 68
(with plinth)
BUSGS 18; CARPG pl 22;
HOR 196; KO pl 13; LULL
pl 192; RICHTH 150, 379;
ROOS 38C; ST 53;
STRONGC 70 GrAK

Stele of Iostrate marble;
41-1/4x23
TOR 99 CTRO (956. 108)

Stele of Klesileos and Theano;
detail: Klesileos Pentelic
marble; 36
LULL pl 200-201 GrAN
(3472)

Stele of Krinuia: Family Group
CHASE 100; CHASEH 126
UPPU

Stele of Lysicrates c 334
B. C.
JANSH 100

Stele of Lysistrate: Family
Group
CHASE 100 UNNMM

Stele of Mnesarete, Attica
marble
DEVA pl 136 GMG

Stele of Pamphile c 350 B. C.
SCHO pl 56 (col) GrAK

Stele of Polyxena marble; 64
KO pl 13 GrAN

Stele of Sostratus marble
BEAZ fig 135; CHASE 100;
DIV 20; RAY 25 UNNMM

Stele of Theano c 370 B. C.
Pentelic marble; 36
BO 149; HOR 272; KO pl
13; NEWTEM pl 22 GrAN

Tanagra Figurines
UPJH pl 36 UNNMM

Temple of Asclepios, facade
detail, west: Nereid of
Epidauros c 370 B. C.
marble
DEVA pl 134 (col) GrAN

--: Female Figures
RICHTH 127

Tetradrachm, Klazomenai:
Swan silver
BEAZ fig 243 ELBr

Tetradrachm, Lysimachus:
Alexander the Great with
Amon Horns c 300 B. C.
silver;Dm: 1-1/8
JANSH 122; JANSK 160

Thebes Drachm: Protesilaos
Advances from his Ship
c 300 B. C. silver
BOSMT pl 13B UMB
(63. 1518)

Thessalian Votive Offerings
marble
DEVA pl 144-145 GrD

Tholos on Marmaria Terrace,
detail: Metope and
Triglyphs
LARA 265 GrDM

Thyiades, Acanthus column
figures c 380 B. C.
AGARC 36 GrDM

Tomb Stele marble; 135 cm
WPN pl 15 PWN (138508)

Vase: Siren Singing plastic
BOSMT pl 49A UMB
(01. 8101)

Venus of Arles, replica of

Aphrodite of Thespiae,
by Praxiteles (Roman copy)
c 376/360 B. C.
marble; 76. 4
BAZINW 149 (col); GAU 84
FPL
Votive Relief, dedicated to
Asklepios: Physician
Treating Patient c 380/350
B. C.
RICHTH 152 GrAN
Votive Relief, dedicated to
Herakles c 400/380 B. C.
RICHTH 153 UMB
Warrior, head, Temple of
Athena, Tegea c 350 B. C.
ROBB 315 GrAN
Wingless Nike or Air-Goddess
(Aura), acroterion marble
with reddish-brown patina;
98 cm
COPGG 31 DCN
(397a--I. N. 2432)
Woman: Holding Child, Tanagra
c 300 B. C. terracotta
RICHTH 228 UNNBak
Woman: In Pointed Hat,
Tanagra c 300 B. C.
terracotta
RICHTH 228 ELBr
Woman: With Clasped Hands,
Tanagra c 300 B. C.
terracotta
RICHTH 228 ELBr
Woman: With Mirror, Attic
grave relief marble;
23-1/4
BOSMI 69 UMB (04. 16)
Woman, draped figure, Attica
marble; 61
DETT 27 UMiD (24. 113)
Woman, grave monument detail
c 370/340 B. C. H: 80
BOSMGR pl 4 UMB
(98. 642)
Woman ("Sappho"), bust,
Herculaneum
(copy)
MAIU 69 INN
Wounded Niobid (Dying
Niobid; Stumbling Niobid),
pediment figure c 440 B. C.
marble; 59
BAZINW 138 (col); BO 143;
CARPG pl 17; CHENSW 115;
CLAK 226; DEVA pl 129-
130; JANSH 106; JANSK
141; LAWC pl 59; NEWTEM
pl 13; RICHTH 122; ROOS
37F IRT (72274)

Young Horseman, relief
marble
DIV 20 UNNMM
Young Woman, head marble;
15-3/16
COOP 33 UNNBak
Young Woman of Eventail,
Boetian terracotta; 32 cm
CHAR-1:171 FPL
Youth marble; 1. 61 m
PRAD pl 38 SpMaP
--, detail bronze
ENC col pl 8 (col) GrANA
--, head
LAWC pl 78B UMCF
Zeus, head, Mylassa,
Caria marble; 18-1/8
BOSMI 75 UMB (04.12)
GREEK--4th/3rd c. B. C.
Boy, head
CHASE 91 UMB
Dionysos, fragment 320, or
271 B. C.
BEAZ fig 174 ELBr
GREEK--4th/2nd c. B. C.
Aphrodite bronze
FAIN 223 URPD
Nude Male Figure bronze
FAIN 223 URPD
GREEK--4th/1st c. B. C.
Brutus, head detail bronze
SCHO pl 63 (col)
GREEK, or ROMAN--4th c. B. C.
Wreath gold; 14-1/2
TOR 95 (col) CTRO
(935. 46)
Greek Athlete Using a Strigil
Niehaus, C. H. The Scraper
Greek Dance. Jennewein
Greek Key
Coptic. Frieze:Greek Key;
Rosettes; Vegetable Devices
Greek Slave. Powers, H.
Greeley, Horace (American
Journalist 1811-72)
Doyle, A. Horace Greeley,
seated figure
Ward, J. Q. A. Horace
Greeley, seated figure
GREEN, Georgianna (American)
Figure in Walnut
CALF-55
Green, Jean Haber
Schneir, J. Jean Haber
Green, head
GREEN, Wayne (American 1909-)
Lady Macbeth 1950 granite
CIN # 20
Green Bird on Red Background.
Schnackenberg, R.

THOR pl 2; USC 365
UDCCap
Samuel F. Morse, bust c
1832 ptd plaster; 21-1/2
UNNMMAS 2 UNNMM
(X. 331)
Portraits
Powers, H. Horatio
Greenough, bust
GREENOUGH, Richard Saltonstall
(American 1819-1904)
Benjamin Franklin 1855
bronze
CRAVS fig 8. 3 City Hall
UMB
Carthaginian Girl 1863
marble
CRAVS fig 8. 4 UMBA
Cornelia Van Rensselaer,
bust 1849 marble; 25
CRAVS fig 8. 1 UNNHS
John Winthrop 1880 marble
PAG-10:43 UMBS
-- (replica)
FAIR 264; MUR 44;
TAFT 197; USC 268
UDCCapS
John Winthrop, seated
figure 1856 marble
CRAVS fig 8. 2 UMCH
greens crossing greens. Flavin, D.
Greenway, John Campbell
(American Soldier and
Industrialist 1872-1926)
Borglum, G. John
Campbell Greenway
GREER, J.
Southwest Indian 1949 cement;
15'
GRID 30 UNmSR
GREGORY, Angela (American
La Belle Augustine bronze
IBM pl 63 UNNIb
Bienville Monument 1955 bronze;
24'
GRID 31 ULaNU
Jack Sparling, head bronze
NYW 198
GREGORY, John Walter (American
1879-1958)
Aphrodite, relief
TAFTM 143
Decorative Figure
TAFTM 142 UNR
Decorative Vase
HOF 209
Fancy
NATS 133

Henry E. Huntington
Mausoleum Panel
NATS 132 UCSmH
The Merchant of Venice.
relief
PUT 35 UDCFo
Orpheus and Dancing Leopard
1941 bronze; 67
AGARC 158; BROO 324;
NYW 195 UScGB
Philomela, kneeling figure
SCHN 12; TAFT 563
UNMW
Toy Venus, fountain figure
plaster model; 3/4 LS
NATSA 86 UNSyo
Wood Nymph marble
WHITNC 225 UNNW
--, garden figure marble
PAG-12:220 UNRW
GREGORY, Waylande (American
1905-)
Kansas Madonna 1932
terracotta; 13-1/2
CHICH pl 67 UNNBoy
Sisters terracotta
IBM pl 75 UNNIb
Gregory. Noguchi
Gregory IX (Pope c 1147-1241)
Jones, T. H. Gregory IX,
medallion head
GREVELOT, Nicholas
William Penn's Treaty with
the Indians, relief 1826/27
USC 290 UDCCap
Greyhounds
Bielefeld. Greyhound
Harvey. Adonis
Grief
Glickman. Grief
Robus, H. Figure in Grief
Saint-Gaudens. Adams
Memorial
Grief-Shape. Solomon
Grieving Woman. Nickerson
GRIFFIN, Mark (American)
Decoy: American Merganser
Drake, Gardiner's
Island, New York 19th c.
ptd pine
CHR 137
Griffins
Achaemenian. Rhyton:
Gryphon
Animal Style. Griffon-
Dragon Devouring
Reindeer
Assyrian. Cylinder Seal:

GROW, Ronald L. (American 1934-)
 Dwelling
 CALF-61
 Figure Sorting the Fruit 1964
 acrylic lacquer over plaster
 wood, masonite, plastic; 60x
 44-1/2 UIA-12:210 UCLCo
Growing. Motonaga
Growing Forms. Taylor, M.
Grown-up. King, W. D.
Growth. Horwitt
Growth# Rood
Growth II. Smith, G. H.
Growth with Oval. Goto
GRUNSHI See AFRICAN--GRUNSHI
GRUPPE, Karl Heinrich (American
 1893-)
 The Fairy, finial figure,
 Italian Towers PERR 84;SFPP
 Goose Girl plaster
 NATSA 90
 La Joie
 NATS 138
 Susan Clarke, head plaster
 NATSS-67:25
Gu Mask. African--Baoule
GUANAJUATO
 Female Figure ptd red pottery;
 4 BUSH 98 UMCP
O Guarda. Howard, R. B.
The Guardian. Swarz, S.
Guardian I. Mayhew, E.
Guardian Kings
 Japanese--Tempyo. Four Deva
 Kings
Guardian of the Art. Ellerhusen
Guardian of the Bones
 African--Bakota. Mbulu Ngulu
Guardian of the Forest. Carter
Guardian of the Waters. Hord
Guardian of the World. Chinese--Sung
Guardians See also Devas; and names of
 Guardians, as Shitsugongojin;
 Tobatsu Bishamon Ten
 African--Bakota. Mbulu Ngulu
 Assyrian. Khorsabad Gate
 Ceylonese. Door Guardian
 (Dwara-Pala)
 --Naga Door Guardian, relief
 Chinese--Liao-Chin. Guardian
 Diety
 Chinese--Ming. Roof Tile:
 Guardian Figure
 Chinese--Sung. Dvarapala
 --Guardian King
 Chinese--T'ang. Bodhisattva, a
 Guardian and a Heavenly King
 --Guardian
 --Guardian Dog
 --Guardian King

 --Temple Guardian
 --Tomb Guardian#
 Chinese--Wei. Buddhist
 Altarpiece#
 Egyptian--19th Dyn. Guardian
 Figure
 Etruscan. Centaur, tomb
 guardian
 --Sphinx, headless funerary
 fragment
 Greco-Roman. Hierothesion of
 Mithridates: Guardian Lion
 Greek--7th c. B. C. Lion:
 Guarding Grave
 Hittite. Lion Gate, Malatya:
 Figure
 Indian--Sunga. Stupa Bharat.
 Guardian, relief
 Indians of Central America--
 Nicaragua. Guardian Spirit:
 Man and Alligator
 Japanese--Ancient. Guardian
 Figure
 Japanese--Fujiwara. Guardian
 King
 Japanese--Kamakura. Guardian
 Figure
 --Santeira, and Bikara, guardi-
 an generals
 Japanese--Tempyo, Kongo
 Rikishi, Nio (Monastery
 Gate Guardians)
 --Guardian: Lokapala
 --Twelve Guardian Kings of
 Yakushi
 Khmer. Temple Guardian
 Korean. Guardian Figures
 Persian. Guard, relief head
 Unkei and Kaikei. Kongo Rikishi
Guatemala. de Creeft
La Guatemalteca. Bundrock-Hurlong
Guatemotzin (Cuauhtemoc; Guatemoc)
 (Last Aztec Emperor of Mexico
 1495?-1525)
 Norena, M. Monument to
 Cuauhtemoc
Gudea (Ruler of Lagash fl c 2350 B. C.)
 Sumerian. Gudea#
Gudea, Son of
 Sumerian. Son of Gudea, head
GUDGELL, Henry (American)
 Hardwood Stick, Missouri
 1863 DOV 68
GUERE See AFRICAN--GUERE
GUERRERO See also Mezcala
 Bar Pendants jadeite; c 9-3/8;
 5-15/16 BL pl 14 (col),
 pl 15 (col) UDCB1
 Bead Necklace stone; L: c 23-
 1/2 BL pl 48 (col) UDCB1

Face Panel c 500 stone
 KUBA pl 58B UCtY
Jaguar, "in flying gallop"
 sericite; L: 8-3/16 BL pl
 LXI (col) UDCBl
Male Figure before 1000 jade-
 ite; 14-1/2 WORC 20 UMWA
Mask green stone; 6-3/4
 NEWA 109 UNjNewM
Olmecoid Head red pottery; 2
 BUSH 99 UMCP
Stone Slab
 SPI-2:pl 35
GUERRERO, or MEZCALA
 Stylized Face green stone; 4-1/2
 BUSH 99 UMCP
Guerrero
 Greek--5th c. B. C.
 Guerrero, bust
GUERZE See AFRICAN--GUERZE
GUETAR
 Bowl, Costa Rica
 CHICB 12 UICA
 Tattooed Man, Costa Rica stone
 NMAS#13 UNNAmM
GUIMARD, Hector (French-American
 1867-1942)
 Figure, Castel Beranger 1897/
 98 iron
 CAS pl 276
GUINEA See AFRICAN--GUINEA
Guinea Hen
 African--Fon. Guinea Hen
GUINZBURG, Frederick Victor
 (American 1897-)
 Satyr and Goose
 NATS 139
Guitar See Musicians and Musical
 Instruments
Guitar Woman. Dahl, R.
GUJERAT See INDIAN--GUJERAT
Guli
 African--Baoule. Buffalo
 (Guli) Mask
GULIELMO, V. (American)
 The Deluge
 HARTS pl 46
 Victory
 HARTS pl 47
Gulliver. Follett
The Gunas. Noguchi
Gunungan
 Balinese. Gunungan
 Javanese. Gunungan, with Gate
 of Heaven
Guns
 Folk Art--American.
 Pennsylvania Rifle Stocks

GUPTA See INDIAN--GUPTA
GURO See AFRICAN--GURO
GURRIA, Angela (Mexican)
 Spiral stone
 LUN
GUSSOW, Roy (American 1918-)
 Mitosis, Number 3 steel
 WHITNA-11
 Mutual 1963 stainless steel;
 21x13-1/2x11-1/4
 CUM 140 -UHil
 Peristaltic Vertical steel; 78
 NM-13:#44
 Three Columns 5-15-68
 stainless steel sheet; 36-1/2
 x27x26
 WHITNA-19
 Three Forms Vertical, Number
 2 stainless steel WHITNA-17
 Two Forms 1965 stainless steel,
 forged and welded
 MEILD 84 UNNB
 Two Forms 9-12-66 steel; W:
 21 WHITNA-18:35
 Vertical stainless steel
 WHITNA-16:13
GUTEMAN, Ernest (American)
 American Scene in Metal
 Structure brass NYW 197
 Monument--model--three views
 sheet brass UNA 27
Guttus
 Hellenistic. Calene Guttus
 (Lamp Feeder): Nike
 Sacrificing a Bull
Guze Kannon
 Japanese--Suiko. Yumedono
 Kwannon
GWALIOR See INDIAN--GWALIOR
Gwendolyn, head. Whitney, G. V.
Gyoja
 Mitsuteru. Gyoja, No Mask
GYOKUYOSAI (Japanese)
 Daruma, netsuke 18/19th c.
 ivory BAR 113 FGarB
Gyoshin Sozu
 Japanese--Tempyo. Priest
 Gyoshin Sozu
The Gypsy. Dine
Gypsy Dancer. Ecuadoran--18th c.
Gypsophila II, mobile. Calder, A.
Gypsophila on Black Skirt.
 Calder, A.